THE ARTISTS' YEARBOOK 2010/11

THE ARTISTS' YEARBOOK 2010/11

On the cover photo Therese Vandling

First published in the United Kingdom in 2009 by
Thames & Hudson Ltd, 181A High Holborn, London wc1v 7QX
thamesandhudson.com

Copyright © 2009 Thames & Hudson Ltd, London
'Navigating the visual arts' copyright © 2009 Susan Jones

All Rights Reserved. No part of this publication may be reproduced or transmitted in any form or by any means, electronic or mechanical, including photocopy, recording or any other information storage and retrieval system, without prior permission in writing from the publisher.

Any copy of this book issued by the publisher as a paperback is sold subject to the condition that it shall not by way of trade or otherwise be lent, resold, hired out or otherwise circulated without the publisher's prior consent in any form of binding or cover other than that in which it is published and without a similar condition including these words being imposed on a subsequent purchaser.

British Library Cataloguing-in-Publication Data

A catalogue record for this book is available from the British Library

ISBN 978-0-500-28833-7

Printed and bound in by Germany by Bercker

Contents

00	Introduction	7
	From art school to art fair: tales from an artist's life Boo Ritson	11
	Photography as alchemy Sam Taylor-Wood	14
01	Commercial galleries, dealers and exhibition spaces Dealing with the galleries: how to build your own community	17
	Nicholas Logsdail	18
02	Public museums and galleries	140
	Culture clashes: are museums where artists go to die?	
	Iwona Blazwick	141
03	The internet	205
	The internet, your gallery and you Rebecca Wilson	206
	A different kind of enthusiast Jeremy Deller	218
04	Suppliers and services	221
	Construct your ambition: making grand ideas become realities	
	Mike Smith	222
	Art materials retailers	225
	Art bookshops	247
	Conservators	254
	Consultants	258
	Founders	261
	Framers	263
	Insurance	268
	Packers and shippers	270
	Photography	272
	Printers and printing	279
	Publishers	285
	Studio space	292

05	Art education	302
	Why art school? Options and approaches for training as an artist	
	Janet Hand and Gerard Hemsworth	303
	Further, higher and adult education	306
	Foundation studies in art and design	338
06	Art fairs and festivals	372
	Navigating the visual arts Susan Jones	373
07	Competitions, residencies, awards and prizes	385
	Studying abroad Tim Braden	386
	Being an artist outside London Heather Morison	414
08	Arts boards, councils, funding and commissioning organizations To make, or not to make: that doesn't have to be the question	416
	Andrew Brown	417
09	Societies and other artists' organizations	433
	Why be an artist? Gavin Turk	434
	How to get the most from your career: advice for recent graduates	
	Elinor Olisa and Isobel Beauchamp	465
10	Art magazines and public relations	469
	Standing out from the crowd: an introduction to arts PR	
	Philip Abraham and Calum Sutton	470
Gen	General index	
Subject index		501

OO Introduction

Introduction to The Artists' Yearbook 2010/11

The first three editions of The Artists' Yearbook were published in the heady days of the art market (and stock market) boom. Now even megastar artists are cutting their expenses and laying off staff in their studios. But, of course. for most artists the amounts of money realized at auctions or art fairs for some contemporary art were never really relevant to their own practice. Most would happily settle for more modest objectives: to enjoy producing their work, have it shown to an interested public, to sell some work for a reasonable price and to make a decent living. Unfortunately, hard economic times seem set to make achievement of even such modest aspirations more difficult. In this edition of The Artists' Yearbook we have asked art world experts to provide some essential advice to help you survive, succeed and thrive in tougher economic times.

All is not gloom by any means. In this edition you will find essential information about several valuable prizes. The FLAMIN Awards offer funding from £20,000—£50,000, The Royal Scottish Academy of Art and Architecture has £45,000 per year for new awards and the National Open Art Competition is worth £10,000. In Wales the Safle Graduate Award pays £10,000, while in Milton Keynes £5,000 is available from the FringeMK Painting Prize. And a number of new galleries provide exciting new venues for artists' work: for example, Calvert 22 in London, The Hepworth Wakefield and Nottingham Contemporary.

Susan Jones, Director of Programmes at a-n, The Artists Information Company based in Newcastle-upon-Tyne, believes that artists are professional people every bit as much as lawyers or accountants and that professionalism is the key to success in the art world. In an essay entitled 'Navigating the Visual Arts', she sets out a code of professionalism that artists should constantly refer to in order to aid their progress and keep their affairs in order. The well-

honed survival skills you will require include communication, negotiation and management. But, as she discusses, a confident, open and aspirational frame of mind is more important than following any rigid guidelines and will give you an edge over some of the other 60,000 artists currently working in the UK and the 3,700 who finish various art degrees and courses across the country every year.

No artist can afford to neglect public relations, so how better to explain how to be a really professional advocate of your own work than two leading experts. We turned to Philip Abraham and Calum Sutton to give our readers advice on this vital area of professional practice. PR is not a mysterious art, there are lots of nuts and bolts that you can learn, and there are skills we can all learn to apply. Mistakes can be costly, so read their essay for many invaluable tips.

More advice for recent graduates comes from Elinor Olisa and Isobel Beauchamp, founders of DegreeArt.com, an organization founded in 2003 to help student artists and recent graduates launch their careers. The student degree show is only the start of a career, but a significant launch pad and it is important to get it right. Aspiring artists need to know how to handle their self-employed status, and how to promote themselves. Olisa and Beauchamp also provide invaluable guidance on organizing your own show (location, sponsorship, funding and promotion are the keys) and working with galleries.

Andrew Brown, Senior Strategy Officer for Visual Arts at Arts Council England, points out that confining yourself to making a career and a living by making and selling art alone is risky. Relatively few artists can truthfully afford to pursue such a purist approach. But do not despair because there are other routes to a rewarding life as an artist. One obvious option is teaching, but this need not be limited to instruction in art schools: many organizations offer education programmes staffed by artists. Artists are highly trained professionals with a set of desirable skills. Brown provides a host of ideas to help you identify opportunities for

your skills and abilities. Opportunities are by no means limited to the art world. Above all, networking and professional skills are essential.

But, of course, the success that young artists dream of can become a reality for those who are talented - and lucky enough - to 'make it'. Boo Ritson, who obtained her MA from the Royal College of Art in London in 2005 is one such success story. In a very personal essay she tells of the excitement as well as some of the challenges that she faced, whether in setting up an installation in Los Angeles, undertaking an ill-planned project in Amsterdam, or the pitfalls of painting powerful figures in New York. Success may be sweet, but it does not always come easily.

Artists who have adopted different, very individual practices offer yet more advice on how to approach your work. Sam Taylor-Wood discusses the ways that photography fits into her work, while Jeremy Deller explains how he established a radically different position in the art world. Unusually, he had no formal art school training, he uses many media and much of his work consists of collaborations with other artists. Mike Smith, whose firm provides engineering solutions for artists, adds some invaluable advice on the practicalities of making your work.

Nowhere is the market for art more open than on the internet and Rebecca Wilson, the editor of Charles Saatchi's popular online meeting place for artists, Your Gallery, writes of the unprecedented levels of communication and collaboration available to artists nowadays, as well as how such democratic websites can also attract the odd appreciative buyer (like Saatchi himself).

Important as the internet has become, 'bricks and mortar' institutions are still vital to most artists. Leading gallery owner Nicholas Logsdail offers an insider's view of how artists can work with a gallery to develop and support their career. Iwona Blazwick, a noted museum director, curator and critic, discusses museums as a vital element of a contemporary artist's practice.

There is still room for those who do not want to rush headlong into a commercial career, especially away from London, the acknowledged centre of all things market related in the UK. Artist duo Heather and Ivan Morison left the capital to settle down and make art in Birmingham, buying an allotment that became the focus of some of their practice. In her essay on the benefits of living outside the conventional hub of art activity, Heather Morison describes how they then moved to a remote spot in Snowdonia and continued to flourish and succeed as artists, albeit under different terms from their colleagues in the capital.

Some artists choose to go further afield to set up their studios. Restless artists will find inspiration in the section devoted to competitions, residencies, awards, prizes and other funding opportunities that facilitate travel and provide useful support for your practice. In a guide to what to expect, Tim Braden recalls the initial bewilderment, followed by his occasionally demanding but happy years spent studying in Amsterdam at the prestigious Rijksakademie.

Just as location need not matter. The Artists' Yearbook does not differentiate between the amateur and the professional artist. It is designed to be useful for everyone, from the undecided undergraduate looking for the right degree course or the best college to the hobbyist painter in search of a local supplier of canvas and paints, as well as the established artist urgently needing to organize safe passage for their work to an exhibition in a Berlin gallery.

When artist Gavin Turk was asked to respond to the provocation 'Why be an artist?' he travelled back in time to find out just how useful the endeavour of creative thinking and doing can be. His break-neck survey of the history of art is one beamed clearly through the lens of the artist - the view of the passionate maker.

The likelihood of making it as an artist is greatly increased by spending time at art school and many courses offer the kind of vocational training that is essential for developing and sustaining an artistic career. Whether you are looking for part-time study, a place on an art foundation or degree course, or even a post-graduate qualification, the essay by Janet Hand and Gerard Hemsworth of Goldsmiths College in London should be required reading: it offers a step-by-step guide to choosing the right course.

As the cycle of making, exhibiting, selling and appreciating art is such a restless process, it naturally follows that the art world itself is a moveable feast. We update this book to account for this constant flux, weeding out the dead wood, adding in the new shoots and supplementing the current categories of information wherever possible. Whether you see being an artist as your calling in life, a professional vocation or just a pastime, hopefully this book should provide advice and contacts to help you meet your personal and professional goals.

A Note on Using The Artists' Yearbook

The Artists' Yearbook is divided into ten sections of listings, each preceded by at least one essay written by an authority on the topic. There are subdivisions within some of these sections. for instance, the chapters on commercial galleries, dealers and exhibition spaces or public museums and galleries are divided by region and each venue is listed alphabetically within the appropriate geographical area. The large section on suppliers and services is broken down into sub-categories, including art insurance, consultants, conservators, packers and shippers, printers, print publishers and printmakers and so on. Art education is divided into two sections: degree-giving institutions and foundation courses; within these two sections listings are alphabetical. The smaller sections. such as art fairs and festivals and art magazines and public relations, are not regionalized, but simply arranged alphabetically by company or event name. While this directory focuses on England, Wales, Scotland and Northern

Ireland, some of the sections, such as competitions, residencies, awards and prizes and societies and other artists' organizations, list a number of overseas artists' groups and opportunities for artists looking to work outside the UK.

If you want to find an organization whose name you already know, turn to the General index. If you know what kind of material, service or style of art you are interested in, but do not know where to find it, use the Subject index. This index is designed to group specialist categories of art, working practices or media together and includes such general terms as painting and sculpture, as well as more particular kinds of media such as ceramics. photography and watercolours. As many galleries and museums cater to multimedia forms of art and do not actively distinguish between them or specialize in one field, this Subject index will by and large not refer you to the listings of non-specialist venues or services.

The listings are generally self-explanatory, but where categories of information are missing – perhaps a website address or a gallery's submission criteria – it is because either the information does not exist or it has not been provided. However, while we have made every effort to confirm that the correct contact details have been included for every entry within *The Artists' Yearbook*, as with all such directories, addresses, contact numbers and email addresses are subject to change. To account for the art world's comings and goings, the book has been updated.

If you would like us to add a new entry, or wish to update or correct an existing entry, or have a suggestion for improvement, please write to:

The Artists' Yearbook Thames & Hudson Ltd 181A High Holborn London WCIV 7QX

E artistsyearbook@thameshudson.co.uk

From art school to art fair: tales from an artist's life

Boo Ritson

When I sat down to write this it was going to be a fairly simple run through of What Happened Next, and How It Happened, but that would have been the ordered, calm and hindsight view - like the revisionism we sometimes practice when asked what our work is about with the benefits of much time spent thinking since making it. It hasn't been what went right that has been the best part of the last three years since graduating, but the unimaginable and unexpected (and just plain wrong) that has shaped my practice. What I have written about here are the situations that being an 'innocent' artist abroad have led me into. There really should be an alternative guidebook for how to work away from home and survive it, with chapters devoted to getting it right with gallerists when neither of you speak the language, how to explain that you don't really paint things that can't sign a consent form and other valuable pieces of advice that someone has to learn the hard way before passing them on. So here are some of my adventures, miscellaneous mistakes and lucky opportunities.

Leaving college

In 2005 I finished my MA at the Royal College of Art in London. I received a great training but it turned out to be a lot harder to become a practising artist than I had thought.

I'd always imagined that life after leaving the Royal College of Art at the end of my MA would follow a straightforward route - that I'd take down the show, hire a van to bring my stuff home, and set about working, both for money and on new work. It was an event I looked forward to, the chance to spend time thinking about all the ideas that had been flying around in my head from all the conversations and tutorials I had experienced in the last two years. It was also a hope that I would get further along

the road in finding an area of ideas to work in that I could stay with for a while - thoughts that would last beyond waking up the next morning and realizing that the thing collapsing under my gaze on the floor of my studio wasn't what I optimistically thought it to be the day before: I had begun to realize that a fundamental shift away from what I had previously been looking at was needed, and I looked forward to it enormously.

Showing your portfolio

It's 2004 and I've been asked by a dealer at a private view if he can see my portfolio. It's probably not the best policy in your first year on an MA at the Royal College to turn things down because you don't feel you're ready and you know the work isn't good enough, even if you think that's the right thing to do. Be very grateful when the same dealer calls again a year later and still wants to see your work, and remember that if dealers are old enough to smoke, then they're old enough to make all kinds of dangerous and risky choices, and can handle the decision on their own. Be especially grateful if, like David Risley, they turn out to want to represent you, and after a few months are giving you the whole gallery to screw up in. They may well turn out to be right to have more confidence in your abilities than you wake up with on an average day - that's why you just make the work.

Making an installation in Los Angeles

It's 2003 and I've made an installation of my degree show piece in Raid Projects, Los Angeles. It's definitely wise to hold onto your degree show work for a while in case you end up being asked to show it again somewhere. And if that somewhere turns out to be in LA, and you have to re-make the work you've thrown away, don't end up working so hard or for such long stretches that you get clumsy, end up slicing your finger to the bone, and earn a seat in LA county charity hospital next to the sixfoot guy in handcuffs and an orange boiler suit. It's a great way to meet new people and may

even provide material for your next piece, but you may find the gallerist a little bit cool until you've managed to complete the installation. And on the subject of showing in LA, don't on your grateful return to exhibit and install at the same gallery the following year work so hard or for such long stretches that you collapse due to heat-stroke. Know that in the desert a long, sun-facing non air-conditioned window will soon fry your brain - and don't take the drugs that the medics offer you - they're way too strong for you to finish installing with any degree of certainty that you have made a single correct creative decision that day. But if you do continue to be asked to travel to new places to work, and you do inevitably find new mistakes to make, remember that you've been given the chance to make them - and know that at least your visit was memorable.

Eindhoven

It's April 2006 and I'm offered a short residency at De Fabriek in Eindhoven. With the red lights of Amsterdam close-by, it's a great opportunity to explore the subject of 'the hooker' - there's a good rail link between the two cities, and a ready source of models to paint. Perfect. I've found the office where the red rooms were rented, and have sat there under the heavy eyes of two bouncers while a huge pile of cash is delivered, with dire warnings not to touch or look at the cash while I wait for permission to talk to the girls. The only trouble was that the girls don't want to talk to me beyond the bit where I start to explain about being a model. When you can't get a hooker to sit for you, and I tried and tried at every red door I could find, you know there may be something a bit amiss with your ideas - or something you haven't considered - and it means you will have to end up sitting for the piece in a too-tight bra and some skimpy towelling shorts. And because it has turned out to be a successful piece it then travels on to an art fair in your home town, so now your mum can see it too and the desire to have done things differently gets a bit stronger.

So I think the three things I learned from this are that it's best not to have an idea for something that you wouldn't be prepared to do yourself, that it's best to leave yourself enough time to find an alternative if you're too chicken and never underestimate what people find unacceptable—hookers have standards too.

New York

It's 2006 and a collector buys my work at an art fair, and it turns out his name is John Lee and he has a gallery in New York and would like to meet me. He reminds me of John Belushi (which is a very good thing) and we agree to work towards a show. Now it's 2008 at BravinLee Programs, New York, It's the week of my first New York solo show and I'm there early to paint a few people before it opens: my paint brushes have made it without getting lost and the paint has been ordered from an international paint palette and is waiting at the apartment. Let's hope this time it really is an international palette and I don't end up with shades of beige and green like the last time I ordered paint from a man I didn't know because I don't have time to bus over to ask Bob in South Hackensack, New Jersey to re-mix it all. It's an unbelievable opportunity to paint some powerful political players, the kind who calmly shower off after the shoot and head straight off on a train to help Hillary with her Pennsylvania campaign. It's the chance to find out what the whole election juggernaut is all about, a chance to get the inside track on how it's all going, and it's best to have prepared at least one intelligent comment or incisive question to ask. There's nothing like being dumb in front of the great and the good to make you wish you could start the day again there are still enough people who see art as the occupation of the intellectually challenged for you still to do some real damage as you stutter and become mute.

Art fairs

It's a real buzz to meet people who have seen your work and are prepared to say that they

like it and this can happen at the art fairs that your gallery takes your work to, so it's not a completely wrong thing to want to go to see your work on the wall, despite it sometimes feeling like a giant Wal-Mart. It would be even better if the all same people came to your show where they could see the work on its own and have a cup of tea and a chat, but that's asking a great deal when there's no parking space in the gallery backyard, so it's best not to forget that we're also in the real world, not just the art world, and if the work isn't always in the best place we want it to be in, at least it might be in a vast hall in Basel, or a nice big tent in a park in London, one day.

The ones that got away

I've said yes to everything that meant I could either make work abroad, or exhibit it, from the group shows after my BA that only a couple of people came to see, to the busier and more publicized exhibitions that get put on when you're represented. I'm really, really grateful that so many different opportunities have come my way - but sometimes an offer comes along and it just can't be done - like the residency in a city in Brazil I was offered last year that would have seen me travelling to and from the gallery in a bullet-proof car on account of the high rate of hostage-taking in the area. Because I'm quite literal I don't know if the gallerist was joking when he told me the story, or whether this was a normal way to travel if you were a local artist, but to my mind if it was true it offered less than ideal conditions for making work, and I was beginning to learn from some of my mistakes, so it didn't happen. Then there are the e-mail

offers and conversations that sound so exciting, only they don't come to anything because you find out you have to pay to use a space, or that they can't afford to ship the work over, or they won't under any circumstances talk to your gallery like they should do, so it becomes too difficult and the opportunity ends up in the might-have-beens.

Finally

The best thing I've learnt about what it has taken for me to get along and get ahead with the work that I now make is that's it has always been about the people and the places where I've met them. Writing this is a reminder to me that while your work may frustrate you and ideas may desert you from time to time, it's the people who've popped up along the way that you take with you, and that you rely on to make today as bright as yesterday. I'll miss seeing Walter the doorman, who flipped the rotating door to the apartment block with panache, but always had time for the grubby and shoddilydressed artist who lowered the tone by staying there for a week. I know I can't always work with the people I'm used to because lives change and people travel and galleries don't stay the same forever, but it'll be OK because tomorrow there will be another piece to make, or a trip to arrange, or a story to tell.

Boo Ritson is an artist who paints people: she literally applies paint to the subjects and then photographs them. Her work is represented by Poppy Sebire Gallery, London, Alan Cristea Gallery, London and BravinLee Programs, New York.

Photography as alchemy

Sam Taylor-Wood

Sam Taylor-Wood is a photographer, film and video artist who explores emotional and physical extremes through carefully crafted and choreographed scenarios. Since graduating from Goldsmiths College in London in 1990, she has produced some of the most complex and cinematic photographs in British art, especially in two early series involving 360-degree panoramas - Five Revolutionary Seconds of 1996 and Soliloquies, begun in 1998. Her self-portraiture ranges from the intensely personal and confrontational images of Slut or Self Portrait in a Single Breasted Suit with Hare to the acrobatic and physically demanding theatrics of her Self Portrait Suspended and Bram Stoker's Chair series of 2004-2005. She has continued to explore the boundaries between art and artifice in her depictions of over two dozen Hollywood movie stars in various degrees of acted or induced breakdown for Crying Men. 2002-2004. In addition to solo shows in 2006 at BALTIC, Gateshead and the Museum of Contemporary Art in Sydney, she was the first woman to be granted a retrospective at the Hayward Gallery in London in 2002 and is represented by White Cube in London. Taylor-Wood discusses the role of photography in her practice, revealing the secrets behind her first photograph, her influences and inspirations.

When did you first pick up a camera?

I took my first picture at around five years of age, of my parents together in Belgium. It's small and square with a yellowing border depicting their feet at an angle, but is a spectacular picture that holds a lot of memory for me. From there I didn't focus much on photography until school when I took an O' level in it.

What specific features of the medium first appealed to you?

The magic of it – the alchemy and the unexpected.

Were your peers or inspirations also photographers?

Not really. Most of my friends were painters, which made photography more special as a medium. I take most inspiration from painting and life.

Which painters have inspired you, and are there any tangible similarities between your practice and painting?

Caravaggio is one artist that springs to mind and I spend a lot of time at the National Gallery looking at religious painting for its sense of pathos, theatre and extreme humanness. As for similarities, I look to painting for the way it represents ideas, thoughts and emotions.

Did you study photography formally? Was it widely or well taught in your opinion? I studied sculpture at Goldsmiths until

I studied sculpture at Goldsmiths until 1990, but it wasn't until over a year after leaving before I quietly began to investigate photography. It suddenly gave me the voice I was looking for. I realized that all my thoughts were images and that sculpture was just a process for me that held limited ideas.

Would you advise young artists to take a course in practical photography (developing techniques, etc.)?

I guess so, although I believe that knowing too much technically can ruin an artist, as you know the tricks without the experiment and adventure.

Is photography more integrated into the art world now, and what is its status relative to other media?

Yes, it is totally integrated now and with equal status.

How does the photography scene in London and the UK seem to you, say in comparison with other major centres such as New York or Paris?

New York has a stronger emphasis on photography as an important medium. There are a lot more dedicated photography galleries there.

Do you see a distinction between photography and fine art?

I look at it this way, art is about ideas - not ideas to promote or sell a product - but ideas or thoughts that can form a conversation within yourself about your deepest psychological feelings. In this way you work with only yourself in mind, no one else matters. The medium of those ideas is specific to the artist but the sphere of commercial photography involves an entirely other world.

How does your appreciation of journalistic or commercial photography differ from that of the photographic work you encounter in a gallery?

I don't see the distinctions as that clear-cut, because one of the most powerful photographs I have ever seen was taken by a journalist in Armenia, of a woman crying next to a wall. It had so many painterly qualities as well - which I am sure he was aware of - with the woman's red shroud recalling images of the Virgin Mary.

Do you have much experience of commercial photography and is it something that struggling artists can take up in order to fund their private work? Would you recommend this to young artists as a valid means of subsistence?

Being commissioned to do other photography work apart from your own is great. It makes you think constantly, it keeps you in motion. Obviously, you have to be discerning, you have to choose work you are interested in and that it is someone or somewhere genuinely interesting to photograph. You may find you can be just as influenced by these people or

places as you can by other art or artists. I don't necessarily see commercial work as a sell-out or a compromise.

How important is reality in photography? The whole notion is questionable. Does photography really depict reality or does it represent an invented reality?

How does your video work relate to your photography? Do you view the two media in parallel or completely separately? Strangely, I view them completely separately. It's almost as though I use two different parts of my brain and work in two contrasting speeds. Film is more meditative and the process is much more constructed but also terribly frustrating. Photography is all over too quickly.

When, if ever, is scale important or relevant for photography? Should artists avoid going big? It is tempting to go big, but big is not necessarily better; you have to balance the idea with the scale. The first series I went big with was Soliloguies, which all had additional captions running below the main images. These totally distinct elements meant that the upper portions had to be large-scale in order to be able to read the texts. On the other hand, I made a series called the Passion Cycle that was photographs of two people having sex, but in this case. I felt the flesh needed to be made small and intimate.

When to use black-and-white and when to use colour?

That is just instinct.

How important is finding a good printer? Essential. If you aren't going to do it yourself you need someone who cares as you do.

Has digital technology endangered or enhanced photography?

Not really, it's just another process - although it is making it harder to get specific film and papers.

Are technological advancements in art-making of any concern to your work?

They are not a concern so much as a means to enable you to do amazing things. Without Photoshop, for example, I wouldn't be able to make a series of images in which I am seemingly suspended in mid-air above my studio floor.

What, in your opinion, elevates the everyday snapshot to a work of art?

Nothing elevates it in that way. It's about the artist, their work and their social context, the context it is made in. Then it comes down to the idea behind the piece and whether it can hold its own or whether it needs to be part of a larger body of work to give it significance.

How do you take pictures? Are you an impulsive photographer or a meticulous controller of your images?

A meticulous controller. I also spend a long time going through my contact sheets.

Can you learn artistry in photography? Is the skill more important than the concept or vice versa?

Skill in conveying your idea is the most succinct way to enable the idea to be understood or at least appreciated.

What other photographers do you admire (contemporary or historical) and why? Diane Arbus for her ability to be courageous and make images you'll never forget. Cindy Sherman for making the path easier to walk. Dorothea Lange for making my all-time

favourite photograph, Migrant Mother, 1936. When I first saw it, I remember wishing that I had taken the picture and she was the same age as me, 32, when she took it.

Do you (have you) used elaborate set-ups and techniques for your work (I am thinking here of your 360-degree images *Five Revolutionary Seconds*)?

I've been working a lot with a bondage expert who comes in and dangles me from the ceiling of my studio for hours on end to produce two recent major bodies of work, the first being *Self Portrait Suspended* and then *Bram Stoker's Chair*, both of which were pretty elaborate.

Should artists be aware of how much their photographs are going to sell for, i.e., taking into account the number of prints or the size of an edition, or are these concerns best left up to a gallery?

I get freaked out by thinking about prices or my work in those terms; besides I have no head for numbers. It really is best left up to the gallery, but I have always stuck to the same edition of six for all my prints.

Do you suggest artists employ a traditional photographer's assistant?

It helps if you are technically challenged, but obviously depends on your budget.

Where do you see the art of photography going next?

I'm not sure but the digital revolution scares me.

01

Commercial galleries, dealers and exhibition spaces

Dealing with the galleries: how to build your own community

Nicholas Logsdail

There is no single pathway to being an artist. If there were it would be much like any other industry such as medicine, accountancy or the legal profession, where there is a structured and ordered process. By its very nature, the art world is both straightforward and yet also quite baffling until you have acquired 'the knowledge' (to use the analogy of the apprenticeship undertaken by every London taxi driver). For anyone who aspires to be an artist with a capital A, this is the only way.

Know your gallery

There is an extraordinary naivety among certain artists who believe that their lack of success is simply because they do not have a good gallery. This has nothing to do with it; the gallery does not make the difference, nor will a good gallery take on an artist unless the work and studio practice are sufficiently interesting.

There is no single system or specific way of discovering new artists. Good galleries are always trying to find the best interface with new art, but it is a complicated process; one can only be enquiring, open-minded and knowing, and hopefully make a decent judgment. You feel it when someone is really interesting, when you can envision the work carving out a place in history. This comes not only from the work itself but from the combination of your knowledge and an original mind. I have seldom encountered a talented artist who subsequently becomes important who was not knowledgeable or clever - not necessarily in the conventional sense, but a degree of artistic intelligence is necessary to any kind of creativity.

Artists are in a difficult position, but generally if they fit the criteria mentioned above they will find the path through their own skill. Just putting a foot in the door doesn't work because there are hundreds of people trying to do that. Neither does cold-calling galleries,

especially if you haven't been there or don't know the names of some of the artists they exhibit.

There is a great resentment among young artists who see galleries as snooty and uncaring, but it is not a closed world - go to openings, know your galleries. This is where knowledge and education come in. Artists should be informed and aware of what is happening. It must be a passion, an obsession.

Know your history

All young artists, particularly students and those in the formative phase of their careers, should immerse themselves in the art history of the past fifty years and come to terms with general art history. This way they can position and judge themselves against the best art out there, which has already been validated. My experience of students is that they are full of the arrogant, intellectual blossom of youth - which is very attractive and can be turned to great advantage - but as often as not, it is merely an excuse not to learn or inform themselves. An ignorant artist is not likely to go very far, because you need to be able to discuss your own work with a breadth and depth of reference that makes such a conversation interesting. There is an enormous difference between being able to talk about your work well and just being pushy or opportunistic.

Being able to convey artistic or intellectual information, and question it, forms part of the mechanics of becoming an artist, but the other part is doing the right thing, at the right time and in the right place, as well as meeting the right people. It is important to foster professional friendships, and building a community around you does this.

Create your own scene

Good art does not come without community. This community is built in many ways and begins, for most artists, when they join the art school system. The conceptual artists of the 1960s and 1970s, the British sculptors Tony Cragg, Richard Deacon, Anish Kapoor et al,

the YBAs or the Royal College situation before that - these were all small, intense young communities of like-minded artists.

My early history was about creating my own community. The Minimal/Conceptual art movement of the late 1960s, when I started, was a particular way of thinking about art that was specific to my generation. When one group forms and becomes powerful it takes a kind of insider control over the international contemporary art world, gaining the support of the serious critics, museums and collectors. Each subsequent generation takes a position that is contrary in some way to the previous one, and this engenders what we call 'movements' in art. Often these are not consciously created. they just happen, but they always happen through the formation of community.

Artists at heart

If you cannot create your own community, you can always look for a community to which you feel you belong. A gallery is one such place.

There is a major distinction between a gallery and an art dealer. Many dealers only manage to sustain their contemporary art programme through backroom sales of secondary-market material. On the other hand, galleries such as the Lisson Gallery aim to develop the careers of emerging or living artists - they are not dealers as such - and this sense of purpose was characteristic of many of the more serious galleries of the past. Clearly, conventional art dealing is the more profitable activity (even if you are only taking ten per cent) because the margins are smaller and all you need are knowledge and contacts. However, galleries whose prime preoccupation is dealing have less time to service or look after the interests of their artists.

Neither of these two different models is right or wrong. When I started the Lisson Gallery 37 years or so ago, it began as an artistcurated space; that was always my idea of what a gallery should be. I came to the field with no formal training or preconceptions: in fact, I was just over 20 years old when I got thrown

out of art school for doing this, which is one of the reasons why I did not continue as an artist myself. Many people who enter the gallery scene come from the business side, the auction houses or the high-powered commercial galleries, and because of their experience and education they have a very different viewpoint.

The challenge or ideal of a gallery that sustains itself through its living artists should be self-fulfilling: if the central focus is on the quality of the artists, then they should be good enough to sustain the gallery economically. This is by no means the easiest path, but it fosters loyalty with artists. The other side of the business is when the gallery becomes a selling operation, rather than a nurturing one; any gallery can enter the scene once an artist has become well known or commercially viable. Loyalty of artist to gallery and vice versa is the only way to build a solid history with the right gallery or community.

Commerce and other dirty words

Unfortunately, the art world has changed so much in the past twenty years that the economic pressures are now greater than ever - everything costs more. Although we have to project ourselves as affluent organizations, galleries are not such profitable enterprises. We turn over relatively vast sums of money many millions of pounds - but if you look at what we have to pay for, there is often not much surplus. A gallery runs essentially on its cash flow, so even as artists become more ambitious and grow with the gallery, we can afford only to share major fabrication costs and generally work to the international art world standard of 50 per cent commission on works of art.

Tying up vital capital in the long term can be problematic, but it is sometimes essential. Galleries' problems are thus linked to artists', because they are part of the same world; if a gallery's artists all have big commercial and financial worries, then so will the gallery.

Lisson is not commercial in the sense that it does not encourage artists to make work

whose significance is only to supply the market. Inevitably, if an artist sells one piece of work they will then make two more - that is how the system works - but artists who continue to churn out their work like a product line, even if it is selling well, can be committing artistic suicide. The art world is full of exceptions and contradictions, of course; take Pablo Picasso, who made thousands of works without undermining his market.

Art, language and vision

Strategically, artists should begin with some vision of the end in mind - perhaps of where they want to be in five or ten years' time. The contemporary art world has become quite black and white, with not a lot of middle ground, so by the time an artist is in their late twenties they really need to be honest with themselves about how they feel about the quality of their work. Artists who blame others for their lack of success are very unlikely ever to do well.

Having said all of this, great artists are not overly concerned about how the world sees them and so make art for themselves rather than the marketplace. Success should not be the only reason why you want to be an artist in the first place, and maybe you should start

out with the idea that there is no such thing as success or failure. For example, some artists with MA qualifications choose to teach one or two days a week, even though they could make more money and be more productive. prolific and successful making art. This doesn't mean they have failed; some teach out of necessity, while others want to put something back into their community. It simply means they have taken a different pathway and understand the journey they have chosen to embark upon.

Instead of seeking 'success', an artist should make it their life's work to develop an original and personal language. It is then the job of the gallery to interpret that language so that it transcends everything the artist does. Although the chances of rising from art school graduate to top international artist are depressingly small, if you want to be a serious artist then there is no point in aspiring to be something less than the best, at least until you find a level you are satisfied with.

Nicholas Logsdail is director of the Lisson Gallery in London, which he founded in 1967. He represents international and British artists, including Douglas Gordon, Anish Kapoor and Julian Opie.

Commercial galleries, dealers, exhibition spaces

East Anglia

Ann Jarman

The Old Fire Engine House, 25 St Mary's Street, Ely, CB7 4ER

T 01353 662582

F 01353 668364

E ofeh65@hotmail.com

W www.theoldfireenginehouse.co.uk

Contact Hannah Jarman

Founded in 1968. All media shown. Artists represented include Julia Ball, Richard Bawden, Robin Boyd, John Brundsen, Anthony Day and Roger Philippo.

Submission Policy No specific entry requirements except gallery's approval of the work.

Price range £50-£2,000 No of exhibitions annually 20

Arna Farrington Gallery

High Street, Thorpe-le-Soken, C016 0EA T 01255 862355 E contact@arnaandfarrington.co.uk

W www.arnaandfarrington.co.uk
Mainly a ceramic and jewelry studio that also
offers a diverse collection of art and craft
from both established and emerging artists.
Promotes work from makers living and working
in Britain.

Submission Policy Submissions welcome. Email or post images and details.

No of exhibitions annually Variable

Big Blue Sky

of Norfolk.

Warham Road, Wells-next-the-Sea, NR23 1QA

T 01328 712023 F 01328 712024

E shop@bigbluesky.uk.com

W www.bigbluesky.uk.com

Opened in 2003, selling an eclectic mix of contemporary art, craft and design by artists and craftspeople from Norfolk. Work includes painting, photographs, print-making, jewelry, glass, ceramics, furniture, wood-turning, fashion accessories and home accessories. Artists include Vanessa Vargo, Simon Cass, Sarah Horton, Peter Lely, Stephen Parry and Claire Robertson.

Submission Policy Artists must live and work in Norfolk or their work must represent something

Price range £5-£4,500No of exhibitions annually 6-8

Bircham Gallery

14 Market Place, Holt, NR25 6BW

T 01263 713312

E birchamgal@aol.com

W www.birchamgallery.co.uk
Contact Deborah Harrison or Gail Richardson
Specializes in contemporary British paintings,
original prints, Modern British graphic works,
ceramics, glass, sculpture and jewelry. Artists
include Elaine Pamphilon, Sophie Knight, Emma
Williams, Reg Cartwright, Richard Bawden, Robert
Greenhalf, John Piper, Victor Pasmore, Nicholas
Homoky, Walter Keeler, John Maltby, Vanessa
Pooley, Disa Allsopp and Elaine Cox. Approved for
Arts Council England's Own Art scheme.
Submission Policy Invites applications from
artists in any medium (UK only). Include images,
statement, CV and sae for return.
Price range \$IO-\$IO.000

Broughton House Gallery

No of exhibitions annually 10

98 King Street, Cambridge, CB1 1LN

T 01223 314960

E bhgallery@btconnect.com

W www.broughtonhousegallery.co.uk
Founded in 1987, exhibiting mainly living artists.
Holds the archive of the work of Gwen Raverat
(prints made by her for sale) and work by G. D.
Aked. Ceri Richards, Jack Hellewell and Norman

Mommens.

Submission Policy Initial approach by email or disc (not by personal visit). No large sculptures or pop art.

Price range £50-£2500No of exhibitions annually 6

Buckenham Galleries

81 High Street, Southwold, IP18 6DS

T 01502 725418

F 01502 722002

E becky@buckenham-galleries.co.uk

W www.buckenham-galleries.co.uk

Contact Becky Munting

Founded in 1999 with the aim of showing contemporary fine and applied art from local, national and international artists. Seeks to maintain a friendly atmosphere in which clients and artists can relax and discuss the work. There are five galleries on two floors.

Submission Policy Any living artist considered.

Price range Usually up to £2,500 No of exhibitions annually 9

Byard Art

4 St Mary's Passage, Cambridge, CB2 3PQ

T 01223 464646 F 01223 464655

E info@byardart.co.uk

W www.byardart.co.uk

Contact Juliet Bowmaker or Ros Cleevely Established in 1993. Runs an exhibition programme of contemporary fine and applied art in a series of solo and group shows throughout the year. Exhibits figurative and abstract art ranging from established names to young emerging artists. Maintains a strong presence at selected art fairs in London and New York.

Submission Policy See website for details.

Price range From £100

No of exhibitions annually 8

Chappel Galleries

15 Colchester Road, Chappel, Colchester, CO6 2DE

T 01206 240326

F 01206 240326

E chappelgalleries@btinternet.com

W www.chappelgalleries.co.uk

Contact Edna Mirecka

Founded in 1986. Sells contemporary painting and sculpture of predominantly East Anglian artists or those with a strong regional connection. Artists represented include Roderic Barrett, Mory Griffiths, Jonathan Clarke, Bernard Meadows, Wlodyslow Mirecki and Paul Rumsey. Submission Policy By invitation only.

Price range Up to £30,000

No of exhibitions annually 13

Choyce Gallery

26A George Street, St Albans, AL3 4ES

T 01727 739931

F 01920 463003

E kaleemwalden@bt.co.uk

W www.choycegallery.co.uk

Housed in a building dating back to the fifteenth century, the gallery exhibits glass art produced by contemporary artists mainly from Britain and Europe. Also contains a designer jewelry and fineart section.

The Darryl Nantais Gallery

59 High Street, Linton, Cambridge, CB21 4HS T 01223 891289

E enquiries@nantais-gallery.co.uk W www.nantais-gallery.co.uk Contact Karl Backhurst

Sells oils, pastels, watercolours, acrylics, charcoals, coloured pencil work, limited-edition prints and silkscreens. Exhibits and sells works covering a range of styles, from traditional to contemporary. Subjects include landscapes, seascapes, flowers, animals and abstract work. Also offers a framing and restoration

Submission Policy Preferred submissions by email with images or website information.

Price range f_{50} to $f_{5,000}$ No of exhibitions annually 5

Harleston Gallery

37-39 The Thoroughfare, Harleston, **IP209AS**

T 01379 855366 F 01379 855366

E challis@harlestongallery.fsnet.co.uk Founded in 2001, with the addition of a coffee shop in 2003. Aims to promote an enjoyment and understanding of the visual arts within the community. Areas of specialization include paintings, prints and contemporary crafts (ceramics, glass, jewelry, sculpture, textiles, wood, etc.)

Submission Policy Artists residing in East Anglia are welcome to submit a CV and images of recent work by post.

Price range $f_5 - f_{1,000}$ No of exhibitions annually 6

Head Street Gallery

Halstead, CO9 2AT

T 01787 472705

E information@headstreetgallery.co.uk

W www.headstreetgallery.co.uk

Mainly shows contemporary work. Exhibitions throughout the year last seven to eight weeks, with a private view during the first week. Two artists are featured each time, each occupying one room. A third room hosts an ongoing display by various local artists. There is also an art library. The gallery sells paintings, sculpture, glass, ceramics, jewelry, handmade gifts, toys and cards.

Submission Policy Submissions from artists are welcome. A CV, statement and at least three images of work should be sent via post or

Price range All price ranges No of exhibitions annually 7

Hertfordshire Gallery

6 St Andrew Street, SG14 1JE

T 01992 503636

F 01992 503244

E info@hertfordshiregallery.com

W www.hertfordshiregallery.com

Contact Colin Gardner

Founded in 2003. Showcases and retails original work by Hertfordshire artists and craftspeople, including paintings, ceramics, glass and photography. Sponsors the Hertford Art Society, Welwyn Garden City Art Club and Enfield Art Circle Exhibitions. Based in the Hertfordshire Graphics art shop.

Hunter Gallery

Coconut House, Hall Street, Long Melford, CO10 9JQ

T 01787 466117

E info@thehuntergallery.com

W www.thehuntergallery.com

Contact Camilla Rodwell

Founded in 2001. Represents painters including Stephen Brown RBA, Andrew King ROI NS, John Lowrie Morrison, Caroline Bailey, Edward Noott and John Tookey PS. Also shows sculpture by Kate Denton, woodturned vases by Richard Chapman and fine contemporary furniture. The gallery is spread over four rooms and there is a large sculpture garden. Also offers bespoke picture framing.

Submission Policy Applications by email to camillarodwell@thehuntergallery.com or by post, including photos or CD.

Price range £40-£10,000 No of exhibitions annually 6

ICAS - Vilas Fine Art

8–10 Leys Avenue, Letchworth Garden City, SG6 3EU

T 01462 677455

E info@vilascollection.co.uk

W www.vilasart.co.uk

Contact Dev Vilas

More than twenty years' experience in international contemporary fine art. Gallery artists include John W. Mills (British sculptor), Domy Reiter-Soffer (modern oil painter), Anne Sudworth (British Landscape artist), Sally Rutherford (equestrian artist and sculptor), Angela Bishop (bronze figurative sculptor), Lara Alridge (British glass sculptor) Mark Clark (figurative artist) Rob Ford (British landscape painter) Asit Kumar Sakar (Indian Figurative

art) Norik Dilanchyan (Armenian Classical Renaissance Figurative art) Sally Mynard (Illustrator & artist).

Submission Policy Portfolio includes established and emerging British and International artists, sculptors and potters. New artists' enquiries welcome at BipinVilas@vilascollection.co.uk.

Price range £500-£65,000+ No of exhibitions annually 6

Letter 'A' Gallery

40 Whitmore Street, Whittlesey, Peterborough, PE7 1HE

T 01733 203595

W www.justfineart.net

Contact Caesar Smith

Founded in 1972. Specializing in paintings by the owner Caesar Smith, whose work is published in limited editions only by the gallery.

Price range £150 for limited editions; up to £16,000 for originals

Lynne Strover Gallery

High Street, Fen Ditton, Cambridge, CB5 8ST

T 01223 295264 W www.strovergallery.co.uk

Opened in the early 1990s. Exhibits range of prints, paintings and sculptures. Many shows have strong Cornish flavour.

McNeill Gallery

112 Watling Street, Radlett, WD7 7AB

T 01923 859594

E info@mcneillgallery.com

W www.mcneillgallery.com

Contact B. McNeill

Since opening in 1996 the gallery has nurtured talented unknowns as well as established artists. Over 80 artists represented, including Alex Rennie, Lawrie Williamson, Leszek Blyszczynski, Georgie Young, Sara Hill, Alain Magallon, Anton Psak, Sara Barrow, Rob Selkirk, Enzo Marra, John Holmes and Inge Clayton.

Submission Policy Quality figurative, landscape & representational artists who wish to be represented are welcome to approach the gallery.

Price range $f_{500}-f_{12,000}$

No of exhibitions annually 7

Patrick Davies Contemporary Art

Barley House, The Old Brewery, Furneux Pelham, Buntingford, SG9 0TS

T 01279 777070

E gallery@patrickdaviesca.com

W www.patrickdaviesca.com

Promotes the work of both emerging and established artists. Offers a consultancy service to corporate and private clients. Digital library with examples of work from over two thousand artists.

Submission Policy Application by email with CV and no more than six digital images.

Price range £1,000-£25,000No of exhibitions annually 6

Peterborough Art House Ltd

245 St Paul's Road, Peterborough, PE1 3RJ T 01733 349024 E helen.mould@btinternet.com W www.peterborougharthouse.com

Contact Helen Mould
Founded in 1996. An independent gallery
specializing in large Abstract Expressionist
paintings by Helen Mould and other artists.
Also has a collectors' room with nineteenthand twentieth-century artists such as John
Bellany, Mary Fedden, Vanessa Bell and Wm A
Delmotte. Provides consultancy, art-search and

advisory services for art collections. **Submission Policy** Artists represented by invitation or stock only.

Price range £100-£16,000 No of exhibitions annually 5

Picturecraft Gallery Ltd

23 Lees Courtyard, off Bull Street, Holt, NR25 6HS T 01263 711040 F 01263 711040 E info@picturecraftgallery.com

W www.picturecraftgallery.com

Contact Adrian Hill

Totally refurbished art gallery and exhibition centre that reopened in 2003. Offers thirty-two display spaces for artists to rent on a three-weekly, no-commission basis.

Submission Policy All artists welcome.

No of exhibitions annually Fourteen mixed and five specialist major exhibitions.

Cost to hire or rent From £30 per week

Primavera

To King's Parade, Cambridge, CB2 1SJ
T 01223 357708
E infoprimavera@aol.com
W www.primaverauk.com
Gallery and shop located over three floors,
presenting fine contemporary British arts and
crafts.

Regency Gallery

39 Fitzroy Street, Cambridge, CB1 1ER T 01223 365454 F 01223 364515

E info@regencygallery.co.uk

W www.regencygallery.co.uk Wide selection of limited edition prints. Also offers framing service.

Roar Art Gallery and Archive

9–10 Redwell Street, Norwich, NR2 4SN

T 01603 766220

E roar-art@hotmail.com

Contact Sarah Ballard

A registered charity founded in 2004 and dedicated to the work of self-taught, marginalized or 'outsider' artists.

Price range £40-£1,000 No of exhibitions annually 6-7

School House Gallery

Wighton, nr Wells-next-the-Sea, NR23 1AL

T 01328 820457

Contact Diana Cohen

Founded in 1983 in the school where Henry Moore lived and sculpted in the 1920s when his sister was headmistress. Artists exhibiting include Norman Ackroyd, Alfred Cohen, Derrick Greaves, Alison Neville, Sula Rubens and Malcolm Weir.

Submission Policy Hosts a mixed exhibition every summer during July, August and September and

considers works submitted for these shows. Price range £250-£5,000No of exhibitions annually 3

Skylark Studios

Hannath Road, Tydd Gote, Wisbech, PE13 5ND T 01945 420403

E louise@skylarkstudios.co.uk

W www.skylarkstudios.co.uk

Founded in 1993. A small gallery set in quiet Fenland countryside offering bi-monthly exhibitions by selection. Stocks original prints, photographs and paintings. Workshops held in etching and blockprinting.

Submission Policy Professional artists working in two dimensions may send slides or photographs of work for consideration.

No of exhibitions annually 6
Cost to hire or rent £100 / month

Southwold Gallery

64A High Street, Southwold, IP18 6DN T 01502 723888

F 01502 723888

E karen@southwoldgallery.co.uk W www.southwoldgallery.co.uk

Exhibits work by 38 regional artists including Karen S J Keable, Mary Gundry, George Gill, Anthony Osler, Mandy Walden, Rosemary Cook, Matthew Garrard and Debbie Faulkner-Stevens. Exhibitions are constantly changing and works can be purchased over the phone and delivered anywhere in the UK by a courier.

Storm Fine Arts

Church Street Barns, Great Shelford, Cambridge, CB2 5EL

T 01223 844786 F 01223 847871

E info@stormfinearts.com

W www.stormfinearts.com

Specializes in British and European painting from 1550 to the present. Also deals in decorative fine arts including textiles, prints, ceramics, pottery and glass of this period.

Thompson Gallery

175 High Street, Aldeburgh, IP15 5AN

T 01728 453743 F 01728 452488

E john@thompsonsgallery.co.uk

W www.thompsonsgallery.co.uk Established in 1982. Specializes in early twentieth-

century and contemporary sculpture and paintings. Artists include Fred Cuming, Terry Frost, Mary Fedden, Edward Seags and Robert Kelsey.

Price range £500-£25,000 No of exhibitions annually 4

Waytemore Art Gallery

10-11 Florence Walk, Bishop's Stortford, CM23 2NZ

T 01279 506206

E info@waytemore-art-gallery.com

Submission Policy Will consider contemporary abstracts, landscapes and figurative works in oil, acrylic and watercolour.

Price range £500-£10,000 No of exhibitions annually 4-5

Whittlesford Gallery

Old School Lane, High Street, CB2 4YS T 01223 836394 F 01223 290061 E johnshead@whitgallery.fsnet.co.uk W www.whittlesfordgallery.co.uk

Shows original work, with an emphasis on East Anglian artists and local landscapes.

Wildlife Art Gallery

97 High Street, Lavenham, CO10 9PZ T 01787 248562

F 01787 247356

E wildlifeartgallery@btinternet.com

W www.wildlifeartgallery.com

Founded in 1988, specializing in wildlife art, both twentieth-century and modern. Represents artists from Europe and the UK.

Price range Up to £10,000 No of exhibitions annually 4

Wildwood Gallery

40 Churchgate Street, Bury St Edmunds, IP33 1RG T 01284 752938

F 01284 752938

E info@wildwoodgallery.co.uk

W www.wildwoodgallery.co.uk

Contact Mr K. Youngman

A contemporary art gallery, opened in 2002. Also sells limited-edition prints, sculptural furniture and ceramics. Offers a full framing service. Exhibited artists include Francis Farmar, Samantha Toft, Anita Klein and Jenny Thompson.

Submission Policy Send photos or CD with CV and artist's statement. Include sae if you want these returned (allow 28 days for response). Artists seen by appointment only.

Price range f_{50} - $f_{5,000}$ No of exhibitions annually 4-5

Yarrow Gallery

Glapthorn Road, Oundle, PE8 4JQ

T 01832 277170

W www.oundleschool.org.uk/arts/yarrow/ Originally opened in 1918 and refurbished in the 1990s. Attached to Oundle School, offers extensive space for exhibitions.

East Midlands

Belvoir Gallery

7 Welby Street, Grantham, NG31 6DY P 01476 579498

Bend In The River

The Shooting Lodge, Scotter Road, Laughton, Gainsborough, DN21 3PT T 01427 628518 E info@bendintheriver.co.uk

W www.bendintheriver.co.uk / www.slumgothic. co.uk

Long-established 'serious-minded' contemporary gallery working with a small group of artists, mostly British painters, many with 'isolationist' tendencies. The gallery hosts five exhibitions a year, four of which are solo shows and includes their presence at the London Art Fair. Artists include: Anastasia Lewis, Michael Bowdidge, Bob Billington, Nicholas de Serra, Susan Michie, Richard Shepherd and Derek Sprawson. Exhibiting venue: 54 Bridge St, Gainsborough. Its sister project, Slumgothic at x-church, runs from the redundant church of St John the Divine in the

No of exhibitions annually 4-5

The Bottle Kiln

High Lane, West Hallam, Near Ilkeston, DE7 6HP P 0115 9329442

Castle Ashby Gallery

The Byre, The Old Farmyard, NN7 1LF P 01604 696787

Christopher Wren Gallery

St Marys Way, 40 Nottingham Street, Melton Mowbray, LE13 1NW T 01664 480220 Established in 1985. Stocks original paintings and fine-art, and limited-edition prints by artists such as David Weston.

Clark Galleries

215 Watling Street West, Towcester, NN12 6BX T 01327 352957 E sales@clarkgalleries.co.uk W www.clarkgalleries.com Established in 1963, specializing in figurative, marine, landscape and animal pictures. Also offers a full conservation service.

Croft Wingates

Wingates Walk, 44A St Mary's Road, LE16 7DU T 01858 465455 E shop@croftwingates.co.uk W www.croftwingates.co.uk Contact John Snape Established since 1975. Stocks a wide range of

images from popular artists including Mackenzie Thorpe, John Waterhouse, Paul James and Govinder Nazran. Carries both limited-edition prints and original work.

Price range £250-£5,000 No of exhibitions annually 6

Evergreen Gallery

Sheaf Street, Daventry, NN11 4AB T 01327 878117 E rsvp@egart.co.uk W www.egart.co.uk Established in 1979, dealing in contemporary original work and some limited editions. Also offers framing service.

Fermynwoods Contemporary Art

Fermyn Woods, Brigstock, Kettering, NN14 3JA T 01536 373469 E gallery@fermynwoods.co.uk

W www.fermynwoods.co.uk An artist-led gallery that shows work by artists of national and international standing alongside others less well known at regional level. Areas of interest include geometric abstraction, artists' prints, architecture, landscape and photography. Runs an educational programme alongside exhibitions. Fermynwoods receives public and private funding. Works are for sale. Submission Policy Artists usually invited.

Price range Up to £20,000 No of exhibitions annually Approx. 5

Focus Gallery

NG15FB T 0115 9537575 E jjames@focus-gallery.co.uk

Gallery 52

Main Road, Brailsford, Ashbourne, DE6 3DA T 01335 360368 Stocks an array of works in various media.

Gallery 93

93 Belper Road, Derby, DE1 3ER T 01332 364574 Contact J.A. Thomas

Opened in 1990 in owner's home, showing art within a domestic environment. Artists represented include Ronald Pope, Walter Beizins, Alan Smith, Ann Ellis, Keith Hayman and James Brereton. Submission Policy Shows mostly work by living artists, with preference for solo shows. No of exhibitions annually 12

Gallery Top

Chatsworth Road, Rowsley, Matlock, DE4 2EH T 01629 735580

E enquiries@gallerytop.co.uk W www.gallerytop.co.uk Exhibits contemporary art by emerging and established artists in painting, sculpture, ceramics, glass and jewelry.

Granby Gallery

Water Lane, Bakewell, DE45 1EU P 01629 813050

Harley Gallery

Welbeck, Worksop, S80 3LW

T 01909 501700 F 01909 488747

E info@harley-welbeck.co.uk

W www.harleygallery.co.uk

Contact Lisa Gee and Susan Sherrit

Funded by The Harley Foundation, a charitable trust set up in 1977 to support artists and craftspeople in their chosen field. As well as the Gallery the Foundation provide studio space at subsidized rents. The Gallery was built in 1994 on the site of the 19th century gasworks at Welbeck. It offers a changing program of contemporary exhibitions which have included Euan Uglow, David Hockney and Peter Blake. The museum displays objects from the Portland Collection and the craft shop sells work by established and emerging makers. Winner of the Civic Trust Award for Architecture, 1994 and H.E.T.B Award for Excellence in Tourism, 1999, there is a new café on site.

Submission Policy To apply for an exhibition or studio contact Lisa Gee (Director). To apply to stock work in the shop contact Susan Sherrit (Gallery Manager).

Price range $f_{10}-f_{1,000}$ (in shop) No of exhibitions annually 6

Hart Gallery

23 Main Street, Linby, Nottingham, NG15 8AE T 0115 9638707

F 0115 9640743

E info@hartgallery.co.uk

W www.hartgallery.co.uk Represents artists, sculptors and studio ceramicists, from the emerging to those with international reputations. (Other branches: 113 Upper Street, Islington, London NI IQN. Tel. 020 7704 II31)

Henry Brewer

3 Tudor Square, West Bridgford, Nottingham, NG2 6BT P 0115 9811623

Hope Gallery

The Courtyard, Castleton Road, Hope Valley, S33 6RD

T 01433 621111

E alanglasby@hotmail.com

Wide range of traditional and contemporary sculpture, fine art and craft by local and national artists.

Little London Gallery

Nightingale House, Church Street, Matlock, DE45AY

T 01629 534825

E info@littlelondongallery.co.uk

W www.littlelondongallery.co.uk

Established in 1991 by Chris and Krystyna Tkacz. A small private gallery in the village of Holloway, nestled in the hillside on the edge of the Peak District. Shows the work of local Derbyshire artists such as Carol Hill, Rosalind Forster, Shirley Anne Johnson, Sandy Bartle and Ursula Newell Walker. A picture-framing service is offered.

Submission Policy Initial submission of CV and photographs of recent work, followed by invitation to bring work for a private selection with the gallery directors.

Price range From £40 No of exhibitions annually 8

Magpie Gallery

2 High Street West, Uppingham, LE15 9QD T 01572 822212

F 01572 822212

E alan@themagpiegallery.com

W www.themagpiegallery.com

Deals in paintings, sculpture, ceramics and glass by a range of local, national and international artists and craftsmen.

Manhattan Galleries

8 Flying Horse Walk, Nottingham, NG1 2HN P 0115 9418916

Mere Jelly

3rd Floor, Oldknows Factory Building, St Anns Hill Road, Nottingham, NG3 4GP

T 0115 9413160

E denisecweston@hotmail.com

Contact Denise Weston or Simon Withers Established in 2003 to facilitate new opportunities for artists, with both a project and gallery space. Seeks to broker interest between the artist and galleries, curators, critics and the public. Focuses on contemporary avant-garde work.

Miller Fine Arts

55 Station Road, Hugglescote, Coalville, LE67 2GB T 01530 810469

E finearts@miller-art.co.uk

W www.miller-art.co.uk / www.miller-art.eu.com **Contact** Pam and Michael Miller Founded in 1989. Specialists in fine art animal portraits and paintings on commission. **Price range** $f_{100}-f_{2,000}$

Mosaic Gallery

10 Hall Bank, Buxton, SK17 6EW P 01298 77557

Nest

43 Francis Street, Stoneygate, Leicester, LE2 2BE T 0116 2709290

F 0116 2709290 A contemporary

A contemporary applied arts gallery founded in 2002. Aims to represent both established makers and new designers currently making in Britain. Permanent collections include the work of Chris Comins, Delan Cookson, Vivienne Ross, Julia Groundsell, Peter Davey and Roger Broady. Submission Policy Professional artists and makers are asked to submit CV, personal statement and images with an sae for return. No telephone submissions.

Price range £25-£300

Oakwood Ceramics

5 Kenmore Close, Mansfield, NG19 6RA T 01623 635777 / 01623 661790 E oakwood.gallery@virgin.net W www.oakwoodceramics.co.uk

Oakwood Ceramics was launched in 2003 to exhibit and promote contemporary studio pottery and ceramics on the internet. The gallery holds both virtual (on-line) and actual exhibitions of ceramic work.

Submission Policy Welcomes approaches from potters and makers. Send CV and images of typical work by email or post.

Price range £25-£4500 No of exhibitions annually 2

Old Coach House

28–30 Nottingham Road, Nottingham, NG16 3NQ P 01773 534030

Opus Gallery

34 St John's Street, Ashbourne, Derbyshire, DE6 1GH T 01335 348919 F 01335 348919

Contact Jill Stone

Established in 2000. Offers monthly painting exhibitions and provides a showcase for British contemporary ceramics, glass, textiles, metalwork and handmade jewelry. Exhibited artists include Guilearia Lazzenni, Glyn Macey, Clare Caulfield and Peter Beard.

No of exhibitions annually 10

Patchings Art Centre

Oxton Road, Calverton, Nottingham, NG14 6NU T 0115 9653479
F 0115 9655308
E Chas@patchingsartcentre.co.uk
W www.patchingsartcentre.co.uk
Contact Liz or Chas Wood
Founded in 1988. A family business aimed at promoting the enjoyment of art. Two exhibition galleries showing two- and three-dimensional work, framing centre, art materials shop, an art school and eight studio workshops. Annual four day Art Craft and Design Festival held each June.
No of exhibitions annually 12

Peter Robinson Fine Art

Bardney Road, Wragby, LN8 5QZ P 01673 858600

Piet's Gallery

102 Lawrence Court, Semilong, NN1 3HD P 01604 624351

Sally Mitchell Fine Arts

Thornlea, Askham, Newark, NG22 0RN T 01777 838234 F 01777 838198 E info@dogart.com W www.dogart.com

Among the largest publishers of limited-edition dog, equestrian and countryside prints and cards for over twenty-five years. Artists represented include John Trickett, Mick Cawston, Malcolm Coward, Paul Doyle and Debbie Gillingham.

Submission Policy Send a good selection of photos or low-res jpegs via email or CD.

Price range £1-£5,000 No of exhibitions annually 12

St John Street Gallery

50 St John Street, Ashbourne, DE6 1GH T 01335 347425 E info@sjsg.co.uk W www.sjsg.co.uk

Founded in 2000, showing sculpture, crafts and paintings by living artists, including Lewis Noble, Andrew Macara and Jiri Borsky. Price range $f_{500}-f_{10,000}$ for paintings. No of exhibitions annually 6

Thoresby Gallery

Thoresby Park, Ollerton, Newark, NG22 9EP T 01623 822009 F 01623 822315 E gallery@thoresby.com

W www.thoresby.com

Founded in 1991 the gallery stocks pictures, prints, cards and crafts from leading national and regional artists and craftspeople. There is a changing exhibition programme throughout the year. Artists include Hazel Lane, Anthony Osler, Elise Savage,

Alison Read and Sally Mitchell Fine Arts. There is also an annual open exhibition.

Submission Policy Photographs of work (with details of size, medium and price) for consideration by the gallery manager and the trustees.

Price range Up to £1,000 No of exhibitions annually 6

Treeline Gallery

Water Street, Bakewell, DE45 1EW T 01629 813749 W www.artandcraftgallery.co.uk

Watling Street Galleries

116 Watling Street East, Towcester, NN12 6BT T 01327 351595 E info@picture-shop.co.uk

W www.picture-shop.co.uk

Established in 1975. Deals in the latest fine-art prints and originals. Offers an in-house framing service.

West End Gallery

4 West End, Wirksworth, Matlock, DE4 4EG T 01629 822356 E wheeldon@westendceramics.co.uk W www.johnwheeldonceramics.co.uk Specializes in Raku-fired ceramics. Viewings by appointment only.

Woodbine Contemporary Arts

21 The Crescent, Whaplode Drove, Spalding, PE12 OTT

T 01406 330693 / 07980 167404

F 01406 331004

E yorath@woodbinecontemporaryarts.co.uk

W www.woodbinecontemporaryarts.co.uk Contact Liz or Rowan Yorath

Founded in 1996 and based in South Lincolnshire, showing high quality fine art and ceramics. Also represented at British and European art fairs and regularly exhibits the work of over thirty established and emerging artists.

Submission Policy By e-mail or non-returnable photographs/CD. To include at least six images of recent work and brief CV.

Price range £6,500 maximum No of exhibitions annually 7 gallery shows and inclusion in five fairs

London

198 Gallery

198 Railton Road, Herne Hill, London, SE24 0LU T 020 79788309 F 020 77375315 E gallery@198gallery.co.uk W www.198gallery.co.uk Established in 1988 to support black artists needing exhibition space. Now used by artists from range of backgrounds, specializing in issues-based

291 Gallery

exhibitions and art education.

291 Hackney Road, London, E28NA T 020 76135676 F 020 76135692 E admin@291gallery.com W www.291gallery.com The grade II-listed, deconsecrated neo-Gothic Victorian church at 291 Hackney Road was restored and converted into an art gallery, restaurant and bar in 1998. Since then it has shown everything from music, digital work and

sculpture to poetry, theatre and visual art.

96 Gillespie

96 Gillespie Road, London, N5 1LN T 020 75033496 E info@96gillespie.com W www.96gillespie.com Founded in 2004. Specializes in photography and American art. Artists represented include Gee Vaucher, Melanie Standage, Pat Graham and Cynthia Connolly. Submission Policy Will accept submissions that include artist's past press, examples of work and ideas for the show. Directors will do their best to respond if possible. Gallery is booked up to one year in advance.

Price range £25-£1,000No of exhibitions annually 6

Abbott and Holder Ltd

30 Museum Street, Bloomsbury, London, WC1A 1LH

T 020 76373981

F 020 76310575 E abbott.holder@virgin.net

W www.abbottandholder.co.uk

Contact Philip Athill or Laura Pocock
Founded in 1036 as a picture dealer as

Founded in 1936 as a picture dealer and conservator. Sells watercolours, drawings, oils and prints from 1780 to the present. A twentieth-century watercolour and drawings show is held every September while the Christmas show has hundreds of works priced between £25 and £250. Changing exhibitions every couple of months which are visible on the website, varying from contemporary to eighteenth- and nineteenth-century artists. There is an in-house conservation studio for works on paper.

Submission Policy Artists should telephone and visit the gallery to establish whether their work is compatible.

Price range f_{25} – $f_{10,000}$ No of exhibitions annually 10

Ackermann & Johnson Ltd

27 Lowndes Street, London, SW1X 9HY T 020 72356464

F 020 7823 1057

E ackermannjohnson@btconnect.com

W www.artnet.com/ackermann-johnson.html A two-floor gallery in the heart of Belgravia, just off Sloane Street. Specializes in eighteenth- and nineteenth-century British paintings, notably the Norwich School, English landscapes, sporting paintings, marine paintings and portraiture. Also exhibits bronzes, watercolours and works by contemporary artists including John King, Douglas Anderson and Peter Howell. **Price range** From £300 for watercolours.

Adonis Art

тв Coleherne Road, Earls Court, London, SW10 9BS

T 020 74603888

E stewart@adonis-art.com

W www.adonis-art.com

Contact Stewart Hardman

Opened in 1995. Specializes in antique and contemporary art of the male form. Monthly exhibitions, plus a large selection of individual

items – bronze figures, statues, nineteenthcentury life study drawings and male figurative art of all types. Artists exhibited include Cornelius McCarthy, Peter Samuelson and Duncan Grant. Submission Policy Always interested in viewing the work of new artists but the subject matter must be the male form.

Price range £100-£10,000 No of exhibitions annually 12

Advanced Graphics London

32 Long Lane, London, SE1 4AY T 020 74072055 F 020 74072066 E gallery@advancedgraphics.co.uk

W www.advancedgraphics.co.uk

Contact Louise Peck

A print studio founded in 1967. Specializing in screenprinting techniques combined, in some cases, with woodblock printing. Moved to current location near London Bridge in 2003. Shows contemporary artists' prints made in the advanced graphics studio and also paintings. Attends selected art fairs. Artists printed at the studio include Craigie Aitchison, Basil Beattie, Neil Canning, Anthony Frost, Albert Irvin, Anita Klein and Ray Richardson.

Price range £200-£20,000No of exhibitions annually 10

The Agency

15A Cremer Street, London, E2 8HD T 020 77296249 E info@theagencygallery.co.uk W www.theagencygallery.co.uk

Founded in 1993 as a space for installation art and new media with a focus on recent critical debates. Launched 1996 as a commercial gallery. Over the past 10 years the Agency has established itself as a gallery representing international young and mid career artists. The works are promoted with a longterm view to museums and collections.

No of exhibitions annually 7

Agnew's

43 Old Bond Street, London, W1S 4BA T 020 72909250

F 020 76294359

E agnews@agnewsgallery.co.uk

W www.agnewsgallery.co.uk

Founded in 1817, primarily as an Old Master paintings dealership, the gallery now also specializes in twentieth-century British art and represents a small selection of contemporary artists.

Air Gallery

32 Dover Street, London, W1S 4NE

T 020 74091255

F 020 74091856

E clare@airgallery.co.uk

W www.airgallery.co.uk

Contact Clare Rea

Founded in 1996, two well-equipped galleries for hire in Mayfair. Has hosted a wide range of exhibitions, mainly but not only of contemporary art. Past clients include national and international artists and dealers and also several art prizes. Submission Policy A hire gallery. Welcomes submissions from any interested artists. Cost to hire or rent Per Week: Upper Gallery is £5500 + VAT and the Lower Gallery is £2,500 + VAT.

Alan Cristea Gallery

31 Cork Street, London, W1S 3NU

T 020 74398166

F 020 77341549

E info@alancristea.com

W www.alancristea.com

Founded in 1995 and the largest publisher and dealer of master graphics and contemporary prints in Europe. Represents an international stable of artists including Gillian Ayres, Ian Davenport, Richard Hamilton, Jan Dibbets, Mimmo Paladino, Julian Opie, Ian McKeever, Lisa Milroy, Gordon Cheung, Boo Ritson, Paul Schütze and Howard Hodgkin.

Submission Policy Does not accept submissions

from artists.

Price range £1,000-£200,000 No of exhibitions annually 8

Albemarle Gallery

49 Albemarle Street, W1S 4JR

T 020 74991616

F 020 74991717

E info@albemarlegallery.com

W www.albemarlegallery.com

Focuses on contemporary figurative, still life and trompe l'oeil work, together with urban and rural landscapes. Presents group and solo shows of established and emerging artists, supported by full-colour catalogues.

Albion

8 Hester Road, London, SW11 4AX T 020 78012480 F 020 78012488

E mhw@albion-gallery.com

W www.albion-gallery.com

Contact Michael Hue-Williams

Founded in 1993 on Cork Street and moved in 2004 to a new Norman Foster-designed space on the banks of the Thames. Comprises 12,500 sq. ft of exhibition space. Exhibited artists include Mark di Suvero, James Turrell and Andy Goldsworthy.

No of exhibitions annually 5

Alison Jacques Gallery

16-18 Berners Street, London, W1X 1RB

T 020 72877675

E info@alisonjacquesgallery.com

W www.alisonjacquesgallery.com Alison Jacques Gallery was established in 2004 and operated from an eighteenth-century townhouse in Mayfair until 2007, when it moved to a new space designed by MRJ Rundell & Associates. Located north of Oxford Circus, the gallery is set over 3,500 sq. ft and includes two ground floor exhibition spaces. British artists represented include Ian Kiaer, Paul Morrison and Catherine Yass. Non UK based artists include André Butzer, Tomory Dodge and Thomas Zipp.

Alma Enterprises

I Vyner Street, London, E2 9DG

T 07769 686826

E info@thisisland.net

W www.almaenterprises.com

Run by a group of artists and curators. Shows a programme of experimental and interdisciplinary exhibitions and events, foregrounding artists and curators who work critically with contemporary ideas and art forms.

Submission Policy Information on submitting a proposal can be found at www.almaenterprises. com/proposals.html

Price range From £350 upwards No of exhibitions annually 5

Anderson Hill

St Peter's House, 6 Cambridge Road, Kingston upon Thames, KT1 3JY

T 020 85463800

F 020 85471227

E info@andersonhill.co.uk

W www.andersonhill.co.uk

Contact Douglas A. Hill

The gallery started in 2001 as an addition to an existing commercial framing and corporateart business established in 1977. Framing

service available to artists, as well as potential exposure to corporate clientele. Gallery space is in a converted Edwardian church-school building.

Price range £50-£10,000No of exhibitions annually 6

Andipa Gallery

162 Walton Street, London, SW3 2JL

F 020 72250305

E art@andipa.com

W www.andipa.com

Dealers in fine art since 1593; London gallery since 1969. Specializes in modern and contemporary art (Picasso, Matisse, Chagall, Warhol, Lichtenstein, Damien Hirst) and Byzantine art. Offers restoration and valuation services.

Price range £500-£100,000

Andrew Coningsby Gallery

30 Tottenham Street, London, W1T 4RJ

T 020 76367478 F 020 75807017

E debutart@coningsbygallery.demon.co.uk

W www.coningsbygallery.com

Established in 1994. Specializes in exhibitions for contemporary illustrators, photographers and fine artists.

Price range £50-£10,000
No of exhibitions annually 52; one per week.

Anne Faggionato

4th Floor, 20 Dering Street, London, W1S 1AJ T 020 7493 6732

F 020 74939693

E info@annefaggionato.com

W www.annefaggionato.com

Dealers in Impressionist, modern and contemporary paintings, sculpture and works on paper.

Submission Policy Not open to submissions. **No of exhibitions annually** 3

Annely Juda Fine Art

4th Floor, 23 Dering Street, London, W1S 1AW T 020 76297578

F 020 74912139

E ajfa@annelyjudafineart.co.uk

W www.annelyjudafineart.co.uk

An established name on the gallery scene for over forty years, showing major figures from the history of twentieth-century art from Britain, Europe and Japan, with a special interest in Russian avantgarde and Constructivist art.

Anthony Reynolds Gallery

60 Great Marlborough Street, London, W1F 7BG T 020 74392201

F 020 74391869

E info@anthonyreynolds.com

W www.anthonyreynolds.com

Established in 1985, the gallery moved to the West End in 1990 and the current building was opened in 2002. There are twenty-two artists represented exclusively by the gallery, including the Atlas Group, David Austen, Richard Billingham, Leon Golub, Paul Graham and Mark Wallinger.

Submission Policy No submissions accepted. **No of exhibitions annually** 9

AOP Gallery

81 Leonard Street, London T 020 77396669 F 020 77398707

E gallery@aophoto.co.uk W www.the-aop.org

Contact Anna Roberts

Part of the Association of Photographers, the gallery has been staging exhibitions and events since 1986. Committed to heightening awareness and promoting photography, exhibition programmes represent a broad range of photography, incorporating both commercial and personal work from established and up-and-coming photographers.

Submission Policy Photography only.

Price range £70-£6,000

No of exhibitions annually 12 Cost to hire or rent £2500 +VAT per week.

Exclusive AOP Member discounts available.

The Approach

ıst Floor, 47 Approach Road, London, E2 9LY

T 020 89833878 F 020 89833919

E info@theapproach.co.uk

W www.theapproach.co.uk

Located on the first floor above a traditional Victorian public house in the Bethnal Green area since 1997, the gallery shows young British artists, including recent graduates, as well as artists from Europe and the USA.

APT Gallery

6 Creekside, Deptford, London, SE8 4SA T 020 86948344 E enquiry@aptstudios.org Gallery of the Art in Perpetuity Trust. Available for hire, starting at £260 per week for shows that hold an educational/community event.

Archeus

3 Albemarle Street, London, W1S 4HE

T 020 74999755

F 020 74995964

E art@archeus.co.uk

W www.archeus.co.uk

Specializes in British and international contemporary art, with an emphasis on established 'blue chip' artists who have genuine influence. Exhibited artists include Yves Klein, Ed Ruscha, Donald Judd and Dan Flavin. Holds a permanent stock of over one-thousand works by the artists in which it deals.

No of exhibitions annually 10-12

Arcola Theatre

27 Arcola Street, London, E8 2DJ

T 020 75031646

E info@arcolatheatre.com

W www.arcolatheatre.com

Contact Levla Nazli

Founded in 2001 to provide a much-needed cultural venue in Dalston, Hackney, and has become a well-respected fringe theatre. The theatre's gallery space is designed to air new and local work in need of a space.

Submission Policy Open to a wide range of work. The decision to exhibit is at the discretion of the booker.

No of exhibitions annually 10–12; exhibitions run to coincide with performance runs, which usually last four weeks.

Arndean Gallery

23 Cork Street, London, W1S 3NJ

T 020 75897742

F 020 75893888

E info@arndeangallery.com

W www.arndeangallery.com

Contact Kate Sadler

High-profile gallery for hire in Cork Street, in the heart of London's art world. Approximately 900 sq. ft over two floors. With neighbours including Flowers Central, Waddingtons, Beaux Arts and the Royal Academy, the gallery is well placed to attract serious buyers.

Art First

Ist Floor, 9 Cork Street, London, W1S 3LLT 020 77340386F 020 77343964

E artfirst@dircon.co.uk

W www.artfirst.co.uk

Established in 1991. A contemporary art gallery exhibiting UK and international artists. Has a regular stable of artists, many of whom have works in public collections in the UK and worldwide. **Submission Policy** Contemporary painting and drawing. No video. Photographs or CDs (with relevant CV) by post only, with sae for any returns. **Price range** $f_500-f_20,000$

No of exhibitions annually 10 major exhibitions in the main gallery and regular shows in the front-room project space.

Art Space Gallery

84 St Peter's Street, London, N1 8JS

T 020 73597002

E mail@artspacegallery.co.uk

W www.artspacegallery.co.uk

Founded in 1986 by Michael and Oya Richardson to show and promote serious painting. Exhibits work of young artists alongside established names.

Artcadia

108 Commercial Street, London, E1 6LZ

T 020 74260733

F 020 73752601

Large stock of contemporary computer-generated art.

Arthouse Gallery

Lewisham Arthouse, 140 Lewisham Way, London, SE14 6PD

T 020 82443168

F 020 86949011

E lewishamarthouse@btconnect.com

W www.lewishamarthouse.co.uk

Contact Gallery Coordinator

An artist-run studio cooperative that aims to offer exhibitions to artists at the start of their careers. Not a commercial gallery and does not represent

artists.

Submission Policy Welcomes applications in any medium (subject to selection) on production of images, an exhibition proposal and a completed application form.

No of exhibitions annually Approx.12

Artist Eye Space

1st Floor, 12 All Saints Road, London, W11 1HH

T 020 77924077

E vlm@artisteye.com

W www.artisteye.com

Opened in 2003. Alongside established

figures, the gallery introduces up-and-coming young artists. Runs a wide-ranging exhibition programme, including salon and corporate events. Exhibited artists include Michelle Molyneux, Paul Maffrett, Simeon Farrar, Amanda Couch. Anastasia Lewis and Jocelyn Clarke. Submission Policy Painting, sculptures, mixed media, video, and installations all considered. Price range $f_{1,000}-f_{16,000}$ No of exhibitions annually 6

Atlas Gallery

49 Dorset Street, London, W1U 7NF T 020 72244192 F 020 72243351 E info@atlasgallery.com W www.atlasgallery.com

Contact Robin Page

Founded in 1994, showing classic twentiethcentury photography, contemporary photography and photo-journalism.

Submission Policy Preferred method of application is by email. Price range £170 +

No of exhibitions annually 6-8

August Art

Wharf Studios, Baldwin Terrace, London, N1 7RU T 020 7354 0677 E info@augustart.co.uk

W www.augustart.co.uk

Inaugural show held in 2004. Hosts 3–5 shows per year of contemporary art by artists the gallery represents or respects.

Submission Policy Email jpgs/tiffs with brief CV or artist statement but limit mail size to 2MB maximum. Due to volume of submissions does not always reply to all requests.

Price range £200-£5,000

No of exhibitions annually 3-6 including art fairs.

Austin/Desmond Fine Art Ltd

Pied Bull Yard, 68-69 Great Russell Street, London, WC1B 3BN

T 020 72424443 F 020 74044480

E gallery@austindesmond.com W www.austindesmond.com

Specializes in modern British, Irish and international art. Established in 1979, the gallery has been located in Bloomsbury since 1988. Deals in paintings, drawings and sculpture by renowned artists including Frank Auerbach, Jean Dubuffet, Dan Flavin, Lucian Freud, Barbara Hepworth,

Howard Hodgkin, David Hockney, Henry Moore, Ben Nicholson, Bridget Riley and Cy Twombly. As well as buying and selling important works, the gallery holds a comprehensive stock with a particular emphasis on twentieth-century British art. A yearly exhibition programme of classic painting and sculpture is complimented with a series of contemporary shows.

Submission Policy Painters and ceramic artists can apply either by email with jpegs or by post with images and sae enclosed.

Price range £300-£300,000 No of exhibitions annually Approximately 7

Barbara Behan Contemporary Art

50 Moreton Street, Pimlico, London, SW1V 2PB T 020 78218793 F 020 78343933

E info@barbarabehan.com W www.barbarabehan.com

Contact Barbara Behan

Barbara Behan opened in 2003 establishing an international platform for an artistic scene hitherto almost completely absent from galleries in London. The cosmic chaos of Italy's Informale experiences of the 1950s and movements such as Spazialismo, Arte povera and Movimento Nucleare opened up a new artistic language for the decades to follow. The gallery seeks to trace the progression of these languages in its contemporary artists to give voice to some of the most original emerging and established artists with strong ties to the cultural heritage of Italy and to place them in dialogue with their British and international contemporaries in a series of thematic group and solo exhibitions. Painting, sculpture, photography, graphic and installation art all feature. Artists include Maria Morganti, Bruna Esposito, Rossella Bellusci, Carmengloria Morales, Giuseppe Spagnulo, Marco Gastini and Paolo Icaro. Submission Policy Email cover letter with artist's statement, CV and examples of recent work. Please visit the gallery or refer to the website first to ensure compatibility.

Price range £200-£100,000 No of exhibitions annually 6

Barrett Marsden Gallery

17-18 Great Sutton Street, London, EC1V 0DN T 020 73366396 E info@bmgallery.co.uk W www.bmgallery.co.uk Established in 1998. Exhibits contemporary studio ceramics, glass, metal and wood including work

by Gordon Baldwin, Alison Britton, Caroline Broadhead, Philip Eglin, Michael Rowe, Martin Smith and Emma Woffenden.

Baumkotter Gallery

63A Kensington Church Street, Kensington, London, W8 4BA

T 020 79375171

E art@baumkottergallery.com

W www.baumkottergallery.com

Specializes in seventeenth- to twenty-first-century paintings, English and European Old Master paintings, and fine oils of modern art. Subjects include hunting, sport, shipping, seascape and landscape. Nicholas Baumkotter has been in the London fine-art trade for twenty-seven years and provides restoration services for fine oil paintings and picture frames. A bespoke framing service is also offered.

Bearspace

152 Deptford High Street, London, SE8 3PQ

T+44(0)20 86948097

E bearspace@thebear.tv W www.thebear.tv/bearspace/

Contact Julia Alvarez

Recently established contemporary art gallery situated on Deptford High Street in South East London. Shows the cutting edge of emerging talent, promoting recently established artists responding to contemporary stimulus and topics with wit and innovation in a range of media. Aims to produce vibrant exhibitions while maintaining and developing a business-like attitude towards artists and artwork, identifying promising work by artists and promoting this on an international scale.

Submission Policy Exhibits painting, photography, film and occasionally three-dimensional work. Contact the gallery for further information.

Price range £500-£5,000 No of exhibitions annually II

Beaux Arts

22 Cork Street, London, W1S 3NA

T 020 74375799

F 020 74375798

E info@beauxartslondon.co.uk

W www.beauxartslondon.co.uk

Opened over twenty-five years ago in Bath and expanded to London's Cork Street in 1993. Shows the best of modern and contemporary British painting and sculpture, with equal focus given to nurturing UK-based emerging artists - selected for their innovative practice as much as the aesthetic qualities of their work - and showing the work of established artists such as John Hoyland and John Bellany. The gallery also represents the estates of Terry Frost, Elisabeth Frink and Lynn Chadwick. Submission Policy Living artists must be UK-based.

No of exhibitions annually 8-10

Ben Brown Fine Arts

1st Floor, 21 Cork Street, London, W1S 3LZ T 020 77348888 F 020 77348892

E info@benbrownfinearts.com W www.benbrownfinearts.com

A newly founded gallery in Cork Street showing mainly twentieth-century masters and recent photography.

Beverley Knowles Fine Art

88 Bevington Road, London, W10 5TW T 020 89690800 E enquiries@beverleyknowles.com W www@beverlevknowles.com Launched in 2002, with an international reputation for championing women artists.

Bischoff/Weiss

95 Rivington Street, London, EC2A 3AY T 020 70330309 E info@bischoffweiss.com

W www.bischoffweiss.com Promotes young and up-and-coming artists in London and abroad. Hosting seven shows per year, the gallery encourages artists to use the space as a laboratory for experimentation, pushing the boundaries of aesthetics visually and conceptually. Artists include Nathaniel Rackowe, Ali Silverstein, Tatiana Trouve, Olivier Millagou, Hildur Margretardottir, Markus Hansen, Maya Hewitt, Michael Ajerman and Nina Gehl. No of exhibitions annually 7

Blackheath Gallery

34A Tranquil Vale, Blackheath, London, SE3 OAX T 020 88521802

E james@blackheath-gallery.co.uk

W www.blackheath-gallery.co.uk

Contact Sue Marshall

Established in 1975. Provides a showcase for artists from the UK, USA and Europe. Stocks fine prints by twentieth-century artists including Francis Bacon, David Hockney and Henry Moore. Gallery artists include Graeme Wilcox, Alan Furneaux,

Colin Ruffell, Olivier Massebeuf, Jennifer Irvine, Charles Malinsky and Ray Donley.

Submission Policy Painters, sculptors, printmakers and glass blowers are invited to submit applications via email with digital attachments or send CD or photographs and CV together with an sae.

Price range £50-£20,000No of exhibitions annually 6–7

Blink Gallery

11 Poland Street, London, W1F 8QA

T 020 74398585

E info@blinkgallery.com

W www.blinkgallery.com

Contact Daniel Hay

Opened in 2002. A contemporary photography gallery specializing in music, celebrity and fashion photography. Artists represented include Terry O'Neill, Michael Cooper, Sir Peter Blake, Gered Mankowitz and Dennis Morris.

Price range £300-£5,000 No of exhibitions annually 5

Blow de la Barra

35 Heddon Street, London, W1B 4BP

T 020 77347477

E info@blowdelabarra.com

W www.blowdelabarra.com

A West End art gallery showing the work of young international avant-garde artists, many of them previously unseen in London. Artists include Stefan Bruggemann, Los Super Elegantes, Frederico Herrero and Marcelo Krasilcic.

Bloxham Galleries

4-5 The Parade, St Johns Hill, London, SW11 1TG

T 020 79247500

F 020 75853901

E info@bloxhamgalleries.com

W www.bloxhamgalleries.com

Contact Julia Lister

John Bloxham, a respected London dealer involved in the arts for over thirty years, opened the galleries in 1994. There are two light and airy spaces at street level with a downstairs exhibition area for smaller, more intimate pieces. Specializes in sculpture and photography and figurative, landscape and abstract pieces.

Submission Policy Welcomes all artists' submissions. Email CV and high-quality jpegs or send postal submissions (including sae) to Julia Lister.

Price range £400-£30,000 No of exhibitions annually 10-12

Boundary Gallery – Agi Katz Fine Art

98 Boundary Road, London, NW8 0RH

T 020 76241126

F 020 76241126

E agi@boundarygallery.com

W www.boundarygallery.com

Contact Agi Katz or Louise Homes

Established for twenty-one years. Specializations include: modern British artists (1900–60), mostly of lewish origin, including David

mostly of Jewish origin, including David Bomberg, Horace Brodzky, Jacob Epstein, Josef Herman, Jacob Kramer, Bernard Meninsky,

Morris Kestelman and Alfred Wolmark; and contemporary figurative work displaying good draughtsmanship and composition and a strong

palette. Artists include Peter Prendergast, David Tress, Sonia Lawson, Anita Klein, Breuer-Weil,

Paul Bloomer, Neil MacPherson and Davina Jackson.

Submission Policy Figurative work (can be representational) with good draughtsmanship, strong composition and a strong palette. Accepts paintings and works on paper. No prints.

Price range £300-£40,000 No of exhibitions annually 7-8

Brent Artists' Resource and Gallery

Willesden Green Library Centre, 95 High Road, London, NW10 2SF

T 020 8459 1421

E info@brentartistsresource.org.uk

W www.brentartistsresource.org.uk

Contact Lorenzo Belenguer

Founded in 1984, an artists-led voluntary organization with a dedicated gallery space ideally suited for group and individual shows. Aims to be the leading forum for contemporary visual art in Brent, presenting a mixture of exhibitions that include painting, installation, video, performance, photography and community art projects.

Price range £20- £2,000

No of exhibitions annually 10

Cost to hire or rent Can be hired for £500 for 4 weeks (no commissions taken). Artists may also become members and exhibit in group shows.

Brick Lane Gallery

196 Brick Lane, London, E1 6SA

T 020 77299721

E tony@thebricklanegallery.com

W www.thebricklanegallery.com

Contact Danielle Horn

New contemporary art gallery showcasing new and established artists from around the world

presenting innovative developments in painting, photography, sculpture and video. Has worked on group projects with Charles Saatchi, Wolfgang Tilmans and Bob and Roberta Smith. Gallery artists include Bjorn Veno, Antti Laitinen, Saul Zanolari, Eduard Bigas, Hektor Mamet, Mike Newton and Rebecca Tabber.

Submission Policy Submissions welcome from artists and curators.

Price range £500-£5,000 No of exhibitions annually 10

Brixton Art Gallery

35 Brixton Station Road, London, SW9 8PB T 020 77336957 E brixart@brixtonartgallery.co.uk

W www.brixtonartgallery.co.uk

Contact Ms D. Parker

Founded in 1983. Specializes in contemporary art. Artists represented include L.Postma, Kudzanai Chiurai, Amos Cherfil, Dubois, Sean Hasan, Teresa Nills. Offers training scheme for artists in

Submission Policy Submit statement, CV and images of work by post or through gallery website. Price range Up to £1,000 No of exhibitions annually 8

Cabinet

Apartment 6, 3rd Floor, 49-59 Old Street, London, EC1V9HX

T 020 72516114 F 020 76082414

E art@cabinetltd.demon.co.uk

Contact Martin McGeown or Andrew Wheatley Founded in 1992. Aims for 'informed, engaged and critical work by artists with an international perspective independent of art-world trends (economic/curatorial/editorial)'. Artists represented include Gillian Carnegie, Enrico David, Mark Leckey, Lucy McKenzie, Paulina Olowskan and Tariq Alvi.

Submission Policy Unsolicited applications not

No of exhibitions annually 6

Calvert 22

22 Calvert Avenue, London, E2 7JP E info@calvert22.com

W www.calvert22.com

Specializing in art from Russia and Central and Eastern Europe, this not-for-profit foundation opened in May 2009. Founded by Russian art collector and economist Nonna Materkova, the

gallery hosts four major curated exhibitions each year, featuring contemporary artists established in their countries of origin, alongside emerging talent. Housed in a converted warehouse in Shoreditch, the foundation also holds talks and debates around the exhibitions.

No of exhibitions annually 4

Campbell Works

27 Belfast Road, London, N16 6UN T 020 88060817 E info@campbellworks.org W www.campbellworks.org Founded in 1997, a project of artists Neil Taylor and Harriet Murray. By developing the collaboration and curation of new ventures with artists, writers, and scientists, Campbell Works acts as a meeting point for ideas and aims to explore contextual relationships between art, spaces and people. Presents both solo and group shows, and particularly supports projects that explore ways to communicate with

Submission Policy Proposals welcome from curators and artists. Initial submission of interest may be by e mail, with jpeg images. Alternatively postal submissions should include a CD of images in Jpeg format, DVD for media-based works, a CV and brief statement,.

Price range f_{10} - $f_{10,000}$ No of exhibitions annually 6 Cost to hire or rent The project space is available for hire at certain times. Call for further information.

Capital Culture

audiences.

3 Bedfordbury, Covent Garden, London, WC2N 4BP

T 020 78360824 or 020 32682184

E info@capitalculture.eu W www.capitalculture.eu

Contact Rachael Dalzell

Opened in 2005. Primary focus is on fine art photography, represents both up and coming and established artists. Takes part in several art fairs each year.

Submission Policy Reviews submissions of work and CVs on CD. Primary focus on photography but other medias considered.

Price range £500-£8000 No of exhibitions annually 4

Cost to hire or rent First week: £2250 Second week: £1750 Third week: £1500 Fourth week: £1000

Centre for Recent Drawing - C4RD

2-4 Highbury Station Road, London, N1 1SB T 020 723969367

E info@c4rd.org.uk

W www.c4rd.org.uk

Charity which provides a museum space dedicated to the exhibition and research of recent drawing; webpresence; studio and online residencies. Submission Policy Artists who register as C4RD Community may submit for programmes or propose group exhibitions focusing on drawing approaches.

Price range Not selling exhibitions; museum editions available at £300.

No of exhibitions annually 10+

The Centre of Attention

67 Clapton Common, London, E5 9AA T 020 88805507

F 020 88805507

E on@thecentreofattention.org

W www.thecentreofattention.org

Contact Pierre Coinde

A London-based contemporary-art organization founded 1999 examining the formalities of production, distribution and consumption of art. Exhibitions take place both in the UK and overseas. Submission Policy Welcomes submissions from artists and curators. Email or post a small number of non-returnable images or other medium (such as DVD) that demonstrate the work or project. Can also view artists websites.

Price range £1-£10,000 No of exhibitions annually 8

Charing X Venue

121-125 Charing Cross Road, London, WC2H 0EW W www.venuereservations.co.uk/charing-x-venue.

Gallery space available for hire. See website for details.

Chinese Contemporary Ltd

21 Dering Street, London, W1S 1AL

T 020 74998898 F 020 74998852

E ccartuk@aol.com

W www.chinesecontemporary.com

Contact Julia Colman

Founded in London in 1996, specializing exclusively in Chinese contemporary art from artists living and working in mainland China, both established and emerging. Sister gallery in Beijing set up in 2004.

Submission Policy Must be Chinese nationals living and working in mainland China. Price range £1,000-£100,000 No of exhibitions annually 8-10 solo shows

Clapham Art Gallery

Unit 02, 40-48 Bromell's Road, London, SW4 0BG

T 020 77200955

E direct@claphamartgallery.com

W www.claphamartgallery.com Established in 1998 to discover and promote emerging artists. Runs a programme of fiveweek curated and one-person exhibitions and participates in selected art fairs and events.

Submission Policy 6-8 medium resolution jpegs sent via email with artist's CV and statement.

Price range £180-£15 000 No of exhibitions annually 8

Clarion Contemporary Art

387 King Street, Hammersmith, London, W6 9NJ T 020 87483369 E info@clariongallery.co.uk W www.clariongallery.co.uk Founded in 2005, specializing in contemporary painting by artists from the UK and abroad. Aims to exhibit a varied selection of work appropriate for both domestic and business settings. Submission Policy Submissions welcome.

Price range £500-£4000 No of exhibitions annually 10

Collins & Hastie Ltd

62 Tournay Road, London, SW6 7UF T 020 73814957 E caroline@collinsandhastie.co.uk W www.collinsandhastie.co.uk Founded in 1993, dealing in contemporary (mainly figurative) art. Specializes in the work of Paul Maze, known as 'the lost British Impressionist'. Gallery runs by appointment only. Also exhibits at the Art on Paper Fair, the Affordable Art Fair and the Chelsea Art Fair. Artists include Glen Preece, Jenny Thompson, Michael Bennallack Hart, Janet Tod, Caroline Chariot Dayez, Jim Bradford, Alex Chamberlain, Rose Shawe-Taylor and Jill Barthorpe. Price range £500-£30,000

No of exhibitions annually 4 solo shows, not including London art fairs.

Contemporary Applied Arts

2 Percy Street, London, W1T 1DD

T 020 74362344

F 020 74362344 W www.caa.org.uk

Among Britain's largest galleries specializing in the exhibition and sale of contemporary crafts. Founded in 1948 as the Craft Centre of Great Britain, the double-level gallery shows leading makers of ceramic, glass, jewelry, textiles, metalwork, silver, wood and furniture. Submission Policy Professional craftpersons working in the British Isles can apply for membership of the society. Following selection, the subscription rate is £75 per year. Price range f_{10} - $f_{10,000}$ No of exhibitions annually 7

Contemporary Ceramics

Somerset House, Strand, WC2R 1LA

W www.cpaceramics.com

Gallery showcasing the work of members of the contemporary potters' association. Previously located at Marshall street until spring 2009, the CPA gallery is temporarily housed within Somerset House while they search for new central London premises.

Price range f15+ No of exhibitions annually Ongoing

Corvi-Mora

IA Kempsford Road, off Wincott Street, London, SE114NU

T 020 78409111

F 020 78409112

E tcm@corvi-mora.com

W www.corvi-mora.com

Specializes in international contemporary art. Exhibited artists include Liam Gillick, Brian Calvin, Roger Hiorns, Dee Ferris, Monique Prieto, Rachel Feinstein, Richard Hawkins and Jason Meadows.

No of exhibitions annually 8

Cosa Gallery

7 Ledbury Mews North, London, W11 2AF T 020 77270398 F 020 77929697 E info@cosalondon.com

W www.cosalondon.com

Contact Julie Pottle

Founded in 2002 to promote innovative and highly crafted work by artists working in a variety of media. Particularly interested in contemporary studio ceramics. Artists include Georgia Peskett, Ana Bianchi, Dominic Theobald, James Evans, Andy Shaw, Noel Hart.

Submission Policy Contact by email. Check website first to determine whether work would complement existing artists' work. Especially interested in sculptural studio ceramics. Price range $f_{500}-f_{7,500}$ No of exhibitions annually 6 Cost to hire or rent See website.

Counter Gallery

44A Charlotte Road, London, EC2A 3PD T 020 7684 8888 F 020 7684 8889 E info@countergallery.com W www.countergallery.com Established in 2003. Presents exhibitions by emerging international artists. Gallery artists include Armando Andrade Tudela, Michael Fullerton, Simon Martin, Gareth McConnell, Peter Peri and Fergal Stapleton. Submission Policy Does not accept submissions. Price range £300-£50,000 No of exhibitions annually 7

Cubitt Gallery and Studios

8 Angel Mews, Islington, London, N1 9HH T 020 72788226 F 020 72782544 E info@cubittartists.org.uk W www.cubittartists.org.uk Established in the early 1990s as an independent artist-run gallery and studios, with a focus on progressive international contemporary art projects and artist-led initiatives. Also provides an 18-month bursary for an independent curator to develop the gallery's artistic programme. Submission Policy We do not accept exhibition submissions from artists No of exhibitions annually 6-10

The Cynthia Corbett Gallery

15 Claremont Lodge, 15 The Downs, Wimbledon, SW20 8UA

T 020 89476782

F 020 89476782

E info@thecynthiacorbettgallery.com

W www.thecynthiacorbettgallery.com

Contact Celia Kinchington

Established in 2000 by former Christie's Education Art History graduate, Cynthia Corbett, and operated from her Victorian home. Promotes both established and emerging artists. Offers a personalized service for clients including advice on collecting, in situ viewings and installation. corbettPROJECTS was launched in 2004 to

focus on young, emerging and experimental artists and art forms, including photography, video, conceptual, installation and performance art.

Submission Policy Via email only.

Price range £350-£15,000

No of exhibitions annually 6 plus UK and international art fairs.

Danielle Arnaud contemporary art

123 Kennington Road, London, SE11 6SF T 020 77358292 F 020 77358292

E danielle@daniellearnaud.com W www.daniellearnaud.com

Founded in 1995 and located in a large Georgian house. Encourages artists with strong individuality to explore freely and present work outside the constraints of markets or trends. Also active in collaborations and temporary public art projects. Artists include David Cotterrell, Sophie Lascelles, Marie-France and Patricia Martin, Helen Maurer, Heather & Ivan Morison, Paulette Phillips and Sarah Woodfine.

Submission Policy Artists should apply via email by sending images and short statement and/ or proposals for themed exhibitions. It is highly recommended that artists visit the gallery and website before applying.

Price range $f_{250} - f_{10,000}$ No of exhibitions annually 6 curated for the gallery; 2–3 touring/off-site projects.

David Risley Gallery

45 Vyner Street, Brunswick Wharf, E2 9DQ
T 020 76134006
F 020 77298008
E info@davidrisleygallery.com
W www.davidrisleygallery.com
Contact David Risley or Poppy Sebire
Opened in 2003, presenting exhibitions of
represented artists alongside curated group shows,
mixing established and emerging artists. Artists
include James Aldridge, Masakatsu Kondo, Henry
Krokatsis, Helen Frik, Peter Jones, John Stezaker,
Jonathan Allen, John Zurier, Matt Calderwood,
James Hyde and Hurvin Anderson.

DegreeArt.com

30 Vyner Street, Bethnal Green, London, E2 9DQ T 020 89800395 / 07971 456396 E info@DegreeArt.com W www.DegreeArt.com Founded in 2003 to provide promising young artists with a platform to launch their careers and to give the art buying public access to the artists and their work through the website, showcases, events and exhibitions. Sells and commissions the finest artwork created by the students and recent graduates from the most prestigious art establishments. Artists represented include Kate Marshall, Andy Owen, Ulrika Andersson, Lorna May Wadsworth and Johan Andersson.

Price range £50-£5000No of exhibitions annually 20 Cost to hire or rent £1350 per week

Dicksmith Gallery

74 Buttesland Street, Hoxton, London, N1 6BY
T 020 72530663
E dicksmithgallery@hotmail.com
W www.dicksmithgallery.co.uk
Founded in 2003. Works with young artists to
develop and present new work.
Submission Policy Accepts application on CD
only; images in jpeg only. Any other information
also on CD.

No of exhibitions annually 6 Dominic Guerrini Fine Art

18 Redburn Street, London, SW3 4BX

Viewing is by appointment only.

T 020 75652333
F 020 75652444
E sales@dominicguerrini.com
W www.dominicguerrini.com
Stocks original watercolours, drawings, signed and unsigned limited editions, paintings and prints.

Domo Baal

3 John Street, London, WC1N 2ES
T 020 7242 9604
F 020 7831 0122
E info@domobaal.com
W www.domobaal.com
Founded in 2000, a contemporary art gallery.
Artists represented include Christiane
Baumgartner, Daniel Gustav Cramer, Haris
Epaminonda, Ansel Krut, Jeffrey T. Y. Lee and
Miho Sato. All artists exhibit internationally and
the gallery exhibits at international art fairs.
No of exhibitions annually 6

The Drawing Room

Brunswick Wharf, 55 Laburnum Street, London, E2 8BD T 020 77295333 F 020 77298008 E mail@drawingroom.org.uk W www.drawingroom.org.uk

Founded in 2002, the only public gallery in the UK dedicated to the investigation and support of contemporary drawing practice, from the traditional to the experimental. Supports the production of new work and runs educational projects as well as public 'in-conversations' between artists, writers and critics. Produces publications and tours its exhibitions to regional museums and galleries.

Submission Policy No unsolicited submissions. Price range $f_{100}-f_{30,000}$

No of exhibitions annually 3

Duncan Campbell

15 Thackeray Street, Kensington Square, London, W8 5ET

T 020 79378665

Founded in 1986. Contemporary artists include John Gillespie, Liz Knox, Janet Freeman, Roberta Booth, Sandra Pepys, Michael Alford, Harry Weinberger, Allan MacDonald, John Newberry RWS and Rowland Hilder. Modern British painters include Paul Maze, Bernard Meninsky, Heinz Koppel, Lamorna Birch and Leonard McComb. Also British wood engravers (1900-2006).

Submission Policy Oils, watercolours and wood engravings.

Price range £200-£50,000 No of exhibitions annually 12

Duncan R. Miller Fine Arts

6 Bury Street, London, SW1Y 6AB

T 020 78398806

F 020 78398806

E DMFineArts@aol.com

W www.duncanmiller.com Contact Tanya R. Saunders

Founded un 1985. Dealers in nineteenth-century European and modern British works. Specialists

in the Scottish Colourists. Artists include J.D. Fergusson, F.C.B. Cadell, S.J. Peploe and G.L. Hunter.

Submission Policy Applications by email or post.

Price range From £500 No of exhibitions annually 4-6

E&R Cyzer

33 Davies Street, London, W1K 4LR T 020 76290100 F 020 74993697

E info@cyzerart.com

W www.cyzerart.com

Opened renovated gallery space in Mayfair in 2002. Deals in twentieth-century modern masters and exhibits at several major international shows. Also acquires works for collectors and institutions both at home and internationally.

Eagle Gallery Emma Hill Fine Art

159 Farringdon Road, London, EC1R 3AL T 020 78332674

E info@emmahilleagle.com

W www.emmahilleagle.com Contact Christian Bonett

The gallery and its associated imprint (EMH Arts) were founded in 1991. Promotes contemporary British artists through exhibitions, installations and graphics publications. Off-site projects have included collaborations with Sadler's Wells and Almeida Opera. Artists include Basil Beattie, Jane

Bustin, James Fisher, Tom Hammick and Terry Smith.

Submission Policy Very few artists are taken on by submission. Phone the gallery for details.

Price range f_{50} - $f_{30,000}$ No of exhibitions annually 8-10

East West Gallery

8 Blenheim Crescent, London, W11 1NN

T 020 72297981 F 020 72210741

E david@eastwestgallery.co.uk

W www.eastwestgallery.co.uk

Contact David Solomon

Established in 1989. Art consultancy; valuations and commissions undertaken. Located in west London (Notting Hill), just off the Portobello Road. Contemporary art, paintings and drawings (some prints and sculpture), mainly figurative with a strong emphasis on drawing, design and

Submission Policy Submissions welcome. Send images either as CD, slides or photos plus CV and sae. Allow thirty days for return of material.

Price range f_{50} - $f_{30,000}$ No of exhibitions annually 10

ecArtspace

18 Temple Fortune Hill, London, NW11 7XN T 020 84554548 F 020 84554548

E info@ecartspace.com

W www.ecartspace.com

Contact Angela Diamandidou

Founded in 1998 as a peripatetic or moving gallery. Aims to show contemporary artists in unused buildings and spaces, connecting the art with the architecture of the building. Organized and curated exhibitions mainly in Clerkenwell (London), and in Mitte (Berlin). The last exhibition in Berlin in 2006 was a collaboration with two other Berlin galleries, showing young British artists. Artists exhibited include established painters (Basil Beattie, John McLean, Frances Aviva Blane) as well as younger artists such as Sarah Douglas and Laura Green.

Submission Policy Interested in site-specific work and architectural projects, depending on type of work and possible building or space setting. Price range $f_{500}-f_{15,000}$

No of exhibitions annually 1-2

Elastic Residence

22 Parfett Street, London, E1 1JR

T 020 72471375

E info@elastic.org.uk

W www.elastic.org.uk

Contact Deej Fabyc Established in 2004. A gallery space for projects and durational performance. Run by artists, it aims to give direct access to exhibition opportunities. Showcasing the work of Micheal Corris, Coco Fusco, Andrew Hurle, Elvis Richardson, Viveka Marksjo, Paula Roush and Deej Fabyc among others. The gallery is currently negotiating a new venue please see the web site for updates.

Submission Policy Does not accept unsolicited applications. Open-call events are advertised on the website.

No of exhibitions annually 10

Eleven

11 Eccleston Street, London, SW1W 9LX

T 020 78235540

F 020 78248383

E info@elevenfineart.com

W www.elevenfineart.com

Contact Coline Milliard

Founded in 2005 by Charlie Phillips, previously founding director of Haunch of Venison, Eleven is committed to showing the best of international contemporary art by established and emerging artists. Artists include Olly & Suzi, Natasha Law, Natasha Kissell, Jonathan Yeo, Rick Giles and Harry Cory Wright.

Price range $f_{400}-f_{15,000}$ No of exhibitions annually 8 **Emily Tsingou Gallery**

10 Charles II Street, London, SW1Y 4AA

T 020 78395320

F 020 78395321

E info@emilytsingougallery.com

W www.emilytsingougallery.com

Founded in 1998. Focuses on international contemporary art. Exhibition programme concentrates on artists represented by the gallery and includes off-site projects and publications. Artists represented: Michael Ashkin, Henry Bond, Kate Bright, Peter Callesen, Lukas Duwenhögger, Paula Kane, Karen Kilimnik, Justine Kurland, Won Ju Lim, Dietmar Lutz, Daniel Pflumm, Sophy Rickett, Jim Shaw, Georgina Starr, Marnie Weber

and Mathew Weir. No of exhibitions annually 7

The Empire

33A Wadeson Street, London, E2 9DR

T 020 89839310

E info@theempirestudios.co.uk

W www.theempirestudios.co.uk

Founded in 2004, putting on high-quality group shows and beginning to represent individual artists. Artists represented include the Council.

Submission Policy Accepts submissions from any area or medium. Specialises in painting.

Price range $f_{1,000}$ - $f_{10,000}$

No of exhibitions annually 12

Cost to hire or rent £1100 per week or £850 per week for shows of two or more weeks.

Enfield Arts Partnership

54-56 Market Square, Edmonton Green, Edmonton, N9 0TZ

T 020 88879500

F 020 88879501

E info@enfieldartspartnership.org

W www.enfieldartspartnership.org Founded in 1999 as a provider to the creative and cultural industries, providing business

advice, training, information and professional development services for artists, arts professionals and businesses in North London. Runs three galleries, as well as a theatre space and

studios. Submission Policy Does not welcome submissions.

No of exhibitions annually 20+

Cost to hire or rent froo for individual artists and £200 for groups up to 6 artists; £300 for businesses and groups over 6; all prices for a minimum of two weeks.

England & Co Gallery

216 Westbourne Grove, Notting Hill, London, W11 2RH

T 020 72210417

F 020 72214499

E england.gallery@virgin.net

Established in Notting Hill since 1987. Hosts monthly shows of contemporary artists, together with exhibitions reappraising avant-garde twentieth-century art and artists. Also offers a corporate consultancy service.

fa projects

I-2 Bear Gardens, Bankside, London, SE1 9ED T 020 79283228

F 020 79285123

E info@faprojects.com

W www.faprojects.com

Founded in 2001, the gallery represents artists from both the UK and abroad, working in a variety of media. Represented artists include John Wood and Paul Harrison, David Burrows, Grazia Toderi, Jason Salavon, Neal Rock and James Ireland. Submission Policy Submissions only considered after initial consultation with gallery directors.

Price range £500-£50,000No of exhibitions annually 7

Fairfax Gallery

5 Park Walk, Chelsea, London, SW10 0AJ

T 020 77514477

E andrew@fairfaxgallery.com

W www.fairfaxgallery.com

Founded in 1995. Exhibits established, award-winning and emerging contemporary artists. Has three permanent galleries and exhibits at major UK art fairs. Artists represented include Mary Jane Ansell, Shaun Ferguson, Mark Johnston, James Naughton, Adrian Parnell, Alice Scrutton and Robert E Wells RBA, ROI. Also has galleries in Burnham Market, Norfolk and Royal Tunbridge Wells

Submission Policy Submit images of work, with CV/statement via email.

Price range £300-£10,000No of exhibitions annually 9

Farmilo Fiumano

27 Connaught Street, London, W2 2AY T 020 74026241 F 020 74026241 E info@farmilofiumano.com

W www.farmilofiumano.com

Specializes in contemporary European art, such

as the Neapolitan Realismo Magico School. Constantly striving to find new artists. Submission Policy Artists should apply to the gallery by sending good-quality images and as much information as possible either via email or by post. Enclose sae if material is to be returned. Price range £200-£25,000 No of exhibitions annually 6

Felix Rosenstiel's Widow & Son Ltd

33–35 Markham Street, London, SW3 3NR T 020 73523551

F 020 73515300

E sales@felixr.com

W www.felixr.com

Rosenstiel's was founded in London 1880 and is one of the world's leading publishers of art prints and posters, selling to accounts in over 100 countries around the world and winning two Queen's Awards for Export, most recently in 2007. Always looking for new artists.

Submission Policy Views artwork as digital files, photographs or catalogues; no originals please. Please send sae for reply.

Price range $f_{100}-f_{3,000}$

Fieldgate Gallery

T 07957 228351
E fieldgategallery@googlemail.com
W www.fieldgategallery.com
Located in Whitechapel, a 10,000 sq. ft
contemporary art gallery and project space.
Does not represent any of the artists who have
participated in shows and is not a hire space.

Fine Art Commissions Ltd

7 Bury Street, St James's, London, SW1Y 6AL
T 07768 864 065
E info@fineartcommissions.com
W www.fineartcommissions.com
Contact Sara Stewart or Lara Bailey
Founded in 1997, specializing in commissioned art (predominantly portraiture). Artists represented include Nick Bashall, Valery Gridnev, Marcus Hodge, Howard Morgan, Paul Benney, Nicky Philipps and Tom Leveritt. Also runs
Arndean Gallery in Cork Street.
Submission Policy Interested in portrait painters who have completed a minimum of five commissions. Also interested in landscape/figurative/still life painters for exhibitions.

Price range £500-£40,000 No of exhibitions annually 10 Cost to hire or rent Arndean Gallery, 23 Cork Street, London WI is available for £4,900 + VAT per week (discounts available at various times of the year).

Fine Art Society Plc

148 New Bond Street, London, W1S 2JT T 020 76295116 F 020 74919454

F and @ f = l = -d = -

E art@faslondon.com

W www.faslondon.com

Established in 1876, specializing in paintings, drawings, prints, sculpture, furniture and decorative arts of the nineteenth, twentieth and twenty-first centuries.

Submission Policy Submissions only in writing with photographs.

Price range £1,000-£500,000 No of exhibitions annually 12

Five Years

E info@fiveyears.org.uk **W** www.fiveyears.org.uk

Founded in 1998, a collaborative artists' project run by Edward Dorrian, Marc Hulson and Alex Schady. Original aim was to set up an artist-run gallery where programming and curation would maintain as direct a relationship as possible to practice. Has since held 56 exhibitions and events including solo, curated and collaborative projects both by members and numerous guest participants. Projects are presented in both gallery and non-gallery spaces.

Flaca

69 Broadway Market, London, E8 4PH **T** 020 72757473

F 020 72757473

E info@flaca.co.uk

W www.flaca.co.uk Contact Kirsty Dixon

Flaca was established by the artist Tom Humphreys in 2003. The gallery is run on a noncommercial, experimental, artist-led basis. Has recently worked closely with artists including Michael Beutler, Jacob Dahl Jurgensen, Sally Osborn and Alexander Wolff.

Flowers East

82 Kingsland Road, London, E2 8DP

T 020 79207777 F 020 79207770

E gallery@flowerseast.com

W www.flowerseast.com

Founded over thirty years ago by Angela Flowers.

Now has two London galleries (one on Kingsland Road, E2, and the other on Cork Street) and one on Madison Avenue in New York. Specializes in a variety of painting, sculpture, prints, photography, installation and also owns its own publishing company, Momentum. Artists represented include Tai-Shan Schierenberg, Glenys Barton, Glen Baxter, Peter Howson, Ken Currie and John Keane. Submission Policy Send photos, printouts or slides of work to Angela Flowers at the above address. Include CV, cover letter and sae for return of work. No of exhibitions annually 12 per site.

Flying Colours Gallery

6 Burnsall Street, King's Road, London, SW3 3ST T 020 73515558

F 020 73515548

E art@flyingcoloursgallery.com

W www.flyingcoloursgallery.com

Founded in Edinburgh in 1986 and moved to Chelsea in 1995. Shows contemporary Scottish artists such as Shona Barr, Claire Harrigan RSW, Stephen Mangan, Jean B. Martin RSW, Sandy Murphy RSW RGI, Anthony Scullion and Ethel Walker. Also John Cunningham RGI (1926–98). Submission Policy Scottish artists and sculptors may submit by email with jpegs.

Price range £500-£25,000 No of exhibitions annually 6

Fosterart

20 Rivington Street, London, EC2A 3DU T 020 77391743

E info@fosterart.net

W www.fosterart.net

Manages a collection of artist-owned work available for placement with individuals and institutions. All work selected by a panel of experts to ensure quality contemporary art.

Submission Policy Agreements are available on the website.

Price range £1,000-£12,000

No of exhibitions annually 10, focusing on artists in the collection.

Foyles Bookshop

113–119 Charing Cross Road, London, WC2H OEB T 020 74375660

W www.foyles.co.uk

The bookshop has been in Charing Cross Road since 1906. The gallery space on the second floor is available for hire. Recent exhibitions have included Lena Herzog and Carlos Reyes-Nanzo. Gallery also suitable for launch parties.

Fred [London] Ltd

45 Vyner Street, London, E2 9DQ

T 020 89812987 F 020 89818912

E info@fred-london.com

W www.fred-london.com

Opened in May 2005, representing twelve international artists. Artists include Mark Fairnington, Abetz/Drescher, Nayland Blake, Stuart Croft, Kate Davis, Paul Hosking, John Jodzio, Phillip Jones, Peter Jones, Jorg Lozek, Melanie Manchot and English Simon.

Frith Street Gallery

59-60 Frith Street, London, W1D 3JJ

T 020 74941550 F 020 72873733

E info@frithstreetgallery.com

W www.frithstreetgallery.com

Opened in 1989. Has developed a programme of exhibitions by international artists working in painting, photography, sculpture, film and video. Currently represents twenty artists from both Britain and abroad and also collaborates with other artists on specific projects. Artists represented include Chantal Akerman, Fiona Banner, Tacita Dean, Marlene Dumas, Craigie Horsfield, Callum Innes, Dayanita Singh, Annelies Strba and Daphne Wright.

No of exhibitions annually 6-7

Frivoli

7a Devonshire Road, London, W4 2EU

T 020 87423255

F 020 89947372

E info@frivoligallery.com

W www.DevonshireRoad.com

Contact Hazel Peiser

Founded by Hazel Peiser in 1991. Shows contemporary works in all media. Work by many artists displayed informally throughout the year in addition to summer and winter exhibitions.

Submission Policy Happy to view current work by professional artists in all permanent media.

Price range f_{150} - $f_{2,500}$

No of exhibitions annually Ongoing changing display; occasional exhibitions.

Frost & Reed

2-4 King Street, St James's, London, SW1Y 6QP T 020 7839 4645

F 020 7839 1166

E info@frostandreed.com

W www.frostandreed.com

Contact Louise Neville

Frost & Reed have been dealers in fine art for over 200 years: from Constable to Klimt in the nineteenth century and Munnings to Picasso in the twentieth, they also have an active interest in living artists. The London gallery currently holds approximately eight exhibitions a year, as well as developing and promoting the careers of its artists and sourcing new talent.

Submission Policy Suitable applications are welcome - initially by email, after which an invitation to make an appointment may be extended.

Price range Up to £100,000 No of exhibitions annually 8

Gagosian Gallery

6-24 Britannia Street, London, WC1X 9JD

T 020 78419960

F 020 78419961

E info@gagosian.com

W www.gagosian.com

Has expanded from its space on Heddon Street in the West End into a 12,500 sq. ft space on Britannia Street, converted by architects Caruso St John in 2004. The gallery represents some of the world's most prestigious living artists and also has branches in New York, where it was founded, and Los Angeles. Branches: 17-19 Davies Street, London, W1K 3DE T 020 7493 3020.

Galerie Besson

15 Royal Arcade, 28 Old Bond Street, London, W1S 4SP

T 020 74911706

F 020 74953203

E enquiries@galeriebesson.co.uk

W www.galeriebesson.co.uk

Has won a worldwide reputation for exhibiting contemporary ceramics since opening in 1988. Runs mainly one-person shows and is the only London ceramic gallery showing international artists. Stock of classic artists includes Lucie Rie and Hans Coper.

Submission Policy Although opportunities for new artists to exhibit at the gallery are rare, introductions and images from ceramic artists are welcomed.

No of exhibitions annually 10

The Gallery at Willesden Green

Willesden Green Centre, 95 High Road, London, NW10 2SF

T 020 84591421

E info@brentartistsresource.org.uk **W** www.brentartistsresource.org.uk

Contact Lorenzo Belenguer, gallery coordinator Aims to serve the cultural needs of the people of Brent and North West London by providing a supportive environment for artists. Offers information, professional development, opportunities to participate in exhibitions and workshops, and mentoring schemes.

Submission Policy Artist can become members by paying an anual fee which will allow them to show in the three group shows held every year.

Price range £20-£2000No of exhibitions annually II

Cost to hire or rent £700/month for the gallery, £250/month for the wall space in the main hall of the centre. £75/month for the glass cabinet.

Gallery in Cork Street Ltd and Gallery 27

28 Cork Street, London, W1S 3NG

T 020 72878408

F 020 72872018

E enquiries@galleryincorkstreet.com

W www.galleryincorkstreet.com

Contact Caroline Edwards (Manager)
One of London's leading suppliers of short-term
gallery rental space. Operates two letting galleries
in the centre of London's art trading area.

No of exhibitions annually 52; one per week.

Gallery Kaleidoscope

64-66 Willesden Lane, London, NW6 7SX

T 020 73285833

F 020 76242913

E info@gallerykaleidoscope.com **W** www.gallerykaleidoscope.com

Established for over thirty years, with a policy of showing well-known names alongside promising newcomers. Artists represented include John Duffin, Elizabeth Taggart, Mark R.Hall, John Afflick, Chuck Monroe, Jean Cairns, Pete Mckee, Gursel Tunali and Inge Clayton.

Submission Policy Welcomes enquiries from artists, sculptors and ceramicists but insists on seeing images first via email or post.

Price range £100-£10,000 No of exhibitions annually 6-8

Gallery N. von Bartha

Contemporary Art – London, 1st Floor, London, W11 1QU

T 020 79850015 F 020 79850016

E info@vonbartha.com

W www.vonbartha.com

Contact N. or D. von Bartha

Founded in 2000, dealing in minimal, conceptual and new-media art. Represents Jill Baroff, Frank Gerritz, Herbert Hamak, Julia Mangold, Eline McGeorge and Winston Roeth.

Submission Policy Does not guarantee to respond to every submission or return submitted material. Advises visiting the gallery or website prior to submitting.

Price range £80-£200,000No of exhibitions annually 6

Gallery One

19 Station Road, London, SW13 0LF

T 020 84872144

E info@galleryone.ws

W www.galleryonelondon.com

Contact Teffany Tooke

Opened in 2001. Committed to sourcing and exhibiting the best of contemporary art. Includes emerging new talent and established names. Stocks and sources an extensive portfolio of original graphics, paintings and sculpture. Also provides a corporate-art consultancy service and a bespoke framing service.

Submission Policy Welcomes submissions from all artists, by email or post in the first instance.

Price range £50-£10,000 No of exhibitions annually 4-8

Getty Images Gallery

46 Eastcastle Street, W1W 8DX

T 020 72915380

W www.gettyimagesgallery

Founded in 1996. Originally based in Chelsea, recently relocated to new space near Oxford Circus. Exhibitions of images from the Getty archive and contemporary library are held regularly.

Gillian Jason Modern & Contemporary Art

Ormond House, 3 Duke of York Street, London, SW1Y 6JP

E art@gillianjason.com

W www.gillianjason.com

Contact n. a.

In the 1980s and early 1990s the gallery in Camden Town was the focus for exhibitions by key artists of the modern British school and 1994 saw the creation of the Jason & Rhodes Gallery. In 1999 Gillian Jason began working as a private dealer, offering a personalized service to collectors and vendors, including sourcing and placing of works of art by British and European artists, consultancy and valuation.

Gimpel Fils

30 Davies Street, London, W1K 4NB

T 020 74932488

F 020 76295732

E info@gimpelfils.com

W www.gimpelfils.com

Founded in 1946. Modern and contemporary art, project space for installations and video. Represents Alan Davie, Pamela Golden, Albert Irvin, Peter Kennard, Antoni Malinowski and the estate of Peter Lanyon.

No of exhibitions annually 8

Greengrassi

IA Kempsford Road, London, SE11 4NU

T 020 78409101

F 020 78409102

E info@greengrassi.com

W www.greengrassi.com

Has recently moved from central London to Kennington, south of the river. The stable of international artists includes Aleksandra Mir, Pae White, Lari Pittman and Margherita Manzelli.

Grosvenor Gallery (Fine Arts) Ltd

21 Ryder Street, London, SW1Y 6PX

T 020 7484 7979

F 020 7484 7980

E art@grosvenorgallery.com

W www.grosvenorgallery.com

Specializes in twentieth-century European and British paintings and sculpture, and modern Indian painting (working in collaboration with the long-established Vadehra Gallery, based in Delhi). Limited to the representation of two contemporary artists, Mark Shields and Victor Newsome.

Submission Policy Currently not looking to take on any more living artists.

No of exhibitions annually 7

Hackelbury Fine Art

4 Launceston Place, London, W8 5RL

T 020 79378688

F 020 79378868

E katestevens@hackelbury.co.uk

W www.hackelbury.co.uk

Opened in 1998, showing twentieth- and twenty-first-century photography by stable of emerging and established artists. Exhibits each year at the AIPAD Photography Show in New York and at Photo-London.

Hales Gallery

7 Bethnal Green Road, London

T 020 70331938

F 020 70331939

E info@halesgallery.com

W www.halesgallery.com

Founded in 1991 in Deptford, Hales moved to the East End in 2004. The gallery represents artists from the UK and abroad working in a variety of media. Represented artists include Tomoko Takahashi, Spencer Tunick, Hew Locke, Adam Dant, Richard Galpin, and Bob and Roberta Smith. Submission Policy Artists' submissions not

Submission Policy Artists' submissions not encouraged.

No of exhibitions annually 8

Hamiltons

13 Carlos Place, London, W1Y 2EU

T 020 74999493

F 020 7629 9919

E art@hamiltonsgallery.com

W www.hamiltonsgallery.com

A major European gallery for nearly twenty years, dealing in late-twentieth century and contemporary photographs. Also shows modern and contemporary paintings.

Hanina Fine Arts

180 Westbourne Grove, London, W11 2RH

T 020 72438877

F 020 72430132

E contact@haninafinearts.com

W www.haninafinearts.com

Specialists in twentieth-century European art, particularly the post-war School of Paris.

Submission Policy Contact from artists or their representatives with relevance to European art from 1900 to 1980 welcome. The gallery does not deal in works on paper or in prints.

Price range £5,000-£250,000 No of exhibitions annually 4

Harlequin Gallery

68 Greenwich High Road, London, SE10 8LF

T 020 86927170

E jr@studio-pots.com

W www.studio-pots.com

Specializes in contemporary exhibitions of work by leading British studio potters including Phil Rogers, Alan Wallwork and Aki Moriuchi, together with older work by Bernard Leach and associates. Paintings and sculpture by artists such as Denis Bowen are often shown in conjunction with the above.

Submission Policy Studio potters and artists may apply but telephone or email first. Price range £25-£5,000 No of exhibitions annually 8

Haunch of Venison

6 Burlington Gardens, London, W1 T 020 74955050 F 020 74954050 E info@haunchofvenison.com W www.haunchofvenison.com

Contact Stephanie Camu, Jade Awdry, Ben

Tufnell, Nina Miall

Haunch of Venison, founded in 2002, is the primary gallery representative for a number of today's leading artists, including Richard Long, Anton Henning and M/M (Paris), to name but a few. The gallery is the exclusive European representative of Bill Viola and The Estate of Ed Kienholz, and had two artists nominated for the Turner Prize 2007. Haunch of Venison presents a broad programme of exhibitions of exciting new works and historically significant shows from important contemporary artists to a large public through its international exhibition spaces in London, Zurich, Berlin and New York.

Submission Policy No unsolicited submissions.

Price range £5,000-£1,000,000+

Hauser & Wirth

196A Piccadilly, London, W1J 9DY T 020 72872300 F 020 72876600 E london@hauserwirth.com

W www.hauserwirth.com

No of exhibitions annually o

Opened in 2003 just across the road from the Royal Academy of Arts in an historic building designed by Sir Edwin Lutyens in the 1920s. Swiss gallerist-collectors Ursula Hauser and Iwan and Manuela Wirth, who represent important international artists, also have branches of their gallery in Zurich and a joint venture in New York.

Hazlitt Holland-Hibbert

38 Bury Street, St James's, London, SW1Y 6BB T 020 78397600 F 020 78397255 E info@hh-h.com W www.hh-h.com

Holds a selected stock of twentieth-century art works with particular emphasis on modern British painting, drawing and sculpture. Also able to offer discreet advice on the purchase and sale of modern paintings and sculpture and the acquisition of new works either for stock or for sale on a consignment basis.

No of exhibitions annually 1-2

Henry Boxer Gallery

98 Stuart Court, Richmond Hill, Richmond,

TW10 6RJ T 020 89481633

F 020 89481633

E henryboxer@aol.com

W www.henryboxergallery.com

Founded in 1980, specializing in modern British, visionary and outsider art. Artists represented include Joe Coleman, Donald Pass, Laurie Lipton, Dora Holzhandler, Scottie Wilson, Madge Gill, George Widener and Austin Spare. Henry Boxer is a director of Raw Vision magazine and curates exhibitions of outsider art both in the UK and the USA.

Submission Policy Submissions welcome from self-taught, visionary and outsider artists. Send sae and photographs or email images of work to be considered.

Price range £500-£10,000 No of exhibitions annually 4

Herald Street

2 Herald Street, London, E2 6JT T 020 71682566 E mail@heraldst.com W www.heraldst.com

Contemporary art gallery which has shown artists including Markus Amm, Alexandra Bircken, Pablo Bronstein, Spartacus Chetwynd, Christina Mackie, Djordje Ozbolt, Oliver Payne & Nick Relph, Klaus Weber and Nicole Wermers.

Hicks Gallery

2–4 Leopold Road, Wimbledon, SW19 7BD T 020 89447171 E jeff.hicks@hicksgallery.co.uk W www.hicksgallery.co.uk Contact Jeff or Ann Hicks

Founded in 1988. Handles the work of mainly contemporary artists with an emphasis on drawing skills. Exhibits both established and up-and-coming artists. Exhibited artists include Andrea Byrne, Amy Judd, Mark Harrison, Caroline Yates, Terry Whybrow, Jeffrey Pratt, Sir Peter Blake(screenprints) and Sandra Blow(screenprints).

Submission Policy Submissions welcome either by email or, if possible, CD. Can also be contacted

by telephone, but would prefer if appointments are made before making submissions.

Price range £250-£15,000 No of exhibitions annually 6

Highgate Fine Art

26 Highgate High Street, Highgate Village, London, N6 5JG

T 020 83477010 / 83407564

F 020 83407564

E sales@oddyart.com

W www.oddyart.com

Contact Laurie MacLaren

The Phoenix Gallery Highgate opened in 1988 and relaunched in 1997 as Highgate Fine Art. Over fifty twentieth-century artists represented including Frederick Gore CBE RA, Paul Demaria, Alan Hepburn, Douglas Wilson RCA, Richard Robbins RBA and Arthur Easton ROI.

Submission Policy Applications reviewed by committee weekly.

Price range £150-£25,000

No of exhibitions annually 15; new shows open every three weeks.

Hiscox Art Café

Ground Floor, Hiscox Building, I Great St Helen's, London, EC3A 6HX

W www.hiscox.com/artprojects.

The Café is a modern art gallery and home to Hiscox Art Projects, established in 2003. The scheme aims to bring contemporary art into the heart of the City and to support and represent talented contemporary artists by providing an exhibition space.

Hofer Printroom

43 Museum Street, London, WC1A 1LY T 020 79301904 E info@hofer-photo.com W www.hofer-photo.com Stocks over 2,000 hand-finished original photographic prints and 500 limited-edition prints.

Honor Oak Gallery Ltd

52 Honor Oak Park, Forest Hill, London, SE23 1DY T 020 82916094

Founded in 1986, the gallery specializes in original works of art on paper dating from the early twentieth-century to the present day. Artists shown include Norman Ackroyd, June Berry, Elizabeth Blackadder, Margarete Berger-Hamerschlag, Sanchia Lewis and Karolina Larusdottir.

A comprehensive framing and conservation service is also offered.

Submission Policy Submissions welcome, provided they are within the area of specialization outlined above.

Price range From £25

No of exhibitions annually I plus 6 'features'.

Hoopers Gallery

15 Clerkenwell Close, London, EC1R 0AA T 020 74903908

E gallery@hoopersgallery.co.uk

W www.hoopersgallery.co.uk

Opened in 2003 by photographer Roger Hooper to provide a platform for up-and-coming as well as established photographers.

Hotel

53 Old Bethnal Green Road, London, E2 6QA

T 020 77293122

F 020 77394095

E info@generalhotel.org

W www.generalhotel.org

Opened in 2003 in a spare room in the flat of Darren Flook and Christabel Stewart, before moving into a groundfloor shop space in 2005. Has held solo shows by Carol Bove, Alan Michael, Richard Kern, Alasatair MacKinven, David Noonan, Steven Claydon, Carter and Michael Bauer. Artists not located in London are invited to stay at Hotel during the production period of their project.

Submission Policy Does not accept submissions. Price range $f_{250} - f_{25,000}$ No of exhibitions annually 6

Hothouse Gallery

Hothouse, 274 Richmond Road, London Fields, E8 30W

T 020 72493394

F 020 72498499

E contact@freeform.org.uk

W www.freeform.org.uk

An artist-led gallery and workspace for visual and new media artists, urban designers and architects working in the public realm. Opened in 2003 and offering a flexible, white 1,982 sq.ft space with mobile screens. Has all-round CAT 5 cabling for installations, digital and ICT media presentations, and external digital art space. Past exhibitions include RIBA London, Ash Sakula Architects, Maggie Ellenby and Hot House Open: Applied Arts. Hosts talks, seminars and events.

Submission Policy Welcomes exhibition proposals from established and emerging visual artists, new-media artists, urban designers and architects working in the public realm.

No of exhibitions annually 3, in visual arts, photography, and architecture and urban design.

Houldsworth

50 Pall Mall Deposit, 124-128 Barlby Road. London, W10 6BL

T 020 89696166

F 020 89696209

E gallery@houldsworth.co.uk

W www.houldsworth.co.uk

Contact Ben Cranfield

Project space promoting and selling the work of contemporary artists of international importance. Focuses on solo exhibitions and external projects for its artists, whilst hosting artist curated projects and open debates to provide work with a critical and collaborative context. Past projects include Gordon Cheung, British Art Show (2006), Laura Ford, Venice Biennale (2005), Jonathan Callan, Mattress Factory, Pittsburgh (2005), Royal Art Lodge, Yerba Buena Center for the Arts, San Francisco (2006).

Submission Policy Submit a small email presentation or, ideally, a website link. Other documentation submitted cannot be returned or retained. Only successful applicants are contacted. Price range £350-£65,000 No of exhibitions annually 6

House Gallery

70 Camberwell Church Street, London, SE5 8QZ T 020 73584475 E info@housegallery.org

W www.housegallery.org

Contact Phil Stokes

Aims to create an independent platform for artists to respond to contemporary stimuli in a professional environment. Featuring experimental, installation, video and performance

Submission Policy Exhibition proposals are accepted. Include a CV, short artist's statement, images and a written proposal for the exhibition. These can be sent or emailed. Group shows are also accepted.

No of exhibitions annually 20

IBID Projects

21 Vyner St, London, E2 9DG T 020 89834355

F 020 89834605 E info@ibidprojects.com W www.ibidprojects.com

Founded in 2003, with a programme focused on a series of solo shows by emerging British and Baltic artists as well as curated shows, off-site mobile projects and publications. Artists include David Adamo, Janis Avotins, Ross Chisholm, Anthea Hamilton, William Hunt, Christopher Orr, Daniel Silver, Anj Smith and Marianne Vitale.

Submission Policy Submissions not encouraged.

Price range $f_{1,000}-f_{100,000}$ No of exhibitions annually 10

leda Basualdo

8-9 Grosvenor Place, Belgravia, London, SW1X7SH

T 020 72359522

F 020 72359577

E ieda@bottaccio.co.uk

W www.bottaccio.co.uk

Particularly suitable for large exhibitions, the Grand Gallery (300m2) has hosted exhibitions for, among others, Arturo Martini, Igor Mitoraj, Giorgio Morandi, Gio Pomodoro, Marino Marini and Damien Hirst. Exhibitions last a minimum of two weeks and a maximum of four weeks.

Price range £80-£50,000 No of exhibitions annually 12

Illustration Cupboard

22 Bury Street, St James's, London, SW1Y 6AL T 020 79761727

E john@illustrationcupboard.com

W www.illustrationcupboard.com Established in 1995, exhibiting original artwork by leading contemporary book illustrators. Continuous schedule of events including a winter exhibition, as well as single artist and two-man shows. Entrance to all events is free.

Ingo Fincke Gallery and Framers

24 Battersea Rise, London, SW11 1EE T 020 72287966 F 020 76527966 E kira@ingofincke.com W www.ingofincke.com

Contact Kira Fincke

Founded in 1958, the gallery specializes in contemporary paintings on canvas. Exhibits both new and established artists and also offers a framing service.

James Hyman Gallery

5 Savile Row, London, W1S 3PD

T 020 7494 3857

E mail@jameshymangallery.com

W www.jameshymanfineart.com

James Hyman Gallery specializes in international contemporary and modern British art, focusings on art of the past fifty years. It has a particular emphasis on the relationship between abstraction and figuration, and between painting and photography. Exhibitions include solo shows as well as specially curated thematic group exhibitions and have included painting, drawing, sculpture, prints, photography, installation and video. The gallery works with, and represents, a select number of artists and artists' estates, as well as having an active publication programme of catalogues and books.

No of exhibitions annually 10

Jerwood Space

171 Union Street, London, SE1 0LN

T 020 76540171 F 020 76540172

E space@jerwoodspace.co.uk

W www.jerwoodspace.co.uk

Contact Sarah Williams

A major initiative of the Jerwood Foundation. As well as providing rehearsal facilities for dance and theatre companies, the refurbished Victorian building houses a contemporary-art gallery. Free to visitors it offers a year-round programme of work by young artists and photographers as part of the Jerwood Visual Arts awards and prizes supported by the Jerwood Charitable Foundation. Emerging artists are shown in the café space and courtyard. Submission Policy Visit www.jerwoodvisualarts. org for information on applying for Jerwood prizes.

No of exhibitions annually 8

Jill George Gallery

38 Lexington Street, London, W1F 0LL

T 020 74397319

F 020 72870478

E jill@jillgeorgegallery.co.uk

W www.jillgeorgegallery.co.uk

Established in 1974. Deals in paintings, drawings, small sculpture, monoprints and edition prints by contemporary British artists, from established names to recent graduates. Participates in British and international art fairs. Member of SLAD. Organizes commissions and undertakes all ancilliary services. Artists include Martyn

Brewster, Jill Frost, Alison Lambert, David Mach, Christina Niederberger, Chris Orr, Gro Thorsen and Tomas Watson.

Submission Policy Media as above. Prefers to see photographs initially.

Price range £200-£40,000 No of exhibitions annually 10

John Martin Gallery

38 Albemarle Street, London, W1S 4JG

T 020 74991314

F 020 74932842

E info@imlondon.com

W www.jmlondon.com

Contact Tara Whelan

Two galleries in London showing the work of contemporary British and Irish artists. Opened in the West End in 1992 and exhibits at major British and American art fairs.

Submission Policy Exhibits both representational and abstract painting and sculpture and artists are always welcome to submit a selection of photographs. Send sae, brief statement and biography (no books or valuable items should be sent). No responsibility is taken for lost items.

Price range $f_{200} - f_{50,000}$ No of exhibitions annually 20

Kate MacGarry

7A Vyner Street, London, E2 9DG

T 020 8981 9100

E mail@katemacgarry.com

W www.katemacgarry.com

Contact Fabio Altamura

Opened in 2002, hosting mainly solo shows with one or two group shows per year. Artists exhibited include Tasha Amini, Matt Bryans, Josh Blackwell, Stuart Cumberland, Luke Gottelier, Dr Lakra, Goshka Macuga, Peter McDonald, Stefan Saffer, Francis Upritchard, Iain Forsyth and Jane Pollard. No of exhibitions annually 6

Keith Talent Gallery

2-4 Tudor Road, London, E9 7SN

T 020 89862181

F 020 85332060

E keithtalent@tiscali.co.uk

W www.keithtalent.com

Established in 2001 in an industrial space in London Fields by two graduates of the Royal Academy Schools. Shows emerging artists, collaborating and forming links with a number of artist-run project spaces and established commercial galleries both in Britain and abroad.

Kings Road Galleries

436 Kings Road, Chelsea, London, SW10 0LJ T 020 73511367

F 020 73517007

E admin@kingsroadgallery.com

W www.kingsroadartgallery.com
Contact Tanya Baxter and Nadya Al-khusaibi
Represents contemporary painters and
sculptors (predominantly figurative but some
strong abstract artists such as Richard Allen),
who tend to be established on the
international art-fair circuit and museum front.
Also has a corporate-art consultancy division. A
reciprocal exhibition programme exists with
galleries in Hong Kong, Singapore and
Shanghai. The Ryder Street Gallery in St James's
opened in 2004, showcasing the same artists and
acting as a host to touring international

Submission Policy Represents artists whose 'fervour for painting and sculpting is markedly different from the current trends, which favour shock art and conceptual works'.

Price range £350-£65,000 No of exhibitions annually 10 Cost to hire or rent Ryder Street Gallery from £3,500 per week.

Laura Bartlett Gallery

22 Leathermarket Street, London, SE1 3HN T 020 74033714

F 020 74033715

exhibitions.

E mail@laurabartlettgallery.com

W www.laurabartlettgallery.com Contemporary art gallery. Artists include Sachiko Abe, Anna Boggon, Harrell Fletcher, Adam

Humphries, Elizabeth McAlpine, Dwayne Moser, Raul Ortega Ayala, Martin Skauen and Michael Whittle.

Lena Boyle Fine Art

1 Earls Court Gardens, London, SW5 0TD

T 020 72592700

F 020 73707460

E lena.boyle@btinternet.com

W www.lenaboyle.com

A small business established in 1989 and run from a private house, with a policy of showing established artists alongside relative unknowns. Attends several of the major London art fairs. Submission Policy Does not have scope to take on many new artists each year. Tends to specialize in contemporary figurative works with an abstract element.

Price range £200-£15,000 No of exhibitions annually 2-3

Lennox Gallery

77 Moore Park Road, London, SW6 2HH
T 01488 681379
F 01488 681379
E sally@poltimore.fsbusiness.co.uk
W www.lennoxgallery.co.uk
Founded in 1998, specializing in Scottish
contemporary art. Artists include Pat Semple
RSW, Leonie Gibbs, Elizabeth Cameron, Jim
Neville, Allan MacDonald and Kate Slaven.
Painting courses available and lectures held on
past and present-day artists. Space also available
for artists to put on their own exhibitions.
Submission Policy Preferably living artists working
in Scotland, using a strong sense of colour.

Price range £300-£5,000 No of exhibitions annually 4

Lesley Craze Gallery

33–35A Clerkenwell Green, London, EC1R 0DU T 020 76080393 (jewelry) or 020 72519200 (textiles)

E textiles@lesleycrazegallery.co.uk W www.lesleycrazegallery.co.uk Showcase for contemporary jewelry, metalwork

and textiles, including work from a hundred artists from around the world. Varied programme shows emerging and established names across a range of techniques and materials.

Limited Edition Graphics

2 Winchester Road, London, N6 5HW T 020 83481354 F 020 83481357 Contact Allan Wolman Specializes in nineteenth- and twentieth-century and contemporary works.

Lisson Gallery

52-54 Bell Street, London, NW1 5DA

T 020 77242739

F 020 77247124

E contact@lisson.co.uk

W www.lisson.co.uk

Opened in 1967 by Nicholas Logsdail and later moved into current premises near Baker Street, Marylebone. One of the world's leading galleries for contemporary art. A second gallery at 29 Bell Street opened in 2002.

No of exhibitions annually Aproximately 10 at each space

Llewellyn Alexander (Fine Paintings) Ltd

124-126 The Cut, SE1 8LN T 020 76201322 / 76201324

F 020 7928 9469

E gallery@llewellynalexander.com

W www.llewellynalexander.com

Contact Diana Holdsworth

Founded in 1987, specializing in figurative paintings, oils, watercolours and pastels by British artists. Other subjects include the architecture and landscapes of Italy, France and London, still lifes and animals. Among the leading galleries in Europe for contemporary miniatures.

Submission Policy Interested in figurative paintings in oils and watercolours. Submissions from living British artists welcome. Send photographs or CD with images (plus sae for return of items within the UK). Replies by post to UK only. Do not email images.

Price range £150-£6,000 No of exhibitions annually 9

London Picture Centre

723 Fulham Road, London, SW6 5HA F 020 77367283 E info@thelondonpicturecentre.co.uk W www.thelondonpicturecentre.co.uk Contact Albert Williams Established for over thirty years, with six sites. Branches: 700 Fulham Road SW6; 18 Crawford Street W1 T: 020 74872895; 75 Leather Lane, EC1 T: 020 74044110; 152 and 287 Hackney Road, E2 T: 020 74044110

Long & Ryle

4 John Islip Street, London, SW1P 4PX

T 020 78341434

E longandryle@btconnect.com

W www.longandryle.com Contact Tom Juneau

Price range 020 77314883

Established over fifteen years ago to promote the work of emerging talents and mid-career artists in the same space. Has a bias towards bold and painterly work. Artists include Brian Sayers, John Monks, Simon Casson, Simon Keenleyside, Balint Bolygo, Ricardo Cinalli, Mark Entwisle and Daisy

Submission Policy Mostly painting, with an emphasis on figuration. Looking for a certain 'edge' in an artist.

Price range £500-£50,000 No of exhibitions annually 10 Lucy B. Campbell Fine Art

123 Kensington Church Street, London, W8 7LP

T 020 77272205

F 020 72294252

E lucy@lucybcampbell.com

W www.lucybcampbell.com

Contact Lucy B.Campbell

Founded in 1984. Represents British, European and American artists and sculptors.

Work includes both figurative and abstract, contemporary, still life, landscape, botanical and naive genres. Artists exhibited include Anna Pugh, Sophie Coryndon, Bernard McGuigan, Mia

Tarney, Christine Pichette, Dawn Reader, Michele Mattei.

Submission Policy Interested in still life, landscape, contemporary paintings and sculpture. Price range $f_{1,000}-f_{40,000}$

No of exhibitions annually 2

Lupe

7 Ezra Street, London, E2 7RH

T 020 76135576

F 020 76132287

E info@lupegallery.com

W www.lupegallery.com

Contact Nicky Sims

Launched in 2002. Represents the work of some thirty of the UK's leading contemporary photographers. Artists include David King, Stuart Redler, Tim Flach, Perou, Morgan Silk and George Kavanagh. Other services include fine-art printing and scanning.

Submission Policy Photography with an emphasis on craft and innovation. Initial contact by email preferred.

Price range £150-£2,000 No of exhibitions annually 3

Maas Gallery

15A Clifford Street, London, W1S 4JZ

T 020 77342302

E mail@maasgallery.com

W www.maasgallery.com

Founded in 1960 by the late Jeremy Maas. Originally a 'revivalist' gallery, specializing in the then unfashionable field of Pre-Raphaelite paintings. Rupert Maas, his son, now owns and runs the gallery. Deals in major Victorian paintings and with myriad lesser-known artists of the period. Also deals in reproductive engravings and has a small stable of living artists.

Price range From \$20 No of exhibitions annually 2

Manya Igel Fine Arts

21–22 Peters Court, Porchester Road, London, W2 5DR

T 020 72291669 / 72298249

F 020 72296770

E paintings@manyaigelfinearts.com

W www.manyaigelfinearts.com

Gallery meets clients by appointment only.
Specializes in traditional, modern British oils by
Royal Academicians, members of the New English
Art Club and other well-known artists. Exhibited
artists include Diana Armfield, Fred Cuming,
Bernard Dunstan, Frederick Gore, Ken Howard,
Geoffrey Humphries, Peter Kuhfeld and Susan
Ryder.

Submission Policy Generally has long-established relationships with artists and purchases their work outright.

Price range £350-£25,000

No of exhibitions annually 3–5 fine-art fairs, including solo shows in the Channel Islands.

Mark Jason Gallery

First Floor, I Bell Street, London, NW1 5BY

T 020 72585800 F 020 72585801

E art@markjasongallery.com

W www.markjasongallery.com

Contact Mark Jason or Kate Jason

Opened in 2001 and showcases young emerging talent from new graduates to mid-career artists. Shows mainly paintings and photography. Artists are selected from most mainstream art schools including the Royal Academy, The Slade School of Art, Goldsmiths, Chelsea School of Art and others around the UK.

Submission Policy For artist enquiries, send information in disc format to gallery address or jpeg images via email.

Price range £300-£10,000

No of exhibitions annually 8

Cost to hire or rent Please call gallery for further details.

Marlborough Fine Art

6 Albemarle Street, London, W1S 4BY

T 020 76295161

F 020 76296338

E mfa@marlboroughfineart.com

W www.marlboroughfineart.com

Founded in 1946. One of the world's leading contemporary art dealers. In addition to being a foremost dealer and publisher of fine-art prints, the gallery deals in paintings and sculpture by

prominent international artists and has branches in New York, Madrid, Monte Carlo and Santiago. No of exhibitions annually 6–8

Matt's Gallery

42-44 Copperfield Road, London, E3 4RR

T 020 89831771

F 020 89831435

E info@mattsgallery.org

W www.mattsgallery.org

Contact Clare Fitzpatrick

Founded in 1979. Specializes in solo exhibitions of young and established artists, especially in installation, performance, video, sculpture and painting, and has a publishing programme. Arts Council-funded. Artists represented include Imogen Stidworthy, Willie Doherty, Mike Nelson, Lucy Gunning, Nathaniel Mellors and Hayley Newman.

Submission Policy Seeks to support artists in the generation of new work, providing them with the time and space to experiment and engage audiences in a critical debate. Welcomes submissions from those familiar with the ethos of the gallery.

Price range £1,500-£100,000 No of exhibitions annually 6

Matthew Bown Gallery

First Floor, 11 Savile Row, London, W15 3PG

T 020 77344790

F 020 77344791

E mail@matthewbown.com

W www.matthewbown.com

Shows leading contemporary artists including Oleg Kulik, Irina Zatulovskaya, Vitali Komar, Katya Arnold, Ilya Tabenkin, Arnis Balcus, Dmitri Gutov, Eduard Shteinberg, Komar & Melamid, Erik Bulatov and Geli Korzhev. Particular focus on art from Russia and the former Soviet Union.

Maureen Paley

21 Herald Street, London, E2 6JT

T 020 77294112

F 020 77294113

E info@maureenpaley.com

W www.maureenpaley.com

Contact Susanna Chisholm or Oliver Evans Since 1999 the gallery has been situated in Bethnal Green in premises of 5,000 sq. ft. Relocated from a Victorian terraced house in London's East End where the gallery programme began in 1984. One of the first galleries to present work in London's East End and a pioneer of the current scene, promoting and showing art from the USA and continental Europe as well as launching new talent from Great Britain. Artists exhibited include Kaye Donachie, Andrew Grassie, Paul Noble, Saskia Olde Wolbers, Seb Patane, David Thorpe, Wolfgang Tillmans, Banks Violette, Rebecca Warren and Gillian Wearing. No of exhibitions annually 8-10

Max Wigram Gallery

99 New Bond Street, London, W1S 1SW T 020 74954960 E info@maxwigram.com W www.maxwigram.com Gallery artists include Cory Arcangel, Michael Ashcroft, Slater Bradley, Jason Brooks, FOS (Thomas Poulsen), James Hopkins, Barnaby Hosking, Pearl C. Hsiung, Marine Hugonnier, Mustafa Hulusi, Alison Moffett, John Pilson, Julian Rosefeldt, Nigel Shafran, Joel Tomlin, Christian Ward, Richard Wathen and James White.

Mayor Gallery

22A Cork Street, London, W1S 3NA T 020 77343558 F 020 74941377 E mail@mayorgallery.com

W www.artnet.com/mayor.html Founded by Fred Mayor in 1925; the first gallery to open in Cork Street. Has exhibited many artists for the first time in England including Bacon, Ernst and Miró. James Mayor, Fred's son, took over the gallery in 1973 and has since shown the work of many leading American artists including Lichtenstein, Oldenburg and Warhol. Continues to show the works of leading American Pop artists and remains London's foremost gallery for Dada and Surrealism.

Submission Policy Deals in most fields of the visual arts but excludes prints. More inclined towards established artists than new submissions. No of exhibitions annually 5

Medici Gallery

5 Cork Street, London, W1S 3LQ T 020 74952565 E info@medicigallery.co.uk W www.medicigallery.co.uk Contact Jenny Kerr

Established in Mayfair for the past ninety-eight years and and now at 5 Cork Street. Known for contemporary figurative art and exhibiting the work of leading British craftmakers.

Submission Policy Images should be sent, preferably by email or via post with sae; include medium, size, artist's CV, etc. Price range $f_{1,000}-f_{60,000}$ No of exhibitions annually 10

Michael Hoppen Gallery

3 Jubilee Place, London, SW3 3TD T 020 73523649 F 020 73523669 E gallery@michaelhoppengallery.com W www.michaelhoppengallery.com Contact Kathlene Caldwell and Lucy Chadwick

(contemporary)

Founded in 1992. Holds various exhibitions across three floors. Specializing in photographic art, it has one of the widest selections of nineteenth-. twentieth- and twenty-first-century works in Europe. The gallery's remit is to present the broadest spectrum of photography that is judged not only on its market value, but also on the quality and integrity of the artist's particular vision. Champions new artists as well as maintaining stock of the recognized masters. Artists represented include Jacques-Henri Lartigue, Desiree Dolron, Daido Moriyama, Sarah Moon, Peter Reard and Bill Brandt. Submission Policy Works must be original and

photography-based, and the artist must have been previously exhibited. Price range £100-£100,000

No of exhibitions annually 6-7

Millinery Works Gallery

85-87 Southgate Road, London, N1 3JS T 020 73592019 F 020 73595792 E jeff@millineryworks.co.uk W www.millineryworks.co.uk

Contact Jeff Jackson Founded in 1996 to exhibit, promote and sell contemporary and modern British fine and applied arts. Exhibited artists include Edward Wolfe RA, John Bratby RA, Gerald Wilde, Hugh Mackinnon, Eric Rimmington and Frances Newman. A leading specialist in the British Arts & Crafts Movement.

Price range £150-£60,000 No of exhibitions annually 9

Modern Art

10 Vyner Street, London, E2 9DG T 020 89807742 F 020 89807743 E info@modernartinc.com

W www.modernartinc.com

Formerly known as Modern Art Inc., the gallery moved from Shoreditch to Bethnal Green in 2004. Represents international and British contemporary artists such as Juergen Teller, Nigel Cooke, Ricky Swallow and Tim Noble and Sue Webster.

Monika Bobinska

242 Cambridge Heath Road, London, E2 9DA T 020 89809393

E mail@monikabobinska.com

W www.monikabobinska.com

The gallery was founded as Lounge in 2004 in Dalston, east London, and relocated to the Vyner Street area in 2007. The gallery has an ongoing programme of solo exhibitions by represented artists, group exhibitions and collaborative projects, participating in international art fairs. Artists collaborated with include Christopher Davies, Adam King, Peter Lamb, Laure Prouvost, D J Roberts and Sinta Tantra.

Submission Policy Artists and curators who are familiar with the gallery's work and feel that their work suits its aims and ethos are welcome to get in touch with a view to collaboration.

Price range £200-£10,000 No of exhibitions annually 6

MOT INTERNATIONAL

Unit 54 Regents Studios, 8 Andrews Road, London, E8 4QN

T 020 79239561

F 020 79239561

E info@motinternational.org

W www.motinternational.org

Founded as MOT in 2002. Exhibitions have included the work of curators and critics, and have showcased emerging and more established artists, including Kelley, Kippenberger, Graham, McCarthy, Gillick, Creed, Lucas, Wallinger, Jeremy Deller and Matthew Higgs.

Submission Policy Will consider submissions from artists or curators. Up to six images, jpegs at 72dpi, or a website link should be e-mailed to the gallery. Include full CV and supporting statement.

Price range £500-£25,000No of exhibitions annually 8

Multiple Store

Central St Martins College of Art & Design, 107–109 Charing Cross Road, London, WC2H ODU T 020 75147258 F 020 75148091 E info@themultiplestore.org W www.themultiplestore.org

Founded in 1998. Commissions limitededition multiples (mostly three-dimensional) by contemporary British artists, both emerging and established. Does not have a permanent exhibiting space but work can be shown to individual collectors at offices of Central St Martins.

Museum 52

52 Redchurch Street, London, E2 7DP

T 020 73665571 F 020 77396707

E admin@museum52.com

W www.museum52.com

Founded in 2003, showing emerging international talent as well as working with established artists on one-off projects. Artists include Tom Gallant, Pierre Ardouvin, Stephen Vitiello, John Issacs, Nick Waplington, Kate Atkin, Kay Harwood, Lee Maelzer, Frank Selby and Peter Macdonald.

Submission Policy Please send two printed full-colour images and a brief description of the work.

Price range £1,000-£50,000

No of exhibitions annually 8

Nancy Victor

Basement, 36 Charlotte Street, London, W1T 2NA

T 020 78130373 F 020 87489818

E info@nancyvictor.com

W www.nancyvictor.com

Non-commercial underground space showing new and up-and-coming artists only. No services offered to artists.

Submission Policy Artists sending applications should be proactive and display a quality of work and commitment.

Price range £20-£10,000No of exhibitions annually 8

Nettie Horn

25B Vyner Street, London, E2 9DG

T 020 89801568

E info@nettiehorn.com

W www.nettiehorn.com

Exhibits an eclectic variety of contemporary British and international artists, showing a broad selection of works with emphasis on experimental techniques and materials. Integrated programme of exhibitions, including solo-shows of gallery artists, as well as curated group exhibitions which focus mainly on emerging artists who have a solid and innovative practice, alongside mid-career artists. Artists exhibited include: Kim Rugg, Annie

Attridge, Antti Laitinen, Bjorn Veno, Kate Street, Debbie Lawson, Sinta Werner, Rebecca Taber, Mike Newton and Hektor Mamet.

New Realms Limited

26 Phipp Street, London, EC2A 4NR T 020 70339721 E contact@newrealms.org.uk

W www.newrealms.org.uk Contact Jonathan Wiggin

Founded in 2004, specializing in contemporary art from the former Soviet Republics, including paintings, prints, drawings, sculpture, installation, performance and new media. Aims to promote young artists representing the highest standards of contemporary art production in their countries of origin, bringing their work to a wider Western European audience.

Submission Policy Only natives of one of the seventeen states that formerly constituted the Soviet Union. Not older than 45 years.

Price range f_{50} - $f_{15,000}$ No of exhibitions annually 8 Cost to hire or rent £500 per week.

Nolias Gallery

the Thomas aBecket, 320 Old Kent Rd, SE1 5UE T 020 79283266

E enquiries@noliasgallery.co.uk

W www.noliasgallery.com

One of the few affordable spaces available to students. It is a 1000sq. ft project exhibition space, with café and bar facilities. Previously hosted a boxing club. Nolia Devlin, director of the gallery, is keen to give undergraduates and up-and-coming artists the chance to exhibit and curate their work. Also has gallery spaces in Great Suffolk Street SE1 and Liverpool Road, N1.

Cost to hire or rent Yes

Northcote Gallery Chelsea

253 King's Road, Chelsea, London, SW3 5EL

T 020 73510830

E info@northcotegallery.com

W www.northcotegallery.com

Contact Ali Pettit, Alexander MacFaul Founded in 1992 on Northcote Road, Battersea followed by expansion into large exhibition space on two floors on King's Road, Chelsea. Consultants in Los Angeles and Melbourne. Exhibits international contemporary and modern British paintings and sculpture. Painters and photographers represented include Jo Barrett, Martin Burton, Louise Butler Adams, Daisy Cook, Sean Cotter, Molly Garnier, Sarah Hillman, Tom Homewood, Katharine Horgan, James Leggat, Colette Leinman, Ffiona Lewis, Sarah Lewis, Fay Macaulay, Rebecca McLynn, Jonathan McCree, Dan McDermott, Robert McKellar, Melanie Miller, Dawn Reader, Gill Rocca, Dion Salvador Lloyd, Alice Scrutton, Oinuen Sprunt, Ann Penman Sweet, Josep Pla, Alice Von Maltzahn, Stephanie Rogers, Ger Sweeney, Malcolm Temple and Richard Whadcock. Sculptors represented include Debi O'Hehir, Carol Peace, Benjamin Piggott, Andrew Smith, Anthony Stern and Petrina Stroud. Submission Policy Selection by committee. Artists are invited to submit portfolios to the committee, which meets every six weeks. Portfolio's to Selection Committee, Northcote Gallery, 110 Northcote Road, Battersea, London SW11 6QP together with sae if to be returned. No of exhibitions annually 20 across the 2 gallery sites.

October Gallery

24 Old Gloucester Street, London, WC1N 3AL T 020 72426367 F 020 74051851

E gallery@octobergallery.co.uk W www.octobergallery.co.uk

Contact Elisabeth Lalouschek

Founded in 1979. A charitable trust dedicated to the advancement and appreciation of art from all cultures. To this end, the gallery is actively engaged in education and the promotion of intercultural exchange. Exhibits and promotes artists of the 'transvangarde' - the trans-cultural avant-garde. Artists represented include Aubrey Williams, William Burroughs, Brion Gysin, Kenji Yoshida, El Anatsui and Rachid Koraichi.

Submission Policy Submissions from artists from the cross-cultural exchange welcome.

Price range $f_{250} - f_{30,000}$ No of exhibitions annually 8

Offer Waterman & Co.

II Langton Street, London, SW10 0JL T 020 73510068 F 020 73512269 E info@waterman.co.uk W www.waterman.co.uk Aims to provide the best of twentieth-century

British painting, drawing and sculpture, with an emphasis on the Camden Town Group, Euston Road School, 7 and 5 Society, Unit One, School of London, Neo-Romantics, St Ives Group and Pop. Can source specific European and contemporary

work where required. Always looking to acquire important pieces and will buy or consign directly from private collectors. Additional services include insurance and probate valuations, research, conservation, framing and display advice.

Represents Diarmuid Kelley and Celia Hegedus.

Price range £2,000—£500,000

No of exhibitions annually 2

Oliver Contemporary

17 Bellevue Road, Wandsworth Common, London, SW17 7EG

T 020 87678822

F 020 87678822

E mail@oliverart.co.uk

W www.oliverart.co.uk

Founded in 2001. Brings together new and established contemporary artists working within the modern British tradition.

Submission Policy Not looking for any new artists.

Price range £250-£5,000

No of exhibitions annually 6

One in the Other

45 Vyner Street, London, E2 9DQ

T 020 72537882

F 020 72537882

E oneintheother@blueyonder.co.uk

W www.oneintheother.com

Works with mainly young UK and international artists, with an emphasis on young radicalism. Submission Policy Does not invite submissions but encourages artists to stage their own shows and inform the gallery of them.

Price range $f_{1,000}$ – $f_{20,000}$ No of exhibitions annually 6

Osborne Samuel

23A Bruton Street, London, W1J 6QG

T 020 74937939

F 020 74937798

E info@osbornesamuel.com

W www.osbornesamuel.com

Formed in 2004 as a partnership between Gordon Samuel (Scolar Fine Art) and Peter Osborne (Berkeley Square Gallery). Exhibition schedule includes established painters, printmakers and sculptors. Known worldwide as a dealer in modern and contemporary sculpture, in particular the work of Moore and Chadwick. Substantial inventory of masterprints by major artists of the last century, specializing in graphics by Picasso and Miró, and 1930s linocuts by artists of the Grosvenor School of Modern Art. Contemporary artists represented

include Sophie Ryder, Sean Henry and Graciela Sacco.

Submission Policy Represents a number of contemporary artists and is therefore fully committed. Will look at submissions, but these will only be returned if an sae is included. Does not invite email submissions.

No of exhibitions annually 10-12

Pangolin Gallery

Kings Place, 90 York Way, London, N1 9AG T 020 75201480

W www.pangolinlondon.com

New contemporary sculpture gallery that opened in 2008. Affiliated with Europe's leading sculpture foundry based in Gloucestershire, Pangolin Editions. The rolling exhibition programme includes work by a range of 20th century British sculptors: Lynn Chadwick, William Tucker, Ralph Brown, Jon Buck, Abigail Fallis, Peter Randall-Page and Ann Christopher, as well as organizing mixed exhibitions featuring a number of well-known contemporary names.

Panter & Hall

9 Shepherd Market, Mayfair, London, W1J 7PF

T 020 73999999

F 020 74994449

E enquiries@panterandhall.com

W www.panterandhall.com

Specialists in contemporary Scottish and modern British paintings.

Submission Policy Only interested in looking at painters with established markets.

Price range £500-£20,000No of exhibitions annually 12

Paradise Row

13 Hereford Street, London, E2 6EX

T 020 76133311

W www.paradiserow.com

Cutting-edge contemporary gallery. Exhibited artists include Diann Bauer, Jake & Dinos Chapman, Poppy de Villeneuve and Kirk Palmer.

Parasol Unit Foundation for Contemporary Art

14 Wharf Road, London, N1 7RW

T 020 74907373

F 020 74907775

E info@parasol-unit.org

W www.parasol-unit.org

A non-profit initiative established to showcase the work of leading international contemporary artists in various media. An 800 sq. m space over

two floors, it comprises an exhibition space, a reading area and a live/work unit to accommodate the artist-in-residence programme. Mounts four exhibitions each year and conducts a programme of events in conjunction with each exhibition. In order to encourage the widest possible access to its exhibition programme, the foundation does not charge admission fees.

Submission Policy Gallery does not welcome submissions from artists but runs an education and artist-in-residence programme.

No of exhibitions annually 4

Paul Mason Gallery

149 Sloane Street, London, SW1X 9BZ T 020 77303683

F 020 77307359

E Paulmasonart@aol.com

Founded in 1964. Specializes in eighteenthcentury through to contemporary marine, sporting and decorative paintings and prints, ship models, nautical artifacts, portfolio stands and picture

Submission Policy Top-quality marine oil paintings.

Price range From £2,000 No of exhibitions annually 3

Peer

99 Hoxton Street, London, N1 6QL T 020 77398080 E mail@peeruk.org W www.peeruk.org

Independent arts organization and registered charity that develops and presents projects in a range of media at the gallery, at other venues and in the public realm. Since 1998 Peer has commissioned and initiated a number of important projects with artists such as Martin Creed, Mike Nelson, Hannah Collins, Siobhan, John Frankland, Juan Cruz and Bob and Roberta Smith. Also produces publications by artists, about artists and about the cultural impact of contemporary art. Submission Policy Because Peer is a very small organization and must raise funds for each project, cannot accept unsolicited applications.

Photofusion

17A Electric Lane, London, SW9 8LA T 020 77385774 F 020 77385509 E gallery@photofusion.org W www.photofusion.org Contact Catherine Williams

Started life in the early 1980s as a photographers' collective and now among London's most comprehensive photography and media centres. Committed to promoting diversity within the photographic arts, encompassing both chemical and digital media. Presents a broad range of exhibitions, from emerging UK-based photographers to internationally recognized ones. Also runs artists' talks, professional-development workshops, and photography and digital training courses, as well as housing a picture library, studios, darkrooms, digital suites and a membership scheme.

Submission Policy Accepts only photographic or digital-based work. Programming by committee. Send a comprehensive written description, CV and examples (not original prints).

Price range From £300 No of exhibitions annually 8

Piano Nobile Fine Paintings Ltd

129 Portland Road, London, W11 4LW T 020 72291099

F 020 72291099

E art@piano-nobile.com

W www.piano-nobile.com

Contact Suzy Meek

Founded in 1985, specializing in fine-quality twentieth-century international, modern British and post-war paintings, drawings, watercolours and sculpture for private, corporate and museum collections. Period work exhibited alongside shows by leading contemporary painters and sculptors including Adam Birtwistle, Dora Holzhandler, Barbara van Hove, Leslie Marr, Kasey Sealy and Nicolaus Widerberg.

Submission Policy Painting and sculpture in all media with a preference for figurative work. Price range £150,000-£250,000

No of exhibitions annually 4-6

Pieroni Studios

I Dickson House, 3 Grove Road, Richmond, TW10 6SP

T 020 89488066

E lark@pieronistudio.co.uk

Contact Lark Harrison

Represents several painters and sculptors. Submission Policy Does not want submissions from other artists at present.

Price range $f_{1,000}$ - $f_{4,000}$ for paintings; $f_{3,500}$ - $f_{7,500}$ for sculpture.

No of exhibitions annually 2 in-house; 6 off-site (mainly London).

Plus One Gallery

91 Pimlico Road, London, SW1W 8PH

T 020 77307656

F 020 77307664

E info@plusonegallery.com

W www.plusonegallery.com

Contact Maggie Bollaert or Colin Pettit
Founded in 2001, specializing in an international
contemporary realist and photorealist art
programme. Deals exclusively in paintings
and sculptures. Artists represented include
Andrew Holmes, Barry Oretsky, John Salt, Cesar
Santander, Gus Heinze, Carl Laubin, John Beader

and Ben Johnson. **Submission Policy** Living artists represented but within all aspects of the genre of contemporary realism.

Price range £300-£100,000No of exhibitions annually 9-10

Pond Gallery

26 The Pavement, Clapham Old Town, London, SW4 0JA

T 020 76224051

F 020 76224051

E info@pondgalleries.co.uk

W www.pondgalleries.co.uk

Contact Dee-Michael Hutchings

Founded in 2002, dealing in contemporary paintings, ceramics and sculpture. Represented artists include Rochelle Andrews, Samantha Barnes, Henrie Haldane, Ilia Petrovic, Jess Pearson and Jason Lilley.

Submission Policy Submissions should be made by sending CD of images or photographs by post with sae.

Price range £500-£5,000

No of exhibitions annually 6–8, plus a summer garden party in the sculpture garden.

Proud Galleries

32 John Adam Street, Off the Strand, London, WC2N 6BP

T 020 78394942

F 020 78394947

E info@proudgalleries.co.uk

W www.proud.co.uk

Contact Kate Boenigk

Photographic galleries established over ten years ago. Operates on two sites, the one in Camden being the largest photo gallery in the UK.

Submission Policy Applications on disk or email to kate@proudgalleries.co.uk. Images, biography and some background information helpful.

Price range $f_50-f_{10,000}$ No of exhibitions annually 15-20Cost to hire or rent f_5 ,500 full day hire. For exhibitions, $f_{15,000}$ for first week and $f_{10,000}$ each additional week.

Purdy Hicks Gallery

65 Hopton Street, Bankside, London, SE1 9GZ T 020 74019229

F 020 74019595

E contact@purdyhicks.com

W www.purdyhicks.com

Represents a number of emerging and pre-eminent British and foreign artists including Susan Derges, Ralph Fleck and Alice Maher. Founded in 1993, specializing in painting and photography. The gallery participates in a number of international art fairs and also regularly publishes catalogues and works with touring exhibitions.

Price range From £500 for prints; from £1,000 for paintings and photographs.

No of exhibitions annually Approx.10

Quantum Contemporary Art

The Old Imperial Laundry, 71–73 Warriner Gardens, London, SW11 4XW

T 020 74986868

F 020 74987878

E quantum.art@virgin.net

W www.quantumart.co.uk

Contact Johnny Gorman

Founded in 1996 in a design hub called the Old Imperial Laundry in Battersea. Represents about forty artists, mainly painters whose style is representational. Participates in art fairs in the UK and USA.

Submission Policy Artists' submissions welcome, but conceptual, abstract, sculpture, photography, digital and performance art are not exhibited.

Price range £250-£10,000 No of exhibitions annually 10

Rachmaninoff's

Unit 106, Kings Wharf, 301 Kingsland Road, London, E8 4DS

T 020 72750757

E info@rachmaninoffs.com

W www.rachmaninoffs.com

Contemporary gallery. Also has a programme of publications.

Rafael Valls Ltd

6 Ryder Street, St James's, London, SW1Y 6QB

T 020 79300029 F 020 79762589 E lizzie@rafaelvalls.co.uk W www.rafaelvalls.co.uk

Contact Caroline Valls or Lizzie Aubrey-Fletcher Over thirty years of experience, specializing in Old Masters. Also holds a number of contemporary

exhibitions each year.

Submission Policy Artists wishing to be given an exhibition should email images or send a link to a website.

Price range f_{500} - $f_{25,000}$ No of exhibitions annually 4

Rebecca Hossack Gallery

35 Windmill Street, Fitzrovia, London, W1T 2JS T 020 74364899 F 020 73233182 E rebecca@r-h-g.co.uk

W www.r-h-g.co.uk Contact Maria Morrow

Opened in central London by Rebecca Hossack in 1988. Programme combines non-Western art with work in the Western tradition.

Submission Policy Artists wishing to apply to the gallery may send a copy of their CV along with images of recent works - jpegs if sent via email or slides with an sae if sent via post.

Price range f_{50} - $f_{50,000}$

No of exhibitions annually 24 (12 in each gallery).

The Red Mansion Foundation

46 Portland Place, London, W1B 1NF T 020 73233700 F 0207 323 0788 E info@redmansion.co.uk

W www.redmansion.co.uk

Contact Isabelle Chalard

A not-for-profit organization that promotes artistic exchange between China and Great Britain. Its vision is to encourage mutual cultural understanding through contemporary art. Staff in China and the UK provide advice to corporate and private clients on contemporary Chinese art. All proceeds from sales and consultancy services support the Foundation's programmes. Represents a cross-section of significant Chinese artists, including Zhao Bandi, Cang Xin, Shi Jing, Zhan Wang, Liu Jianhua and Weng Fen among others.

Submission Policy Represents and welcomes submissions from contemporary Chinese artists.

Price range £500-£300,000 No of exhibitions annually 6

Redfern Gallery

20 Cork Street, London, W1S 3HL

T 020 77341732 F 020 74942908

E art@redfern-gallery.com

W www.redfern-gallery.com

Founded in 1923. One of London's oldest commercial galleries, dealing mainly in modern and contemporary British and European art. Artists represented include Paul Feiler, Eileen Agar, Patrick Procktor, David Tindle, Paul Jenkins and Linda Karshan.

Submission Policy No unsolicited submissions.

Price range £500-£500,000 No of exhibitions annually 11

The Residence

Verger's Cottage, St. Mary of Eton Church, London, E9 5JA T 020 89862324 F 020 89862324

E info@residence-gallery.com W www.residence-gallery.com

Contact Ingrid Z

The Residence exhibits contemporary art in a gallery 'work' produced by artist Ingrid Z. Formerly situated in a shop front, the gallery opened in 2007 in a church cottage residence. It is home to experimental programming and new arrivals from local and international artists working in a diversity of media. Presents an ever-evolving social environment and situation for artists and audience. The gallery is a live structure to be experienced as a whole or in its individual pieces. In addition, the gallery boutique sells artist multiples, limited edition publications and curiosities.

Submission Policy See website. Price range f_1 - f_1 0,000 No of exhibitions annually 12 (+ undetermined amount of spontaneous events).

Richard Green

147 New Bond Street, London, W1S 2TS

T 020 74933939 F 020 76292609

W www.richard-green.com

Dealing in paintings for over forty years. Has three galleries in London's West End, specializing mainly in Old Master, Impressionist, marine and sporting paintings, as well as twentieth-century British art, with artists such as Sir Terry Frost RA and Ken Howard RA.

Riflemaker

79 Beak Street, Regent Street, London, W1F 9SU T 020 74390000 E info@riflemaker.org

W www.riflemaker.org

Contact Robin Mann

Independent contemporary art gallery in a boutique-sized former riflemaker's workshop in Soho. Presents visually potent, conceptually rigorous exhibitions by both new and established British and international artists. Artist's represented include Andrey Bartenev, Christopher Bucklow, William S. Burroughs, Juan Fontanive, Aisheen Lester, Jose Maria Cano, Chosil Kil, Jaime Gili, Francesca Lowe, John Maeda, Marta Marce, Anja Niemi, Daniela Schonbachler, and Julie Verhoeven.

Submission Policy The gallery accepts submissions via email only. Price range £1,000-£100,000

Ritter/Zamet

2 Bear Gardens, London, SE1 9ED

No of exhibitions annually 8

T 020 72619510 F 020 72619516

E info@ritterzamet.com

W www.ritterzamet.com

Founded in 2003, aims to present a cohesive programme of emerging European and American contemporary artists. Artists represented include Simon Bedwell (UK), Krysten Cunningham (USA), Nogah Engler (Israel), Paule Hammer (Germany), Kate Hawkins (UK), Nate Lowman (USA), Moriceau and Mrzyk (France), Danica Phelps (USA), and Peter Stauss (Germany). Submission Policy Does not normally work on an artist-submission basis.

Price range £500-£30,000 No of exhibitions annually 5

Rivington Gallery

69 Rivington Street, London, EC2A 3AY T 020 77397835 F 020 77397855 E rivingtongallery@aol.com

Founded in 1997. Shows painting, sculpture, drawing, photography and crafts. Represented artists include Tom Kemp, Michael Green, Nichollas Hamper, Neave Brown and Julie Oakes. Submission Policy Has a very complete roster of artists but will look at work by appointment.

Price range £200-£10,000 No of exhibitions annually 10-12

Robert Sandelson

5 Cork Street, London, W1S 3NY
T 020 74391001
F 020 74392299
E info@robertsandelson.com
Opened in Cork Street in 1999 and specializes
in modern and contemporary British and
international art. The gallery also presents
changing exhibitions of sculptures in the grounds
and premises of Narborough Hall in Norfolk.

Rocket

Tea Building, 56 Shoreditch High Street, London, E1 6JJ

T 020 77297594

F 020 77290079

E js.rocket@btinternet.com

W www.rocketgallery.com

Founded in 1995. Contemporary art with an emphasis on minimalism and photography. Artists include Martin Parr, Michelle Grabner, Charles Christopher Hill, Lars Wolter, David James Smith, Keld Helmer-Petersen and Paul Shambroom. Alongside the contemporary program Rocket also exhibits abstract artists from the 1960s and exclusively represents the Estate of Jeremy Moon.

Price range £100-£30,000No of exhibitions annually 5

Rokeby

37 Store Street, London, WC1E 7QF T 020 71689942 E rokeby@rokebygallery.com W www.rokebygallery.com Founded in 2005, an independent commercial gallery for contemporary art. Exhibits work by emerging and established artists from the UK and beyond, in a wide range of media. Presents solo shows or curated exhibitions focusing on no more than two artists. Gallery artists include Kathrine Ærtebjerg, Sam Dargan, Craig Fisher, Graham Hudson, Simon Keenleyside, Raul Ortega Ayala, Claire Pestaille and Michael Samuels. Submission Policy Submissions by email only, with ten low-resolution jpegs, a statement and biography. Replies to email not guaranteed. Price range f_{10} - $f_{30,000}$

Rona Gallery

1–2 Weighhouse Street, London, W1K 5LR T 020 74913718 F 020 74914171

No of exhibitions annually 8

E info@ronagallery.com

W www.ronagallery.com

Contact Stanley Harries

Founded in 1980. Shows figurative art mostly by living artists. Particular focus on painting by 'one-off individualists'. Artists include Richard Adams, Alfred Daniels RBA, Nicola Slattery, Christopher Hall RBA, Martin Leman and Michael Kidd.

Submission Policy Paintings in oil or acrylic (figurative only). Phone or email first.

Price range £2,000-£10,000 No of exhibitions annually 8-9

ROOM

31 Waterson Street, London, E28HT T 0207 6132636

E info@roomartspace.co.uk

W www.roomartspace.co.uk

The gallery's exhibition programme presents a broad range of contemporary art practice together with performance events and screenings. Also offers art consultancy service.

Rowley Gallery Contemporary Arts

115 Kensington Church Street, London, W8 7LN T 020 72295561

F 020 72295561

E art@rowleygallery.com

W www.rowleygallery.com

Contact David Kitchin

Exhibits a continuous mixed exhibition, with an average of fifteen to twenty artists at any one time. Submission Policy Submissions always welcome from artists.

Price range £125-£4,500 No of exhibitions annually 2

Royal Exchange Art Gallery

7 Bury Street, St James's, London, SW1Y 6AL

T 020 78394477 F 020 78398085

E enquiries@marinepictures.com

W www.marinepictures.com

Contact Adrian Thomas

Founded in 1974. Specializes in fine marine oils, watercolours and etchings from the eighteenth century to the present day. Leading contemporary marine artists represented include Steven Dews, Martyn Mackrill and Paul Freeman. Other earlier artists include A. Briscoe, T. Buttersworth, N.M. Condy, G. Chambers, T. Luny, E. Seago, N. Wilkinson and W.L. Wyllie.

Submission Policy Always looking for fine-quality

marine pictures. Send photographs and size details via email first.

Price range £650-£140,000

No of exhibitions annually 2 major shows, but a regular change of stock.

Sadie Coles HQ

69 South Audley Street, London, W1K 2QZ T 020 74938611

F 020 74994878

E info@sadiecoles.com

W www.sadiecoles.com

Established in 1997. Represents over thirty British and international artists working across all media. Artists include Sarah Lucas, John Currin, Wilhelm Sasnal, Urs Fischer, Elizabeth Peyton and Richard Prince.

Submission Policy Does not accept unsolicited artist submissions.

Price range £500-£3,000,000 No of exhibitions annually Approx.12

Sartorial Contemporary Art

101A Kensington Church Street, London, W8 7LN T 020 77925882

F 020 77925820

E art@sartorialart.com

W www.sartorialart.com

Founded in 2002 in an eighteenth-century Georgian house in Notting Hill, London. A projectled space set up by artist/curator Gretta Sarfaty Marchant. The aim of the gallery is to present work by both emerging and established artists/curators and to promote the exchange of current ideas and practices. Artists include James Jessop, Harry Pye, Gavin Nolan, Jasper Joffe, Chris Davies and Tim Parr.

Submission Policy No submissions.

Price range £200-£10,000

No of exhibitions annually 10

Scout

1-3 Mundy Street, off Hoxton Square, London, N1 6QT

T 020 77490909

F 020 77396691

E mail@scoutgallery.com

W www.scoutgallery.com

Contact Simon Pearce

Founded in 2002 as an east London gallery dedicated to international contemporary photography and associated film or video work. Artists shown so far include Ben Watts, cinematographer Christopher Doyle, Steven Klein, Royal College of Art graduate Marc Wayland, Kyoichi Tsuzuki and Magnum photographer Susan Meiselas.

Submission Policy Accepts photography proposals by email with a brief written statement accompanied by low-resolution jpegs or a website referral.

Price range £300-£10,000 No of exhibitions annually 6-7

Sesame Gallery

354 Upper Street, Islington, London, N1 0PD T 020 72263300

E info@sesameart.com

W www.sesameart.com

Dedicated to exhibiting the work of emerging artists in the UK. Specializes mainly in painting. **Submission Policy** Send CV, six to eight images of work plus a brief statement giving insight into artist's approach.

Price range £500-£10,000 No of exhibitions annually 6-8

Seven Seven Contemporary Art

77 Broadway Market, London Fields, London, E8 4PH

T 07808 166215

E info@sevenseven.org.uk

W www.sevenseven.org.uk

Founded in 2002, the gallery has evolved from a not-for-profit, artist-led organization. Works closely with international partners and affiliated artists. The gallery keeps some slots available for very high quality applications from organizations, curators and artists and continues to participate in a wide range of projects, both locally and internationally.

Submission Policy Artists and curators should refer to website for application information and to see examples of recent shows.

Price range £200-£7000 No of exhibitions annually 10 Cost to hire or rent no

The Sheen Gallery

245 Upper Richmond Road West, London, SW14 8QS
T 0208 3921662
F 0208 8760422
E info@thesheengallery.com
W www.thesheengallery.co.uk
Specializes in modern British and contemporary artists. Prominent contemporary artists represented include Diana Armfield, Sonia

Lawson, Mick Rooney, Charles Williams, Susan Ryder and Arthur Neal. Submission Policy Paintings and drawings. Price range £350-£12,000 No of exhibitions annually 4

The Ship

387 Cable Street, London, E1 OAH **T** 020 77900409

E The Ship@Mail.com

A non-commercial project space in the East End of London, situated in a disused pub on Cable Street with a history of the sex industry and right-wing activism. All shows are curated projects focusing on contemporary art.

Submission Policy Not currently handling any submissions.

No of exhibitions annually 7

The Showroom

44 Bonner Road, London, E2 9JS T 020 89834115

F 020 89814112

E tellmemore@theshowroom.org

W www.theshowroom.org

The Showroom has existed as a publicly-funded, not-for-profit contemporary art gallery since 1989. It has offered many artists their first solo show in London, including Mona Hatoum, Sam Taylor-Wood, Simon Starling, Jim Lambie, Claire Barclay and Eva Rothschild. The Showroom programmes four shows a year of newly commissioned work by individual artists or collaborative groups.

Submission Policy No unsolicited proposals. Price range £500-£30,000
No of exhibitions annually 4

Simon Lee Gallery

12 Berkeley Street, London, W1J 8DT

T 020 74910100

F 020 74910200

E info@simonleegallery.com

W www.simonleegallery.com

Represents prominent and influential artists including George Condo, Christopher Wool, Larry Clark, Michelangelo Pistoletto, Hans-Peter Feldmann, Jim Shaw, Marnie Weber and Bernard Frize but has also added some younger artists to the programme such as New Yorker Gary Simmons, London based painter and sculptor Toby Ziegler and Norwegian artist Matias Faldbakken.

No of exhibitions annually 9

Skylark Galleries

Unit 1.09 (First Floor Riverside), Oxo Tower Wharf, Barge House Street, London, SE1 9PH T 020 74019666

E info@skylarkgallery.com

W www.skylarkgallery.com

Two artist-run galleries in the Oxo Tower and Gabriel's Wharf on London's South Bank. Skylark I (Gabriel's Wharf) was founded 1994 and Skylark 2 (Oxo Tower) in 2001. Entirely staffed by exhibiting artists.

Submission Policy Contact gallery (by email / post with sae) for joining details. Exhibiting artists work in gallery one day every three weeks.

Price range $f_{20}-f_{1,000}$

No of exhibitions annually 3-5 including Affordable Art Fairs London and Bristol

Space Station Sixty-Five

65 North Cross Road, London, SE22 9ET T 020 86935995

E spacestationsixtyfive@btopenworld.com

W www.spacestationsixtyfive.com Opened in 2002. An artist-run space that works

closely with artists being shown. Does not currently represent artists. A shop-front gallery in a busy street, particularly interested in live art, sculpture, video, time-based/process work and installation. Hosts window exhibitions (viewed from the street) as well as exhibitions where the space is open to the public.

Submission Policy Proposals should be a maximum of one side of A4. Also include a CV and visuals. Artists are strongly recommended to visit the gallery before sending proposals.

Price range Prices decided by artists and directors. No of exhibitions annually 3-6

Spectrum Fine Art

77 Great Titchfield Street, London, W1W 6RF T 020 76377778

E anne@intelligent-pr.com

W www.spectrumlondon.co.uk

Opened in 2004, aiming to bring the work of a new generation of artists to the public and to provide a springboard for newly graduated talent. Artists include Craigie Aitchison, Marco Amura and Peter Howson.

Price range £150-£40,000 No of exhibitions annually 9

Spencer Coleman Fine Art

I Cloisters Walk, St Katharine Docks, London, E1W 1LD

T 020 74811199

Contact Spencer Coleman

Established for over ten years, specializing in a selection of oils, watercolours and pastel paintings by British, Russian and continental artists. These include Jorge Anguilar AEA APB FRSA, Andrew White, Crin Gale, Israel Zohar (Royal Portrait Artist), Douglas Gray, Juriy Ochremovich and Pippa Chapman. Branches at 8 Gordon Road, Lincoln LN1 3AJ; 5-9 The George Mews, The George Hotel, St Martin's, Stamford PE9 2LB and 22a North Bar Without, Beverley, East Yorkshire HU177AB.

Submission Policy New artists welcome (local and international) in all media, covering narrative, landscape, still life, seascape and equestrian topics. Price range $f_{300}-f_{15,000}$

No of exhibitions annually 2

Spitz Gallery

109 Commercial Street, Old Spitalfields Market, London, E1 6BG

T 020 72479747 F 020 73778915

E gallery@spitz.co.uk

W www.spitz.co.uk

Founded in 1996. Background in photography but displays other art forms including painting, graphic design, video art, sculpture, etc.

Submission Policy Submissions accepted in June and November only. Email image(s) in body of email, or post on CD. Will contact if interested.

Price range $f_{200}-f_{3,000}$ No of exhibitions annually 20

SS Robin Gallery

SS Robin, West India Quay, London, E14 4AE T 020 75380652

F 0870 1316566

E info@ssrobin.com

W www.ssrobin.com

Contact David Kampfner

Documentary photography gallery based onboard SS Robin, the world's oldest complete steamship, moored at West India Quay in the heart of Canary Wharf in London. Founded by two photographers, David and Nishani Kampfner, in 2002. Shows a rolling programme of photography in the newly restored cargo hold, open from March to September.

Submission Policy Visit the website to download the curation policy.

Price range £500-£5,000 No of exhibitions annually 6

Standpoint Gallery

45 Coronet Street, Hoxton, London, N1 6HD

T 020 77394921

F 020 77394921

E standpointgallery@btconnect.com

W www.standpointlondon.co.uk

Contact Fiona MacDonald (Gallery Curator) Standpoint Gallery is an independent, artist run project and exhibition space that opened in 1992. Artists are selected both from application and by invitation. Acts as a platform for emerging and mid-career artists from London, UK and internationally. Exhibits a range of media and reflects the diverse nature of contemporary artistic practice. The gallery runs and hosts the Mark Tanner Sculpture Award, a yearly award worth $f_{10,000}$ to an exceptional emerging sculptor from Greater London.

Submission Policy Submission by proposal or invitation. See website for details on submission and application process for the Mark Tanner Sculpture Award.

Price range £50-£10,000 No of exhibitions annually 8

Stephen Friedman Gallery

25-28 Old Burlington Street, London, W1S 3AN

T 020 74941434

F 020 74941431

E info@stephenfriedman.com

W www.stephenfriedman.com

Founded in 1995. Specializes in contemporary art. Mamma Andersson (Sweden), Stephan Balkenhol (Germany), Tom Friedman (USA), Kendell Geers (South Africa), Dryden Goodwin (UK), Donald Moffett (USA), Yoshitomo Nara (Japan), Rivane Neuenschwander (Brazil), Yinka Shonibare (UK), Catherine Opie (USA) and David Shrigley (UK). Submission Policy Post CV and a maximum of ten slides demonstrating work. Enclose sae for return of material.

No of exhibitions annually 6

The Steps Gallery

45 Moreton Street, Pimlico, London, SW1V 2NY

T 020 7630 8367

E contact@stepsgallery.co.uk

W www.stepsgallery.co.uk Contact Sidonio Costa

Founded in 2004The Steps Gallery, London, is recognised as one of the UK's leading promoters and exporters of young contemporary art. Over the years, we have established a reputation for identifying pioneering artists. The comprehensive

gallery program is inclusive of innovative media, technology-based work, photography, sculpture and site-specific installations. Exhibitions of gallery and guest artists expose and explore critical themes within contemporary art. The gallery is dedicated to supporting the placement of important work in all markets and premiers talent through an international program of curated exhibitions, participation in art fairs and publications. Extensive research and educational programs support the knowledge development of the Collector's Club members. Emphasis is placed on investment in young to mid-career artists from all markets and in providing gallery clients access to the strongest emerging talent first. Some of the Gallery artists are: Carolina Sardi, Gabriela Morawetz, Kuldeep Malhi, Karim Ghidinelli, Tim Tate, Simon Heijdens.

Submission Policy Interested in contemporary work, including paintings and sculptures. Corporate art portfolio includes digital work/ computer generated images. Exhibitions can be arranged in spaces outside the gallery.

Price range £100-£30,000 No of exhibitions annually 10

STORE

27 Hoxton Street, London, N1 6NH

T 020 77298171

F 020 77298171 E info@storegallery.co.uk

W www.storegallery.co.uk

Opened in 2003. Presents new work by British and international emerging artists. Artists represented include Chris Evans, Aurelien Froment, Ryan Gander, Dan Holdsworth, Claire Harvey, Pamela Rosenkrantz, Bedwyr Williams and Roman Wolgin.

Submission Policy Does not welcome unsolicited submissions. Details of exhibitions welcome.

Price range $f_{400}-f_{20,000}$ No of exhibitions annually 7

Studio 1.1

57A Redchurch Street, London, E2 7DJ

T 07952 986696

E studio1-1.gallery@virgin.net

W www.studio1-1.co.uk

Contact M. Keenan

Collective begun in 2003 with 'no particular battleplan'. Has evolved with a diverse range of shows, presenting artists at any stage of their career, from any country, in any discipline. Commitment is to the work itself and to fostering the three-way

relationship between artist, artwork, and viewer. Artists shown include Phyllda Barlow, John Summers, Cees Krijnen, Oliver Bancroft, Annie Kevans and Craig Andrews.

Submission Policy Refer to website.

Price range £200-£10,000 No of exhibitions annually 6

Studio Glass Gallery

63 Connaught Street, Marble Arch, London, W2 2AE

T 020 77063013

E mail@studioglass.co.uk

W www.studioglass.co.uk

Contact Zaf Iqbal

Established in 1994. Represents leading English and Czech artists working in glass including Libensky/Brychtova, Annja Matouskova, Ivana Sramkova, Dany Lane, Colin Reid, Max Jacquard, Richard Jackson, Sally Fawkes and Javier Gomez. Undertake commissions for fabricating glass art, conceptual and architectural.

Submission Policy Artists working in the glass medium

Price range £1,500-£45,000 No of exhibitions annually 4

Studio Voltaire

IA Nelson's Row, Clapham, London, SW47IR T 020 76221294

F 020 76278008

E info@studiovoltaire.org

W www.studiovoltaire.org

Contact Ioe Scotland

Founded in 1994. An artist-led gallery in southwest London promoting access and participation in contemporary art with its exhibition, education and studio programmes. Past exhibitors have included Pablo Bronstein, Lali Chetwynd, Liam Gillick, Lawerence Weiner, Joanne Tatham and Tom O'Sullivan and Allison Smith.

Submission Policy No areas excluded. Does not represent artists but works in collaboration with artists to achieve projects and exhibitions. Artists and curators are encouraged to contact the gallery to receive a copy of the artistic policy if they are interested in submitting a proposal.

Price range f_2 - f_2 0,000 No of exhibitions annually 5

Sutton Lane

I Sutton Lane, Entrance at 25-27 Great Sutton Street, London, EC1M 5PU T 020 72538580

F 020 72536580 E info@suttonlane.com W www.suttonlane.com No of exhibitions annually 8

Terry Duffy - 340 Old Street

340 Old Street, Shoreditch, London, EC1V 9DS E terryduffy@340oldstreet.co.uk

W www.340oldstreet.co.uk

Established in 1998 as an experimental art space to question and confront contemporary art, culture and society.

Submission Policy Apply by email only with CV and jpegs of images. No media, method, sex, race, religion, nationality or beliefs excluded. No deadlines.

Price range $f_{1,000-f_{25,000}}$ No of exhibitions annually 10

Theresa McCullough Ltd

80 Riverview Gardens, Barnes, London, SW13 8RA T 020 85631680

E info@theresamccullough.com

W www.theresamccullough.com

Opened in 2000 and moved to current riverside location in 2004. Dealer specializing in Indian and South-east Asian works of art (predominantly stone and bronze sculpture) as well as South-east Asian gold jewelry. Exhibits at the Asian Art in London fair in November and in New York at the International Asian Art Fair in March.

Submission Policy Deals in antique South Asian sculpture. Submissions welcome from contemporary Indian artists.

No of exhibitions annually 2

Thomas Dane

11 Duke Street, St James's, London, SW1Y 6BN T 020 79252505

F 020 79252506

E info@thomasdane.com

W www.thomasdane.com

Established in 2004 as the culmination of over a decade of behind-the-scenes activity, including supporting artists, hosting landmark exhibitions and dealing privately. Closely associated from the start with the generation of British artists whose work grew in stature in the 1990s, the gallery has now developed an expertise and reputation in the international arena. Exhibitions of selected international contemporary artists employing a wide range of media. Artists include Paul Pfeiffer, Michael Landy, Stefan Kürten, Anya Gallaccio, Hurvin Anderson and Albert Oehlen.

Submission Policy No unsolicited submissions. No of exhibitions annually 5

Timothy Taylor Gallery

24 Dering Street, London, W1S 1TT

T 020 74093344

F 020 74091316

E mail@timothytaylorgallery.com

W www.timothytaylorgallery.com Founded in 1996, specializing in contemporary art. Artists include Craigie Aitchison, Tim Braden, Jean-Marc Bustamante, Marcel Dzama, Ewan Gibbs, Susan Hiller, Fiona Rae, Bridget Riley, Sean Scully, Alex Katz, Jonathan Lasker, James Rielly, Kiki Smith and Miquel Barceló. Submission Policy Submissions not welcome. No of exhibitions annually 7-10

Tom Blau Gallery - Camera Press

21 Queen Elizabeth Street, London, SE1 2PD

T 020 73781300

F 020 72785126

E info@tomblaugallery.com

W www.tomblaugallery.com

Founded in 1993 and named after the founder of the photographic agency Camera Press. Specializes in vintage, modern and contemporary photography. Exhibited artists have included Jacques Lowe, Yousef Karsh, Jason Bell, Patrick Lichfield, Chris Shaw, and Morten Nisson. Also shows photographs from the Camera Press Archives and hosts the annual Ian Parry Scholarship Awards for young photojournalists. Submission Policy Submissions from artists not welcome. Exhibitions by Camera Pressrepresented photographers only.

Price range From £200

No of exhibitions annually 6-10

Transition Gallery

Unit 25a / 2nd Floor Regent Studios, 8 Andrews Road, London, E8 4QN

T 020 72544202

E info@transitiongallery.co.uk

W www.transitiongallery.co.uk

An artist-run space founded in 2002, showing work by emerging and established artists with a particular interest in strong curatorial themed projects. Transition Editions, the gallery's publishing imprint, works in tandem with the gallery to expand upon themes and instigate new critical writing. Artists shown include Laura Oldfield Ford, Stella Vine, Liz Neal, Delaine Le Bas, Emma Talbot, Hew Locke and Zoe Mendelson.

Submission Policy Artists are welcome to submit images, statements and proposals by email or post. No of exhibitions annually 8

Trolley

73a Redchurch Street, London, E2 7DJ

T 020 77395948

E info@trolleynet.com

W www.trolleybooks.com

Specializing in art and photography books, Trolley operates a gallery space primarily exhibiting work linked to books projects but with exceptions. Artists include Deirdre O'Callaghan, Adam Broomberg and Oliver Chanarin, Chris Steele-Perkins, Alex Majoli, Philip Jones Griffiths, Werner Bischof, Vedovamazzei, Doris Vassmer, Mia Enell and Stanley Greene.

The Troubadour Gallery

267 Old Brompton Road, Earls Court, London, SW59JA

T 020 73701434

F 020 72416329

E susie@troubadour.co.uk

W www.troubadour.co.uk/gallery.php Opened in 2001 with the idea of creating a dedicated space in which the many artists who come to the associated Café could display their work. Each exhibition is individually tailored but the space is ideally suited for short shows one week or less - with one or more private views.

Submission Policy Welcomes approaches from artists to hire the gallery. Does not take any commission on sales.

No of exhibitions annually 50-60 Cost to hire or rent Single day at £200, from 2 days or more at £150 per day.

Tryon Galleries

7 Bury Street, St James's, London, SW1Y 6AL

T 020 78398083

F 020 78398085

E info@tryon.co.uk

W www.tryon.co.uk

Contact Liz Thorold

Founded in 1959 with a strong reputation in the fields of sporting, wildlife and Scottish paintings, and bronzes. Deals in nineteenth- and twentiethcentury and contemporary artists, from Archibald Thorburn, George Lodge and Lionel Edwards to Rodger McPhail.

Price range £500-£50,000 No of exhibitions annually 6

Union

57 Ewer Street, London, SE1 ONR T 020 79283388 F 020 79283389 E info@union-gallery.com

W www.union-gallery.com Five minutes' walk from Tate Modern and established at the start of 2003. Presents group and solo shows by established and emerging international contemporary artists, many of whom are showing to a UK audience for the first time. Has an ambitious programme of exhibitions, effectively allowing museum shows previously only seen overseas to be brought to a London audience in the context of a commercial space. Submission Policy Does not look at submissions from artists.

No of exhibitions annually 4-5

Victoria Miro Gallery

16 Wharf Road, London, N1 7RW T 020 73368109 F 020 72515596 E info@victoria-miro.com W www.victoria-miro.com

Established in Cork Street in 1985 and moved to the East End in 2002. Has been associated with many emerging artists and has two Turner Prize winners to date, Chris Ofili in 1998 and Grayson Perry in 2003.

Vilma Gold

6 Minerva Street, London, E2 9EH T 020 77299888 F 020 77299898 E mail@vilmagold.com W www.vilmagold.com Represents international, young and mid-career

contemporary artists such as Mark Titchner, Sophie von Hellermann, Dubossarsky and Vinogradov, William Daniels and Felix Gmelin. Vilma Gold was founded in 2000 and in 2005/6 ran a one year project space in Berlin.

Submission Policy Does not accept submissions from artists.

W.H. Patterson Ltd

19 Albemarle Street, Mayfair, London, W1S 4BB T 020 76294119 F 020 74990119 E info@whpatterson.com W www.whpatterson.com Founded in 1964. Deals in contemporary art and

has a nineteenth-century department. Hosts an

annual 'Venice in Peril' (VIP) exhibition; ten per cent of proceeds donated to the VIP Fund. Price range £450-£60,000 No of exhibitions annually 10

Waddington Galleries

11 Cork Street, London, W1S 3LT T 020 78512200 F 020 77344146 E mail@waddington-galleries.com W www.waddington-galleries.com Deals in modern and contemporary works of art - paintings, sculpture, and works on paper. A substantial inventory is held of major twentiethth-century artists including Jean Dubuffet, Giorgio De Chirico, Henri Matisse, Ioan Miró, Henry Moore and Pablo Picasso. Represents a number of contemporary artists from Great Britain, Europe, and North America including Craigie Aitchison, Peter Blake, Ian Davenport, Barry Flanagan, Peter Halley, Mimmo Paladino, Antoni Tàpies, William Turnbull, and Bill Woodrow, and represents the estates of Josef Albers, Milton Avery, Patrick Caulfield and Patrick Heron.

White Cube

48 Hoxton Square, London, N1 6PB T 020 79305373 F 020 77497480 E enquiries@whitecube.com W www.whitecube.com Contact Susannah Hyman Founded in 1993. Has presented solo shows of British artists such as Jake and Dinos Chapman,

Tracey Emin, Lucian Freud, Gilbert & George, Antony Gormley and Damien Hirst. International artists include Franz Ackermann, Chuck Close, Ellsworth Kelly, Julie Mehretu, Doris Salcedo and Hiroshi Sugimoto. Also frequent group shows. Branches: 25-26 Mason's Yard, London, SW1Y 6BU T 020 7930 5373 Submission Policy All works considered by any

living artist.

Price range From £1,000 No of exhibitions annually 8-10

Whitechapel Project Space

20 Fordham Street, London, E1 1HS T 07748 235428 E info@whitechapelprojectspace.org.uk W www.whitechapelprojectspace.org.uk Contact Maria Trimikliniotis or Richard Birkett Founded in 2002. Aims to facilitate artist

and curatorial practice that is in many senses unfinished and unprescribed. Submission Policy Artist proposals and submissions considered.

Whitford Fine Art

6 Duke Street, St James's, London, SW1Y 6BN

T 020 79309332 F 020 79305577

E info@whitfordfineart.com

W www.whitfordfineart.com

Opened in 1973, Whitford & Hughes and changed its name to Whitford Fine Art in 1991. Stock spans the twentieth century, from Modernism up to postwar abstraction and British Pop Art. Examples of 1960s and 1970s designer furniture are a permanent feature of the gallery. Living Pop artists represented are Clive Barker and Peter Phillips.

Price range £1,000-£500,000 No of exhibitions annually 4

Whitgift Galleries

77 South End, Croydon, CRO 1BF T 020 86880990 F 020 87600522 E info@whitgiftgalleries.co.uk W www.whitgiftgalleries.co.uk Founded in 1945, showing fine-quality oil paintings and watercolours. Artists include Brian Davies, Ben Maile and David Smith. Limited editions by Sir William Russsell Flint and others. Also offers a framing and restoration service. Price range £50-£10,000 No of exhibitions annually 2

Wilkinson Gallery T 020 89802662

F 020 89800028

E info@wilkinsongallery.com W www.wilkinsongallery.com A major gallery in the Hackney and Bethnal Green area since 1998, showing a mixture of international and British art by mostly young and emerging artists including David Batchelor, George Shaw, Ged Quinn, Robert Orchardson and Tilo Baumgartel.

William Thuillier

14 Old Bond Street, London, W1S 4PP T 020 74990106 F 020 72338965 E thuillart@aol.com W www.thuillart.com

50/58 Vyner Street, London, E2 9DQ

The gallery specializes in Old Master and British paintings 1600-1850, with an emphasis on classical landscapes and historical portraits. Shows some contemporary artists, including Philip Chitty, Annalisa Catelli and Rosalind Adams. Price range £500-£250,000 No of exhibitions annually 2 Cost to hire or rent By discussion

Williams & Son

Ic Royal Parade, Kew Gardens, Richmond, TW9 3QD T 020 89407333 E art@williamsandson.com

W www.williamsandson.com

Contact John R. Williams

Founded in 1932. Specializes in nineteenth- and twentieth-century paintings. Handles the work of a few contemporary artists who paint in the academic and traditional styles and who can hang with stock of nineteenth-century paintings. Visits by appointment only.

Price range £1,000-£200,000

North-east

Belford Craft Gallery

2 Market Place, Belford. **NE707ND** T 01668 213888

W www.belfordcraftgallery.com

Quality crafts, paintings, woodworks and prints by artists local to Northumbria and the Borders. New courtyard gallery space opened recently. Submission Policy Preference given to artists from

the local area.

Biscuit Factory

Stoddart Street, Newcastle-upon-Tyne, NE2 1AN T 0191 2611103 F 0191 2610057 E art@thebiscuitfactory.com

W www.thebiscuitfactory.com

Contact Karen Tait

One of Europe's largest commercial galleries, exhibiting a wide range of artists (national and international) and art forms including glass, ceramics, sculpture and paintings. Has shown and sold work by over a thousand artists, including Damien Hirst and Andy Warhol.

Submission Policy Artists who feel their work is suitable for the gallery should apply via criteria on the website.

Price range £20-£50,000

No of exhibitions annually A rolling programme, with four preview nights per year.

Centre Gallery

Deptford Terrace, Sunderland, SR4 6DD P 0191 5658584

Chatton Gallery

Church House, New Road, Chatton, Alnwick, **NE66 5PU** T 01668 215494 W www.chattongallery.co.uk

Colliers

Milburn House, Dean Street, Newcastle-upon-Tyne, NE1 1LF T 0191 2322819 F 0191 2302026

E anne@colliers.wanadoo.co.uk W www.colliersgallery.co.uk

Contact Anne Collier

Founded in 1975, initially specializing in framing. Now a contemporary gallery showing mainly local artists. Wall space available to rent. Some in-house publishing of mainly local images.

Submission Policy Well-executed art of a professional standard welcome.

Price range f_5 - f_5 000 No of exhibitions annually Varies.

Corrymella Scott Gallery

5 Tankerville Terrace, Jesmond, Newcastle-upon-Tyne, NE8 4EL

T 0191 2818284

E corrymella@corrymella.co.uk W www.corrymellascottgallery.co.uk Exhibits and sells Scottish art of high quality, including works by John Bellany, Anne Redpath, S.J. Peploe, Joan Eardley, J.D. Fergusson and Christopher Wood among many others.

Crown Studio Gallery

Bridge Street, Rothbury, NE65 7SE T 01669 622890 E info@crownstudio.co.uk W www.crownstudio.co.uk Founded in 2001, specializing in painting, prints, sculpture and ceramics. Exhibits professional (mostly regional) artists, both emerging and established. Space is domestic in scale but carefully arranged to show work to its best advantage. Shows high-quality contemporary art in a rural setting.

Submission Policy Exhibition proposals welcome.

Send photographs, prints, slides or jpegs, CV and statement. Enclose sae for return of material. Price range £20-£5,000

No of exhibitions annually Up to 6

Customs House

Mill Dam, South Shields, Tyne & Wear, **NE33 1ES**

T 0191 4541234

F 0191 4565979

E mail@customshouse.co.uk

W www.customshouse.co.uk

Contact Anna Snell

With a riverside location, the exhibition programme incorporates a diversity of art forms by artists of regional, national and international standing.

Submission Policy Contact Anna Snell on 0191 4278199.

No of exhibitions annually 20

Fenwick Gallery

21 Castle Street, Morpeth, NE65 0UW T 01665 711136 E enquiry@fenwickgallery.co.uk W www.fenwickgallery.co.uk Established in 1990, offering a range of paintings and prints, ceramics, studio glass, wood pieces and jewelry.

fifiefofum

Westside Farm, Newton Hall, Near Newcastle, **NE43 7TW** T 01661 843778

E sue@fifiefofum.com

W www.fifiefofum.com

Contact Sue Moffitt

Established in 2003. A rural contemporary gallery specializing in original fine art from established, emerging and graduate north-eastern artists. Artist-led, with a specific focus on supporting the artist. Also offers art-related workshops and courses. Venue hire is available along with light refreshments and catering facilities.

Submission Policy All artists' work is considered on an individual basis but it is expected that artists have some formal relevant qualifications or have been working as artists for many years. Aims to support and show work from graduates from BA, MA and PhD programmes as well as more established artists.

Price range £65-£4,000. From £3.50 for original hand-printed cards.

No of exhibitions annually 6

Cost to hire or rent Venue hire available from 2006, approx. £150 per day.

Gallagher & Turner

St Thomas Workshops, St Thomas Street, Newcastle-upon-Tyne, NE1 4LE

T 0191 2614465 F 0191 2614465

E gallery@gallagher-turner.co.uk

W www.gallagherandturner.co.uk

Contact Clare Turner

A small, established gallery with eclectic tastes, showing local and national artists. Mostly solo shows but some mixed. Past exhibitions include Ray Richardson, Albert Irvin and Norman Ackroyd. Also show Japanese woodblock prints and work by original printmakers. As a specialist high quality conservation framer, is prepared to take exhibitions unframed. Other services include gilding, conservation and restoration.

Submission Policy Does not currently display craft or jewelry. Welcomes submissions by email with images or post containing slides, with CV attached.

All submissions by post will be returned safely.

Price range £40-£5,000

No of exhibitions annually Approx. 5

Gate Gallery

12 Bondgate Within, Alnwick, NE66 1TD T 01665 602165 W www.thegategallery.co.uk

Glass and Art Gallery

194 Medomsley Road, Consett, County Durham, DH8 5HX

T 01207 583353

F 01207 500218

E glassdesigner@hotmail.com W www.glassdesign.co.uk

Founded in 1999, exhibiting art from over one hundred regional artists. The gallery also houses three studio/workshops where stained glass is designed and made. Weekend workshops are held once per month.

Submission Policy All work must be unique, original and not mass-produced. All artists must either be regional or have some connection with the northeast.

Price range £5-£5,000No of exhibitions annually 8

Globe Gallery - City

4th Floor Curtis Mayfield House, Carliol Square, Newcastle upon Tyne, NE1 6UQ T 0191 2221666

W www.globegallery.org

Independent contemporary art gallery showing the work of emerging and established artists. The gallery's two venues, City and Hub, provide informative, challenging and accessible dialogue between artist, artwork and audience through exhibitions, events and opportunities to participate in projects.

Globe Gallery - Hub

97 Howard Street, North Shields, NE30 1NA T 0191 2592614

W www.globegallery.org

Independent contemporary art gallery showing the work of emerging and established artists across two venues, City and Hub. Provides informative, challenging and accessible dialogue between artist, artwork and audience through exhibitions, events and opportunities to participate in projects.

Submission Policy Download exhibition proposal form from website.

Lime Tree Gallery

6 The Butts, Stanhope, Bishop Auckland,
DL13 2UF
T 01388 526110
W www.alexclarkart.co.uk
Exhibits and stocks Alex Clark original

watercolours and limited-edition prints, cards, etc.

Macdonalds Fine Art

6 Ashburton Road, Gosforth, Newcastle-upon-Tyne, NE3 4XN P 0191 2844214

Red Box Gallery

St. Nicholas Chare, Newcastle upon Tyne, NE1 1RJ T 0191 2455555

W www.redboxgallery.com

Established in 2003, the gallery hosts a series of five shows per year, showcasing innovative, significant contemporary art by north East artists in exhibitions of regional and national importance. Work exhibited in various media, including painting, photography, sculpture and video work. No of exhibitions annually 5

Saltburn Gallery

30–32 Marske Road, Saltburn-by-the-Sea, TS12 1QG T 01287 626060 E info@saltburnartistsprojects.org.uk W www.saltburnartistsprojects.org.uk

SaltburnArtists' Projects is a registered charity which has run the Saltburn Gallery, the adjoining artists' studio complex and an arts development programme in Saltburn-by-the-Sea, since 1998. The gallery exhibits a wide variety of different art forms from a range of artists and aims to create an inspirational environment for artists, curators, educationalists and the community.

Submission Policy Encourages applications from artists. Download exhibition procedure details from the website.

No of exhibitions annually 6

Side Gallery

5 & 9 Side, Newcastle-upon-Tyne, NE1 3JE T 0191 2322000 W www.amber-online.com Specializes in photography.

T.B. & R. Jordan Lapada

Aslak, Eaglescliffe, Stockton-on-Tees, TS16 OQN T 01642 782599

E info@tbrj.co.uk

W www.tbri.co.uk

Founded in 1974. Sources works by Impressionist artists painting in the North East of England a century ago, especially pictures by members of the Staitnes Group and Cullercoats Colony. Also acts as agents for Richard Marshall b. 1944 and the estate of the late Robert L. Harvey 1900-1981. Submission Policy By appointment and through exhibitions. No facilities to show more living artists work.

Price range £200-£25,000 No of exhibitions annually 8

The Teesdale Gallery

6a The Bank, Barnard Castle, DL12 8PQ

T 01833 695201

E info@teesdalegallery.co.uk

W www.teesdalegallery.co.uk

Originally founded as Newgate Gallery, this stocks original paintings and prints featuring landscape and wildlife scenes in oils and watercolours, including work by local artist Andy Beck. The gallery also stocks pottery, sculpture and jewelry. Framing service offered.

Kings House, Forth Banks, Newcastle Upon Tyne, NE1 3PA T 0191 2618281

F 0191 2618281

E info@vane.org.uk

W www.vane.org.uk

Contact Paul Stone / Christopher Yeats Founded in 1997. Having worked with over 500 artists from around the world and presenting a series of one-off projects in a variety of temporary venues, Vane opened a permanent gallery space in Newcastle city centre in July 2005. Represents the work of a number of artists, both from across the UK and abroad, as well as showing the work of invited artists in collaboration with other galleries. Submission Policy Exhibitions are by invitation.

Waygood Studios and Gallery

548-560 Shields Road, Byker, Newcastle Upon Tyne, NE6 2UT

T 0191 2656857 F 0191 2244187

E art@waygood.org

W www.waygood.org

Founded in 1995 with the aims of providing a place of practice for artists and engaging audiences with contemporary art. Its site on High Bridge is currently being redeveloped into new, state-of-theart facilities to include daylight-lit 400m2 galleries, fully accessible studios, a visual arts learning centre, workshop facilities and an international residency programme. Waygood Associates is a new membership scheme open to everyone. Currently the associate scheme has a web presence for sharing information and generating projects. In the future a subscription membership will allow use of shared facilities and communal resources. Submission Policy See website for details.

Workplace Gallery

The Old Post Office, 19/21 West Street, Gateshead, NE8 1AD

T 0191 4772200

E info@workplacegallery.co.uk

W www.workplacegallery.co.uk

Commercial gallery run by artists. Represents a portfolio of emerging and established artists through the gallery's programme of exhibitions, curatorial projects and art fairs.

Yarm Gallery

37 High Street, Yarm, Stockton-on-Tees, TS15 9BH T 01642 789432

F 01642 767733

E enquiries@yarmgallery.co.uk

W www.yarmgallery.co.uk

Contact Carol Byrne

Founded in 2004, showing contemporary art. Artists include Mackenzie Thorpe and Alexander Millar. Also offers bespoke conservation level framing and giclée printing services. Submission Policy No requirements for formally trained artists.

Price range £60-£5,000+ No of exhibitions annually 4

North-west

'A' Foundation - Greenland Street

67 Greenland Street, Liverpool, L1 OBY T 0151 7060600

F 0151 7060601

E info@afoundation.org.uk

W www.afoundation.com/greenlandstreet Recently redeveloped in 2007, Greenland Street comprises three former industrial buildings transformed into inspiring and challenging gallery spaces: The Coach Shed, The Furnace and The Blade Factory. Aims to showcase the very best local, regional, national and international contemporary visual arts practice. Commissions up to four major new projects each year. Also delivers an annual architecture commission that profiles emerging architects whose hybrid practices reference both art and architecture, and an education and outreach programme that aims to provide a wide range of participants with the opportunity to look at, talk about and make art. Submission Policy Proposals not accepted. No of exhibitions annually 4

Ainscough Gallery

The Racquet Club, Hargreaves Building, 5 Chapel Street, Liverpool, L3 9AG T 0151 2366676 F 0151 2366870 E gallery@ainscoughs.co.uk W www.ainscoughs.co.uk Established 15 years ago as Merhmal gallery and

located at the Racquet Club Hotel's Hargreaves building with intermittent exhibitions of predominately Northern artists' work. Submission Policy Not looking for artists.

Price range £50-£12,000

No of exhibitions annually Intermittent Cost to hire or rent n.a

Arena Gallery

82-84 Duke Street, Liverpool, L1 5AA T 0151 7079879 F 0151 7071667 E arenastudios@clara.co.uk W www.arena.uk.com

Contact James Buso or Paul Luckraft Artist-led space within walking distance of all of Liverpool's major public galleries. Aims to show the work of emerging talent and to build dialogue and exchange with other artist-led organizations. The 9m × 9m gallery is suitable for one-person and small group exhibitions.

Submission Policy Send written proposal and CV. No of exhibitions annually 6

Artizana

The Village, Prestbury, Cheshire, SK10 4DG T 01625 827582 F 01625 827582 E art@artizana.co.uk

W www.artizana.co.uk

Founded in 1984 as a private gallery. Aims to promote contemporary British crafts, with a particular emphasis on one-off furniture designs. Exhibited artists include Rachel Woodman (studio glass), Magdalene Odundo (ceramics), Ahmed Moustafa (calligraphy), Alan Peters OBE (furniture), Stephen Broadbent (sculpture), Tim Stead MBE (furniture), Kevin O'Dwyer (silver), Verina Warren (embroidery) and Charles Bray (glass sculpture). Commissions undertaken for private clients and public institutions. Submission Policy Most craft disciplines

considered. Primary requirement is that work is contemporary, original and of the highest quality. Price range £50-£15,000

No of exhibitions annually 2

Benny Browne & Co. Ltd

63 Lawton Street, Congleton, CW12 1RU T 01260 279100

W www.bennybrowne.com Contact William Kemp

Art gallery and artist's studio located below hairdressing salon offering original paintings and limited-edition giclée prints by living artists and designers. Offers bespoke commissioning service through permanent artist-in-residence, William Kemp, specializing in abstract landscapes and portraits. Also shows 3D work from other artists. Submission Policy Contact via website.

Price range £100-£2,500

No of exhibitions annually Regularly changing works.

Blyth Gallery

Amazon House, Brazil Street, Manchester, M1 3PJ T 0161 2361004 F 0161 2880633

E gallery@artmanchester.com W www.artmanchester.com

Contact Denise Thornton (Gallery Director) Established in 1997 and located in the Canal Street area of central Manchester. Catering for corporate and private clients, it exhibits contemporary paintings, sculpture, ceramics and glass works by both northern-based and international artists. Has an eclectic selection policy, with an associated art shop on the premises.

Submission Policy Professional/established artists and sculptors should submit a CV, statement and captioned images with an sae. No photography, installations or video.

Price range f80-f1,800No of exhibitions annually 12

Bureau

Ground Floor, Islington Mill, James Street, Salford/Manchester, M3 5HW

T +44 (0)7757 956555

E info@bureaugallery.com

W www.bureaugallery.com

Bureau is a purpose-built gallery, launched in 2006. Delivering several exhibitions a year, ranging across all media, the gallery promotes dynamic and exciting new work by emerging and established artists from the UK and internationally. Bureau also works on collaborative projects with international galleries and organisations. Complimentary to the exhibitions programme, Bureau regularly commissions new work and critical writing, houses collections of artists' film and video and publication projects, and presents performances, screenings, symposiums and off-site events.

No of exhibitions annually 7

Castlefield Gallery

2 Hewitt Street, Knott Mill, Manchester, M15 4GB

T 0161 832 8034 F 0161 819 2295

E info@castlefieldgallery.co.uk

W www.castlefieldgallery.co.uk

Contact Clarissa Corfe

Supports the professional careers of artists and curators through research, production, presentation and interpretation, offering an exhibition and events programme, project space, professional development scheme, and PureScreen, a platform for artists' film and video. It engages with new audiences by working with regional, national and international partners. Submission Policy Exhibitions programmed

through invitations and open calls on an ad hoc basis.

Price range £80+ No of exhibitions annually 6

Colin Jellicoe Gallery

82 Portland Street, Manchester, M1 4QX T 0161 2362716

W www.colinjellicoe.co.uk

Opened in 1963 by Colin Jellicoe, a painter since the late 1950s. Specializes in figurative and modern drawings, paintings, graphics and sculpture. Gallery artists include Granville, Colin Gilbert, Debbie Hill, Jellicoe, Jackie Mitchell and John Picking. Agent for several art competitions (Royal Academy Summer Exhibition, Singer Friedland Watercolour).

Submission Policy Only shows living artists. Send a CV and up to ten good colour prints.

Price range f_{50} - f_{500}

No of exhibitions annually 2-4

Comme Ca Art Gallery

24 Worsley Street, Castlefield, Manchester, M15 4LD

T 0161 8397187

E info@commecaart.com

W www.commecaart.com

Established in 1994, an art and design agency with a pool of over 800 artists and designers covering a range of disciplines.

De Lacey Fine Art

15 The Colonnades, Albert Dock, Liverpool, L3 4AA

T 0151 7076020

E info@delaceyfineart.co.uk

W www.delaceyfineart.co.uk

Contact Gordon or Martin Farmer

Founded in 2001, specializing in modern British and contemporary art. Deals in original works and original printed works of established artists.

Submission Policy Approachable, but does not usually welcome submissions from artists.

Price range £200-£200,000 No of exhibitions annually 6

Domino Gallery

11 Upper Newington, Liverpool, L1 2SR T 0151 7070764 / 07775 605326

E felicity.wren@fsbdial.co.uk

W www.dominogallery.com

Founded in 1989. Shows local, national and international artists (established and new) such as John Bratby, Adrian Henri, George Jardine, Nicholas Horsfield, Jason Jones, Claire Chinnery and Lisa Cole Kronenburg. Has a wide range of work including painting, photography, both digital and traditional, prints, drawings, jewelry and small-scale ceramics.

Submission Policy Director chooses exhibitors according to fairly strict criteria but all approaches welcomed. Advice given to new graduates regarding portfolios and presentation, etc.

Price range £75-£3,000

No of exhibitions annually Approx. 6

dot-art

16 Queen Avenue, Castle Street, Liverpool, L2 4TX

T 0845 0176660

F 0870 1412116 E artists@dot-art.com

W www.dot-art.com

Contact Lucy Byrne

Art gallery and consultants set up in 2006, based in Liverpool city centre. Operates a membership system which gives artists their own web page, exhibition and promotional opportunities, access to sales and rental avenues, as well as help and advice, networking events and discounts on art supplies and framing.

Submission Policy Artists are welcome to submit work for consideration at any time, via email. All media considered. Full membership open to artists based in Merseyside, Cheshire and Greater Manchester; Virtual Membership open to all other areas of the UK.

Price range £50-£5,000 No of exhibitions annually 6

EggSpace

2nd Floor, 16–18 Newington, Liverpool, L1 4ED

T 0151 7072755 / 077905 15044 E headspace@eggspace.org

W www.eggspace.org

Contact Karen Henley, Jazamin Sinclair, Carolyn Sinclair

Founded in 1984 as the Egg Cafe, now independent artist/curator run 'British underground art' space in city centre, providing a platform for emerging artists and artists' groups. The space has attracted many artists and curators including Peter Dannials, Chris Gjertsen, Tony Knox, Gaynor Evelyn Sweeney and George Lund. Submission Policy Submissions welcomed. Email submissions@eggspace.org

Gallery 2000

Windle Court, Clayhill Industrial Park, Neston, CH64 3UH

T 0151 3531522

E sales@gallery2000.co.uk

W www.gallery2000.co.uk

The Gallery - Manchester's Art House

131 Portland Street, Manchester, M1 4PY

T 0161 2373551 F 0161 2283621

E enquiries@manchestersarthouse.com

W www.manchestersarthouse.com

Henry Donn Gallery

138–142 Bury New Road, Whitefield, Manchester, M45 6TD

T 0161 7668819

F 0161 7668819

E donn@netline.uk.net

W www.henrydonngallery.com

Sells contemporary original art and prints. Runs an on-line gallery facility.

Howarth Gallery

134–138 St James Street, Burnley, BB11 1NR T 01282 416079

E richard@howarth-gallery.co.uk

W www.howarth-gallery.co.uk

W www.howarth-gallery.co.uk
Established for over twenty years. Deals in
both antique and contemporary art and prints.
Also offers framing and valuation services.
Contemporary artists include McKenzie Thorpe,
Sandra Blow RA, Sir Terry Frost RA, Alex Millar,
Stephen Ormerod, Sir Peter Blake RA and Roy
Fairchild-Woodard.

Submission Policy Always willing to look at new work.

Price range £20-£30,000No of exhibitions annually 6

International 3

8 Fairfield Street, Manchester, M1 3GF

T 0161 2373336

Ell@international3.com

W www.international3.com

A non-profit gallery founded in 2000. Exhibits and commissions new work by contemporary artists, both initiating projects and working with invited curators. Artists commissioned include Andrew McDonald, Bob and Roberta Smith, Ryan Gander, Rachel Goodyear, Matt Stokes and Hayley Newman. Also represents a core group of eight artists: Brass Art, Rachel Goodyear, Josephine

Flynn, Pat Flynn, David Mackintosh, Andrew McDonald, Kristin Mojsiewicz and Magnus Quaife.

Submission Policy Artists wishing to exhibit should visit the gallery and be familiar with its programme. Most exhibitions are initiated by the gallery rather than as a result of unsolicited applications.

Price range £100-£10,000 No of exhibitions annually 7

The Kif

23a Parr Street, Liverpool, L1 4JN T 0151 7060008 E kif@livingbrain.co.uk W www.livingbrain.co.uk

Founded in 2003 as an exhibition, workshop, recording and rehearsal space in a disused warehouse in Liverpool city centre. There is also a pottery on site. Aims to assist artists young and old within the city to become established and move forward into self-sustainability.

Submission Policy Artists should phone or visit the space to assess suitability.

Price range f_{25} - f_{500} No of exhibitions annually 10

Liverpool History Shop

5 The Colonnades, Albert Dock, Liverpool, L3 4AA

T 0151 7093566

E norma@liverpoolpictures.co.uk

W www.liverpoolpictures.co.uk

Contact Norma Lyons

Founded in 1991, specializing in photographs, prints and paintings of Liverpool and surrounding areas. Showcases many Liverpool artists.

Submission Policy Must be of local interest. Laser prints not accepted.

Price range £120-£1,500 for original paintings; \$20-\$200 for original photographs

Lowes Court Gallery

12 Main Street, Egremont, CA22 2DW T 01946 820693

E lowescourt@btconnect.com

W www.lowescourtgallery.co.uk

Contact Gallery Manager or Exhibition Organizer Established in 1972 to promote appreciation of visual arts in Cumbria. Aims to show a high standard of contemporary and traditional arts and crafts by emerging and established artists. Exhibitions are in the main gallery; members' work is displayed in the back gallery.

Submission Policy Submissions welcomed from artists working in Cumbria or bordering counties only. Hard copy preferred. Limited space available.

Price range Up to £500

No of exhibitions annually 8, at least two of which are reserved for specific local features.

Manchester Craft & Design Centre

17 Oak Street, Northern Quarter, M4 5JD

T 0161 8324274 F 0161 8323416

E info@craftanddesign.com

W www.craftanddesign.com

Sited in the heart of Manchester's Northern Ouarter, the hub of the city's artistic and innovative community. Occupying the old Smithfield fish market, it provides studio and retail space for a wide range of contemporary applied artists producing ceramics, jewelry, furniture and interiors, textiles and fashion, photography and visual arts, in workshops over two floors. Also has a year-round programme of exhibitions; the exhibition space can be hired when not in use. Open to the public throughout the year. Admission free. All work is for sale and commissions are welcome.

Submission Policy Focuses on contemporary crafts, both for tenant artists and temporary exhibitions.

No of exhibitions annually 5

Mathew Street Gallery

31 Mathew Street, Liverpool, L2 6RE

T 0151 2350009

E lennonart@mathewstgallery.co.uk

W www.lennonart.co.uk

Opened in 1999 with a particular emphasis on The Beatles and related work.

Mill House Gallery

The Old Windmill, Mill Lane, Parbold

T 01257 462333

E jb.millhousegallery@virgin.net

W www.jamesbartholomew.co.uk

Founded in 1997, specializing in work by James Bartholomew. Also sells work of other artists including Neville Fleetwood ROI, David Stanley NAPA and Lawrence Isherwood. Offers a full framing service ('Space Framing') in adjoined premises.

Submission Policy All media considered. Apply in the first instance by photos, slides, etc.

Price range £100-£2,000

No of exhibitions annually 4

Northern Lights Gallery

22 St John Street, Keswick, CA12 5AS

T 01768 775402

E info@northernlightsgallery.co.uk

W www.northernlightsgallery.co.uk

Contact Paul Martin

Founded in 1999, specializing in contemporary art and crafts from the north of England and Scotland. Artists represented include Jonathan Trotman, Alison Critchlow, Matt Jardine and Joe Dias. Submission Policy Artists must be resident in Cumbria or neighbouring counties.

Price range £10-£2,000No of exhibitions annually 4–6

Percy House Gallery

38–42 Market Place, Cockermouth, CA13 9NG T 01900 829667

F 01900 829667

W www.percyhouse.co.uk

Established in 2002 in Cockermouth's oldest town house, dating back to 1598 and still with many original features. Displays unique arts and crafts. Exhibition area upstairs.

Submission Policy Main priority of gallery is to support living, working UK artists. Occasional exhibitions by artists living abroad.

Price range £5-£4,000 No of exhibitions annually 12

Philips Contemporary Art

Studio 10, 10a Little Lever Street, Manchester, M1 1HR

T 0161 9414197

E philipsgallery@supanet.com

W www.philipscontemporaryart.com

Platform Gallery

Station Road, Clitheroe, BB7 2JT

T 01200 443071

F 01200 414556

E platform.gallery@ribblevalley.gov.uk

W www.ribblevalley.gov.uk/platformgallery

Contact Grace Whowell

A showcase for contemporary craft in Lancashire, run by Ribble Valley Borough Council. Specializes in textiles, ceramics, glass, jewelry and wood by local and national makers. There is also a craft shop and education space for workshops and talks. Submission Policy Work must be craft-based, rather than painting or photography. Send images, CV and artist's statement.

Price range £3-£3,000 No of exhibitions annually 8

Richard Goodall Gallery

59 Thomas Street, Northern Quarter, Manchester, M4 1NA

T 0161 8323435

F 0161 8323266

E richard@richardgoodallgallery.com W www.richardgoodallgallery.com

Stocks wide range of prints and posters.

Thornthwaite Galleries

Thornthwaite, Keswick, CA12 5SA

T 01768 778248

E enquiries@thornthwaite.net

W www.thornthwaite.net

Contact Ron Monk

Now in its thirty-fifth year, displaying over one hundred artists. Work includes paintings (oil, pastel, watercolour, etc.), wood-turning, wood sculpture, metal sculpture, pottery, ceramics, jewelry, photography and furniture.

Price range £5-£2,000

Tib Lane Gallery

14A Tib Lane, Manchester, M2 4JA

T 0161 8346928

Contact J.M. Green

Founded in 1959, dealing primarily in British (mainly figurative) twentieth-century works. Established and less widely known artists are shown in both solo and mixed exhibitions from October to June. Exhibited artists include Frink, Herman, Valette and Vaughan.

Submission Policy Gallery exhibits oil paintings, watercolours, drawings and pastels. No ceramics.

Price range From £200 No of exhibitions annually 5

Unicorn Gallery

I Kings Court, Water Lane, Wilmslow, SK9 5AR

T 01625 525276

E originalpaintings@btconnect.com W www.originalpaintings.com

Established in 1950, dealing in traditional and contemporary original works of art. Specialists in northern artists including L.S. Lowry, Arthur Delany and Braag. Others include portrait artist Robert Lenkiewicz, teddy-bear artist Deborah Jones and landscape artist Gerhard Neswadba. Large studio space may be available for use by artists.

Submission Policy Always looking for talented new artists. Both painters and sculptors are welcome to submit work.

Price range £175-£40,000No of exhibitions annually 2-3

Victorian Gallery

40 St John's Hill, Shrewsbury, SY1 1JQ

T 01743 356351

F 01743 356351

E victoriangallery@xln.co.uk

Founded in 1987. A specialist in antique maps and prints. Also stocks etchings, aquatints, etc. by contemporary artists, including Piers Browne and other British and Latvian etchers.

Price range f_{50} - f_{300}

View Two Gallery

23 Mathew Street, Liverpool, L2 6RE T 0151 2369555 W www.viewtwogallery.co.uk

Watergate Street Gallery

60 Watergate Street, Chester, CH12LA

T 01244 345698 F 01244 3458837

W www.watergatestreetgallery.co.uk Opened in 1992, offering original paintings, etchings and screenprints. Artists include Bernhard Vogel, Roy Fairchild Woodard, Willi

Kissmer, Jurgen Gorg and Ian Fennelly. Price range £250-£4,000

Wendy J. Levy Contemporary Art

17 Warburton Street, Didsbury, Manchester, M20 6WA

T 0161 4464880

E wendy@wendyjlevy-art.com

W www.wendyjlevy-art.com

Specializes in paintings, drawings and sculpture by local, national and international artists. Also offers consultancy service.

Northern Ireland

Annexe Gallery

15 Main Street, Eglinton, BT47 3AA T 028 71810389 E aml.davidson@talk21.com

W www.annexegallery.co.uk

Stocks original paintings, many by local artists, and a wide selection of prints and limited editions. Also offers framing service.

Ballance House

118a Lisburn Road, Glenavy, Crumlin, **BT29 4NY** P 028 92648492

Belfast Exposed Gallery

The Exchange Place, 23 Donegall Street, Belfast, BT1 2FF

T 028 90230965

W www.belfastexposed.org

Founded in 1983 as a community photography initiative, Belfast Exposed Photography now functions as a gallery for contemporary photography with emphasis on commissioning and publication of new work. Also holds a community photography archive and runs an extensive educational outreach network, providing hands-on experience in photography, digital and darkroom development.

Bell Gallery

13 Adelaide Park, Lisburn Road, Belfast, BT9 6FX T 028 90662998

F 028 90381524

E bellgallery@btinternet.com

W www.bellgallery.com

Contact Pauline McLarnon

Founded in 1964, dealing in work by Irish artists of all periods and providing exhibition space throughout the Troubles. Specializes in modern British paintings, drawings and sculpture, and also nineteenth- and twentieth-century Irish sculpture. The gallery consists of three rooms.

Submission Policy Lack of space precludes very large exhibitions or excessively large individual video or installation work.

Price range £500-£10,000

Collett Art Gallery

73 Dublin Road, Belfast, BT2 7HF T 028 90319589 E marion@collettartgallery.com W www.collettartgallery.com Established in 1990 and moved to its current premises in 1995. Displays and sells paintings by Irish artists to buyers all over the world.

Context Gallery

St Columbs Hall, Orchard Street, Derry, **BT48 6EG**

T 028 71373538

E contextgallery@yahoo.co.uk

W www.contextgallery.com

Contemporary gallery established in 1993 to support and encourage emerging fine and applied Irish artists, and to develop links between them and emerging artists in other countries. Exhibits work in all media.

Submission Policy Proposals for solo, group and

curatorial projects, one night performances and other off-site events all welcomed. Please see website for details.

Eakin Gallery Belfast

237 Lisburn Road, BT9 7EN T 028 90668522 E info@eakingallery.co.uk W www.eakingallery.co.uk 2009 marks the 20th anniversary of the Eakin Gallery in Belfast. It stocks one of Ireland's largest selection of traditional and contemporary Irish paintings. Currently on view are works by artists such as Basil Blackshaw, Neil Shawcross, Colin Middleton, William Conor, Frank McKelvey, Maurice Wilks, Louis le Brocquy, William Scott, Charles McAuley, George Callaghan, Ian McAllister, Cecil Maguire, Paul Walls, Paul Bell, Tom Carr, Hamilton Sloan, Tom Kerr, J B Vallely. Norman McCaig, Brian Ballard, Tom Ryan, etc. Submission Policy Leading Irish artists are welcome to show work on acceptance by the gallery. Price range £150-£10,000

Emer Gallery

467 Antrim Road, Belfast, BT15 3BJ T o28 90778777 F o28 90779444 E info@emergallery.com W www.emergallery.com

No of exhibitions annually 6

Displays and sells Irish art of the nineteenth and twentieth centuries alongside contemporary artists. Has a particular interest in naive and primitive painting. Artists include Jimmy Bingham, Comhghall Casey, Sasha Harding, John McCart, Noel Murphy, Rhonda Paisley, J.B. Valley and Ross Wilson.

No of exhibitions annually 7-10

Gallery 148.com

I48 High Street, Holywood
E mail@galleryI48.com
W www.galleryI48.com
Shows established and emerging contemporary
Irish artists in online gallery.

Gallery One

r Brewery Lane, Cookstown, BT80 8LL T 028 86765438 F 028 86765438 E info@galleryone.co.uk W www.galleryone.co.uk Stocks traditional and contemporary fine art by European, UK and Irish artists in media including oils, watercolours and acrylics and mixed media.

215 Lisburn Road, Belfast, BT9 7EN

Gormleys Fine Art

T o28 90663313
E info@gormleys.ie
W www.gormleys.ie
Established in 2003, Gormleys Fine Art Gallery specialises in contemporary paintings and sculpture by emerging and established artists. The gallery hosts group and solo shows throughout the year, with an eclectic mix of artists. The gallery also has a collection of Fine Irish Art by deceased artists continually on view at the gallery. Also has a gallery in Dublin (see Ireland section) and Omagh (3–4 Dromore Road, Omagh, BT78 1RE; T: 028 82247738).
No of exhibitions annually 12+

Laneside Gallery

T 028 70353600

5 Stable Lane, Coleraine, BT52 1DQ

F 078 16585184
E info@lanesidegallery.com
W www.lanesidegallery.com
Contact David Green
Established in 1999 and moved to purpose-built
premises in 2001. Accommodates wide range
of original paintings by leading and emerging
artists, as well as hand-made artists prints, original
drawings and sculptures. Commissions both
paintings and sculpture on behalf of individual
and corporate clients from most of its represented
artists. Ranges from modern to traditional styles.
Bespoke in-house framing service offered.

....

Price range £100-£20,000

No of exhibitions annually 4

Manor Fine Arts
18 Rathfriland Street, Banbridge, BT32 3LA
T 028 40623434
F 028 40623434
W www.manorfinearts.co.uk
Exhibits both emerging and established artists and

offers a framing service.

Ormeau Baths Gallery

T8a Ormeau Avenue, Belfast, BT2 8HS
T 028 90321402
F 028 90312232
E admin@obgonline.net
W www.ormeaubathsgallery.co.uk

Sloan and Maurice C. Wilks.

429 Lisburn Road, Belfast, BT9 7EY

E info@tomcaldwellgallery.com

W www.tomcaldwellgallery.com

Tom Caldwell Gallery

Contact Chris Caldwell

T 028 90661890 F 028 90681890

Opened in 1995. An innovative exhibition and education programme features nationally and internationally recognized artists working across a broad range of contemporary visual-art practice.

Stables Gallery

6 Heathmount Hall, Portstewart, BT557RA T 028 7083 4006 E stewart-moore@btconnect.com W www.stablesgallery.co.uk Founded in 1980. Deals in twentieth-century and contemporary paintings. Specializes primarily in Irish art but also represents the work of several French, Spanish and English artists. Submission Policy The gallery is happy to look objectively at submissions by artists of quality.

Price range £500-£40,000 No of exhibitions annually 9

TailorMadeArt

2 Brookmount Road, Omagh, BT78 5HZ T 028 82246613 F 028 82252097 E info@tailormadeart.com W www.tailormadeart.com

A team of artists and art specialists produce paintings and digitally created images on canvas, board, card or premium-quality art paper to order.

Taylor Gallery

471 Lisburn Road, Belfast, BT9 7EZ T 028 90687687 E taylorgallery@btinternet.com W www.taylorgallery.co.uk Contact Stephen Donnelly Established in 1998. Generally features works

by leading Irish and contemporary artists such as Michael Gemmell, Patsy Dan Rodgers (King of Tory Island), Gladys Maccabe, Dennis Orme Shaw and Joop Smits. Also specializes in original screenprints by Andy Warhol and keeps an extensive range of these in stock. Offers a professional appraisal and valuation service. Submission Policy Usually Irish artists.

Price range £195-£100,000 No of exhibitions annually 5

Throatlake

68_B Rathmore Road, Dunadry, County Antrim, **BT41 2HX** T 07841 506166 E info@throatlake.com W www.throatlake.com

Deals in contemporary and traditional paintings

Founded in 1969. A two-floor gallery specializing in Irish living art (primarily painting but also sculpture and ceramics). Exhibited artists include Colin Middleton, George Campbell, Gerard Dillon, Paddy Collins, Tom Carr and Basil Blackshaw. Currently represents fifteen to twenty artists including Christine Bowen, Colin Davidson, Carol Graham PRUA, Barbara Rae RA, Neil Shawcross and Ronnie Wood. Price range £300-£50,000

via an online gallery. Artists include R.B. Higgins,

Paul Holmes, Darren Paul, J.P. Rooney, Hamilton

No of exhibitions annually 9

Townhouse Gallery Portrush 6 Bath Street, Portrush, BT56 8AW

T 028 70822826 E frankie@townhousegalleryportrush.com W www.townhousegalleryportrush.com Opened in 2003, exhibiting photographs, paintings and prints by leading contemporary artists as well as ceramics, textiles and jewelry. Artists include Jonathan Aiken, Frankie Creith Hill, Naomi Horner, John Johnson, Martin Lloyd, Brian Magee, Anne Michael, Peter McCausland, Patricia McCormack-French, Vincent McDonnell, James McNulty, Ross Wilson, Simon Craig, Stephen Duke, Andrew Hill and Alastair McCook.

WhiteImage.com

34 Lisburn Street, Hillsborough, BT26 6AB T 028 92689896 F 028 92688433 E info@whiteimage.com W www.whiteimage.com Contact Bill Morrison

Founded in 1994. Specializes in contemporary Irish art. Aims to bring affordable Irish art to the widest possible audience. Gallery artists currently represented include J.P. Rooney, Sue Howells, Marie Carroll, Colin Middleton, Louis Le Brocquy and Darren Paul.

Submission Policy Interested artists should submit at least six works. See website for details.

Price range $f_{75}-f_{14,000}$ No of exhibitions annually 6

Scotland

Amber Roome Contemporary Art

75–79 Cumberland Street, Edinburgh, EH3 6RD

T 07765 557338

E mail@amberroome.co.uk

W www.amberroome.co.uk

Amber Roome and Duncan Bremner have join forces to create a partnership developing a nomadic gallery, which will take over new and unusual venues. Exhibits a changing programme of contemporary art by established and emerging artists from Scotland and beyond. Includes exhibitions of work by artists such as Jackie Anderson, Michael Craik, Delia Baillie, Andrew Mackenzie, James Lumsden, Graham Flack. Submission Policy Accepts submissions from artists in painting, photography, printmaking, drawing and mixed media. Send a CD of images in the first instance.

Price range £150-£5,000 No of exhibitions annually 9

Anthony Woodd Gallery

4 Dundas Street, Edinburgh, EH3 6HZ

T 0131 5589544

F 0131 5589525

E sales@anthonywoodd.com

W www.anthonywoodd.com

Specialist in Scottish, sporting, military, landscape and contemporary works. Framing, restoration, valuation and commission services undertaken.

No of exhibitions annually 4

Bourne Fine Art

6 Dundas Street, Edinburgh, EH3 6HZ

T 0131 5574050

F 0131 5578382

E art@bournefineart.com

W www.bournefineart.com

Founded in 1978, the leading dealer in Scottish art from 1650 to the present, specializing in paintings and sculpture. Artists represented include Allan Ramsay, Sir Henry Raeburn, Sir David Wilkie and the Scottish Colourists as well as contemporary artists including John Byrne and John Mclean. The gallery also offers framing and restoration services. In 2003 Bourne Fine Art merged with the Fine Art Society of New Bond Street, London, established 1876. Both galleries combine exhibitions with fairs and shows in Dubai, New York, Hong Kong, Maastricht and London.

Submission Policy Not currently taking on any new artists.

Price range £200-£650,000 No of exhibitions annually 8

Cost to hire or rent The Dundas Street Gallery is available for rent through Bourne Fine Art and is situated below the premises on Dundas Street. Prices per week vary from between £600 and £1,300.

Castle Gallery

43 Castle Street, Inverness, IV2 3DU

T 01463729512

E info@castlegallery.co.uk

W www.castlegallery.co.uk

Contact Denise Collins

Founded in 2001. A leading contemporary art gallery in Scotland. Exhibitions feature paintings, sculpture, handmade prints, crafts and designer jewelry. Represents established artists and emerging talent including Karolina Larusdottir, Shazia Mahmood, Jonathan Shearer, Vega, Blandine Anderson, Ian McWhinnie and Dorothy Stirling.

Submission Policy Artists should send a CD by post with the following: ten recent images as jpegs; details of the images with titles, sizes and artist's prices; biographical information; a sae.

Price range £100-£5,000

No of exhibitions annually 5 solo or joint shows. Also a constantly changing mixed display

throughout the year.

Cat's Moustache Gallery

54 St John's Street, Creetown, nr Newton Stewart, DG8 7JT

T 01671 820577 / 01659 50680

F 01671 820577

E rtrevanion@hotmail.com

W www.thecatsmoustachegallery.co.uk

Contact Penelope Nye

Offers original unique handmade arts and crafts from Scotland, the UK and beyond. Stocks a wide range of paintings in oils, acrylics and watercolours, silk painting, calligraphy and lettercutting, ceramics, jewelry, wood, glass, textiles and other handmade gifts. Runs a regular series of exhibitions and demonstrations throughout the year, all of which are free. Open all year Fridays, Saturdays and Sundays and seven days a week during July and August, or by appointment.

Price range £1-£500

No of exhibitions annually 12

Collective Gallery

22-28 Cockburn Street, Edinburgh, EH1 1NY

T 0131 2201260

E mail@collectivegallery.org

W www.collectivegallery.org

Originally established as an artist-run space in 1984 and now an independent, publicly funded exhibition, commissioning and development agency. Aims to support emergent Scottish contemporary art and artists within the context of an international programme. Committed to creating access to the contemporary visual arts through a range of innovative projects and structures. Ongoing exhibition programme in the two galleries and project room. Increasingly interested in inviting artists to design specific projects operating within the framework of the city's contemporary social, economic, political and physical spheres.

Submission Policy Has extensive membership scheme, costing f5 for Scottish-based artists and £15 for all other artists. Members are entitled to submit exhibition applications twice a year (deadlines are in March and September). No of exhibitions annually 8 in main gallery; 8 in

project room.

Compass Gallery

178 West Regent Street, Glasgow, G2 4RL

T 0141 2216370

F 0141 2481322

E compass@gerberfineart.co.uk

W www.compassgallery.co.uk

Contact Iill Gerber

In its thirty-seventh year, promoting young, emerging Scottish-based artists and established contemporary artists throughout the UK. A registered charity and non-profit-making company.

Submission Policy By email or post (CD preferred).

Price range f_{50} - $f_{10,000}$

No of exhibitions annually 6-8

Custom House Art Gallery and Studios

Custom House, 19 High Street, Kirkcudbright, DG64IZ

T 01557 330585

E customhouse@btinternet.com

W www.customhousegallery.co.uk

Contact Suzanne Davies

Shows contemporary art in the traditional setting of Kirkcudbright, an attractive coastal town in south-west Scotland with strong links to the

Glasgow Boys and the Scottish Colourists. Painter Suzanne Davies and printmaker-illustrator Malcolm Davies live and work here, showing their own work and work by other professional artists and makers, mostly from Dumfries and Galloway. Non-residential drawing and painting courses are held all year.

Submission Policy CV and recent images welcome from professional artists and makers in southern Scotland, northern England and Northern Ireland. Price range $f_{20}-f_{1,000}$

No of exhibitions annually 5-6

Cyril Gerber Fine Art

148 West Regent Street, Glasgow, G2 2RQ

T 0141 2213095

F 0141 2481322

E cyril@gerberfineart.co.uk

W www.gerberfineart.co.uk

Contact Jill Gerber

Established in 1983, the gallery's large stock includes prominent nineteenth- and twentiethcentury British artists (including the Glasgow School, Scottish Colourists and twentieth-century Scottish masters) as well as contemporary work. Submission Policy Apply by email or post (CDs preferred).

Price range £100-£95,000 No of exhibitions annually 4-6

doggerfisher

11 Gayfield Square, Edinburgh, EH1 3NT

T 0131 5587110

F 0131 5587179

E mail@doggerfisher.com

W www.doggerfisher.com

Established in 2001. Exhibits and promotes new-generation and established artists from Scotland and beyond. The 100m2 gallery in a former tyre garage was designed by architect Oliver Chapman. Participated in over ten international art fairs including the Art Statements, Art Basel, Armory in New York, and Frieze in London. In addition to the programmed exhibitions, it holds an archive of represented artists' work available to view in the gallery. Represented artists include Charles Avery, Claire Barclay, Nathan Coley, Graham Fagen, Moyna Flannigan, Louise Hopkins, Rosalind Nashashibi, Sally Osborn, Lucy Skaer and Hanneline Visnes.

Submission Policy The gallery is programmed by the director, showing exhibitions by represented and invited artists. It does not accept proposals for exhibitions. Non-returnable invites and details of exhibitions welcomed.

Price range £200-£45,000

No of exhibitions annually 6

Dundas Street Gallery

6a Dundas Street, Edinburgh, EH3 6HZ
T 0131 5589363
E carolyn@bournefineart.com
W www.bournefineart.com
Contact Carolyn Henderson
A recently refurbished gallery offering 700 sq. ft of exhibition space available for hire.

Edinburgh Printmakers

23 Union Street, Edinburgh, EH1 3LR
T 0131 5572479
F 0131 5588418
E enquiries@edinburgh-printmakers.co.uk
W www.edinburgh-printmakers.co.uk
Contact Alastair Clark Assistant Director
Established in 1967. Dedicated to promoting
contemporary printmaking practice. It achieves
this by providing, maintaining and staffing an
entrance-free gallery and open-access print studio,
where artists and members of the public can
use equipment and source technical expertise to
develop their printmaking skills.
Submission Policy Annually selects a set number
of exhibitions from artists' proposals.

Price range £30-£3,000 No of exhibitions annually 10

English-Speaking Union Scotland

23 Atholl Crescent, Edinburgh, EH3 8HQ T 0131 2291528 F 0131 2298620 E director@esuscotland.org.uk W www.esuscotland.org.uk Contact John A. Duncan

A charity founded in 1918 to promote international understanding through English. The Edinburgh gallery has provided high-quality exhibition space in the heart of the city for the last forty years.

Submission Policy No restrictions. **Price range** Depends on exhibitors.

No of exhibitions annually 5–6

Cost to hire or rent f1,000 per week (7 days), or 30% commission on sales – whichever is higher.

Glasgow Print Studio

22 & 25 King Street, Merchant City, Glasgow, G1 5QP

T 01415 520704

F 01415 522919 E gallery@gpsart.co.uk W www.gpsart.co.uk

Active since 1972 in encouraging and promoting the art of printmaking through practice, exhibition, education and sales. One of the largest publishers of original prints in the UK. A memberled organization offering artist members openaccess facilities in etching, lithography, relief print, screenprint and digital print production. Also offers introductory classes in printmaking.

Submission Policy Exhibition submissions welcome from artists specializing in printmaking.

Price range £100-£5,000

No of exhibitions annually 20

Infrared Gallery

18a Meadow Road, Glasgow Harbour, Glasgow, G11 6HX

T 0141 3371283

E infraredgallery@btconnect.com

Contact James Russell

Founded in 2003, specializing in contemporary Scottish art. Artists represented include Rick Ulman, Leila Smith, Evan Sutherland, Simon Laurie, Michelle Dawn Hannah and James Russell.

Submission Policy All contemporary living artists considered. Work viewed preferably on slides or as digital photos on CD.

Price range £50-£10,000 No of exhibitions annually 12

Ingleby Gallery

15 Calton Road, Edinburgh, EH8 8DL T 0131 5564441 F 0131 5564454 E info@inglebygallery.com

W www.inglebygallery.com
Founded 1998 and has an exhibition programme of international contemporary art by established and emerging artists from Scotland and beyond.
Since 2000 the gallery has also published a series of artist books, prints and editions. Artists represented include David Austen, Anna Barriball, Ian Davenport, Ian Hamilton Finlay, Howard Hodgkin, Callum Innes, Peter Liversidge, Sean Scully and Alison Watt.

Submission Policy Welcomes serious submissions from artists but recommends artists consider the gallery programme and the specific kinds of work exhibited before making a proposal. Prefers an initial submission of a CV and a small number of images by email.

Price range From £10 for prints; from £500 for original works.

No of exhibitions annually 6

The Jerdan Gallery

42 Marketgate South, Crail, Fife, KY10 3TL

T 01333 450797

E david@thejerdangallery.com

W www.thejerdangallery.com

Founded in 2002, the gallery specializes in Scottish contemporary art, woodwork, sculpture, glass and jewelry. Works regularly in stock by Duncan Macleod, Joe McIntyre, Lin Pattullo, Derek Sanderson, Pat Kramek and Tom Scott.

Price range $f_{100}-f_{10,000}$ No of exhibitions annually 8

John Green Fine Art

182 Bath Street, Glasgow, G2 4HG

T 0141 3331991

E mail@johngreenfineart.co.uk

W www.johngreenfineart.co.uk

Contact Phyllis Malcolm

Founded in 1984. Dealers in nineteenth- and twentieth-century and contemporary oils and watercolours, mostly by Scottish artists but also including British and continental artists. Current stock includes works by the Glasgow Boys and Girls, the Scottish Colourists, post-war artists Sir Robin Philipson and William Gear, and contemporary artists Blair Thompson, Jonathan Robertson and Norman Edgar. Also offers specialist framing and restoration services. Submission Policy Welcomes submissions from artists. Initial contact should be made via email or

Price range From f_{100} . No of exhibitions annually 4

Lloyd Jerome Gallery

200 Bath Street, Glasgow, G2 4HG

T 0141 3310722

telephone.

F 0141 3310733

Eli@dentalpractice.com

W www.dentalpractice.com

Opened in 1994 with the aim of creating a space that would show work that might not otherwise be seen in Glasgow.

Price range Up to £50,000 No of exhibitions annually 10

Marchmont Gallery and Picture Framer 56 Warrender Park Road, Edinburgh,

EH9 1EX

T 0131 2288228

E enquiries@marchmontgallery.com

W www.marchmontgallery.com

Contact James Sutherland

Founded in 2004. Mixed exhibitions of mainly new and up-and-coming artists including Claudia Massie, Nicola Moir, Catherine Rayner and Peter Gorrie. Professional in-house picture-framing service including mount cutting and canvasstretching.

Submission Policy Always interested in any arts, crafts, ceramics etc, from Scotland and the UK. E-mail any pictures of your work with any relevant info to the gallery.

Price range $f_5 - f_{1,500}$

Modern Institute/Toby Webster Ltd

Suite 6, 1st Floor, 73 Robertson Street, Glasgow, G2 8QD

T 0141 2483 711

F 0141 2483280

E mail@themoderninstitute.com

W www.themoderninstitute.com

Contact Andrew Hamilton

Founded in 1998. Represents thirty artists, including Jim Lambie, Cathy Wilkes, Victoria Morton, Simon Starling, Richard Wright, Martin Boyce, Jeremy Deller, Richard Hughes, Scott Myles, Toby Paterson, Eva Rothschild, Tony Swain, Hayley Tompkins, Sue Tompkins, Urs Fischer, Mark Handforth and Monika Soswsnowska. No of exhibitions annually 10

Open Eye Gallery and i2 Gallery

34 Abercromby Place, Edinburgh, EH3 6QE

T 0131 5571020 / 5589872

F 0131 5571020

E mail@openeyegallery.co.uk

W www.openeyegallery.co.uk

Contact Michelle Norman Established in 1982 and situated in Edinburgh's historic New Town, the Open Eye Gallery is equidistant between the Scottish National Gallery and the Portrait Gallery. Deals with both established and young contemporary artists.

Exhibitors include Alan Davie, John Bellany, Calum Colvin and Adrian Wiszniewski. In addition to paintings, the gallery exhibits applied arts. i2 focuses on British and international printmaking, exhibiting Picasso, Miró, Albers, Warhol, Lucian Freud, William Scott and David Hockney.

Price range $f_{100}-f_{50,000}$ No of exhibitions annually 16

Peacock Visual Arts

2I Castle Street, off the Castlegate, Aberdeen, AB11 5BQ

T 01224 639539

F 01224 627094

E info@peacockvisualarts.co.uk

W www.peacockvisualarts.co.uk

Contact Monika Vykoukal (Assistant Curator)
Founded in 1974. An educational charity funded by Aberdeen City Council and the Scottish Arts
Council. It exists to bring artists and public together to share and explore ideas and to make and present art in innovative ways. Has developed a wide range of production facilities and skills (in design, digital imaging, photography, printmaking and video) and promotes numerous artists' participatory and exhibition projects each year.

Submission Policy Artists are invited to submit exhibition or project proposals, focusing on participatory, socially-engaged practice. No areas or media are excluded.

Price range From £25

No of exhibitions annually Exhibition programme changes regularly throughout the year.

scotlandart.com

2 St Stephen's Place, Stockbridge, Edinburgh, EH3 5AJ

T 0131 2256257

E edinburgh@scotlandart.com

W www.scotlandart.com

Contact Marion Ferguson

Established in 1999. Carries Scotland's largest stock of original art work (over 1,400 paintings). Has a number of top Scottish artists, including Blair Thompson, Patsy Macarthur, Lesley Banks, Barry Mcglashan, Kirsty Whitten and Ian King. The website has a page for each artist where purchases can be made. Offers gift vouchers, wedding lists, free art consultancy to homes or offices and a leasing service. Takes artists' work to art fairs all over the UK, arranges commissions, ships work nationally and internationally. Holds exhibitions every month of selected artists. Can also arrange framing for artists and reframes for customers.

Submission Policy Only accepts original paintings, sculptures and jewelry from living artists. Applications welcome all year round, preferably jpegs or photos.

Price range £80-£6,000

No of exhibitions annually 12 in each gallery (total of 24).

The Scottish Gallery

16 Dundas Street, Edinburgh, EH3 6HZ

T 0131 5581200 F 0131 5583900

E mail@scottish-gallery.co.uk

W www.scottish-gallery.co.uk

Established by Aitken Dott in 1842. Deals in contemporary and twentieth-century Scottish painting and contemporary objects by established figures and talented newcomers. A craft department was established in 1986. Work by gallery artists and makers always available. Also exhibits at major art fairs and holds an annual exhibition in London.

Submission Policy Specializes in the work of Scottish artists, artists with a strong Scottish connection through training, etc. or artists living and working in Scotland. International craft artists.

Price range £20-£300,000

No of exhibitions annually Changing monthly programme

Shoreline Studio

2 Shore Road, Aberdour, KY3 0TR

T 01383 860705

F 01383 860705

E ianmcc@shoreline.demon.co.uk

W www.shoreline.sco.fm / www.artis-33.co.uk

Contact Ian McCrorie

Founded in 1997. A compact gallery aiming to promote quality works of art primarily from artists living and/or working in Scotland. Adjacent listed buildings, now known as Artis-33, incorporate a space exhibiting ceramics, glass, jewelry, paintings, prints and sculpture and workshop where art classes are held on ceramics, jewelry, painting and printmaking.

Submission Policy Contact the gallery.

Price range $f_1-f_1,000$ No of exhibitions annually 6

Sorcha Dallas

5–9 St Margaret's Place, Glasgow, G1 5JY T 0141 5532662 / 07812 605745

F 0141 5532662

E info@sorchadallas.com

W www.sorchadallas.com

Contact Jo Charlton (Director's Assistant)
Founded in 2004, representing fourteen local
and international emerging artists. Develops
and co-ordinates commissioning, purchasing
and exhibiting opportunities on a local, national
and international level. Represented artists are:

Rob Churm, Henry Coombes, Raphael Danke. Kate Davis, Alex Frost, Alasdair Gray, Charlie Hammond, Sophie Macpherson, Alan Michael, Craig Mulholland, Alex Pollard, Gary Rough, Clare Stephenson and Michael Stumpf. Submission Policy Does not run an open submissions policy. By invitation only. Price range £300-£15,000 No of exhibitions annually 7

Stills

E info@stills.org W www.stills.org Established in 1977 and now one of Scotland's most important centres for research and for showing works utilizing existing and developing

23 Cockburn Street, Edinburgh, EH1 1BP

Street Level Photoworks

technologies.

1st Floor, 48 King Street, Glasgow, G1 5QT T 0141 5522151 F 0141 5522323 E info@streetlevelphotoworks.org W www.streetlevelphotoworks.org Contact Malcolm Dickson Founded in 1989, promoting the creative use of photomedia. Recognized for its integrated practice, it presents an ongoing series of exhibitions and an education and open-access programme. The organization promotes both emerging and established artists from local, national and international sources. Earlier exhibitions have included such diverse artists as Ian Breakwell, Chila Kumari Burman, Peter Kennard, Daniel

Reeves, Maud Sulter, Andrew Stones, David Levinthal, and Elizabeth and Iftikhar Dadi. Critical

ideas are also fostered through talks, symposia,

and publications. **Torrance Gallery**

36 Dundas Street, Edinburgh, EH3 6JN T 0131 5566366 F 0131 5566366 E enquiries@torrancegallery.co.uk W www.torrancegallery.co.uk Contact Brian Torrance

Founded in 1970. The first contemporary art gallery in Dundas Street. Presents continually changing contemporary art exhibitions, mainly in one or two person exhibitions, plus mixed group shows twice a year. Also offers a picture framing service.

Price range f_{100} - $f_{8,000}$ No of exhibitions annually 15

Tracey McNee Fine Art

47 Parnie Street, Merchant City, Glasgow, G1 5LU T 0141 5525627 F 0141 5528207 E info@tracevmcnee.com W www.traceymcnee.com

Contact Tracey McNee Seeks to exhibit the best in contemporary art from Scotland and beyond. Promotes artists in the gallery and at the major art fairs throughout the UK. Artists represented include Gerard M. Burns, Francis Boag, Sandra Bell and James Hawkins. Submission Policy Artists from all media welcomed. Preferably send CV, statement and images by email.

Price range £200-£40,000 No of exhibitions annually 8

Westgate Gallery

30-41 Westgate, North Berwick, EH39 4AG T 0160 894976 F 01620 800452 E admin@westgate-gallery.co.uk W www.westgate-gallery.co.uk A gallery and gift shop selling original and limitededition works by local, Scottish and UK artists. Includes jewelry, glass and ceramics. Submission Policy All submissions, from both new and established artists, considered. Price range Up to £3,000 No of exhibitions annually 4

South-east

The Afton Gallery

4 Eastcliff Road, Shanklin Old Village, Isle of Wight, PO37 6AA T 01983 868373 F 01983 531447

W www.aftongalleryfineart.co.uk

Founded in 1988, exhibiting an extensive range of Isle of Wight paintings and prints, limited and signed editions of Anne Cotterill (floral) and Tim Thompson (marine), and handpainted bone china. Also offers picture-framing and restoration service.

Submission Policy No further submissions

Price range Framed prints up to £200. Framed originals up to $f_{1,500}$.

Alan Kluckow Fine Art

65 Chobham Road, Sunningdale, SL5 ODT T 01344 875296

E alan@kluckow.com W www.kluckow.com Contact Alan Kluckow

Founded in 1999. Promotes contemporary British and international painters, sculptors and photographers. Shows styles from traditional representational through abstract and new media. Aside from regular exhibitions featuring gallery artists, it also runs collaborative shows with other national and international galleries and arts organizations. Artists include Anne Penman Sweet, Ian Rank Broadley, John Meyer, Martin Yeoman, Robbie Wraith and Susan Leyland. Other services offered include consultancy for corporate and private collectors, arts management, career advice for artists and portfolio analysis. Submission Policy Preferably send a CD with a minimum of six images, including a CV and artist statement (with sae if returns necessary). Price range $f_{250}-f_{30,000}$

Albion / AAR

No of exhibitions annually 10

Albion House, North Street, Turners Hill, Worth, RH104NS

T 01342 715670

E albion.art.research@gmail.com Contact Please contact to speak to a specialist Art Research consultants founded in 1965 specializing in all aspects and mediums of international old master, modern and contemporary art from fifteenth century to present day, with a particular interest in American, European, Asian. Undertakes complete research and administration for private collectors, artist estates and public institutions, for single items or complete collections. Artworks researched for authenticity/history particularly where an artworks authorship or provenance may be questioned. Research and advice for Art Restitution. Condition/restoration reports and valuations provided. Artworks discreetly purchased and/or sold via private treaty on a consignment basis. Submission Policy Submissions are welcomed in writing or email from established international

Price range £500-£5,000,000+ No of exhibitions annually Strictly by appointment only.

artists or executors of artists' estates/collections

Alexander-Morgan Gallery 7b Station Road, Epping, CM16 4HA T 01992 571639

please include images.

F 01992 571639 Contact Dee Alexander-Morgan Opened in 1997. Sells original paintings, handmade prints such as etchings and silkscreens, sculptures, ceramics and one-off glass pieces. Mostly abstract and humorous pieces. Submission Policy Always happy to look at new work. Usually asks to see photos or flysheets first. Price range f_{10} - $f_{3,000}$ No of exhibitions annually 3

Alexandra Wettstein Fine Art

52 Wendover Way, Welling, DA16 2BN T 020 83047920 E alexandra.wettstein@virgin.net Deals in paintings, sculpture, prints and ceramics. Exhibited artists include John Piper, Charles Newington, Dale Devereux Barker and Sandy Sykes. Has arranged exhibitions of twentiethcentury and contemporary British artists at museums and galleries around the country. including three major retrospectives of John Piper's work.

Price range From f100

Animal Arts

20 Orange Street, Canterbury, CT1 2JA T 01227 451145 E info@AnimalArts.co.uk W www.AnimalArts.co.uk Contact Keith Williams

Founded in 2001. An independent publisher of wildlife art producing giclée prints from artists' original work. The gallery is situated in the shadow of Canterbury Cathedral and sells throughout the world and to the fine-art trade.

Submission Policy Only sells prints (not originals). All media are accepted. Price range £45-£300

Art in Action Gallery

Waterperry Gardens, Waterperry, nr Wheatley, OX33 1JZ

T 01844 338085

E info@artinaction.org.uk

W www.artinaction.org Contact Wendy Farha

Founded in 1994 as a spin-off from 'Art in Action' and a haven for highly crafted decorative and fine arts. Emphasis is on excellence and originality, with work by John Leach, T. Millway, Jennie Gilbert and Laurence McGowan, among others. Submission Policy Highly trained and exhibited artists from all media welcome.

Price range $f_{10}-f_{16,500}$ No of exhibitions annually 4

Art@94

94 London Road, Apsley, Hemel Hempstead, HP39SD

T 01442 234123 F 01442 239761

E info@art4interiors.co.uk

W www.art4interiors.co.uk

Retail and trade (wholesale) outlet for abstract, contemporary, mixed media and traditional paintings on canvas. Most media are catered for. Artists include Kriss Keer, Lizzie Gregory, D. Zealey, S. Ringer, Saiqa, Edward Clarke and John Greenwell. Suppliers of blank canvases (singleand double-stretched). Trade and contract framing also undertaken. Specializes in art for homes, interior designers and businesses.

Submission Policy Requires mature artists painting contemporary seascapes and abstracts in oils on canvas (not panels). Apply by sending in photos of work or email high-resolution jpegs. Price range Price range £35-£7,500

No of exhibitions annually 3-4

Arthouse Gallery

10 Western Road, Brighton, BN3 1AE

T 01273 770083

E info@brightonarthouse.com W www.brightonarthouse.com

Opened in 2005. One of the largest commercial contemporary-art galleries in Brighton and Hove. Provides a retail outlet for a diverse range of artists producing paintings, prints, sculptures, ceramics, jewelry and furniture.

Submission Policy Constantly looking for new, exciting artists. Offers highly competitive commission rates and hard-working representation.

Price range £50-£5,000

No of exhibitions annually Private views every month.

artrepublic

13 Bond Street, Brighton, BN1 1RD

T 01273 724829 F 01273 746016

E info@artrepublic.com

W www.artrepublic.com

Contact Lawrence Alkin

Features thousands of art prints from hundreds of famous artists including Dali, Warhol, Lichtenstein, de Lempicka, Klee and Hockney.

Also offers a high-quality mounting and framing service.

Submission Policy Although most prints are by famous artists, it occasionally features prints by local artists.

Price range f_{10} - $f_{2,500}$

Artwork Sculpture Gallery

3 The Shambles, Sevenoaks, TN13 1LJ

T 01732 450960

E info@artworksgallery.co.uk

W www.artworksgallery.co.uk

Founded in 1990. Specializes in sculptures in bronze, bronze resin, steel and stone. Artists represented include Tom Greenshields, Kate Denton, Everard Meynell, Gill Brown, Angela Bishop and Martin Roberts.

Price range £200-£15,000

The Barker Gallery

100 High Street, Eton, Windsor, SL4 6AF

T 01753 865265 F 01753 865265

E info@thebarkergallery.co.uk

W www.thebarkergallery.co.uk

Contact Jon Barker and Soozy Barker

Formerly Art Connection Eton, the gallery specializes in contemporary landscape, abstract and figurative work in oils and mixed media, showing owners' work, plus that of other artists, including George Thomas, David Pearce, Debbie

Goldsmith and Ian Elliot. Submission Policy Email applications preferred.

Price range £300-£7,500 No of exhibitions annually 4

Barn Galleries

Aston, Henley-on-Thames, RG9 3DX

T 01491 577786 F 01491 577786

E info@barngalleries.com

W www.barngalleries.com

Contact Bridget Fraser

Established in 1990. Hosts Artspace, an annual contemporary art event where around 80 invited artists show in unique setting of eighteenthcentury timbered barns and gardens. Works include sculpture, paintings, ceramics, designer jewelry, metalwork and woodwork. Hosts guest exhibition in autumn and various art related events during summer - poetry, performance etc.

Submission Policy Applications invited from September to December for the following summer

season.

Price range £20-£5,000. Most paintings under £1,000. No of exhibitions annually 2-3

Barry Keene Gallery

12 Thameside, Henley-on-Thames, RG9 1BH T 01491 577119
E barrykeene@fsbdial.co.uk
W www.barrykeenegallery.co.uk
Opened in 1971. Shows antique, modern
and contemporary art including paintings,
watercolours, etchings, prints, drawings and
sculpture. Master frame-maker, picture restorer
and conservator. Artists represented include
Ronald Ossary Dunlop, RA RBA NEAC, L.G.
Samuel Palmer RWS, John Martin RBA, Helen
Hale ROI NS SWA FPS, David Eustace RBA and
Richard Pikesley RWS NEAC.

Submission Policy Details and photos by post or email.

Price range From £50 No of exhibitions annually 2

BCA Gallery

13 The High Street, Bedford, MK40 1RN
T 01234 273580
E BCAGallery@bedfordcreativearts.org
W www.bedfordcreativearts.org.uk
Exhibits contemporary, visual art with a focus on film, photography and digital media.

Bell Fine Art Ltd

67b Parchment Street, Winchester, SO23 8AT
T 01962 860439
F 01962 860439
E bellfineart@btclick.com
W www.bellfineart.co.uk
Founded in 1977, specializing in original art from 1800 to the present day. Also sells sculpture, ceramics and glass, and offers a full picture-framing service. Exhibits at ten art and antique fairs annually.

Submission Policy No video or installations. Price range £5-£10000 No of exhibitions annually 2

Bluemoon Gallery

18 Camden Road, Tunbridge Wells, TN1 2PT
T 01892 540100
E info@bluemoongallery.co.uk
W www.bluemoongallery.co.uk
Originally opened as a base for owner Iaysha Salih
to show her paintings, now also exhibits work by

other artists. Items exhibited include paintings,

sculpture, ceramics, textiles, bags, jewelry etc, and are all handmade. The gallery's primary focus is to raise awareness of healing with art.

Submission Policy Original art only (no prints). Artists wishing to exhibit should send in a CD of their work.

No of exhibitions annually 4

Brian Sinfield Gallery Ltd

150 High Street, Burford, 0X18 4QU T 01993 824464 E gallery@briansinfield.com W www.briansinfield.com

Established in 1972. Specializes in contemporary and twentieth-century painters including Fred Cuming, P.J. Crook, Peter Kuhfeld, L.S. Lowry and Alan Lowndes. Up to eight exhibitions a year with catalogues. Also art broker.

Submission Policy Will consider the work of new artists in any medium, but of traditional styles. Price range £500—£100,000. Most paintings sell between £1,500 and £12,000. No of exhibitions annually 8

Brighton Artists' Gallery of Contemporary Art

108A Dyke Road, Brighton, BN1 3TE T 01273 711016 E alicia.murphy@baggallery.co.uk W www.baggallery.co.uk

Established in 2001 and one of the largest commercial galleries in East Sussex. Exhibited artists include Man Ray and Damien Hirst as well as local artists. Gallery restructured in 2005 to include a café-bar. Solo-show, print and photographic galleries available. Framing service offered.

Submission Policy Artists looking for solo shows should send jpegs at 300 pixels high and no more than 72 dpi, plus short biography and statement. Only contemporary artists will be considered. **Price range** From £50 for limited – edition prints to £2,500 for paintings.

No of exhibitions annually 12 in each gallery space.

Canon Gallery

New Street, Petworth, GU28 0AS
T 01798 344422
F 01798 344422
E enquiries@canongallery.co.uk
W www.thecanongallery.co.uk
Founded in 1985, specializing in eighteenth-, nineteenth- and twentieth-century oils and watercolours. Also sells work by contemporary artists.

Submission Policy 'Any artist who can paint!' Price range £400-£50,000 No of exhibitions annually 3

Chagford Galleries

20 The Square, Chagford, TQ13 8AB T 01647 433287

F 01647 433287

E sales@chagfordgalleries.fsnet.co.uk

W www.chagfordgalleries.co.uk

In existence for over thirty-five years and under present ownership for fifteen years. Specializes in West Country artists and craftspeople, with Dartmoor providing a lot of inspiration. Sells original paintings, prints, ceramics, jewelry, glass and woodwork.

Submission Policy West Country artists only, preferably from Devon or Cornwall. No of exhibitions annually 2

Chameleon Gallery

13A Prince Albert Street, Brighton, BN1 1HE

T 01273 324432 F 01273 324432

E info@chameleongallery.co.uk

W www.chameleongallery.org

Contact Mark Francis Positioned at the heart of Brighton in the Lanes,

the gallery displays work on two floors, holding over one hundred pieces. As well as showing local artists, the owner travels extensively across the country looking for new talent. The gallery's philosophy is to show art of the highest quality at affordable prices.

Submission Policy Considers all contemporary art. Artists should send examples of work via email.

Price range $f_{100}-f_{1,000}$ No of exhibitions annually 6

Chichester Gallery

8 The Hornet, Chichester, PO19 7JG

T 01243 779821 F 01243 773345

Founded to encourage interest in and acquisition of all forms of painting (contemporary and period). Aims to help encourage up-and-coming painters, often by promoting their work through exhibitions held on the premises. Gallery housed in a grade-2 Georgian building, comprising seven rooms, five of which are permanently used for displaying pictures. Cleaning and restoration of oils and watercolours also undertaken. Artists include

Claude Hayyes, Lennard Lewis, William Gallcott Knell, Christopher John Adams, Kenneth Child and Richard Rennie.

Price range f_{75} - $f_{7,000}$ No of exhibitions annually 2

Craftsmen's Gallery

I Market Street, Woodstock, **OX20 1SU**

T 01993 811995 F 01993 811995

E richard.marriott@btclick.com

W www.craftsmensgallery.co.uk

Art and craft gallery under present ownership for over 20 years, specializing in work by contemporary British artists and craftsmen including Valerie Petts, Ken Messer, Andrea Bates, Colin Tuffrey, Isis Ceramics and Poole Pottery. Complete picture framing service and art and crafts supplies.

Price range £30-£1500 No of exhibitions annually 1-2

Cranbrook Gallery

Stone Street, Cranbrook, TN17 3HF T 01580 720720 E info@britishfineart.com

W www.britishfineart.com

Contact Paul Rodgers

Founded in 1977, specializing in watercolours by British artists working from the eighteenth to early twentieth centuries. Also UK sales agents for award-winning equestrian artist Alison Guest. Publishers of fine-art prints.

Submission Policy Submissions from living artists working in watercolour are welcome.

Price range £100-£16,000 No of exhibitions annually 2

Daniel Laurence Home & Garden

226 and 246 Kings Road Arches, Brighton Seafront, BN1 1NB

T 01273 739694 / 07780 616223 F 01273 739694

E info@daniellaurence.co.uk

W www.daniellaurence.co.uk

Contact Daniel Laurence

Paintings and sculptures of a marine/seascape theme available from the artist in this seafront gallery, showroom and studio.

Submission Policy Open to applications by painters, sculptors and craftspeople.

Price range f_{35} – f_{355} for limited – edition prints; f_{250} - f_{1000} for original works.

Farnham Maltings East Wing Gallery

Bridge Square, Farnham, GU9 7QR

T 01252 726234 F 01252 718177

E info@farnhammaltings.com

W www.farnhammaltings.com

Contact Kate Martin (Visual Arts Officer) Set in one of the old kilns. Hosts a variety of exhibitions throughout the year, ranging from graduate shows to national touring exhibitions. Exhibited artists include David Hockney, Matisse and Andy Goldsworthy.

Submission Policy Space is for rental to individuals and art groups. All artists are asked to present work for selection. All media considered. No of exhibitions annually 15-20

Four Square Fine Arts

5 Waterloo Place, Lewes, BN7 2PP T 01273 479646 / 01273 474005

E sonia@foursquarearts.co.uk W www.foursquarearts.co.uk

Presents a portfolio of well-established artists from a variety of disciplines including painting, printmaking, photography mixed media and film. Curates shows in hired galleries in London and Sussex and exhibits at major art fairs throughout the UK.

Submission Policy Send a CD, CV and statement about the work.

Price range £500-£10,000 No of exhibitions annually 6-8

Fourwalls

Contact Lara Bowen

31A Hamilton Road, Brighton, BN1 5DL T 01273 694405 E info@four-walls.co.uk W www.four-walls.co.uk

An art agency with an eclectic portfolio of quality contemporary work from artists in Brighton and the surrounding area. From portraiture to landscapes, oils to photography, there is no house style. Manages, promotes and publishes work by artists including Sophie Abbott, Becky Blair, Emma Brownjohn, Simon Dixon, Sam Hewitt, Shyama Ruffell and Adrian Talbot. Also curates group and solo shows in a range of spaces including non-gallery settings. Does not have a set gallery space, prefering to utilize other exhibition opportunities.

Submission Policy Artists interested in working wth Fourwalls should initially send five images, a CV and statement by email or post.

Price range £100-£2,500 No of exhibitions annually 50, many rotated.

Francis Iles

Rutland House, 103 High Street, Rochester, ME1 1LX T 01634 843081

F 01634 846681

E nettie@francis-iles.com

W www.artycat.com

Contact Nettie Iles-North

Established in 1962. Exhibited living artists work mainly in a representative vein but there is some contemporary work as well. Handles the estates of Rowland Hilder OBE PPRI RSMA and Roland Batchelor RWS. Shows over seven hundred works at any one time.

Price range f_{60} - $f_{20,000}$ No of exhibitions annually 4 in-house; 4 art fairs.

Gallery 99

25 High Street, Knaphill, GU21 2PP T 01483 797884 F 01483 797884

Sells mainly original paintings. Also offers a picture-framing service and sells artists' materials. Submission Policy Applications welcome in person by prior arrangement. All works sold on commission (thirty per cent to the gallery, seventy per cent to the artist). Two-dimensional work only. Price range £50-£500

Gallery Beckenham

71A High Street, Beckenham, BR3 1AW T 020 86503040

E enquiries@gallerybeckenham.com

W www.gallerybeckenham.com Family-owned gallery specializing in contemporary art from noteworthy young artists and those more established. Specializations include original canvases, sculpture, glass and art photography. Artists include Yuri Gorbachev, Sandro Negri, Anna Bocek, Susan Caines, Mark Leach, Enver Gursev, Manuel Quintanilla, Ev Meynell and Danny Green. Submission Policy Email contact details with six images of work.

Price range £200-£40,000 No of exhibitions annually 6

George Street Gallery

4 George Street, Kemptown, Brighton, BN2 1RH T 01273 681852 E gsg@onetel.com W www.gsfg.co.uk

300 square feet of gallery space available for hire from February to December, including a caretaker so artist's presence is required only on hanging and removal days. Also offers a bespoke picture framing service from a basement workshop established over 100 years ago.

Submission Policy Artists should submit images of work and CV by post or email. Most types of wall-hung art considered ,including abstract and photographic.

Price range £50-£2,000 No of exhibitions annually 10 Cost to hire or rent £300 per month basic, then

25% com [vat not charged].

Hannah Peschar Sculpture Garden

Black & White Cottage, Standon Lane, Ockley, RH5 5QR

T 01306 627269 F 01306 627662

E hpeschar@easynet.co.uk

W www.hannahpescharsculpture.com

Contact Hannah Peschar

The Sculpture Garden has developed over the last twenty-five years and shows over one hundred different national and international contemporary sculptors, including Peter Randall-Page, Stephen Cox, Charlotte Mayer, Neil Wilkin and Bert Frijns. Submission Policy Good-quality images and CV in the first instance. All work must be durable for the outdoors, i.e.frost and storm-proof.

Price range £200-£70,000No of exhibitions annually 1

Heathfield Art

65 High Street, Heathfield, TN21 8HO T 01435 862184 W www.nickwhistler.com

Contact Nick Whistler

Established in 2000, showing contemporary paintings by British and Canadian artists including Andrew James, Alan Rankle, Heather Stuart, John Holdcroft, Bewabon and Travis Shilling, Tim Pryke, Graham Sendall, Alvaro Petritoli, Erik Addison and Paul Jackson.

Price range £50-£10,000

No of exhibitions annually Rotating exhibitions in three locations.

IceTwice

25 High Street, South Olney, MK46 4AA T 01234 714499 E info@icetwice.com Large contemporary commercial gallery, design shop and exhibition space — eight rooms on two floors. Features artists from the USA, Europe and Asia, plus recent graduates from London's fine art schools and studios and local artists from Buckinghamshire, Bedfordshire and Northamptonshire. Includes painters, photographers, sculptors, ceramicists, printmakers and many other disciplines.

Cost to hire or rent Yes, contact gallery for details.

Inspires Art Gallery

27 Little Clarendon Street, Oxford, Oxon, OX1 2HU

T 01865 556555 F 01865 556555

E artgallery@inspires.co.uk

W www.inspires.co.uk

Opened in 2000. Stocks a wide range of original limited-edition prints, original canvases, ceramics, sculpture and glassware. Artists include Heidi Konig, Terry Frost, Carol Peace and Peter Layton. Also offers a framing service with full conservation framing if needed. Accepted on to the Arts Council 'Own Art' scheme in 2005.

Submission Policy The gallery requests images on slides or transparencies or by email for the owner's consideration. Does not accept jewelry or embroidery.

Price range £20-£13,000No of exhibitions annually 10, including 5 solo exhibitions.

Island Fine Arts Ltd

53 High Street, Bembridge, Isle of Wight, PO35 5SE T 01983 875133 E gallery@islandfinearts.com

W www.islandfinearts.com

Contact Nick Fletcher, Liz Fletcher and Melita Mence

Founded in 1997 and based in the seaside village of Bembridge, the gallery is split into four rooms and deals in works by twentieth- and twenty-first-century modern British painters. Artists include Fred Cuming, RA, Ken Howard RA, LS Lowry RA, Mary Fedden RA, George Devlin, Trevor Chamberlain, Jo Bemis, Rod Pearce and Edward Seago RBA RWS. Exhibitions take place throughout the year both on the Island and in London. We are very happy to talk to companies about their requirements.

Submission Policy Always interested in meeting painters and viewing their works.

Price range £450-£50,000No of exhibitions annually 10

The Jointure Studios

11 South Street, Ditchling, BN6 8UQ

T 01273 841244 F 01273 841244

E gallery@jointurestudios.co.uk

W www.jointurestudios.co.uk

Contact Shirley Crowther

Spacious gallery for rental created from the late Sir Frank Brangwyn's studios. Holds two major themed exhibitions a year, showing work by professional makers and artists. Also has an artistin-residence.

Cost to hire or rent From £300 upwards.

Kent Potters' Gallery

22 Union Street, Maidstone, ME14 1ED

T 01622 681962

E mail@kentpotters.co.uk

W www.kentpotters.co.uk

Contact Janet Jackson

Opened in 1994. Promotes original, exclusive and innovative work. The centre of excellence for the Kent Potters' Association (KPA) and over twelve members represented at any one time. Includes a resource centre on courses, etc. and is stewarded by members. Work is for sale and/or commission. Submission Policy Entry is by being a member of the KPA. Applications from non-members are not accepted.

Price range £4-£400

Legra Gallery

8 The Broadway, Leigh-on-Sea, SS9 1AW T 01702 713572

Contact Peter Vinten

Founded in 1973, specializing in marine paintings (traditional and contemporary). Also offers conservation-framing service to artists and public and an oils-restoration service. Resident artists include Colin Moore, Peter Vinten, Eric Pead, John Dawkins and Rod Brown. The gallery has also shown work by the late Vic Ellis in recent years.

Submission Policy No specific entry requirements. Preference given to local artists.

Price range £20-£500. £200-£2,000 for Vic Ellis works, when available.

Lincoln Joyce Fine Art

40 Church Road, Great Bookham, KT23 3PW T 01372 458481 F 01372 458481 E rosemarylincolnjoyce@hotmail.com W www.artgalleries.uk.com

Contact Rosemary Pearson

Gallery since 1987, aiming to present fine quality paintings in a relaxed and friendly atmosphere. Focuses on watercolours and oil paintings. Subject matter (mostly representational) includes landscapes, marine scenes, figures, still lifes and genre paintings. Artists represented include Paul Banning RI RSMA, Keith Noble ARSMA, David Bellamy, Hugh Chevin, F. Donald Blake RI RSMA, Rowland Hilder OBE, PRI, RSMA, Gordon Rushmer, Sonia Robinson RSMA SWA, Anthony Flemming, George Busby MCSD RBSA FRSA, Clive Madgwick RBA, Peter Newcombe, Edward Stamp RI, Mervyn Goode, John Uht RI and Neil Spilman. Valuation and framing services also offered.

Price range £50-£20,000 No of exhibitions annually 11

Linda Blackstone Gallery

The Old Slaughterhouse, R/O 13 High Street, Pinner, HA5 5QQ

T 020 88685765

F 020 88684465

E linda@lindablackstone.com W www.lindablackstone.com

Founded in 1985 to exhibit contemporary British representational artists, including Mike Bernard RI, Leo McDowell RI, Janet Ledger, Colin Kent RI, Mat Barber Kennedy RI, Ken Paine PS SPF. Also shows paintings, sculpture, ceramics and studio glass. Offers a bespoke framing service. Artists' work is shown at many national and international art fairs as well as in-house exhibitions.

Submission Policy No print, photography, abstract or installation work. Apply by email or post with examples of work and full CV. Seen by appointment only.

Price range £150-£8,000

No of exhibitions annually 2 set exhibitions and ongoing exhibition of works.

Magic Flute Gallery

231 Swanwick Lane, Lower Swanwick, Southampton, SO31 7GT

T 01489 570283

E art@magicfluteartworks.co.uk

W www.magicfluteartworks.co.uk

Contact Bryan Dunleavy

At current location since the late 1990s. Exhibits paintings, original prints and small sculpture. Features south-coast and national artists including Russell Baker, Dorothy Brook, Bryan Dunleavy, John Horsewell, Michael Morgan and Stan Rosenthal.

Submission Policy Applications should be made in the first instance by email with low-resolution ipeg images.

Price range Up to $f_{3,000}$; most under $f_{1,000}$. No of exhibitions annually 6

Modern Artists' Gallery

High Street, Whitchurch-on-Thames, Reading, **RG88 7EX**

T 0118 9845893

E info@modernartistsgallery.com

W www.modernartistsgallery.com

Contact Olivia O'Sullivan

Founded in 2000. Aims to support professional and emerging artists. Specializes in contemporary abstract and figurative work. Artists include Anita Austwick, Stuart Buchanan, Mark Hall, Kate Kessling, Paul Kessling, Patrick John Mills, Lucy Orchard and Paul Wright

Submission Policy Artists should submit by email or telephone, sending jpegs or directions to own

website.

Price range £50-£5,000 No of exhibitions annually 6 Cost to hire or rent 6 months' notice required. Costs negotiable.

Neville Pundole Gallery

Contact Neville Pundole

8A-9 The Friars, Canterbury, CT1 2AS T 01227 453471 F 01227 453471 E neville@pundole.co.uk W www.pundole.co.uk

Established in 1980 and moved to current premises in 1996. Artists represented include Sally Tuffin, Siddy Langley, Peter Layton, Roger Cockram, Martin Evans and the Moorcroft family. Specializes in art pottery and studio glass with pictures, textiles and sculpture. Gallery space for self-promoting artists.

Submission Policy The owner 'must like the work'. Price range f_{50} - $f_{5,000}$

No of exhibitions annually 8

Nicholas Bowlby

Owl House, Poundgate, TN22 4DE T 01892 667809 F 01892 667809 E info@nicholasbowlby.co.uk W www.nicholasbowlby.co.uk Contact Nicholas Bowlby A direct descendant of Sir Henry Tate, Nicholas Bowlby started to deal in early English watercolours in 1976, and since then has extended his interests to include modern British paintings from the first half of the twentieth century, as well as representing a number of contemporary painters and sculptors.

Submission Policy Enquiries welcome. Send photographs in the first instance, preferably by email. All submissions answered.

Price range £100-£55,000 No of exhibitions annually 6

North Laine Photography Gallery

Upstairs at Snoopers Paradise, 7-8 Kensington Gardens, Brighton, BN1 8AR

T 01273 628794

E studio@northlainephotography.co.uk

W www.brightonphotography.com

Contact Daryl Swallow

Founded in 2003. Spacious gallery with in-house studio and print services. Offers photographic prints for all budgets and taste, from the timeless and classic work of NK Swallow and R Bamber to the surreal world inhabited by resident favourite Petrusco, via the acclaimed DarkDaze, innovative Karen Neal and others.

Submission Policy All interpretations of the photographic medium accepted for review. Bi-annual Brighton-based competition. Otherwise email images/CV etc.

Price range Exhibition pieces f_{75} to $f_{5,000}$ No of exhibitions annually 8

Cost to hire or rent Gallery exchanges considered internationally

Omell Galleries

The Corner House, Course Road, Ascot, SL57LH

T 01344 873443 F 01344 873467

E aomell@aol.com

W www.omellgalleries.co.uk

Founded in 1947, offering fine-quality paintings at realistic prices. Specializes in traditional oil paintings. Artists include Antoine Blanchard, Pierre Bittar, David Dipnall, Raymond Campbell, John Donaldson and Ivars Jansons.

Submission Policy Traditional works by professional artists.

Price range £300-£15,000

No of exhibitions annually 6

Oxmarket Centre of Arts

St Andrew's Court, East Street, Chichester, PO19 1YH

T 01243 779103

F 01243 779103

E info@oxmarket.com

W www.oxmarket.com

Contact Sharonne Lane (Administrator) Founded in 1971 with the aim of promoting the arts in the community. Works with music and the arts generally, but with a concentration on visual arts. Exhibits paintings and drawings, sculpture and ceramics. Mainly used by artists from West Sussex and Home Counties but hosts national figures too.

Submission Policy All two- and three-dimensional work welcomed. Selection is by a panel of professional artists.

Price range Varies from exhibition to exhibition. No artist represented permanently.

No of exhibitions annually 150, in six gallery spaces.

Cost to hire or rent see website

Paddon & Paddon

113 South Street, Eastbourne, BN21 4LU

T 01323 411887

E paddon@uk2.net

W www.paddonandpaddon.co.uk

Contact Henry Paddon

Established in 1992. Offers a diverse range of two- and three-dimensional work by leading studio makers based in the UK and Europe. Media offered include ceramics, glass, metalwork, jewelry, wood, sculpture, printmaking and furniture. A commissioning service is available. Selected by Arts Council England for participation in the Own Art scheme.

Price range $f_{10}-f_{3,750}$

No of exhibitions annually Up to 4

Permanent Gallery

20 Bedford Place, Brighton, BN1 2PT

T 01273 710771

E info@permanentgallery.com

W www.permanentgallery.com A not-for-profit space, opened in 2003. Dedicated to bringing challenging and innovative contemporary art to the public. Programme includes local, national and international artists exhibiting work of all disciplines. Houses an independent art bookshop selling artist-made books, small-press publications, magazines and multiples sourced both locally and internationally. The gallery runs a varied events programme, which has featured group drawing on the beach,

live drawing in the gallery, readings, discussion forums and artists talks.

Submission Policy Accepts submissions by email or post all year round from artists creating contemporary work in any medium. No of exhibitions annually 12

Pierrepont Fine Art

52 Vicarage Road, Oxford, OX1 4RE T 01865 724957 E kate@pierrepontfineart.co.uk W www.pierrepontfineart.co.uk Specializes in British and European twentiethcentury and contemporary art.

Planet Janet

86 Church Road, Hove, BN3 2EB

T 01273 738230

E richard@onehappymother.co.uk

W www.planet-janet.com

Founded in 2002. A healthy vegetarian café and therapy centre specializing in alternative therapies, complete with a changing collection of art work on

Submission Policy Artists' work must be shown to one of the managers.

Price range f_{40} – f_{500} No of exhibitions annually 6

Red Gallery

54 North Street, Thame, OX9 3BH T 01844 217622

E micky@redgallery.co.uk W www.redgallery.co.uk

Founded in 1998 to showcase renowned artists and promote fresh graduates through solo gallery exhibitions and representation at international art fairs. Artists represented include Claire Boyce, Stanley Dove, Robin Eckardt, Cat James, Paul Lemmon, Garry Raymond-Peirera, Trevor Price and Alexander Smith.

Submission Policy Submissions must be hard copy only. Include photos or CD, CV and biography, plus sae for reply.

Price range $f_{100}-f_{12,000}$

No of exhibitions annually Up to 9 international art fairs along with gallery exhibitions.

Robert Phillips Gallery

Riverhouse Barn, Manor Road, Walton-on-Thames, KT12 2PF T 01932 254198 E arts@riverhousebarn.co.uk W www.riverhousebarn.co.uk

Contact Prue Robinson, Manager Opened in 2000 as part of the Riverhouse Arts Centre. Exhibits contemporary works by artists practising in all media, including painting, sculpture, prints, new media, video, performance and applied arts. Also hosts touring exhibitions. A designated space for applied and decorative arts exhibits three makers per month. A cafe-bar wall space is also available.

Submission Policy Send at least five images plus a CV and artist statement either by post or email. There is 30% commission on sales.

Price range £20-£50,000 No of exhibitions annually 12

Roche Gallery

93 High Street, Rye, TN317JN

T 01797 222259

E timroche@onetel.com

W www.rochegallery.com

Contact Timothy Roche

Showcases the work of Marina Kim, a painter and printmaker from Tashkent, Uzbekistan. Also regularly exhibits paintings from other leading contemporary artists from the former Soviet Union including Lena Lee, Alexander Kim and Gairat Baimatov.

Submission Policy Interested in original paintings, drawings, prints and sculpture in any medium. Overseas artists preferred. No crafts or photography.

Price range £55-£1,500 No of exhibitions annually 6

Room for Art Gallery

15a Church Street, Cobham, **KT11 3EG** T 01932 865825 F 01932 865825 (phone first) E john@roomforart.co.uk W www.roomforart.co.uk

Contact Hilary Donnelly

Opened in 2004, specializing in contemporary original British and South African art. Also specializes in Zimbabwean stone sculpture (also known as Shona sculpture), with one of the widest ongoing selections of this genre in the UK. Submission Policy Preference for contemporary oils and acrylic work, mainly figurative or landscape.

Price range £250-£5,000

No of exhibitions annually 4-6, each of 4-5 weeks' duration. Mixed shows in between.

Royall Fine Art

52 The Pantiles, Tunbridge Wells, TN2 5TN T 01892 536534

F 01892 536534

E royallfineart@tiscali.co.uk

W www.royallfineart.co.uk

Established in 1983. Specializes in finequality paintings, sculpture and studio glass by established and emerging artists. Regular exhibitors include Matthew Alexander, Raymond Campbell, Jonathan Pike, Paddy Burrow and Ronald Cameron.

Submission Policy Applications should be made by photograph, email or appointment.

Price range £300-£20,000 No of exhibitions annually 4

Saltgrass Gallery

1 Angel Courtyard, Lymington, SO41 9AP T 01590 678148 / 07976 830569 F 01590 678148 E info@saltgrassgallery.co.uk W www.saltgrassgallery.co.uk Owned and run by practising painter Jenny

Sutton. Alongside her own work in oil, watercolour and acrylic, she exhibits a varied selection of paintings, prints, ceramics and glass by chosen contemporaries. The work is largely representational and mostly under f1,000 Submission Policy Telephone in the first instance to see whether submission is advisable.

Price range $f_{10}-f_{1,000}$ No of exhibitions annually 4

Sarah Wiseman Gallery

40-41 South Parade, Summertown, Oxford, OX27JL

T 01865 515123

E sarahjane@wisegal.com

W www.wisegal.com

Almost a decade's experience of selling original contemporary art from established and emerging names. Specializes in original painting, ceramics, prints and jewelry by new artists.

Submission Policy The gallery applications from new artists throughout the year. See website for details.

No of exhibitions annually 6

Simon Fairless

27 Balmoral Gardens, Windsor, SL4 3SG T 01753 841216 E simon@simonsgallery.com W www.simonsgallery.com

Contact Simon Fairless

Specializes in abstract, landscape and Pop Art works using acrylic on canvas. Exhibits owner's own work as well as work of other artists.

Price range £50-£5000 No of exhibitions annually 8

Six Chapel Row Contemporary Art

The Elm Coach House, Church Lane, Chipping Norton, OX7 5NS

T 01608 645258

E sixchapelrow@btinternet.com

W www.sixchapelrow.com

Contact Tim Heywood

Six Chapel Row Contemporary Art was founded in Bath in October 1995 where it became one of the leading regional art galleries in the UK showing a wide variety of high quality contemporary fine and applied art. Now based in Oxfordshire, Six Chapel Row is open by appointment and continues to deal with a wide selection of painting, sculpture, photography, furniture, ceramics and glass.

Price range £100-£100,000

No of exhibitions annually Varies annually. See website.

Star Gallery

Castle Ditch Lane, Lewes, BN7 1YJ

T 01273 480218 F 01273 488241

E info@stargallery.co.uk

W www.stargallery.co.uk

Contact Hayley Brown

Established in 1989 and now a centre where artists of local, national and international reputation sell their work. As well as the contemporary gallery in the old brewery building, it also features a series of creative workshops and studios for hire.

Submission Policy Welcomes artists' submissions. Work can be emailed as jpegs or posted as slides or on CD with an sae.

Price range Prices vary according to artist being shown.

No of exhibitions annually Approx.12 Cost to hire or rent From f_{150} per week

Start Contemporary Gallery

8 Church Street, Brighton, BN1 1US T 01273 233984 E email@startgallery.co.uk

W www.startgallery.co.uk

Contact Edward Milbourn

Opened in 2000. Shows and sells new work in

all mediums from photography to performance. Recent exhibitors include Foxtrot Echo (Coum Transmission) and photographs by Karen Fuchs and Robert Yager.

Submission Policy Contact the gallery for an information pack (email preferred). All exhibitions considered. No unsolicited work.

Price range £40-£2,000 No of exhibitions annually 20

Cost to hire or rent Between £225–£400 a week depending on the time of year.

Sundridge Gallery

9 Church Road, Sundridge, Sevenoaks, TN14 6DT

T 01959 564104

Founded in 1986. Sells well-draughted watercolours, oil paintings and drawings in good condition. Mostly nineteenth- and twentieth-century but does sell some twenty-first-century modern and traditional work. Artists include Robert Thone Waite, David Cox Jr, F.J.Aldridge, Frank Henry Mason and Edward Wesson. Restoration service also offered.

Submission Policy Traditional fine art only.

Price range £100-£5,000

No of exhibitions annually 1-2

Sussex Arts Club Ltd

7 Ship, The Laines, Brighton, BN1 1AD

T 01273 778020

E info@sussexarts.com

W www.sussexarts.com

Contact Michael Fowdrey (Events Manager)
Submission Policy Ring to arrange appointment

and viewing of portfolio.

No of exhibitions annually Monthly for individuals; bimonthly for joint shows.

Taurus Gallery

16 North Parade, off Banbury Road, Oxford, OX2 6LX

T 01865 514870

Sells paintings, sculpture and ceramics. Also offers framing and restoration services.

Upstairs at the Halcyon

The Halcyon Bookshop, 11 The Broadway, Haywards Heath, RH16 3AQ

T 01444 412785

F 01444 443509

E halcyonbookshop@aol.com

W www.halcyonbookshop.com

Contact Kay O'Regan

Opened in 2003, specializing in works by Sussex

artists.

Submission Policy Chooses exhibitors from

samples of their work. Encourages new talent. **Price range** $f_{50}-f_{10,000}$

No of exhibitions annually 15

Verandah

13 North Parade, Oxford, OX2 6LX

T 01865 310123

Small gallery opened in 1999 by five designers and makers. Offers jewelry, ceramics, glass, textiles, metal and paper work and some paintings. Contributors include James C. Cochrane, Sara Withers and Prue Cooper among others.

Submission Policy Welcomes submissions from craftspeople and artists at the lower end of the size and price scale, as the gallery is small.

Price range £8-£800

No of exhibitions annually 2, plus featured artists.

Webb Fine Arts

The Museum Room, Avington Park, Winchester, SO21 1DB

T 01962 779777 F 01962 880602

E davieswebb@hotmail.com

W www.webbfinearts.co.uk

A gallery established by Davies Webb, an international art dealer for over forty years. Holds a large stock of nineteenth- and twentieth-century oil paintings.

Price range £350-£10,000

Webster Gallery

13 Pevensey Road, Eastbourne, BN21 3HH

T 01323 735753

Contact Simon Webster

Founded in 1984, dealing in twentieth-century paintings (mainly French). Offers full restoration and valuation service. Artists include Frank Wootton, Pierre de Clausade, Gabriel Deschamps, Erwin Eicheiger, Rene His, James Noble, Frank Archer and Roland Batchelor.

Price range £500-£3,000No of exhibitions annually 2

Whittington Fine Art

26 Hart Street, Henley-on-Thames, RG9 2AU T 01491 410787 F 01491 410787 E barry@whittingtonfineart.com
W www.whittingtonfineart.com
Contact Barry Whittington
Opened in 1992 and relocated to Henley-onThames in 2001. Specializes in contemporary
paintings and bronze sculpture. Has a large stock
of traditional watercolours and oil paintings
dating from 1796 to 1940, as well as works
by approximately thirty contemporary artists
including Peter Graham VPROI, Jeremy Barlow
ROI, Jacqueline Rizvi RBA RWS NEAC, Nick
Hebditch and Aldo Balding. Other artists include
Mary Fedden RA, Donald Hamilton Fraser RA,
Ceri Richards, Sir William Russell Flint RA,
Jonathan Wylder, Adrian Sorrell, Anne Smith and

Submission Policy Portfolios welcomed for viewing. Time and advice will always be given, although wall space is limited.

Price range £400-£52,000 No of exhibitions annually 6

Wren Gallery

Peter Knapton.

Bear Court, 34 Lower High Street, Burford, OX18 4RR

T 01993 823495

F 01993 823247

E enquiries@wrenfineart.com

W www.wrenfineart.com

Specializes in contemporary British and Irish art.

Price range £500-£10,000 No of exhibitions annually 11

Zimmer Stewart Gallery

29 Tarrant Street, Arundel, BN18 9DG

T 01903 885867

E james@zimmerstewart.co.uk W www.zimmerstewart.co.uk

Contact James Stewart

Founded in 2003, specializing in contemporary art in all media by living artists. Represented artists include Felix Anaut, Nick Bodimeade, Ann Sutton MBE, Barbara Macfarlane, Anthony Frost, Christopher Marvell, and Richard Walker. Works directly with artists and aims to show work to both buyers and as many other visitors to the gallery as possible. Licensed to offer Own Art loans in conjunction with the Arts Council.

Submission Policy Send in via email or on disc details of training, exhibitions and examples current work.

Price range £100-£7,000 No of exhibitions annually 8-10

South-west

Alexander Gallery

122 Whiteladies Road, Bristol, BS8 2RP

T 0117 9734692

F 0117 9466991

W www.alexander-gallery.co.uk

Established for over 30 years. Artists include John Yardley RI, Michael Barnfather, Edward Wesson RI, Beryl Cook, Sir William Russell Flint RA, David Shepherd, Karl Taylor, Peter Graham and Richard Thorn. Also offers conservation, restoration and consultancy services.

Anthony Hepworth Fine Art Dealers Ltd

3 Margarets Buildings, Brock Street, Bath, BA1 2LP

T 01225 447480

F 01225 442917

E anthony.hepworth@btinternet.com
Founded 1989. Dealers in twentieth-century and contemporary British painting, sculpture and drawings, specializing in post-war British pictures. Artists represented include Peter Lanyon, Keith Vaughan, Christopher Wood, Roger Hilton, Ben Nicholson, Barbara Hepworth. Offers services to executors of deceased estates regarding the

dispersal of collections on their behalf. **Submission Policy** Artists are invited to send slides of their work for consideration if they feel their work would fit in with the gallery's ethos.

Price range £500-£400,000 No of exhibitions annually 2

Art Space Gallery

The Wharf, St Ives, TR26 1PU

T 01736 799744

E lesley@artspace-cornwall.co.uk

W www.artspace-cornwall.co.uk

Contact Lesley Ninnes

A seven-member cooperative gallery established in 2000. An offshoot of Taking Space, a local group of women artists formed ten years ago to find venues for regular exhibitions. Founding members took the next logical step and acquired permanent exhibiting space.

Submission Policy Artists can submit contact details for when a vacancy arises. Members pay a share of rent/rates, spend one day per week in the gallery and attend a monthly meeting/rehanging.

Price range £45-£1400

No of exhibitions annually Monthly rotation of work, with an optional monthly theme.

ArtFrame Galleries

61 Cornwall Street, Plymouth, PL1 1NS

T 01752 227127

F 01752 672235

E artframegallery@supanet.com

W www.artframegallery.co.uk

Contact Harry or Sally Eves

Founded in 1984. Exhibits 'special and different' art and craft work. With an emphasis on quality and affordability, the gallery stocks a wide selection of artists and makers working in diverse media. Bespoke picture-framers, with discounts to exhibiting artists. Painters include Ben Maile, Lee Woods and James Martin. Makers include Rudge Ceramics, Jennie Hale and Suzie Marsh.

Astley House Contemporary

Astley House, London Road, Moreton-in-Marsh, GL5 60LL

T 01608 650601 / 652896

F 01608 651777

E astart333@aol.com

W www.contemporaryart-uk.com

Family business opened in 1973. Contemporary gallery opened in 1997. Artists include Charles Neal, Daniel Van der Putten, Chris Bruce, Michael Kitchen-Hurle, Helen Haywood and Kay Elliott. Ceramics by Peter Beard and Ashraf and Sue Hanna. Jewelry by Guen Palmer and Gordon Yates. Submission Policy Happy to look at artists' original work to decide if it is suitable.

Price range £250-£12,000. No of exhibitions annually 3

Atishoo Designs

71 Charlestown Road, Charlestown, St. Austell, PL25 3NL

T 01726 65900

E enquiries@atishoodesigns.co.uk

W www.terras.fsnet.co.uk

Established in 2003. Contemporary gallery mainly featuring West Country artists including David Wheeler, Paul Clark, Lamorna Penrose, Alan Arthurs, Keith Bunt and Sue Bryant. Handmade ceramics and glassware. Picture-framing workshop on site.

Submission Policy Mainly West Country artists.

Price range $f_{100}-f_{1,000}$ No of exhibitions annually 2

Atrium Gallery

Units 2 & 3, The Podium, Northgate Street, Bath, BA1 5AL

T 01225 443446

F 01225 422910

E framing@theframingworkshop.com

W www.theframingworkshop.com

Recently expanded, having been established for five years selling both limited-edition prints and originals by artists including Doug Hyde, David Cobley, Jonathan Shaw, Fletcher Sibthorpe and Michael Austin. Also sources poster prints. A specialist framing service is available from the workshop at 80 Walcot Street in Bath, which stocks a selection of art work by local artists depicting local scenes.

Submission Policy Contact the gallery via email.

Baytree Gallery

48 St Margaret's Street, Bradford on Avon, BA15 1DE

T 01225 864918

E jane.gibson@ukonline.co.uk

Situated in the centre of town, has exhibitions of two or three complementary artists' work lasting for about three weeks. Artists showing include David Cox, Diana Heeks, Jackie Morins, Estienne Sheppard, Lizzie Macrae and Amanda Backhouse. No of exhibitions annually 8

Beaux Arts

12-13 York Street, Bath, BA1 1NG

T 01225 464850

F 01225 422256

E info@beauxartsbath.co.uk

W www.beauxartsbath.co.uk

Contact Aidan Quinn

Has exhibited the work of contemporary and modern British painters, sculptors and ceramicists since 1980 including Dame Elisabeth Frink, the post-war St Ives School and Lynn Chadwick. Current exhibitors include Akash Bhatt, Nathan Ford and Roxana Halls and other young British artists working in a mainly figurative style. Submission Policy Does not accept email applications from artists. Slides, photos or CDs with sae will be returned after viewing.

Price range £60-£30,000

No of exhibitions annually 8, including a selected summer exhibition of painting, sculpture and ceramics.

Bettles Gallery

82 Christchurch Road, Ringwood, BH24 1DR

T 01425 470410

W www.bettles.net

Founded in 1989, specializing in original contemporary paintings and studio ceramics by

British artists and makers. Work in stock from leading established potters and painters, plus some from promising newcomers. Painters include Brian Graham, Martyn Brewster and Paul Jones. Ceramicists include Peter Hayes, William Marshall, Jim Malone, Ian Gregory and Walter Keeler.

Submission Policy Original paintings and individual one-off ceramics considered. First approach should be photographs (not slides or CD) accompanied by CV.

Price range Up to £2,500 No of exhibitions annually 8

Bi-Hand

121 St George's Road, Hotwells, Bristol, BS1 5UW T 0117 9210053 E joandsimon@bihand.co.uk

Black Swan Arts

2 Bridge Street, Frome, BA11 1BB

T 01373 473980

F 01373 473980

E office@blackswan.org.uk

W www.blackswan.org.uk

Set up in 1986. Has three exhibition spaces, Gallery One, Gallery Two in the Round Tower, and the Arts Café. Shows a variety of both twoand three-dimensional visual art and holds an open competition biannually (next scheduled for February 2010.)

Submission Policy Submissions accepted. Send images and artist information (CV, statement).

No of exhibitions annually 8-10

Blue Dot Gallery

14 Regent Street, Clifton, Bristol, BS8 4HG

T 0117 9467777

E lee.purvis@bluedotgallery.com

W www.bluedotgallery.com

Showcases wide range of original paintings, limited editions, sculptures and glassware. Artists include Charlotte Atkinson, Doug Hyde, Jonathan Shaw and Peter Wileman.

Blue Lias Gallery

47 Coombe Street, Lyme Regis, DT7 3PY

T 01297 444919

E office@bluelias.co.uk

W www.bluelias.co.uk

Contact Jennie Pearson

Founded in 1996 and under present ownership since 2002. Specializes in contemporary art and craft works celebrating especially the Jurassic

Coast (sea, cliffs, beaches, fish, etc). Particular emphasis on artists from the locality and southwest region. Commissioning actively undertaken. Artists include David Potter, Cath Read, Rebecca Stidson, Joy White, Rachel Jennings and Albert Duplock.

Submission Policy All artists considered whose work is compatible with the ambience of the

gallery.

Price range Up to £2,000. Works of higher value considered.

No of exhibitions annually 6

Bristol Guild

68-70 Park Street, Bristol, BS1 5JY T 0177 9265548 F 0177 9255659 E info@bristolguild.co.uk W www.bristolguild.co.uk

Contact Simone Andre (Manager)

The gallery is on the second floor of the Bristol Guild shop, which was founded in 1908 as a guild of craftsmen.

Submission Policy Exhibitors are selected for the high standard of their work. Paintings, prints, ceramics and glass are the main exhibits.

Price range Up to £2,000No of exhibitions annually 12

Chapel Gallery

Saltram House, Plympton, Plymouth, PL7 1UH T 01752 347852

F 01752 347852

E kirsty.eales@nationaltrust.org.uk Shows local arts and crafts from Devon and Cornwall. Work on display includes pottery, ceramics, original paintings, prints, jewelry, glass and woodturning. Holds three large art-and-craft fairs every year.

Submission Policy Artists need to live in Devon or Cornwall.

Price range £1-£4,000

No of exhibitions annually 6 solo exhibitions in the upper gallery; 4 exhibitions in the lower gallery.

Church House Designs

Church House, Broad Street, Congresbury, BS49 5DG

T 01934 833660 F 01934 833660

E robert-coles@btconnect.com

W www.churchhousedesigns.co.uk Established for over twenty years. Specializes in quality handmade British crafts (ceramics, glass, textiles, jewelry and woodware). Artists include Lucy Willis (prints), John Leach (ceramics), Peter Layton (glass), Nick Rees (ceramics), Richard Dewar (ceramics) and Clive Bowen (ceramics).

Clifton Gallery

18 Princess Victoria Street, Clifton, Bristol, BS8 4BP

T 0117 9706650

E info@cliftonart.co.uk

W www.cliftonart.co.uk

Opened in 1992 in an exclusive area of Clifton Village. Specializing in original-only, contemporary fine art, mainly paintings with some sculpture. Showing artists from all around the world. Represented artists include Shen Ming Cun, Les Matthews, Stephen Brown and Hennie De Korte.

Submission Policy Only original work will be considered. Does not show abstract and conceptual work. Artists must have minimum of ten years' experience.

Price range £500-£25,000 No of exhibitions annually 6

Contemporary Studio Pottery

6 Mill Street, Chagford, TQ13 8AW T 01647 432900

W www.contemporarystudiopottery.co.uk

Contact B. Chivers

Founded in 1999, specializing in studio ceramics. Artists include Clive Bowen, Bruce Chivers, Nic Collins, Penny Simpson, Ross Emerson and Svend Bayer.

Submission Policy National and international potters invited.

Price range £20-£3,000No of exhibitions annually 4

Coombe Gallery

20 Foss Street, Dartmouth, Devon, TQ6 9DR

T 01803 835820 F 01803 722275

E mark@coombegallery.com

W www.coombegallery.com

Contact Mark Riley

Opened in 2004 as an extension of Coombe
Farm Gallery, which was established in 1989.
Exhibits fine and applied arts from predominantly
UK-based artists. Exhibitors include Mary Stork,
David Leach OBE, Gerry Dudgeon, Paul Riley,
Tom Rickman and Diane Nevitt. Displays work
from recent graduates alongside artists and
makers with international reputations.

Submission Policy Living artists whose work displays skill, integrity and imagination. Price range f100-f10,000 No of exhibitions annually 4

Cornwall Galleries

4 Bank Street, Newquay, TR7 1JF T 01637 873678 E enquiries@cornwallgalleries.co.uk W www.cornwallgalleries.co.uk Founded in 1960 by Leonard Charles Rollason and run as a family business since the early 1990s. Aims to provide quality oil paintings that anybody can afford. Exhibited artists include Josephine Wall, Deborah Jones, Joel Kirk, Graham Petley,

Price range $f_16-f_6,000$

Courtenays Fine Art

II Westbourne Arcade, Bournemouth, BH4 9AY T 01202 764884

E info@courtenaysfineart.com

Peter Cosslett and John Bampfield.

W www.courtenaysfineart.com

Contact Roy Carder

Gallery opened in 1998. Shows originals, limited editions and prints. Over fifty artists, including Josephine Wall, Bill Tolley and David Dancey-

Submission Policy Initial contact by photographs then, if interested, four originals required.

Price range f_{50} - $f_{5,000}$

Cowdy Gallery

31 Culver Street, Newent, GI.18 1DB

T 01531 821173

F 01531 821173

E info@cowdygallery.co.uk

W www.cowdygallery.co.uk

Contact Harry Cowdy

Established in 1990. A 125m2 private glass gallery showing leading established artists alongside notable emerging makers. Selection is based on quality, integrity and craftsmanship. A permanent collection is displayed between exhibitions. Exhibited artists include Keith Cummings, Sally Fawkes, Ronald Pennell, Pauline Solven, Colin Reid and Rachael Woodman.

Submission Policy Applicants should have an art or craft degree. Submissions should include CV and illustrations (CD, slides or prints). Interested in glass only.

Price range £100-£3,000 No of exhibitions annually 2

Crescent Galleries Ltd

9 Bath Place, Taunton, TA1 4ER

T 01823 335050 F 01278 663317

E ian@crescentgallery.co.uk

W www.crescentgallery.co.uk

Under current ownership since 2001. Two galleries in Somerset actively supporting local artists with shows and free hangings. Open policy, with work encompassing the traditional to contemporary abstract.

Submission Policy Only considers artists from the West Country.

Price range f_{150} - $f_{2,500}$ No of exhibitions annually 6

Croft Gallery

22 Devizes Road, Old Town, Swindon,

SN21 4BH

T 01793 615821 F 01793 615821

E info@thecroftgallery.co.uk

W www.thecroftgallery.co.uk

Opened in 2000. Promotes up-and-coming and established artists, and sells variety of original art work (oils, acrylics, pastel, watercolours, limited editions). Specialist framing service available. Artists include Carl Scanes, Ken White, Henderson Cisz, Victoria Stewart, William Tolley and Alex Jawdokimov. Offers to sell art work (featured on website) on commission basis. Submission Policy Submissions from artists always welcome.

Price range $f_{100}-f_{2,500}$

Crown Gallery

7 Winchcombe Street, Cheltenham, GL52 2LZ

T 01242 515716

E paul-bott@tiscali.co.uk

W www.crowngallery.co.uk Contact Paul or Donald Bott

Opened in 1984. Offers a framing service and discount plans for artists and repeat clients.

Price range $f_{30}-f_{2,500}$

No of exhibitions annually 2-3

Cube Gallery

12 Perry Road, Bristol, BS1 5BG

T 0117 3771470

E info@cube-gallery.co.uk

W www.cube-gallery.co.uk

Opened in 2002, showing original works in oil, acrylic or pastel plus some sculpture, mainly

from Bristol-based artists, including Barrington Tabb, Karen Edwards, Rachel Nee, Dawn Sidoli, Margaret Gregory and Melissa Kiernan. National artists' work considered.

Submission Policy Submissions by appointment only.

Price range £250-£10,000 No of exhibitions annually 4

Delamore Arts

Delamore Gallery, Delamore Park, Cornwood, PL21 9QP

T 01752 837719

E admin@delamore.com

W www.delamoregallery.co.uk or www.delamoreart.co.uk

Contact Abby Keverne or Gavin Dollard The art and sculpture park on Delamore Estate promotes the work of artists through an annual exhibition of more than 100 painters and sculptors each May (now in its seventh year). Interests in publishing. Also, the gallery in a Grade II listed medieval farmstead opened in 2007 and brings together the work of regional, national and international artists all year round.

Submission Policy Send CV and samples of work by email or post.

Price range £10-£20,000 No of exhibitions annually 8+

Cost to hire or rent Yes - please enquire by email or post

Dolphin House Gallery

Dolphin House, Dolphin Street, Colyton, EX24 6NA

T 01297 553805

E art@dolphinhousegallery.co.uk

W www.dolphinhousegallery.co.uk

Founded in 1990, specializing in the works of etcher Roger St Barbe, with guest exhibitions several times a year (e.g. the late Mary Shields). Ceramics by Nicholas Hillyard. Framing service offered.

Submission Policy Original works or handmade original prints only (no reproductions or photographs exhibited). Small works preferred due to limited space.

Price range f_{50} - f_{800} No of exhibitions annually 5

Elliott Gallery

Hillsview, Braunton, EX33 2LA T 01271 812100 / 863539 W www.elliottartgallery.co.uk

Contact Walter A. Elliott

Founded in 1984. Aims to encourage local and West Country arts (especially painting and sculpture) and crafts. Strives to be a valuable amenity for the local community and visitors to the region.

Submission Policy Artists are invited to send photographs of their paintings, craft works or sculpture and, if considered suitable, to submit art work for exhibition.

No of exhibitions annually 2-8 one-person exhibitions in the two smaller halls. Continuously changing displays in the two large galleries.

Exmouth Gallery

46 Exeter Road, Exmouth, EX8 1PY

T 01395 273155

E info@exmouthgallery.co.uk

W www.exmouthgallery.co.uk

The main room shows changing exhibitions; a second room shows prints and illustrated books; a third shows botanical illustrations by Royal Horticultural Society Medallists; and a fourth shows gallery artists including Bob Clement, Alan Richards, Michael Buckland, Jean Esther Brook, Rob Ritchie, Pat Johnn, Mark Abdey, John Stone and Tim Hogben.

Submission Policy No pottery or jewelry, but outdoor sculpture can be displayed in the enclosed garden.

Price range f_{50} - $f_{2,000}$ No of exhibitions annually 8

Fisherton Mill - Galleries Cafe Studios

Fisherton Mill, 108 Fisherton Street, Salisbury, SP2 7QY

T 01722 415121

F none

E thegallery@fishertonmill.co.uk

W www.fishertonmill.co.uk

Set within an 1880s converted grain mill, Fisherton Mill is one of the region's largest independent galleries. Work exhibited is predominantly from artists in the south-west. Artists include Nick Andrew (painting), Michael Peckitt (jewelry), Stephanie Wooster (textiles), Stuart Akroyd (glass), Eric French (furniture) and Kim Norton (ceramics). There are a cafe serving and studio workshops. Submission Policy Applications should be made with images of the work in the first instance. No specific entry requirements or restrictions.

Price range f_3 - f_4 ,000

Cost to hire or rent Beams Gallery available to hire. $f_{250.00}$ a week including an evening private

view and access to mailing list. Reductions for longer run.

Frances Roden Fine Art Ltd

Beacon House, New Street, Painswick, GL6 6UN T 01452 814877

E info@francesrodenfineart.com

W www.francesrodenfineart.com

Founded in 2004. Specializes in contemporary art. Artists represented include Stephen Goddard, Sally Trueman, Alan Thornhill and Jon Edgar.

Price range £1,000-£40,000 No of exhibitions annually 2

Gallerie Marin

31 Market Street, Appledore, nr Bideford, **EX39 1PP**

T 01237 473679

F 01237 421655

E audreyhinks@galleriemarin.co.uk

W www.galleriemarin.co.uk

Contact Audrey Hinks

Established in 1972, specializing in contemporary marine art. Artists include Mark E. Myers PP RSMA, Michael Les, David Brackman, Tim Thompson, Steven Thor Johanneson RSMA and Jenny Morgan.

Price range £200-£6,000 No of exhibitions annually I

Glass House Gallery

Kenwyn Street, Truro, TR1 3DJ

T 01872 262376

E theteam@glasshousegallery.co.uk

W www.glasshousegallery.co.uk

Founded in 1995 to represent the work of established and rising Cornish artists, sculptors, ceramicists, jewelers and printmakers. Exhibitions have included the first solo shows of artists such as Naomi Frears and Sasha Harding. Other artists represented include David Briggs, Jason Lilley, John Middlemiss and Colin Orchard. The gallery undertakes commissions.

Price range $f_{100}-f_{2,000}$ No of exhibitions annually 2

Goldfish Contemporary Fine Art

56 Chapel Street, Penzance, TR18 4AE

T 01736 360573

E mail@goldfishfineart.co.uk

W www.goldfishfineart.co.uk Contact Joseph Clarke

Founded in 2000 in St Ives and relocated to the current multiple-floor space in 2003. Specializes

in the best of Cornish contemporary painting and sculpture, from figurative to abstract with an emphasis on originality and personal expression. Gallery artists include Kenneth Spooner, Nicola Bealing, Zoe Cameron, David Briggs, Andrew Litten, Nicola Bealing, Tim Shaw, Simon Allen and Joy Wolfenden Brown.

Price range $f_{300}-f_{30,000}$

No of exhibitions annually 9 solo shows alongside mixed exhibitions.

Great Atlantic Map Works Gallery

St Just, Penzance, TR19 7JB T 01736 788911 / 786016 F 01736 786005

E gallery@greatatlantic.co.uk

W www.greatatlantic.co.uk

Contact Sarah Brittain

Founded in 1995, the Great Atlantic Group specializes in painting, sculpture, printmaking and ceramics from both Cornwall and Wales where its galleries are situated. Travelling exhibitions are staged annually around the UK and also in Canada and America.

Submission Policy Submissions welcome (no textiles, jewelry or photography). In the first instance approach in writing to Sarah Brittain.

Price range $f_{100}-f_{10,000}$

No of exhibitions annually Exhibitions change fortnightly.

Grimes House Fine Art

High Street, Moreton in Marsh, GL56 0AT

T 01608 651029

E grimes_house@cix.co.uk W www.grimeshouse.co.uk

Contact Steve or Val Farnsworth

Founded in 1978, representing many nationally known living artists with a traditional, rather than contemporary, style. Artists featured include Edward Hersey, Gordon King, Brian Jull and John Trickett.

Submission Policy Must reflect gallery tastes.

Price range $f_{100}-f_{7,000}$

No of exhibitions annually I ongoing exhibition; 2 additional specialist exhibitions.

Hartworks Contemporary Art

12 Foss Street, Dartmouth, TQ6 9DR

T 01803 839000

F 01803 839000

E art@hartworks.co.uk

W www.hartworks.co.uk

Contact Theresa or Simon Hart

Established in 1999 and features work by many renowned contemporary artists from the West Country, as well as prominent British artists, printmakers and ceramicists. Artists include Simon Hart, Sue McDonald, Gerry Plumb, Louise Braithwaite, Michael Turner and Glyn Macey. Submission Policy Submissions by slide, photographs or email invited from contemporary makers and artists (excluding photography, jewelry and watercolour).

Price range £20-£2,000No of exhibitions annually 4

Here Shop & Gallery

108 Stokes Croft, Bristol, BS1 3RU

T 01179 422222 .

E gallery@thingsfromhere.co.uk

W www.thingsfromhere.co.uk

An entirely unfunded not-for-profit workers coop. Open to humour and experimentation, showing everything from illustration to graffiti to sound art. The shop specializes in comics/zines/books/artist made/limited edition/prints.

Submission Policy Please see submission details

on http://www.thingsfromhere.co.uk/contact

Price range £10-£300No of exhibitions annually 12 Cost to hire or rent £100+

Hind Street Gallery and Frame Makers

Hind Street, Ottery St Mary, EX11 1BW

T 01404 815641

E info@therealart.co.uk

W www.therealart.co.uk

Established in 1978, showing original art works from local and international artists. Bespoke frame-making service offered.

Price range £50-£5,000 No of exhibitions annually 4

Innocent Fine Art

7A Boyces Avenue, Bristol, BS8 4AA
T 0117 9732614
F 0117 9741425
E enquiries@innocentfineart.co.uk
W www.innocentfineart.co.uk
Founded in 1997, specializing in contemporary
West Country art. Has a large collection of
twentieth-century Cornish artists including Sir
Terry Frost, Barbara Hepworth and Sandra Blow.
Contemporary artists include Paul Lewin, Mary
Stork, Gerry Plumb, Neil Pinkett and Elaine Jones.
We also show one show a year of School of Paris,

Picasso, Miro, Chagall and others.

Submission Policy Prints and paintings only. Send slides or photos, or email first.

Price range £250-£4,000

No of exhibitions annually About four one person or themed exhibitions rest mixed shows.

John Davies Gallery

Church Street, Stow-on-the-Wold, GL54 1BB

T 01451 831698

F 01451 870750

E daviesart@aol.com W www.johndaviesgallery.com

Contact John Davies

Established in 1977, showing European Post-Impressionist paintings (1890–1950), nineteenth-and twentieth-century British art, including Scottish and Welsh painters past and present. Works from the studios of Alexander Goudie and Will Roberts. Contemporary painters include: Lionel Aggett, Malcolm Edwards, Peter Evans, Philip Hicks, John Kingsley, Sandy Murphy, Gareth Parry, David Prentice, William Selby Submission Policy The gallery is always interested in seeing new work. Send photos or images on disc. Do not e-mail images.

Price range £250-£100,000No of exhibitions annually 8

Jonathan Poole Gallery

Compton Cassey House, nr Withington, Cheltenham, GL54 4DE

T 01242 890224

F 01242 890479

Established for over thirty years, specializing in contemporary sculpture and exhibition-organizing throughout the world. Represents the art estates of John Lennon and Miles Davis. Exhibited artists include Lucy Kinsella, Jonathan Poole, Bobby Plisnier, Vicky Wallis, Dennis Westwood, Jill Sanders and Ronnie Wood.

Jordan & Chard Fine Art

c/o Bridge House, Truro, Cornwall, TR1 1ER

T 01872 262202

F 01872 266199

E taraphysick@jordanchard.com

W www.jordanchard.com

Contact Tara Physick

Specializes in the plein air painting of the Newlyn and early St Ives Schools (1880–1940). The gallery presents an ever-changing selection of these paintings, many sourced from private local collections. Works are offered by the leading and lesser names from the schools, including

Stanhope and Elizabeth Forbes, Walter Langley, Harold Harvey, Henry Scott Tuke, Lamorna Birch, Laura Knight, Dorothea Sharp and Newlyn Copper. Viewing is by appointment. Telephone or visit the website to view paintings, reference material and artists' biographies.

Submission Policy Interested in contemporary, impressionist and realist painters, particularly those working in Cornwall. Subjects of interest include figurative, seascape, marine/nautical subjects and local landscape.

Price range £450-£100,000 No of exhibitions annually 3-4

Kangaroo Kourt

68 Thornleigh Rd, Horfield, Bristol, BS78PJ

T 01179 080485

E kangarookourt@blueyonder.co.uk

W www.kangarookourt.pwp.blueyonder.co.uk Began as a domestic/alternative artspace in 2002 concentrating on stencil graffiti hosting local names such as gHOSTbOY, Nick Walker and Kid Carpet. Has since shown a wide range of experimental and conceptual sculpture, installation and performance. Open to artist/ curators who are keen on interacting directly with their audience.

Submission Policy Artist/curators with ideas to challenge preconceived ideas of a domestic artspace. Contact via email.

Lander Gallery

Contact Viv Hendra

Lemon Street Market, Truro, TR1 2PN T 01872 275578 F 01872 275578 E landergallery@btconnect.com W www.landergallery.co.uk

Housed in an award-winning new building, making the gallery one of the largest in the southwest. Shows fine art from four centuries, with a rich Cornish flavour. Contemporary artists share Cornish inspiration with the more traditional Lander Classics - from all periods and styles including celebrated Newlyn, Lamorna, St Ives and Falmouth.

Submission Policy Particularly interested in work with a Cornish connection. New and established artists shown; new artists are welcome to make an appointment.

Price range From £100-£50,000

No of exhibitions annually 10 featured exhibitions (solo or mixed) and a large permanent show of

artists working today. Also Lander Classics historic works. Cost to hire or rent Open to discussion

Market House Gallery

Market House, Marazion, TR17 OAR T 01736 710252 Specializes in post-war West Country artists

such as Sir Terry Frost, Alfred Wallis and Ben Nicholson, and potters such as Leach and Troike. Submission Policy Applications welcome from living local artists in any media.

Price range f_{120} - $f_{20,000}$ No of exhibitions annually 8

Martin's Gallery

Imperial House, Montpellier Parade, Cheltenham, GL50 1UA

T 01242 526044

E ian@martinsgallery.co.uk

W www.martinsgallery.co.uk

Started in 1987 to present art in the home environment. Concentration on Modern British, Vietnamese contemporary and west European. Also sculpture in stainless steel, stone, bronze, glass and porcelain. Exhibited artists include Thomas Bush Hardy (Victorian watercolours), Sir William Russell Flint (Modern British), Dan Llywelyn Hall, Inge Clayton, Sophie Raine, Míla Judge-Fürstová, Michael B. Edwards and Ray Hedger(contemporary), and Thanh Binh, Dinh Quan, Ng Dieu Thuy and Van Ngoc (Vietnamese).

Submission Policy Artists should submit a CV and some photos of their work initially (preferably by email and including contact details). If the gallery is interested, artists will then be contacted.

Price range £300-£20,000 No of exhibitions annually 12-15

Mayfield Gallery

907 Wimborne Road, Moordown, BH9 2BJ E mayfield.gallery@tiscali.co.uk

W www.juliestooksart.com

Contact Julie Stooks

Opened in 1987. Attracts well-known artists who exhibit regularly, both contemporary (Simon Stooks, James Preston) and traditional (David Dipnall, Josephine Wall, Sally Winter). Solo and group exhibitions held. Commissions accepted for portrait and animal studies.

Submission Policy Always interested in seeing new artists.

Price range £100-£5,000; gallery commission applies.

No of exhibitions annually 4

Michael Wood Fine Art

The Gallery, 17 The Parade, The Barbican, Plymouth, PL1 2JW

T 01752 225533 F 01752 225770

E michael@michaelwoodfineart.com

W www.michaelwoodfineart.com

Contact Michael Wood

Established in 1967, offering an eclectic selection of work from 1800 to the present day. Over three thousand five hundred works in stock at any time including paintings, watercolours, original prints, sculptures, ceramics and studio glass. Exhibited artists include local, national and international artists of the Newlyn School, St Ives Society of Artists and Royal Academicians. Notable past exhibitions include works by Sir Terry Frost, Justin Knowles and Robert Oscar Lenkiewicz.

Price range £100-£250,000No of exhibitions annually 1

Mid Cornwall Galleries

Mid Cornwall Galleries, St Blazey Gate, Par, PL24 2EG

T 01726 812131

E info@midcornwallgalleries.co.uk **W** www.midcornwallgalleries.co.uk

Opened in 1980 and housed in a Victorian school three miles east of St Austell. Regularly shows new collections of fine contemporary arts and crafts. Artists include Jo March, Glyn Macey, Ray Balkwill, Amanda Hoskin, Trevor Price and Arthur Homeshaw.

Submission Policy New submissions welcome either on CD, by post (with return postage) or via

Price range £100-£2,500No of exhibitions annually 6

New Art Centre Sculpture Park & Gallery

Roche Court, East Winterslow, Salisbury, SP5 1BG

T 01980 862244

F 01980 862447 E nac@globalnet.co.uk

W www.sculpture.uk.com

Contact Helen Waters (Curator)

Founded in 1957 in London and relocated to Roche Court in Wiltshire in 1993. Represents the Estates of Barbara Hepworth and Kenneth Armitage and shows sculpture from 1950 to the present day in an art-historical context, including works by Antony Gormley, Richard Long, Gavin Turk and Rachel Whiteread. In two contemporary buildings there is a changing exhibition programme and there is an active education programme. All works are for sale.

Submission Policy Sculptors are welcome to send CVs and images of their work, although space is limited.

Price range From £100 No of exhibitions annually 6-8

New Craftsman

24 Fore Street, St Ives, TR26 1HE T 01736 795652 F 01736 795652 E stella.redgrave@btinternet.com W www.newcraftsmanstives.com

Contact Stella Redgrave

The oldest established craft shop in St Ives, established in the 1960s. Stocks paintings, prints, ceramics and crafts, mostly modern and contemporary. Artists represented include Peter Lanyon, Tony O'Malley, Bryan Pearce, John Miller and John Piper.

Submission Policy Artists must be living and working in Cornwall. Craftmakers from throughout the UK. Submissions welcome in any form.

Price range £10-£10,000 No of exhibitions annually 2

The New Gallery

Portscatho, nr Truro, TR2 5HW T 01872 580445

E a.insoll@virgin.net

Founded in 1984. An artist-run gallery, showroom and studio. Artists include Chris Insoll, Andrea Insoll, Lynn Golden, Trevor Felcey, Eric Ward, Endel White, Paul Clarke, Anne Plummer and Grace Gardner. Also Toby Insoll, framer GCF. Submission Policy Submissions from painters welcome

Price range £60-£6,000 No of exhibitions annually 12

Organised Gallery

Churchill House, Olveston, Bristol, BS35 4DP T 01454 613788 F 01454 202606 E gallery@organised.com W www.organisedgallery.co.uk

Opened in 2002 to show quality glass art from

Seattle. Paintings and furniture added in 2003 but specialization remains glass. Glass artists exhibited include Mel Munsen, Sabine Lintzen, Yosuke Otsuki and James Minson. Painters exhibited include Richard Howell and Anne Mieke Van Ogtrop.

Submission Policy Will look at submissions. Price range $f_{200}-f_{3,000}$

Plan 9

P.O. Box 2590, Bristol, BS6 9BJ

E info@plang.org.uk

W www.plang.org.uk

Founded in 2005 as an artist-led experimental project space. Originally sited in a disused retail space in Bristol's Broadmead shopping area, Plan o now has no fixed location and operates as an independent curating/commissioning body. In the first year it ran ten shows/events including works by Matt Stokes, Mike Stubbs, the Caravan Gallery, Chris Barr and Martin Parr. In 2006 it was scheduled to run four main events with the likes of Marcus Coates, Claire Barclay and Simon Morrissey.

No of exhibitions annually 4-10 Cost to hire or rent no

Rainyday Gallery

116 Market Jew Street, Penzance, TR18 2LD

T 01736 366077

E info@rainydaygallery.co.uk

W www.rainydaygallery.co.uk

Started in 1992 and shows mostly Cornwall-based artists. Abstract, landscape, seascape and naive. Monthly exhibition is complemented by about one hundred other works. Artists include Matthew Lanyon, Chris Hankey, Phil Whiting, Anthony Frost, Jo March and Nick Williams.

Submission Policy Cornwall/Devon based artists mainly. Paintings only. Send photos (and sae) or indicate website if useful.

Price range $f_{100}-f_{5,000}$ No of exhibitions annually 12

Red Rag Gallery

Church Street, Stow-on-the-Wold, GL54 1BB

T 01451 832563

E mail@redraggallery.co.uk

W www.redraggallery.co.uk

Contact Carole Teagle

Originally the studio of influential British artist John Blockley, the building has operated as a gallery for twenty years. Specializes in the original art works of present-day British artists, including

Davy Brown, Andrew Macara, Romeo di Girolamo, Charles Hardaker, Joe Hargan, Louis McNally David Cobley and Dawn Sidoli. Price range £300-£20,000 No of exhibitions annually 10

Rostra & Rooksmoor Galleries

5 George Street, Bath, BA1 2EH T 01225 448121 E info@rostragallery.co.uk W www.rostragallery.co.uk Contact Verity James (Manager) Specializing in most contemporary art forms except photography and works in wood. Artists represented include Amanda Popham, Trevor Price, David Inshaw and Theo Boothe, among others. The gallery promotes artists at the London Affordable Art Fair. Offers a framing service. Submission Policy Open to submissions three times a year. Contact the gallery for information.

Price range f_{25} - $f_{3,000}$ No of exhibitions annually 12

Sadler Street Gallery

23 Market Place, Wells, BA5 2RF T 01749 670220 E jillswale@thesadlerstreetgallery.co.uk W www.thesadlerstreetgallery.co.uk Contact Jill Swale

Founded in 1993 and moved to present location in 2003 (one minute from Wells Cathedral). Specializes in watercolours and etchings from 1750 to 1950, some oils, small bronzes and contemporary work in all media. Particular focus on work by West Country artists. Artists include John Yardley RI and David Sawyer RI. Submission Policy Landscape, marines, figure studies, etc.

Price range f_{50} - $f_{10,000}$ No of exhibitions annually 8

Salar Gallery

20 Bridge Street, Hatherleigh, EX20 3HY T 01837 810940

W www.salargallery.co.uk

Founded in 1991. Exhibits paintings, sculpture, crafts, photography and multimedia prints in contemporary and traditional styles by living West Country artists. Subject matter largely inspired by the land, animals and rural subjects. Featured artists include Pam Cox, Hermione Dunn, Adrienne Fryer, Ken Hildrew, Jo Seccombe and Maryjane Carruthers.

Submission Policy Send photos/disc of work,

details of work and career history to the gallery. Chosen work is usually taken on consignment. Price range Up to f1,000 No of exhibitions annually 6

Salisbury Playhouse Gallery

Malthouse Lane, Salisbury, SP2 7RA T 01722 320117 / 320333

F 01722 421991

E marketing2@salisburyplayhouse.com

W www.salisburyplayhouse.com

Contact Jane Wilkinson (Gallery Officer) Founded in 1977. A large space within a wellattended theatre, with room for sixty to eighty paintings or photographs from new and established artists. Design and distribution of preview invitations, preview organization, and all sales, publicity, etc. catered for by the gallery. Exhibiting artists include Elisabeth Frink, Bill Toop, Hugh Casson, Mary Feddon and Julian Barrow. Submission Policy Selection by gallery committee

based on suitability to venue. No fee; thirty-five per cent commission plus VAT. No facility for threedimensional work.

Price range £95-£2,500

No of exhibitions annually 10, approximately three weeks each (January to June and September to December).

Somerville Gallery

25 Mayflower Street, Plymouth, PL1 1QJ

T 01752 221600

W www.somervillegallery.com

Contact Ben Somerville

Established in 1995 to represent the best of West Country painters. Specialists in Robert Lemkiewicz, Sir Terry Frost, Anthony Frost, Luke Frost, Henrietta Dybrey and Bob Crossley. Submission Policy Local established artists welcome. Gifted newcomers need to work their passage through established means.

Price range Up to £50,000 No of exhibitions annually 5

St Ives Society of Artists Gallery

Norway Quare, St Ives, TR26 1NA

T 01736 795582

E gallery@stisa.co.uk

W www.stisa.co.uk

Contact April Brooks

Founded in 1927. Aims to provide an independent exhibition space for the visual arts in St Ives for members and other groups and individuals. Judges work on artistic worth, regardless of

commercial appeal. Prominent members include Ken Howard RA. Lionel Aggett, Nicholas St John Rosse, Ken Symonds, Raymund M. Rogers and Sonia Robinson. The Mariners Gallery in the former crypt of the old Church (which houses the society) is also available for artists to hire for individual separate exhibitions.

Submission Policy Membership is currently about sixty living artists and applications are welcomed from all good artists in any medium.

Price range £120-£20,000 for framed work and sculptures. Unframed etchings, prints and cards also available.

No of exhibitions annually 3 members' exhibitions and 2 invited exhibitions in the main gallery as well as 2 Open Exhibitions; 20 exhibitions in the Mariners Gallery.

Cost to hire or rent Mariners Gallery is available for hire at about £175 per week.

Steam Pottery

Pendeen, Penzance, TR19 7DN E patrick@steampottery.co.uk W www.steampottery.co.uk Established in the late 1990s, showing highquality ceramics in stoneware and porcelain by Patrick Lester. Has now broadened its range to include work by a number of known and emerging potters including Walter Keeler, Emma Johnstone, Daniel Boyle, Richard Henham, Simon Rich and Georgina Dunkley. Price range f_{10} - f_{800}

Strand Art Gallery

2 The Strand, Brixham Harbourside, Brixham, TQ5 8EH

T 01803 854762

E strandartgallerybrixham@hotmail.com

W www.strandartgallery.com

Contact Andrew Stockman and Tina Stockman A marine gallery with a strong West Country flavour, with the emphasise on original paintings by living artists. Founded in 1972. Artists-inresidence with studios open to the public all year round. Artists include Gordon Allen, Bill Stockman, Terry Burke, David Deakins, Bob Tucker, Karen Chapman, Peter Duffield, Donald Ayres and 'Alicia'.

Submission Policy Submissions considered from local (South Devon area) professional fine art artists only. Acrylics, oils or watercolours preferred.

Price range f_{25} - f_{5000}

No of exhibitions annually Ever-changing

exhibition runs for fifty weeks per year. As work is sold, a 'rolling' exhibition takes place, with new works being added daily.

Street Gallery

I The Bayliss Centre, 147 High Street, Street, BA16 0EX

T 01458 447722

E andrew@street-gallery.co.uk

W www.street-gallery.co.uk

Specialists of Edward Wesson, Archibald Thorburn and Rolf Harris. Stockists of signed prints by Sir Peter Scott, L.S. Lowry, David Shepherd, Robert Taylor, Alan Fearnley, Nick Eatts, Govinder, Mackenzie Thorpe and E.R. Sturgeon. Originals by Richard Thorn, Cecil Rice and Edward Wesson.

Price range £100-£10,000

No of exhibitions annually Annual Edward Wesson and Rolf Harris exhibitions.

Stroud House Gallery

Station Road, Stroud, GL5 3AP

T 01453 750575

E info@stroudhousegallery.co.uk

W www.stroudhousegallery.co.uk Founded in 1997, specializing in conceptual, contemporary works of art (including fine art, installation, performance and film). Work is curated around a theme from artists selected throughout the UK.

No of exhibitions annually 8-10

Summerleaze Gallery

East Knoyle, Salisbury, SP3 6BY

T 01747 830790

F 01747 830790 E trish@summerleazegallery.co.uk

W www.summerleazegallery.co.uk

Established fifteen years ago. Exhibits work of contemporary and modern British painters and sculptors, both local and national, including Charlie Baird, Ursula Leach, Paul Macdermot, Tobit Roche, Tim Scott Bolton and Henrietta Young. Gallery also hosts fine-art courses and

lectures.

Price range $f_{150}-f_{20,000}$ No of exhibitions annually 3

Susan Megson Gallery

Digbeth Street, Stow-on-the-Wold, GL54 1BN

T 01451 870484

F 01451 831051

E info@susanmegsongallery.co.uk

W www.susanmegsongallery.co.uk

Founded in 2000, showing unique examples of creative glass art from around the world. Exhibited artists include Bob Crooks, Amanda Brisbane, Jonathan Harris, Isle of Wight Glass, Vandermark-Merrit and French artists such as Lohe, Loumani, Mallemouche and Didier Saba.

Submission Policy Pieces must be unique and handblown.

Price range £50-£2,000 No of exhibitions annually 4

Swan Gallery

51 Cheap Street, Sherborne, DT9 3AX

T 01935 814465 F 01308 8868195

E L4949@aol.com

W www.swangallery.co.uk

Founded in 1982. Specializations include fine eighteenth-, nineteenth- and twentieth-century watercolours and oil paintings, and antique maps and prints. Artists represented include Myles Birkett-Foster, Harry Sutton Palmer, John Varley, W. Tatton Winter, Henry Alken and T.B. Hardy. Other services offered include restoration, framing and valuation.

Submission Policy Occasional exhibitions by living artists.

Price range £15-£20,000 No of exhibitions annually 3

The Toll House Gallery

The Beach, Clevedon, BS21 YQU

T 01275 878846

F 01275 790077

E enquiries@clevedonpier.com

W www.clevedonpier.com

Contact Linda Strong

Each month different local artists display their work, including oils, watercolours, mixed media, acrylics, photography, ceramics and wooden sculpture.

No of exhibitions annually 12

Cost to hire or rent Approx. £200 per month.

Tregony Gallery

58 Fore Street, Tregony, Truro, TR2 5RW

T 01872 530505

F 01872 530505

W www.tregonygallery.co.uk

Established in 1998, selling fine contemporary Cornish art. All original work, predominantly seascapes. Hosts a constantly changing display

of paintings, sculpture, ceramics, jewelry and glassware. Artists represented include John Brenton, David Rust, Josep Pla, John Piper, Paul Lewin and Robert Jones.

Price range f_{100} - $f_{6,000}$ No of exhibitions annually I

Turn of the Tide Gallery

7 The Triangle, Teignmouth, TQ14 8AU T 01626 777455

W www.turnofthetide.co.uk

Opened in 2000, showing mainly Cornish and Devon painters. Most work has connections to the sea. Artists include Robert Jones, Michael Praed, Judy Hempstead, Andrea Stokes, and Norman and Lesley Stuart Clarke. Originals, prints and cards by Sally Anderson. Shows etchings, collographs, ceramics, handmade jewelry and open prints. Submission Policy Existing work includes boats, beaches and the Devon countryside painted on board, canvas and driftwood.

Price range $f_{1.50}$ - $f_{1,500}$ No of exhibitions annually 1

Turner Gallery

88 Queen Street, Exeter, EX4 3RP T 01392 204314

E turnergallery@yahoo.com W www.bibleproject.co.uk

Founded in 1997 with the aim of showing paintings of quality by artists dedicated to the traditions of painting (landscape, figurative, abstract and idiosyncratic, in acrylic, oil and watercolour). Artists include Brian J.Turner, Philip James ROI, Richard Slater RI, Peter Davies, Julian Anniss and Keiron Leach. Tutorial scheme offered.

Submission Policy Applications welcome but from professional artists only. Send hard-copy examples of work with CV, letter of introduction and sae.

Price range f_{150} - $f_{5,000}$ No of exhibitions annually Continually changing with occasional keynote exhibitions.

Vitreous Contemporary Art

7 Mitchell Hill, Truro, TR1 1ED T 01872 274288 E info@vitreous.biz

W www.vitreous.biz

Contact Jake Bose

Founded in 2004. Specializes in contemporary living artists and aims to represent both established and up-and-coming artists. Exhibitions change every month. Most media and styles shown, including sculpture, ceramics and fine art. Solo and joint shows, and small themed group exhibitions.

Submission Policy Always looking to introduce new artists to the exhibition programme and is committed to considering all applications. Initially provide at least four images either by email or on CD, slides or hard copy.

Price range £300-£2,000 No of exhibitions annually 10

Wharf Gallery

The Wharf Arts Centre, Canal Road, Tavistock, PL198AT

T 01822 611166 (box office) / 613928 (office) F 01822 613974

E enquiries@tavistockwharf.com

W www.tavistockwharf.com

Contact Chris Burchell

Founded in 1996. One of West Devon's leading arts and entertainment centres. Aims to promote local artists, arts groups, schools and photographers.

Submission Policy Interested in well-presented work in any medium (limited sculpture). West Country artists welcome.

Price range From £25 No of exhibitions annually 12

Widcombe Studios Gallery

The Old Malthouse, Comfortable Place, Bath, BA1 3AJ T 01225 482480 E admin@widcombestudios.co.uk W www.widcombestudios.co.uk Founded in 1996 to provide studio accommodation, gallery and exhibition space and a programme of courses and talks. Submission Policy Applications for hiring the gallery should be made to the studios' administrator. There is a selection process.

The Wonderwall Gallery

7 Gosditch Street, Cirencester, GL7 2AG

T 01285 650555

E gallery@thewonderwallgallery.com W www.thewonderwallgallery.com

Original paintings, ceramics, sculpture, glass and jewelry by leading artists from across the UK. Regular exhibitions of new work are displayed throughout the year.

No of exhibitions annually 2+

Wales

Art 2 By Ltd

Harbour Lights Gallery, Porthgain, Haverfordwest, SA62 5BW T 01348 831549 F 01348 831549 (phone first)

E info@art2by.com

W www.art2bv.com

Founded in 1995 to promote the art of Pembrokeshire and Welsh artists. Artists include Bernard Green, Sheils Knapp Fisher, Wendy Yeo, Gillian McDonald, Cherry Pickles and Graham Hurd-Wood.

Submission Policy Artists' work is viewed strictly by appointment.

Price range $f_{19.50} - f_{20,000}$ No of exhibitions annually 4

Art Matters Gallery

@ The White Lion Street Gallery, I White Lion Street, Tenby, SA70 7ET T 01834 843375 E Info@artmatters.org.uk

W www.artmatters.org.uk Contact John Faulkner or Margaret Welsh Established in 2001. A large gallery with an eclectic and changing mix of work. More than fifty current artists including Leonard Beard, Andrew Douglas Forbes, Elizabeth Haines, Hilary Paynter and Derek Williams. Mostly paintings but also shows sculpture, ceramics, wood (carved and turned) and wood engravings.

Submission Policy Application by post or email with CV and images, prior to possible appointment for viewing.

Price range f.100-f.2,000

Attic Gallery

14 Cambrian Place, Swansea, SA1 1RG T 01792 653387

E roe@atticgallery.co.uk W www.atticgallery.co.uk

Contact David Roe

Founded in 1962 and among Wales's longest established private galleries. Aims to highlight the work of contemporary artists working in Wales. Runs a full exhibition programme of solo and mixed shows with a changing display of new paintings, graphics and sculpture.

Submission Policy Initial approach by post (include sae) with photos and CV, or by email.

Price range f_{50} - $f_{10,000}$ No of exhibitions annually 8 **Black Mountain Gallery**

The Square, Cwmllynfell, Swansea, SA9 2FJ

T 01639 830920

E sales@blackmountaingallery.com

W www.blackmountaingallery.com

Contact Mark Williams

Publishing the work of contemporary commercial artists Muriel Williams and Mark Williams.

Price range all

Cost to hire or rent no

Bowie & Hulbert

5 Market Street, Hav-on-Wye, HR3 5AF

T 01497 821026

F 01497 821801

E info@hayclay.co.uk

W www.hayclay.co.uk

Partner gallery to Brook Street Pottery (also in Hay-on-Wye), founded in 1994. Specializes in applied arts (ceramics and jewelry) and some fine-art prints. Artists include Walter Keeler, Jane Hamlyn, Peter Beard and Catherine Mannheim. Only shows UK artists and makers.

Submission Policy Apply only by letter with slides or photographs and other relevant information.

Price range £50-£2,000 No of exhibitions annually 3-4

Brooklyn Art Gallery

52 Birchgrove Road, Birchgrove, Cardiff, CF14 1RS T 029 20529950

E info@brooklynartgallery.co.uk

W www.brooklynartgallery.co.uk

Founded in 1999 by artist Nasir Shiraz. Continuously exhibits new works by resident artists including Nasir Shiraz, Rob Lee, Babette Edwards, Huw Walters and Victoria Stewart. Art works are

presented on large canvas to suit the modern interior. Submission Policy Artists should send a CV and

photos of work by email. Price range £100-£5,000

No of exhibitions annually 8

Capsule

48 Charles Street, Cardiff, CF10 2GF T 020 20382882

E info@acidcasuals.com

W www.acidcasuals.com

Owned and run by Acid Casuals. Represents Ruth Mclees, Mark Cadwallader and R. Mer.

Submission Policy All applications welcome.

Price range $f_36-f_{2,000}$

No of exhibitions annually 8-10

Cost to hire or rent f1000 per week

Celf

85 Newton Road, Mumbles, Swansea, SA3 4BN T 01792 366800

E info@celfdesign.co.uk

W www.celfdesign.co.uk

Celf was set up in 2002 to exhibit paintings by Michelle Scragg and architectural decorative glass designed by Caroline Rees

Price range $f_{100}-f_{2,000}$

No of exhibitions annually I

Chapel of Art - Capel Celfyddyd

8 Marine Crescent, Criccieth, LL52 0EA

T 01766 523570

E mail@the-coa.org.uk

W www.the-coa.org.uk

Contact Eckhard or Janet Kaiser

Established in 1995. Exhibits contemporary fine art and selected crafts by local, regional and international artists and makers. A specialist ceramic gallery and home of the International Potters' Path, made by potters and ceramic artists from around the world.

Submission Policy Artists are required to submit work appropriate to the exhibition titles as published on the website and are advised to contact Janet Kaiser about size and weight restrictions. Textiles and jewelry are only accepted in exceptional circumstances.

Price range £25-£2,000No of exhibitions annually 6

Chepstow Ceramics Workshop Gallery

13 Lower Church Street, Chepstow, NP16 5HJ

T 01291 624836

F 01291 624836

E nedheywood@aol.com

W www.nedheywood.com

Founded in 1982, specializing in studio ceramics. Exhibited artists include Walter Keeler, Julia Land and Ned Heywood.

Submission Policy Ceramics only.

Price range £20-£1,000

No of exhibitions annually 6

Coed Hills Rural Artspace

St Hilary, Cowbridge, CF71 7DP

T 01446 774084

E mail@coedhills.co.uk

W www.coedhills.co.uk

An arts venue based on a philosophy of positive living in environmental and social contexts. Has workshops, galleries and a woodland sculpture trail, among other facilities.

Submission Policy Welcomes proposals of all types.

Craftsman Gallery

58 St Helen Road, Swansea, SA1 4BE T 01792 642043 F 01792 642043 E bowden@craftsmangallery.co.uk

W www.craftsmangallery.co.uk Established since 1978, specializing in works by Welsh artists or artists working in Wales.

GPF Gallery

18 George Street, Newport, NP20 1EN T 01633 264581

E gpfgallery@aol.com

W www.gwentpictureframing.co.uk

Contact Janet Martin

Established for over twenty-five years. The associated GPF Gallery opened in the late 1990s. Artists represented include Philip Muirden, John Selway, Sarah Ball and Michael Organ. Opened Robbins Lane Studios in 2004, housing eight studios and an artist's studio-flat, as well as providing exhibition space and meeting-room hire. Submission Policy Any living artist is welcome to contact the gallery to make an appointment to show work.

Price range £100-£3,000No of exhibitions annually 6

Green Gallery

The Green, Rhossili, Swansea, SA3 1PL

T 01792 391190

E GreenGalRhossili@aol.com

W www.thegreengallery.co.uk

Contact Fiona Ryall

Founded in 2001. Specializes in fine art, mainly traditional twentieth-century paintings. Also stocks a broad spectrum of modern work including sculptures in bronze and stone. Artists represented include Helen Sinclair, Kevin Ryall, Stuart Mulligan, James Selway and Janet Bligh. Submission Policy Welcomes applications and keen to represent new talent.

Price range £60-£3,000 No of exhibitions annually 2

Kilvert Gallery

Ashbrook House, Clyro, nr Hay-on-Wye, HR3 5RZ

T 01497 820831

F 01497 820831

E art@clyro.co.uk

W www.kilvertgallery.co.uk, www.clyro.co.uk

Founded in 1986 by the painter Elizabeth Organ to promote recent graduates in fine art and specialist crafts. The gallery's artist-in-residence is portrait painter Eugene Fisk. Other artists represented include Peter Bishop, Roger Cecil, Maryclare Foa, Sally Matthews, Kate Milsom Hawkins, Betty Pennell, Ronald Pennell, Charles Shearer and Alfred Stockham.

Submission Policy Not currently taking any more artists.

Price range f_{50} - $f_{5,000}$ No of exhibitions annually 2

Kooywood Gallery

8 Museum Place, Cardiff, CF10 3BF

T 021 20235093

E enquiries@kooywoodgallery.com

W www.kooywoodgallery.com

Opened in 2004 to provide a forum for established and new artists to show and sell work. Exhibits and exhibitions cover a wide range of contemporary visual art, including painting, sculpture, ceramics, glass, photography and prints.

Price range £85-£15,000 No of exhibitions annually 12

La Mostra Gallery

Mermaid Quay, Cardiff Bay, Cardiff, CF10 5BZ

T 029 20492225 F 029 20492226

E enquiries@lamostragallery.com

W www.lamostragallery.com

Cardiff's first commercial art gallery to exhibit international paintings, sculpture and objets d'art exclusively. Periodically holds group and personal exhibitions, with special evening openings and private viewings. International artists represented include Julian Murphy (UK), Andrew Buryah (Belarus), Sandro Soravia (Italy) and Rebecca Adams (UK).

Submission Policy Send CV, exhibition history and images of work, plus sae if you wish images to be returned.

Price range From £150

The Makers Guild in Wales

Craft in the Bay, The Flourish, Lloyd George Avenue, Cardiff Bay, Cardiff, CF10 4QH T 029 20484611 F 029 20491136 E admin@makersguildinwales.org.uk W www.makersguildinwales.org.uk **Contact** Exhibitions Officer Founded in 1984, with a permanent exhibition venue at Craft in the Bay in Cardiff. All work is for sale. There are seventy four members of the guild and the work exhibited includes ceramics, jewelry, textiles, woodwork and metalwork. Also shows temporary exhibitions of contemporary designs created by artists throughout the UK and abroad. A comprehensive education programme provides opportunities for young people and adults to participate in practical courses, demonstrations and talks.

Submission Policy Artists living and working in Wales wishing to apply for membership should contact the manager at Craft in the Bay for further details. Artists interested in showing work in the temporary exhibitions area should contact the exhibitions officer at Craft in the Bay.

No of exhibitions annually 7, temporary. Guild members have permanent displays of their work.

manorhaus

10 Well Street, Ruthin, LL15 1AH

T 01824 704830

F 01824 707333

E post@manorhaus.com

W www.manorhaus.com

Contact Christopher Frost

Founded in 2001 and housed within a listed Georgian townhouse hotel and restaurant. Artists include Ann Bridges RCA, Ian Williams, Dave Merrills RCA, Meurig Watkins, Terry Duffy and Alan Baynes.

Submission Policy Preference for contemporary works and wall-hung pieces; no space for sculpture or display cabinets. Solo exhibitions require approximately twenty to forty pieces, depending on size.

Price range $f_{100}-f_{1,000}$ No of exhibitions annually 6

Martin Tinney Gallery

18 St Andrew's Crescent, Cardiff, CF10 3DD

T 029 20641411

E mtg@artwales.com

W www.artwales.com

Contact Myfanwy Shorey

Founded in 1990, promoting the best of twentiethcentury and contemporary Welsh art in Cardiff, London and abroad. Clients include Tate Gallery and National Museum of Wales. Artists include Augustus John, Gwen John, Ceri Richards, Harry Holland, Gwilym Prichard, Shani Rhys James, Peter Prendergast, Kevin Sinnott, Evelyn Williams and Sir Kyffin Williams.

Submission Policy Welsh or Wales-based artists. Submit a portfolio of images (digital, photograph or slide format) and current CV with sae.

Price range £100-£250,000 No of exhibitions annually 12

Mission Gallery

Gloucester Place, Maritime Quarter, Swansea, SA1 1TY

T 01792 652016

F 01792 652016

E missiongallery@btconnect.com

W www.missiongallery.co.uk

Founded in 1977. Hosts a changing exhibition programme of contemporary visual art photography, film, installation, painting and craft. The gallery's Craft Space shows work by established and emerging makers and designers. Submission Policy Contact the gallery for application procedure.

No of exhibitions annually 8

Number 15

15 Victoria Road, Penrith, CA11 8HN T 01768 867453 E number15@btinternet.com Contact Andy Askins or Kat Thomas Exhibits contemporary national and international artists working in mixed media, paintings, prints, photography and film. A spacious exhibition room is connected by double doors to Number 15 Café. Submission Policy Wall-hung work only. Submit photographs to Andy Askins. Artists must have

their own insurance. Price range £30-£10,000

Oriel

2 Tyn-Y-Coed Buildings, High Street, Barmouth, Gwynedd, LL42 1DS

T 01341 280285

E info@orielgallery.com

W www.orielgallery.com

Founded in 1992. Offers a broad selection of contemporary work, as well as more traditional work. Apart from work by Valerie McArdell and Sue Moore (both working full-time at the gallery), also promotes the work of Keith Davis, Alex McArdell and Janet Bell. Offers giclée printing services in-house, as well as bespoke framing.

Submission Policy Considers other artists' work. However, it has to fit in well with other work being exhibited at that time. If the gallery rejects, it may well reconsider at a later date.

Price range £50-£1500

Oriel Canfas Gallery

44a Glamorgan Street, Cardiff, CF5 1OS T 029 20666455 F 029 20666455 E info@olacanfas.co.uk W www.olacanfas.co.uk Contact Old Library Artists Ltd An artists' cooperative formed in 1994. In 1996, with the help of Lottery funding, it secured the present building, studios and education space. Exhibits a wide variety of visual art including painting, sculpture and photography, as well as

mixed and multimedia. Price range £50-£5,000 No of exhibitions annually 10

Philip Davies Fine Art

130 Overland Road, Mumbles, Swansea, SA3 4EU P 01792 361766

St Anthony Fine Art

30A St Anthony Road, Heath, Cardiff, CF11 6JZ T 029 20400160 E keith@stanthonyfineart.co.uk W www.stanthonyfineart.co.uk Founded in 2004, representing established and emerging artists. Previous exhibitors include Jack Crabtree, Peter Nicholas and John Selway. Price range From £50 No of exhibitions annually 8

Washington Gallery 1-3 Washington Buildings, Stanwell Road, Penarth, CF64 2AD

T 029 20712100 F 029 20708047 E info@washingtongallery.co.uk W www.washingtongallery.co.uk Founded in 1998, specializing in Welsh contemporary art. Artists include Dan Llywelyn Hall, John Selway, James Charlton, Arthur Giardelli, Aneurin Jones, Iwan Lewis, Laurie Williams and Artes Mundi finalist in 2005, Sue Williams.

Submission Policy Entry open to contemporary artists in all media (but restricted for video or photographic artists). Send examples of work. Enquiries welcome from Welsh artists (based in Wales or working elsewhere).

Price range £100-£6,000

No of exhibitions annually 30, over two levels. Cost to hire or rent Special hire from £500 per week: Upper Gallery (2000 sq ft).

West Wales Arts Centre

16 West Street, Fishguard, SA65 9AE

T 01348 873867

E westwalesarts@btconnect.com

W www.westwalesartscentre.com

Contact Myles Pepper

Established for over twenty years, exhibiting contemporary paintings, sculpture and ceramics and featuring established and emerging artists including David Tress, James MacKeown, David A Light, Brendan Stuart Burns, Sonya Dawn Flewitt, Judy Linnell and Jay Lear. Lectures, seminars and music performances throughout the year.

Price range £100-£5,000No of exhibitions annually 5

Workshop Wales Gallery

Manorowen, Fishguard, SA65 9QA T 01348 891619 F 01348 891619 E alicecleal@hotmail.com

Contact Alice Cleal Founded in 1970. Currently exhibits about forty contemporary artists, including Daniel Backhouse, Mitchell Cleal, Jack Crabtree, David Humphreys, Barbara Stewart and Alice

Tennant. Submission Policy Only original works accepted. No prints, photography, jewelry or craft items. Price range $f_{100}-f_{5,000}$

No of exhibitions annually 2

West Midlands

Artist's Gallery

373 Bearwood Road, Smethwick, Birmingham, B66 4DL

T 0121 4292298
E support@artistsgallery.co.uk
W www.artistsgallery.co.uk
Founded in 1990, specializing in Italian
oil paintings and contemporary art.
Artists represented include Sue Canonico,
Mario Sanzone, Franco Casalloni and Nino
D'Amorie.

Submission Policy All artists welcome to exhibit work after prior agreement.

Price range £100-£2,000

No of exhibitions annually 1, permanent.

Birties of Worcester

46 Friar Street, Worcester, WR1 2NA T 01905 28836 F 01905 339418 E linda.birtwhistle@birties.fsnet.co.uk

W www.birtiesofworcester.com

Contact Linda Birtwhistle
Founded in 1979 to promote contemporary
fine art by local and nationally known artists.
Artists include David Birtwhistle (watercolours),
Graham Clarke (etchings), Martin Caulkin
RI(watercolours), Tom Greenshields (sculpture),
Howard Coles (mixed media) and Nancy Turnbull
(oils).

Submission Policy By appointment only. Gallery requires to see at least six original recent works. Decisions cannot be made based solely on slides or photographs. Work exhibited must be framed to conservation standard.

Price range £100-£5,000 No of exhibitions annually 6

Bond Gallery

180–182 Fazeley Street, Digbeth, Birmingham, B5 5SE T 0121 7532065 Specializes in contemporary art.

Broadway Modern

Io The Green, Broadway, WR12 7AA

T 01386 858436

F 01386 858957

E modern@john-noott.com

W www.broadwaymodern.com

Contact Amanda Noott

Founded in 1999, showing contemporary
painting, sculpture, glass, ceramics and furniture.

Price range £50-£5,000

No of exhibitions annually 6

Castle Galleries

Bards Walk, Stratford-upon-Avon, CV37 6EY
T 01789 262031
F 01789 262480
E stratford@castlegalleries.com
W www.castlegalleries.co.uk
Artists include Mackenzie Thorpe, Paul Horton,
Alex Miller and Rolf Harris.
Price range £100-£20,000
No of exhibitions annually 4

Castle Gallery

The International Convention Centre, Broad Street, Birmingham, B1 2EA T 0121 2488484 Eicc@halcyongallery.com W www.halcyon.co.uk

Originally founded as The Halcyon, the renamed Castle Gallery still runs under the umbrella of the Halcyon Gallery in London. Has over twenty years' experience dealing in original paintings, drawings and sculpture, master graphics and limited editions. Changing programme of exhibitions.

Cowleigh Gallery

14 Cowleigh Road, Malvern, **WR141QD** T 01684 560646

F 01684 560646 E cowgall@tiscali.co.uk

Contact William E. Nicholls or Caroline A. Nicholls Has hosted six exhibitions per year for the last six years, including the Society of Wildlife, the ROI, the RWA and the Bath Society.

Submission Policy Encourages emerging painters, but has a large list of gallery artists who are professional and established.

Price range £100-£5,000

No of exhibitions annually 2-3 special solo shows, in addition to continual display.

Custard Factory

Gibbs Square, Birmingham, B9 4AA T 0121 6047777 F 0121 6048888 E info@custardfactory.com W www.custardfactory.com

A new arts and media quarter for Birmingham, in development since 1990 and covering over five acres of riverside factories built a hundred years ago by Sir Alfred Bird, the inventor of custard. Houses over five hundred artists and small creative enterprises, offering not only exhibition spaces but also affordable studio workshops and examples of large-scale public art.

Driffold Gallery

78 Birmingham Road, Sutton Coldfield, B72 1QR

T 0121 3555433

W www.driffoldgallery.com

Established in 1983, specializing in British and European paintings by valued artists from 1840 to the present. Living artists include members of British academies and societies.

Price range £300-£25,000 No of exhibitions annually 4-5 **England's Gallery**

Ball Haye House, I Ball Haye Terrace, Leek, ST136AP

T 01538 373451 F 01538 373451

Founded in 1967, showing mainly nineteenth- and twentieth-century oils and watercolours. Holds specialist exhibition of lithography, etching, engravings and woodcuts. Offers framing, restoration, conservation and valuation services.

Price range £45-£8,000

No of exhibitions annually 5 named exhibitions; gallery stock on show when no featured exhibition. Open from 2 p.m.to 5 p.m.daily (except Sunday and Monday) throughout the year.

Eyestorm-Britart Gallery

Radio House, Swan Street, Warwick, CV34 4BJ T 01926 495506

E alan@aeart.co.uk

W www.eyestorm.com

Founded in 1989, now specializing in modern art. Artists exhibited include Damien Hirst, Sir Terry Frost, Helmut Newton, Willi Kissmer and Bob Carlos Clarke.

Submission Policy Submissions from new artists should be sent to head office at 18 Maddox Street, London WIS IPL.

Price range £200-£20,000 No of exhibitions annually 6-8

Filthy But Gorgeous

116 Regent Street, Learnington Spa, CV32 4NR T 01926 339966 W www.filthybutgorgeous.co.uk Sister gallery to The Warwick Gallery in

Leamington Spa and Warwick. Supplies a broader range of work, focusing on contemporary designs by established and emerging British artists, covering a wide variety of fine art, paintings, crafts and sculpture.

Friswell's Picture Gallery Ltd

223 Albany Road, Earlsdon, Coventry, CV5 6NF T 024 76674883

W www.friswells.net

Contact Patrick Kelly

Established 1870. Offers artists the opportunity to exhibit their work in a prominent location (subject to approval). Holds work by artists including Govinder, Lawrence Coulson, Mark Spain, Russell Baker and David Morgan. A full bespoke framing service is also available.

Submission Policy A portfolio of works needs

to be submitted by artists wishing to exhibit. If approved, details are then discussed.

Price range From £2.50 No of exhibitions annually 10

Cost to hire or rent Starting prices from £60

The Gallery Upstairs

Torquil, 81 High Street, Henley-in-Arden, B95 5AT T 01564 792174

E galleryupstairs@aol.com

W www.thegalleryupstairstorquil.co.uk Shows work of contemporary artists in ceramics and fine art. Deals with leading artists in their fields but also likes to promote those starting out. Has run two large group exhibitions a year (November to December and May to June) since 1985. Artists exhibited include Ian Gregory, Sue Hanna, Ashraf Hanna and John Ward.

Price range £50-£5,000

The Gallery

17A Broad Street, Leek, ST13 5NR T 01538 372961 F 01538 399696 E info@leekbooks.co.uk

Contact Lisa Salt Established in 2001, specializing in paintings, art work and crafts by local artists. Artists exhibited include Leslie Gilbert RI, Tom Mountford and Ivan Taylor. Framing service also offered. Submission Policy Artists welcome to leave work at the gallery for inspection. All work must be framed for hanging to a reasonable standard.

Price range £50-£600

No of exhibitions annually 3, including a Christmas exhibition in November and December.

Helios at the Spinney

The Spinney, Birmingham, Broad Lane, Tanworthin-Arden, Solihull, B94 5HR

T 01564 742506

E mail@heliosgallery.co.uk

W www.heliosgallery.co.uk

Established for over twenty years, selling paintings, prints, sculpture, glass and ceramics. Artists include Gillian Lever, Sue Howell, Angela Palmer, Siobhan Jones and Elaine Hind. Runs extensive art library and offers framing service.

John Noott Galleries

Dickens House, 20 High Street, Broadway, WR127DT T 01386 858969 E aj@john-noott.com

W www.john-noott.com

Contact Amanda Noott

Founded in 1972, showing works of art by leading painters and sculptors from the nineteenth century to the present day.

Submission Policy Artists apply via website.

Price range £50-£50,000

No of exhibitions annually 10

Manser Fine Art

Coleham Head, Shrewsbury, SY3 7BJ

T 01743 240328

F 01743 270066

E info@fineartdealers.co.uk

W www.fineartdealers.co.uk

Contact Charlotte Cash

Founded in 1994 and owned and managed by the third generation of the Manser family. Sells eighteenth-, nineteenth- and twentieth-century works of art, including sculpture and works with a Russian or maritime theme. Artists include Anton Bouvard, Alfred de Breanski, Oliver Clare, Paul Gribble, Richard Hilder and Edgar Hunt. Also offers restoration, valuation and framing services. Submission Policy Contact the gallery by phone, post or email. Send slides or jpegs of works.

Price range £500-£150,000 No of exhibitions annually 3

Montpellier Gallery

8 Chapel Street, Stratford-upon-Avon, CV37 6EP T 01789 261161

F 01789 261161

W www.montpelliergallery.com

Contact Peter Burridge

Established in 1991, specializing in contemporary paintings, printmaking, sculpture, studio ceramics, glass and designer jewelry by established and emerging artists. Annual exhibition programmes feature group and solo shows. Exhibited artists include John Hammond, Brenda Hartill, Anita Klein and Peter Eugine Ball. Submission Policy Artists should be semiprofessional or professional, showing a consistency of style and technique.

Price range f_{25} - $f_{5,000}$

No of exhibitions annually 4

Moya Bucknall Fine Art

Barn End, Park Avenue, Solihull, B91 3EJ T 0121 7056215 F 0121 7051699 E moya@moyabucknall.co.u W www.moyabucknall.co.uk

Formed over thirty years ago. Specializes in sourcing and commissioning original works of art for both companies and private individuals. Represents a wide range of established artists, including James Butler, Iestyn Davies, Peter Evans, Pam Hawkes and Terrence Millington. Always on the lookout for new artists. Works with all types of media, from paintings, drawings and etchings to ceramics, glassware, fabric installations and three-dimensional sculpture in bronze, wood and other materials.

Submission Policy Requires digital images, photographs or samples of actual work prior to a meeting to view the artist's portfolio.

Price range £100-£40,000 No of exhibitions annually 2

New Gallery

St Paul's Square, Birmingham, B3 1RL

T 0121 2330800

E info@thenewgallery.co.uk

W www.thenewgallery.co.uk

Specializes in British twentieth-century greats (John Piper, Graham Sutherland et al.), living UK-based artists of international renown (Royal Academicians, etc.) and other professional UK-based artists in all styles (Roger Oakes, John Hodgett, Sara Hayward, David John Robinson). Limited-edition prints and photographic prints, monoprints and originals available. Caters to private and corporate collectors. Offers interest-free Arts Council England Own Art loans.

Submission Policy By email with CV. images and

Submission Policy By email with CV, images and exhibition history.

Price range £100-£5,000 No of exhibitions annually 8

Number Nine the Gallery

9 Brindley Place, Birmingham, B1 2JA T 0121 6439099 F 0121 6439199

F 0121 6439199
E noninethegallery@btclick.com
W www.numberninethegallery.com
Established in 1999, selling a diverse range of
Midlands-linked and international artists in
painting, glass, ceramics and sculptures, original
prints and rock art. Linked to Arts Council England's
Own Art scheme. Artists include Ralph Brown RA,
Mila Judge Furstova RCA, Glenn Badham, Kevin
Pearsh, Bertil Valien and Matthew Draper.
Submission Policy Does not take published
commercial artists. Sells mainly original works
of art.

Price range £100-£50,000
No of exhibitions annually 6
Cost to hire or rent Buttermarket available from £1200 per week.

Owen Taylor Art

The Hunting Lodge, Castle Park, Warwick, CV34 6SZ

T 01926 400058

F 01926 402898

E cyril@owentaylorart.com

W www.owentaylorart.com

Founded in 2002. Stocks British contemporary painting and graphics. Work is varied in style and content. Artists range from Royal Academicians and London Group to recent art-school graduates. Operates Arts Council England's Own Art purchase scheme.

Submission Policy Artists should review the gallery website to establish suitability of their work. **Price range** $f_50-f_3,000$

No of exhibitions annually 4, plus a mixed stock.

Park View Gallery

70 Vicarage Road, Kings Heath, Birmingham, B14 7QL

T 0121 4444851

Opened 1998 and now has three spaces. Shows solo and group exhibitions, mostly by aritsts with links to the local region.

Priory Gallery Broadway

34 The High Street, Broadway, Worcestershire, WR12 7DT

T 01386 853783 F 01386 853783

E info@priorybroadway.com

W www.priorybroadway.com

Deals in twenty-first-century artists and sculptors including Dianne Flynn, Paul Hedley, Paul Gribble, Tony Sheath, Bruce Hardley and Tina Morgan.

Price range £200-£5,000 No of exhibitions annually 4-6

Retrospectives Gallery

The Minories, Rother Street, Stratford-upon-Avon, CV37 6NE

T 01789 297706

E info@retrospectives.co.uk

W www.retrospectives.co.uk

Offers modern and contemporary art, specializing in originals and some limited editions. Exhibitions of local artists include David Collins, Tom Ashridge FRSA and Kay Elliott. International artists supplying originals include Starlie Sokol-Hohne (USA), Pinto (Portugal) and Wilfred (USA). Submission Policy Looking for contemporary and mainly abstract art in oils, acrylic and mixed media. Also quality traditional art.

Price range £100-£800 No of exhibitions annually 1

Shell House Gallery

36 The Homend, Ledbury, HR8 1BT
T 01531 632557
E padireland@aol.com
W www.shellhousegallery.co.uk
Founded in 1979, specializing in original
watercolours and mixed media by living
artists. Main exhibitions are by the Royal Institute
of Painters in Watercolours and the Royal
Institute of Oil Painters. Also offers a framing and
restoration service and publishes limited-edition
prints.

Price range £50-£3,000No of exhibitions annually 10

Spectacle

38 Freeth Street, Ladywood, Birmingham, B16 0QP

E info@spectacle-gallery.co.uk **W** www.spectacle-gallery.co.uk

Contact Greg Cox

Artist-led gallery space on the outskirts of Birmingham's city centre. The program is varied and non-specific but ambitious in outlook. Artists include Reactor, Dan Mort, Jon Lockhart, Dr Brian D Haddock, Captain Ed, Harminder Singh Judge, Matt Robinson.

Submission Policy Exhibitions run for four weeks. **No of exhibitions annually** 4

St Paul's Gallery

94–108 Northwood Street, Birmingham, B3 1TH T 0121 2365800
F 0121 2360098
E info@stpaulsgallery.com
W www.stpaulsgallery.com
Sells originals and editioned pieces as well as working with other galleries to bring internationally-important shows to Birmingham.

Valentyne Dawes Gallery

Church Street, Ludlow, SY8 1AP
T 01584 874160
E sales@gallery.wyenet.co.uk
W www.maritime-paintings.com
Founded in mid-1980s, specializing in coastal

and maritime paintings. Mainly nineteenth and early twentieth century. Artists include E.W. Cooke RA, David James and John Brett. Modern British artists are also represented, in particular Terrick Williams RA. Contemporary painters include Ian Cryer.

Price range £80-£80,000

No of exhibitions annually 1 – the December

Maritime Exhibition continues until Christmas.

Warstone & Turner

67 Warstone Lane, Hockley, Birmingham, B18 6NG T 0121 6936968

The Warwick Gallery

14 Smith Street, Warwick, CV34 4HH T 01926 495880 E wg@artisatart.fsnet.co.uk

W www.art-is-a-tart.com
A contemporary gallery featuring the works of over 100 artists. Continually changing selection of arts and crafts. Other branches based at 82 Regent Street, Leamington Spa, CV32 4NS, and Filthy But Gorgeous Gallery, 116 Regent Street, Leamington Spa.

Submission Policy Chooses work that appeals to the gallery.

Price range £1-£3,000No of exhibitions annually 2

Wenlock Fine Art

3 The Square, Much Wenlock, TF13 6LX T 01952 728232

Opened in 1991, dealing in twentieth and twentyfirst century artists. Artists represented include William Gear RA, John Piper, Mich Rooney RA, Henry Inlander, John Christopherson and Adrian Ryan.

Price range £100-£15,000 No of exhibitions annually 3

Wolseley Fine Arts Ltd

Middle Hunt House, Walterstone, HR2 0DY
T 01873 860525
F 01873 860529
E info@wolseleyfinearts.com
W www.wolseleyfinearts.com
Founded in 1990. Recently become a subsidi
Monnow Valley Arts Centre, a registered cha

Founded in 1990. Recently become a subsidiary of Monnow Valley Arts Centre, a registered charity. Attends trade fairs only, including London Art, The European Fine Art Fair and the London Original Print Fair.

Price range £150-£50,000

Yorkshire and Humberside

108 Fine Art

108 West End Avenue, Harrogate, HG2 9BT

T 01423 819108 F 01423 525847

E andrew@108fineart.com

W www.108fineart.com

Established in 1997 to promote the work of emerging and established contemporary artists. Artists shown include Joash Woodrow, Ana Maria Pacheco, Paul Reid, Alan Davie, Peter Sedgley. Christopher P. Wood, George Rowlett and Robert MacMillan. Also stock works by twentieth century British artists. Offers a comprehensive paintings conservation service to collectors, museums and galleries.

Submission Policy Welcomes work by artists working in all media.

Price range $f_{100}-f_{100,000}$ No of exhibitions annually 6

Archipelago Art Gallery and Studio

18-20 Sidney Street, Sheffield, S11 8TB

T 0114 2634493

E info@archipelago-art.co.uk

W www.archipelago-art.co.uk

Opened in 2002, featuring contemporary painters, printmakers and photographers. Also incorporates digital printmaking and giclée services, and a framing and making workshop. Exhibitions in 2005 included work by Heidi Konig. Charlotte Cornish, Pete McKee and flyeronthewall.

Submission Policy Submissions welcome from active painters, printmakers or designers. Also illustrators working in the fashion and music industries.

Price range £250-£2,500 No of exhibitions annually 10

Artco

I Meanwood Close, Leeds, LS7 2JF

T 0113 2620056

F 0113 2628388

E info@artco.co.uk

W www.artco.co.uk

Established for over twenty years. Exhibits work from both well-established artists and emerging talent, maintaining a strong presence at selected art fairs throughout the UK. The gallery covers 2,000 sq.ft, exhibiting a diverse selection of styles of art work. Bespoke and commercial framing service offered.

Submission Policy Submissions from artists welcome. No installation or video art.

Artolicana

25 Church Street, Ilkley, LS29 9DR

T 01943 603866

E info@artolicana.org

W www.artolicana.org

Established over ten years ago, selling local artists' work. Deals in original paintings only. Artists exhibited include Giuliana Lazzerini, David Greenwood, Tamara Lawson, Judith Levin, Jane Fielder and Brian Irving.

Submission Policy Established artists with proven mailing lists considered for inclusion in the gallery's programme of exhibitions.

Price range $f_{100}-f_{5,500}$

No of exhibitions annually Every three weeks for established artists; unsold work held in stock after three weeks for further month.

Bianco Nero Gallery

14 Bridge Road, Stokesley, TS9 5AA

T 01642 714433

E info@bianconero.co.uk

W www.bianconero.co.uk

Contact Michele Bianco

Founded in 2003, showing a wide range of contemporary art. From artists prints and paintings to 3-D work, including glass, ceramics and sculpture. Exhibited artists include Emma Stothard (willow sculptures), Richard Spare (prints) Joanne Mitchell (glass), Jim Wright (painting), Malcolm Teasdale (painting) and Lorna Graves (ceramics). Bespoke picture framing service available.

Submission Policy Applications welcome and should include biographical details and sample images (slide, photo or digital only).

Price range f_{10} - $f_{2,500}$ No of exhibitions annually o

Blake Gallery

18 Blake Street, York, YO1 8QH

T 01904 733666

F 01904 733730

E info@blakegallery.com

W www.blakegallery.com

Shows contemporary art including a permanent collection of sculpture by Sally Arnup and an extensive range of works by Piers Browne. Other artists include Mamdoh Badran, Lesley Fotherby, Roy Hammond, Tom Wanless and Walter Holmes.

Price range $f_{50}-f_{20,000}$ No of exhibitions annually 6

Bohemia Galleries

7 Gillygate, York, YO31 7EA T 01904 466488 / 01482 881882 E sheena@bohemia-galleries.com W www.bohemia-galleries.com Opened in the mid-1990s. Has developed a reputation for innovative stock, which includes contemporary works of art, ceramics and glass of the last two centuries. Artists represented include Mark Halsey, Frank Bentley, David Baumforth, Ludmila Curilova, Giluliana Lazzerini and Emilija Pasagic. Bohemia Galleries Two is found at 2 Sow-Hill Road, Beverley, HU17 8BG. Submission Policy Submissions welcome.

Braithwaite Gallery

42 Low Petergate, York, YO1 7HZ T 01904 655707 F 01904 655707 E artist@yorkartist.com W www.yorkartist.com

Located a few yards from the South Transept of York Minster in a historic, beamed, listed building belonging to York Minster. Owned by the Braithwaite family. Resident artist Mark Braithwaite has a constant display and there are prints and originals of many other artists including Kay Boyce, John Silver, David Shepherd, Christine Comyn and Warwick Higgs. Offers an in-house giclée printing service for artists.

Submission Policy Most originals are purchased from leading publishers. Self-publishing artists can contact via email or phone (no coldcalling; contact Anne or Vicky for an informal chat).

Price range $f_1-f_{10,000}$ No of exhibitions annually Permanent selling exhibition.

Browns Gallery

Wesley Street Chambers, Wesley Street, Otley, LS21 1AZ

T 01943 464656 / 850404 F 01943 464328 E sales@brownsgallery.co.uk W www.brownsgallery.co.uk

Established over fifteen years ago and situated in a building occupying the site of Chippendale's birthplace. A family company representing wellknown artists such as Shepherd, Flint, Rolf Harris, Mackenzie Thorpe, Doug Hyde and Kay Boyce, in addition to established and emerging local artists. Price range f_{25} - $f_{4,000}$ No of exhibitions annually 4

Bruton Gallery

P.O.Box 145, Holmfirth, HD9 1YU T 0870 7471800 E art@brutongallery.co.uk W www.brutongallery.co.uk Over thirty years of experience, selling art and sculpture by British and international artists to individual and corporate clients.

Crescent Arts

The Crescent, Scarborough, YO11 2PW T 01723 351461 E info@crescentarts.co.uk

W www.crescentarts.co.uk Established in 1979, providing: studio space for up to eight resident artists; support and resources for artists across the Borough of Scarborough; a programme of contemporary exhibitions; related education workshops; open-access facilities including darkroom, kiln and printmaking facilities. Resident artists pay subsidized rent in return for their time administering the exhibition/ education programme. They are expected to undertake a personal, tailormade programme of professional training, supported by the management committee.

Submission Policy Look at website or phone for details of exhibition opportunities, studio vacancies, workshops or open-access bookings. No of exhibitions annually 6

Cupola Contemporary Art Ltd

178A Middlewood Road, Hillsborough, Sheffield,

T 0114 2852665 / 2812154 F 0114 2852665 E info@cupolagallery.com W www.cupolagallery.com Contact Ian Gracey

Established in 1991, specializing in contemporary art. Exhibits a broad range of work from both new, emerging talent and more established artists. Covers painting, sculpture, photography, original printmaking (etching, lino cuts, mezzotint, collograph, etc.), ceramics, glass, textiles and jewelry. Installations, film, video and new media work are also occasionally exhibited. Cupola Framing offers a comprehensive bespoke framing service (contact Ben or Nix on 0114 20011023).

Karen Sherwood is also the director of Cupola consultancy. Artists represented include Lyn Hodnett, Derek McQueen, John Brokenshire, Anne Penman Sweet, Anita Klein and Corinna Button.

Submission Policy For submission requirements contact the gallery.

Price range £10-£5,000 No of exhibitions annually 8-10Cost to hire or rent Negotiable

Eyecandy

118 Trafalgar Street, Devonshire Quarter, Sheffield, S1 4JT T 0114 2787979

F 0114 2787979

E info@eyecandyimagesuk.com

W www.eyecandyimagesuk.com
Opened in 2004, Eyecandy merges gallery,
retail outlet and workshop in a loft-style setting.
Offers contemporary and fine-art prints, limited
editions, originals, quality greeting cards and
ceramics. There is also an in-house framing
service. Exhibited artists include Caroline Wood,
Sheryl Lee, Alistaire Scarlett, Elvis Davis and Ben
Sutcliffe.

Submission Policy Accepts submissions at any time. All works considered.

Price range £25-£600 No of exhibitions annually 4

Forge Gallery

15 Cleveland Terrace, Whitby, YO21 1PB T 01947 821832 E dave@forgegallery.co.uk

W www.forgegallery.co.uk

Contact Dave Jeffery

Gallery opened in 1998 in Robin Hood's Bay and now relocated to Whitby North Yorkshire. Original paintings by Dave Jeffery for sale; paintings produced in various mediums and of varied subject matter including landscapes, seascapes, buildings, the human form, abstract and horses. Commissions undertaken. Art tuition holidays arranged and conducted by Dave Jeffery.

Submission Policy Contact Dave Jeffery by letter,

Submission Policy Contact Dave Jeffery by letter, phone or email. Alternatively, please call in at the gallery (by appointment only).

Price range £10-£1,500

Gallery 42

42 St Joseph's Street, Tadcaster, LS24 9HA T 01937 530465 F 01937 530465 E art@gallery42.com

W www.gallery42.com

Contact Elizabeth or Roderick Allison Founded in 1989. Aims to take modern art into

the local community and encourage local artists. Artists exhibited include Nel Whatmore, Graham Illingworth, Doreen Greenshields, Janet Rogers, Sue Howells

Submission Policy Work taken on a commission basis.

Price range £20-£15,000 No of exhibitions annually 2-3

The Gallery

24 Market Place, Masham, HG4 4EB

T 01765 689554

E enquiries@mashamgallery.co.uk

W www.mashamgallery.co.uk

Founded in 1994. Exhibits high-quality

contemporary art and craft.

Submission Policy Work should be clearly labelled and include an sae if posted. Do not send original pieces. Submissions are welcomed by email but the gallery should be contacted before sending images. Restriction include no installations, photography or video art. Artists must be living and working in the UK.

Price range $f_5-f_2,000$ No of exhibitions annually 4

Gascoigne Gallery

E info@thegascoignegallery.com
W www.thegascoignegallery.com
Founded in 1998, showing original contemporary
work that is semi-abstract and marginally
representational. Landscape predominates, with
the aim of conveying the essence and atmosphere
of a subject rather than describing each minute
detail. Left permanent home in Harrogate in 2008
but retains internet presence.
Price range £200-£4,000

Godfrey & Watt

7–8 Westminster Arcade, Parliament Street, Harrogate, HG1 2RN

T 01423 525300

E mail@godfreyandwatt.co.uk

W www.godfreyandwatt.co.uk

Founded in 1985 by Alex and Mary Godfrey. Constantly changing range of ceramics, jewelry, studio glass, sculpture, paintings and original prints. In addition to this, a series of exhibitions is mounted each year, usually focusing on the work of an individual artist. Artists and makers exhibited include John Maltby, Morgen Hall, Lucy Casson, Guy Taplin, Piers Browne and Elaine Pamphilon.

Submission Policy Submissions welcome from artists by post or email. Should include photos, biography and prices.

Price range £50-£2,000No of exhibitions annually 5

Grosmont Gallery

Front Street, Grosmont, Whitby, YO22 5QE T 01947 895007

E info@grosmontgallery.com W www.grosmontgallery.com

Promotes and sells fine art and quality crafts. Most artists currently on show are reasonably local but not exclusively. Among current artists exhibiting are David Baumforth, Sally Gatie, Chris Geall, Janet Moodie, Angela Chalmers and Bren Head. Submission Policy All artists are welcome to make contact, especially those with new and challenging work.

Price range £5-£5,000No of exhibitions annually 4

Headrow Gallery

588 Harrogate Road, Alwoodley, Leeds, LS17 8DP

T 0113 2694244 F 0113 2694244

E maxwellroberts@btconnect.com

W www.headrowgallery.com

Founded in 1900. Specializes in contemporary North American and European art work. Submission Policy Artists' submissions always

welcome.

Price range £150-£5,000 No of exhibitions annually 2-3

Jim Robison and Booth House Gallery and Pottery

3 Booth House Lane, Holmfirth, Huddersfield, HD9 2QT

T 01484 685270

E jim.robison@virgin.net

W www.jimrobison.co.uk, www.

boothhousegallery.co.uk

Began in 1975 as a studio for Jim Robison and exhibition space for invited artists. Specializes in ceramics with continuous displays of both established and emerging talent. Paintings and prints also exhibited. Commissions undertaken. Submission Policy Exhibition by invitation only. Price range f10-f1500

No of exhibitions annually Two major shows summer and winter, plus ongoing individual displays.

Kentmere House Gallery

53 Scarcroft Hill, York, YO24 1DF T 01904 656507

E ann@kentmerehouse.co.uk

W www.kentmerehouse.co.uk

Contact Ann Petherick

Established in 1991, the gallery aims to show the best of the region's artists alongside those seldom shown in the north. Promising newcomers' work is hung alongside nationally-known artists, and the style is between abstract and figurative. Represented artists include Roy Freer, Susan Bower ROI, Tessa Newcomb, Louis Turpin and the late Jack Hellewell. Stocks mainly paintings and some original prints, plus ceramics and small sculpture. Selected for the 'Own Art' scheme, the gallery also provides a wedding gift service and art leasing for business.

Submission Policy Priority given to those who have visited the gallery. No machine-made prints or photography.

Price range £50-£3,000No of exhibitions annually 6

London Road Gallery

100 London Road, Sheffield, S2 4LR

T 0114 201 0630

E info@londonroadgallery.co.uk

W www.londonroadgallery.co.uk

Founded in 2004 as an outlet for the work of the Hallamshire Crafts Co-operative and of other artists/makers in the Sheffield area. Stocks a wide variety of quality original art and craft items and holds regular one-day workshops.

Submission Policy Selection meetings are held regularly. Work must be made locally and is assessed on quality, originality and ability to fit within the gallery environment.

Price range £2-£600

No of exhibitions annually 12

Cost to hire or rent Exhibition space available at £75 per month

Massarella Fine Art and Darren Baker Gallery

14 Victoria Road, Saltaire, Shipley, BD18 3LQ T 01274 580129

E admin@dbfinearts.co.uk

Founded in 1998 to promote and raise awareness of the local art scene as well as to represent national artists. Artists include Darren Baker, Joe

Scarborough, Stuart Hirst, Jeremy Taylor, Chris Wade and Steve Capper.

Submission Policy Artists should submit CV and five examples of work (photos or CD). All media considered.

Price range £100-£6,000 No of exhibitions annually 4

McTague of Harrogate

17-19 Cheltenham Mount, Harrogate, HG11DW

T 01423 567086

E paul@mctague.co.uk

W www.mctague.co.uk

A traditional art gallery established in 1974, dealing in old watercolours, antique prints, maps and oil paintings. Specialities include Yorkshire and northern artists, and sporting and rural subjects.

Price range $f_{50}-f_{1,500}$ No of exhibitions annually I

Phoenix Fine Arts Ltd

11 Finkle Street, Richmond, DL10 4QA T 01748 822400

Founded in 2002, exhibiting mostly local original art. Has shown over 250 different artists including Piers Browne, Chris Mounay, Peter Bailey, John Degnan and Barbara Lamb. Commissions undertaken and an art purchase plan offered.

Submission Policy New artists welcome. Work shown on a commission basis for five

Price range £25-£3,000 No of exhibitions annually 12

Pybus Fine Arts

127 Church Street, Whitby, **YO22 4DE**

T 01947 820028

E enquiries@mpybusfinearts.co.uk

W www.mpybusfinearts.co.uk

Founded 1997, selling modern and antique works including early twentieth-century works by the Staithes group of artists. Contemporary artists include David Curtis, Trevor Chamberlain, David Allen, Peter Hicks, Howard Bedford and Christine

Submission Policy Solo shows of loosely realist works, mainly by artists with an established track

Price range £200-£6,000 No of exhibitions annually 4

Rachel Gretton Glass

Workshop I, Dalby Courtyard, Pickering, YO18 7LT

T 01751 460174

E info@rachelgrettonglass.com

W www.rachelgrettonglass.com Rachel Gretton Glass was established in 2004 by artist Rachel Gretton. The working studio based in the centre of North Yorkshires National Park, Dalby Forest was opened in 2006 with support from the Arts Council. A showcase gallery displays sculptural glass alongside a selection of work from both established and emerging local artists. The gallery supports the high quality and skill of contemporary artists based in the North-East and North Yorkshire area. Artists include Claudia Phipps, Sarah Cilia, Rebbecca Stoner, Alice Highet and Rachel Gretton.

Submission Policy Artists are approached by the gallery.

Price range £20-£1500 No of exhibitions annually 2

Sculpture Lounge

Unit 27, Bottoms Mill, Woodhead Road, Holmfirth, HD9 2PX

T 01484 687425

E info@sculpturelounge.com

W www.sculpturelounge.com

Founded in 2002, specializing in ceramics, ceramic scupture, sculpture, paintings and jewelry. Prominent artists represented include Brendon Hesmondhalgh, Elizabeth Price, Mari-Ruth-Oda, Annie Peaker, Christine Cummings and Melanie

Submission Policy Artist applications by post, including photographs of works, artist statement and CV.

Price range £20-£5,000 No of exhibitions annually 8

Smart Gallery

Redbrick Mill, 218 Bradford Road, Batley, WF176JF

T 01924 455445

F 01924 455425

E info@smartgallery.co.uk

W www.smartgallery.co.uk

Founded in 2002 at Redbrick Mill, followed by a second at Christopher Pratts in Leeds. Sells Washington Green limited-edition and original prints and has a craft and design centre based in Batley. Encourages local artists to exhibit.

Submission Policy Encourages work from a wide range of artists in a variety of media. Price range £100-£5,000 No of exhibitions annually 8

Talents Fine Arts

7 Market Place, Malton, YO17 7LP T 01653 600020 F 01653 600020 E talentsfinearts@hotmail.com Established for almost twenty years. Contemporary

artists include David Howel, John Gibson, Neil Spelman, Barry Peckham, Susan Bower, Steven Lingham. Shows glass and ceramics. Framing and restoration services offered.

Submission Policy Submissions by prior notice only.

Price range $f_{100}-f_{3,000}$ No of exhibitions annually 2

Taylor-Pick Fine Art

Westwood House, Nafferton

T 01377 240360 F 01377 240185 E andrew@taylor-pick.com W www.taylor-pick.com

Originally founded in 1996, the gallery has now developed into an online gallery with exhibitions held at Westwood House, Nafferton. The gallery has an established and growing regular client base and represents artists from the UK, Spain, Ireland and the Czech Republic, including George Hainsworth, Beltran Bofill, Gordon King, Fraser King and Jan Vich.

Submission Policy Contact Andrew Taylor. Price range £400-£25,000

Walker Galleries Ltd

Contact Angela Noble

13 Montpellier Parade, Harrogate, H91 2TJ T 01423 526366 F 01423 525975 E walkercontemp@aol.com W www.walkerfineart.co.uk

Founded in 1971, presenting a wide array of styles from photographic to semi abstract. Gallery artists include Jeremy Barlow Roi, John Mackie, John Lowrie Morrison, Peter Graham, Caroline Bailey and Mike Bernard. Branches 104 High Street Honiton, Devon.

Submission Policy Only handles living artists. Submissions welcome from established artists but will consider other artists if photographs supplied.

Price range f_{250} - $f_{10,000}$ for paintings; $f_{200}-f_{4,500}$ for bronzes; $f_{40}-f_{400}$ for ceramics. No of exhibitions annually 10

Ireland

Access to Arts

Third Floor, The Design Tower, Trinity Centre, Grand Canal Quay, Dublin 2

T 01 6770107

E info@accesstoarts.com

W www.accesstoarts.com

Contact Patricia Clyne-Kelly

Promotes Irish contemporary applied art and fine art through exhibitions and commissions. The gallery is housed in an historic stone-built tower with brick-vaulted ceilings and white and natural stone walls, on the fringe of the Docklands area in Dublin. Exhibitions are also arranged in corporate settings.

Submission Policy Applications from all artists living in Ireland are welcomed.

Apollo Gallery

51c Dawson Street, Dublin 2 T 01 6712609 E art@apollogallery.ie W www.apollogallery.ie Specializes in the work of Irish artists, aiming to bring Irish paintings, sculpture and prints to an

Price range €190-€250,000 No of exhibitions annually 1-2

Arklow Fine Art Gallery

international audience.

7 Lower Main Street, Arklow, Co. Wicklow E info@arklowfineartgallery.com Opened in 2004 to showcase art by Irish artists, and especially those from Co. Wicklow. Hosts several exhibitions a year, showing local and international artists, including Robert Harcus, Tony Kew and Carol-Ann Waldron.

Artselect Ireland

13 Ros Mor View, Scholarstown Road, Dublin 16 T 01 4952474

E greved@eircom.net

W www.greved.com

Contact Greville Edwards

Founded in 2000, initially as a gallery space and art provider with graphic design and photography services available.

Submission Policy Established and emerging artists are welcome to submit examples of work via the website or by email. Exhibitions held each year in the Dublin area depending on sponsorship and popularity. Undertakes private and corporate commissions.

Price range €300–€5,000 No of exhibitions annually 2

Bad Art Gallery

Francis Street, Dublin 8

T or 4537588

E info@thebadartgallerydublin.com

W www.thebadartgallerydublin.com

Opened in 2005. Can exhibit 200 pictures at a time. Work changed regularly and also available via website. Artists include Deborah Donnelly, Val Byrne B.Arch, FRIAI, Anna-Marie Dowical, Daragh Muldowney, Olgu Fitzpatrick, Tony O'Dwyer, Gareth Daly, Jim Kilgarriff and Robert Andrew Smyth.

Barn Gallery

Garranes South, Drimoleague, County Cork
T 028 31677
F 028 31677
E sheilahooks@eircom.net
W www.barngalleryireland.com
Opened in 1996. Open studio of Sheila Hooks
BA ATD, specializing in Irish landscapes and life
drawings.
Price range €100-€1000

Bin Ban Gallery & Antiques Beech Lodge, Ballyenerghty, The Kerries, Tralee, County Kerry

No of exhibitions annually Continuously changing

T 066 7122520

exhibition.

E info@binbanart.com

W www.binbanart.com

Hosts major exhibitions of national and international contemporary works and limited-edition prints.

Black Cat Gallery

17 Market Street, Galway T 091 566422

E jvinnell@eircom.net

W www.janetvinnell.com / www.tedturton.com Founded 1997. Sells original artwork, paintings in pastel and watercolour and photo-generated artwork by artists-in-residence Janet Vinnell and Ted Turton. Also shows glass and ceramics by other artists.

Submission Policy Submissions not encouraged. Price range €100-€2,000

No of exhibitions annually Continually rotating work on view and for sale

Cost to hire or rent By arrangement in January or February. Negotiable.

Blue Leaf Gallery

IO marino mart, Fairview, Dublin 3 T or 8333456 E info@blueleafgallery.com W www.blueleafgallery.com Contact Jane Ross

Opened on current premises in 2001, presenting work by Irish and international artists.

Submission Policy We require a disc of 3–10 images of recent works, a biography and an artist statement.

Price range €500–€10000 No of exhibitions annually 6

Bold Art Gallery

Merchants Road, Galway T 00353 91 539900 E info@boldartgallery.com W www.boldartgallery.com

Represents 85 artists producing work in range of styles. Specializes in original fine art paintings by Irish and international artists and also displays a small selection of sculpture. Does not deal in reproductions of any kind.

Submission Policy Submit a portfolio of recent works as slides, printed photographs or digital images on CD. All illustrations should have details such as size, medium and title. Submissions should be clearly marked with contact details and include an sae. Details of previous exhibitions, gallery representation (if represented) and artist's biography should be attached.

Price range €200–€50,000 No of exhibitions annually 12

Bridge Gallery

6 Upper Ormond Quay, Dublin 7 T or 872 9702 F or 872 9699 E mail@thebridgegallery.com W www.thebridgegallery.com

Contact Deirdre Carroll

Gallery within restored eighteenth-century Georgian building. Features work of established and rising artists, contemporary arts and crafts, watercolours, oils, prints, etchings, ceramics, wood, glass and jewelry. Artists include Frank Boag, Sheelagh Flannery, Brigit Beemster, Sara Flynn, Leonard Sexton and Shane Johnson. Submission Policy Contemporary work only. New artists welcome. Price range €20–€3,000 No of exhibitions annually 12

Canvas

Suite 9, Herbert Hall, 16 Herbert Street, Dublin 2

T 087 6339208

E info@canvas.ie

W www.canvas.ie

Established in 2004. Representing and promoting emerging artists.

Submission Policy Submissions and enquiries are welcome from working artists by email or phone.

Price range €100–€20,000 No of exhibitions annually 6

Catherine Hammond Gallery

Glengarriff Center, West Cork

E info@hammondgallery.com

W www.hammondgallery.com

Contemporary art gallery founded in 2004 by
Catherine Hammond, who has over 20 years'
experience working with leading American
cultural organizations, including the Institute
of Contemporary Art (Boston), the MacArthur
Foundation (Chicago), and the Smithsonian
Institution (Washington, D.C.).

Cavanacor Gallery

Ballindrait, Lifford, County Donegal T 00353 74 9141143

F 00353 749141143

E art@cavanacorgallery.ie

W www.cavanacorgallery.ie

Contact Joanna O'Kane (Director)
Initiated in 1999, a professional private gallery exhibiting emerging, established national and international artists. Exhibitors to date include Eamon O'Kane, Brian Ballard, David O'Kane, Felim Egan, Sean Fingleton, Nadja Bouronville, Neil Shawcross, Hughie O'Donoghue, Deborah Brown, Matthew O'Kane, Eddie O'Kane, Martin Gale and Alice Hanratty. The gallery operates primarily through solo and themed group exhibitions. Consultancy is offered on private and corporate collections.

Submission Policy Submissions are welcomed from artists and should consist of biographical information accompanied by a maximum of ten images on slide or CD format.

Price range €250–€30,000 No of exhibitions annually 5

Cherrylane Fine Arts

Cherrylane, Wicklow

T of 2875565

E michael@cherrylanefinearts.com

W www.cherrylanefinearts.com

Family-run art gallery housed in seventeenthcentury rustic buildings. Exhibits contemporary paintings, prints and photography as well as indoor and outdoor sculpture.

Claremorris Art Gallery

Mount Street, Claremorris, County Mayo

T 094 9371348

F 094 9372961

E drpnoone@eircom.net

Contact Brian Bourke, Jay Murphy or Mary Kelly Gallery established in 1988 to promote professional Irish artists. Artists represented include Brian Bourke, Tony O'Malley, John Shinnors, Michael Farrell, Basil Blackshaw and Camille Souter. Exhibitions have been toured internationally and an artist's studio and residence is under construction.

Submission Policy Professional artists only. Painting, prints, mixed media, photography, film and sculpture all accepted. Installations and performance art generally not accepted.

Price range €250–€50,000

No of exhibitions annually 6 Cost to hire or rent €100–€300 per week

Combridge Fine Arts Ltd

17 South William Street, Dublin 2

T 01 6774652

E artsales@cfa.ie

W www.cfa.ie

Contact Brian Sibley

Experience of selling and promoting the work of Irish artists for over ninety years. Specialists in Irish landscape. Current artists can be viewed on website.

Courthouse Gallery, Ballinglen Arts Foundation

Main Street, Ballycastle, County Mayo

T 096 43184

F 096 43184

E baf@iol.ie

W www.ballinglenartsfoundation.org

Contact Una Forde

Founded in 1991, the Foundation aims to support serious international artists by giving housing and studio space, allowing them to make important work to benefit themselves and the local community.

Submission Policy Ballinglen's programmes are by application (form downloaded from website). Each successful artist receives a sky-lit studio and a house (where friends and family can stay or visit). In return each artist leaves a piece of work which remains in the archive, which now boast 349 pieces.

Courtyard Arts Limited

The Courtyard Craft & Exhibition Centre, 8 Main Street, Midleton, County Cork

T 021 4634644 F 021 4630919

E thecourtyardgallery@eircom.net

W www.thecourtyardmidleton.ie
Contact Anne Ahern or Sue van Coppenhagen
Founded in 2000. Two galleries for rent to
individual artists/crafters or groups, for two-week
slots. Also an Art Source Network, representing
thirty member artists, whose work is promoted
on an ongoing basis to buyers, particularly those
looking for commissioned work. A craft shop

displays Irish-made crafts.

Submission Policy Artists' work is vetted by committee before being accepted for exhibition or membership of Art Source Network.

Price range €100–€3,000 No of exhibitions annually 30

Cost to hire or rent Main gallery €520 for 2 weeks; Studio One €450 for two weeks.

Cristeph Gallery

Port Road, Letterkenny, Donegal T 074 26411 Established in 1982. Shows paintings by local and international names. Also offers framing and consultancy services.

Cross Gallery

59 Francis Street, Dublin 8 T or 4738978 F or 4545391 E info@crossgallery.ie W www.crossgallery.ie

Work shown over four spaces. Artists include David Begley, Michael Coleman, Jack Donovan, Simon English, Bridget Flannery, Gillian Lawler, Horace Lysaght, Ann Quinn, Ian Stuart and Clea van der Grijn.

Cunnamore Galleries

Cunnamore Point, Skibbereen, West Cork T o28 38483 E art@cunnamore.com W www.cunnamore.com

Shows contemporary works by artists such as Patrick Barker, Monica Boyle, Anthony Gross, Majella O'Neill Collins and Ian Humphreys.

CY Gallery

Cotters Yard, Main Street, Schull, Cork T 028 28165 F 028 28413 E freewheelin@eircom.net Gallery of drawings, paintings and sculpture.

Cynthia O'Connor Gallery

Swords, Dublin

T oi 8405045 F oi 8401220 E ballinacorestate@eircom.net Specializing in Irish paintings and watercolours, from the eighteenth century to the present day.

D FOUR Gallery @ The Berkeley Court

Lansdowne Road, Dublin 4
T or 6653200
F or 6617238
W www.jurys-dublin-hotels.com/
berkeleycourt_dublin
Housed in the Berkeley Court Hotel, dealing in Irish
fine art and antiques. Stocks work by artists including

Dorothy Smith, Celine Eagle and Doris Houston.

Daffodil Gallery

Skerries, Co. Dublin T o1 8492142 F o1 8492535 E daffodil@iol.ie W www.daffodilgallery.com

19 Railway Road, Dalkey, Dublin

A garden gallery, representing artists living and working in Ireland. Shows paintings, drawings, sculpture and prints from emerging and established names.

Dalkey Arts

T oi 2849663
E info@dalkeyarts.com
W www.dalkeyarts.com
Offers range of contemporary paintings, drawings, prints and glass from Irish and international artists. Also offers a full framing service.
Price range €100 to €10,000
No of exhibitions annually 4

Dyehouse Gallery

Mary Street, Waterford

T 051 844770 F 051 850399

E info@dyehouse-gallery.com

W www.dyehouse-gallery.com

Contact Liz McCay

Established in 1995 with the aim of bringing the best of contemporary Irish and international art to the south-east of Ireland. Moved to current premises in 2005 and maintains a lively exhibition programme with works by Tony O'Malley, John Shinnors, Brian Bourke, Jane O'Malley, Rosemary Higbee and Paddy Lennon.

No of exhibitions annually 6-7

Fado

Main Street, Dingle, Co. Kerry T 066 9151452 F 066 9152530 E evahennessy@eircom.net Contact Pat Hennessy and Eva Hennessy. Founded in 1976, the oldest gallery, framers and

Fenton Gallery

5 Wandesford Quay, Cork T 021 4315294 F 021 4917100 E nualafenton@eircom.net

antiques shop in Dingle.

W www.artireland.net

Contact Nuala Fenton, Ita Freeney and Helena Tobin.

Established in 2000 by Nuala Fenton, the gallery, which occupies over 2,000 sq. ft, is five minutes from the city centre. Exhibition programme changes every three weeks and includes artists such as Basil Blackshaw, William Crozier, Hughie O'Donoghue, Tony O'Malley, Charles Tyrrell and Patrick Scott. Emerging, younger artists are also profiled. Submission Policy Applications taken by post. Include images in CD or slide format. No of exhibitions annually 10

Form Gallery

Unit 2, Paul Street Shopping Centre, Cork T 021 4271333 F 021 4271414 E form@affordableart-ireland.com W www.affordableart-ireland.com Exhibits broad range of contemporary art.

Framework Gallery

55 Upper Georges Street, Dun Laoghaire, County Dublin T of 280 5756

E info@theframeworkgallery.com

W www.theframeworkgallery.com

Deals in contemporary and traditional paintings, drawings, etchings and prints. Also offers framing and giclee print services.

Frank Lewis Gallery

6 Bridewell Lane, Killarney, County Kerry T 064 31108 F 064 31570 E info@franklewisgallery.com W www.franklewisgallery.com Presents different monthly individual and group exhibitions of paintings and sculpture, showing emerging and established names.

Gallery 44

44 MacCurtain Street, Cork T 021 4501319 Set on three floors, with around six solo shows a year. Framing services also offered. No of exhibitions annually 6

Gallery 75

75 O'Connell Street, Limerick T 061 315650 Deals in paintings, drawings and sculpture. Artists include Patrick Cahill, Gerald Davis, Michael Gemmel, Paul Quane, Thomas Ryan R.H.A and Viale.

The Gallery

Dunfanaghy, County Donegal

T 074 9136224 Founded in 1968, specializing in fine watercolours and oil paintings. Works on display by artists including Frank Egginton, James McConnell, Kenneth Webb, Thomas Ryan, Pat Cowley and Robert Egginton.

Submission Policy Pleased to discuss and view any professional work. Quality and suitability the main

Price range €250-€12,000 No of exhibitions annually Continuous, changing, mixed exhibitions.

Gormleys Fine Art

24 South Frederick Street, Dublin 2 T 01 6729031 E info@gormleys.ie W www.gormleys.ie

Gormleys Fine Art Gallery specialises in contemporary painting and sculpture by emerging and established artists. Solo shows are held every four weeks, with annual group shows throughout the year. The gallery also has a collection of Fine Irish Art by deceased artists continually on view at the gallery. No of exhibitions annually 12+

Gorry Gallery Ltd

20 Molesworth Street, Dublin 2

T oi 6795319

F 01 6795319

W www.gorrygallery.ie

Established 1885. Picture restorers and fine art dealers. Specialists in eighteenth-, nineteenth- and twentieth-century Irish art.

No of exhibitions annually 3

Graphic Studio Gallery

Through the Arch, Cope Street, Temple Bar, Dublin 2

T 01 6798021

F 01 6794575

E gsg@iol.ie

W www.graphicstudiodublin.com

Opened in Temple Bar in 1988, exhibiting and selling fine art prints by emerging and established names from both Ireland and abroad.

Price range From €60

Green Door Studio

Port-Na-Blagh, Dunfanaghy, County Donegal **T** 07491 36864

E kandkraff@hotmail.com

Founded 2001. Presents and exhibits original paintings by a family of three (mother, father and daughter), who work from a purpose-built studio. Specializing in oils, watercolours, acrylics, handmade prints, abstract and figurative works.

Price range €225-€3,030

No of exhibitions annually Two, one at Easter and one at beginning of August, both ongoing until Christmas. Studio closed Christmas until St. Patrick's Day.

Green Gallery Dublin

Top Floor, St Stephen's Green Centre, Dublin 2

T 01 4783122

E info@greengallerydublin.com

W www.greengallerydublin.com

Retails broad range of contemporary works from national and international artists. Comprehensive framing service also available.

Green On Red Gallery

26-28 Lombard Street East, Dublin 2

T 01 6713414

F 01 6727117

E info@greenonredgallery.com

W www.greenonredgallery.com

Contact Mary Conlon

Established in 1997. Occupies a nineteenthcentury converted warehouse space. Exhibits more experimental contemporary Irish and international art. Mixture of solo exhibitions, group exhibitions and art fairs, and programmes guest-curated contemporary international exhibitions, concerts, talks and one-off events.

Submission Policy Cannot accept artist submissions at this time.

Price range €500–€150,000 No of exhibitions annually 8–10

Greenacres

Selskar, Wexford

T 053 9122975

F 053 24905

E info@greenacres.ie

W www.greenacres.ie

Contact Marianne Jackman

Established in 2001, the gallery now operates in a 7,000 sq. ft space arranged over two floors in a newly renovated building. Shows work by such renowned artists as Brian Ballard RUA, John Behan RHA, James Brohan, Eamon Colman, Felim Egan, James English RHA, Gemma Guihan, Paul Kelly, Paddy Lennon, John Morris, Ian McAllister, Eamonn O'Doherty and Gwen O'Dowd. Full details of upcoming exhibitions and images of work can be viewed on the website.

Submission Policy Email or post an up-to-date CV and biography with images and prices of work to Marianne Jackman (marianne@greenacres.ie).

Price range €1,000-€65,000

No of exhibitions annually 5

Greenlane Gallery

Holy Ground, Dingle, County Kerry T o66 9152018 / 9152047

E info@greenlanegallery.com

W www.greenlanegallery.com
Contact Ms Julie O'Neill / Áine McEvoy
Established in 1992. Takes its name from the
street where it was originally located – Greenlane
in Dingle town. Shows contemporary Irish
paintings and sculpture by leading Irish artists.
Paintings by Liam O'Neill, Tomás Ó Ciobháin,
Patsy Farr and Michael Flaherty with sculpture by
Ana Duncan and Hans Blank.

Submission Policy Welcomes submissions from artists via email.

Price range €30-€25,000

No of exhibitions annually 9

Hallward Gallery

65 Merrion Square, Dublin 2 T oi 6621482/3 F 01 6621700 E info@hallwardgallery.com Opened in 1991 to show Irish contemporary fine art and encourage emerging talents.

Hillsboro Fine Art

49 Parnell Square West, Dublin 1 T of 8788242 E info@hillsborofineart.com W www.hillsborofineart.com

Founded in 1995, the gallery has recently moved to Parnell Square in the cultural and social heart of Georgian Dublin. Deals in works by leading twentieth- and twenty-first century artists from Ireland, UK, Europe and the USA. Artists represented include Alex Katz, John Hoyland, Anthony Caro, Markus Lupertz, Jules Olitski, Gillian Ayres, Michael Warren, Tjibbe Hooghiemstra, John Noel Smith and many others. Large inventory of drawings, paintings and sculpture.

Price range €500-€250,000 No of exhibitions annually 12

Howth Harbour Gallery

6 Abbey Street, Howth Village, Howth, County Dublin T of 8393366 E gjb97@dial.pipex.com W www.gjb97.dial.pipex.com Deals in contemporary and traditional

paintings and drawings, with an emphasis on Irish scenes.

James Joyce House of the Dead

15 Usher's Island, Dublin 8 T 086 1579546 E info@jamesjoycehouse.com W www.jamesjoycehouse.com Founded 2000, exhibiting contemporary Irish and European Art of all genres and media. Submission Policy Please email medium resolution jpegs, maximum 15. Include brief CV media and prices. No of exhibitions annually 12 Cost to hire or rent Price on application.

Joan Clancy Gallery

Mullinahorna, Ring, County Waterford, Ireland T 058 46205

E info@joanclancygallery.com

W www.joanclancygallery.com

A private space established in 1999. Specializes in promoting new, emerging and established artists, including Katarzyna Gajewska, Blawnin Clancy, Maderson, Rayleen Clancy, Ross Stewart, Dave West, Andrea Jameson.

Submission Policy Favours wall-mounted works. E-mail submissions welcome from artists accompanied by CV, artist statement and two images of work.

Price range €200-€4,500 No of exhibitions annually 4

Jones Art Gallery

Harbour Mill, Davitt's Quay, Dungarvan, County Waterford

T 058 45610

E cjones@thejonesartgallery.com W www.thejonesartgallery.com

Founded in 2004, with the intention of bringing the work of Irish artists to public attention in Waterford. Artists include John Nolan, Molly Poencet and many up-and-coming young artists. Submission Policy All artists welcome to contact gallery.

Price range €100+ No of exhibitions annually 12-14

Jorgensen Fine Art

29 Molesworth Street, Dublin 2 T or 6619758/9 F 01 6619760 E info@jorgensenfineart.com W www.jorgensenfineart.com

Contact Sile Connaughton Deeny or Kevin Gaines

Established in 1991, specializing in late-nineteenth and early-twentieth century Irish, British and European paintings, drawings, watercolours and sculptures (of which the gallery has three major exhibitions annually). Featured artists include Roderic O'Conor, Paul Henry, Mary Swanzy, George Campbell, Rose Barton, Evie Hone and Mainie Jellett. Also hosts approx. six solo exhibitions of contemporary Irish and international artists such as Barbara Rae, Olivia Musgrave, Alexey Krasnovsky, Joe Dunne, John Long, Robert Wraith and Anna Kostenko. Submission Policy Areas excluded: paintings and sculpture pre-1850. Submissions from living artists welcome.

Price range €300-€100,000 No of exhibitions annually 10

Keane on Ceramics

Francis Keane, Pier Road, Kinsale, County Cork
T 021 4774553
E keaneceramics@oceanfree.net
One of Ireland's leading ceramics galleries
specializing in one-off ceramics for fifteen years.
Submission Policy Studio ceramics.
Price range €20-€20,000
No of exhibitions annually 2

Kenmare Art Gallery

Bridge Street, Kenmare, County Kerry
T o64 42999
E martinaviscardi@eircom.net
W www.kenmareartgallery.com
Exhibits works by artists including Robin
Forrester, Tim Goulding, John Philip Murray,
Nealie Sullivan, Claudio Viscardi and Sarah
Walker. Many works influenced by the local Beara
area.

The Kenny Gallery

High Street/Middle Street, Galway T 091534760 F 091568544 E art@kennys.ie W www.kennys.ie Contact Tom Kenny

Has been selling original works of art for over half a century. Has hosted major exhibitions by George Campbell, Sean Keating, Andy Warhol, Kenneth Webb, Jack B. Yeats and Paul Henry. The conversion of the bookshop to the largest commercial art gallery in Ireland took place early in 2006 and extends from street to street over three floors. Exhibits national and international art across variety of media. Ongoing collections of artworks from almost two hundred artists.

Submission Policy Send a number of images of

work and a profile/CV of the artist.

Price range €100 to €100,000

No of exhibitions annually 15 solo exhibitions 5 group exhibitions

Kerlin Gallery

Anne's Lane, South Anne Street, Dublin 2
T or 6709093
F or 6709096
E gallery@kerlin.ie
W www.kerlingallery.com
Established in 1088, one of Ireland's most

Established in 1988, one of Ireland's most important galleries with a programme of national and international contemporary art. Offers 3,600 sq. ft of exhibition space on two floors.

Kevin Kavanagh Gallery

66 Great Strand Street, Dublin I
T or 874 0064.
E info@kevinkavanaghgallery.ie
W www.kevinkavanaghgallery.ie
Major contemporary art gallery, hosting mostly
solo, but some group, shows.

Kilcock Art Gallery

School Street, Kilcock, Kildare

T oi 6287619
F oi 6284293
E info@kilcockartgallery.ie
W www.kilcockartg
Founded in 1978, dealing in fine paintings,
sculpture and prints by major Irish artists. Works
with both individual and corporate clients.

Killarney Art Gallery

13 Main Street, Killarney
T 064 34628
E art@irishartcollector.com
W www.irishartcollector.com
Contact Declan and Brenda Mulvany
Founded 15 years ago to present leading Irish
artists, including Mark O'Neill, Ted Jones, James
English, James Brohan, Liam O'Neill and Paul
Kelly. Has worldwide exclusivity on Ted Jones's
work, including his signed limited-edition prints.
Submission Policy Artists are encouraged to send
digital proper fewer for the services of their work via email.

Price range €400-€20,000

No of exhibitions annually Two major exhibitions each year, one in September and one in December. Also has a featured artist mini-exhibition every month.

Kinsale Art Gallery

Pier Head, Kinsale, Cork
T 021 477 3622
E b.andrews@kinsale-art-gallery.ie
W www.kinsale-art-gallery.ie/
Specializes in paintings (contemporary and traditional) and drawings.

La Gallerie

32 Grand Parade, Cork T 021 427 7376 Deals in paintings, drawings and prints. Artists include James Flack, Maurice Henderson, Pat Maher, Liz Morris, and Victor Richardson. Framing service also offered.

Lavit Gallery

5 Father Mathew Street, Cork

T 021 4277749 F 021 4279123

E thelavitgallery@eircom.net

Shows paintings, prints and photography as well as sculpture and ceramics from established Irish artists.

Legge Gallery

9 Chelmsford la Ranelagh, Dublin 6 T 01 4962399 Specializes in contemporary paintings and offers

Leinster Gallery

27 South Frederick Street, Dublin 2 T of 6790834

comprehensive framing service.

E art@leinstergallery.com

W www.leinstergallery.com

Located in a restored Georgian town house, specializing in twentieth century and contemporary Irish art. Shows several solo and seasonal mixed exhibitions a year. A constantly changing exhibition of pieces by gallery artists is also on display.

No of exhibitions annually 6

Lemon Street Gallery

24-26 City Quay, Dublin 2

T 01 6710244

F 01 6710240

E lea@lemonstreet.com

W www.lemonstreet.com

Shows contemporary graphic art by national and international artists.

Limerick Printmakers Studio and Gallery

4 Robert Street, Limerick

T 061 311806

E limprintmakers@eircom.net

W www.limerickprintmakers.com

Contact Melissa O'Brien

Founded in 1999. Dedicated to supporting artists of all art forms and at all stages in their career. Work shown includes a wide variety of media such as printmaking, painting, photography, film, installation and performance art. Exhibiting artists include Martin Finnin, Jack Donovan, Brian Mac Mahon, Charlie Harper, Des Mac Mahon, Suzannah O'Reilly, Clare Gilmour, and Gillian Kenny. Annual group exhibitions are held for studio members as well as an open submission print show. Submission Policy Open to artists in any media. Send a cover letter, CV, artist's statement and visuals of the work.

Price range €50-€10,000

No of exhibitions annually 10

Cost to hire or rent Artists are not charged for the use of the space but the cost of the exhibition opening is the responsibility of the artist/s. Limerick Printmakers provides some financial support and commission is kept to a low of 30%.

Magil Fine Art

13A Bachelors Walk, Dublin 1

T of 8720618

F of 8720618

E magil_art@hotmail.com

W www.magilfineart.com

Contact Bernadette Murphy

Founded in 1999. Specializes in contemporary and twentieth-century Irish art. Recently branched into contemporary Russian art. Framing and restoration work offered by qualified in-house fine art restorer. Valuations of paintings also offered. Submission Policy Submissions welcome from artists.

Price range €500-€2500 No of exhibitions annually 6

Mill Cove Gallery

Castletownbere, County Cork

T 027 70393

E millcove@iol.ie

W www.millcovegallery.com

Opened in 2000, showing contemporary fine art by established and emerging artists.

Molesworth Gallery

16 Molesworth Street, Dublin 2

T of 679 1548

F oi 679 6667

E molesworth.gallery@indigo.ie

W www.molesworthgallery.com

Founded in 1999 to exhibit contemporary painting and sculpture by emerging and established artists. The gallery represents about twenty artists, hosting ten or so mainly solo exhbitions annually. A broad sprectrum of artists are represented including young representational painters (Blaise Smith, Maeve McCarthy ARHA, John Hearne and Sheila Pomeroy), St Ives based abstract landscape painter Padraig MacMiadhachain, photorealist Patrick Redmond and sculptor Anna Linnane.

Submission Policy Do not send huge email attachments or unsolicited CDs. Will not necessarily reply to every submission.

Price range €500-€20,000

No of exhibitions annually 10

Mothers Tankstation

41–43 Watling Street, Ushers Island, Dublin 8 T or 6717654

E gallery@motherstankstation.com

W www.motherstankstation.com

Contact Finola Jones

Exhibits contemporary visual art, working with Irish and international artists at different career stages who demonstrate individuality and a distinct vision. Artists include Petri Ala-Maunus, Ian Burns, Nina Canell, Atsushi Kaga, Ciaran Murphy, Alan Phelan, Garrett Phelan and David Sherry.

No of exhibitions annually 6

Mulvany Bros.

Kingswood Art Gallery, Kingswood Cross, Old Naas Road, Dublin 22

T 01 4594242

E gallery@mulvanybros.ie

W www.mulvanybros.ie

Established in 1885, specializing in original paintings, prints and engravings. Sells wide range of art materials and offers framing and restoration services.

Narrow Space

14 Mitchel Street, Clonmel, County Tipperary T 052 27838

E thenarrowspace@eircom.net

W wwww.thenarrowspace.com

Contact Aisling Kilroy

Opened in late 2003. Committed to showcasing the work of both established and up-and-coming Irish and international painters and sculptors, including John Behan RHA, MercË CaOadell, Eoin de Leastar, Lucy Doyle, Ana Duncan, Ella Kavanagh, James MacCarthy, Patrick Morrison, Eilis O'Toole and Robert Ryan. Also regularly shows the work of both established and younger ceramicists including Bernadette Doolan, Sara Flynn, Catherine Hunter, Bridget Lyons, Maura Smyth and Grainne Watts. Submission Policy Submissions from artists are welcome. Interested artists should send covering letter, CV and CD, a minimum of six months in advance of hoped-for exhibition.

Price range €150-€12,000+

No of exhibitions annually 8+, including groups shows at summer and Christmas.

Norman Villa Gallery

86 Lower Salthill, Galway

T 091 521131

F 091 521131

E info@normanvillagallery.com W www.normanvillagallery.com Opened in 2004, specializing in contemporary

Irish art. Aims to support and build relationships with artists. Represents Christopher Banahan, Brian Burke, Mary Donnelly, John Ffrench, Philip Lindey and Lisa Sweeney, among others.

Submission Policy Letter of introduction required

Submission Policy Letter of introduction required plus a CV and a CD of works along with any proposals. Artists welcome to visit the gallery.

Price range €300–€30,000 No of exhibitions annually 10

Cost to hire or rent Open to discussion

Oisin Art Gallery

44 Westland Row, Dublin 2

T of 6611315

F 01 6610464

E info@oisingallery.com

W www.oisingallery.com

Established in 1978, showing Irish and international artists, both established and emerging. Specializes in original fine art paintings and also displays a small selection of sculpture. Exhibitions are held every four to six weeks and two annual group shows are held in July and November. Artists include Ronan Goti, Katy Simpson, Katherine Liddy, Alan Kenny, David Turner, Thomas Halloran and Tina Spratt. Represents over forty artists in all and also offers a consultancy service.

Submission Policy Post a portfolio/CD of recent works, clearly indicate size, medium and framing and include details of previous exhibitions, gallery representation (if any) and an approximate price guide if currently exhibiting. Submissions should be clearly marked with contact details. Enclose an sae for returns. Mark for the attention of Antoinette L. Sinclair, Gallery Curator. If submitting by email, forward details of website or a selection of images, no larger than IMB per email, to AntoinetteL@oisingallery.com.

Price range €900–€20,000 No of exhibitions annually 8

Oriel Gallery

17 Clare Street, Dublin 2

T 01 6763410

F 01 6763410

E oriel@eircom.net

W www.theoriel.com

Opened in 1968, specializing in Irish works from the eighteenth to the twenty-first centuries. The oldest independent gallery in Ireland. The Origin Gallery

83 Harcourt Street, Dublin 2

T of 4785159 F 01 4785826

E theorigingallery@gmail.com

Contact Dr Noelle Campbell Sharp

Established 12 years ago. Has launched the careers of several emerging artists including Martin Finnin, Mark Redden, Linda Graham and Brian Harte. Includes a private members' bar.

Price range €500-€25,000 No of exhibitions anually 8 or 9

Original Print Gallery

4 Temple Bar, Dublin 2 T of 6773657 E info@originalprint.ie

W www.originalprint.ie

In the Temple Bar area of Dublin, a contemporary, custom-built space, exhibiting framed and unframed original prints. The gallery has been in operation for over ten years. Showcases Irish and international printmakers including Mary Fitzgerald, Stephen Lawlor, Margaret McLoughlin, Richard Gorman, Maria Simonds-Gooding, Christian Bozon, Albert Irvin and Anthony Frost. Submission Policy Artists should send a CD-Rom with images, CV and artist's statement, or email the same. Exclusively represent printmakers, predominently Irish, but also international. Price range €30-€1500 unframed

OSB Gallery Ltd

Church Hill, Enniskerry, County Wicklow

No of exhibitions annually 6-8, as well as

exhibitions of artists' work from the gallery's portfolio of over 150 artists. Twice a year the

Black Church Print Studio holds group exhibitions.

T of 2862065 F 01 2862075

E info@osbgallery.com

W www.osbgallery.com

Exhibits contemporary Irish art, including sculpture and ceramics, from new and established artists.

Pallas Studios

17 Foley Street, Dublin 1 T 01 8561404 E info@pallasstudios.org

W www.pallasstudios.org Founded in 1996 to facilitate artist-initiated projects/exhibitions in urban settings. Opened a dedicated gallery space in 2007 and has studio facilities for thirty artists in four buildings.

Submission Policy Only send proposals via email. No of exhibitions annually 8

Paul Kane Gallery

6 Merrion Square, Dublin 2 W www.thepaulkanegallery.com Opened in 1997. Exhibits dynamic, emerging and established contemporary artists including Marc Reilly, Megan Eustace, Colin Crotty and Leonard Sheil.

People's Art Hall

Unit 28B, Top Floor, Powerscourt Tower, Dublin 2 T of 6725432 General gallery selling paintings and drawings.

People's Gallery

2 Shear Street, Cork

T 021 4223577

E thepeoplesgallery@eircom.net

W www.thepeoplesgallery.tripod.com

Deals in traditional and contemporary paintings, drawings, prints and sculpture from national and international artists.

Rowan Tree

Glanmore Lake, Lauragh, Killarney, County Kerry T 064 83982

E healysmits@hotmail.com

W www.deborahhealy.com

Originally founded in 1996 at The Old Forge, Ardea, Tuosist by Joop Smits and Deborah Healy, Rowan Tree is a collective of independent artists living and working in south-west Ireland. Artists exhibited include Matt Lamb, John Kingerlee, Lili le Cain, Thomas Kay, Dermot McCarthy, Con Kelleher, Christopher O'Connor, Joan Hodes, Joop Smits and Deborah Healy. Visitors welcome, by appointment. Submission Policy Artists by invitation or personal contact.

Price range €100-€50,000

No of exhibitions annually 4 (and by appointment year round)

Rubicon Gallery

10 St. Stephens Green, Dublin 2

T 01 6708055

E info@rubicongallery.ie

W www.rubicongallery.ie

Contact Iseult Dunne (Director) and Cate Kelliher

Opened in 1995 with the core objective of enabling contemporary Irish and international artists to realize projects in all media in the gallery

venue or elsewhere. Produces 4–6 publications and participates in international art fairs, commissioning new works and introducing Irish artists in Europe and the rest of the world.

No of exhibitions annually 10 (mostly solo-projects and some curated events).

Sandford Gallery

Ranelagh, Dublin 6
T 01 4910320
F 087 2361132
E art@sandfordgallery.net
W www.sandfsordgallery.net
Shows contemporary Irish art.

Sarah Walker

T 027 70387
F 027 70378
E sarahwalker@eircom.net
W www.sarahwalker.ie
Founded 2000, mostly showing the owner's
paintings but with one exhibition in the summer
for various artists. Past exhibitors include Frieda

The Pier, Castletownbere, County Cork

paintings but with one exhibition in the summer for various artists. Past exhibitors include Frieda Meaney, Monika Fabig, Margaret Fitzgibbon, Rachel Parry, Esther Balazs and Corban Walker. Submission Policy Interested in artists submitting ideas for installation work.

Price range €400-€11,000

No of exhibitions annually I exhibition with opening, otherwise permanent display of Sarah Walker.

Cost to hire or rent Negotiable

Siopa Cill Rialaig Gallery

Ballinskelligs, County Kerry, Ireland T o66 9479277 F o66 9479324 E cillrialaigarts@esatclear.ie Contact Mary O'Connor

Impressive round stone thatched building in much visited Ballinskelligs. Only work by previous Cill Rialaig Retreat residents exhibited.

Submission Policy Leading Irish and international artists represented in association with Cill Rialaig Artists Retreat.

Price range €200–€20,000 No of exhibitions annually 6

Solo Arte

Coolgower, Tramore Road, Waterford City
T 051 355758
F 051 355758
E info@soloarte.ie
W www.soloarte.ie

Gallery specializing in contemporary Irish and European art.

Solomon Gallery

Powerscourt Townhouse, South William Street, Dublin 2

T 01 6794237

E info@solomongallery.com

W www.solomongallery.com

Contact Tara Murphy

Established in 1981, one of Ireland's leading contemporary art galleries and dealers in important Irish twentieth-century paintings and sculpture. Represents Irish and international artists working primarily in a figurative style. Solo exhibitions are mounted every three weeks and two annual group shows are held in August and December. In addition to hosting regular exhibitions, Solomon also deals in fine Irish period paintings and sculpture, including work by Jack B. Yeats, Louis le Brocquy HRHA, William Scott and F.E. McWilliam. Submission Policy Welcomes artist applications. Send six slides/photographs, CV, statement and catalogues.

Price range €700-€250,000 No of exhibitions annually 14

Spiller Art

19 Sandymount Green, Dublin 4 E info@spillerart.com W www.spillerart.com

Runs programmes of changing shows throughout the year. Also holds a permanent stock by artists such as Brian Ballard, George Campbell, George Russell, Graham Knuttel, James H. Craig, Kenneth Webb, Maurice C. Wilks, Norah McGuinness and Tony O'Malley.

Stone Gallery

70 Pearse Street, Dublin 2 T 01 6711020 F 01 6752166 E art@stonegallery.ie W www.stonegallery.ie Contact Anne Hendrick

Opened in 2005. Actively provides a platform for, and cultivates the work of, emerging artists as well as mid-career and international artists, through participation in both group and solo shows. Focuses on painting, drawing and photography with occasional video installations and sculpture. Submission Policy No unsolicited submissions.

Price range €150-€10,000 No of exhibitions annually 10

Taylor Galleries

16 Kildare Street, Dublin 2

T of 6766055

F oi 6766642

Gallery dealing in contemporary drawings, paintings and prints, as well as sculpture and ceramics. Featured artists include William Crozier, Louis Le Brocquy, Sean McSweeny, Patrick Scott and Charles Tyrrell.

Temple Bar Gallery and Studios

5-9 Temple Bar, Dublin 2

T 01 6710073

F 01 6777527

E info@templebargallery.com

W www.templebargallery.com

Centrally located in Dublin's Cultural Quarter, dedicated to the practice and promotion of contemporary visual art. Organisation was established by artists in its present location in 1983 and has since developed into one of the largest gallery and studio complexes in Europe. There are 29 studios occupied by artists either as full studio members or on short term projects.

Submission Policy Generally does not welcome submissions from artists for the gallery programme. Applications to studio spaces are invited on an annual basis usually advertised in March/April with the deadline in May.

No of exhibitions annually 8

Tigh Fill

MacCurtain Street, Cork

T 021 4509274

E admin@cwpc.ie

W www.tighfili.com

Split into a main exhibition space, Gallery 9, and a second alternative space, Shrine 9, which jointly host around 18 exhibitions per year. Main gallery can show large sculpture while the alternative space is used particularly for new media and soundworks. Gallery exhibits both established and emerging artists from Ireland and throughout Europe.

No of exhibitions annually 18

Tuckmill Gallery

Dublin Road, Naas, County Kildare

T 045 879761

W www.kildare.ie/arts/housing/tuckmill-gallery.htm Shows painting, sculpture, wood-turning and ceramics by local artists. Annual open exhibition held each mid-November, plus one solo exhibition a year.

Waldock Gallery

Blackrock Shopping Centre,

County Dublin

T 01 2781861

F 01 2781861

E sales@irishpaintings.com

W www.irishpaintings.com

Over twenty years' experience of selling professional contemporary Irish paintings.

Waterfront Gallery

Rosses Point, Sligo

T 071 9151688

E waterfrontart@eircom.net

W www.waterfrontart.com

Opened in 2004, showing an eclectic range of work by local, national and international artists.

Western Light Art Gallery

The Sandybanks, Keel, Achill Island,

County Mayo

T 098 43325

E cannonphoto@eircom.net

W www.art-gallery-ireland.com

Opened in 1989 and represents artists including John Behan RHA, Rene Boell, Alexandra Van Tuyll, Alex McKenna, Sean Cannon (photography) and William Mulhall. The gallery has become know for landscape work from west Mayo.

Submission Policy Send CV, list of exhibitions and images on CD.

Price range To €2,500

No of exhibitions annually Continuous group exhibition from Easter to November.

William Frank Gallery

91 Monkstown Road, Monkstown Village

T 01 214 8547

E info@williamfrankgallery.com

W www.williamfrankgallery.com

Specializes in contemporary and traditional paintings, drawing and sculpture.

Yello Gallery

35 Kildare Street, Dublin 2

T 01 6449459

F or 6449459

E oliversears@yellogallery.net

W www.yellogallery.net

Opened in 1992, specializing in modern and contemporary Irish and international art. Stocks wide range of prints as well as paintings by both emerging and established artists. Will also source works on request.

Public museums and galleries

Culture clashes: are museums where artists go to die?

Iwona Blazwick

Museums: cemeteries! ... Identical, surely in the sinister promiscuity of so many bodies unknown to one another. Museums: public dormitories where one lies forever beside hated or unknown beings. Museums: absurd abattoirs of painters and sculptors ferociously slaughtering each other ... (cemeteries of empty exertion. Calvaries of crucified dreams, registries of aborted beginnings!). ... Smash them...pitilessly.

- F. T. Marinetti, 'Futurist Manifesto', Le Figaro, 20 February 1909

A hundred years on from the Futurists' demand for their destruction, museums of art are more ubiquitous and powerful than ever before. Ranked as one of the most successful brands in the world. Tate joins the Guggenheim in Bilbao, the Centre Georges Pompidou in Paris and MoMA in New York, as not only a repository of art but also an urban spectacle, a destination for mass entertainment and a source of cultural capital. Museums are platforms for corporate promotions and political ambitions. They not only bestow value on art, but they also generate revenues from it. Why should artists have anything to do with them?

Artists' love-hate relationship with the institution stems as much from being left out of the 'absurd abattoir' as being made part of it. The modern museum collects art and arranges it into a narrative sequence often chronological, sometimes thematic. It also presents high-profile temporary exhibitions, increasingly of living artists. And so it makes history, as much by its exclusions as its inclusions. Until the end of the twentieth century, many artists who happened to be female, of colour, living outside the West, or just not making objects, were absented from the 'cemeteries of empty exertion' and consequently found themselves also absent from art history and from the art market.

But museums and public galleries haven't stood still. Fired by the assaults of the avantgarde they have grown ever more dynamic and central to the life of art. So what makes them important for artists?

Inspiration and influence

To enter the modern art museum is to move across time and space, to revel in aesthetic, phenomenological and even erotic sensations that are encapsulated both in individual works of art and the spaces between them. A museum's collection also immerses us in historical, political and mythic narratives. These might generate intense stimulation but also provocation, even revulsion. Critical judgments, assessments of technique and wrestling with meaning must all surely be part of the work of the artist immeasurably enhanced by an encounter with the history of art.

Finding love

We rarely encounter works of art in isolation. Rather, they are experienced in relation to each other in a series of juxtapositions. These can be very contentious - why is this work hung next to that work and what do they say about each other? The display of a collection or the installation of a show is like arranging words in a sentence: curators create meta-narratives that may enhance - or distort - the meaning of works of art. Often these arrangements reveal completely unexpected qualities in works of art by different practitioners.

These juxtapositions also include the architecture of the museum - its windows, doorways, corridors and stairwells, each of which impact on our experience of the work. Finally, we see works of art in juxtaposition with other people. Museums are great places to look at each other, which is why they are popular cruising destinations and great places to pick people up.

Being loved and understood

To have your work acquired by a museum is perhaps the most powerful endorsement of its value, not just in monetary but also in symbolic terms. Entering a collection marks entry into a grand narrative.

Museums are also scientific institutions. dedicated to the conservation and study of the objects of art. Conservators analyse the effects of environment, movement and time on the art object and will go to extraordinary lengths to guarantee its preservation for posterity and to restore it lovingly to perfection in the face of damage or old age.

To have a work in a museum collection is also to offer it to art-historical appraisal through indexes and catalogue entries. Curators are often scholars who use expert art-historical and technical knowledge to investigate the origin, technique and provenance of a work. Artists can describe their creative processes, motivations and intentions through exhibition guides and publications. Conversely, these interpretive tools offer invaluable research materials to artists investigating individuals, themes and movements across time.

Having room to breathe

Since the founding of what some would call the first museum of modern art, the Louvre. museum architecture has mutated from palace to pavilion, from architect's signature piece to factory conversion. Throughout the twentieth century there has also been a shift in art from offering a picture of the world to creating a world in its own right. Sculpture has expanded into environment, picture-making has mutated into projection. Just as works of art have become bigger, so have public museums and galleries. They are often the only kind of buildings that can physically accommodate works of art that defy domestic space.

It is as a platform for an encounter with the public that is the most vital aspect of the museum or public gallery. When a work of art makes its debut into the exhibition space, it begins a dynamic and ever-changing encounter with the viewer. Arguably the point where a work of art comes to life, it can communicate with an audience far wider than could ever be reached in a studio, private collection or commercial gallery.

Changing the world

The great works of art we can encounter in the museum can move us and inspire profound philosophical meditations on the nature of being and the world around us. Museums are also full of representations. However, the life experience and aesthetic sensibilities of entire sections of society may never surface in their parades of movements and masterpieces. The inclusion of art by those historically left out. by virtue of gender or geography, also offers a moment of recognition to those communities that feel disenfranchized. Not only may they encounter their own view of the world, but they might also find public recognition for an artist from their community.

Making money

A popular misconception about artists is that they don't need to eat. The media and the public are often outraged that an artist has exchanged a work of art for money, in a way that they seldom do in relation to sports, pop or film stars. Nonetheless, most artists struggle to survive through their art. Museums are beneficial in two ways: they both buy works of art and also provide employment.

The most skilled and sensitive handlers of art are artists themselves; most technical teams in museums and galleries are made up of artists. The growth of education departments has also seen artists become educators, working with a range of audiences - from schoolchildren to senior citizens - on interpreting art and using their experience of an exhibition to tap into their own creativity.

Artists also make the best curators. For many, curating, writing and promoting the work of other artists is a way of making art. The operation of a museum or even a small municipal gallery involves many people; not just curators and education staff, but also registrars, technicians, guards, reception staff, accountants, press officers, fund-raisers, editors, designers, archivists and librarians. These positions offer opportunities for being involved in art and enjoying your job, while making a bit of money.

The downside

Even if you are lucky enough to have your work acquired by a museum, there is no guarantee that it might not just languish in its crate, unseen for decades. An artist's oeuvre might be reduced to representing a fleeting moment in the parade of movements - now past - or 'isms' - now unfashionable. Worse still, artists might find their work on display with art they despise. Some may shudder at the interpretations a curator imposes on their art through labels and catalogues, establishing misconceptions for posterity. Others may feel discomfort as they find the art they created to be part of the flux of people and places being suspended in the timeless, placeless vacuum of the white cube or reduced to a trophy for a multinational marketing campaign. The worst of all is being 'de-accessioned' - the fancy euphemism for having your work sold by a museum.

Visitors, too, can experience the downside of museums: they might feel uncomfortable with

the increasingly corporate style of museum architecture or overwhelmed by the throngs who might be just as happy in a shopping mall.

Hope on the horizon

None of this can detract from the fact that museums and public galleries are playing an ever more central role in providing a platform for art in society. In Britain, where museums are free, audiences are expanding exponentially every year. The media are increasingly recognizing that readers and viewers want engaged, knowledgeable criticism and guidance, and not just sensationalism. Politicians are waking up to the fact that there is a substantial economy generated by artists and art institutions, and that ordinary people derive enormous satisfaction from their encounters with contemporary as well as historical art.

Rather than being mausoleums, these spaces can be playgrounds, cruising destinations, laboratories, political platforms, temples of worship, black boxes or white cubes it's up to you.

Iwona Blazwick is the Director of the Whitechapel Gallery, London, and an independent curator and critic.

Public museums and galleries **East Anglia**

Boxfield Gallery

Stevenage Arts and Leisure Centre, Lytton Way, Stevenage, SG1 1RZ

T 01438 242637

F 01438 242342 / 242679

E enquiries@stevenage-leisure.co.uk Part of the Gordon Craig Theatre situated within the Stevenage Leisure Centre complex and opened in 1975. Hosts ten exhibitions per year (suitable for large-scale works and group shows). The smaller Foxer Gallery puts on twelve exhibitions per year (suitable for water-colourists, printmakers and photographers).

Submission Policy Application by portfolio and interview with the Visual Arts Officer. Will show artists of national and local standing, and both retrospective or topical shows.

Talks/Events/Education Outreach to all local schools. Workshop and classes run in studio facilities for all age and skill groups. Also competitions.

Bury St Edmunds Art Gallery

The Market Cross, Bury St Edmunds, IP33 1BT T 01284 762081

E enquiries@burystedmundsartgallery.org W www.burystedmundsartgallery.org A contemporary art gallery in the centre of the market town, situated in a Robert Adam building. Showing changing exhibitions though the year. The shop sells both regional and national makers in jewelry, ceramics, textiles, artist prints and handmade cards.

Talks/Events/Education The exhibition programme is supported by events, talks and workshops related to current exhibition.

Fitzwilliam Museum

Trumpington Street, Cambridge, CB2 1RB T 01223 332900 F 01223 332923 E fitzmuseum-enquiries@lists.cam.ac.uk W www.fitzmuseum.cam.ac.uk Founded in 1816 by the bequest of the Seventh Viscount Fitzwilliam to the University of Cambridge. Houses collections of art and antiquities spanning centuries and civilizations. Highlights include antiquities from Egypt, the Ancient Near East, Greece, Rome and Cyprus;

English and European pottery and glass; sculpture;

Oriental art; Korean ceramics; coins and medals; masterpieces by Domenico Veneziano, Leonardo da Vinci, Titian, Rembrandt, Rubens and Van Dyck; outstanding works by British artists including Gainsborough, Reynolds, Stubbs and Constable; and a collection of twentieth-century art. Runs programme of temporary exhibitions, events, courses and activities for all ages.

Focal Point Gallery

Southend Central Library, Victoria Avenue, Southend-on-Sea, SS2 6EX

T 01702 534108 F 01702 469241

E focalpointgallery@southend.gov.uk

W www.focalpoint.org.uk

Since its opening in 1991, Focal Point Gallery has established itself as an innovative and lively gallery with a regional, national and international profile. The gallery programme has evolved to reflect the changes in practice of artists working with lens-based media within the expanded field of contemporary art. The organisation shows approximately seven exhibitions each year, while the emphasis in the programme is on work that explores new developments in contemporary art and photography, and which challenges traditional definitions of the medium.

Submission Policy Guidelines on submitting a proposal are available on the gallery website. Talks/Events/Education Runs a regular programme of events for adults, children and family groups to accompany exhibitions. These include artists' talks and workshops, film screenings and drop-in events. Free exhibition tours can be arranged by gallery staff for school, college and community groups who book in advance.

Gainsborough's House

46 Gainsborough Street, Sudbury, CO10 2EU T 01787 372958 F 01787 376991

E mail@gainsborough.org

W www.gainsborough.org

The museum and art gallery at the birthplace of Thomas Gainsborough (1727-1788) with an outstanding collection of his paintings, drawings and prints. The House also offers visitors a varied programme of temporary exhibitions. The annual programme includes one or two contemporary exhibitions of work that relate to the collection, its location or the legacy of Gainsborough, as well as contemporary sculpture in the garden. The print

workshop is available to members and runs a year-round programme of printmaking courses. Talks/Events/Education Life classes, children's art workshops and art lectures are held throughout the year.

Gallery at Norwich University College of the Arts

(formerly Norwich Gallery/Project Space), Norwich, NR2 4SN

T 01603 756247

W www.nuca.ac.uk

Temporary exhibitions of contemporary art all year round, featuring national and international artists showing painting, sculpture, photography, video and new media.

Submission Policy Contact the gallery via the university website.

Gwen Raverat Archive

Broughton House Gallery, 98 King Street, Cambridge, CB1 1LN

T 01223 314960

E bhgallery@btconnect.com

W www.broughtonhousegallery.co.uk Founded in 1987. Home of the Gwen Raverat Archive of wood engravings, holding over five hundred prints. Accessible by appointment and invitation only.

Kettle's Yard

Castle Street, Cambridge, CB3 0AQ T 01223 748100 F 01223 324377 E mail@kettlesyard.cam.ac.uk

W www.kettlesyard.co.uk Once the home of Jim Ede, a curator at the Tate Gallery. The house displays Ede's collection, including works by Ben and Winifred Nicholson, Alfred Wallis, Christopher Wood, David Jones, Ioan Miro, Henri Gaudier-Brzeska, Constantin Brancusi, Henry Moore and Barbara Hepworth. Holds regular exhibitions of modern and contemporary art, including a biannual open exhibition of artists working in the Eastern region. Submission Policy Include an outline of proposed project together with examples of work and an sae for return of material.

Talks/Events/Education There is a wide programme of events, open to all. Details on web site. Prices and times vary, some events including regular lunch time talks, are free.

King's Lynn Arts Centre

27-29 King Street, King's Lynn, PE30 1HA

T 01553 779095 F 01553 766834

W www.kingslynnarts.co.uk

Founded in the 1960s, including four main exhibition spaces covering film and video, sculpture, painting, drawing, photography, textiles, ceramics and crafts showcases. There are also workshops in association with the exhibitions, informal art lectures and a Saturday art club. Some annual highlights include the Eastern Open (a competition with cash prizes for artists in East Anglia), King's Lynn Festival and Christmas Crafts Fair.

Letchworth Museum and Art Gallery

Broadway, Letchworth Garden City, SG6 3PF T 01462 685647

F 01462 481879

E letchworth.museum@north-herts.gov.uk

W www.north-herts.gov.uk

Founded in 1914 by the Letchworth Naturalists' Society. Main permanent displays are on archaeology, particularly Iron Age and Roman, and natural history. Has regular temporary displays of works from the museum's fine- and decorative-art collections, and its social history collection. Art collections include the largest holding of works by Camden Town artist William Ratcliffe. Also has a good collection of oils by Margaret Thomas. Decorative art includes glass and ceramics.

Submission Policy Exhibits work in all media except digital and film.

Minories Art Gallery

High Street, Colchester, CO1 1UE T 01206 577067 F 01206 577161 W www.theminories.co.uk Shows contemporary art and sculpture.

Norwich Castle Museum and Art Gallery

Shirehall, Market Avenue, Norwich, NR1 3JQ

T 01603 493625

F 01603 493623

E museums@norfolk.gov.uk

W www.museums.norfolk.gov.uk

One of the city's most famous landmarks, Norwich Castle was built by the Normans as a Royal Palace nine hundred years ago. The gallery houses an important collection of fine art.

Talks/Events/Education Holds regular talks and events connected to exhibitions, some of which are free.

Saffron Walden Museum

Museum Street, Saffron Walden, CB10 1JL

T 01799 510333

F 01799 510333

E museum@uttlesford.gov.uk

W www.saffronwaldenmuseum.org

Founded in 1835. Collections include decorative arts (ceramics and glass), textiles, woodwork, prints, photos and drawings. Limited amount of fine art. Submission Policy Small special exhibition space is programmed two to three years ahead. Art exhibitions tend to have local connections or relevance to collections.

Talks/Events/Education Events held but infrequently; some free (e.g. ceramics workshop).

Sainsbury Centre for Visual Arts

University of East Anglia, Norwich, NR4 7TJ

T 01603 593199 F 01603 591053

E scva@uea.ac.uk

W www.scva.ac.uk

Designed by Sir Norman Foster and opened in 1978, the building is home to three permanent collections of international importance and also affords space for special exhibitions and the delivery of a wide range of educational and public programmes. Some exhibitions are developed by the Sainsbury Centre, some in partnership with other galleries and others by external curators or institutions.

Talks/Events/Education Organizes over one hundred and twenty events a year (some free).

Sir Alfred Munnings Art Museum

Castle House, Castle Hill, Dedham, CO7 6AZ

T 01206 322127

F 01206 322127 W www.siralfredmunnings.co.uk

Sir Alfred Munnings KCVO PRA lived and worked at Castle House from 1919 until his death in 1959. The house has a comprehensive collection of Munnings's work, some of which is housed in his studio.

University of Essex Collection of Latin American Art (UECLAA)

Department of Art History and Theory, University of Essex, Wivenhoe Park, Colchester, CO4 3SQ

T 01206 873971

F 01206 873702

W www.ueclaa.org Founded in 1993, the only public collection in Europe dedicated exclusively to modern and

contemporary Latin American art. The collection comprises over six hundred works by modern and contemporary artists including Carlos Cruz-Diez, Guillermo Kuitca, Roberto Matta, Cildo Meireles, Ana Maria Pacheco, Nadin Ospina, Fernando de Szyszlo, Rufino Tamayo and Mariana Yampolsky. UECLAA Online is a fully-searchable catalogue available to internet users worldwide.

University of Hertfordshire (UH) Galleries

College Lane, Hatfied, AL10 9AB

T 01707 284290

F 01707 285310

E euharts@herts.ac.uk

W www.herts.ac.uk

Founded in 1996, aiming to offer exhibition and publishing opportunities to artists, designers and makers in the early stages of their careers. Collection based on acquisitions from past programming.

Submission Policy Submissions from professional artists and groups welcome after May 2007. Short text and some images sufficient in the first instance.

Talks/Events/Education Currently establishing an education programme.

Visual Arts Ipswich

The Town Hall Galleries, Cornhill, Ipswich, IP1 1DH

T 01473 432863

E visualarts@ipswich.gov.uk

W www.visualarts-ipswich.org.uk

Programmes are hosted across four exhibition spaces, which include exhibitions of contemporary visual arts by practitioners from the area and beyond, community and heritage projects and work showcased by the region's designer makers. Also offers a range of complementary activities and arts provision - Children's Saturday Art Club, drop in activities, and an area for arts resources/ research that also includes an area for refreshment and informal discussion.

Watford Museum

194 Lower High Street, Watford, WD17 2DT T 01923 232297

F 01923 224772

E info@watfordmuseum.org.uk

W www.watfordmuseum.org.uk

Housed in the former Benskins Brewery Mansion and includes the Cassiobury Collection of fine art. A changing programme of exhibitions gives opportunities for local artists to display their work. Submission Policy Opportunities are available for local artists to display and be employed to deliver art workshops and projects.

Talks/Events/Education Active programme includes workshops for children and adults, and talks on local art and history.

East Midlands

20-21 Visual Arts Centre

St John's Church, Church Square, Scunthorpe, **DN156TB**

T 01724 297070

F 01724 297080

E 20-21.epd@northlincs.gov.uk

W www.northlincs.gov.uk/20-21

Founded in 2001 and housed in a converted church. An exhibition centre focusing on contemporary fine art, crafts and design. Has six exhibition spaces including an outdoor sculpture courtvard. The centre also houses a contemporary art and craft shop and cafe.

Submission Policy Welcomes submissions from contemporary artists working in all media. An exhibition request form is available online or from

Talks/Events/Education Continuous programme of events and courses (prices vary).

Alfred East Art Gallery

c/o Coach House, Sheep Street, Kettering, NN16 0AN

T 01536 534274 F 01536 534370

E museum@kettering.gov.uk W www.kettering.gov.uk/gallery

Opened in 1913 with an initial donation of seventy works by Sir Alfred East. Has subsequently expanded its collections to nine hundred works including major collections of East and Thomas Cooper Gotch alongside other local artists, and contemporary art collected between the 1950s and 1980s. Temporary exhibitions by local artists and national touring groups are on display all year as well the permanent collection.

Submission Policy Programmes a year in advance. For terms and conditions, phone or see website.

Brewhouse Gallery

The Old Malthouse, Springfield Road, Grantham, NG31 7BG

T 01476 576703 F 01476 576703

E lmtbrady@aol.com

W www.grantham-online.co.uk/pp/business/ detail.asp?id=20619

A public gallery of painting, sculpture, prints and furniture, as well as commissioned work. Runs art workshops, and community projects in schools, businesses and organizations. Participates in public art including mosaics, mapmaking, textiles, murals and temporary installations. Also offers framing, antique restoration and consultation services.

Burghley

Burghley House, Stamford, PE9 3JY

T 01780 752451

F 01780 480125

E burghley@burghley.co.uk

W www.burghley.co.uk

One of the grandest houses of the Elizabethan age. Includes imposing painted ceilings by Antonio Verrio, over four hundred paintings and an important collection of Japanese porcelain. Submission Policy Burghley's sculpture garden features new exhibitions annually to showcase work from new artists. Burghley also hosts several exhibitions throughout the year for artists working in a variety of media.

Derby Museum and Art Gallery

The Strand, Derby, DE1 1BS

T 01332 641910 F 01332 716670

E exhibitions@derby.gov.uk

W www.visitderby.co.uk

Shows contemporary artists of international, national and regional importance. Work includes digital media, photography, sculpture, textiles, decorative and applied art, contemporary and fine art, together with the museum's reserve collection. Main collections: Joseph Wright of Derby, Derby Porcelains, Military, Natural History, Archaeology, Social History, Egyptology.

Submission Policy Applications welcomed. Email or phone exhibitions team to receive an exhibition proposal form.

Talks/Events/Education Exhibitions are accompanied by talks and lectures for the public, other artists and students. Workshops and related activities for both children and adults. See website for details.

Dianogly Art Gallery

Lakeside Arts Centre, University Park, Nottingham, NG7 2RD T 0115 9513192

F 0115 9513194

W www.lakesidearts.org.uk

The exhibition programme ranges from major historical shows to groundbreaking contemporary installations.

Future Factory

Nottingham Trent University, Dryden Street, Nottingham, NG1 4GG T 0115 8486131

F 0115 8486132

E sam.rose@ntu.ac.uk

W www2.ntu.ac.uk/ntsad/bonington/ Houses the Bonington and 1851 art galleries, as well as the performance venue Powerhouse. The venues present work of multidisciplinary art forms, with emphasis on new media, performance, live art and installation work.

Talks/Events/Education Active education programme. Contact sam.rose@ntu.ac.uk or annette.foster@ntu.ac.uk.

Harley Gallery

Welbeck, Worksop, S80 3LW

T 01909 501700

F 01909 488747

E info@harley-welbeck.co.uk W www.harleygallery.co.uk

Built in 1994 on the site of the original nineteenthcentury gasworks for Welbeck Estate. Includes three gallery spaces, displaying a changing programme of contemporary art and craft, and a museum with select displays of objects from the Portland Collection.

Submission Policy Artists should apply in writing to Lisa Gee (Director).

Leicester City Art Gallery

90 Granby Street, Leicester, LE1 1D] W www.leicester.gov.uk/citygallery Three exhibition spaces, including fine art and crafts. Changing exhibitions programme (twelve shows per year). Programme is balanced to include all art and craft disciplines and aims to show local, regional, national and international work.

Northampton Museum and Art Gallery

Guildhall Road, Northampton, NN1 1DP T 01604 838111

F 01604 83872

E museums@northampton.gov.uk

W www.northampton.gov.uk/museums Founded in 1865. Collections include fifteenthand eighteenth-century Italian and British art, and Oriental and British ceramics.

Submission Policy Any application welcome (only criterion being the enrichment of visitors' experience), but currently oversubscribed. Talks/Events/Education Talks and educational events frequently held and often free, although not specifically aimed at artists. Opportunities for artists and practitioners to lead and/or devise workshops, etc.

Nottingham Contemporary

Weekday Cross, High Pavement, Nottingham E info@nottinghamcontemporary.org W www.nottinghamcontemporary.org Opened in Autumn 2009, this is one of the largest contemporary art spaces in the UK, with four galleries, an auditorium, education space, study centre, café-bar and shop. Hosting four to five major exhibitions a year, bringing the work of the world's most important and exciting contemporary artists to the East Midlands.

Talks/Events/Education Educational activities and events for all ages. See website for details.

Quad Derby

Market Place, Cathedral Quarter, Derby, DE1 3AS

T 01332 285444

E info@derbyquad.co.uk

W www.derbyquad.co.uk

Purpose-built, dynamic regional centre for contemporary visual arts and media. Houses contemporary art gallery spaces, artist residency, cinemas, BFI Mediatheque, hi-tech computer suite, bar, cafe and shop.

Submission Policy The curated programme is booked eighteen months to two years in advance. Contact the gallery for information.

Talks/Events/Education See website for details.

Rugby Art Gallery and Museum

Little Elborow Street, Rugby, CV21 3BZ T 01788 533201

F 01788 533204

E rugbyartgalleryandmuseum@rugby.gov.uk W www.rugbygalleryandmuseum.org.uk Rugby Art Gallery and Museum hosts temporary exhibitions of contemporary visual art and craft, and work from the Rugby Collection of 20th century British Art, which includes pieces by Freud, Lowry, Spencer, Hepworth and Sutherland.

Usher Gallery

Lindum Road, Lincoln, LN2 1NN

T 01522 527980 F 01522 560165

E usher.gallery@lincolnshire.gov.uk Founded in 1926 to house the collection of James Ward Usher and set in the grounds of the Temple Gardens. Includes paintings by J.M.W. Turner, Thomas Girtin, John Piper, L.S. Lowry and Duncan Grant, as well as works by Lincolnshire artists. Since 1999 the Usher Gallery has commissioned annual residencies.

London

176 Gallery / The Zabludowicz Collection

176 Prince of Wales Road, NW5 3PT

T 020 74288940 F 020 74288949

E info@projectspace176.com

W www.zabludowiczcollection.com

A privately funded contemporary art collection, managed by The Zabludowicz Art Trust. Founded in 1995 and currently comprises over 1,000 works by more than 350 contemporary artists from 33 countries. The Collection is one of the first in the UK to focus on emerging global artists of the late 20th and 21st centuries. 176 is the first time the Collection has been opened to the public, though countless international museums and institutions have borrowed works for exhibitions large and small - from the UK to Israel, America, and east and west Europe.

Talks/Events/Education Regular events and a project space. See website for details.

Architectural Association

36 Bedford Square, London, WC1B 3ES

T 020 78874000

F 020 74140782 E press@aaschool.ac.uk

W www.aaschool.ac.uk

Annually hosts five main gallery exhibitions, ten smaller exhibitions in its other exhibition spaces, and an end-of-year show, 'Projects Review' in July. Exhibitions primarily focus on current debate within the architectural and design world and themes relating to projects being undertaken at the school. All exhibitions are open to the public and there is no admission fee.

Submission Policy Artists should have an architectural direction or concern. Applications in writing only. Do not include original material. Talks/Events/Education Each exhibition has related lectures and events, which are free to attend and publicized online.

Arts Gallery

University of the Arts London, 65 Davies Street, London, W1K 5DA

T 020 75148083

F 020 7514 8179

E gallery@arts.ac.uk

W www.arts.ac.uk

Exists to promote the work of alumni of University of the Arts London. Primary emphasis on those who have been practising for at least two years since graduation. Aims to reflect the diversity of practice across the Colleges of the University and to remain at the cutting edge of art and design. Opened in 1993, underwent major refurbishment in summer 2006.

Submission Policy To make an application to exhibit, contact the gallery for a proposal application form.

Talks/Events/Education Public talks by exhibitors are held to coincide with most exhibitions.

Austrian Cultural Forum London

28 Rutland Gate, London, SW7 1PQ

T 020 75848653

F 020 72250470

E culture@austria.org.uk

W www.austria.org.uk/culture

Founded in 1956, the Austrian Cultural Forum in London promotes cultural contacts between the UK and Austria by organizing events and supporting artists and projects in the fields of the visual arts, music, performing arts, literature and film. Also runs academic symposia and public discussions. Talks/Events/Education If not stated otherwise, events at the Austrian Cultural Forum London are free.

Bankside Gallery

48 Hopton Street, London, SE1 9JH

T 020 79287521

F 020 79282820

E info@banksidegallery.com

W www.banksidegallery.com

The gallery of the Royal Watercolour Society and the Royal Society of Painter-Printmakers. Runs changing exhibitions featuring contemporary watercolours and prints by members of both societies, as well as work by invited guests in a variety of media, including video installation, photography and oil painting.

Submission Policy Elections for both Societies take place in February/March each year. Contact the Gallery for further details. The Royal Watercolour Society organizes an annual open watercolour

competition called 21st Century Watercolour in February. Successful entries of water-based paintings on paper will be shown at Bankside Gallery and successful applicants will be invited to apply for election to the Royal Watercolour Society. Talks/Events/Education Holds workshops, talks, lectures and demonstrations, free to friends of the gallery. See website for details.

Barbican Art Gallery

Silk Street, London, EC2Y 8DS T 020 76384141 E info@barbican.org.uk W www.barbican.org.uk/artgallery Europe's largest multi-arts and conference venue, with a regularly changing exhibitions programme backed by talks and workshops. Talks/Events/Education See website.

Beaconsfield

22 Newport Street, Vauxhall, London, SE11 6AY T 020 75826465 F 020 75826486 E info@beaconsfield.ltd.uk W www.beaconsfield.ltd.uk Founded in 1994, an independent, commissioning organization and artist-led space for contemporary

Submission Policy Send artist CV and images of work by post or email.

Talks/Events/Education Organizes talks and events and maintains links within higher education and with local schools.

50 Finsbury Square, London, EC2A 1HD

Bloomberg SPACE

T 020 73307959 E gallery@bloomberg.net W www.bloomberg.com Founded in 2002. Not a conventional corporate art collection, but rather a dynamic space dedicated to commissioning and exhibiting contemporary art. Submission Policy Programmed by three independent freelance curators. Does not accept open submissions.

Talks/Events/Education Every exhibition is accompanied by an events programme, free and open to all.

Bow Arts Trust and Nunnery Gallery

181-183 Bow Road, London, E3 2SJ T 020 75381719 F 020 89807770 E info@bowarts.com

W www.bowarts.com

Bow Arts Trust was founded in 1995 as an Educational Arts Charity. The Nunnery Gallery is a contemporary project space that initiates and develops projects that reflect and address issues in contemporary art, and in doing so works with a range of artists, curators, writers and arts organizations. Holds approximately five exhibitions per year including a guest-curated in-house summer show. Previous curators include Mo Mowlam, David Dimbleby and Graham Norton. It is available for hire for a variety of functions. Submission Policy Gallery proposals and applications are required eight to twelve months before the projected start date. Include images, biographies, a clear outline of show and a clear and realistic budget structure.

Talks/Events/Education Free educational events, seminars and talks usually accompany each show in the gallery. Occasional skills-sharing workshops for local artists.

Great Russell Street, London, WC1H 8DG

British Museum

T 020 73238000 E information@thebritishmuseum.org W www.thebritishmuseum.org Founded in 1753, the first national public museum in the world. From the outset its collection was made available to every citizen, to all 'studious and curious' people regardless of rank or status, free of charge. Its role is to display the world's great civilizations and cultures, and to tell the story of human achievement throughout its ages. Its collections include archaeological and ethnographic material, prints and drawings and coins and medals.

Submission Policy The museum does show and collect work by living artists through the Department of Prints and Drawings and Africa, Oceania and the Americas. It does not welcome submissions direct from artists, however. Talks/Events/Education Runs a full education programme that covers all aspects of its collections. Many events are free.

Brunei Gallery

School of Oriental and African Studies. Thornhaugh Street, London, WC1H 0XG T 020 78984023 / 4026 E gallery@soas.ac.uk W www.soas.ac.uk/gallery Founded in 1995 and run as a non-commercial gallery. As part of the School of Oriental and

African Studies (University of London), Europe's leading centre for the study of Asia and Africa, the gallery is dedicated to showing work of and from Asia and Africa, of both a historical and contemporary nature, through a programme of changing exhibitions.

Cafe Gallery Projects London

Cafe Gallery - Centre of Southwark Park, Dilston Grove, London, SE16 2UA

T 020 72371230

E cgp.mail@virgin.net

W www.cafegalleryprojects.org

Founded in 1984, a major southeast London artist-led exhibition space. It was rebuilt in 2000 with money from the National Lottery. Dilston Grove, a space for installation, site-specific and experimental art, is closed for repairs and due to re-open in 2010. Cafe Gallery Projects London are administered by the Bermondsey Artists' Group. All exhibitions and events are free.

Submission Policy Unsolicited applications are viewed at the end of September. There is an unselected open exhibition every November/ December.

Talks/Events/Education Holds artists talks and has a varied education programme. Information available on the website.

Camden Arts Centre

Arkwright Road, London, NW3 6DG

T 020 74725500 F 020 74725501

E info@camdenartscentre.org

W www.camdenartscentre.org

A centre for contemporary visual arts and art education, comprising three gallery spaces and three studios, where visitors are invited to actively engage with art, artists and ideas through a frequently changing programme of exhibitions and education. The centre is housed in a grade II-listed building that began life in 1898 as a library and was converted into an arts centre in 1964. Submission Policy Proposals from artists are

welcome although majority of exhibitions and residencies arise from direct invitations to artists and curators.

Talks/Events/Education Full programme of courses, talks and events. For more information see the website or contact by phone.

CHELSEA space

Chelsea College of Art & Design, 16 John Islip Street, Millbank, London, SW1P 4JU

T 020 75146000 ext.3710 Ed.s.smith@chelsea.arts.ac.uk W www.chelseaspace.org

Opened in 2005 and set within Chelsea College of Art & Design's campus next to Tate Britain, CHELSEA Space is a research development centre where invited contemporary art and design professionals are encouraged to work on experimental curatorial projects that may not otherwise be realised. The programme is international and interdisciplinary covering art design and popular culture. The emphasis is on curatorial experimentation, the exposure of process and ideas, and re-readings of artworks and archives and their re-presentation for contemporary audiences.

Submission Policy Does not accept submissions from artists.

Talks/Events/Education Regular public events including free talks, concerts.

Chisenhale Gallery

64 Chisenhale Road, London, E3 5QZ

T 020 89814518

F 020 89807169

E mail@chisenhale.org.uk

W www.chisenhale.org.uk

Founded in 1986. One of London's most important public spaces for contemporary art, in a converted factory offering 2,500 sq. ft of space with a dedicated education studio. A charitable organization whose mission is to encourage and promote innovation and experimentation in contemporary visual arts and art education. Organizes five solo exhibitions each year from British and international artists.

Submission Policy Unsolicited proposals are very rarely taken up as part of the Director's gallery programme.

Talks/Events/Education Organizes free talks, events and conferences alongside each exhibition and education project.

Courtauld Institute of Art Gallery

Somerset House, Strand, London, WC2R ORN T 020 78482526

F 020 78482589

E galleryinfo@courtauld.ac.uk

W www.courtauld.ac.uk

Among the most important small collections in Britain, including world-famous Impressionist and Post-Impressionist paintings, as well as Old Master paintings, sculpture and decorative arts from the fourteenth to twentieth centuries.

Founded in 1932 and housed at Somerset House, one of the finest eighteenth-century buildings in London. Resources include a book library and two image libraries of national significance. Submission Policy Does not show living artists' work apart from well-known or successful comtemporary artists.

Talks/Events/Education Regular talks, lectures, and activities are often free on purchasing an admission ticket.

Croydon Museum Service

Clocktower, Katharine Street, Croydon, CR9 1ET T 020 82531022 F 020 82531003

E museum@croydon.gov.uk

W www.croydon.gov.uk/clocktower A multipurpose cultural centre with three galleries, including the Riesco Gallery of Chinese Pottery and Porcelain and a gallery for programmed temporary exhibitions. Also manages a programme of changing exhibitions by local artists in the café-gallery.

Czech Centre London

13 Harley Street, London, W1G 9QG T 020 73075180 F 020 73233709 E info@czechcentre.org.uk W www.czechcentres.cz/london Organizes frequent exhibitions of Czech art.

Design Museum

Shad Thames, London, SE1 2YD T 0870 9099009 F 0870 9091909 E info@designmuseum.org W www.designmuseum.org Leading museum of design, fashion and architecture. Constantly changing programme of exhibitions, ranging from design history to innovations in contemporary design. Talks/Events/Education Hosts talks by some of the world's leading designers and architects, from Jonathan Ive to Zaha Hadid.

Dulwich Picture Gallery

Gallery Road, London, SE21 7AD T 020 86935254 F 020 82998700 E info@dulwichpicturegallery.org.uk W www.dulwichpicturegallery.org.uk Founded in 1811. Houses a collection of seventeenth- and eighteenth-century Old Masters, including Rembrandt, Poussin, Claude, Rubens, Murillo, Van Dyck, Watteau and Gainsborough, collected by the King of Poland in the 1790s. When Poland was partitioned, Dulwich Picture Gallery was designed for the collection by the famed Regency architect Sir John Soane. The gallery houses loan exhibitions as well as the permanent collection.

Submission Policy Has occasional exhibitions of living artists (Lucian Freud, Paula Rego, Howard Hodgkin, Eileen Cooper RA, and Humphrey Ocean RA for example). From time to time also has an artist-in-residence, who reinterprets the collection and teaches.

Talks/Events/Education The education department runs many courses including masterclasses.

Estorick Collection of Modern Italian Art

39a Canonbury Square, London, N1 2AN T 020 77049522

F 020 77049531

E curator@estorickcollection.com

W www.estorickcollection.com

Formed by Eric and Salome Estorick during the 1950s and housed in a converted Georgian villa, the collection has been open to the public since 1998. Known internationally for its core of Futurist works, as well as figurative painting and sculpture from 1895 to the 1950s. Artists include Balla, Boccioni, Carra, Russolo, Severini, de Chirico, Modigliani and Morandi. Also runs a programme of temporary exhibitions, all connected to the permanent collection.

Submission Policy Does not accept applications from contemporary artists.

Talks/Events/Education See website for programme of talks.

Fashion Space Gallery

20 John Princes Street, London, W1G 0BJ T 020 75142998 / 75147701 F 020 75148388 E pr@fashion.arts.ac.uk W www.fashion.arts.ac.uk

A contemporary exhibition space located in the heart of London's West End. Based within London College of Fashion, the gallery runs a programme of exhibitions by students, staff and visiting artists. Displays of fashion, photography and fine art can be visited for free all year round.

Submission Policy Artists' exhibition proposals are judged upon individual merit and should be submitted to the Events Office for consideration.

Fleming Collection

13 Berkeley Street, London, W1J 8DU

T 020 74095730

F 020 74095601

E flemingcollection@ffandp.com

W www.flemingcollection.co.uk

Opened to the public in 2002, consisting of works by Scottish artists from 1770 to the present day. Includes works by early nineteenth-century artists, the Glasgow Boys, the Scottish Colourists, the Edinburgh School and many contemporary Scottish names. Holds four exhibitions a year drawn from the collection as well as loans from public and private collections.

Talks/Events/Education Regular public lectures and events. There is also a Friends Association and

Patrons Group.

Foundling Museum

40 Brunswick Square, London, WC1N 1AZ

T 020 78413600

F 020 78413601

E enquiries@foundlingmuseum.org.uk

W www.foundlingmuseum.org.uk

London's first public art gallery and the precursor to the Royal Academy, created by William Hogarth in Thomas Coram's Foundling Hospital in the eighteenth century. The collection contains works by Hogarth, Reynolds, Gainsborough, Wilson, Hayman, Highmore, Roubiliac and Rysbrack, displayed as they would have been seen by visitors to the hospital in the 1700s. Permanent social history exhibition and temporary exhibitions include contemporary artists.

Submission Policy Submissions welcome which are relevant to Museum's history or collections (otherwise will not be considered). Cafe available

for more general work.

Talks/Events/Education A variety of talks, workshops, concerts and other events, some of which are free. Details can be found in "What's on" leaflet.

Geffrye Museum

136 Kingsland Road, Shoreditch, London, E2 8EA

T 020 77399893

F 020 77295647

E info@geffrye-museum.org.uk

W www.geffrye-museum.org.uk

Established in 1914, the museum's specialist area of research is middle-class domestic interiors and gardens. It presents the history of English interiors from 1600 to the present day through a chronological sequence of period rooms

containing furniture, paintings and decorative arts. Also has a series of period gardens.

Gilbert Collection

Somerset House, Strand, London, WC2R 1LA

T 020 74209400

F 020 74209440

W www.gilbert-collection.org.uk

Opened in 2000. Comprises gifts given to the nation by the late Sir Arthur Gilbert, including fine examples of silver snuffboxes Italian mosaics. Also holds related temporary exhibitions.

Talks/Events/Education Gallery talks held each Thursday from 1.15 p.m.to 1.35 p.m.(free with admission). For information on other educational events, call 020 74209406 or email education@ somerset-house.org.uk.

Goethe-Institut London

50 Princes Gate, Exhibition Road, London, SW7 2PH

T 020 75964000

F 020 75940240

E arts@london.goethe.org

W www.goethe.de/london

The Goethe-Institut is the cultural institute of the Federal Republic of Germany with a global reach. Promotes knowledge of the German language abroad and fosters international cultural cooperation. The gallery at Hugo's Restaurant focuses on young German photography. Also displays films and video installations on the in-house cinema screen.

Submission Policy Focus on photographic works with a strong German element. A clear link to the institute's key themes is necessary.

Talks/Events/Education Frequently invites artists for panel discussions and artist talks. Admission is usually f_3 .

Guildhall Art Gallery

Guildhall Yard, London, EC2P 2EJ

T 020 73323700

F 020 73323342

E guildhall.artgallery@cityoflondon.gov.uk

W www.guildhall-art-gallery.org.uk

Originally founded in 1885 to house the City of London's art collection. A new gallery opened in 1999. Holds collections of Pre-Raphaelite works and images of London and its people from the sixteenth century to the present. Now specializes in London-related material.

Talks/Events/Education For education information phone 020 73321632.

Hayward Gallery

Belvedere Road, London, SE1 8XX T 0871 6632501

E customer@southbankcentre.co.uk

W www.hayward.org.uk

Opened in 1968. An icon of 1960s brutalist architecture at the centre of London's Southbank Centre. In addition to its programme of four to five contemporary exhibitions each year, the gallery commissions new work.

Talks/Events/Education A creative programme of talks and events runs alongside each exhibition.

Hermitage Rooms at Somerset House

Somerset House, Strand, London, WC2R 1LA

T 020 78454600 F 020 78454637

W www.hermitagerooms.org.uk

Opened in 2000 and now administered by the Courtauld, the first exhibition space to be created in the West to show rotating exhibitions of works from the collections of the State Hermitage Museum in St Petersburg.

Talks/Events/Education Gallery talks each Friday from 1.15 p. m to 1.35 p.m.(free with admission). For further information, call 020 74209406 or email education@somerset-house.org.uk.

Imperial War Museum

Lambeth Road, London, SE1 6HZ

T 020 7416 5320/1

F 020 7416 5409 E art@iwm.org.uk

W www.iwm.org.uk

The national museum of conflict involving Britain and the Commonwealth since 1914. Founded in 1917, the museum seeks to provide for, and to encourage, the study and understanding of the history of modern war. The collections include one hundred and twenty million feet of cine film, thirty thousand posters and some of the nation's best-known twentieth-century paintings.

Submission Policy The Artists Records Committee commissions work on specific projects.

Talks/Events/Education Hosts a varied programme of talks and events. For details visit website or call 020 74165320.

Institute of Contemporary Arts (ICA)

The Mall, London, SW1Y 5AH
T 020 79300493
E exhibit@ica.org.uk

W www.ica.org.uk

A multi-disciplinary arts centre; the home of

artistic and cultural thinking and presentation of contemporary arts across all its forms. It houses two galleries, two cinemas, a theatre, bookshop, education resources, café and bar and dedicated education spac. Founded 60 years ago, with a reputation for presenting many radical exhibitions, artists, films and musicians. Entrance to galleries, bookshop, café and bar events is free of charge before 11pm.

Institute of International Visual Arts (inIVA)

Rivington Place, London, EC2A 3BE

T 020 77299616

F 020 77299509

E institute@iniva.org

W www.iniva.org

Since it was established in 1994, inIVA has developed and produced a diverse portfolio of projects that have engaged audiences throughout the UK and worldwide in a creative dialogue with contemporary art. Creates exhibitions and publications, as well as multimedia, education and research projects designed to bring the work of artists from culturally diverse backgrounds to the attention of the widest possible public. Submission Policy Proposals for education or research projects should be submitted to the projects curator. Include details of the nature of the proposed project and a brief synopsis (no more than one page). If applicable, also include a statement on artist's practice (no more than one page), potential or identified collaborators, participants and audience, biographical information (no more than one page) and any supporting material (text, image, audio and/or

Iveagh Bequest

visual).

Kenwood House, Hampstead Lane, London, NW3 7IR

T 020 84381286

F 020 76540172

W www.english-heritage.org.uk
Founded in 1827. The gift of Arthur Cecil
Guinness to the nation. The grade I-listed Adam
building contains Guinness's collection of
masters, including works by Rembrandt, Vermeer,
Gainsborough, Turner, Constable, Van Dyck and
Reynolds.

Jewish Museum

Raymond Burton House, 129–131 Albert Street, London, NW1 7NB T 020 72841997 F 020 72679008

E admin@iewishmuseum.org.uk

W www.jewishmuseum.org.uk

Founded in 1932. Moved to Camden location in 1995 and underwent major redevelopment to enlarge the space in 2009. The art collection includes Jewish ceremonial art and a collection of paintings, prints and drawings.

Leighton House Museum

12 Holland Park Road, London, W14 8LZ

T 020 76023316

F 020 73712467

E museums@rbkc.gov.uk

W www.rbkc.gov.uk/leightonhousemuseum Former home of the eminent Victorian artist and president of the Royal Academy, Frederic, Lord Leighton. House includes a substantial collection of Leighton's work as well as important examples by his contemporaries including G.F. Watts, Edward Burne-Jones and Waterhouse. A temporary exhibition gallery is used for a programme of exhibitions exploring Victorian painting, design and architecture and Leighton's interest in the art of the Middle East. Work by contemporary artists is also shown.

Submission Policy Work exhibited by living artists exploring themes of 'East meets West' or by artists from the Middle East.

Talks/Events/Education Study days, life-drawing classes and educational events held regularly. Charges apply.

London Jewish Cultural Centre

Ivy House, 94-96 North End Road, London,

NW117HU

T 020 84575000

F 020 84575024

E admin@ljcc.org.uk

W www.ljcc.org.uk

Hosts exhibitions as part of cultural and educational programmes aimed at a broad audience of Jews and non-Jews, encouraging interfaith and inter-cultural dialogue and activities.

Talks/Events/Education Holds events on most Tuesdays and Thursdays (usually cost f_5). Also runs mid-week courses.

London Print Studio Gallery

425 Harrow Road, London, W10 4RE T 020 89693247 E info@londonprintstudio.org.uk W www.londonprintstudio.org.uk Promotes the graphic arts in both traditional and innovative media. Presents programmes of projects and exhibitions that reflect the cultural diversity of London.

National Gallery

Trafalgar Square, London, WC2N 5DN T 020 77472885

F 020 77472423

E information@ng-london.org.uk

W www.nationalgallery.org.uk

In April 1824 the House of Commons agreed to pay \$57,000 for the picture collection of the banker John Julius Angerstein and in 1831 decided to build a permanent home for the gallery in Trafalgar Square. The permanent collection spans the period from about 1250 to 1900 and consists of western European paintings. The entire permanent collection and long-term loans are illustrated and described in the collection online. Also hosts many exhibitions.

National Maritime Museum

Park Row, Greenwich, London, SE10 9NF T 020 83126565

F 020 83126632

W www.nmm.ac.uk

Opened in 1937. A museum celebrating Britain's seagoing history. Includes an extensive collection of maritime art works.

National Portrait Gallery

St Martin's Place, London, WC2H 0HE

T 020 73122463

F 020 73060056

E jrowbotham@npg.org.uk

W www.npg.org.uk

Founded in 1856. The primary collection consists of over 10,500 portraits and constitutes a record of the people who have shaped the history and culture of the UK. Admission to the gallery is free, although an entry fee is charged for some special exhibitions.

Talks/Events/Education Every month the gallery offers a wide variety of talks and events. Most activities are free with no need to book.

The Orangery and Ice House Galleries

Holland Park, London, W8 6LU T 020 76031123 / 76023316

F 020 73712467

E museums@rbkc.gov.uk

W www.rbkc.gov.uk/theorangery www.rbkc.gov. uk/theicehouse

Available for hire for public exhibitions of the

visual and applied arts. The galleries are situated in the grounds of Holland Park. The Orangery Gallery costs £600 for thirteen days (including setting up and taking down time) and the Ice House Gallery roughly £700 for twenty days (as above). Artists set up and take down their own exhibitions.

Submission Policy Artists should submit six slides of work with a CV and details of any previous exhibitions. The gallery welcomes works from every discipline. Artists' work is approved by a selection panel, which sits annually during November.

Photofusion

17A Electric Lane, Brixton, London, SW9 8LA

T 020 77385774 E info@photofusion.org

W www.photofusion.org

Founded in 1981. Aims to encourage all members of the community to use and enjoy its photographic facilities and to raise the profile of the photographic arts in London and the UK. Provides access to a full range of facilities including a contemporary gallery space, studio, digital imaging training, picture library, agency, darkrooms, digital printing & mounting, film processing and an ongoing education programme for professional, student and amateur photographers.

Submission Policy The gallery accepts proposals from photographers. The programme promotes diversity within the photographic arts reflecting on current cultural and political issues that have widespread relevance.

Talks/Events/Education An ongoing education programme includes basic to advanced technical courses on darkroom and digital practices and a professional development programme. We also have gallery talks relating to current exhibitions. Charges payable.

The Photographers' Gallery

16-18 Ramillies Street, London, W1F 7LW T 0845 2621618

E info@photonet.org.uk

W www.photonet.org.uk

Founded in 1971 in Great Newport Street, the gallery recently relocated. The first independent gallery in Britain devoted to photography. Has developed a reputation as the UK's primary venue for contemporary photography and was first in the country to show key names in world photography such as André Kertész, Jacques-Henri Lartigue

and Irving Penn. Runs an integrated programme of exhibitions and educational events as well as an internationally renowned bookshop and print sales.

Submission Policy For exhibition submissions, visit the gallery website to download an application form and receive further information.

Talks/Events/Education Presents an ongoing programme of talks and events that offers access to ideas about photography to non-specialist and specialist audiences. Some events are free and others charged for.

PM Gallery and House

Walpole Park, Mattock Lane, Ealing, London, W5 5EQ

T 020 85671227

E pmgalleryandhouse@ealing.gov.uk Comprises Pitshanger Manor (owned and designed by Sir John Soane) and an extension to the house, built in 1940. The largest public art gallery in west London, hosting exhibitions of professional contemporary art in all media. Recently opened a new studio exhibition space for community exhibitions and educational activities.

Pump House Gallery

Battersea Park, London, SW11 4NJ T 020 73500523 F 020 7228 9062

E pumphouse@wandsworth.gov.uk W www.wandsworth.gov.uk/gallery A public contemporary-art space located in a Victorian listed building in Battersea Park. Offers a diverse and innovative year-round exhibition programme in four gallery spaces.

Talks/Events/Education Holds a range of talks and workshops for both artists and the general public. Call gallery for current information.

The Queen's Gallery

Buckingham Palace, London, SW1A 1AA T 020 77667301 F 020 79309625 E press@royalcollection.org.uk W www.royal.gov.uk Reopened in 2002 to celebrate the Queen's

Golden Jubilee, the gallery hosts a series of changing exhibitions of works of art from the Royal Collection.

Talks/Events/Education Private evening tours available for pre-booked groups (admission charged).

Royal Academy of Arts

Burlington House, Piccadilly, London, W1J 0BD T 020 73008000

W www.royalacademy.org.uk

Founded in 1768. An independent fine arts institution that supports contemporary artists and promotes interest in the arts through a comprehensive exhibition programme.

Talks/Events/Education Designs events to help stimulate understanding and provide a focus for the interests of artists and art-lovers.

Royal College of Art

Kensington Gore, London, SW7 2EU

T 020 75904444

F 020 75904500

E info@rca.ac.uk

W www.rca.ac.uk

The world's only wholly postgraduate university of art and design. Displays a changing programme of student exhibitions and hosts external events, such as art fairs and prizes.

Talks/Events/Education Regular series of talks, lectures and symposia, regularly featuring leading figures from the art and design world. Many events are free.

Royal Institute of British Architects (RIBA)

66 Portland Place, London, W1B 1AD

T 020 75805533

F 020 73073703

E gallery@inst.riba.org W www.riba-gallery.com

Promotes excellence in architecture through a programme of exhibitions, lectures, debates and outreach activities. Houses the RIBA collections of drawings and manuscripts and collections of paintings, models and photographs.

Submission Policy Work must be related to architecture. Submissions in writing.

Talks/Events/Education Three seasons per year of talks by architects and conferences, etc. All open to members of the public.

Saatchi Gallery

Duke of York's HQ, King's Road, London T 020 79288195

W www.saatchi-gallery.co.uk

Based around the collection of Charles Saatchi, one of the UK's leading arts patrons, this newly refurbished 70,000sq.ft gallery includes permanent and temporary curated exhibitions of contemporary art. Aims to provide a forum

for contemporary art, presenting work by largely unseen young artists or by established international artists whose work has rarely or never been exhibited in the UK.

SE8 Gallery

171 Deptford High Street, London, SE8 3NU

T 020 84694140 E Info@se8.org.uk

W www.se8.org.uk

A venue for the making, appraisal and discussion of major installation works, experimental projects and educational events. SE8 also includes the holdings of the digital archive of the Museum of Installation. Submission Policy Contact as above.

Serpentine Gallery

Kensington Gardens, London, W2 3XA

T 020 74026075

F 020 74024103

E information@serpentinegallery.org

W www.serpentinegallery.org

A publicly funded modern and contemporary art gallery located in Kensington Gardens, in the heart of central London. The gallery has gained an international reputation for its exhibition, architecture and education programmes, and showcases both established artists and those in the early stages of their career. Free admission.

Submission Policy Accepts exhibition proposals from artists and curators. Programming is decided by the gallery director and chief curator.

Talks/Events/Education Education programme consists of free public gallery talks, events, seminars, artist residencies and workshops that welcome artist participation.

Sir John Soane's Museum

13 Lincoln's Inn Fields, London, WC2A 3BP

T 020 74052107

F 020 78313957

E jbrock@soane.org.uk

W www.soane.org

Sir John Soane's (1753-1837) house, which became a museum after his death. The collection includes paintings by Hogarth, Canaletto, Turner and Reynolds, antique sculpture, plaster casts, architectural models, and the sarcophagus of Pharaoh Seti I.

Talks/Events/Education Regular talks and courses throughout the year.

South London Gallery

65 Peckham Road, London, SE5 8UH

T 020 77036120 F 020 72524730

E mail@southlondongallery.org

W www.southlondongallery.org

Shows the work of mid-career British artists. and emerging and established international artists, in an annual programme of contemporary art exhibitions, live art and off-site projects complemented by workshops, events, residencies, artists' talks and outreach projects.

Talks/Events/Education Educational events and community projects are open to artists and general public. Further details can be found on our website.

Stanley Picker Gallery

Faculty of Art, Design & Architecture, Kingston University, Knights Park, Kingston upon Thames, KT1 201

T 020 85478074

E picker@kingston.ac.uk

W www.kingston.ac.uk/picker

Established in 1997, working with artists, designers and musicians to facilitate and provide access to a broad programme of exhibitions, collaborative projects, events and education initiatives. Also available for hire.

Tate Britain

Millbank, London, SW1P 4RG T 020 78878888

E visiting.britain@tate.org.uk

W www.tate.org.uk

Tells the story of British art from 1500 to the present day, through the largest collection of it in the world. Includes masterpieces from the Pre-Raphaelites, Turner, Gainsborough, Blake, Constable, Bacon, Hepworth and Gormley. Also holds six temporary exhibitions annually, focusing on the work of wellknown British artists or movements.

Talks/Events/Education A wide range of events, courses, seminars and workshops, many of which are free.

Tate Modern

Bankside, London, SE1 9TG T 020 78878888 E visiting.modern@tate.org.uk

W www.tate.org.uk

National museum of modern art, opened in the restored Bankside power station in 2000.

University College London (UCL) Art Collections Strang Print Room, University College London, Gower Street, London, WC1E 6BT

T 020 76792540 F 020 78132803

E college.art@ucl.ac.uk

W www.art.museum.ucl.ac.uk

Founded in 1847 with the gift of John Flaxman's sculpture models to UCL, the collection includes sixteenth- to eighteenth-century Old Master prints and drawings from northern Europe, English watercolours, Japanese Ukiyo-E Prints and the Slade Collection of student prize works, which illustrates the history of the Slade School of Fine Art and includes works by Augustus John, William Orpen, Gwen John, Stanley Spencer. David Bomberg, Dora Carrington and Paula Rego.

Submission Policy Work by living artists is limited to works by artists who attended the Slade School

Talks/Events/Education Two to four gallery talks and workshops per term, all free. Open to all groups or individuals wishing to work from the collection. Appointments may be booked.

Victoria & Albert Museum

Cromwell Road, London, SW7 2RL

T 020 79422000

E vanda@vam.ac.uk

W www.vam.ac.uk

One of the world's leading museums of art and design, with collections of great scope and diversity covering three thousand years of civilization.

Talks/Events/Education A wide range of events and activities for families, adults, older learners, students, teachers and young professionals complement the exhibitions and collections.

Wallace Collection

Hertford House, Manchester Square, London, W1U 3BN

T 020 75639500

F 020 72242155 W www.wallacecollection.org

A national museum based around one of the finest private collections of art ever assembled by one family. It was bequeathed to the nation by Lady Wallace, widow of Sir Richard Wallace, in 1897 and opened to the public in 1900. Among its holdings are an important collection of French eighteenth-century pictures, porcelain and furniture, and an extensive range of seventeenthcentury paintings.

Talks/Events/Education Produces a quarterly publication, What's On, detailing lectures, seminars and other events.

Wapping Project

Wapping Hydraulic Power Station, Wapping Wall, London, E1W 3ST

T 020 76802080

W www.thewappingproject.com Opened in 2000, a centre for the arts in east London, located in the historic Wapping Hydraulic Power Station, A multipurpose exhibition and performance space, featuring newly commissioned works by visual artists. choreographers, composers, writers, poets, designers and film-makers.

Wellcome Collection

215 Euston Road, London, NW1 2BE T 020 76118888/76112222 F 020 76118545

F contact@wellcomecollection.org W www.wellcome.ac.uk

Organizes exhibitions on science and art in a range of exhibition initiatives including shows at the Science Museum, British Museum and TwoTen Gallery. A suite of permanent and temporary exhibition spaces will be a major feature of the trust's new public facility opened in 2006.

Talks/Events/Education Has collaborated with the Institute of Contemporary Arts on a series of public debates on science and its applications in broad contexts.

Whitechapel Gallery

77-82 Whitechapel High Street, London, E170X

T 020 75227888

F 020 75227887

E info@whitechapelgallery.org W www.whitechapelgallery.org

The Whitechapel Gallery has been in the heart of east London for over a century. It has provided a platform for many of Britain's most significant artists, from Gilbert & George to Lucian Freud and Mark Wallinger, as well as premiering key international artists such as Pablo Picasso, Frida Kahlo, Jackson Pollock and Mark Rothko. In addition to exhibitions, the gallery provides a platform for leading art practitioners, commentators and thinkers through talks, debates and events. Following a £13.5 million expansion project, the Whitechapel Gallery reopened in April 2000 with five new exhibition spaces and new education facilities.

Submission Policy The Whitechapel Gallery runs a triennial submission exhibition called the East End Academy, showcasing work from east London artists.

Talks/Events/Education The Whitechapel Gallery regularly holds courses, discussions and workshops on subjects ranging from collecting contemporary art to artists' survival strategies.

North-east

Ad Hoc Gallery

Buddle Arts Centre. 258b Station Road, Wallsend, NF28 8RG

T 0101 2007132

E the.buddle@northtyneside.gov.uk

W www.northtynesidearts.org.uk

Located within the Buddle Arts Centre and managed by North Tyneside Arts. The gallery's key objective is to promote and maintain a balanced programme that is accessible to audiences, supportive of artists, and provides opportunities for schools, community groups and the voluntary arts sector to exhibit in a dedicated contemporary gallery space.

Submission Policy Approximately six to ten exhibitions per year. Proposals are welcome from artists, curators and artists' groups at any time.

BALTIC Centre for Contemporary Art

South Shore Road, Gateshead, NE8 3BA

T 0101 4781810 E info@balticmill.com

W www.balticmill.com

Opened in 2002. A major international centre for contemporary art. The landmark building is situated on the south bank of the River Tyne in Gateshead. With no permanent collection, it provides a programme that places a heavy emphasis on commissions, invitations to artists and the work of artists-in-residence.

Submission Policy Programmed two years in advance. The majority of exhibitions and residencies arise from direct invitations to artists and curators. Rarely able to accommodate unsolicited submissions for exhibitions.

Talks/Events/Education Runs education and public programmes, and artists' workshops, talks and seminars. Most are free.

Berwick Gymnasium Art Gallery

Berwick Barracks, Berwick-upon-Tweed, **TD15 1DG**

T 01289 304493

W www.internationalfellowships.org.uk Opened in 1993, the gallery has established itself as a leading venue for contemporary art and artists in the region. Details of current exhibitions are available from English Heritage.

Billingham Art Gallery

Queensway, Billingham Town Centre, Billingham, Stockton-on-Tees, TS23 2LN

T 01642 397590

F 01642 397594

E billinghamartgallery@stockton.gov.uk

W www.stockton.gov.uk/citizenservices/ leisureandents/artandculture/artscentres

Exhibits work by local artists.

Talks/Events/Education Runs art classes and workshops for adults.

The Bowes Museum

Barnard Castle, Barnard Castle, DL12 8NP

T 01833 690606

F 01833 637163

E info@bowesmuseum.org.uk

W www.bowesmuseum.org.uk

Based on an extensive collection of European fine and decorative arts of the period between 1400 and 1875, originally collected by John and Josephine Bowes in the nineteenth century.

Submission Policy A limited number of artists' works are represented in the museum's exhibition programme. Applications can be made by post. Talks/Events/Education Some events are free.

The Customs House

Mill Dam, South Shields, NE33 1ES

T 0191 4541234

F 0191 4565979

E mail@customshouse.co.uk

W www.customshouse.co.uk

Shows contemporary visual art by local, regional, national and international artists working in a variety of art forms and styles, and working from differing theoretical backgrounds. Artists are at varying stages of their careers.

Submission Policy Submission guidelines are available on the website.

Talks/Events/Education Free lectures, talks, activities and workshops relating to artist's exhibitions and projects currently shown. Events held in gallery and as part of outreach programme.

Durham Light Infantry Museum and Durham Art Gallery

Aykley Heads, Durham, DH1 5TU T 0191 3842214 F 0191 3861770 E dli@durham.gov.uk

W www.durham.gov.uk/dli

Founded in 1968, the museum features displays covering the history of the County Regiment, the Durham Light Infantry. The art gallery provides a changing programme of exhibitions related to all aspects of the visual arts, linked to an ongoing series of workshops, concerts and other events.

Submission Policy Applications are welcomed from all fields of artistic activity.

Talks/Events/Education Most activities are aimed at general and family audiences. More specific events may be held depending on the current exhibition.

Green Dragon Museum and Focus Photography Gallery

Theatre Yard, Calverts Lane, Stockton-on-Tees, TS18 1JZ

T 01642 393933

E greendragon@stockton.gov.uk

W www.stockton.gov.uk/museums Located in the historic Georgian area of Stockton, the building houses a local history and archive photography gallery on the upper floor and the Focus Gallery on the ground floor. The Focus

Gallery has a varied programme of photographic displays throughout the year.

Submission Policy Artists may submit photography or digital-art exhibition proposals at any time. Contact the Exhibitions Coordinator for

Talks/Events/Education Occasional free photography-based events or talks.

Hatton Gallery

The Quadrangle, Newcastle University, Newcastle-upon-Tyne, NE1 7RU

T 0191 2226059

F 0191 2223454

E hatton-gallery@ncl.ac.uk

W www.ncl.ac.uk/hatton

Presents a programme of historical and contemporary exhibitions. Over recent years this programme has included major historical monographs, diverse partnership projects and new commissions from leading contemporary artists. On permanent display is Kurt Schwitters' Merzbarn, considered one of the seminal artworks of the twentieth century. The permanent collection comprises over 3,500 works, ranging from the Renaissance to the twentieth century, and includes works in painting, sculpture, printmaking and

drawing. Also runs a learning programme and has an active Friends group.

Submission Policy Unsolicited exhibition proposals will be considered by the programming team. However, the gallery normally initiates projects.

Talks/Events/Education Regularly holds talks and educational events for individuals, community groups and schools. Contact the gallery for further details.

Laing Art Gallery

Blandford Square, Newcastle-upon-Tyne, NE1 4JA

W www.twmuseums.org.uk/laing/ Founded in 1901. Houses an extensive collection of British oil paintings, watercolours, ceramics, silver and glassware. There is also an active temporary exhibition programme.

mima - Middlesbrough Institute of Modern Art

Centre Square, Middlesbrough TS1 2AZ

T 01642 726720

E mima@middlesbrough.gov.uk

W www.visitmima.com

A major new contemporary art gallery. Hosts an internationally important programme of exhibitions, presenting the very best of art and craft from 1900 to the present day. Exhibited artists include Ben Nicholson, David Bomberg, Stanley Spencer, Gwen John, David Hockney and Bridget Riley, Steve McQueen, Gerhard Richter, Edmund de Waal and Anders Ruhwald. Exhibitions change every quarter.

Myles Meehan Gallery

Darlington Arts Centre, Vane Terrace, Darlington, DI 3 7AX

T 01325 348845

F 01325 365794

E wendy.scott@darlington.gov.uk

W www.darlingtonarts.co.uk

Founded in 1983, supporting new and emerging innovative artists. Provides visitors with a balanced programme of media including installation and film, sculpture, painting, textiles and photography. **Submission Policy** Welcomes innovative and contemporary exhibition applications with a focus on collaboration and experimentation.

Newcastle Arts Centre

67 Westgate Road, Newcastle-upon-Tyne, NE1 1SG E venue@newcastle-arts-centre.co.uk W www.newcastle-arts-centre.co.uk Opened in 1988, the centre is only 100m from Newcastle Central Station and Metro. Underwent an extensive upgrade in 2000 to include a full-time gallery and art materials store. The gallery holds frequent exhibitions.

Northern Gallery for Contemporary Art

City Library and Arts Centre, Fawcett Street, Sunderland, SR1 1RE

T 0191 5141235

F 0191 5148444

E ngca@sunderland.gov.uk

W www.ngca.co.uk

Opened in 1995 as part of the Sunderland City Library and Arts Centre. Presents changing exhibitions of new work by emerging and established artists from the UK and abroad.

Submission Policy Artists wishing to apply should send six images, CV and artist's statement addressed to the programme director.

Talks/Events/Education Gallery talks accompany major exhibitions.

Shipley Art Gallery

Prince Consort Road, Gateshead, NE8 4JB

T 0191 4771495

W www.twmuseums.org.uk/shipley Permanent collection includes studio ceramics, glass, metalwork, jewelry, textiles and furniture. Collection of historical paintings has examples of Dutch and Flemish Old Masters. Temporary programme of mainly craft-based exhibitions.

Talks/Events/Education Hosts a wide range of regular events and activities.

South Shields Museum and Art Gallery

Ocean Road, South Shields, NE33 2JA

T 0191 4568740

F 0191 4567850

W www.twmuseums.org.uk/southshields Includes extensive collection of fine and applied art.

Sunderland Museum and Winter Gardens

Burdon Road, Sunderland, SR1 1PP

T 0191 5532323

F 0191 5537828

W www.twmuseums.org.uk/sunderland Gallery houses works by by L.S. Lowry alongside an important collection of Victorian masterpieces.

North-west

Abbot Hall Art Gallery

Kendal, LA9 5AL

T 01539 722464

F 01539 722494

E info@abbothall.org.uk

W www.abbothall.org.uk

A small independent gallery with a reputation for showing important exhibitions of British artists. The permanent collection includes eighteenth-century portraits by George Romney and watercolours by Turner and Ruskin. The modern collection includes works by Ben Nicholson, Kurt Schwitters, Lucian Freud, Bridget Riley and Paula

Submission Policy Main gallery shows British art and artists. All media considered. Coffee shop has a focus on printmaking. Exhibition proposals considered by a curatorial panel.

Talks/Events/Education Hosts lectures, 'meet the artist' events and walking tours associated with the exhibitions programme (ticketed; admission charge applies).

Astley Hall Museum and Art Gallery

Astley Park, off Hallgate, Chorley, PR7 1NP T 01257 515928

F contact@chos

E contact@chorley.gov.uk

W www.chorley.gov.uk

A grade-I listed, refashioned Elizabethan mansion with a Renassiance-style great hall. The art gallery hosts four temporary exhibitions each year. Submission Policy Exhibition proposals welcome from established and up-and-coming

Talks/Events/Education Talks and courses held throughout the year and educational visits (all levels) welcomed.

The Beacon

West Strand, Whitehaven, CA28 7LY

T 01946 592302

F 01946 598150 E thebeacon@copelandbc.gov.uk

W www.thebeacon-whitehaven.co.uk
Founded in 1996 on Whitehaven's harbourside
and having undergone a major refurbishment
in 2007, The Beacon is home to Copeland's
museum collection and art gallery. Regular
exhibitions change every six weeks, featuring local
and national artists using a variety of mediums.
Admission to the gallery is free.

Submission Policy Artists in any medium are

welcome to submit exhibition proposals for consideration by exhibition panel each autumn. Talks/Events/Education School activity sessions available and young people's craft workshops held every school holiday.

Blackwell Arts & Crafts House

Bowness-on-Windermere, LA23 3JT

T 015394 46139

F 015394 88486

E info@blackwell.org.uk

W www.blackwell.org.uk

An Arts and Crafts Movement house dating from 1900. Blackwell was restored by the Lakeland Arts Trust and opened to the public in 2001 as a showcase for important Arts and Crafts furniture and objects, and a platform for contemporary craft. The growing collection includes important examples of the arts and crafts, twentieth-century and contemporary applied arts.

Submission Policy Send a CV and details, including images, to Harvey Wilkinson (Curator). Exhibitions are planned at least a year ahead. The shop and selling exhibitions concentrate on contemporary craft (e.g. jewelry, ceramics, glass, textiles).

Talks/Events/Education Evening lectures and occasional workshops, which artists are welcome to attend. 2005 lecture prices: £5 for students and Friends, patrons and benefactors of the Lakeland Arts Trust; £7.50 for non-members. Prices of courses may vary.

Bluecoat Display Centre

Bluecoat Chambers, College Lane, Liverpool, L1 3BX

T 0151 7094014

F 0151 7078106

E crafts@bluecoatdisplaycentre.com

W www.bluecoatdisplaycentre.com

Founded in 1959 as a not-for-profit organization to exhibit and retail the finest contemporary applied art, including jewelry, ceramics and glass.

Submission Policy Artists working in

contemporary craft media should apply to Maureen Bampton (Director) with images, CV, supporting statement and price guide to the work illustrated. A selection committee meets regularly

to consider new work.

Talks/Events/Education Occasional events; details via mailing list or website.

Bolton Museum, Art Gallery and Aquarium

Le Mans Crescent, Bolton, BL1 1SE

T 01204 332211

F 01204 332241

E museum.customerservices@bolton.gov.uk

W www.boltonmuseums.org.uk

Bolton Museum, founded in the 19th century, has collections ranging from fine and decorative art to Egyptian archaeology. The art collections include seventeenth - twenty-first century works of art and the Mass Observation Archive.

Submission Policy Exhibits living artists with connections to Bolton and the North West. Talks/Events/Education Holds a range of events that are usually free of charge. Contact the

museum for more details.

Bury Art Gallery, Museum and Archives

Moss Street, Bury, BL9 0DR

T 0161 2535878

F 0161 2535857

E artgallery@bury.gov.uk

W www.bury.gov.uk/arts

Opened in 1901, the art gallery houses an internationally important collection of Victorian paintings, including works by Turner, Constable and Landseer. These pictures are hung alongside twentieth-century works in a display called 'Contrasts'. The temporary exhibition programme is driven by contemporary-art shows, showcasing both international and up-and-coming artists. Recent commissions include a neon installation in the Ring Balcony by Maurizio Nannucci. The museum has recently been transformed into a light, contemporary exhibition space in a minimalist design.

Submission Policy Artists' applications for exhibitions should be addressed to the curator. Calls for submissions to themed exhibitions are advertised through a-n.

Talks/Events/Education Hosts talks, events, workshops, and family-friendly and adult learning activities relating to the building, exhibitions and collections.

Castlefield Gallery

2 Hewitt Street, Manchester, M15 4GB T 0161 8328034 F 0161 8192295 E info@castlefieldgallery.co.uk W www.castlefieldgallery.co.uk Founded by Manchester's Artists Studio Association in 1984. The gallery presents six main exhibitions per year, focusing on new and commissioned work. Supports emergent practice through 'Project Space' residency, and artists' film and video through 'Purescreen' events consisting of an annual 'open call'-curated screening programme.

Submission Policy Welcomes exhibition proposals in any art form by artists and curators. Deadline is the last day of February each year, for programming twelve months in advance.

Talks/Events/Education Presents interpretive exhibition and professional-development talks and events. All events are free unless otherwise stated and require booking.

Chapel Gallery

St. Helens Rd, Ormskirk, L39 4QR

T 01695 571328

E ruth.owen@westlancsdc.gov.uk

W www.chapelgallery.org.uk

Offers a diverse programme of exhibitions with some of the most inventive contemporary fine art and craft from across the UK, including locally based artists.

Submission Policy Contact Ruth Owen, gallery officer.

Chinese Arts Centre

Market Buildings, 7 Thomas Street, Manchester, **M41EU**

T 0161 8327271

F 0161 8327513

E info@chinese-arts-centre.org

W www.chinese-arts-centre.org

Founded in 1986, UK flagship for the promotion and interpretation of Chinese arts and culture. Holds exhibitions of contemporary art by artists of Chinese descent, an education programme, artistin-residence scheme and surgeries offering artists advice. The building houses two galleries and a fully equipped education and conference suite. Submission Policy Submissions accepted for exhibition and residency proposals. Those wishing to be involved in the education programme should contact the participation programme manager. Talks/Events/Education See website.

Cornerhouse

70 Oxford Street, Manchester, M1 5NH

T 0161 200 1500

E exhibitions@cornerhouse.org

W www.cornerhouse.org

Opened in 1985 as Manchester's centre for international contemporary art and film. Exhibitions and events bring together artists, critics, curators, filmmakers, educators and audiences to discuss contemporary culture.

The programme of visual art, film and moving image aims to question currently accepted art and cultural practice.

Submission Policy Submissions from North West based artists are considered for projects in the cafe and bar areas. Applicants should send a proposal, CV and images (slide/CD-ROM).

Talks/Events/Education Runs a programme of events examining relevant issues within contemporary art including curators' talks, Q&As, discussions and live perfomances. Specifically curated events for artists, students and the public are regular and often free.

Dock Museum

North Road, Barrow-in-Furness, LA14 2PW **T** 01229 894444

E dockmuseum@barrowbc.gov.uk W www.dockmuseum.org.uk

Has a small fine-art gallery displaying a selection of works collected over the past hundred years. The gallery includes work by local artists William McDowell, Edward Beckett and John Duffin.

Folly

26 Castle Park, Lancaster, LA1 1YQ T 01524 388550 F 01524 388550 E director@folly.co.uk W www.folly.co.uk

Founded in 1982. A non-profit media arts organization that promotes photographic, video and new-media work. There is an annual members' exhibition.

Talks/Events/Education Events include summer courses, webstreaming, live events, video, audio and purescreen showings.

Foundation for Art and Creative Technology (FACT)

88 Wood Street, Liverpool, L1 4DQ

T 0151 7074450

F 0151 7074445 E info@fact.co.uk

W www.fact.co.uk

Opened in 2003 and dedicated to inspiring and promoting creativity through film, video and new and emerging media forms. It was the first cultural building to be purpose-built in Liverpool for sixty years. Combines state-of-the-art cinemas, galleries and flexible exhibition spaces.

Submission Policy Presents existing work and commissions new pieces from artists working in the field of new media. The exhibitions are programmed by the exhibitions department, which can be contacted on 0151 7074444.

Talks/Events/Education Regular talks and events open to the public linked to exhibitions and films at FACT.

Gallery Oldham

Oldham Cultural Quarter, Greaves Street, Oldham, OL1 1AL

T 0161 7704653 F 0161 7704669

E galleryoldham@oldham.gov.uk

W www.galleryoldham.org.uk

The new building opened in 2002 and forms the first phase of Oldham's Cultural Quarter development. A changing exhibition programme incorporates extensive art, social and natural history collections alongside touring work, newly commissioned and contemporary art, international art and work produced with local communities.

Submission Policy Exhibition proposals should be sent to the senior exhibition and collection co-ordinator for consideration.

Talks/Events/Education Regular events include gallery talks, family activities and live music.

Grizedale Sculpture Park

Grizedale, Ambleside, LA22 0QJ

T 01229 860291 F 01229 860050

W www.grizedale.org

A major sculpture park, set in a dramatic Cumbrian setting.

Grosvenor Museum

25–27 Grosvenor Street, Chester, CH1 2DD T 01244 321616

E grosvenormuseum@chester.gov.uk

W www.grosvenormuseum.co.uk

Opened in 1886, with collections of archaeology, fine and decorative arts (including Chester silver), natural history and social history. Art shown is related to Cheshire or North Wales, illuminating artistic practice and patronage in the region since the sixteenth century. Also has a growing contemporary collection and a multidisciplinary exhibition programme.

Submission Policy Hosts a biennial open art exhibition. There are also a small number of solo and group shows each year by artists from Cheshire and North Wales.

Talks/Events/Education A full programme of public events including lectures, gallery tours, and

art and craft workshops for children and adults. Some are free.

Grundy Art Gallery

Queen Street, Blackpool, FY1 1PX T 01253 478170 E grundyartgallery@blackpool.gov.uk Opened in 1911, the collection contains close to two thousand objects, including Victorian oils and watercolours, modern British paintings, contemporary prints, jewelry and video, oriental ivories, ceramics, and photographs of historic Blackpool, Dame Laura Knight, Lucy Kemp-Welch, Eric Ravilious, Augustus John, Charles Spencelayh, Martin Creed, Craigie Aitchison and Gilbert and George are amongst the artists represented. Exhibitions featuring works from the gallery's collection are organized throughout the

Harris Museum and Art Gallery

Market Square, Preston, PR1 2PP T 01772 258248 F 01772 886764 E harris.museum@preston.gov.uk W www.harrismuseum.org.uk A grade I-listed building and an outstanding example of Greek Revival architecture. Opened in 1893, it houses a major collection of historical and contemporary painting and sculpture, including work by L.S. Lowry, Lucian Freud, Stanley Spencer, Walter Sickert, Jacob Epstein and J.W. Waterhouse. Decorative art is housed in a newly refurbished ceramics & glass gallery. Also runs programme of temporary exhibitions including international contemporary art, historical art and local history.

Submission Policy Opportunities for a small number of professional artists to exhibit as part of the stairway exhibitions programme. Contact exhibitions assistant.

Talks/Events/Education A full programme of public events including lectures, gallery tours, and art and craft workshops for children and adults. Some are free.

Lady Lever Art Gallery

Port Sunlight Village, Wirral, CH62 5EQ T 0151 4784136 E ladylever@liverpoolmuseums.org.uk W www.ladyleverartgallery.org.uk Home to the extensive personal collection of William Hesketh Lever, first Lord Leverhulme, an

entrepreneur who made his fortune as founder of

Lever Brothers. Holds a large collection of British eighteenth- and nineteenth-century art, including Victorian and Pre-Raphaelite paintings by artists such as Leighton and Rossetti. Also exhibits a collection of the 'Sunlight Soap' paintings. Talks/Events/Education Free talks and tours.

The Lowry

Pier 8, Salford Quays, Salford, M50 3AZ T 0870 7875780 F 0161 8762001 E info@thelowry.com W www.thelowry.com Centred around the L.S. Lowry Collection, with regularly changing displays encouraging visitors to take a fresh look at the artist. Other exhibitions place emphasis on the work of contemporary artists and photographers, and particularly on the

locality and context of The Lowry. These shows often complement the Lowry Collection. Submission Policy Welcomes applications. Submit proposals to the Exhibitions Programmer.

Manchester Art Gallery

Mosley Street, Manchester, M2 3JL T 0161 2358888 F 0161 2358899 E t.wilcox@manchester.gov.uk W www.manchestergalleries.org Houses an extensive art collection with a varied programme of special exhibitions and events. Particularly strong on nineteenth- and twentieth-century British paintings in both oil and watercolour. Featured artists include Henry Moore, Paul Nash, Ben Nicholson, Francis Bacon, Lucien Freud and David Hockney. Also important collections of Impressionist and seventeenthcentury Dutch paintings, and decorative art, craft

Ruskin Gallery

and design.

Ruskin Museum, Coniston, LA21 8DU T 015394 41164 W www.ruskinmuseum.com Gallery contains works by John Ruskin, J.M.W. Turner and W.G. Collingwood.

Saddleworth Museum

High Street, Uppermill, Oldham, OL3 6HS T 01457 874093 F 01457 870336 E curator@saddleworthmuseum.co.uk W www.saddleworthmuseum.co.uk Opened in 1962 and housed in a Victorian Mill. Exhibitions change every six weeks and showcase the best local and regional contemporary art. If you want more information email for gallery information pack.

Salford Museum and Art Gallery

Peel Park, Crescent, Salford, M5 4WU T 01617362649 F 01617459490 E salford.museum@salford.gov.uk W www.salford.gov.uk Houses an extensive collection of paintings, pottery and fine art.

Sudley House

Mossley Hill Road, Liverpool, L18 8BX
T 01517243245
E sudleyhouse@liverpoolmuseums.org.uk
W www.sudleyhouse.org.uk
Situated in Mossley Hill, the house belonged
to Victorian ship-owner George Holt, whose
extensive art collection is exhibited. Highlights
include works by Landseer, Turner, Millais,
Romney, Reynolds, Gainsborough, Benjamin
Spence and Conrad Dressler.

Tate Liverpool

Albert Dock, Liverpool, L3 4BB

T 01517027400
F 01517027401
E visiting.liverpool@tate.org.uk
W www.tate.org.uk/liverpool
Opened in 1988, displaying modern and contemporary art from 1900 to the present day.
Submission Policy Send a covering letter, CV and visuals to the exhibitions department at Tate Liverpool.
Talks/Events/Education A programme of free

Talks/Events/Education A programme of free introductory tours, exhibition talks and lectures. Also special events around exhibitions and displays.

Tullie House Museum and Art Gallery

Castle Street, Carlisle, CA3 8TP
T 01228 618718
F 01228 810249
E enquiries@tulliehouse.co.uk
W www.tulliehouse.co.uk

Established since 1893, owned and managed by Carlisle City Council. Significant collections of fine and decorative arts, human history and natural sciences. Underwent redevelopment in 1990, which included building the Border Galleries and a purpose-built art gallery. The latter hosts a changing programme of primarily contemporary art exhibitions of regional, national and international significance.

Submission Policy Artists' proposals should be submitted in the form of an exhibition outline, CV and a selection of good-quality images. Talks/Events/Education Presents a wide range

Talks/Events/Education Presents a wide range of events and activities, from free drop-ins to workshops and illustrated talks.

Turnpike Gallery

Civic Square, Market St, Leigh, WN7 1EB T 01942 404469 F 01942 404447 E turnpikegallery@wlct.org W www.wlct.org/turnpike

Built in 1971. The only purpose-built public gallery in the borough of Wigan. Presents around six to eight exhibitions per year, including new commissions, solo, group, community and touring shows, reflecting contemporary visual arts practice by artists with a local, regional or national profile. The gallery has a commitment to developing learning and outreach opportunities for the local community.

Submission Policy Artists are welcome to submit exhibition proposals to the gallery, but only a very few of such proposals will make up part of the programme.

Talks/Events/Education Talks associated with exhibitions and other educational/training events for artists are usually free, and arranged on an occasional basis.

University of Liverpool Art Gallery

3 Abercromby Square, Liverpool, L69 7WY T 0151 7942348 F 0151 7942343 E artgall@liv.ac.uk

W www.liv.ac.uk/artgall/

Fine and decorative art from the university collections, displayed in an elegant Georgian house. Includes works by Turner, Wright of Derby, Burne-Jones, Augustus John, Epstein, Freud and Frink.

Submission Policy Apply in writing to the Curator. Talks/Events/Education Talks and events advertised on website. Free of charge.

Viewpoint Photography Gallery

The Old Fire Station, The Crescent, Salford, M6 T 0161 7371040
Has a programme of regularly changing photography exhibitions.

Walker Art Gallery

William Brown Street, Liverpool, L3 8EL

T 0151 4784199

W www.thewalker.org.uk

Founded in 1877 and popularly regarded as the National Gallery of the north. Exhibits an internationally important collection of art from the fourteenth- to the twenty-first centuries. Especially rich in European Old Masters, Victorian and Pre-Raphaelite pictures and modern British works. Talks/Events/Education Extensive free talks and educational events open to all. Often themed on exhibitions or particular art works.

Whitworth Art Gallery

University of Manchester, Oxford Road, Manchester, M15 6ER

T 0161 2757450

F 0161 2757451

E whitworth@manchester.ac.uk

W www.manchester.ac.uk/whitworth

Founded in 1889, the gallery has been part of the university since 1958. Houses important collections of watercolours, prints, drawings, modern art and sculpture, as well as the largest collections of textiles and wallpapers outside London.

Submission Policy Gallery exhibition policy available on website.

Talks/Events/Education Education Department organizes a full programme of activities for formal and informal learning. Special events and talks are available from time to time.

Wordsworth Museum Art Gallery

Dove Cottage, Grasmere, Cumbria, LA22 9SH

T 015394 35544 F 015394 35748

E enquiries@wordsworth.org.uk

W www.wordsworth.org.uk

Exhibitions are held year round in both the Wordsworth Museum and the contemporary art gallery. Also runs a prestigious residency programme. Past residents include Conrad Atkinson, Judith Dean, Kate Davis and Daniel Sturgis. The manuscript and book collection is regarded as the greatest poetry library of the Romantic period in Britain. The fine-art collection includes paintings by John Constable, David Cox, J.M.W. Turner, Joseph Wright of Derby, James Gillray. Sir Joshua Reynolds and an extensive collection of landscape drawings.

Submission Policy Write to the arts officer with covering letter, CV and samples of work.

Talks/Events/Education See website.

Northern Ireland

Ards Arts Centre

Ards Town Hall, Conway Square, Newtownards, BT23 4NP T 028 91810803

F 028 91823131

Presents varied monthly programme of visual arts, primarily in two galleries in the town arts centre. Covers range of media and styles, by local, national and international artists.

Armagh County Museum

The Mall East, Armagh, BT61 9BE

T 028 37523070

F 028 37522631

E acm.um@nics.gov.uk

W www.armaghcountymuseum.org.uk Two exhibition spaces regularly display the museum's collection, plus changing exhibitions throughout the year. Featured artists include James Black, Tom Carr, William Conor, James Humbert Craig, T.P. Flanagan, Charles Lamb, John Luke, J.B. Vallely and G.W. Russell.

Belfast Exposed Photography

The Exchange Place, 23 Donegall Street, Belfast, BT1 2FF

T 028 90230965

F 028 90314343

E info@belfastexposed.org

W www.belfastexposed.org

A photographic resource, archive and Northern Ireland's only dedicated photography gallery. Through its annual programme of exhibitions and the commissioning of new work, it aims to raise the profile of photography as an art form. Active in project origination, production of publications and generation of discussion through seminars and talks around projects.

Submission Policy Only exhibits and supports photographic projects. There is no formal application process. Project proposals, artist's statement, examples of work, CVs etc. should be submitted to the Exhibition Manager in a MAC-compatible format. Work is looked at once a year in January and applicants should receive a response after this.

Talks/Events/Education Hosts a number of workshops for both indviduals and facilitators. Contact for further details.

Belfast Waterfront

2 Lanyon Place, Belfast, BT1 3WH

T 028 90334400 F 028 90249862

W www.waterfront.co.uk

A major arts and entertainment centre, with a regularly changing programme of exhibitions.

Catalyst Arts

5 College Court, Belfast, BT1 6BS

T 028 90313303 F 028 90312737

E info@catalystarts.org

W www.catalystarts.org

A non-commercial artist-run gallery and resource centre based in Belfast, which celebrated its tenth anniversary in 2003. Aims to maintain, to the highest possible standard, a Northern Irish centre for contemporary arts. The organization is run by a volunteer committee of artists who work there for a two-year period on a rolling committee basis.

Fenderesky Gallery

2-4 University Road, Belfast, BT7 1NH

T 028 90235245

Occupies three areas of the Crescent Arts Centre, with exhibitions of contemporary Irish artists. Shows last up to four weeks.

Golden Thread Gallery

Switch Room, 84–94 Great Patrick Street, Belfast, BT1 2LU

T 028 90330920

E info@gtgallery.org.uk

W www.gtgallery.org.uk

Aims to contribute to the visual arts provision in Northern Ireland by creating an accessible, high quality programme of exhibitions, touring products, commercial opportunities for artists and complimentary education/outreach activities. Over the coming years the gallery will be realising a series of exhibitions and publications titled 'Collective Histories of Northern Irish Art' alongside its continued commitment to creating major curated solo and group exhibitions by local and international contemporary artists. Shows seven exhibitions a year.

Submission Policy Runs a curated program of activities and does not encourage submissions. Talks/Events/Education Artists talks, gallery talks and tours are free. Contact gallery for details.

Island Arts Centre

The Island, Lisburn, BT27 4RL T 028 92509509 F 028 92509288 E enquiries@lisburn.gov.uk

W www.islandartscentre.com

An arts centre that includes an artist-in-residence studio, artists' studios and exhibition galleries.

Naughton Gallery at Queens

Lanyon Building, Queens University, Belfast, BT7 1NN

T 028 90273580 E art@qub.ac.uk

W www.naughtongallery.org

Founded in 2001, holding Queens's fine-art collection, compiled since the mid-nineteenth century. Includes an extensive selection of landscapes, genre paintings and portraits as well as sculpture and silver. Irish artists include Sir John Lavery, William Conor, James Humbert Craig, Louis le Brocquy, Paul Henry, John Luke and Frank McKelvey. Queen's has an active and wide-ranging acquisitions and commissioning policy. Also provides a platform for local, national and international artists through a programme of temporary exhibitions across whole range of artistic practice.

Submission Policy Artists should submit work to the Curator of Art for presentation to the Art Board. Annual open art competition linked to area of academic endeavour and an annual residency. Talks/Events/Education Regular free talks, lectures and artist's workshops.

Old Museum Arts Centre

7 College Square North, Belfast, BT1 6AR T 028 90235053

F 028 90233332

W www.oldmuseumartscentre.org
Established in 1990, with a visual arts programme
committed to presenting new and emerging as
well as established visual artists from the UK,
Ireland and beyond. Work is exhibited in a small
white-box gallery space and exhibitions change on
a six-weekly basis.

Submission Policy Exhibition is by invitation only. Proposals are welcome from interested artists.

Ormeau Baths Gallery

18a Ormeau Avenue, Belfast, BT2 8HS

T 028 90321402

F 028 90312232

E mail@ormeaubaths.co.uk

W www.ormeaubaths.co.uk

This 10,000sq. ft gallery opened in 1995, showing major exhibitions of work by contemporary artists of national and international standing.

Safehouse

25 Lower Donegall Street, Belfast, BT1 2FF T 028 90314499

F 028 90319950

E info@safehouseartsspace.org

W www.safehousearts.org

Has a varied programme of contemporary paintings, traditional paintings, drawings, sculpture and ceramics.

Ulster Museum

Botanic Gardens, Belfast, BT9 5AB

T 028 90383000

W www.ulstermuseum.org.uk

Recently refurbished in 2009, the museum is home to the most important public holdings of art in Northern Ireland, collected since the 1880s. Includes continental Old Masters and icons, seventeenth-, eighteenth-, and nineteenth-century British masters, twentieth-century British, European and American paintings, and Irish painting from the seventeenth century to the present. Also has sculpture by the likes of Henry Moore, Barbara Hepworth, F.E. McWilliam, Kenneth Armitage, Anthony Caro, Philip King, Barry Flanagan and Isamo Noguchi.

Scotland

Aberdeen Art Gallery

Schoolhill, Aberdeen, AB10 1FQ

T 01224 523700

F 01224 632133

E info@aagm.co.uk

W www.aagm.co.uk

Houses an important fine-art collection with particularly good examples of nineteenth-, twentieth- and twenty-first century works and a diverse applied art collection. Hosts a programme of special exhibitions.

Submission Policy Submissions should be sent to the exhibitions officer at the above address. To discuss proposals prior to submission, phone O1224 523713.

Burrell Collection

Pollok Country Park, 2060 Pollokshaws Road, Glasgow, G43 1AT

T 0141 2872550

F 0141 2872597

E museums@cls.glasgow.gov.uk

W www.glasgowmuseums.com

Major collections include medieval art, tapestries, alabasters, stained glass, English oak furniture,

European paintings by Degas and Cézanne, Islamic art, and modern sculpture by Epstein and Rodin. Also has collection of works from ancient China, Egypt, Greece and Rome.

Submission Policy Exhibition proposals considered at monthly meetings of Exhibitions Committee. Email museums@cls.glasgow.gov.uk in the first instance.

Talks/Events/Education Ongoing events programme, mostly free.

Centre for Contemporary Arts (CCA)

350 Sauchiehall Street, Glasgow, G2 3JD

T 0141 3524900

F 0141 3323226

E gen@cca-glasgow.com

W www.cca-glasgow.com

CCA is a vibrant temporary arts organization in Glasgow's city centre, with an eclectic programme offering visual arts, music, film, talks and performance. Curates six major exhibitions a year, showing a wide range of Scottish and international contemporary art, as well as emerging artists. Also screens independent short, dance and documentary films otherwise unavailable across the city. Offers a programme of artist residencies providing studio space and mentoring support. Submission Policy Please visit CCA website for invitations to submit work for the Creative Lab and CALQ residencies.

Talks/Events/Education CCA programmes regular events for all, and occassional events for artists and practitioners, providing a platform for discussion and collaboration.

City Art Centre (CAC)

2 Market Street, Edinburgh, EH1 1DE

T 0131 5293993

F 0131 5293977

E enquiries@city-art-centre.demon.uk

W www.cac.org.uk

Founded in 1980, the CAC is home to a large range of Edinburgh's fine-art collections.

Temporary exhibits in the past have ranged from Star Wars to the Glasgow Boys, the Titanic to Cecil

Submission Policy Submissions from artists welcome.

Talks/Events/Education Occasional events (prices vary).

Collective Gallery

22–28 Cockburn Street, Edinburgh, EH1 1NY T 0131 2201260

E mail@collectivegallery.net W www.collectivegallerv.net

Originally established as an artist-run space in 1984, the Collective has developed into an independent, publicly funded exhibition, commissioning and development agency. Aims to support emergent Scottish contemporary art and artists within the context of an international programme.

Submission Policy There are two deadlines a year for submitting applications - contact the gallery for details.

Talks/Events/Education Organizes regular talks and events for all exhibitions.

Collins Gallery

University of Strathclyde, 22 Richmond Street, Glasgow, G1 1XQ

T 0141 5482558

F 0141 5524053

E collinsgallery@strath.ac.uk

W www.strath.ac.uk/collinsgallery

Housed within the University of Strathclyde, the annual programme of ten temporary exhibitions is broad-ranging, representing contemporary and historic, fine and applied art by established and new artists throughout Britain and abroad.

Submission Policy The exhibition programme is generally planned up to two years in advance. However, open to artists submitting work for interim exhibition opportunities. See website for details.

Talks/Events/Education See website for details.

Dean Gallery

73 Belford Road, Edinburgh, EH4 3DS

T 0131 6246200

F 0131 3432802 E deaninfo@nationalgalleries.org

W www.nationalgalleries.org

An art centre situated in parkland opposite the Scottish National Gallery of Modern Art. Opened in 1999, it provides a home for the Eduardo Paolozzi gift of sculpture and graphic art, including a reconstruction of Paolozzi's studio. Also houses the Scottish National Gallery of Modern Art's renowned Dada and Surrealist collections, one of the best collections of Surrealist art in the world. Contains a library and archive, and a gallery fitted out as a library for the display of artists' books. Shows temporary exhibitions on a regular basis. In the grounds are sculptures by Bourdelle, Rickey, Hamilton Finlay, Paolozzi and Turnbull.

Talks/Events/Education Various talks, events and lectures throughout the year. Contact the gallery for further information.

Dick Institute

Elmbank Avenue, Dean Road, Kilmarnock, KA3 1XB

T 01563 554343

W www.east-ayrshire.gov.uk/comser/ arts_ museums

Opened in 1901. Two art galleries and three museum galleries house permanent and temporary displays of fine and contemporary art and craft.

Duff House Country House Gallery

Banff, AB45 3SX

T 01261 818181

F 01261 818900

E duff.house@aberdeenshire.gov.uk

W www.duffhouse.com

Duff House was designed by William Adam and built between 1735 and 1740 for the Earls Fife. It now houses a permanent collection, including furniture, tapestries, and Old Masters by artists such as Sir Henry Raeburn, El Greco and François Boucher. Regular visiting exhibitions are held.

Dundee Contemporary Arts

152 Nethergate, Dundee, DD1 4DY

T 01382 909900

F 01382 909221 E dca@dca.org.uk

W www.dca.org.uk

An internationally renowned centre for the arts, opened in 1999. Houses five floors of cinemas. galleries, artists' facilities, education resources and the University of Dundee Visual Research Centre.

Fife Contemporary Art & Craft (FCAC)

Town Hall, Queens Gardens, St Andrews, KY16 T 01334 474610

F 01334 479880

E angela.turner@fcac.co.uk

W www.fcac.co.uk

Established since 2006 (formerly knows as Crawford Arts), the gallery organizes a programme of visual art and craft through partner venues. A new online retail shop sells crafts from nationally acclaimed makers.

Submission Policy Professional artists should send visuals, CV and info.

Talks/Events/Education Talks and exhibitions are free and open to all. Workshops relating to exhibitions are charged.

Fruitmarket Gallery

45 Market Street, Edinburgh, EH1 1DF T 0131 2252383 F 0131 2203130

E info@fruitmarket.co.uk

W www.fruitmarket.co.uk

Established in 1984 as an independent public gallery. Committed to exhibiting contemporary art made by established and emerging international and Scottish artists. Major recent exhibitions include Ellen Gallagher, Fred Tomaselli and Louise Bourgeois in 2004, Hiroshi Sugimoto in 2002 and Shirin Neshat in 2000. Exhibitions emphasise new work as part of a consistent and developing artistic practice, and seek to engage new and existing audiences through an integrated education, interpretation and publishing programme. Submission Policy Submissions made directly to the Gallery Director. The gallery programme is subject to fourteen months' lead time. Talks/Events/Education Free gallery tours and artist's talk for each exhibition. Workshops for adults, young people and small children for a small

Gallery of Modern Art

fee.

Royal Exchange Square, Glasgow, G1 3AH T 0141 2873050

E museums@cls.glasgow.gov.uk W www.glasgowmuseums.com

Opened in 1996. Housed in an elegant Neoclassical building in the heart of Glasgow city centre. Refurbished to hold the city's contemporary-art collection, the building is an appealing combination of old and new architecture, incorporating a number of artists' commissions. Displays work by local and international artists as well as addressing contemporary social issues through major biannual projects.

Submission Policy Exhibition proposals are considered at monthly meetings of Exhibitions Committee. Email museums@cls.glasgow.gov.uk in the first instance.

Talks/Events/Education Ongoing events programme, mostly free.

Hunterian Art Gallery

82 Hillhead Street, University of Glasgow, Glasgow, G128QQ T 0141 3305431

F 0141 3303618

E hunter@museum.gla.ac.uk

W www.hunterian.gla.ac.uk

In 1783 William Hunter bequeathed his substantial and varied collections to the University of Glasgow and the museum was opened to the public in 1807. In 1870 the Hunterian collections were transferred to the university's present site. The art collection is now housed separately. There are five collections: Mackintosh House, Glasgow Boys, Mackintosh Collection, Scottish Colourists and the Whistler Collection.

Inverleith House

Royal Botanic Garden Edinburgh, Inverleith Place/ Row, Edinburgh, EH3 5LR

T 0131 2482971

F 0131 2482901

E ihouse@rbge.org.uk

W www.rbge.org.uk/inverleith-house

Presents a continuous programme of exhibitions (by invitation only) on three floors of a naturally lit Georgian House in the Royal Botanic Garden. Solo exhibitions by artists based overseas have included: Carl Andre, Louise Bourgeois, William Eggleston, Roni Horn, Agnes Martin, Ed Ruscha, Robert Ryman, Rudolf Stingel, Cy Twombly, Lawrence Weiner and Franz West and in Scotland/UK; Ian Hamilton Finlay, Douglas Gordon, Richard Hamilton, Jim Lambie, Mark Leckey, Cathy Wilkes and Richard Wright. A parallel programme of exhibitions results from projects designed to improve access to the visual arts - and small publishing, teaching and internship programmes are also run.

Talks/Events/Education Talks and workshops accompany most exhibitions.

Kelvingrove Art Gallery and Museum

Argyle Street, Glasgow, G3 8AG

T 0141 2769599

W www.glasgowmuseums.com

Opened in 1901 and reopened in summer 2006 after a three-year restoration project. Large fineand applied-art collections, including several major European works as well as natural history, ethnography, and arms and armour.

Submission Policy All exhibition proposals are considered by an exhibition committee that meets monthly. In the first instance email museums@ cls.glasgow.gov.uk.

Kirkcaldy Museum and Art Gallery

War Memorial Gardens, Kirkcaldy, KY1 1YG

T 01592 583213

E Kirkcaldy.museum@fife.gov.uk

W www.fifedirect.org.uk/museums

Founded in 1925, housing a collection of fine and decorative arts of local and national importance. Holds an outstanding collection of eighteenth- to twentieth-century Scottish paintings, including large bodies of work by William McTaggart and Scottish Colourist S.J. Peploe. Also has three galleries showing a changing programme of temporary exhibitions.

Submission Policy Applications should be in writing to the Exhibitions Officer.

Talks/Events/Education Occasional talks and workshops, advertised in the local press.

The Lighthouse

Scotland's Centre for Architecture, Design and the City, 11 Mitchell Lane, Glasgow, G1 3NU T 0141 2216362

F 0141 2216362

E enquiries@thelighthouse.co.uk

The building comprises 1,400m2 of exhibition space. Shows fifteen to twenty exhibitions per year, many of international calibre. Also contains a Charles Rennie Mackintosh interpretation centre and a dedicated education floor, including workshop, computer laboratory, gallery space and an innovative project called the Urban Learning Space.

Mount Stuart

Isle of Bute, PA20 9LR
T 01700 503877
F 01700 505313
E contactus@mountstuart.com

W www.mountstuart.com

The Visual Arts Programme was created in 2001 as a way to promote interest in contemporary visual arts. Its objectives are to stimulate fresh perspectives and utilise the setting of Mount Stuart and the Isle of Bute as an exciting opportunity for public artwork. Since its launch, the programme has attracted many exceptional artists, including Turner Prize nominees Nathan Coley, Anya Gallaccio, Christine Borland and Langlands & Bell. Each project is the result of a unique collaborative process between the artist and Mount Stuart Trust. The exhibition programme enhances visitors' experience of Mount Stuart and continue a time-honoured tradition of supporting artistic endeavour.

Submission Policy Please send proposals to contactus@mountstuart.com.

Talks/Events/Education The programme for each exhibition includes artists' talks and school and adult workshops. Free of charge.

National Gallery of Scotland

The Mound, Edinburgh, EH2 2EL T 0131 6246200 F 0131 2200917 E nginfo@nationalgalleries.org W www.nationalgalleries.org Home to Scotland's greatest collection of European paintings and sculpture from the Renaissance to Post-Impressionism. The collection of watercolours, prints and drawings features some twenty thousand items and is particularly rich in Italian and Netherlandish drawings. Also has a comprehensive collection of Scottish art, representing all the major names including Ramsay, Raeburn, McTaggart and Wilkie. The Playfair Project recently extended and upgraded the gallery's site on the Mound to incorporate the newly refurbished Royal Scottish Academy Building, which hosts a series of exhibitions all year round, and the Weston Link, which is connected by means of a modern underground visitor facility including a state-of-

the-art education centre and lecture theatre.

Talks/Events/Education Various talks, events and lectures throughout the year. Contact the gallery for further information.

National Museum of Scotland

Chambers Street, Edinburgh, EH1 1JF

T 0131 2257534 E info@nms.ac.uk

W www.nms.ac.uk/scotland

The museum presents the history of Scotland through collections ranging from everyday objects to some of Scotland's most precious treasures. Undergoing a £46.4 million refurbishment to transform exhibition and learning facilities. Half the galleries closed until 2011.

Talks/Events/Education See website.

National War Museum

Edinburgh Castle, Edinburgh, EH1 2NG

T 0131 2474413 F 0131 2253848

E info@nms.ac.uk

W www.nms@ac.uk/war

Collections of paintings, prints, ceramics and glass illustrating everything from worldchanging events to the everyday lives of Scottish servicemen.

Peacock Visual Arts

21 Castle Street, off the Castlegate, Aberdeen, **AB115BQ**

T 01224 639539

F 01224 627094

E info@peacockvisualarts.co.uk

W www.peacockvisualarts.co.uk

A contemporary visual arts organization supported by Aberdeen City Council and the Scottish Arts Council. Established in 1974 as a printmaking workshop, the facility has developed into a centre for the promotion of art and visual media. Submission Policy All submissions for projects

and proposals welcome. Contact Monika Vykonkal (Curator) in the first instance at monika@ peacockvisualarts.co.uk.

Talks/Events/Education Frequent talks, educational events and courses throughout the year. Admission is free.

The Queen's Gallery, Palace of Holyroodhouse

Edinburgh, EH8 8DX

T 0131 5565100 F 020 79309625

E press@royalcollection.org.uk

W www.royal.gov.uk

Opened in 2002 to celebrate the Queen's Golden Jubilee, the gallery hosts a series of changing exhibitions of works of art (predominantly works on paper) from the Royal Collection.

Talks/Events/Education Private evening tours available for pre-booked groups (admission charged).

Royal Scottish Academy Building

The Mound, Edinburgh, EH2 2EL

T 0131 2256671 F 0131 2206016

E enquiries@nationalgalleries.org

W www.nationalgalleries.org

Designed by architect William Henry Playfair at the junction of Princes Street and the Mound. Has undergone refurbishment by the National Galleries of Scotland and offers nearly 1,500m2 of international exhibition space, housed in eleven

Talks/Events/Education A range of free public events is created to appeal to as many people as possible.

Scottish National Gallery of Modern Art

75 Belford Road, Edinburgh, EH43DR

T 0131 6246200

F 0131 6237126

E enquiries@nationalgalleries.org

W www.nationalgalleries.org

Opened in 1960, with a small number of twentieth-century works from the National Gallery of Scotland. Now comprises more than five thousand items, ranging from the late nineteenth century to the present and encompassing a wide variety of media, from paintings, bronzes and works on paper, to kinetic sculpture and video installations.

Talks/Events/Education A range of free public events.

Scottish National Portrait Gallery

I Queen Street, Edinburgh,

EH2 1JD

T 0131 6246200

F 0131 5583691

E pginfo@nationalgalleries.org

W www.nationalgalleries.org Situated in the heart of the New Town on Queen Street. Provides a unique visual history of Scotland, told through portraits of the figures who shaped it. Includes work not only by Scottish artists but by great English, European and American masters such as Van Dyck, Gainsborough, Rodin and Kokoschka. Also displays sculptures, miniatures, coins, medallions, drawings and watercolours. The Scottish National Photography Collection is also based at the gallery.

Talks/Events/Education Various talks, events and lectures held throughout the year.

St Mungo Museum of Religious Life and Art

2 Castle Street, Glasgow, G4 0RH

T 0141 5532557

F 0141 5524744

E museums@cls.glasgow.gov.uk

W www.glasgowmuseums.com

Opened in April 1993. The aim of the museum is to promote understanding and respect between people of different faiths and none. Displays occupy three floors and are divided into four exhibition areas: the Gallery of Religious Art, the Gallery of Religious Life, the Scottish Gallery and a temporary exhibition space.

Submission Policy All exhibition proposals are considered by an exhibition committee that meets monthly. In the first instance email museums@ cls.glasgow.gov.uk.

Talks/Events/Education Ongoing events programme, mostly free.

Talbot Rice Gallery

University of Edinburgh, Old College, South Bridge, Edinburgh, EH8 9YL

T 0131 6502210 F 0131 6502213

E info.talbotrice@ed.ac.uk

W www.trg.ed.ac.uk

Established in 1975, the public gallery of the University of Edinburgh. Presenting major contemporary exhibitions in the White Gallery, showing a variety of painting, sculpture, drawing and installation along with the round room programme, a unique architectural space showing small installations and experimental projects. The University's fine-art collections are on display in the Georgian Gallery. Admission to all galleries and events is free.

Talks/Events/Education Has a broad educational remit, offering a programme of regular tours, lectures, seminars and artists' talks accompanying each exhibition (free to the public).

Timespan

Dunrobin Street, Helmsdale, Sutherland, KW8 6JX

T 01431 821327 F 01431 821058

E enquiries@timespan.org.uk

W www.timespan.org.uk

A museum and gallery with changing exhibitions of contemporary art, showcasing work of international, national and local artists. Exhibition programme of diverse fine and applied arts. The gallery offers residency opportunities.

Transmission

45 King Street, Glasgow, G1 5QP

T 0141 5527141

F 0141 5521577

E info@transmissi

E info@transmissiongallery.org W www.transmissiongallery.org

An artist-run space set up in 1983 by graduates from Glasgow School of Art who were dissatisfied with the lack of exhibition spaces and opportunities for young artists in Glasgow. Through support from the Scottish Arts Council, they manage and maintain a space in which to exhibit their work and that of local artists and invited artists working nationally and internationally.

Talks/Events/Education Maintains an image bank of slides, which are made available to visiting curators and artists.

Verdant Works

West Henderson's Wynd, Dundee, DD1 5BT T 01382 309060

F 01382 225891

E admin@dundeeheritage.co.uk

W www.verdantworks.com

A museum of Dundee's textile industries (primarily focused on jute), opened in 1996 and housed in a nineteenth-century mill building. Submission Policy The Exhibitions Director assesses all potential exhibitions for quality and suitability. Two- and three-dimensional material can be shown. Booked up a year in advance.

South-east

ArtSway

Station Road, Sway, SO41 6BA

T 01590 682260 F 01590 681989

E mail@artsway.org.uk

W www.artsway.org.uk

Established in 1997, ArtSway is a contemporary visual arts venue deep in the New Forest. In addition to a programme of high-quality contemporary art exhibitions of international significance, the gallery also hosts artists-inresidence and offers professional development and production facilities for artists. The white cube galleries were designed by architect Tony Fretton. Submission Policy See website for information on residency opportunities and deadlines for the ArtSway open exhibition held annually in December and January. Submission by proposal are welcomed but opportunities are very limited. Talks/Events/Education Offers free gallery talks throughout the year by artists and staff. A comprehensive range of workshops and short-courses are offered throughout the year including regular life-drawing sessions and holiday workshops. ArtSway also develops specific workshops and courses for various groups including children, young people and those who are normally exculded from engaging in creativity.

Ashmolean Museum

Beaumont Street, Oxford, OX1 2PH

T 01865 278000 F 01865 278018

W www.ashmol.ox.ac.uk

Founded in 1683, the Ashmolean is one of the oldest museums in the world. Recently expanded and enlarged following a ± 61 million redevelopment, the collection includes everything from Chinese watercolours to Renaissance drawings and Picasso paintings.

Submission Policy For artist submissions, send information to Dr Christopher Brown (Director of the Ashmolean).

Talks/Events/Education Presents study days, lectures and talks. All groups must book. See website for details.

Aspex Gallery

The Vulcan Building, Gunwharf Quays, Portsmouth, PO1 3BF T 023 92778080

E info@aspex.org.uk

W www.aspex.org.uk
Exists to provide the people of Portsmouth,
the locality and visitors with opportunities
to experience some of the most innovative
contemporary visual arts locally, nationally, and
internationally. The exhibitions policy is to show
work of high quality that reveals the full potential
of the artist or artists chosen. In the main it has
concentrated on younger artists who are in the
possession of a body of work that has not been
seen in public (or in the region). Access Aspex, a

small exhibition and project space, focuses on the

work of artists based in Portsmouth and the south-

work or that of an experimental nature. **Submission Policy** Proposals from artists and curators are welcomed. See the background section on the website.

east region. This space is suited to small-scale

Talks/Events/Education Programme of free artist's talks alongside each exhibition. Aspex Artists' Ressource Centre (ARC) provides information, guidance and support for artists.

Brighton Museum and Art Gallery

Royal Pavilion Gardens, Brighton, BN1 1EE **T** 03000 290900

E visitor.services@brighton-hove.gov.uk
W www.brighton.virtualmuseum.info
Following a £10m redevelopment in 2002,
the gallery has become one of the most visited
museums in the south-east. Includes nationally
important collections of twentieth-century art and
design, fashion, paintings, ceramics and world art.
Talks/Events/Education Runs programme of
special events, talks and courses.

Buckinghamshire Art Gallery

Buckinghamshire County Museum, Church Street, Aylesbury, HP20 2QP T 01296 331441 F 01296 334884

E museumwebsiteenquiries@buckscc.gov.uk
W www.buckscc.gov.uk/museum/index.stm
Housed in a fifteenth-century building refurbished
in 1995, the gallery has a permanent collection.
Up to five exhibitions, ranging across a variety
of art forms and subjects, are held annually.
Talks/Events/Education Hosts various events,
activities and gallery talks.

Cass Sculpture Foundation

Sculpture Park, Goodwood, Chichester, PO18 0QP

T 01243 538449

F 01243 531853

E info@sculpture.org.uk

W www.sculpture.org.uk

Focusing on twenty-first century British sculpture, the park consists of twenty-six acres of woodland in an area of outstanding natural beauty, containing over sixty large-scale sculptures by Britain's leading artists. The foundation was established in 1994 as a charity and aims to empower sculptors (both young and established) to take their careers to a new level.

Charleston Farmhouse and Gallery

The Charleston Trust, Firle, Lewes, BN8 6LL

T 01323 811265

F 01323 811628

E info@charleston.org.uk

W www.charleston.org.uk

Founded in 1981 to conserve Charleston Farmhouse, a unique example of the decorative art and bohemian ideals of the Bloomsbury artists Vanessa Bell and Duncan Grant. Open to visitors and stages workshops and events.

Submission Policy The gallery is open to established artists in all media (applications close 30 September for the following season; contact c.baron@charleston.org.uk). Free to exhibit. Twenty per cent commission taken.

Talks/Events/Education Welcomes applications by artists to lead workshops for children and young people. Work should use Charleston as the inspiration. In addition, there is a full annual programme of special events, lectures and creative workshops open to all.

Christ Church Picture Gallery

Christ Church, St Aldates, Oxford, OX1 1DP T 01865 276172

F 01865 202429

E picturegallery@chch.ox.ac.uk

W www.christ-church.ox.ac.uk

Houses an internationally important collection of Old Master paintings, drawings and prints in a listed modern building. Especially known for its holdings of Italian art, dating from the early Renaissance to the eighteenth century. Among its highlights are paintings by Filipino Lippi, Veronese, Tintoretto, Annibale Carracci and Salvator Rosa, together with drawings by Leonardo, Michelangelo and Raphael. Also possesses a small number of works by renowned northern European artists, including Van Dyck, Rubens, Frans Hals and Hugo Van der Goes. The gallery holds regular exhibitions of its Old Master drawings and shows by local living artists. Submission Policy Artists should consider what will fit into the gallery and exhibition programme. Send illustrative material, CV and covering letter. No hire charge. Twenty-five per cent commission. Talks/Events/Education Free guided tours every Thursday at 2.15 p.m. Special talks relating to current exhibitions or the collection held from time to time.

Crafts Study Centre

University College for the Creative Arts at Farnham, Falkner Road, Farnham, GU9 7DS

T 01252 891450

F 01252 891451

E craftscentre@ucreative.ac.uk

W www.csc.ucreative.ac.uk

Established in 1970. Located at the front of the Farnham campus of the University College for the Creative Arts in Surrey, it is the first purpose-built museum and research facility for modern and contemporary crafts. Two galleries feature free exhibitions and a research room/library is available for booking by individual researchers and groups by appointment. Annual exhibitions in the ground floor Tanner Gallery show items from the Centre's collections and archives including ceramics, textiles, calligraphy, wood and metalwork. Today's makers feature in new exhibitions held every three months in the first floor gallery.

Submission Policy Programme is selected up to two years in advance. Proposals from contemporary craft practitioners should be made in writing to the Director.

Talks/Events/Education Gallery Talks featuring contemporary artist-makers and curator's are held to accompany most exhibitons. For details visit the 'Events' page on the website.

De La Warr Pavilion

Marina, Bexhill on Sea, TN40 1DP

T 01424 787949

F 01424 787940

E celia.davies@dlwp.com

W www.dlwp.com

Built in 1935, this grade I-listed Modernist building is a leading centre for contemporary art, architecture and live performance.

Submission Policy Contact Celia Davies (Head of Exhibitions).

Talks/Events/Education Talks are a major part of the programme.

Ditchling Museum

Church Lane, Ditchling, BN6 8TB

T 01273 844744

E info@ditchling-museum.com

W www.ditchling-museum.com

Home to the artists Eric Gill, Edward Johnston and Frank Brangwyn in the twentieth century. Gill founded the artists' community of St Joseph and St Dominic, which included artists, letterers, weavers and silversmiths. Much of their work and that of other artists drawn to the area is represented in the collection. The museum has a temporary exhibition space and holds three or four exhibitions per year.

Submission Policy Open to written submissions only. The museum cannot return images, etc. and will only be able to respond to artists that it feels may be suitable to exhibit.

Talks/Events/Education Talks and events throughout the year.

Eastleigh Museum

25 High Street, Eastleigh, SO50 5LF

T 023 80643026

F 023 80653582

E gill.budden@hants.gov.uk

W www.hants.gov.uk/museum/eastlmus Holds regularly changing special exhibitions, which include art, crafts, photography, local and natural history. National and regional touring exhibitions shown, as well as the work of local artists, societies and collectors.

Talks/Events/Education Talks accompany some exhibitions. Admission is free.

Guildford House Gallery

155 High Street, Guildford, GU1 3AJ

T 01483 444742

F 01483 458563

E guildfordhouse@guildford.gov.uk

W www.guildfordhouse.co.uk

Home of Guildford borough's art collection since

1959. Has a varied programme of temporary exhibitions including local groups and touring exhibitions.

Submission Policy Artists must be connected to Guildford or Surrey. The waiting list is approximately two years.

Talks/Events/Education A programme of free talks, workshops and tours accompanies the exhibition programme.

HMAG (Hastings Museum and Art Gallery)

Johns Place, Bohemia Road, Hastings, TN34 1ET T 01424 451052

E museum@hastings.gov.uk

W www.hmag.org.uk

Houses historical and cultural displays, a local studies room and an art gallery, with collections of fine and applied art. The gallery focuses on contemporary visual art, with occasional art history exhibitions. There are four-five exhibitions in each year's programme.

Submission Policy Artists should submit exhibition proposals in writing (with illustrations of their work) to the exhibitions officer.

Talks/Events/Education Workshops and talks are arranged with each exhibition. These are usually free but on occasion may have a nominal fee.

Hove Museum and Art Gallery

19 New Church Road, Hove, BN3 4AB

T 01273 290900

E museums@brighton-hove.gov.uk

W www.virtualmuseum.info

Houses permanent collections of toys, film, local history, paintings and contemporary craft. Underwent major redevelopment in 2003. Hosts temporary exhibitions of varying forms of art (paintings, photography, craft, etc.).

Submission Policy Contact the exhibitions office for more details on 03000 290900.

Talks/Events/Education Runs a programme of events, talks and courses.

James Hockey Gallery

University for the Creative Arts, Falkner Road, Farnham, GU9 7DS

T 01252 892646 / 892668

F 01252 892667

E galleries@surrart.ac.uk

W www.surrart.ac.uk/galleries

This public exhibition space within the university complex shows a wide range of work, including art, craft, design and lens-based media. Aims

to present work of lasting and educational importance.

Submission Policy The exhibitions programme focuses on contemporary work. Application procedures are available from the galleries office. Talks/Events/Education Workshops and public events are associated with most exhibitions and open to an inclusive audience of professionals, amateurs and general visitors.

John Hansard Gallery

University of Southampton, Highfield, Southampton, SO17 1BJ

T 023 80592158

F 023 80594192

E info@hansardgallery.org.uk

W www.hansardgallery.org.uk

Submission Policy The gallery does not represent artists. The selection process is made at the discretion of the Director and Exhibitions Officer.

Talks/Events/Education Presents a wide programme of talks, symposia and conferences, tours and workshops. Talks are free and normally accompany each new show. For symposia and conferences, a fee is charged.

Manor House Gallery

Chipping Norton, OX7 5LH

T 01608 642620

E luigi@manorhousegallery.co.uk

W www.manorhousegallery.co.uk

Shows oils and watercolours by contemporary British painters, specializing in Scottish artists.

Metropole Galleries

The Leas, Folkestone, CT20 2LS

T 01303 244706

F 01303 851353

E info@metropole.org.uk

W www.metropole.org.uk

Founded in 1960. Has hosted a broad range of exhibitions over the years. Current priorities are to present contemporary art with meaning and resonance for the locale and physical space. In most cases the galleries work with artists to devise exhibitions. Has a strong education and audience development programme.

Submission Policy Artists should send details about themselves, their work and what they would like to produce for the Metropole. Applicants are advised to visit the gallery in advance as the space is rather unusual.

Talks/Events/Education Hosts occasional talks, discussions, etc.

Millais Gallery

Southampton Solent University, East Park Terrace, Southampton, SO14 0YN

T 023 80319916

F 023 80334161

E millais.gallery@solent.ac.uk

W www.solent.ac.uk/millais

A city-centre public art gallery committed to the exhibition of mainly contemporary visual arts that address issues of relevance to culturally diverse communities locally, regionally and nationally. The programme of exhibitions and events complements the work of staff and students in art, design and media.

Submission Policy Artists may submit proposals to the curator.

Talks/Events/Education Public talks during each exhibition. All are welcome and admission is free.

Milton Keynes Gallery

900 Midsummer Boulevard, Central Milton Keynes, MK9 3OA

T 01908 676900

F 01908 558308

E info@mk-g.org

W www.mk-g.org

Opened in 1999, Milton Keynes Gallery presents around six free exhibitions of contemporary art per year from around the world. Aims to stimulate participation and debate, building relationships between artists and audiences. It has three interconnected strands: gallery exhibitions, off-site projects in and around the city, and education events aimed at interpreting and generating critical debate about the practice of contemporary artists and their relationship with their audience. Talks/Events/Education Series of 'In Conversation' events with artists and critics and free lectures on related programme.

Modern Art Oxford

30 Pembroke Street, Oxford, 0X1 1BP

T 01865 722733

F 01865 722573

E info@modernartoxford.org.uk

W www.modernartoxford.org.uk

Established in 1965, a leading public gallery. Working with artists from around the world

to enable audiences and communities to participate in and engage with contemporary art.

Admission to the gallery and all exhibitions is free.

Talks/Events/Education During exhibitions, gallery runs workshops for families, students,

teachers and schools. Artist talks and free exhibition tours are open to all. Booking is essential for workshops, courses and artist talks and entry is subject to availability. Some events are subject to ticket prices, for which concessions are often available.

Open Hand Open Space

571 Oxford Road, Reading, RG30 1HL

T 0118 9597752

E contact@ohos.org.uk

W www.ohos.org.uk

Artist-run studios and public gallery, established over twenty-four years ago by former Reading University MA students to provide arts and artists' provisions for the local area (while showing international shows). Previous members include Cornelia Parker and Paul Bonaventura.

Submission Policy Members' applications should include a CV and slides. The gallery welcomes detailed proposals for shows by artists, which are then presented to committee.

Talks/Events/Education All events are free. Hosts numerous artists' talks, seminars and visiting artists throughout the year, usually corresponding to the current exhibit.

Pallant House Gallery

9 North Pallant, Chichester, PO19 1TI

T 01243 774557 F 01243 536038

E info@pallant.org.uk

W www.pallant.org.uk

The Gallery of Modern Art in the South, located in a Queen Anne townhouse and a contemporary building holding a major collection of twentieth-century British art. Extensive exhibition programme includes international touring exhibitions and print room shows. The collection includes important works by, among others, Auerbach, Blake, Bomberg, Caulfield, Freud, Goldsworthy, Hamilton, Hodgkin, Langlands and Bell, Moore, Nicholson, Paolozzi, Piper, Sickert and Sutherland.

Talks/Events/Education Talks and educational events throughout the year.

Parham House

Parham Park, Storrington, Pulborough,

RH20 4HS

T 01903 742021 F 01903 746557

E enquiries@parhaminsussex.co.uk

W www.parhaminsussex.co.uk

Opened to visitors in 1948. An important collection of paintings by artists such as Gainsborough, Lely, Barlow, Stubbs, Badmin, Muncaster, Devis, Castro, Lutterhuys, Peake, Wootton and Zoffany. Shown in light panelled rooms of Elizabethan house. Open from Easter to September on Wednesdays, Thursdays, Sundays and Bank Holiday Mondays, as well as Tuesdays and Fridays in August.

Submission Policy Does not show any living

Pitt Rivers Museum

South Parks Road, Oxford, OX1 3PP T o1865 270927 F o1865 270943 E prm@prm.ox.ac.uk W www.prm.ox.ac.uk

Founded in 1884 when General Pitt Rivers gave 18,000 objects to the university, the museum now houses over 500,000 objects from around the world and across time. Recently refurbished, the collections include textiles and looms, Benin brasses and ivories, masks, sculpture, jewelry and ceramics.

Submission Policy Welcomes submissions by I October each year for its occasional programme of exhibitions and installations relating to the collections (and developed in collaboration with curatorial staff).

Talks/Events/Education A changing programme of activities and events are listed on the website.

Portsmouth City Museum and Records Office

Museum Road, Portsmouth, PO1 2LJ

T 023 92827261

F 023 92875276

E Christopher.Spendlove@portsmouthcc.gov.uk W www.portsmouthmuseums.co.uk

The museum's main display is 'The Story of Portsmouth'. It also features a fine- and decorative- art gallery, and a temporary exhibition gallery with regular changing exhibitions. Among the most important exhibits are collections of 17th-century furniture, Art Deco furniture, Frank Dobson sculptures, Ceri Richards relief workand paintings by Turner and Ronald Ossory Dunlop.

Quay Arts

15 Sea Street, Newport Harbour, Newport, Isle of Wight, PO30 5BD

T 01983 822490 F 01983 526606

E info@quayarts.org

W www.quayarts.org

Founded in 1979. Has three gallery spaces showing work by international, national and local artists. Also has seven artists' studios for hire. Submission Policy Submit images of work to Jo Hummel-Newell (Exhibitions Organizer) at j.hummel-newell@quayarts.org

Talks/Events/Education Has a full programme of talks and courses for artists of all levels. Some are free. In July and August there is a summer school for artists.

Rochester Art Gallery & Craft Case

c/o Visitors Information Centre, Rochester
T 01634 338319
E arts@medway.gov.uk
The gallery was scheduled to relocate during 2009
at time of publication. Please check website for
new details. Holds regularly changing exhibitions

Russell-Cotes Art Gallery and Museum

of fine art, craft and photography.

East Cliff, Bournemouth, BH1 3AA
T 01202 451858
F 01202 451851
E russelll-cotes@bournemouth.gov.uk
Museum of nineteenth-century paintings,
sculpture and Japanese art pieces.

St Peter's Street, Canterbury, CT1 2BQ

Sidney Cooper Gallery

T 01227 453267
E gallery@canterbury.ac.uk
W www.canterbury.ac.uk
Founded in 2004 by Canterbury Christ
Church University College, the gallery shows
contemporary work by local, national and
international artists. Aims to show the process
of making art, supported by lectures and a public
programme.

Submission Policy Welcomes portfolio-backed submissions from artists in all media. Yearly programme decided by November. Exclusive university use from mid-June to mid-September. Talks/Events/Education Each exhibition is supported by free lectures, workshops and sometimes concerts.

Southampton City Art Gallery

Civic Centre, Commercial Road, Southampton, SO14 7LP T 023 80832277 F 023 80842153

E art.gallery@southampton.gov.uk

W www.southampton.gov.uk/leisure/arts/ art%2Dgallery

Collection comprises 3,500 works, with the earliest being Allegretto Nuzzi's fourteenth-century altarpiece. Also includes seventeenth-century Dutch landscapes and French Impressionist paintings. The modern-art holdings include works by Sir Stanley Spencer, Philip Wilson Steer, Tony Cragg, Richard Long, Shirazeh Houshiary, Antony Gormley, Michael Craig-Martin and Chris Ofili. Talks/Events/Education Workshops for children and adults and also gallery talks.

St Barbe Museum and Art Gallery

New Street, Lymington, SO41 9BH

T 01590 676969

F 01590 679997

E office@stbarbe-museum.org.uk

W www.stbarbe-museum.org.uk

Opened in 1999, with art works related to the local area.

Stanley Spencer Gallery

The Kings Hall, High Street, Cookham, SL6 9SJ T 01628 471885

E info@stanleyspencer.org.uk **W** www.stanleyspencer.org.uk

Opened in 1962, devoted exclusively to Spencer's work and life. The trust holds a collection of over 100 original works by Spencer and changes its exhibition twice a year, augmenting its own collection with temporary loans of major works from other institutions and private owners. An extensive archive and library are available to the public in the Gallery, as well as a collection of memorabilia associated with the artist. The Gallery has recently undergone extensive refurbishment, and is now a modern fully accessible space.

Talks/Events/Education Talks about aspects of the artist's life and work by arrangement; a small group booking fee is applicable.

Tourse

Devonshire Park, College Road, Eastbourne, BN214JJ

T 01323 434660

F 01323 648182

E towner@eastbourne.gov.uk

W www.towner.org.uk

A local-authority art gallery founded in 1923, but recently relocated to a purpose-built facility. The permanent fine-art collection holds in excess of four thousand works by artists including Eric Ravilious, Christopher Wood and Alfred Wallis. Has a lively temporary contemporary exhibitions programme.

Submission Policy Welcomes exhibition proposals from living artists, addressed for the attention of the curator.

Talks/Events/Education Talks accompany some temporary exhibitions, changing approximately every six to eight weeks (some are free). Often held on Thursday evenings or Saturday afternoons.

Trinity Gallery

Trinity Theatre, Church Road, Tunbridge Wells, TN1 7IP

T 01892 678670 F 01892 678680

E info@trinitytheatre.net

W www.trinitytheatre.net

Founded in 1977, the gallery runs a programme aimed at showing diverse contemporary art.

Submission Policy Contact the gallery for an application form. Can only accommodate work that can hang on the wall. Exhibitions are generally monthly.

Tunbridge Wells Museum and Art Gallery

Civic Centre, Mount Pleasant, Tunbridge Wells, TN1 1JN

T 01892 554171

F 01892 554131 E museum@tunbridgewells.gov.uk

W www.tunbridgewellsmuseum.org
Gallery space is used for six exhibitions a year,
ranging from the work of local artists and
craftspeople to selections from the Museum's
collection, and from exhibitions created by artists
working in residence with local community
groups to national touring exhibitions. Major
art collections held by the Museum include the
Ashton Bequest of Victorian Oil paintings, early
photographs by Henry Peach Robinson and work
by Charles Tattershall Dodd.

Submission Policy Artists are selected for the following year by a bi-annual exhibitions panel. Talks/Events/Education Various educational workshops and events are held with specific exhibitions. There is usually something every two months. Anyone is welcome to attend and the events are free.

University of Brighton Gallery

Grand Parade, Brighton, BN2 0JY T 01273 643010 F 01273 643038 E g.wilson@brighton.ac.uk W www.brighton.ac.uk/gallery
Housed within the university's Faculty of Arts
and Architecture and curated by the Centre
for Contemporary Visual Arts. Holds between
eight to twelve exhibitions per year, including
the university's own student shows, touring
exhibitions, shows by leading contemporary artists

and installations. **Submission Policy** Only exhibits contemporary collections. Proposals are welcomed from interested artists or groups.

Talks/Events/Education The university has a number of full- and part-time courses, plus talks and lectures open to the public.

Waddesdon Manor

Waddesdon, nr Aylesbury, HP18 0JH T 01296 653211/226 E vicky.darby@nationaltrust.org.uk W www.waddesdon.org.uk

Waddesdon Manor was built between 1874 and 1889 by Baron Ferdinand de Rothschild to display his collection of art treasures and entertain the fashionable world. Contains textiles and decorative arts from the eighteenth century, important examples of English portraiture, several Dutch Old Masters and a fine collection of Sevres porcelain. Talks/Events/Education Many public events

Talks/Events/Education Many public events are organized each season, details of which are available on the website or in a diary of events. The events focus on the exhibitions of the year or on items in the collection that are of particular note like the Seyres or furniture.

Winchester Gallery

Winchester School of Art, Park Avenue, Winchester, SO23 8DL

T 01962 852500

E WING@soton.ac.uk

W WING.org. UK and fotonet.org. UK Offers a programme of contemporary visual art, craft, photography and new media along with Winchester School of Art degree exhibitions. Also holds off-site exhibitions in venues up and down the country which don't usually have exhibitions. Runs strong educational programme involving contemporary artists. The gallery is amalgamated with Fotonet, a photography and new media website offering on line exhibitions, international symposia and portfolio days.

Windsor & Royal Borough Museum (W&RBM) Windsor Library, Bachelors Acre, Windsor, SL4 1ER T 01628 796829 F 01628 796121

E museum.collections@rbwm.gov.uk

W www.rbwm.gov.uk/web/museum_index.htm Small local history collection which achieved registered museum status in 2002. Aims to make the history of the borough accessible to residents and visitors. The collection includes 6,000 objects including prehistoric tools, Roman and Saxon artefacts, maps, textiles, paintings, objects and ephemera from before Victorian times to the 1950s. Small displays are housed in Windsor Library and other borough venues. Museum Store open by appointment. Loans boxes of artefacts for use in schools are administered from Reading Museum Service (T 0118 9399800). Submission Policy No space to show living artists. Talks/Events/Education Friends of W&RBM have an annual calendar of historical talks and

visits. Talks cost approximately £2 each. (T 01753)

Worthing Museum and Art Gallery

Chapel Road, Worthing, BN11 1HP

T 01903 221150

774642).

F 01903 236277

E museum@worthing.gov.uk

W www.worthing.gov.uk/Leisure/

MuseumArtGallery

Collections include British works (by artists including Hitchens, Pissarro and Hunt), European works (by artists including Roerich, Hobbema and Wynants) and a piece from the School of Bassano. Works by local artists are also represented. There is a small sculpture collection and decorative arts and textiles. The studio was opened in the early 1990s as a temporary exhibition space for the museum's collections as well as invited artists and groups.

South-west

Arnolfini

16 Narrow Quay, Bristol, BS1 4QA

T 0117 9172300

F 0117 9172303

E info@arnolfini.org.uk

W www.arnolfini.org.uk

Created in 1961. An internationally renowned contemporary arts centre situated in Bristol's vibrant harbourside, presenting new, innovative work in visual arts, performance, dance, film, literature and music. Open seven days a week, with free admission to the building, exhibitions and café-bar.

Submission Policy For further information, contact the Exhibitions Department. Talks/Events/Education Education programme includes talks, tours, workshops and events.

The Art Gym

Petherton Road, Hengrove, Bristol, BS14 9BU T 0117 3772800 ext.268 F 0117 3772807

E rfitzger@hengrove.bristol.sch.uk

W www.theartgym.co.uk

Purpose-built in 2002, a non-commercial gallery space hosting exhibitions from contemporary artists working in all media. Ongoing exhibition programme shows established, international artists, emerging contemporary artists, and individual curatorial projects. Based in the grounds of Hengrove Community Arts College. **Submission Policy** The gallery accepts proposals from artists and curators. Contact the Art College manager for a submission pack. Artists and curators are advised to consider the context of the space when developing a proposal.

Talks/Events/Education Ongoing programme of educational activities and workshops. For full details contact the gallery manager on 0117 3772800 ext.268.

Barbara Hepworth Museum and Sculpture

Barnoon Hill, St Ives, TR26 1AD

T 01736 796226

W www.tate.org.uk/stives/hepworth.htm Run by the Tate since 1980 and now an integral part of Tate St Ives. Hepworth, who died in 1975, asked in her will that Trewyn Studios and the adjacent garden, with a group of her sculptures placed as she wished, be permanently open to the public.

Bristol's City Museum and Art Gallery

Queens Road, Bristol, BS8 1RL

T 0117 9223571

F 0117 9222047

E general_museum@bristol-city.gov.uk W www.bristol-city.gov.uk/museums Contains several galleries of fine and applied art, including works from the Bristol School, Old Masters, and British works from the seventeenth to the twentieth centuries. Houses important collections of Eastern art, largely Chinese and Japanese, and has an ever-changing programme of temporary exhibitions and a public events programme.

Talks/Events/Education Programme of events includes talks which are free and open to anyone.

Burton Art Gallery and Museum

Kingsley Road, Bideford, EX39 2QQ T 01237 471455

F 01237 473813

E burtonartgallery@torridge.gov.uk W www.burtonartgallery.co.uk

Founded in 1951 with a core collection of English watercolours and ceramics. Rebuilt in 1993 and extended to three gallery spaces, a craft gallery and a local museum. Shows about twenty visiting exhibitions a year, ranging from national touring shows to mixed exhibitions and the work of individual artists.

Submission Policy Interested in all kinds of art and craft, with a leaning towards accessible art. Talks/Events/Education Hosts artists' talks and workshops.

Cheltenham Art Gallery & Museum

Clarence Street, Cheltenham, GL50 3IT

T 01242 237431 F 01242 262334

E ArtGallery@cheltenham.gov.uk

W www.cheltenham.artgallery.museum Houses a major collection relating to the Arts and Crafts Movement including furniture and metalwork made by Cotswold craftsmen, inspired by William Morris. Additional collections include rare Chinese and English pottery, four hundred years of painting by Dutch and British artists, and the story of Edward Wilson, Cheltenham's Antarctic explorer. Special exhibitions are held throughout the year and the museum also has a shop and café.

Submission Policy Artists should write in with a CV and photos or slides of their work. Artists should have some connection with Cheltenham. the Cotswolds or Gloucestershire.

Talks/Events/Education Workshops, talks and events held at various times throughout the year.

Design Collection Museum

Arts Institute at Bournemouth, Fern Barrow, Wallisdown, Poole, BH12 5HH

T 01202 533011

F 01202 537729

E designcollection@aic.ac.uk

W www.aic.ac.uk

Founded in 1988. Became a registered museum in 2001. A study and research resource that

facilitates an understanding and appreciation of international mass-produced popular design and culture of the twentieth- and twenty-first centuries. Diverse yet cohesive collections consist of approximately 7,500 items which relate directly to the academic courses and specialist areas of study offered at the Institute. Organized into key collection categories that identify specific object types (e.g. electrical, product design, fashion, printed ephemera, plastics, packaging,

Submission Policy The collection comprises examples of mass-produced twentieth- and twentyfirst-century design only.

Dorset County Museum

High West Street, Dorchester, DT1 1XA T 01305 262735 F 01305 257180

E enquiries@dorsetcountymuseum.org W www.dorsetcountymuseum.org Founded in 1846 the museum's diverse art collection includes oil paintings by Thomas Gainsborough, James Thornhill, Thomas Hudson, Alfred Wallis and Christopher Wood. With the assistance of HLF and the Art Fund, it recently

acquired three portraits by George Romney of the Rackett family, including an important 1768 full-length of Thomas Rackett. Thousands of topographical watercolours and prints of Dorset include local scenes by Henry Joseph Moule. Although only a small proportion of the oil paintings, works on paper and sculpture are on display, the reserve art collection work is exhibited through the museum's temporary exhibition programme. Appointments can be made to see the

Submission Policy All media accepted for the regular temporary exhibitions programme. Proposals submitted to a selection committee, which meets five times a year. Thirty per cent commission.

Fairfields Arts Centre

reserve collection.

Council Road, Basingstoke, RG21 3DH T 01256 321621

F 01256 357694

E enquiries@fairfields.org

W www.fairfields.org

Main public gallery/arts space in North Hampshire. Houses galleries, dance studio and theatre, digital media suite and printroom. Regular exhibition and events programme.

Talks/Events/Education Yes, see website.

Fox Talbot Museum

High Street, Lacock, nr Chippenham, SN15 2LG T 01249 730176

W www.nationaltrust.org.uk

Commemorates the life and work of William Henry Fox Talbot (1800-1877), who in 1835 discovered the negative-positive photographic process. The museum is located inside a medieval barn at the entrance to Lacock Abbey, with the upper gallery hosting two to three annual exhibitions showing work by contemporary and nineteenth-century photographers.

The Gallery - text+work

The Arts Institute at Bournemouth, Wallisdown, Poole, BH125HH

T 01202 363351

F 01202 537729 E gallery@aib.ac.uk

W www.textandwork.org.uk

text+work is a forum for artists, writers, performers and curators to examine and extend the boundaries between contemporary practice and critical discourse. Holds regular gallery events, touring exhibitions, performances and shared and networked exhibitions. The programme includes collections on loan from galleries and museums, as well as initiated and curated exhibitions by some of today's leading artists and critical writers including Ian McKeever+David Miller (poet) and John Hopkins+Grenville Davey (Turner Prize Winner). An essay is published to accompany each exhibition and event.

Submission Policy See website.

Talks/Events/Education All exhibitions are supported by a text+work talk/event. For further information on touring exhibitions, publications and events, please contact Violet McClean - gallery officer.

Gloucester City Museum and Art Gallery

Brunswick Road, Gloucester, GL1 1HP T 01452 396131

F 01452 410898

W www.gloucester.gov.uk/citymuseum Opened in 1860, with important collection of fine and applied art.

Holburne Museum of Art

Great Pulteney Street, Bath, BA2 4DB T 01225 466669 F 01225 333121

E holburne@bath.ac.uk

W www.bath.ac.uk/holburne

Located in the former Georgian Sydney Hotel. housing a dispay of fine and decorative arts collected by Sir William Holburne, including English and continental silver, porcelain, maiolica. glass and Renaissance bronzes. The picture gallery contains works by Turner, Guardi and Stubbs, plus notable portraits of Bath society by Gainsborough. There are also several temporary exhibitions during the year.

Talks/Events/Education The Holburne hosts lunchtime and evening lectures as well as day courses which may be suitable for artists to attend. Fee applicable.

Kelmscott Manor

Kelmscott, Lechlade, GL7 3HJ T 01367 253348 / 252486 F 01367 253754 E admin@kelmscottmanor.co.uk

W www.kelmscottmanor.co.uk

The country home of William Morris (poet, craftsman, artist and socialist) from 1871 until his death in 1896. The house contains a collection of the possessions and works of Morris and his associates, including furniture, textiles, ceramics and paintings.

The Lighthouse

Centre for the Arts, Kingland Road, Poole, **BH15 1UG**

T 0844 4068666

E info@lighthousepoole.co.uk W www.lighthousepoole.co.uk

Reopened in 2002 following major refurbishment. Part of the largest arts centre outside London, the gallery is programmed in partnership with The Study Gallery of Modern Art in Poole. Enquiries regarding exhibition opportunities should be made direct to The Study Gallery.

Submission Policy Bi-annual open exhibition (details on website) open to residents of the BH and DT postcode areas.

Museum of East Asian Art

12 Bennett Street, Bath, BA1 201

T 01225 464640 F 01225 461718

E museum@east-asian-art.freeserve.co.uk

W www.meaa.org.uk

Situated in a restored Georgian house, housing a fine collection of ceramics, jades, bronzes and more from China, Japan, Korea and Southeast Asia. Since opening to the public in 1993, the museum has become one of the most extensive

collections of East Asian art outside London, with almost 2,000 objects dating from c. 5000 BC to the present day.

Submission Policy Apply directly by post, phone or email. Art work should be relevant to East Asia. Talks/Events/Education Holds creative adult workshops, talks, tours and children's workshops. Price ranges from free events to some workshops costing f_{15} .

National Monuments Record Centre

Kemble Drive, Churchward, Swindon, SN2 2GZ T 01793 414600 E nmrinfo@english-heritage.org.uk W www.english-heritage.org.uk/nmr The centre is home to the archive of England's heritage. Holds a stock of over ten million photographs, drawings and other documents recording the archaeology and architecture of England.

Nature In Art

Wallsworth Hall, Twigworth, Gloucester, GL2 9PA T 01452 731422 F 01452 730937 E ninart@globlnet.co.uk W www.nature-in-art.org.uk

The world's first museum dedicated exclusively to art inspired by nature.

New Art Centre

Roche Court, East Winterslow, Salisbury, SP5 1BG T 01980 862244

F 01980 862447

E nac@sculpture.uk.com W www.sculpture.uk.com

Founded in 1958, specializing in British and international sculpture from 1950 onwards, in parkland, a gallery and an Artists' House. Exhibition programme of 5-6 shows a year. Sole representative of the Estate of Barbara Hepworth (1903-1975). Other featured artists include Antony Gormley, Richard Long, Alison Wilding, Richard Deacon, Henry Moore, Anthony Caro, Kenneth Armitage, Anya Gallaccio, Barry Flanagan and Gavin Turk.

Talks/Events/Education Contact the Roche Court Educational Trust at edu@sculpture.uk.com

New Brewery Arts Centre

Brewery Court, Cirencester, GL7 1JH T 01285 657181 F 01285 644060 W www.newbreweryarts.org.uk

Visual and performing arts and crafts centre with theatre, education studios, artists' workshops, gallery, shop and café. Regular exhibitions of national/international art and craft in upstairs gallery space.

Talks/Events/Education Run adult, childrens' and family classes and workshops, have drop-in sessions and community/schools-based events. See website for details.

Newlyn Art Gallery

24 New Road, Newlyn, Penzance, TR18 5PZ T 01736 363715 F 01736 331578

E mail@Newlynartgallery.co.uk W www.Newlynartgallery.co.uk

Originally opened in 1895, the newly refurbished gallery reopened in 2007, alongside major new art space The Exchange, in the heart of Penzance. Delivers nationally significant programmes of contemporary art exhibitions and education projects.

P.J. Crook Foundation

39 Priory Lane, Bishop's Cleeve, Cheltenham, GL52 8JL

T 01242 675963

E museum@pjcrook.com

W www.pjcrook.com/museum.html
Established in 2004 with the aim of opening
and maintaining Crook's studios and house as
an educational resource and for the benefit of
the public. Exhibits significant paintings from
throughout Crook's career, as well as works by
artists who taught her, are from the region or
have relevance to the main collection (particularly
women artists and Surrealism, and prints and
works on paper).

Submission Policy Hopes to curate shows by living artists in future years but is not seeking applications at present.

Penlee House Gallery and Museum

Morrab Road, Penzance, TR18 4HE T 01736 363625

F 01736 361312

E info@penleehouse.org.uk

W www.penleehouse.org.uk

Founded in 1839, the district museum and art gallery for Penzance and Penwith. A programme of changing art exhibitions exclusively focuses on the historic art of west Cornwall, often featuring the Newlyn and Lamorna artists' colonies (1880–1940). Note that Penlee House does not

have a contemporary art remit and opportunities for artists are therefore limited to workshops and/or partnership activities with other exhibition venues.

Submission Policy Does not handle or show any living artists and therefore does not welcome submissions.

Talks/Events/Education Holds regular talks, educational events and occasional artist-led workshops.

Penwith Galleries and Penwith Society of Arts

Back Road West, St Ives, TR26 1NL

T 01736 795579

Founded in 1949. Aims to encourage practising artists and craftworkers in Cornwall and to promote public interest in the arts. The organization includes public galleries, artists' studios and a bookshop and a print workshop. Holds continuous exhibitions of paintings, ceramics and sculpture.

Plymouth City Museums and Art Gallery

Drake Circus, Plymouth, PL4 8AJ

T 01752 304774

F 01752 304775

E plymouth.museum@plymouth.gov.uk **W** www.plymouthmuseum.gov.uk, www.

cottoniancollection.org.uk

The current museum opened in 1910 and houses the designated Cottonian Collection featuring paintings by Plymouth-born Joshua Reynolds. The collection includes maritime pictures, oil paintings, watercolours, prints, drawings and ceramics. Good examples of works from the Newlyn School and by other important local painters. Free, regularly changing exhibitions. Submission Policy Annual exhibitions open to non-members by Plymouth Society of Artists and Plymouth Arts Club. Phone for details.

Talks/Events/Education Free Tuesday-lunchtime talks, regular family and children's activities and other events.

Prema

South Street, Uley, nr Dursley, GL11 5SS T 01453 860703

E info@prema.demon.co.uk

W www.prema.demon.co.uk

Founded almost thirty years ago, this small, independent rural arts centre has a year-round programme of arts activities (performances, classes, workshops, exhibitions, installations, etc.). The main exhibition space is multifunctional; a

smaller space is available, though less often used. Exhibitions last five to six weeks.

Submission Policy First contact by phone or email, then send in a CV and images (as attachments, on CD or as hard copies), and then discuss with the Director.

Talks/Events/Education Regular classes and workshops, all artist-led. Occasionally artists' talks.

Red House Museum and Art Gallery

Quay Road, Christchurch, BH23 1BU T 01202 482860

F 01202 481924

W www.hants.gov.uk/museum/redhouse Built as a workhouse in 1764, the building now houses several locally relevant collections, including an extensive range of Arts and Crafts pieces. Also hosts temporary exhibitions.

Royal Cornwall Museum

River Street, Truro, TR1 2SJ

T 01872 272205

F 01872 240514

E enquiries@royalcornwallmuseum.org.uk W www.royalcornwallmuseum.org.uk Founded in 1818. Owned and managed by the Royal Institution of Cornwall, which was created to advance the education of the public by encouraging and promoting the study and knowledge of literature, natural sciences, archaeology, history, ethnology, geology and the fine and applied arts, with special reference to Cornwall.

Submission Policy Contact the exhibitions officer.

Talks/Events/Education Talks and educational events held throughout the year. See website for details.

Royal West of England Academy (RWA)

Queen's Road, Clifton, Bristol, BS8 1PX

T 0117 9735129

F 0117 9237874 E info@rwa.org.uk

W www.rwa.org.uk

Founded in 1944 as Bristol's first art gallery. Houses five naturally-lit galleries. Stages major solo, mixed and open exhibitions all year round, and has a collection of works spanning the nineteenth, twentieth and twenty-first centuries. Submission Policy Annual Autumn Exhibition is an open exhibition of painting, printmaking, sculpture and architecture. Entry regulations available from August from www.rwa.org.uk.

Talks/Events/Education A programme of educational activities accompanies each exhibition. These include lectures, gallery tours, demonstrations and workshops. Charges may apply.

SPACEX

45 Preston Street, Exeter, EX1 1DF T 01392 431786 F 01392 213786 E mail@spacex.org.uk W www.spacex.co.uk

Established in 1974 by an Exeter-based artists' cooperative, extending the SPACE philosophy of artist-led studios and exhibition initiatives beyond London. A publicly-funded contemporary art space and registered educational charity. Encourages public engagement with the latest developments in contemporary art through commissioned projects, exhibitions, events and activities for all ages. Talks/Events/Education A regular programme of talks, symposia and workshops, as well as participatory projects out of the gallery. Also weekly after-school and Saturday Art Club activities for children and young people.

St Ives Society of Artists Gallery

Norway Square, St Ives, TR26 2SX T 01736 795582 E gallery@stisa.co.uk

W www.stivessocietyofartists.com and also www.stisa.co.uk

The society first organized exhibitions of members' work in 1927. There are two galleries, with the main gallery housing several exhibitions during the year of contemporary work, including traditional as well as semi-abstract. Some exhibitions feature work from artists and organizations outside the membership. The Mariners' Gallery is available for hire by artists or

Submission Policy Welcomes applications for membership by artists from Cornwall. Work must be of a high standard.

Talks/Events/Education See website.

Study Gallery

North Road, Parkstone, Poole, BH14 0LS T 01202 205200 F 01202 205240 E info@thestudygallery.org W www.thestudygallery.org Opened in 2000. Runs feature exhibitions presenting work in different forms on changing themes and of high professional status. Also has a programme of project exhibitions, displaying the results of projects that the gallery initiates or is involved in through partnerships. Home to Bournemouth and Poole College's mid-twentiethcentury art collection, including work by Henry Moore, Barbara Hepworth, Ivon Hitchens and Bridget Riley.

Swindon Community Heritage Museum and Art

Bath Road, Swindon, SN1 4BA

T 01793 466556

W www.steam-museum.org.uk

A museum and art gallery telling the story of local history.

Tate St Ives

Porthmeor Beach, St Ives, TR26 1TG

T 01736 796226

F 01736 793794

E visiting.stives@tate.org.uk

W www.tate.org.uk/stives

Open since 1993. Aims, through its varied international exhibition programme and education programmes, to encourage a greater understanding and enjoyment of modern and contemporary art in the cultural context of St Ives. A selection of works from the St Ives School of Artists is always on display. Three seasons of exhibitions each year show major figures in British contemporary art.

Talks/Events/Education An extensive programme of talks, events and study days (some free and some chargeable).

Victoria Art Gallery

Bridge Street, Bath, BA2 4AT

T 01225 477232

F 01225 477231

E victoria_enquiries@bathnes.gov.uk

W www.victoriagal.org.uk

The permanent collection occupies two rooms on the first floor, while the ground floor is given over to two temporary exhibition spaces, which change every two months. Permanent collections range from the fifteenth century to the present day and were formed mainly by gift and bequest since the building first opened in 1900. Highlights include eighteenth-century portraits, views of Bath, Victorian paintings, English Delftware and Staffordshire ceramic dogs. Modern artists include John Nash, Walter Sickert, William Roberts and Kenneth Armitage.

Watershed

I Canon's Road, Harbourside, Bristol, BS1 5TX

T 0117 9276444

E info@watershed.co.uk

W www.watershed.co.uk

A media centre for the digital age, with a programme of feature films, video, digital media, courses and events presented in three cinemas, three event suites and online.

Talks/Events/Education Runs an extensive education programme and a programme of digital courses. Other events include talks such as the 'Alternative Series', run by the Centre for Critical Theory at Bristol UWE in conjunction with Watershed.

Wales

Aberystwyth Arts Centre

Aberystwyth University Campus, SY23 3DE

T 01970 622882

F 01970 622883

E s2s@aber.ac.uk

W www.aberystwythartscentre.co.uk Houses a concert-hall theatre, gallery spaces specializing in large-scale contemporary-art shows and photography exhibitions, studiotheatre workshop spaces, two cafés, a cinema, craft design shop, bookshop and bars. Hosts one of Britain's most important collections of studio

Submission Policy Apply in writing with visuals to Eve Ropek. Applications are put before a programming committee.

Talks/Events/Education Courses, workshops and talks are held on a weekly basis. Other specialized events covering all art forms are held annually.

Andrew Logan Museum of Sculpture

Berriew, nr Welshpool, SY22 8AH T 01686 640689 E info@andrewlogan.com

W www.andrewlogan.com

A collection of works by sculptor Andrew Logan.

The Bleddfa Centre

The Old School Room Gallery, Bleddfa, Knighton, LD7 1PA

T 01547 550377

F 01547 550370

E enquiries@bleddfacentre.com

W www.bleddfacentre.com

The Old School Room Gallery hosts exhibitions of paintings, sculpture and crafts, while the Hall Barn hosts meetings, talks and workshops, all with a spiritual content.

Submission Policy Artists must exhibit work which shows a link between creativity and spirituality.

Chapter Gallery

Chapter Arts Centre, Market Road, Canton. Cardiff, CF5 1QE

T 029 20311050

F 029 20311059

E enquiry@chapter.org

W www.chapter.org

Established over thirty years ago. Comprises galleries, two residency studios, a theatre, cinemas and fifty artists' studios. Operates an international programme of contemporary visual arts activity through commissioning, touring, residencies and exhibitions, publishing and commissioning essays, talks and events. Recent commissions and exhibitions have included Ansuman Biswas, Harold Offeh, Erika Tan, Zoë Mendleson, Joel Tomlin, Salla Tykkä and Chris Evans. Also established May You Live In Interesting Times, Cardiff's biannual city-wide Festival of Creative Technology (mayyouliveininterestingtimes.org). Submission Policy Exhibition is generally by invitation only.

Talks/Events/Education Hosts a wide programme of talks and events. See website.

Ffotogallery

c/o Chapter, Market Road, Cardiff, CF5 1QE

T 029 20341667

F 029 20341672

E info@ffotogallery.org

W www.ffotogallery.org

The national development agency for photography in Wales. Initiates exhibitions that explore mainstream documentary photography as well as more expansive uses of the medium, which may involve the use of projection and other forms of extended and digital media. The gallery's exhibition programme is run from the grade II-listed Turner House Gallery in Penarth, a ten-minute drive from Cardiff. Hosts touring exhibitions, collaborates with other organizations and runs education and outreach programmes. Submission Policy All work by artists working with any form of lens-based art considered. Talks/Events/Education Runs a regular programme of gallery talks and an extensive programme of photography and digital courses and classes. The talks programme is free.

Glynn Vivian Art Gallery

Alexandra Road, Swansea, SA15DZ

T 01792 516900

F 01792 516903

E glynn.vivian.gallery@swansea.gov.uk

W www.glynnviviangallery.org

Founded in 1911. An Edwardian gallery offering a broad range of visual arts from the original bequest of Richard Glynn Vivian (1835-1910) to art of the twentieth century. The latter is well represented with painting and sculpture by Hepworth, Nicholson and Nash alongside Welsh artists such as Ceri Richards, Gwen John and Augustus John. The exhibitions programme in the modern wing gives a contemporary overview of the arts in local, national and international contexts.

Submission Policy Applications are considered throughout the year, and should include a CV. examples of the work (on slides, CD, video, DVD, etc.), plus publications and support material. Talks/Events/Education An education service for schools and a programme of artists' talks and events, plus lectures organized by Friends of the gallery.

Howard Gardens Gallery

Cardiff School of Art and Design, UWK Howard Gardens, Cardiff, CF24 0SP

T 029 20418608

F 029 20416944

E rcox@uwk.ac.uk

W www.csad.uwic.ac.uk/summergallery Situated at the centre of Cardiff School of Art and Design, the programme presents a combination of contemporary fine-art and craft exhibitions from local, national and international sources. Also holds annual BA degree and MA postgraduate exhibitions in the summer and autumn terms. Submission Policy Contemporary visual artists and craftspeople may apply during the academic year (September to June) with a CV, ten slides and sae.

Talks/Events/Education Occasional seminars and conferences associated with specific exhibitions.

MOMA Wales

The Tabernacle, Heol Penrallt, Machynlleth, **SY20 8AJ**

T 01654 703355

F 01654 702160

E info@momawales.org.uk

W www.momawales.org.uk

MOMA Wales has grown up alongside the Tabernacle, a former Wesleyan chapel, which in 1986 reopened as a centre for the performing arts. It has six exhibition spaces, which house, throughout the year, the Tabernacle Collection and modern Welsh art. Individual artists are spotlighted in temporary exhibitions. Talks/Events/Education Workshops for adults and

children in July. Tabernacle Art Competition in August, with winners chosen by expert judges and the public. Many works in MOMA Wales for sale.

National Museum and Gallery, Cardiff

Cathays Park, Cardiff, CF10 3NP

T 29 20397951

E art@nmgw.ac.uk

W www.museumwales.ac.uk/en/cardiff Collections include the Williams-Wynn Collection, the De Winton Collection of European porcelain, the Morton Nance Collection of Welsh ceramics, the Davies Sisters' Collection, historical paintings, works on paper and contemporary craft. The Davies Collection is one of the great British art collections of the twentieth century and was donated to the museum in the 1950s. Historical paintings includes sixteenth-century Welsh portraits, a collection of miniatures and works from across Europe.

Oriel Davies Gallery

W www.orieldavies.org

The Park, Newtown, SY16 2NZ T 01686 625041 F 01686 623633 E enquiries@orieldavies.org

Formerly Oriel 31, Oriel Davies Gallery was started in Newtown in 1985 as a contemporary-art gallery in Mid-Wales. Following an extensive threeyear refurbishment beginning in 2002, it now boasts two new galleries that cater specifically to displaying temporary exhibitions of modern and contemporary art.

Submission Policy Welcomes applications from contemporary artists to exhibit, but does not represent artists.

Oriel Mostyn Gallery

12 Vaughan Street, Llandudno, LL30 1AB T 01492 879201 F 01492 878869 E post@mostyn.org W www.mostyn.org

Founded in 1978 as a gallery for contemporary arts. Shows five or six changing exhibitions of all contemporary art forms per year.

Submission Policy The gallery references and

curates its own shows and collaborates with other galleries, but submissions from artists are considered. There is an annual open exhibition with a £6,000 prize, where entries are solicited from artists without conditions of age, theme or any other restriction.

Talks/Events/Education Free 'Artists Talking' series, where exhibiting artists discuss their work. Other events are also organized, some of which are free.

Riverfront

T 01633 656677 E theriverfront@newport.gov.uk W www.newport.gov.uk In 1999 Newport received funding for a new arts centre, which includes a small gallery displaying exhibitions of art, design and photography. Rooms

Bristol Packet Wharf, Newport, NP20 IHG

Royal Cambrian Academy of Art

Crown Lane, Conwy, LL32 8AN T 01492 593413 Erca@rcaconwy.org W www.rcaconwy.org Founded in 1881. Home to a significant collection of Welsh art.

Ruthin Craft Centre

are available for hire.

Lon Parcwr (Park Road), Ruthin, LL15 1BB T 01824 704774 W www.ruthincraftcentre.org.uk Modern new gallery for contemporary applied art and craft, set within the Clwydian hills. Houses three galleries, six artist studios, retail gallery, education and residency workshops, tourist information gateway and café with courtyard terrace.

School of Art Gallery and Museum

The University of Wales, Aberystwyth, Buarth Mawr, Aberystwyth, SY23 1NG T 01970 622460 F 01970 622461 E neh@aber.ac.uk W www.aber.ac.uk/museum Has changing exhibitions from the permanent collection and touring shows. The collection includes graphic art from the fifteenth century to the present, art in Wales since 1945, contemporary Welsh and post-war Italian photography, early twentieth-century pioneer

and contemporary British studio pottery,

eighteenth- and nineteenth-century slipware, Swansea and Nantgarw porcelain, art pottery and Oriental ceramics (Ceramics Collection is housed in Aberystwyth Arts Centre). Studies of the collection by appointment.

Tenby Museum and Gallery

Castle Hill, Tenby, SA70 7BP

T 01834 842809

E info@tenbymuseum.org.uk

W www.tenbymuseum.org.uk

The permanent collection includes works by Augustus John, Gwen John, Nina Hamnet, E.J. Head, Julius Caesar Ibbetson, John Piper and David Jones.

Wrexham Arts Centre

Rhosddu Road, Wrexham, LL11 1AU

T 01978 292093 F 01978 292611

E oriel.wrecsam@wrexham.gov.uk

W www.wrexham.gov.uk/arts

Established in 1973, the centre is funded by the Arts Council of Wales and local-authority administered. Exhibits contemporary, temporary visual and applied art exhibitions highlighting a variety of artists and media. Works in collaboration with many partners. Hosts and tours exhibitions.

Submission Policy Artists can send in exhibition proposal, including images, CV and vision of proposed exhibition.

Talks/Events/Education An education programme supports every exhibition and can include talks and workshops.

West Midlands

Barber Institute of Fine Arts

University of Birmingham, Edgbaston, Birmingham, B15 2TS

T 0121 4147333

F 0121 4143370

E info@barber.org.uk

W www.barber.org.uk

Comprises works from the thirteenth to the twentieth centuries, with particularly important Old Master and Impressionist collections. The gallery includes work by Baschenis, Bellini, Botticelli, Degas, Delacroix, Gainsborough, Gauguin, Holbein, Ingres, Magritte, Manet, Matisse, Monet, Picasso, Poussin, Rembrandt, Rodin, Rossetti, Rubens, Schiele, Stom, Turner, Van Dyck, van Gogh, Veronese and Whistler.

Birmingham Museum and Art Gallery

Chamberlain Square, Birmingham, B3 3DH

T 0121 3032834 / 3031966

F 0121 3031394

E bmag_enquiries@birmingham.gov.uk

W www.bmag.org.uk

Founded in 1885. The collections cover fine and applied arts, archaeology and ethnography, and local and industrial history. The fine- and applied- art collections include paintings and drawings, British watercolours and arts and crafts. There is an ever-changing programme of temporary exhibitions and the permanent collection includes the Pre-Raphaelites. Major shows are housed in the restored gas hall. Entrance to the museum and art gallery is free.

Compton Verney

Compton Verney, CV35 9HZ

T 01926 645500 F 01926 645501

E info@comptonverney.org.uk

W www.comptonverney.org.uk

Launched in 2004. Collections include Naples (1600 to 1800), German (1450 to 1650), Chinese bronzes, British portraits, British folk art and the Marx-Lambert Collection of popular art. Also runs a major temporary exhibitions programme.

Talks/Events/Education An extensive events programme accompanies each exhibition. Events are charged for.

The Herbert

Jordan Well, Coventry, CV1 5QP

T 024 76832386

F 024 76832410

E info@theherbert.org

W www.theherbert.org

Recently undergone £20 million redevelopment. Now home to eight permanent galleries, temporary exhibition and event spaces, education spaces, a history centre and media studios.

Hereford Museum and Art Gallery

Broad Street, Hereford, HR4 9AU

T 01432 260692

F 01432 342492

E herefordmuseums@herefordshire.gov.uk

W www.herefordshire.gov.uk (click on Leisure and

Museums)

The museum was founded in 1874 and the gallery added as an extension in the 1920s. Houses changing exhibitions of a wide variety of media and styles. Has an extensive collection of fine

art, costume and social history, as well as natural

history and archaeology.

Submission Policy All submissions welcome, but especially interested in applications from artists who have considered accessibility for the visually impaired.

Talks/Events/Education Exhibitions are often accompanied by talks (a small fee is usually charged). Workshops are usually aimed at nonprofessionals.

Ikon Gallery

I Oozells Square, Brindleyplace, Birmingham, B12HS

T 0121 2480708

F 0121 2480709

E programming@ikon-gallery.co.uk

W www.ikon-gallery.co.uk

Founded about forty years ago and originally a small kiosk in the Bull Ring. It is now housed in the neo-Gothic Oozells Street School. Holds temporary exhibitions in a variety of media and organizes programmes outside the gallery. Submission Policy Welcomes exhibition proposals, reviewed quartlerly. See website. Talks/Events/Education A variety of talks, tours, workshops and seminars are held. For education enquiries, email education@ikon-gallery.co.uk. In addition, a limited number of placements are offered to third-year art students; for details contact above.

Initial Access Frank Cohen Collection

Units 19 and 20 Calibre Industrial Park, Laches Close Off Enterprise Drive, Wolverhampton, WV107DZ

T 01902 790419 F 01902 798810

E visit@initialaccess.co.uk

W www.initialaccess.co.uk

Initial Access opened in 2007, as a new exhibition space to present exhibitions from Frank Cohen's internationally important collection of contemporary art. Sited on the outskirts of Wolverhampton, in two refurbished warehouses that provide 10,000 sq. ft of exhibition space. Presents different aspects of the collection in a series of exhibitions curated by David Thorp. The programme is designed to mount shows of new acquisitions to the collection, explore themes amongst works that may not have been seen before and give the public an opportunity to see more of the collection currently in store.

Leamington Spa Art Gallery and Museum

The Royal Pump Rooms, The Parade, Leamington Spa, CV32 4AA

T 01926 742700

F 01926 742705 E prooms@warwickdc.gov.uk

W www.royal-pump-rooms.co.uk

Opened at the Royal Pump Rooms in 1999. Facilities include an art gallery, a museum with a historic hammam room, a temporary exhibition space, an interactive learning gallery and an education room. The permanent exhibition of art works from the collection changes every eighteen months. A new collection of contemporary works explores links between art and medical science. Shows exhibitions of contemporary art, historical art and social history for an average of six to eight weeks at a time.

Submission Policy Exhibition proposals from individuals or groups should be addressed to the

Talks/Events/Education Details of events given in the quarterly Exhibition & Events publication.

Mead Gallery

Warwick Arts Centre, University of Warwick, Coventry, CV47AL

T 024 76522589

F 024 76572664

E meadgallery@warwick.ac.uk

W www.warwickartscentre.co.uk

Hosts curated exhibitions of international contemporary art and runs an access programme utilizing expertise within the university. The university art collection was founded in 1966 and includes over eight hundred works of modern and contemporary art on open display across campus, including paintings, prints, sculptures, photographs and ceramics.

Submission Policy Welcomes submissions with previous permission from the Senior Curator, although the programme is booked up well in advance.

Talks/Events/Education Open during term time only and holds talks and events relating to each exhibition.

Meadow Gallery

Cumberley, Knowbury, Ludlow, SY8 3LJ T 01584 891659 E info@meadowgallery.co.uk W www.meadowgallery.co.uk

A West Midlands-based contemporary arts organization which produces site specific

exhibitions in outdoor locations, and commissions new work. It operates as a 'roving' gallery working alongside venues with similar or compatible aims (garden, landscape or historic house open to the public) to present contemporary art in an outdoor

Monnow Valley Arts Centre

Walterstone, nr Abergavenny, HR2 0DY T 01873 860529

W www.monnowvalleyarts.org

The Centre was founded in 2007 as a charity and operates an art gallery, sculpture garden, an artist's studio and artist's residency. The Foundation aims to promote contemporary sculpture, carved lettering and landscape painting through exhibitions, workshops and lectures. It curates exhibitions for its own gallery and for touring to other venues. Closed during winter months.

New Art Gallery, Walsall

Gallery Square, Walsall, WS2 8LG T 01922 654400 F 01922 654401 E info@artatwalsall.org.uk W www.artatwalsall.org.uk

Has collections of European art, including major paintings by Rembrandt, Goya, Constable, Manet, Degas and Freud. The Garman Ryan Collection galleries chart the career of Jacob Epstein. There is also an interactive children's gallery, library and changing exhibitions programme.

Talks/Events/Education Holds events and activities, family workshops, artists' talks about exhibitions, and introductory talks about the Garman Ryan Collection.

Potteries Museum and Art Gallery

Bethesda Street, City Centre, Stoke-on-Trent, ST1 3DW

T 01782 232323

F 01782 232500 E museums@stoke.gov.uk

W www.stoke.gov.uk/museums

Opened in 1981, the museum houses the world's greatest collection of Staffordshire ceramics, plus displays of art and local history. There is also a lively programme of exhibitions and events, with the emphasis on contemporary art and

Submission Policy Shows work by artists either based in the region or with a national or international reputation.

Talks/Events/Education Organizes talks and events for specific exhibitions on a regular basis. There is a charge for each event.

Shire Hall Gallery

Market Square, Stafford, ST16 2LD T 01785 278345 E shirehallgallery@staffordshire.gov.uk Dedicated to promoting the visual arts and crafts across a range of subjects and styles. Comprises seven hundred prints, drawings, watercolours, maps and oil paintings.

Shrewsbury Museum and Art Gallery

Rowley's House, Barker Street, Shrewsbury, **SY110H**

T 01743 361196

F 01743 358411

E museums@shrewsbury.gov.uk

W www.shrewsburymuseums.com www.

darwincountry.org

The museum is to be closed to the public until 2011 due to major redevelopment at a new venue. See website for details. Rowley's House will remain open for special exhibitions, including the Open Art exhibition.

Submission Policy Annual open competition (May

closing date for applications).

Talks/Events/Education Occasional exhibitionrelated events, on a one-off basis. Support for young and emerging artists through mediamaker and Young Curators project.

Lichfield Street, Wolverhampton, WV1 1DU

Wolverhampton Art Gallery

T 01902 552055 F 01902 552053 E info@wolverhamptonart.org.uk W www.wolverhamptonart.org.uk Built in 1884 and situated in the heart of the town centre. Recently extended, the gallery's collections include contemporary Pop Art, displays of Victorian and Georgian paintings and video and digital media. The gallery also manages The Makers Dozen Studios, artist studios situated within the art gallery complex, purpose-designed for artists and makers.

Yorkshire and Humberside

Bankfield Museum

Akroyd Park, Boothtown Road, Halifax, HX36HG T 01422 354823 / 352334

E bankfield.museum@calderdale.gov.uk W www.calderdale.gov.uk/leisure/museumsgalleries

Set in a Victorian mill owner's house, Bankfield has a growing reputation as a centre for textiles and contemporary craft. Holds an internationally important collection of textiles, plus weird and wonderful objects from around the world. The museum commissions leading makers and offers a varied programme of exhibitions and events throughout the year.

Cartwright Hall Art Gallery

Lister Park, Bradford, BD9 4NS

T 01274 431212

F 01274 481045

E cartwright.hall@bradford.gov.uk

W www.bradfordmuseums.org/cartwrighthall Built in 1904, this Baroque-style gallery houses four permanent exhibition rooms. Contains collections of nineteenth- and twentieth-century British art (particularly strong in Victorian art), arts from the Indian subcontinent and contemporary South Asian art. Also shows temporary exhibitions.

Cooper Gallery

Church Street, Barnsley, S70 2AH

T 01226 242905

F 01226 297283

W www.barnsley.gov.uk/tourism/coopergallery/ index.asp

Founded in 1912 to house the collection of Samuel Joshua Cooper. The permanent collection holds paintings, watercolours and drawings from the seventeenth to the twentieth centuries. Also hosts visiting contemporary exhibitions, such as the South Yorkshire Open Art Exhibition.

Talks/Events/Education Full year-round programme of artists' talks, workshops and schools activities.

Dean Clough Galleries

Halifax, HX3 5AX

T 01422 250250

F 01422 255250

E dean.clough.ltd@deanclough.com

W www.deanclough.com

An arts, business and design complex created on the derelict site of what was once the world's largest carpet mill. Eight galleries host a range of exhibitions spanning the arts. The Dean Clough Studios, based in Mill House, the Stable Yard and the Band Room, house twenty-four fine artists,

designers and craftworkers working in a variety of media.

Ferens Art Gallery

Queen Victoria Square, Hull, HU1 3RA

T 01482 613902

F 01482 613710

E museums@hullcc.gov.uk

W www.hullcc.gov.uk/museums

Opened in 1927, the gallery combines an internationally renowned permanent collection and a programme of temporary exhibitions. Particular strengths of the collection include European Old Masters (notably Dutch and Flemish), portraiture, marine paintings, and modern and contemporary British art.

Submission Policy Welcomes written proposals from artists involved in fine art. For the temporary exhibitions programme include a CV, statement

and good-quality visuals. Talks/Events/Education Frequently holds talks and education events, most of which are free.

Graves Art Gallery

Central Library, Surrey Street, Sheffield, S1 1XZ T 0114 2782600

F 0114 2782604

W www.shef.ac.uk/city/artgals/graves.html Founded in 1934, the gallery covers all periods of British art from the sixteenth century to the present. Other collections include French, Italian, Spanish and Dutch paintings of all major periods, watercolours, drawings and prints, and a collection of decorative art from diverse cultures (including the Grice Collection of Chinese ivories). Also hosts temporary exhibitions.

Harewood House

Harewood, Leeds, LS17 9LG

T 0113 2181010

F 0113 2181002

E info@harewood.org

W www.harewood.org

The home of the Lascelles family, built in 1759-71 by John Carr in the Palladian style with interiors by Robert Adam. The house was altered and heightened in 1843 by Sir Charles Barry in an Italianate style. Has rich and diverse fine and decorative art collections ranging from Chippendale furniture to Renaissance masterpieces and works from the sixteenth- to twentieth-centuries. British artists are represented by works of Romney, Reynolds, Cotman and Turner. Decorative collections include a collection

of Sèvres porcelain with a tea service made for Queen Marie-Antoinettte and clocks made by the royal clockmaker Benjamin Vulliamy. There are approximately 7,000 objects, 10,000 photographs and approximately 100,000 archival items in the collections. In addition to displaying the collections of the house, there is a programme of temporary exhibitions of historical and contemporary art.

Talks/Events/Education Programme of year-round lectures, demonstrations and workshops.

Henry Moore Institute

74 The Headrow, Leeds, LS1 3AH

T 0113 2467467

F 0113 2461481

E info@henry-moore.ac.uk

W www.henry-moore-fdn.co.uk

A centre for the study of sculpture, with exhibition galleries and an active research programme. Originally set up in partnership between the Henry Moore Foundation and Leeds City Council in the city where Moore began his training as a sculptor, it is now concerned with a wide variety of sculpture, both historical and contemporary. The institute, an award-winning, architecturally designed building, opened in 1993 and comprises a suite of galleries on the ground floor, the library and archive on the first floor, and a seminar room in the basement.

Submission Policy Welcomes applications for research fellowships from artists and academics. Deadline for applications each year is usually end of first week in January.

Talks/Events/Education Runs a series of Wednesday-evening talks for each of its main exhibitions, as well as seminars and conferences. Events are usually free.

The Hepworth Wakefield

Waterfront, Wakefield

W www.hepworthwakefield.com

Scheduled to open in autumn 2010, this extensive gallery, designed by British architect David Chipperfield, will show for the first time a unique collection of work by Barbara Hepworth. One of the most important sculptors of the 20th century, she was born and raised in Wakefield. The gallery will also house a significant permanent collection of British art, and programme international contemporary art and historical exhibitions, alongside talks, workshops, screenings and educational events.

Talks/Events/Education See website.

Huddersfield Art Gallery

Princess Alexandra Walk, Huddersfield, HD1 2SU

T 01484 221964 F 01484 221952

E info.galleries@kirklees.gov.uk

W www.kirklees.gov.uk/art

In current building (along with library) since 1945. The collection consists mainly of twentieth-century British art in all media. Exhibitions throughout the year include one-person and group shows, and touring (Arts Council, Crafts Council, etc.). Current interests particularly in post-war British art, especially sculpture and Constructivism. Submission Policy Written or emailed submissions with slides or CD are accepted. Unlikely to exhibit without local or regional link. Talks/Events/Education Events held. Contact the

Hull Maritime Museum

Queen Victoria Square, Hull, HU1 3DX

T 01482 613902

F 01482 613710

E Arthur.Credland@hullcc.gov.uk

W www.hullcc.gov.uk/museums

education and outreach officer.

Maritime collections go back to 1822. Includes marine paintings (chiefly by local artists), decorative arts of the sea and an outstanding collection of scrimshaw work (carved whale bone and ivory). Recent exhibitions have shown the

work of David Bell and Colin Verity. **Submission Policy** Interested in work incorporating maritime themes, decorative art

with sea connections, or marine painting in the traditional sense.

Impressions Gallery

Centenary Square, Bradford, BD1 1SD

T 08450 515882

F 01274 734635

E enquiries@impressions-gallery.com

W www.impressions-gallery.com

Leading gallery of contemporary art, specializing in photography. Re-opened in a new Bradford gallery space in 2007 with enhanced facilities. Submission Policy Does not generally solicit

exhibition proposals.

Talks/Events/Education Offers range of events including talks by exhibiting artists, film screenings, gallery tours and workshops. Many events are free.

Leeds City Art Gallery

The Headrow, Leeds, LS1 3AA **W** www.leeds.gov.uk/artgallery

Emphasis is on significant and interesting new developments in contemporary art and exhibitions that explore the history of nineteenth- and twentieth-century art. Works on paper include pieces by Turner, Rembrandt, Cotman, Cozens, Girtin, Derain, Sisley, Rose Garrard and Atkinson Grimshaw. Recent contemporary-art acquisitions include works by Bill Woodrow, Paula Rego, Mark Wallinger, Stephen Willats, Alison Wilding and Bridget Riley. With support from the Henry Moore Foundation, the modern sculpture collection is second only to that of the Tate.

Submission Policy The exhibitions programme is put together twelve to eighteen months in advance, and larger-scale exhibitions at least two years in advance. Welcomes applications from artists. Send a proposal outlining the exhibition, supporting visual material (preferably transparencies or slides; five or six and not more than fifteen), which will be returned, a CV and an outline of what makes the proposal distinctive and how it might be of interest to the gallery's audiences. Send to Nigel Walsh (Exhibitions Curator).

Leeds Met Gallery and Studio Theatre

Leeds Metropolitan University, Civic Quarter, Leeds, LS1 3HE

T 0113 2833140

F 0113 283 5999

E gallerytheatre@leedsmet.ac.uk

W www.leedsmet.ac.uk/arts

Founded in 1990. Six exhibitions held each year, including shows based on artists' proposals, initiated projects and occasional hired-in exhibitions.

Submission Policy Submissions should contain good-quality visuals in a format that best represents the work (e.g.slides, video, DVD, CD; digital images should be PC-compatible). Also include a statement about the content of the work, a CV and supporting website links. Do not send full proposals by email. Proposals will be considered by the curator in consultation with education and technical staff at fixed points in the year (mid-November, mid-March and mid-June). Talks/Events/Education Most exhibitions include an education strand, such as talks and critical feedback. These events are generally free of charge.

Mercer Art Gallery

Swan Road, Harrogate, HG1 2SA T 01423 556188 F 01423 556130 E museums@harrogate.gov.uk

W www.harrogate.gov.uk/museums Founded in 1991 in the Promenade Rooms to house the Harrogate Fine Art Collection. The permanent collection is shown in changing themed displays as part of annnual programme of exhibitions of both historic and contemporary art. Submission Policy Submissions welcome from living artists. Written proposals by post only. Artists with regional connections favoured. Talks/Events/Education Wide ranging programmes of events, talks and courses for a broad audience. Some charging, some free.

Millennium Galleries

Arundel Gate, Sheffield, S1 2PP

T 0114 2782600

W www.sheffieldgalleries.org.uk/coresite/html/ millennium.asp

Displays visual arts, craft and design. Incorporates a special exhibition gallery, a craft and design gallery, a metalwork gallery and the Ruskin Gallery, containing a collection compiled by John Ruskin over many years.

Talks/Events/Education The learning centre organizes talks, events and practical workshops.

National Media Museum

Pictureville, Bradford, BD1 1NQ

T 0870 7010200

F 01274 723155

E talk.nmpft@nmsi.ac.uk

W www.nationalmediamuseum.org.uk Founded in 1983, with collections covering the past, present and future of photography, television and film. Includes the Royal Photographic Society Collection, the National Collection, the Daily Herald Archive and the National Cinematography Collection. Formerly called the National Museum of Photography, Film & Television.

Submission Policy Exhibition proposals encouraged. New work is regularly commissioned. For more details, telephone 01274 203325. Talks/Events/Education See website.

Newby Hall and Gardens

The Estate Office, Newby Hall, Ripon,

HG45AE

T 01423 322583

F 01423 324452

W www.newbyhall.com

Now in its seventh year, the Sculpture Park (which opens I June) at Newby Hall is set among 25 acres of award-winning gardens, park and woodland surrounding one of Robert Adam's finest houses.

A number of art exhibitions are held in the Grantham Room each season. Submission Policy The Sculpture Park includes high quality work across a range of style, media and price by both established and emerging artists.

North Light Gallery

Armitage Bridge, Huddersfield, HD4 7NR
T 01484 340003
F 01484 340001
W www.northlightgallery.org.uk

W www.northlightgallery.org.uk
Opened in 2000 to show contemporary British
art. A charity, the gallery was created out of
a nineteenth-century wool textile mill and is
available to hire by artists or groups of artists or
other museums. Houses a collection of Yorkshire
artists in 15,000 sq. ft of airy industrial space.
Submission Policy To show, the artist must
finance the costs of transport, catalogue,
insurance, invitation cards and printing.
Talks/Events/Education Artists must be prepared
to give one talk as part of exhibition.

Salts Mill

Shipley, Saltaire, BD18 3LB
T 01274 531185
F 01274 531184
E post@saltsmill.demon.co.uk
W www.saltsmill.org.uk
Includes an extensive collection of works by David
Hockney, housed in the 1853 Gallery.

Scarborough Art Gallery

Scarborough Museums Trust, Scarborough, YO11 2PW T 01723 374753

F 01723 376941 E info@smtrust.uk.com

W www.scarboroughartgallery.co.uk Housed in an Italianate villa built in the 1840s, the permanent collection includes works by Grimshaw, H.B. Carter, Lord Leighton, Ivon Hitchens, Matthew Smith, Edward Bawden and Eric Ravilious. Also runs a temporary exhibition programme.

Site Gallery

I Brown Street, Sheffield, S1 2BS

T 0114 2812077

F 0114 2812078

E info@sitegallery.org

W www.sitegallery.org

Founded as Untitled Gallery in 1978 by a group of photographers who set up a darkroom and

gallery in a small shop. Site Gallery launched in 1995, giving a new direction to the gallery's programming of exhibitions and events by incorporating the new and experimental, digital and multimedia alongside traditional forms of image production. Also runs commissioning and residency programme.

Talks/Events/Education Education and training activities and open-access production facilities.

Towneley Hall Art Gallery & Museum

Towneley Park, Burnley, BB11 3RP T 01282 424213 F 01282 436138 E towneley@burnley.gov.uk

W www.towneleyhall.org.uk
A country house opened as Burnley's art
gallery in 1902. Houses permanent collection
of eighteenth—twentieth century oils and
watercolours and hosts regular contemporary
exhibitions. Various rooms available for small and
medium sized exhibitions.

Submission Policy CV and image of work with details of medium, sizes etc. to the curator. Talks/Events/Education Occasional artists demonstrations, usually held on Sundays.

York City Art Gallery

Exhibition Square, York, YO1 7EW T 01904 687687

W www.yorkartgallery.org.uk Founded in 1879 and houses notable collections of continental Old Masters from the fourteenth to the eighteenth centuries, British paintings from the seventeenth to the twentieth centuries, and twentieth-century studio ceramics. The galleries were rehung in 2005 in thematic displays.

Yorkshire Sculpture Park

West Bretton, Wakefield, WF4 4LG T 01924 832631 F 01924 832600 E info@ysp.co.uk W www.ysp.co.uk

Founded in 1977, an international, outdoor centre for modern and contemporary sculpture. Changing exhibitions and projects are sited in five hundred acres of historical gardens and parkland, four indoor galleries and an award-winning visitor centre. Outdoor sculpture includes work by Barbara Hepworth, Anthony Caro, Antony Gormley, Elisabeth Frink and Sol LeWitt as well as one of the world's largest open air displays of bronzes by Henry Moore.

Talks/Events/Education Educational events are held throughout the year and include workshops, sculpture courses, lectures, study days talks and tours

Ireland

The Ark

11a Eustace Street, Dublin 2

T of 6707788 F 01 6707758

E boxoffice@ark.ie

W www.ark.ie

Opened in 1995, Europe's first custom-designed cultural centre devoted exclusively to innovative arts programming for children. Houses an indoor theatre, an outdoor amphitheatre, gallery spaces and a workshop. The centre provides entertaining and stimulating programmes across the arts for children aged between 4 and 14 years and their families. The programme changes regularly and features plays, exhibitions, workshops, festivals, concerts, readings, opera, dance and multimedia.

Talks/Events/Education The Ark offers interactive programmes for primary schools during school time and for individual children and family groups at other times.

Reit Art Collection

Russborough House, Blessington, County Wicklow

T 045 865239

F 045 865054

E russborough@eircom.net Includes paintings by Vernet, Guardi, Bellotto, Gainsborough, Rubens and Reynolds.

Belltable Arts Centre

69 O'Connell Street, Limerick

T 061 315871 F 061 418552

E info@belltable.ie

W www.belltable.ie

Belltable provides access to all forms of performance and visual arts, as well as developing outreach and education programmes. It is among the major venues hosting "e v+ a, the exhibition of visual+ art", an annual exhibition of contemporary art, now in its thirtieth year.

Bourn Vincent Gallery

Foundation Building, University, Limerick T 061 213052

Offers gallery facilities for professional artists from around Ireland to show and sell their work. No commission taken.

Butler Gallery

The Castle, Kilkenny T 056 7761106 F 056 7770031 E info@butlergallery.com

W www.butlergallery.com Established in 1942, a major contemporary art space hosting established international artists as

well as local emerging artists. Carlow Public Art Collection

County Library, Dublin Street, Carlow T 059 9131126 Exhibits local crafts and paintings.

Chester Beatty Library

Dublin Castle, Dublin 2 T 01 4070750 F 01 4070760 E info@cbl.ie W www.chlie

One of Ireland's National Cultural Institutions, the library was established in Dublin in 1950 by Sir Alfred Chester Beatty and moved to its present location at Dublin Castle in 2000. The Library is both an art museum and library, housing a collection of Islamic manuscripts, Chinese, Japanese, Indian and other Oriental art. Early papyri and early Christian manuscripts, western prints and printed books. Admission is free. The CBL Reference Library contains 8,000 volumes relating to the collection.

Talks/Events/Education Hosts talks, demonstrations in techniques (such as calligraphy, painting, printing) and public tours and films. All free of charge.

Clonmel Gallery

Clonmel, South Tipperary Gallery of paintings by range of notable Irish artists of the twentieth century.

Courthouse Arts Centre

Tinahely, County Wicklow T 0402 38529 E tinahely@iol.ie W www.tinahely-courthouse.ie

The courthouse in Tinahely was built in 1843 and reopened in 1996 as a centre for arts, culture and heritage. Presents a varied programme of events

including visual arts exhibitions and installations, musical and theatre performances, and arthouse and foreign cinema. The visual arts programme aims to provide a space for art in virtually all media, by both emerging and established artists from Ireland and abroad.

Submission Policy Artists wishing to be considered for an exhibition are encouraged to contact the Centre. Annual selection process takes place in June. Send a CV and up to twelve slides (and sae), a CD or other photographic documentation of your work to Shelley Hayes.

Crawford Municipal Art Gallery

Emmet Place, Cork T 021 4907855 F 021 4805043

E crawfordinfo@eircom.net

W www.crawfordartgallery.com

The city art museum for Cork has a permanent collection comprising over 2,000 works, ranging from eighteenth-century Irish and European painting and sculpture through to contemporary video installations. At its heart is a collection of Greek and Roman sculpture casts. It is also particularly strong in Irish art of the nineteenth and early-twentieth centuries. Admission is free.

Submission Policy Artists can submit work for the annual 'Crawford Open' exhibition of contemporary art. Contact Anne Boddaert (021 4907857) for information.

Douglas Hyde Gallery

Trinity College, Dublin 2 T 01 6081116 F 01 6708330 E dhgallery@tcd.ie

W www.douglashydegallery.com Opened in 1978 and forms part of Trinity College's Arts block. Particular focus on installations, photography/video, conceptual work and painting. Has held exhibitions in recent years by celebrated older modern and contemporary artists such as Gerhard Richter, Bruce Nauman and Louise Bourgeois. More typically work with the younger generation, though - Marlene Dumas, Peter Doig, Felix Gonzalez-Torres, Gabriel Orozco and Luc Tuymans all held their first one-person Irish exhibitions here. Many Irish artists have held major exhibitions at the gallery, including Gerard Byrne and Michael Craig-Martin.

Talks/Events/Education Staff, student guides, artists and other guest speakers give regular talks during the shows.

Draíocht Arts Centre

The Blanchardstown Centre, Blanchardstown, Dublin 15

T of 885 2622

F OI 824 3434

E marketing@draiocht.ie

W www.draiocht.ie

Ireland's largest purpose built arts centre, opened in 2001. Aims to provide stimulating and accessible arts programming to visitors from Dublin 15 and its environs. Children, young people and families form a major part of the audience base. The multi-purpose venue is used for a broad range of activities, including contemporary visual arts and crafts, multi-media arts activities, music, drama and dance. The centre has two gallery spaces, a self-contained artist's studio and other spaces available for hire. Also offers artists-in-residence schemes, community outreach and education projects and conference facilities.

Submission Policy Applications accepted all year round. Contact Carissa Farrell (T or 8098026 or email carissa@draiocht.ie) for further information.

Talks/Events/Education Regular evening courses for adults, teaching basic skills in painting, pottery techniques and art appreciation.

Dublin City Gallery, The Hugh Lane

Charlemont House, Parnell Square North, Dublin 1

T OI 2225550 F 01 8741132

E info.hughlane@dublincity.ie

W www.hughlane.ie

Houses one of Ireland's foremost collections of modern and contemporary art. The original collection, donated by the Gallery's founder Sir Hugh Lane, has grown to almost 2,000 artworks and includes paintings, sculpture, works on paper and stained glass. The collection ranges from the Impressionist masterpieces of Manet, Monet, Renoir and Degas to works by leading national and international contemporary artists. Also has a temporary exhibitions programme and stages historical and retrospective exhibitions, particularly of Irish art. A recent €13 million expansion added a contemporary wing and thirteen new galleries to complement the existing thirteen galleries in Charlemont House, the gallery's home since 1933.

Talks/Events/Education Adult education courses and weekend lecture series. For further information contact Katy Fitzpatrick, Education Curator (T o1 222553).

Dublin Writers' Museum

18 Parnell Square, Dublin 1 T 01 8722077

F 01 8722231

W www.writersmuseum.com

Includes protraits of many of Ireland's most famous writers.

Dunamaise Arts Centre

Church Street. Portlaoise T 057 866 3356 F 057 866 3357 E info@dunamaise.ie W www.dunamaise.ie

Aims to provide the people of Laois and the surrounding counties with access to the best in contemporary arts practice, both professional and community, in the performing and visual arts. Funded by the Arts Council and Laois County Council, the centre presents work by leading local, national and international performance and visual artists.

Submission Policy Submit a CV and portfolio of work to the Director, Louise Donlon. Closing dates for applications on website.

Gallery of Photography

Meeting House Square, Temple Bar, Dublin 2 T 01 6714654 F 01 6709293 E gallery@irish-photography.com W www.irish-photography.com Founded in 1978, a leading non-profit making gallery for photography, exhibiting many major names. Moved to current location (complete with well-equipped darkrooms) in 1995. Talks/Events/Education The gallery runs a wide range of courses and talks all year to facilitate both

Galway Arts Centre

47 Dominick Street, Galway T 091 565886 F 091 568642 E info@galwayartscentre.ie W www.galwayartscentre.ie

the analogue and digital photographer.

Operates from two buildings, both located in Galway city centre. First established in 1982 at 23 Nun's Island, in 1988 the centre took over its second premises at 47 Dominick Street, which houses its art galleries, workshop/studios and administrative offices. Aims to nurture all forms of artistic activity, to facilitate emerging artists and arts groups, to heighten awareness of the arts via its education programme and to provide access to its facilities for all sectors of the community. Exhibits work in a range of media including painting, print sculpture and new media. Submission Policy Artists are welcome to submit work through out the year, on CD/DVD/slides. Submissions to be made to Maeve Mulreann (Visual Arts Officer).

Talks/Events/Education Classes in lifedrawing, still life drawing and painting, photography and history of art. Courses run for 10 weeks. Contact Victoria Mc Cormack (T: 091 565886 or email victoria@galwayartscentre.ie).

Garter Lane Arts Centre

5 O'Connell Street, Waterford T 051 877153 E admin@garterlane.ie W www.garterlane.ie

Gallery opened in 1984 in a late-eighteenth century town house which was used as the Waterford Municipal Library until 1983. The building also houses a children's art room, artists' studios and a dance room. Shows current visual art practice of local, national and international standing. Also exhibits the work of recent graduates/new artists.

Submission Policy Proposals should include a current CV, brief artist statement and images of current work in slide, photographic or digital format. The Gallery takes 25% on all work sold. Calls for submission are advertised through the Visual Arts Bulletin etc.

Talks/Events/Education Artists are invited to give talks about their work. Various children's and adult classes are held through the year.

Glebe House and Gallery

Churchill, Letterkenny, County Donegal T 074 9137071 F 074 9137521 E info@heritageireland.ie W www.heritageireland.ie Home to the Derek Hill Permanent Collection, which includes 300 works by leading twentieth century artists, both Irish and international.

The house itself has fine collection of William Morris designs and examples of Islamic and Japanese art.

Helen Hooker O'Malley Roelofs Sculpture Collection

Castletroy, Limerick **T** o61 333644

Permanent collection of around forty sculptures by Helen Hooker O' Malley Roelofs (1906–1993) held at the University of Limerick. Subjects include Eamon De Valera, Seamus Heaney, Samuel Beckett and James Galway, cast during 1992–93 at the Dublin Art Foundry.

Hunt Museum

Rutland Street, Limerick T o61 312833 F o61 312834 E info@huntmuseum.com

W www.huntmuseum.com

One of Ireland's most important private art collections of art, spanning the centuries and including works from Picasso, Renoir and Yeats.

Irish Museum of Modern Art

Royal Hospital, Military Road, Kilmainham, Dublin 8

T o1 6129900 F o1 6129999

E info@imma.ie

W www.imma.ie

Ireland's leading national institution for the collection and presentation of modern and contemporary art. Presents a wide variety of art in a programme of exhibitions, which regularly includes bodies of work from its own collection and its award-winning education and community department. It also creates access to art and artists through its studio and national programmes. The museum is housed in the seventeenth-century Royal Hospital building, whose grounds include a formal garden, meadow and medieval burial grounds.

Submission Policy Artists should send in a CV with an example of three slides of their work.

Talks/Events/Education Has a regular series of talks, lectures and events to allow the general public and targeted audiences an opportunity to interact with a cross section of artists, curators and specialists. All talks and lectures are free and open to the public.

Leitrim Sculpture Centre

Manorhamilton, County Leitrim

T 071 9855098

E info@leitrimsculpturecentre.ie

W www.leitrimsculpturecentrie.ie

Provides training and workshops facilities for sculptors and more general support for local visual artists working in a variety of media. The Centre was founded by the Manorhamilton Arts Group whose members include a number of locally based full time artists of national and international repute in stone, wood and bronze.

Lewis Glucksman Gallery

University College Cork, Western Road, Cork T 021 4901844 F 021 4901823 E info@glucksman.org

W www.glucksman.org Opened in 2004 as a cultural and educational institution to promote the research, creation and exploration of the visual arts. Located in a landmark building that includes display spaces, lecture facilities, a riverside restaurant and specialist art bookshop. The shop stocks a wide range of art, architecture, design and culture books, alongside exhibition catalogues and the largest selection of art magazines in Ireland. A book ordering service is available and there are monthly promotions. Exhibitions programme places particular emphasis on the role of visual media in communicating knowledge. Central to this is the creation of discursive relationships between academic disciplines and art practice, reflected in exhibitions that span various media and historical periods.

Submission Policy Does not accept unsolicited proposals for its artistic programme.

Talks/Events/Education Offers a wide range of art workshops, film screenings, seminars, lecture series and artists' talks, many of which are available free of charge.

Limerick City Gallery

Carnegie Building, Pery Square, Limerick T 061 310633
E artgallery@limerickcity.ie
W www.limerickcitygallery.ie
Founded in 1948 as a purpose-built gallery addition to the Carnegie Free Library and Museum. Now all the building is used as exhibition space and recently a new South Wing Gallery was added. LCGA houses a permanent collection of paintings, sculptures and drawings

by early eighteenth-, nineteenth- and twentieth-century Irish artists. The gallery is the home of the Irish National Collection of Contemporary Drawing, the Michael O'Connor Poster Collection and also hosts exhibitions by contemporary Irish and International artists including the annual EV+A (exhibition of Visual Art). There are 40–45 temporary exhibitions per annum and admission is free.

Submission Policy Submissions for exhibition are welcome. Contact the gallery for any relevant information.

Linenhall Arts Centre

Linenhall Street, Castlebar, County Mayo

T 094 9023733

F 094 9026162 E linenhall@anu.ie

W www.thelinenhall.com

Established in 1990, the Linenhall exhibits a range of contemporary art in all disciplines with work ranging from that of young emerging artists to those of international reputation, both Irish and non-Irish. Produces an invitation/catalogue to accompany each exhibition and is responsible for promoting the exhibition. Also organizes associated gallery talks and an extensive schools programme of workshops. Offers support to visual artists and acts as a contact point for arts-oriented inquiries.

Submission Policy Invites submissions for specific visual arts-based projects and events both in-house and externally. Submissions judged by a panel. Send 8—10 images on 35mm slide or CD, plus CV and statement of intent.

Talks/Events/Education Talks take place regularly and are generally free.

The Market House

Market Street, Monaghan Town

T 047 38162

F 047 71113

E themarkethouse@eircom.net

W www.themarkethouse.ie

Showing work by artists from Ireland and overseas. 12–15 shows annually. Owned and run by Monaghan County Council.

Talks/Events/Education Every exhibition involves the artist holding a talk and workshop.

Maynooth Exhibition Centre

St. Patrick's College, Maynooth, County Kildare T oı 6285222 F oı 7083954 W kildare.ie/arts/housing/maynooth-exhibition-centre.htm

Opened in 1992, an exhibition space in the foyer of the Arts Block show local, national and international works.

Model Arts and Niland Gallery

The Mall, Sligo
T 071 9141405
F 071 9143694
E info@modelart.ie
W www.modelart.ie

A vibrant centre for the arts in Sligo, with an extensive visual and performing arts programme. Built in 1862, it was redeveloped in 2009, adding extended gallery and performance spaces, artists' studios, recording facilities and an artist's residency space. Home to the Niland Art Collection, which has over 260 paintings, drawings and prints by leading Irish artists including works by John and Jack B. Yeats, Estella Solomons, Paul Henry, Sean Keating and Louis Le Broquy. The contemporary exhibition programme features nine solo or group exhibitions annually drawn from local, national and international artists. Previous artists have included Vivienne Roche, John Shinnors, Camille Souter and Barrie Cooke. Admission is free.

Talks/Events/Education Painting, life drawing, printing and creativity workshops.

Monaghan County Museum

1–2 Hill Street, Monaghan T 047 82928 F 047 71189

E comuseum@monaghancoco.ie W www.monaghan.ie/museum Opened in 1974, becoming the first local

Opened in 1974, becoming the first local authority-funded museum in the Republic of Ireland. Displays Monaghan's rich culture and heritage in its permanent exhibition galleries. Its collection consists of over 7,000 objects spanning some 9,000 years. There is a reference library with an extensive collection of periodicals and journals, particularly useful for archaeology and the arts. Admission to the museum is free.

Talks/Events/Education Occasionally holds lecture series inspired by the collection.

National Gallery of Ireland

Merrion Square West and Clare Street, Dublin 2 T or 6615133 F or 6615372 E info@ngi.ie

W www.nationalgallery.ie

Founded in 1854 and opened to the public in 1864, the National Gallery of Ireland today houses over 13,000 items, including European Old Master paintings (fourteenth to twentieth centuries), Irish paintings (seventeenth century to present) and a collection of European and Irish prints, drawings, miniatures and sculpture. Among the major artists represented are Fra Angelic, Rembrandt, Poussin, Vermeer, Caravaggio, Goya, Joshua Reynolds, Thomas Gainsborough, James Barry, O'Conor, William Orpen, John Lavery. The Gallery also offers extensive research services, a fine art library, print room, the centre for the study of Irish art and the Yeats Archive. There is also a picture library service. The gallery runs a varied exhibitions programme; education and outreach activities, a publishing arm and a bookshop. Admission to the permanent collection is free.

Talks/Events/Education There is a regular programme of activities, including talks, tours, and workshops for both adults and young people, teachers, school groups. Nearly all events are free.

National Photographic Archive

Meeting House Square, Temple Bar, Dublin 2 T oi 6030374

F or 6777451

E photoarchive@nli.ie

W www.nli.ie/en/national-photographic-archive. aspx

Comprises approximately 600,000 photographs, the vast majority of which are Irish. While most of the collections are historical there are also some contemporary collections. Subject matter ranges from topographical views to studio portraits, and from political events to early tourist photographs. The NPA is part of the National Library of Ireland and other collections include prints, manuscripts, music, books and periodicals. The Library maintains an active collecting policy and additional material is constantly added to the collections. There is a Reading Room, an exhibition area and a small shop. An online catalogue is accessible via the website or in the Reading Room, which is accessible by appointment only.

National Print Museum of Ireland

Garrison Chapel, Beggars Bush, Dublin 4 T oi 6603770 F oi 6673545 E npmuseum@iol.ie W www.nationalprintmuseum.ie Documents, preserves, exhibits and encourages the future development of the printing craft in Ireland. Provides an archive and study facilities for students researching printing in Ireland.

Talks/Events/Education One- or two-day workshops for adults are held teaching skills such as print-making, calligraphy and paper-making.

National Self-Portrait Collection of Ireland

Univeristy of Limerick, Castletroy, Limerick T 061 213052

Shows over 400 mixed media pieces by artists including Derek Hill, Andrew Kearney, Sean Keating, Alice Maher and Sarah Purser. New additions exhibition held each June.

Office of Public Works

Art Management Office, 51 St Stephen's Green, Dublin 2

T 01 6476000

F 01 6610747

E info@opw.ie

W www.opw.ie

The OPW manages the State art collection, which includes nearly 6,000 pieces by over 1,250 artists, located in State buildings throughout Ireland. OPW's funding for art in State buildings comes from a scheme which involves setting aside a basic 1% of all construction budgets for artistic features.

Old Market House Arts Centre

Lower Main Street, Dungarvan

T 058 48944

F 058 42911

E artscentre@waterfordcoco.ie

W www.waterfordcoco.ie

Opened in 2000 as an arts centre for County Waterford. Displays work in a variety of media including photographs, paintings and installations. Admission is free.

Submission Policy Applications to exhibit reviewed on regular basis. Send a one-page written statement of work, 6–12 slides or colour photographs of work, CV, indication of availability and selling price of work.

Project Arts Centre

39 East Essex Street, Temple Bar, Dublin 2 **T** or 8819613

F 01 0792310

E info@projectartscentre.ie

W www.projectartscentre.ie

Project Arts Centre was established in 1966, and moved into a purpose built multi-disciplinary

building in Dublin's Temple Bar in 2000. The gallery is programmed by a curator, with the exhibition program being reflective of contemporary artistic, political, and cultural debate. The exhibitions range from one-person investigations to conceptual group shows. Project also presents a challenging programme of lectures, gallery dialogue, and philosophy sessions. Submission Policy All work is selected and invited by the curator.

Talks/Events/Education There is a free talk with every exhibition, and further notices of lectures, symposia and performances can be received by signing up to gallery@projectartscentre.ie.

Regional Cultural Centre

Port Road, Letterkenny, Co. Donegal T 074 9129186

Ercc@donegalcoco.ie

W www.donegalculture.com

New multi-disciplinary arts facility housing three galleries, workshops, studios, music rooms and digital media suites. Specializes in visual arts, community arts, music, literature and film and hosts a programme of exhibitions, festivals and workshops.

Riverbank Arts Centre

Main Street, Newbridge, County Kildare

T 045 448333

F 045 432490

E info@riverbank.ie W www.riverbank.ie

Provides a high-profile, regionally and nationally significant visual arts venue. Gallery facilities include a foyer exhibition area and a designated exhibition (white box) space.

Submission Policy Send a letter of proposal, biographical information, visual documentation and copies of press releases (if any).

Sirius Arts Centre

Cobh, County Cork

T 021 4813790

F 021 4813790 E cobharts@iol.ie

W www.iol.ie/~cobharts / www.siriusartscentre.

blogspot.com

A multidisciplinary non-profit centre for the arts in the East Cork area, established in 1988. Annual programme focuses on raising artistic awareness, providing opportunities for participation in and enjoyment of the arts. Also runs a prestigious artists-in-residence programme.

Sligo Art Gallery

Yeats Memorial Building, Hyde Bridge, Sligo T 071 9145847

E sagal@eircom.net

W www.sligoartgallery.com

Founded in 1977 under the auspices of the Yeats Society to provide exhibition facilities for all art forms, with a particular emphasis on contemporary art. Mounts 15-20 major exhibitions annually. There are also a number of showings outside the Gallery and projects which involve active public participation. Artists whose work has been individually exhibited include Patrick Collins, Antoni Tapies, Mary Swanzy and Patrick Heron. Solo show opportunities are given to emerging artists each year. Organizes the annual Iontas National Small Works Art Competition and Exhibition to provide a forum for contemporary Irish artists working in small format in any medium.

Submission Policy The Iontas National Small Works Art Competition requests entries in any medium (maximum size of 600mm/60cm in their greatest dimension including frame or plinth).

Solstice Arts Centre

Railway Street, Navan, County Meath

E info@solsticeartscentre.ie

W www.solsticeartscentre.ie

Opened to the public in April 2006. Facilities include three gallery spaces, a studio space and

Talks/Events/Education See website.

South Tipperary Arts Centre

Nelson Street, Clonmel

T 052 27877

F 052 27866

E reception@southtipparts.com

W www.southtipparts.com

Opened in 1996, the centre contains a gallery and workshop space. Hosts approximately thirteen visual art exhibitions annually. The centre is also a meeting place for the South Tipperary Arts Group and the home of the quarterly START magazine, the independent arts and cultural magazine for the region.

Submission Policy Submissions should have strong visual support with a minimum of six slides or CD with six images, a proposal and CV. Talks/Events/Education Runs regular classes and

workshops for adults and children. Contact the centre's education/outreach officer for details.

Triskel

Tobin Street, Cork

T 021 4272022

F 02I 4272592

E info@triskelartscentre.com

W www.triskelart.com

Opened in 1978 and currently comprises three galleries, an auditorium, an education workshop. artists' room and cafe/restaurant.

Submission Policy Tries to incorporate an education programme into every exhibition and works closely with local schools, community groups, etc.

Tyrone Guthrie Centre

Newbliss, County Monaghan

T 047 54003

F 047 54380

E info@tyroneguthrie.ie

W www.tyroneguthrie.ie

Offers artists's residencies in the house of the former actor and theatre director.

Watercolour Society of Ireland's Permanent Collection

University of Limerick, Castletroy, Limerick T 061 333644 W www.watercoloursocietyofireland.ie

A permanent collection of over 150 watercolours, added to annually by the Society. Includes works by artists such as Pheobe Donovan, Arthur Gibney, Jo Kinney and Muiris McGonagle. Free to the public during office hours and concert performances.

West Cork Arts Centre

North Street, Skibbereen, County Cork T 028 22000 F 028 23237

E info@westcorkartscentre.com

W www.westcorkartscentre.com Established in 1985 in Skibbereen, County Cork. It is a publicly funded arts facility that creates opportunities for the people of West Cork to have access to local and global arts practice of excellence. It supports a multi-disciplinary arts program with a focus on modern and contemporary visual art and a range of education

Wexford Arts Centre

and community programmes.

Cornmarket, Wexford, County Wexford T 053 23764 F 053 24544 E wexfordartscentre@eircom.net W www.wexfordartscentre.ie Runs programme of regular visual arts shows.

O3 The internet

The internet, your gallery and you

Rebecca Wilson

In December 2006 TIME announced its Person of the Year as 'You', arguing that no individual has had the same impact in 2006 as the billions of people who use the internet. For the first time in its history, the magazine gave its annual award not to one person, but to all the people who together have created what it termed 'a new digital democracy'. Online sites such as MySpace and YouTube have enabled millions of people all over the world to make global connections, to find audiences for their work – and all without the approval or aid of experts and professionals. As TIME put it, 'It's a story about community and collaboration on a scale never seen before.'

The collector Charles Saatchi, an influential force in the art world over the past 20 years, saw the huge potential for a site similar to MySpace, but dedicated to artists and the art world. In April 2006 the Saatchi Gallery launched Your Gallery (saatchigallery.com/ yourgallery), a site designed to provide a global platform for artists all over the world to exhibit their work and to connect with other artists. dealers, collectors and exhibition curators. As Saatchi commented at the time, 'Many artists find it very hard to break into the gallery world. If they don't have the connections or aren't skilled at selling themselves, even good artists can struggle. We think that artists and collectors will benefit from working together without the dealer commission, and dealers have seemed to welcome the chance to view a lot of artists both domestically and internationally in their own time without commitment.'

Your Gallery is a non-profit site, now used by over 20,000 artists, each of whom have their own homepages on the site. Artists can upload images, information about themselves and their work, and contact details. No fee is charged for this service and the Saatchi Gallery takes no commission when artists sell their work via the site.

Your Gallery also publishes an online daily art magazine covering the international art world, publishing previews and reviews of exhibitions, tips on art to buy and emerging artists to watch out for, interviews with artists, book reviews, essays on topical issues and a weekly round-up of art news. Readers can also air their views on Your Gallery's public blog, take part in discussions on its forum and artists registered on the site can chat live to other Your Gallery artists and receive feedback on their work, expanding their circle of contacts and friends around the world. They can swap notes on their work and interests, find out about trends in different countries, learn about new techniques from other artists, and feel part of a huge community of like-minded, creative people.

Within six weeks Your Gallery had attracted over 1.7 million visitors from all over the world (the split for both artists and visitors to the site is one third from the UK, one third from the US and one third from the rest of the world) with thousands of artists exhibiting their work for the first time. Most registered artists don't have gallery representation, but many do and Your Gallery gives them access to far more people than an exhibition at a commercial gallery. As a result of posting images on the site, artists have sold their work, participated in exhibitions and have been taken on by galleries who might never have seen their art.

In November 2006 the Saatchi Gallery introduced another element to its Your Gallery site. Stuart, short for 'student art' (www.saatchigallery.co.uk/stuart/), functions in the same way as Your Gallery, but is exclusively designed for art students. This initiative not only tapped into collectors' and dealers' hunger to snap up work before art school degree shows, but also appealed to young people who have grown up using the internet and are its most frequent users.

Whether it is used to exhibit art or to convey information about the art world on a daily basis, the internet is perceived by some critics, dealers and publishers of print magazines as a potential threat – the *Guardian*'s critic Jonathan Jones went so far as to suggest that showing art on sites such as Your Gallery 'may undermine the entire system of dealers, magazines and art fairs that calls itself the "art world".' Even if Jones's prediction proves not to be the case, sites such as Your Gallery and Stuart have provided an alternative platform for artists to exhibit their work and make contacts, and for the international art community to encounter art being made beyond the so-called capitals

of the art world. Your Gallery has enabled traditional hierarchies within the art world to be circumvented – no longer is it necessary for critics to give their approval before an artist's work is noticed and bought, no longer does an artist have to be on the books of a prestigious gallery in order to attract collectors to their work.

Rebecca Wilson, formerly deputy editor of *Modern Painters* and editor of *ArtReview*, is the editor of the online magazine Your Gallery.

The internet

Online art news, magazines and listings

24 Hour Museum

E info@www.24hourmuseum.org.uk
W www.24hourmuseum.org.uk
The UK's national virtual museum, offering
content including daily arts and museum news,
exhibition reviews and in-depth online trails.
Promotes publicly funded UK museums, galleries
and heritage attractions and seeks to develop new
audiences for UK culture. Venue and listings
information is driven by a searchable database of
over three thousand museum, gallery and heritage
sites.

Submission Policy Welcomes press releases from not-for-profit galleries and museums.

a-n The Artists Information Company / a-n Magazine

E info@a-n.co.uk

W www.a-n.co.uk

National organization with a mission to stimulate and support contemporary visual arts practice. www.a-n.co.uk is the leading UK resource for visual artists with daily updated artists' jobs and opps, Knowledge Bank of material on strategies of contemporary art practice, professional practice toolkits, and publications including current and archive a-n Magazine issues. Artists Talking, Interface and Degrees unedited sites provide blog and posting space for artists and writers. Annual subscription from £28 (practising artists) available at www.a-n.co.uk/subscribe.

Art Guide

E artguide@cogapp.com

W www.artguide.org

Founded in the late 1990s. A free online database of museums and galleries across the UK and Ireland. Visitors can search the site by artist and by special interest. Also a comprehensive, up-to-date exhibitions guide.

Art MoCo

E sabine@mocoloco.com

W www.mocoloco.com/art

Contact Sabine Modder - Editor

A web magazine featuring contemporary art and design news and views, founded in 2005 by Harry Wakefield, publisher of design blog MoCo Loco.

New posts on contemporary artists from all over the world appear from Monday through Friday, while art tidbits from other blogs and capsule book reviews appear on the weekend.

Submission Policy Accept submissions from any artists using a wide variety of media.

Art News Blog

W www.artnewsblog.com A selection of visual art news, art reviews and art related stories taken from the web.

art-online - The Fine Art Directory

W www.art-online.com

Contains links to editor-reviewed websites organized into the subject categories of art history, the art market, art venues, artists, education, employment, events, galleries, governments, legal, museums, professionals, resources, rewards and shopping.

art-shopper

E mail@art-shopper.co.uk
W www.art-shopper.com
Guide to commercial galleries throughout the
UK.

artcourses.co.uk

E thah@artcourses.co.uk

W www.artcourses.co.uk

Contact Jonathan Wickens

An online directory of art classes, craft workshops, painting holidays, etc. Europe-wide coverage of all media and all levels. Course providers with or without their own website can apply for an entry via the website. Offers a starter webpage service for artists without websites.

artdaily.com

E ignacio@artdaily.com

W www.artdaily.com

Contact Ignacio Villarreal (Editor and Publisher) Founded in 1996. The 'first art newspaper on the net'.

artefact

W www.artefact.co.uk

Online editions of *Galleries* and *The Collector* magazines, with searchable databases.

ArtInLiverpool.com

W www.artinliverpool.com Includes gallery listings, blogs, artist profiles, a forum and art news for Liverpool.

artist-info: Contemporary Art Database

E mail@artist-info.com

W www.artist-info.com

An international contemporary art database. Includes artists, galleries and museums search function as well as extensive classifieds and offers from galleries.

Artlistings.com

W www.artlistings.com

An extensive art-related directory, encompassing galleries, schools, assorted media and profiles of famous artists.

Arts Culture Media Jobs

W www.artsculturemediajobs.com Online database of jobs for people in the creative industries.

Arts Hub

E info@artshub.co.uk

W www.artshub.co.uk

A resource for UK arts workers, containing news and information on jobs and events.

Arts Journal

E mclennan@artsjournal.com

W www.artsjournal.com

A weekday digest of some of the best arts and cultural journalism in the English-speaking world. Combs more than two hundred English-language newspapers, magazines and publications every day.

Arts Professional Online

E editors@artsprofessional.co.uk W www.artsprofessional.co.uk The web edition of the leading arts management magazine.

ArtSouthEast

E editor@artsoutheast.co.uk

W www.artsoutheast.co.uk

An online gateway to arts events and information in the south-east of England.

Artupdate.com

E info@artupdate.com

W www.artupdate.com

A contemporary art exhibitions information service in print and online for a worldwide audience. Publishes bimonthly gallery maps for cities including London, Paris, Berlin, New York, Los Angeles, San Francisco. Specialist artworld email service ArtupdateMail.

Conservation Register

E info@conservationregister.com

W www.conservationregister.com

Online information on conservator-restorers throughout the UK and Ireland. Also offers guidance on caring for art, antiques and decorative features of buildings.

Submission Policy See website for criteria for inclusion, which include professional accreditation.

Designspotter

W www.designspotter.com

A design web magazine dedicated to everything related to contemporary design. Offer young designers a platform to upload an image of their work, a short description and a weblink.

Digital Consciousness

W www.digitalconsciousness.com A public database of contemporary art, with art and biographies of emerging and established artists exhibited through galleries and artists' pages.

The GalleryChannel

E support@thegallerychannel.com

W www.thegallerychannel.com

An online illustrated and searchable database of galleries, venues, artists and exhibitions worldwide. Since 1998 the database has grown to include more than 12,000 venues, 28,000 exhibitions and 27,000 artists. Add listings free of charge.

Submission Policy Open submission policy.

Global Art Jobs

W www.globalartjobs.com

A website with details of international visual arts vacancies.

Isendyouthis.com

W www.isendyouthis.com

Independent art hub that promotes artists, galleries and exhibitions. Free for artists to subscribe work for sale.

KultureFlash

E events@kultureflash.net

W www.kultureflash.net

A free, weekly newsletter covering contemporary culture in and around London. Does not receive any payment from venues, artists, managers or promoters.

National Disability Arts Forum (NDAF)

E silvie@ndaf.org

W www.ndaf.org

Contact Silvie Fisch

NDAF's ArtsAccessUK is an online database of disabled access provided by art venues throughout the UK. Also displays the work of disabled artists on its website, and publishes a free weekly e-newsletter.

New Exhibitions of Contemporary Art

E listings@newexhibitions.com

W www.newexhibitions.com

Founded in 1978. A bi-monthly, contemporary art listings brochure free of charge at all galleries listed and website version with linked gallery locations.

NewsGrist

W newsgrist.typepad.com/underbelly With extensive comment on art issues. Describes itself as 'where spin is art.'

Online Arts Consultants and Trainers Register

E arts@dimensions.co.uk

W www.arts-consultants.org.uk

Online register for organizations looking for consultants or trainers, or for consultants and trainers seeking to increase their public presence.

re-title.com

E info@re-title.com

W www.re-title.com

Independent platform for the contemporary art professional and enthusiast. Provides exclusive membership services for contemporary art galleries, represented artists & independent artists; and email announcements for art industry. Artist members receive self-editing portfolio pages, regular international "artist opportunities" newsletters and have the opportunity to post their exhibitions in the exhibitions directory.

Submission Policy Applications are encouraged

from all active emerging contemporary artists, curators and galleries.

Studiopottery.co.uk

E sdee@studiopottery.co.uk

W www.studiopottery.co.uk

Contact Simon Dee

Independent contemporary ceramics and pottery listings website. Profiles approximately 400 potters and ceramic artists, lists exhibitions, galleries and events worldwide – over 3000 in

a year, plus information on courses at all levels. Artists can add entries free of charge. Submission Policy Full members are subject to invitation or a selection process, but all applications are reviewed with great care. All ceramic artists are welcomed to the comprehensive list of potters.

theSeer.info

W www.theSeer.info

Free online directory and resource for London's creative individuals, organisations, venues, commissioners and bookers to find, receive and promote arts and creative information in London. It is also a key research and communication resource for London's Local Authorities, Arts Council England, London, arts policy makers and researchers. Artists or organizations can register for free directory listing.

The UK Sponsorship Database

E info@uksponsorship.com W www.uksponsorship.com Contact Richard Fox

Founded in 2000. Offers those seeking sponsorship a means of displaying their sponsorship offering and requirements to sponsors via a categorized, online database. A range of formats and prices for listings is available. Low cost listings start at a one-off cost of £15.00.

uk.culture.info

W uk.culture.info

Provides links to key UK cultural information and resource websites including associations and networks; funding and development bodies; support and resource agencies; and portals and information sources.

VADS

E info@vads.ac.uk

W vads.ac.uk

Based at the University for the Creative Arts at Canterbury, Epsom, Farnham, Maidstone and Rochester. Aim is to support the research and learning and teaching communities by providing high quality digital resources for the visual arts, delivered through robust systems for Internet access and the long-term preservation of educational resources.

WorldwideReview.com

W www.worldwidereview.com
Website for art and culture reviews, with a mix

of open submissions and regular reviewers. No restriction on subject though with a focus on contemporary art.

Online art networks and communities

APD

E apd@a-n.co.uk

W www.apd-network.info

The Artists' Professional Development (APD) network, initiated by a-n in 2001, is a UK-wide intelligence and exchange forum for organizations that are proactively developing information, advice, training and professional-development services for visual and applied artists.

Submission Policy Organisations for whom professional development provision is a core function are invited to visit www.apd-network.info to download an information pack on joining the network.

The Art History Blog

W www.arthistory.we-wish.net A collection of articles, essays, reviews and news about art, art history and museums written by 'art-obsessed under-graduates' based in New York.

Art in Context

E editor@artincontext.org

W www.artincontext.org

Established in 1995, offering free public access to information added by curators, dealers, artists, writers and others from around the world.

Art on the Net

E webmasters@art.net

W www.art.net

An international collective of artists sharing their works online. Currently represents over one hundred artists.

ArtForums.co.uk

W www.artforums.co.uk

Includes forums for artists, art-lovers and those looking to buy.

ArtNews.info

E info@artnews.info

W www.artnews.info

A non-profit online network where art professionals can explore, publish and exchange information on contemporary art. Includes free exhibition calendar and online catalogues for artists, galleries, curators and collectors.

Artquest

E info@artquest.org.uk W www.artquest.org.uk

Contact Stephen Beddoe (Programme Manager). Provides advice, information and critical support to visual artists and craftspeople living in London. All information is free. Also works with UK and international partners to create new projects; online projects include Artlaw (an online legal archive and advice service) and Artelier (a networking tool for artists to arrange studio exchanges with their international peers). Artquest also run annual artist's residencies in Berlin and Sydney.

ArtRabbit

W www.artrabbit.com

Aims to accommodate the needs and desires of today's art world and art enthusiasts. Includes a forum, extensive listings and opinion pieces.

Asian Arts Access

E kalwant.ajimal@which.net W www.asianartsaccess.org The website for Asian Arts Access, an arts development agency, research and development organization and production house.

Backspace

E info@backspace.org

W www.bak.spc.org

An 'open environment for exploration and expression on the Internet and the focal point for related events, audio, visual and otherwise, with particular bias toward the diverse talents of its subscribers'.

CreativePeople

E info@creativepeople.org.uk W www.creativepeople.org.uk

Contact Barbara Brunsdon

A UK network of organizations, individually supplying training and professional-development information, advice and guidance services to current and aspiring arts and crafts practitioners. Details of and links to the member organizations are provided on the website. As well as signposting arts practitioners to resources, the network provides a peer community for anyone supplying professional development services in the sector.

Submission Policy Address for postal applications: P.O. Box 2677, Caterham, CR3 6WJ Tel: 01883 371112.

Cybersalon

E lewis@cybersalon.org W www.cybersalon.org Contact Lewis Sykes

Aims to be a forum for debate and discussion on digital-media issues, a showcase for new work and a meeting place for people to exchange ideas and make new contacts.

digital art source

E contact@digitalartsource.com
W www.digitalartsource.com
An online resource for digital art and culture information.

The Digital Artist

E carol@thedigitalartist.com W www.thedigitalartist.com Contact Carol Pentleton

An exhibition site for artists, designers and artisans. Free exhibits include name, contact information, biography, artist's statement, webpage link and one image. Exhibitors are from around the world, from students to established professionals. Offers free monthly newsletters and e-books, classifieds, forums and articles.

Submission Policy Artists, designers and artisans in all media welcome.

Disability Cultural Projects

W www.disabilityarts.info
Contact Geof Armstrong / Silvie Fisch
Established in 2008 by Geof Armstrong and Silvie
Fisch following the closure of the charity National
Disability Arts Forum. Aims to further the cultural
equality of deaf and disabled artists through arts
practice delivery in the UK and internationally.
Offers arts listings etc through its sister site at

e-flux

W www.e-flux.com

www.ArtsAccessUK.org.

A New York-based information bureau dedicated to worldwide distribution of intelligence via the Internet for contemporary visual arts institutions.

Foundation for Art and Creative Technology (FACT)

E info@fact.co.uk

W www.fact.co.uk

Commissions, exhibits, promotes and supports

artists' work and innovation in the fields of film, video and creative technology. Founded in 1988 as Moviola), FACT has commissioned and presented over 100 digital media artworks with artists including Mark Wallinger, Barbara Kruger, Tony Oursler and Isaac Julien.

Furtherfield

E info@furtherfield.org W www.furtherfield.org Contact Marc Garrett

Creates 'imaginative strategies that actively communicate ideas and issues in a range of digital and terrestrial media contexts'. Features works online and organizes global, contributory projects on the Internet, the streets and at public venues simultaneously.

Hidden Art

E info@hiddenart.co.uk W www.hiddenart.com

A membership organization that supports and promotes designer-makers, while offering companies and members of the public access to original design. Focuses on works or products with a predominantly functional use, covering a broad range of disciplines including textiles, furniture, lighting, interior products, ceramics, glass design, fashion accessories and jewelry.

Submission Policy Can only support designermakers, not visual or fine artists. There is no selection procedure for membership – selection procedures are only required for certain projects.

Intute Arts and Humanities

E artsandhumanities@intute.ac.uk
W www.intute.ac.uk/artsandhumanities
Contact James A J Wilson
Formerly known as Artifact, this is a free,
searchable guide to the best of the web for the
arts and creative industries' teaching, learning
and research community. Part of Intute, aimed at
Internet users in UK further and higher education
but freely available to all.

metamute

E mute@metamute.org
W www.metamute.org
A web platform for debates on culture, politics and globalization.

nettime

W www.nettime.org A mailing list and 'an effort to formulate an international, networked discourse that neither promotes a dominant euphoria (to sell products) nor continues the cynical pessimism, spread by journalists and intellectuals in the "old" media who generalize about "new" media with no clear understanding of their communication aspects.'

No Knock Room

E info@noknockroom.com

W www.noknockroom.com/indexmain.php A contemporary art portal which opened in 2006 with the aim of supporting emerging artists and showcasing trends in contemporary art. Relaunched in 2009.

Nottingham Studios

W www.nottinghamstudios.org.uk Web resource listing studio spaces, artists, artists' groups and networking opportunities in the Nottingham area.

Rhizome.org

E webmaster@rhizome.org

W www.rhizome.org

A non-profit organization founded in 1996 to provide an online platform for the global newmedia art community. Offers nine commission projects annually for emerging new media artists of all nationalities. Also houses ArtBase, an expanding archive of new media art.

stot

E stot@stot.org W www.stot.org

Contact Jonathan Rust

A not-for-profit contemporary art platform that, in addition to producing artist projects, facilitates a comprehensive online resource of thousands of links to international galleries, festivals, fairs, biennials, publications and residencies. Also includes an extensive section devoted to new media, and user forums providing an outlet for news and opportunities in related arts.

Trans Artists

E info@transartists.nl W www.transartists.nl

Offers independent information to artists, artistrun initiatives and cultural institutions about cultural exchanges, residency programmes and work opportunities in the Netherlands and abroad.

Universes in Universe - Worlds of Art

E info@universes-in-universe.de

W www.universes-in-universe.de A non-commercial online information system focusing on the visual arts of Africa, Latin America and Asia within the context of international art

Online galleries

processes.

absolutearts.com and World Wide Arts Resources Corp.

E help@absolutearts.com

W www.absolutearts.com and wwar.com

Contact Ianet Thomas

One of the largest art sites on the internet, wwar. com (founded in 1995) expanded in 1999 to include absolutearts.com, which began as a daily arts news outlet and is now a comprehensive contemporary art online portfolio and art sales programme, with artists selecting a level of online portfolio from free to premiere. Also offers artblogs written by artists, curators and collectors from around the world.

Submission Policy Arts news submissions and complete press releases (in English) must be received two weeks before exhibition opening. The venue, exhibition or artists must have a website.

apob Original Art Galleries

E info@apob.co.uk

W www.apob.co.uk

Showcase of work by UK artists, all for sale. Currently over 300 artists showing over 2,000 works across genres.

Art in the City

E admin@artinthecity.co.uk W www.ArtintheCity.co.uk

Founded in 2003, now with over fifty professional or semi-professional artists. Each artist page has room for sixteen pictures, with artist maintaining total control over editorial and picture content via access to a secure database. Includes personal email and message system. Artists able to show work at two quality sites in Manchester City Centre. (Small extra charges for these exhibitions.) No commission on sales from the site organized by artist.

Submission Policy Artists need to complete internet application and submit work. Small annual charge on acceptance. Maximum of sixteen pictures on own page.

Art Industri

W www.artindustri.com Promotes the work of students, amateur and professional artists, and art galleries via a network of sites offering promotional tools, reference information and resource services to the art community.

artart.co.uk

E curator@artart.co.uk

W www.artart.co.uk

Contact Lawrie Simonson

Founded in 2000. Offers professional artists a platform to exhibit and sell art. Has a varied stable of professional artists and welcomes recent arts graduates onto the site. Tends to show predominantly modern painting and sculpture but also a good selection of other specialized media, including ceramics and photography.

Submission Policy Requires eight to twelve images/jpegs of good quality, CV and statement.

Artistri

W www.artistri.co.uk

Online gallery showcasing original modern art by graduates and exceptional undergraduates from Scottish Art Schools.

artroof.com

E info@artroof.com

W www.artroof.com

Helps artists to establish an online art gallery in a few minutes.

ArtsAccess.org

W www.artsaccessuk.org

Listings and access guide to arts in Britain run by the Disability Cultural Projects charity.

ArtsCurator Ltd

E info@artsCurator.co.uk

W www.artscurator.co.uk

Contact Simon Clark

Formed in 2004 to provide a fully supported service for artists who wish to promote their work via the Internet. Each artist gets their own contentmanaged website, which takes no technical expertise to update. Subscription to the service is f_{25} per month.

Artshole.co.uk

E tony@artshole.co.uk

W www.artshole.co.uk

Founded in 2002, providing professional, emerging and student artists with a free platform to showcase and sell their art work. Currently shows over two thousand artists. Free listings section and many online links and resourses.

Axis

E info@axisweb.org

W www.axisweb.org

Features a directory of professional artists and curators, interviews, discussions, art news, debates and showcases the artists to watch. Members gain access to the best opportunities, get editable online profile, exhibition promotion and networking opportunities.

Submission Policy Apply online. Selection criteria applies. Available to professional artists and curators, from £25 per year.

britart.com / eyestorm.com

W www.britart.com

An online forum for buying and selling limited editions of contemporary UK art works.

Clikpic

E support@clikpic.com

W www.clikpic.com

Offers websites for artists for as little as £35 per year. With an easy-to-use template system and a range of design schemes created especially for artists and photographers, artists can create a professional-looking web site within hours, which can be edited at will. Works sold online via PayPal. Free seven-day trial for interested artists.

Counter

E info@countereditions.com

W www.countereditions.com

A website of prints and multiples by contemporary artists.

DegreeArt.com

E info@DegreeArt.com

W www.DegreeArt.com

Contact Elinor Olisa or Isobel Beauchamp
Established in 2003, inviting clients to buy, rent
or commission contemporary artwork created
by students and recent graduates from the UK's
leading art establishments. Artists showcased
through the web, in exhibitions and at art fairs.
Represents all genres including painting,
photography, sculpture, print, design, installation,
video and drawing and can offer artists support
and marketing advice.

Submission Policy Accepts applications from current students and artists who graduated within three years. Application details on website.

Emerging Artists Art Gallery

W www.emergingartists.com

Formed in 2005. Allows the buying and selling of original pieces of art from emerging artists on secure site. Artists sign up and list their art for free, paying a commission on sales. Sells digital art, drawing, pottery, sculpture, jewelry, printmaking and paintings.

Submission Policy See website for details.

eyestorm

E emma.poole@eyestorm.com

W www.eyestorm.com

Contact Angie Davey

Founded in 1999. An online company offering exclusive signed limited-edition prints by many leading contemporary artists, including Damien Hirst, Jeff Koons, Peter Blake and Helmut Newton.

Fine Art Surrey

E leon@fineartsurrey.com

W www.fineartsurrey.com

Contact Leon Deith

International online gallery selling oil paintings, watercolours, sculpture and prints by British contemporary and traditional artists including members of the Federation of British Artists and other leading art societies. Spearheading sales into China, Russia and the Middle East, with future exhibitions planned. Prices range from £95–150,000.

Submission Policy Always looking for new artists. In first instance visit the website and submit via artists' registration.

Folk Archive

W www.britishcouncil.org/folkarchive Virtual archive of an exhibition of folk art from Britain and Ireland curated by Jeremy Deller and Alan Kane.

Fotonet

E office@fotonet.org.uk W www.fotonet.org.uk

Contact Susie Medley (Director)

A website showing curated online exhibitions and a source of information for photographers. Run by Fotonet (founded in 1999), a photography development organization based at the Winchester Gallery, Winchester School of Art.

Gallery 1839

E kevin@lpa-management.com W www.gallery1839.com

Contact Kevin O'Connor

Founded in 2007. Specializes in the sale of 20thand 21st-century photographs. Represents eclectic mix of photographers including members of the London Photographic Association and invited international artists and fine art photographers. Holds competitions throughout the year. Submission Policy Contact Kevin O'Connor above in the first instance.

GlimpseOnline.com

W www.glimpseonline.com

Contact Isobel Beauchamp / Elinor Olisa Created in 2007 by Isobel Beauchamp and Elinor Olisa, the founders of the successful graduate art dealership, DegreeArt.com Ltd, this selling and promotional site gives artists and designers direct access to trade and private buyers. Designers each have an online 'shop'. Charges 20% commission on sales.

Irving Sandler Artists File

E artifle@artistsspace.org
W www.afonline.artistsspace.org
A digitized image database and slide registry
open to the public free-of-charge. Regularly used
by curators, artists, gallery owners, collectors,
consultants, and students. Artists can include 12
images, statement and CV in their online portfolio.
No fee to join or view the Artists File, and users

Londonart.co.uk

E paul@londonart.co.uk

contact the artists directly.

W www.londonart.co.uk

Contact Paul Wynter

Set up in 1997 to provide artists with an opportunity to show their work online, and buyers with a wide choice of original contemporary art.

The site now offers 20 thousand works for sale from over 2000 thousand artists, with prices ranging from £50 to over £40,000.

Submission Policy Welcomes applications from

Submission Policy Welcomes applications from visual artists making original contemporary art. All applications will be carefully considered.

Mini Gallery

E enquiries@minigalleryworld.com W www.minigalleryworld.com Contact Hazel Semple or Chris Storey Established in 2002, showcasing art by selfrepresenting contemporary artists. Each member artist has own mini-website, including online gallery space to display and sell art commission-free, and is provided with all the tools necessary to manage their online profile. Membership subscriptions are available from f_{25} .

Submission Policy Applications are welcome at any time via the online application form.

On-lineGallery

E info@on-linegallery.co.uk W www.on-linegallery.co.uk Contact Laureen Bromley

Founded in 2005, selling hundreds of original art pieces and art prints from a number of artists. Works range from watercolour landscapes to abstract oils and photography, all available to buy online. Different membership options offered depending on the needs of the artist, starting with free membership with a 37.5% commission on sales and rising to a £30 monthly membership fee with 5% commission on sales.

Submission Policy Before acceptance, an artist must submit at least 3 images for approval.

Paintings and Prints 2 - Artists of the World

W www.paintingsandprints2.com
Contact John and Susan Wood
Founded in 1999. An artists' directory including
paintings and prints by various amateur and semiprofessional artists.

scotlandart.com

E enquiries@scotlandart.com W www.scotlandart.com The largest original art website in Scotland.

shopforprints

E shopforprints@shopforprints.com W www.shopforprints.com

Contact Peter Learoyd
Online printshop and gallery selling editioned
prints and photographs for artists, illustrators
and photographers. Artists receive 50% of the
selling price. Giclée prints made to order. Shipped
worldwide.

Stuart

W www.saatchi-gallery.co.uk/stuart/ Supported by the Saatchi Gallery, an online resource where art students can showcase their work by uploading photos, profiles, videos and images.

Studioworx Contemporary Art Ltd

E help@studioworx.co.uk

W www.studioworx.co.uk

Contact Mark Withers

Founded in 2004, an online art store which has sold over 800 works. Specializes in abstract, pop art, naturalistic, surreal and futuristic works. Prices start at £25. Artists include Mark Withers, Tom Reed, Rachel Stewart and Joh Jackson.

Your Gallery

W www.saatchi-gallery.co.uk/yourgallery Free resource offering online space to artists. Supported by the Saatchi Gallery.The order that artists appear on the website is random and changes regularly.

Online reference

Art & Architecture Thesaurus Online

E AAT@getty.edu

W www.getty.edu/research/conducting_research/vocabularies/aat

A structured vocabulary of 133,000 terms, descriptions, bibliographic citations and other information relating to fine art, architecture, decorative arts, archival materials and material culture.

Art Movements

W www.artmovements.co.uk A concise reference guide to the major art movements and periods.

Artcyclopedia

E jmalyon@artcyclopedia.com

W www.artcyclopedia.com

Aims to be 'the definitive guide to museum-quality fine art on the Internet'.

ArtInfo

E newseditors@artinfo.com W www.artinfo.com

Run by LTB Media, features include news, an artprice database, a calendar of international events, a directory of artists and art institutions, cultural travel guides, job listings, analysis of market trends and education information.

Artlex Art Dictionary

W www.artlex.com

Offers over 3,500 definitions of terms relevant to art and visual culture. Includes images, pronunciation notes, quotations and crossreferences.

artnet

E ilaplaca@artnet.com

W www.artnet.com

A site for buying, selling and researching fine art online. Serves dealers and buyers alike by providing a survey of the market and its pricing trends. A price database represents auction results from over five hundred international auction houses since 1985, covering more than 2.6 million art works by over 180,000 artists.

artprice.com

W www.artprice.com

Leading information source on the art market. Hosts a database of over 20 million auction prices and indices, auction results and over 300,000 artists.

British Arts

E arts@britisharts.co.uk W www.britisharts.co.uk

Wide-ranging guide to the British art scene, including online resources, a shop, printing information and guides to different artists and styles.

Creative Space Agency

E info@creativespaceagency.co.uk W www.creativespaceagency.co.uk Links owners of vacant properties with the creative sector, helping to locate vacant space in London to work, exhibit, perform or rehearse. Offers up-to-date listing of available spaces in London, fact sheets and regular training sessions.

culturebase.net

E info@culturebase.net.

W www.culturebase.net

An online information source on contemporary international artists from all fields.

FindArtInfo.com

E contact@findartinfo.com

W www.findartinfo.com

Contains price information for fine art across genres, styles and eras.

Grove Art Online

W www.groveart.com

A subscription website offering online content of the Grove Dictionary of Art. Contains over 45,000 articles on fine arts, decorative arts, and architecture and 130,000 art images, with links to museums and galleries around the world. Fully explorable.

National Museums Online Learning

W www.vam.ac.uk/about_va/online_learning/ index.html

An e-learning initiative led by the V&A, bringing together the online collections of nine museums and galleries: the British Museum, Imperial War Museum, National Portrait Gallery, Natural History Museum, Royal Armouries, Sir John Soane's Museum, Tate, the Wallace Collection, and the V&A. Allows online visitors to browse the collections across all participating partners free of charge. "Creative Spaces" offers a social networking application while "WebQuests" are open-ended enquiry investigations for schools.

Own Art

W www.artscouncil.org.uk/ownart An online guide to Arts Council England's interest-free loan scheme for purchasing art, listing participating venues.

Own It

E info@own-it.org

W www.own-it.org

Offers free advice, resources and events on the protection, management and exploitation of intellectual property for creative businesses, including information on copyright, design rights, trademarks, licensing, royalties and contracts. Membership is free and members can attend events, download event podcasts, sample legal contracts, legal factsheets and can also access free IP legal advice and attend IP clinics (free 45-minute one-to-ones with lawyers).

the-artists.org

W www.the-artists.org

A database of biographical information on leading twentieth-century and contemporary visual artists.

Visual Collections

E carto@luna-img.com

W www.davidrumsey.com/collections A searchable archive of over 300,000 images of fine art works, photographs, maps and other items from thirty-five major international museum, academic and private collections. Administered by Cartography Associates.

A different kind of enthusiast

Jeremy Deller

Jeremy Deller occupies a radically different position to most artists in the UK. Perhaps as a result of not progressing through an art school system, his work has never conformed to any one mode of production and consists of anything from performance, photography and film to public art or even music. Indeed, many of his works are collaborations with other artists, musicians, scientists or ordinary members of the public. In 1995 Deller conceived 'Acid Brass', a series of concerts in which compositions taken from acid-house music were reinterpreted by the Williams Fairey Brass Band at prominent events such as the opening of Tate Modern in London. Famously in 2001, he staged a re-enactment of a 1984 pitched battle between police and striking Yorkshire miners - many of whom were embroiled in the original fighting - all of which was filmed by film director Mike Figgis and televized as 'The Battle of Orgreave'. Deller has, at varying times, organized other participatory art marches and street parades that highlight a whole range of historical, contemporary, political and social concerns. Often he turns curator: the 'Folk Archive' (www.britishcouncil.org/folkarchive/folk. html), which he initiated with fellow artist Alan Kane, is an ongoing investigation into the state of contemporary folk art in Britain. Despite Deller's contrary and complex role as an artist, he was awarded the ultimate industry accolade - the Turner Prize - in 2004 and has exhibited and sold work internationally. His open-ended artistic practice is one of the many diverse ways that exist to pursue a career as an artist. Here he discusses how to be, or perhaps how not to be, an alternative artist.

Do you see yourself as an alternative artist, or would you characterize your work as conceptual art?

I'm an artist.

Did you study art with a view to a professional career?

No, in fact I did art history at university.

How did your background in art history influence your work?

I studied 17th-century Baroque art, which was a movement that actively sought an audience, in that the work often tried to involve the spectator through a variety of devices such as eye contact, lighting or a realistic depiction of the body. The Catholic church at that time was going through the Counter Reformation, a back-to-basics approach to the religion that stripped it to its essentials, meaning that the faithful were put at the centre of the action, most literally in the art works. I'm interested in the relationship between audience, artist, spectator and how these distinctions can be melted.

What kind of work did you begin making as an artist?

Small works on paper and small interventions; cheap work basically, as I had very little money.

How did you get your first break in the art world?

There isn't such a thing, or there wasn't for me. It was about a series of breaks, maybe five to ten different ones, but you make your own breaks; they don't fall into your lap.

Why are collaborations so important to you? They're fun and you never know where you'll end up. Making art can be a lonely business so it's good to work with someone on projects.

How do you include members of the public? I approach them; it's as simple as that.

How might you explain your practice to the layman?

I work with what's around me, I make small films, I work with people who are often experts in their field – which can mean musicians or scientists – and I organize exhibitions of other people's work.

Would you encourage artists to experiment beyond traditional categories of art-making paintings, sculpture, photography, etc? Yes, of course, but only if it's something you would want to do. There's no point forcing something.

Does winning the Turner Prize somehow validate your practice, or change the audience for your work?

It validates it for other people and it's a good calling card in that people know what I do, which can make things easier.

What about material costs? Are yours lower than the average painter or sculptor?

I don't know what an average artist spends, but I travel a lot and that can be expensive, especially in the UK.

Do you need a studio to produce your kind of work? If so, what's in it?

It's more of an office with a phone and a computer. Some of my archive is here as well. It's a small room 10 × 12 feet but it's OK; there's not much space to stretch out.

Is it harder to get gallery support for your kind of work?

No, I think galleries are always keen to work with a variety of artists. A good dealer will see commercial potential where others don't.

Have you approached funding in other ways? Perhaps government or Arts Council, private or commercial sponsorship?

I have a phobia of filling in forms so I try to do this as little as possible. Much of my work is sponsored but luckily that part of the equation is something I have little to do with.

Often your work doesn't have any tangible product. Do you consciously make art that's not commercially viable?

Sometimes it just happens like that, especially if the end result is something that I haven't made myself or is a large collaboration. On the other

hand I do make work that has a definite product that can be sold. It really boils down to what is suitable for each project.

Does this signify a political intent in the work? If anything it's a way of trying to limit the amount of stuff in the world. You only have to go to an art fair to see how much unnecessary art there is in the world.

What can you sell to support a conceptual or alternative art career - films or photographic documentation, for example?

Yes, those two are the main ways, also ephemera, drawings (not that I draw); it can be anything really and is again dependent on the skill of the dealer to imagine how something can be represented.

How did you finance a big production like the Battle of Orgreave? Did you have to pay for extras, cameras and everything?

Channel 4 mainly paid for that. I had nothing to do with the financial aspect, but the majority of the money went to the extras. There were 1,000 of them and they each got paid for two days' work. It was really good to pay them as so often everyone has to work for free on art projects the artist especially - it's so boring.

What other kind of support do you need for a big work like this - assistants, production teams?

There were two production companies working on that piece: Artangel and the TV production company chosen by Channel 4. It would have been impossible otherwise and would have sent me to an early grave. There were literally hundreds of people working on it towards the end.

How does your work develop - on paper, in your head, over the phone or email?

Some would argue it doesn't develop; in a variety of ways, often from a written idea or just thinking about things. The moment just before I fall asleep can be quite good.

How many of your ideas never get produced and why?

Like anyone I have more ideas than art work. Thank God some of my ideas never make it because they're so bad. A few things regretfully can't be made because they are more or less impossible, given budget and time constraints.

How important is travel to your work and why? How much time do you spend in London currently?

I go where I'm asked to go, i.e., where the work is. At the moment the USA seems to be a place where I am in demand. It broadens the bank balance as well as my horizons. It's good to get out of London and not to be too reliant on the London art scene and I don't have a gallery here, which is a bit odd now that I come to think about it. On average I am away a week to ten days a month.

Have you ever thought about turning to painting or photography or more traditional ways of art-making?

I can't paint, although I'd like to, as it seems so settled and cosy. If it's going well, I actually think I'm quite traditional. Most of the general public by now has a pretty good handle on conceptual art. I think the Tate and the Turner Prize especially have helped with that.

The 'Folk Archive' is an interesting concept. Can you explain the idea behind it a little? It's an ongoing accumulation of material that looks at UK folk and popular art as it is today, I do it with a friend, Alan Kane. It deals with the creative life of the UK and is really things that visually and conceptually excite us made by people all around the country.

You are essentially building up a collection of work by other people, so what is your role in this activity – collector, curator or artist? Most of the stuff we don't actually own and we don't have the space to store it all, so we have to borrow the works when we put on the shows. We are essentially enthusiasts who have a bit of clout in the art world.

Is there a right or wrong way to be an artist? Hopefully wrong – as that's when it's good.

O4 Suppliers and services

Construct your ambition: making grand ideas become realities

Mike Smith

The range of materials, techniques and services available to artists is becoming more astonishing every day. As you might expect, any choice of materials derives naturally from the sorts of references and influences required of the work. For example, you may want the traditional associations of bronze-casting and marble sculpture, the highly finished industrial aesthetic, or even something in between made from plaster or wood. The crucial factor in these artistic choices is to know what you want and why you want it, in which case many of your problems will solve themselves.

An artist needs to be interested in the process of making their own work, but if they do not have access to the facilities, space or skills to make the work they have envisioned, there are others who can help. Art fabricators such as myself can work with artists in lots of different ways — we can advise or consult on a project, aid the design of an object, make a part of something or make the whole work from start to finish, including transportation and installation.

I started out as a studio assistant while at Camberwell College in the 1980s, working for painters such as Ian McKeever and Christopher Le Brun, stretching, preparing and priming canvases. It is vital to learn these skills because even if you get to a position where you can employ someone else to help out, then at least you can explain whether you like the painting surface to be loose or as tight as a drum.

My knowledge grew as I began to experiment in different materials such as wax, steel and formica, while assisting the sculptor Edward Allington as well as hanging shows and making pieces of furniture for galleries in my spare time and at weekends.

As soon as I finished college in 1989, I set up as a business and went into production fulltime. Eventually in 1994 I stopped my own art practice because the prospect of making work with others was more exciting and offered more possibilities. Initially I worked with a relatively small number of artists and galleries. It was during this period that I constructed a number of works for Damien Hirst's first major London show, 'Internal Affairs', at the Institute of Contemporary Arts in 1991, developing a method of manufacturing his trademark vitrines of glass and steel. More recently the studio produced a large-scale, site-specific house by Michael Landy called Semi-Detached for Tate Britain in 2004 that weighed around 13 tonnes and consisted of ten truckloads of panels and components, which was later demolished.

Although you can get emotionally attached to a work of art, what I really enjoy is the collaboration, the whole discursive process of bringing something new into the world; from the initial exchange of information via conversations and sketches through to the finished three-dimensional object. Of course, the big projects are more risky, challenging and ultimately more rewarding, but even if you are not working on a grand scale, there are some points to bear in mind before attempting to realize your project.

Sourcing materials

The Internet has made it much easier to find materials, specialist equipment or companies that can supply and cut material to order. Advances in technology have produced the means to create very particular objects. One particular technique is known as rapid prototyping; this involves constructing a computer model that is then rendered in plastic by a machine, so avoiding the costs and trouble of making a mould and then casting a maquette, although it also has limitations because of the cost and the size of objects that can be produced.

A problem you may face is finding companies that are sympathetic and prepared

Fabrication

There has been a steady demise in artists' ability to handle materials, partly because there are so many health and safety conditions at colleges that students can no longer use machinery anymore owing to the institutions' fear of being sued. Much of a work's fabrication – whether it is in plastic or resin, made from copper, stainless steel, brass or aluminium, painted, carved, handmade or machined – is down to your curiosity about how things are made and how you can manipulate a material to suit your aims and ideas.

A lot of people think that if they can imagine a work of art, then it can be made, but often the creation of an object is subject to all sorts of negotiation and compromise. Again, if you know what you want and have a sense of why you want it to look a certain way, then your aesthetic concerns are more likely to prevail.

Budget

There are many things to bear in mind when drawing up an initial budget for a work of art, including its making, delivering, installing and the all-important VAT. Artists often waive the idea that they are actually going to make any money from it themselves, but you should nonetheless value your own time — especially if you are not yet making a living from your art — and only consider doing something for an

insignificant financial return if it is potentially an investment in your future. Depending on where you are in your career and your position in the art market, there is no reason to invest everything you have in making one piece. Someone once asked me to make a two-metredeep water tank for a performance that had to be big enough for someone to swim in but also had to be built in a tiny venue in half a day. Apart from the fact that it would have buckled the hollow gallery floor, the £2,500 budget would only have bought a few square metres of glass. So, make sure that absolutely everything is accounted for in your budgets, and factor in all logistics such as manoeuvrability, specialist equipment, planning permission, and health and safety requirements.

Planning and safety

Many artists involved in commissioned, semi-permanent or public art for the first time make assumptions about what they can do in a public space, without proper regard for the complicated issues of planning permission or health and safety. Much of it is common sense – knowing that if you mix bleach and chlorine you get a deadly gas, for instance – so always read the labels and take your work seriously.

If you are not well prepared on these topics, you can waste a lot of time putting forward a proposal that will fall foul of the rules and regulations in the final reckoning. We have had a lot of experience with these issues and found ways to circumvent or incorporate them without prohibitive compromise. Before we went to install Rachel Whiteread's Monument on the empty plinth in Trafalgar Square, we discovered that it was not possible to drive vehicles onto the square and we were not permitted to drill holes in the plinth. Not only did we have to get the 11-tonne resin piece there by closing major roads and avoiding low bridges, but we then had to crane it into position between two and five o'clock in the morning, when the centre of London was full of drunks, and figure out a way to secure it that wasn't mechanical or architecturally invasive.

Crating and conservation

Although custom-made crates may seem excessive and expensive, they can protect and greatly prolong the life of a sculpture or installation, or even keep a painting clean almost indefinitely. There is always a chance that a work might get damaged because you cannot be there every time it is handled or moved, but if it is in a box it will hopefully arrive at its destination in one piece. If your work is in multiple parts already, then these should definitely be crated and kept together.

Conservation and cost are intrinsically linked, so if an art work is not worth a huge amount of money then people will not be up in arms about conserving it. However, all artists, whatever their age or status, should think in the long term. We manufacture a variety of painting supports including aluminium panels

for artists such as Gary Hume, Jason Martin and Ian Davenport. Apart from its rigidity, the aluminium substrate is profoundly stable; museum conservators know that if you put household paint on aluminium it will last a long time, but if you apply it to canvas it will rot and fall off, even if the surface is properly primed. Also, it is wise to keep some sort of record of a work's manufacture. Take note of what colours, materials and adhesives you used, and hold on to early sketches, computer drawings and invoices, in case something needs to be repaired, restored or even refabricated.

Mike Smith provides technical and intellectual engineering solutions for artists and has been designing and fabricating works of art for many prominent British artists for over 15 years (www.mikesmithstudio.com).

Art materials retailers

East Anglia

Ashley Studio

19 Staithe Street, Wells-next-the-Sea, NR23 1AG

T 01328 710923

F 01328 710923

Contact Hazel Ashley

Founded in 1979. A small studio for the artist Hazel Ashley, selling a comprehensive range of artists materials. Contacts with local artists and Wells's thriving art group. Open all year round.

Berkhamsted Arts & Crafts

29–31 Lower Kings Road, Berkhamsted, HP4 2AB

T 01442 866632

E info@art4crafts.co.uk

W www.art4crafts.co.uk

Contact Paula Daddow

Established in 1972, stocking an extensive range of art and craft materials. Small classes held on site.

David Potter Ltd

The Old Forge, Rockland St Mary, Norwich, NR14 7AH

T 01508 538570

F 01508 538636

E info@davidpotter.co.uk

W www.davidpotter.co.uk

A manufacturer of a range of high-quality artists' easels, studio furniture and accessories.

Heffers Art & Graphics

15-21 King Street, Cambridge, CB1 1LH

T 01223 568495

F 01223 568411

E sales@tindalls.co.uk W www.tindalls.co.uk

Suppliers of art materials to Cambridge artists and students for over thirty years. Orders accepted by email, phone and fax. Now owned by Tindalls The Stationers.

Hertfordshire Graphics Ltd

6 St Andrew Street, Hertford, SG14 1JE

T 01992 503636

F 01992 503244

E sales@hertfordshiregraphics.co.uk

W www.hertfordshiregraphics.co.uk

Contact Rod Lewis

Founded in 1983. Supplies graphic and art materials to graphic designers and advertising studios and includes a retail art shop and gallery. A sponsor of many local art events. Based in an historic sixteenth-century listed building.

Hobbycraft - The Arts & Crafts Superstore

Westgate Park, Fodderwick, Basildon, SS14 1WP T 0845 0510635 / 01263 240100 W www.hobbycraft.co.uk Suppliers of arts and crafts materials with

larrold's

I London Street, Norwich, NR2 1JF

T 01603 660661

branches nationwide.

F 01603 611295

E info@jarroldthestore.co.uk

W www.jarroldthestore.co.uk

Contact Patrick Clarke (Art and Craft Head

Buyer)

Founded in 1823. Respected retailer of leadingbrand art and craft materials.

Laurence Mathews Art & Craft Store

I Queens Road, Southend-on-Sea, SS1 1LT

T 01702 435196

F 01702 435377

W www.laurencemathews.co.uk

An art and graphics materials supplier in business since 1948. Also offers a bespoke picture-framing service.

Tim's Art Supplies

85 Tilehouse Street, Hitchin, SG5 2DY

T 01462 455376

F 01462 421898

E info@timsartsupplies.co.uk

W www.timsartsupplies.co.uk

Contact Tim Farr

Founded in 1976, specializing in fine art, craft, graphic and office supplies for the artist and amateur, and offering a picture-framing service. Holds regular classes covering a range of subjects, for both adults and children. Mail order available.

Tindalls The Stationers Ltd

50-52 High Street, Newmarket, CB8 8LE

T 01638 668855

F 01638 663633

E sales@tindalls.co.uk

W www.tindalls.co.uk

Contact Jamie Gaskin

Branches: 8 Bridge Street, St Ives PE27 5EG

T: 01480 493765 F: 01480 493766;

4 Market Place, Ely CB7 4NP T: 01353 669498

F: 01353 669382

Windsor Gallery

167 London Road South, Lowestoft, NR33 OBL

T 01502 512278

E products@windsorgallery.fsnet.co.uk

W www.windsorgallery.fsnet.co.uk

Contact Ray Glanfield

Established in 1981. Stocks art and craft materials from a wide range of manufacturers. Also offers a bespoke framing service.

Wrights

15-17 Stanley Road, Great Yarmouth, **NR304IB**

T 01493 844618

E wrights.norfolk@btopenworld.com

W www.wrightsofnorfolk.co.uk

A family business, started in 1957. Stocks a comprehensive range of all artist materials. Offers a full framing service, from supplying mouldings to framing finished articles.

East Midlands

The Art Cafe

185 Mansfield Road, Nottingham, NG1 3FS

T 01159 474421 F 01159 523683

E info@pspowageartcafe.co.uk

W www.pspowageartcafe.co.uk

Contact P. Spowage

Specialists in artist materials from beginner to professional. Stockists of many major brands. Canvas off or on the role. Gallery space takes commissions and exhibitions. Advice given. Also runs art lessons.

Art Essentials

26 Main Street, Kimberley, Nottingham, NG162LL

T 0115 9385551

General art materials retailer.

The Art Shop

45a High Street, Oakham, Rutland, LE15 6AJ

T 01572 723943 F 01572 770068

E hopsdavis@aol.com

Contact Christine Davis

Founded in 1985. An independent retailer specializing in art and craft materials.

Knowledgeable staff always available to give directions. Mail order and student discounts offered.

Artworks

86-88 Chilwell Road, Beeston, Nottingham, NG9 1ES

T 0115 9223743

W www.artworks-ltd.co.uk

Stocks wide range of arts and crafts materials and offers a framing service. Runs workshops and classes. See website for details.

Colemans of Stamford

39 High Street, Stamford, P69 2BE

T 01780 480635

F 01780 766424

E Stamford@colemangroup.co.uk

W www.colemans-online.co.uk

Contact Joan Dale

Established in 1969, stocking a wide range of materials and now operating twelve branches across Northants, Cambridgeshire, Bedfordshire and Herefordshire.

Dominoes of Leicester Ltd

66 High Street, Leicester, LE1 5YP

T 0116 2533363

F 0116 2628066

E ann.land@dominoestoys.co.uk

W www.dominoestoys.co.uk

Contact Tony Wilmot or Darroll Cramp

A large, independent retailer of arts and crafts, toys and models. Two artists staff the art room. Also has a comprehensive craft room covering most popular crafts.

Gadsby's / Artshopper

22 Market Place, Leicester, LE1 5GH

T 0116 2517792

F 0116 2517792

E info@gadsbys.co.uk W www.gadsbys.co.uk / www.artshopper.co.uk An art materials retailer. Branches: 260 High Street, Lincoln LN2 1LH T: 01522 527485 and 347 High Street, Lincoln LN5 7DQ

Hills of Newark Ltd

T: 01522 527487.

34-38 Barnbygate, Newark, NG24 1PZ

T 01636 702240

F 01636 612627

E sales@hillsofnewark.co.uk

W www.hillsofnewark.co.uk

Contact Nick Hill

Established in 1977. A family-run artists' materials shop with picture-framing service on the premises.

J. Ruddock Ltd

287 High Street, Lincoln, LN2 1AW T 01522 528285

F 01522 532162

E shop@ruddocksoflincoln.co.uk

W www.ruddocksoflincoln.co.uk Has supplied art materials for over a hundred years and runs courses in its own studios,

including watercolour and life drawing.

Price range £25 per day for main studios (e.g. for teaching or workshops).

John E Wright & Co. Ltd

Blue Print House, 115 Huntingdon Street, Nottingham, NG1 3NF

T 0115 950 6633 F 0115 958 5067

E sales@johnewright.com

W www.johnewright.com

Established 1900 as a plan printers. Suppliers of fine art and graphic art materials and one of the leading suppliers of digital printing services in the East Midlands. Offices also in Derby and Leicester.

P.H. Graphic Supplies

Unit 11 Bulwell Business Centre, Sellers Wood Drive, Bulwell, NG6 8GN T 0115 9771122

SAA Home Shop

PO Box 50, Newark, NG23 5GY

T 0800 9801123

F 01949 844051

E info@saa.co.uk

W www.saa.co.uk
Catalogue with over 10,000 art material products, catering for all mediums, subjects and levels of artist. Includes instructional books and art tuition on DVD. Orders taken by phone, fax, post or via secure online ordering system.

Shawe's the Art Shop

68–70 Mansfield Road, Nottingham, NG1 3GY T 0115 9418646

E contact@shawes.co.uk

W www.shawes.co.uk

Stocks art and craft materials from leading suppliers.

London

A.P. Fitzpatrick

142 Cambridge Heath Road, Bethnal Green, London, El 5QJ T 020 77900884 E info@apfitzpatrick.co.uk W www.apfitzpatrick.co.uk A leading stockist of artists' pigments.

A.S. Handover Ltd

Unit 8, Leeds Place, Tollington Park, London, N4 3RF

T 020 72729624

F 020 72638670

E m_venus@handover.co.uk

W www.handover.co.uk

Contact Michael Venus

Founded in 1949, manufacturing artists' brushes in London. Will make small orders to customers' specifications. Also supplies tools, paints and sundries for artists and craftsmen.

Alustretch UK Limited

Unit 261, Grosvenor Terrace, London, SE5 0NP T 07968 719361 / 020 72525913

F 0870 0512302

E bstins@gmail.com

W www.alustretch.co.uk

Contact Bruce Stinson

Sells aluminium stretcher frames (warp and distortion free, lightweight and easy to handle). In a variety of profile depths or cut to size. Available pre-assembled, stretched on site, or in kit form. Can be stretched with a range of quality linens or cottons. Price list available on request.

The Art Shop

117c High Street, Wanstead, London, E11 2RL

T 020 89890154 F 020 85188110

Contact Dill

Established in 1955 to serve local artists with all products needed. Runs a service whereby specialist materials can be ordered on a weekly basis. Also sells a large range of craft materials for adults and children.

Atlantis Art

7-9 Plumber's Row, London, E1 1EQ

T 020 73778855

F 020 73778850

W www.atlantisart.co.uk

One of London's leading suppliers of arts and crafts materials. Mail order available.

Bird & Davis Ltd - The Artist's Manufactory

45 Holmes Road, Kentish Town, London, NW5 3AN

T 020 74853797 F 020 72840509

E birdltd@aol.com

W www.birdanddavis.co.uk

Contact Rob or Jayne

Established in 1928. One of the UK's oldest and leading stretcher frame manufacturers for both trade and retail. Bespoke canvases made to exacting standards in various linens and cottons, primed and unprimed. Also stocks a comprehensive range of art materials and easels, with student discounts offered. Mail-order available. Also offers easel hire. Branches: The Royal Academy, Schools Shop – Schools Entrance, Burlington Gardens London W1 (open Monday–Friday 10.00–11.30).

Booer & Sons Ltd

216–218 Eltham High Street, Eltham, London, SE9 1BA

T 020 88502503

F 020 88506323

Contact Brenda Jackson

Established for nearly ninety years. Wide range of artists' materials and also a stationery department.

Canonbury Arts

266 Upper Street, Islington, London, N1 2UQ

T 020 72264652 F 020 77041781

E sc@canonburyarts.co.uk

W www.canonburyarts.co.uk

Contact Shaun, Lucy or Emelie

Established in 1949. A specialist art and sculpting materials supplier, moulder and caster. Also offers a picture-framing service.

Cass Art

66–67 Colebrooke Row, Islington, London, N1 8AB

T 020 79309940

E info@cassart.co.uk

W www.cassart.co.uk

Established for over 25 years. Wide range of professional art materials including a large variety of papers plus leading paint brands. Branches: 13 Charing Cross Road, WC2; 220 Kensington High Street; 24 Berwick Street, W1. All open 7 days a week.

Chromacolour International

Unit 5 Pilton Estate, Pitlake, Croydon, Surrey, CRO 3RA

T 020 86881991 / 0800 592235

F 020 86881441

E sales@chromacolour.co.uk

W www.chromacolour.co.uk

Contact Miss Kelly Hedger

Established over thirty years ago as animation supplier. Maker and supplier of unique artists' paints in eighty vibrant colours, high in pigment content, which can be used as watercolour, acrylic, gouache, ink, wash or as an impasto. Full range of artist products including custom made brushes, artists' paper and canvases. Secure-payment website for online ordering.

Colart Fine Art & Graphics Ltd

Whitefriars Avenue, Harrow, HA3 5RH

T 020 84243200

F 020 84243328 E n.montrose@colart.co.uk

W www.winsornewton.com

Contact Natasha Montrose

Among the world's largest suppliers and manufacturers of fine-art materials. Main brands include Windsor & Newton, Liquitex and Conte A Paris. Also distributes Artcare, Copic, Canson and Slater Harrison in the UK.

Cowling & Wilcox Ltd

26-28 Broadwick Street, London, W1V 1FG

T 020 77349557

F 020 74344513

E art@cowlingandwilcox.com

W www.cowlingandwilcox.com

Stock a wide range of art materials and presentation supplies. Branches also in Shoreditch

and Camberwell.

D & J Simons & Sons Ltd and SimonArt

SimonArt House, 122–150 Hackney Road, London, E2 7QS

T 020 77393744

F 020 77394452

E dsimons@djsimons.co.uk

W www.djsimons.co.uk

Company founded in 1900. Major stockists of Ferrario paints from Italy. Wide range of paints, artists' brushes, canvas products, pallets, painting mediums and accessories. Catalogue available on request.

Daler-Rowney Percy Street/Arch One Picture Framing

12 Percy Street, London, W1T 1DW T 020 76368241 E dr@artmat.co.uk W www.dalerrowney.co.uk/www.archonestudio.

Situated on the site of the original 1952 George Rowney 'showroom', this is still the only shop to stock the entire range of Daler-Rowney art materials. Also offers a complete framing service including gilded and hand-finished frames and mount cutting.

Darcy Turner

175 Leytonstone Road, Stratford, London, E15 1LH T 020 89818307 F 020 89818307 E darcyturner180@hotmail.com

W www.darcyturner.com

Practising artist who has devised the 'Stixx Newspaper Technology Construction System', an inexpensive and simple-to-use 3-D modelling medium. Has been widely used in national curriculum design technology projects.

Falkiner Fine Papers

76 Southampton Row, Bloomsbury, London, WC1B 4AR

T 020 78311151 F 020 74301248 E sales@falkiners.com

W www.falkiners.com

Founded in 1973, specializing in large range of papers for all art, craft and conservation purposes. Unusual papers sourced worldwide, including Japanese papers and handmade sheets. Stocks a wide selection of bookbinding supplies and materials and provides a bespoke thesis and fine binding service. Customers include art students, bookbinders, printmakers, calligraphers, architects, film prop buyers and the arts and crafts enthusiasts.

Fielders

54 Wimbledon Hill Road, London, SW19 7PA T 020 89465044 F 020 89441320 E shop@fielders.co.uk W www.fielders.co.uk Founded in 1928, specializing in art and craft materials, framing, copying/design services and art-related books. Branches: 8 High Street, Kingston-upon-Thames KT1 1EY T: 020 85471304 F 020 85472066

Gallery Gifts Ltd

157-159 High Street, Sutton, SM1 1JH T 020 86432945

F 020 86420990 E gallerygifts@hotmail.com Contact Judith Palmer Trading in art materials since 2001 and stocking major brands.

Green and Stone of Chelsea

259 Kings Road, London, SW3 5EL T 020 73520837 F 020 73511098 E sales@greenandstone.com

W www.greenandstone.com Established in 1927. One of the most highly respected artists' material shops in Europe. Stock includes painting and display easels in oak, beech and mahogany, and oil paints by leading manufacturers, including Mike Harding and Jacques Blockx. Linen and cotton canvases are premade or made to order. Also available are balanced palettes, and handmade and antique papers. Handmade picture frames are designed and made to order (by appointment only). A mail-order service is available.

Harris Fine Art Ltd

712 High Road, North Finchley, London, N12 9QD T 020 84452804 E sales@harrisfineart.co.uk W www.harrisfineart.co.uk Contact Mr C. Harris Established in 1971, stocking a wide range of art and craft materials from leading manufacturers.

Also offers a picture-framing service and a large modern gallery space. Website gives secure online ordering and guaranteed delivery.

Holloway Art & Stationers

222 Holloway Road, Islington, London, N7 8DA T 020 76074738 F 020 77004943 E hollowayartandstationers@ouvip.com A family business since 1874, stocking leading brands of art, graphic and drafting materials including airbrushes and compressors. Branches: Perrys, 777 Fulham Road SW6 5HA T: 020 77367225 F: 020 77366893. Perrys, 109 East Street, Southampton SO14 3HD T: 023 80339444 F: 023 80231644

Intaglio Printmaker

o Playhouse Court, 62 Southwark Bridge Road, London, SE1 0AT T 020 79282633 F 020 79282711

E info@intaglioprintmaker.com
W www.intaglioprintmaker.com
Opened in London in 1981, supplying extensive
range of printmaking materials sourced worldwide.
Also offers a reliable mail order service to artists,
studios and colleges. Initiated an artist-in-residency
scheme in the 1990s to provide professional
development opportunities for graduate
printmakers in the early stages of their career.

Jackson's Art Supplies

1 Farleigh Place, Farleigh Road, London, N16 7SX

T 020 72540077

F 020 72540088

E sales@jacksonsart.co.uk

W www.jacksonsart.co.uk

A mail-order supplier of quality art materials, with over 50,000 customers worldwide.

John Jones Ltd

4 Morris Place, London, N4 3JG

T 020 72815439

F 020 72815956

E info@johnjones.co.uk

W www.johnjones.co.uk

With forty years experience in creating bespoke frames, encompassing a team of 90 craftspeople and designers. Offers a creative approach to the fabrication, presentation, documentation and reproduction of artwork. Incorporates four key departments: Artist Surfaces, Museum Standard Framing, Fine Art Photography and Printing.

John Purcell Paper

15 Rumsey Road, London, SW9 0TR

T 020 77375199

F 020 77376765

E jpp@johnpurcell.net

W www.johnpurcell.net

A wholesale paper merchant supplying an extensive range of papers and boards from stock. Suitable for many applications including printmaking, drawing and watercolour, inkjet printing, picture-framing, bookbinding and commercial printing. Comprehensive price list available on request.

L. Cornelissen & Son

105 Great Russell Street, London, WC1B 3RY

T 020 76361045

F 020 76363655

E info@cornelissen.com

W www.cornelissen.com

Established in 1855. Specialists in pigments,

gilding and printmaking as well as more widely available materials. Provides a canvas-stretching service and offers easel-hire/delivery for short periods. Fast worldwide mail-order service. Two minutes' walk from either the British Museum or Tottenham Court Road tube station (exit 3).

London Art Ltd

132 Finchley Road, Hampstead, London, NW3 5HS

T 020 74331571 / 74356830

F 020 74331747

E email@londonart-shop.co.uk

W www.londonart-shop.co.uk

Specialists in art and craft materials with over fifteen years of experience. Also runs an online shop.

London Graphic Centre

16–18 Shelton Street, Covent Garden, London, WC2H 9JL

T 020 77594500

F 020 77594585

E info@londongraphics.co.uk

W www.londongraphics.co.uk

Contact Andrew Parsonage

Established for over thirty years. One of Europe's largest independent dealers in art and graphic supplies. Over twenty thousand products available to order over the phone or by visiting flagship retail store in Covent Garden. As well as traditional artists' materials, also offers wide range of specialist papers and portfolios.

Lyndons Art & Graphics

197 Portobello Road, London, W11 2ED

T 020 77274357

F 020 77929429

Contact Peter Kalyan

Established in 1904. Supplies art and graphics materials. Branches: 164 Portobello Road, London W11 2EB.

Michael Harding's Artists Oil Colours

88 Mile End Road, Whitechapel, London, E1 4UN

T 020 77028338

F 020 77910060

E oilpaint@michaelharding.freeserve.co.uk

W www.michaelharding.co.uk

Contact Michael Harding

Wholesale only (not open to the public). Founded in 1980, manufacturing the finest-quality oil paint available using recipes that date prior to the Industrial Revolution. Involved in restoration for, among others, the National Trust, English

Heritage and the Tate. Seventy-four colours available, soon extending to over one hundred. Available throughout the UK and through some major suppliers worldwide.

Owen Clark & Co. Ltd

129–133 Cranbrook Road, Ilford, IG1 4QB T 020 84788478

F 020 84783983

E sales@owen-clark.fsnet.co.uk

W www.owenclark.com

Contact Tony Clark

A retail art and stationery store established in 1928. Specializes in educational supplies, serving hundreds of local secondary schools and colleges with art materials, technical drawing equipment and educational stationery. Also caters for needs of amateur and professional artists and offers a mailorder service with generous discounts.

Paintworks Ltd

99-101 Kingsland Road, London, E2 8AG

T 020 77297451

F 020 77390439

E shop@paintworks.biz

W www.paintworks.biz

Contact Dorothy Wood

An artist-run shop and mail-order service founded in 1985. A major national stockist of fine-art paints, canvas and papers, supplying the education sector. Offers a product and technical information resource and a conservation-framing service for contemporary art works in all media. Specialist advice available.

Paperchase Products Ltd

213–215 Tottenham Court Road, London, W1T 7PS T 020 74676200

E write@paperchase.co.uk

W www.paperchase.co.uk

A flagship London store for innovative papers and stationery for over thirty years. Specializes in imported and effect papers, with a full selection of media and artists' requisites. The North of England flagship store is situated at St Marys Gate, Manchester.

Perrys Art & Office

777 Fulham Road, London, SW6 5HA T 020 77367225 F 020 77366893 E info@perrysartoffice.com Contact Nish Chande

Established in 1986. Stockists of a comprehensive

range of art and craft materials including all leading brands.

R.K. Burt & Co. Ltd

57 Union Street, London, SE1 1SG

T 020 74076474

F 020 74033672

E sales@rkburt.co.uk

W www.rkburt.co.uk

Established in 1892. One of the largest wholesale paper merchants in the UK, specializing in high-quality paper for every type of artist use. The first wholesale distributor in the UK for many leading mills, with a reputation for commissioning paper produced to its own specifications as required.

Russell & Chapple

68 Drury Lane, London, WC2B 5SP

T 020 78367521

F 020 74970554

E info@randc.net

W www.randc.net

Contact Andrew Milne

Founded in 1770. One of the UK's leading specialist suppliers of artists' canvas, selling a wide range of cottons, linens and canvases, both primed and unprimed. Products include canvases for digital printing, artists' stretcher bars and professional-quality artists' paints. Also offers a bespoke stretching service and can restretch original art work and inkjet prints to order.

Selwyn-Smith Studio

148 High Street, Teddington, TW11 8HZ

T 020 89730771

F 020 89730772

Contact Jo Selwyn-Smith

Founded in 2001. A traditional supplier of art materials specializing in the provision of drawing and painting equipment. The shop is always well stocked with both student- and artist-quality paint, a selection of stretched canvases, watercolour papers, easels and brushes.

Tiranti Tools

27 Warren Street, London, W1T 5NB

T 020 76368565

E enquiries@tiranti.co.uk

W www.tiranti.co.uk

Supplies complete range of tools, materials and studio equipment for sculptors, model- and mould-makers, potters, ceramicists, woodworkers, restorers and stonecarvers. Main showroom in Thatcham.

Unik Art & Craft

4 Astoria Parade, Streatham High Road, London, SW16 1PR

T 020 87690422

F 020 86773737

E nwacke@btinternet.com

Founded in 2000, specializing in the supply of professional-artist materials and a wide range of craft materials.

Vandy's Art and Graphic Centre

621 Forest Road, Walthamstow, London, E17 4NE T 020 85273492 Contact Zahir Mawani (Proprietor)

Stockists of fine-art and graphic materials. All major brands stocked.

Wheatsheaf Art Shop

56 Baker Street, London, W1U 7BU T 020 79355510

F 020 79353794

E sales@wheatsheaf-art.co.uk

W www.wheatsheaf-art.co.uk

Contact Tony Berrington

Stockists of fine art and craft materials from leading manufacturers. Online shop. Mail-order service available and experienced team on hand to answer questions. Founded in 1946.

North-east

The Art Shop

II-12 Bondgate, Darlington, DL3 7JE
T 01325 465484
E info@theartshop.co.uk
W www.theartshop.co.uk
Retails wide selection of arts and crafts materials.

The Art Shop

15 Station Road, Whitley Bay, NE26 2QY T 0191 2511726 Stock range of artists' supplies from leading manufacturers.

The Art Shop and Kemble Gallery

62 Saddler Street, Durham, DH1 3NU T 0191 3864034 Sells supplies to suit all artists and craftsmen. Also has a gallery space.

City Art

76 North Road, Durham, DH1 4SQ T 0191 3831919 Comprehensive range of art materials.

City Art Store

23 Vine Place, Sunderland, SR1 3NA
T 0191 5659254
W www.framecraftuk.com

Stocks broad range of art and craft materials, with a framing service in the basement.

Details @ Newcastle Arts Centre

67 Westgate Road, Newcastle-upon-Tyne, NE1 1SG T 0191 2615999 E sales@details.co.uk W www.details.co.uk

Contact www.details.co.uk Wide range of artists' supplies available.

Jarred's Arts & Craft

59 Borough Road, Middlesbrough, TS1 3AA T 01642 222531 Art materials retailer.

R.R. Bailey

12 Grange Road, Newcastle-upon-Tyne, NE4 9LD
 T 0191 2746126
 Stocks broad range of major-name art and craft materials.

Stratford & York Ltd

Whickham Industrial Estate, Swalwell, Newcastleupon-Tyne, NE16 3BY T 0191 4960111

F 0191 4960111

F 0191 4960211

E andrew.eccles@delbanco.com

Contact Andrew Eccles (Sales Manager)
Manufacturers of fine-art brushes in the UK since
1939. Seeks to serve both professional artists and
accomplished amateurs. Each brush is made by
hand

Team Valley Brush Co.

Whickham Industrial Estate, Swalwell, Newcastleupon-Tyne, NE16 3BY T 0191 4960111 Specialist manufacturers of fine art brushes.

Ward's Arts & Crafts

Halifax Road, Dunston Industrial Estate, Gateshead, NE11 9HW T 0191 4605915 F 0191 4608540 E info@doart.co.uk W www.doart.co.uk

Established for over 150 years. One of the north's leading retailers of arts and crafts supplies and materials. Also offers a professional photographic

and repro lab providing high quality giclée printing to artists.

North-west

The Art House

The Triangle, Hanging Ditch, Manchester, M43TR T 0161 8345545

General art materials supplier.

Artisan

115 Penny Lane, Allerton, Liverpool, L18 1DF T 0151 7350707 Specialists in paper and textile art.

Artstat

Creative House, Tilson Road, Roundhouse Industrial Estate, Manchester, M23 9WR T 0161 9023800

F 0161 9023801

Contact Patrick Swindell

Established in 1978. Wholesale distributors of artists' materials, craft and stationery products. Over eleven thousand items held in stock at the Manchester warehouse and showroom. Cash-andcarry facility or delivery by carrier.

Blots Pen & Ink Supplies

14 Lyndhurst Avenue, Prestwich, Manchester, M25 0GF

T 0161 7206916

F 0161 7206916

E sales@blotspens.co.uk

W www.blotspens.co.uk

Contact John Winstanley

Trading since 1993, specializing in the mail order of calligraphy pens, inks and sundries. Manufacturers of Iron Gall Ink, a medieval ink suitable for fine sketching and line and wash. Orders accepted online or via a paper catalogue.

Bluecoat Books & Art Ltd

Gostin's Building, 32-36 Hanover Street, Liverpool, L1 4LN

T 0151 7095449

F 0151 7087131

E paul.mccue@btconnect.com

W www.bluecoatbooks.com

Contact Paul McCue

Founded in 1988 at Bluecoat Arts Centre, a retail business selling art materials and specialist art books. Over 6,000 lines stocked at discounted prices.

Blyth's Artshop & Gallery

Amazon House, Brazil Street, Manchester, M13PJ

T 0161 2361302

F 0161 2280633

E sales@artmanchester.com

W www.artmanchester.com

Contact na

A major supplier of fine art and graphics materials and accessories, with a gallery specializing in contemporary art and sculpture.

Bottomleys Ltd

The Wheatsheaf Centre, Yorkshire Street,

Rochdale, OL16 1JZ

T 01706 653211

F 01706 653229

E janice@bottomleys.com

W www.bottomleys.com

Contact Janice Bottomley

An art and craft retailer situated in the centre of Rochdale. Operates a mail-order service and an online shop. Free delivery within UK. Regularly holds product demonstrations in the shop.

Chapter 1

35 Derby Street, Leek, ST13 6HU T 01538 399885 F 01538 399885 E chapter.1@btconnect.com

Contact Ann Vaughan

Founded in 1990. A retailer of art materials, stationery and books.

Colours and Crafts

61 London Road, Alderley Edge, SK97DY

T 01625 586100

F 01625 586100

E seahorse6259@aol.com

Contact Stella Batchelor

Founded in 2003. An art and craft retail outlet on two sites (Alderley Edge and Victoria Mill, Foundry Bank, Congleton, Cheshire). Workshops in all art and craft media available, lasting from half an hour to a full day.

Creative Shop Ltd

79 Strand Street, Douglas, Isle of Man, IM12EN

T 01624 628618

Founded in 1991, stocking artists' materials and craft supplies. Also sells fine-art prints and offers a framing service (bespoke and ready-made).

Daisy Designs (Crafts) Ltd

Hutpine House, 21 Sandown Lane, Liverpool, L15 8HY

T 0151 7341385

E daisydesigns@yahoo.com

W www.daisy-designs.co.uk

Founded in 1993. Specialists in textile-based crafts.

Edwin Allen Arts & Crafts

14-16 Buttermarket Street, Warrington, WA1 2LR T 01925 630264

F 01925 444620

E mike@edwinallen.co.uk

W www.edwin-allen.u-net.com

Contact Michael Allen

Founded in 1894 and still a family-run business. Specializes in the supply of fine-art materials, craft products, picture-framing and mount-cutting services.

Fred Aldous Ltd

37 Lever Street, Manchester, M1 1LW

T 0161 2364224

F 0161 2366075

E sales@fredaldous.net

W www.fredaldous.co.uk

Stocks wide supply of art and craft materials from array of major manufacturers.

Galleria Fine Arts

6 Green Street, Sanbach, CW11 1GX

T 01270 753233

F 01270 753233

Contact Peter Brown

Established in 1995, supplying a full range of artists' materials. Bespoke framing a speciality.

Granthams Art Discount

Graphics House, Charnley Road, Blackpool, FY1 4PE

T 01253 624402

F 01253 295743

E info@artdiscount.co.uk

W www.artdiscount.co.uk

Contact John Thompson

Founded in 1890, originally as a signwriting business. Moved into art materials supplies in the late 1960s and today operates out of two major sites. Orders can be made via website.

Heaton Cooper Studio Ltd

Grasmere, Ambleside, LA22 9SX

T 015394 35280

F 015394 35797

E info@heatoncooper.co.uk

W www.heatoncooper.co.uk

Contact John Heaton Cooper

Suppliers of high-quality art materials with worldwide mailing service available online or by phone. Stocks artists' accessories of all kinds, including a large range of brand-name and handmade papers. The retail shop is attached to the Heaton Cooper studio, selling originals and prints of works by the Heaton Cooper family.

Icthus Arts & Graphics

Graphic House, 106-110 School Lane, Didsbury, Manchester, M20 6HR T 0161 4342560 Wide-ranging stock of art and craft materials.

Ken Bromley Art Supplies

Curzon House, Curzon Road, Bolton, BL1 4RW T 0845 3303234

F 01204 381123

E sales@artsupplies.co.uk

W www.artsupplies.co.uk

Contact Laureen Bromley

Suppliers of art materials at discount prices. The company originated from the success of the Ken Bromley Perfect Paper Stretcher (invented during World War II). Since 1994, the shop has increased its range of paints, paper, canvas, brushes and accessories. Most business is carried out by mail order and via the online shopping site. Artists and tutors can also have a free link to their own website.

The Potters' Barn

Roughwood Lane, Hassall Green, Sandbach, CW114XX

T 01270 884080

E info@thepottersbarn.co.uk

W www.thepottersbarn.co.uk

Contact Andrew Pollard, Steve Marr Founded in 1979. Suppliers of discus potter's wheels. Producers of handthrown reduction-fired stoneware, raku and pit-fired ware. Regular classes for adults and children in pottery. Courses in other crafts run throughout the year. Group visits, parties, corporate events/team days and personal tuition also available.

Printing House

102 Main Street, Cockermouth, CA13 GLX T 01900 824984 F 01900 823124 E info@printinghouse.co.uk Contact Jenny Holliday

Founded in 1968, supplying materials for artists (ordering service available) and secondhand books. Occasional artists' workshops and advice on printing given. Working museum of printing.

R. Jackson & Sons

20 Slater Street, Liverpool, L1 4BS

T 0151 7092647

Wide range of artists materials. Also offers canvas stretching and picture framing services. Student discount available.

Rennies Arts & Crafts Ltd

61-63 Bold Street, Liverpool, L1 4EZ

T 01517080599

F 0151 7072362

Contact Duncan Rennie

Founded in 1975, offering a wide range of art and craft materials. Also specializes in limited-edition prints and a complete framing service. Branches: 34 Bridge Street, St Helens WA10 1NW; 3 Hill Street, Southport PR9 0PE; 30 Burscough Street, Ormskirk L39 2ES

Shinglers

Compston Road, Ambleside, LA22 9DR T 015394 33433 F 015394 34634

W www.shinglers-ambleside.co.uk Contact Elsie Dugdale

Suppliers of a broad range of art materials.

Studio Arts - Dodgson Fine Arts Ltd

50 North Road, Lancaster, LA1 1LT

T 01524 271810

F 01524 68013 E tonyd@studioarts.co.uk

W www.studioarts.co.uk / www.studioartshop.com

Contact Graeme Atkinson

Founded in 1972. Sells arts, graphics, crafts and card-making materials from major suppliers, with an online shop.

Turners Graphic Art & Drawing Office Supplies

91 Wellington Road South, Stockport, SK1 3SL

T 0161 4804713

F 0161 4764744

E jill@turnersart.co.uk

W www.turnersart.co.uk

Contact Jill Limmack

Founded over one hundred years ago and counts famous artists past and present among its customers. Specializes in all art materials for beginners to the experienced artist, students to drawing offices.

Ziggy Art Ltd

40 Dover Road, Birkdale, Southport,

PR8 4TD

T 01704 551322

F 01704 565155

E sales@ziggyart.co.uk

W www.ziggyart.co.uk

Specializes in the online supply of all art and graphic materials, operating a next-day delivery service from a large stockholding.

Northern Ireland

Artquip

31a Upper Dunmurry Lane, Dunmurry, Belfast, **BT17 0AA**

T 028 90605552

Stocks broad range of art and craft supplies.

Bradbury Graphics

3 Lyndon Court, Queen Street, Belfast,

BT1 6BT

T 028 90233535

F 028 90572065

E art@bradbury-graphics.co.uk

W www.bradburygraphics.co.uk

Contact Richard or Una

A city-centre store stocking a wide range of branded art materials, stationery items and presentation goods. Caters for all, from children to established career artists and those associated with creative industries such as technical drawing, design and communication.

EDCO

47-49 Queen Street, Belfast, BT1 6HP T 028 90324687

E theshop@edco.co.uk

W www.edco.co.uk

Major educational supplier with wide range of art materials.

Milliken Bros

11 May Street, Greyabbey, Newtownards, County

Down, BT22 2NE

T 028 42788005

F 028 42788293

E info@millikenbros.com

W www.millikenbros.com

Suppliers of fine art materials and makers of stretched canvases.

Proctor & Co. Ltd

201-213 Castlereagh Road, Belfast, BT5 5FH T 028 90456582

F 028 90732500

E proctors@btclick.com

W www.proctors.uk.com

Contact Carol McNaughton

Established for forty years, offering an extensive range of art, craft and stationery supplies. Printing service also available.

Scarva Pottery Supplies

Unit 20, Scarva Road Industrial Estate, Scarva Road, Banbridge, BT32 3QD

T 028 40669699

F 028 40669700

E david@scarvapottery.com

W www.scarvapottery.com Contact David Maybin

In business for over twenty years. Stocks quality products for the professional potter, from raw materials to tools and equipment. Competitive pricing structure and delivery charges.

Vision Applied Arts & Crafts

42 Waring Street, Belfast, BT1 2ED T 028 90246665 E geri@primavera.fsnet.co.uk Comprehensive range of art and craft materials.

Scotland

Art Mediums Ltd

Block E, Unit 7 Glenwood Business Park, 50 Glenwood Place, Glasgow, G45 9UH T 0141 6309339 E sales@artmediums.co.uk W www.artmediums.co.uk Supplier of specialized art and craft materials to educational outlets.

Artstore at the Artschool Ltd

11 Dalhousie Street, Glasgow, G3 6RQ T 0141 3311277 F 0141 3324470 General art supplies stockist.

Artwrap Ltd

4-5 West Park Place, Edinburgh, EH11 2DP T 0131 3467878 Sells broad spectrum of arts and crafts materials.

Broadford Books and Gallery

Broadford, Isle of Skye, IV49 9AB

T 01471 822748 E broadfordbooks@lineone.net W www.broadfordbooks.co.uk Contact Ian and Rosemary Chard In business since 1987, supplying a wide range of artists' materials and books. Also has a picture gallery and offers a full framing service using conservation-quality materials.

Burns & Harris (Retail) Ltd

97-99 Commercial Street, Dundee, DD1 2AF T 01382 322591 F 01382 226979 E shop@burns-harris.co.uk W www.burns-harris.co.uk **Contact** Pauline Barker Established in 1886, stocking art and craft supplies from leading manufacturers. Staff are happy to offer advice to beginners. Branches: 11 The Postings, Kirkcaldy KY1 1HN T: 01592 644004 F: 01592 644004.

Get Creative

1 Portobello High Street, Edinburgh, **EH15 1DW** T 0131 6695214 W www.getcreativeonline.co.uk Retails supplies for all arts and crafts. Runs workshops and classes.

20 Dundas Street, Edinburgh, EH3 6HZ

Greyfriars Art Shop

T 0131 5566565 E info@greyfriarsart.co.uk W www.greyfriarsart.co.uk Established 1840. Listed in The Times among the top five art shops in the country. Large range of stock for painters and a helpful, knowledgeable staff. Closed Sundays.

Healthcraft 12 Commercial Road, Lerwick, Shetland, ZE1 OLX T 01595 692924 W www.mysite.freeserve.com/healthcraft Contact Lena Miller Founded in 1990, selling a wide range of artists' materials. Has a small gallery selling original paintings by local artists, as well as prints.

Henderson Art Shop

28a Raeburn Place, Edinburgh, EH4 1HN T 0131 3327800 Retails broad selection of artists' materials.

InkSpot

Castle Street, Hamilton, ML3 6BU

T 01698 286401

F 01698 201300

E shop@inkspot.uk.com

W www.inkspot.uk.com

Contact Craig Moore

Specializes in art materials, stocking a full range of watercolours, oils, acrylics, gouache, pastels, etc. for the artist and hobbyist alike. Also provides classes, workshops and demonstrations for the not-so-experienced.

lust-Art

81 Morningside Road, Edinburgh, EH10 4AY

T 0131 4471671

E enquiries@just-art-online.co.uk

W www.just-art-online.co.uk

Contact Ritchie Collins

Founded in 1988 by Justine Marjoribanks, a working artist. Stock a wide range of fine-artists' materials and also has a gallery. Specializes in providing advice from professional artists.

Kirkintilloch Fine Arts

110 Townhead, Kirkintilloch, Glasgow, G66 1NZ **T** 0141 7750822

Sells range of art materials and has gallery space.

Lemon Tree

15, Howard Court, Nerston Industrial Estate, East Kilbride, Glasgow, G74 4QZ

T 01355 570577

Offers range of art and craft supplies.

Millers City Art Shop

28 Stockwell Street, Glasgow, G1 4RT

T 0141 5531660

F 0141 5531583

E info@millers-art.co.uk

W www.millers-art.co.uk

Contact Paul Miller

Suppliers to artists and makers since 1824.
Stocks many major manufacturers. Orders taken online.

Moray Office Supplies

Edgar Road, Elgin, IV30 6YQ

T 01343 549869

F 01343 549300

E sales@moray-office.co.uk

W www.morayoffice.co.uk

Contact Aileen Neil

Wide selection of art materials.

Mulberry Bush

77 Morningside Road, Edinburgh, EH10 4AY T 0131 4475145

Wide range of craft supplies.

South-east

Alec Tiranti Ltd

3 Pipers Court, Berkshire Drive (Off Enterprize Way), Thatcham, Berkshire, RG19 4ER

T 0845 1232100

F 0845 1232101

E enquiries@tiranti.co.uk

W www.tiranti.co.uk

Founded 1895. Supplies a complete range of tools, materials and studio equipment for sculptors, mould and model makers, potters, woodworkers, stonecarvers and restorers. Branch at 27 Warren Street, London, W1T 5NB T: 020 76368565.

Annetts (Horsham) Ltd

7B The Carfax, Horsham, RH12 1DW

T 01403 265878

F 01403 265878

Founded in 1964. An independent family-run art store retailing artists' and craft supplies from most major stockists.

Art Centre and Gallery

7 Howard Street, Bedford, MK40 3HS

T 01234 344784

F 01234360237

E info@artcentre.biz

Founded in 1923. A large store specializing in art and craft materials and offering a complete picture-framing service from own studio. The gallery holds regular exhibitions displaying works by local and established artists. Gallery is also available for private exhibitions. Phone for more information.

Art for All

230 High Street, Bromley, BR1 1PQ

T 020 83139368

Founded in 1990. Supplies a range of art materials to suit all levels in all media. Also runs art classes and courses. Other services include framing.

Art-Write (Hythe) Ltd

90a High Street, Hythe, CT21 5AJ

T 01303 261925

F 01303 237933

E artwritehythe@hotmail.com

W www.artwritehythe.co.uk

Contact Clive Brown, Helen Brown or Louise Moore

A recently established family-run art supplier. Stocks a comprehensive ranges of artists' materials and textbooks. A diary detailing daily classes, courses and demonstrations in the attached studio is available on request.

Artworker

Unit 1–3, 1–6 Grand Parade, Brighton, BN2 9QB T 01273 689822

E sales@artworker.co.uk

W www.artworker.co.uk

Specialists in supplying products to the graphics and publishing industries since 1972. Branches: 153/155 Ewell Road, Surbiton, Surrey KT6 6AW T: 0208 390 4661.

Bovilles Art Shop

127–128, High Street, Uxbridge, UB8 1DJ

T 01895 450300 F 01895 450323

E sales@bovilles.co.uk

W www.bovilles.co.uk

Famous for art materials since 1904. Other branches at Maidenhead, Amersham and Gerrards Cross.

Brackendale Arts

1 Sparvell Way, Camberley, GU15 3SF

T 01276 681344

F 01276 681344

W www.brackendalearts.co.uk

A family-owned company established for over twenty years. Keeps a well-stocked and comprehensive range of art and craft supplies.

Broad Canvas

20 Broad Street, Oxford, OX1 3AS

T 01865 244025

Art and craft supplies, including materials for screen printers and framers. Small attached gallery.

Chromos (Tunbridge Wells) Ltd

58 High Street, Tunbridge Wells, TN1 1XF

T 01892 518854

F 01892 528967

Contact Suna Lambert

Established in 1996, stocking a comprehensive range of fine art and craft materials from many leading manufacturers. Also offers a canvasstretching service (all sizes) and is home to in-store fine art gallery and showroom.

Country Love Ceramics

37d Milton Park, Abingdon, OX14 4RT

T 01235 861700

F 01235 861900

E sales@countryloveceramics.co.uk

W www.countryloveceramics.com

Wholesale suppliers to the paint-your-own pottery market. Bisque, kilns, glazes, brushes and accessories all available. Full training and support given to business start-ups.

Creative Crafts

11 The Square, Winchester, SO23 9ES

T 01962 856266

E sales@creativecrafts.co.uk

W www.creativecrafts.co.uk

Contact Lyn Symonds

A retailer of fine-art supplies, founded in 1972. Also stocks a large range of craft materials.

Creative World

The Bishop Centre, Bath Road, Maidenhead, SL6 0NX

T 01628 665422

F 01628 665424

E create@creativeworld.co.uk

W www.creativeworld.co.uk

Contact Sue Gowers

An art, craft and gift superstore founded in 1996. Aims to provide a comprehensive, carefully selected range and stocks over seventeen thousand products.

Daler-Rowney Ltd

P.O. Box 10, Bracknell, RG12 8ST

T 01344 461000

F 01344 486511

E customer.service@daler-rowney.com

W www.daler-rowney.com

Founded over two hundred years ago.

Manufactures and distributes fine-art materials in more than 150 countries worldwide. A range of quality art materials encompasses more than 7,500 products.

Economy of Brighton

82 St Georges Road, Kemptown, Brighton, BN2 1EF

T 01273 682831

F 01273 624466

E sales@economyofbrighton.co.uk

W www.economyofbrighton.co.uk

Over thirty years' experience supplying broad range of art and craft supplies.

EKA Services Ltd

II-I2 Hampton Court Parade, East Molesey, **KT89HB**

T 020 89793466

E ekaservices@btclick.com

W www.ekaservices.co.uk

Contact Anup Patel

Established for over fifty years, stocking all major manufacturers of art and graphic materials.

Expressions

49 Kings Road, St Leonards-on-Sea, TN37 6DY T 01424 446260

F 01424 442652

Contact Mr or Mrs King

Retails wide range of art and craft supplies and canvases. Friendly and knowledgable staff.

Forget Me Not

69-70 St James Street, Newport (Isle of Wight), PO30 1LQ

T 01983 522291

F 01983 522291

Contact Anne Toogood

Founded in 1984, supplying artists' materials, stationery, etc.

Godalming Art Shop

45 Bridge Street, Godalming, GU7 1HL

T 01483 423432

F 01483 423432

W www.thegodalmingartshop.co.uk

Contact Charlotte Albrecht or Alan Watson Stocks a wide range of artists' materials from leading manufacturers, including technical equipment and ancillary, plus craft materials.

Great Art (Gerstaecker UK Ltd)

Normandy House, I Nether Street, Alton, **GU34 1EA**

T 0845 601 5772

F 01420 593333

E welcome@greatart.co.uk

W www.greatart.co.uk

Major supplier of quality artist's supplies and materials, including leading brands and hardto-find specialist items. Over 40,000 products available at competitive prices, ranging from painting and drawing equipment to printing press and sculpture supply. Free delivery on all orders over £50. Stock most major brands.

Hearn & Scott

10 Bridge Street, Andover, SP10 1BH

T 01264 400200

F 01264 400205

E sales@hearnscott.co.uk

W www.hearnscott.co.uk

Contact Maureen Mallett

Established in 1973. A stationer, printer, digital copy shop and art shop. Also has a gallery where local artists exhibit their work.

Hockles

166 Kennington Road, Kennington, Oxford, OX15PG

T 01865 736611

E sales@hockles.com

W www.hockles.com

Opened in 2004, carrying a stock of 6,000 products.

Lunns of Ringwood

13 Christchurch Road, Ringwood, BH24 1DG

T 01425 480347 / 473335

F 01425 480347

E lunnsofringwood@btconnect.com

Contact Heidi Killen

A family-run business for nearly forty years. Stocks leading brands of art materials. Discounts on bulk orders and mail order available. New craft department opened in 2006.

On-linepaper.co.uk

Unit 19 Bassetts Manor, Butcherfield Lane, Hartfield, TN7 4LA T 01892 771245 F 01892 771241 E on-linep@per.co.uk W www.on-linepaper.co.uk Web-based seller of paper for art and design.

Oxford Craft Studio

443 Banbury Road, Oxford, OX2 8ED T 01865 513909 Specialist manufacturers of ceramics and stockists of ceramic and craft materials.

Pure South

6 Meeting House Lane, Brighton, BN1 1HB T 01273 321718 Stocks art, craft and interior design supplies.

Rural Art Company

Milton Ernest Garden Centre, Radwell Road, Milton Ernest, MK44 1SH T 01234 823592 F 01234 823562

Contact Pauline Hurst

An art materials shop and on-site framer. Also sells original paintings and prints, displayed on walls and in the garden centre coffee shop.

Sevenoaks Art Shop

45 London Road, Sevenoaks, TN13 1AR
T 01732 452551
E sevenoaksartshop@hotmail.com
Established in 1927, supplying fine-art materials
and offering a picture-framing service.

Smitcraft

Unit 1, Eastern Road, Aldershot, GU12 4TE T 01252 342626 F 01252 311700 E info@smitcraft.com W www.smitcraft.com

Founded in 1938, a mail-order supplier predominantly serving the institutional market e.g. hospitals, prisons, schools. Supplies over fifteen thousand art and craft items.

T.N. Lawrence & Son Ltd

208 Portland Road, Hove, BN3 5QT T 01273 260260 F 01273 260270 E artbox@lawrence.co.uk

W www.lawrence.co.uk
Founded in 1859, specializing in the supply of
printmaking and painting materials. Importing
top quality brands from around the world. Fast,
efficient mail order service.

T S Two

41 Queensway, Bletchley, Milton Keynes, MK2 2DR

T 01908 646521 F 01908 646526

E sales@tuppers.co.uk

Contact Olga Prentice or Jeff Wyatt

Retails art, craft and graphic materials and offers a bespoke framing service.

Terry Harrison Arts Limited

28 Cove Road, Cove, Farnborough, GU14 0EN T 01252 545012

F 01252 545012

E harrisonarts@aol.com

W www.terryharrison.com

Contact Terry Harrison or Derek Whitcher Books, videos, DVDs, brushes and art materials are available via website. Terry Harrison himself is available to give demonstrations to art societies and other groups and holds workshops all over the UK.

ToolPost

To 1235 Brunstock Beck, Didcot, OX11 7YG
T 01235 810658
F 01235 810905
E peter@toolpost.co.uk
W www.toolpost.co.uk
Contact Peter Hemsley

An online vendor of tools and materials, specializing in quality tools for woodturning, woodcarving and handcrafted woodworking. Other materials available include timber (hardwoods), finishes, adhesives, polishing systems, lathes and copy-carving machines. Delivers worldwide.

Tuppers

696 North Row, Lloyds Court, Central Milton Keynes, MK9 3AP T 01908 678033 F 01908 663695 E sales@tuppers.co.uk W www.tuppers.co.uk Contact Nick Lambert Retails art and graphic materials and provides bespoke framing service.

South-west

Alms House

20 Silver Street, Trowbridge, BA14 8AE T 01225 776329

F 01225 774740

E mjcreek@almshouse.net

W www.almshouse.net

Contact Jim Creek

Founded in 1987, stocking a wide range of materials and offering art classes. Mail order available via website. Studio space occasionally available; rates on application.

Art at Bristol

44 Gloucester Road, Bishopston, Bristol, BS7 8AR T 0117 9232259

F 0117 9232259

E enquires@artatbristol.co.uk

W www.artatbristol.co.uk

Extensive range of supplies for all artists, from the amateur to the professional.

Art Centre

135 High Street, nr Playhouse Theatre, Westonsuper-Mare, BS23 1HN

T 01934 644102 E mikekbeaumont@aol.com

W www.artysus.co.uk

Contact Mike Beaumont

Established since 1992, with a large range of artists' materials including grounds, easels, brushes, paints and mounting boards. A comprehensive range of acrylics and pastels are held in stock. Silk, glass painting and other specialist materials are also available.

Art Centre and Tamar Valley Gallery

Block A, Florence Road Business Park, Kelly Bray, PL17 8EX

T 01579 383523

F 01579 384043

E artcentre@fsmail.net

Contact Darren Gardiner
Discount art and craft materials retailer. Also
offers commercial framing service, art and craft
classes and workshops, and an art gallery. Studios,

classrooms and gallery space for hire. **Price range** $f_{10}-f_{50}$ per week.

The Art Shop

54 Castle Street, Trowbridge, BA14 8AU T 01225 765139 Wide range of art and craft supplies.

Art@Bristol

44 Gloucester Road, Bishopston, Bristol, BS7 8AR T 0117 9232259

E enquiries@artatbristol.co.uk

W www.artatbristol.co.uk

Contact Peter Probyn

Materials for professional and amateur artists, model-makers and animators. A wide variety of well-known and lesser-known products.

Artboxdirect

23–25 The Pollet, St Peter Port, Guernsey, GY2 4GB

T 01481 701351

F 01481 710383

E info@artboxdirect.co.uk

W www.artboxdirect.co.uk Contact Julie Queripel

A premier art store for over twenty-five years. The internet selling arm of the Lexicon, with sales primarily to the UK and Europe. Four thousand products online from major manufacturers.

Arts & Interiors Ltd

48 Princes Street, Yeovil, BA20 1EQ

T 01935 477790
F 01935 434183
E brenda.phil@ramlands.freeserve.co.uk
Contact Brenda Drayton

Blue Gallery

16 Joy Street, Barnstaple, EX31 1BS T 01271 343536 F 01271 321896 E sales@bluegallery.co.uk

W www.bluegallery.co.uk

Contact Roy Smith

Specialist retailers of art and craft materials for over forty years. Most leading suppliers stocked. Online shopping.

Bristol Fine Art

72–74 Park Row, Bristol, BS1 5LE
T 0117 9260344
W www.bristolfineart.org
Offers all manner of artists' materials. Experience staff on hand to give advice.

Ceres Crafts Ltd

Lansdown Road, Bude, EX23 8BH T 01288 354070

Contact Mr T.A. Miell

Established in 1981, selling a complete range of artist materials and a comprehensive range of craft materials and kits.

Cherry Art Centre

18–20 Ellacombe Road, Longwell Green, Bristol, BS30 9BA

T 0117 9048287

E mail@cherryartcentre.co.uk

Contact Lynne and Martyn Holehouse
Offers a range of services to artists, including
bespoke and ready-made picture frames, art and
craft materials, children's and adults' art classes
and 'Arty Parties'. As well as seasonal open art
exhibitions, the Centre offers luxury painting
holidays in Cornwall with tuition.

Children's Scrapstore

Scrapstore House, 21 Sevier St, St Werburghs, Bristol, BS2 9LB

T 0117 9143025 F 0117 9085645

E enquiries@childrensscrapstore.co.uk

W www.childrensscrapstore.co.uk

An arts, crafts and gift shop which is part of Children's Scrapstore Charity. All profits are gift aided to the charity.

The Compleat Artist

102 Crane Street, Salisbury, SP1 2QD

T 01722 335928

W www.compleatartist.co.uk

Contact Martyn Kennard

by Martyn Kennard. Caters for the student, intermediate and professional artist. The bowfronted shop is situated on the bridge over the River Avon on the North side. Mail order service can be accessed via website or phone.

Creativity

7-9 Worrall Road, Bristol, BS8 2UF

T 0117 9731710

E createbs8@aol.com

W www.creativitycraftsuppliers.co.uk
Family-run art and craft supplies shop with over
twenty-five years of experience.

F.J. Harris & Son

13 Green Street, Bath, BA1 2JZ

T 01225 462116

F 01225 338442

Contact Jackie Gluschke

Founded in 1821. A retail outlet for all art materials for artists and students. A wide range of stretched canvases.

Fred Keetch Gallery

46 The Strand, Exmouth, EX8 1AL

T 01395 227226

W www.fredkeetchgallery.co.uk

An art materials stockist, framer and gallery, exhibiting local artists' work.

Harberton Art Workshop

27 High Street, Totnes, TQ9 5NP

T 01803 862390

F 01803 867881

E harbertonartworkshop@tiscali.co.uk

Founded in 1970, selling a comprehensive range of artists' materials from all the main suppliers.

Hardings

59-61 High Street, Shaftesbury, SP7 8JE

T 01747 852156

F 01747 851587

E hardshaf@freenetname.co.uk

Contact Tracey

Retail shop founded in the late nineteenth century.

Inside Art

18 Colliers Walk, Nailsea, Bristol, BS48 1RG

T 01275 859990

W www.insideart.co.uk

Wide range of general art materials for sale.

Jim's Mail Order

56 Fore Street, Redruth, TR15 2AQ

T 01209 211903

F 01209 313994

E enquiries@jims.org.uk

W www.jims-mail-order.co.uk

Founded in 1984, supplying a range of art and craft materials.

Lexicon

23-25 The Pollet, St Peter Port, Guernsey,

GY2 4GB

T 01481 721120

F 01481 710383

E sales@thelexicon.co.uk

W www.thelexicon.co.uk

Contact Julie Queripel

Operating as an art materials retailer for over twenty-five years.

Litchfield Artists' Centre

6 Southampton Road, Lymington, SO41 9GG

T 01590 672503

E artistsmaterials@yahoo.co.uk

W www.litchfieldartistscentre.co.uk

Contact P.D. Merrick

Founded in 1974 and still under the same owner/ managers. Stocks all major brands and many larger sized products not found elsewhere.

Minerva Graphics

12a Trim Street, Bath, BA1 1HB

T 01225 464054

W www.minervaartsupplies.co.uk

Wide range of art and craft materials available.

Riverbank Centre

1a Pool Road, Kingswood, Bristol, BS15 1XL

T 0117 9674804

E riverbank.centre@tiscali.co.uk

Contact Gill Punter

Started in 2001. Sells art materials. Has teaching studio for up to fourteen people (covering range of media and age groups). Holds stock of original works. One exhibition per year (for charity).

Stationery/Art Ltd

104–105 High Street, Tewkesbury, GL20 5JZ

T 01684 273100

F 01684 273300

Contact Gordon Bird or Lynne Horsbrurgh Established on current site for over twenty years, carrying a wide range of artists' materials and craft and hobby materials.

T. N. Lawrence & Son Ltd

38 Barncoose Industrial Estate, Pool, Redruth, TR15 3RQ

T 01209 313181

F 01209 315353

E artbox@lawrence.co.uk

W www.lawrence.co.uk

Painting and printmaking supplies specialist, established 1859. Mail order and retail sales available, alongside an online shop.

Wales

The Art Shop

8 Cross Street, Abergavenny, NP7 5EH

T 01873 852690

F 01873 853516

E info@artshopandgallery.co.uk

W www.artshopandgallery.co.uk

Contact Pauline Griffiths

Founded in 2001. Housed in a renovated sixteenth-century building, the ground floor stocks a comprehensive range of artists' materials, papers, specialist art and illustrated children's books and Dover publications. First floor and basement galleries show a regularly changing programme of exhibitions of fine and applied arts. Framing service offered. Collector plan from Arts Council of Wales available.

Blades the Art Works

2 Cornwall Place, Mumbles, Swansea, SA3 4DP

T 01792 366673

W www.anneblades.co.uk

Sells art and craft materials. Also has range of photography, paintings and sculpture.

Browsers Bookshop

73 High Street, Porthmadog, Gwynedd, LL49 9EU

T 01766 512066

F 01766 512066

Contact Anne Davies, Sian Cowper

Founded in 1976. Retails artist and craft materials, books and maps. Daily/weekly ordering for non-stocked and unusual book/art items.

Major Brushes Ltd

Units C2 and C3, Capital Point, Capital Business Park, Parkway, Cardiff, CF3 2PY T 029 20770835

E artproducts@majorbrushes.co.uk

W www.majorbrushes.co.uk

Contact Mr. Balazs Altordai

Founded in the early 1990s and now supplies over 80% of the brushes sold in the UK educational market. Also offers broad variety of art and craft materials, painting palettes, pots, stencils, clay tools and specialist brushes.

Makit

21 Rectory Road, Cardiff, CF5 1QL

T 029 20343609

E janfarr@makit.co.uk

W www.makit.co.uk

Stocks good range of craft materials.

Mumbles Art & Craft Centre

Treasure, 29-33 Newton Road, Mumbles,

Swansea, SA3 4AS

T 01792 410717

E info@mumblescraft.co.uk

W www.mumblescraft.co.uk

Opened in 1997 as a co-operative shop, run by the members who selling materials and work which they have designed and produced themselves. All the members share in the running of the enterprise. Selected guests are also invited to show their work for set periods.

Pen and Paper Stationery Co.

13-17 Royal Arcade, Cardiff, CF10 1AE

T 029 20373738

F 029 20373038

E sales@penandpaper.co.uk

W www.penandpaper.co.uk

Contact Wendy

Stationery and art-materials store selling quality pens and materials for the general artist. Also holds a wide-ranging stock of papers for art and craft.

The Print Partnership

7 De La Beche Street, Swansea, SA1 3EZ

T 01792 455433

F 01792 455433

The Artbox was taken over by The Print
Partnership to provide printing and copying
facilities as well as artists' materials. Founded in
1997 and run by a qualified artist with over twenty
years' experience of art materials and techniques.
Complete picture-framing service also available,
along with colour-copying, laminating service and
comb-binding.

West Midlands

Cromartie Hobbycraft Ltd

Park Hall Road, Longton, Stoke-on-Trent, ST3 5AY T 01782 313947

F 01782 599723

E enquiries@cromartie.co.uk

W www.cromartie.co.uk

Over fifty years' experience of making kilns in Britain and one of the UK's leading distributors of colours and glazes.

Everyman Artist's Supply Co.

36–38 Islington Row, Edgbaston, Birmingham, B15 1LD

T 0121 4550099 F 0121 4565983

E everymans@tiscali.co.uk

Contact D. Argall

All artists' materials supplied. Old Holland Oil stockist. Graphic supplies. Canvas available by the metre. Branches: 169 Warwick Road, Olton, Solihull B92 7AR. Tel: 0121 7072323.

Fearnside's Art Ltd

34 Belle Vue Terrace, Malvern, WR14 4PZ T 01684 573221

E fearnsides_arts@tiscali.co.uk

Contact John Edwards

A long-established business selling a wide range of art materials from all major suppliers. Signed prints also available and art tutoring classes held.

Fly Art & Crafts Company

Unit E₅, The Pallasades, Birmingham, B2 4XA T 0121 6436388
General supplier of materials for the arts and craft markets.

Gadsby's / Artshopper

15 Darlington Street, Wolverhampton, WV1 4HW

T 01902 424029

W www.gadsbys.co.uk / www.artshopper.co.uk General art materials retailer with online shop. Branch also at Unit 5, Queen Street, Walsall WS2 9NX T: 01922 623104.

Harris-Moore Canvases Ltd

Unit 108 Jubilee Trades Centre, 130 Pershore Street, Birmingham, B5 6ND T 0121 2480030 E sales@stretchershop.co.uk W www.stretchershop.co.uk

Contact Louise Moore

A maker of bespoke artists' stretched canvases and linens. Specializes in deep-sided and gallery-wrapped canvases with a wide choice of fabrics and finishes. Any size made to order. National delivery from £6. Online shop on website.

Oasis Art & Graphics

68 East Meadway, Birmingham, B33 0AP

T 0121 7862988

W www.oasisag.co.uk

Wide range of art materials. Also undertakes comercial printing.

The Paper House

19a Greengate Street, Stafford, ST16 2HS

T 01785 212953

F 01785 606611

W www.thepaperhousestafford.co.uk

Contact Martin Dalgarno

Founded in 1984. A retailer of fine-art materials operating from a large store in the centre of Stafford.

Spectrum Fine Art & Graphic Materials

5 Fletchers Walk, Paradise Place,

Birmingham, B3 3HJ

T 0121 2331780

F 0121 2331780

E info@spectrumfinearts.co.uk

W www.spectrumfinearts.co.uk

Stocks complete range of art materials plus instructional materials.

Tales Press

7 Dam Street, Lichfield, WS13 6AE T 01543 256777 Contact Peter Mott Established in 1970, selling artists' materials and needlework.

Vesey Art and Crafts

48–50 Chester Road, New Oscott, Sutton Coldfield, B73 5DA

T 0121 3546350

F 0121 3550220

E info@veseyartsandcrafts.co.uk

W www.veseyartsandcrafts.co.uk

Specializes in selling artist and craft supplies, stocking all major manufacturers. Offers a bespoke picture-framing service with workshop on-site.

Yorkshire and Humberside

Art Centre

6 Albion Street, Halifax, HX1 1DU

T 01422 366936

E theartcentre@aol.com

W www.craftersparadise.craftyshop.com

Contact M. Laycock

Stocks a wide range of materials for arts and crafts from leading manufacturers. Holds regular craft demonstrations & workshops and offers student discount and loyalty card.

Art Express

Design House, Sizers Court, Yeadon, Leeds, LS19 7DP

T 0113 2500077

General art materials retailer.

The Art Shop

27 Shambles, York, YO1 7LX

T 01904 623898

Contact Mr or Mrs Fletcher

Situated in York's famous medieval street, stocking a comprehensive range of art, craft and graphics materials.

Artcraft

Stephen H. Smith's Garden & Leisure, Pool Road, Otley, LS21 1DY

T 01943 462195

F 01943 850074

E wharfe@artcraft.co.uk

W www.artcraft.co.uk

Established in 1966, stocking thousands of artists' and craft materials items.

Bar Street Arts Ltd

14 Bar Street, Scarborough, YO11 2HT

T 01723 507622 F 01723 507622

Contact Dave Colley

Founded in 1996. A specialist supplier of fine-art materials and papers, stocking many of the leading brands.

Biskit Tin

6 Regent Buildings, York Road, York, YO26 4LT T 01904 787799 Well-established craft supply business.

Calder Graphics

5 Byram Arcade, Westgate, Huddersfield, HD1 1ND

T 01484 422991

F 01484 421191

W www.caldergraphics.co.uk

Founded in 1979, retailing a wide range of fine art materials and craft products from most of the major manufacturers.

Centagraph

18 Station Parade, Harrogate, HG1 1UE

T 01423 566327

F 01423 505486

E info@centagraph.co.uk

W www.centagraph.co.uk

Large retail art and craft shop, offering a full range of fine art materials from all the leading manufacturers. Efficient and reliable mail order sevice available.

Discount Art

Unit I Riverside Business Park, Dockfield Road, Shipley, BD17 7AD

T 0845 2415646

F 0845 2415647

E sales@discountart.co.uk

W www.discountart.co.uk

Contact Amanda Pearson

Internet-based supplier offering all materials; from easels and canvases to pencils and brushes.

Samuel Taylors

10 Central Road, Leeds, LS1 6DE

T 0113 2459737

W www.clickoncrafts.co.uk

Stocks extensive range of craft materials.

York Art & Framing

7 Castlegate, York, YO1 9RN

T 01904 637619

E framing@totalserve.co.uk

W www.yorkartandframing.co.uk

Supplies quality art materials to art enthusiasts and professionals. Also offers framing service.

Ireland

63A Heather Road, Sandyford Industrial Estate, Dublin 18, County Dublin

T of 2952444

Sells extensive range of art materials from major manufacturers.

Art & Craft Company

Merchants Square, Ennis, County Clare

T o65 6821559 E info@artandcraft.ie W www.artandcraft.ie

Supplies wide range of arts and crafts materials. Branch in Shannon.

Art & Craft Emporium / Silkes One Stop Stationery

64 Catherine Street, Limerick **T** 061 417997

F 061 409958

E owensilke@iolfree.ie

Founded in the early 1990s, one of the largest art and craft suppliers in the south-west of Ireland, stocking many major manufacturers as well as craft supplies and ready made frames.

Art Choice Supplies

Unit 8, Ryebrook Industrial Estate, Maynooth Road, Leixlip T o1 6247594 F o1 6247305

Retalier of wide range of art supplies and materials.

Art Materials Company

Terenure Enterprise Centre, 17 Rathfarnham Road, Terenure, Dublin 6W T or 4992248 F or 4938399 E info@artmaterialsco.com W www.artmaterialsco.com

Range of materials from leading manufacturers.

Art Upstairs

43 High Street, Sligo, County Sligo T 071 9143158 W www.irishartsupplies.com Sells wide range of artists' supplies.

Blackrock Art & Hobby Shop

Unit 23–24, Blackrock Shopping Centre, Blackrock, County Dublin

T or 2832394

F or 2832394

E info@artnhobby.ie

W www.artnhobby.ie

Retails wide range of art materials and craft supplies. 19 stores operate throughout Ireland.

Callan Art Supplies

107 Cois Cairn, Old Conna Avenue, Bray, County Wicklow T oi 2722480 Supplies art materials to artists, students, art groups and children's classes.

Carlow Art and Framing Shop

3 Lismard House, Tullow Street, Carlow T 059 9139100
F 059 9139100
E carlowartandframing@oceanfree.net
W www.carlowartandframing.com
Opened in 2002, run by self-taught artists
specializing in oil, watercolour, acrylic and pastels.
Also specialize in hand-finished frames. Retails art
materials from major brand names and offer wide
choice in readymade frames.

Cork Art Supplies Ltd

26-28 Princes Street, Cork

T 02I 4277488
F 02I 4277856
W www.corkartsupplies.com
Over twenty years of experience in retailing artists' supplies and materials. Also operates an online store. Ireland's first art and craft

webstore. Cregal Art

Monivea Road, Galway T 091751864 F 091752449 E info@crgal.com W www.cregalart.com

Opened in 1964, offering wide range of art, craft and framing products. Branches: 30 William Street, Limerick 061 417910.

Daintree Paper

61 Camden Street, Dublin 2 T 01 4757500 E paper@daintree.ie W www.daintree.ie

Suppliers of handmade and fine quality papers and accessories.

G.E. Kee

17 Bridge Street, Coleraine, BT52 1DR
 T 028 70343525
 E shop@kee-arts.demon.co.uk
 W www.kee-arts.demon.co.uk
 Opened in 1948. An arts and crafts retaile

Opened in 1948. An arts and crafts retailer, gallery and framing service.

K & M Evans

5 Meeting House Lane, Dublin 7 T or 8726855

F 01 8726940 W www.kmevans.com

Kennedy Gallery

M. Kennedy & Sons Ltd, 12 Harcourt Street, Dublin 2

T oi 4751749 F 01 4753851

E gallery@kennedyart.com

W www.kennedyart.com

One of Ireland's oldest artists' materials shops, dating back to 1887. Family-run, selling wide range of supplies from leading manufacturers.

Leapfrog

Rock Street, Kenmare, Kerry

T 064 40994 E info@leapfrog.ie

W www.leapfrog.ie

Stocks wide array of artist supplies.

Mandel's Art Shop

Main Street, Castlebar, County Mayo

T 00353 94 9022263 F 00353 94 9022263

E info@artshop.ie

W www.artshop.ie

Contact Nora Mandel

Stocks wide range of artists' supplies.

O'Sullivans

23-25 Grantham Street, Dublin 8

T 01 4700890

F 01 4700880 W www.dosgs.ie

Founded in 1935, a family-run fine art, craft and graphic materials superstore.

Paint Box

Terryland Retail Park Studio, County Galway T 091 569579

Sells range of art materials. Framing service also offered.

Premier Arts & Craft Store

36 Florence Road, Bray, County Wicklow

T of 2862130 F 01 2861188

E info@premierartsandcraft.ie

W www.premierartsandcraft.ie

Full range of artists' materials stocked. Under new ownership. Another branch at Blacklion Shopping Centre, Greystones T: 01 2873796.

Art bookshops

1853 Gallery Shop

Salts Mill, Victoria Road, Saltaire, Shipley, Bradford, BD18 3LB T 01274 531163

E post@saltsmill.org.uk

W www.salstmill.org.uk

Analogue Books

102 West Bow, Edinburgh, EH1 2HH

T 0131 2200601

E info@analoguebooks.co.uk

W www.analoguebooks.co.uk

Founded in 2001. Bookshop and gallery holding regular exhibitions by artists and illustrators. Stocks wide selection of art and design books and publishes a series of zines called Running Amok.

Arnolfini Bookshop

16 Narrow Quay, Bristol, BS1 4QA

T 0117 9172304

F 0117 917 2303

E bookshop@arnolfini.org.uk

W www.arnolfini.org.uk

Arts centre with a high-quality specialist arts bookshop.

Art & Design

26 High Street, Bishop's Castle,

SY95BQ

T 01588 630435

E info@artandartisanbooks.co.uk

W www.artandartisanbooks.co.uk

Specializes in many areas of art, design, fashion and landscape gardens.

Art Books Etc

81 Westwater Way, Didcot, Oxon,

OX117TY

T 01235 812834

F 01235 813535

E sales@artbooksetc.co.uk W www.artbooksetc.co.uk

Specialist art and design bookseller catering for students and lecturers as well as libraries at schools and colleges. Special emphasis on contemporary titles on fine art, graphics, product and interior design, fashion, animation, advertizing and architecture. Sales either through the website or a site visit can be arranged, setting up a bookshop for direct sales to students at discount prices.

Art Data

12 Bell Industrial Estate, 50 Cunington Street, London, W4 5HB T 020 87471061 F 020 87422319 E orders@artdata.co.uk W www.artdata.co.uk

Arts Bibliographic

37 Cumberland Business Park, Cumberland Avenue, London, NW107SL

T 020 89614277 F 020 89618246 E sales@artsbib.com W www.artsbib.com

Library suppliers, founded in 1978, specializing in books and catalogues on art and design, and supplying university and public libraries in the UK and abroad.

Artwords

65a Rivington Street, London, EC2A 3QQ T 020 77292000 F 020 77294400 E shop@artwords.co.uk W www.artwords.co.uk

Artwords at the Whitechapel

Whitechapel Art Gallery, 80 Whitechapel High Street, London, E1 7QX T 020 72476924 F 020 77294400 E shop@artwords.co.uk W www.artwords.co.uk

Ashmolean Museum Shop

Beaumont Street, Oxford, OX1 2PH T o1865 288185 F o1865 288195 E publications@ashmus.ox.ac.uk W www.ashmolean.org/shop

BALTIC Shop

South Shore Road, Gateshead, Newcastle, NE8 3BA T 0191 4404947 F 0191 4781922

E shop@balticmill.com W www.balticmill.com

BFI Filmstore

Belvedere Road, London, SE1 8XT T 020 78151350 E filmstore@bfi.org.uk W www.filmstore.bfi.org.uk

14 Market Place, Holt, NR25 6BW

Bircham Gallery Shop

T 01263 713312
E Birchamgal@aol.com
W www.birchamgallery.co.uk
Attached to the Bircham Gallery, a light and
spacious art gallery in the centre of Georgian Holt
specializing in contemporary British paintings,
sculpture, original prints, studio glass, ceramics,
and designer jewelry. Selected for the Crafts
Council list of craft shops and galleries, and is
approved by Arts Council England for the 'Own
Art' interest free purchase scheme. The gallery
shop sells art books and specialist magazines,

Blackwell

crafts and cards.

100 Charing Cross Road, London, WC2H 0JG T 020 72925100 E orders@blackwell.co.uk W www.blackwell.co.uk

Blackwell Art & Poster Shop

27 Broad Street, Oxford, OX1 3BS T o1865 333641 F o1865 794143 E art@blackwell.co.uk W www.blackwell.co.uk Contact Alan Pointer

A specialist art bookshop including sections on fine art, architecture, photography, fashion, design, cinema, art techniques and decorative

arts. Art prints, posters and frames are also available, and a large range of art cards & postcards, calendars & diaries. Part of the Blackwell chain, originally founded in Oxford in 1879.

Blenheim Books

T Blenheim Crescent, London, W11 2EE
T 020 77920777
E sales@blenheimbooks.co.uk
W www.blenheimbooks.co.uk
Founded in 1996 as Garden Books when it
specialized only in books on this subject. Su

specialized only in books on this subject. Success encouraged the owner to enlarge on the titles held and in 2000 the shop name was changed to Blenheim Books. Since then it has supplied books on architecture, interiors, fashion, landscape and graphic design. Also well stocked photography, wildlife and children's sections.

British Museum Bookshop

British Museum, Great Russell Street, London, WC1

T 020 73238587

F 020 74367315

E customerservices@britishmuseum.co.uk

W www.britishmuseum.co.uk

Chapters Bookstore

Ivy Exchange, Parnell Street, Dublin 1 T of 8723297 E info@chapters.ie W www.chapters.ie

Charles Vernon-Hunt Books

Geoffrey Van Arcade, 107 Portobello Road, London, W11 2QB T 0208 854 1588 F 020 8854 1588 E c.vernonhunt@btinternet.com W Books listed on www.abebooks.com Bookseller specializing in non-Western art reference books (African, Oceanic, Indian, Islamic, Chinese and Japanese). Sells latest publications and exhibition catalogues from around the world and out-of-print and rare books. Mail order service available. Book stall open Saturdays only.

Chester Beatty Library Shop

Dublin Castle, Dublin 2 T 01 4070750 E giftshop@cbl.ie W www.cbl.ie

Claire de Rouen Books

First Level, 125 Charing Cross Road, London, WC2H 0EA T 020 72871813 F 020 72871925 E clairederouen@sohobooks.co.uk Bookshop with particular reputation for fashion

photography titles. **Cornerhouse Shop**

70 Oxford Road, Manchester, M1 5NH T 0161 2287621 E info@cornerhouse.org

Courtyard Shop

Fitzwilliam Museum, Trumpington Street, Cambridge, CB2 1RB T 01223 764399 F 01223 764406 E shops@fitzwilliammuseum.org

W www.fitzwilliammuseum.org Offers a large selection of books, stationery, gifts and jewelry in relation to the museum's collections and temporary exhibitions.

Coutauld Gallery Bookshop

Somerset House, The Strand, London, WC2R 0RN T 020 78482579 F 020 78482417 E shop@sctenterprises.com W www.courtauld.ac.uk/gallery/furtherinfo.html

De La Warr Pavilion Shop

Marina, Bexhill-on-Sea, TN40 1DP T 01424 787900 E info@dlwp.com W www.dlwp.com

Dean Gallery Shop

73 Belford Road, Edinburgh, EH4 3DS T 0131 6246272 F 0131 6237126 E deanshop@nationalgalleries.org W www.nationalgalleries.org A wide selection of art books, NGS publications, prints, cards and posters from the NGS's collections. Also sells educational toys and books for children.

Design Museum Shop

Shad Thames, London, SE1 2YD T 0870 9099009 F 0870 9091909 E shop@designmuseum.org W www.designmuseum.org

18 Earlham Street, London, WC2H 9LG

The Dover Bookshop

T 020 78362111 F 020 78361603 E images@doverbooks.co.uk W www.doverbooks.co.uk Founded in 1986, specialists in copyright free, permission free and royalty free images, engravings, patterns, designs and clip art. Also a selection of related art books. Images contained in sourcebooks and CD-Roms.

Dundee Contemporary Arts Shop

152 Nethergate, Dundee, DD1 4DY T 01382 909900 F 01382 909221 E mail@dca.org.uk W www.dca.org.uk

FACT Shop

88 Wood Street, Liverpool, L1 4DQ **T** 0151 7074443 **F** 0151 7074445

E shop@fact.co.uk

W www.shop.fact.co.uk

Offers books and gifts relating to a range of modern visual arts, including digital and film.

Foyles Bookshop

113–119 Charing Cross Road, London, WC2H 0EB

T 020 74375660

E orders@foyles.co.uk

W www.foyles.co.uk

Founded in 1903 and situated at the heart of Soho, Foyles is amongst the world's most famous bookshops. The shop is divided into fifty-six subject areas over five floors and has its own gallery space and specialist art department on the second floor. Customers can expect to find an extensive range of art, architecture, photography and design titles.

Fruitmarket Gallery Bookshop

45 Market Street, Edinburgh,
EH1 1DF
T 0131 2268181
F 0131 2203130
E info@fruitmarket.co.uk
W www.fruitmarket.co.uk/bookshop.html
The gallery also has its own publishing
programme.

Hatchards

187 Piccadilly, London, W1J 9LE T 020 74399921 F 020 74941313 E books@hatchards.co.uk

W www.hatchards.co.uk

Hayward Gallery Shop

Belvedere Road, London, SE1 8XZ T 020 79283144 E hginfo@hayward.org.uk W www.hayward.org.uk

Heffers Academic & General Books

20 Trinity Street, Cambridge, CB2 1TY T 01223 568568 F 01223 568591 E heffers@heffers.co.uk W www.heffers.co.uk

Hodges Figgis

56–58 Dawson Street, Dublin 2 T o1 6774754 E books@hodgesfiggis.ie W www.waterstones.co.uk

ICA Bookshop

The Mall, London, SW1Y 5AH
T 020 77661452
F 020 78730015
E bookshop@ica.org.uk
W www.ica.org.uk/bookshop
Contact Russell Herron (Manager)
Stockists of books on cultural theory, philosophy, art, art theory and new media. Also has a range of hard-to-find magazines and art DVDs.

Icetwice Gallery

25 High Street, Olney, MK46 4AA
T 01234 714499
E info@icetwice.com
W www.icetwice.com
Contemporary commercial art gallery and bookshop.

The Ikon Gallery Shop

I Oozells Square, Brindley Place, Birmingham, B1 2HS T 0121 2480711 E shop@ikon-gallery.co.uk W www.ikon-gallery.co.uk/shop

John Sandoe (Books) Ltd

10 Blacklands Terrace, London, SW3 2SR T 020 75899473 F 020 75812084 E sales@johnsandoe.com W www.johnsandoe.com

An independent bookshop in Chelsea, founded in 1957. Stocks a wide range of art titles covering individual artists, the decorative arts and architecture.

Koenig Books Ltd.

at the Serpentine Gallery, Kensington Gardens, London, W2 3XA T 020 77064907

F 020 77064911

E mail@koenigbooks.co.uk W www.koenigbooks.co.uk

An independent bookshop in the Serpentine Gallery with a wide range of stock on modern and contemporary art, photography, architecture and art theory. Specializes in artists' books, monographs and catalogues. Has full access to the stock and services of Buchhandlung Walther Koenig in Cologne.

Lady Lever Art Gallery Shop

Port Sunlight Village, Wirral, CH62 5EQ T 0151 4784136 W www.liverpoolmuseums.org.uk Offers books and gifts relating to the gallery's exhibitions, especially Pre-Raphaelites.

Leeds City Art Gallery Shop

Headrow, Leeds, LS1 3AA T 0113 2478256 E info@bridgeman.co.uk W www.leeds.gov.uk/artgallery

London Graphic Centre

16-18 Shelton Street, London, WC2H 9JL T 020 77594500 E info@londongraphics.co.uk W www.londongraphics.co.uk Stocks art books and magazines, plus graphic and art supplies.

MAGMA Covent Garden

8 Earlham Street, Covent Garden, London, WC2H 9RY

T 020 72408498 E enquiries@magmabooks.com W www.magmabooks.com

Branches: MAGMA Manchester, 22 Oldham Street, Northern Quarter, Manchester M1 1JN T: 0161 2368777

Magma Design Ltd

117-119 Clerkenwell Road, London, EC1R 5BY

T 020 72429503 F 020 72429504 E enquiries@magmabooks.com W www.magmabooks.com

MAGMA Manchester

Manchester, M1 1JN T 020 72429503 E enquiries@magmabooks.com W www.magmabooks.com Independent specialist art/design bookshop.

22 Oldham Streeet, Northern Quarter,

Manchester City Gallery Shop

Mosley Street, Manchester, M2 3JL T 0161 2358832

F 0161 2358831 E magshop@manchester.gov.uk

Marcus Campbell Art Books

43 Holland Street, Bankside, London, SE1 9JR T 020 72610111 F 020 72610129 E info@marcuscampbell.co.uk W www.marcuscampbell.co.uk Specializes in out-of-print, second-hand and rare books on twentieth century and contemporary art. Focus on individual artists' monographs and catalogues, important movements and artists'

Modern Art Oxford Shop

books.

30 Pembroke Street, Oxford, OX1 1BP T 01865 722733 F 01865 722573 W www.modernartoxford.org.uk

National Gallery of Ireland Shop

Merrion Square West, Dublin 2 T of 6633518 E bookshop@ngi.ie W www.nationalgallery.ie Contact Lydia Furlong (Manager)

National Gallery of Scotland Shop

The Mound, Edinburgh, EH2 2EL T 0131 6246567 F 0131 6237126 Engshop@nationalgalleries.org W www.nationalgalleries.org A wide selection of art books, NGS publications, prints, cards and posters from the NGS's collections. Also sells educational toys and books for children.

National Gallery Shop

National Gallery, Sainsbury Wing, London, WC2H

T 020 77472461 E help@nationalgallery.co.uk W www.nationalgallery.co.uk Holds a comprehensive range of art books covering Western European art from around 1250 to 1900, an extensive range of gifts and souvenirs and a print-on-demand service, allowing customers to print high quality, full-colour, prints of any painting in the gallery's collection.

National Portrait Gallery Shop 2 St Martin's Place, London, WC2H 0HE T 020 73122463 F 020 73060056

Noble & Beggarman Books

Dublin City Gallery The Hugh Lane, Charlemont House, Parnell Square, Dublin 1

T 01 8749294

W www.nobleandbeggarmanbooks.com
W www.nobleandbeggarmanbooks.com
Independent bookshop stocking a wide range of
titles on Irish art, modern and contemporary art,
photography, architecture and art theory. Also
located in Royal Hibernian Academy.

Oriel Mostyn Art Gallery Shop

12 Vaughan Street, Llandudno, LL30 1AB
T 01492 879201
F 01492 878869
E post@mostyn.org
W www.mostyn.org
Will reopen in 2011 following gallery
refurbishment

Pennies from Heaven

Osierbed House, Hall Road, Little Bealings, Woodbridge, IP12 1PL
T 01473 612800
F 01473 612800
E sales@penniesfromheaven.org.uk
W www.penniesfromheaven.org.uk
Contact John or Stephanie Simmonds
Art, design and architecture bookseller since 1985.
Specializes in the sale of current issue, remainder and publishers' returns direct to educational establishments throughout the UK and abroad.
Contact to arrange a visit/presentation 1,500 titles at discounted prices.

Photographers' Gallery Shop

16–18 Ramillies Street, London, W1F 7LW
T 0845 2621618
E bookshop@photonet.org.uk
W www.photonet.org.uk

Potterton Books

93 Lower Sloane Street, London, SW1W 8DA T 020 77304235 E shop@pottertonbookslondon.co.uk W www.pottertonbookslondon.co.uk

R.D. Franks

5 Winsley Street, London, W1W 8HG T 020 76361244 E shop@RDFranks.co.uk **W** www.rdfranks.co.uk Fashion bookshop. Closed weekends.

RIAS Bookshop

Royal Incorporation of Architects in Scotland, 15 Rutland Square, Edinburgh, EH1 2BE T 0231 2297545 E bookshop@rias.org.uk W www.rias.org.uk

Specialist bookshop stocking the widest range of architecture books, technical documents and building contracts in Scotland. Also has a shop with The Lighthouse in Glasgow.

RIAS Bookshop

The Lighthouse, 11 Mitchell Lane, Glasgow, G1 3NU

T 0141 2258455

E rias@thelighthouse.co.uk

W www.thelighthouse.co.uk

Housed within The Form Shop at The Lighthouse, the Royal Incorporation of Architects in Scotland offers a wide selection of architecture books and technical documents.

RIBA Bookshop

66 Portland Place, London, W1B 1AD T 020 72567222 F 020 76377185

W www.ribabookshops.com
Other branches: Manchester CUBE, 113–115
Portland Street, Manchester M1 6DW T 0161 236
7691; West Midlands Region, Margaret Street,
Birmingham B3 3SP T 0121 233 2321; Yorkshire
Region, The Centre for Design, 8 Woodhouse
Square, Leeds LS3 1AD T 0113 245 6250; Royal
Society of Ulster Architects, 2 Mount Charles,
Belfast BT7 1NZ T 028 90323760.

Royal Academy of Arts Shop

Burlington House, Piccadilly, London, W1J 0BD T 0800 6346341 E mailorder@royalacademy.org.uk W www.royalacademy.org.uk

Scottish National Gallery of Modern Art Shop

75 Belford Road, Edinburgh, EH4 3DR T 0131 6246307

F 0131 6237126

E gmashop@nationalgalleries.org

W www.nationalgalleries.org
A wide selection of art books, NGS publications, prints, cards and posters from the NGS's

collections. Also sells educational toys and books for children.

Scottish National Portrait Gallery Shop

I Queen Street, Edinburgh, EH2 1JD T 0131 6246418 F 0131 6237126 E pgshop@nationalgalleries.org W www.nationalgalleries.org A wide selection of art books, NGS publications, prints, cards and posters from the NGS's collections. Also sells educational toys and books for children.

Selfridges Book Department

400 Oxford Street, London, W1A 1AB T 08708 377377 W www.selfridges.co.uk

Tate Britain Shop

Millbank, London, SW1P 4RG T 020 78878876 W www.tate.org.uk/shop

Tate Liverpool

Albert Dock, Liverpool, L3 4BB T 0151 7027575 W www.tate.org.uk/shop Closed Mondays (except Bank Holiday Mondays).

Tate Modern Shop

Bankside, London, SE1 9TGT T 020 74015167 E shop.modern@tate.org.uk W www.tate.org.uk/shop

Tate St Ives Shop

Porthmeor Beach, St Ives, TR26 1TG T 01736 791110 E shop.stives@tate.org.uk W www.tate.org.uk/shop

Thomas Heneage Art Books 42 Duke Street, St James's, London, SW1Y 6DJ T 020 79309223 F 020 78399223 E artbooks@heneage.com W www.heneage.com Founded in 1977 and among the UK's largest art bookshops, selling art reference books, catalogues raisonnés, monographs and exhibition

catalogues worldwide. Shop policy is to stock

the most authoritative book on any subject and in any language, irrespective of it being new or secondhand.

Three Counties Bookshop

6 High Street, Ledbury, HR8 1DS T 01531 635699 E threecountiesbookshop@supanet.com Contact Alan Cowan Stockists of artists' materials by leading manufacturers as well as books.

Trinity College Library Shop

College Street, Dublin 2 T 01 6081171 E paul.corrigan@tcd.ie Contact Paul Corrigan (Manager)

V&A Shop

Victoria & Albert Museum, Cromwell Road, London, SW7 2RL T 020 79422696 W www.vandashop.co.uk

Vibes and Scribes

3 Bridge Street, Cork T 021 4505370 F 021 4551294

Walker Art Gallery Shop

William Brown Street, Liverpool, L3 8EL T 0151 478 4199 E thewalker@liverpoolmuseums.org.uk

Wallace Collection Shop

Hertford House, Manchester Square, London, W1U 3BN T 020 75639522 F 020 75639566 E shop@wallacecollection.org W www.wallacecollection.org/s/index_shop.htm

The Watermill

Mill Street, Aberfeldy, PH15 2BG T 01887 822896 E info@aberfeldywatermill.com W www.aberfeldywatermill.com

Waterstone's

9-13 Garrick Street, London, WC2E 9BA T 020 78366757 E manager@covent-garden.waterstones.co.uk W www.waterstones.co.uk Branches: 203/206 Piccadilly, London

SW1Y 6WW T: 020 78512400; 82 Gower Street, London WC1E 6EQ, T: 0207 636 1577.

Whitworth Gallery Shop

The University of Manchester, Oxford Road, Manchester, M15 6ER T 0161 2757450 F 0161 2757451 E Whitworth@man.ac.uk

Conservators

Allyson Rae

Peacehaven, Long Stratton Road, Forncett St Peter, Norwich, NR16 1HT T 01953 788544 E allysonrae@btinternet.com

W Approx. £45 per hour.

Contact Allyson Rae

Allyson Rae is an ICON accredited conservator with 28 years' experience, latterly as head of organic artefacts conservation at the British Museum. Specializing in ethnography, featherwork, textiles and organic artefacts, services include all aspects of collection assessment and care, conservation treatment and advice on insect pest management for heritage organizations and private clients. Recent clients include the Royal Ontario Museum, Canterbury Cathedral Archive and Norwich Castle Museum.

C.S. Wellby

The Malt House, 4 Church End, Haddenham. Aylesbury, HP178AH T 01844 290036

E candm@wellby.plus.com

Contact Christopher Wellby

Practising since 1973. Specializes in the conservation and restoration of oil paintings on canvas and panel. Also provides reports and surveys of collections. Fellow of the British Association of Paintings Conservator

Caroline Harrison Conservation Ltd

15 Church Road, Bristol, BS7 8SA

T 0117 9079976

E caroline@harrisonconservation.co.uk Specializes in the conservation of works of art on paper, particularly twentieth-century and contemporary work. Works for many West End galleries. Also gives advice and consultation on materials for contemporary artists.

Price range Varies according to the nature of the work. Estimates are always given before starting

Christine Bullick

5 Belford Terrace, Edinburgh, EH4 3DQ T 0131 3326948 F 0131 3326948 E mail@bullickconservation.com W www.bullickconservation.com

An accredited painting conservator with thirty years' experience in the conservation of paintings on panel, canvas and metal supports. Works for public collections and private clients.

Ciara Brennan Conservation of Fine Art

Basement, 93 South Circular Road, Dublin 8 T 01 4734814 F 01 4734814

E brennan.ciara@gmail.com Specializing in easel paintings; oil, acrylic and tempera on canvas, wood and metal supports. Also offers advice on environmental monitoring and storage for works of art.

Clare Finn & Co. Ltd

38 Cornwall Gardens, London, SW7 4AA T 020 79371895 F 020 79374198 E FinnClare@aol.com

Contact Dr. Clare Finn

Founded in 1983. Offers a full range of conservation services for paintings, including consolidation, tear repair, cleaning, lining, filling, retouching and varnishing. Clare Finn herself has wide-ranging specialist knowledge of different periods and styles from Old Masters to contemporary painting techniques. Additional services offered include coordinating scientific examinations, mounting, framing, and treating existing frames. Advice to purchasers and research projects are also undertaken.

Conservation Studio

59 Peverells Wood Avenue, Chandler's Ford, SO53 2FX

T 023 80268167

F 023 80268267

E winstudio@aol.com W www.conservationstudio.org

Contact Paul Congdon-Clelford

A specialist studio workshop that provides a complete restoration and conservation service for paintings, specializing in oils and works of art on

paper. Home and business consultations available, together with collection and delivery nationwide. Clients include museums, institutions, dealers and private individuals.

Consultant Conservators of Fine Art

Ramsor Farm, Ramshorn, ST10 3BT T 01538 702928 / 07974 791627 F 01538 703714

E huonweaver@aol.com

Contact Marilyn Jackson-Mooney or Ian Mooney Founded in 1974, providing conservation and restoration of paintings, prints and watercolours by qualified conservation graduates of Gateshead Conservation College. Undertakes work for museums, church dioceses and private clients. Relining, wood panel and miniatures repairs, and large paintings are specialities.

Price range Subject to an hourly rate or quote.

Eddie Sinclair

10 Park Street, Crediton, EX17 3EQ

T 01363 775552

E eddie@sinclair-polychromy.co.uk Operating since 1979, conserving and researching medieval materials and techniques in historic buildings such as Exeter and Salisbury Cathedrals. Has published and lectured widely on aspects of historical painting techniques and has acted as a consultant to the BBC.

Egan, Matthews & Rose

12 Douglas Court, West Henderson's Wynd, Dundee, DD1 5BY

T 01382 229772

F 01382 229772

E eganmatthewsrose@ecosse.net

Carries out all aspects of structural work, cleaning and restoration of easel paintings, including works on fabric, wood and metal supports. Experienced in working on site, on collections and on outsized paintings. Also undertakes collection surveys and loan reports. Welcomes enquiries seeking advice on any aspect of the care of easel paintings.

Ellen L. Breheny

10 Glenisla Gardens, Edinburgh, EH9 2HR T 0131 6672620

E ellen@breheny.com

Contact Ellen L Breheny

Founded in 1988 for the conservation and restoration of ceramics, vessel glass and related materials, e.g.enamels, jade, plastics and non-architectural plaster.

Fitzgerald Conservation

The Rise, Sevenoaks, TN13

T 01732 460096

E julie.fitzgerald1@virgin.net

W www.paperconservation.org.uk

Specializes in the conservation of works of art on paper, including prints and drawings, watercolours, photographs, parchment, pith and wallpapers. Conservation assessments and treatments carried out. Consultations, surveys, preservation programmes and environmental advice and disaster advice given. Also offers training seminars and workshops.

Graham Bignell Paper Conservation

Standpoint Studios, 45 Coronet Street, London, N1 6HD

T 020 77293161

F 020 77293161

E graham.bignell@talk21.com

W www.grahambignellpaperconservation.co.uk

Contact Graham Bignell

Founded in 1980 the studio specializes in the conservation of prints, drawings, posters, watercolours and all archive material. Graham Bignell also runs the New North Press, producing limited editions of woodcuts, linocuts and wood engravings and publishes artists books as a letterpress printer.

Halahan Associates

38 Kitson Road, London, SE5 7LF T 020 77030806

F 020 77030806

E frances.halahan@halahan.co.uk

W www.halahan.co.uk

Contact Frances Halahan

Offers pragmatic advice on collection care issues. Specializes in exhibition work, condition surveys, audits of collections, advising on storage and display solutions and environmental regulation and pest control for museums, galleries, historic houses and collectors. Also undertakes remedial conservation work for museums and galleries and private collections. Over fifteen years of experience in the museum sector.

Hamish Dewar Ltd

14 Mason's Yard, Duke Street, St James's, London, SW1Y 6BU

T 020 79304004

F 020 79304100

E hamish@hamishdewar.co.uk

Contact Hamish Dewar

Established in 1980, specializing in the conservation and restoration of paintings.

Ines Santy Paintings Conservation and Restoration

15 Leopold Place, Edinburgh, EH7 5LB

T 0131 5565002

F 0131 5565002

E isanty@btinternet.com

Established in 1998, specializing in conservation and restoration of oil paintings on canvas and panel. Accredited since 2003. Undertakes interventive treatment (e.g. surface cleaning, varnish removal, retouching) and structural work (consolidation of paint or ground layers, strip-lining, lining, replacement of stretchers, conservation framing). Small repairs may be undertaken to accompanying frames.

Institute for the Conservation of Historic and Artistic Works in Ireland

I Lower Grand Canal Street, Dublin 2

T 01 6030904

E ichawi@eircom.net

W www.irelandconservation.org

Established in 1991 'to promote for the benefit of Ireland the preservation and conservation of historic and artistic works'. Membership is exclusive to accredited conservator/restorers. Institute organizes courses for heritage sector and awards bursaries to conservation students.

International Fine Art Conservation Studios Ltd

43-45 Park Street, Bristol, BS1 5NL

T 0117 9293480 / 020 85491671

F 0117 9225511

E enquiries@ifacs.co.uk

W www.ifacs.co.uk

Contact Richard Pelter ACR FBAPCR

Established in 1969 and has been involved in conservation projects throughout the UK and overseas. A fully-qualified team can accommodate paintings of any size, period or contemporary. Other services include technical research and paint analysis schemes.

Jane McAusland Ltd

Flat 3, 41 Lexington Street, Soho, London, W1F 9AJ

T 020 74371070

F 01449 770689

E janemca@globalnet.co.uk

A large, well-equipped studio founded in 1970. Conserves fine art on paper from any period including pastels and Oriental works. Also offers advice on general conservation of paper supported art through storage and display.

Judith Gowland

Leases Barn, Braiseworth, Eye, IP23 7DS **T** 01379 871556 / 07714 895916 E paperdoc@madasafish.com Established in 1992, specializing in conservation of works of art on paper.

Judith Wetherall (trading as J.B.Symes)

28 Silverlea Gardens, Horley, Surrey, RH6 9BB

T 01293 775024

F 01293 775024

E judith@thewetheralls.org.uk

Contact Judith Wetherall

A studio set up in 1977. Conservation, restoration and new work undertaken. Expert knowledge of gilding and paint history and techniques.

Julian Spencer-Smith

The Studio, 30a College Road, Woking, **GU228BU**

T 01483 726070

F 01483 726070

E jupastudio@btconnect.com

W www.picturerestorer.com

Contact Julian Spencer-Smith

Founded in 1982. Restorers and conservators of oil paintings. Cleaning and restoration work uses minimal intervention and follows ethical restoration standards in reversibility. Does all lining and structural work in-house.

Julie Crick Art Conservation

The Old Laboratory, Anstey Hall, Maris Lane, Trumpington, Cambridge, CB2 2LG

T 01223 846699

E julie@crickcollins.com

W painting-conservation-restoration.co.uk

Contact Julie Crick (Dip.Con.) Founded in 1984. Undertakes the conservation and care of easel paintings on canvas or wood for museums, churches and collections large and small. Also offers advice on packing and transportation of paintings, on the best methods of protecting works of art and on repairing paintings if they become damaged. Will work on extremely large paintings down to very small ones.

Lesley Bower Paper Conservation

34 Park House Gardens, Twickenham, TW1 2DE T 020 88929391

E bower@blueyonder.co.uk

W www.westlondonartists.co.uk Provides surveys for small museums and undertakes preventive conservation including environmental control. Offers advice on storage and display and provides staff training.

Life - A New Life for Old Documents

87 St Georges Road, Great Yarmouth, NR30 2JR T 01493 854395

E lorraine.finch@paperconservation.fsnet.co.uk W www.paperconservation.fsnet.co.uk Has over a decade of experience in providing conservation and preservation services to institutions and individuals. All aspects of archives and art on paper conservation and preservation are undertaken, from large-scale projects to single items, as well as photographic conservation.

Lucia Scalisi

13 Burnsall Street, London, SW3 3SR
T 020 7351 6112
E luciascalisi@ukonline.co.uk
Conservation of easel paintings. Formerly Senior
Conservator of Paintings, Victoria & Albert
Museum. Accredited Conservator, Institute of
Conservation and Fellow of the International
Institute of Conservation.

Rachel Howells

61 Geraints Way, Cowbridge, CF71 7AY T 01446 773038 F 01446 773038

E Rachel@RachelHowells.co.uk
Working on a freelance basis since 1990. Main
activities include conservation and restoration,
including structural work, tear repair, linings,
and also surface treatments, cleaning and
consolidation. Work with artists in the past
has included giving advice on materials and
techniques, treating accidental damages, treating
mould growth, improving structural conditions
of canvases and accessory supports, and offering
advice on framing.

Ronald Moore Fine Art Conservation

consultation and valuation services.

Upper Sydcombe, Dorstone, Hay-on-Wye, HR3 6BA

T 01497 831566

E moorerestoration@aol.com Thirty years' experience, with particular expertise in fire, water, bomb and structural damage to oil paintings and works on paper. Also offers **Rupert Harris Conservation**

Studio 5c, Block A, No 1 Fawe Street, London, E14 6PD

T 020 75152020 F 020 79877994

E enquiries@rupertharris.com

W www.rupertharris.com

Contact Rupert Harris

Established in 1982 and appointed metalwork conservation adviser to the National Trust in the same year. Work covers bronze, lead, zinc and electrotype sculpture, modern and contemporary art, historical lighting, casting and replication, gilding, consultancy and maintenance. Can advise artists on the use of materials and paint finishes, security fixings and maintenance of public sculpture.

Simon Gillespie Studio

To Albemarle Street, London, W1S 4HW
To 2074930988
Fo 2074930955
E info@simongillespie.com
W www.simongillespie.com
Founded in 1982, specializing in restoring paintings. Advice on techniques and conservation given.

Siobhan Conyngham Fine Art Conservation

Dundrocken, Carrick Macross, County Monaghan T 042 9661734
E pconyngham@eircom.net
Carries out conservation and restoration of oil paintings.

Taylor Pearce Ltd

Fishers Court, Besson Street, London, SE14 5AF T 020 72529800 F 020 72778169 E admin@taylorpearce.co.uk

Founded in 1986. Sculpture conservators by appointment to the Queen. Lists all major public galleries and collections on client list. Carries out restoration and conservation to sculpture, ranging from classical to medieval to contemporary. Also makes and installs (mainly stone) sculpture for prominent contemporary artists and acts as consultant exhibitions conservators to institutions such as the Royal Academy and National Gallery.

Textile Conservancy Company Ltd

3A Pickhill Business Centre, Smallhythe Road, Tenterden, TN30 7LZ T 01580 761600 F 01580 761600 E alex@textile-conservation.co.uk W www.textile-conservation.co.uk Contact Alexandra Seth-Smith Founded in 1998, providing the cleaning and repair of historical textiles, rugs and tapestries. Clients include English Heritage, and National Maritime Museum, the Wellcome Trust Library and a variety of private collectors.

Valentine Walsh

3 Whitehorse Mews, London, SE1 7QD

T 020 72611691

F 020 74019049

E valentine@valentinewalsh.co.uk

W www.valentinewalsh.co.uk

Contact Valentine Walsh

Over twenty years' experience of conservation of easel paintings and polychrome sculpture and works for West End dealers and national museums on pieces from all art periods. Works to museum standards and advises on transport, insurance, care and maintenance and preventive conservation. Services include disaster response, collection surveys, condition reporting and scientific analysis. All work is fully documented.

Consultants

Artquest

University of the Arts London, 65 Davies Street, London, W1K 5DA

E info@artquest.org.uk

W www.artquest.org.uk

Provides advice and information to London's visual arts sector. The programme responds to the professional needs of artists in the region throughout their careers by providing a website, telephone and email helpline, advisory sessions, and training and seminars. Support covers areas such as presenting and selling work, research and development of new work practices and techniques, financial advice and ongoing professional-development and training opportunities. Also provides a comprehensive legal advice archive and advice service for visual artists. The programme is funded by Arts Council England and University of the Arts London.

Bridgeman Art Library

17-19 Garway Road, London, W2 4PH T 020 77274065 F 020 77928509

E adrian.gibbs@bridgeman.co.uk W www.bridgemanart.co.uk Contact Adrian Gibbs

A commercial picture library established in 1972 by Harriet Bridgeman and specializing in images of art, history and culture. The archive holds approximately one million images from collections around the world, covering every aspect of art and including works by over five hundred artists in copyright. Operates a no-fee service for contemporary artists to administer their copyright and to sell reproduction licences in their work. Accepts 5 × 4 colour transparencies or digital files of 50-megabyte RGB tiffs.

Business Art Service

Curwen & New Academy Gallery, 34 Windmill Street, London, W1T 2JR T 020 73234700

F 020 74363059

E gallery@curwengallery.com

W www.curwengallery.com

Among Britain's most established art consultancies, having been set up in 1978 as part of the Royal Academy to provide art to businesses. In 1988 the company moved premises and set up the New Academy Gallery in Fitzrovia. In the following years the company purchased the Curwen Gallery at 4 Windmill Street, originally set up in the area by the famous Curwen Studio in 1958. At the start of 2005, the galleries combined in one space at 34 Windmill Street.

Business2Arts

44 East Essex Street, Temple Bar, Dublin 2 T of 6725336 F oi 6725373 E info@businesstoarts.ie W www.businesstoarts.ie Started in 1988 to promote the benefits to businesses of supporting Irish arts.

Corman Arts

24 Daleham Gardens, London, NW3 5DA F 02074331339

E tca@btinternet.com

W www.cormanarts.com

Contact Ruth Corman

Specializes in consultancy for both corporate and private clients. Clients can choose from over three hundred artists and makers producing paintings, prints, photography, textile art, wall hangings, contemporary ceramics, metalwork and sculpture.

Davidson Arts Partnership

34 Quainton Street, Neasden Village, London, NW10 0BE

T 020 89000880

F 020 89000880

E phil@davidsonarts.com

W www.davidsonarts.com

Contact Philomena Davidson

Formed in 1999, an independent consultancy, specializing in the field of public art, managing projects involving all forms of art. Experienced in providing services to a wide range of clients, guiding them through the process of programming, selection, planning and implementation, and project managing major corporate and civic art commissions and events.

Dickson Russell Art Management

23 St Peter's Square, Hammersmith, London, W6 9NW

T 020 87419577 / 020 77337137

F 020 85639249

E dickson.russell@ntlworld.com

W www.dicksonrussell.co.uk

Contact Emma Russell and Rachel Dickson Established in 1992 to offer comprehensive art-management and consultancy services to public, corporate and private clients. Deals with acquisition, exhibition curation, management of existing collections and commissioning of artworks, across a wide range of media to include painting, works on paper, sculpture, installation, photography and film-based work. Contemporary and period work sourced according to client requirements. Additional services include shipping, art handling, framing, restoration, valuation and catalogue preparation.

FotoLibra

22 Mount View Road, London, N4 4HX

E info@fotoLibra.com

W www.fotoLibra.com

Contact Jacqui Norman

foto Libra is an open access picture library / stock agency that markets & licenses usage rights in copyright images to publishers, ad. agencies etc., splitting the fee 50/50 with the artist. Also provides secure digital storage for images.

Getty Images

IOI Bayham Street, London, NW1 0AG T 0800 3767977 W www.getty-images.com The world's foremost image provider of visual content to communication professionals.

HS Projects

Unit 86, 188 Baker Street, London, NW1 5TE

T 020 7487 5448

E info@hsprojects.com

W www.hsprojects.com

Over fifteen years' experience working with artists, private collectors, corporate collectors and businesses. Work undertaken includes exhibitions, commissions, project management, contracts, workshops and advice. Do not represent artists except on a project basis when retained by the artist. Visit by appointment only.

Impact Art

Walstead Chapel, East Mascalls Lane, Haywards Heath, RH16 2QY

T 01444 484847

E art@impactart.co.uk

W www.impactart.co.uk

An independent art consultancy that delivers professionally managed programmes of site-specific art and built environment art works involving artists from a broad spectrum of disciplines. Projects range from large-scale public commissioning programmes to commercial headquarters and smaller-scale projects sourcing art works. Notice of open-competition projects are through the national art press, but will view new work for consideration. Initial contact via email.

International Art Consultants Ltd

The Galleries, 15 Dock Street, London, E1 8JL

T 020 74811337

F 020 74813425

W www.afo.co.uk

Established in 1979, a consultancy sourcing and commissioning art from around the globe. Works with clients in the corporate, hotel, healthcare and urban regeneration sectors, with budgets ranging from very little to £1 million+.

Mac Medicine Ltd

90 Elmore Street, London, N1 3AL T 07968 271048 E help@macmedicine.net W www.macmedicine.net

Offers web design advice to artists. Modus Operandi Art Consultants

4th Floor, 2–6 Northburgh Street, London, EC1V 0AY

T 020 74900009 F 020 74900018

E mail@modusoperandi-art.com

W www.modusoperandi-art.com

Independent art consultancy, providing artistic direction and a commissioning service to a range of clients. Client base includes regenerative agencies, developers, architectural practices, local authorities, private sector companies, transport authorities, educational establishments, environmental and arts organizations. Particular emphasis on urban and rural regenerative projects.

Pilot

1 Percy Harris House, 30 Barnet Grove, London, E2 6BD

T 07813 801024

W www.pilotlondon.org

An independent not-for-profit initiative led by artists and independent curators to provide ongoing support for emerging artists who do not have commercial representation. Project is designed to be a platform, and catalyst, where information is exchanged and contacts made between artists, curators, collectors and gallerists. One hundred curators choose one hundred suitable artists for an annual event

plan art consultants

63 Squirries Street, Bethnal Green, London, E2 6AJ

T 020 77393007

F 020 77393189

E art@plan-art.co.uk

W www.plan-art.co.uk

Contact Ivan Tennant

Founded in 1997. Includes a multidisciplinary team of consultants who advise on all aspects of the development and implementation of public, corporate and hotel art strategies.

Royal Jelly Factory

11 Kemp House, 103 Berwick Street, London, W1F 0QT

T 020 77346032

F 0870 0549832

E info@royaljellyfactory.com

W www.royaljellyfactory.com

Web-design and coding services aimed primarily at those involved in the arts, particularly individual artists and small-scale organizations. Also produces art books.

Sheeran Lock Ltd

P.O. Box 279, Woodbridge, IP13 9WU

T 01728 621126

E imogenlock@sheeranlock.com

W www.sheeranlockartgallery.com

Contact Imogen Lock

Founded in 1990 by John Sheeran, an art curator, and Imogen Lock, a specialist in communications. Creates art exhibitions, competitions, events and education programmes, and is best known for the ways it cross-fertilizes art, education and business. Helps artists maximize their potential and develop their careers through its artist consultancy service and generates cultural projects commissioned and sponsored by the corporate sector. Launched an innovative online commercial art gallery in 2007 featuring themed collections of artists' work and over 50 specially commissioned educational videos.

Snowgoose

12 Chaytor Terrace South, Craghead, DH9 6AZ **T** 01207 290639 **F** 01207 299791

E info@snowgoose.co.uk W www.snowgoose.co.uk

Designs and builds websites for artists and designers.

thecentralhouse

I Chapel Place, Rivington Street, London, EC2A 3DP

T 020 77397572

F 077397552

E elle@thecentralhouse.com

W www.thecentralhouse.com

Contact Elyse Eales

Founded in 2002, representing young contemporary British artists. Acts as consultants for developers, interior designers and corporate clients.

Wetpaint Gallery

The Old Chapel, 14 London Road, Cirencester, GL7 1AE

F 01285 644990

E cah@contemporary-art-holdings.co.uk

W www.contemporary-art-holdings.co.uk

Contact Celia Wickham

A corporate art consultancy established in 1990. Specializes in providing art work for offices and commercial environments such as conference centres, hotels and exhibition spaces. Pieces range from original prints and paintings to fabric wall hangings, tapestries, contemporary glass and site specific sculpture. The consultancy also operates an art rental scheme. Artists wishing to submit their work for consideration should send images on disk together with an sae for returns.

Workplace Art Consultancy

12 Adderley Grove, London, SW11 6NA

T 020 77397500

F 020 77298170

E enquiries@wacart.com

W www.wacart.com

Contact Michael Boitier

A corporate, residential, healthcare and digital-art consultancy established in 1990. Clients include the Bank of England, the Ministry of Defence, the Bank of New York, Reuters and the Institute of Directors. Also works extensively with architects and designers both in the UK and abroad.

Founders

AB Fine Art Foundry Ltd

1 Fawe Street, London, E14 6PD

T 020 75158052

F 020 79877339 E enquiries@abfineart.com

W www.abfineart.com

Contact Henry or Jerry

Art Bronze Foundry (London) Ltd

1-3 Michael Road, Kings Road, London, SW6 2ER

T 020 77367292

F 020 77315460

E service@artbronze.co.uk

Contact Philip Freiensener

Bronze Age Sculpture Casting Foundry Ltd and Limehouse Gallery

272 Island Row, Basin Approach, Limehouse, London, E14 7HY

T 020 75381388

F 020 75389723

E info@bronzeage.co.uk

W www.bronzeage.co.uk

Contact Susan Rolfe (Production and General

Manager)

Established for over fifteen years, offering a full service to artists looking to cast their sculpture into bronze. Service includes scaling up and on-site moulding. Limehouse Gallery adjoined to the foundry, exhibits a variety of sculpture for sale, predominantly bronze, year round.

Cast Iron Co. Ltd

Home Farm, Shere Road, Albury, GU5 9BL

T 01483 203388

E info@castiron.co.uk

W www.castiron.co.uk

Contact Gary Young

Founded in 1987, specializing in casting in iron, bronze, etc. and in the fabrication of street furniture. Specialists in architectural metalwork and restoration. Able to work with sculptor to produce patterns, moulds and castings in any metal type.

Castle Fine Arts Foundry

Tanat Foundry, Llanrhaeadr Ym Mochnant,

Oswestry, SY10 OAA T 01691 780261

F 01691 780011

E info@bronzefoundry.co.uk

W www.bronzefoundry.co.uk

Contact Chris Butler or Paul Daiton

Established in 1990, producing quality bronze castings. Specialists in casting both public art and gallery pieces. Provide an enlarging facility and project management to their clients. Also has foundry in Stroud.

Dublin Art Foundry

3a Rostrevor Terrace, Dublin 2

T 01 6760690

F 01 6760690

E info@dublinartfoundry.com

W www.dublinartfoundry.com

Opened in 1970 and now one of the most important and respected foundries in Ireland.

Lakeland Mouldings

Soulby, Pooley Bridge, Penrith, CA11 0JF

T 017684 86989

F 017684 86989

E anne@lakelandmouldings.co.uk

W www.lakelandmouldings.co.uk

Contact Anne Woods

A freelance mouldmaking and resin casting company with over fifteen years' experience. Offers a professional service to individual sculptors, businesses, galleries and giftware manufacturers. Able to produce silicone moulds and resin casts from original pieces of work.

Livingstone Art Founders

Maidstone Road, Matfield, Tonbridge, TN12 7LQ T 01892 722474

Foundry specializing in the 'Lost Wax' process of

bronze casting in the traditional plaster and grog investment and ceramic shell coatings. Operate a weekly delivery and collection service to London.

LS Sculpture Casting

367 Westcott Venture Park, Westcott, Aylesbury, HP180XB

T 01296 658884

F 01296 658882

E david@lssculpturecasting.com

W www.lssculpturecasting.com

Contact David Challis

Operating for over 21 years, specializing in bronze resin casting - although they do have foundry connections. Run by experienced team of moulders, casters and finishers.

Lunts Castings Ltd

Unit 7, Hawthorns Industrial Estate, Middlemore Road, Birmingham, B21 0BJ

T 0121 5514301

F 0121 5237954

E info@luntscastings.co.uk

W www.luntscastings.co.uk

Contact Tony Limb

Cast in bronze, brass, silver and gold, primarily for the sculptural trade.

MFH Art Foundry Ltd

Project Workshops, Quarley, SP11 8PX

T 01264 889544

F 01264 889898

Contact Roger Squires

Founded 1980. Specialist silver and bronze sculpture foundry, offering complete service including mould making, casting, fabrication and patination.

Mike Smith Studio

Unit 4, 709 Old Kent Road, London, SE15 1JZ

T 020 72775377

F 020 72775420

E projects@mikesmithstudio.com

W www.mikesmithstudio.com

The studio was started in 1989 by Michael Smith. Works with all materials and processes appropriate to realizing a project, with the exception of metal casting. Studio occupies 10,000 sq. ft and is fully equipped to handle projects of any scale. Works with artists, architects, designers and other clients in a variety of ways, including fabricaton, consultancy, design development, production, installation and project management. Has a worldwide client base.

Milwyn Casting

Old Brook Farm, Murthering Lane, Navestock, nr Romford, RM4 1HL

T 01277 373779

E mwcast@artistsfolio.com

Contact Alex Davies

A fine-art foundry offering bronze-casting, steel fabrication and a silicon mouldmaking service.

Morris Singer Art Founders

9 Swinborne Drive, Springwood Industrial Estate, Braintree, CM7 2YP

T 01256 475301

F 01256 381565

E info@msaf.co.uk

W www.msaf.co.uk

Contact Chris Boverhoff

Founded in 1848. Services include art-work enlarging, lost wax and sand casting, installation and restoration.

Pangolin Editions

Unit 9, Chalford Industrial Estate, Chalford, GL68NT

T 01453 886527

F 01453 731499

E foundry@pangolin-editions.com

W www.pangolin-editions.com

Foundry casting on a scale ranging from miniature to monumental for an international clientele. One of the last foundries still practising the traditional skills of lost wax block investment alongside the latest casting technologies. Specializes in a wide spectrum of patinas from traditional shades to unusual colours.

Powderhall Bronze

21 Graham Street, Edinburgh, EH65QN

T 0131 5553013

F 0131 5553013 E info@powderhallbronze.co.uk

W www.powderhallbronze.co.uk

Founded in 1989 and offering a full casting service to sculptors in bronze, lead and aluminium using ceramic shell, grog investment and sandcasting techniques. Other services include enlarging and conservation works. The foundry has a gallery showing bronze sculptures by a wide selection of artists. Group tours can be arranged. A variety of sculpture classes are held in the foundry classroom throughout the week.

Framers

A. Bliss

5 Bakers Yard, Bakers Row, London, EC1R 3HF

T 020 78374959

F 020 78378244 E edward@abliss.co.uk

W www.abliss.co.uk

Contact Edward Mawby

Specialist fine-art dry-mounters of photographs and digital prints on to many surfaces, including aluminium and glass.

Acacia Works

20 Gayal Croft, Shenley Brook End, Milton Keynes, MK5 7HX

T 01908 501268

E trudv@acaciaworks.co.uk

W www.acaciaworks.co.uk

Contact Trudy Phillips

Offers picture-framing and mount-cutting up to museum standard. Art commissions also undertaken and full consultancy service available. Original art and prints available.

Alec Drew Picture Frames Ltd

7 Cale Street, Chelsea Green, London, **SW33OT**

T 020 73528716

F 020 73528716

E framing@alec-drew.co.uk

W www.alec-drew.co.uk

Founded in 1977. A bespoke framer, mainly catering to the local area. Offers a full framing service from simple certificates to gesso and gilded frames via perspex or hand-laid veneer. Can also recommend restorers or picturehangers.

Art & Frame

35 South Parade, Yate Shopping Centre, Yate, BS37 4BB

T 01454 327010

E info@artandframe.co.uk

W www.artandframe.co.uk

Contact John Evans

Offers a full range of framing services, with a wide selection of frames to choose from in both contemporary and traditional styles. Mounts are only cut from conservation- and museum-quality boards, with a choice of many colours and textures. Also stocks a large range of artist materials, readymade frames and mounts.

Art and Soul

G14 Belgravia Workshops, 157 Marlborough Road, London, N19 4NF

T 020 72630421

E bec.b@mac.com

W www.artandsoulframes.com

Contact Rebecca Bramwell

A framing service with a wide range of mouldings, box-frames, acid-free mounts, etc. Established in 1989 by St Martin's graduate Rebecca Bramwell. Happy to offer advice to artists.

Art of Framing

26 Albert Avenue, Bray, County Wicklow T of 2828967 Offers range of framing services.

Artisan for Unusual Things

80 London Road, Teynham, Sittingbourne, ME9 90H

T 01795 522121

F 01795 520744

Established in 1983. A retail shop and workshops specializing in design-led miscellanea for contemporary and classic interiors. Offers bespoke on-site framing for two- and three-dimensional items, whenever possible utilizing recycled materials.

Artlines

Unit o Europark, Lathaleere Industrial Estate, Baltinglass, County Wicklow

T 059 6482132

F 059 6482132

E info@artlines.ie W www.artlines.ie

Contact Helen Blake

Founded in 2001, creative picture framers offering over 60 colours of mountboard and over 250 mouldings. Also stocks extensive range of readymade frames and very wide selection of artists' materials.

Artworks

Port Road, Letterkenny, County Donegal T 074 9125073 Specialist picture framers.

Attic Picture Framing Supplies

11 Boulton Industrial Centre, Hockley, Birmingham, B185AU T 0121 5515454 F 0121 2135072

E frame.tec@virgin.net

Contact Peter Frith

Supplies framing materials to the trade and public. A large range of mouldings in stock and a full range of mounting boards, along with all the sundries required for framing. Can either frame art work from start to finish or supply kits that include frame rims, pre-cut mounts, glass and backing. Will send samples of frames on request.

Barbers

18 Chertsey Road, Woking, GU21 5AB T 01483 769926

Contact Stuart Herring

Under present management since 1985. Offers a full bespoke and contract picture-framing service. Stocks a wide range of artist materials and houses a modern gallery providing exhibition possibilities.

Bourlet Fine Art Frame Makers

32 Connaught Street, London, W2 2AF F 020 77244837 E gabrielle@bourlet.co.uk

W www.bourlet.co.uk

Contact Gabrielle Rendell

Founded in 1838. Gilders, carvers and restorers specializing in making fine-art frames for period and contemporary art. Clients include museums in the UK and overseas, interior designers, West End galleries, artists and private collectors. Price range From f_{150}

Caffrey's Gallery & Framing Studio

Garden Street, Ballina, County Mayo T 096 22352 Offers range of framing services.

Campbell's of London

33 Thurloe Place, South Kensington, London, SW7 2HQ

T 020 75849268 F 020 75813499

E wendel.clement@campbellsoflondon.co.uk

W www.campbellsoflondon.co.uk

Contact W. Clement

Founded in 1966, stocking a large collection of handmade frames. The Campbell's Gallery also carries a range of original paintings and signed limited-edition prints. Consultancy service available.

Cregal Art

Morlivea Road, Galway T 091 751864 F 091 752449 E info@cregalart.ie W www.cregalart.ie Offers professional picture framing service.

Darbyshire Frame Makers

19–23 White Lion Street, London, N1 9PD T 020 7812 1200
F 020 7812 1201
E enquiries@darbyshire.uk.com
W www.darbyshire.uk.com
Contact Dan Edwards or Richard Law
Founded in 1992. A leading framer and art fabricator to the contemporary art world. Aims to provide the right creative solution through a process of collaborative consultation.

Dealg Design Ltd

Deeside Industrial Estate, Irish Street, Ardee, County Louth

T 041 6853338 F 041 6856280

E dealgdesign@iol.ie

Over twenty-five years' experience in the bespoke and contract framing market. Clients include National Gallery of Ireland and leading hotels and offices.

Fairgreen Picture Framing

Old Barrack Road, Collooney, County Sligo T 086 3818829
Picture framers founded in 2002.

Coorydarrigan, Schull, County Cork

Fastnet Framing

T 028 28404 E framer@iol.ie Contact Geoff or Martina McCarthy Founded 1985. All forms of picture framing and canvas stretching undertaken. Specialists in individual one-off frames for artists. Large variety of finishes and woods.

Fine Art Framing Studio

12 Main Street, Midleton, County Cork T 021 4631540 F 021 4631540 E 1goldframe@eircom.net Fine art framers.

Frame Tec

Tamic Tec 8 Greenfield Road, Harborne, Birmingham, B170EE T 0121 4281038 E frame.tec@virgin.net

Contact Peter Frith

Founded in 1988, a picture-framer and art gallery specializing in original art exhibited on a sale-orreturn basis. Although art work is vetted, it is not necessary that it is framed as the gallery can undertake this and add the cost onto the selling price. Charges a commission on sales of thirtythree per cent plus VAT, but does not charge for hanging space.

Framemaker (Cork) Ltd

Carrigaline Industrial Park, Carrigaline, County Cork T 021 4376008 E theframemaker@eircom.net W www.theframemaker.ie

Contact Paddy Costigan

Founded 1987, principally undertaking picture framing and large-format giclée printing. Also offers image-capturing service, artists' studios and a gallery space. Branch at 36 Cook Street, Cork T: 021 4276008.

The Framework Gallery

55 Upper George Street, Dun Laoghaire T of 2805756 E theframeworkgallery@gmail.com

Specialists in conservation framing and handfinished timber mouldings. Many different woods and profiles. Unlimited range of colours and finishes and an artists' discount of 20% offered.

Framework Picture Framing

5-9 Creekside, Deptford, London, SE8 4SA T 020 86915140 F 020 86915140 E enquiries@frameworkgallery.co.uk W www.frameworkgallery.co.uk Contact Adrian Morris-Thomas Founded in 1988. A specialist bespoke pictureframer with a large range of mouldings. All

materials used are of conservation quality. Acrylic frames and dry-mounting available. A large workshop and experienced team of framers can accommodate most framing requirements. Free consultation. Also available are exhibitionstandard readymade frames. Premises include the Framework Gallery, showing contemporary fine art.

Frameworks

Hanbury Lane, Lucan, County Dublin T 01 6100788 W www.frameworksireland.ie Range of framing services offered.

Framing Fantastic

149 Sevenmile Straight, Muckamore, Antrim, **BT41 4QT**

T 028 94439287 F 028 94439287

E info@framingfantastic.com

W www.framingfantastic.com

Contact Shane Noble

Bespoke picture framing and computerised mount cutting service. Online ordering of conservation and white core mounts cut to order for delivery throughout UK and Ireland. Member of the Fine Art Trade Guild. Also runs online gallery of Irish and Ireland-related art and prints.

The Framing Workshop

80 Walcot Street, Bath, BA1 5BD

T 01225 482748 F 01225 422910

E framing@theframingworkshop.com

W www.theframingworkshop.com

Offers a comprehensive framing service. Expertise in hand-finishing skills including gilding, painting, liming and staining. Stocks over 120 plain wood and five hundred finished mouldings including swept, oval and circular frames. Also home to art work by established local artists including Peter Brown and Nick Cudworth.

Frandsen Fine Art Framers Ltd

7 Lillie Yard, Fulham, London, SW6 1UB T 020 73859930

F 020 76101404

E frandsenframes@msn.com

Contact Derek Tanous

Handmade picture frames, period and modern style, gilded and decape finishes. Established for nearly a hundred years.

Frank B. Scragg & Co.

68 Vittoria Street, Birmingham, B1 3PB

T 0121 2367219

F 0121 2363633

E sales@frankscragg.co.uk

W www.frankscragg.co.uk

Contact John Lewis

A long-established company distributing a wide range of items for framing and hanging pictures, including the Gallery Hanging System of rods and sliding hooks. Free catalogue on request.

Fringe Arts Picture Framers

'Great Down', Hog's Back, Seale, Farnham, GU101HD

T 08707 482253 F 08707482254 E lyn@fringearts.co.uk

W www.fringearts.co.uk

Contact Irm Hall

Contact Lyn Hall

Run by Lyn Hall, with over twenty-two years of bespoke framing experience. Offers a wide range of specialisms, including handling textiles (modern and traditional), conservation framing, specialist mount-cutting skills, and canvasstretching. Currently working for a large number of well-known and amateur artists.

Gallery 2000

11–13 Windle Court, Clayhill Park, Neston, CH64 3UH

T 0151 3531522

F 0151 3531300

E art@gallery2000.co.uk

W www.gallery2000.co.uk

Contact Jenny Holland

A family business founded in 1986 by resident artist Jenny Holland. Specialist framer of pictures and all memorabilia using readymade frames and decorative mounts, offering a 'while-youwait' service. Comprehensive stock of artists' materials. In-house, scanning and wide-format giclée printing. Illustrated website selling UK local scenes, dispatched worldwide.

Geoghegans Picture Framing Service

Rathkeale, Limerick, County Limerick T 069 64286 Extensive range of framing services offered.

Goslings

50 Station Road, Sudbury, CO10 2SP

T 01787 371932

Contact Miss W. Allen

In business for over twenty-five years, offering a full picture-framing service and stocking art materials. Accompanying gallery holds exhibitions throughout the year.

Graham Harrison Framing Ltd

Studio 8, Grand Union Centre, West Row, London, W10 5AS

T 020 89694599

F 020 89640238

E graham@ghframing.com

W www.ghframing.com

Contact Graham

Founded 1994, offering a bespoke framing service to artists, galleries, corporate and private clients.

Specializing in high quality gilding and hand finishes of contemporary and traditional frames. Also offers conservation and restoration services. Quotes provided free of charge.

Grays of Shenstone

Lynn Lane, Shenstone, WS14 0DU T 01543 483344

Ian Dixon GCF Bespoke Framers

White Timbers, Forest Road, East Horsley, KT24 5ER

T 01483 282059

F 01483 282059

E dixonframes@btinternet.com

W www.dixonframes.com

Contact Ian Dixon GCF

Award-winning framing expert, specializing in needlework and memorabilia but all other framing accepted. Also offers conservation framing, cleaning and restoration, with computerised mount cutting service. Giclée printing offered and artists materials, original paintings and prints for sale.

Largs Hardware Services & Gallery Eight

3-11 Stanlane Place, Largs, KA30 8DA

T 01475 672634

F 01475 672634

Founded in 1888, offering a picture-framing service in an on-site workshop. Also houses a gallery and sells artists' materials.

Old Church Galleries

98 Fulham Road, Chelsea, London, SW3 6HS

T 020 75918790

F 020 75918791

E sales@oldchurchgalleries.com

W www.oldchurchgalleries.com

A bespoke picture-framing and mounting service, from conservation to museum standards. Offers a large choice of handmade and manufactured frames and decorative mounts, as well as stretching and oil and paper restoration services.

Paul Mitchell Ltd

17 Avery Row, Brook Street, London, W1K 4BF

T 020 74938732 F 020 74097136

E admin@paulmitchell.co.uk

W www.paulmitchell.co.uk

Contact Paul Mitchell or Mary Ross-Trevor Provides a comprehensive framing and conservation service. From an extensive inventory of antique European frames, the company is able to supply dealers, auctioneers, museums and private collectors worldwide with expertly researched framing proposals.

Paul Treadaway

Field Cottage, North Road, Widmer End, HP15 6ND

T 01494 716313

F 01494 716313

E paul@fineartframes.co.uk

W www.fineartframes.co.uk / www.verre-

eglomise.com

Founded in 1970. Restoration and gilding of antique picture frames. A maker of verre-eglomise glass mounts for antique and contemporary art work.

Pendragon Frames

1-3 Yorkton Street, London, E2 8NH

T 020 77290608

F 020 772977II

E sales@pendragonframes.com

W www.pendragonframes.com

Dedicated to producing fine handmade frames using conservation techniques. Portfolio of clients in the museums and galleries sector, plus photographers, artists, private collectors, consultants and companies.

pictureframes.co.uk

Unit 22d, Wincombe Business Park, Shaftesbury, SP7 9QI

T 0845 2267249

E mail@pictureframes.co.uk

W www.pictureframes.co.uk

Contact Hope Elletson GCF

Professional framers since 1989, offering full bespoke framing up to museum standard including gilding etc. Website offers custom-made picture frames direct to the door as well as ready-made frames and other goods and services for artists. Since 2007 has marketed and reproduced artists' work using modern printing technology and provided internet-based framing technology to work on the artists website. High quality GCF framing available through your local artists studio.

Railings Gallery

5 New Cavendish Street, London, W1G 8UT
T 020 79351114
F 020 74869250
E artists@railings-gallery.com
W www.railings-gallery.com
Contact Geible Sander

Founded in 1980. An in-house framing workshop offering artists and photographers advice and competitive prices for framing for exhibitions and one-off bespoke frames, using conservation materials. Also stocks contemporary limitededition original prints and paintings with a figurative or abstract feel.

Rebecca's Picture Framing

Cara Main Street, Leap, County Cork T o28 33332 Provides wide selection of framing services.

Reeves Art Studio

33 Church Street, Athlone, County Westmeath T 090 6478507
W www.reevesartstudio.com
Offers variety of framing services.

Renaissance 2

36 Town End, Golcar, Huddersfield, HD7 4NL T 01484 659596 E info@renaissance2.co.uk W www.renaissance2.co.uk

Contact Diane Myzak

Offers bespoke and small-run picture-framing services to artists and photographers with an emphasis on innovative design. Also produces and sells limited-edition giclée prints. Can produce fine art prints from artists' own work at economical prices.

Riccardo Giaccherini Ltd

39 Newman Street, London, W1T 1QB
T 020 75801783
F 020 76375221
E louise.liddell@riccardogiaccherini.co.uk
Contact Louise Liddell
A traditional Florentine-style workshop,

specializing in handmaking, joining, carving and gilding mirror and picture frames. Old Master and contemporary works framed by international staff.

Riverside Gallery

4 Popes Quay Cork, County Cork T 021 4502730 Offers extensive framing service.

Simon Beaugie Picture Frames Ltd

Manor Farm Workshops, Hamstreet Rd, Shadoxhurst, Ashford, Kent, TN26 1NW T 01233 733353 F 01233 732354 E framing@simonbeaugie.com
Established for over ten years, offering a
comprehensive conservation picture-framing
service for the trade. Free consultation, collection
and delivery service in Central London.

Strahan Framing

4 Landscape Park, Churchtown, Dublin 14 T or 2166913 E sales@pictureframing.ie W www.pictureframing.ie Offers wide range of framing services.

Thomas Ellis

7 Beaumont Street, Hexham, NE46 3LZ T 01434 602050 Established 1829. Picture-framing (tapestries, needleworks, etc.). Artists' supplies by Daler-Rowney. Picture sales, including local artists.

Vereker Picture Framing

Cork Road, Mallow, County Cork

10 Duke Street, Bedford, MK40 3HR

T 022 22384
E derriveri@eircom.net
Founded in 1992, undertaking framing for
private individuals, commercial enterprises
and artists. Also carries out conservation work,
including acid-free mountboard, backing board
and tape.

Wallace Brown Studio

T 01234 360237

F 012234 360237 Contact Wally Greenaway Founded in 1960. Framing studio offering a complete bespoke and ready-made contract service to the trade, industry and professionals alike. The modern studio incorporates up-todate equipment together with an experienced workforce.

Insurance

Aon Artscope

consultants.

B Devonshire Square, Cutlers Gardens, London, EC2M 4PL
T 020 78820470
F 020 78820383
E private-clients@aon.co.uk
W www.privateclients.aon.co.uk
Specialist art insurers for collectors, dealers and

AUA Insurance

De Vere House, 90 St Faiths Lane, Norwich, NR1 1NL T 01603 628034 F 01603 761384

F 01003 701384

E sales@aua-insurance.com W www.aua-insurance.com

Specialist provider of insurance facilities for individuals and businesses involved in photography and other creative arts. You choose the cover you need, which can include liability and professional negligence.

AXA Art Insurance Ltd

106 Fenchurch Street, London, EC3M 5JE T 020 72654600 F 020 77020016 E info@axa-art.co.uk W www.axa-art.co.uk

Contact Helen George

Specialists in art and antiques for over 40 years, from single objects to high-risk commercial proposals. Offer detailed advice on risk management, protection, conservation and recovery. Clients include private and corporate collectors, museums, galleries and dealers.

Carroll & Partners

2 White Lion Court, Cornhill, London, EC3V 3NP T 020 76232228

Golden Valley Insurance Services

The Olde Shoppe, Ewyas Harold, HR2 0ES T 0845 2261303 F 0845 2261304 E gvinsurance@aol.com Offers specialist insurance for photographers.

Gwennap Stevenson Brown Ltd

I Tomlins Corner, Queen Street, Gillingham, SP8 4DJ

T 01747 821188 F 01747 821177

E gsbltdgillingham@aol.com

Hallett Independent Ltd

Asset House, 7–9 Quay Street, Lymington, S041 3AS

T 01590 672888

F 01590 673222

E info@hallettindependent.com W www.hallettindependent.com

Provides specialist art insurance for both UK and international galleries dealing in contemporary art,

and for collectors of contemporary art and artists. Also advises on installation, transport, framing, storage, security, maintenance, valuations, photography, management computer software etc.

Heath Lambert Group

133 Houndsditch, London, EC3A 7AH T 020 75603000

E rnorthcott@heathlambert.com

W www.heathlambert.com

Contact Richard Northcott

One of the largest brokers in the London market for fine art, collectables and private jewelry. Caters for clients ranging from galleries and museums to individual private collectors, corporate collectors, art and antique dealers and shippers. Acts for many major museums and galleries in the UK and Europe as well as arranging exhibitions worldwide.

Hiscox PLC

I Great St Helen's, London, EC3A 6HX T 020 74486000 F 020 74486797 E enquiry@hiscox.co.uk W www.hiscox.com Eight UK offices, plus worldwide.

HSBC Insurance Brokers Ltd

Fine Arts and Antiques Section, Bishops Court, 27-33 Artillery Lane, London, E1 7LP T 020 7661 2474 F 020 7661 2175

E peterclifford@hsbc.com

W www.insurancebrokers.hsbc.com

Contact Peter Clifford

A leading independent specialist dedicated to the insurance needs of the art and related risks market.

HSBC Insurance Brokers Ltd

Jewelry and Fine Arts Division, Bishops Court, 27-33 Artillery Lane, London, E1 7LP

T 020 72475433 F 020 73772139

W www.insurancebrokers.hsbc.com/hsbc/ jewellery

Contact Bruno LeRoy

Insurancenow Services Ltd

1st Floor, 413a Chingford Road, Walthamstow, London, E17 5AF

T 020 85315336

F 020 85274527

E paul@insurancenow.co.uk

W www.insurancenow.co.uk

Contact Paul

Established in 1999, incorporating an insurance directory website that provides links to specialist fine-art insurers.

Masterpiece

Chubb Insurance Company of Europe S.A., 106 Fenchurch Street, London, EC3M 5NB T 0800 111511 W www.chubb.com

Phillippa Levy & Associates

19 Louisa Street, London, E1 4NF T 020 77901963 F 020 77904100 E leavypitt@aol.com Contact Phillippa Levy Established in 1981, offering insurance to artists

and craftspeople (public/employers' liability, exhibitions, studio contents). All policies are tailormade to individual needs. Exhibitions covered worldwide, including transit to and from venue. Personal accident cover also available.

Photoguard

Pavilion Insurance Management Ltd, Pavilion House, Mercia Business Village, Coventry, CV48HX

T 02476 851000 F 02476 851080

E admin@Photoguard.co.uk W www.Photoguard.co.uk

Insurance for photographers and their equipment.

Society for All Artists (SAA)

P.O.Box 50, Newark, NG23 5GY

T 01949 844050

F 01949 844051 E info@saa.co.uk

W www.saa.co.uk

The SAA, society for all artists, provides free insurance for paintings (two-dimensional works of art) at exhibitions for all its UK members. Also offers £5 million third party public liability insurance with Zurich Insurance for all members. See website for membership details and costs.

T.H.March & Co.Ltd

10-12 Ely Place, London, EC1N 6RY T 020 74050009 F 020 74044629 E insurance@thmarch.co.uk W www.thmarch.co.uk

Willis

Fine Art, Jewelry and Specie Division, 10 Trinity Square, London, EC3P 3AX T 020 74888111 E molloyl@willis.com

Windsor Insurance Brokers Ltd

Fine Art and Antiquities Division, Lyon House, 160–166 Borough High Street, London, SE1 1JR T 020 71331200

F 020 71331500

E info.windsor@windsor.co.uk

Packers and shippers

01 Art Services Ltd

W www.windsor.co.uk

Unit 2, Towcester Road, London, E3 3ND T 020 75157510 F 020 75382479 E info@o1artservices.co.uk

W www.o1artservices.co.uk

Contact Liz Cooper

Founded in 1992, specializing in the transportation, installation and storage of fine art within the UK. Can cater for all types of project, from the carriage or hanging of a single art work to the management and coordination of whole exhibitions and collections. Client base includes leading artists, galleries, museums, consultants, fine framers, designers, and corporate and private collectors.

3 Lanes Transport Ltd

5 Albany Terrace, St Ives, TR26 2BS T 01736 799298 / 07970 896256 F 01736 798400 E info@3lanes.com W www.3lanes.com

Anglo Pacific

Units I & 2 Bush Industrial Estate, Standard Road, North Acton, London, NW10 6DF T 020 89651234 F 020 89654954 E info@anglopacific.co.uk W www.anglopacific.co.uk

Art Move Ltd

Unit 3, The Arches, Grant Road, London, SW11 2NU
T 020 75851801
F 020 72230241

E mail@artmove.co.uk W www.artmove.co.uk

Contact Alistair Adie

Founded in 1983. Transports, stores and installs art works, from single pieces to whole shows. Also provides an export packing service and ships worldwide. Has regular (weekly) run between London and Scotland at part-load prices from £70 plus VAT (also the minimum charge for work around London).

C'Art Art Transport Ltd

Unit 7, Brunel Court, Enterprise Drive, Four Ashes, Wolverhampton, WV10 7DF T 01902 791797 F 01902 790687 E info@cart.uk.com W www.cart.uk.com

Specialists in art transportation, packing and shipping. Climate controlled storage. Also offer public sculpture installation, exhibition hanging and courier services.

Cadogan Tate Fine Art Logistics

6-12 Ponton Road, London, SW8 5BA T 020 78196611 F 020 78196601 E c.evans@cadogantate.com W www.cadogantate.com Contact Chris Evans

Professional packers and shippers of art. Offices in London, New York and Paris. Weekly shuttle service to Paris, Geneva and Zurich. London warehouse is bonded allowing art to be stored in bond VAT unpaid. Private temperature-controlled vaults also available.

Constantine Ltd

Constantine House, 20–26 Sandgate Street, London, SE15 1LE T 020 77328123 F 020 77322631 E enquiries@const.co.uk W www.const.co.uk

Damon Bramley

Box Cottage, Viney Woodside, Lydney, GL15 4LX
T 01594 510365
F 01594 510365
E damon@boxcottage.plus.com
Founded in 1998, specializing in the transport and

installation of sculpture and similar 3-D artwork. Four-wheel drive lorry equipped with six-tonne crane enables access to almost any site. Large van also in fleet for smaller pieces. All aspects of installation undertaken from foundations to fixing. Contact for obligation-free quote.

Davies Turner Worldwide Movers

49 Wates Way, Mitcham, CR4 4HR T 020 76224393 F 020 77203897 E T.Hutchison@daviesturner.co.uk W www.daviesturner.com

Gallery Support Group

Unit 02, 37 Cremer Street, London, E28HD

T 020 77296692

E charlotte@gallerysupportgroup.com

W www.gallerysupportgroup.com Specialists in art logistics and installation. Operating from central London and Scotland. Clients range from museums to established and contemporary galleries, artists and private collectors.

Hedley's Humpers

3 St Leonard's Road, North Acton, London, NW106SX

T 020 89658733 F 020 89650249

E london@hedleyshumpers.com

W www.hedleyshumpers.com

HMC Logistics Ltd

Unit 21. Newington Industrial Estate, Crampton Street, London, SE17 3AZ

T 020 77031666

F 020 77036999

E info@hmclogistics.com

W www.hmclogistics.com

Contact Andy Keir

Kent Services Ltd

Unit 3 Phase 2, Grace Road, Sheerness, **ME121DB**

T 01795 660812

F 01795 669906

E ksl@kent-services.com

W www.kent-services.com

Contact Sheila Amey (Director)

Provides economical and ready access to a large quantity of high-standard containers for safe and secure transportation of art objects. Containers also for sale. Small-quantity materials service. Transportation and storage of cases for temporary exhibitions.

Lockson UK

Unit I. Heath Park Industrial Estate, Freshwater Road, Chadwell Heath, RM8 1RX T 020 85972889 F 020 85975265 E shipping@lockson.co.uk

W www.lockson.co.uk

M&G Transport & Technical Services Limited

18 Maple Crescent, Rishton, Blackburn, BB1 4RJ

T 01254 884244

F 01254 884244

E enquiries@museumtransport.co.uk

W www.museumtransport.co.uk

Contact Karen Yates

Founded in 1997, providing transport and technical services to museums, galleries, artists, collectors, etc. Also offers picture-hanging, exhibition installation, mounting and framing services.

Martinspeed Ltd

Albert Yard, 7 Glasshouse Walk, London, SE11 5ES T 020 77350566

F 020 77930137

E richard.chapman@martinspeed.com Established in 1975 to provide specialized art handling services for artists, collectors, dealers, commercial galleries, public museums and galleries world-wide. Specializes in the storage, packing, casing, installation, transport, import and export of individual works and whole exhibitions. Facilities include a fleet of climate controlled airride fine art vehicles, indemnity approved storage warehouses, case making to all specifications and an airport office, all staffed by fully-trained, experienced and knowledgeable people.

Maxtrans London

Unit 7, Heathrow International Trading Estate, Green Lane, Hounslow, TW4 6HB

T 0870 2245555 F 0870 2245556

E info@maxtrans.com

W www.maxtrans.com

Momart Limited

The Denim Factory, 4-6 Davenant Street, London, E15AQ

T 020 74263000

F 020 74263001

E enquiries@momart.co.uk

W www.momart.co.uk

Fine art handling, including transportation, case making and packing, import/export services,

exhibition installation, preventive conservation and storage.

Moving Experience

19A Alexandra Road, St John's Wood, London, NW8 0DP

T 020 74832501

F 020 74834088

E roberto@movexp.co.uk

In business since 1997, offering picture-hanging and art-installation services. Clients include private individuals, artists, galleries, museums and commercial companies. Charges are per art installer and are for half a day (up to four hours) or a full day (four to eight hours). Only installs and hangs pictures; does not supply hanging systems.

MTec Freight Group

Unit 10, Gentlemans Field, Westmill Road, Ware, SG12 0EF

T 01920 461800

F 01920 466606

E info@mtechfreightgroup.com

W www.arttransport.com

Oxford Exhibition Services Ltd

Station Road, Uffington, Faringdon, SN7 7QD

T 01367 820713

F 01367 820504

E enquiries@oxex.co.uk

W www.oxex.co.uk

Contact Michael Festenstein (Managing Director) Established in 1986. Provides safe packing, secure domestic (air-suspension, climate controlled vehicles) and international shipping, specialist temperature and humidity controlled storage and installation of museum objects and works of art to the highest standards of conservation and security. International and London office: 2 Sandgate Trading Estate, Sandgate Street, London, SE15 1LE; T 020 77327610.

Seabourne Mailpack Worldwide

13 Saxon Way, Moor Lane, Harmondsworth, **UB7 OLW**

T 020 83221700

F 020 83221701

E info@seabourne-mailpack.com

W www.seabourne-mailpack.com

Founded in 1962, offering a specialist collection, packing and delivery service worldwide. In conjunction with parent company Seabourne Express Courier Ltd, any transit time can be catered for. Services are often tailormade.

Sovereign International Freight Ltd

Sovereign House, 8-10 St Dunstans Road,

Feltham, TW13 4JU

T 020 87513131

F 020 87514517

E info@sovereignlondon.co.uk

W www.sovereignlondon.co.uk

T. Rogers & Co. Ltd

P.O.Box 8, 1a Broughton Street, London, SW8 3QL

T 020 76229151

F 020 76273318

Team Relocations

Drury Way, London, NW10 0JN

T 020 87840100

F 020 84510061

W www.teamrelocations.com

Transeuro (Fine Art Division)

Drury Way, London, NW10 OJN

T 020 87840100

F 020 84593376

E Richard. Edwards@transeuro.com

W www.transeuro.com

Collections throughout the UK and Europe, packing and casing to museum standard. Air-ride transport with full 'climate control' and experienced staff of fine art handlers. Secure storage in North West London on demand. World-wide shipments by sea and air, with all export documentation, including carnets and insurance if necessary. Also exhibition handling and installation.

Photography

AJ's Studio and Camera Supplies

T 01749 813044

E enquiries@aj-s.co.uk

W www.aj-s.co.uk

Established in 1994, specializing in new and used professional photographic equipment.

artistsprinting

Southgate Studios, 2-4 Southgate Road, London,

N1 3JJ

T 01608 641070

F 08700 549825

E mail@artistsprinting.com

W www.artistsprinting.co.uk

Contact Stephan

Offers large-format digital printing and unique installation and mounting techniques (specializing in one-off billboard format digital photography). Hosts workshops for artists in, among other subjects, file-processing for digital printing and mounting and display applications for digital prints. Collaborates with individual artists and groups working on digital printing or web-based projects.

Bob Rigby Photographic Limited

Store Street, Bollington, SK10 5PN

T 01625 575591 F 01625 574954

E info@bobrigby.com

W www.bobrigby.com

Family-owned business with over 20 years' experience of supplying photographic equipment.

BPD Photech Ltd

Unit 20, Aston Court, Kingsland Grange,

Warrington, WA1 4SG

T 01925 821281

F 01925 813375

E info@bpdphotech.com

W www.bpdphotech.com

Photographic printers since 1989, offering a comprehensive range of professional colour processing services, specialising in CIBA or CIBACHROME prints from transparencies. Photographic digital printing on a range of surfaces, plus professional scanning and canvas printing.

Calumet Photographic UK

Promandis House, Bradbourne Drive, Tilbrook,

Milton Keynes, MK7 8AJ

T 08706 030303 F 01908 366322

E website@calumetphoto.co.uk

W www.calumetphoto.co.uk

Supplier of high-quality imaging products since 1939, with eleven branches nationwide, plus online shopping facility.

Camera Box

39 Newland Street, Kettering, NN168JH

T 01536 523245

F 01536 522602

E sales@camera-box.com

W www.camera-box.com

Photographic supplier with online shop.

Camera Centre

High Street, Hailsham, BN27 1AR

T 01323 840559

F 01323 442295

E robert@camcentre.co.uk

W www.camcentre.co.uk Long-established retailer of new and old photographic equipment.

Cameraking.co.uk

Unit 20, Oliver Business Park, Oliver Road, Park Royal, London, NW10 7JB

T 0845 6443155

F 0845 6443115

E info@cameraking.co.uk

W www.cameraking.co.uk

Supplies extensive range of general photographic supplies and materials through online store.

CameraWorld

14 Wells Street, London, W1T 3PB

T 020 76365005

F 020 76365006

E sales@cameraworld.co.uk

W www.cameraworld.co.uk

Photographic retailer established for over thirtyfive years. Branches: 7 Exchange Way, High Chelmer Shopping Centre, Chelmsford, Essex CM1 1XB Tel: 01245 255510 Email: Chelmer@ cameraworld.co.uk.

Carmarthen Camera Centre

I Parcmaen Street, SA31 3DP

T 01267 222300

E info@carmarthencameras.co.uk

W www.carmarthencameras.co.uk

Second-hand used cameras, digital cameras, equipment and accessories.

Chaudigital

19 Rosebery Avenue, London, EC1R 4SP

T 020 78333938

F 020 78379130

E sales@chaudigital.com

Founded in 1983, specializing in digital imaging services.

Dale Photographic

60–62 The Balcony, The Merrion Centre, Leeds, LS2 8NG

T 0113 2454256

F 0113 2343869

E info@dalephotographic.co.uk

W www.dalephotographic.co.uk

Sells new and used photographic equipment.

The Darkroom UK Ltd

15 Berkeley Mews, High Street, Cheltenham, GL50 1DY T 01242 239031
E info@the-darkroom.co.uk
W www.the-darkroom.co.uk
Offers wide range of printing and processing
services to photographers and imaging businesses.

Digitalab

8 Stepney Bank, Ouseburn, Newcastle-upon-Tyne, NE1 2PW

T 0191 2323558 F 0191 2610990 E info@digitalab.co.uk W www.digitalab.co.uk

Formerly known as MPS Photographic, founded in 1949, Digitalab are specialists in high quality Lightjet C-type photographic printing, film processing and digital imaging services. Online digital printing service now available. Photography of artist's original artwork and consequent faithful reproduction prints available on photographic paper, fine art giclée papers or canvas. Also in-house bespoke picture framing service and new gallery space.

Direct Lighting

200–203 Hercules Road, London, SE1 7LD T 020 70145000
F 020 70145001
E mail@directlighting.co.uk
W www.directlighting.co.uk
One of London's leading rental suppliers of camera and lighting equipment.

Downtown Darkroom

12 Valentine Place, London, SE1 8QH
T 020 76200844
F 020 76200129
E darkroom@silverprint.co.uk
W www.silverprint.co.uk
Operating for around eighteen years, the lab recently underwent full refurbishment.

DTEK Systems

Parkside, Basingstoke Road, Reading, RG7 1AE T 0870 4287008
F 0870 4287011
E sales@dteksys.co.uk
W www.dtek.co.uk
Web-based suppliers of high-end imaging equipment.

Dunn's Imaging Group Plc

Chester Road, Cradley Heath, B64 6AA T 01384 564770

F 01384 637165 E enquiries@dunns.co.uk W www.dunnsphoto.co.uk Offers wide range of photographic, printing and processing services.

Eden Imaging

Unit 6a, 9 Park Hill, Clapham, London, SW4 9NS T 020 76278222 F 020 76274666 W info@edenimaging.co.uk Offers processing services and studio hire.

Farnell Photographic Laboratory

Lancaster, LA1 3NX
T 01524 847647
F 01524 382403
E lab@farnells.plus.com
W www.farnellphotographiclab.co.uk
Professional photographic lab, offering array of

printing, processing and finishing services.

Unit 26, Lakes Enterprise Park, Caton Road,

Ffordes Photographic Ltd

The Kirk, Wester Balblair, By Beauly, IV4 7BQ
T 01463 783850
F 01463 782072
E info@ffordes.com
W www.ffordes.com
Stocks wide range of new and used photographic

materials.

Fixation

Suite 508, 71 Bondway, London, SW8 1SQ T 020 75823294
F 020 75829050
E Sales@FixationUK.com
W www.fixationUK.com
Photographic suppliers, also offering rental and repair services.

The Flash Centre

54 Brunswick Centre, London, WC1N 1AE T 020 78376163 W www.theflashcentre.com

Stocks cameras and films, and distributes flash equipment to photographic studios. Branches in Leeds and Birmingham. See website for details.

fotoLibra

Murmur Y Don, Harlech, LL46 2RA T 020 83481234 E artists@fotoLibra.com W www.fotoLibra.com

Contact Yvonne Seeley

Founded in 2005 as the first open access stock agency. Sells digital image rights for photographs, paintings and other artwork to professional picture buyers.

Four Corners

121 Roman Road, Bethnal Green, London, E2 OQN T 020 89816111

F 020 89837866

E info@fourcornersfilm.co.uk

W www.fourcornersfilm.co.uk

Professional-standard film, video and darkroom facilities for film-makers, photographers and artists working at all levels. Training offered in film specialisms and photographic techniques. Gallery run with digital projection facilities. Screenings, discussion and networking events organized.

Genesis Imaging Ltd

Unit I, Hurlingham Business Park, Sulivan Road, London, SW6 3DU

T 020 73846299

F 020 73846277

E sales@genesis-digital.net

W www.genesis-digital.net

Contact Mark Foxwell

A photographic processing and printing company offering a full range of services; from large format fine art and giclée photographic prints and finishing to digital imaging, large format display graphics, film processing and printing, scanning and retouching.

Geoff Marshall Photography Ltd / Cornwall Cameras

4 Cathedral Lane, Truro, TR1 2QS T 01872 276819

E sales@cornwallcameras.co.uk

W www.cornwallcameras.co.uk

Giles Cameras

1510 London Road, Leigh-On-Sea, SS9 2UR T 01702 478820 F 01702 478820

E sales@gilescameras.co.uk W www.gilescameras.co.uk

Harman Technology Ltd

Ilford Way, Mobberley, Knutsford, WA16 7JL T 01565 684000

F 01565 872734

W www.harmantechnology.com

HARMAN Technology Limited was formed in 2005 by six former managers of ILFORD Imaging UK Limited. Specialists in black and white film, photographic papers and printing.

Ian Stewart

4 Wood Walk, Wombwell, Barnsley, S73 ONG T 07944 384418 E ijstew@bushinternet.com Quality black and white hand processing and printing of traditional photographic film. Film

Intro 2020

Priors Way, Maidenhead, SL6 2HP T 01628 674411 E service@intro2020.co.uk W www.intro2020.co.uk Importers and distributors of photographic products from a range of suppliers.

from 35mm to 6×7 cm roll accepted.

lessops

Jessop House, Scudamore Road, Leicester, LE3 1TZ

T 0116 2326000

W www.jessops.com

Founded in 1935. A photographic retailer with over two hundred and seventy stores nationwide.

IP Distributrion

Hempstalls Lane, Newcastle-under-Lyme, ST5 OSW

T 01782 753300 F 01782 753399

E info@johnsons-photopia.co.uk

W www.johnsons-photopia.co.uk

The distribution division of Johnsons-photopia Ltd, which dates back to 1743. Exclusively distributing professional photographic brands including Namiya, Sekonic, Peli, Lastolite, Billingham, Gepe, Giottos and Schneider.

Kamera Direct

6-8 Cotham Street, St Helens, WA10 1SA T 01744 453111 E sales@bestcameras.co.uk W www.bestcameras.co.uk Web-based camera supplier.

Kaz Studio

Unit 2, Plot 11, Rawreth Industrial Estate, Rayleigh, SS6 9RL

T 01268 782582

E photos@kazstudio.co.uk

W www.kaz-studio.co.uk Contact Clive Austen Established in 1988, specializing in commercial photography. Holds teaching sessions for amateur photographers.

Kingsley Photographic

E sales@kingsleyphoto.co.uk W www.kingsleyphoto.co.uk Family-run business with over 40 years experience of selling new and used camera and darkroom

90 Tottenham Court Road, London, W1T 4HL

Lab35 Imaging

equipment.

89 Aylestone Road, Leicester, LE2 7LN T 08455 211254 W www.lab35imaging.com Founded in 1981 as a specialist laboratory for the 35mm photographer, but fully embraces new imaging technologies.

Linhof & Studio Ltd

Image House, 204 Leigh Road, Leigh-on-Sea, **SS9 1BS** T 01702 716116 F 01702 716662 E info@linhofstudio.com W www.linhofstudio.com

Stocks wide range of cameras and photographic equipment, particularly large format photographs for architectural and large scale displays.

London Camera Exchange Group

98 Strand, London, WC2R 0EW T 020 73790200 E strand@lcegroup.co.uk

W www.lcegroup.co.uk Offers new, used and digital cameras and parts. Runs a mail-order service. Twenty-nine branches nationwide.

M Billingham and Co.

Little Cottage Street, Brierley Hill, DY5 1RG T 01384 482828 F 01384 482399 E admin@billingham.co.uk W www.billingham.co.uk Established in 1978, specilist retailers of camera bags.

Metro Imaging Ltd

32 Great Sutton Street, London, EC1V ONB

T 020 78650000 F 020 78650001 E comment@metroimaging.co.uk W www.metroimaging.co.uk Specialists in photographic and digital services.

Michael Dyer Associates Ltd

81a Endell Street, Covent Garden, London, WC2H 9DX

T 020 78368354 / 72400165 F 020 78362858

E photo@michaeldyer.co.uk W www.michaeldyer.co.uk/

Founded over thirty-five years ago, offering high-quality professional photographic services, including studio and location photography, and a full range of laboratory services. Clients comprise mainly of artists, designers, publishers, and architects. Offers discount for students.

Mifsuds Photographic

T 01803 852400 F 01803 855907 E info@mifsuds.com W www.mifsuds.com Major photographic supplier for over fifty years.

27 Bolton Street, Brixham, TQ5 9BZ

Monolab

123 St James Street, Brighton, BN2 1TH T 01273 686726 E info@monolab.biz W www.monolab.biz A professional black and white photographic printers with long experience of photography, printing and image manipulation.

Monoprint

Applegarth House, Tumbledown Hill, Cumnor, Oxford, OX2 9QE T 07989 777359

E enquiry@monoprint.co.uk W www.monoprint.co.uk

Contact Lesley Annetts

Providing specialist black and white processing and handprinting services for the professional and amateur photographer since 1990. Each individual print is assessed before being dispatched to ensure customer satisfaction.

20 Oak Tree Business Park, Oak Tree Lane, Mansfield, NG18 3HQ T 01623 422828

F 01623 422818 E sales@morco.uk.com W www.morco.uk.com Stocks wide range of photographic materials.

Morris Photographic

Unit 9, Worcester Road Industrial Estate, Chipping Norton, OX7 5XW T 0845 430 2030 F 01865 793113 E sales@morrisphoto.co.uk W www.morrisphoto.co.uk Suppliers of broad range of photography equipment, projectors and digital imaging

MXV Photographic

equipment and accessories.

Hempstead Rise, Uckfield, TN22 1QX T 01825 761940 F 01825 761950 E sales@mxvphotographic.com W www.mxvphotographic.com

Dealer in high-quality second-hand cameras and photography supplies.

OldTimerCameras.com

24 Market Place, Hatfield, AL10 0LN T 01707 273773

E sales@otcworld.co.uk W www.otcworld.co.uk

Established with aim of supplying manuals/ instructions for every camera and accessory ever made.

Palm Laboratory (Midlands) Ltd

69 Rea Street, Birmingham, B5 6BB

T 0121 6225644

W www.palmlabs.co.uk

Established in 1983 as a photographic laboratory for the professional photographer, but also caters for the enthusiast, amateur or student who appreciates a personal and professional approach to their photographic needs.

Park Cameras Ltd

York Road, Victoria Business Park, Burgess Hill, **RH159TT**

T 01444 237070

F 01444 245319

E sales@parkcameras.com

W www.parkcameras.com

Established over thirty-five years ago, supplying general photographic equipment from large new showroom in South West England.

Paterson Photographic Ltd (UK)

4 Malthouse Road, Tipton, DY4 9AE

T 0121 5204830 F 0121 5204831

E sales@patersonphoto.co.uk

W www.patersonphotographic.com

Known for the quality darkroom equipment it manufactures in the UK. In the late 80s it also took over the manufacture of Benbo Tripods and has continued to develop the range.

Photo Plus

14 High Street, Tibshelf, Alfreton, DE55 5NY T 01773 875627 E photoplus@photoplus-uk.co.uk W www.photoplus-uk.co.uk Online suppliers of photographic and imaging equipment.

PhotoArtistry Ltd

St Peters Way, Northampton, NN1 1SZ T 01604 700608 F 01604 763834 E info@photoartistry.co.uk W www.photoartistry.co.uk Provides an online digital printing service to artists and photographers using novelty printing techniques.

Positive Images (UK Ltd)

44 Wates Way, Mitcham, CR4 4HR T 020 85445500 F 020 83321932 E enquiry@positiveimages.co.uk W www.positivemages.co.uk Photographic studio and processing laboratory, relocated to Surrey from Richmond, London.

Potosi Ltd

Unit 23, Cremer Business Centre, 37 Cremer Street, London, E28HD T 020 77295353 A photographic printworks, specializing in black

Process Supplies (London) Ltd

13-25 Mount Pleasant, London, WC1X OAR T 020 78372179 F 020 78378551 E sales@process-supplies.co.uk W www.process-supplies.co.uk Contact Neil Willes, Paul Willes Established in 1928. Family-run business, offering

a specialized supply service for all conventional

and digital photographic materials, including films, papers, chemicals, archival storage pockets, leather portfolios, CDs and DVDs etc.

Rapid Eye

79 Leonard Street, London, EC2A 4QS

T 0871 8731257

E hire@rapideye.uk.com

W www.rapideye.uk.com

Opened in 1996 as an affordable colour print darkroom, where photographers could experiment with ideas and techniques. Services offered now include bespoke hand printing, and film processing and proofing, a mini lab service providing film-to-digital and digital-to-print solutions, high-end film and print scanning, retouching services and inkjet printing. Also rents out an Imacon 848 film scanner by the hour.

Resolution Creative

204 Latimer Road, London, W10 6QY

T 020 89697333

F 020 89697444

E info@resolveandcreate.eu

W www.resolveandcreate.eu

Offers extensive range of photographic and digital supplies and services.

Retro Photographic

Hollybush Cottage Barn, Candy, Nr Oswestry, **SY109BA**

T 0845 2262647

E info@retrophotographic.com

W www.retrophotographic.com

Specialists in black and white photographic supplies.

Richards of Hull

Unit I, Acorn Estate, Bontoft Avenue, Hull,

HU5 4HF

T 01482 442422

F 01482 442362

E sales@richards.uk.com

W www.richards.uk.com

Manufacturers of darkroom and processing equipment.

Robert White

Unit 4, Alder Hills Industrial Estate, 16 Alder Hills, Poole, BH12 4AR

T 01202 723046

F 01202 737428

E sales@robertwhite.co.uk

W www.robertwhite.co.uk

Sell and distribute extensive selection of photographic equipment.

Sameday Snaps - Mitcham Arts

256 London Road, Mitcham, CR4 3HD

T 020 86850010

F 020 86408666

E samedaysnaps@mitchamarts.fsnet.co.uk

Contact Vijay

Specializes in digital imaging, printing on a variety of media, from photographic paper to canvas, from miniature to poster size. In-house picture-framing and stretching of canvas provided.

Second Hand Darkroom Supplies

The Old Manse, The Ridings, Leafield, OX29 9NN

T 01993 878323

F 01993 878200

E sales@secondhanddarkroom.co.uk

W www.secondhanddarkroom.co.uk

Sells range of new and pre-owned darkroom equipment and supplies.

Sigma Imaging (UK) Ltd

13 Little Mundells, Welwyn Garden City, AL7 1EW

E sales@sigma-imaging-uk.com

W www.sigma-imaging-uk.com

Family-owned business, distributing high-quality lenses and cameras.

Tapestry MM Ltd

51-52 Frith Street, London, W1D 4SH

T 020 78963000 / 78963103

F 020 78963109

E info@tapestrymm.com

W www.tapestrymm.com

Established in 1972. An independent creative services company with wide experience of

photographic services.

Transpacolor Ltd

90 Commercial Square, Freemans Common,

Leicester, LE2 7SR

T 0116 2550726

W www.transpacolor.com

Founded over twenty-six years ago, aiming to provide a one-stop solution for photographic and digital imaging needs.

The Vault

1 Dorset Place, Brighton, BN2 1ST

T 01273 688733

E info@thevaultimaging.co.uk

W www.thevaultimaging.co.uk

Offers professional-standard photographic digital imaging services.

Warehouse Express

Unit B. Frenbury Estate, Norwich, NR6 5DP T 01603 481933 / 486413 F 01603 258950 E Sales@warehouseexpress.com

W www.warehouseexpress.com

Founded in 1997 for the professional and enthusiast. Retails extensive range of photographic equipment.

Zoom In Photography

Clapham Leisure Centre, Clapham Manor Street, London, SW4 6DB

T 020 77207437

E info@zoom-in.org

W www.zoom-in.org

Offers courses on using your camera. Also has a gallery space.

Printers and printing

107 Workshop

The Courtyard, Bath Road, Shaw, Melksham, **SN128EF**

T 01225 791800

F 01225 790948

E 107w@shirrett.demon.co.uk W www.107workshop.co.uk

Established in 1976, with 7,000 sq. ft of fully equipped studio space designed to enable artists to create an environment suitable to their own individual specifications. Processes available include multiplate-printing using copper, carborundum, liftground, aquatint, handpainting, relief woodcut and mono-printing. Artists include Ayers, Hodgkin, Hughes, Aitchison, Heindorf and Ackroyd. Livres d'artiste by Howard Hodgkin, Kidner and Hayter.

Abacus (Colour Printers) Ltd

Lowick House, Lowick, nr Ulverston, LA12 8DX T 01229 885361

F 01229 885348

E sales@abacusprinters.co.uk

W www.abacusprinters.co.uk

The company has been established in Cumbria for twenty years. Specializes in turning artists' images into print. Offers high-quality 'waterless' offset printing of postcards, greetings cards, folders, posters, catalogues, calendars, limited-edition

prints and giclèe prints. Potential customers should contact for a free sample pack.

Advantage Printers

Unit C3, Newtown Estate, Coolock Industrial Estate, Dublin 17 T oi 8476711

F of 8484433

E artroom@advantageprinters.ie

W www.advantageprinters.ie

Established in 1969, offering wide range of printing services, including digital and screen printing.

Art Marketing Ltd

Unit 3, Redbourn Industrial Park, High Street, Redbourn, nr St Albans, AL3 7LG

T 01582 794541 F 01582 792664

E sales@artmarketing.co.uk

W www.artmarketing.co.uk

Contact The Design Manager

A family company formed in 1980, developing trading relationships with major high-street retailers as well as 1,500 independent galleries and lifestyle and home-interior stores. Employs and publishes artists working on open edition, original or limited-edition bases and supplies products in many formats. Aims to develop and encourage artists to identify popular furnishing colour trends and themes to maximize their success.

ArtChroma

P.O. Box 627, Portsmouth, PO6 2WZ

T 0777 9325222

E info@artchroma.com

W www.artchroma.co.uk

Contact Roland Clarke

Giclée printer providing services for artists, photographers, galleries and fine-art publishers. Specializes in printing onto fine-art paper or canvas, and large-format poster printing.

Artline Media

Gloucester Place, Briston, Melton Constable, NR24 2LD

T 01263 860103

F 01263 860138

E phillip@artlinemedia.co.uk

W www.artlinemedia.co.uk

Contact Phillip Round

Established for thirty years. Original roots were in the photographic industry before moving over completely to digital technology. Supplies

high-quality prints up to A3-size, plus low runs, including calendars, greetings cards, postcards, notelets and up to A1-size giclée prints. Also has an online art gallery where customers can sell cards, prints and original artwork.

Beaver Lodge Prints Ltd

Units 25–26 Broomhills Industrial Estate, Braintree, CM7 2RW

T 01376 552558

F 01376 553881

E sales@beaverlodgeprints.co.uk

W www.beaverlodgeprints.co.uk

Contact James Arnold

A print-distribution company for over twelve years, sourcing artists of modern and contemporary art work to be published. Works on behalf of publishers in Germany, Italy and the USA.

Black Church Print Studio

4 Temple Bar, Dublin 2

T oi 6773629

F oi 6773676

E info@print.ie

W www.print.ie

Not-for-profit fine art print studio established in 1982. Dedicated to the provision of a professional workspace for its members, the studio provides facilities for artists working in intaglio, lithography, screenprint, relief and digital media. Also offers a regular schedule of courses for both beginner and advanced students in all areas of printmaking.

Price range Full membership costs €484.

Broad Oak Colour Ltd

Units A&B 254 Broad Oak Road, Canterbury, CT2 7QH

T 01227 767856

F 01227 762593

E enquiries@broadoakltd.co.uk

W www.broadoakltd.co.uk

Contact Simon Young or Terry Tilbury
Colour printers for twenty-three years, produc

Colour printers for twenty-three years, producing limited-edition prints on Bockingford paper, etc.

CanvasRus

Ladds House, Old Otford Road, Sevenoaks, TN14 5EZ

T 01732 454092

E sales@canvasRus.co.uk

W www.canvasRus.co.uk

A leading specialist in the manufacture and supply of contemporary digital printed canvas art.

Colorworld Imaging

PO Box 2, Norham Road, North Shields, NE29 0YQ

T 0191 2596926

F 0191 2576948

E enquiries@colorworldimaging.co.uk

W www.colorworldimaging.co.uk

Offers wide range of film processing and printing services, both traditional and digital.

Cork Printmakers

Wandesford Quay, Clarke's Bridge, Cork

T 021 4322422

E info@corkprintmakers.ie

W www.corkprintmakers.ie

Set up in 1991 to support artists working in the medium of print. Offers open access workshop (equipment and materials) to artists specializing in fine art printmaking, extensive education programme and promotion of artists' work through sales and exhibitions.

Dayfold Solvit

27 Black Moor Road, Ebblake Industrial Estate, Verwood, BH31 6BE

T 01202 827141

F 01202 825841

E mark@dayfold.com

W www.dayfold.com

Contact Mark Smith

Founded in 1979. A fine-art lithographic printer specializing in the production of high-quality limited-edition prints and promotional material, including show catalogues and leaflets.

DesignerPrint

8 Stafford Road, Southampton, SO15 5EA

T 023 80333564

F 023 80333564

E info@designerprint.co.uk

W www.designerprint.co.uk

Contact Peter Horner

Company specializing in printing images onto canvas, block-mounting and poster-printing.

Digital Print Studio

The Finsbury Business Centre, 40 Bowling Green Lane, London, EC1R ONE

T 07790 368 554

E info@dprints.co.uk

W www.dprints.co.uk

Contact Andrew Turnbull MA (RCA)

Digital print studio run by artist Andrew Turnbull MA(RCA), who has over ten years' experience in digital and traditional printmaking. Producing high quality, archival giclée digital prints for artists, photographers and illustrators using the latest large format printers and visual software.

Dolphin Fine Art Printers

37 Nuffield Road, Nuffield Estate, Poole, BH17 0RA

T 01202 673048 F 01202 661500

E info@dolphin-printers.co.uk

W www.dolphin-printers.co.uk

Founded in 1970, producing open- and limitededition prints and giclée. Specializes in offering guidance for those starting out.

East London Printmakers

SPACE, The Triangle, 129 Mare Street, Hackney, London, E8 3RH

T 020 85254330 (SPACE Studios)

E info@eastlondonprintmakers.co.uk

W www.eastlondonprintmakers.co.uk

Contact Nick Morley (Studio Manager)

A group of artist-printmakers, formed in 1998, running a spacious, modern printmaking studio with open access. Facilities for water-based screenprinting, copper and zinc etching, intaglio printing, rosin aquatint, relief printing and fabric printing. The studio is used by rent-paying keyholders, who have twenty-four-hour access, and by open-access users who pay per session. ELP run workshops in various printmaking techniques at all levels. Non-studio members (£30/£15 per year) can attend talks and meetings and participate in exhibitions.

Price range £60 per month for 24-hour access and £12 or £15 for 3- or 4-hour open-access sessions.

Eyes Wide Digital Ltd

The Old Coach House, Unit I, Charman Road, Redhill, RH1 6AH

T 01737 780789

F 01737 780987

E info@eyeswidedigital.com

W www.eyeswidedigital.com

Contact Ian Ingle

Specializes in bespoke canvas printing.
Reproduces fine art onto canvas or art paper for artists and galleries throughout Europe. Images can be supplied in print format, as negatives or transparencies, or as a digital file through email or on CD.

Gemini Digital Colour Ltd

North Road, Bridgend Industrial Estate, Bridgend, CF31 3TP

T 01656 652447

F 01656 661266

E info@geminidigitalcolour.co.uk

W www.geminidigitalcolour.co.uk

Contact Dominic Lee

Fine-art printers, specializing in print-on-demand, giclée and short-run printing from postcards to limited-edition canvases and prints. Offers personal advice and assistance to the amateur and professional artist alike.

Genesis Imaging Ltd

Unit I, Hurlingham Business Park, Sulivan Road, London, SW6 3DU

T 020 73846299

F 020 73846277

E sales@genesis-digital.net

W www.genesis-digital.net

Contact Lynda Blackwell

A photographic processing and printing company offering a full range of services; from large format fine art and giclée photographic prints and finishing to digital imaging, large format display graphics, film processing and printing, scanning and retouching.

Graal Press

Eskhill Cottage, Roslin, Midlothian, EH25 9QW **T** 0131 440 2589

E graalpress@btinternet.com

W www.graalpress.com

Contact Robert Adam or Carol Robertson A fine-art print studio founded in 1998 in a rural location eight miles from Edinburgh city centre. Specializes in collaborative projects and innovative approaches to printmaking using media such as artist's water-based paints for screenprinting, acrylic-resist etching and recently developed tusches for light-sensitive processes. Courses are available in progressive and safer printmaking methods as well as in personal and artistic development. Robert Adam and Carol Robertson are the authors of Screenprinting: The Complete Water-Based System (Thames & Hudson 2004) and Intaglio: The Complete Safety-First System for Creative Printmaking (Thames & Hudson 2007).

The Hermit Press

Liverpool

E info@thehermitpress.com

W www.thehermitpress.com

Produces prints for artists, photographers, galleries, artist's agents etc. with no restriction on the size of order. Use digital technology coupled with light fast pigment inks and natural, acid-free papers or canvas for long-lasting, high-quality prints up to 44 inches wide.

Hole Editions

Unit 12, Mushroom Works, St Lawrence Road, Newcastle-upon-Tyne, NE6 1AR

T 0191 2243449

E info@holeeditions.co.uk

W www.holeeditions.co.uk

Contact Lee Turner

Founded in 2005 by Master Printer Lee Turner, specializing in collaborative hand lithography. Producing original lithographs from stones, plates and photo plates. Work undertaken is either in the capacity of publisher or as contract printer. Monotype sessions are available.

Hot Chilli Studio

Cockport Farm, Otterham, Camelford, PL32 9SS

T 0845 2269331

E info@hotchillistudio.co.uk

W www.hotchillistudio.co.uk

Contact Julia Phillips

Supplier of high quality wide-format fine art printing, postcards, business cards and stationery. Uses fine art papers and lightfast, pigment based inks. Latest digital print technology allows reproduction of images to any size (dependent on image quality) up to 44" wide × 100' long. Extensive range of quality media from fine art papers to canvas. All work is quoted for on an individual basis.

Hudson Killeen

130 Slaney Road, Dublin Industrial Estate, Glasnevin, Dublin 11

T 01 8306128

F 01 8306993

E print@hudsonkilleen.ie

W www.hudsonkilleen.ie

Lithographic printers.

imagiclee.com

48 Wynford Terrace, Leeds, LS16 6HY

T 0113 274 4954

E printit@imagiclee.com

W www.imagiclee.com

Contact Peter Learoyd

Produces museum-quality fine art giclée prints from original artwork, scans, photographs and digital files. Prints only with light-fast archival

pigmented inks on to a wide range of materials from watercolour papers and canvases to poster and photographic papers. Also helps customers to sell their prints by providing space in an online gallery at shopforprints.com.

J. Thomson Colour Printers Ltd

14 Carnoustie Place, Glasgow, G5 8PB

T 0141 4291094

F 0141 4295638

E production@jtcp.co.uk

W www.jtcp.co.uk

Specialists in lithographic fine-art reproduction and high-quality scanning from transparencies. Over fifty years' experience in the production of fine-art prints, catalogues, brochures, fine-art books and fine-art cards.

Leicester Print Workshop

50 St Stephen's Road, Highfields, Leicester, LE2 1GG

E info@leicesterprintworkshop.com

W www.leicesterprintworkshop.com

Contact Angela Harding - Director Artist-led organization providing facilities and equipment to artists and those interested in printmaking. Equipped for etching, lithography, screenprinting, relief printing, framing and mounting. Studio space available on the upper levels.

Price range $f_{60}-f_{120}$

Limerick Printmakers

4 Robert Street, Limerick

T 061 311806

E limprintmakers@eircom.net

W www.limerickprintmakers.com

Fine art printmaking studio and gallery.

London Print Studio

425 Harrow Road, London, W10 4RE

T 020 89693247

F 020 89640008

E info@londonprintstudio.org.uk

W www.londonprintstudio.org.uk An independent, not-for-profit arts organization providing low-cost training and access to artists' print and graphic arts facilities. The studio has a printmaking studio with facilities for screenprinting, etching, blockprinting and lithography, a computer facility with computers, scanners and printers, and a large-format digital printing service. Also incorporates gallery with a changing programme of exhibitions and events.

Services offered include an MA in Printmaking & Professional Practice, various education and training programmes, and editioning. Use of facilities open to artists, community organizations, members of the general public and anyone interested in art.

Price range Studio hire from $f_{1.56}$ per hour.

Loudmouth Art Eco-Printing

5 Hendon Street, Sheffield, S13 9AX

T 0845 2309805

F 0114 2880044

E info@loudworld.co.uk

W www.loudworld.co.uk

Contact Paul Jenkinson

Design-led printer specializing in producing quality print for the arts and crafts industries for over twenty years. Business cards, artists cards, private view cards, eco-bags, brochures, catalogues, exhibition printing, banners etc. No minimum quantity. 500 quality postcards cost f_{59} . Turnaround from 24 hours. Call for free 400gsm samples or visit website.

Mark Harwood Photography / LocaMotive

12 The Waterside, 44-48 Wharf Road, London, **N17SF**

T 020 74908787

F 020 74901009

E mail@markharwood.plus.com

W www.markharwoodstudio.co.uk / www.

locamotive.co.uk

Contact Mark Harwood

A multi award-winning photographer offering original photography, in-house scanning and fineart printing up to very large sizes. Photographic tuition and support for artists and creative projects also available.

Price range Studio rented out on daily basis for photographers. See www.locamotive.co.uk for prices.

Mat Sant Studio

47 Great Western Studios, Paddington (New) Yard, Great Western Road, London, W9 3NY

T 07754 702090

E mat@matsant.com

W www.matsant.com

Contact Mat Sant

Fine art printing for artists and galleries. Large and grand format giclée printing, silkscreen and copper plate printing. Central/West London location. Mat Sant MA (RCA)is also a practising artist, living and working in London.

Metro Imaging Ltd

32 Great Sutton Street, London, EC1V 0NB T 020 78650000 F 020 78650001 E comments@metroimaging.co.uk W www.metroimaging.co.uk Contact Michael Mardon Specialists in professional hand and digital photographic prints.

New North Press

Standpoint Studios, 45 Coronet Street, London,

T 020 77293161

F 020 77293161

E graham.bignell@talk21.com

W www.new-north-press.co.uk

Contact Graham Bignell

Founded in 1985, specializing in the editioning of linocuts, woodcuts and wood engravings and editions of letter press artist's books. The studio has a broad range of types available for small editions.

Newnum Art

29 Oxford Road, Worthing, BN11 1UT

T 01903 821191

F 01903 820507

E enquiries@newnumart.co.uk

W www.newnumart.co.uk

Contact Mandy Newnum

Founded in 2001 as an offshoot of a litho and digital-printing company and consequently has considerable print expertise. Specializes in giclée printing as well as conventional litho and waterless litho using a Heidelberg DI press.

Price range Studio of 600 sq. ft available for hire from £75.

Oberon Art Ltd

67 High Street, Burnham, SL1 7JX T 01628 600500

E sales@oberonart.co.uk

W www.oberonart.co.uk

Contact Susie Lipman

An artist-run fine art publishing company, supplying limited-edition prints by selected artists. Provides a high quality, giclée printing service. Also runs a gallery exhibiting original paintings and prints by local and national artists alongside hand-made ceramics, sculpture, blown and cast glass and greeting cards. A bespoke picture framer is resident in the workshop at the rear and is a member of the Fine Art Trade Guild.

Paulsharma.com

91 Blackheath Park, London, SE3 0EU

E enquires@paulsharma.com

W www.paulsharma.com

Contact Paul Sharma

Founded in 2002. Offers high-quality limitededition prints for the home or office.

Peak Imaging

FREEPOST RLSY-YZJX-SLXC, Sheffield, S20 3PP

T 0870 126 6100

F 0114 2243205

E info@peak-imaging.com

W www.peak-imaging.com

Contact Wayne Gledhill

A full service lab, with twenty-five years in the industry. Leading mail order pro-am photographic laboratories. From film processing to digital printing, mounting and framing. Call for a welcome pack.

Pratt Contemporary Art and Pratt Editions

The Gallery, Ightham, Sevenoaks, Kent, TN15 9HH

T 01732 882326

F 01732 885502

E pca@prattcontemporaryart.co.uk

W www.prattcontemporaryart.co.uk

Contact Bernard Pratt or Susan Pratt

Printers, publishers and dealers, founded in 1977. Alongside a regular publishing programme, the studios also provide an editioning service to artists and galleries. Working in close collaboration with a master printer, artists are given time to fully explore and experiment with the various processes available, including screenprinting, intaglio, relief and large-format digital printing. Gallery open by appointment.

Press On Digital Imaging

Unit 17 Lakeside Park, Neptune Close, Medway City Estate, Rochester, ME2 4LT

T 0845 0450335

F 01634 716604

E enquiries@presson.biz

W www.presson.biz

Specialists in large format digital printing for hoardings, banners, exhibition display stands and outdoor advertising.

Printmaker Studio

14 Rowallan Close, Caversham, Reading, RG4 6QS T 0118 9461964

E enquiries@printmaker.co.uk

W www.printmaker.co.uk

Contact Chris Mercier

A silkscreen and giclée editioning studio founded in 1990. Specializes in screenprinting projects and editioning for artists and printmakers. Also offers a large-format digital giclée printing service for digital art work and reproductions.

The Printrooms

194 Brick Lane, London, E1 6SA

T 020 77399923

E ian@theprintrooms.co.uk

W www.theprintrooms.com

Ian Cartwright has been producing fine art prints for well-known artists and galleries for the past 25 years. Specializes in Piezo pigment prints for exhibitions, print editions, books and portfolios.

Prism Proofing

Unit 28 School Close, Chandlers Ford, Eastleigh, SO53 4RA

T 02380 266256

F 02380 266256

E stewart.goldsmith@ntlworld.com

Contact Ian Goldsmith

A lithographic reprographics and printing company founded in 1991. Reproduces originals from A5 cards up to large B1 posters. Sample pack available and advice given.

Redfoxpress

Dugort, Achill Island, County Mayo
E info@redfoxpress.com

W www.redfoxpress.com

Specializes in screen printing and artist's books.

Reggie Hastings

Grennan Mill, Mill Street, Thomastown, County Kilkenny

T 056 7754050

F 087 2236376

E cartoltd@eircom.net

Founded in 2000 as a large format giclée printing facility for artists wanting to edition their prints. Artists include Gottfried Heluwein, Peter Curling and Francis Tansey. Offers full photographic and printing services. A full graphic design service is also provided, plus a library of imaging for clients to draw from.

Reprotech Studios Ltd

22 Trinity Lane, Micklegate, York, YO1 6EL

T 01904 644006

F 01904 611264

E repstudios@aol.com

Contact John Hall

Founded in 1986, specializing in digital printing and fine-art reproduction. Produces limitededition giclée prints onto watercolour paper and canvas.

St Ives Printing & Publishing Co.

High Street, St Ives, TR26 1RS

T 01736 795813 F 01736 795813

E toni@stivesnews.co.uk

W www.stivesnews.co.uk

Contact Mr Toni Carver (Proprietor)

A printer and publisher of a local newspaper and books, founded in 1951. Offers a range of services for artists, including fine-art lithographic prints and photo-litho reproductions, private-view invitations, greeting cards, catalogues and fine-art photographs.

Stoney Road Press

Stoney Road, Dublin 3

T of 8878544

E info@stoneyroadpress.com

W www.stoneyroadpress.com

A fine art publishing and editioning house, collaborating with artists on limited-edition prints in traditional and experimental media. Also provides editioning services to professional printmakers.

Think Ink Ltd

11-13 Philip Road, Ipswich, IP2 8BH

T 01473 400162

F 01473 400163

E charles@think-ink.co.uk

W www.think-ink.co.uk

Specializes in the production of printing for artists, e.g. greeting cards, postcards, private view cards, giclée prints.

Wall Candi Ltd

High Street, Lane End, High Wycombe, HP14 3JG

T 01494 883250

F 01494 881826

E info@wallcandi.com

W www.wallcandi.com

Contact Ionathan Burns

Specializes in giclée digital fine-art reproduction. Uses state-of-the-art giclée and colour management technology and prints onto a variety of media, producing archival quality prints. Other services include a professional in-house

photographic studio for capturing original art work digitally or onto traditional transparency film. Member of the Fine Art Trade Guild.

West Yorkshire Print Workshop

75a Huddersfield Road, Mirfield, SF14 8AT

T 01924 497646

E info@wypw.org

W www.wypw.org

An open access printmaking facility that supports artists and creative businesses by providing printmaking facilities, affordable studio spaces and exhibiting opportunities for members.

Publishers

A&C Black Publishing

36-38 Soho Square, London, W1D 3QZ

T 020 77580200

W www.acblack.com

Founded in 1807. Subject areas include visual arts, glass, ceramics and printmaking.

Anova Books Group Ltd

The Old Magistrates Court, 10 Southcombe Street,

London, W14 0RA

T 020 76051400

F 020 76051401

E customerservices@anovabooks.com

W www.anovabooks.com

Founded in 2005. Independent publishing company with established publishing imprints including Batsford, Collins & Brown, Conway, Pavilion, Robson and Salamander, plus newer publishing ventures such as Portico and National Trust Books.

Antique Collectors' Club

Sandy Lane, Old Martlesham, Woodbridge,

IP124SD

T 01394 389950

F 01394 389999

E sales@antique-acc.com

W www.antiquecollectorsclub.com

Publishes and distributed specialist books on antiques, the decorative arts, gardens and architecture.

Art Data

12 Bell Industrial Estate, 50 Cunnington Street, London, W45HB

T 020 87471061

F 020 87422319

E orders@artdata.co.uk

W www.artdata.co.uk

Contact Tim Borton

Established in 1978, primarily to distribute books and catalogues of contemporary visual arts (fine art, sculpture, architecture, photography, design, illustration and fashion). Handles over five thousand titles and sells throughout the world. Also produces about six titles of its own a year.

Art Sales Index Ltd

1st Floor, 54 Station Road, Egham, TW20 9LF

T 01784 473136

F 01784 435207

E info@art-sales-index.com

W www.art-sales-index.com

Founded in 1968 to record the price and details of works of fine art sold at auction to help collectors and dealers to value art. The database has over 3.3 million entries and is available in book form, on CD-ROM and on the web.

Ashgate Publishing Ltd

Wey Court East, Union Road, Farnham, GU9 7PT

T 01252 331551

F 01252 736736

W www.ashgate.com

Scholarly monographs in visual studies.

Ashmolean Museum Publications

Ashmolean Museum, Beaumont Street, Oxford, OX1 2PH

T 01865 278010

F 01865 278016

W www.ashmolean.org/services/publications Publishes widely on fine and applied arts.

Bardon Enterprises

6 Winter Road, Southsea, PO4 9BT

W www.bardon-music.com

Specializes in books about art and music.

Black Dog Publishing

10A Acton Street, London, WC1X 9NG

T 020 77135097

F 020 77138682

E info@blackdogonline.com

W www.blackdogonline.com

Specializes in books on contemporary art, architecture, design and photography.

Blackwell Publishing

9600 Garsington Road, Oxford, OX4 2DQ T 01865 776868

F 01865 714591

E customerservices@oxon.blackwellpublishing.com

W www.blackwellpublishing.com

A humanities and social sciences publisher with an art and theory list. Longstanding relationships with the journals Art History and The Art Book. Edinburgh office at 100 George Street, Edinburgh EH2 3ES T: 0131 2267232. Offices across Europe.

Book Works Publishing

19 Holywell Row, London, EC2A 4JB

T 020 72472203

F 020 72472540

E mail@bookworks.org.uk

W www.bookworks.org.uk

A publicly funded contemporary visual arts publisher, dedicated to distributing significant and cutting-edge work to a wide audience.

Brepols Publishers

Begijnhof 67, B-2300 Turnhout (Belgium)

E info@brepols.net

W www.brepols.net/publishers

Belgian academic publisher of monographs and collections across the humanities. Its imprint, Harvey Miller Publishers, specializes in academic studies of medieval and Renaissance art history.

British Museum Press

38 Russell Square, London, WC1B 3QQ

T 020 73231234

F 020 74367315

W www.britishmuseum.co.uk

Founded in 1973. Publishes around sixty books each year.

BT Batsford

Anova Books Group Limited, The Old Magistrates Court, 10 Southcombe Street, London, W14 0RA

T 020 76051400

F 020 76051401

E customerservices@anovabooks.com

W www.anovabooks.com

An Anova Books Group imprint, formerly an imprint of Chrysalis Books. Produces a range of practical books for artists.

Cambridge University Press

The Edinburgh Building, Shaftesbury Road, Cambridge, CB2 8RU

T 01223 312393

F 01223 315052

E information@cambridge.org

W www.cambridge.org/uk

The oldest printing and publishing house in the world, with an extensive art and architecture backlist.

Collins and Brown

Anova Books Group Limited, The Old Magistrates Court, 10 Southcombe Street, London, W14 0RA

T 020 76051400 F 020 76051401

E customerservices@anovabooks.com

W www.anovabooks.com

An Anova Books Group imprint, (formerly a Chrysalis Books imprint). Publishes high-quality practical art books for those keen to improve their techniques or broaden their specialities. Authors include John Raynes and Albany Wiseman.

Constable & Robinson Ltd

3 The Lanchesters, 162 Fulham Palace Road, London, W6 9ER

T 020 87413663 F 020 87487562

E enquiries@constablerobinson.com

W www.constablerobinson.com

Contact Max Burnell

A general trade publisher with several landscape photography titles.

David & Charles

Brunel House, Forde Close, Newton Abbot, TQ12 4PU

T 01626 323200 F 01626 323319

E postmaster@davidandcharles.co.uk

W www.davidandcharles.co.uk

An international publisher of illustrated nonfiction books, including practical instruction books on art techniques. Also the distributor in UK and Europe of North Light art instruction books, and of Dover Publications, including their range of books of copyright-free range images.

Dorling Kindersley Ltd

The Penguin Group (UK), 80 Strand, London, WC2R ORL

T 020 70103000

F 020 70106060 W www.dk.com

An international publisher of highly illustrated books, with a specialist arts and culture list.

Enitharmon Editions Ltd

26b Caversham Road, London, NW5 2DU T 020 74825967 F 020 72841787

E books@enitharmon.co.uk

W www.enitharmon.co.uk

Contact Stephen Stuart-Smith

Established in 2001 as an associated company of Enitharmon Press (founded in 1967). Specialist publisher of artists' books, commissioning collaborations between artists and writers, which take the form of deluxe books incorporating original art works.

Focal Press (an imprint of Elsevier)

Linacre House, Jordan Hill, Oxford, OX2 8DP

T 01865 474010

E focalquestions@elsevier.com

W www.focalpress.com

A leading publisher for quality technical information and practical instruction in media technology, with many titles becoming standard texts for students and professionals. Subject areas include: photography, digital imaging, graphics, animation, gaming, film, television, video, digital media, broadcast technology, communications, journalism, new media, audio, theatre and live performance.

Four Courts Press

7 Malpas Street, Dublin 8

T 01 4534668

F 01 4534672

E info@four-courts-press.ie

W www.four-courts-press.ie

Leading academic publisher founded in 1970. Publishes around seventy titles per year, with an important arts list.

Frances Lincoln Ltd

4 Torriano Mews, Torriano Avenue, London, NW5 2RZ

T 020 72844009

F 020 74850490

E reception@frances-lincoln.com

W www.franceslincoln.com

Publishes highly illustrated non-fiction, including art and design books.

Garnet Publishing / Ithaca Press

8 Southern Court, South Street, Reading, RG1 4QS

T 0118 9597847

F 0118 9597356

E info@garnetpublishing.co.uk

W www.garnetpublishing.co.uk

Contact Emma G. Hawker

Independent publishers, producing some art and architecture titles.

Giles de la Mare Publishers Ltd

P.O.Box 25351, London, NW5 1ZT

T 020 74852533 F 020 74852534

E gilesdelamare@dial.pipex.com

W www.gilesdelamare.co.uk

Began publishing in 1995. Publishes mainly nonfiction, especially art and architecture, biography, music, travel and current affairs.

Golden Cockerel Press Ltd

16 Barter Street, London, WC1A 2AH T 020 74057979

F 020 74043598

E aup.uk@btinternet.com

An academic publisher with list of art titles.

Guild of Master Craftsman Publications Ltd

166 High Street, Lewes, BN7 1XU

T 01273 477374

W www.thegmcgroup.com

Contact Liz Clarke

A publisher and distributor of over 1,000 craft books and magazines.

Halsgrove Publishing

Halsgrove House, Ryelands Industrial Estate, Bagley Road, Wellington, TA1 9PZ

T 01884 653777

F 01884 216796

E sales@halsgrove.com **W** www.halsgrove.com

Contact Simon Butler

A publisher of books about art and artists, specializing in illustrated studies of individual artists and on books with a regional content. Often works with galleries and their artists to create publications to coincide with exhibitions.

Harvard University Press

Fitzroy House, 11 Chenies Street, London, WC1E 7EY

T 020 73060603

F 020 73060604

E info@HUP-MITpress.co.uk

W www.hup.harvard.edu

Produces scholarly books and serious works of general interest.

Hilmarton Manor Press

(Who's Who in Art), Hilmarton Manor, Calne, SN11 8SB

T 01249 760208

F 01249 760379

W www.hilmartonpress.co.uk

Contact Charles Baile de Laperriere

The first edition of Who's Who in Art was published in 1927 and every two years thereafter. Hilmarton Manor Press, founded in 1969,

specializes in the publishing and distribution of fine art and art reference books.

I.B.Tauris & Co. Ltd

6 Salem Road, London, W2 4BU

T 020 72431225

F 020 72431226

W www.ibtauris.com

An independent publishing house, producing both general and academic titles. Operates strong lists in art, architecture and visual culture.

Irish Academic Press

44 Northumberland Road, Dublin 4

T 020 89529526

F 020 89529242

E info@iap.ie

W www.iap.ie

Long-established Dublin-based publisher of high quality books of Irish interest. Publishing programme includes history, literature, arts and the media, and women's studies.

Koenig Books London

The Serpentine Gallery, Kensington Gardens, London, W2 3XA

T 020 77064907

F 020 77064911

E info@koenigbooks.co.uk

W www.koenigbooks.co.uk

The UK art-book imprint of Buchhandlung Walther Koenig in Cologne.

Laurence King Publishing Ltd

4th Floor, 361-373 City Road, London, EC1V 1LR

T 020 78416900

F 020 78416910

E info@laurenceking.com

W www.laurenceking.com

Publisher of illustrated books. Specialist in graphic design, contemporary architecture, fashion, illustration, interiors, photography and art history for the student, professional and general reader.

The Lilliput Press

62-63 Sitric Road, Arbour Hill, Dublin 7

T oi 6711647

F 01 6711233

E info@lilliputpress.ie

W www.lilliputpress.ie

Founded in 1984, and has published around 150 titles, with a strong art and architecture list.

Liverpool University Press

4 Cambridge Street, Liverpool, L69 7ZU

T 0151 7942233

F 0151 7942235

E J.M.Smith@liv.ac.uk

W www.liverpool-unipress.co.uk

Publishes academic books and journals on a range of subjects including art and architecture.

Lund Humphries

Sardinia House, 51–52 Lincoln's Inn Fields, London, WC2A 3LZ

T 020 74407530

F 020 74407545

E info@lundhumphries.com

W www.lundhumphries.com

Contact Lucy Clark (Commissioning Editor) at

lclark@lundhumphries.com

Illustrated artist monographs and exhibition catalogues.

Mainstream Publishing

7 Albany Street, Edinburgh, EH1 3UG

T 0131 5572959

F 0131 5568720

E enquiries@mainstreampublishing.com

W www.mainstreampublishing.com

Contact Bill Campbell

Founded in 1978. A publisher of a wide-ranging general list including art, photography and popular culture.

Manchester University Press

Oxford Road, Manchester, M13 9NR

T 0161 2752310

F 0161 2743346

E mup@manchester.ac.uk

W www.manchesteruniversitypress.co.uk Includes a programme of paperbacks in art history and design.

Marston House

Marston Magna, Yeovil, BA22 8DH

T 01935 851331

F 01935 851372

Publishes on fine art, architecture and ceramics.

Merrell Publishers

42 Southwark Street, London, SE1 1UN

T 020 74032047

F 020 74071333

E mail@merrellpublishers.com

W www.merrellpublishers.com

Publishers of books on all aspects of visual culture, from key titles on major artists to surveys of international architecture and explorations of cutting-edge developments in world design.

National Portrait Gallery Publications

St Martins Place, London, WC2H 0HE

T 020 73060055

F 020 73216657

E sellis@npg.org.uk

W www.npg.org.uk/live/pubs.asp

Aims to support the work of the gallery and to increase visitors' knowledge and enjoyment of its collections.

NMS Publishing Ltd

Royal Museum, Chambers Street, Edinburgh,

EH11JF

T 0131 2474026

F 0131 2474012

E ltaylor@nms.ac.uk

W www.nms.ac.uk

Publishes non-fiction related to the National Museums of Scotland collections.

Octopus Publishing Group 2-4 Heron Quays, London, E14 4JP

T 020 75318400

F 020 75318650

E firstnamelastname@octopus-publishing.co.uk

W www.octopus-publishing.co.uk

Contact Derek Freeman or Henri Masonlel Imprints include Cassell Illustrated (illustrated books for the international market) and Conran

Octopus (quality illustrated books).

Oxford University Press

Great Clarendon Street, Oxford, OX2 6DP

T 01865 556767

F 01865 556646

E WebEnquiry.UK@oup.com

W www.oup.com

Founded in the sixteenth century, producing scholarly and reference works.

Pavilion

Anova Books Group Limited, The Old Magistrates Court. 10 Southcombe Street, London, W14 0RA

T 020 76051400

F 020 76051401

E customerservices@anovabooks.com

W www.anovabooks.com

An Anova Books Group imprint (formerly an imprint of Chrysalis Books). Publishes quality art books, featuring artists such as Jack Vettriano.

Phaidon Press Ltd

Regent's Wharf, All Saints Street, London, N1 9PA T 020 78431000

F 02078431111

W www.phaidon.com

A publisher on the visual arts since 1923. Offices in New York, London, Paris and Berlin.

Philip Wilson Publishers Ltd

109 Drysdale Street, The Timber Yard, London, N1 6ND

T 020 70339900

F 020 70339922

E pwilson@philip-wilson.co.uk

W www.philip-wilson.co.uk

Contact Philip Wilson

Publishers of art books, museum and exhibition catalogues, monographs of contemporary artists and complete catalogues of twentieth-century artists.

Prestel Publishing Ltd

4 Bloomsbury Place, London, WC1A 2QA

T 020 73235004

F 020 76368004

E sales@prestel-uk.co.uk

W www.prestel.com Contact Andrew Hansen

Established in Germany in 1923. A leading publisher of high-quality, illustrated books on art, architecture, design and photography. The London office opened in 1997 and has its own publishing programme.

Primrose Hill Press Ltd

Stratton Audley Park, nr Bicester, OX27 9AB T 01869 278000 F 01869 277820 E info@primrosehillpress.co.uk W www.primrosehillpress.co.uk Specializes in the art of wood-engraving.

Reaktion Books Ltd

33 Great Sutton Street, London, EC1V 0DX

T 020 72531071

F 020 72531208

E info@reaktionbooks.co.uk

W www.reaktionbooks.co.uk

Founded in 1985. Publishing programme includes

titles on art history, architecture, design, film and photography.

RotoVision

4th Floor, Sheridan House, 112–116A Western Road, Hove, BN3 1DD

T 01273 727268

F 01273 727269

E sales@rotovision.com

W www.rotovision.com

For over 30 years, publisher of illustrated books on all aspects of design, photography and the performing arts.

Routledge Publishers

2 Park Square, Milton Park, Abingdon, OX14 4RN

T 020 70176000

F 020 70176708

E tom.church@tandf.co.uk

W www.routledge.com

Publishers in the fields of art, art history, design, visual culture and aesthetics.

Royal Jelly Factory

11 Kemp House, 103 Berwick Street, London, W1F 0QT

T 020 77346032

F 0870 0549832

E info@royaljellyfactory.com

W www.royaljellyfactory.com

Publishers of New Art Up-Close, a series of pocket-sized books on living artists. Also offer web-design services to artists and small arts organizations.

Sangam Books Ltd

57 London Fruit Exchange, Brushfield Street, London, E1 6EP

T 020 73776399

F 020 73751230

Traditionally a publisher of textbooks but with some art titles.

Search Press Ltd

Wellwood, North Farm Road, Tunbridge Wells, TN2 3DR

T 01892 510850

F 01892 515903

E searchpress@searchpress.com

W www.searchpress.com

A specialist art and craft publisher for thirty-five years. Series include leisure arts, watercolour tips and techniques, design source books and handmade greetings cards.

Seren

57 Nolton Street, Bridgend, CF31 3AE T 01656 663018

E general@seren-books.com

W www.seren-books.com

An independent literary publisher. Publishes on art and photography produced in Wales, both historical and contemporary. Seren's list includes David Jones, Josef Herman, Peter Prendergast, Brendan Stuart Burns, Iwan Bala, Rhodri Jones, Anthony Stokes, Kevin Sinnott and David Hurn.

Taschen UK Ltd

1 Heathcock Court, 5th Floor, 415 Strand, London, WC2R ONS

T 020 78458585 F 020 78363696

E contact-uk@taschen.com

W www.taschen.com

Contact Christa Urbain

Founded in 1980 by Benedict Taschen in Cologne, Germany. All editorial submissions are handled by the German office.

Tate Publishing

Millbank, London, SW1P 4RG

T 020 78878869 F 020 78878878

E tp.enquiries@tate.org.uk

W www.tate.org.uk/publishing

Publishing since 1932, including scholarly works, series and exhibition catalogues.

Textile & Art Publications

Studio, 28 Liddell Road, London,

NW6 2EW

T 020 73284844

F 020 76241732 E post@textile-art.com

W www.textile-art.com

Founded in 1993. Publishes a limited number of titles each year, covering a variety of subjects from Oriental and Islamic art to Pre-Columbian and medieval art

Thames & Hudson

181A High Holborn, London,

WC1V7QX

T 020 78455000

F 020 78455050

E editorial@thameshudson.co.uk

W www.thamesandhudson.com

Founded in 1949. An international publisher of books on visual culture throughout the world,

from prehistory to the twenty-first century. Art titles include the World of Art series, monographs, surveys of major contemporary movements and trends, artists' books (collaborations with David Hockney, Lucian Freud and many others), art theory, practical instruction and art history (all periods). Target audiences include students, professionals and the general public.

TownHouse Dublin

Mountpleasant Business Centre, Mountpleasant Avenue, Dublin 6

T oi 4972399

F 01 4995150

E books@townhouse.ie

W www.townhouse.ie

Founded in the early 1980s, publishing extensive list of art and architecture titles.

V&A Publications

Victoria and Albert Museum,

South Kensington, London, SW7 2RL

T 020 79422000 / 79422966

F 020 79422967

E vapubs.info@vam.ac.uk

W www.vandabooks.com

Publishers of popular and scholarly, illustrated books on fashion and interior design, fine and decorative arts, architecture and photography.

Worple Press

Achill Sound, 2b Dry Hill Road, Tonbridge, TN9 1LX

T 01732 368958

E theworpleco@aol.com

W www.worplepress.com

Contact Amanda Knight or Peter Carpenter Founded in 1997, specializing in poetry and alternative arts titles. Four to five titles per year. Submissions welcome. Authors include Iain Sinclair, Kevin Jackson, Elizabeth Cook and Peter Kane Dufault.

Yale University Press

47 Bedford Square, London,

WC1B 3DP

T 020 70794000

F 020 70794901

E sales@yaleup.co.uk

W www.valebooks.co.uk

The London headquarters were established in 1967. Publishes scholarly books in the humanities, with a particular emphasis on art history.

Studio space

107 Workshop

The Courtyard, Bath Road, Shaw, Melksham, SN12 8EF

T 01225 791800

F 01225 790948

E 107w@shirrett.demon.co.uk

W www.107workshop.co.uk

Established in 1976, with 7,000 sq. ft of fully equipped studio space designed to enable artists to create an environment suitable to their own individual specifications. Processes available include multiplate-printing using copper, carborundum, liftground, aquatint, handpainting, relief woodcut and mono-printing. Artists include Ayers, Hodgkin, Hughes, Aitchison, Heindorf and Ackroyd. Livres d'artiste by Howard Hodgkin, Kidner and Hayter.

Price range £800-£15,000

36 Lime Street Ltd

Ouseburn Valley, Newcastle-upon-Tyne, NE1 2PQ T 0191 6452555

E limest36@yahoo.co.uk

W www.36limestreet.co.uk

Founded in 1984, a tenants' cooperative and the largest artists' studio group in the north-east, representing an eclectic mix of artists, designers, makers, performers and musicians in the region. Price range Low – cost studio space. Purchase of a lease for each studio is required.

ACAVA – Association for Cultural Advancement through Visual Art

54 Blechynden Street, London, W10 6RJ

T 020 89605015

F 020 89609269 E post@acava.org

W www.acava.org

Contact Duncan Smith

Founded 1984. Provides three hundred studios for artists and arts organizations throughout London. Associate members have access to facilities and projects and may apply for studios. ACAVA also provides professional development training, educational and public art services, and consultancy on studio development, regeneration and arts for health and sustainable communities. Price range $\pounds 7.50-\pounds 12.50$ per sq. ft.

Acme Studios

44 Copperfield Road, Bow, London, E3 4RR T 020 89816811

F 020 89830567 E mail@acme.org.uk W www.acme.org.uk

A charity formed in 1972 to provide artists with low-cost studio and living space. Provides 380 studios (over 170,000 sq.ft) throughout east and south-east London, as well as twenty-five accommodation units. Active in other residency and studio and accommodation programmes. Also offers free advice on property issues to artists.

Price range £6.50-£8.50 per sq. ft per year, inclusive.

Art Space Portsmouth Ltd

27 Brougham Road, Portsmouth, PO5 4PA T 02392 874523

E marcia@artspace.co.uk

W www.artspace.co.uk

Contact Marcia Allen (Studio Manager)
Formed in 1980, providing affordable studio space for artists working in a wide range of art forms and media. Aims to encourage the widest audience for the visual arts through education workshops, residencies, open studios and exhibitions.

Price range From £46.66 to £223 per month, inclusive of heat and light.

artists @ redlees

Redlees Studios, Redlees Park, Worton Road, Isleworth, TW7 6DW

T 020 85834457 / 85834464 E artists@redlees.org

W www.redlees.org

Contact John Carbery

A diverse group of artists formed to organize and promote the collective and individual work of the residents of Redlees Studios. Members' work includes jewelry, glass, ceramics, painting, sculpture and mixed media. Works closely with the Community Initiative Partnership, who maintain the buildings, to organize shows of members' creations.

Price range £100-£200 per month.

Artists and Restorers (A&R) Studios

7 Farm Mews, Farm Road, Hove, BN3 1GH

T 01273 207470 F 01273 207470

E artistandrestorer@fastmail.com.uk

Contact Caroline

Founded in 1996, with the aim of giving artists and craftspeople an affordable place to practise their craft in an art environment. Members include artists, jewellers, textile makers and designers, and picture-restorers.

Price range £100-£130 per month.

Artspace Studios

7/8 Addley Park, Liosban Industrial Park, Galway **T** 091 773046

E artspacegalway@eircom.net

W www.artspacegalway.com

Formed as an artist's collective by a group of Galway-based artists in 1986, to develop studio space for professional artists and support group and individual work and exhibitions. Strives to upgrade working conditions, and develop employment, educational and exhibition potential. Price range £90–100 euro per month per studio.

ASC

3rd Floor, 246 Stockwell Road, Brixton, SW9 9SP T 020 72747474

F 020 72741744

E info@ascstudios.co.uk

W www.ascstudios.co.uk

Contact Lisa Wilson

A London-based registered charity that provides studio and exhibition space to visual artists and not-for-profit arts organizations. Currently manages 350 artists' studios across six buildings. Registration is free and there is a waiting list for most studios. There is studio space available in Bethnal Green, E2, Newcross, SW14, Brixton, SW9, and Camberwell, SE5. Exhibition space is offered free of charge to visual artists and not-for-profit arts organizations. Selection is through a committee of ASC artists. The organization also provides free advice on all matters relating to studio development and can help with property negotiation.

Price range Rents are inclusive of building insurance, service charges, heating and electric and are based on £9.50-£12 per sq. ft per year.

Racklit

The Factory, Dakeyne Street, Nottingham, NG3 2AR

T 0115 9508751

E info@backlit.org.uk

W www.backlit.org.uk

Formed in 2008 by a group of Nottingham Trent University graduates, this complex of artists' studios and gallery spaces acts as a hub for creativity. Dedicated to experimental work and cross-pollination of artistic practices.

Price range Contact via website.

Barbican Arts Trust / Hertford Road Studios

12-14 Hereford Road, London, N1

T 020 72411675

Twenty studio spaces available. Artists should send slides of their work, a CV and an sae for consideration. Developing around 30 new studios at 114 Blackhorse Lane, E17 6AA.

Bath Artists' Studios (formerly Widcombe Studios Ltd)

The Old Malthouse, Comfortable Place, Upper Bristol Road, Bath, BA1 3AJ

T 01225 482480

E admin@widcombestudios.co.uk

W www.widcombestudios.co.uk

Contact Claire Loder (Studios Administrator) Founded in 1996, providing studios for sixty artists. Also runs courses and has a gallery space available for hire.

Price range £10.50 per sq. m per calendar month.

Blue Door Studios

46 High Street, Nairn, IV12 4AU

T 01667 455521

E bluedoorstudios5000@yahoo.com

W www.waspsstudio.org.uk

Contact Shaun MacDonald on 07968 416833 Six light, airy studios to rent. Ceiling heights in all rooms approximately 11ft, all rooms have power points. One months deposit, one months notice to quit.

Price range f_{50} - f_{140} per month.

Bow Arts Trust and Nunnery Gallery

183 Bow Road, London, E3 2SJ

T 020 75381719

F 020 89807770

E jclarke@bowarts.com

W www.bowarts.org

Contact Jeremy Clarke on 05601 255669
Founded in 1995. Designed to provide long-term affordable workspace for artists and to operate as an arts conduit for local communities, and national and international audiences. Offers space for approximately one hundred artists, open studios, employment and training. The Nunnery Gallery is a contemporary project space for national and international shows. Education at Bow Arts runs an outreach programme across London reaching over 20,000 young people a year. The Bow Arts now run a growing number of short life Live Work properties across East London with their partner Poplar HARCA a local RSL.

Price range Approx £9.50 per sq. ft per annum eg. £237.50 pcm for 300 sq.ft (including insurance, education levy, open studios).

Broadstone Studios

Hendron Building, 36–40 Upper Dominick Street, Dublin 7

T 01 8301428

F 01 8301950

E contact@broadstonestudios.com

W www.broadstonestudios.com

Artist-led studio group creating projects and putting on shows.

The Camera Club

16 Bowden Street, London, SE11 4DS

T 020 75871809

E info@thecameraclub.co.uk

W www.thecameraclub.co.uk

Founded in 1885. Offers high quality studio and darkroom facilities, a programme of group workshops and club events, and members' gallery exhibitions.

cell project space

4-8 Arcola Street, London, E8 2DJ

T 020 72413600

E info@cell.org.uk

W www.cell.org.uk

Studio space for over one hundred visual artists in four buildings in east London.

Chelsea Bridge Studios

1 The Field, 103 Prince of Wales Drive, London, SW11 3UN

T 07990 843943 / 020 74988730

E chelseabridgestudios@btinternet.com

W www.chelseabridgestudio.com

Contact Roy Woods

Managing and letting artist studios since 1979, the Bedford Hill Gallery currently manages these twelve exclusive artist studios in a Victorian mansion house, which stands in its own grounds near Chelsea Bridge. All studios have high ceilings, and come equipped with 'natural daylight' secondary lighting.

Price range Around £130 per week for 190 sq. ft up to £200 per week for 280 sq. ft studio.

Chocolate Factory Artists Studios

Chocolate Factory I & 2, Wood Green, London T 020 83657500 W www.chocolatefactoryartists.co.uk Contact tania@collage-arts.org Two buildings in north London house over 180 artists and designers working in the areas of sculpture, film, crafts, fashion and photography in spaces ranging from 200 sq. ft to 1,500 sq. ft.

Price range From £13.50 per sq. ft per annum.

Clevedon Craft Centre

Moor Lane, Clevedon, BS21 6TD

T 01275 872149

E enquiries@clevedoncraftcentre.co.uk

W www.clevedoncraftcentre.co.uk

Established in 1971, the ten craft design studios and artspace workshops are housed in the outbuildings of a seventeenth-century Somerset 'long farm', which was once part of the Clevedon Court Estate. The arts space workshop is available for rent for day or weekend courses.

Price range £20-£75 per week, exclusive of rates, etc.

Coin Street Community Builders

Oxo Tower Wharf, Barge House Street, London, SE1 9PH

T 020 74013610

F 020 79280111

E info@coin-street.org

W www.coinstreet.org

A social enterprise and development trust responsible for thirteen acres on the South Bank of London. Includes design studios, shops and galleries for hire to designers and artists at Oxo Tower Wharf and Gabriel's Wharf.

Price range From £400 per month.

Craft Central

33–35 St John's Square, London, EC1M 4DS T 020 72510276

E placesandspaces@craftcentral.org.uk

W www.craftcentral.org.uk

Secure and professional workspace in a unique central London location from which designers and makers can base their business. Available full-time, part-time or on a more flexible basis. The ways of taking on workspace have developed to suit makers at different stages of their business development, from pre-start up to mid-career and beyond. Has twice-yearly open studios.

Creekside Artists Studios

Units AIIO, AII2 and AII4, Faircharm Trading Estate, Deptford, London, SE8 3DX E info@creeksideartists.co.uk W www.creeksideartists.co.uk Contact Mauricio Vincenzi (Chairman) Not-for-profit artist-led studios founded in 2000. There are several 250 sq. ft units in an open-plan setting, with skylights throughout. The membership of twenty-four artists includes photographers, painters, printmakers, filmmakers, sculptors, and textile and installation artists. The studios have a communal 'chillout' area, as well as a workbench supplied with basic tools for communal use. Twenty-four-hour access. Two open studios a year, as well as exhibitions in London and abroad. Founding members of Deptford Arts Network, a network of artists based in the Creative Hub of Deptford/Greenwich in London, who work together to share resources and ideas.

Price range Visit website for more information.

Cuckoo Farm Studios

Boxted Road, Colchester, CO4 5HH
T 01206 843530
E info@cuckoofarmstudios.org.uk
W www.cuckoofarmstudios.org.uk
An artist-run studio group consisting of over thirty studios for artists and craftspeople. Set in a rural location, two miles from Colchester train station.
Includes gallery, print workshop and outside

space. **Price range** £50–£90 per month, inclusive of all

Custom House Studios Ltd

The Quay, Westport, County Mayo T 098 28735 F 098 28735

E info@customhousestudios.ie W www.customhousestudios.ie

Opened in 2002. Provides seven studio spaces, a fully equipped printmaking studio and a gallery. Operated on a not-for-profit basis by local artists in conjunction with the local authority, the Department of Arts, and the Arts Council of Ireland. Gallery hosts 13 exhibitions each year, selected by panel of artists. To apply for a studio and exhibition send letter of interest and examples of work.

Price range £25 per week including utilities for studio space. 25% commission on all gallery sales.

Dalston Underground Studios

The Basement, 28 Shacklewell Lane, Dalston, London, E8 2EZ T 07941 715888

E info@dalstonunderground.org.uk W www.dalstonunderground.org.uk

Contact Calum F. Kerr

Established in 2000, providing workspace for contemporary fine artists and offering long-term studio space. Currently has space for ten to twelve artists. Practice is varied and includes painting, film and performance. Examples of work can be viewed through website. Provides a space from which artists can develop projects and exhibit in a national and international context. A second studio building housing seven artists opened in 2005 at Unit B, Leswin Place, off Leswin Road, Stoke Newington, N16 7NJ.

Price range £90-£180 per month.

Diesel House Studios

Kew Bridge Steam Museum, Green Dragon Lane, Brentford, London, TW8 0EN T 020 85698780 / 07971 264964

F 020 85698781

E elizabeth@dieselhousestudios.com W www.dieselhousestudios.com

Contact Elizabeth Rollins-Scott

Founded in 2001. Specializes in studio rental and consultancy for private and local government arts projects. Currently manages thirty studios in west London (expected to rise to fifty). All artists are provided with a free website, marketing support, art library and access to digital media as well as advice on commercial career development. Two major exhibitions each year (summer and Christmas), with up to fifty artists and over five hundred works on show.

Price range £100-£525 per calendar month, including all bills.

The Drill Hall

16 Chenies Street, London, WC1E 7EX
T 020 73075061
F 020 73075062
E admin@drillhall.co.uk
W www.drillhall.co.uk
Operates a fully-accessible photographic darkroom suite.

Fire Station Artists Studios

9–11 Lr. Buckingham Street, Dublin 1 **T** o1 8556735 **F** o1 855632

W www.firestation.ie

Established by the Arts Council in 1991 to assist the needs of practising visual artists, and officially opened in 1993. Independent since 1997, it now houses residential studios and the headquarters of the North Centre City Community Training Workshop. Although primarily a studio facility, the Fire Station has developed its activities beyond provision of studios and workshop spaces.

Flameworks Creative Arts Facility

7 Richmond Walk, Devonport, Plymouth, PL1 4LL **T** 01752 559326

E flameworks@tiscali.co.uk

W www.flameworks.co.uk

Contact Katie Lake

Founded in 1999, providing artists with workspace and specialist equipment and services. Group activities include exhibitions, commissions, publicart schemes, newsletter production, marketing and schools residencies. Artist workshops and taster sessions available in metalwork, jewelry, ceramics, mosaic, glass, painting, stone- and wood-carving, printmaking and sculpture.

Price range $f_{40}-f_{150}$ per month.

Flax Art Studios

44–46 Corporation Street, Belfast, BT1 3DE T 028 00234300

W www.flaxartstudios.com

An artist-run organization founded in 1989 by a group of Belfast-based artists who were looking for space to make large sculptural and installation works. Runs an artist-in-residence scheme for four international artists each year and also a graduating student residency. Has initiated a community outreach project in partnership with five community groups.

Florence Trust Studios

St Saviour's, Aberdeen Park, London, N5 2AR T 020 73544771

E info@florencetrust.org

W www.florencetrust.org

Contact Paul Bayley (Director)

Founded in 1989, providing up to twelve studios for one year from August in a grade I-listed church. An in-house project/gallery space and director are on hand to offer guidance, ensuring artists receive 'much more than just a studio space'. Annual selection process.

Price range Studios cost approximately £215 to £245 per calendar month, inclusive of electricity and insurance.

Framework Studios

5–9 Creekside, Deptford, London, SE8 4SA T 020 86915140 F 020 86915140 E admin@frameworkgallery.co.uk W www.arthubi.org

Contact Adrian, Debbie or Maria Contemporary fine art and applied arts studios to rent in large complex run by Art Hub. Situated

rent in large complex run by Art Hub. Situated in South London's Creative Hub area. Good working facilities with 24-hour access. Exhibitions available.

Price range £55 to £95 per week inclusive.

Gasworks

155 Vauxhall, London, SE11 5RH

T 020 75875202 F 020 75820150

E info@gasworks.org.uk

W www.gasworks.org.uk

Contact Catalina Lozano

A contemporary arts organization housing twelve artists' studios and presenting a programme of exhibitions, residencies, international fellowships and educational projects.

Price range £200-£300. Studio spaces rarely available. No waiting list. Enquiries to Amy Walker.

Great Western Studios

Great Western Road, London, W9 3NY

T 020 72210100

F 020 72210200

E studio@greatwesternstudios.com

W www.greatwesternstudios.com

Founded in 1994, providing workspace for over 140 artists and craftspeople. Communal facilities include a café, project spaces and general business services. Individual studio spaces range in size from 225 sq. ft up to 1050 sq. ft and feature high ceilings, natural light and good sound insulation. Price range Approx. f8-f10 per sq. ft per year.

Green Door Studios

112 Highgate, Kendal, LA9 4HE

T 01539 721147

E artists@greendoorkendal.fsnet.co.uk

W www.greendoorstudios.co.uk

Contact Rosie Wates (Administrator)

Formed in 1995. Currently has sixteen artists in twelve studio spaces and a further seventy associate members who form part of the Green Door organization/network. All members are equally entitled to participate in the exhibitions, open studios, studio trails, educational activities and professional-development workshops that are undertaken. Members receive regular email communications with news, opportunities, offers and requests.

Price range Twelve studio spaces ranging in price from £119-£257 per quarter or £476-£1028 per year.

Harrington Mill Studios (HMS)

ıst Floor Turret H, Harrington Mill, Leopold St, Long Eaton, NG10 4QE

T 01159 728029

E jackie@harringtonmillstudios.co.uk

W www.harringtonmillstudios.co.uk

Contact Jackie Berridge

HMS was set up in 2007 to provide 18 'wet & dirty' affordable spaces by artist Jackie Berridge. The studios benefit from an exhibition area and a curatorial research space. Also offers one graduate residency per year with a materials bursary. See website for details.

Price range £84pcm for 160 sq. ft—£105pcm for 200 sq. ft inclusive of bills.

Holborn Studios

49/50 Eagle Wharf Road, London, N1 7ED T 020 74904099 F 020 72538120 E studiomanager@holborn-studios.co.uk W www.holborn-studios.co.uk

One of Europe's largest photographic studio complexes, renting studio space in London for over twenty-five years.

Hoxton Street Studios

I2–I8 Hoxton Street, London, N1 6NG
T 020 7033I984
F 020 7033I985
E info@hoxtonstreetstudios.co.uk
W www.hoxtonstreetstudios.co.uk
Photographic studio hire company established in 2004.

Islington Arts Factory

2 Parkhurst Road, Islington, London, N7 OSF T 020 76070561

E IAF@islingtonartsfactory.fsnet.co.uk
W www.islingtonartsfactory.org.uk
Founded in 1977, this thriving community arts
centre combines art, music and dance studios
with two gallery spaces. Also offers a wide range of
after-school and evening classes for children and
adults.

JAM Studios

Lews Castle Grounds, Stornoway, HS2 0XR T 01851 643261 E info@jam-studios.org W www.jam-studios.org

Contact Emma Drye

Independent artists' studios running courses including a portfolio course, short courses and evening classes on the Isle of Lewis in the Outer Hebrides. Hosts contemporary art exhibitions and events throughout the year and is always open to artists, musicians, film makers, poets and performance artists with ideas for using the studio or exhibition space.

Price range Studio space is free subject to availability.

Kingsgate Workshops Trust and Gallery

IIO-II6 Kingsgate Road, London, NW6 2JG T 020 73287878

W www.kingsgateworkshops.org.uk
W www.kingsgateworkshops.org.uk
Established in 1978, Kingsgate Workshops has
been providing studio spaces for 50 artists and
craftspeople for over 30 years. The gallery hosts
about a dozen exhibitions a year. Application
forms for studios and gallery exhibition proposals
can be downloaded from the website, or e-mail for

Krowji

The Old Grammar School, West Park, Redruth, TR15 3AJ

T 01209 313200

more information.

F 01209 219145

E admin@actcornwall.org.uk

W www.krowji.org.uk

Cornwall's biggest creative sector cluster, providing studios, workspaces, offices, a café, meeting rooms and other facilities for a wide range of creative businesses at the Old Grammar School buildings in Redruth. It's home to a vibrant creative community which currently includes painters, jewellers, furniture makers, ceramicists, textile artists, web designers, theatre companies and musicians as well as several of Cornwall's main sector support agencies such as Creative Skills and the County Council's Creative Unit. Undergoing major redevelopment so check website for details.

La Catedral Studios (incorporating Phoenix Art Studios)

7–11 St. Augustine Street, Dublin D8
E lacatedralstudios@yahoo.com
Contact Antonella Scanu / Costanzo Idini
A self-funded initiative by Antonella Scanu and
Costanzo Idini, located in a restored former

Victorian factory in the Liberties area of Dublin. The current premises, comprising 24 artists' studios and a multi-disciplinary space for artistic events (the Back Loft), was established in June 2005.

Maryland Studios

2nd Floor, 80 Wallis Road, Hackney Wick, London, E9 5LW

T 020 89862555

Contact Thomas Helyar-Cardwell
Established in 1995 to provide a secure, affordable
and professional environment for the production
of art. Architect-designed studios give good light,
access and maximum space. Studio members are
expected to participate in annual open studios and
contribute to educational workshops.

Price range £150-£300 (£6.75 per sq. ft).

Mivart Street Studios

Epstein Building, Bristol, BS5 6JF T 0117 3305209 E info@mivartists.co.uk W www.mivartists.co.uk Contact Barbara Orme

Home to over fifty artists, makers and performers. Hosts an annual open studios event.

Price range f_{17} - f_{50} per week.

Mother Studios

D-F 9 Queens Yard, White Post Lane, Hackney Wick, London, E9 5EN T 07968 760550

E info@motherstudios.co.uk

W www.motherstudios.co.uk

Contact Joanna Hughes

A non-profit-making studio founded in 2001 by artist Joanna Hughes for fine artists, designers and makers. There are thirty-four studios with twenty-four-hour access and parking. Mother, a 2,000 sq. ft exhibition space on site is available free to all Mother artists. Send proposals for projects and exhibitions to Joanna Hughes – rates on an indidviual basis.

Price range From £90 per calendar month, inclusive of electricity, water and service charge.

No 19 Cataibh, Dornoch Studio

19 Achavandra Muir, Dornoch, IV25 3JB
T o1862 811099
E sue@cataibh.fsnet.co.uk
Contact Sue Jane Taylor or Ian Westacott
An open-access etching studio located in the
north-east Highlands, four miles from the coastal

town of Dornoch. The studio has two presses, one 800mm wide and one 400mm wide, and uses non-toxic methods. Artists who have no experience of the etching process are welcome and offered technical assistance. Accommodation available for one to two people (own transport required). **Price range** Studio rent per day (plus sundries) £25; accommodation £15 per person; technical assistance £20. Rates vary according to season and availability.

Nottingham Artists' Group

32–36 Carrington Street, Nottingham, NG1 7FG T 0115 9581450

W www.nottinghamstudios.org.uk/nag
Contact Geoffrey Grant / Emma Williams
Founded in 1982 Nottingham Artists Group
was the first studio group to be established in
Nottingham. Currently provides studio space to
nine artists working independently. Work includes
oil and acrylic paintings, ceramics, sculpture,
photography and prints.

Price range £60-£80

Openhand Openspace

571 Oxford Road, Reading, RG30 1HL T 0118 9597752

E info@ohos.org.uk

W www.ohos.org.uk

Founded in 1980. An artist-led organization providing affordable artists' studios and facilities for the production of contemporary visual art. Also runs an exhibitions and education programme to promote public access to contemporary visual art and artists.

Price range From £29 per month, inclusive of bills.

Pallas Studios

17 Foley Street, Dublin 1
T or 8561404
E info@pallasstudios.org
W www.pallasstudios.org

Pallas Studios was established in inner-city Dublin in 1996. A multi-functional artist-run space, presenting exhibitions of contemporary works and offering studio space and other services across three locations. Houses 200 artists.

Pavilion Studios / Dukes Meadows Trust

Market Drive, Chiswick, London, W4 2RX , T 020 87422225 E studios@dukesmeadows.org.uk

W www.pavilionstudios.org

Founded in 2002, offering private lockable spaces to ten artists in a converted farm building on the edge of a park. Twenty-four-hour access, free parking, central heating and use of a shared kitchen. Spaces vary in size, but most are around 100 sq.ft.

Phoenix Arts Association

IO-14 Waterloo Place, Brighton, BN2 9NB T 01273 603700 E info@phoenixarts.org W www.phoenixarts.org

Contact Belinda Greenhalgh (Office Manager) Established in 1992, providing over one hundred high-quality studios for individual artists as well as larger workspaces for short-term projects. Also a gallery presenting exhibitions of contemporary visual art in all media with an integrated education programme.

Red Gate Gallery & Studios

209a Coldharbour Lane, London, SW9 8RU T 020 73260993

E info@redgategallery.co.uk W www.redgategallery.co.uk

Offers studio space and internships for artists who are interested in gaining work experience within a gallery environment. Gallery hire, which includes press mailings, posting of press release on various art-related event websites, invigilation as well as curating of the booked exhibitions, costs \pounds 430 per week.

Price range £120-£200

Resipole Studios

Loch Sunart, Acharacle, Nr Ardnamurchan, PH36 4HX

T 01967 431506

E info@resipolestudios.co.uk

W www.resipolestudios.co.uk

Contact Andrew Sinclair

New studio facilities available to hire in the heart of Ardnamurchan. The studios range from 9m2 and are all well-lit and heated. Serviced.

Price range £25 per week; £60 per month; £600 per year.

Rogue Artists' Studios

66–72 Chapeltown Street, Manchester, M1 2WH T 0161 2737492 E info@rogueartistsstudios.co.uk W www.rogueartistsstudios.co.uk

Established in 1995. A not-for-profit, cooperative

Contact Martin Nash / David Gledhill

that supports visual arts practice by providing artists with accessible and affordable studios in Manchester city centre. Houses sixty artists over two floors of studios and includes Rogue Project Space, used primarily for residency and exchange projects.

Price range Email for details.

Southgate Studios

2–4 Southgate Road, London, N1 3JJ
T 020 72546485
E adrian@adrianhemming.com
W www.adrianhemming.com
Contact Adam Gray or Adrian Hemming
Founded in 1990, providing approximately ten
studio spaces (average size 400 sq.ft).
Price range On application. Two months' deposit
required.

SPACE

129–131 Mare Street, London, E8 3RH
T 020 85254330
F 020 85254342
E mail@spacestudios.org.uk
W www.spacestudios.org.uk
Founded in 1968, SPACE is a charitable
organization providing affordable studios across
London, currently serving over five hundred
artists. SPACE also runs professional development
courses and projects for artists as well as a range
of media courses. Hosts an active exhibitions
programme, with gallery space for hire. Also runs
artist-in-residence schemes.
Price range f70–f600 per month.

Spotlight Studios

Canonbury Yard, 202 New North Road, London, N1 7BJ
T 020 73549955
F 020 73548333
E info@spotlightstudios.co.uk
W www.spotlightstudios.co.uk
Well-equipped photographic studio for hire.

Stockwell Studios

McCall Close, 39 Jeffreys Road, London, SW4 6QU T 020 79782299 E info@stockwellstudios.org.uk

Stu-Stu-Studio

10 Gate Street, London, WC2A 3HP T 020 72421919

W www.stockwellstudios.org.uk

E louise@warwickworldwide.com

W www.stu-stu-studio.com

Contact Louise Durham

A daylight studio based in the heart of central London, suitable for portraiture, still photography, video etc. Use of the lighting system is included in the hire charge.

Price range f_{250} full day; f_{150} half day.

Studio Voltaire

1A Nelsons Row, Clapham, London, SW47JR

T 020 76221294

E info@studiovoltaire.org

W www.studiovoltaire.org

Contact Joe Scotland

Founded in 1994. The first and only artist-run gallery and studio complex in south-west London, offering a service for local residents, schools and community groups. Actively promotes access to and participation in contemporary-art practice with its exhibition, education and studio programmes. Price range f60-f250 per calendar month.

Theatro Technis

26 Crowndale Road, London, NW1

T 0207 3876617

F 020 73832545

E info@theatrotechnis.com

W www.theatrotechnis.com

Fringe theatre that offers photographic darkroom facilities for manual black and white and colour print and film developing. Black and white chemicals are provided but not colour.

Viking Studios and Bede Gallery

4 Viking Precinct, Jarrow, NE32 3LQ

T 0191 4200560

Contact Vince Rea

Founded in 1996, providing ten artists' studios. Small window space on ground floor used to display work, situated in Jarrow Shopping Centre.

Visual Arts Centre

32 North Brunswick Street, Dublin 7

T of 6337937

F oi 6337937

E info@visualartscentre.com

W www.visualartscentre.com

Eight affordable studio spaces for professional visual artists at various stages of their careers.

Wakefield Artsmill

Rutland Mills, Kirkgate Bridge, Wakefield, WF1 5JR

T 01924 215873

E w-artsmill@pop3.poptel.org.uk

Contact Ian Smith

Incorporated as a company limited by guarantee in 1997. Provides low-cost studio accommodation, an exhibition space and production facilities for up to forty artists at all stages of their careers.

Price range Spaces are charged at £3.50 per sq. ft per year (£24–£114 per month).

Wasps Artists' Studios

77 Hanson Street, Dennistoun, Glasgow, G31 2HF

T 0141 5548299

F 0141 5547330

E info@waspsstudios.org.uk

W www.waspsstudios.org.uk

Contact Helen Moore (Administration Assistant) Over the last twenty-five years, Wasps has grown to become the largest visual arts organization in Scotland, providing low-cost studio space to over 650 artists each year at sixteen locations throughout Scotland. Aims to sustain and develop Scotland's visual artist community, provide a network of working spaces and other low-cost services to artists and arts organizations.

Price range Between £55 to £100 per month, with £75 being the average rental for a 200 sq. ft studio.

Waygood Gallery and Studios

548–560 Shields Road, Byker, Newcastle-upon-Tyne, NE6 2UT

T 0191 265 6857

F 0191 2244187

E art@waygood.org

W www.waygood.org

Contact Alex Evans

Founded in 1995 with the aims of providing a place of practice for artists and engaging audiences with contemporary art. Its site on High Bridge is currently being redeveloped into new, state-of-the-art facilities to include daylight-lit 400m2 galleries, fully accessible studios, a visual arts learning centre, workshop facilities and an international residency programme. Waygood Associates is a new membership scheme open to everyone. Currently the associate scheme has a web presence for sharing information and generating projects. See website for details. In the future a subscription membership will allow use of shared facilities and communal resources.

Price range See website for details.

West Walls Studios

53 West Walls, Carlisle, CA3 8UH

T 01228 515127

E west.walls@virgin.net

W www.westwallsstudios.com

Contact Paul Taylor

Established in 1993, an artists' cooperative working collaboratively and individually on projects, community activities and exhibitions. Twelve artists' spaces and small gallery/project space are available to hire, subject to application. Studios open to public by appointment and on annual open weekend.

Price range £60-£150 per month for studios; £150 per month for gallery/project space.

Westbourne Studios

242 Acklam Road, London, W10 5JJ

T 020 75753000

F 020 75753001

E lettings@westbournestudios.com

W www.westbournestudios.com

Contact Natalie Westhorpe

Situated underneath the Westway, ninety-two studios are available to hire as well as a space for gallery exhibitions, a screening room and a project space.

Price range On application.

Westland Place Studios

3–II Westland Place, London, N1 7LP E info@westlandplacestudios.co.uk W www.westlandplacestudios.co.uk One of the longest established surviving studio complexes in the Hoxton/Moorlands area. Home to painters, printmakers, illustrators, sculptors, designers, and installation artists.

Wimbledon Art Studios

Riverside Yard, Riverside Road, London, SW17 0BA

T 020 89471183

F 020 89445162

E wimbledonartstudios@yahoo.co.uk W www.WimbledonArtStudios.co.uk

Contact Jane Cavanagh (Art Studio Coordinator) Established ten years ago and now one of the largest art studios in Europe, with over one hundred artists, sculptors, ceramicists, photographers, jewelers and costume designers under one roof. There are two open-studio shows each year. Twenty-four-hour access, seven days a week, and a good community atmosphere.

Price range Contact office.

Wollaton Street Studios

179 Wollaton Street, Nottingham, NG1 5GE E bobrobinsonrig@hotmail.com W www.nottinghamstudios.org/wollaton

Contact Bob Robinson or Rob Hart Formed in 1985 and located close to the city centre. Six separate studios arranged around a central stairwell, with two studios to each floor. Completely artist-run and predominantly encouraging the activity of painting.

Price range $f_{...}$ 65- $f_{...}$ 100 per month, inclusive.

The Worx

10 Heathmans Road, Fulham, London, SW6 4TJ

T 020 73719777

F 020 73719888 E enquiries@theworx.co.uk

W www.theworx.co.uk

Photographic, film and TV studios offered for hire.

Yorkshire Artspace Society

Persistence Works, 21 Brown Street, Sheffield, S1 2BS

T 0114 2761769

F 0114 2761769

E info@artspace.org.uk

W www.artspace.org.uk

Contact Viv Mager

Established in 1977. A purpose-built complex for artists and craftspeople housing fifty-one studios. Offers business support and training to visual artists and a wide-ranging community outreach programme to schools, community groups and the public.

Price range £90-£250 per month, all-inclusive.

Zoom In Ltd

Clapham Leisure Centre, Clapham Manor Street, London, SW4 6DB

T 020 77207437

E enquiries@zoom-in.org

W www.zoom-in.org

Contact Course Administrator

Exists to provide education and services through photography. Provides part-time evening and weekend photography courses from beginners to advanced levels. All proceeds are committed to providing workshops with community groups aimed at those who may not otherwise have access to photography such as excluded young people, refugees and asylum seekers. Studio space to hire per day.

Price range f_{120} - f_{175} per day.

O5 Art education

Why art school? Options and approaches for training as an artist

Janet Hand and Gerard Hemsworth

You may want to be an artist and are therefore seriously considering how to turn wanting into doing, and doing into an abiding practice; in this case you may well be asking what art school can offer you. You might already have an involvement in the arts and are at a time in your career when you are considering further study, or you may want to shift the emphasis of your practice. In any case, your first questions will be 'Where do I start?', 'Whom do I approach?' and 'Do I have what it takes?'

Like any practice, art requires commitment and hard work. If you are just starting out, you will need to consider your education and the specific approach to art or design that suits you; this is the first difficult choice on your career path.

Solid foundation

The conventional starting point is a foundation course, which will introduce you to a variety of media and career options, from product design to fashion, textiles and fine art. The availability of courses varies from one institution to another: Byam Shaw School of Art, for example, only offers a foundation in fine art; Central St Martins, on the other hand, has a vast foundation programme with a range of choices across art and design.

This kind of study lasts for a year and aids in choosing the degree that suits your interests and abilities best. Foundation courses are by nature 'diagnostic', so you need not be too concerned that you have not yet come to a decision about which area of art you might wish to pursue eventually. They are geared towards entry into art school degree courses and will nurture your strengths while guiding you in basic technical requirements. The teaching staff will advise you on which BA programme

they think will be most appropriate for the development of your work. Since portfolios need to be ready by Easter, you may consider taking a year out to develop work rather than accepting a place at a college that is not your first choice.

First degree inspection

At BA level, there are numerous art schools vying for your attention through their prospectuses, websites, admissions tutors and admissions offices - all potential first points of contact with colleges on your shortlist. Remember, art schools need your potential as much as you need their expertise, so you will have to identify preferred institutions on your shortlist and visit them on organized open days. Talk to the students who are currently studying there to get a flavour of what is going on, so that you can make an informed choice about which is the right place for you. On college open days you can ask all the questions you need in order to make an appropriate application. A phone call to the admissions office will tell you when and how often these occur.

It is not necessary to have done a foundation course when applying for a degree, although it does give applicants a distinct advantage; some colleges will not interview a student who has not. When making a decision about which BAs to apply for, you should consider the nature of the overall programme in relation to your own aspirations within art practice. Not all applicants to art degrees aspire to be practising artists and many courses offer transferable skills that can be applied in a broader context of art culture.

Consider, also, the ethos of the art school. These generally fall into two categories: the first is interdisciplinary and enables you to move from one medium to another; the second is media-led and will have, for example, a painting department or a standalone photography course. Colleges that are media-led may advertise to applicants that you can still make video work within, say, the sculpture department, but make sure

this will not be a problem by asking current students.

When you initially visit colleges you are thinking of applying to, you will get a general feel of this ethos. You will also see the size of studio spaces, discover the technical facilities and hear how current students describe the quality of the teaching and learning environment. Students will often volunteer other practical information about their experiences that will help you make a decision. They may tell you how often they get tutorials and from whom. If there are regular visiting tutors to the college, it is worth asking about their involvement in the arts. Are they artists, writers, curators, educationalists?

Students will also give an account of their contextual studies and how these help develop their art practice. Find out if there are separate or integrated history of art or critical studies courses. The way programmes are organized and the courses they offer are not necessarily better or worse from college to college, but they are different. Your understanding of the differences and their appropriateness to you is the basis of making a good choice.

Furthering your education

Some BA graduates acquire professional success as practising artists within months of completion. At Goldsmiths, for example, Damien Hirst, Sarah Lucas, Gary Hume and others had no need for postgraduate studies, but they are the exception and not the rule. In most cases, students who are committed to becoming full-time artists start thinking of applying for postgraduate study after completing their BA.

Postgraduate study is usually when art students begin to consider their practice alongside contemporary artists working in the field. This doesn't mean you have to get to postgraduate level to become a professional artist, but most BA graduates will tell you that the discipline of their profession and their sense of maintaining a serious practice only begins after graduation, and that it is a

hard apprenticeship to build a portfolio of interest by working on your own. If you want or need to continue your study at postgraduate level, you can expect exacting criticism as well as a level of support that artists rarely get otherwise. Remember that your colleagues and fellow students are not only your closest allies but also an embryonic professional network, so it is important that you choose a place to study where you can share ideas and expectations, and most importantly begin to put them into practice through exhibition.

When applying for a postgraduate degree, consider whether or not it is the right time in the development of your career to take full advantage of further study. In the majority of cases, it is worth taking some time between BA and MA in order to develop your concerns and a 'professional practice'.

Generally, you will be asking similar questions of postgraduate programmes as applicants ask of BA programmes. You may also want to know if the MA has an international profile and whether applicants apply from around the world. Again, students are the best people to let applicants know how the college works day to day.

One thing current students may not be able to ascertain is the standard of their programme in comparison to other postgraduate courses. A way to assess the teaching and learning environment of a college is to ask about recent alumni. Is the programme enabling graduates to have careers as practising artists? Is it offering a platform for them to operate? Does it have a network of alumni that can be of help and support?

Recent alumni from the Fine Art MA at Goldsmiths, for example, include many who have gained international recognition, along with many who have been shortlisted for and won the Turner Prize. These include Mark Wallinger, who also represented Great Britain at the Venice Biennale, Yinka Shonibare, who was shortlisted for the 2004 Turner Prize, and Glenn Brown, who had a solo exhibition at the

Serpentine in London in 2004. Other major luminaries include Jane and Louise Wilson, Bob and Roberta Smith, Thomas Demand, David Thorpe, Gillian Wearing, Michael Raedecker and many more.

These days, you can go on to PhD study in art practice - the highest degree of attainment in academic terms, although many colleges also offer fellowships for professional artists and academics. Artists who study towards a PhD often have a commitment to teaching alongside their professional practice, or wish to vitalize their work in a sustained way through research. PhD study is designed for artists and curators who also wish to write a research project proposed and developed by them in support of their practice. Artists pursuing this level of research are most often already exhibiting, curating or working within the profession and continue to do so throughout their course of study. Research students at Goldsmiths, past and present, are working nationally and internationally and have exhibited in venues such as the Whitechapel and Tate galleries in London.

Status report

Some art schools have independent college status and others operate within a university setting, as is the case with the Department of Visual Arts at Goldsmiths. Goldsmiths is part of the University of London and so has access to the activities, open lectures, libraries and other facilities of the college and university more widely. Independent art schools will organize lectures and talks geared to their student cohort, often in conjunction with galleries.

The learning and teaching environment at any reputable college is as important as its alumni network, with one feeding into the other at all levels. Staff who have contributed significantly in building and maintaining Goldsmiths' reputation have included Professor Nick de Ville, who currently directs our research programme, and Professor Victor Burgin, the current Millard Professor of Fine Art: Peter Creswell, John Thompson and Michael Craig-Martin have also made noteworthy contributions along the way. The department offers programmes in fine art, textiles and curating, as well as a joint BA in art and art history in collaboration with the Department of Visual Culture.

Whatever level of study you wish to pursue, it is always worth asking yourself what kind of support and facilities you will need in the continuation and development of your work. It is then a question of best matching your potential and demonstrable abilities with the most appropriate environment and expertise.

Janet Hand and Gerard Hemsworth are Assistant Director of Research and Director of Postgraduate Studies in Fine Art, respectively, of the Visual Arts Department at Goldsmiths College, London.

Further, higher and adult education East Anglia

Cambridge School of Art, Anglia Ruskin University

East Road, Cambridge, CB1 1PT

T 0845 2713333

E answers@anglia.ac.uk

W www.anglia.ac.uk

In 1858 John Ruskin opened a school of art in Cambridge and the School now has over 500 students. The studios and workshops cluster in the distinctive Ruskin Building close to the centre of Cambridge. Public exhibitions are held throughout the year in the Ruskin Gallery and the annual Ruskin lecture takes place each October. Retaining its traditional strengths in illustration and the graphic arts, the School now also extends its activities into the contemporary media arts. Film and video benefit from a close relationship with the Cambridge Arts Picturehouse, and computer games design from a location at the heart of Silicon Fen.

Degrees offered BA (Hons): Fine Art, Illustration, Illustration and Animation, Graphic Design, Graphic and Web Design, Photography, Fashion Design, Computer Games and Visual Effects, Film, Television and Theatre Design. FdA: Professional Photography. MA and PgDip: Children's Book Illustration; Printmaking. Admissions Policy Applicants for practice-based single honours degrees will normally have taken an art and design foundation, BTEC ND, A-levels, level 3 GNVQ or AVCE. While academic qualifications are taken into consideration, admission is also based upon the portfolio of work presented at interview. Applications from those offering other qualifications and/or relevant professional experience are welcomed.

Colchester Institute

Sheepen Road, Colchester, C03 3LL

T 01206 712777

E info@colchester.ac.uk

W www.colchester.ac.uk

Over ten thousand students at two main campuses: Sheepen Road in Colchester and Church Road in Clacton.

Degrees offered BA (Hons): Art and Design (fulland part-time)in Fine Art, Fashion & Textiles, Graphic Media and 3D Design and Craft. Other Fine Art courses BTEC FD: Art and Design.

Dip. in Foundation Studies: Art and Design (full-

and part-time). HND: Art and Design (full- and part-time). ND: Graphic Design; Digital Media. Admissions Policy For BA (Hons) Art and Design: appropriate ND, Dip. in Foundation Studies or Advanced GNVQ in Art and Design. Mature students do not need formal qualifications but are considered on merit. Entry requirements vary depending on degree.

College of West Anglia

King's Lynn Centre, Tennyson Avenue, King's Lynn, PE30 2QW

T 01553 761144

F 01553 815555

E enquiries@col-westanglia.ac.uk

W www.col-westanglia.ac.uk

Contact Mike Williams

Founded in 1893

Degrees offered BA: Fine Art.

Other Fine Art courses HND: Fine Art. ND: Fine Art. Access to Art foundation diploma: Art and Design.

Admissions Policy Entry requirements: a substantial portfolio; four GCEs A to C for ND; four GCEs A to C plus at least one A-level for foundation; no formal qualifications for Access diploma; four GCSEs A to C, at least one A-level and foundation diploma or equivalent for BA.

Dunstable College

Kingsway, Dunstable, LU5 4HG

T 01582 477776

F 01582 478801

E enquiries@dunstable.ac.uk

W www.dunstable.ac.uk

Degrees offered BA (Hons) in Graphic Design for Print & New Media. Foundation Degrees in: Creative and Editorial Photography; Contemporary Fine Art Practice; Graphic Design & Advertising; Fashion & Surface Pattern Design.

Other Fine Art courses BTEC 1st Dip.: Media; Performing Arts. BTEC National Diploma: Performing Arts; Art and Design. BTEC National Diploma in Photography. BTEC ND: Media. BTEC Foundation Dip.: Art and Design.

Norwich School of Art & Design

Francis House, 3–7 Redwell Street, Norwich,

NR2 4SN

T 01603 610561

F 01603 615728

E info@nsad.ac.uk

W www.nsad.ac.uk

The only specialist art and design institution in the

east of England. Provision ranges from foundation degree to PhD level.

Degrees offered BA (Hons): Fine Art; Contemporary Textile Practices; Visual Studies. MA: Design and Education; Digital Practices: Fine Art; Textile Culture; Photographic Studies. FdA: Arts and the Community.

South East Essex College

Luker Road, Southend-on-Sea, SS1 1ND

T 01702 220400

F 01702 432320

E learning@southend.ac.uk

W www.southend.ac.uk

Contact Admissions Department

Degrees offered BA (Hons): Fine Art. Other HE courses: Digital Animation; Ceramics; Three-Dimensional Product Design; Fashion; Graphic Design; Interior Design; Photography.

Other Fine Art courses A wide range of arts courses at FE level, and adult courses in the daytime, evenings and weekends, including oil painting, screenprinting and watercolour classes. Admissions Policy For degrees: 160 UCAS points or mature-entry portfolio. Refer to HE prospectus for full details (phone to request copy).

Suffolk College

Rope Walk, Ipswich, IP4 1LT T 01473 255885 F 01473 296352

E info@suffolk.ac.uk

W www.suffolk.ac.uk

Contact Sheila Thomas

Has run art and design courses for over one hundred years.

Degrees offered BA (Hons): Fine Art (full- and part-time); Fine Art combined with other subjects such as Psychology, Media Studies, and Early Childhood Studies.

Admissions Policy Normal entry requirements: two A-level passes or equivalent; foundation or ND in related subject. All applicants normally interviewed with their portfolios.

University of Hertfordshire

Faculty for the Creative and Cultural Industries, College Lane, Hatfield, AL10 9AB

T 01707 285300 F 01707 285312

E ad.information@herts.ac.uk

W www.herts.ac.uk

Contact David McGravie

Well-resourced faculty contains two schools,

Art and Design and Film, Music and Media, which grew out of the original St Albans School of Art, founded around 1880. Students have access to purpose-built studios and workshops, two professional galleries and modern learningresource centres. Staff are all practising artists. Degrees offered BA (Hons): Fine Art; Fine Art with Marketing (subject to validation); Applied Art; Applied Art with Marketing (subject to validation); Digital and Lens Media: Digital and Lens Media with Marketing (subject to validation). MA: Fine and Applied Arts Practice.

Other Fine Art courses All degrees are offered on a part-time basis. Autumn-, spring- and summerterm courses: Drawing and Painting; Photography; Printmaking; Sculpture; Digital Photography; Glass: various design subjects. Sixth-form class: Life Drawing.

Admissions Policy Normally foundation diploma. Access certificate, VCE Double Award or BTEC ND/NC in Art and Design, plus GCSE English at grade C or above.

University of Luton

Park Square, Luton, LU1 3JU

T 01582 734111 F 01582 743400

E enquiries@luton.ac.uk

W www.luton.ac.uk

Degrees offered BA (Hons): Art and Design; Digital Photography and Video Art; Fashion Design (top-up); Fine Art. MA: Art and Design. Other Fine Art courses A range of practical courses and workshops such as Painting, Drawing, Graphic Design, Web Design, Printmaking and Illustration.

Fast Midlands

Bishop Grosseteste University College Lincoln

Newport, Lincoln, LN1 3DY

T 01522 527347

F 01522 530243

E info@bishopg.ac.uk

W www.bishopg.ac.uk

Contact Victoria Hind

A small University College, established in 1862 with a campus in uphill Lincoln. Subjects within the art curriculum are painting, drawing, printmaking, textiles, ceramics, sculpture, glass and computer-manipulated imagery.

Degrees offered BA (Hons): Education Studies and Art & Design (three years); Primary Education and QTS (three years) with specialization in Art.

Admissions Policy Applicants should apply through the UCAS system. Entry requirements for the course are 2 A levels at grades C or above, one to be in a relevant subject. Alternative qualifications such as BTEC, GNVQs, etc. are considered in Art and Design. GCSEs in English Language and Mathematics are also required. For further clarification, contact the Registry on 01522 583658.

Chesterfield College

Infirmary Road, Chesterfield, S41 7NG T 01246 500562 / 500563 E advice@chesterfield.ac.uk

W www.chesterfield.ac.uk

Started life in 1841 as the Chesterfield and Brampton Mechanics' Institute, and went through various incarnations, including a merger in 1984 of Chesterfield Art College and Chesterfield College of Technology, before becoming Chesterfield College. Over 21,000 students (around 3,600 full-time).

Degrees offered Courses include: Fine Art; Photography; Ceramics and Silversmithing; Three-Dimensional Design; Fashion and Textiles; Illustration and Graphics.

Other Fine Art courses Introductory and Intermediate Access to HE: Art and Design. HNC/HND: Fine Art (Book Arts). BTEC level I Introductory Dip.: Art, Design and Media. BTEC FD: Art and Design. BTEC ND: Art and Design. Dip. in Foundation Studies: Art and Design. OCN Photography levels I and 2. Drawing for Beginners.

Admissions Policy Requirements vary. See website.

De Montfort University

The Gateway, Leicester, LE1 9BH

T 0116 2577570 F 0116 2506281

E artanddesign@dmu.ac.uk

W www.dmu.ac.uk/artanddesign

School of Fine Art established in 1897. The course is studio-based and students can specialize in one discipline, or opt for a broad-based pattern of study across the range of disciplines.

Degrees offered BA (Hons): Fine Art; Design; Crafts.

Other Fine Art courses Fashion; Contour Design; Textile Design; Architecture; Graphic Design; Multimedia Design; Interior Design; Photography and Video; Footwear Design; Product, Furniture and Industrial Design. Admissions Policy All offers dependent on interview with portfolio. For further information contact Student Recruitment on 0116 2577555.

Grimsby Institute of Further and Higher Education

Nuns Corner, Grimsby, DN34 5BQ T 01472 311222

E headmissions@grimsby.ac.uk

Contact Helen Geer

Offers an interdisciplinary, contemporary approach. Close links are established between theory and practice. Students benefit from designated studio space and a range of appropriate facilities and workshops. First-year students work across painting, printmaking, sculpture, ceramics, art metalwork and textiles, visual language and critical studies. Contemporary practice is introduced through workshops in film, sound, performance and light. Second- and third-year students confirm choice of discipline, culminating in the final degree show.

Degrees offered BA Hons: Fine and Applied Arts (three years full-time; six years part-time).

Admissions Policy Foundation or AVCE Art and Design required. Exceptions may be made for mature applicants. UCAS route B.

Loughborough University

School of Art & Design, Loughborough, LE11 3TU

T 01509 263171

E R.Turner@lboro.ac.uk

W www.lboro.ac.uk

Contact Rebecca Turner

Has twelve thousand students and a 410-acre campus. In 1966, the College obtained a Royal Charter to become the first University of

Technology in the country.

Degrees offered BA (Hons): Fine Art (Painting, Printmaking, Sculpture); Visual Communication (Graphic Communication, Illustration); Three-Dimensional Design (Ceramics, Furniture Design, Silversmithing and Jewelry); Textile Design (Printed Textiles, Multi-Media Textiles, Woven Textiles); History of Art and Design. MA: Art and Design (Studio Practice).

Admissions Policy For BA: through UCAS. For MA: candidates are normally expected to have obtained a good honours bachelor degree or equivalent in an art and design discipline or a closely related subject. A lower-level qualification with appropriate professional or industrial experience may also be considered.

New College Nottingham

P.O.Box 6598, Nottingham, NG1 1NS

T 0115 9100100

E headmissions@ncn.ac.uk

W www.ncn.ac.uk

Contact Central Admissions

One of the largest colleges of further education in the UK with a wide range of full and part-time study programmes.

Degrees offered FdA: Digital Arts.

Other Fine Art courses BTEC FD: Art and Design. BTEC ND: Fine Art. Dip. in Foundation Studies: Art and Design.

Nottingham Trent University

Burton Street, Nottingham, NG1 4BU

T 0115 9418418

E reg.web@ntu.ac.uk

W www.ntu.ac.uk

Total student population of around 26,000.

Degrees offered BA (Hons): Decorative Arts; Fine Art; Graphic Design; Photography/Photography in Europe; Textile Design. MA: Art and Design, Language and Culture Bridging Programme; Decorative Arts; Fine Art; Graphic Design; Textile Design and Innovation. MPhil/PhD studies and an art and design international access programme also offered.

Admissions Policy For undergraduate: through UCAS, plus other requirements.

South Nottingham College

West Bridgford Centre, Greythorn Drive, Nottingham, NG2 7GA

T 0115 9146400

F 0115 9146444

E enquiries@south-nottingham.ac.uk

W www.south-nottingham.ac.uk

Other Fine Art courses BTEC FD: Design.
BTEC ND: Art and Design; Three-Dimensional
Design; Textile Design. Foundation diploma:
Art and Design (post-A-level). HND: Design;
Three-Dimensional Design; Graphic Design; Fine

Admissions Policy For HND: through UCAS.

Stamford College

Drift Road, Stamford, PE9 1XA

T 01780 484300

F 01780 484301

E enquiries@stamford.ac.uk

W www.stamford.ac.uk

Contact Jayne Olney

The Visual Arts Centre has specifically equipped

life-drawing room, photographic studio,

3-D workshops and Apple Macintosh suites.Degrees are validated by Anglia Poytechnic

University.

Degrees offered BA (Hons): Fine Art; Graphic Design.

Other Fine Art courses Foundation diploma: Art and Design.

Admissions Policy All applicants are interviewed. Mature students are encouraged to apply and are considered on a portfolio of work.

University of Derby

Faculty of Arts, Design and Technology, Britannia Mill Campus, Derby, DE22 3BL

T 01332 594008

F 01332 597760

E adtenquiry@derby.ac.uk

W vertigo.derby.ac.uk/

Contact Jas Dhillon on 01442 594058.

Courses in fine art date back to the beginning of the nineteenth century.

Degrees offered BA (Hons): Fine Art;

Photography; Film and Video; Illustration. MA: Advanced Art and Design Theory and Practice (ADAPT).

Other Fine Art courses PgCert: Arts Practice. Admissions Policy Applications are invited from students who are studying art and design subjects at A2 level. Application can be through UCAS routes A or B. There will be a portfolio interview for each applicant.

University of Lincoln

Brayford Pool, Lincoln, LN6 7TS T 01522 882000

E enquiries@lincoln.ac.uk W www.lincoln.ac.uk

The Art, Architecture and Design Faculty's three schools provide undergraduate, taught postgraduate and postgraduate research programmes. The Hull and Lincoln Schools of Art and Design were both founded in the 1860s while the School of Architecture was established in the 1930s.

Degrees offered BA (Hons): Fine Art; Animation; Conservation and Restoration; Contemporary Decorative Crafts; Contemporary Lens Media; Fashion Studies; Furniture Design and Practice; Graphic Design; Heritage Investigation; Illustration; Museum and Exhibition Design. MA: Fine Art; Design; Art, Architecture and Design. Fine-art research opportunities (MRes/MPhil/PhD) also offered.

University of Northampton

School of the Arts, St George's Avenue, Northampton, NN2 6JD

T 01604 735500 / 893210

F 01604 717813

E christine.midgley@northampton.ac.uk

W www.northampton.ac.uk

Contact Nikki Harford

A college of art was first established in the 1800s and is now, as the School of the Arts, a part of the new University of Northampton. It offers specialist facilities and studios and flexible programmes of study where students are encouraged to work within and across diciplinary boundaries. Alumni include Will Alsop, Andrew Collins and the Bill Drummond.

Degrees offered BA (Hons): Fine Art; Fine Art Painting and Drawing; Photographic Practice; Illustration. MA: Fine Art.

Other Fine Art courses Joint Honours: Fine Art Painting & Drawing.

Admissions Policy Via UCAS routes A and B. Normally Foundation Art and Design or equivalent. Applicants interviewed. Non-standard applications welcome.

London

The Art Academy

201 Union Street, Southwark, London, SE1 0LN

T 020 74016539 F 020 74016541

E info@artacademy.org.uk

W www.artacademy.org.uk

Contact Isabella Byerley (Course Administrator) Founded in 2000, aiming to train artists to the highest standard and to provide access to the arts for the community through a wide range of short course, lectures and exhibitions. Have had over two-thousand enrolled students.

Degrees offered Offers an intensive, three-year, in-house Fine Art Diploma for students specializing in either sculpture or painting. The course is predominately practice based and offers an average of thirty tutored hours per week (one of the highest levels of contact hours in the country for a fine arts course). Twenty places available each year.

Other Fine Art courses Part-time, evening, short and weekend courses in painting, drawing and sculpture.

Byam Shaw School of Art

(University of the Arts London), 2 Elthorne Road, Archway, N19

T 020 72814111

W www.csm.arts.ac.uk/csm_byam_shaw.htm Contact John O'Sullivan

A small school found in 1910, focusing on the study of fine art. Joined with Central Saint Martins in 2003.

Degrees offered BA (Hons) Fine Art; PG Diploma Fine Art; MA Fine Art; Foundation Degree in Fine Art Skills and Practices (two-year degree). Other Fine Art courses Fine Art Foundation.

Camberwell College of Arts

(University of the Arts London), Peckham Road, SE5 8UF

T 020 75146302

F 020 75146310

E enquiries@camberwell.arts.ac.uk

W www.camberwell.arts.ac.uk

Over a hundred years old. Alumni includes Howard Hodgkin, Maggi Hambling, Tom Phillips, Gillian Ayres, Richard Long and Cathy de Monchaux.

Degrees offered BA (Hons): Drawing; Painting; Sculpture; Ceramics. MA: Printmaking; Book Arts; Drawing; Digital Arts; Digital Arts (online). Other Fine Art courses An extensive programme of short courses, tailormade courses and summer schools offered in conjunction with Chelsea College of Art and Design. For further details contact Short Course Unit on 020 7514 6311 or email shortcourses@camberwell.arts.ac.uk. Admissions Policy For undergraduate: through UCAS and completion of a foundation year or related qualifications and/or experience (particularly for mature students). For postgraduate: Direct to the college, accompanied by a project proposal. Deadline for AHRB funding: mid-February.

Central St Martins College of Art & Design

(University of the Arts London), Southampton Row, WC1B 4AP

T 020 75147000

E info@csm.arts.ac.uk

W www.csm.arts.ac.uk

Founded in 1989 by the merger of Central School of Art & Crafts (1869) and St Martin's School of Art (1854). St Martin's was particularly well known for fashion and fine art and the Central School for a wide range of design and art, including theatre design, industrial design and graphic design. In 2003 the Byam Shaw School of Art joined Central St Martins. Alumni include Lucian Freud and Frank Auerbach.

Degrees offered BA (Hons): Fine Art; Art, Design and Environment: Criticism, Communication and Curation: Arts and Design; Ceramic Design. FdA: Fine Art Skills and Practice. PgCert: Drawing; Glass; Printmaking; Photography; Fine Arts. MA: Fine Art. PhD programmes.

Other Fine Art courses Fine-art foundation and Foundation Studies in Art and Design. Short courses (summer school, Christmas school, Easter school and evening and weekend courses) and study-abroad courses.

Chelsea College of Art & Design

(University of the Arts London), John Islip Street, SW1

T 020 75147751 F 020 75147778

E enquiries@chelsea.arts.ac.uk

W www.chelsea.arts.ac.uk Degrees offered BA (Hons): Fine Art; Textile Design; Interior and Spatial Design; Graphic Design Communication. MA: Fine Art; Textile Design; Interior and Spatial Design. PgDip: Fine Art. Foundation Studies: Art and Design. Other Fine Art courses Art foundation: Interior Design, Graduate Dip.: Interior Design (subject to validation). Short course programme, including evening, Saturday and summer schools. Admissions Policy UCAS route B. Portfolio. Two GCE A-levels and three GCSEs (grade C or above). IELTS 6.5. Although most applicants to BA courses have completed foundation studies, Chelsea welcomes applications from a wide range

Croydon College

College Road, Croydon, CR9 1DX

of people with differing qualifications.

T 020 87605914 E info@croydon.ac.uk

W www.croydon.ac.uk

Established for over one hundred years. Strong African, Caribbean and Asian influences and links with many other ethnic communities. Two main sites. Fairfield and the adjacent dedicated Higher Education Centre.

Degrees offered BA (Hons): Fine Art (Combined Media) (also Dip./Cert. of HE); Fine Art (Combined Media with Digital Art) (also Dip. of HE); Fine Art (Combined Media with Print and Book) (also Dip. of HE); Photomedia (also Dip./ Cert. of HE).

Other Fine Art courses BTEC Dip. in Foundation Studies: Art and Design. BTEC FD: Art and Design. All courses offered part-time. Admissions policy Dependent upon portfolio work and UCAS points.

Goldsmiths - University of London

New Cross, London, SE14 6NW

T 020 79197171

E admissions@gold.ac.uk

W www.goldsmiths.ac.uk

Founded in 1891 and part of the University of London since 1904. Almost 5,400 undergraduates and 3,000 postgraduates. Alumni in art and design include Lucian Freud, Antony Gormley, Damien Hirst, Margaret Howell, Gary Hume, Steve McQueen, Mary Quant, Bridget Riley, Sam Taylor-Wood, Gillian Wearing, Jane and Louise Wilson.

Degrees offered BA (Hons): Fine Art (Studio Practice and Contemporary Critical Studies); Fine Art (extension degree); Fine Art and History of Art; Fine Art and History of Art (extension degree); Design. MA: Design (Critical Theory and Practice); Fine Art. PgDip: Fine Art.

Admissions Policy Admission is based on the UCAS system for undergraduates. Postgraduate admission is normally by interview and portfolio inspection. Entrance requirements are normally a first degree of at least second-class standard in Fine Art or the equivalent; or Goldsmiths' PgDip in Fine Art; or a proven record of experience as a practising artist.

Kingston University

River House, 53-57 High Street, KT1 1LQ T 020 85472000

E admissions-info@kingston.ac.uk

W www.kingston.ac.uk

17,500 students over four campuses.

Degrees offered BA (Hons): Fine Art; Graphic Design: Photography with Graphic Design. MA: Communication Design.

Other Fine Art courses Edexcel Dip. in Foundation Studies: Art and Design.

Admissions Policy For undergraduate: through UCAS. Requirements vary depending on degree.

London College of Communication

(University of the Arts London), Elephant and Castle, SE1 6SB

T 020 75146853

F 020 75146848

E media@lcc.arts.ac.uk

W www.lcc.arts.ac.uk

Founded in 1883 as St Bride Foundation and the North-western Polytechnic. Formerly known as

the London College of Printing. Granted university status in 2003. Around nine thousand students. Degrees offered Digital Media; Film and Video; Photography; Surface Design.

Other Fine Art courses FE, Young at Art and professional training courses.

London Metropolitan University

31 Jewry Street, London, EC3N 2EY

T 020 74230000

E admissions@londonmet.ac.uk

W www.londonmet.ac.uk

Can trace its roots back to 1848 with the establishment of the Metropolitan evening classes for young men. Ranks as London's largest unitary university with over 35,000 students.

Degrees offered BA (Hons): Design; Design (Graphics); Fine Art; Fine Art (specialist route); Fine Art Contemporary Theory and Practice. MA by project: Applied Art; Art, Design and Visual Culture; Design; Drawing; Fine Art; Visual Culture. Other Fine Art courses Dip. in Foundation Studies: Art and Design.

Admissions Policy See the university's standard entry requirements (for both postgraduate and undergraduate). In addition, students should have undertaken an art foundation course. Students are selected by portfolio inspection and interview.

London South Bank University

103 Borough Road, London, SE1 0AA

T 020 79288989

E enquiry@lsbu.ac.uk

W www.lsbu.ac.uk

Founded in 1892 as the Borough Polytechnic and amalgamated with four other colleges in 1970 to become South Bank Polytechnic. Granted university status in 1992. Nearly eighteen thousand students.

Degrees offered BA (Hons): Digital Media Arts; Digital Photography.

Admissions Policy See website.

Middlesex University

North London Business Park, Oakleigh Road South, London, N11 1QS

T 020 84115000

E admissions@mdx.ac.uk

W www.mdx.ac.uk

Degrees offered BA (Hons): Fine Art; Applied Arts; Design; Graphic Design; Illustration; Photography. MA: Fine Art Practice and Theory. MFA: Graphic Design.

Other Fine Art courses FdA: Graphic Design;

Fine Art Practice and Theory. Edexcel Dip. in Foundation Studies: Art and Design. Dip. of HE: Three-Dimensional Design; Visual Communication Design (Graphic Design). HND/ HNC: Fine Art; Graphic Design; Public Art. Admissions Policy For undergraduate: UCAS (requirements depend on degree). For full- and part-time postgraduate programmes, normally apply direct to the university. See website.

Prince's Drawing School

19-22 Charlotte Road, London, EC2A 3SG T 020 76138527

F 020 76138599

E enquiry@princesdrawingschool.org.uk W www.princesdrawingschool.org.uk An independent educational organization that enables artists to broaden and extend their drawing practice. Founded by the Prince of Wales in 2000. Initially a part of the Prince's Foundation, the Drawing School became a charity in its own right in 2004. Over four hundred students attend classes run by the school each term.

Other Fine Art courses Runs twenty-six courses over each ten-week term, during the daytime from Monday to Saturday and most evenings. Geared mainly for students with some experience of drawing, enrolment is open and students don't need to submit a portfolio.

The Richmond American International University in London

Richmond Hill Campus, Queen's Road, Richmond-upon-Thames, TW10 6JP

T 020 83329000 F 020 83321596

E enroll@richmond.ac.uk

W www.richmond.ac.uk

Attended by students from over one hundred countries. Degrees recognized in the UK and USA. Degrees offered BA: Art, Design and Media. Offers a range of contemporary, cross-disciplinary, multimedia core courses dealing with concepts in art, design and media, and the interfaces between

them. Students also schooled in professional skills

and techniques and appropriate theory. Admissions Policy See website.

Roehampton University

School of Arts, Erasmus House, Roehampton Lane, London, SW15 5PU T 020 83923000

W www.roehampton.ac.uk

Degrees offered Undergraduate courses: Art

Practice and Critical Skills; Childhood and the Arts; Painting and Printmaking. Postgraduate courses: Art Studies.

Royal Academy Schools

Burlington Gardens, Piccadilly, London, W1J 0BD T 020 73005650

F 020 73005856

E schools@royalacademy.org.uk

W www.royalacademy.org.uk

Contact The Schools Administrator

A small independent institution offering the only three-year full-time postgraduate course in Britain. Traces its routes back to 1768. No fees charged and every effort made to support students with bursaries, awards and grants for materials, albeit at a modest level. Many students need to take some part-time work – often in the Royal Academy itself – to offset the high cost of living and studying in London.

Degrees offered Postgraduate Diploma in Fine Art Admissions Policy Looks for artists who show complete commitment to their work, a potential for creative growth and a passionate and obsessive desire to discover an original and personal vision.

Royal College of Art

Kensington Gore, London, SW7 2EU

T 020 75904444

F 020 75904500

E admissions@rca.ac.uk

W www.rca.ac.uk

Contact Assistant Registrar

The world's only wholly postgraduate university of art and design, specializing in teaching and research. Alumni include James Dyson, Ridley Scott, Robin Day, Zandra Rhodes, Philip Treacy, Tracey Emin, David Hockney and Henry Moore. Degrees offered MA, MPhil and PhD degrees. School of Fine Art: Painting; Printmaking; Photography; Sculpture. School of Applied Arts: Ceramics and Glass; Goldsmithing; Silversmithing; Metalwork; Jewelry. School of Communications: Animation; Communication; Art and Design. School of Humanities: Conservation; Curating; Contemporary Art; History of Design. School of Fashion and Textiles: Fashion Menswear; Fashion Womenswear; Constructed Textiles: Printed Textiles. School of Architecture and Design: Architecture and Interiors Design; Products; Industrial Design; Engineering; Interaction Design; Vehicle Design. Admissions Policy Entry requirements and application deadlines all listed on website.

Slade School of Fine Art (UCL)

Gower Street, London, WC1E 6BT

T 020 76792313

F 020 76797801

E slade.enquiries@ucl.ac.uk

W www.ucl.ac.uk/slade

Contact Caroline Nicholas

Concerned with contemporary art and the practice, history and theories that inform it. Provides for the education of professional artists by professional artists and scholars of the history and theory of art. Founded in 1871 as a department of UCL. Located in the centre of London close to many important galleries, museums and theatres.

Degrees offered BA: Fine Art. MA: Fine Art. MFA: Fine Art. MPhil/PhD: Fine Art.

Other Fine Art courses Summer, Easter and Saturday classes. Continuing education opportunities including a specialist research development programme.

Admissions Policy For BA: UCAS route A. For graduate taught programmes: direct application. Email for further details.

Thames Valley University

Ealing Campus, St Mary's Road, Ealing, London, W5 5RF

T 020 85795000

W www.tvu.ac.uk

Campuses in Ealing, Slough and Reading. Degrees offered BAs and MAs in fine art, design, digital arts and photography.

University of East London

Longbridge Road, Dagenham, RM17 6UG

T 020 82233333

F 020 82232900

E admiss@uel.ac.uk

W www.uel.ac.uk

Degrees offered BA (Hons): Fine Art (three years full-time; five years part-time); Fine Art with foundation year (four years full-time). MA/PgDip: Fine Art (MA: one year full-time or two years part-time; PgDip: one year part-time with the option of a second year to complete the MA). Professional Doctorate: Fine Art (three years full-time or four to five years part-time).

Admissions Policy Contact Beryl Watson on 020 82233400 for details on admission to all fine-art programmes.

University of the Arts London

See entries under: Byam School of Art; Camberwell College of Arts; Central St Martins College of Art and Design; Chelsea College of Art and Design; London College of Communication; Wimbledon School of Art.

University of Westminster

309 Regent Street, London, W1B 2UW **T** 020 79115000

W www.wmin.ac.uk

Founded in 1838 as Britain's first polytechnic.

Degrees offered BA (Hons): Animation; Mixed

Media Fine Art (full- and part-time); Photographic

Arts; Photography (part-time); Digital and

Photographic Imaging, all at the Harrow Campus

Media, Art and Design faculty.

Admissions Policy Online for part-time and postgraduate courses. For BA (Hons): through UCAS.

West Thames College

London Road, Isleworth, TW7 4HS

T 020 83262000

E info@west-thames.ac.uk

W www.west-thames.ac.uk

Contact Siobhan Fitzgerald

HND programmes have been running at West Thames since 1985.

Other Fine Art courses HND: Graphics and Advertising; Fine Art; Fashion. Foundation diploma: Art and Design.ND: Art and Design. Various part-time classes.

Admissions Policy ND, AVCE, foundation or A-levels. Mature students with relevant experience welcomed. Portfolio required at interview. Applications accepted from January to September. Enrolment from late August.

Wimbledon College of Art

(University of the Arts London), Merton Hall Road, SW19 3QA

T 020 75149641 / 020 75149687

F 020 75149642

E info@wimbledon.ac.uk

W www.wimbledon.ac.uk

Contact Linda Tinsley, Admissions Officer Founded in 1890, a specialist art and design school. Staff are all practising artists, designers and scholars within their specialist fields. Current students show work in exhibitions, performances and costume parades at key venues in London. Alumni include Anthony Cragg, Kenny Ho, Raymond Briggs and Jeff Beck.

Degrees offered BA (Hons): Fine Art (Painting); Fine Art (Sculpture); Fine Art (Graphic Media); Theatre (Costume Design); Theatre (Costume Interpretation); Theatre (Set Design for Stage and Screen); Theatre (Design for Performance); Theatre (Technical Arts and Special Effects). MA: Fine Art (Painting); Fine Art (Drawing); Fine Art (Sculpture); Fine Art (Graphic Media); Theatre (Visual Language of Performance). MPhil and PhD programmes of research.

Working Men's College

44 Crowndale Road, London, NW1 1TR T 020 72554700 / 0800 3581854 (freephone) F 020 73835561

E info@wmcollege.ac.uk **W** www.wmcollege.ac.uk

Founded in 1854 to provide a liberal arts education for the Victorian skilled artisan class and was associated with the Cooperative Movement. Among the first adult education institutes in the country. Caters for both women and men.

Other Fine Art courses Foundation course: Art and Design.

Admissions Policy By completion of enrolment form. Concessionary fees for some students.

North-east

City of Sunderland College

Bede Centre, Durham Road, Sunderland, SR3 4AH T 0191 5116260 / 5116060

W www.citysun.ac.uk

Approximately 24,000 students at five main college centres. Courses also offered by distance learning and at community centres.

Other Fine Art courses Art and Design Cert. in Advanced Studies: Calligraphy; Digital Imaging and Photography. FdA: Applied Art; Life Drawing; Oil Painting; Painting and Drawing; Photography; Printed Textiles; Silk Painting; Stained Glass; Watercolours.

Admissions Policy Entry requirements vary depending upon the course and level of study. Contact the college for individual fact sheets.

Cleveland College of Art & Design

Green Lane, Linthorpe, Middlesbrough, TS5 7RJ T 01642 288888

F 01642 288828

E studentrecruitment@ccad.ac.uk

W www.ccad.ac.uk

A specialist art and design college; one of four nationally, offering further, higher and continuing education courses in the creative professions. Has roots that go back to 1880 and was formed by the merger of Teesside and Hartlepool Colleges of Art.

Degrees offered BA (Hons): Fine Art.

Other Fine Art courses BTEC Dip.: Fine Art.

Admissions Policy Full-time applications through UCAS routes A and B.Part-time direct to college.

Newcastle College

Rye Hill Campus, Scotswood Road, Newcastle-upon-Tyne, NE4 $5\mathrm{BR}$

T 0191 2004000

F 0191 2004517

E enquiries@ncl-coll.ac.uk

W www.newcastlecollege.co.uk

Four hundred staff and thirty thousand students. **Degrees offered** BA (Hons): Fine Art. FdA:

Contemporary Ceramic Practice; Fine Art Practice; Photographic Practice; Textile Design and Practice.

Other Fine Art courses HNC: Photography.

Newcastle University

Fine Art, School of Arts & Cultures, The Quadrangle, Newcastle-upon-Tyne, NE1 7RU

T 0191 2226047 F 0191 2228013

E fineart@ncl.ac.uk

W www.ncl.ac.uk/sacs/fineart

Contact Nigel Villalard

Distinguished history dating back to its its foundation as the King Edward VII School of Art over a hundred years ago. Since the 1950s it has been associated with artists and teachers including Richard Hamilton, Victor Pasmore, Sean Scully and Susan Hiller. Housed in purpose-built accommodation which includes studios, workshop facilities and the Hatton Gallery.

Degrees offered BA (Hons): Fine Art (UCAS codes: W150 route A; E100 route B): 4 year undergraduate programme with studio practice studied alongside the history of art. MFA: Fine Art: Two-year full-time postgraduate programme.

Other Fine Art courses Art history modules can be taken as part of the BA Hons Combined Studies programme. Studio-based and history of art research degree programmes.

Admissions Policy Selection for both BA and MA is made principally on consideration of examples of studio work and interview.

Northumbria University

Division of Visual Arts, School of Arts and Social Sciences, Room 123, Lipman Building, Newcastleupon-Tyne, NE1 8ST

T 0191 2274444

E ar.admissions@unn.ac.uk

W www.northumbria.ac.uk

Contact Liz Candlish

The BA(Hons)Fine Art was established in 1969 and recruits 60-70 students per year. The Fine Art programmes offer specialist and crossdisciplinary teaching in all areas of contemporary art practice, including painting, print, sculpture, photography and time based media. A visiting programme of artists offer talks on their work and tutorial advice. Galleries such as the BALTIC Centre for Contemporary Art and Waygood Gallery collaborate with the university to offer educational opportunities. The University Gallery has an ongoing programme of exhibitions and Gallery North, in the Division of Visual Arts itself, is a research and teaching resource administered by Fine Art. Alumni include Jane Wilson, Louise Hopkins, Matthew Higgs, Daphne Wright and Richard Grayson.

Degrees offered BA (Hons): Fine Art; Contemporary Photographic Practice; MA: Art Practices (Fine Art); Art Practices (Media); Fine Art and Education; Fine Art (part-time). Other Fine Art courses Portfolio foundation course; Foundation diploma: Art and Design (overseas).

Admissions Policy At undergraduate level applicants will normally have satisfactorily completed a foundation course in art and design. For entry to MA programmes a good degree in visual arts is required.

University of Sunderland

Edinburgh Building, City Campus, Chester Road, Sunderland, SR1 3SD

T 0191 5153154

W www.welcome.sunderland.ac.uk

Degrees offered BA (Hons): Art and Design; Fine Art; Glass, Architectural Glass and Ceramics; Photography, Video and Digital Imaging.

Admissions Policy For degree, foundation degrees and HND programmes applicants need to be at least 18 years of age on 31 December in the proposed year of entry.

University of Teeside

Middlesbrough, TS1 3BA

T 01642 218121

F 01642 342067

E registry@tees.ac.uk

W www.tees.ac.uk

Originally founded as Constantine College, the institution was officially opened in 1930. Has twenty thousand students.

Degrees offered BA (Hons): Fine Art;

Contemporary Three-Dimensional Design; Design; Graphic Design. MA: Design. Art foundation: Design for Exhibition and Display; Graphic Design.

North-west

Blackpool and the Fylde College

School of Art and Design, Palatine Road, Blackpool, FY1 4DW

T 01253 352352

E mp@blackpool.ac.uk

W www.art-design.ac.uk

Contact Malcolm Pearson

Offers recently created fine-art course, covering the specialist disciplines of drawing, painting, printmaking and digital imaging. Has evolved from the grade-I foundation course.

Degrees offered BA (Hons): Fine Art: Profesional Practice (subject to validation by Lancaster University). MA: Visual Design as Creative Practice.

Admissions Policy Fine art applications through UCAS for BA and direct to the institution for MA.

East Lancashire Institute of Higher Education Blackburn College, Feilden Street, Blackburn,

BB2 1LH T 01254 292594

W www.elihe.ac.uk

Contact Carla Patchett

Offers a range of art and design provision through full- and part-time study routes.

Degrees offered BA (Hons): Fine Art (Integrated Media). FdA: Multimedia.

Other Fine Art courses HND: Photography; Textile Design.

Admissions Policy All candidates applying to the school are interviewed for places. For details of admission requirements see website.

Frink School of Figurative Sculpture

Cross St Mill, Leek, ST13 6BL

T 01538 399210

E info@frinkschool.org

W www.frinkschool.org

Set up to preserve and continue the teaching of figurative sculpture. Established in 1996 and named after the sculptor Elisabeth Frink (1933–93). Operates from the Moorland Arts Centre in Leek on the edge of the Peak District. Other Fine Art courses Offers a mix of parttime weekday, weekend and one-week courses, covering aspects of sculpture and also drawing and

painting, including: Life and Portrait Modelling; Life Drawing and Painting; Wood Carving; Stone Carving; Related Modelling and Casting Processes; Welding; Terracotta Firing.

Lancaster University

Bailrigg, Lancaster, LA1 4YW

T 01524 65201

E ugadmissions@lancaster.ac.uk

W www.lancs.ac.uk/depts/art/

Art is a part of the new Lancaster Institute for the Contemporary Arts that also includes Music and Theatre Studies. The BA Fine Art degree nurtures the "informed practitioner" and comprises two thirds studio practice (painting, drawing, digital, installation options or hybrids) and one third art history/professional practice. The MA continues the notion of the "informed practitioner".

Degrees offered BA (Hons): Fine Art. MA: Art (Studio Practice). MPhil/PhD: Fine Art; Art

History.

Admissions Policy Takes 35 students a year. Normally look for a good portfolio plus academic grades of BCC. A foundation year is not essential.

Liverpool Community College

Bankfield Road, Liverpool, L13 0BQ

T 01512 523214

E enquiry@liv-coll.ac.uk

W www.liv-coll.ac.uk

Other Fine Art courses AVCE in Art & Design; BTEC First Diploma in Design; BTEC GNVQ Intermediate in Art and Design; BTEC HNC/HND in Fine Arts; BTEC National Diploma in Foundation Art & Design; BTEC National Diploma in Graphic Design; BTEC National Diploma in 3-Dimensional Design; GNVQ Foundation Art & Design.

Liverpool Hope University College

Hope Park, Liverpool, L16 9JD

T 0151 2913000

F 0151 2913444

E admission@hope.ac.uk

W www.hope.ac.uk

Tradition stretching back over 150 years, when the Church of England Diocese of Chester and the Roman Catholic Sisters of Notre Dame established separate teacher education colleges for women. An ecumenical Christian foundation.

Degrees offered BA (Hons): Design. BA (Combined Hons): Fine Art and Design (with another subject of your choice). BA, QTS: Fine Art and Design with Teacher Training.

Other Fine Art courses Cert. of HE (Combined Hons): Fine Art and Design (with another subject). Admissions policy.

Admissions Policy Applications should be made through UCAS.

Liverpool John Moores University

Rodney House, 70 Mount Pleasant, Liverpool, L3 5UX

T 0151 2312121

E artadmissions@livjm.ac.uk

W www.livjm.ac.uk

Contact Karen Davis

University took its name from Sir John Moores, the founder of the Littlewoods empire. Originally a small mechanics institution (Liverpool Mechanics' School of Arts). Now has over 24,000 students studying over two hundred courses at undergraduate and postgraduate level.

Degrees offered BA (Hons): Fine Art; Graphic Arts; Fashion and Textile Design. PGCE: Art and Design.

Admissions Policy Looks for evidence of creative ability and motivation regardless of entry route. Applications through UCAS system and portfolio interview.

Manchester Metropolitan University

Faculty of Art and Design, Chatham Building, Cavendish Street, Manchester, M15 6BR T 0161 2476969

E courses@mmu.ac.uk

W www.artdes.mmu.ac.uk

The faculty has a distinguished history dating back over 150 years. The painter Adolphe Valette, a contemporary of L.S. Lowry, was both a student and a teacher at the faculty.

Degrees offered BA (Hons): Fine Art; Interactive Arts; Creative Practice, Photography. MA: Fine Art.

Other Fine Art courses We offer a range of short courses including: Bookbinding, ceramics, jewelry, life drawing, photography (digital), photography (traditional) and printmaking. http://www.artdes.mmu.ac.uk/shortcourses

Admissions Policy For BA: 160 tariff points. Most applicants are undertaking or have completed a pre-degree foundation qualification. For MA: good undergraduate fine-art degree.

Mid-Cheshire College

Hartford Campus, Chester Road, Northwich, CW8 1LJ T 01606 74444 E info@midchesh.ac.uk

W www.midchesh.ac.uk

Around ten thousand students.

Other Fine Art courses BTEC FD: Art and Design. BTEC Introductory Dip.: Art and Design. BTEC ND: Graphic Design. BTEC ND: Photography. Edexcel Dip. in Foundation Studies: Art and Design. HND: Photography. HND: Graphic Design. Various part-time courses.

Admissions Policy In general, a number of GCSEs

at a certain grade or above, portfolio and interview.

Oldham College

Rochdale Road, Oldham, OL9 6AA

T 0161 6245214

F 0161 7854234

E info@oldham.ac.uk

W www.oldham.ac.uk

Contact Patricia Walkenden

Other Fine Art courses HND: Fine Art (two years); Multimedia (two years). ND: Art and Design (one year). Adult Access to Art and Design (two years). Admissions Policy All students receive a one-to-one interview for advice and guidance with an experienced member of teaching staff. Students can apply at any time of year.

Runshaw College

Euxton Lane, Chorley, PR7 6AD

T 01772 642040

E justask@runshaw.ac.uk

W www.runshaw.ac.uk

Established as a sixth-form college in 1974.

Other Fine Art courses Foundation Studies: Art and Design. HND: Graphic Design; Fine Art.

Admissions Policy Apply through UCAS.

Southport College

Mornington Road, Southport, PR9 0TT T 01704 500606

F 01704 392794

E guidance@southport-college.ac.uk W www.southport-college.ac.uk

All foundation-degree programmes are offered in conjunction with either the University of Central Lancashire in Preston or Liverpool John Moores University. Around twelve thousand students (two thousand studying on full-time or modular

Other Fine Art courses Dip. in Foundation Studies: Art and Design. ND: General Design and Art. Admissions Policy Entry requirements for ND in General Design and Art: four GCSE passes at grade C or above (three if the portfolio presented at

interview is exceptionally good). A good standard of Intermediate GNVQ in Art and Design is also acceptable. For Dip. in Foundation Studies (Art and Design), candidates are expected to: possess at least two AS levels supported by a minimum of three GCSEs grades A to C, or equivalent; exhibit a portfolio that shows a satisfactory standard of work, particularly in the area of objective drawing; project a high level of commitment and enthusiasm. If an applicant's work exhibits exceptional ability, the need for minimum number of formal academic qualifications may be waived. Mature students with a good portfolio may be accepted without academic qualifications.

St Helens College

Brook Street, St Helens, WA10 1PZ T 01744 733766 F 01744 623400 E enquire@sthelens.ac.uk

W www.sthelens.ac.uk

Founded as the Gamble Institute in 1896. Degrees offered FdA: Photography and Digital Imaging; Multimedia Arts and Animation.

Other Fine Art courses Access, BTEC, HND and foundation courses in a wide range of subjects including calligraphy, ceramics, digital video production, painting and drawing, photography. textiles, visual studies, oil and watercolours.

Admissions Policy For all HND and degree programmes: through UCAS. For all FE programmes (including part-time HNC): apply directly to the college's admissions unit.

St Martin's College

Bowerham Road, Lancaster, LA1 3JD T 01524 384384

E admissions@ucsm.ac.uk

W www.ucsm.ac.uk

Founded in 1963 by the Church of England as a College of Education to train teachers. Over ten thousand students (twenty-eight per cent being mature students).

Degrees offered BA (Hons)/Dip. of HE: Fine Art (part-time studies available).

Admissions Policy See website.

Stockport College of Further and Higher Education

Wellington Road South, Stockport, SK1 3UQ T 0845 2303107 F 0161 9583452 E enquiries@stockport.ac.uk W www.stockport.ac.uk

Founded in 1887. Has fifteen thousand students enrolled within twelve vocational areas offering qualifications from GCSE to degrees validated by local universities.

Degrees offered BA (Hons): Documentary and Fine Art Photography.

Admissions Policy Five GCSE passes and two A-levels or satisfactory completion of art and design foundation, Access course, BTEC ND or Advanced GNVO.

University College Chester

Parkgate Road, Chester, CH1 4BI

T 01244 375444

E enquiries@chester.ac.uk

W www.chester.ac.uk

Contact For enquiries about course content, contact Pete Turnbull. Head of Fine Art. Housed in a modern, custom-built facility, part of the main campus. Aims of the programme are to develop practical skills and creative potential relevant to fine-art practice, and to provide a theoretical framework that allows students to engage in informed discourse and constructive self-evaluation of work.

Degrees offered BA (Single and Combined Hons): Fine Art; New Media. PgDip/MA: Fine Art. Admissions Policy See website.

The University of Bolton

Deane Road, Bolton, BL3 5AB

T 01204 900600

E enquiries@bolton.ac.uk

W www.bolton.ac.uk

Contact Art and Design Admissions, phone 01204

Formerly known as Bolton Institute. Became the north-west's newest university in 2005. Of eight thousand students, approximately seventy-two per cent are from the north-west.

Degrees offered BA (Hons): Art and Design; Textile/Surface Design.

Other Fine Art courses Art and design foundation. Admissions Policy For BA Art and Design: art foundation course; or four GCSE passes and two A-levels including Art; or Intermediate or Advanced GNVQ in Art and Design or related subjects; or BTEC ND in Art and Design subjects; or Access to HE Programme in Art and Design subjects. For two-year foundation: four GCSEs at grade C or above. For one-year foundation: five GCSEs at grade C or above and one A-level, preferably in Art. Special consideration given to candidates over 21 without these qualifications.

University of Central Lancashire

Department of Art and Fashion, Victoria Building, Room VB338, Preston, PR1 2HE

T 01772 893182

F 01772 892921

E omwells@uclan.ac.uk

W www.uclan.ac.uk/facs/destech/artfash/ index. htm

Contact admissions@uclan.ac.uk

Degrees offered BA (Hons): Fine Art;
Photography; Art and Design. MA: Fine Art:
Archive Interventions; Fine Art: Curatorial
Initiatives; Fine Art: Painting and Printmaking;
Fine Art: Site and Place; Fine Art: Time-Based
Media and Photography.

University of Cumbria (formerly Cumbria Institute of the Arts)

Brampton Road, Carlisle, CA3 9AY

T 01228 400300 F 01228 514491

E info@cumbria.ac.uk

W www.cumbria.ac.uk

Contact Admissions Officer

Around 1,200 full-time students. Founded in the 1820s. Delivers a variety of courses at FE and HE levels in the visual, performing and media arts, crafts, design and cultural heritage.

Degrees offered BA (Hons): Fine Art;

Contemporary Applied Arts; Graphic Design; Multimedia Design and Digital Animation. MA: Contemporary Fine Art; Contemporary Applied Arts. Research degrees up to PhD level.

Other Fine Art courses Some evening classes.

Phone for part-time brochure.

Admissions Policy Entry to undergraduate programmes through UCAS routes A and B. Most applicants will have completed a BTEC ND, Dip. in Foundation Studies, Access to HE course, Advanced GNVQ or equivalent course, and have two grade C passes at A2 or, for Scottish students, three Highers at grades BBC. Applicants for MAs will normally have a first degree at 2:1 or above. However, applicants with equivalent professional experience are invited to contact the institute.

University of Salford

School of Art and Design, Centenary Building, Peru Street, Salford, M3 6EQ

T 0161 2956088

Ei.n.howe@salford.ac.uk

W www.artdes.salford.ac.uk

The BA (Hons) in Visual Arts offers a broad-based fine-art course, which encourages self-directed

study in the studio across any chosen media. The students' individual personal development and study is supported by relevant theory, studio tutorials and peer learning events. There is an emphasis on contextualization and a high degree of freedom in the studio. The MA in Contemporary Fine Art is located in adjacent studios.

Degrees offered BA (Hons): Visual Arts. PgDip: Contemporary Fine Art. MA: Contemporary Fine Art.

Other Fine Art courses A range of continuing professional-development courses for postgraduates or mid-career practitioners.

Admissions Policy Normal entry requirements: foundation diploma in art and design or 160 tariff points. All applicants are interviewed. Mature students welcomed. At postgraduate level applicants would normally hold an upper second class degree with honours. However, all applicants are interviewed with portfolios.

Wirral Metropolitan College

Conway Park Campus, Europa Boulevard, Conway Park, Birkenhead, CH41 4NT

T 0151 5517777

F 0151 5517001

W www.wmc.ac.uk

Degrees offered BA (Hons): Fine Art (full- or parttime).

Other Fine Art courses Foundation diploma: Art and Design. BTEC FD: Art and Design. BTEC: Introduction to Art, Design and Media. BTEC ND: Art and Design.

Northern Ireland

Ulster University

Belfast Campus, York Street, Belfast, BT15 1ED T 0870 0400700

E online@ulster.ac.uk

W www.ulst.ac.uk

School of Art and Design located at both York Street campus in Belfast city centre and at the Foyle Arts Centre at the Magee campus. The largest art and design education centre on the island of Ireland. INTERFACE is a new research centre based in the School of Art and Design, part of a multi-million-pound redevelopment of the Belfast campus.

Degrees offered BA (Hons): Art and Design; Fine and Applied Arts; Textiles and Fashion Design.

Other Fine Art courses Foundation Studies: Art and Design.

Scotland

Duncan of Jordanstone College of Art and Design

School of Fine Art, University of Dundee, Perth Road, Dundee, DD1 4HT

T 01382 343291

F 01382 200983

E j.a.ritchie@dundee.ac.uk

W www.dundee.ac.uk/fineart/

Contact Tracey Drummond

College founded in 1892 and merged with the university in 1994. Fine Art is one of four schools in the faculty (the others being Architecture, Design and Television & Imaging). Fine Art students work across the full range of contemporary media, including painting, sculpture, printmaking, photography, video and digital, performance, installation and artists' publication. Staff are all practising artists working at national and international levels.

Degrees offered BA (Hons): Fine Art; Art and Philosophy; Contemporary Practices. Also MFA programmes.

Admissions Policy See website for details of level I (general course) and level 2 entry requirements and dates of application.

Edinburgh College of Art

74 Lauriston Place, Edinburgh, EH3 9DF

T 0131 2216000

F 0131 2216000

E m.wood@eca.ac.uk

W www.eca.ac.uk

The College traces its routes back to 1760, the oldest established drawing academy in Britain. Founded on its present site in 1907 in a beaux arts' building. The building includes a Sculpture Court built on Palladian principles and has a complete case (made in situ) of the Parthenon Frieze. Alumni include: Dame Elizabeth Blackadder, Sir Eduardo Paolozzi, Alan Davie, John Bellany, Sir Basil Spence, John Arden, Sir Nicholas Grimshaw and Barbara Rae.

Degrees offered BA (Hons): Painting; Design and Applied Arts; Visual Communication; Sculpture. Other Fine Art courses BA: Combined Studies (part-time). ECA Summer School Centre of Continuing Studies offers part-time courses. Admissions Policy Policy Entry through UCAS for all full-time undergraduate courses. Interview and portfolio information is specific to different courses.

Glasgow School of Art

167 Renfrew Street, Glasgow, G3 6RQ

T 0141 3534500

F 0141 3534746

E info@gsa.ac.uk

W www.gsa.ac.uk

Founded in 1845 as one of the first government schools of design. Now a leading institution for the study and advancement of fine art, design and architecture. International community of over 1,600 (primarily undergraduate) students studying in ten specialist fine art or design departments, or within the Mackintosh School of Architecture. Growing postgraduate community studying for taught and research degrees. The history of the GSA is inextricably linked to Charles Rennie Mackintosh, who graduated from the School in 1896 and went on to design the School of Art building. Graduates include the Turner Prize winners Simon Starling and Douglas Gordon and the Beck's Futures Winners Roderick Buchanan, Toby Paterson and Rosalind Nashashibi.

Degrees offered BA (Hons): Fine Art (Painting and Printmaking, Photography, Sculpture and Environmental Art); Design (Ceramics, Interior Design, Silversmithing and Jewelry, Textiles, Visual Communication); Product Design; Product Design Engineering. MA: Fine Art; 2D/3D Motion Graphics; Design Textiles as Fashion; Art, Design and Architecture in Education; Architecture; Research. Mphil. PhD.

Other Fine Art courses Continuing education programme including portfolio preparation, weekend and evening classes, summer schools and easter vacation courses in art design and architecture.

Admissions Policy Entry through UCAS for all undergraduate programmes. Postgraduate applications direct to the School. Scholarships available.

Heriot-Watt University

Edinburgh, EH14 4AS

T 0131 4495111

E edu.liaison@hw.ac.uk

W www.hw.ac.uk

More than 6,300 students on campus in Scotland plus over 9,500 on external programmes in 140 countries worldwide. The eighth oldest HE institution in the UK. Established by Royal Charter in 1966, its origins date back to 1821 through the School of Arts of Edinburgh.

Degrees offered BA (Hons): Design for Textiles.

Taught courses at postgraduate level are either MA. PgDip or PCert courses.

Other Fine Art courses Part-time study is available. Admissions Policy For undergraduate: through UCAS. For PgDip: applicants need a first degree.

Robert Gordon University

Gray's School of Art, Garthdee Road, Aberdeen, AB10 7QD

T 01224 263600

F 01224 263636

E a.young@rgu.ac.uk

W www2.rgu.ac.uk

Gray's School of Science and Art was founded in 1885. It later merged with Robert Gordon's Technical College and became the Robert Gordon University in 1992.

Degrees offered BA (Hons): Design and Craft; Fine Art; Design for Digital Media. MA: Fine Art. Admissions Policy For admission requirements for specific courses see website.

Studio Art School

St Leonard's House, Lasswade Road, Loanhead, EH20 9SD

T 0131 4402754

E info@studioartschool.co.uk

W www.studioartschool.co.uk

Contact Arlene Stewart

The Studio Art School was established in 2004 and provides practical, online art and design tuition for those who wish to progress onto degree level programmes at art college or university and those who wish to develop their skills through certified and non-certified vocational courses. Online teaching and learning environment allows students complete flexibility in their studies.

Other Fine Art courses City & Guilds level 1:
Drawing & Painting; Introduction to Sketchbooks;
Introduction to Fashion Design and Illustration.
City & Guilds level 2: Creative Sketchbooks;
Fashion Design and Illustration; Drawing
& Painting; also at level 2, Art Appreciation.
Preparation for Higher Education: Undergraduate
Bridging Course; Level 3 Diploma in Foundation
Studies: Art & Design; Pre-Masters Diploma in Art
and Design.

Admissions Policy There are no specific entry requirements although the School offers a free portfolio appraisal and study advice service – "Which Course?".

UHI Millennium Institute

Executive Office, Ness Walk, Inverness, IV3 5SQ

T 01463 279000

F 01463 279001

E EO@uhi.ac.uk

W www.uhi.ac.uk

Granted status of HE Institute in 2001, providing university level courses throughout the Highlands and Islands of Scotland. Partnership of fourteen colleges and research institutions in the region, coordinated by UHI executive office based in Inverness.

Degrees offered BA: Creative Media; Fine Art. Other Fine Art courses HND: Art and Design. HNC: Fine Art.

University of Edinburgh

History of Art, 20 Chambers Street, Edinburgh, EH1 1JZ

T 0131 6504124

F 0131 6508019

E histart@ed.ac.uk

W www.arts.ed.ac.uk/fineart

Contact Lisa Kendall (Arts Admissions)
Founded in 1880, History of Art at the University
of Edinburgh has the oldest chair of Art History in
Britain. A leading centre for the discipline, in a city
with world-class art collections.

Degrees offered MA: Fine Art (five years), jointly run with Edinburgh College of Art.

Admissions Policy UCAS requirements – minimum BBB at 'A' level. Portfolio to be submitted to Edinburgh College of Art in January.

University of Paisley

Ayr Campus, Beechgrove, Ayr, KA8 0SR T 01292 886388

F 01292 886387

E william.strachan@paisley.ac.uk

Contact William Strachan

Degrees offered BA (Hons): Digital Art. Aims to unite 'traditional' art skills to skills in digital technologies. The routes to specialism are digital media, creative video and filmmaking, and animation. Some academic study as well as work in art and digital contexts.

Admissions Policy Entry requirements involve three parts: (1) three SQA Highers (BBC) (or equivalents), including English; (2) an art and design portfolio; (3) a brief interview based on (2).

South-east

Bedford College

Cauldwell Street, Bedford, MK42 9AH T 01234 291000 F 01234 342674 E info@bedford.ac.uk.

W www.bedford.ac.uk

Contact Enquiries and Admissions at Bedford College, FREEPOST BF 356, Bedford MK42 9BR, or phone 0800 0740234.

Courses for all levels of ability, both in art and design and in the more specialist disciplines of fine art, graphic design, multimedia, threedimensional design and textiles. Provide practical sessions and projects to help develop artistic skills, and academic study into the social, cultural and historical development of chosen media.

Degrees offered GNVQ in Art & Design Level 1 & 2; BTEC Diploma in Foundation Studies; BTEC National Diploma in Fine Art; BTEC National Diploma in Photography; BTEC National Diploma in Textiles; BTEC HNC/D in Fine Art; BTEC HNC/D in Textiles.

Admissions Policy For requirements see website. Students with no previous qualifications can take an Access to Art and Design course.

Brighton University

68 Grand Parade, Brighton, BN2 2JY

T 01273 600900

E postmaster@brighton.ac.uk

W www.brighton.ac.uk

Brighton School of Art opened in the Royal Pavilion Kitchens in 1859. It merged with Brighton Technical College in 1970 to form Brighton Polytechnic. The Polytechnic became Brighton University in 1992. The School of Arts and Communication encompasses painting, sculpture, printmaking, critical fine-art practice, dance, music and theatre with visual practice, graphic design, illustration and editorial photography. With thirty staff and 400 students; the school has an international profile and student exchanges links are established with art schools in Bordeaux, Limoges, Chicago, Kansas, New York and Warsaw. Located at Grand Parade.

Degrees offered BA (Hons): Art and Design; Illustration; Painting; Printmaking; Sculpture. MA/PgDip: Fine Art Printmaking; Printmaking and Professional Practice; Fine Art; Photography. New route PhD: Art and Design.

Other Fine Art courses HNC and HND: Fine Art. For part-time evening and Saturday classes contact arthouse@brighton.ac.uk or 01273 643015.

Admissions Policy UCAS routes A or B. Candidates are interviewed and should bring a portfolio of work. For MA courses apply by I July. **Buckinghamshire New University**

Faculty of Creativity & Culture, Queen Alexandra Road, High Wycombe, HP11 2JZ

T 01494 603054

E advice@bucks.ac.uk

W www.bucks.ac.uk

Formerly Buckinghamshire Chilterns University College, Buckinghamshire New University offers courses to over 1,300 students studying at all levels from Foundation to PhD.

Degrees offered BA (Hons): Fine Art (full- and part-time); Textiles and Surface Design. MA: Art and Design: Illustration; Ceramics with Glass; Printmaking.

Other Fine Art courses Edexcel Dip. in Foundation Studies: Art and Design. Part-time drawing course.

Canterbury Christchurch University College

Department of Media and Art, North Holmes Road, Canterbury, CT1 1QU

T 01227 767700

F 01227 782888 / 470442

E M.S.Holt@cant.ac.uk

W www.cant.ac.uk

Contact Department of Admissions.

Founded by the Church of England in 1962, built on what was the old orchard ground of St Augustine's Abbey. Welcomes students from all faiths and none. The Department of Media and Art is located on the Canterbury campus.

Degrees offered BA: Digital Culture, Arts and Media; Ceramics; Fine Art; Painting; Sculpture. Also teacher training with art and design. MA: Ceramics; Fine Art.

Admissions Policy All college students must be at least 17 years of age by 1 October in the year of admission and fulfil the minimum entry requirements. Offers will be made in terms of grades rather than points. Candidates who have not had the opportunity to take a recognized qualification in key skills will not be disadvantaged in terms of their application. See website.

Northbrook College Sussex

Littlehampton Road, Goring-by-Sea, Worthing, **BN126NU**

T 01903 606060

F 01903 606073

E enquiries@nbcol.ac.uk

W www.northbrook.ac.uk

Formed in 1987 when three local colleges merged, including the West Sussex College of Design. Degrees offered BA (Hons): Fine Art (Painting):

Fine Art (Sculpture); Fine Art (Printmaking). All courses run full- and part-time.

Other Fine Art courses Cert./Dip. of HE: Fine Art.

Admissions Policy Applicants should have two A-levels/BTEC ND/GNVQ. All applicants will be interviewed with a portfolio that should include drawing and demonstrate creative, technical, written and visual abilities.

Oxford & Cherwell College

Oxpens Road, Oxford, OX1 1SA

T 01865 550550

E enquiries@oxford.occ.ac.uk

W www.ocvc.ac.uk

Degrees offered BA (Hons): Graphic Design and Illustration: Fine Art.

Other Fine Art courses Foundation Studies: Art and Design. HND: Graphic Design; Illustration; Advertising and Multimedia.

Admissions Policy See website.

Oxford Brookes University

Department of Arts and Humanities, Richard Hamilton Building, Headington Campus, Oxford, OX3 OBP

T 01865 484995

F 01865 484952

E lisa.atkinson@brookes.ac.uk

W http://ah.brookes.ac.uk

Contact Lisa Atkinson

Degrees offered BA (Hons): Fine Art. MA: Contemporary Arts and Music; Social Sculpture; Composition and Sonic Art; Contemporary Art. Other Fine Art courses Foundation Diploma in Art

and Design

Admissions Policy CCD at A level (or equivalent) and successful completion of foundation or access course in Art and Design is normally required. Applicants with alternative qualifications welcomed, UCAS routes A and B.

Oxford University

University Offices, Wellington Square, Oxford, OX1 2JD

T 01865 270000

 $\textbf{E} \ under graduate.admissions@admin.ox.ac.uk$

W www.ox.ac.uk

Oxford is the oldest university in the Englishspeaking world and lays claim to nine centuries of continuous existence. More than 130 nationalities represented in student population of over sixteen thousand.

Degrees offered BFA: Fine Art. MFA: Fine Art.

Admissions Policy Undergraduate: UCAS system. All candidates are required to submit a portfolio of their work (see the Ruskin School of Drawing and Fine Art prospectus for further information). The School is not looking for a particular style or skill, although it is generally felt that a foundation course can be beneficial to a candidate. Should be a sufficient amount of work to demonstrate real commitment and interests, with a good selection of drawings. Must be sent or delivered in a strong standard type portfolio (A1). Postgraduate: Entry requirements as outlined in Applications and Admissions procedure (completion of a bachelor's degree with a first or upper second-class honours or the international equivalent). Additional: Applicants will be expected to have completed or be about to complete a good Honours Degree which would normally be in Fine Art.

Reigate School of Art, Design and Media (East Surrey College)

Gatton Point North, Claremont Road, Redhill, RH1 2IX

T 01737 788391

F 01737 788392

E afowler@esc.ac.uk

W www.esc.ac.uk

Contact Allison Fowle (Art School Administrator). Celebrated its 110th anniversary in 2005.

Celebrated its 110th anniversary in 2005.

Other Fine Art courses Level 4 BTEC HND/HNC: Fine Art; Graphic Design and Illustration; Digital Photography; Textile Design; Modelmaking and Special Effects; Lettering, Calligraphy and Heraldic Art. Level 3 BTEC ND: Fine Art; Graphic Design; Photography; Fashion and Clothing; Multimedia. Level 3 BTEC foundation diploma: Art and Design. Admissions Policy For ND: four GCSEs, grade C and above. For HND: ND in Art or A-level Art. Mature students – acceptable portfolio.

Southampton Solent University

East Park Terrace, Southampton, SO14 OYN

T 023 80319000

F 023 80334161

E enquiries@solent.ac.uk

W www.solent.ac.uk

Origins can be traced back to a private school of art founded in 1856. More recently Southampton Institute became Southampton Solent University in July 2005, with 16,000 students. Campus also houses the Millais public art gallery.

Degrees offered BA(Hons): Fine Art; Fine Arts Valuation; Fine Art Media; Illustration; Photography; Animation; Computer & Video Games; Digital Media; Performance; Comedy, Writing & Performance; Design Studies; Graphic Design; Multimedia Design; Product Design & Marketing; Film Studies; TV & Video Production. Foundation: Art, Design & Media.

Admissions Policy Admission to all undergraduate courses is via UCAS.

University College Chichester

Bishop Otter Campus, College Lane, Chichester, PO19 6PE

T 01243 816000

E admissions@ucc.ac.uk

W www.ucc.ac.uk/arts/fineart/index.html
Contact Admissions Office on 01243 816002
Bishop Otter College was established in 1839
to train schoolmasters. In 1946 Bognor Regis
Emergency Training College was founded in 'an
emergency' effort to staff the nation's schools in
the aftermath of the Second World War. In 1977
the two colleges merged and became known as
the West Sussex Institute of Higher Education.
In 1999 it became University College Chichester.
Broad artistic interdisciplinarity welcomed as part
of fine-art practice.

Degrees offered BA (Hons): Fine Art. Minor: New Media Arts. MA: Fine Art.

Admissions Policy Qualifications recommended: Art Foundation Course with Pass. Basic Requirement: Advanced GNVQ Art with Merit, or Pass in approved Access course, or 2–3 A-level passes, including Art A-level grade C/B, or equivalent mix of A-levels and AS levels, or equivalent. Applicants must also present a portfolio.

University for the Creative Arts - Maidstone

Maidstone Campus, Oakwood Park, ME16 8AG T 01622 620000

F 01622 621100

E info@ucreative.ac.uk

W www.ucreative.ac.uk

Formed through the merger of the Surrey Institute of Art & Design, University College and the Kent Institute of Art & Design. As well as Maidstone, there are four other campus sites: Canterbury, Epsom, Farnham and Fort Pitt in Rochester.

Degrees offered BA (Hons): 3D Design: Ceramics or Glass or Metalwork & Jewelry; Animation; Applied Arts; Arts & Media; Design, Branding & Marketing; Digital 3D Design; Digital Screen Arts; Fashion; Film Production; Fine Art; Graphic Communication; Graphic Design; Illustration; Interior Design; Modelmaking; Photography; Photography & Media Arts; Design or Graphic Design; Printmaking; Product Design; Silversmithing, Goldsmithing & Jewelry; Textile Design; Video & Photography; Video Media Production. MA: Animation; Artists' Film, Video & Photography; Contemporary Crafts (Ceramics, Glass, Jewelry; Textiles); Creative Enterprise; Curating Contemporary Craft; Design; Fashion; Fashion; Film & Video; Fine Art; Graphic Design & Communication; Graphic Design & New Media; Interior Design; Museums & Contemporary Curating; Photography; Spatial Practices: Art, Architecture & Performance; Sustainable Product Design; Urban Design.

Other Fine Art courses A wide range of foundation, access and part-time courses (including evening, and summer school courses) are available.

University of Kent

The Registry, Canterbury, CT2 7NZ

T 01227 764000

E recruitment@kent.ac.uk

W www.kent.ac.uk

The school consists of thirty-three academic staff, supported in their work by two administrators, four secretaries and six technicians. Over eight hundred students from the UK, Europe and beyond. Many programmes involve practical creative elements, some involve work placements, and some allow students to spend a year abroad, in Europe or the USA.

Degrees offered BA (Hons): Contemporary Art; Fine Art (one year top-up at South Kent College). Other Fine Art courses HND: Fine Art.

University of Portsmouth

University House, Winston Churchill Avenue, Portsmouth, PO1 2UP

T 023 92848484

F 023 92843082

E info.centre@port.ac.uk

W www.port.ac.uk

Inaugurated in 1992. The former polytechnic grew from the Portsmouth and Gosport School of Science and Arts, founded in 1869.

Degrees offered MA: Art, Design and Media. Other Fine Art courses Dip. in Foundation Studies: Art and Design; Art, Design and Photography.

Admissions Policy Applications through UCAS where applicable. All other applications by university application form.

University of Reading

Department of Fine Art, I Earley Gate, Reading, RG6 6AT

T 0118 3788050 / 3788051

F 0118 9262667

E FineArt@reading.ac.uk

W www.rdg.ac.uk/fineart Contact Tina O'Connell

Constituted by Royal Charter in 1926. Has its origins in the union of the Schools of Art and Science in 1892, forming a university extension college of Oxford ten years later. Distinguished visitors and lecturers include Marc Camille Chaimowicz, Dr. John Russell, Amikam Toren, Alun Rowlands, Cornelia Parker, Richard Wilson and Mike Nelson.

Degrees offered BA Art (four-year programme): BA Art and Philosophy; BA Art and Psychology; BA Art and History of Art; BA Art and Film & Theatre; BA Fine Art (three-year programme); MFA Fine Art (two-year postgraduate programme); Mphil/PhD Art. Admissions Policy See website.

University of Southampton

Winchester School of Art, Park Avenue,

Winchester, SO23 8DL

T 023 80596900

F 023 80596901

E ii@soton.ac.uk W www.wsa.soton.ac.uk

Originally founded in 1872, Winchester School of Art joined the University of Southampton in 1996. Offers opportunitites for interdesciplinary research and study combined with excellent facilities.

Degrees offered BA (Hons): Graphic Arts (pathways in Graphic Design, Advertising Design Management, Photography and Digital Media, Digital Animation); Fine Art (pathways in Painting, Printmaking, Sculpture, New Media); Textiles, Fashion and Fibre (pathways in Textile Design, Fashion, Textile Art); Heritage Studies: Museums & Galleries. MA: Fine Art (pathways in Painting, Sculpture, Printmaking, Fine Art by Project); Design (pathways in Fashion Management; Fashion Design; Fashion and Design Journalism; Communication Design; Advertising Design; Design Management; Textile Design; Textile and Fibre Art); Museums and Galleries (pathways in Culture, Collections and Communications; Collections Management; History of Textiles and Dress; Interpreting Historic Interiors; Access and Learning; Archives in Museums); Textile Conservation; Organics Conservation. MRes Programmes. MPhil and PhD opportunities. Note that the only studio-based parttime course now on offer is the MA Fine Art. The Textile Conservation, Organics Conservation and Museums and Galleries programmes can all be taken on a part-time or full-time basis. Admissions Policy Refer to website for latest information.

South-west

Arts Institute at Bournemouth

Wallisdown, Poole, BH125HH

T 01202 533011

F 01202 537729

E general@aib.ac.uk

W www.aib.ac.uk

Contact Alison Aspery

Established in 1883

Degrees offered BA (Hons): Fine Art (full- and part-time). FdA: Printmaking (part-time).

Other Fine Art courses NCFE Cert.: Art and

Design (part-time). Institute Cert.: Fine Art; Life Drawing; Printmaking (part-time plus short Easter and summer courses).

Admissions Policy Full-time: through UCAS. Parttime: direct to institute (forms available through Short Course Department).

Bath School of Art and Design

Bath Spa University College, Sion Hill, Lansdown, Bath, BA15SF

T 01225 875875

F 01225 875666

E enquiries@bathspa.ac.uk

W www.bathspa.ac.uk/schools/art-and-design

Contact enquiries@bathspa.ac.uk

Founded in 1898, becoming Bath College of Higher Education in 1975 and granted degreeawarding powers in 1992. Became Bath Spa University in 1999. About 4,500 students in total. Degrees offered BA (Hons): Fine Art (Painting/

Sculpture/Media); Creative Arts. MA: Fine Art. PgCert: Fine Art. PgDip: Fine Art.

Admissions Policy For undergraduate courses, a foundation course in art and design or appropriate BTEC course plus five subjects at GCSE level (or one subject at GCE/VCE A-level with three different subjects at GCSE level; or other qualifications considered equivalent). If applying to study Art and Design, creative ability and suitability for chosen course important criteria. Entry also possible via Access courses.

Bristol School of Art, Media and Design

University of the West of England, Bower Ashton Campus, Kennel Lodge Road, Bristol, BS3 2JT T 0117 3284716

F 0117 3284745

E amd.enquiries@uwe.ac.uk

W www.uwe.ac.uk

Founded in 1853. More than 1,600 students studying at all levels.

Degrees offered BA (Hons): Art and Visual Culture; Drawing and Applied Arts; Fine Art; Fine Art in Context; Illustration; Illustration with Animation; Textile Design. MA: Fine Art (Research); Illustration (Research); Illustration with Animation (Research); Interactive Media; Interactive Media (Research); Multidisciplinary Printmaking. PhD and New Route PhDs.

Other Fine Art courses Foundation Studies: Art and Design. Short courses: Animation; Applied Arts; Computing for Artists; Drawing; Photography; Printmaking. Also runs Easter courses, evening classes, Saturday workshops and summer schools.

Dartington College of Arts

Dartington Hall Estate, Dartington, Totnes, TQ9 6EJ

T 01803 862224 F 01803 861666

E enquiries@dartington.ac.uk

W www.dartington.ac.uk

Contact Margaret Eggleton

Founded in 1961, having evolved as part of a rural regeneration experiment. Situated on a private estate with approximately 850 acres on the outskirts of Totnes in South Devon. Has an international reputation for experimental arts practices within a close-knit community of 500+ undergraduates and 100+ postgraduate students. Degrees are validated in partnership with the University of Plymouth. Alumni include Josie Lawrence, Verity Sharp, Matthew Linley, Marcus Davey and Matthew Strachan.

Degrees offered BA (Hons): Fine Art (Contemporary Practices); Fine Art (with Digital Arts Practices/ Choreographic Practices/ Cultural Entrepreneurship/ Textual Practices/ Theatre Practices/ Sound Practices/ Community Practices); Art and Performance; Art and Performance (with Digital Arts Practices/ Choreographic Practices/ Cultural Entrepreneurship/ Textual Practices/ Theatre Practices/ Sound Practices/ Community Practices).

Admissions Policy A foundation course in art and design and/or Art A-level/AS or vocational A-level (160 UCAS points). Minimum 140 points from six- or twelve-unit awards. Equivalent experience also taken into consideration. Selection based on presentation of a portfolio and interview.

Exeter College

Victoria House, 33–36 Queen Street, Exeter, EX4 3SR

T 01392 205232

E admissions@exe-coll.ac.uk

W www.exe-coll.ac.uk

The tertiary college for the City of Exeter and surrounding parts of Mid-, East and South Devon. Victoria Yard Studios is the college's centre for higher-level study in art and design. The fully equipped premises have light and spacious studios, facilities for printmaking, photography, wood, metal workshops and IT. Nearby are various gallery venues including the V&A, Phoenix Arts Centre and Spacex Gallery.

Degrees offered BA (Hons): Fine Art.
Other Fine Art courses Foundation Studies: Art and Design. HND: Three-Dimensional Applied Arts.

Filton College

Filton Avenue, Bristol, BS34 7AT
T 0117 9092324
F 0117 9312233
E info@filton.ac.uk

W www.filton.ac.uk Large range of art and design courses across three sites: Bristol School of Art in the city centre; Western Institute of Specialist Education (WISE); and Filton College, north Bristol.

Other Fine Art courses HND: Fine Art; Graphic Design. Bristol School of Art offers a wide range of open-access part-time courses (varying length across the year): Life Drawing; Ceramics; Painting; Stained Glass; Jewelry; Enamelling; Printmaking; Sculpture; Digital Imaging.

Admissions Policy For HND: apply through UCAS. For other courses: apply directly. Phone, email or fax the college for further information.

Plymouth College of Art and Design

Tavistock Place, Plymouth, PL11 2QP T 01752 203434 F 01752 203444 E enquiries@pcad.ac.uk W www.pcad.ac.uk Contact Jean Edmonds

Originally founded as an art school in the nineteenth century and now one of the few remaining specialist art colleges in the country providing both FE and HE. Composed of four subject areas: Three-Dimensional Design; Media and Photography; Design Communications; and Fine Art, Diagnostic Drawing and Painting. The Viewpoint Gallery allows students and local artists to exhibit work.

Degrees offered BA (Hons): Applied Arts; Fine

Other Fine Art courses FdA: Fine Art; Applied Arts: Spatial Design. ABC Dip. in Foundation Studies. BTEC ND: Fine Art.

Admissions Policy For all HE courses: through UCAS. Selected applicants will then be invited to attend an interview and present a portfolio of work. For FE courses: apply direct to the college.

Somerset College of Arts and Technology

Wellington Road, Taunton, TA1 5AX T 01823 366366

E enquiries@somerset.ac.uk

W www.somerset.ac.uk Contact Admissions Office

Formed in 1974 from the Taunton Technical

College and Somerset College of Art, institutions with histories going back over a

Degrees offered Fashion; Fashion and Textiles; Interior Textiles; Surface Design; Interior Textiles and Surface Design; Graphic Design (top-up year); Packaging Design (top-up year); Advertising Design (top-up year); Fine Art (top-up year; awaiting validation). Foundation: Graphic Design; Fine Art; Three-Dimensional Design (Product); Interior Spatial Design.

Admissions Policy UCAS routes A and B. Art-related ND, Advanced GNVQ, A-levels or foundation year. Five GCSEs grade C or above (including English Language). Top-ups require relevant art foundation or HND.

Swindon College

Department of Fine Art, School of Art and Design, Phoenix Building, North Star Avenue, Swindon, SN2 1DY

T 01793 498989

E fineart@swindon-college.ac.uk W www.scsa.swindon-college.ac.uk

Contact Student services on 01793 498308 or admissions@swindon-college.ac.uk.

Offers a wide range of art and design programmes at HND, BA and MA levels.

Degrees offered BA (Hons) Fine Art: Drawing for Fine Art Practice.

Other Fine Art courses Foundation Diploma: Art and Design; Access Art and Design.

Admissions Policy UCAS routes A or B. Students should have: Foundation or Access (Art and Design); or ND (Art and Design); or two A-levels and five GCSEs at grade C or above; or entry to year two with HND in appropriate subject; or other equivalent qualifications or experience.

University College Falmouth

Woodlane, Falmouth, TR11 4RH

T 01326 211077

F 01326 213880

E admissions@falmouth.ac.uk

W www.falmouth.ac.uk

Contact Admissions

Founded as an art school in 1902. Now a leading specialist university college for art, design and media at undergraduate and postgraduate level, having been granted the power to award its own degrees in 2004. An award-winning design centre and broadcast-industry-standard media centre at Tremough in Penryn complement the College's specialist studios in Falmouth.

Degrees offered BA (Hons): Fine Art. MA: Contemporary Visual Arts. (Full- and part-time.) Other Fine Art courses Dip. in Foundation Studies (full- or part-time): Art and Design. Annual printmaking summer school.

Admissions Policy For BA: foundation, ND, AVCE/Advanced GNVQ, qualifications or experience. For MA: degree or relevant qualifications or experience.

University of Bath

Claverton Down, Bath, BA2 7AY

T 01225 383019

E admissions@bath.ac.uk

W www.bath.ac.uk

Received Royal Charter in 1966 but can trace its history back to the Bristol Trade School of 1856.

Degrees offered FdA: Digital Media Arts (Multimedia); Digital Media Arts (Moving Image Production).

Other Fine Art courses Workshops include: Contemporary Ceramics; Painting in the Twenty-First Century; Drawing in the Twenty-First Century; Contemporary Flat Glass; Digital Video; Ceramics: Throwing on the Wheel; Ceramics: Figurative Sculpture; Ceramics: Raku Digital Art. Admissions Policy For foundation degree programmes: apply through UCAS. Minimum

entry requirements will normally be at least four GCSE passes (at grades C or above), including Maths and English together with one or more of the following: UCAS tariff of 80; one pass at Advanced GCE level; one pass in a six-unit vocational A-level; a broader base of studies incorporating AS level; success in an Access to HE course; formally assessed outcomes acquired by dint of APEL. There may be additional entry requirements for each specific foundation degree programme.

University of Gloucestershire

Pittville Campus, Albert Road, Cheltenham, **GL523IG**

T 01242 714929

F 01242 714949

W www.glos.ac.uk

Contact Bob Davison

Art education began in Cheltenham 150 years ago and became part of the University of Gloucestershire in 2001. Pittville Campus specializes in courses in art, media and design. The fine-art courses build on strong theoretical and practical foundations, incorporating new media and contemporary practices.

Degrees offered Fine Art: Painting and Drawing: Fine Art: Photography.

Admissions Policy Applicants interviewed through UCAS routes A and B would normally have completed a foundation course or equivalent.

University of Plymouth

Faculty of Arts, 2 Endsleigh Place, Plymouth, PL48AA

T 01752 238106

F 01752 238102

E arts.admissions@plymouth.ac.uk

W www.plymouth.ac.uk

Founded as Exeter School of Art over 150 years ago. Situated on Exeter campus of the university and moving to Plymouth in 2007.

Degrees offered BA (Hons): Fine Art (full- and part-time). MA: Fine Art (full- and part-time). Admissions Policy For BA (Hons): through UCAS routes A and B. Portfolio required.

Weston College

Knightstone Road, Weston-super-Mare, BS23 2AL T 01934 411411

F 01934 411410

E enquiries@weston.ac.uk

W www.weston.ac.uk

Can trace its origins to private drawing and

painting classes provided by Henry Stacy in Oriel Terrace in 1859. The School of Art was opened in 1865 and since 1993 the college has been an autonomous public body.

Degrees offered BA (Hons): Fine Art (in association with Bath Spa University College). Other Fine Art courses HND: Fine Art (three years part-time or two years full-time).

Wales

North Wales School of Art and Design

North East Wales Institute of Higher Education, Regent Street, Wrexham, LL11 1PF

T 01978 293502

F 01978 310060

E d.loonie@newi.ac.uk

W www.newi.ac.uk/nwsad

Founded as School of Science and Art in 1887. Full member of the University of Wales since 2002.

Degrees offered BA (Hons): Applied Arts; Fine Art. MA: Animation; Contemporary Applied Arts.

Swansea Institute

Faculty of Art & Design, Dynevor Centre for Art, Design and Media, De-La-Beche Street, Swansea. SA13EU

T 01792 481285

F 01792 470385

E artanddesign@sihe.ac.uk

W www.sihe.ac.uk

A member of the University of Wales. Faculty of Art and Design, founded over 150 years ago, is now housed in a new multi-million pound city-centre complex.

Degrees offered BA (Hons): Design for Advertising; Fine Art (Ceramics); Fine Art (Combined Media); Fine Art (Painting and Drawing); General Illustration; Graphic Design: Joint Honours: Art History; Art History and Visual Arts Practice; Photography in the Arts; Photojournalism; Video; Documentary Video; Video Arts; Surface Pattern Design (Contemporary Applied Arts Practice); Surface Pattern Design (Textiles for Fashion); Surface Pattern Design (Textiles for Interiors). MA: Fine Art; Photography; Visual Arts Enterprise; Visual Communication. MPhil and PhD research degrees.

Trinity College

School of Creative Arts and Humanities. Carmarthen, SA31 3EP T 01267 676767 F 01267 676766

E registry@trinity-cm.ac.uk W www.trinity-cm.ac.uk Degrees offered BA (Hons): Fine Art. Admissions Policy Via UCAS.

University of Glamorgan

Pontypridd, CF37 1DL

T 0800 716925

F 01443 822055

E enquiries@glam.ac.uk

W www.glam.ac.uk

Over twenty thousand students.

Degrees offered BA (Hons): Art Practice; Media Studies and Art Practice. MA: Art in the Community.

Other Fine Art courses Foundation certificate: Visual and Community Art.

University of Wales Institute Cardiff

Cardiff School of Art and Design, Howard Gardens, Cardiff, CF24 0SP

T 029 20416154

E csad@uwic.ac.uk

W www.csad.uwic.ac.uk

There has been a college of art in Cardiff for over 130 years. School located on two campuses. The Howard Gardens campus in the city centre houses the Howard Gardens Gallery, a public gallery and community resource with a continuous programme of curated and touring exhibitions. The second campus is at Llandaff on the northern edge of the city centre, with purpose-built studios and a student learning resource.

Degrees offered BA (Hons): Art and Theory Matrix; Broadcast Media & Popular Culture; Ceramics; Contemporary Textile Practice; Design for Interactive Media; Fine Art; Graphic Communication; Interior Architecutre. MA: Ceramics; Fine Art. Foundation Dip.: Art & Design.

Other Fine Art courses Cardiff Open Art School: Evening classes and short summer courses (Painting; Life Drawing; Printmaking; Photoshop). Admissions Policy Refer to website.

University of Wales, Aberystwyth

School of Art, Buarth Mawr, Aberystwyth, SY23 1NG

T 01970 622460

F 01970 622461

E cpw@aber.ac.uk

W www.aber.ac.uk/art

Contact Chris Webster

Founded in 1872. The first university institution

to be established in Wales. Over seven thousand registered students, including over I,Ioo postgraduates across eighteen academic departments. Art practice can be studied along with art history or another subject as part of the university degree.

Degrees offered BA (Hons): Art; Art History; Art with Art History. MA: Art; Art and Art History. MPhil and PhD: Art; Art History. Art Practice may be taken in Drawing and Painting, Printmaking, Photography, and Book Illustration with Typography.

Other Fine Art courses Degree courses also available on a part-time basis.

Admissions Policy Entry onto all art practice courses will only be considered in conjunction with the submission of a portfolio.

University of Wales, Bangor

Bangor, LL57 2DG

T 01248 382016 / 382017

E Admissions@bangor.ac.uk

W www.bangor.ac.uk

Opened in 1884 in an old coaching inn with fiftyeight students and ten members of staff. In 1893 it became one of the three constituent colleges of the University of Wales.

Degrees offered HE Cert. in Fine Art (part-time). Other Fine Art courses Part time courses: Colour in Fine Art; Explorations in Fine Art Drawing and Painting; Drawing and Painting from Life; Fine Art Challenge (Module 2); Modernism; Painting and Composition; Exploring Three-Dimensional and Sculpture; Life, Costume and Portrait Study; Working from Nature; Atelier Life Class; Fine Art Printmaking.

Admissions Policy No particular academic qualifications required for the certificate. However, it is only suitable for those with some competence in art e.g. experienced amateur artists, or those who have previously attended an art foundation course. Prospective students with no foundation experience may be offered direct entry if they can produce a satisfactory portfolio of work.

University of Wales, Newport

Caerleon Campus, P.O.Box 101, Newport, NP18 3YH

T 01633 432432

F 01633 432046

E uic@newport.ac.uk

W www.newport.ac.uk

Degrees offered BA (Hons): Animation; Fine Art; Documentary Photography; (Contemporary

Media); Photographic Art; Photography. BScEd (Hons): Design and Technology. Dip. in Foundation Studies: Art and Design. Admissions Policy For BA (Hons): through UCAS.

West Wales School of the Arts

College of Carmarthenshire/Coleg Sir Gar, Graig Campus, Sandy Road, Llanelli, SA15

T 01554 74800

F 01554 756088

E admissions@colegsirgar.ac.uk

W www.colegsirgar.ac.uk

Coleg Sir Gar has five campuses spread throughout Carmarthenshire, offering courses from GCSE up to postgraduate-degree level. Degrees offered BA (Hons): Three-Dimensional Art in the Landscape; Fine Art Sculpture; Fine Art Painting; Art and Design Multidisciplinary; Graphic Design (including pathways in Illustration and Computer Arts); Contemporary

Textiles (including interpretive pathway in Surface Decoration); Ceramics; Photography. Many BA degrees can be taken part-time.

Other Fine Art courses Part-time courses in ceramics, drawing and painting, textile printing, figurative sculpture, fine art, life drawing, photography (beginner and advanced). FD: Art, Design and Craft; Advanced Art; Design and Craft. ND: Ceramics.

West Midlands

Birmingham Institute of Art and Design

Department of Art, University of Central England, Margaret Street, Birmingham, B3 3BX

T 0121 3315970

F 0121 3316970 E art@students.uce.ac.uk

W www.biad.uce.ac.uk/home.htm

Contact General admissions enquiries: info@ ucechoices.com. International admissions: Pauline Burke, pauline.burke@uce.ac.uk. Provides education for nearly four thousand students on five campuses located in central Birmingham.

Degrees offered BA (Hons): Art and Design by Negotiated Study; Fine Art; Fine Art (Painting and Sculpture); Textile Design; Visual Communication; Multimedia Art. PgCert: Research Practice in Art, Design and Media. PGCE: Art and Design. MA: Art and Education; Fine Art; Textiles, Fashion and Surface Design; Visual Arts: Critical and Contextual Practices:

Multimedia Art; Artist/Teacher Scheme. MPhil and PhD degrees.

Other Fine Art courses BTEC foundation diploma: Art and Design. HND: Fine Art; Visual Communication; Textiles. Cert. or Dip.: Art and Design by Negotiated Study; Fine Art. Short and leisure courses: Art Club; Watercolour

Admissions Policy See website.

Coventry University

Priory Street, Coventry, CV1 5FB T 024 76888248 F 024 76888667

E afuture.ad@coventry.ac.uk

W www.coventry.ac.uk

Founded in 1843, expertise is wide-ranging, including practising artists, designers, leading researchers and scholars.

Degrees offered BA: Fine Art; Illustration; Graphic Design; Applied Arts; Fashion; Fine Art and Illustration; Graphic Design and Illustration. MA: Design and Digital Media; Media Arts; Fine Art; Contemporary Crafts; Performance and Media Arts.

Admissions Policy Undergraduate: 200-220 tariff points, GCSE English Language, attend portfiolio review. Postgraduate: relevant undergraduate degree and portfolio

Dudley College of Technology

The Broadway, Dudley, DY1 4AS T 01384 363000

E admissions@dudleycol.ac.uk

W www.dudleycol.ac.uk

Other Fine Art courses Art and Design (levels 1 to 3); Three-Dimensional Design; Graphic Design; Photography; Sculpture; Glass Design.

Admissions Policy Depends on the course but generally a portfolio is required.

Herefordshire College of Art & Design

Folly Lane, Hereford, HR1 1LT

T 01432 273359 F 01432 359615

E hcad@hereford-art-col.ac.uk

W www.hereford-art-col.ac.uk

Contact Fiona Watkins

A small specialist arts college, founded 150 years ago. Offers a range of courses in art, design and the performing arts - from entry level including GCSEs or A-levels, through to foundation and honours degrees, or part-time courses for those returning as a mature student.

Degrees offered FDA/BA (Hons): Fine and Applied Arts; Illustration.

Other Fine Art courses Portfolio course (parttime). Many short/evening courses.

Admissions Policy All applicants will need to provide a portfolio of work and attend an interview.

North East Worcestershire College

Slideslow Drive, Bromsgrove, Worcs, B60 1PQ

T 01527 570020

F 01527 572900

E admissions@ne-worcs.ac.uk

W www.ne-worcs.ac.uk

Contact Susan Greetham

Other Fine Art courses BTEC HND: Fine Art. Course was set up in 2001 and aims to offer a broad-based fine art programme of study. BTEC HNC: Fine Art.

Admissions Policy For HND: applications can only be accepted through UCAS (either Route A or B). For HNC: apply direct to College. All applicants are interviewed and a portfolio of artwork is required.

North Warwickshire & Hinckley College

Hinckley Road, Nuneaton, CV11 6BH

T 024 76243000

E the.college@nwhc.ac.uk

W www.nwhc.ac.uk

Degrees offered BA (Hons) in Negotiated Studies: Art and Design.

Other Fine Art courses BTEC FD: Design.
BTEC Introductory Dip.: Art, Design and Media.
Certified Dip. in HE: Art and Design. Edexcel
foundation diploma: Art and Design; Edexcel
ND: Fine Art; Graphic Design. HND: Visual
Communication; HND: Three-Dimensional
Design Practice. Also adult education classes.

Solihull College

Art and Design, Blossomfield Road, Solihull, B91 1SB

T 0121 6787006

F 0121 6787200

E tammv.dennis@solihull.ac.uk

W www.solihull.ac.uk

Contact Tammy Dennis (HE Admissions Officer) Opened in 1993, the college has purpose-built painting and sculpture studios.

Degrees offered BA (Hons): Fine Art (three years full-time or six years part-time; validated by UCE). Admissions Policy Full-time applications via UCAS – twenty places per year. Part-time applications direct to the college – five places per year.

Staffordshire University

Faculty of Arts, Media and Design, College Road, Stoke-on-Trent, ST4 2XW

T 01782 294552

F 01782 294760

E n.a.powell@staffs.ac.uk

W www.staffs.ac.uk

Contact Neil Powell

School of Art established in 1876

Degrees offered BA (Hons): Fine Art. MA: Fine Art. Full- or part-time.

Admissions Policy Portfolio interview plus 160 points. UCAS routes A and B. Requires English GCSE at grade C or above. Applications welcome from those who wish to experience a broadbased art course and who may already have an established area of practice and wish to deepen their knowledge of a particular specialism.

Stourbridge College

Longlands Centre, Brook Street, Stourbridge, DY8 3XB

T 01384 344600

F 01384 344601

W www.stourbridge.ac.uk

Contact Elaine Dunn

Other Fine Art courses HND: Fine Arts (full- or part-time).*Course provides a progression route to either the second or third year of BA (Hons) in Fine Art or employment in related areas. Emphasis on the vocational nature of fine art and students gain an understanding of professional practice. Admissions Policy Art and design qualifications in either a foundation diploma, ND, AVCE Double Award or a high level of skill. UCAS route B.

Sutton Coldfield College

34 Lichfield Road, Sutton Coldfield, B74 2NW

T 0121 3555671

F 0121 3550799

E heenquiries@sutcol.ac.uk

W www.sutcol.ac.uk

Other Fine Art courses BTEC Dip. in Foundation Studies: Art and Design. BTEC HND: Three-Dimensional Design (Crafts); Fine Art; Graphic Design; Textiles.

Telford College of Arts & Technology

Haybridge Road, Wellington, Telford, TF1 2NP

T 01952 642200

F 01952 642263

E studserv@tcat.ac.uk

W www.tcat.ac.uk

Established over one hundred years ago.

Over 16,000 students (1,200 full-time). Courses include NVQs, professional, preparatory degrees and tailor-made programmes.

Other Fine Art courses GNVQ Foundation in Art. Art & Design Diploma in Foundation Studies. Foundation Diploma in Art & Design. Encaustic art workshop.

University College Worcester

Henwick Grove, Worcester, WR2 6AJ

T 01905 855000

F 01905 8555132

E registry@worc.ac.uk

W www.worc.ac.uk

Contact Francesca Fairhurst

Worcester College of Higher Education was founded in 1947. Won degree-awarding powers in 1997 and has a strong strategic partnership with Birmingham University. Has eighteen thousand students. Awarded £Im in 2002 from HEFC to develop a digital arts centre.

Degrees offered BA (Hons): Art and Design (Single honours); Visual Arts (Major honours); Communication Design (Major honours); Creative Digital Media (Single honours); Interactive Media (Major honours); Communication Design (Major honours).

Other Fine Art courses Three modules available for both part- and full-time students at Malvern Hills and Evesham College, one of which is available as a three-week summer school. These are all level I courses and include: Fine Art Practice and Theory; Landscape and Visual Identity; Textile Design.

Admissions Policy Grades CC or equivalent. UCAS routes A and B. Portfolio interviews in the spring.

University of Wolverhampton

Wulfruna Street, Wolverhampton, WV1 1SB

T 01902 321000

E enquiries@wlv.ac.uk

W www.asp.wlv.ac.uk

Four campuses covering the West Midlands and Shropshire.

Other Fine Art courses Various foundation degrees.

Walsall College of Arts & Technology

St Paul's Street, Walsall, WS1 1XN

T 01922 657000

F 01922 657083

E info@walcat.ac.uk

W www.walcat.ac.uk

Contact Alan Tyler

Other Fine Art courses Edexcel Foundation Studies: Art and Design (post-A-level). Admissions Policy Apply November/December for admission the following September.

Warwickshire College

Warwick New Road, Leamington Spa, CV32 5IE

T 01926 318207

F 01926 319025

E jherbert@warkscol.ac.uk

W www.warkscol.ac.uk

Contact John Herbert

The School of Art in Leamington was founded in 1866 and is now a part of Warwickshire College. Alumni include Sir Terry Frost. The Dip. of HE fine-art course is run in conjunction with the Birmingham Institute of Art and Design at the University of Central England.

Other Fine Art courses Diploma of Higher Education in Fine Art. A wide range of full-time courses include BTEC Diploma in Foundation Studies (Art & Design) and ND Art & Design, which include studies in fine art plus a variety of short courses in life drawing, painting and sculpture.

Admissions Policy Applicants to be at least 18 years old at entry. A comprehensive portfolio of work plus one of the following: successful completion of a foundation course in Art & Design; a merit profile at National Diploma in a relevant subject; a merit at Advanced VCE in a relevant subject; A-Levels (18 points); equivalent qualifications and experience. Apply through UCAS Route A or Route B

Yorkshire and Humberside

Barnsley College

P.O.Box 266, Church Street, Barnsley, S20 2YW T 01226 216216

F 01226 216553

E programme.enquiries@barnsley.ac.uk

W www.barnsley.ac.uk

Offers courses from AS, HNC and HND to degree level. Most students come from Barnsley and surrounding areas of Yorkshire. Access courses for mature students with few or no qualifications.

Degrees offered BA: Art and Design (Fine Art). Other Fine Art courses Intermediate and foundation certificates: Art and Design; Ceramics; Drawing and Painting; Photography; Textiles.

Bradford College

Great Horton Road, Bradford, BD7 1AY

T 01274 433333

F 01274 741060

E admissions@bilk.ac.uk

W www.bradfordcollege.ac.uk

Origins go back to 1863 when the School of Industrial Design and Art was formed. Runs courses to postgraduate level. Past students include David Hockney and Andy Goldsworthy.

Degrees offered BA (Hons): Art and Design; Fashion Design; Fine Art; Graphic Media Communication (Graphic Design, Moving Image, Interactive Multimedia, Illustration); Textile Design; Photography (stage 3, top-up). PgCert/PgDip/MA: Photography; Politics of Visual Representation; Representation in Film; Printmaking.

Other Fine Art courses Most full-time courses may be taken on a part-time basis. HND: Spatial Design (Interior Design); Photography (Editorial, Advertising and Fine Art).

Admissions Policy Entry normally based on portfolio and interview. Entry requirements for full-time undergraduate courses published in college prospectus or on UCAS site. Encourages applications from potential students who can demonstrate suitable qualifications or experience in an appropriate area of study.

Craven College, Skipton

School of Art and Media, Aireville Campus, Skipton, BD23 1US

T 01756 693855

F 01756 797047

E enquiries@craven-college.ac.uk

W www.craven-college.ac.uk

Contact Christine Bailey

Housed in a custom-built centre opened in 2001. There are fifteen specialist studios including Three-Dimensional Design, Graphic Design, Photography, Textiles, Ceramics, Fine Art and Printmaking.

Other Fine Art courses Dip. in Foundation Studies: Art and Design. HNC: Three-Dimensional Design (Jewelry); Fine Art. HNC/ HND: Graphic Design; Textiles. Range of full- and part-time art courses.

Dewsbury College

Halifax Road, Dewsbury, WF13 2AS T 01924 465916 F 01924 457047 E info@dewsbury.ac.uk

W www.dewsbury.ac.uk

The main campus on Halifax Road hosts the majority of general courses, while the Batley and Wheelwright campuses (Batley School of Art and Design) deliver mainly art and design courses. Degrees offered BA (Hons): Contemporary Photographic Arts: Creative Imaging; Fine Art and Design. FdA: Applied Arts; Digital Arts; Graphic Design.

Doncaster College

Waterdale, Doncaster, DN1 3EX T 01302 553610 E he@don.ac.uk W www.don.ac.uk Contact Joanne Crapper Degrees offered BA (Hons): Visual Communication: Combined Design; Art & Associated Crafts; Art & Design (1 year top-up). Admissions Policy 100 tariff points. Applications accepted through UCAS right up to clearing.

Hull School of Art and Design

Queens Gardens, Wilberforce Drive, Hull, HU13DG

T 01482 490970 F 01482 480971

Ermoore@artdesignhull.ac.uk

W www.artdesignhull.ac.uk

Contact Gina Marie Peckitt at Hull College,

Oueens Gardens, Hull HUI.

Founded in 1861. Its staff are research active and links with creative industry employers are strong. Students work with museums and galleries including Ferens, and have the opportunity for exchange study abroad, including China.

Degrees offered The BA in Contemporary Fine Art Practice allows specialism in all traditional fine art areas, supporting cross-disciplinary practice using digital and other new media and film. A strong theoretical studies and visiting lecturer programme underpins the course.

Other Fine Art courses National Dip. Fine Art (two-year). OCN Drawing and Painting courses (part-time day and evening options). Fine art one-week summer school, with painting and/or printing.

Admissions Policy See website.

Leeds College of Art & Design

Blenheim Walk, Leeds, LS2 9AQ T 0113 2028000 F 0113 2028001 E info@leeds-art.ac.uk

W www.leeds-art.ac.uk

Contact Student Advice Team

Founded over one hundred years ago. Past students include Henry Moore, Barbara Hepworth and Damien Hirst.

Degrees offered BA (Hons): Art and Design (interdisciplinary); Fine Art (part-time).

Other Fine Art courses HND: Photography.
Dip. in Foundation Studies: Art and Design.
College diploma: Design. ND: Art and Design.
College certificate: Art and Design. Access to Art
and Design A2 levels: Fine Art; Sculpture and
Ceramics; Photography. Also a selection of parttime courses both in the day and evening.
Admissions Policy Apply through UCAS for BA
(Hons) Art & Design (interdisciplinary) and HND
Photography. All other applications should be

Leeds School of Contemporary Art and Graphic Design

Leeds Metropolitan University, Calverley Street, Leeds, LS1 3HE

T 0113 2833108

F 0113 2833094

Et.gray@leedsmet.ac.uk

W www.leedsmet.ac.uk/as/cagd/

made on a College application form.

Contact Tracy Gray

Evolved from the Leeds College of Art.

Degrees offered BA (Hons): Fine Art;

Contemporary Creative Practice.

Admissions Policy Admission is by direct entry and UCAS routes A and B. Preference is given to applicants with pre-degree experience of study at FE level.

Park Lane College Keighley

Cavendish Street, Keighley, BD21 3DF

T 0845 0457275

E course.enquiry@parklanecoll.ac.uk

W www.parklanecoll.ac.uk

Runs art-based courses across a range of levels.

Admissions Policy See website for details.

Sheffield College, Hillsborough Centre

Livesey Street, Sheffield, S6 2ET

T 0114 2602248

F 0114 2602201

E sheila.smith@sheffcol.ac.uk

W www.sheffcol.ac.uk

Contact Sheila Smith

Other Fine Art courses HND/Foundation Degree: Fashion.

Admissions Policy UCAS routes A or B.

Sheffield Hallam University

Faculty of Arts, Computing, Engineering and Sciences, Psalter Lane Campus, Sheffield, S11 8UZ

T 0114 2252607

F 0114 2252603

E cultural@shu.ac.uk

W www.shu.ac.uk

Contact Jane Leadston

Founded as Sheffield School of Design in 1843, name changed to Sheffield School of Art some years later. At present location since 1950.

Degrees offered BA (Hons): Fine Art. MA: Fine Art. Part- and full-time.

Admissions Policy BA: Diploma in Foundation Studies in Art and Design plus portfolio preferred; application through UCAS Route A and Route B.

University of Huddersfield

School of Art and Design, Queensgate, Huddersfield, HD1 3DH

T 01484 422288

E admissionsandrecords@hud.ac.uk

W www.hud.ac.uk

Degrees offered MA Fine Art

University of Hull

School of Arts, Scarborough Campus, Filey Road, Scarborough, YO11 3AZ

T 01723 362392

E ssa@hull.ac.uk

W www.hull.ac.uk

Contact admissions@hull.ac.uk

Degrees offered BA: Digital Arts; Design For Digital Media.

University of Leeds

The School of Fine Art, History of Art and Cultural Studies, Old Mining Building, Leeds, LS2 9JT

T 0113 3431822

F 0113 2451977

E fine.art.enquiries@leeds.ac.uk

W www.leeds.ac.uk

Contact James Bober – Admissions Secretary Founded in 1950 the uniqueness and prestige of the Fine Art course at Leeds lies in its 50/50 integrated practice / theory content and its reputation for producing high calibre and critically aware graduates. Students engage in the debates and modes of presentation involved in contemporary fine art practice in synergie with current discourses on the theories and histories of art and cultural studies.

Degrees offered BA (Hons): Fine Art MA Fine Art MFA

Admissions Policy Typical offer: 'A' Level - BBB, excluding general studies and critical thinking. Foundation and other post-18 courses are also considered. All candidates must provide a satisfactory portfolio of practical work as part of the interviewing process. Candidates will be considered for interview on submission of 12 digital images from their portfolio.

York College

Sim Balk Lane, York, YO23 2BB

T 01904 770200

F 01904 770499

E customer-services@yorkcollege.ac.uk

W www.vorkcollege.ac.uk

Contact Customer Services Unit

The new f60 million college opened in 2007. Has the latest technology, teaching and learning facilities.

Degrees offered Diploma in Foundation Studies Art & Design: BA (Hons) Contemporary 3D Crafts: BA (Hons) Graphic Design; HNC Graphic Design; HNC Fine Arts; Foundation Degree in Fashion: Foundation Degree in Creative Digital Communications.

Other Fine Art courses A range of part-time Fine Art, Design and Craft courses available: See website.

Admissions Policy Full-time HND and degree course applications through the standard UCAS route. For part-time course admissions call 01904 770400.

York St John College

Lord Mayor's Walk, York, YO31 7EX

T 01904 624624

F 01904 716931

W www.yorksj.ac.uk

Contact Fiona Coventry

Founded in 1841.

Degrees offered BA (Hons): Art and Design;

Design and Technology.

Admissions Policy UCAS routes A or B applicants. Minimum entry is 140 to 160 points plus portfolio.

Yorkshire Coast College

Lady Edith's Drive, Scarborough, YO12 5RN

T 01723 372105

F 01723 501918

E admissions@ycoastco.ac.uk

W www.yorkshirecoastcollege.ac.uk

Over ten thousand students.

Degrees offered BA (Hons): Fine Art. FdA:

Applied Digital Media (Design).

Other Fine Art courses BTEC Dip. in Foundation Studies: Art and Design (from level 3). BTEC HNC: Graphic and Multimedia Design. ND: Art and Design (level 3).

Ireland

Burren College of Art

Newtown Castle, Ballyvaughan, County Clare

T 065 7077200

F 065 7077201

E admin@burrencollege.ie

W www.burrencollege.com

Contact Anna Downes (Director of

Communications and Admissions)

Founded in 1993 by Michael Greene and Mary Hawkes-Greene, a not-for-profit charitable foundation that offers graduate, undergraduate and artist residency programmes to students and artists from around the world. The college is set in the grounds of a sixteenth-century castle on the Atlantic coast of Ireland. Facilities include studios, photography studio and dark room, sculpture workshop, gallery, library, art supplies shop, lecture theatre and seminar rooms, cafeteria and accommodation.

Degrees offered Master of Fine Art.

Other Fine Art courses Post-Baccalaureate, individual and group study abroad programmes, summer school, artist residencies and five day

Admissions Policy For the MFA, a BA with Hons or a Major in Fine Arts, or evidence of equivalent achievement. Applicants should normally have either first class or upper second class honours or a grade point average of 3.50 or above. Portfolio and supporting statement also required. In the case of an outstanding portfolio, 2.2 honours standing or GPA of 3.0 may be considered. For the Post Bac, a BA with Hons. Applicants should normally have either first class or upper second class honours or a grade point average of 3.50 or above. Portfolio and supporting statement also required.

Crawford College of Art and Design

Cork Institute of Technology, Sharman Crawford Street, Cork

T 021 4966777

F 021 4962267

W www.cit.ie

Has provided education in the arts for over 200 years, with a strong tradition in the fields of fine art, ceramic design, art teacher training and adult education in the creative arts. There are

Degrees offered Offers full-time courses to BA, MA and Adv. Dip. levels, all validated by the Cork Institute of Technology and/or the Higher Education and Training Awards Council. BA (Hons): Ceramic Design; Fine Art. BA: Ceramic Design; Fine Art. Higher Dip. in Arts: Art & Design Teachers. MA: Art Therapy; Fine Art. Admissions Policy Entry Requirements: Leaving Certificate Grade D3 in five subjects at Ordinary or Higher Level, plus Portfolio. A pass in foundation level mathematics is recognised as a subject for courses in Crawford College of Art & Design but carries a maximum 25 CAO points.

Dublin Institute of Technology, Faculty of Applied Arts

Mountjoy Square, Dublin T o1 4024138 / 4181 F o1 4024297 E artdesignprinting@dit.ie

W www.dit.ie

Contact Vincent O'Hara, Admissions Officer The largest provider of multi-disciplinary and professional-level education across the visual and performing arts and media in Ireland. The School of Art, Design and Printing offers undergraduate and graduate qualifications. Approximately thirty-five students per year are admitted to the BA Fine Art course, combining studio practice with critical theory.

Degrees offered BA: Fine Art; Photography. MA: Digital Media Technology (full- and part-time). Admissions Policy Six subjects with a minimum of two at honours level. Applicants must submit a portfolio and for the BA Fine Art must demonstrate drawing, practical and conceptual abilities.

Dun Laoghaire Institute of Art, Design & Technology

Carraiglea Park, Kill Avenue, Dun Laoghaire, County Dublin

T or 214 4600

F 01 214 4700 E celine.blacow@iadt.ie

W www.iadt.ie

Contact Celine Blacow (Administrator, School of Creative Arts)

With 1,500+ students, IADT is Ireland's only

Institute of Art, Design and Technology. Organized in three schools (Creative Arts, Creative Technologies and Business and Humanities), it is home to the National Film School. The School of Creative Arts runs programmes in makeup for film, TV and theatre, radio, visual arts practice, photography, visual communications, production design, animation and modelmaking. Students in the School of Creative Arts can undertake crossprogramme projects with the School of Creative Technologies.

Degrees offered BA (Hons): Fine Art; Photography; Film & TV Production; Visual Arts Practice; Animation; Visual Communications. MA: Visual Art Practice; Screenwriting. Full-time and modular part-time courses are available. Other Fine Art courses Summer School and Autumn School (for information contact ptc@iadt.ie).

Admissions Policy For entry and portfolio requirements see the "all courses" section of the IADT website.

Galway-Mayo Institute of Technology

Dublin Road, Galway

T 091 753161

E info@gmit.ie **W** www.gmit.ie

Founded in 1972 as a regional technical college, the college became an Institute of Technology in 1992. Enrolment is almost 9,000. Has five specialized schools, with the art and design department part of the School of Humanities. Courses are given at the Galway and Castlebar campuses.

Degrees offered BA (Hons): Fine Art; Textiles; Art & Design (full-time and part-time); Film and Television.

Admissions Policy Minimum requirements for full-time courses are a pass in portfolio assessment and a pass in six Leaving Certificate subjects.

Mature applicants may be exempted from the Leaving Certificate requirement and attend an interview instead. For course and admission details see website.

Gorey School of Art

Railway Road, Gorey, County Wexford

T 055 20585

F 055 20585

E gsa@itcarlow.ie

Contact Declan Doyle

Gorey School of Art is a small-scale school offering a BA in Fine Art. The school is committed

to providing courses taught by artists for the education of artists. It was founded in 2003 and offers electives in painting and sculpture.

Degrees offered BA in Art

Admissions Policy Portfolio and CAO application – portfolios can be submitted in the second week of March, April and May.

Institute of Technology, Tallaght

Baile Aitha Cliath 24, Tamlacht

T 01 4042000

F 01 4042700

E info@it-tallaght.ie

W www.it-tallaght.ie

Established in 1992.

Degrees offered BA (Ordinary and Honours): Audio Visual Media.

Other Fine Art courses Higher Certificate: Audio Visual Media.

Admissions Policy Applications for Higher Certificate and BA degrees are made through the Central Applications Office in Galway. Minimum of five grades D3 in the Leaving Certificate at ordinary or higher level, including English or Irish and Mathematics. Comparable qualifications from other EU countries are accepted. For part-time courses apply direct to the Institute. For details see website.

Institute of Techonology Sligo

Ballinode, Sligo

T 071 9155222

F 071 9160475

E info@itsligo.ie

W www.itsligo.ie

Contact Admissions Office: 071 9155379 or admissions@itsligo.ie.

Degrees offered BA: Fine Art (Ordinary and Honours).

Admissions Policy Applicants for BA Fine Art must successfully complete a portfolio assessment prior to offer of a place. Applicants for admission to the first year of the Institute's full-time courses should apply to the Central Applications Office in Galway. International students from non-EU countries apply direct to the Institute. Normal minimum entry requirements for Higher Certificate and Ordinary Degree courses are 5 grade Ds in Leaving Certificate Examinations ordinary level including English or Irish and Mathematics. For UK students the normal minimum entry requirements are 2 A-levels at Grade D or better and 4 GCSEs to gain entry to a degree course or a minimum of 1 A-level at Grade

E or better and 4 GCSEs to gain entry to certificate/diploma courses.

Limerick Institute of Technology

Moylish Park, Limerick

T 061 208208

F 061 208209

E Information@lit.ie

W www.lit.ie

Contact o61 208262 / 208263

Dates back to 1852 when the Athenaeum Society started a School Of Arts and Fine Crafts in Limerick. Has over four-thousand full-time students and sixteen-hundred part-time. Institute

tooks its current form in 1992.

Degrees offered BA: Fine Art in Painting; Fine Art in Printmaking; Fine Art in Sculpture & Combined Media. BA (Hons): Fine Art (in Painting, Printmaking, Sculpture & Combined Media); Graphic Design, Ceramic Design and Fashion Design. MA and PhD by Research: Art and Design. Other Fine Art courses Higher Dip. in Arts for Art & Design Teachers. Accumulation of Credits and Certification of Subjects (ACCS) courses enable students to take single subject courses to obtain a certificate. There is an adult education course in Portfolio Preparation.

Admissions Policy All undergraduate applications should be made to the Central Applications Office in Galway. This includes NCVA applicants who also use the CAO form to apply for an Institute place. Students for other years apply direct to the Institute. For ACCS courses application forms are available from the admissions office and the closing date is in September.

National College of Art and Design

100 Thomas Street, Dublin 8

T 01 6364200

F 01 6364207

E fios@ncad.ie

W www.ncad.ie

Founded in 1746 by Robert West as a private drawing school. The school was given its current name in 1971. Alumni include WB Yeats, AE Russell and teachers include Sir William Orpen, Sean Keating, Harry Clark and Maurice MacGonigal. Current enrolment of day and evening students is over 1,500. The Faculty of Fine Art consists of departments of Media, Painting, Fine Print and Sculpture.

Degrees offered BA: Fine Art (Media; Painting; Fine Print; Sculpture; History of Art; Fine Art; Crafts Design (Ceramics, Glass and Metals);

Textile Design). BdeS: Textile Design. Graduates may apply for Higher Dip. in Art and Design Education. MA: Fine Art (Media; Painting; Fine Print; Sculpture; Virtual Realities; Ceramics; Glass and Metals and Textiles). PhDs also offered.

Other Fine Art courses A broad selection of art, craft and design classes, plus autumn evening classes and day-time courses at Easter and in the summer months.

Admissions Policy Applicants must be seventeen years or older. All students must submit portfolios and for some courses interviews are required. See website for portfolio requirements.

Waterford Institute of Technology

School of Humanities, College Street Campus, Waterford

T 051 302251

F 051 302800

E mhowlett@wit.ie

W www2.wit.ie

Contact Dr Michael Howlett (Head of Department of Applied Arts)

A university-level institution with over 10,000 students and almost 1000 staff. WIT offers tuition and research programs in many areas up to doctoral level and is the largest of the Institutes of Technology outside Dublin. Established as Waterford Regional Technical College in 1970, its current designation was awarded in 1998. Degrees offered BA in Art (WD 022) and BA (Hons) in Art and Society (WD 072). Other Fine Art courses Part time courses: Introduction to Photography, Digital Photography, Drawing and Painting, Life Drawing, Art Mixed Media.

Foundation studies in art and design

East Anglia

Barking College

Dagenham Road, Romford, RM7 0XU T 01708 770000 E admissions@barkingcollege.ac.uk W www.barkingcollege.ac.uk

Barnfield College

New Bedford Road, Luton, LU2 7BF T 01582 569637 E enquiries@barnfield.ac.uk W www.barnfield.ac.uk

Bedford College

Cauldwell Street, Bedford, MK42 9AH T 0800 0740234 F 01234 342674 E info@bedford.ac.uk W www.bedford.ac.uk

Braintree College

Church Lane, Braintree, CM7 5SN T 01376 557020 E enquiries@braintree.ac.uk W www.braintree.ac.uk

Cambridge Regional College

Kings Hedges Road, Kings Hedges, CB4 2QT T 01223 418518 F 01223 418519 E skelly@mail.camre.ac.uk W www.camre.ac.uk. Contact Steve Kelly

Cambridge School of Visual & Performing Arts

Bridge House, Bridge Street, Cambridge, CB2 1UA T 01223 341302 E enquiries@csvpa.com

W www.ceg-uk.com/en/csvpa/

Chelmsford College

Moulsham Street, Chelmsford, CM2 0JQ T 01245 265611 E savilld@chelmsford-college.ac.uk W www.chelmsford-college.ac.uk Contact Deborah Savill

City College Norwich

Ipswich Road, Norwich, NR2 T o1603 773350 E h2baxter@ccn.ac.uk W www.ccn.ac.uk

College of West Anglia - Kings Lynn

Tennyson Avenue, King's Lynn, PE30 2QW T 01553 761144 E enquiries@col-westanglia.ac.uk W www.col-westanglia.ac.uk

College of West Anglia - Wisbech

Ramnoth Road, Wisbech, Cambridge, PE13 2JE T 01945 582561 F 01945 582706 E enquiries@col-westanglia.ac.uk W www.col-westanglia.ac.uk Contact Ian Coulson

Dunstable College

School of Art and Design, Kingsway, LU5 4HG T o845 3552525 E enquiries@dunstable.ac.uk W www.dunstable.ac.uk Contact Rachel Joy

Epping Forest College

Borders Lane, Debden, Loughton, IG10 3SA T 020 85088311 E r.bromich@efc.ac.uk W www.epping-forest.ac.uk/ Contact Robert Bramich

Great Yarmouth College

Southtown, Great Yarmouth, NR31 0ED T 01493 655261 E info@gyc.ac.uk W www.gyc.ac.uk

Harlow College

Visual Arts, Velizy Avenue, Harlow, CM20 3LH T 01279 868000 E full-time@harlow-college.ac.uk W www.harlow-college.ac.uk Contact Lin Hilton

Havering College of Further and Higher Education

Ardleigh Green Road, Hornchurch, RM11 2LL T 01708 462801 E information@havering-college.ac.uk W www.havering-college.ac.uk Contact Jeremy Kilburn

Hertford Regional College

Ware Centre, Scotts Road, SG12 9JF T 01992 411411 E ptowers@hertreg.ac.uk W www.hertreg.ac.uk Contact Peer Towers

Lowestoft College

St Peters Street, Lowestoft, NR32 2NB T 01502 583521 E info@lowestoft.ac.uk W www.lowestoft.ac.uk

Luton Sixth-Form College

Bradgers Hill Road, Luton, LU2 7EW T 01582 877500 E college@lutonsfc.ac.uk W www.lutonsfc.ac.uk Contact Jake Robson

North Hertfordshire College

Centre for the Arts, Willian Road, Hitchin, SG4 0LS
T 01462 424242
E bbarton@nhc.ac.uk
W www.nhc.ac.uk
Contact Brian Barton

Oaklands College

City Campus, St Peter's Road, St Albans, AL1 3RX T 01727 737000
E help.line@oaklands.ac.uk
W www.oaklands.ac.uk
Contact Stephanie Newell-Price

Peterborough Regional College

Creative Studies, Park Crescent, Peterborough, PE1 2QU T 0845 8728722 E info@peterborough.ac.uk W www.peterborough.ac.uk Contact Rob Fuller

Suffolk New College

Rope Walk, Ipswich, IP4 1LT T 01473 255885 F 01473 343657 E info@suffolk.ac.uk W www.suffolk.ac.uk Contact Malcolm Moseley

University of Hertfordshire

Faculty of Art and Design, College Lane, Hatfield AL10 9AB T 01707 285347 E a.meredith@herts.ac.uk W www.herts.ac.uk Contact Mr A.Meredith

West Herts College

Hempstead Road, Watford, WD17 3EZ
T 01923 812674
E isobelw@westherts.ac.uk
W www.westherts.ac.uk
Contact Isobel Warrender

West Suffolk College

Out Risbygate, Bury St Edmunds, IP33 3RL
T 01284 716333
E simon.smith@westsuffolk.ac.uk
W www.wsc.ac.uk
Contact Simon Smith

East Midlands

Boston College

Skirbeck Road, Boston, PE21 0HF T 01205 365701 F 01205 313252 E info@boston.ac.uk W www.boston.ac.uk

Burton College

Lichfield Street, Burton-on-Trent, DE14 3RL T 01283 494400 E enquiries@burton-college.ac.uk W www.burton-college.ac.uk

Castle College Nottingham

Maid Marian Way, Nottingham, NG1 6AB T 0845 8450500 E learn@castlecollege.ac.uk W www.castlecollege.ac.uk

De Montfort University

Faculty of Art and Design, The Gateway, Leicester, LE1 9BH T 0116 2577555 E artanddesign@dmu.ac.uk W www.dmu.ac.uk

Derby College

Prince Charles Avenue, Derby, DE22 4LR T 0800 0280289 E enquiries@derby-college.ac.uk W www.derby-college.ac.uk

Gateway College

The Newarke, Leicester, LE2 7BY T 0116 580700 E dlovegrove@gateway.ac.uk W www.gateway.ac.uk Contact Deborah Lovegrove

Huntingdonshire Regional College

California Road, Huntingdon, PE29 1BL T 01480 379100 E arts@huntingdon.ac.uk W www.huntingdon.ac.uk

Leicester College

St Margaret's Campus, Grafton Place, LE1 3WL T 0116 2242002 E ipepperill-clarke@leicestercollege.ac.uk W www.leicestercollege.ac.uk Contact I.Pepperill-Clarke

Lincoln School of Art and Design

University of Lincoln, Braypool, Lincoln, LN6 7TS T 01522 837437 E aadenquiries@lincoln.ac.uk W www.lincoln.ac.uk/lsad

Loughborough University

School of Art and Design, 12 Frederick Street, LE11 3BJ T 01509 228941 E y.s.clayton@lboro.ac.uk W www.lboro.ac.uk Contact Yvonne Clayton

New College Nottingham

25 Stoney Street, The Lace Market, NG1 1LP T 01159 100100 E carl.marshall@ncn.ac.uk W www.ncn.ac.uk Contact Carl Marshall

New College Stamford

Visual Arts Centre, Drift Road, Stamford, PE9 1XA T 01780 484300 W www.stamford.ac.uk

North Lindsey College

Kingsway, Scunthorpe, DN17 1AJ T 01724 281111 E info@northlindsey.ac.uk W www.northlindsey.ac.uk Contact Angie Hodgson

South East Derbyshire College

Cavendish Site, Cavendish Road, DE7 5AN
T 0115 8492000
E admissions@sedc.ac.uk
W www.sedc.ac.uk

South Nottingham College

Charnwood Centre, Farnborough Road, Clifton, NG11 8LU T 0115 9146300 E enquiries@snc.ac.uk W www.snc.ac.uk Contact Claire Smedley

Tresham Institute of Further and Higher Education

Windmill Avenue Campus, Windmill Avenue, Kettering, NN15 6ER T 0845 6588990 F 01536 522500 E info@tresham.ac.uk W www.tresham.ac.uk

University of Northampton

St Georges Avenue, Northampton, NN26ID

T 01604 735500

E clive.ramsdale@northampton.ac.uk

W www.northampton.ac.uk

Contact Clive Ramsdale

West Nottinghamshire College

Derby Road, Mansfield, NG18 5BH T 0808 1003626 E info@wnc.ac.uk W www.westnotts.ac.uk Contact Julian Bray

London

Barnet College

Wood Street, Barnet, EN5 4AZ T 02082 664000 E info@barnet.ac.uk W www.barnet.ac.uk

Bexley College

Tower Road, Belvedere, London, **DA176IA** T 01322 442331 E courses@bexley.ac.uk W www.bexley.ac.uk

Blake College

162 New Cavendish Street, London, W1W 6YS T 020 76360658 F 020 74360049 E study@blake.ac.uk W www.blake.ac.uk **Contact** Robert Persey

Camberwell College of Arts

(University of the Arts London), SE5 8UF T 020 75146302 E enquiries@camberwell.arts.ac.uk W www.camberwell.arts.ac.uk

The Central School of Speech and Drama

Embassy Theatre, Eton Avenue, London, NW3 3HY T 020 77228183 E enquiries@cssd.ac.uk W www.cssd.ac.uk

Central St Martins College of Art & Design

(University of the Arts London), Southampton Row, WC1B 4AP T 020 75147000 E info@csm.arts.ac.uk W www.csm.arts.ac.uk **Contact** Cally Saunders

Chelsea College of Art & Design

(University of the Arts London), 16 John Islip Street, SW1P 4IU T 020 75147751 E enquiries@chelsea.arts.ac.uk W www.chelsea.arts.ac.uk Contact John Crossley

City and Guilds of London Art School

124 Kennington Park Road, London, SE114DI T 020 77352306 E info@cityandguildsartschool.ac.uk W www.cityandguildsartschool.ac.uk

City and Islington College

383 Holloway Road, London, N7 0RN T 020 77009200 E courseinfo@candi.ac.uk W www.candi.ac.uk

City Lit

Keeley Street, London, WC2B 4BA T 020 74922600 E infoline@citylit.ac.uk W www.citylit.ac.uk/

City of Westminster College

25 Paddington Green, London, W2 1NB T 020 77238826 W www.cwc.ac.uk

College of North East London

High Road, Tottenham, London, N15 4RU T 020 88024352 E grider@staff.conel.ac.uk W www.conel.ac.uk Contact Gordon Rider

Croydon College

Fairfield Campus, College Road, Croydon, CR9 1DX T 020 87605914 E info@croydon.ac.uk W www.croydon.ac.uk

Ealing, Hammersmith and West London College

Gliddon Road, Barons Court, London, W14 9BL

T 0800 9802185

E cic@wlc.ac.uk
W www.wlc.ac.uk

Contact Beatrice Movathar

Enfield College

73 Hertford Road, Enfield, EN3 5HA T 020 84433434 E courseinformation@enfield.ac.uk W www.enfield.ac.uk

Greenwich Community College

95 Plumstead Road, London, SE18 7DQ T 020 84884800 F 020 84884899 E info@gcc.ac.uk W www.gcc.ac.uk

Hackney Community College

Hackney, London T 020 76139123 E enquiries@tcch.ac.uk W www.tcch.ac.uk

Kensington and Chelsea College

Hortensia Road, London, SW10 0QS T 020 75735248 E p.ritson@kcc.ac.uk W www.kcc.ac.uk Contact Phillip Ritson

Kingston College

55 Richmond Road, Kingston-upon-Thames, KT2 5BP T 020 89394601 E judy.dibiase@kingston-college.ac.uk W www.kingston.ac.uk/design Contact Judy Dibiase

Kingston University

Knights Park, 53–57 High Street, Kingston-upon-Thames, KT1 2QJ T 020 85472000 E p.stafford@kingston.ac.uk W www.kingston.ac.uk Contact Paul Stafford

Lewisham College

2 Deptford Church Street, Lewisham, SE8 4RZ T 0800 834545 E info@lewisham.ac.uk W www.lewisham.ac.uk

London College of Communication

(University of the Arts London), Elephant and Castle, SE1 6SB T 020 75146569 E info@lcc.arts.ac.uk W www.lcc.arts.ac.uk Contact David Sowerby

London College of Fashion

(University of the Arts London), 20 John Princes Street, E8 3RE T 020 75147344 E enquiries@fashion.arts.ac.uk W www.fashion.arts.ac.uk Contact Sarah Atkinson

London Metropolitan University

Sir John Cass Department, Art Media and Design, 59–63 Whitechapel High Street, E1 7PF T 020 71334200 E admissions@londonmet.ac.uk W www.londonmet.ac.uk/jcamd

Newham College of Further Education

East Ham Campus, High Street South, E6 6ER T 020 82574205
E steph.hodges@newham.ac.uk
W www.newham.ac.uk
Contact Mr Steph Hodges

Richmond Adult Community College

Park Shot Centre, Richmond, TW9 2RE T 020 88437921 E info@racc.ac.uk W www.racc.ac.uk Contact Richard Beard

Richmond-upon-Thames College

Egerton Road, Twickenham, TW2 7SJ T 020 86078000 E courses@rutc.ac.uk W www.rutc.ac.uk Contact Rosanna Bottiglieri

South Thames College

Wandsworth High Street, SW18 2PP T 020 89187000 E studentservices@south-thames.ac.uk W www.south-thames.ac.uk Contact Daye Atkins

Southgate College

High Street, Southgate, N14 6BS T 020 88866521

E admiss@southgate.ac.uk W www.southgate.ac.uk

Southwark College

Bermondsey Centre, Keetons Road, Bermondsey, SE16 4EE
T 020 78151600
E info@southwark.ac.uk
W www.southwark.ac.uk
Contact Mark Trompeteler

Tower Hamlets College

Poplar Centre, Poplar High Street, E14 0AF T 020 75107777 F 020 75389153 E advice@tower.ac.uk W www.tower.ac.uk

Uxbridge College

Uxbridge Campus, Park Road, Uxbridge, UB8 1NQ T o1895 853459 E j.weeks@uxbridgecollege.ac.uk W www.uxbridge.ac.uk Contact Jayne Weeks

Waltham Forest College

Forest Road, Walthamstow, E17 4JB T 020 85018217 E robinp@waltham.ac.uk W www.waltham.ac.uk Contact Peter Robinson

West Thames College

Art, Design and Engineering, London Road, Isleworth, TW7 4HS
T 020 83262000
E sarah.howat@west-thames.ac.uk
W www.west-thames.ac.uk
Contact Sarah Howat

Westminster Kingsway College

Kentish Town Centre, 87 Holmes Road, NW5 3AX T 0870 609800 E courseinfo@westking.ac.uk W www.westking.ac.uk

Wimbledon College of Art

(University of the Arts London), Merton Hall Road, SW19 3QA T 020 75149641 E info@wimbledon.arts.ac.uk W www.wimbledon.arts.ac.uk Contact Sarah Ulfsparre

North-east

City of Sunderland College

Shiny Row Centre, Philadelphia, Houghton-le-Spring, DH4 4TL T 0191 5116060 F 0191 5116380 W www.citysun.ac.uk Contact Linda Anderson

Cleveland College of Art & Design – Hartlepool Campus

Church Square, Hartlepool, TS24 7EX T 01429 422000 F 01429 422122 W www.ccad.ac.uk Contact Sue Dewey

Cleveland College of Art & Design – Middlesbrough Campus

Green Lane, Linthorpe, Middlesbrough, TS5 7RJ T 01642 288000 F 01642 288828 W www.ccad.ac.uk

Derwentside College

Park Road, Consett, DH8 5EE
T 01207 585900
E ian_holmes@derwentside.ac.uk
W www.derwentside.ac.uk
Contact Ian Holmes

Gateshead College

Durham Road, Low Fell, NE9 5BN T 0191 4902308 E karen.little@gateshead.ac.uk W www.gateshead.ac.uk Contact Karen Little (Foundation Art and Design)

New College Durham

Framwellgate Moor Centre, Durham, DH1 5ES **T** 0191 3754000 **W** www.newcollegedurham.ac.uk

Newcastle College

Rye Hill Campus, Scotswood Road, NE4 7SA
T 0191 2004431
E david.wild@ncl-coll.ac.uk
W www.ncl-coll.ac.uk
Contact David Lawrence

North Tyneside College

Embleton Avenue, Wallsend, NE28 9NJ

T 0191 2295000 E enquiries@tynemet.ac.uk W www.ntyneside.ac.uk

Northumberland College

College Road, Ashington, NE63 9RG T 01670 841200 E david.goard@northland.ac.uk W www.northumberland.ac.uk Contact David Goard

South Tyneside College

St Georges Avenue, South Shields, NE34 6ET T 0191 4273500 W www.stc.ac.uk

University of Sunderland

Ashburne House, Ryhope Road, Sunderland, SR2 7EF
T 0191 5152000
E admenquiries@sunderland.ac.uk
W www.sunderland.ac.uk

North-west

Accrington & Rossendale College

Sandy Lane, Accrington, BB5 2AW
E info@accross.ac.uk
W www.accross.ac.uk

Barrow Sixth-Form College

Rating Lane, Barrow-in-Furness, LA13 9LE T 01229 828377 F 01229 836874 E colinaldred@barrow6fc.org.uk W www.barrow6fc.ac.uk Contact Colin Aldred

Blackburn College

Feilden Street, Blackburn, BB2 1LH T 01254 292929 E studentservices@blackburn.ac.uk W www.blackburn.ac.uk Contact Gordon Huxley

Blackpool and the Fylde College

Palatine Road, Blackpool, FY1 4DW T 01253 352352 ext.4606 E pla@blackpool.ac.uk W www.blackpool.ac.uk Contact Peter Layzell

Burnley College

Shorey Bank, Ormerod Road, BB11 2RX T 01282 711200 E student.services@burnley.ac.uk W www.burnley.ac.uk Contact Neil Horsefield

Bury College

Woodbury Centre, Market Street, BL9 0BG T 0161 2808280 E information@burycollege.ac.uk W www.burycollege.ac.uk

Carmel College

Prescot Road, St Helens, WA10 3AG T 01744 452200 E sbo@carmel.ac.uk W www.carmel.ac.uk Contact Steve Bonati

Chesterfield College

Infirmary Road, Chesterfield, S41 7NG T 01246 500500 E advice@chesterfield.ac.uk W www.chesterfield.ac.uk

Hugh Baird College

Balliol Road, Bootle, L20 7EW T 0151 3534444 E enquiries@hughbaird.ac.uk W www.hughbaird.ac.uk Contact John A.Horrigan

Isle of Man College

Homefield Road, Douglas, Isle of Man, IM2 6RB T 01624 648200 W info.iomcollege.ac.im Contact Ian Coulson

Kendal College

Milnthorpe Road, Kendal, LA9 5AY T 01539 814700 E enquiries@kendal.ac.uk W www.kendal.ac.uk Contact Matt Burke

Knowsley Community College

Rupert Road, Roby, L36 9TD

T 0151 4775793

E ghwilliams@knowsleycollege.ac.uk

W www.knowsleycollege.ac.uk

Contact Graham Williams

Lancaster and Morecambe College

White Cross Education Centre, Quarry Road, Lancaster, LA1 3SD

T 0800 306306

E info@lmc.ac.uk

W www.lmc.ac.uk

Contact Emma Grover

Leek College

Stockwell Street, Leek, ST13 6DP

T 01538 398866

E kbrown@leek.ac.uk

W www.leek.ac.uk

Contact Kevin Brown

Liverpool Community College

Arts Centre, Myrtle Street, L7 7JA T 0151 2521515

W www.liv-coll.ac.uk

Macclesfield College

Park Lane, Macclesfield, SK11 8LF

T 01625 410000

F 01625 410001

E info@macclesfield.ac.uk

W www.macclesfield.ac.uk

The Manchester College

(formerly City College and MANCAT),

Manchester

T 0800 0688585

E enquiries@themanchestercollege.ac.uk

W www.themanchestercollege.co.uk

Manchester Metropolitan University

All Saints Building, All Saints, M15 6BH

T 0161 2476969

F 0161 2476335

E enquiries@mmu.ac.uk

W www.mmu.ac.uk

Mid-Cheshire College

Hartford Campus, Northwich, CW8 1LJ

T 01606 74444

F 01606 720700

E info@midchesh.ac.uk

W www.midchesh.ac.uk

Nelson and Colne College

Scotland Road, Nelson, BB9 7YT

T 01282 440209

E learnerservices@nelson.ac.uk

W www.nelson.ac.uk

Contact Dennis Roberts

Preston College

The Park School, Moor Park Avenue, Preston,

PR16AS

T 01772 225604

E iturner2@preston.ac.uk

W www.preston.ac.uk

Contact Ian Turner

Priestley College

Loushers Lane, Warrington, WA4 6RD

T 01925 633591

F 01925 413887

W www.priestleycollege.ac.uk

Contact Alan Evans

Runshaw College

Langdale Road, Leyland, PR25 3DQ

T 01772 643013

E enquiries@runshaw.ac.uk

W www.runshaw.ac.uk

Contact Alex Lowman

Salford College

Worsley Campus, Walkden Road, M28 7QD

T 0161 7028272

E enquiries@salford-col.ac.uk

W www.salford-col.ac.uk

South Cheshire College

Creative Arts Department, Dane Bank Avenue,

Crewe, CW2 8AB

T 01270 654654

E admissions@s-cheshire.ac.uk

W www.s-cheshire.ac.uk

Southport College

Mornington Road, Southport, PR9 0TT

T 01704 500606

W www.southport-college.ac.uk

St Helens College

School of Arts, Water Street, St Helens,

WA10 1PP

T 01744 733766

W www.sthelens.ac.uk

Stockport College of Further and Higher Education

Foundation Art and Design, Wellington Road

South, SK1 3UQ

T 0161 9583100

F 0161 4806636

E admissions@stockport.ac.uk

W www.stockport.ac.uk

Tameside College

Beauford Road, Ashton-under-Lyne, OL6 6NX T 0161 9086600 F 0161 9086611 W www.tameside.ac.uk

Trafford College

Manchester Road, Altrincham, WA14 5PQ T 0161 8867070 F 0161 9524672 E enquiries@trafford.ac.uk W www.trafford.ac.uk

University of Cumbria (formerly Cumbria Institute of the Arts)

Brampton Road, Carlisle, CA3 9AY T 01228 400300 E enquiries@cumbriacad.uk W www.cumbria.ac.uk

University of Salford

School of Art & Design, Centenary Building, Peru Street, Salford, M3 6EQ T 0161 2956088 E j.n.howe@salford.ac.uk W www.artdes.salford.ac.uk

Warrington Collegiate Institute

School of Art and Design, Padgate Campus, Warrington, WA2 0DB T 01925 494494 E d.fye@warr.ac.uk W www.warrington.ac.uk Contact Deryk Fye

West Cheshire College

Grange Centre, Regent Street, L65 8EJ T 01244 670359 E a.hirst@west-cheshire.ac.uk W www.west-cheshire.ac.uk Contact Phil Clarkson

Wigan & Leigh College

School of Art and Design, Parsons Walk, Wigan, WN1 1RS T 01942 761111 F 01942 761603 W www.wigan-leigh.ac.uk Contact Robin Salt

Winstanley College

Winstanley Road, Wigan, WN5 7XF T 01695 628610 / 611 W www.winstanley.ac.uk

Wirral Metropolitan College

12 Quays Campus, Shore Road, Birkenhead, CH41 1AG T 0151 55177777 W www.mc.ac.uk

Xaverian Sixth Form College

Lower Park Road, Manchester, M145RB T 0161 2241781 F 0161 2489039 E admissions@xaverian.ac.uk W www.xaverian.ac.uk

Northern Ireland

Belfast Metropolitan College

Millfield Building, Belfast T o28 90265625 E central_admissions@belfastmet.ac.uk W www.belfastmet.ac.uk

North West Regional College - Limavady

Main Street, Limavady, BT49 0EX T 028 71278700 F 028 77761018 W www.nwrc.ac.uk Contact David Hanna

North West Regional College - Londonderry

Arts Department, Strand Road, Londonderry, BT48 7AL
T 028 71276000
E gerard.maxwell@nwrc.ac.uk
W www.nwrc.ac.uk
Contact Gerard Maxwell

Northern Regional College (formerly North East/West Institutes of Further and Higher Education)

Trostan Avenue Building, Ballymena, BT43 7BN T o28 25652871 W www.nrc.ac.uk Contact Jeanette Lammey

South West College

Dungannon Campus, Circular Road, Dungannon, BT71 6BQ
T o28 87722323
F o28 87722323
E dungannon@swc.ac.uk
W www.swc.ac.uk
Formerly East Tyrone FE College

South West College - Omagh Campus

2 Mountjoy Road, Omagh, BT79 7AH T 028 82245433 / 0800 0327890 W www.swc.ac.uk

Southern Regional College - Lurgan Campus

(formerly Upper Bann Institute of Further and Higher Education), 2–8 Kitchen Hill, Lurgan, Craigavon, BT66 6AZ T o28 38397800 E info@src.ac.uk

Southern Regional College - Newry Campus

(formerly Newry and Kilkeel Institute of Further and Higher Education), Patrick Street, Newry, BT35 8DN

T 028 30261071 E info@src.ac.uk W www.src.ac.uk

Southern Regional College - Armagh Campus

(formerly Armagh College of Further Education), Lonsdale Street, Armagh, BT61 7HN T 02837 522205

E info@src.ac.uk W www.src.ac.uk

South-east

Abingdon & Witney College

Northcolt Road, Abingdon, OX14 1NN
T 01235 555585
E enquiry@abingdon-witneycollege.ac.uk
W www.abingdon-witney.ac.uk
Contact Emma Baldwin

Alton College

Old Oldham Road, Alton, GU34 1NX T 01420 592200 ext.330 E mark.taylor@altoncollege.ac.uk W www.altoncollege.ac.uk Contact Mark Taylor

Amersham & Wycombe College

Amersham Campus, Stanley Hill, HP7 9HN T 0800 614016
E abeaumont@amersham.ac.uk
W www.amersham.ac.uk
Contact Anya Beaumont

Basingstoke College of Technology (BCOT)

School of Art, Design and Media, Worting Road, Basingstoke, RG21 8TN

T 01256 354141 E information@bcot.ac.uk W www.bcot.ac.uk Contact Brian C. Stevens

Bracknell & Wokingham College

Church Road, Bracknell, RG12 1DJ T 01344 460200 E study@bracknell.ac.uk Contact Lorraine Zutshi

Brooklands College

Heath Road, Weybridge, KT13 8TT T 01932 797700 E info@brooklands.ac.uk W www.brooklands.ac.uk Contact Cherry Solon

Buckinghamshire New University

Queen Alexandra Road, High Wycombe, HP11 2JZ T 01494 603054 E advice@bucks.ac.uk W www.bucks.ac.uk

Chichester College of Arts, Science and Technology

Westgate Fields, Chichester, PO19 1SB T 01243 539481 E info@chichester.ac.uk W www.chichester.ac.uk

City College Brighton & Hove

Pelham Street, Brighton, BN1 4FA T 01273 667788 E info@ccb.ac.uk W www.ccb.ac.uk Contact Wendy Sherratt

Colchester Institute

Sheepen Road, Colchester, CO3 3LL T 01206 712777 W www.colchester.ac.uk Contact Alan Smith

Cricklade College

Charlton Road, Andover, SP10 1EJ T 01264 360000 E info@cricklade.ac.uk W www.cricklade.ac.uk Contact Peter Matthews

East Berkshire College

Station Road, Langley, SL3 8BY T 0845 3732500 E info@eastberks.ac.uk W www.eastberks.ac.uk

East Surrey College

(Reigate School of Art and Design), Gatton Point, Redhill, RH1 2JZ T 01737 788444 E studentenquiries@esc.ac.uk W www.esc.ac.uk

Fareham College

Bishopsfield Road, Fareham, PO14 1NH T 01329 815200 F 01329 822483 E info@fareham.ac.uk W www.fareham.ac.uk

Guildford College of Further and Higher Education

School of Art, Design and Media, GU1 1EZ T 01483 448500 ext.4877 E info@guildford.ac.uk W www.guildford.ac.uk

Hastings College of Arts & Technology

Archery Road, St Leonards-on-Sea, TN38 0HX T 01424 458458 E studentadvisor@hastings.ac.uk W www.hastings.ac.uk

Henley College

Deanfield Avenue, Henley-on-Thames, RG9 1UH T 01491 634027 E jdoe@heleycol.ac.uk W www.henleycol.ac.uk

Isle of Wight College

Medina Way, Newport,
PO30 5TA
T 01983 526631
E judith.salmon@iwightc.ac.uk
W www.iwightc.ac.uk
Contact Judith Salmon

Milton Keynes College

Bletchley Centre, Sherwood Drive, Milton Keynes, MK3 6DR T 01908 684452 / 53 F 01908 684199 E info@mkcollege.ac.uk W www.mkcollege.ac.uk **NESCOT**

Reigate Road, Ewell, Epsom, KT17 3DS T 020 83943261 E p.allen@nescot.ac.uk W www.nescot.ac.uk Contact Philip Allen

Newbury College

Oxford Road, Newbury, RG14 1PQ T 01634 845000 E l-jones@newbury-college.ac.uk W www.newbury-college.ac.uk Contact Linda Jones

Northbrook College

Union Place Campus, Worthing, BN11 1LU T o845 556060 E enquiries@nbcol.ac.uk W www.nbcol.ac.uk Contact Geoff Hands

Oxford & Cherwell Valley College

Broughton Road, Banbury, OX16 9QA T 01865 550622 E enquiries@ocvc.ac.uk W www.ocvc.ac.uk Contact Martin Carrolchick

Oxford Brookes University

School of Arts And Humanities, Headington Campus, Gipsy Lane, Oxford, OX3 0BP T 01865 741111 E fad@brookes.ac.uk W http://ah.brookes.ac.uk/foundation

Ravensbourne College of Design and Communication

Walden Road, Chislehurst, BR7 5SN T 020 82894900
F 020 83258320
E info@rave.ac.uk
W www.rave.ac.uk
Contact Louise Liddington

South Downs College

College Road, Waterlooville, PO7 8AA T 023 9279 7979 E enquiries@southdowns.ac.uk W www.southdowns.ac.u

South East Essex College

Luker Road Campus, High Street, Southend-on-Sea, SS1 1ND T 01702 220400 E guidance@southend.ac.uk W www.southend.ac.uk

South Kent College – Ashford School of Art & Design

Jemmett Road, Ashford, TN23 4RJ T o845 207 8220 / 01233 628276 E asad@southkent.ac.uk W www.southkent.ac.uk

Southampton City College

St Mary Street, Southampton, SO14 1AR
T 023 80484848
F 023 80577473
E paul.everitt@southampton-city.ac.uk
W www.southampton-city.ac.uk
Contact Paul Everitt

Sussex Downs College

Cross Levels Way, Eastbourne, BN21 2UF T 01323 637637 F 01323 637472 E info@sussexdowns.ac.uk W www.sussexdowns.ac.uk

Thames Valley University

Reading Campus, Kings Road, Reading, RG1 4HJ
T 0118 9675000
E learning.advice@tvu.ac.uk
W www.tvu.ac.uk
Contact Robin Hamilton-Farey

Thanet College

Ramsgate Road, Broadstairs, CT10 1PN T o1843 605040 F o1843 605031 W www.thanet.ac.uk

Thurrock and Basildon College

Woodview Campus, Grays, RM16 2YR T 0845 6015746 F 01375 373356 E Enquire@TAB.ac.uk W www.tab.ac.uk Contact Tony Dobson

Totton College

Calmore Road, Totton, SO40 3ZX
T 0238 0874874
F 023 80874879
E info@totton.ac.uk
W www.totton.ac.uk

University for the Creative Arts - Canterbury

New Dover Road, Canterbury, CT1 3AN T 01227 817302 E admissions@ucreative.ac.uk W www.ucreative.ac.uk Contact Mary Stockton-Smith

University for the Creative Arts - Epsom

Ashley Road, Epsom, KT18 5BE
T 01372 728811
E admissions@ucreative.ac.uk
W www.ucreative.ac.uk
Contact Ian Parker

University for the Creative Arts - Farnham

Falkner Road, Farnham, GU9 7DS T 01252 722441 E admissions@ucreative.ac.uk W www.ucreative.ac.uk Contact Jane Cradock-Watson

University for the Creative Arts - Maidstone

Oakwood Park, Maidstone, ME16 8AG T 01622 620000 E admissions@ucreative.ac.uk W www.ucreative.ac.uk Contact Mike Addison

University for the Creative Arts - Rochester

Fort Pitt, Rochester, ME1 1DZ T 01634 888702 E admissions@ucreative.ac.uk W www.ucreative.ac.uk Contact Gary Clough

University of Portsmouth

School of Art, Design and Media, Eldon Building, PO1 2DJ T 02392 843863 E janet.pullen@port.ac.uk W www.port.ac.uk Contact Janet Pullen

University of Southampton

Winchester School of Art, Park Avenue, Winchester, SO23 8DL T 023 80596900 E askwsa@soton.ac.uk W http://wsa.soton.ac.uk

West Kent College

Brook Street, Tonbridge, TN9 2PW T 01732 358101 E enquiries@wkc.ac.uk W www.wkc.ac.uk Contact Barbara Giles

South-west

Bournemouth & Poole College

North Road, Poole, BH14 0LS T 01202 205205 E apiesley@bpc.ac.uk W www.thecollege.co.uk Contact Andrew Piesley

Bridgwater College

Bath Road, TA6 4PZ
T 01278 441292
E wrightj@bridgwater.ac.uk
W www.bridgwater.ac.uk.
Contact Nichola Kingsbury

City of Bath College

Avon Street, Bath, BA1 1UP T 01225 312191 E admissions@citybathcoll.ac.uk W www.citybathcoll.ac.uk Contact David Hyde

City of Bristol College

College Green Centre, St Georges Road, Bristol, BS1 5UA
T 0117 3125000
F 0117 3125051
E enquiries@cityofbristol.ac.uk
W www.cityofbristol.ac.uk

Cornwall College

Trevarthian Road, St Austell, PL25 4BU T 01726 67911 E sovay.berriman@cornwall.ac.uk W www.cornwall.ac.uk Contact David Bartram

Cornwall College Camborne

Trevenson Road, Poole, Redruth,
TR15 3RD
T 01209 611612
E enquiries@cornwall.ac.uk
W www.cornwall.ac.uk
Formerly known as Camborne Poole Redruth
College.

Exeter College

Victoria Yard Studios, Queen Street, Exeter, EX4 3SR

T 0845 1116000 E info@exe-coll.ac.uk W www.exe-coll.ac.uk Contact Carol Kennedy

Ferndown Upper School

Cherry Grove, Ferndown, BH22 9EY T 01202 871243 F 01202 893383 E school@fernup.dorset.sch.uk W www.fernup.dorset.sch.uk

Filton College

Filton Avenue, Bristol, BS34 7AT T 0117 9312121 F 0117 9312233 E info@filton.ac.uk W www.filton.ac.uk

Gloucester College

Centre for the Arts, Brunswick Road, GL1 1HS T 01452 426602
E williso1@gloscat.ac.uk
W www.gloscat.ac.uk
Contact Sally Williams

Highlands College

P.O. Box 1000, St Saviour, JE4 9QA T 01534 608620 E glyn.burton@highlands.ac.uk W www.highlands.ac.uk Contact Glyn Burton

North Devon College

EX31 2BQ T 01271 338100 E he@ndevon.ac.uk W www.ndevon.ac.uk Contact Erica Burley, Helen Colledge or Lesley Simpson

Old Sticklepath Hill, Sticklepath, Barnstable,

Plymouth College of Art and Design

Tavistock Place, Plymouth, PL4 8AT T 01752 203434 E enquiries@pcad.ac.uk W www.pcad.ac.uk

Somerset College of Arts and Technology

Wellington Road, Taunton, TA1 5AX T o1823 366366 F o1823 366418 E enquiries@somerset.ac.uk W www.somerset.ac.uk

South Devon College

Vantage Point, Long Road, Paignton, TQ4 7EJ

T 08000 380123

E enquiries@southdevon.ac.uk

W www.southdevon.ac.uk

St Brendan's Sixth Form College

Broomhill Road, Brislington, Bristol,

BS45RO

T 0117 9777766

E info@stbrn.ac.uk

W www.stbrn.ac.uk

Strode College

Church Road, Street, BA16 0AB

T 01458 844444

F 01458 844411

E ftadmissions@strode-college.ac.uk

W www.strode-college.ac.uk

Contact Mark Tinsley

Stroud College

Stratford Road, Stroud, GL5 4AH

T 01453 763424

F 01453 753543

E enquire@stroudcol.ac.uk

W www.stroud.ac.uk

Contact Justin Gregory

Swindon College

North Star Av, Swindon, SN2 1DY

T 0800 7312250

E studentservices@swindon-college.ac.uk

W www.swindon-college.ac.uk

The Arts Institute at Bournemouth

The School of Art. Wallisdown, BH125HH

T 01202 363210

E morton@aib.ac.uk

W www.arts-inst-bournemouth.ac.uk

Contact Mark Orton

Truro College

College Road, Truro, TR1 3XX

T 01872 267000

E enquiry@Truro-Penwith.ac.uk

W www.trurocollege.ac.uk

University College Falmouth

Woodlane, Falmouth, TR11 4RA

T 01326 211077

F 01326 213880

E admissions@falmouth.ac.uk

W www.falmouth.ac.uk

University of Gloucestershire

Park Campus, P.O. Box 220,

GL502OF

T 01242 532700

F 01242 532810

Enpride@glos.ac.uk

W www.glos.ac.uk

Contact Nick Pride

University of the West of England

Faculty of Art, Media and Design, Kennel Lodge

Road, Bower Ashton, Bristol, BS3 2JT

T 0117 3444768

E dawn.mason@uwe.ac.uk

W www niwe ac nk

Contact Dawn Mason

Weston College

Knightstone Road, Weston-super-Mare,

BS23 2AL

T 01934 411411

F 01934 411410

W www.weston.ac.uk

Contact Fiona Hunter

Weymouth College

Cranford Avenue, Weymouth, DT47LQ

T 01305 761100

Eigs@weymouth.ac.uk

W www.weymouth.ac.uk

Wiltshire College Salisbury (formerly

Salisbury College)

Southampton Road, Salisbury, SP1 2LW

T 01722 344344

F 01722 344345

E info@wiltshire.ac.uk

W www.wilshire.ac.uk

Contact David Mackerth

Wiltshire College Trowbridge

College Road, Trowbridge, BA14 0ES

T 01225 766241

F 01225 777148

E info@wiltshire.ac.uk

W www.wiltshire.ac.uk

Contact Tony Williams

Yeovil College

Mudford Road, Yeovil, BA21 4DR

T 01935 423921

F 01935 429962

E maryj@yeovil-college.ac.uk

Contact Mary Jacobsen

Wales

Barry College

Colcot Road, Barry, CT62 8YJ T 01446 725000 E ametcalf@barry.ac.uk W www.barry.ac.uk Contact Adrian Metcalfe

Bridgend College

Cowbridge Road, Bridgend, CF31 3DF T 01656 302302 E admissions@bridgend.ac.uk W www.bridgend.ac.uk

Coleg Gwent

The Rhadyr, Usk, Gwent, NP15 1XJ
T 01495 333333
E christopher.williams@coleggwent.ac.uk
W www.coleggwent.ac.uk
Contact Christopher Williams

Coleg Llandrillo College

Llandudno Road, Rhos-on-Sea, Colwyn Bay, LL28 4HZ T 01492 546666 E r.williams@llandrillo.ac.uk W www.llandrillo.ac.uk

Coleg Meirion-Dwyfor

Ffordd Ty'n y Coed, Dolgellau, Gwynedd, LL40 2SW T 01341 422827 F 01341 422393 E coleg@meirion-dwyfor.ac.uk W www.meirion-dwyfor.ac.uk

Coleg Menai

Arts, Design and Media Centre, Bangor Business Park, Bangor, LL57 4BN T 01248 383333 / 01248 370125 E student.services@menai.ac.uk W www.menai.ac.uk

Coleg Powys

Llanidloes Road, Newton, Powys, SY16 4HU
T 0845 4086200
E enquiries@coleg-powys.ac.uk
W www.coleg-powys.ac.uk
Contact Robert Loupart

Deeside College

Kelsterton Road, Connah's Quay, CH5 4BR T 01244 831531 E enquiries@deeside.ac.uk W www.deeside.ac.uk Contact David Craig

Glamorgan Centre for Art & Design

Glyntaff Road, Glyntaff, CF37 4AT
T 01443 663309
F 01443 663313
W www.gcadt.ac.uk
Contact Robert Griffin

Pembrokeshire College

Merlins Bridge, Haverfordwest, SA61 1SZ T 01437 765247 E admissions@pembrokeshire.ac.uk W www.pembrokeshire.ac.uk

Swansea Metropolitan University

Faculty of Art, Design and Media, Dynevor Centre,
De La Beche Street, Swansea, SA1 3EU
T 01792 481285
F 01792 205305
E dawn.lake@smu.ac.uk
W www.sihe.ac.uk
Contact Dawn Lake

University of Glamorgan

Cardiff School of Creative & Cultural Industries, Adam Street, Cardiff, CA24 2XF T 0800 716925 E enquiries@glam.ac.uk W www.glam.ac.uk

University of Wales College, Newport

Caerleon Campus, P.O.Box 101, Newport, NP18 3YH
T 01633 432183
E charles.penwarden@newport.ac.uk
W www.newport.ac.uk
Contact Charles Penwarden

University of Wales Institute, Cardiff

Western Avenue, Cardiff, CF5 2YB T 029 20416689 F 029 20416640 E dgould@uwic.ac.uk W www.csad.uwic.ac.uk Contact David Gould

West Wales School of the Arts

Faculty of Art/Design, Jobs Well Road, Carmarthen, SA31 3HY T 01267 221774 / 01554 748229 E carol.gwizdak@ccta.ac.uk W www.wwsota.ac.uk Contact Carol Gwizdak

Yale College of Wrexham

Grove Park Road, Wrexham, LL12 7AA T 01978 311794 F 01978 291569 / 364254 E sab@yale-wrexham.ac.uk W www.vale-wrexham.co.uk Contact Sheena Bain

West Midlands

Birmingham City University (formerly UCE Birmingham)

City North Campus, Birmingham, B42 2SU T 0121 3315000 F 0121 3317994 E foundation.com@students.bcu.ac.uk W www.bcu.ac.uk

Cannock Chase Technical College

Progress Centre, Walsall Road, Bridgetown, **WS11 1UE** T 01543 462200 W www.cannock.ac.uk

City College, Birmingham

Admissions, Freepost MID 1755, Birmingham, B33 0BR T 084 50501144 W www.citycol.ac.uk

City of Wolverhampton College

Paget Road Campus, WV6 ODU T 01902 836000 / 01902 836000 F 01902 423070 E mail@wolvcoll.ac.uk W www.wolverhamptoncollege.ac.uk

Coventry University

School of Art and Design, Priory Street, CV1 5FB T 02476 152222 E studentenquiries@coventry.ac.uk W www.coventry.ac.uk

Dudley College of Technology

The Broadway, Dudley, DY1 4AS T 01384 363000 F 01384 363311 E matt.westbrook@dudleycol.ac.uk W www.dudleycol.ac.uk Contact Gordon Heath

Halesowen College

Whittingham Road, Halesowen, B63 3NA T 01216 027777 E info@halesowen.ac.uk W www.halesowen.ac.uk

Herefordshire College of Art & Design

Folly Lane, Hereford, HR1 1LT T 01432 273359 F hcad@hereford-art-col.ac.uk W www.hereford-art-col.ac.uk Contact Roger Collins

Hereward College

Bramston Crescent, Tile Hill Lane, Coventry, CV49SW T 024 76461231 E margarettaylor@hereward.ac.uk W www.hereward.ac.uk Contact Margaret Taylor

Kidderminster College of Further Education

Art and Design Department, Hoo Road, Kidderminster, DY10 1LX T 01562 512113 E iwilletts@kidderminster.ac.uk W www.kidderminster.ac.uk Contact Ian Willetts

Malvern College

College Road, Malvern, WR14 3DF T 01684 581500 E enquiries@malcol.org W www.malvern-college.co.uk

Matthew Boulton College of Further and Higher Education

Jennens Road, Birmingham, B47PS T 0121 5038590 F 0121 4463105 E ask@matthew-boulton.ac.uk W www.matthew-boulton.ac.uk

Newcastle-under-Lyme College

Liverpool Road, Newcastle-under-Lyme, ST5 2DF T 01782 254357 E malcolm.fahey@nulc.ac.uk W www.nulc.ac.uk Contact Malcolm Fahey

North East Worcestershire College Bromsgrove Campus, Blackwood Road,

Bromsgrove, B60 1PQ T 01527 585041

E info@ne-worcs.ac.uk W www.ne-worcs.ac.uk Contact Linda Taylor

North Warwickshire & Hinckley College

Hinchley Road, Nuneaton, CV11 6BU T 02476343000 W www.nwhc.ac.uk Contact Dale Robertson

Sandwell College

High Street, West Bromwich, B70 8DW T 0121 2536648
E lenoraminto@fsmail.net
W www.sandwell.ac.uk
Contact Lenora Minto

Shrewsbury College of Arts and Technology

London Road, Shrewsbury, SY2 6PR T 01743 342342 E prospects@shrewsbury.ac.uk W www.shrewsbury.ac.uk Contact Graham Brownridge

Solihull College

Blossomfield Road, Solihull, B91 1SB T 0121 6787000 E enquiries@solihull.ac.uk W www.solihull.ac.uk

Stafford College

Earl Street, Stafford, ST16 2QR T 01785 223800 W www.staffordcoll.ac.uk Contact Neil Vodrey

Staffordshire University

School of Art and Design, College Road, ST5 4HL T 01782 294625 F 01782 294873 W www.staffs.ac.uk Contact Keith Malkin

Stourbridge College

Hagley Road Centre, Hagley Road, Stourbridge, DY8 1QU T 01384 344344 F 01384 344601 E info@stourbridge.ac.uk W www.stourbridge.ac.uk

Sutton Coldfield College

Design Centre, 90 Upper Holland Road, Sutton Coldfield, B72 1RD

T 0121 3621158 E infoc@sutcol.ac.uk W www.sutcol.ac.uk

Tamworth & Lichfield College

Lichfield Campus, The Friary, WS13 6QG T 01543 301100 E enquiries@lichfield.ac.uk W www.tamworth.ac.uk

Telford College of Arts & Technology

Haybridge Rd, Wellington, Telford, TF1 2NP T 01952 642200 E studserv@tcat.ac.uk W www.tcat.ac.uk

Walford and North Shropshire College

College Road, Oswestry, SY11 2SA T 01691 688000 E enquiries@wnsc.ac.uk W www.wnsc.ac.uk Contact Graham Cox

Walsall College of Arts & Technology

St Pauls Street, Walsall, WS1 1XN T 01922 657000 E info@walcat.ac.uk W www.walcat.ac.uk

Warwickshire College

Leamington Centre, Warwick New Road, Leamington Spa, CV32 5JE T 01926 318077 E shenderson@warkscol.ac.uk W www.warkscol.ac.uk Contact Sue Henderson

Worcester College of Technology

School of Art and Design, Barbourne, Worcester, WR1 1RT T 01905 725631 E ask@art.wortech.ac.uk W www.wortech.ac.uk Contact Sandra Maund

Yorkshire and Humberside

Barnsley College

P.O. Box 266, Church Street, S70 2YW T 01226 216431
E c.odoherty@barnsley.ac.uk
W www.barnsley.ac.uk
Contact Christine O'Doherty

Bradford College

Great Horton Road, Bradford, BD7 1AY T 01274 433333 E i.aldcroft@bilk.ac.uk W www.bradfordcollege.ac.uk

Calderdale College

School of Integrated Arts, Francis Street, HX1 3UZ T 01422 399399 E info@calderdale.ac.uk

W www.calderdale.ac.uk Craven College, Skipton

Gargrave Road, Skipton, BD23 1US T 01752 791411 E enquiries@craven-college.ac.uk W www.craven-college.ac.uk Contact Lisa Stansbie

Dewsbury College

Wheelwright Campus, Dewsbury, **WF13 4HQ** T 01924 451649 F 01924 469491 E info@dewsbury.ac.uk W www.dewsbury.ac.uk

Doncaster College

The Hub, Doncaster, DN1 2RF T 01302 553553 E infocentre@don.ac.uk W www.don.ac.uk

East Riding College

Gallows Lane, Beverley, HU17 7DT T 01482 868362 E penny.kealey@eastridingcollege.ac.uk W www.eastridingcollege.ac.uk Contact Penny Kealey

Grantham College

Stonebridge Road, Grantham, NG31 9AP T 01476 400200 E enquiry@grantham.ac.uk W www.grantham.ac.uk Contact Eileen Strange

Grimsby College

Nuns Corner, Grimsby, DN34 5BQ T 01472 311231 F 01472 315507 E infocent@grimsby.ac.uk W www.grimsby.ac.uk

Hopwood Hall College

Rochdale Campus, St Mary's Gate, OL12 6RY T 01706 345346 ext.2214 E john.brisland@hopwood.ac.uk W www.hopwood.ac.uk Contact John Brisland

Huddersfield Technical College

New North Road, Huddersfield, HD1 5NN T 01484 536521 E t.parker@huddcoll.ac.uk W www.huddcoll.ac.uk Contact Tim Parker

Hull School of Art and Design

Oueen's Gardens, Hull, HU1 3DG T 01482 480970 E info@artdesignhull.ac.uk W www.artdesignhull.ac.uk

Leeds College of Art and Design

Blenheim Walk, Leeds, LS2 9AQ T 0113 2028000 E info@leeds-art.ac.uk W www.leeds-art.ac.uk Contact Sue Garland

Leeds Metropolitan University

The Leeds School of Contemporary Art and Graphic Design, Civic Quarter, Room H708, Calverley Street, LS1 3HE T 0113 8125659 E artsandsociety@leedsmet.ac.uk W www.leedsmet.ac.uk/as/

Oldham College

Rochdale Road, Oldham, OL9 6AA T 0161 7854068 E joanne.manship@oldham.ac.uk W www.oldham.ac.uk Contact Ioanne Manship

Park Lane College Keighley

Cavendish Street, Keighley, BD21 3DF T 0845 0457275 E course.enquiry@parklanecoll.ac.uk W www.parklanecoll.ac.uk

Queen Elizabeth Sixth-Form College

Vane Terrace, Darlington, DL3 7AU T 01325 461315 F 01325 361705 E enquiry@qeliz.ac.uk

W www.qeliz.ac.uk Contact Rita Smith

Rotherham College of Arts and Technology

Eastwood Lane, Rotherham, S65 1EG T 01709 362111 E info@rotherham.ac.uk W www.rotherham.ac.uk

Selby College

Abbots Road, Selby, YO8 8AT T 01757 211000 F 01757 213137 W www.selby.ac.uk

Sheffield College

Hillsborough Centre, Livesey Street, Sheffield, S6 5ET
T 01142602600
E enquiries@sheffcol.ac.uk
W www.sheffcol.ac.uk

Wakefield College

Thornes Park Centre, Thornes Park, WF2 8QZ T 01924 789800 E m.grant@wakcoll.ac.uk W www.wakcoll.ac.uk Contact Mandi Grant

Wyke College

Grammar School Road, Hull, HU5 4NX T 01482 346347 F 01482 473336 E office@wyke.ac.co.uk W www.wyke.ac.uk Contact Ian Potter

York College

Art, Design and Craft, Tadcaster Road, York, YO24 1UA
T 01904 770400
F 01904 770499
E enrolment@yorkcollege.ac.uk

Yorkshire Coast College

W yorkcollege.ac.uk

School of Art and Design, Westwood Campus, Valley Bridge Parade, Scarborough, YO11 2PF T 01723 361960 F 01723 366057 W http://ycc.uyrdevelopment.com

Art libraries

East Anglia

Albert Sloman Library

University of Essex, Wivenhoe Park, Colchester, CO4 3SQ T 01206 873192 E libcomment@essex.ac.uk W libwww.essex.ac.uk

Anglia Polytechnic University

Cambridge Campus Library, Éast Road, Cambridge, CB1 1PT T 01223 363271 ext.2301 W www.lib.cam.ac.uk

Colchester Institute

Sheepen Road, Colchester, CO3 3LL T 01206 518642 E philip.smith@colch-inst.ac.uk W www.colch-inst.ac.uk

Fitzwilliam Museum

Trumpington Street, Cambridge, CB4 1SL T 01223 332900 W www.fitzmuseum.cam.ac.uk

Henry Moore Foundation

Dane Tree House, Perry Green, Much Hadham, SG10 6EE T 01279 843333 E library@henry-moore-fdn.co.uk

Norwich School of Art & Design Library

St George Street, Norwich, NR3 1BB T 01603 610561 ext.3073 E info@nsad.ac.uk W www.nsad.ac.uk

Sainsbury Research Unit Library

Sainsbury Centre, University of East Anglia, University Plain, Norwich, NR4 7TJ T 01603 592659 E sru.library@uea.ac.uk W www.uea.ac.uk/art/sru/library/library.htm

Southend-on-Sea Borough Libraries

Victoria Avenue, Southend-on-Sea, SS2 6EX T 01702 612621 W www.southendlibrary.com Suffolk College Library

Rope Walk, Ipswich, IP4 1LT

T 01473 255885 E info@suffolk.ac.uk

W www.suffolk.ac.uk/content/supp_learn/library.

University of Bedfordshire Library

Learning Resources Centre, Park Square, Luton, LU13JU

T 01234 400400

W www.lrweb.bed.ac.uk

University of Cambridge

Faculty of Architecture & History of Art Library, 1 Scroope Terrace, Cambridge, CB2 1PX T 01223 332953

E library@aha.cam.ac.uk

W http://www.arct.cam.ac.uk/library.html

University of East Anglia Library

University of East Anglia, Norwich,

NR47TI

T 01603 592421

E library@uea.ac.uk W www.lib.uea.ac.uk

University of Hertfordshire Learning Resources Centres

College Lane, Hatfield, AL10 9AB

T 01707 284800

W www.herts.ac.uk

East Midlands

The Boots Library, Nottingham Trent University

Goldsmith Street, Nottingham, NG1 5LS

T 0115 8482175

E libinfodirect@ntu.ac.uk

W www.ntu.ac.uk/LLR

Kimberlin Library

De Montfort University, The Gateway, Leicester, LE19BH

T 0116 2577042 F 0116 2577145

W www.library.dmu.ac.uk

Loughborough University Library

Loughborough University, Loughborough,

LE11 3TU

T 01509 222360

W www.lboro.ac.uk/library

Nottingham Arts Library

Angel Row, Nottingham, NG1 6HP

T 0115 9152811

E arts.library@nottinghamcity.gov.uk

W www.nottinghamcity.gov.uk/libraries

University College Northampton Learning Resources

Avenue Campus, St George's Avenue, Northampton, NN2 6JD

W www.library.northampton.ac.uk

University of Derby Britannia Mill **Learning Centre**

Mackworth Road, Derby, DE22 3BL

T 01332 594050

W www.lib.derby.ac.uk/library/homelib.html

University of Leicester Library

P.O. Box 248, University Road, Leicester,

LE19QD

T 0116 252 2042

E libdesk@le.ac.uk

W www.le.ac.uk/li/index.html

University of Nottingham Hallward Library

University Park, Nottingham,

NG7 2RD

T 0115 9514555

E library-arts-enquiries@nottingham.ac.uk

W www.nottingham.ac.uk/is/library

London

Africa Centre

38 King Street, London, WC2E 8JT

T 020 78361973

E info@africacentre.org.uk

W www.africacentre.org.uk

Anthroposophical Society in Great Britain

Rudolf Steiner House, 35 Park Road,

London, NW1 6XT

T 020 72248398

E RSH-Library@anth.org.uk

W www.anthroposophy.org.uk

Archbishops' Council

Council for the Care of Churches, Church House, Great Smith Street, London,

SW1P 3AZ

T 020 78981884

Arts Council England

2 Pear Tree Court, London, EC1R 0DS T 020 79736564 E enquiries@artscouncil.org.uk W www.artscouncil.org.uk

Austrian Cultural Forum

28 Rutland Gate, Knightsbridge, London, SW7 1PQ T 020 75848653 E andrea.rauter@bmaa.gv.at W http:www.austria.org.uk/culture

Barnet College Independent Learning Centre

Academic Library, Wood Street, Barnet, EN5 4AZ T 020 84406321 ext.2832 E anne.rowlandsd@barnet.ac.uk W www.barnet.ac.uk

BFI National Library

21 Stephen Street, London, W1T 1LN T 020 72551444 E information@bfi.org.uk W www.bfi.org.uk/filmtvinfo/library

Birkbeck College Library

Malet Street, London, WC1E 7HX T 020 76316063 E library-help@bbk.ac.uk W www.bbk.ac.uk/lib

Bridgeman Art Library

17–19 Garway Road, London, W2 4PH T 020 77274065 W www.bridgemanart.com

British Architectural Library

RIBA Library, 66 Portland Place, London, W1B 1AD

T 020 75805533 F 020 72551541 E info@inst.riba.org W www.riba-library.com

British Council Visual Arts Library

IO Spring Gardens, London, SW1A 2BN T 020 73893194 F 020 73893088 W www.britishcouncil.org/arts-art-architecture-design-library.htm

British Library

Scholarship & Collections, 96 Euston Road, London, NW1 2DB T 020 74127676 E reader-services-enquiries@bl.uk W www.bl.uk

British Library

Map Library, 96 Euston Road, London, NW1 2DB T 020 74127702
E maps@bl.uk
W www.bl.uk/collections/maps

British Museum Anthropology Library

Centre for Anthropology, Great Russell Street, London, WC1B 3DG T 020 73238041 E aoa@thebritishmuseum.ac.uk

British Museum Department of Prints and Drawings

Great Russell Street, London, WC1B 3DG T 020 73238408 F 020 73238999 E prints@britishmuseum.org W www.britishmuseum.org

British Universities Film & Video Council

77 Wells Street, W1T 3QJ T 020 73931500 F 020 73931555 E ask@bufvc.ac.uk W www.bufvc.ac.uk

Byam Shaw School of Art Library

(University of the Arts London), 2 Elthorne Road, N19 4AG T 020 75142350 E info@byam-shaw.ac.uk W www.byam-shaw.ac.uk

Camberwell College of Arts Library

(University of the Arts London), Peckham Road, SE5 8UF T 020 75146349 W www.arts.ac.uk/library

Central St Martins College of Art & Design Library

(University of the Arts London), 107–109 Charing Cross Road, WC2H 0DU T 020 75147190 W www.arts.ac.uk/library

Chelsea College of Art & Design Library

(University of the Arts London), 16 John Islip Street, SW1P 4JU **T** 020 75147773 **W** www.arts.ac.uk/library

Cinema Theatre Association

44 Harrowdene Gardens, Teddington, TW11 0DJ T 020 89772608 W www.cta.org.uk

Courtauld Institute of Art Library

Somerset House, Strand, London, WC2R 0RN
T 020 78482701
E booklib@courtauld.ac.uk
W www.courtauld.ac.uk

Crafts Council Research Library

44a Pentonville Road, Islington, London, N1 9BY T 020 78062501 E reference@craftscouncil.org.uk W www.craftscouncil.org.uk

Fine Art Trade Guild Archive

16–18 Empress Place, London, SW6 1TT T 020 73816616 E info@fineart.co.uk W www.fineart.co.uk

Folklore Society Library

University College London, Gower Street, London, WC1E 6BT T 020 78628564 E enquiries@folklore-society.com W www.folklore-society.com

Fulham Reference Library

598 Fulham Road, London, SW6 5NX T 020 85765254 W www.lbhf.gov.uk

Geffrye Museum Archive

Kingsland Road, London, E2 8EA T 020 77399893 W www.geffrye-museum.org.uk

Getty Images Hulton Archive

IOI Bayham Street, London, NW1 0AG W www.gettyimages.com

Goethe-Institut Inter Nationes Library

50 Princes Gate, Exhibition Road, London, SW7 2PH T 020 75964040 E library@london.goethe.org W www.goethe.de/gr/lon/enindex.htm

Goldsmiths Library

Lewisham Way, New Cross, London, SE14 6NW T 020 79197150 E library@gold.ac.uk W http://libweb.gold.ac.uk

Guildhall Library (Print Room)

Aldermanbury, London, EC2P 2EJ T 020 73321839 W www.cityoflondon.gov.uk

Hayward Gallery Library

Belvedere Road, London, SE1 8XX T 020 79210854 E pgriffin@hayward.org.uk W www.haywardgallery.org.uk

Historical Manuscripts Commission

Quality House, Quality Court, Chancery Lane, London, WC2A 1HP T 020 72421198 E nra@hmc.gov.uk W www.hmc.gov.uk

Horniman Museum Library

100 London Road, Forest Hill, London, SE23 3PQ T 020 82918681 E Enquiry@horniman.ac.uk W www.horniman.ac.uk/visiting/library.cfm

Hyman Kreitman Research Centre for the Tate Library & Archive

Millbank, London, SW1P 4RG
T 020 78878838
E research.centre@tate.org.uk
W www.tate.org.uk/researchservices/
research.centre

Imperial College of Science, Technology and Medicine Central Library

Exhibition Road, London, SW7 2AZ T 020 75948820 E libhelp@ic.ac.uk W www.lib.ic.ac.uk

Imperial War Museum, Photographic Archive

All Saints Annexe, Austral Street, London, SE11 4SL T 020 74165338 E photos@iwm.org.uk

Inchbald School of Design Library

32 Eccleston Square, London, SW1V ONR T 020 76309011 E info@inchbald.co.uk W www.inchbald.co.uk

Institute of International Visual Arts Library

6–8 Standard Place, Rivington St, London, EC2A 3BE T 020 77491255

E library@iniva.org
W www.iniva.org/library

Kensington Central Library

Phillimore Walk, London, W8 7RX
T 020 73613010
F 020 73612976
E information.services@rbkc.gov.uk
W www.rbkc.gov.uk/libraries

Kingston University Learning Resources Centre

Knights Park, Kingston upon Thames, KT1 2QJ W T 020 85477057 l E library@kingston.ac.uk W www.kingston.ac.uk/library

Lambeth Palace Library

Lambeth Palace Road, London, SE1 7JU T 020 78981400 E lpl.staff@c-of-e.org.uk W www.lambethpalacelibrary.org

London College of Communication Library

(University of the Arts London), Elephant & Castle, SE1 6SB T 020 75146527 / 8026 E libraryenquiries@lcp.linst.ac.uk W www.arts.ac.uk/library

London College of Fashion Library

(University of the Arts London), 20 John Princes Street, London, W1G 0BJ T 020 75147453 / 7455 W www.arts.ac.uk/library

London Metropolitan University Learning Centre

North Campus, 236–250 Holloway Road, London, N7 6PP T 020 77535170 W www.unl.ac.uk/library

London Metropolitan University Library and Learning Resource Centre

City Campus, 41–71 Commercial Road, London, E1 1IA T 020 73201869

W www.lgu.ac.uk/as/library/ilrc/index.htm

London Metropolitan University The Women's Library

Old Castle Street, London, E1 7NT
T 020 73202222
E enquirydesk@thewomenslibrary.ac.uk
W www.thewomenslibrary.ac.uk

London Transport Museum Reference Library

39 Wellington St, London, WC2E 7BB T 020 75657280 W www.ltmuseum.co.uk/collections

MAKE

Central St. Martins College of Art, 107–109 Charing Cross Road, London, WC2H 0DU T 020 75148869 E womensart@csm.linst.ac.uk W www.womensart.org.uk

Mary Evans Picture Library

59 Tranquil Vale, Blackheath, London, SE3 OBS T 020 83180034 E pictures@maryevans.com W www.maryevans.com

Middlesex University Art & Design Learning Resources

Cat Hill, Barnet, EN4 8HT T 020 84115111 W www.ilrs.mdx.ac.uk

Museum of Domestic Design & Architecture (MODA)

Middlesex University, Cat Hill, Barnet, EN4 8HT T 020 84115244 E moda@mdx.ac.uk W www.moda.mdx.ac.uk

Museum of London Library

150 London Wall, London, EC2Y 5HN T 020 78145605 W www.museumoflondon.org.uk

National Maritime Museum Caird Library

Park Row, Greenwich, London, SE10 9NF T 020 83126673 E library@nmm.ac.uk W www.nmm.ac.uk/researchers/library Limited access until the opening of the new Library in 2012. See website for details.

National Portrait Gallery Archive & Library

Orange St Entrance, St Martin's Place, London, WC2H 0HE

T 020 73216617 E archive@npg.org.uk W www.npg.org.uk/research

Natural History Museum Library

Cromwell Road, London, SW7 5BD T 020 79425460 / 5000 E library@nhm.ac.uk W www.nhm.ac.uk/library

Paul Mellon Centre for Studies in British Art

16 Bedford Square, London, WC1B 3JA T 020 75800311 E library@paul-mellon-centre.ac.uk W www.paul-mellon-centre.ac.uk

Roehampton Learning Resources Centre

University of Surrey, Roehampton Lane, London, SW15 5SZ T 020 83923770 E enquiry.desk@roehampton.ac.uk

Royal Academy of Arts

W www.roehampton.ac.uk

Burlington House, Piccadilly, London, W1J 0BD
T 020 73005737
E library@royalacademy.org.uk
W www.royalacademy.org.uk/
collectionsandlibrary

Royal College of Art Library

Kensington Gore, London, SW7 2EU T 020 75904224 E library@rca.ac.uk W www.rca.ac.uk

School of Oriental & African Studies Library

University of London Art Section, Thornhaugh Street, Russell Square, London, WC1H 0XG T 020 78984163 E libenquiry@soas.ac.uk W www.soas.ac.uk/library

Society for the Protection of Ancient Buildings

37 Spital Square, London, E1 6DY T 020 73771644 E info@spab.org.uk W www.spab.org.uk

Society of Antiquaries of London

Burlington House, Piccadilly, London, W1J 0BE T 020 74797084 E library@sal.org.uk W www.sal.org.uk

Sotheby's Institute of Art

30 Oxford Street, London,
W1D 1AU
T 020 74623230
E library@sothebysinstitute.com
W www.sothebysinstitute.com

St Bride Library

Bride Lane, Fleet St, London, EC4Y 8EE T 020 73534660 E stbride@corpoflondon.gov.uk W www.stbride.org

Swiss Cottage Library

88 Avenue Road, London, NW3 3HA T 020 74280456 W www.camden.gov.uk/swisscottagelibrary

The National Gallery

Libraries & Archive Department, Trafalgar Square, London, WC2N 5DN T 020 77472542 E lad@ng-london.org.uk W www.nationalgallery.org.uk/about/history/ library

University College London Library

Gower St, London, WC1E 6BT T 020 76792000 ext.7789 E library@ucl.ac.uk W www.ucl.ac.uk/library

University of East London Docklands Learning Resources Centre

University Way, Docklands, London, E16 2RD T 020 82233434 W www.uel.ac.uk/lss

University of East London Duncan House Library

High Street, Stratford, London, E15 2JB **W** www.uel.ac.uk/lss

University of East London Stratford Library

University House, Romford Road, E15 4LZ T 020 82234224

W www.uel.ac.uk/lss

University of London Queen Mary Library

328 Mile End Road, London, E1 4NS T 020 78823300 E library-enquiries@qmul.ac.uk W www.library.gmul.ac.uk/

University of London Senate Library

Malet Street, London, WC1E 7HU T 020 78628461 E shl.enquiries@london.ac.uk W www.ull.ac.uk

University of Westminster Harrow Library

Watford Road, Northwick Park, Harrow, HA1 3TP

T 020 79115000 W www.wmin.ac.uk

Victoria and Albert Museum Archive of Art and Design

Word & Image Department, Blythe House, 23 Blythe Road, London, W14 0QX T 020 76031514 E archive@vam.ac.uk W www.vam.ac.uk/resources/archives/aad

Victoria and Albert Museum National Art Library

Word & Image Department, Cromwell Road, London, SW7 2RL T 020 79422400 E nal.enquiries@vam.ac.uk W www.vam.ac.uk/nal

Victoria and Albert Museum Prints, Drawings, **Paintings and Photographs Collection**

Word & Image Department, Cromwell Road, London, SW7 2RL T 020 79422563 E pdp@vam.ac.uk

W www.vam.ac.uk/resources/print_study_reading

Victoria and Albert Museum Theatre Museum

Archive of Art and Design, Word & Image Department, Blythe House, 23 Blythe Road, London, W14 0QX T 020 79422698 E tmenquiries@vam.ac.uk W www.vam.ac.uk/vastatic/theatre/researching. html

Wallace Collection Library

Hertford House, Manchester Square, London, W1U 3BN T 020 75639528 E andrea.gilbert@wallacecollection.org

W www.wallacecollection.org

Warburg Institute

School of Advanced Study, University of London, Woburn Square, London, WC1H 0AB T 020 78628935 E Warburg.Library@sas.ac.uk W ww.sas.ac.uk/warburg

Wellcome Library

183 Euston Road, London, NW1 2BE T 020 76118722 E Library@wellcome.ac.uk W http://library.wellcome.ac.uk

William Morris Gallery

Lloyd Park, Forest Road, Walthamstow, London, E17 4PP T 020 85273782

W www.walthamforest.gov.uk/wmg/home

William Morris Society

Kelmscott House, 26 Upper Mall, Hammersmith, London, W6 9TA T 020 87413735 Euk@morrissociety.org W www.morrissociety.org

Wimbledon College of Art Library

(University of the Arts London), Merton Hall Road, SW19 3QA T 020 75149690 W www.arts.ac.uk/library

Worshipful Company of Goldsmiths

Goldsmiths' Hall, Foster Lane, London, EC2V 6BN T 020 76067010 E the.library@thegoldsmiths.co.uk W www.thegoldsmiths.co.uk/thelibrary

North-east

Ashburne Library, University of Sunderland

Ashburne House, Ryhope Road, Sunderland, SR2 7EF T 0191 5152992 / 0800 6944888 E library@sunderland.ac.uk

W www.library.sunderland.ac.uk

Newcastle College School of Art & Design Library

Rye Hill Campus, Scotswood Road, Newcastleupon-Tyne, NE4 7SA T 0191 2004000 E enquiries@ncl-coll.ac.uk W www.ncl-coll.ac.uk/student-information/ library.aspx

Newcastle Libraries

Princess Square, Newcastle-upon-Tyne, **NE99 1DX** T 0191 2774100 E information@newcastle.gov.uk W www.newcastle.gov.uk/libraries

Northumbria University Library

City Campus, Ellison Terrace, Newcastle-upon-Tyne, NE1 8ST T 0191 2274125 E ask4help@northumbria.ac.uk W www.northumbria.ac.uk/sd/central/library/

Robinson Library

University of Newcastle-upon-Tyne, NE24HQ T 0191 2227662 E library@ncl.ac.uk W www.ncl.ac.uk/library

University of Teesside Library

Borough Road, Middlesbrough, TS1 3BA T 01642 342100 W www.tees.ac.uk/lis

North-west

Chester College Learning Resources

Parkgate Road, Chester, CH1 4BJ T 01244 511000 / 511234 E enquiries@chester.ac.uk W www.chester.ac.uk/~smilne

John Rylands University Library

University of Manchester, Oxford Road, Manchester, M13 9PP T 016 12753751 W www.library.manchester.ac.uk/

Lancaster University Library

Bailrigg, Lancaster, LA1 4YH T 01524 592516 E library@lancs.ac.uk W libweb.lancs.ac.uk

Liverpool John Moores University Learning Resource Centre

Mount Pleasant, Liverpool, L3 5UZ T 0151 2313701 W www.limu.ac.uk/lea/

Manchester Central Library

St Peter's Square, Manchester, M2 5PD T 016 12341900 F 0161 2341963 W www.manchester.gov.uk/libraries/central

Manchester Metropolitan University All Saints Library

Oxford Road, Manchester, M15 6BH T 0161 2476104 F 0161 2476349 E artdesign-lib-enq@mmu.ac.uk W www.mmu.ac.uk/services/library

Museum of Science & Industry in Manchester

Liverpool Road, Castlefield, Manchester, M3 4FP T 0161 8322244 W www.msim.org.uk

Ruskin Library, Lancaster University

Library Avenue, Lancaster, LA1 4YH T 01524 593587 E ruskin.library@lancaster.ac.uk W www.lancs.ac.uk/users/ruskinlib

Sheppard Worlock Library

Liverpool Hope, Taggart Avenue, Liverpool, L169ID T 0151 2912001 W www.hope.ac.uk/lib/lrd.htm

Southport College Library

Mornington Road, Southport, PR9 0TT T 01704 392651 W www.southport-college.ac.uk

Sydney Jones Library, University of Liverpool

Chatham Street, Liverpool, L69 3DA T 0151 7942679 W www.liv.ac.uk/library

University of Central Lancashire Library Services

St. Peter's Square, Preston, PR1 2HE T 01772 895355 W www.uclan.ac.uk/information/services/ library

University of Cumbria Library

Brampton Rd, Carlisle, CA3 9AY T 01228 400300

W www.cumbria.ac.uk

Walker Art Gallery Library/Archive

William Brown Street, Liverpool, L3 8EL T 0151 4784199 W www.liverpoolmuseums.org.uk/walker

Whitworth Art Gallery

Oxford Road, Manchester, M15 6ER T 0161 2757450 E whitworth@man.ac.uk W www.whitworth.manchester.ac.uk/

Northern Ireland

Architecture & Planning Library

Queen's University Belfast, Lennoxvale, Belfast, BT9 5EQ T 028 90973613 W www.qub.ac.uk/lib

Centre for Migration Studies at the Ulster-American Folk Park

2 Mellon Road, Castletown, Omagh, BT78 5QY T 028 82256315 E CentreMigStudies@ni-libraries.net W www.qub.ac.uk/cms

University of Ulster Library

York Street, Belfast, BT15 1ED T 028 90267268 W www.ulster.ac.uk/library

Scotland

Aberdeen University Library

Meston Walk, Aberdeen, AB24 3UE T 01224 273600 E library@abdn.ac.uk **W** www.abdn.ac.uk/library

Duncan of Jordanstone College of Art & Design Library

Perth Road, Dundee, DD1 4HT T 01382 385255 E doj-library@dundee.ac.uk W www.dundee.ac.uk/library

Dundee City Library Art and Music Department

Wellgate Centre, Dundee, DD1 1DB T 01382 431528

E Arts.video@dundeecity.gov.uk W www.dundeecity.gov.uk

Edinburgh College of Art Library

Evolution House, 78 West Port, Edinburgh, EH1 2LE T 0131 2216180 W http://eportal.eca.ac.uk

Edinburgh University Library

George Square, Edinburgh, EH8 9LJ T 0131 6501000 E Library@ed.ac.uk W www.lib.ed.ac.uk

Fine Art Library

Central Library, George IV Bridge, Edinburgh, EH1 1EG T 0131 2428040 **E** central.fineart.library@edinburgh.gov.uk W www.edinburgh.gov.uk/libraries

Gallery of Modern Art Reading Library

75 Belford Road, Edinburgh, EH4 3DR T 0131 6246253 E gmalibrary@nationalgalleries.org W www.nationalgalleries.org/research

Glasgow School of Art Library

167 Renfrew Street, Glasgow, G3 6RQ T 0141 3534551 E k.molloy@gsa.ac.uk W www2.gsa.ac.uk/library

Glasgow University Library

Hillhead Street, Glasgow, G12 8QE T 0141 3306704 / 5 E library@lib.gla.ac.uk W www.lib.gla.ac.uk

Napier University Merchiston Learning Centre

10 Colinton Road, Edinburgh, EH10 5DT T 0131 4552582 W http://staff.napier.ac.uk/Services/Library

National Gallery of Scotland Library

The Mound, Edinburgh, EH2 2EL T 0131 6246501 E nglibrary@nationalgalleries.org W www.nationalgalleries.org

National Library of Scotland

George IV Bridge, Edinburgh, EH1 1EW

T 0131 6233700 E enquiries@nls.uk W www.nls.uk

National Monuments Record of Scotland

John Sinclair House, 16 Bernard Terrace, Edinburgh, EH8 9NX T 0131 6621456 E info@rcahms.gov.uk W www.rcahms.gov.uk

National Museums of Scotland Library

Chambers Street, Edinburgh, EH1 1JF T 0131 2474137 E library@nms.ac.uk

W www.nms.ac.uk

The National Museums Scotland Library is closed to visitors until January 2011 but still offers an enquiry service via mail, email or phone.

Robert Gordon University Georgina Scott Sutherland Library

Garthdee Road, Aberdeen, AB10 7QE T 01224 263450 E library@rgu.ac.uk W www2.rgu.ac.uk/library

Scottish Arts Council

12 Manor Place, Edinburgh, EH3 7DD T 0845 6036000 E help.desk@scottisharts.org.uk W www.scottisharts.org.uk

Scottish National Portrait Gallery Library

I Queen Street, Edinburgh, EH2 1JD
 T 0131 6246420
 E pglibrary@nationalgalleries.org
 W www.nationalgalleries.org/research

St Andrews University Library

North Street, St Andrews, KY16 9TR T 01334 462281 E library@st-and.ac.uk W www-library.st-and.ac.uk

The Mitchell Library

North Street, Glasgow, G3 7DN T 0141 2872999 E archives@csglasgow.org W www.mitchelllibrary.org

University of Strathclyde Library 101 St James' Road, Glasgow, G4 0NS

T 0141 5484622 / 23 W www.lib.strath.ac.uk

South-east

Amersham & Wycombe College Learning Resources Centre

Stanley Hill, Amersham, HP7 9HN **T** 01494 735553

BBC Written Archives Centre

Peppard Road, Caversham Park, Reading, RG48TZ
T 0118 9486281
E heritage@bbc.co.uk
W www.bbc.co.uk/heritage/more/wac.shtml
By appointment only.

Bodleian Library

Broad Street, Oxford, OX1 3BG T 01865 277162 W www.bodley.ox.ac.uk

Buckinghamshire New University Library

High Wycombe Campus, Queen Alexandra Road, High Wycombe, HP11 2JZ T 01494 522141 W www.bucks.ac.uk

Canterbury Christ Church University College Library

North Holmes Road, Canterbury, CT1 1QU T 01227 782352 W www.canterbury.ac.uk/library/

East Surrey College Library

Gatton Park, London Road, Redhill, RH1 2JT T 01737 772611 W www.esc.ac.uk

Edward Barnsley Furniture Archive

Cockshott Lane, Froxfield, GU32 1BB T 01730 827233 E enquiries@barnsley-furniture.co.uk W www.barnsley-furniture.co.uk

Embroiderers' Guild Library

Apt.41, Hampton Court Palace, KT8 9AU E administrator@embroiderersguild.com W www.embroiderersguild.org.uk

Epsom Library

6 The Derby Square, Epsom, KT19 8AG

T 01372 721707

W epsom.information@surreycc.gov.uk

Gayton Library

Harrow Library Services, Gayton Road, Harrow, HA1 2HL

T 020 84276012 / 6986

E Gayton.library@harrow.gov.uk

W www.harrow.gov.uk/council/departments/ libraries

Hampshire County Council Museums Service Library

Chilcomb House, Chilcomb Lane, Winchester, SO23 8RD

T 01962 846304

W www.hants.gov.uk/museums

High Wycombe Study Centre

5 Eden Place, High Wycombe, HP11 2DH T 0845 2303232 E lib-info@buckscc.gov.uk W www.buckscc.gov.uk/bcc

Jubilee Library

Jubilee Street, Brighton, BN1 1GE T 01273 290800 / 296969 W www.citylibraries.info/libraries

Northbrook College Library

Littlehampton Road, Durrington, Worthing, BN12 6NU
T 0845 1556060
E enquiries@nbcol.ac.uk
W www.northbrook.ac.uk/resources

Open University Library

Walton Hall, Milton Keynes, MK7 6AA T 01908 659001 E Lib-help@open.ac.uk W http://library.open.ac.uk

Oxford Brookes University Library (Headington Library)

Gipsy Lane, Headington, Oxford, OX3 0BP T 01865 483156 W www.brookes.ac.uk/library/headton.html

Ravensbourne College of Design and Communication

Walden Road, Chislehurst, BR7 5SN T 020 82894919 E info@rave.ac.uk W www.rave.ac.uk

Reading University Library

Whiteknights, P.O. Box 223, Reading, RG6 6AE T 0118 3788770
E library@reading.ac.uk
W www.reading.ac.uk/library

Sackler Library

University of Oxford, 1 St John Street, Oxford, OX1 2LG
T 01865 288190
E enquiries@saclib.ox.ac.uk
W www.saclib.ox.ac.uk

Southampton City Libraries

Civic Centre, Southampton, SO14 7LW
T 023 80832462
E reference.library@southampton.gov.uk
W www.southampton.gov.uk/education/libraries

Southampton Institute Mountbatten Library

East Park Terrace, Southampton, SO14 0YN T 02380 319249 W www.solent.ac.uk/library

Sutton Library

St Nicholas Way, Sutton, SM1 1EA T 0208 7704765 E sutton.music@sutton.gov.uk W www.sutton.gov.uk/lfl/librarie/index.htm

Templeman Library

University of Kent at Canterbury, Canterbury, CT2 7NU T 01227 764000 ext.3570 E library-enqiry@ukc.ac.uk W www.ukc.ac.uk/library

The Bate Collection of Musical Instruments

Faculty of Music, St Aldate's, Oxford, OX1 1DB T 01865 276128 E andrew.lamb@music.ox.ac.uk W www.bate.ox.ac.uk/

The British Cartoon Archive, Templeman Library

University of Kent, Canterbury, CT2 7NU T 01227 823127 W www.cartoons.ac.uk

University for the Creative Arts – Canterbury Library

New Dover Road, Canterbury, CT1 3AN T 01227 817326
E librarycant@ucreative.ac.uk
W www.ucreative.ac.uk

University for the Creative Arts - Epsom Library

Ashley Road, Epsom, KT18 5BE

T 01372 202460

E libraryepsm@ucreative.ac.uk

W www.ucreative.ac.uk

University for the Creative Arts – Maidstone Library

Oakwood Park, Maidstone, ME16 8AG

T 01622 620120

E librarymaid@ucreative.ac.uk

W www.ucreative.ac.uk

University for the Creative Arts – Rochester Library

Fort Pitt. Rochester, ME1 1DZ

T 01634 888649

E libraryroch@ucreative.ac.uk

W www.ucreative.ac.uk

University Library

University of Surrey, Guildford,

GU27XH

T 01483 683325

E library-enquiries@surrey.ac.uk

W www.surrey.ac.uk/library

University of Brighton Aldrich Library

Cockcroft Building, Moulsecoomb, Brighton, BN2 4GI

T 01273 642760

W ww.brighton.ac.uk/studentlife/libraries.php

University of Brighton Design Archives

Centre for Research and Development, Faculty of Art & Architecture, Grand Parade, Brighton, BN2 2IY

T 01273 643219 / 643209

E designarchives@brighton.ac.uk

W www.brighton.ac.uk/designarchives/

University of Brighton St Peter's House Library

16–18 Richmond Place, Brighton,

BN2 9NA

T 01273 643221

E Asksph@brighton.ac.uk

W www.brighton.ac.uk/is/lstpeter.html

University of Southampton, Winchester School of Art Library

Park Avenue, Winchester, SO23 8DL

T 023 80596982 / 4

E wsaenqs@soton.ac.uk

W www.library.soton.ac.uk/wsal/index.shtml

University of Sussex Library

Falmer, Brighton, BN1 9QL T 01273 678163 ext.8163

E library@sussex.ac.uk

Worthing Reference Library

Richmond Road, Worthing, BN11 1HD

T 01903 212060

W www.westsussex.gov.uk/Li/home.htm

South-west

American Museum in Britain Library

Claverton Manor, Bath, BA2 7BD

T 01225 460503

E info@americanmuseum.org

W www.americanmuseum.org

Arts Institute at Bournemouth Library

Wallisdown, Poole, BH12 5HH

T 01202 363308

E library@aib.ac.uk

W www.aib.ac.uk

Bath Spa University College, Sion Hill Library

8 Somerset Place, Bath, BA1 5HB

T 01225 875648

W www.bathspa.ac.uk/library

Bournemouth & Poole College Learning Resources Centre

Resources Centre
North Road, Parkstone, Poole, BH14 0LS

T 01202 205681

W www.thecollege.co.uk

Bournemouth University Library

Fern Barrow, Poole, BH12 5BB

T 01202 595083

W www.bournemouth.ac.uk/library

Bristol Art Reference Library

Central Library, College Green, Bristol, BS1 5TL

T 0117 9037202

E refandinfo@bristol.gov.uk

W www.bristol.gov.uk

Cheltenham Library

Clarence Street, Cheltenham,

GL50 3JT

T 01242 532585 / 6

E cheltref@gloscc.gov.uk

Dartington College of Arts Library

Dartington Hall Estate, Totnes, TQ9 6EJ

T 01803 861651

E Library@dartington.ac.uk

W www.dartington.ac.uk/studentsup/llrc.htm

English Heritage Library

NMRC, Kemble Drive, Swindon,

SN2 2GZ

T 01793 414600

E nmrinfo@english-heritage.org.uk

W www.english-heritage.org.uk

English Heritage Photo Library

NMRC, Kemble Drive, Swindon, SW2 2GZ

T 01793 414903

E images@english-heritage.org.uk

W www.english-heritage.org.uk

Fashion Museum Research Centre

Assembly Rooms, Bennett Street, Bath, BA12QH

T 01225 477173 / 477754

E fashion_enquiries@bathnes.gov.uk

W www.museumofcostume.co.uk

Frewen Library, University of Portsmouth

Cambridge Road, Portsmouth, PO1 2ST

T 02392 843228

E library@port.ac.uk

W www.libr.port.ac.uk

Information and Learning Services, University of Plymouth

Earl Richard Road North, Exeter,

EX46HU

T 01392 475049

W www.plymouth.ac.uk

National Monuments Record

Kemble Drive, Swindon, SN2 2GZ

T 01793 414600

E nmrinfo@english-heritage.org.uk

W www.english-heritage.org.uk/knowledge/nmr

Plymouth College of Art and Design Library

Tavistock Place, Plymouth, PL48AT

T 01752 203412

W www.pcad.ac.uk/library.htm

Russell-Cotes Art Gallery & Museum

East Cliff, Bournemouth, BH1 3AA

T 01202 451858

W www.russell-cotes.bournemouth.gov.uk

Shakespeare Centre Library

Henley Street, Stratford-upon-Avon,

CV37 6QW

T 01789 201816

E library@shakespeare.org.uk

W www.shakespeare.org.uk

University of Bath Library & Learning Centre

Claverton Down, Bath, BA2 7AY

T 01225 388388

E Library@bath.ac.uk

W www.bath.ac.uk/libary

University of Bristol Arts & Social Sciences Library

Tyndall Avenue, Bristol, BS8 1TJ

T 0117 9288017

E library@bristol.ac.uk

W www.bris.ac.uk/is

University of Exeter Library & Information Service

Stocker Road, Exeter, EX4 4PT

T 01392 263873

E library@ex.ac.uk

W www.ex.ac.uk/library

University of Gloucestershire Pittville Learning

Pittville Campus, Albert Road, Pittville,

Cheltenham, GL52 3JG

T 01242 532254

W www.glos.ac.uk

University of the West of England, Faculty of Art, Media & Design Library

Bower Ashton Campus, Kennel Lodge Road,

Bristol, BS3 2JT

T 0117 3444750

W www.uwe.ac.uk/library

Wales

Architecture Library, Cardiff University

Bute Building, King Edward VII Avenue, Cardiff,

CF10 3NB

T 029 20875974

E archliby@cardiff.ac.uk

W www.cardiff.ac.uk/insrv/libraries/architecture

Cardiff County Central Library

St David's Link, Frederick Street, Cardiff, CF102DU

T 029 20382116

E enquiry@libraries.cardiff.gov.uk W www.cardiff.gov.uk/libraries

National Museums of Wales, Main Library

Cathays Park, Cardiff, CF10 3NP T 02920 573202 W www.nmgw.ac.uk

University of Wales College, Newport Library

Caerleon Campus, P.O. Box 179, Newport, NP18 3YG
T 01633 432294
E llr@newport.ac.uk
W lis.newport.ac.uk

University of Wales Institute, Howard Gardens Library

Cardiff, CF2 1SP T 0292 0416243 W www.uwic.ac.uk/library

West Midlands

Barber Fine Art Library, University of Birmingham

Edgbaston, B15 2TT T 0121 4147334 E bblib@bham.ac.uk W www.is.bham.ac.uk/barberart

Birmingham City University Institute of Art & Design Library

Bournville Centre, Birmingham, B30 1JX T 0121 3315756 W www.biad.bcu.ac.uk/

Coventry University Lanchester Library

Frederick Lanchester Building, Gosford Street, Coventry, CV1 5DD T 02476 887542 W www.library.coventry.ac.uk

Gosta Green Library, Birmingham Institute of Art & Design

Birmingham City University, Corporation Street, Birmingham, B4 7DX T 0121 331 5860 W www.biad.bcu.ac.uk/

Harrison Learning Centre

St Peters Square, Wolverhampton, WV1 1RH T 01902 322300 W www.wlv.ac.uk/lib

Herefordshire College of Art & Design Library

Folly Lane, Hereford, HR1 1LT T 01432 845315 E library@hca.ac.uk W www.hereford-art-col.ac.uk

Keele University Library

Keele Information Services, Keele, ST5 5BG T 01782 733535 E libhelp@keele.ac.uk W www.keele.ac.uk/depts/li

Kidderminster Library

Market Street, Kidderminster, DY10 1AD T 01562 824500 E kiddersminsterlib@worcestershire.gov.uk W www.worcestershire.gov.uk/libraries

School of Jewellery Library, Birmingham City University

Vittoria Street, Birmingham, B1 3PA

T 0121 3316470

W www.bcu.ac.uk/library/public/index.htm

Staffordshire University, Thompson Library

College Road, Stoke-on-Trent, ST4 2XS
T 01782 294771
E libraryhelpdesk@staffs.ac.uk
W www.staffs.ac.uk/uniservices/infoservices/library/

Stoke-on-Trent Libraries Information & Archives Bethesda Street, Hanley, Stoke-on-Trent,

ST1 3RS
T 01782 238420
E hanley.ref@stoke.gov.uk
W www.stoke.gov.uk/council/libraries

The Lace Guild

The Hollies, 53 Audnam, Stourbridge, DY8 4AE T 01384 390739 E hollies@laceguild.org W www.laceguild.demon.co.uk

University of Warwick Library

Gibbet Hill Road, Coventry, CV4 7AL
T 024 76522026
E library@warwick.ac.uk
W www2.warwick.ac.uk/services/library

Worcester College of Technology School of Art & Design

Barbourne Road, Worcester, WR1 1RT

T 01905 725631 E smaund@wortech.ac.uk W www.wortech.ac.uk

Yorkshire and Humberside

Bowes Museum

Newgate, Barnard Castle, DL12 8NP T o1833 690606 E info@bowes.org.uk W www.bowesmuseum.org.uk

Bradford Central Library

Prince's Way, Bradford, BD1 1NN
T 01274 753688
E bradford.libraries@bradford.gov.uk
W www.bradford.gov.uk/council/libraries/frames.

Doncaster College Learning Resource Centre

Church View, Doncaster, DN1 1RF T 01302 553816 W www.don.ac.uk/facilities/lrc.htm

Grove Library, Bradford College

Great Horton Road, Bradford, BD7 1AY T 01274 753156 W www.bradfordcollege.ac.uk/college/facilities/ collfac/libraries

Henry Moore Institute Library & Archive

74 The Headrow, Leeds, LS1 3AH T 0113 2469469 W www.henry-moore-fdn.co.uk

Insight Museum Collections & Research Centre

The National Media Museum, Bradford, BD1 1NQ T 0870 7010200 E enquiries@nationalmediamuseum.org.uk W www.nationalmediamuseum.org.uk/ Collections/Insight.asp

Leeds Art Library

Calverley Street, Leeds, LS1 3AB T 0113 2478247 E artlibrary@leedslearning.net

Leeds College of Art & Design

Vernon Street, Leeds, LS2 8PH T 0113 2028096 W www.leeds-art.ac.uk

Leeds Metropolitan University Learning Centre

Leslie Silver Building, Woodhouse Lane, Leeds, LS1 3HE T 0113 8123106

Leeds University Library

Woodhouse Lane, Leeds, LS2 9JT T 0113 2335513 E library@library.leeds.ac.uk W www.leeds.ac.uk/library

W www.leedsmet.ac.uk/lis/lss

National Arts Education Archive (Trust)

Bretton Hall, Wakefield, WF4 4LG T 01924 830690 E leonard@leonardbartle.orangehome.co.uk W www.artsedarchive.org.uk

Royal Armouries Library

Armouries Drive, Leeds, LS10 1LT
T 0113 2201832
E enquiries@armouries.org.uk
W www.armouries.org.uk/leeds/library.html

Sheffield Arts & Social Sciences Central Library

Surrey Street, Sheffield, S1 1XZ

T 0114 2734747

E artsandsport.library@sheffield.gov.uk

W www.sheffield.gov.uk/libraries

Sheffield Hallam University Library

Centre City Campus, Howard Street, Sheffield, S1 1WB T 0114 2253333 E learning.centre@shu.ac.uk W www.shu.ac.uk/services/lits/resources.html

University of Huddersfield Learning Centre

Queensgate, Huddersfield, HD1 3DH T 01484 473830 E lc@hud.ac.uk W www.hud.ac.uk/cls/

University of Sheffield Main Library

Western Bank, Sheffield, S10 2TN T 0114 2227200 E library@sheffield.ac.uk W www.shef.ac.uk/library

University of York Library

Heslington, York, YO10 5DD T 01904 433873 E lib-enquiry@york.ac.uk W www.york.ac.uk/services/library

Ireland

Burren College of Art Library

Newtown Castle, Ballyvaughan, County Clare T 0353 65 7077200

E Admin@burrencollege.com

W www.burrencollege.com

Crawford College of Art & Design Library

Sharman, Crawford St, Cork T 353 21 4966777 ext.251 W www.cit.ie

Dublin City Central Library

ILAC Centre, Henry Street, Dublin

T 353 I 8734333 E centrallibrary@dublincity.ie

W www.dublincity.ie/RecreationandCulture/ libraries

Dublin Institute of Technology Library

40-45 Mountjoy Square, Dublin T 353 I 4024108 E mjs.library@dit.ie

W www.dit.ie/library/index.html

National College of Art & Design Library

100 Thomas Street, Dublin

T 353 I 6364347 E romanod@ncad.ie W www.ncad.ie/library/index.shtml

National Gallery of Ireland Library

Merrion Square West, Dublin 2 T 353 I 6325500 E library@ngi.ie W www.nationalgallery.ie/html/library.html

National Library of Ireland

Department of Prints & Drawings, Kildare Street, Dublin 2 T 353 I 6030200 E ifinegan@nli.ie

Trinity College Library

W www.nli.ie

College Street, Dublin 2 T 353 1 8961661 F 353 I 8963774

W www.tcd.ie/Library

University College Dublin Library Richview, Clonskeagh, Dublin 4 T 353 1 7162741 E richview.library@ucd.ie W www.ucd.ie/library

06 Art fairs and festivals

Navigating the visual arts

Susan lones

The reasons people decide to become an artist are varied, ranging from the need for pure freedom of artistic expression to expanding a well-loved hobby post retirement. With perhaps as many as 60,000 people already describing themselves as artists and over 3,700 joining the profession annually as they graduate from art and design courses, competition is fierce for that much-needed status and recognition within the art world.1

Combine this crowded arena with the economic recession, which by all accounts is going to last for a while, and the outlook for artists may not look so great. Even more reason then for artists to consider all the aspects that make up a visual arts practice and recognize that there is more to 'being an artist' than making good works of art. Manoeuvring yourself into a position to be selected or commissioned requires the 'good art' to be presented by an artist who also demonstrates well-honed skills in communication, negotiation and management - of themselves and their professional arrangements. As artist Mark Gubb advises. 'Don't be afraid to call yourself an artist and be professional in everything you do.'2

Artists nowadays are presented with diverse contexts and audiences for their work. Processbased and socially engaged artists must balance their own aspirations for their work with the desires of commissioners who tend to look to artists to provide solutions to social problems - such as poor education, housing and mental health. And, as artist Becky Shaw once commented, 'While I will always value the energy of working to commission or on a residency, it has dawned on me that this often makes me feel powerless. I work if the phone rings, apply to things - I never know when I will be working and when I won't.'3

It is the ability of artists to 'sell' skills and services that plays a key role in enabling them to make a living. In 2007 commissions made up around 63 per cent of the value of openly advertised opportunities to artists published by a-n⁴, with an average value of f_{44} , 885. The average artists' residency, however, which paid a mere $f_4,861$ may not provide you with a materials and expenses budget. It is exhibitions that validate an artist's work and widen their career options, but offer little or no financial return for the artists selected.5 Forty-one per cent of artists see selling their work as a priority, although the markets for art beyond London are ripe for development.6 The Own Art scheme⁷ and Collectorplan have been set up to increase sales of contemporary art to private and domestic collectors by providing interest-free credit to purchasers at selected galleries. However, it is through a portfolio of opportunities, including income from sales, that most artists maintain an artistic livelihood.8

So within this complex and diverse environment for contemporary visual arts practice what are the common concerns among all who would describe themselves as an artist, whatever the medium or genre, their cultural background or career stage or the kinds of audiences they seek for their work? The answer might be a desire to experience good practice: to be respected and valued for the contribution they make to society as a whole, to be treated fairly by employers and commissioners, and to have their professional status recognized.

These needs are encapsulated within a-n's The Code of Practice for the Visual Arts.9 This takes commonly agreed principles and demonstrates through the experiences of artists, arts commissioners and employers why and how they should be applied. In short, it explains that good practice prevails when artists and their collaborators:

· Contribute confidently - engaging with the development of ideas and solutions to problems, challenging stereotypes and assumptions about who knows what, being generous with knowledge and skills and knowing their worth.

- Prepare thoroughly researching the context, legislative implications and environmental factors as well as the interests of partners and colleagues.
- Collaborate creatively establishing mutual respect by identifying shared goals and welcoming discussion and debate.
- Aim high aspiring to bring quality to everything they do, from the work and the presentation of their ideas, to negotiating projects or managing professional relationships.

Although at first glance these principles may appear to be too simply expressed to carry any weight, many artists are reporting that having taken responsibility to define their professional practices themselves, both their artistic status and employment prospects have improved as a result. As Carey Young comments, 'The more you are seen as an independent specialist...the more respect you will get.'¹⁰

The Code of Practice and the interactive 'The artist's fees toolkit' 11 form part of a matrix of support structures available to visual artists nowadays. Over 85 per cent of artists recognize the value of networking with like-minded people. Artist Mark Gubb urges new artists to, 'Attend conferences, exhibition openings and have a drink in the pub with friends, as these are all part of building the networks to support your work. For all the slide banks and databases that exist actually and e-phemerally, talking to people about what you do is always going to be the primary way of getting your work about.' 12

AIR (Artists' Interaction & Representation)¹³ is a membership body that supports practitioners through a combination of professional benefits such as free public liability insurance and artists' events, as well as lobbying to ensure that artists' views and concerns are represented within decision-making.

All professions are dependent on such peer networks, which provide the basis for sharing contacts and knowledge, exchanging advice, and lifting spirits when you're downhearted. Artists' networks are strengthened through internet tools and e-groups. While some artists' networks are built around open studio events, with websites promoting the artists and their work throughout the year, others are based on specific artistic media or specialist 'interest groups' and, increasingly, these stretch way beyond the UK, generating exchange between artists and collaborations for new, global art projects. a-n's UK-wide Networking Artists' Networks (NAN) initiative¹⁴ aims to provide greater visibility for such activity and to support it through events, research visits and bursaries.

Over the last couple of years artists have also benefited from websites such as Artists talking 15 which provide unfiltered spaces for them to talk about and show images of their projects and practices. At the same time they may be 'spotted' by curators and arts organizers such as Kirstie Beaven, Exhibitions Editor at Tate Online, who rates the site because its like taking a 'continuous studio visit'.

Although successful artists may say they have 'been lucky' to get where they are, such a throwaway remark generally belies a far more complex set of circumstances and recognition factors. Brian Eno, renowned first because of his key role in Roxy Music and later as an artist working with Laurie Anderson, says that luck is more about 'being ready', that is being aware of the art world ladders and seeking them out. Look at the CV of an up-and-coming artist and it usually reveals that somewhere along their career path they have been 'spotted' by a respected curator, selected for a notable open submission show, or reviewed in an art magazine. Getting together with other artists and generating your own projects can attract public funding as well as increase your chances of getting reviews and art-world recognition. The internet has also expanded the opportunities for more work to be critiqued, including through sites such as Interface16 and Art Rabbit17.

Most artists invited to show at a gallery will already have an exhibiting track record or a recommendation from another gallery or artist already represented there. Artistcurator Gavin Wade calls this, 'The organic process of relationships with other people, and development of your work over a period of time. You have to meet and talk to other people. It's as simple and as difficult as that. You are only going to be invited, introduced or recommended by being seen.'18

So, the attitudes of other people make up the final part of the jigsaw that is 'being an artist'. When asked about the role and impact of artists, key personalities in public life offer differing perspectives. Shreela Ghosh, Deputy Director of InIVA says, 'I'm on artists' side, to be convinced by their ideas and at the same time offer constructive feedback.' Yvette Vaughan-Jones of Visiting Arts recognizes that, 'Artists are fundamental to my work: without them. I wouldn't have a job.' But, as Guardian columnist Jonathan Freedland notes, 'If art continues to be a largely minority interest, one that is the province of a small group of the economically comfortable cognoscenti, then its relevance will be limited.' 19

A researcher and published writer on the visual arts, Susan Jones is Director of Programmes at a-n The Artists Information Company, publishers of www.a-n.co.uk, a comprehensive UK and international resource that exposes the diversity and complexity of artists' practice and provides a context for good practice. She provided evidence for the 2005 Commons Select Committee enquiry into the Market for Art and advised on Arts Council England's Turning Point, visual arts strategy.

- www.a-n.co.uk/research
- Signpost on www.a-n.co.uk
- Evidence by Becky Shaw in Future Forecast: Social space www.a-n.co.uk/research
- Daily-updated opportunities and jobs service with News feeds on www.a-n.co.uk/jobs_and_opps
- Art work 2007 is published on www.a-n.co.uk/ research
- Report on www.artscouncil.org.uk
- See www.artscouncil.org.uk/ownart/
- Research paper: Making a living as an artist on www.a-n.co.uk/research
- The Code of Practice for the Visual Arts with versions for artists and arts organizers is freely available on www.a-n.co.uk/professional_practice
- Artist's profile on www.a-n.co.uk/artists_talking
- 11 This free interactive toolkit enables all artists to work out what they need to earn annually, taking into account their overheads such as studio, travel, research, insurance, etc., and career stage
- Networker, report on the Networking artists' networks initiative in 'Reflections on Networking' on www.a-n. co.uk/publications
- Practising visual and applied artists become an AIR member an a-n Artist subscription on www.a-n.co.uk/
- See Networking on www.a-n.co.uk/nan
- www.a-n.co.uk/artists_talking is a platform for artists' blogs - any artist can start a blog and upload images
- www.a-n.co.uk/interface is an open access site anyone can post critical writing and read the reviews
- www.artrabbit.com
- Approaching galleries on www.a-n.co.uk/knowledge_ bank
- From interviews in Future forecast: Outer space, published on www.a-n.co.uk/research

Art fairs and festivals

20/21 British Art Fair

Royal College of Art, Kensington Gore, London, SW7 2EU

T 020 87421611

F 020 89955094

E info@britishartfair.co.uk

W www.britishartfair.co.uk

Founded in 1988. The only event to showcase British art from 1900 to the present day. Sixty of the UK's leading dealers exhibit a wide range of painting and sculpture featuring all the great names of twentieth- and twenty first-century British art up.

Submission Policy The fair is only open to dealers and galleries.

Frequency Annual.

20/21 International Art Fair

Royal College of Art, Kensington Gore, London, SW7 2EU

T 020 87421611

F 020 89955094

E info@20-21intartfair.com

W www.20-21intartfair.com

Launched in 2007. Features modern and contemporary art from around the world: Asia, Australia, Europe, the US plus a strong British content. Some fifty dealers and galleries take part.

Frequency Annual.

Affordable Art Fair

Sadler's House, 180 Lower Richmond Road, Putney, London, SW15 1LY T 020 82464848

F 020 82464841

E enquiries@affordableartfair.com

W www.affordableartfair.com

Founded in 1999 with the aim of making original art work more accessible. The ceiling on price is currently £3,000 but prices are as low as £30. Attracts not only first-time buyers but also collectors in search of work by emerging artists. Submission Policy The fair is for dealers and galleries (rather than independent artists) that represent living artists producing contemporary, original paintings, prints, sculpture and photography.

Frequency Twice a year in London (March and October) and annual in Bristol, Amsterdam, Paris, Brussels, New York, Sydney and Melbourne.

Appledore Visual Arts Festival

3 Marine Parade, Appledore, EX39 1PJ

T 07900 212747

E fionasmermaids@netzero.net

W www.appledorearts.org

Contact Jane Bartlett

Founded in 1997. Includes exhibitions, artist talks, open studios, workshops and residencies. Events for adults and children of mixed ages and abilities. Several further education establishments involved, including SCATS, Falmouth, Plymouth and North Devon College.

Submission Policy Artists from all art forms are encouraged to submit proposals for inclusion in the festival. Stalls allocated by selection.

Frequency An annual four-day festival (on the weekend after the spring bank holiday).

Art Fortnight London Ltd

44 Duke Street, St James's, London, SW1Y 6DD

T 020 78398139

F 020 79252903

E sophie@artfortnightlondon.com

W www.artfortnightlondon.com

A programme of events, exhibitions, private views, master classes, VIP art tours and art parties held over two weeks every summer. Aims to bring together galleries, auction houses and museums. Other events run throughout the year.

Art in Action

96 Sedlescombe Road, Fulham, London, SW6 1RB

T 020 73813192

E info@artinaction.org.uk W www.artinaction.org.uk

Contact Patricia Prendergast

Exhibition of over 250 participating artists and craftsmen held in the grounds of Waterperry House near Oxford. Over 25,000 visitors come to watch and speak to working demonstrators over a

four-day period.

Submission Policy Application details available from the above address. Applications are invited in September and October.

Frequency Annual.

Art Ireland

Unit 29, 17 Rathfarnham Road, Terenure, Dublin

T 01 4992244

E maria@eriva.com

W www.artireland.ie

Ireland's largest and best attended art fair. Hosts exhibitions from over 190 artists and galleries.

Submission Policy Artists are invited to submit work for vetting process. There is a cost for exhibition spaces.

Art Ireland Spring Collection

RDS, Ballsbridge, Dublin 4

T 01 4992244

F 01 4903238

E maria@eriva.com

W www.artireland.ie

An annual art fair hosting exhibitions from eighty artists and galleries from Ireland and abroad. Particularly known for modern, contemporary work from up-and-coming artists.

Submission Policy There is a vetting process for all new exhibitors. Welcomes applications from artists, artist groups and galleries. There is a charge to exhibit (€1,650 for an eight sq. metre space).

Frequency Annually in March/April.

Art London

Burton's Court, St Leonard's Terrace, Chelsea, London, SW3

T 020 72599399

E info@artlondon.net

W www.artlondon.net

Over eighty UK and international galleries showing twentieth-century and contemporary art (paintings, sculpture, photography, works on paper and ceramics), priced from £300 to over £100,000.

Art Sheffield

Sheffield Contemporary Art Forum, P.O. Box 3754, Sheffield, S19AH

T 0114 2812013

E contact@artsheffield.org

W www.artsheffield.org

Biennial festival of contemporary art held in venues throughout the city.

ARTfutures

Contemporary Art Society, Bloomsbury House, 74-77 Great Russell Street, London,

WC1B 3DA

T 020 76120730

F 020 76314230

E cas@contempart.org.uk

W www.contempart.org.uk

Organized by the Contemporary Art Society, with a track record of recognizing emerging talent. Past exhibitors include Damien Hirst, Sam Taylor-Wood and Douglas Gordon.

Submission Policy Entry to the festival is free and selection of work is by invitation only.

Artists & Makers Festival

Revolutionary Arts Group, 35 Lanfranc Road, Worthing, BN14 7ES

T 01903 526268

E rag@artistsandmakers.com

W www.artistsandmakers.com

Programme of music, poetry and performance alongside a trail of Worthing and Horsham artists' open houses and studios. Previous years have seen Bill Drummond's myDeath.net project, Big Chill Recordings, photography from writer Dave Gorman, the Textile Arts Forum, West Sussex Writers' Club.

Submission Policy Application details are posted on the website.

Frequency July

ArtsFest

10th Floor, Alpha Tower, Suffolk Street, Queensway, Birmingham, B1 1TT

T 0121 6852605

F 0121 6852606

E mail@artsfest.org.uk

W www.artsfest.org.uk

Contact Sabra Khan

The UK's largest free arts festival, attracting audiences in excess of 100,000. Over three hundred performances take place over the weekend across arts venues and the streets and squares of Birmingham.

Submission Policy West Midlands-based, or performing in West Midlands in months following the event.

Frequency Annual.

Asian Art in London

32 Dover Street, Mayfair, London, W1S 4NE

T 020 74992215

F 020 74992216

E info@asianartinlondon.com

W www.asianartinlondon.com

Contact Virginia Sykes-Wright (PR Marketing) or Antonia Howard-Sneyd (Company Secretary) Established in 1997, bringing together London's leading Asian art dealers, major auction houses and societies in a series of selling exhibitions, auctions, receptions, lectures and seminars. These are complemented by exhibitions at leading museums. Prices range from £5 to over £500,000. Works span all media and ages.

Submission Policy Participants must be

dealing within central London. Does not handle submissions from artists.

Frequency Annual.

Battersea Contemporary Art Fair

Battersea Arts Centre, Lavender Hill, London, SW11 T 0870 2860066

E maria@bcaf.info

W www.bcaf.info

Contact Maria Scaman

Founded in 1991 and bought by current directors on previous organizers' retirement in 2001. Features 150 artists, sculptors, printmakers and photographers. Works priced from £25 to £4,000. Submission Policy Send CV with four examples of work in hard copy or jpegs. Artists only – no galleries or agents to: Maria Scaman, Mollington House, Midhurst Road, Haslemere GU27 3LL. Frequency Twice a year, in May and November.

Belfast Festival at Queen's

8 Fitzwilliam Street, Belfast, BT9 6AW

T 029 90971034

E festival@qub.ac.uk

W www.belfastfestival.com

Every year since 1963, the largest festival of its kind in Ireland has celebrated the best of international art and culture. Runs for three weeks.

Frequency Annual.

The Big Draw

The Campaign for Drawing, 7 Gentleman's Row, Enfield, EN2 6PT

T 020 8351 1719

E info@drawingpower.org.uk

W www.drawingpower.org.uk

Contact Sue Grayson Ford (Campaign Director) Includes over 1,000 events held throughout the UK each October to promote the art of drawing for all. Quentin Blake is campaign patron.

Bow Festival

Space, 129–131 Mare Street, London, E8 3RH E melanie@spacestudios.org.uk

W www.spacestudios.org.uk

A fortnight of collaborative public-art projects that engage with the community and built environment of Bow. Space project-manages and produces the festival on behalf of the Roman Road Revel Group, which is made up of local volunteers.

Brighton Art Fair

P.O. Box 4729, Worthing, BN11 9LD E info@brightonartfair.co.uk

W www.brightonartfair.co.uk

Contact Jon Tutton

Now in its sixth year Brighton Art Fair offers the opportunity for art buyers to meet with and purchase work direct from the artists. With over 100 exhibitors and work across all media, prices range from £50 to £2000+.

Submission Policy Open to all artists in the UK and beyond, artists groups and Sussex-based galleries. Painting, photography, sculpture and original prints.

Frequency Annual, October.

Brighton Festival

Festival Office, 12a Pavilion Buildings, BN1 1EE T 01273 700747
F 01273 707505
E info@brighton-festival.org.uk
W www.brighton-festival.org.uk
Started in 1966, one of the UK's largest international arts festivals.

Brighton Photo Biennial

University of Brighton, Grand Parade, Brighton, BN2 0JY

T 01273 643052

F 01273 643052

E mail@bpb.org.uk

W www.bpb.org.uk

A celebration of international photographic practice committed to stimulating critical debate on photography in all its forms. Bringing together known and unknown bodies of work, new commissions and previously unseen images. Runs a continuous education programme that is active during and between biennials, creating grass roots projects with local communities, artists and individuals.

Frequency Every two years. Next in 2010.

Buy Art Fair

Urbis, Manchester

T 01612375237

W www.buyartfair.co.uk

Launched in 2008. Based at Urbis in central Manchester. Galleries promoting work by UK and international contemporary artists.

Submission Policy Via gallery representation. See website for application/stand details.

Frequency Annual. September.

Celf Caerleon Arts Festival

c/o Hambrook Cottage, Isca Road, Caerleon, Newport, NP18 1QG

T 01633 423354

E editor@caerleon-arts.org

W www.caerleon-arts.org

A two-week summer festival which launched in 2003. The main event is an international sculpture symposium in which around ten sculptors are selected to create new works from wood. Sculptors are paid a fee and their work is sited around the town.

Submission Policy Applications from sculptors working in wood are usually invited towards the end of the year for selection in January and February, See website for details.

Frequency Annual.

Ceramic Art London

Royal College of Art. Kensington Gore, London, SW7 2EU

T 020 74393377 F 020 72879954

E organiser@ceramics.org.uk

W www.ceramics.org.uk

Contact Tony Ainsworth

The festival's vision is to be the national focus for studio ceramics. Components include a selling fair of ninety of the best potters worldwide (prices range from \$30 to \$30,000); a major free talks and events programme; an exhibition of student work; major prizes for potters; full-colour catalogue. Presented by the Craft Potters Association of Great Britain and Ceramic Review Magazine, in association with the Arts Council.

Submission Policy Open to all working studio potters (not students) worldwide, in any ceramic form. Selection of exhibitors is by independent selection panel. Applications via website - deadline September for exhibition the following spring. Frequency Annual - Feb/March.

Chelsea Arts Fair

Penman Antiques Fairs, Widdicombe, Bedford Place, Uckfield, TN22 1LW

T 01825 744074

F 01825 744012

E info@penman-fairs.co.uk

W www.penman-fairs.co.uk

Over forty British and international galleries display contemporary and twentieth-century works of art in a relaxed atmosphere. Held in Chelsea Old Town Hall.

Cheltenham Artists Open Houses

59 Cirencester Road, Charlton Kings, Cheltenham, GL53 8EX

T 01242 580506

F robertfreemana@compuserve.com

W www.artistsopenhouses.org.uk

Contact Bob Freeman

Founded 2000 to promote local artists and to provide the public with an opportunity for closer contact with artists and their creative processes in their studios and homes.

Submission Policy Open to artists in Cheltenham and 10-mile radius. Subscription £30. Application form on website

Frequency Biannual.

Collect

Saatchi Gallery, The Duke of York's HQ, Chelsea, London

W www.craftscouncil.org.uk/collect Collect: The International Art Fair for Contemporary Objects is presented by the Crafts Council and re-launched in 2000 from the Saatchi Gallery, London, Bringing together selected galleries from around the globe, it showcases the very best in decorative and applied arts.

Submission Policy Gallery representation only, via Crafts Council website.

Frequency Annual - May.

Cork Art Fair

Cork City Hall, Cork

T 01 4992244 F 01 4903238

E maria@eriva.com

W www.thecorkartfair.com

Contact Maria McMenamin

The second annual fair took place in 2007, with nearly twice as many exhibitors as 2005. Over sixty artists and galleries exhibited a wide range of painting, sculpture and prints. Prices range from €500 upwards.

Submission Policy Always looking for new artists, groups and galleries to exhibit. Post or email a selection of images and a list of previous exhibitions to maria@eriva.com or Maria McMenamin, Unit 19, 17 Rathfarnham Road, Terenure, Dublin 6W.

Frequency Annually in August.

Deptford X

c/o Creative Lewisham Agency, I Resolution Way, Deptford, London, SE8 4NT

E info@deptfordx.org

W www.deptford.org.uk

A programme of integrated exhibitions for different sites and venues in and around Deptford.

Dorset Art Weeks

I Cross Tree Close, Broadmayne, Dorchester, DT2 8EN

T 01305 853100

E admin@dorsetartweeks.co.uk

W www.dorsetartweeks.co.uk

Contact Peter Lightfoot

Hosts a biennial open-studios event showing the work of artists and makers across the county. Artists exhibiting in their own workplaces and homes sell work and receive feedback directly from visitors. Held over sixteen days in May/June. The event does not at present operate a selection policy but this is under constant review. In future years, the newly formed organization (charitable trust status applied for), Dorset Visual Arts, will organize visual arts events of which Dorset Art Weeks will remain at the core.

Frequency Biennial.

Dulwich Art Fair

London

E info@penman-fairs.co.uk

W www.penman-fairs.co.uk

Held at Dulwich College, south London. Features galleries from London and across the

UK offering contemporary art from £50 to over

Submission Policy Galleries wishing to participate should contact: Penman Antiques Fairs, Widdicombe, Bedford Place, Uckfield TN22 1LW T: 01825 744074.

Dumfries & Galloway Arts Festival

Gracefield Arts Centre, 28 Edinburgh Road, Dumfries, DG1 1JQ

T 01387 260447

F 01387 260447

E info@dgartsfestival.org.uk

W www.dgartsfestival.org.uk

Contact Annette Rogers

Started in 1979. Presents a wide range of art forms, including jazz, folk and classical music, drama, literature, children's events, films and exhibitions, in various venues located between Langholm in the east, to Gatehouse of Fleet in the west of the region.

Frequency Annual.

Earagail Arts Festival

Unit B6, Donegal County Enterprise Fund Business Centre, Lisneannan, Letterkenny T 074 9168800 F 074 9168490

E info@eaf.ie

W www.eaf.ie

Annual festival of contemporary and traditional arts, held throughout Donegal.

Frequency July.

East Neuk Open

Barronhall, George Terrace, St Monans, **KY102AY**

T 01333 730249

E eastneukstudios@yahoo.co.uk

W www.eastneukopenstudios.org

Contact Jo Whitney

Large open studios event across East Fife over two weekends during summer and winter. Up to thirty artists and makers open their workplaces to the public. See website for dates.

Frequency Twice yearly.

Edinburgh Art Fair

Arte in Europa, 77 Poplar Park, Port Seton, East Lothian, EH32 0TE

T 01875 819 595

F 01875 819857

E enquiries@arteineuropa.com

W www.artedinburgh.com

Inaugural festival held in 2005. Over seventy exhibitors from throughout Europe and the UK, showcasing over five hundred artists, sculptors and photographers, from recent graduates and self-taught artists to established names.

Frequency Every November.

Edinburgh International Festival

Hub, Castlehill, Edinburgh, EH1 2NE

T 0131 4732001

W www.eif.co.uk

Founded over fifty years ago and one of the world's leading festivals of the arts. Held in locations throughout Edinburgh.

Euroart Live Festival

Euroart Studios & Gallery, Unit 22F @ N17 Studios, 784-788 High Road, London, N17 0DA

W www.euroart.co.uk

A festival of live-art performances drawn from a diversity of cultures. Aims to instigate dialogue and debate across art forms and cultural borders and, by presenting work from both mature and emerging artists, across generations.

ev+a - Limerick Biennial

69 O'Connell Street, Limerick

T 087 9477042

E info@eva.ie W www.eva.ie Major festival of contemporary art.

Folkestone Triennial Visitor Centre

55-57 Tontine Street, Folkestone, CT20 1JR T 01303 245799 / 0845 2020190 W www.folkestonetriennial.org.uk Contact Martin Wills (Assistant Curator) A three-yearly exhibition of temporary and permanent works specially commissioned for public spaces in and around Folkestone. Held in 2008, the first Triennial, Tales of Time and Space, featured work by internationally acclaimed contemporary artists and artist groups including Christian Boltanski, Tracey Emin, Mark Dion, Jeremy Deller, Tacita Dean and Mark Wallinger.

Frequency Every three years. Next is in 2011.

Free Range

The Old Truman Brewery, 91 Brick Lane, London, E1 60L

T 020 7770 6003 F 020 7770 6005

E tamsin@trumanbrewery.com

W www.free-range.org.uk

Contact Tamsin O'Hanlon

Annual festival, bringing together fresh talent from the UK's premier art and design courses. The largest of its kind in Europe, with exhibitions covering a range of disciplines focused into three categories - Art, Design & Photography. Now in its seventh year.

Submission Policy Submissions welcome from graduate art and design colleges and courses. Frequency Every summer over two months.

Frieze Art Fair

Regent's Park, London T 020 7833 7238 F 020 7833 7271 E info@friezeartfair.com W www.frieze.com

London's largest international art fair launched in 2003 by the publishers of frieze magazine. Takes place in Regent's Park, London and features over 150 of the most exciting contemporary art galleries in the world. As well as these exhibitors, the fair includes specially commissioned artists' projects and a talks programme.

Submission Policy Accepts gallery applications only.

Frequency Annual.

Gi - Glasgow International

Trongate 103, Glasgow, G1 5ES T 0141 2878994 E info@glasgowinternational.org W www.glasgowinternational.org Contact Katrina Brown (Head Curator) Glasgow's curated and commissioning festival of contemporary visual art, established in 2005. Hosts new work and commissions by Scottish and international artists across key venues and spaces throughout the city. Attracts some 28,000 visitors, including major international collectors and curators.

Submission Policy Proposals are considered but not the primary means of curation. Frequency Biennial from 2008.

Glasgow Art Fair

UZ Events, 125-129 High Street, Glasgow, G1 1PH T 0141 5526027 F 0141 5526048 E artfair@uzevents.com W www.glasgowartfair.com **Contact** Cristina Armstrong Scotland's national art fair brings together 43 selected galleries from Scotland, the UK and Europe to offer over 16,000 visitors the opportunity to invest in a wide range of quality contemporary art. Representing work by over a thousand artists and attracting dedicated art

International Ceramics Fair and Seminar

collectors and first-time buyers.

Haughton International Fairs, 15 Duke Street, St James's, London, SW1Y 6DB

T 020 73896555 F 020 73896556 E info@haughton.com

W www.haughton.com

Founded in 1982, bringing together leading international ceramics dealers to display and sell the finest 15th century to contemporary English and Continental pottery, porcelain and glass. Includes lecture series.

International Festival of the Image

Rhubarb-Rhubarb, 212 The Custard Factory, Gibb Street, Digbeth, Birmingham, B9 4AA T 0121 7737889

F 0121 7737888

E info@rhubarb-rhubarb.net

W www.rhubarb-rhubarb.net

Contact Lorna-Mary Webb

A three-day portfolio review established in 2000

that draws international curators, gallery directors, publishers, agents and picture editors to advise and inform photographers on portfolio content, opportunities for becoming more visible and future sector developments. Prices to participate vary each year, but can be viewed on the website. Supported by exhibitions, seminars, portfolio promenade and events.

Submission Policy Photographers wishing to show folios should have experience of an exhibition, publication or commission.

Frequency Annually.

Leeds Art Fair

61A Weetwood Lane, Leeds, LS16 5NP

T 0113 2425242 E info@ytb.org

W www.leedsartfair.org

A contemporary visual arts event, with preference given to artists with ties to or living and working in the local area.

Frequency Each May

Liverpool Biennial

P.O.Box 1200, The Tea Factory, 82 Wood Street, Liverpool, L69 1XB

T 0151 7097444

F 0151 7097377

E info@biennial.com

W www.biennial.com

Established in 1998. A major international festival of contemporary art.

Frequency September every two years. Next in 2010.

London Art Fair

Business Design Centre, 52 Upper Street, London, N1 0QH

T 020 72886736

F 020 72886446

E laf@upperstreetevents.co.uk

W www.londonartfair.co.uk

Contact Sarah Monk

Features the best of Modern British and contemporary art in a spectacular venue in the heart of Islington by one-hundred leading UK galleries.

Submission Policy UK Galleries dealing in Modern British and contemporary art welcome to apply.

Frequency Annual.

London Design Festival

56 Kingsway Place, Sans Walk, London, EC1R 0LU

T 020 70145313

F 020 70145301

E info@londondesignfestival.com

W www.londondesignfestival.com

The Festival has grown quickly from 40 partner events in 2003 to 170 in 2005 reflecting the sheer breadth and depth of design in London. Seeks to celebrate excellence in every design discipline. In 2006 over forty retailers took part for first time, ensuring an expanding audience. 150,000 people attended events in 2004.

Submission Policy Partners stage events and activities all over London. These events are eclectic – they might be serious seminars or exhibitions, film screenings, competitions and awards, receptions, private views and parties.

Frequency Annual though dates vary from year.

Frequency Annual, though dates vary from year to year.

The London Original Print Fair

T 020 7439 2000

E info@londonprintfair.com

W www.londonprintfair.com

First held in 1985. Now at the Royal Academy of Arts (Burlington House, Burlington Gardens, London W1). Features forty-five international dealers, showing prints from Dürer to Hockney and Hirst.

MADE Brighton

P.O. Box 4729, Worthing, BN11 9LD

T 01903 206850

E info@brightoncraftfair.co.uk

W www.brightoncraftfair.co.uk

The fourth year of the Brighton Craft Fair – now MADE BRIGHTON. With over 100 designer / makers selling original and high quality work direct to the public and galleries. Organized by the same team as the Brighton Art Fair.

Submission Policy Designer/makers across all media, artists groups and Sussex based galleries are welcome to apply. Applications can be downloaded from the website. Deadline for applications end March.

Frequency Annual. November.

Margate Rocks

P.O. Box 373, Birchington, CT7 9WY E info@margaterocks.co.uk

W www.margaterocks.co.uk

Established in 2001. An eclectic mix of contemporary art, using alternative venues and existing businesses as exhibition spaces. Centred around the Old Town and Harbour area of Margate,

with other events happening throughout Thanet. Artists' open-studio programme began in 2005. Submission Policy Work must be inventive, interesting and able to engage the public. Frequency Annual, in July.

Museums and Galleries Month (MGM)

The Campaign for Museums, 35-37 Grosvenor Gardens, London, SW1W OBS

T 020 72339796 F 020 7 2336770

E info@campaignformuseums.org.uk

W www.mgm.org.uk

Celebration of the UK's museums and galleries, with special events, workshops and exhibitions in museums and galleries around the country. Organized by the Campaign for Museums, MGM is an opportunity for museums and galleries to try out new events to attract visitors.

Frequency Annual, in May.

National Review of Live Art

New Moves International Ltd, P.O. Box 16870, Glasgow, G11 9DS

T 0141 3575538

E colin_newmoves@mac.com

W www.newmoves.co.uk

Europe's longest-running festival of live art forms part of New Moves International's annual festival programme, New Territories.

Submission Policy Artists are selected and invited and sometimes commissioned by the Artistic Director. Submissions welcome, but please enclose SAE. If sending parcels that require a signature, first contact the New Moves office, above.

Frequency Annual

Nine Days of Art

T 01803 868805 E anneward@onetel.net.uk W www.ninedaysofart.co.uk Contact Anne Ward (Secretary) A festival organized in the south-west of England by the Skills Training and Rural Arts Week (STRAW) Project.

Open Studios Northamptonshire

P.O. Box 7139, Kettering, NN16 6BR T 01536 741493 E info@openstudios.org.uk W www.openstudios.org.uk Contact Emma Davies An annual visual arts event since 1996 where artists from Northamptonshire and the borders of

surrounding counties open up their studios to the public. Normally held in August or September. Also exhibitions in alternative venues such as churches, pubs and cafes, and heritage buildings. A year round colour directory is also produced and participating artists' events and exhibitions are posted onto the website throughout the year. Submission Policy Open to all visual artists at any stage of their career from Northamptonshire and the surrounding county borders. Year-round enquiries welcome but applications received between January and March.

Oxfordshire Artweeks

P.O. Box 559, Abingdon, OX14 9EF T 01865 865596

W www.artweeks.org

Contact Caryn Paladina

First held in 1981. Now the largest open-studio festival of visual art in the country. The festival operates a non-selection policy and welcomes all artists, commercial galleries, public-art spaces, schools and any other organization wishing to take

Submission Policy See website for details. Must apply by December.

Frequency May / June.

Photo-London

and Floor, 13 Mason's Yard, St James's, London, SW1Y 6BU

T 020 78399300

E info@photo-london.com

Began in 2004 as London's first international photography fair. Around fifty exhibitors from ten countries showing photography, film and video from throughout the history of the art form. Takes place in the Royal Academy of Arts' Burlington Gardens.

Frequency Annual.

Raw Arts Festival

New York

T 011482 28423281

E rawartsfestival@yahoo.co.uk

Contact Piers Midwinter

Legendary 'outsider' festival, dedicated to exhibiting work by non-mainstream artists, focusing on outsider, folk, self-taught and raw art. First exhibited at the Candid Arts Trust, London in 2004 and 2005, then in Valencia, Spain in October 2006 and New York in January 2007, moving to LA in 2008.

Frequency Annual.

Redbridge Arts Festival

London Borough of Redbridge Leisure Services, 8th Floor, Lynton House, 255–259 High Road, Ilford, IG1 1NY

E jacqueline.eggleston@redbridge.gov.uk A showcase of artistic disciplines held at a range of locations throughout Redbridge.

Rye Festival

P.O. Box 33, Rye, TN31 7YB T 01797 224442 E info@ryefestival.co.uk W www.ryefestival.co.uk

Contact Gill Clamp

A festival of the arts founded in 1971 and now including more than fifty events over two weeks. Frequency Annual, held in September.

SCOPE Art Fairs

London/Basel/Miami/Hamptons/New York, 355 West 36th Street 3rd FL, New York, NY 10018 T 212 2681522

F 212 2686258

E info@scope-art.com

W www.scope-art.com / www.scopelondon.com International art fairs of cutting-edge art and emerging culture. The fairs bring together up-andcoming dealers, curators and artists in a relaxed atmosphere. Founded in 2002 and currently producing fairs throughout the year in Basel, Miami, New York, The Hamptons and London. Submission Policy The fair is vetted for exhibitors. Interested artists should work through a gallery only. See website for application details.

Somerset Art Weeks

SAW (Somerset Art Works) Ltd, The Town Hall, Bow Street, Langport, TA10 9QR

T 01458 253800

E info@somersetartworks.org.uk

W www.somersetartworks.org.uk

Since its inception in 1994 Art Weeks has become an important event in Somerset's calendar. Due to increasing popularity and growth the decision was made in 2007 to turn the biennial festival into an annual two week event with an alternating focus of Events and Exhibitions in 2009 and Open Studios in 2010.

Submission Policy See website for details.

Zoo Art Fair

London

T 020 72478597

F 020 72470070

E info@zooartfair.com

W www.zooartfair.com

Zoo Art Fair, which was founded in 2004, identifies and supports emerging commercial and non-commercial art organizations on an international platform. Exhibitors include galleries, project spaces, artist collectives, curatorial groups and publications. Zoo Art Fair is a non-profit enterprise, sponsored by established collectors, galleries, arts businesses and public funders.

Submission Policy Via gallery/artist collective etc. Deadline in March. See website for details. Frequency October, annually.

07

Competitions, residencies, awards and prizes

Studying abroad

Tim Braden

Jumping ship Amsterdam, 15 February 2005

'Hey Nat, can you do me a favour when you come over and bring me a packet of razor blades from Boots? I need the old-fashioned double-sided blades (like razors in cartoons, a rectangular plate, sharp on the 2 long edges with a jagged shape punched out of the centre). I think they come in packs of 10 by Wilkinson Sword. I use them to prepare canvas so need 2 or 3 packs if possible. Eternally grateful etc...'

(An email to a friend during my first month in Holland: I was clearly not as adaptable to life abroad as I thought.)

There are so many artists from around the world working in London that you can get lazy and kid yourself that you are being international just by going to an exhibition by a friend who may have been born in Mexico.

Unless you are invited, or already have friends to introduce you, it can be pretty hard to go abroad and meet local artists. Residencies provide that introduction: the quick answer to the inevitable 'so, what are you doing here?' question.

I have friends who went to London, expecting a warm greeting from the 'art scene' and were shocked by the level of indifference to outsiders. Smaller towns might have less going on, but they are much more accessible. Go to New York as a young artist and, like an aspiring actress in Hollywood, you're unlikely to cause much of a stir. In Amsterdam, you're allowed to feel part of things from the first weekend. It's also good to shake off the 'Europe-is-something-that-happens-in-Brussels' indoctrination fed to us by the English press and realize that art is being made outside of East London.

Help is at hand

Amsterdam, 2 October 2006

To: residents@rijksakademie.nl
Dear all, Next week, 5 and 6 October, Philippe
Pirotte is coming for studio visits and a workshop/

seminar (details to come). David Claerbout will be here for studio visits 20 and 21 October. Please let me know if you would like an appointment with either of them. Thank you! Mirella

I had just finished a two-year residency at the Rijksakademie, a fine art programme in Amsterdam. It takes around 50 artists – half from Holland and the other half from the rest of the world – and the average age is 30. You are given a healthy stipend, a flat and a studio and access to a lot of technical assistance. Every week or so, a group of interesting artists, curators or theoreticians are paid to come and spend time with you to talk about your work for hours.

A residency can take some getting used to. After years in a lonely studio wishing for more attention, it can feel pretty strange being looked at so much; in fact, I slightly resented it at times. I always used to like working when nobody expected me to (or cared). On a residency, nobody is going to tell you what to make, but there is a lot of healthy expectation. With hindsight, this is probably the closest thing to 'professional training' that an artist could ever hope for. As the academy took care of almost everything else - from housing, to grants, to a canteen and a bicycle repair shop - this left me feeling strangely disempowered. But I soon got over it and remembered that I didn't have to think about gas bills and I could get on with making art. Although with all the other artists around, you can't stay locked away for too long because it is like being part of one big, happy family.

14 April 2006

To: residents@rijksakademie.nl Subject: good intentions

Evi's birthday
Bradley goes USA
Helen shipped her paintings and goes to the
USA
Inti in cuba
Vincent back from Poland

Chiara and Peggy still didn't start exercise
Kuang-Yu goes Miami-Vice
Dachi in the house
Tomoko happy
Stephanos back from Athens.
Welcome back Hala!
Goodbye Sasha Korea!
Is Cevdet back?
Gal's new residency card.
Nicolas in the house
Karina happy
Mu going to China for the sake of love
Brody leaving the rijks soon
Easter!
Special act: 'Brody and the hula hoop'

Monday April 17

Party in smoking room under the canteen. Starts at 9 pm. Please bring your own drinks!

A residency is a time to experiment and a rare second chance to do the kind of things you're supposed to do at art school (like learn to weld, or try out lithography). And, perhaps more importantly, that sense of disorientation of being somewhere new can be a great way to get some distance from your own work.

Don't feel rejected

I applied to the Rijksakademie in 2003 and was rejected after the first interview, which was painful (and expensive as I had flown over with a number of paintings and put myself up in a hotel). Foreign residencies are often prepared to pay, or help, with the airfare if you ask (I discovered later), although this has no bearing on whether or not you are likely to succeed in the interview. I know people who were given the money to fly over from South America for the interview, and then didn't get in (which must have hurt too).

Unlike art schools, residency programmes tend to be much more open and treat you more like a real, adult person. There is no mystique about the selection procedure, they will happily tell you why you did or didn't get in. It is always worth calling back after the interview or after you receive a letter. You might as well get some good advice out of the whole ordeal. Call, say that you are disappointed, and ask how you could have presented yourself better. Ask if it is worth applying again. They are usually pretty straight with you and, if you think about it, it is almost strange not to call.

A letter of recommendation always helps, either by an ex-resident artist, or just someone who knows you and the place (I'm sure this applies to any institution/competition/grant application) and goes much further than a boring letter from your old art teacher.

Get out there

25 May 2005

'...just got back from a great trip to Iceland for 10 days, have you ever been there? A mad place...really tiny scene. We were in Reykjavik for an arts festival, then travelling round in a tour bus with 18 of us from the Rijks. Snowing one minute and desert-like the next with hot steam blasting out of the ground all over the place, and glaciers melting into the sea. Seals swim around in bright sunshine, we went whale watching wrapped in fisherman's thermals and all of us sat in a 30-foot long old cheese-making tub full of hot water on a hilltop 35 kilometres from the Arctic Circle watching the sun (which never really set) come up at 3 in the morning. Still on a bit of a high from lack of sleep, I think...'

So, studying abroad is great for getting out of your own environment for a bit, great if you want to experiment for a while in a new system, great for making new friends from around the world, and not great if you are in a serious relationship back home. It's not going to solve all your problems, but I can assure you, you will miss it when it's finished.

Tim Braden is an artist who lives and works in London and Amsterdam. He was on the residency program at the Rijksakademie from 2005 to 2006. He is represented by Timothy Taylor Gallery, London and Galerie Arquebuse, Geneva.

Competitions, residencies, awards and prizes

1871 Fellowship

Ruskin School of Drawing and Fine Art, 74 High Street, Oxford, OX1 4BG

T 01865 276940 F 01865 276949

E vanda.wilkinson@ruskin-school.ox.ac.uk

W www.ruskin-sch.ox.ac.uk/lab

Established in 2001 by the Laboratory at the Ruskin School of Drawing and Fine Art and the San Francisco Art Institute to help artists make new work by spending periods of time in Oxford and San Francisco. The fellow devotes two months to research-related activities in England before travelling to San Francisco for up to four months of intensive studio-based production. The fellowship was implemented in 2001. Current value of award is £18,000.

Frequency One award annually.

Entry Policy The award is by nomination only.

Abbey Awards in Painting and Abbey Scholarship in Painting

Abbey Council, 43 Carson Road, London, **SE218HT**

T 020 87617980

E admin@abbey.org.uk

W www.abbey.org.uk

Contact Jane Reid

Awards enable artists to work in the British School at Rome for two to three months. Exhibition of scholars' and awardees' work held at the end of each academic year. The British School has a Curator (Contemporary Arts Programme) to assist with exhibitions and in making contact with an artistic community in Rome, and an Arts Adviser responsible for direct support of painters. Fellowship award is £700 per month. Scholarship is f_{500} per month.

Entry Policy Open to mid-career painters who are UK, Commonwealth or US citizens with an established record of achievement. No age limit.

ACE Award for Art in a Religious Context

All Hallows on the Wall, 83 London Wall, London, EC2M 5ND

T 020 7374 0600

F 020 7374 0600

E awards@acetrust.org

W www.acetrust.org

Presented by the Art and Christianity Enquiry

(ACE) in association with the Michael Marks Charitable Trust. The commissioned work, in any visual medium, must be within the building or grounds of a worship space of any faith group; it may be permanent or a temporary, completed and in situ before or by the time of the entry deadline. £2,000 of the prize goes to the artist and £1,000 to the client as well as a specially commissioned artwork to display for a period of six weeks. Competition is open to all faiths.

Frequency One award of f_3 ,000 every two years. Entry Policy Entries should reflect both theological insight and aesthetic excellence.

ACE/MERCERS International Book Award

All Hallows on the Wall, 83 London Wall, London, EC2M 5ND

T 020 7374 0600

F 020 7374 0600

E awards@acetrust.org

W www.acetrust.org

Given by the Art and Christianity Enquiry (ACE) in association with the Mercers' Company for a book that makes an outstanding contribution to the dialogue between religious faith and the visual arts. The subject matter may relate to any major faith tradition, and to any visual medium (including film, performance arts, design and architecture). Entries should be written in or translated into English. **Frequency** One award of f_3 ,000 every two years.

ACE/REEP Award

17 Allan House, 55 Saffron Hill, London, EC1N 8QX

T 020 74046859

F 020 74046859

E gardenawards@reep.org

W www.reep.org

Contact Diana Lazenby

Given jointly by the Religious Education and Environment Programme (REEP) and the Art and Christianity Enquiry (ACE) to an artist working with a school to design a garden that includes an art work incorporating text. First presented in 2003 and runs every two years. Artists working on community projects are encouraged to work with a primary or secondary school to design a school garden. This should involve cross-curricular work, especially RE and Spirituality. A specific theme for the art work varies each time. $f_{2,500}$ goes to the winning artist and f_{500} to the school. Entry Policy Visit website to register and view

curriculum and practical advice. Only submit

plans and a proposal for this award.

Adolph & Esther Gottlieb Foundation Grants

Adolph & Esther Gottlieb Foundation, 380 West Broadway, New York, NY 10012, USA

T+1 212 2260581

F +1 212 2260584

W www.gottliebfoundation.org

Contact Jenny Gillis (Grants Manager) Ten individual support grants available through an annual juried competition. Grant amounts are determined each year (typically US\$20,000 each, awarded end March). The foundation also administers a year-round emergency assistance grants programme, which assists artists suffering from recent catastrophic circumstances such as fire, flood, medical emergency, and who have worked for a minimum of ten years in a mature phase of their art. Grant amounts range from US\$1,000 to US\$10,000.

Entry Policy Open to painters, sculptors and printmakers who have been working for minimum twenty years in a mature phase of their art and have financial need. Application forms available by post in early September. Only written requests for application forms honoured; none sent out in response to telephone/fax requests.

Akademie Schloss Solitude

Stiftung des öffentlichen Rechts, Solitude 3, Stuttgart, 70197, Germany

T+49711996190

F+497119961950

E mail@akademie-solitude.de W www.akademie-solitude.de

A public foundation, the Akademie Schloss Solitude operates an international artist programme awarding live/work fellowships to artists working in the disciplines of architecture, the visual arts, the performing arts, design, literature, music/sound and video/film/new media. Also awards fellowships to emerging scientists and managers to work on collaborative projects with artistic fellows at the Akademie. Fellows from the seven art disciplines can participate in the programme but only scientists and managers can apply for a fellowship within the program. The Akademie was opened in 1990 and is subsidized by the state of Baden-Württemberg. A total of 45 furnished live/work studios are available to fellows and guests.

Frequency Grants awarded every two years. Entry Policy General age limit 35, or studies should be completed within the past five years. Application forms by request only.

Alexander Graham Munro Travel Award

The Royal Scottish Society of Painters in Watercolour, 29 Waterloo Street, Glasgow, G2 6BZ

T 01355 233725

Contact Roger Frame (Secretary)

An award of $f_{3,500}$ to an artist under 30 years of age, to be used in conjunction with travel. Council to be informed of proposed itinerary and benefits to artist.

Entry Policy Only work in a water-based medium.

Artes Mundi Prize

Room A2.10, UWIC Llandaff Campus, Western Avenue, Cardiff, CF5 2YB

T 02920 555300

F 02920 555800

E info@artesmundi.org

W www.artesmundi.org

Contact Tessa Jackson

First awarded in 2004 to celebrate artists who have gained recognition in their own country and are emerging internationally. Focuses upon those who discuss the human form, the human condition and add to our understanding of humanity. A shortlist is drawn up by two international selectors; the shortlisted artists exhibit a body of work at the National Museum Wales in Cardiff; and a panel of curators and artists award the £40,000 prize to the artist who consistently makes work of note and quality, and is thought-provoking within the criteria of the prize.

Frequency Every two years (even-numbered years). Entry Policy Artists considered through nomination process only. See website for details.

Artist of the Year by the Society for All Artists (SAA)

AOY SAA, P.O.Box 50, Newark, NG23 5GY

T 01949 844050

F 01949 844051

E AOY@saa.co.uk

W www.saa.co.uk

Contact Susan Caughtry

The SAA exists to inform, encourage and inspire all who want to paint, from beginners to professionals. This competition is open to all, with SAA members benefitting from free unlimited entries.

Frequency One main competition per year. Entry Policy Open to paintings (not previously published) in the main categories of landscape, seascape, flowers, still life, abstract and figure, with prizes for Artist of the Year, Young, Junior, Beginner, Amateur and Professional.

Artist-in-Residence, Durham Cathedral

c/o Reg Vardy Gallery, Ashburne House, Ryhope Road, Sunderland, SR2 7EF

W www.artschaplaincy.org.uk / www.

regvardygallery.org

Founded in 1983, the residency offers an artist time and space to assess their practice and development while responding to the cathedral as a powerful creative statement. Should the artist wish, currently there is also the offer of a short-term collaboration with another artist, perhaps from another art form.

Frequency Twelve-month residency beginning each year in October, £17,000 fee + teaching fee.

Entry Policy A good first degree/MA. Artists should be over 25 years old and be able to demonstrate a continuous theme of exploration. Accepts postal applications only. See website for procedure.

Artists in Berlin Programme (DAAD)

Deutscher Akademischer Austauschdienst, Markgrafenstrasse 37, Berlin, 10117, Germany T +49 302312080

F blen bowlin@dood

E bkp.berlin@daad.de W www.berliner-kuenstlerp

W www.berliner-kuenstlerprogramm.de
To promote the exchange of artists' experiences
and the concern for current cultural issues in
other countries. Each year fifteen to twenty artists
of international reputation are invited to live and
work in Berlin for twelve months to present their
work to the Berlin public. Invitations issued with
grants to allow adequate standard of living and
rental of apartments/workrooms.

Entry Policy No application process for visual arts; a commission issues invitations.

Artists Residences (Cyprus)

Cyprus College of Art, 27 Holywell Row, London, EC2A 4JB

T 020 8676 4610

F 07092 194514

E enquiries@artcyprus.org

W www.artcyprus.org

Contact Michael Paraskos

Since 1969 offered artists a unique opportunity to spend an extended period of time on the island of Cyprus. Low-tech and primitive facilities are geared towards painters and hands-on sculptors. Artists must pay for their own travel to Cyprus and subsistence, but rent-free studio space and living accommodation available to some artists in return for some teaching at the College.

Frequency Up to two at any one time. Artists must be self-funding.

Entry Policy Initially applicants should email with prospective dates of any stay. Further information may then be requested depending on space. No conceptualists.

Arts and Crafts in Architecture Awards

The Saltire Society, 9 Fountain Close, 22 Hugh Street, Edinburgh, EH1 1TF

T 0131 5561836

F 0131 5571675

E saltire@saltiresociety.org.uk

W www.saltiresociety.org.uk

Contact The Administrator

Exists to promote art and culture of Scotland. Awards made for works of art and craft designed to enhance and enrich buildings. Examples include sculpture, painting, tilework, mosaic, tapestry, textile hangings, glass, plaster, metalwork and enamel. Artists and craftsmen working in any suitable medium are invited to enter the competition. The Society may arrange for members of the panel to inspect selected entries on site. Adjudication will take place as soon as possible after closing date. Awards or commendations, each in the form of a certificate, will be made to the artist or craftsman and commissioning body or person.

Frequency Biennially and number of awards given

Entry Policy Work must: (1) be located in Scotland; (2) have been completed within the two year period being assessed; and (3) be an intrinsic part of a building or group of buildings. Each entry must be accompanied by a fee of £35.

Arts Awards

The Wellcome Trust, 215 Euston Road, London, NW1 2BE

T 020 76117222

F 020 76118269

E arts@wellcome.ac.uk

W www.wellcome.ac.uk/funding/

publicengagement/arts

Contact Marie-Lise Sheppard

The Arts Awards support arts projects which stimulate interest and debate in biomedical science, encourage new ways of thinking and foster high quality practice and collaborative partnerships across the arts, science and/or education. Supports a range of projects working in any art form and any area of biomedical science. Encourages collaboration between professionals from different disciplines, between adults and young people and between experts and the

public. Aims to support projects that ask difficult questions and give fresh perspectives on science and its role in our lives.

Frequency Deadlines throughout the year Entry Policy Applicants must be based in the UK or the Republic of Ireland and the activity must take place in the UK or Republic of Ireland. Projects must involve the creation of new artistic work and have some biomedical scientific input either through a scientist taking on an advisory role or through direct collaboration. This scheme does not fund academic courses or research such as Masters degrees or PhDs. Standard health promotion projects, arts projects for therapeutic purposes, or projects dealing purely with nonbiomedical sciences are not eligible.

Arts Council England - Helen Chadwick **Fellowship**

Ruskin School of Drawing and Fine Art, 74 High Street, Oxford, OX1 4BG

T 01865 276940

F 01865 276949

E vanda.wilkinson@ruskin-school.ox.ac.uk

W www.ruskin-sch.ox.ac.uk/lab

Contact Paul Bonaventura Established by the Laboratory at the Ruskin School of Drawing and Fine Art and the British School at Rome to help artists make new work by spending periods of time in Oxford and Rome. After visiting Italy for a one-month reconnaissance period, the fellow devotes two months to researchrelated activities in England before returning to Italy for three months of intensive studio-based production. The fellowship was implemented in 1997 and the current value of the award is £7,500. Frequency One award annually.

Entry Policy The award is advertised in the specialist press. Applicants must be British nationals or have been continuously resident in the UK since March 2002. It is expected that the fellowship will attract visual artists who have established their practices in the years following graduation and who have identified a project that could be made possible or enhanced by spending periods of time both in Oxford and Rome.

Arts Council England - Oxford-Melbourne

Ruskin School of Drawing and Fine Art, 74 High Street, Oxford, OX1 4BG

T 01865 276940 F 01865 2276949

E vanda.wilkinson@ruskin-school.ox.ac.uk

W www.ruskin-sch.ox.ac.uk/lab Contact Paul Bonaventura Established by the Laboratory at the Ruskin School of Drawing and Fine Art and the Victorian College of the Arts to help artists make new work by spending periods of time in Oxford and Melbourne. The fellow devotes two months to research-related activities in England before travelling to Melbourne for up to four months of intensive studio-based production. The fellowship was implemented in 2002. The current value of

Frequency One award biannually.

the award is $f_{7,500}$.

Entry Policy The award is advertised in the specialist press. Applicants must be British nationals or have been continuously resident in the UK since March 2002. It is expected that the fellowship will attract visual artists who have established their practices in the years following graduation and who have identified a project that could be made possible or enhanced by spending periods of time both in Oxford and Melbourne.

Arts Council of Northern Ireland International Residencies

MacNiece House, 77 Malone Road, Belfast, BT9 6AQ

T 028 9038 5200

F 028 9066 1715 E info@artscouncil-ni.org

W www.artscouncil-ni.org

The Banff Residency offers two funded residencies for established Irish artists, one from Northern Ireland and one from the Republic, for 8-10 weeks at the Leighton Studios in Banff, Canada. The Winnipeg Residency is a four-week funded placement at the Platform Centre for the Photographic and Digital Arts at Winnipeg, Canada, for a photographer or lens-based or digital artist. The St James Cavalier, Malta residency is a three-week placement to work on a specific project in Valletta, Malta, There is also a British School of Rome Fellowship providing a visual artist with a nine-month residency to work on a project of their choosing. Scholars are encouraged to use the time to work on ideas in sketch or maquette form.

Arts Council of Northern Ireland Support for **Individual Artists Programme**

MacNiece House, 77 Malone Road, Belfast, **BT9 6AQ**

T 028 9038 5200 F 028 9066 1715

E info@artscouncil-ni.org

W www.artscouncil-ni.org

Offers a portfolio of awards. The General Arts Award is given for specific projects, specialized research, personal artistic development and certain materials/equipment. The Major Individual Award aims to help established artists develop extended or ambitious work, and are awarded annually for a specific discipline. There are also Travel Awards to allow individual artists to travel from Northern Ireland to assist their development. Applicants must have been invited by a host organization in the destination country. The International Awards enable individual artists to arrange exchanges or take up self-arranged residencies. The New York Residency Award allows an artist the opportunity to take up a self-arranged residency in the city. The Council also offers the International Artists Profile service, offering assistance with profiling and international marketing material.

Arts Grant Committee (Sweden)

Konstnärsnämnden, P.O.Box 1610, Stockholm 11186, Sweden

T+46 84023570

F+46 84023590

E info@konstnarsnamnden.se

Contact Nils Johansson (Director)

The Visual Arts Fund, part of the Arts Grant Committee, runs a programme called Artists in Residence in Sweden (AIRIS). Offers an opportunity for Swedish artists to invite foreign artists with whom they wish to work/collaborate to Sweden to participate in workshops, symposia or to work towards an art exhibition.

Frequency Grants are issued four times a year and range from £3,500 to £20,000 to cover the costs of travel, accommodation, fees, materials, premises and documentation.

Entry Policy Approach must be made by Swedish artists.

Arts/Industry Artist-in-Residency

John Michael Kohler Arts Center, 608 New York Avenue, P.O.Box 489, Sheboygan, WI 53082-0489, USA

T +1 920 4586144

E kcridler@jmkac.org

W www.jmkac.org

Contact Kim Cridler (Arts/Industry Coordinator) Provides artists worldwide with access to plumbingware firm Kohler Co., through two six-month residencies. Artists-in-residence are provided with studio space in the factory, accessible twenty-four hours a day, seven days a week. Additionally, they receive free materials, use of equipment, technical assistance, photographic services, housing, round-trip transportation within continental USA from their home to the site, and weekly honoraria. Available media are vitreous china, iron, enamel and brass.

Entry Policy Emerging and established artists in any discipline are invited to apply for arts/industry residencies. Closing date: August for the following year. Send sae for application form or visit website.

Association of Photographers (AOP) Open

The AOP, 81 Leonard Street, London, EC2A 4QS W www.the-aop.org / www.the-awards.com Open to professional and amateur photographers, with a mission to celebrate the diversity of photography as an artistic medium. The AOP also administers a Bursary (£15,000), an Assistant Photographer's Award, Document (awarded for documentary photography) and Zeitgeist (to provide an overview of trends and fashions in published photography).

Entry Policy Membership of the AOP is not necessary and no set themes or categories are imposed for the open. May deadline.

Balmoral Scholarship for Fine Arts

Künstlerhaus Schloss Balmoral, Villenpromenade II, Bad Ems. 56130, Germany

T +49 260394190 F +49 2603941916

E info@balmoral.de

W www.balmoral.de

Contact Dr Sabine Jung

An international institution for fine arts. Allocates grants to qualified artists of all ages in fields of painting, drawing, sculpture, installation, graphics and design, photography and art theory. Not an art college, but a meeting place where gifted artists can widen their horizons by meeting colleagues from various art sectors and from different parts of the world. Eight apartments and 8 studios available.

Frequency Monthly grant given for eleven-month residency, €1,200.

Entry Policy Applicants should have relevant training/study or degree followed by at least 3-years experience. Knowledge of at least one language (German, English or French) is requested.

Bellagio Individual, Collaborative and Parallel Residencies

The Rockefeller Foundation, 420 Fifth Avenue, New York, NY 10018-2702, USA

E bellagio@rockfound.org W www.rockfound.org

Provides a stimulating international environment for month-long study residencies for scholars, scientists and artists. Scholars, artists and others may apply as individual or with one collaborator who is also qualified for the residency. Entry Policy Applicants must be scholars, scientists, policymakers, practitioners or artists who expect their work at the centre to result in publication, exhibition, performance or other concrete product. Request application one year in advance of residency period.

Bloomberg New Contemporaries

Studio I. Rochelle School, Arnold Circus, London, **E2 7ES**

T 07785 706227

E info@newcontemporaries.org.uk W www.newcontemporaries.org.uk An annual exhibition of work by students and recent graduates from the UK's art colleges. Tours major UK arts venues each year. First established in 1949 and much-respected, New Contemporaries helps support emerging artists at the start of their careers.

Frequency Annual

Entry Policy New Contemporaries is open to all final year undergraduates and current postgraduates of Fine Art at UK colleges and those artists who graduated in the previous 12 months. Selection by an invited panel of artists, initially from slides through to a final selection from actual work from a shortlist. Submission forms are available from the website from October-January.

BP Portrait Award

National Portrait Gallery, St Martin's Place, London, WC2H OHE

E bpaward@npg.org.uk W www.npg.org.uk

An annual event aimed at encouraging young artists to focus on and develop the theme of portraiture within their work. Many artists shown have gained commissions as a result of interest in the award and resulting exhibition.

Entry Policy Four annual prizes. First prize of £25,000, plus at the judges' discretion, a commission worth £4,000 to be agreed between the National Portrait Gallery and the artist.

Braziers International Artists Workshop c/o 164 Swaton Road, London, E3 4ER T 020 75154798

F 020 73893101 E info@braziersworkshop.org

W www.braziersworkshop.org

Contact Bernadette Moloney

An artist-led initiative, providing opportunities for international exchange and dialogue between professional artists. Founded in 1995. the annual residential workshop takes place in rural Oxfordshire for 16 days each August. The workshop provides a rich and challenging environment that encourages artists to experiment and try new ideas. The rural location encourages site-specific, installation, collaborative projects as well as new media, painting and sculpture. The organization also manages a number of longer term residencies for overseas artists in the southeast and an Arts Council England International Fellowship for a UK artist overseas. Frequency I International Fellowship and 3 regional residencies awarded annually Entry Policy Open to visual artists across all disciplines. Recent graduates should not apply. Deadline: February/March. See website for details.

British Glass Biennale

Ruskin Glass Centre, Wollaston Road, Stourbridge, DY8 4HF

T 07836280938

E info@biennale.org.uk

Contact Candice-Elena Greer Landmark juried exhibition of contemporary

glass by artists working and living in the UK and working in glass. The winning artists receive professional support and promotional materials. The next British Glass Biennale will take place in August 2010.

Frequency Every two years.

Entry Policy Work for selection must have been made in the last two years and be available to purchase. Makers have to be living and working the UK for the last two years.

British Journal of Photography

Incisive Media, Haymarket House, London, SW1Y 4RX

T 020 74849944

F 020 74849989

E bjp.endframe@bjphoto.co.uk

W www.bjp-online.com/endframe

Contact Mick Moore

The BJP/Nikon Endframe Award began three years ago. Entrants must submit a portfolio of photographs and supplementary material, including a 'dream project' proposal (see website)

to be published in BIP. From the 51 published each year, eight finalists are chosen, interviewed and given f_{300} to develop their proposal idea with full costings. A winner is then chosen, who must then use the bursary to complete their project and then present it our annual Vision event in November. Frequency \$5,000 awarded annually as a bursary Entry Policy This is a photographic competition. and entrants must be living in the UK and be available for interview if they are selected as a finalist.

Byard Art Open Competition

Byard Art, 4 St Mary's Passage, Cambridge, CB2 3PO

T 01223 464646 F 01223 464655

E info@byardart.co.uk

W www.byardart.co.uk

Contact Ruth Hawkins

Established 1993. Annual competition with winners selected by professional panel of judges. General public invited to vote for 'The People's Prize'.

Entry Policy Open to professional artists living or working within a 25-mile radius of Cambridge. Acceptable media: painting, printmaking, photography, sculpture, ceramics, textiles and glass.

Calouste Gulbenkian Foundation Awards 98 Portland Place, London, W1B 1ET

T 020 76365313

F 020 79087580

The work of the foundation is divided into programmes in arts, education and social welfare, with a separate programme for Anglo-Portuguese cultural relations. The arts programme is principally for professional or individual professional artists working in partnerships or groups. It aims to support the development of new art-making in any form, though activities must not be linked to mainstream education. There are also grants available for non-professional participants outside the formal education and community sectors for the research and development of unusual experimental projects.

Entry Policy Open to UK and Irish organizations. Closing date: at least three months before project starting date.

Celeste Prize

London

E info@celesteprize.com

W www.celesteprize.com

Formerly the Celeste Art Prize, this is a new online submission competition with eventual gallery exhibition. The Celeste Prize 2000 offered 5 prizes totalling €40,000, with €8,000 to each winner from categories of Painting; Photography & Digital Graphics: Video & Animation: Installation & Sculpture: Live Media. The 46 finalist works will be exhibited in Berlin. Germany, during the Art Forum, end-September 2000, at the Alte AEG Fabrik, 5 Voltastrasse, Germany.

Frequency Annual, five prizes, totalling €40,000. Entry Policy See website for application details.

The Cill Rialaig Project Artists Retreat

c/o Origin Gallery, 83 Harcourt Street, Dublin 2 T 01 4785159

E origingallery@eircom.net

Founded in 1991 the Cill Rialaig Artists Retreat is situated on a remote Cliffside in County Kerry. consisting of seven renovated cottages, with a meeting house and composer's house, each selfcontained with kitchen, bedroom, bathroom and studio. One- to six-week residencies are awarded free of charge (donations while welcomed are not obligatory). Cill Rialaig is a registered charity, founded with the intention of maintaining and developing the arts in both Ireland and abroad. International applications welcomed.

Frequency Up to 12 residencies awarded monthly.

Entry Policy Submit via email or post, CV, artist statement, 10-12 copies of recent work (hard copies prefereble).

Commonwealth Connections International Arts Residencies

The Commonwealth Foundation, Marlborough House, Pall Mall, London, SW1Y 5HY

T 020 79303783 F 020 78398157

E geninfo@commonwealth.int

W www.oneworld.org

Formerly the Commonwealth Arts and Crafts Awards biennial awards, the Commonwealth Foundation's rolling annual residency programme for visual arts has developed to bring the benefits of its successful model to an increasing number of practitioners. From 2009, performance art and photography were included as eligible categories for the first time and the scheme is due to expand and extend to disciplines outside the visual arts. No age limit to applications.

CORE Program

The Glassell School of Art, Museum of Fine Arts. P.O. Box 6826, Houston, TX 77265 USA

T+1713 6397500

W www.core.mfah.org/home.asp Awards one- and two-year residencies to highly motivated, exceptional visual artists and art scholars who have graduated but have yet to develop a professional career. Established in 1982 within Glassell School of Art, the teaching wing of Houston's Museum of Fine Arts. Residents engage in ongoing dialogue with each other and with invited guests. Each artist-resident is given approximately 450 sq. ft of private studio space, twenty-four-hour access to school facilities and equipment, and a US\$9,000 annual stipend. Entry Policy Send twelve slides of work (include name of artist and practical details of each piece) completed in previous two years. The selection jury views six slides from each applicant in first elimination round. The remaining six slides will only be viewed in the second round. Applicants are encouraged to number their slides 1 to 12, in order of priority. Also include a CV, statement of intent, three letters of recommendation and an sae for return of slides. \$10 application fee applies.

Cove Park Residency Programme

Peaton Hill, Cove, Argyll and Bute, G84 0PE T 01436 850123 F 01436 850445 E information@covepark.org

W www.covepark.org

Contact Alexia Holt

Founded in 1999. Located on a fifty-acre site overlooking Loch Long on the west coast of Scotland. Organizes residencies for national and international artists working in all art forms. Up to ten residencies at any one time, lasting from one week to three months. The programme runs from May to October. Artists receive a fee (determined by the duration of the residency), accommodation and, when appropriate, studio space.

Frequency Up to fifty residencies each year. Entry Policy Selection is by both invitation and application. When applications are required, the residency is advertised nationally and internationally and on Cove Park's website. Requirements vary following open submission and application, depending on the form of the residency itself.

Crafts Council Development Award

44A Pentonville Road, Islington, London, N1 9BX

T 020 72787700 F 020 78376891

E maker@craftscouncil.org.uk

W www.craftscouncil.org.uk

For makers who are about to set up their business, or who are within three years of doing so. The award includes: an equipment grant of up to f_{5000} , which must be matched by the recipient; a maintenance grant of £2,500; a residential course in business training aimed specifically at small creative practices; provision of 1,000 promotional postcards; one-to-one support from a Crafts Council Professional Development Officer, which includes two studio visits; four years representation on Photostore, the Crafts Council's visual database.

Entry Policy Applicants must have completed their studies, be about to or have practised as craftsperson for no more than three years, live and work in England and be resident for tax purposes. (The Award is open to non-UK nationals as long as they fulfill this condition.) Annual deadlines for the award are I March, I June, I September and I December.

Crafts Council Next Move Scheme

44A Pentonville Road, Islington, London, N1 9BY T 020 78062504

F 020 78376891

E makerdev@craftscouncil.org.uk

W www.craftscouncil.org.uk

A setting-up scheme designed to put new designer-makers on the fast track. Placements include rent-free studio space in a college department over a two-year period, maintenance grant of \$6,000, business/equipment grant of $f_{\rm I,000}$, in depth support and business training and access to specialist equipment.

Entry Policy Open to MA or BA applied arts and 3D design graduates wanting to develop their practice and business.

Creekside Open

APT, 6 Creekside, Deptford, London, SE8 4SA E enquiry@creeksideopen.org

W www.creeksideopen.org

Contact Liz May

Launched in 2005 to celebrate the tenth anniversary of the Art in Perpetuity Trust. A bi-annual competition for inclusion in an exhibition at the APT Gallery. Awards of £500 are given. Open to all visual/fine artists living or working in greater London.

Entry Policy Entry by slide submission.

David Canter Memorial Fund

c/o Devon Guild of Craftsmen, Riverside Mill, Bovey Tracey, TQ13 9AF

T 01626 832223

F 01626 834220

E jenny@crafts.org.uk

W www.crafts.org.uk

Contact Jenny Plackett (Secretary)

Provides support for special projects, such as setting up a workshop, buying materials and equipment or for research and travel. Grants usually range between £500 and £1,000.

usually range between £500 and £1,000.

Entry Policy Open to artists who have finished formal training, working full- or part-time. Awards are usually made in the autumn, and the selection process falls into two stages: (1) preliminary application using the application form, for shortlisting; and (2) shortlisted applicants are asked to send further information about their work, together with six slides of recent pieces for final selection.

The David Gluck Memorial Bursary

ING Discerning Eye, c/o Parker Harris, P.O. Box 279, Esher, KT10 8YZ

E info@parkerharris.co.uk

W www.discerningeye.org / www.parkerharris.co.uk

This annual bursary, awarded by ING Discerning Eye (previously known as the DE Bursary) gives the selected artist $f_{\rm I,000}$ chosen by the DE panel and inclusion in an exhibition at the Mall Gallery, London. In recent years it has been awarded for drawing.

Frequency Annual.

De Ateliers

Stadhouderskade 86, Amsterdam, 1073 AT, Netherlands

T+31 206739359

F +31 206755039 E office@de-ateliers.nl

E office@de-ateliers.nl W www.de-ateliers.nl

Founded in 1963. An international studio programme run by artists at a postgraduate level. Offers twenty young artists at the beginning of their professional career the opportunity to develop their work in a private studio during a maximum of two years, supported with a stipend and the critical guidance from prominent artists who do weekly individual studio visits. Tutors include Rob Birza, Dominic van den Boogerd, Marlene Dumas, Ceal Floyer, Willem de Rooij, Marien Schouten, Didier Vermeiren and Marijke van Warmerdam.

Frequency Some ten studios available annually. Entry Policy Application is possible at any time and open to young artists from Holland and abroad at the beginning of their professional career. Ability to speak English is required. Apply by sending documentation of work (slides, CDs, videotapes) and application form to be found on the website. Applications are selected by tutors. Main criteria are visual qualities, artistic ambitions and prospects for future development.

Delfina Studio Trust

50 Bermondsey Street, London, SE1 3UD T 020 73576600

E admin@delfina.org.uk

W www.delfina.org.uk

The largest residency programme in the UK, awarding studio space to as many as eighteen artists each year for periods ranging from two months to two years. Set up in 1988 as a registered charity with the aim of providing high-quality studio space and related facilities for visual artists. Housed in a renovated factory in the Bankside area of central London, it provides thirty studios in total.

Submission Policy Applications should be mailed between 1st and 31st January each year for artists from abroad, and during the same period every other year for British artists (next 2006. Artists should send eight slides of recent work and/or VHS/DVDs, a CV, and a self-addressed envelope with return postage. For further information please visit the Delfina website www.delfina.org.uk Entry Policy The Trust was not accepting residency applications at time of going to press. Check website for availability.

Grants awarded 6 international residencies awards every year and 6 British residency awards every two years. The Trust does not provide stipends or grants, and does not provide for everyday costs.

Derek Hill Foundation Scholarship in Portraiture

The British School at Rome, at the British Academy, 10 Carlton House Terrace, London, SW1Y 5AH

T 020 79695202

F 020 79695401

E bsr@britac.ac.uk

W www.bsr.ac.uk

Contact Dr Gill Clark (The Registrar)
Founded in 2004 and funded by the Derek Hill
Foundation. Aims to encourage painters to focus
upon and develop the theme of portraiture within
their work. Offers full board and lodging at the

British School at Rome for three months, with a grant of approximately \$950 per month.

Frequency One each year.

Entry Policy Applicants must be of British or Irish nationality and aged 24 or over on I September of the academic year in which the scholarship will be held. An application form must be completed. Closing date: mid-December.

Deutsche Börse Photography Prize

5 & 8 Great Newport Street, London, WC2H 7HY T 020 78311772 F 020 78369704 E info@photonet.org.uk

W www.photonet.org.uk

Aims to reward a living photographer of any nationality who has made the most significant contribution to the medium of photography during the past year. Photographers are nominated for a significant exhibition or publication that took place in that year. Nominations are made by an academy, a diverse group of people invited by the Photographers' Gallery from photography institutions throughout Europe. From these, four shortlisted photographers are selected by a jury and invited to present their work in an exhibition at the Photographers' Gallery. The winner receives $f_{30,000}$; three runners-up each receive $f_{3,000}$. Frequency An annual exhibition and award.

Deveron Arts Residency Programme

The Studio, Brander Building, The Square, Huntly, AB548BR T 01466 794494 F 01466 794494 E info@deveron-arts.com W www.deveron-arts.com

Contact Claudia Zeiske

Founded in 1995 to engage artists for short- and long-term residency programmes to work within the community, bringing contemporary art to a wide audience. Aims to work within a theme that is of local significance but also of national and even global concern. Deveron Arts has no dedicated gallery space as 'the town is the venue'. Frequency Average of four residencies per year.

Entry Policy Artists are advised to write or email for further information before submitting CVs.

Djerassi Resident Artists Program

2325 Bear Gulch Road, Woodside, CA 94062-4405, USA T+1 650 7471250

F +1 650 7470105

E drap@djerassi.org W www.djerassi.org

Based in the foothills of Santa Cruz Mountains of Northern California. Visual arts studios and living quarters are located in a twelve-sided barn. The Artists' Barn also houses a choreography studio, darkroom and composers' studio. Artists pay for travel, personal needs, materials and supplies. Frequency Residencies last for four to six weeks, from April through to October. No residency fee and all meals are provided.

Entry Policy Application deadline is February for a residency in the following year. Instructions and forms available from the website.

EAC Over 60s Art Awards

Art Awards, PO Box 279, Esher, KT10 8YZ T 01372 462190 F 01372 460032

W www.artawards.eac.org.uk

Annual open competition for amateur artists over the age of 60 living in the UK. Created by the Elderly Accomodation Counsel, this competition celebrates the talent and creativity of older artists. Around 120 artists are selected for exhibition in the prestigious Mall Galleries, and prizes are awarded in a range of categories.

East End Academy

Whitechapel Art Gallery, 80-82 Whitechapel High Street, London, E17QX E info@whitechapel.org

W www.whitechapel.org/eastendacademy Every three years the Academy showcases new work from emerging artists living and working in east London. Works on show range from penciland-ink drawings to room-sized environments, and include painting, photography, video and installation. There are also off-site commissions. The 2009 exhibition was devoted to painting. Admission is free and most works are for sale. Frequency Every 3 years.

Entry Policy Must be emerging artist living/ working in East London.

East International

Norwich University College of the Arts, Francis House, 3-7 Redwell Street, Norwich, NR2 4SN T 01603 756248

E east@nuca.ac.uk

W www.eastinternational.net An exhibition open to visual artists working in

any medium. Each year one artist is given $f_5,000$. Takes place at Norwich Gallery, the Fine Art

Studios of Norwich School of Art and Design and the Sainsbury Centre for Visual Art at the University of East Anglia. Emphasis is on choosing artists from work submitted on slide. Previous selection panel has included distinguished curators and artists including David Tremlett, Helen Chadwick, Konrad Fischer, Marian Goodman, Rudi Fuchs and Richard Long. Frequency Annual.

Entry Policy No rules of age, status, place of residence or medium to limit those who may enter. For entry form and further information contact above address/website from April.

ECO - Exeter Contemporary Open

Exeter Phoenix Gallery, Bradninch Place, Gandy Street, Exeter, EX4 3LS

E galleries@exeterphoenix.org.uk W www.exeterphoenix.org.uk

An established event on the contemporary art annual calendar, Exeter Phoenix Gallery promotes this platform for emerging talent to exhibit alongside more established artists. Submissions are invited in all media.

Frequency Annual, £1,000 first prize. Entry Policy For guidelines and application form email or write to above, enclosing a first class SAE.

Elephant Trust Award

512 Bankside Lofts, 65 Hopton Street, London, SE19GZ

T 020 79221160

F 020 79221160

E ruth@elephanttrust.org.uk

W www.elephanttrust.org.uk

Contact Ruth Rattenbury

Founded in 1975. Aims to make it possible for artists and those presenting their work to complete projects when frustrated by lack of funds. Bias towards the visual arts; particularly interested in funding projects that depart from the routine and signal distinct and imaginative sets of possibilities. Value of awards usually about £2,000.

Frequency The trustees meet four times a year to consider applications and decide on awards. Entry Policy Grants not available for students or for educational and other study purposes.

Elizabeth Fitzpatrick Travel Bursary

Royal Hibernian Academy, 15 Ely Place, Dublin 2 E ciara@rhagallery.ie W www.rhagallery.ie

Contact Academy Co-ordinator

The Royal Hibernian Academy will be inviting

applications for this travel bursary worth €2,500, later in 2009.

Frequency Annual

Entry Policy See website for details or contact as

Elizabeth Foundation for the Arts

P.O.Box 2670, New York, NY 10108, USA

T +1 212 5635855

F +1 212 5631875

E grants@efa1.org

W www.efai.org

Offers a grants programme for individuals in the visual arts. Selection is based on quality of work, financial need, background and dedication to career, and proposals for use of grant. Grant amounts range from US\$2,500 and US\$12,000 and are targeted to assist artists in creating new work and/or gaining recognition for work. Twelve to fifteen grants awarded per year. Applicant pool averages one thousand applications. Previous grantees not eligible to apply for five years following their grant periods.

Entry Policy Open to artists in all media except photography, video/film and crafts. Must be over 30 or have been working for at least six years since completing formal schooling. Closing date:

I May.

Elizabeth Greenshields Foundation Grants

1814 Sherbrooke Street West, Suite #1, Montreal, Quebec, H3H 1E4, Canada

T+15149379225

F+15149370141

E greenshields@bellnet.ca

Grants for artists in early stages of career, working in painting, drawing, printmaking and sculpture. Work must be representational or figurative. The award of C\$12,500 is tenable anywhere in the world and may be used for any art-related purpose. Entry Policy Applicants must have started or already completed art-school training and/or demonstrate through past work and future plans a commitment to making art a lifetime career.

Erna & Victor Hasselblad Foundation Awards and Bursaries

Ekmansgatan 8, Göteborg, SE-412 56, Sweden W www.hasselbladfoundation.org An international photography award selected by jury (no applications accepted). Also stipends and research grants for photographic research and scholarly projects. Bias towards research in photographic theory and history, scientific

photography, conservation and restoration of photographic material and experimental projects. Entry Policy Open to photographers, researchers and other professionals working primarily within the field of still photography. Open to all nationalities. Closing date: usually March.

European Association for Jewish Culture Grants

London Office, 79 Wimpole Street, London, W1G 9RY

T 020 79358266

F 020 79353252

E london@jewishcultureineurope.org

W www.jewishcultureineurope.org

Contact Lena Stanley-Clamp

Founded in 2001, the EAIC awards grants for new work in performing and visual arts with a Jewish dimension. The value of grants is from €5.000-10,000.

Frequency Grants awarded annually Entry Policy Priority given to individual artists, playwrights, choreographers and curators. Applicants must be European nationals or longterm residents. Record of artistic or scholarly achievement must be appended to application. Application forms and guidelines available on website.

Federation of British Artists (FBA) Annual Open

Mall Galleries, 17 Carlton House Terrace, London, SW1Y5BD

T 020 79306844 F 020 78397830

E info@mallgalleries.com

W www.mallgalleries.org.uk

Of nine member art societies, eight hold their annual open exhibitions in the Mall Galleries. Any artist may submit work for selection. Work for exhibition is selected by a committee of members from the society where work has been submitted. Entry Policy See website or send sae (35p) to Mall Galleries for full details. Indicate the relevant society and address to 'Entry Details' at the above address. A maximum of six works may be entered.

Feiweles Trust

Yorkshire Sculpture Park, West Bretton, Wakefield, WF4 4LG

Established in 1989, supporting work in schools and the community by artists at the beginning of their careers. A sculpture bursary in the region of f10,000 is awarded to a sculptor to work with schools and the community for approximately one hundred days. Some preliminary planning work

will need to be undertaken before the bursary begins. It is expected that the appointed artist will use this bursary experience to develop their own artistic practice.

Flamin Awards

Film London Artists' Moving Image Network T 020 76137694

E flaming@filmlondon.org.uk

W www.filmlondon.org.uk/flamin

A new open submission development and production scheme for artists' moving image work that is ambitious in premise and duration. Flamin supports London-based artists working in moving image - whether film, video, digital or new technologies and for installation, animation, cinema, gallery exhibition, the public realm or broadcast. Awards from £20,000 to £50,000 available for projects that reflect significant leap in artists' careers.

Entry Policy The scheme is for single screen work (20mins+). Deadline: May.

Florence Trust Residencies

St Saviour's, Aberdeen Park, London, N5 2AR

T 020 73544771

E info@florencetrust.org

W www.florencetrust.org

Contact Paul Bayley (Director) or Lea O'Loughlin

(Studio Manager)

Founded in 1988, offering 10-12 twelve-month studio residencies (July-August) and career development support. Artists benefit from one-toone sessions, an open studios event and a summer exhibition with full-colour catalogue. For artists' professional development (including business planning, marketing, interview and presentation skills and applying to other trusts and foundations for funding) and production of new work. Housed in grade-1-listed Victorian church.

Entry Policy Send application form (available from website), artist's CV, 10-15 examples of work (slides or CD-Rom), an sae and application fee. Rolling submissions accepted, closing I June each year.

Franklin Furnace Fund for Performance Art and Franklin Furnace Future of the Present

80 Hanson Place #301, Brooklyn, NY 11217, USA

T+1 212 3987255

F +1 212 3987256

E mail@franklinfurnace.org

W www.franklinfurnace.org

Contact Dolores Zorreguieta

An avant-garde arts organization founded in

1976. The Fund for Performance Art (supported by Jerome Foundation and the New York State Council on the Arts) awards grants of between US\$2,000 and US\$5,000 to emerging performance artists, allowing them to produce major works in the New York area. Artists from all areas of the world are invited to apply. The Future of the Present awards artists an honorarium and offers its resources to facilitate the creation of 'live art on the Internet'. Open to artists worldwide. Frequency Around ten awards per year. Entry Policy See website for full details.

Friends of Israel Educational Foundation

P.O. Box 42763, London, N2 0YJ

T 020 4440777 F 020 84440681

E info@foi-asg.org W www.foi-asg.org

Contact John D A Levy

The award consists of return air passage to Israel, a minimum of six weeks' work on a kibbutz with time for painting/art instruction by the award winner, a ten-day placement at the Bezalel School of Art in Jerusalem, and free time to travel around the country and an exhibition.

Entry Policy Open to British students graduating from art school: painters, printmakers and illustrators are invited to apply. Send a CV, academic letter of reference, statement of reasons for wishing to visit Israel and a representative selection of work (transparencies to be submitted initially). Closing date: 1 May each year.

Friends of the Royal Scottish Academy Artist

The RSA, The Mound, Edinburgh, EH2 2EL T 0131 2253922 F 0131 2206016

E friends@royalscottishacademy.org W www.royalscottishacademy.org Founded in 1995 to enable artists to continue and extend their creative development. The bursary will assist in the cost of a specific developmental project such as travel or research, attending a course or workshop, or to supplement or replace income in order to permit a period of exploration and experimentation. Worth $f_{2,000}$.

Frequency Annual.

Entry Policy Applications invited from artists permanently resident in Scotland, qualified and working within the disciplines of the RSA (painting, drawings, sculpture, architecture and printmaking). Must have completed full-time

education (including postgraduate study) at least three years beforehand. Strong preference to those over 35 years old or working professionally for ten years or more. Closing date: 1 July.

FringeMK Annual Painting Prize

c/o Anita Allen, Senior Administrator, 10 Sybils Way, Houghton Conquest, Bedford, MK45 3AQ W www.fringemk.com

This is a new open, national, juried competition for contemporary painting and drawing, created to promote the visual arts in the UK. First prize of $f_{5,000}$, plus three runners up prizes of $f_{1,000}$ each. Dates for submission: March to June.

Frequency Annual, four prizes.

Entry Policy £20 application fee. See website for application details/form.

Gallery 1839

www.gallery1839.com E kevin@lpa-management.com W www.gallery1839.com Contact Kevin O'Connor Online photographic gallery specializing in the sale of 20th- and 21st-century photographs. Competitions held on an ongoing basis approximately nine annually. See website for details.

Entry Policy Contact Kevin O'Connor.

Gen Foundation

45 Old Bond Street, London, W1X 2AQ T 020 74955564 F 020 74954450

E info@genfoundation.org.uk Provides substantial scholarships and grants to students and scholars from a broad cross-section of fields. Aims to further academic research in both the humanities and natural sciences by awarding grants to candidates from a variety of disciplines. In recognition of the importance of cross-cultural exchange in today's global society. also aims to deepen understanding between Japan and the rest of the world. Scholarships are one-off, non-renewable grants of approximately $f_{2,000}$. **Entry Policy** The foundation will make preliminary selection of candidates on the basis of submitted application forms, then conduct interviews. Scholarships are awarded annually to candidates mainly from the UK and Japan.

The Getty Foundation

1200 Getty Center Drive, Suite 800, Los Angeles, CA 90049-1685, USA

T +1 310 4407320 F +1 310 4407703

W www.getty.edu

Provides support to institutions and individuals throughout the world for projects that promote the understanding of art and its history and the conservation of cultural heritage. Projects are sought that set high standards and provide opportunities for collaboration.

Global Arts Village

Utsav Mandir, Tropical Drive, Ghitorni, Mehrauli-Gurgoan Road, New Delhi, 110030, India

T +91 1155657265 / 1126804790 **E** info@globalartsvillage.com

W www.globalartsvillage.com

Contact Julie Upmeyer

Residencies offered at the Village, an emerging art centre in New Delhi. Open to emerging, midcareer and established artists. Encourages diversity and multicultural exchange among creative people of all kinds. Practices community living, sharing meals and evening activities on a threeacre property that includes: gardens; ceramics, sculpture and two-dimensional studios; a meditation hall; a common building; dance studio; performance spaces; and accommodation. Caters for studio ceramics, sculpture, photography, Ikebana, digital arts, arts management, land art, fibre arts, installation art and public art. Offers five different types of residency; details on website. Entry Policy Applications to include: a completed residency application; documentation of creative work in the form of digital photos attached to an email; thin frame slides or photographs (twelve maximum); a brief description of the project (two hundred words maximum); a brief explanation of why the project is especially suited to the Village and India (two hundred words maximum).

Gunk Foundation Grants for Public Arts Projects

P.O.Box 333, Gardiner, NY 12525, USA

T +1 914 2558252

F +1 914 2558252 E gunk@mhv.net

W www.gunk.org

Provides grants to individuals and organizations as well as national and international projects. From 2007 its grants for public art projects were temporarily suspended, but it supports projects that are seen out of the museum space by those from outside the art/academic world.

Entry Policy Applications suspended from 2007 for public arts projects. See website for updates.

Inches Carr Trust Craft Bursaries

The Inches Carr Trust, 2 Blacket Place, Edinburgh, EH9 1RI.

T 0131 6672906

W www.inchescarr.org

Annual awards to craft workers based in Scotland with a minimum of five years' experience in their craft. Each award is £5,000 to enable the applicant to develop a specific aspect of their work or to undertake a specific project.

Frequency Annual. Maximum of three awards per

Entry Policy Provide a description of current work, the specific project or aspect for development proposed and a CV. Closing date: end April.

ING Discerning Eye Exhibition

c/o Parker Harris Pr, 15 Church Street, Esher, KT10 8YZ

T 01372 462190

E DE@parkerharris.co.uk

W www.discerningeye.org / www.parkerharris.co.uk

Open competition for artists born or resident in the UK, working in any media, including moving image. A selection panel of six prominent figures from the art world each curate their own section, inviting well known artists to exhibit alongside lesser known artists selected from the open competition. Prizes awarded in a range of categories, including a £5,000 purchase prize, and new from 2008, an annual Founders Prize in memory of the charity's founder Michael Reynolds. Winning entries exhibited at The Mall Galleries, London.

Frequency Annual.

Entry Policy Works to be no larger than 20 × 20 inches. Deadline: autumn. See website.

International Artists' Centre, Poland – Miedzynarodowe Centrum Sztuki

ul.Jackowskiego 5/7, Poznan, 60-508, Poland

T +48 618483777

E artistscentre@dialcom.com.pl

W www.dialcom.com.pl/artistscentre Residencies open to all artists from various disciplines and cultural backgrounds. Usually last three months.

J.D. Fergusson Arts Award

The Fergusson Gallery, Marshall Place, Perth, PH2 8NS

T 01738 783425

F 01738 621152

E museum@pkc.gov.uk

W www.perthshire.com/museums

Contact Jenny Kinnear

Inaugural award presented in 1997. Aims to support artists who have shown a high level of commitment but have not yet received any awards or recognition. Artists working in any medium considered. Value between $f_2,000-4,000$.

Frequency Annual award, alternating year-on-year between an exhibition award and a travel bursary. Entry Policy Must be Scottish by birth or lived in Scotland for more than 50% of their life. Closing date 31 October.

James Milne Memorial Trust

Scottish Trade Union Congress, Middleton House, 333 Woodlands Road, Glasgow, G3 6NG

T 0141 3378100

F 0141 3378101

Grants open to Scots aged 26 and under of outstanding talent, based in Scotland and who will be able to extend their skills by a period of study out of the UK. Study may be formal or informal.

Jeff Vickers/Genix Imaging Bursary

Royal Photographic Society, Fenton House, 122 Wells Road, Bath, BA2 3AH

T 01225 325733

W www.rps.org/bursaries

Contact Stuart Blake – Director General Three-year bursary sponsored by well-known commercial photographer Jeff Vickers. Worth £15,000. Talented young photographer (under 30) either already working in commercial photography or at college or university and can demonstrate a true commitment to becoming a professional photographer, ideally in fashion, editorial and advertising.

Frequency Ongoing
Entry Policy Must be under 30.

Jerwood Contemporary Makers Prize

Jerwood Foundation, 171 Union Street, London, SE1 0LN

T 020 72610279

E info@jerwood.org

W www.jerwoodvisualarts.org

Replacing the Jerwood Applied Arts Prize, which was run in partnership with the Crafts Council for II years, this new initiative supports the applied arts and encourages new and stimulating ways of showing work across a range of disciplines. The exhibition series will run over three years to showcase work by the new generation of

contemporary makers in a fresh and unexpected way. Each exhibitor will be awarded a share of £30,000 to take part.

Frequency Annual. £30,000 divided between winners.

Entry Policy Selected curators combine to create an exhibition that explores a theme and brings together work by the new generation of contemporary craft and design talent.

Jerwood Contemporary Painters

c/o Parker Harris PR, P.O. Box 279, Esher, KT10 8YZ

T 01372 462190

F 01372 460032

E info@parkerharris.co.uk

f W www.jerwoodvisualarts.org / www.parkerharris.co.uk

An exhibition of works by thirty emerging artists. Created by the Jerwood Charitable Foundation, this exhibition promotes the work of those who have moved on from student status but have not yet attained recognition as artists. It also presents a perspective on the concerns and debates in contemporary painting, particularly among artists in the early stages of their careers.

Frequency Selected artists receive a $f_{1,000}$ participation fee.

Jerwood Drawing Prize

University of the Arts London, Wimbledon College of Art, Merton Hall Road, London, SW19 3QA

T 020 7514 9709 F 020 7514 9642

Firms 10-i-11-1--

E jerwood@wimbledon.arts.ac.uk
W www.wimbledon.arts.ac.uk/jerwood

Contact Exhibition Administrator

Aims to promote and reward talent and excellence in contemporary drawing. Every year, a changing panel of distinguished artists, writers, critics, collectors and curators select the show independently, defining their own priorities for an exhibition of current drawing practice.

Frequency Prizes awarded yearly. First Prize: £6,000; Second Prize: £3,000; Student Awards: £1,000 each.

Entry Policy Open to artists resident or domiciled in the UK. Application forms available from the end of April.

Jerwood Sculpture Prize

c/o Parker Harris, P.O. Box 279, Esher, KT10 8YZ T 01372 462190 F 01372 460032 E isp@parkerharris.co.uk

W www.jerwoodvisualarts.org / www.parkerharris.

Biennial prize promoting excellence in sculpture. Artists within 15 years of graduation submit a proposal to create a large scale outdoor sculpture. Short list is awarded with a £1,000 commission to create small scale maquettes, and the winner is awarded a £25,000 commission to create their proposal, which will go on display in Jerwood Sculpture Park at Ragley. Closing date: Autumn 2010.

Ioan Wakelin Bursary

Royal Photographic Society, Fenton House, 122 Wells Road, Bath, BA2 3AH

T 01225 325733

W www.rps.org/bursaries

Contact Jo Macdonald – Awards Manager on

01225 325721

The £2,000 bursary, administered by the Guardian and The Royal Photographic Society, is awarded to the photographer who presents the best proposal for a photographic essay on an overseas social documentary issue.

Frequency Autumn

Entry Policy Open submission, with no restriction on age or qualification. Entrants must submit a maximum of six images of their work, along with a written proposal (max 500 words) describing their intended project and a completed entry form (from website). A shortlist will be selected by a jury nominated by the Guardian and The RPS.

John Moores Contemporary Painting Prize

Walker Art Gallery, William Brown Street, Liverpool, L3 8EL

T 0151 478 4199

F 0151 478 4199

 $\textbf{E}\ johnmoores 24@liver pool museums.org.uk$

W www.thewalker.org.uk

Contact Lisa Baker

A major exhibition of contemporary paintings selected through open competition. First prize of £25,000 in cash; ten smaller prizes also awarded. Founded by the late Sir John Moores the exhibition continues to be supported by the Moores family, has a track record for spotting rising talent. The exhibition will also play a major part in the Liverpool Biennial, the only biennial of contemporary art in the UK. Supported by John Moores Liverpool Exhibition Trust and the aFoundation.

Submission Policy Entries must be original new

paintings, by someone who is based in the U.K. Full conditions see www.thewalker.org.uk.

Entry Policy For entry form and further information send sae. Handling fee payable on request of an entry form. First phase judged on slides and second phase on actual work.

Kettle's Yard Open / Residency Opportunities

Castle Street, Cambridge, CB3 0AQ

T 01223 748100

E mail@kettlesyard.cam.ac.uk

W www.kettlesyard.co.uk

Biennial exhibition open to artists in the east of England in all media. Also runs an interdisciplinary fellowship scheme that runs for one to two years.

Entry Policy Fellowship vacancies announced via

Lady Artists Club Trust Award

McGrigor Donald Solicitors, 70 Wellington Street, Glasgow, G2 6SB

T 0141 2486677

E enquiries@mcgrigors.com

W www.mcgrigors.com

For women artists who either live within thirtyfive miles from Glasgow city centre or were born, educated or trained in Glasgow. Students not eligible to apply.

Laing Solo

Laing Art Gallery, Tyne and Wear Museums, Blandford Street, Newcastle Upon Tyne, NE1 4JA

T 0191 2326789 F 0191 2302614

E laing@twmuseums.org.uk

W www.twmuseums.sorg.uk/laing

A national competition for emerging artists.

Leverhulme Trust Grants and Awards

I Pemberton Row, London, EC4A 3BG

T 020 78225220

F 020 78225084

E gdupin@leverhulme.ac.uk

W www.leverhulme.org.uk

Established in 1925 at the wish of William Hesketh Lever, the first Viscount Leverhulme. The trust provides academic and education research grants across the UK. In the area of performing and fine arts, there are grants available in the following schemes: artists-in-residence; training and professional development; education.

Entry Policy New guidelines published annually accompanied by new application forms and all

applicants need to ensure that they use both. Closing dates: vary from scheme to scheme. Study website before applying.

London Photographic Association

23 Roehampton Lane, London, SW15 5LS T 020 8392 8557

E kevin@london-photographic-association.com W www.london-photographic-association.com

Contact Kevin O'Connor

The principal objective of the Association is to give photographers and photography international exposure through its awards structure, online exhibitions, portfolio and essay space, public space exhibitions and relationships with other members of the media, creative and photographic communities worldwide.

Frequency Competitions run throughout the year.

Entry Policy See website for up-to-date information.

Lynn Painter-Stainers Prize

c/o Parker Harris, P.O. Box 279, Esher, KT10 8YZ

T 01372 462190

F 01372 460032 E lps@parkerharris.co.uk

W www.painter-stainers.org or www.parkerharris.

Annual prize for representational painting. Total prize money: £22,500. Open to artists born or resident in the UK. Winning entries will be exhibited in the Painters' Hall in London in November. Launched 2005.

Manchester Academy of Fine Arts Open

c/o The Portico Library & Gallery, 57 Mosley Street, Manchester, M2 3HY

E secretary@mafa.org.uk

W www.mafa.org.uk

The Academy holds Members Only Exhibition whilst seeking a venue for its previous annual open exhibition which invited submissions from painters, sculptors and printmakers and had prizes ranging up to \pounds 2,000.

Entry Policy No restriction on style or subject.

Mark Tanner Sculpture Award

Standpoint, 45 Coronet Street, Hoxton, London, N1 6HD

W www.standpointlondon.co.uk/mta.html Established in 2001, the largest sculpture prize of its kind in the UK, offering financial support towards the production of new work (£6,000) and a solo exhibition (£4,000) to an exceptional emerging sculptor. The exhibition is held at the Standpoint Gallery. Founded in memory of the sculptor Mark Tanner, one of the first artists to show at Standpoint who died in 1998 after a long illness.

Entry Policy Aimed at sculptors based in Greater London who are making ambitious, outstanding work within fine art practice. Particularly interested in work that demonstrates a commitment to process and material. See website for details. Deadline: May.

Max Mara Art Prize for Women

Stephanie Churchill PR, 15–17 Huntsworth Mews, London, NW1 6DD

T 020 72986530

F 020 77064730

W www.collezionemaramotti.org

Biennial prize for female artists, sponsored by the Italian fashion house and the Whitechapel Gallery. Prize includes a six-month residency in Italy to realize art project which may then be exhibited at the Whitechapel Gallery, London.

Frequency Biennial

Entry Policy Judges nominate artists.

Montana Artists' Refuge Residency Program

Box 8, Basin, Montana, MT 59631, USA

T +1 406 2253500

F +1 406 2259225 E mar@mt.net

W www.montanaartistsrefuge.org

An artist-run residency programme located near the Continental Divide. Founded in 1993 by four local artists and area residents to provide living and work space to artists in all media. Mission is to further the creative work of artists, to create residencies for artists, and to provide arts programmes and art education for both artists and community members.

Frequency Residencies last three months to one year (year-round). Only two artists present at a time.

Entry Policy Accepts applications from visual artists in arts and crafts, book art, ceramics, clay/pottery, drawing, fibre/textile, film-/video-making, folk art, installation, jewelry, mixed media, painting, paper art, photography, and sculpture. To request application form, send sae. Closing date: August for winter residencies (January to March). Applications for other months accepted on ongoing basis.

Mostyn Open

12 Heol Vaughan, Llandudno, LL30 1AB

T 01492 879201

F 01492 878869

E post@mostyn.org

W www.mostyn.org

Open to artists working in any medium. There is a prize of £6,000 but selectors reserve the right to split the prize money if appropriate.

Entry Policy Gallery currently under expansion. Check website for details end of 2009.

National Endowment for Science, Technology and the Arts (NESTA)

I Plough Place, London, EC4A 1DE

T 020 74382500

F 020 74382501

E nesta@nesta.org.uk

W www.nesta.org.uk

NESTA's purpose is to support and promote talent, innovation and creativity in the fields of science, technology and the arts. Primary activity is the support of individuals, rather than organizations, existing businesses or projects. Each fellow is supported for between three to five years and receives a support package of between £25,000 to £75,000 over the term of the fellowship. Frequency Fifty to a hundred projects funded each

Entry Policy Open to UK residents or organizations (registered in the UK for three years). Under-18s must be sponsored by an adult. Applications assessed throughout year. Forms available on website or on disk.

National Museum of Women in the Arts (NMWA) Library Fellows Programme

Library and Research Centre, National Museum of Women in the Arts, 1250 New York Avenue, NW, Washington, D.C., USA

T +1 202 7835000

F +1 202 3933234

E library@nmwa.org W www.nmwa.org

Established in 1989 to encourage the creation of quality book art and to support the NMWA's Library and Research and book art programmes. Fellows provide up to \$12,000 annually for the production of an artist's book in an edition of 125. Winning artist is selected at Fellows' annual meeting in Spring.

Frequency One annually.

Entry Policy Only women may apply. Artists must complete application available from the library or on the website. Deadline is 31st January.

The National Open Art Competition

The Administrator, Chichester Art Trust, P.O. Box 372, Chichester, PO20 1ZQ

T 01243 513873

W www.thenationalopenartcompetition.com
Previously known as The Chichester Open
Art Exhibition, this national competition was
relaunched in 2008 to encourage entries from
across the UK. The competition is open to all fine
artists, from the emerging to the established,
currently based in the UK. Selectors have included
Professor Maurice Cockrill RA, Keeper of the
Royal Academy Schools and Richard Cork, Art
Critic, and Gavin Turk. Deadline for online
registration: July.

Frequency Annual. First prize of £10,000. Entry Policy Representational or non-representational work including painting, drawing or print making, in any medium (no photographs, video or exclusively computer generated imagery will be accepted). Three-stage process. Submission Fees – £20 per work and £10 per student work (up to 3 works accepted).

National Sculpture Factory Residencies

National Sculpture Factory, Albert Road, Cork City, Ireland

T 021 4314353

F 021 4313247

E info@nationalsculpturefactory.com
W www.nationalsculpturefactory.com
National organization strengthening support
networks for professional artists and acting as a
public art resource centre (see Societies and Other
Artists' Organizations). The National Sculpture
Factory offers four major residency opportunities
for artists working in any medium or practice:
Emerging Irish Artist Professional Development
Award; Award for an International or Irish Artist
in Mid-Career; Ireland / Australia Exchange
Residency; Pépinières Européennes Pour Jeunes
Artistes Programme.

Frequency Four annually.

Entry Policy See website for details. Some awards only open to Irish residents.

Northern Art Prize

Leeds Art Gallery, Leeds T 0845 6801357

E info@northernartprize.org.uk

W www.northernartprize.org.uk

The Northern Art Prize is open to professional artists of any age, working in any medium, living in the north of England (North West, North East and Yorkshire regions as defined by Arts Council England). Nominations come from arts professionals across the north, ranging from curators of public galleries and museums to directors of artist-led spaces and independent curators. Each nominator puts forward two artists to a selection panel. The selectors for 2008 were Iwona Blazwick (Director Whitechapel Art Gallery), Louisa Buck (Writer and contemporary art critic), Georgina Starr (Artist) and Anita Zabludowicz (Art Collector), chaired by Tanja Pirsig-Marshall (Curator of Exhibitions, Leeds Art Gallery). First prize is £16,500, with the runners-up receiving £1500 each.

Frequency Annual, exhibition held in autumn/ winter, with prize awarded the following January. Entry Policy Via nomination (see above).

Paisley Art Institute Annual Exhibition Prizes and Biennial Scottish Drawing Competition

2 Wemyss Ave, Glasgow, G77 6AR E pai@tangledwebs.co.uk

W www.paisleyartinstitute.org.uk
Paisley Art Institute was founded in 1876. The
present Galleries were built by Sir Peter Coats
and presented to the Institute in 1915. In turn
the Institute made a gift of them to the town
of Paisley. There is an annual exhibition each
Spring and also a Biennial Scottish Drawing
Competition. Open entrants are eligible for prizes
at both exhibitions.

Submission Policy no performance art Frequency Drawing competition held every two years (prizes over $f_{1,000}$). Numerous prizes are awarded at the annual exhibition for painting and sculpture.

Entry Policy Annual exhibition is held in the Spring. Write to the Secretary Noreen Sharkey Paisley.

Paul Hamlyn Foundation Awards For Artists

18 Queen Anne's Gate, London, SW1H 9AA

T 020 72273500

F 020 72223575

E information@phf.org.uk

W www.phf.org.uk/artists

Categories covered by the foundation are: General Arts Grants; Increasing Awareness of the Arts; Art in Education; and Individual Artists. Awards for artists can total £45,000 in three annual installments of £15,000.

Frequency Five awards for visual artists annually. Entry Policy Open to UK citizens. Apply in writing. Also by nomination.

Pépinières Europeénnes Pour Jeunes Artistes

Patrice Bonnaffé, BP 13 9/11 rue Paul Leplat, Marly Le Roi, Cedex 78164, France

T +33 139171100

F+33 139171109

E info@art4eu.net

W www.art4eu.net

Contact Andrea Cooke, 62 Gabriels Road, London NW2 4SA; telephone on 020 8450 8257 or fax on

020 8450 8257.

Running for 15 years. Offers residencies for emerging artists to aid advancement and professional development. The Map Programme is intended for emerging artists between 20 and 35 years old who are starting their career. The artist is associated with a professional organization, a city representative and a coordinator and stays for a period of three to nine months in a hosting organization of their choice. Artists in Context – Artists against Exclusion is intended for artists aged 18 to 25, taking place in the framework of European voluntary service. Allows for an artistic project focused on social realities to be carried out during a six-month period.

Entry Policy Open to artists between 18 and 35 living in a country hosting a Pépinière. Send sae (A4 size) to request application form.

The Pilar Juncosa & Sotheby's Awards

Fundació Pilar I Joan Miró a Mallorca, Joan de Saridakis 29, Palma, Mallorca, 07015 Spain

T 0034 71 701420 **F** 0034 71 702102

E premibeques@fpjmiro.org

W miro.palmademallorca.es

Annual prize for works of art/installations created for the area of Fundació Pilar i Joan Miró a Mallorca, known as the 'Cubic Space'. Jury gives priority to artistic value of projects entered, technical skills and any other innovative or experimental aspect they deem important. Total of €24,000 awarded to winning project: €12,000 for the project itself, which must later be mounted in the 'Cubic Space' during the following 12 months, and up to €12,000 for the actual creation of the project, following the presentation of a cost estimate. There are also Pilar Juncosa Grants for training, experimentation and creative work in the Foundation's Graphic Art Workshops and other grants available (see website).

Entry Policy Artists may present one creative project or work designed for the 'Cubic Space'. The project/work must be original and the only one of

its kind. Works previously exhibited or entered in other competitions will not be admitted.

Polish Cultural Institute

52/53 Poland Street, London,

W1F7LX

T 020 32062004

F 020 74340139

W www.polishculture.org.uk

Offers sponsorship and exhibition opportunities, and occasionally two-week study visits to Poland. Entry Policy Open to UK citizens and residents. Apply in writing. Proposals to be made at least eight weeks in advance to the institution in their own country.

Pollock-Krasner Foundation

863 Park Avenue, New York, NY 10021, USA

T +1 212 5175400

F +1 212 2882836 E grants@pkf.org

W www.pkf.org

Established in 1985 to provide financial assistance to individual artists of established ability (painters, sculptors and artists who work on paper). Grants range from US\$1,000 to US\$30,000.

Entry Policy Year-round applications accepted. Restrictions apply – see website.

Purchase Prize BlindArt Permanent Collection

P.O.Box 50113, London, SW1X 9EY

T 020 72459977 F 020 72451228

E info@blindart.net

W www.blindart.net

An innovative, all-inclusive charity founded in 2004, promoting contemporary works of art that can be explored through all five senses, especially touch. The BlindArt Permanent Collection is the world's first permanent showcase of visual art accessible to visually impaired people, and includes paintings, sculpture, installations and other works of art. Organizes the multi-sensory, interactive Sense & Sensuality exhibitions that break down traditional artistic barriers by helping to dispel the notion that sight is essential to creating or enjoying exceptional art. The overall message is artistic excellence regardless of visual ability.

Frequency Annually and by commission and donations.

Entry Policy Submissions are welcome. Contact info@blindart.net for further details.

Queen Elizabeth Scholarship Trust

The Secretary, No.1 Buckingham Place, London, SW1E 6HR

E quest@rwha.co.uk

W www.qest.org.uk

Makes annual craft awards to fund further study, training and practical experience for men and women who want to improve their craft or trade skills. Grants between $f_2,000$ and $f_{15},000$. Winners also receive emblazoned certificate and engraved sterling silver medal. The trust looks for well-thought-out proposals that will contribute to excellence in modern and traditional British crafts.

Frequency Scholarships awarded twice a year, in spring and autumn.

Entry Policy No age limit. Need to be able to demonstrate a high level of skill and show firm committment to craft or trade. Scholarships not awarded for buying or leasing equipment or premises or for funding courses in general further education. Must live and work in UK to be eligible for a scholarship. Forms downloadable from website or send A4 sae.

The Rencontres Contemporary Book Prize

RP, 10 Rond-point des Arènes, Arles, BP 96-13620, France

E info@rencontres-arles.com

W www.rencontres-arles.com

International award for the best photographer's book project published in the previous year. The €8,000 prize is shared between the publisher and the photographer and awarded each July at the Rencontres Internationales de la Photographie in Arles, France.

Frequency Annual prize.
Entry Policy Closing date: June.

The Rencontres d'Arles Discovery Award

10 Rond-Point des Arenes, Arles,

BP 96-13620, France

T +33 490967606 F +33 4900499439

E info@rencontres-arles.com

W www.rencontres-arles.com

Contact Prune Blachere

International award for a photographer or an artist making use of photography whose work has been recently discovered internationally or deserves to be. The winner is chosen by a vote of photography professionals present in Arles, France, during opening week of the Rencontres d'Arles festival and receives €25,000.

Entry Policy Qualified international jury determines an artist in each category except for the Book Award, which is open to all comers.

Royal British Society of Sculptors

108 Old Brompton Road, London, SW7 3RA

T 020 73738615

F 020 73703721

E info@rbs.org.uk

W www.rbs.org.uk

The Royal British Society of Sculptors exists to promote and advance the practice and art of sculpture. It has professional members throughout the UK and internationally, offers bursary memberships on a regular basis and runs an open National Register of Sculptors. Hosts annual bursary and bronze-casting award exhibitions.

Entry Policy Applications for full membership are considered every two months, on average. The non-selective National Register of Sculptors can be joined at any time during the year. Bursary award deadline: May.

The Royal Hibernian Academy Thomas Dammann Junior Memorial Trust Awards

Royal Hibernian Academy, 15 Ely Place. Dublin 2

E ciara@rhagallery.ie

W www.rhagallery.ie Contact Academy Co-ordinator

Awards applicants for furthering their research and practice through visiting exhibitions, museums, galleries and buildings of architectural importance. Applicants must have a special purpose and a specific programme intended to broaden their practice in the visual or applied arts, craft, design, architecture or history of art and design.

Frequency Maximum €10,000 grant. Entry Policy There is no age limit. Previous award winners and unsuccessful applicants are eligible to reapply. Download application and referee forms from website. March deadline.

Royal Scottish Academy Alastair Salvesen Art Scholarship

The Competitions Office, Royal Scottish Academy of Art and Architecture, The Mound, Edinburgh, EH2 2EL

T 0131 2256671 F 0131 2206016

E info@royalscottishacademy.org

W www.royalscottishacademy.org

A major initiative intended to encourage young professional painters. Alastair Salvesen is one of Scotland's foremost benefactors and has offered a three- to six-month travel scholarship in association with the RSA since 1989. The £10,000 scholarship is accompanied by a solo exhibition at the RSA

Frequency Annual.

The Royal Scottish Academy Residencies for Scotland

Royal Scottish Academy of Art and Architecture, The Mound, Edinburgh, ED2 2EL T 0131 2256671

F 0131 2206016

E info@royalscottishacademy.org

W www.royalscottishacademy.org New scheme offered from 2009 in conjunction

with the Scottish Arts Council. With a total budget of $f_{45,000}$, there are up to 15 residencies offered in studios across Scotland, plus exhibition opportunities at the RSA in Edinburgh. Deadline

for applications July. Frequency 15 residencies.

Entry Policy Details on website.

Royal West of England Academy (RWA) Student **Bursaries**

Queens Road, Clifton, Bristol, BS8 1PX

T 0117 9735129

F 0117 9237874

E info@rwa.org.uk W www.rwa.org.uk

The council of the RWA offers two bursaries of $f_{1,000}$ each to students in the final year of their degree course in painting, printmaking, sculpture or architecture. Postgraduate students in their first year are also eligible to apply. Also runs two open exhibitions annually.

Entry Policy See website.

RSA Barns-Graham Travel Award

Royal Scottish Academy of Art and Architecture, The Mound, Edinburgh, ED2 2EL

T 0131 2256671

F 0131 2206016

E info@royalscottishacademy.org

W www.royalscottishacademy.org

New from 2009, £2,000 travel award for graduates of the Fine Art department of the five Scottish Art Schools of Glasgow, Edinburgh,

Aberdeen, Dundee and Moray. Open to painters, printmakers and sculptors.

Entry Policy See website for details.

RSA John Kinross Scholarships

The Royal Scottish Academy, The Mound, Edinburgh, EH2 2EL

T 0131 225 6671

E press@royalscottishacademy.org **W** www.royalscottishacademy.org

The £2,000 scholarship is intended to assist students in Scotland within the disciplines of painting, sculpture, printmaking and architecture to live and study in Florence for a period of up to three months. The RSA also arranges a galleries and museums pass for the students allowing them free access to the city's artistic and historical

treasures.

Frequency Up to twelve scholarships annually Entry Policy Painting, sculpture and printmaking: applications are invited from students in their final or post-graduate years of study at one of the four Scottish Colleges of Art. Architecture: applicants must be senior students at one of the six Scottish Schools of Architecture presenting work which would normally be related to the requirements of the RIBA Part 1 or Part 2 Syllabus. Group work is not admissible and only one project may be entered by any one student. All applications must be supported by not more than eight digital images of current work on CD and an A4 statement setting out their reasons for wishing to study in Florence.

RSA New Contemporaries Scotland Award

Royal Scottish Academy, The Mound, Edinburgh, ED2 2EL

T 0131 2256671 F 0131 2206016

E info@royalscottishacademy.org

W www.royalscottishacademy.org

Contact Colin Greenslade

New award started in 2009. Artists selected from Fine Art and Architecture degree shows from the main colleges in Glasgow, Edinburgh, Aberdeen, Dundee and the University of the Highlands & Islands will be chosen to exhibit in the Royal Scottish Academies New Contemporaries Scotland exhibition in spring 2010. Up to £9,000 worth of prizes also given.

Frequency Annual

Entry Policy Artists selected from Fine Art and Architecture degree shows from Scotland's universities.

RSA William Littlejohn Watercolour Award

Royal Scottish Academy of Art and Architecture, The Mound, Edinburgh, ED2 2EL T 0131 2256671

F 0131 2206016

E info@royalscottishacademy.org

W www.royalscottishacademy.org

New award from 2009 for watercolour artists born or living and working in Scotland.

Frequency Annual

Entry Policy The award must be used to fund research within a residency centre in Scotland. Application details on website.

Ruth Davidson Memorial Scholarship

RDAM – Elphinstone Institute, Taylor Building, University of Aberdeen, Regent Walk, Aberedeen, AB24 3UB

T 01224 272996

E elphinstone@abdn.ac.uk

Offers the successful applicant three months' rentfree accommodation in the Languedoc Roussillon region of the south of France to develop/express new ideas in their work. Also provides £3,000 to cover all costs associated with residency including return travel to France, travel in local area (driving licence essential), materials and living expenses. Entry Policy Open to a painter currently living and working in Scotland of at least four years' experience since graduation or since beginning to exhibit. Students are not eligible. Key criteria used in selecting artists are quality of work, as shown in a selection of slides, and the nature of the proposal for residency period.

The RWS/Sunday Times Watercolour Competition

c/o Parker Harris, P.O. Box 279, Esher, KT10 8YZ

T 01372 462190

F 01372 460032

E rws@parkerharris.co.uk W www.parkerharris.co.uk

Now sponsored by the Royal Watercolour Society and the Sunday Times, this is an annual open competition for UK artists working in any waterbased media. Now in its twentieth year. 2007 judges included Peter Blake, Frank Whitford and Dr Joanna Selborne. Prize money totalling £30,000, with £15,000 first prize.

Frequency Annual

Entry Policy Details posted on website.

Safle Graduate Award

Unit 4, Sovereign Quay, Havannah Street, Cardiff, CF105SF

T 0845 2413684

F 02920 487473

E info@safle.com

W www.safle.com

Originated in 2009/10 this £10,000 annual award is given to a BA Visual Arts graduate studying in Wales, given to make their first professional intervention in the public realm, with the support and guidance of Safle and project partners. The award aims to offer an opportunity to progress personal creative practice through collaboration and an inter-disciplinary exchange within a professional context, while encouraging students to remain in Wales following their studies.

Frequency Annual

Entry Policy Every year colleges throughout Wales will be asked to nominate up to three of their visual art BA final year students.

Sainsbury Scholarship in Painting and Sculpture

The British School at Rome at the British Academy, 10 Carlton House Terrace, London, SW1Y5AH

T 020 79695202

F 020 79695401

E bsr@britac.ac.uk

W www.bsr.ac.uk

Contact Dr Gill Clark (The Registrar)
Founded in 2001 and funded by the Linbury
Trust, open to painters and sculptors who can
demonstrate a commitment to drawing within
their artistic practice and who can present a wellargued case for the continuation of their studies in
Italy and in particular Rome. Offers full board and
lodging at the British School at Rome for twelve
months (with, at the discretion of the selection
committee, an opportunity for a further nine
months in the following academic year). There is
a grant of approximately £900 per month, plus a
one-off travel grant of £1,000.

Frequency One per year.

Entry Policy Applicants must be: of British nationality or have been working professionally or studying at postgraduate level for at least the last five years in the UK; under 30 on I October of the academic year in which the scholarship will be held; have graduated or expect to graduate before I October of the academic year in which the scholarship would commence. An application form must be completed. Closing date for applications: See website.

Sargant Fellowship

The British School at Rome at the British Academy, 10 Carlton House Terrace, London, SW1Y 5AH T 020 79695202
F 020 79695401
E bsr@britac.ac.uk
W www.bsr.ac.uk
Contact Dr Gill Clark (The Registrar)
Founded in 1990, one of the senior and most prestigious residencies offered by the British School at Rome. Open to distinguished artists and architects to enable them to research and make new work within the historical context of Rome.
Offers full board and lodging in a residential

Offers full board and lodging in a residential studio at the school, a grant of £2,000 per month, and a one-off travel allowance of £500.

Frequency Each year or every other year.

Entry Policy Applicants must be of British or Commonwealth nationality, or have been living in the UK or Commonwealth for at least the last three years. An application form must be completed. Closing date: usually early to mid-December or

Scottish Sculpture Workshop Programme

I Main Street, Lumsden, Huntley, AB54 4JN

T 01464 861372

F 01464 861550

E office@ssw.org.uk W www.ssw.org.uk

early to mid-January.

The Scottish Sculpture Workshop has initiated a programme of fellowships funded by the Scottish Arts Council and the PF Charitable Trust. It also runs a residency programme.

Entry Policy See website.

Skopelos Foundation for the Arts

P.O.Box 56, Skopelos Island, 37003, Greece

T+30 2424024143

F+30 2424024143

E info@skopart.org

W www.skopart.org

Contact Jill Somer (Associate Director)
Founded in 1999. Committed to honouring and sharing the Greek artistic tradition while fostering innovative artistic expression and development.
The foundation offers residencies in ceramics, painting, printmaking and screenprinting, from September through to May.

Entry Policy An application is required and reviewed by the board of directors. Experience is necessary and college graduates are preferred.

Society of Wildlife Artists Bursaries

C/o Mall Galleries, 17 Carlton House Terrace, London, SW1Y 5BD

T 020 79306844

F 020 78397830

E info@mallgalleries.com

W www.swla.co.uk

Awards of up to £750 each are open to young artists aged 15 to 30 to enable them to develop their skills through mounting a special project, travel or education. Download applications from website.

Soros Centres for Contemporary Arts (SCCA) **Network Residencies**

83 Gagarin Avenue, 2nd Floor, Almaty, Kazakhstan

E scc@scca.kz

W www.scca.kz

The SCCA is a network of nineteen offices devoted to development of contemporary arts in central and eastern Europe and the former Soviet Union. Runs a residencies scheme. Apply in writing.

St Hugh's Fellowship

The Administrator c/o Andrew & Company Solicitors. St Swithin's Court, 1 Flavian Road, Nettleham, LN2 4GR

E sthughscharity@tiscali.co.uk

To assist established arts practitioners and animators to develop their careers in the arts and to contribute their knowledge and experience to the wider growth and dissemination of arts practice in the region. Proposals should be for a substantial and sustained programme of work, to be carried out over a period of at least 6 months (2 years maximum). The average fellowship grant is up to $f_{14,000}$. Entry Policy Open to individuals working as practitioners in any field of arts (under 30 years old on I May); resident and working full or parttime in Lincolnshire or former Humberside area. Application cover sheet and application requirements should be completed and returned by noon on I May. Obtain leaflet by sending sae.

Stockport Art Gallery Annual Open Exhibition

Wellington Road South, Stockport, SK3 8AB

T 0161 4744453 F 0161 4804960

E stockport.artgallery@stockport.gov.uk

W www.stockport.gov.uk

Contact Andy Firth

An annual event with four prizes of f_{100} each. Entry Policy Information and application forms available in May each year by sending an A5 sae.

Straumur International Art Commune

v/Reykjanesbraut, P.O.Box 33.222, Hafnarfjordur, Iceland

T+354 5650128

F +354 5650655

E solar@tv.is

Contact Sverrir Olafsson (Director)

Established in 1988, since when more than eight hundred artists have visited from twentynine countries and all fields of media and art. Funded by the city of Hafnarfjordur and Sol-Art, a private non-profit organization that handles daily operations in close cooperation with the city's cultural committee. The commune consists of five spacious studios of various sizes. Residencies are one to five months, with a maximum of twelve months under special circumstances. The artist has to pay all living and working expenses. Entry Policy Applications are accepted from all

professional artists regardless of artistic media, citizenship, nationality, sex or race.

Summer Exhibition - Royal Academy of Arts

Burlington House, Piccadilly, London, W1J OBD

T 020 7300 5929/5969

F 020 7300 5812

E summerexhibition@royalacademy.org.uk

W www.royalacademy.org.uk

Contact Chris Cook

Founded in 1768. The largest open contemporaryart exhibition in the world encompassing all styles and media. Over a thousand works, the majority of which are for sale. Over 150,000 visitors.

Frequency Annual. Over £70,000 in prize money awarded.

Entry Policy Maximum of three works in any media (f18 per work, non-refundable).

Swansea Open

Glynn Vivian Art Gallery, Alexandra Road, Swansea, SA15DZ

T 01792 516900

F 01792 516903

E glynn.vivian.gallery@swansea.gov.uk

W www.glynnviviangallery.org

Open to professional artists as well as to those who have never had the opportunity to show their work in a public art gallery. Three winners are selected from all the entries, with a first prize of £250, second prize of £150 and third prize of £100. These are announced at the beginning of the exhibition, usually held from July to September.

The Threadneedle Prize for Painting and Sculpture

Mall Galleries, 17 Carlton House Terrace, London, SW1Y5BD

T 020 79306844

E threadneedleprize@mallgalleries.com

W www.threadneedleprize.com

Showcase for the best in contemporary painting and sculpture, open to all artists – established and emerging talent – aged 18 and over, living or working in the UK. Approximately 60 works, selected from a national open submission, are exhibited at the Mall Galleries, London in

the autumn. Two major prizes are available: The Threadneedle Prize (£25,000) and a new Emerging Artist Prize (£5,000). Each of the six runners-up for The Threadneedle Prize receive £1,000.

Frequency Annual

Entry Policy See website for registration details.

Turner Prize

Tate Britain, Millbank, London, SW1P 4RG T 020 78878000 F 020 78878007

W www.tate.org.uk/britain/turnerprize
An annual contemporary art award founded in
1984. Considered among the most prestigious and
influential awards available.Worth £40,000.
Entry Policy Nominated artists must be under
the age of 50 and British, which includes artists
working in the UK and British-born artists who
may be working abroad. Need to have had an
outstanding exhibition or display in the twelve
months preceding the competition.

UNESCO Aschberg Bursaries for Artists

UNESCO Division of Arts and Cultural Life, Bureau B10.29, rue Miollis, Paris Cedex 15, 75732, France

T +33 145684328

F +33 142730401

W http://portal.unesco.org/culture
Promotes the mobility of young artists in order
to enrich their personal perspectives, to enable
them to engage in an intercultural dialogue and
expose them to cultural diversity. The Programme
offers residencies to young artists (between 25 and
35 years old) worldwide, and advocates cultural
exchanges and highlights creativity and the need
for artists to enrich their experience through
contact with other cultures. The bursaries are
limited and are awarded on a selective basis.

Entry Policy The pre-selection of candidates is carried out by host institutions. Artists must therefore apply directly to the institution of their interest, depending on the discipline or country sought. Deadline: September for the following year

V&A Illustration Awards

Victoria & Albert Museum, Cromwell Road, London, SW7 2RL

T 020 79422392 E villa@vam.ac.uk

W www.vam.ac.uk/illustrationawards

Contact Annemarie Bilclough

Contact Annemarie Bilclough
The V&A Museum has offered awards for professional illustration since 1972. Originally called the Francis Williams Awards (1972–1982) after their benefactor, they became annual in 1987. Prizes up to £2,500 in three categories: Book Illustration; Book Cover and Jacket Illustration; Editorial Illustration. Separate Student Illustrator of the Year category with top prize £1,300. Display of the winning entries hosted at the V&A.

Entry Policy Illustration published in UK in previous twelve months; unpublished work by illustration students. Closing dates: students
March; other categories July.

Virginia A. Groot Foundation

P.O.Box 1050, Evanston, IL 60204-1050, USA E virginia@virginiagrootfoundation.org
W www.virginiagrootfoundation.org
Offers up to three grants of \$5,000, \$10,000 and \$30,000 annually for an artist of exceptional talent with a demonstrated ability in the areas of ceramic sculpture or sculpture. Open to artists at any stage of career.

Entry Policy Deadline: 1 March.

Wesley-Barrell Craft Awards

Wesley-Barrell, Ducklington Mill, Standlake Road, Ducklington, OX29 7YR

T 01993 893100

W www.wesley-barrell.co.uk

Contact Ali Griffiths

Founded in 2007, the Wesley-Barrell Craft
Awards, in association with the Crafts Council,
resulted in over 100 applicants competing in two
categories; furniture and textiles for interiors.
Check website for latest competition details.

Frequency Annual Entry Policy See website.

Entry Policy See website.

Wingate Rome Scholarship in the Fine Arts

The British School at Rome at the British Academy, 10 Carlton House Terrace, London, SW1Y 5AH

T 020 79695202

F 020 79695401

E bsr@britac.ac.uk

W www.bsr.ac.uk

Contact Dr Gill Clark (The Registrar)

Founded in 1998 and funded by the Harold Hyam Wingate Foundation. Open to painters, sculptors and mixed-media artists who can demonstrate that they are establishing a significant position in their chosen field. Offers full board and lodging in a residential studio at the school for five months. plus a grant equivalent to f500 per month.

Frequency One each year.

Entry Policy Applicants must be: able to satisfy the selection panel that they need financial support to undertake the work projected; living in the British Isles during the period of application; citizens of the UK or other Commonwealth country, Ireland or Israel - or citizens of another EU country provided that they are and have been for the last three years resident in the UK; aged 24 or over on I September of the academic year in which the scholarship will be held. An application form must be completed. Closing date: mid-December.

Women's Studio Workshop Fellowship Grants

P.O. Box 489, Rosendale, New York, 12472, USA T+1 914 6589133

F+1 914 6589031

E info@wsworkshop.net

W www.wsworkshop.org

Fellowship Grants designed to provide concentrated work time for artists to explore new ideas in dynamic and supportive community of women artists. Facilities feature complete studios in intaglio, silkscreen, papermaking,

photography, letterpress and clay. 2-6 week sessions available each year from September to Iune. Fellowships awarded through jury process. Cost to Fellowship recipients is \$200 per week plus materials (approximately one fifth the cost of actual residency). The award includes on-site housing and unlimited access to studios. Artists given studio orientation but should be able to work independently. Technical assistance available for additional fee.

Frequency Five residencies; three fellowships. Entry Policy Open to women artists. Fellowship grants applicants should submit an application form, a resume, six to ten slides, letter of interest that addresses the purpose of the residency (explaining areas of proficiency and studio skills) and sae for return of material.

Woo Charitable Foundation Arts Bursaries

The Administrator, Arts Bursaries, 277 Green Lanes, London, N13 4XS

The foundation offers arts bursaries for artists who have finished their formal education. Approximately ten bursaries of $f_5,000$ are awarded to artists working in the visual arts sector

(fine and applied).

Entry Policy Open to artists who have finished formal education. All applications must include a CV, ten 35mm slides or colour photos, a short A4 written critique, details of a professional referee, and a brief summary of how the bursary would benefit the applicant.

Being an artist outside London

Heather Morison

I think if you make good art, where you live doesn't matter. After all it is your art, not you, that is important. However, your environment does have a huge influence on whether you are able or equipped to make good art, so you should make sure you feel happy with your general situation.

We have lived outside of London for about ten years now and currently reside in Snowdonia, very close to a piece of woodland that we are gradually turning into an arboretum. The UK is a very small place, making it relatively easy to travel about visiting people, seeing shows, doing research and making work. As long as we can do that, we can live anywhere we want. Where we live has a major influence on our work, perhaps more so than for many artists. We make art about where we are. Being somewhat on the edge or the periphery of the art world is a very interesting place to be and gives us a rather unusual view of what is going on. Lots of people come to visit us here and we travel all the time to London and other cities, so we are not cut off, just a little remote. It suits us, but it wouldn't suit everyone.

Advantages to living outside of London

There are lots of advantages to living outside London. We lived there for two years after graduating and then moved to Birmingham. The most obvious benefit for us was that the cost of living was dramatically lower, which meant we could afford the rent on a decent studio. There are fewer artists outside of London and so it is much easier to get to know the arts community and make friends. There are also fewer art events, but this means that everyone always goes and will normally all end up in the same pub afterwards. There are also lots of opportunities outside of London and, quite frankly, not so much competition. Organizations and funding bodies seem much

more willing to help less established artists in order to keep them in the regions and stop them migrating to London.

Support structures

Living next to a mountain, one thing we do miss a bit is having an arts community to mix with readily. I think if we worked alone this might be more of a problem, but we try to keep in regular contact with as many people as possible by email, telephone and on our frequents travels. Having some kind of support structure can be invaluable, especially when you are just starting out after art school. Going to talks, openings and events is a good way to build up a network, while volunteering and looking out for opportunities at your local arts organizations can start to place you in the arts community, even if you aren't yet a successful practitioner.

Showing work

When we arrived in Birmingham we had access to a large, leaky warehouse-sized space, so we started to put on shows. The amazing thing about regional cities is that there always seem to be disused buildings or shops – especially with the amount of regeneration taking place – and they make great temporary exhibition spaces.

The only way to be a successful artist is to show really good work. It is nonsense to be put off if you are finding it difficult to get a gallery show because the only way to show better work is to be showing work in the first place. You can break this vicious circle by showing work anywhere, from disused buildings to billboards and fly posters, and you can do site-specific performances and so on - the list is endless. Invite people, including the press, to come along and just keep doing it, although always remember to document it on the web (this is very important especially when you are outside of London). Make friends with your local contemporary art galleries because when you are ready and your work is good enough, you will have a show there.

Collaborative working

As well as working collaboratively with people in your locale, don't ignore the other cities around you. It is so easy to travel between Bristol and Birmingham, or Swansea and Cardiff, or Manchester and Leeds, so going to events and extending your arts knowledge and community just takes a little bit of effort. Then invite people to see you too.

Don't ignore London

In the UK, London is the centre of the commercial art world and so it would be foolish to ignore it entirely. Making regular visits to London to see all the big shows as well as visiting the smaller galleries in the East End is incredibly important. Be inspired by all the amazing work that is being shown, don't get bitter. Trying to imitate what you see in London, say in Wrexham, may not be appropriate, but it is a good idea to be as professional as if you were trying to be an artist in London. Don't act regional, keep up to date. Read Frieze, read Artforum, go to the art shows and whenever you can visit the Venice Biennale or Documenta as well as travelling to other regional cities that show amazing art, places such as Berlin and Rotterdam.

Funding

Make friends with your local Arts Council officer. This is easy to do outside of London simply because there are less artists. Look out for funding schemes that are aimed specifically at regional artists (there are many around) and then start to make applications. Don't be put off by rejection; we reckon that you should aim for a one-in-ten success rate. Nearly all the contemporary commercial art galleries are in London and the only way you'll catch their eye is by showing great work in non-commercial shows, so make sure you always invite them to your openings. (And just a quick word about finding a gallery to represent you: wherever you live, research thoroughly and find the right gallery for you before you approach them in any way.)

Having said all this, just live where you feel happiest, and if you make amazing work you'll be a successful artist.

Heather and Ivan Morison have been observing, collecting and documenting their everyday lives - whether tending their garden in Birmingham or travelling across the world - since they left art school. They have exhibited nationally and internationally and represented Wales at the 2007 Venice Biennale. For more information about their work, visit www.morison.info.

08

Arts boards, councils, funding and commissioning organizations

To make, or not to make: that doesn't have to be the question

Andrew Brown

So you're no longer an art student. You've finished your course, gained your qualification, left college, and...then what? The answer may seem clear: you carry on making, of course. Each summer, thousands of aspiring artists leave art school with just that ambition. And many of them will hope to earn a living from doing so. Some do, and are very successful. But with more and more art students being produced each year, and with markets for their work limited, the unhappy truth is that competition grows ever fiercer, and not every qualified artist will be able to support themselves by making and selling art alone. Instead, many will find that they need to take on temporary or casual jobs to subsidize their work; others will leave art altogether and find employment elsewhere, never to return.

And yet there is an alternative. For the happy truth is that the value of being an artist is not measured solely by the objects you make. Artists are sought after in a variety of ways because of the unique skills, vision and processes they can bring, both to the art world and to other professions and disciplines. Here I will highlight a few of the opportunities that lie outside the studio, and point to some of the ways you can achieve success as an artist alongside your artistic practice.

Work and learn

One of the most common opportunities for a recent art student is to become an assistant to an established artist. As an artist becomes more successful, the demands on his or her time increase significantly, and they often employ younger artists to assist them. Assistants may offer technical help in the studio - mixing paint, stretching canvas, casting metal, filming, developing, printing, and so on - or they may provide administrative support to the artist. They may also handle press enquiries or deal

with museums, publishers, suppliers, or couriers, negotiating on the artist's behalf. In short, they assist with all of the day-to-day affairs of running a busy studio - and all the time they are learning on the job what it means to be a professional artist.

Similarly, arts organizations take on artists because of the knowledge and expertise they bring. Across the country, studio providers, commissioning agencies, funders, art magazines, commercial dealers, public and private galleries, and museums all look for experienced administrative, curatorial and creative staff who have a wide knowledge of the art world and understand the needs of the practitioners with whom they work. As a trained artist, you will be greatly attractive to such employers, especially if you can bring other relevant experience with you as well, such as curating or writing about art. Here at Arts Council England many members of staff are practitioners who continue to produce work of their own, enabling them to have an informed view when assessing other artists' applications for funding. And many of the organizations we support are staffed by artists, who work part time as curatorial, education, production and administrative staff while making their own art. Unlike employment outside the visual arts, these jobs have huge benefits for your own practice because they bring you into contact with arts professionals on a daily basis - artists, curators, producers, commissioners, critics, funders, and the like. Not only will you learn a great deal about the processes of making, showing and discussing work, but you will also widen your circle of contacts and raise your own profile.

Know your worth

Museums and galleries offer several opportunities for artists at all stages of their careers. Many run education and outreach programmes, and employ artists to work with children, young people and lifelong learners to help them understand how an artist thinks and works and to encourage them to make art themselves. Such programmes are vital in

helping the next generation become creatively and critically aware, to help them see the world in a different way, appreciate diverse views, approaches and choices, and to imagine new possibilities. These are essential and highly desirable skills that you possess as an artist, that have value, and that you can capitalize on. Artists who contribute to such programmes speak of how the experience has fed directly into their own work by broadening their perspectives and sources of influence. But they also help an artist's career in an indirect way too by creating new audiences for the art of the future and fostering a society that values the role of the artist.

The artist's unique way of viewing the world is attractive to museums in other ways, too. Increasingly, they are turning to practitioners to curate exhibitions and to reinterpret their collections. Recent examples include Grayson Perry's exhibition of works from the Arts Council Collection, which toured England in 2008 and 2009, and Mark Wallinger's curated show at the Hayward Gallery, London, and Michael Craig-Martin's selection of work from the British Council Collection shown at the Whitechapel Gallery, London, both in 2009. Other less well-known artists have also been invited to work with museum collections. either by selecting objects and showing them in innovative ways or by making new work in response to the permanent displays. The Alchemy fellowship programme at Manchester Museum, for example, has offered young and mid-career practitioners the opportunity to engage with the museum's several million objects and to reinvigorate the collections by producing new work, exhibitions, talks and events. And Arts Council England and Museums, Libraries and Archives Council's Museumaker scheme similarly offers artists and makers access to museum collections around the country as an inspiration for creating commissioned work.

Teaching and lecturing about art in museums and galleries, art colleges and schools is another avenue open to the artist, and can be a productive way of supplementing your income. Almost all major museums and galleries, and many smaller ones, run talks programmes for the general public, and often invite artists to give tours of displays, to take part in discussions about works or artists in the collections, or to write texts for exhibition catalogues and books. And many art colleges employ professional artists as visiting lecturers or tutors to work with foundation or degree students for one or more days each month. Alternatively, the Artists' Access to Art Colleges scheme (AA2A) provides free technical support and studio space in art colleges, usually for an academic year, in return for a small amount of unpaid teaching. Similarly, schools look for practising artists to work on an occasional basis in support of teachers of art and other subjects, such as history. Again, this experience can have great benefits for your own practice, thanks to the stimulating engagement with the new ideas and questions of younger students and pupils.

Think beyond the art world

Interaction with other sectors can also refresh the way you work too. Many artists seek out the opportunities afforded by exposure to different social and economic contexts in the form of placements and residencies in business, health. science or industry. Arts Council England's Interact programme, established in partnership with Manchester Metropolitan University, is just one example of how an artist's presence within industry and research settings, even on a temporary basis, can have an inspirational effect, enabling exchange of valuable knowledge and skills between both artist and host organization. Around 30 practitioners on the Interact scheme took up placements in institutions such as Adobe, Hewlett-Packard Labs, the BBC, the National Science Learning Centre and the University of Birmingham. The benefits were two way: not only did the host gain from having the perspective of a creative professional who approached a particular problem from a fresh angle and asked difficult and pertinent questions a specialist might not have considered, but also the artist had access to expertise and knowledge

Network, network, network

But how can I find out about such opportunities, you may ask. Information is key, of course, and you gain access to that information by being plugged into as many communities and networks as possible. Much is written about the economics of the art world, but before it is an economy it is an ecology. And like any ecology it is made up of many distinct but interconnected parts that depend on each other for survival. Public or private, commercial or not-for-profit, professional or voluntary: they all feed off and cross-fertilize one another. To flourish, you need to spread yourself widely across these different elements of the sector, learn how they operate, and cultivate as many potential contacts as possible. Elsewhere in this book Nicholas Logsdail writes about the importance of finding a community of like-minded individuals. I would go further and say that you should find several such communities. In the art world, possibilities arise from knowing people who know people who know others still, and there really is no substitute for constant networking.

Start with your own artist friends and fellow students. Use that existing informal network to share information and to look for opportunities together. But reach out further too. Get yourself on mailing lists for arts organizations (these lists are often shared, so being on one will mean that you will get mailouts from several), go to as many openings as you can, and – most importantly – meet people. From such acquaintances you may hear about internships, fellowships, assistant posts or other arts jobs that are available.

Signing up to information websites for artists and joining membership organizations are also easy ways of keeping up to date with new opportunities. Sites such as a-n The Artists Information Company, axis, Artquest, Art Jobs, Engage and others that are part of the nationwide Artists Professional Development Network offer extensive listings of jobs, residencies and placements, as well as useful things to keep in mind when applying for positions; while bulletins from organizations such as Artsadmin and studio providers also give regular news of paid and unpaid opportunities (a list of web addresses appears below). Some of these online organizations are also membership societies - axis and a-n's AIR group in particular - and by joining them and others such as the Contemporary Art Society, Engage (the association for gallery, art and education professionals) and the Visual Arts and Galleries Association (VAGA) you can become part of wider communities of interest, share knowledge and experience, stay in touch with new developments, promote your work and get other members' benefits, such as free insurance and legal support.

Skill yourself up

Many of the organizations listed here also provide practical advice and training for artists on a range of skills and professional development issues. The fact that they do points to the other important thing to remember when you leave college and set out to be a working artist: most art colleges do not provide all the skills and expertise that you will need throughout your career. All of them teach you how to be an artist; very few teach you how to be a professional artist. In order to maximize the opportunities open to you outside the studio but also in order to function effectively within it - it is important continuously to develop new skills beyond the technical know-how you learned in college. Expertise in public speaking, writing and publishing, working with children, and teaching are just some of the useful skills you should have if you're looking for the

opportunities I've mentioned above. But you will need to acquire many more as you progress as an artist, even if you choose to stay in the studio and concentrate on making and selling your work.

As a professional artist, you are a selfemployed individual - that is to say, you are a small business. And like anyone who runs a successful small business you will need to have an understanding of a number of financial, management and legal issues. Even if you can afford to employ an accountant, you will need to have some basic book-keeping skills and know how to keep accurate records of all your income and outgoings. You should be able to monitor cashflow and keep on top of invoices and payments, as well as understand how the tax, VAT and National Insurance systems work. You will also need to be familiar with specific areas of the law as they relate to artistic creativity, especially public liability insurance, copyright, and health and safety (Artquest is especially good on all legal matters). And if at any time you employ an assistant of your own you will need to be aware of employment law and employer's insurance; and if you set up in business with others, you must know about company law. In addition to this specialist knowledge, you should also have a number of general business skills, including project planning and management (so that you can deliver artistic projects on time and in budget), negotiation and team working. These last two are often forgotten but they are of particular importance for the artist, who generally works alone in his or her studio most of the time. As soon as you start dealing with others, whether they be curators, funders, publishers, commercial galleries, collectors or other clients and suppliers, you will need to understand how to work in partnership with others whose expertise, objectives and pressures may be different from your own.

IT, editing, design and print skills are equally important. Not only may you need to produce effective promotional material such as résumés, invitations and press releases, but also you may wish to create an engaging website or attractive publications to promote your work. Similarly,

if you are seeking support from public funders or private trusts and foundations, or if you are applying for residencies, you should be able to write clear and persuasive applications.

Finally, you will require a number of professional skills that are more closely related to your practice, but which you may not have learned at college. It may seem quite simple, but taking high-quality photographs of art, whether with digital or film, is not as easy as it first looks, and yet artists at every stage of their careers need reproduction-quality images of their work. Investing in a how-to book or a short course could save you lots of money employing a professional photographer. Similarly, learning how to frame your work yourself could also avoid a large and recurring expense. And at some point you may want to organize a show of your art in which case you will need expertise in art handling and transportation, exhibition making and events management.

Some of these skills you can acquire only over time and by doing; for the rest, you may need some formal or informal training. Fortunately, there are many sources of free or affordable help and support, some of which I mentioned above and list below. Armed with all your newfound knowledge, you should be equipped and ready to enjoy the many benefits a career as a successful artist can bring.

www.AA2A.org www.a-n.co.uk www.apd-network.info www.artquest.org.uk www.artsadmin.co.uk www.artsjobs.org.uk www.artsjobsonline.com www.axisweb.org www.contempart.org.uk www.culturalenterpriseoffice.co.uk www.engage.org www.freelanceuk.com www.vaga.co.uk

Andrew Brown is Senior Strategy Officer for Visual Arts at Arts Council England.

Arts boards, councils, funding and commissioning organizations

'A' Foundation

67 Greenland Street, Liverpool, L1 OBY

T 0151 7060600

F 0151 7060601

E info@afoundation.org.uk

W www.afoundation.com/greenlandstreet A Foundation is committed to developing and encouraging new audiences for the visual arts. In 2007-2009 redeveloped Greenland Street three former industrial buildings transformed into inspiring and challenging gallery spaces: The Coach Shed, The Furnace and The Blade Factory. Aims to showcase the very best local, regional, national and international contemporary visual arts practice. Commissions up to four major new projects each year. Also delivers an annual architecture commission that profiles emerging architects whose hybrid practices reference both art and architecture, and an education and outreach programme that aims to provide a wide range of participants with the opportunity to look at, talk about and make art.

Grants awarded Three art-related grants: Liverpool Biennial Trust, Liverpool Biennial of Contemporary Art Ltd and Liverpool Biennial Fringe.

MEA House, Ellison Place, Newcastle-upon-Tyne, NE18XS

T 0191 2220708

W www.arcadea.org

A development agency for art, culture and disability equality. Aims to promote the artistic and cultural equality of disabled people in the Northeast region.

Art Consultants Ltd - Art For Offices

15 Dock Street, London, E1 8JL

T 020 74811337

F 020 74813425

E enquiries@afo.co.uk

W www.afo.co.uk

Established in 1979, specializing in sourcing and commissioning art. Works with developers, architects and interior designers to provide art work for the corporate, hotel and leisure sectors. Can advise on a consultancy basis through International Art Consultants Ltd or supply art directly through Art For Offices.

Art Point Trust

2 Littlegate Street, Oxford, OX1 1QT

T 01865 248822 F 01865 248899

E info@artpointtrust.org.uk

W www.artpointtrust.org.uk

A creative company working with artists to support new thinking and practice for the built environment and public space. Advocates and establishes opportunities for artists to create new work within public contexts. This includes public-art commissioning, consultancy, research projects and audience engagement activities. Based in Oxford and works throughout the south-east of England. Grants awarded Has delivered sixty projects worth $f_{2.5}$ m in the past five years.

ART.e @ the art of change

6 Container City, Trinity Buoy Wharf, 64 Orchard Place, London, E14 OJW

T 0845 5053003

F 020 79879922

E pete@artofchange.demon.co.uk

W www.arte-ofchange.com

Contact Peter Dunn

Founded 2001. A visual arts organization concerned with issues of change and, particularly, the transformation of the urban environment and its impact upon quality of life and cultural identity. The practice ranges from strategy through creative development to production. The core team is a combination of visual arts practitioners and strategists, resourced with new technology and administrative backup. Produces art works in the public domain in all its aspects, be they physical, virtual or social, through a process of working with communities of interest and location.

Artangel

31 Eyre Street Hill, London, EC1R 5EW T 020 77131400

F 020 77131401

E info@artangel.org.uk

W www.artangel.org.uk

Has pioneered a new way of collaborating with artists and engaging audiences in a series of commissions since the early 1990s. Previous projects include Rachel Whiteread's House, Janet Cardiff's The Missing Voice, Michael Landy's Break Down and Jeremy Deller's The Battle of Orgreave.

Artists' General Benevolent Institution

Burlington House, Piccadilly, London, W1J 0BB T 020 77341193

F 020 77349966

W www.agbi.org.uk

Founded in 1814. Aids professional artists whose work has been known to the public for some time and who, through accident, old age or illness, are unable to support their families.

Arts & Disability Forum

Ground Floor, 109–113 Royal Avenue, Belfast, BT1 1FF

T 028 9023 9450 F 028 9024 7770

E info@adf.ie

W www.adf.ie

Contact Kim Andrews

The ADF was formed in 1993 and, as a cross-community charity, aims to provide information to disabled people and organizations. Administers the Arts & Disability Awards Ireland Scheme, distributing over £50,000 each year to artists with disabilities working in all art forms. A gallery was launched in 2002 which hosts monthly exhibitions, showcasing disabled artists works. There are no media exclusions.

Submission Policy Applicants must 1) be a disabled artist; 2) have ADF membership; 3) complete a proposal form and submit artwork. Grants awarded Total value: £50,000.

Arts and Humanities Research Council

Whitefriars, Lewins Mead, Bristol, BS1 2AE

T 0117 9876500 **F** 0117 9876600

W www.ahrc.ac.uk

Various schemes funded, including Core Funding Scheme for Higher Education, Museums, Galleries & Collections, Postgraduate Awards in the Arts and Humanities, and Advanced Research Awards in the Arts and Humanities.

Submission Policy See website for details of schemes and funding available.

Arts Council - Ireland

70 Merrion Square, Dublin, Dublin 2

T 01 6180200

F 01 6181302

E info@artscouncil.ie

W www.artscouncil.ie

Contact Stephanie O'Callaghan (Arts

Development Director)

The Arts Council is the Irish government agency for developing the arts. It provides financial assistance to artists, arts organizations, local authorities and others for artistic purposes. It offers advice and information on the arts to government and to a wide range of individuals and organizations. As an advocate for the arts and artists, the Arts Council undertakes projects and research, often in new and emerging areas of arts practice, and increasingly in co-operation with partner organizations.

Grants awarded Funding from government for 2007 was f80m.

Arts Council England

National Office, 14 Great Peter Street, London, SW1P 3NQ

T 0845 3006200

E enquiries@artscouncil.org.uk

W www.artscouncil.org.uk

The national development agency for the arts, founded in 1946. Supports artists and organizations working professionally in the contemporary arts. 'Visual arts' is an inclusive term to represent a range of practices including architecture, craft, fine art, live art, moving image, new-media art, public-art and socially engaged practice, including education.

Submission Policy Grants for the Arts are for individuals, arts organizations, national touring companies and other people who use the arts in their work. The application season runs from 31 October to 31 August. Application packs become available in the late summer. See website for more detailed instructions.

Grants awarded Grants for the Arts worth approximately £50m a year.

Arts Council England – East England Arts

Eden House, 48–49 Bateman Street, Cambridge, CB2 1LR

T 0845 300 6200

F 0870 2421271

E enquiries@artscouncil.org.uk

W www.artscouncil.org.uk

Areas covered: Bedfordshire, Cambridgeshire, Essex, Hertfordshire, Norfolk, Suffolk and unitary authorities of Luton, Peterborough, Southend-on-Sea, Thurrock.

Arts Council England – East Midlands Arts

St Nicholas Court, 25–27 Castle Gate, Nottingham, NG1 7AR

T 0845 3006200

F 0115 9502467

E enquiries@artscouncil.org.uk

W www.arts.org.uk

Areas covered: Derbyshire, Leicestershire,

Lincolnshire (excluding North and Northeast Lincolnshire), Northamptonshire, Nottinghamshire; unitary authorities of Derby, Leicester, Nottingham, Rutland.

Arts Council England - London Arts

2 Pear Tree Court, London, EC1R 0DS T 0845 3006200 F 020 76084100 E enquiries@artscouncil.org.uk W www.arts.org.uk Area covered: Greater London.

Arts Council England - North East Arts

Central Square, Forth Street, Newcastle-upon-Tyne, NE1 3PJ T 0845 3006200 F 0191 2301020 E enquiries@artscouncil.org.uk W www.arts.org.uk Areas covered: Durham, Northumberland;

Areas covered: Durham, Northumberland; unitary authorities of Darlington, Hartlepool, Middlesbrough, Redcar and Cleveland, Stocktonon-Tees; metropolitan authorities of Newcastleupon-Tyne, Gateshead, North Tyneside, Sunderland and South Tyneside.

Arts Council England - North West Arts

Manchester House, 22 Bridge Street, Manchester, M3 3AB

T 0845 3006200 F 0161 8346969 E enquiries@artscouncil.org.uk W www.arts.org.uk

Areas covered: Cheshire, Cumbria and Lancashire; unitary authorities of Blackburn with Darwen, Blackpool, Halton and Warrington; metropolitan authorities of Bolton, Bury, Knowsley, Liverpool, Manchester, Oldham, Rochdale, St Helens, Salford, Sefton, Stockport, Teeside, Trafford, Wigan and Wirral.

Arts Council England - South East Arts

Sovereign House, Church Street, Brighton, BN1 1RA

T 0845 3006200 F 0870 2421257

E enquiries@artscouncil.org.uk

W www.arts.org.uk

Areas covered: Kent, Surrey, East Sussex, West Sussex, Buckinghamshire, Hampshire, Isle of Wight, Oxfordshire; unitary authorities of Bracknell Forest, Brighton and Hove, the Medway towns, Milton Keynes, Portsmouth, Reading,

Slough, Southampton, West Berkshire, Windsor and Maidenhead, Wokingham.

Arts Council England - South West Arts

Senate Court, Southernhay Gardens, Exeter, EX1 1UG T 0845 300 6200

F 01392 498546 E enquiries@artscouncil.org.uk

W www.artscouncil.org.uk

Areas covered: Cornwall, Devon, Dorset,
Gloucestershire, Somerset and Wiltshire; unitary
authorities of Bath and North-east Somerset,
Bournemouth, Bristol, North Somerset, Plymouth,
Poole, South Gloucestershire, Swindon and Torbay.

Arts Council England - West Midlands Arts

82 Granville Street, Birmingham, B1 2LH T 0845 3006200

F 0121 6437239

E enquiries@artscouncil.org.uk

W www.arts.org.uk

Www.staffordshire, Areas covered: Shropshire, Staffordshire, Warwickshire, Worcestershire; metropolitan districts of Birmingham, Coventry, Dudley, Sandwell, Solihull, Walsall and Wolverhampton; unitary authorities of Hereford, Stoke-on-Trent, Telford and Wrekin.

Arts Council England - Yorkshire Arts

21 Bond Street, Dewsbury, WF13 1AX

T 0845 300 6200 F 01924 466522

E enquiries@artscouncil.org.uk

W www.artscouncil.org.uk

Areas covered: North Yorkshire; unitary authorities of East Riding, Kingston-upon-Hull, North-East Lincolnshire, North Lincolnshire and York; metropolitan districts of Barnsley, Bradford, Calderdale, Doncaster, Kirklees, Leeds, Rotherham, Sheffield and Wakefield.

Arts Council of Northern Ireland

77 Malone Road, Belfast, BT9 6AQ

T 028 90385200 F 028 90661715

E info@artscouncil-ni.org

W www.artscouncil-ni.org

Contact Iain Davidson

The Arts Council is the development agency for the arts in Northern Ireland, providing the main support for artists and arts organisations throughout the region through a range of funding opportunities. We distribute public money and

National Lottery funds to organizations and people who develop and deliver arts programmes across all of society. Arts Officers offer specialist guidance on funding and project development to artists and organisations working across the spectrum of arts activities in Northern Ireland. Details about funding programmes, current five-year arts plan and art form funding policies are available on the Arts Council's website.

Submission Policy Specific criteria vary according to scheme but for all schemes, applicants must satisfy the following criteria: (1) have made a contribution to artistic activities in Northern Ireland for a minimum period of one year; and (2) be domiciled (as distinct from a national or resident) in Northern Ireland. Priority is given to practising individual artists.

Grants awarded Arts Council awards across all artforms in 2007-08 totalled approximately £21m.

Arts Council of Wales

9 Museum Place, Cardiff, CF1 3NX T 029 20376500 F 029 20221447

E enquiries@artswales.org.uk

W www.artswales.org.uk

A national organization with specific responsibility for the funding and development of the arts in Wales. Main sources of funds are an annual grant from the Welsh Assembly and its share of the 'good causes fund' for the arts from the National Lottery. Also receives funds from other sources, including local authorities.

The Arts Foundation

2nd Floor, 6 Salem Road, London, W2 4BU T 020 82293813 F 020 82299410 W www.artsfoundation.co.uk Contact Shelley Warren (Director) Funds artists living and working in England, Scotland or Wales who have demonstrated commitment to and proven their ability in their chosen art form. A minimum of five annual fellowships awarded, worth \$\int_{10,000}\$ each, in five specific art forms that change every year. Submission Policy Programme not open to

then invited to make an application. Artsadmin

Toynbee Studios, 28 Commercial Street, London, E16AB

applications. Seventy established artists and other

professionals nominate individual artists who are

T 020 7247 5102 E admin@artsadmin.co.uk W www.artsadmin.co.uk Contact Artists' Advisory Service

A creative organization that produces, resources and promotes contemporary theatre, visual arts, dance, live art and performance. Artsadmin has established Toynbee Studios as a centre for the development and presentation of new work, where it offers a range of opportunities for emerging and unfunded artists including bursaries, rehearsal spaces, a free advisory service, mentoring schemes, education programme, residencies and showcases.

Submission Policy Each scheme has different requirements and deadlines. See website for specific application criteria.

Grants awarded Varied - see website.

Awards for All

T 0845 6002040

W www.awardsforall.org.uk

A grants programme for small groups involved in arts, sports, heritage, education, environment, health and voluntary and community activities that need grants of between £50 and £5,000. Criteria include increasing skills and creativity and improving quality of life. Operates through a series of regional offices.

Submission Policy Open to small, non-profit organizations and some statutory bodies such as parish town councils, schools and health bodies, but not to fund statutory responsibilities. Priority given to groups with a lower income. Groups must spend the money within twelve months of receiving the grant. No requirement for match funding.

The Baring Foundation

60 London Wall, London, EC2M 5TQ T 020 77671348

F 020 77677121

E baring.foundation@uk.ing.com

W www.baringfoundation.org.uk Set up in 1969 to give money to charities and voluntary organisations pursuing charitable purposes. In 40 years given over £98 million in grants. Budget for grant-making in 2009 is £2.2 million. Specific grants programmes concerned with strengthening the voluntary sector, the arts and international development. The Arts programme deadline will re-open with a new theme in September 2009.

Submission Policy See website for details.

Grants awarded £2.2 million

Belfast Exposed Photography

The Exchange Place, 23 Donegall Street, Belfast, BT1 2FF

T 028 90230965

F 028 90314343

E info@belfastexposed.org

W www.belfastexposed.org

Contact Karen Downey (Exhibitions Director)
A photographic resource, archive and gallery
which commissions new work and runs an annual
programme of exhibitions. By developing a policy
of project origination, placing its main emphasis
on the commissioning of new work, producing
publications and generating discussion through
seminars and talks around projects, it aims to aid
the development of an infrastructure in which the
photographic arts can flourish.

Submission Policy Only exhibits and supports photographic projects. To submit work for consideration, post samples of work (not more than 20 images) either on disk (Mac-compatible) or printed, along with a statement about the work, a CV and project proposal. Also include an sae for the return of all work. All submissions should be made for the attention of Karen Downey (Exhibitions Director). Submissions are looked at twice a year, at the end of January and June.

Bloomberg

City Gate House, 39–45 Finsbury Square, London, EC2A 1PQ

T 020 73307500 F 020 73926000

W www.bloomberg.com/uk

Contact Jemma Read (Head of Arts Sponsorship and Charitable Investment)

Handles sponsorships and donations together, with no stated preference between them or for any particular art form. Policy is to 'support contemporary arts projects that enrich the community and involve our employees in new and challenging cultural areas'. Has a commitment to the arts and young people.

British Council Arts Group

10 Spring Gardens, London, SW1A 2BN

T 020 73893194 F 020 73893199

E artweb@britishcouncil.org

W www.britishcouncil.org/arts

Contact Emily Butler

The British Council's Arts Group aims to 'mobilise the best of British creative talent to develop innovative programmes that will engage with thousands of people all over the world, drawing them into a closer relationship with the UK'. **Submission Policy** See website.

Business2Arts

44 East Essex Street, Temple Bar, Dublin 2 **T** or 6725336

F oi 6725373

E info@business2arts.ie

W www.business2arts.ie

Contact Rowena Neville

Founded in 1988 as a business council for the arts. With over 130 business members, aims to promote and encourage partnerships between business and the arts, whether through promoting the value of corporate art collections, encouraging companies to use the arts as a tool for client entertainment, or informing business about the marketing benefits of sponsoring the arts. Also has over 120 affiliated arts organizations who make use of a range of programmes, including a Training Programme for the Arts. Also provides advice on approaching companies for sponsorship, writing proposals and marketing an organization. Carries out a national arts sponsorship survey, runs an annual arts showcase for business, and a successful mentoring programme, matching senior arts managers with their peers in the arts.

Submission Policy The Awards are open to arts organizations who have received sponsorship from business in the last year. Call for entries is made in February every year, with a one month application time-frame.

Grants awarded Arts Sponsor of the Year Awards runs annually in May.

Calouste Gulbenkian Foundation

98 Portland Place, London, W1B 1ET **E** info@gulbenkian.org.uk

W www.gulbenkian.org.uk

Contact Sian Ede (Deputy Director)
Please note from 2000 that there is no longer a

discrete arts programme for funding individuals. The Innovation Fund is for not-for-profit organizations only, awarding grants between $f_{10,000}$ to $f_{25,000}$.

Submission Policy For detailed information on grant programmes and exclusions see the

Commissions East

foundation's website.

St Giles Hall, Pound Hill, Cambridge, CB3 0AE T 01223 356882 F 01223 356883 W www.commissionseast.org.uk

A visual arts development agency that works with artists and commissioners to create innovative visual arts projects that place artists' work at the heart of everyday life.

Common Ground

Gold Hill House, 21 High Street, Shaftesbury, SP7 8JE

T 01747 850820

F 01747 850821

E info@commonground.org.uk

W www.commonground.org.uk and

www.england-in-particular.info

Contact Sue Clifford (Director)

Plays a unique role in the arts and environmental fields, distinguished by the linking of nature with culture, focusing upon the positive investment people can make in their own localities and championing popular democratic involvement.

Submission Policy Only occasionally commissions artists but welcomes contact from artists and also facilitators who work directly with communities.

Crafts Council

44A Pentonville Road, Islington, London, N1 9BY

T 020 78062500

F 020 78376891

 $\textbf{E} \ reference@craftscouncil.org.uk$

W www.craftscouncil.org.uk

The UK development agency for contemporary crafts. An independent organisation offering a range of services to makers and the public.

Creative Skills

The Old Grammar School, West Park, Redruth, TR15 3AJ

T 01209 218879

F 01209 219145

E admin@creativeskills.org.uk

W www.creativeskills.org.uk Contact Jane Sutherland

The professional-development organization for all creative industries practitioners in Cornwall. Set up in 2001 to equip creative practitioners in Cornwall with the skills, knowledge and opportunities to develop and share their creativity and increase their prosperity. Grants depend on funding available.

Submission Policy Professional practitioners working within the creative industries who live in Cornwall.

Elephant Trust

512 Bankside Lofts, 65 Hopton Street, London, SE1 9GZ

T 020 79221160

E ruth@elephanttrust.org.uk

W www.elephanttrust.org.uk

Contact Ruth Rattenbury

Aims to 'advance public education in all aspects of the arts and to develop artistic taste and the knowledge, understanding and appreciation of the fine arts'. Support principally given to individuals, art galleries and other organizations in furtherance of these aims.

Submission Policy Excludes students and any other study-related funding. Send applications in writing together with sae. Guidelines are issued. Trustees meet quarterly.

Grants awarded Various grants awarded.

European Associaton for Jewish Culture

79 Wimpole Street, London, W1G 9RY

T 020 79358266

F 020 79353252

E london@jewishcultureineurope.org

W www.jewishcultureineurope.org

Contact Lena Stanley-Clamp

Established in 2001 with mission to foster and support artistic creativity and achievement, and to promote access to Jewish culture in Europe. Grant programmes include visual arts, performing arts and documentary films.

Grants awarded Approximately twenty grants annually in September. Total value approx \pounds 100,000.

Federation of British Artists (FBA)

17 Carlton House Terrace, London, SW1Y 5BD

T 020 79306844

F 020 78397830

E info@mallgalleries.com

W www.mallgalleries.org.uk

Contact John Deston (Gallery Manager)
The Federation of British Artists was founded in 1961 and is the umbrella organization for nine of the countries leading art societies. The FBA offers open art exhibitions and competitions, gallery tours and workshops, gallery hire, a portrait and fine art commissions service and life-drawing classes.

Submission Policy The FBA runs many open exhibitions, which are open to all artists. Election to membership of art societies is by merit.

Grants awarded Over £100,000 worth of prizes awarded every year.

Freeform

Hothouse, 274 Richmond Road, London Fields, London, E8 3OW

T 020 72493394

F 020 72498499

E contact@freeform.org.uk

W www.freeform.org.uk

Active in urban renewal and regeneration through art- and design-led solutions to humanize the social and physical environment locally, nationally and internationally. Combines the skills of artists, architects and local people on urban regeneration projects.

Helix Arts

and Floor, The Old Casino, 1-4 Forth Lane, Newcastle-upon-Tyne, NE1 5HX

T 0191 2414931

F 0191 2414933 E info@helixarts.com

W www.helixarts.com

Specializes in the development of projects and initiatives, including artist residencies and commissions, which explore the role and potential of the arts in a social context.

Henry Moore Foundation

Dane Tree House, Perry Green, Much Hadham, SG10 6EE

T 01279 843333 F 01279 843647

E curator@henry-moore-fdn.co.uk

W www.henry-moore-fdn.co.uk

Contact Alice O'Connor

Established to 'advance the education of the public by the promotion of their appreciation of the fine arts and in particular the works of Henry Moore'. Concentrates its support on sculpture, drawing and printmaking. Promotes exhibitions and publications about Henry Moore, both nationally and internationally.

Submission Policy Grants for organizations only. From $f_{5,000}$ to $f_{20,000}$. Also offers PHD Fellowships and R&D Fund for Collections and New Projects. Applications considered at quarterly meetings of the foundation's grants committee. Grants awarded Various - see website.

Impact Arts

The Factory, 319 Craigpark Drive, Dennistoun, Glasgow, G31 2TB T 0141 5753001 F 0141 5753009

E mail@impactarts.co.uk

W www.impactarts.co.uk Contact Mairi Sanders

A leading community arts company committed to involving people of all ages and abilities in innovative, arts-based activities across Glasgow, Scotland and the UK. Established in 1994, the company works in partnership with a variety of community groups, schools, housing associations and funding agencies, developing and delivering

tailored long- and short-term projects and events.

Iris, International Women's Photographic Research Resource

Loughborough University, LUSAD, Epinal Way, Loughborough, LE11 3TU

T 01509 228949

E iris@lboro.ac.uk

W www.irisphoto.org

Contact Mort Marsh

IRIS is a research centre within the School of Art and Design at Loughborough University, with a focus on the initiation of conferencing, publishing, exhibiting and educational projects within the field of contemporary womens' photographic practice, and broadening access to the medium through books, exhibitions and educational activities. Submission Policy See website. Not open to students.

ISIS Arts

1st Floor, 5 Charlotte Square, Newcastle-upon-Tyne, NE1 4XF

T 0191 2614407

F 0191 2616818

E isis@isisarts.org.uk W www.isisarts.org.uk

Initiates and manages productions, exhibitions and artist residencies, and works with artists on collaborative projects and events. Track record of providing quality arts projects to benefit individual artists, schools and communities alike, while promoting the professional status of the artist. Has a digital facility serving artists in the region and promotes an interdisciplinary approach to the use of new media in the arts. Works with around seventy artists a year on residencies programmes and a further forty as part of training programmes.

J. Paul Getty Jr. Charitable Trust

I Park Square West, London, NW1 4LI

T 020 74861859

W www.jpgettytrust.org.uk

Contact Bridget O'Brien Twohig (Administrator) Aims to fund projects to do with poverty and

misery in general, and unpopular causes in particular, within the UK. With regard to the arts grants only the following will be considered: therapeutic use of the arts for the long-term benefit of groups under social welfare (people with mental illness, communities that are clearly disadvantaged, offenders, the homeless, the unemployed and ethnic minorities); projects that enable people in these groups to feel welcome in arts venues, or that enable them to make long-term constructive use of their leisure. Has made total grants worth over £26m since 1986.

Submission Policy Only accepts applications by post. Send a letter no more than two sides long in

post. Send a letter no more than two sides long in the first instance, giving an outline of the project and who will benefit, a detailed costing, the existing sources of finance of the organization, and what other applications have been made, including those to statutory sources and the National Lottery. Applicants should disclose if they have applied to or received a grant previously from the trust.

Jerwood Charitable Foundation

17 Union Street, Bankside, London, SE1 0LN T 020 72610279

E info@jerwood.org

W www.jerwood.org.uk

Contact Roanne Dods (Director)

Dedicated to rewarding excellence in the visual and performing arts, and to education. Supports 'outstanding national institutions', along with projects in their early stages which are unable to secure funding from other sources.

Submission Policy Applications should be by letter, outlining the aims and objectives of the organization and those of the specific project or scheme for which assistance is sought. Also include a detailed budget for the project.

include a detailed budget for the project. **Grants awarded** Various grants, varying from up to \pounds 10,000 in the lower range to \pounds 50,000.

Lime

St Mary's Hospital, Hathersage Road, Manchester, M13 OJH

T 0161 2564389

F 0161 2564390

E lime@limeart.org

W www.limeart.org

Contact Brian Chapman

Founded (as Hospital Arts) in 1974. Works to initiate and deliver arts projects within the arena of health and well-being through collaborative and consultative arts practice. The aim is to develop sustainable artistic initiatives in healthcare

through embedding the expertise of artists and the cultural industries into care planning and delivery and into the social fabric of hospitals. Commissions around 30 artists per year. **Submission Policy** Send CV and examples of current work for consideration. From this, selected artists will be invited to present to the team.

Grants awarded Ten to fifteen grants worth £450,000.

Locus+

17, 3rd Floor Wards Building, 31–39 High Bridge, Newcastle-upon-Tyne, NE1 1EW

T 0191 2331450

F 0191 2331451

E locusplus@newart.demon.co.uk

W www.locusplus.org.uk

Formally established in 1993 but preceded by the Basement Group (1979–1984) and Projects UK (1982–1992). A visual arts commissioning agency that works with artists on the production and presentation of socially engaged, collaborative and temporary projects, primarily for non-gallery locations. In each project, place or context is integral to the meaning of the art work. To date, the organization has completed over fifty projects touring to a further twenty-five other venues, and produced over twenty publications and nine artists multiples.

Mid Pennine Arts

Yorke Street, Burnley, BB11 1HD
T 01282 421986
F 01282 429513
E info@midpenninearts.org.uk
W www.midpenninearts.org.uk
A north-west arts agency with a diverse variety of projects running at any one time.

National Endowment for Science, Technology and the Arts (NESTA)

1 Plough Place, London, EC4A 1DE

T 020 74382500

F 020 74382501 E nesta@nesta.org.uk

W www.nesta.org.uk

Set up by an Act of Parliament in 1998 to help maximize the country's creative and innovative potential. Funded by an endowment from the National Lottery, using the interest to back people of exceptional talent and imagination. Offers support to explore new ideas, develop new products and services, or experiment with new

ways of nurturing creativity in science, technology and the arts.

Nigel Moores Family Charitable Trust

c/o Macfarlane & Co., 2nd Floor, Cunard Building, Water Street, Liverpool, L3 1DS Aims to raise the artistic taste of the public 'whether in relation to music, drama, opera, painting, sculpture or otherwise in connection with the fine arts'. Also promotes education in fine arts and academic education in general, as well as providing support for environmental causes, the provision of recreation and leisure facilities, and the promotion of religion. Has supported institutions that benefit children and young adults, actors and entertainment professionals, musicians, students, textile workers and designers. Submission Policy Apply in writing enclosing a synopsis of aims and funds required, together with financial statements. However, the trust has usually committed its funds for designated projects, making unsolicited applications unlikely to succeed. Trustees meet three times a year.

Peter Moores Foundation

c/o Messrs Wallwork, Nelson & Johnson, Chandler House, 7 Ferry Road, Office Park, Riversway, Fulwood, Preston, PR2 2YH

W www.pmf.org.uk

Aim is 'the raising of the taste of the public whether in relation to music, drama, opera, painting, sculpture or otherwise in connection with the fine arts'. Causes which promote education in fine arts, academic education or the Christian religion also attract support from the foundation, as does the provision of facilities for recreation and leisure. Activities supported tend to reflect the personal interests of its founder and patron, Peter Moores, a director of The Littlewoods Organisation, the pools and mail order company. Submission Policy Prospective applicants should note that the foundation will normally support projects that come to the attention of its patron or trustees through their interests or special knowledge. General applications for sponsorship are not encouraged and are unlikely to succeed. Grants awarded Grants in the following categories: music (performance); music (recording); music (training); fine art; heritage; youth/race relations; social; health; environment.

Picture This

40 Sydney Row, Spike Island, Bristol, BS1 6UU T 0117 9257010

F 0117 9257040 E office@picture-this.org.uk W www.picture-this.org.uk Contact Josephine Lanyon (Director) A moving-image projects agency that commissions contemporary visual art works and produces exhibitions, publications and touring initiatives. Works in partnership with a range of organizations, from galleries and colleges to public sites. The agency develops a range of projects, residencies, research and presentation opportunities as well as providing creative technology services.

Submission Policy Aims to provide a range of opportunities for artists to produce new work, for audiences to engage with moving-image projects and for individuals to gain the experience necessary to find paid employment. Each year the agency aims to advertise one or two opensubmission schemes.

Prince's Trust

Head Office, 18 Park Square East, London, NW14LH

T 020 75431234

F 020 75431200

E webinfops@princes-trust.org.uk

W www.princes-trust.org.uk

A charity aiming to offer young people (14 to 30 years old) practical support including training, mentoring and financial assistance. Focuses on those who have struggled at school, been in care, been in trouble with the law, or are long-term unemployed.

Public Art Commissions and Exhibitions (PACE)

7 John Street, Edinburgh, EH15 2EB T 0131 6200445

E juliet@paceprojects.org W www.paceprojects.org

Contact Juliet Dean

Established in 1996. A public arts agency dedicated to the integration of art into environmental and building projects. Works in a range of sectors including health, education and the environment. Applies for grants for projects on behalf of the client. Recent awards include $f_{350,000}$ from the arts lottery for the Royal Aberdeen Children's Project.

Submission Policy Advertises for artists when opportunities for commissions arise. Works with a range of artists in media such as sculpture, glass, installation, light, photography and new media.

Public Art South West

Arts Council England, 2nd Floor, Senate Court, Southernhay Gardens, Exeter, EX1 1UG

T 01392 229227

E pasw@artscouncil.org.uk

W www.publicartonline.org.uk

Contact Linda Geddes

Recognized as one of the leading public art-development agencies in the UK. Primarily serving the south-west of England, its work extends beyond geographical boundaries in terms of the critical thinking and application of artists' skills and creativity it promotes. Works with artists and national and regional public- and private-sector organizations across Britain, and actively networks with a range of professions within art, design and architecture.

Submission Policy Can advise artists on all aspects of the commissioning process but does not act as a project manager nor recommend artists for individual commissions. Organizes two regional network meetings a year, which have a reduced rate for artists.

Rhizome Commissions

New Museum, 235 Bowery, New York, NY 10002

E nick.hasty@rhizome.org

W www.rhizome.org

Contact Nick Hasty

Rhizome is a non-profit organization founded in 1996, affiliated with the New Museum of Contemporary Art. Provides an online platform for the global new-media art community. Artists who receive a commission will also be invited to speak at Rhizome's affiliate, the New Museum of Contemporary Art, and to archive their work in the ArtBase, a comprehensive online art collection.

Submission Policy Commissioned works can take the final form of online works, performance, video, installation or sound art. Projects can be made for the context of the gallery, the public, the web or networked devices. The call for submissions is open to both national and international artists. Proposed projects can be at any stage of production, from conception to distribution. Applications must be made and submitted online. Grant amounts range from \$1,000 to \$5,000 and can be applied to any aspect of the work, including labour costs, technology, or materials.

Grants awarded Awards up to nine grants: seven grants will be determined by a jury of experts in

the field, and two will be determined by Rhizome's membership through an open vote.

SAFLE

Unit 4 Sovereign Quay, Havannah Street, Cardiff, CF10 5SF

T 0845 2413684

F 02920 487473

E info@safle.com

W www.safle.com

An independent public art consultancy formed in 2007 through the merger of CBAT - The Arts & Regeneration Agency and Cywaith Cymru Artworks Wales. In addition to managing public art commissions and developing bespoke strategies, the Stiwdio Safle Programme runs Artists' Contemporary Projects and Residencies. a mentoring scheme and an annual student award (see Competitions/Residencies/Awards/ Prizes). Also supports short-term, temporary and innovative projects. Awards up to 50% match funding, with upper limit of £15,000. Submission Policy Projects should be based mainly in Wales. Application deadline 30 March and 30 September annually. See website for further details/application criteria.

Scottish Arts Council

12 Manor Place, Edinburgh, EH3 7DD

T 0845 603 6051

E help.desk@scottisharts.org.uk

W www.scottisharts.org.uk

Champions and sustains the arts for Scotland, investing funding from the Scottish Executive and National Lottery to support and develop artistic excellence and creativity throughout Scotland.

Submission Policy For detailed guidelines and application forms to each fund and the latest information, see website or contact the help desk from Monday to Friday between 9am and 5pm.

Stanley Picker Fellowships

I Warren Park, Kingston Hill, Kingston-upon-Thames, KT2 7HX

T 01722 412412

Primarily supports the arts, giving annual grants and fellowships to the arts faculties at the University of Kingston and bursaries to selected schools of music and drama. The trustowned Warren Park, Surrey, used as a gallery to display the trust's own art works, is also a major beneficiary, annually receiving the trust's largest grant. Funding is also given in the fields of music,

writing, acting, printing and sculpture and a few grants to arts organizations. Grants awarded Grants total over £250,000.

Tees Valley Arts

Melrose House, Melrose Street, Middlesbrough, TS12HZ

T 01642 264651 F 01642 264955

E info@teesvalleyarts.org.uk

W www.teesvalleyarts.org.uk

Contact Tim Coyte

TVA has 25 years' experience of managing and delivering high quality creative projects in and around the North East of England. Established in 1982 as Cleveland Arts, TVA specialize in socially engaged arts practice across the public realm.

Visiting Arts

Units 4.01 & 4.02 Enterprise House, 1-2 Hatfields, London, SE1 9PG T 020 7960 9631 F 020 7960 9643

E information@visitingarts.org.uk W www.visitingarts.org.uk

Contact Andy Kyriakides, General Manager Visiting Arts's purpose is to strengthen intercultural understanding through the arts. It supports artists and arts organizations through advice, information and awards involving artist residencies, collaborations, presentations and exhibitions, and presenter, promoter and curator development. It delivers training and professional development programmes for overseas arts managers and UK-based cultural attachés, organizes seminars, conferences and networking events to deepen intercultural understanding, provides consultancy and networking services internationally and for the UK, delivers work across the UK and works with an average of forty countries per year.

Submission Policy No open access funding

Grants awarded For details of specific projects visit the website.

VIVID

140 Heath Mill Lane, Birmingham, B9 4AR T 0121 7667876 F 0871 2510747 E info@vivid.org.uk W www.vivid.org.uk Contact Helen Street Dedicated to the development of contemporary media art and interdisciplinary practice. Supports and commissions research, new works, artists' residencies, events and publications. A project space accommodates the production and exhibition of media arts, bringing together technical resources, support services and presentation facilities.

Voluntary Arts Ireland

12 English Street, Downpatrick, BT30 6AB

T 028 44839327 F 028 44839192

E info@vaireland.org

W www.vaireland.org **Contact** Olive Broderick

Seeks to promote participation in the arts and crafts by supporting the development of the voluntary arts sector, primarily by facilitating the development of a strong infrastructure, strategic thinking and good practice across the sector. Linked to similar bodies in England, Scotland and Wales via the Voluntary Arts Network (VAN). Weekly e-news - sign up at www.vaireland.org Submission Policy Register online.

Wellcome Trust Arts Awards

Gibbs Building, 215 Euston Road, London, NW12BE

T 020 76117222

E arts@wellcome.ac.uk

W www.wellcome.ac.uk

A main funder of scientific biomedical research in Britain, with spending on par with the government's Medical Research Council. Within their schemes are the People Awards, a mechanism for funding initiatives up to £30,000 that encourage and support public engagement with biosciences, especially novel and imaginative activities. The scheme is open to academics, mediators and practitioners (including artists).

Submission Policy Applications can be made at any time during the year and will be subject to review by referees.

Winston Churchill Memorial Trust

15 Queen's Gate Terrace, London, SW7 5PR

T 020 75849315 F 020 75810410

E office@wcmt.org.uk

W www.wcmt.org.uk

A living tribute to Churchill, running since 1965, when thousands of people subscribed £3m to provide travelling fellowships. Since then, the net income from investments has been used to fund over three thousand fellowships. Approximately one hundred are awarded annually for projects overseas lasting four to eight weeks on average. The grant awarded covers all fellowship expenses, return airfare, travel within the country(-ies) to be visited, daily living and travel insurance.

Submission Policy British citizens may apply. No formal education or professional qualifications required. No grants awarded for attending courses, academic studies, student grants or gap-year projects.

Woo Charitable Foundation

277 Green Lanes, London, N13 4XS T 07974 570475 F 020 88863814

Contact John Dowling (Administrator/Secretary) Established for the advancement of education through supporting, organizing, promoting and assisting the development of the arts in England, together with the specific aim of helping those less able to help themselves. Funding is usually spread over a number of years.

Grants awarded Over £250,000 in 'artistic grants'.

09

Societies and other artists' organizations

Why be an artist?

Gavin Turk

This simple question is very complex. Being an artist in 2008 is greatly motivated by an analysis of this question. The answers could seem simple:

Because you can... Why not? Because I like making pictures. Because I can't think of anything better to do...

Instead of answering in these obtuse ways, I have gone on a little meander: wondering about art's purpose, tracing the use of art within the landscape of art history.

One, Two, Skip-a-Few, Ninety-Nine, a Hundred...

The first artists

The earliest forms of representation referred to as art are cave paintings: dream-like hieroglyphs of cattle made schematically with purpose-built tools. Were the people who made them spending time just grinding up coloured rocks and acquiring esoteric skills while others were doing the necessary jobs to sustain life?

The cave walls became not windows to the outside world, but some form of testament to the inside one, in both senses of dwelling and mind. These pictures were made to last, made to remember something. The author was making something for the community to use as a thinking space.

Turning their hand to god

As this philosophical space grew, so the community created what might be called gods: 'special forces' that explained the presence of certain unfathomable phenomena. These gods needed to find some earthly stasis and certain characters in the community had the provision and vision to create forms that could represent these life-affirming powers. These people were simultaneously in contact with the gods while

being servants of the social group – producing objects and images for people to use in the act of worship. History was conceptually initiated and continued, growing in breadth and depth.

The Emperor's new painting

Eventually powerful parties in societies started to employ the services of artists to represent not just the gods, but also themselves as some historic marker of their existence. The images of kings, queens and men of the cloth gave way to nobles, lords, barons and businessmen, in fact anyone who had the *wasta* or finances to employ artists to depict the subject of their desires. Artists (as they had begun to be known) were employed to record aspects of the way the world looked and by the middle of the 16th century an art market was in existence.

Art as storytelling (with codes and messages)

Art was not only a space for acting in an objective or political way, but also a means of storytelling in a more passive narrative sense. In 1638 Nicolas Poussin painted *The Shepherds of Arcadia* as a commission for Cardinal Richelieu. It shows three shepherds standing in a romantic landscape pointing out an old sarcophagus with the Latin inscription 'et in arcadia ego'. Even in utopia, death existed. Allegedly the picture also contained secret messages hidden in the composition, so it may serve as a kind of map to those who know how to read it.

The artist paints himself into the picture...

In 1656 the artist Diego Velázquez painted his masterpiece *Las Meninas* (the Maids of Honour). In the picture he is in the process of painting a portrait of King Philip IV of Spain and his wife Mariana. Standing beside the artist is the young Princess Margarita surrounded by her various servants. In the presence of the work, the audience is flattered to be in the place of the monarchs (reflected in the mirror) as they look up at the painting, but they also find themselves looking at the artist and have to think of his lifestyle and his ego. Art starts

to take the audience on some sort of Mobius journey travelling out from and arriving back at the artist.

Social politics

The use of the art platform for social commentary was already an artistic tradition when William Hogarth made his series of eight paintings collectively named A Rake's Progress in 1735. This moralizing tale designed to entertain and educate the audience depicted the rich merchant's son. Tom Rakewell. frittering his wealth away in brothels and gambling dens, only to end his days in Bedlam.

The art goes public

Artists were soon being collected like anthropological artefacts from distant lands. Museums and galleries were being constructed and art was becoming public property, causing the audiences for art exhibitions to swell.

Artists who wanted to change the world

In the 1020s a collective group of artists formed and called themselves Surrealists. Headed by André Breton, they wrote manifestos claiming that through art a radical shift in political reason could be achieved. Culture was the life-affirming glue between people and art was a major part of its political make up. Like the Dada artists (1916-20) before them, who refused all accepted or existent forms of art, the Surrealists believed that the truth was to be found in Sigmund Freud's notion of the murkier recesses of the subconscious. Cathartic, freed-up experiences lay in wait for those who came in contact with it, much like a dream being seen as a sorting of unprocessed, unfiled thoughts. The effect these artists had in changing the visual fabric of the western world is still in evidence today, although as usual not perhaps in ways that they intended.

More politics, less dreams

In the 1960s the Situationists, another collective of politicized artists, began remixing ideas from Dada and Surrealism, adding in Karl Marx. For them, art was primarily propaganda: a means of disseminating revolutionary socialist ideas about how to, or how not to. think, which was ironic given the prescriptive art coming out of the Soviet Union at the time. Daily life was a political scenario and so was art. Art was made to express community ideals: it was part of a discussion, which in the case of the Situationists revolved around driving a critical wedge into the heart of the bourgeoisie. After meetings in shady cafés or bars in Paris members would jump into cars and drive around defacing posters and advertisements put up in prominent communal sites. By adding or removing bits of material, satirical social comments were inadvertently exposed to the audience in much the same way that some graffiti art functions today.

The artist addresses the audience

By the mid-1970s the notion of a culture travelling full steam ahead for progress started coming up against issues of gender and race. This coupled together with new technologies gave rise to artists choosing to work with new media such as video or film, avoiding the historically male and colonialist forms of painting and sculpture. New forms of democratic art production ensued, most memorably when the artist Joseph Beuys claimed in a 1973 lecture that 'civilization is an art work and everybody is an artist'.

Colour and marketing

Colour itself has been used to express certain meanings in art. The use of ultramarine blue (Lapis Lazurite) in religious paintings of the Middle Ages became synonymous with depictions of the Virgin Mary. It also increased the value and status of the work, as Lapis was more expensive than gold at the time. In 1964 Yves Klein created his own blue, which he termed 'International Klein Blue' or IKB, making several series of works using the colour as a kind of signature or worldview. In 1961 Johannes Itten wrote The Art of Color: The

Subjective Experience and Objective Rationale of Color where he tried to outline how particular colours make people feel.

Art makes you feel better

The simple activity of 'creating art' has been understood to have therapeutic properties as seen in institutions using art therapy; this also has roots in outsider art or Art Brut, a subcategory of art from around the beginning of the last century. One of the earliest and most prolific exponents was the Swiss psychiatric patient Adolf Wölfli who produced over 2,000 super-intricate and elaborate drawings at the beginning of the 20th century.

Art as self expression: the need for originality

A history of expressing ideas and emotions through art is a complex thread culminating in the image of Jackson Pollock wildly and energetically throwing paint onto his canvas to enter the new virgin territory of art as pure emotion.

Knowing your place in the world

The process of making art puts the author in direct contact with the artistic context; art history and cultural background surround the work and all act on it in a discursive way. So new art is always in some form of synergetic relationship with both the past and the present as well as its cultural context. As China opens up its trade routes to the West so Chinese artists are beginning to be able to communicate across cultural boundaries through museums and galleries of the western world.

The last frontier of the real

Recently, art has become a kind of last bastion to the real. Its contemporary status has been cast by former challenges to 'the perceived reality of things'. Art is always a picture making, once an object is situated in an artistic context it is fated to be an artistic version of its former self, for instance, the clichéd image of *Fountain*, the 1917 sculpture by Marcel Duchamp. But situated in the image-flooded, mass-marketed culture of today, ironically art is probably more than ever a confirmation of time, space and actual object.

Societies and other artists' organizations

a-n The Artists Information Company / a-n Magazine

ıst Floor, 7–15 Pink Lane, Newcastle-upon-Tyne, NE1 5DW

T 0191 241 8000

F 0191 241 8001

E info@a-n.co.uk

W www.a-n.co.uk

A leading UK organization for supporting contemporary visual arts practice. Publications, programmes and services meet the professional needs of artists and the visual arts sector, identifying changing trends and new needs. Subscriptions for artists and arts professionals combine a-n Magazine with expert resources on www.a-n.co.uk, including daily updated artists' jobs and opportunities. a-n developed and manages AIR (Artists Interaction and Representation) to provide artists with a voice and representation within arts decision-making and develop professional benefits including automatic fsm Public Liability insurance.

Admissions Policy Subscription packages open to all. AIR (Artists Interaction and Representation) membership is only available to professional artists within the Artist subscription.

Subscription rates Annual artist subscription + AIR £36 (£44 for arts organizers, £72 for organizations) provides access to resources on www.a-n.co.uk. and ten issues of a-n Magazine.

Air Space Gallery

No4 Broad Street, Stoke-On-Trent, ST1 4HL T 01782 261221

E airspaceinfo@btinternet.com

W www.airspacegallery.org

Founded in 2006. Stoke-on-Trent's first contemporary art gallery. Exhibiting professional as well as developing artists, the project caters for a range of contemporary art forms and artists. Runs workshops and other community projects. In process of developing artists' studios.

Admissions Policy Applications welcome. See website.

All Arts

Creation Station, c/o Newsham ALC, 83 Newsham Drive, Liverpool, L67UH W www.allarts.org.uk Contact Anthony Mantova (Manager)

Founded in 1998 to promote, support, develop and create art in all its forms and bridge the traditional void between different arts and art organizations. Runs arts, education and employment open days to show the links between these industries, and has performed plays and run workshops to encourage adults and children to participate in the arts. Has a network of national and international contacts. Works with a number of local and national agencies.

Admissions Policy Artists in various disciplines are welcome to become members and all receive a weekly newsletter.

Subscription rates Annual: £10. Under 18s - free.

Alternative Arts

Top Studio, Montefiore Centre, Hanbury Street, London, E1 5HZ

T 020 73750441

F 020 73750484

E info@alternativearts.co.uk

W www.alternativearts.co.uk

Contact Maggie Pinhorn

Founded in 1971 to invest in new artists and ideas and to make the arts accessible to the public. Produces a wide range of arts events including exhibitions, festivals, dance, music, poetry, mime, theatre, fashion, photography and literature.

Admissions Policy Only invites submissions when necessary.

Anne Peaker Centre for Arts in Criminal Justice (Unit for the Arts and Offenders)

20 Newburn Street, London, SE11 5PJ

T 020 77356831

E info@apcentre.org.uk

W www.apcentre.org.uk

Contact Carol Clewlow

Set up by Anne Peaker and Dr Jill Vincent in 1992 as part of the Centre for Research in Social Policy at Loughborough University. Supports the development of the arts within criminal-justice settings. Currently its work falls within the following broad objectives: to influence policy; to promote the value of the arts; to provide clear, up-to-date information, advice and support to all those interested or involved in this field of work; to develop a national framework for continuous professional development for artists working or wishing to work in criminal-justice settings; and to put the organization's knowledge and expertise at the service of the sector.

Art and Spirituality Network

c/o 48 Kenilworth Avenue, London, SW19 7LW E artandspirituality@gmail.com

W www.artandspirituality.net

A small self-run network of artists and non-artists which provides a supportive and challenging space for people to find spiritual fellowship and nourishment through making art. Workshops aim to bring spiritual refreshment and companionship as well as fostering inspiration and creativity and are open to active artists and those of no artistic experience. Welcomes those of all faiths and none, drawing on a variety of wisdom and faith traditions and on the wider world. Occasional electronic newsletter publicises events and news.

Subscription rates Free (small donations welcome).

Art Connections

The Art Depot, Asquith Industrial Estate, Eshton Road, Gargrave, Skipton, BD23 3SE

T 01756 748529

F 01756 749934 E admin@art-connections.org.uk

W www.art-connections.org.uk

A project initiated and managed by Chrysalis Arts Ltd, developing and supporting creative businesses in the visual arts, crafts and public art sectors in North Yorkshire. Offers professional artists and makers information, advice, training and marketing support services. Also coordinates a county-wide open-studio programme.

Admissions Policy Services only available to professional North Yorkshire-based artists and makers.

The Art House

Drury Lane, Wakefield, WF1 2TE

T 01924 377740

F 01924 377090

E info@the-arthouse.org.uk

W www.the-arthouse.org.uk

Contact Helen Darlington (Artists Officer)
A national visual arts organization established
to create equality of opportunity for disabled and
non-disabled artists and craftspeople. Founded in
1994 by a group of visual artists, it is an inclusive
organization that believes in enabling all artists
to have access to work, training and exhibition
opportunities in accessible settings. The Art House
building provides 12 studios, accommodation for
artists and their carers and project space.

Admissions Policy Visual artists and craftspeople with and without disabilities.

Subscription rates All fees annual: £15 or £7.50 (concessions) per person; £32.50 for group membership; £20 for two persons in the same household.

Art in Partnership

34 Blair Street, Edinburgh, EH1 1QR

T 0131 2254463 F 0131 2256879

E info@art-in-partnership.org.uk

W www.art-in-partnership.org.uk

Contact Lesley Woodbridge

An independent visual arts consultancy and public art-commissioning agency. Provides an advisory, curatorial and project-management service for architects, planners, urban designers and publicand private-sector organizations considering commissioning works of art or developing a collection.

Admissions Policy Send current CV and documentation of work, e.g.CD, DVD or slides/publications.

Art in Perpetuity Trust (APT)

Harold Wharf, 6 Creekside, Deptford, London, SE8 4SA

T 020 86948344 F 020 86948344

E aptlondon@btconnect.com

W www.aptstudios.org

Contact Liz May

APT encourages participation in the visual arts through creative practice, exhibitions and education.

Admissions Policy Supports thirty-seven fineart studios. Prospective artists should check the website for availability.

Art Safari

46 Victoria Road, Woodbridge, IP12 1EJ

T 01394 382235

E info@artsafari.co.uk

W www.artsafari.co.uk

Contact Mary-Anne Bartlett

Adventurous painting holidays worldwide. Art Safari takes artists to paint and sketch the wildlife and landscapes of Africa, Asia & Antarctica. The tutored safaris are based in national parks and areas of outstanding natural beauty and give insight into conservation, village life and natural creativity. Designed to be eye-opening and fun, trips also include visits to centres for carving, textiles, painting and ceramics. Group departures and tailor-made safaris. ATOL registered 9916.

Founded in 2003 by travel artist Mary-Anne Bartlett who also runs sketching workshops in UK 2008.

Admissions Policy Open to artists of all standards. Bursaries available to professional artists on application. Opportunities to work alongside artists from the host country. Non-painters also welcome for photography.

Artists' Network Bedfordshire

30 Osburn Road, Barton-le-Cley, MK45 4PA T 0844 357520

E karen.cameron@artsnetbeds.org.uk

W www.artsnetbeds.org.uk

Contact Karen Cameron

Founded in 1995 to promote the visual arts in the county. A voluntary artist-led organization promoting exhibitions and studio events. An open studio event is held every year in September over three weekends, during which artists open their houses and studios to the public for free.

Admissions Policy Membership of the network is

Admissions Policy Membership of the network is open to artists living or working in Bedfordshire. Selection procedure by committee.

Subscription rates £35 showing member; £15 student member; £15 associate member.

Artpoint

2 Littlegate Street, Oxford, OX1 1QT

T 01865 248822

F 01865 248899

E info@artpointtrust.org.uk W www.artpointtrust.org.uk

Contact Kevin Wilson (Director)

Works with artists to support new thinking and practice for the built environment and public space across the South East region. Operates as a 'not for profit' limited company with charitable status. In the past five years has delivered over sixty projects, worth over £5 million. Offers specific project management skills and works on small to multimillion pound developments. Aims to advocate for, and establish, opportunities for artists to create new work within public contexts. This includes public art commissioning, consultancy, research projects, audience engagement activities and education programmes.

Admissions Policy Artists are welcome to submit their website, CV or contact details.

Arts & Business

Nutmeg House, 60 Gainsford Street, Butler's Wharf, London, SE1 2NY T 020 73788143 F 020 74077527

E head.office@aandb.org.uk

W www.aandb.org.uk

A creative network that seeks to help business people support the arts and the arts to inspire business people. Fosters long-term partnerships between business and the arts through an investment programme, New Partners. Runs a series of professional-development programmes, which promote the exchange and development of skills between the two communities. In association with the Prince of Wales Arts & Kids Foundation, it helps businesses develop practical ways of helping children engage with the arts. Also offers advice, training, networking and consultancy on a wide range of issues to business and the arts through a membership programme.

The Arts Catalyst

Toynbee Studios, 28 Commercial Street, London, E1 6LS

T 020 73753690

F 020 73770298

E info@artscatalyst.org

W www.artscatalyst.org

Established since 1993. Mission to extend, promote and activate a fundamental shift in the dialogue between art and science and its perception by the public. Facilitates collaborative art-science projects, expanding new territories for artistic practice and setting up multidisciplinary research laboratories. Particular current concerns focus on artists' engagement (practical, artistic, political) with biotechnology, ecology, space research, micro- and hyper-gravity research, astrophysics, biodynamics, and remote independent research in science, art and tactile media.

Arts Education Development

16a Broad Street, Bath, BA1 5LJ

T 01225 396425

E penny_hay@bathnes.gov.uk

W www.bathnes.gov/arts

Contact penny hay

Runs several major research projects in creative education: $5\times5\times5$ = Creativity, researching creative learning and teaching strategies in the early years and primary education; Creative Education for Disaffected and Excluded Students (CEDES), researching creative learning and teaching strategies to engage disaffected and excluded students, and those at risk of disaffection and exclusion; The Learning Centre (TLC), academic

research into creative learning and teaching strategies, including teacher training. Also offers professional-development courses for teachers to support arts coordination and creative learning and teaching strategies.

Admissions Policy Open to artists in education.

Arts Project

Northgate Hospital, Morpeth, NE61 3BP T 01670 394174

E Brian.Scott@nap.nhs.uk

Contact Brian Scott

Operating since 1982. Runs a programme of participatory arts workshops where visual artists, musicians, etc. work primarily with people with learning disabilities. Though based at Northgate Hospital, workshops also take place in community venues throughout the region. Special ad hoc projects offer occasional opportunities for commissioned work.

Admissions Policy Keen to hear from artists of all disciplines who might be able to work in this demanding field.

ARTS UK

71 Westmacott Street, Newburn, Newcastle-upon-Tyne, NE15 8NA

T 0191 2646686

F 0191 2646686 E email@arts-uk.com

W www.arts-uk.com

Contact Steve Chettle

Set up in 2000 as an arts organization to provide commissioning and other services to private, public and voluntary sectors. Specializes in public art commissions.

Admissions Policy Artists interested in being considered for the database should submit a CV and CD of images.

The Artspace Lifespace Project

The Island, Silver Street, Bristol, BS1 2PY **T** 0117 9297534 / 07846 086969

E info@artspacelifespace.com

W www.artspacelifespace.com

The Artspace Lifespace Project is an artist-led initiative that recycles vacant, under used and often semi-derelict urban and rural sites into thriving active creative arts resources. Recent redevelopments include: workshops, studio spaces, galleries, café's and performance spaces, which are made available to the local creative community and general public at affordable rates.

Association of Illustrators

2nd Floor Back Building, 150 Curtain Road, London, EC2A 3AT

T 020 76134328

F 020 76134417

E info@theaoi.com

W www.theaoi.com

Contact Ramón Blomfield

Established in 1973 to promote illustration, advance and protect illustrators' rights and encourage professional standards. A non-profit-making trade association dedicated to its members' professional interests. Membership consists of freelance illustrators as well as agents, clients, students and universities.

Admissions Policy Full members must supply three printed illustrations produced within the last year. Associate membership is for those yet to be commissioned.

Subscription rates £24 joining fee plus: £132 for full members; £108 for associate members; £51 for student members; £185 for corporate members; £100 for college members.

Aune Head Arts

High Moorland Business Centre, Old Duchy Hotel, Princetown, Yelverton, PL20 6QF

T 01822 890539

F 01822 890539

E info@auneheadarts.org.uk

W www.auneheadarts.org.uk

Contact Nancy Sinclair

A rural-centric arts organization based on Dartmoor. Works with artists and audiences to bring new work to diverse audiences. Aims to develop projects utilizing traditional and new technologies; engage communities and audiences in aesthetic reflection and debate on issues of rural life; collaborate with organizations engaged in similar work; provide continuing professional development and mentoring to artists within the region; and develop and disseminate models of best practice and innovation for contemporary artists working within a rural context.

Admissions Policy Project artists are generally selected via invitation or a commissioning process. Time permitting, it may review unsolicited project outlines that complement the organization's work. Subscription rates Membership fees range from £5 to £100 life membership. Artists need not be members to be involved in projects.

Autograph ABP

Rivington Place, London, EC2A 3BA

T 020 77299200

E info@autograph-abp.co.uk

W www.autograph-abp.co.uk

A non-profit photographic arts organization established in 1988. Primary role is to develop, exhibit and publish the work of photographers and artists from culturally diverse backgrounds and to act as an advocate for their inclusion in all mainstream areas of exhibition, publishing, training, education and commerce. To this end, it produces its own programme of activities, exhibitions, events, residencies, publications, etc. and collaborates with other arts organizations nationally and internationally.

Admissions Policy Email up to 12 jpegs of work (each 100KB or less) plus CV and artist's statement.

Avis

Round Foundry Media Centre, Foundry Street, Leeds, LS11 5OP

T 0870 4430701

F 0870 4430701

E info@axisweb.org

W www.axisweb.org

Organization which administers a leading online guide to artists practising in the UK today. Champions the work of artists by presenting authoritative information about their practice (web links, biographies, images, video and audio clips), enabling artists to profile their work to an expanding audience. Also collaborates with a network of advisors (artists, curators, commissioners, academics and visual arts writers) to inform content on the website. The only artist directory funded by Arts Council England, the Arts Council of Wales and the Scottish Arts Council. Admissions Policy Encourages applications from practising artists living and working in the UK and who demonstrate a critical engagement with contemporary practice.

Subscription rates Free, then £25 single directory membership.

Bankside Gallery, gallery of the Royal Watercolour Society and the Royal Society of Painter-Printmakers

Bankside Gallery, 48 Hopton Street, London, SE1 9JH

T 020 7928 7521

F 020 7928 2820

E info@banksidegallery.com

W www.banksidegallery.com

Contact Angela Parker (Director)

Gallery of the RWS and RE, RWS founded over two hundred years ago and was the first institution in the world to specialize in watercolours. Members have included John Sell Cotman, David Cox. Edward Burne-Iones. Helen Allingham and currently include Leslie Worth and Ken Howard. RE founded in 1880 and recognises printmaking as a creative rather than reproductive art. Members have include Auguste Rodin and Graham Sutherland. Norman Ackrovd and Paula Rego are among current Members. Programme of exhibitions at Bankside Gallery includes two RWS Members' exhibitions (spring and autumn). RE Annual exhibition (May) and several joint exhibitions. RWS also runs an open exhibition during February and both Societies offer a series of educational activities.

Admissions Policy Elections are held annually for both Societies – see website for details.

Bath Area Network for Artists (BANA)

The Old Malthouse, Comfortable Place, Bath, BA1 3AI

T 01225 471714

E enquiries@bana-arts.co.uk

W www.bana-arts.co.uk

Contact Administrator

An artist-led network established in 1998 to address the needs of the large number of visual artists based in Bath and surrounding areas. It is a non-selective, membership-led organization for artists with a commitment to professional practice. Aims to raise the profile of visual arts activity in the Bath area, establish and strengthen links between artists, artists' groups and art promoters, and advocates increased investment in local arts activities. Members' benefits include a website, newsletter, professional-development opportunities and regular events.

Admissions Policy Membership open to visual artists living or working in the southwest region, particularly Bath and North East Somerset.

Subscription rates £18 for individuals; £54 for groups; £12 for full time students/within one year of graduation. Membership including public liability insurance for artists is also available.

Rean

The Orangery, Back Lane, Wakefield, WF1 2TG

T 01924 215550

F 01924 215560

E contact@beam.uk.net

W www.beam.uk.net

Offers professional services and programmes in

education and training, public art commissioning, consultancy, general project management and conferencing. Aims to help people make better places through the promotion of good design and imaginative use of arts in the public realm.

Bonhoga Gallery

Weisdale Mill, Weisdale, Shetland, ZE2 9LW T 01595 830400

F 01595 830444

 $\textbf{E}\ bonhoga-gallery@shetland-arts-trust.co.uk$

W www.shetlandarts.org

The visual arts arm of Shetland Arts Trust, which celebrated its 10th anniversary in 2004. Open year-round showing local, national and international exhibitions of art and craft. Has a touring exhibition programme to five satellite venues throughout Shetland, runs an education and outreach programme, community workshops and a successful residency programme at The Booth in the nearby village of Scalloway. Housed in an old converted mill and about 20 minutes to the west of Lerwick, the main town in Shetland. The Booth is available to rent for £250 per month.

Bristol Creatives

Old Schoolhouse , Salisbury Street Studios, Barton Hill, Bristol

E sally@bristolcreatives.co.uk

W www.bristolcreatives.co.uk

An artist-led networking and marketing initiative launched in 2006, for local visual and applied artists and designer-makers. Originally granted pilot funding by the Arts Council England South West and Bristol City Council, but now relies solely on Gold Membership subscriptions and ongoing support from BEST (Bristol East Side Traders). Admissions Policy Open to applied and visual artists working in the Bristol area. Currently over 1,200 registered members.

Subscription rates £30 annual membership.

British Academy

10 Carlton House Terrace, London, SW1Y 5AH

T 020 79695200

F 020 79695300

E secretary@britac.ac.uk

W www.britac.ac.uk

The national academy for the humanities and the social sciences, established by Royal Charter in 1902. An independent and self-governing fellowship of scholars, elected for distinction and achievement in one or more branches of the academic disciplines that make up the humanities and social sciences, organized in eighteen sections by academic discipline.

Admissions Policy There are Ordinary Fellows, Senior Fellows (over the age of 70), overseas Corresponding Fellows and Honorary Fellows (whose numbers are limited to twenty). Up to thirty-five new Ordinary Fellows may be elected in any one year.

British Association of Art Therapists (BAAT)

24-27 White Lion Street, London, N1 9PD

T 020 7686 4216

E info@baat.org

W www.baat.org

The professional organization for art therapists in the UK, formed in 1964. Maintains a comprehensive directory of qualified art therapists and works to promote art therapy in the UK.

British Society of Master Glass Painters

6 Queen Square, London, WC1N 3AR

T 01643 862807

E secretary@bsmgp.org.uk

W www.bsmgp.org.uk

Contact Chris Wyard

Founded in 1926. A society for individuals involved in the production of stained and painted glass and other glass treatments (etching, sandblasting, fusing, etc.), both traditional leaded methods and non-leaded, for religious and secular public buildings or private commissions. Members also involved in research, history, recording, photography and sale of glass.

Subscription rates Associate £33.25 per year.

Concessions: £15 for students; £18 for seniors.

Bureau of Freelance Photographers

Focus House, 497 Green Lanes, London, N13 4BP

T 020 88823315

F 020 88863933

E info@thebfp.com

W www.thebfp.com

Contact Angela Kidd

Founded in 1965, aiming to help freelance and aspiring freelance photographers to sell their work. Publishes a monthly Market Newsletter for members and an annual Freelance Photographer's Market Handbook. Members also have access to advice and mediation services.

Admissions Policy Membership open to anyone interested in freelance photography.

Subscription rates £54 per annum UK; £70 per annum overseas.

Cambridge Open Studios

12A High Street, Fulbourn, Cambridge, CB21 5DH **T** 01223 561192

E info@cambridgeopenstudios.co.uk W www.cambridgeopenstudios.co.uk

Contact Jane Gaskell (Administrator)

Exists to promote the making of original works of art and craft and to provide an opportunity for the public to become involved by meeting artists in their studios, seeing their work and how it is produced. Started with six artists in 1974 and by 2004 had three hundred.

Admissions Policy Must be makers or designers of original works of art or craft and live and/or have a studio in Cambridgeshire.

Subscription rates 2007 Fees: £30 membership fee; £15 joining fee for new or lapsed members; £140 participation fee; £500 group fee.

Candid Arts Trust

3 Torrens Street, Angel Islington, London, EC1V 1NQ

T 020 78374237

F 020 78374123 E info@candidarts.com

W www.candidarts.com

Founded in 1980. A thriving arts centre consisting of three galleries (6,000 sq. ft in total), a café and artists' studios, all available for hire. As a self-funded charity, the trust aims to promote the arts, with an emphasis on newly graduated artists and designers through a marketing package providing exhibition space and artist websites, and acting as an agent for sales and commissions. Also runs the Islington Contemporary Art & Design Fair, regular artists' screenings/film events and life-drawing and painting classes.

Admissions Policy Entry requirements for Network AD (Candid's graduate marketing package): a BA or MA certificate; all media and areas are accepted. Welcomes submissions for exhibitions from artists generally.

Subscription rates £60 for annual subscription to Network AD.

Chelsea Arts Club

143 Old Church Street, London, SW3 6EB
T 020 73763311
E secretary@chelseaartsclub.com
W www.chelseaartsclub.com
Contact Dudley Winterbottom
A hundred-year-old members' club for painters, sculptors, architects, designers, photographers

and craftsmen. With dining room, bar, garden and

thirteen bedrooms (from £38 a night), based in central London.

Admissions Policy Proposer and seconder required. Election by committee.

Chrysalis Arts Ltd

The Art Depot, Asquith Industrial Estate, Eshton Road, Gargrave, BD23 3SE

T 01756 749222

F 01756 749934

E chrysalis@artdepot.org.uk

W www.chrysalisarts.org.uk

An artist-led company that has been creating art in public spaces since 1987. Besides working in close collaboration with architects, landscape architects, planners and developers, Chrysalis has pioneered techniques for facilitating community involvement in public art. In 1997, the company built the Art Depot as its base and established an international training centre where artists and others involved in work in public spaces come to learn and work together.

Admissions Policy Does not have the capacity to respond to unsolicited applications. See the website for training opportunities, etc.

The Common Guild

Suite 5, 2nd Floor, 73 Robertson Street, Glasgow, G2 8QD

T 0141 2230087

E info@thecommonguild.org.uk

W www.thecommonguild.org.uk

Contact Katrina Brown (Director)
A a charitable, not-for-profit visual arts
organisation established in 2006, dedicated to
producing a dynamic international programme of
contemporary visual art projects, exhibitions, and
events. These include gallery-based exhibitions
and ephemeral, non-gallery projects, interventions
and collaborations. Commissions new works.

Community Arts Forum

15 Church Street, Belfast, BT1 1PG T 028 90242910

F 028 9031264

W www.community-arts-forum.org
Founded at a meeting of community arts
activists in Belfast in 1993. A membership-based
organization that elects a fifteen-person executive
annually. Currently has over three hundred
groups and over 150 individual artists affiliated,
representing all sections of society in Northern
Ireland and all areas, and whose activities cover all
art forms. Has been at the forefront of the growth

of community arts activity in Northern Ireland over the last ten years.

Subscription rates Indivual f10; Groups f30 per year.

Conceptual Artists Network -CAN

W www.conceptualartistsnetwork.com

Admissions Policy CAN is a tool for networking artists whose work is driven by concepts and ideas. Aims to create awareness of the conceptual art scene and the artists within it, whilst also creating opportunities, instigating collaboration and allowing discussion. CAN is based in Brighton and welcomes artists from anywhere. See website for membership details.

Contemporary Art Society

11-15 Emerald Street, London, WC1N 3QL T 020 78311234 E info@contemporaryartsociety.org W www.contemporaryartsociety.org Founded in 1910. Promotes the collection of contemporary arts through gifts to public galleries and guidance to individuals and companies. Subscription rates See website.

Contemporary Art Society for Wales -Cymdeithas Gelfydoyd Gyfoes Cymru

I Court Cottages, St Fagans, Cardiff, CF5 6EN T 029 20595206

E seccasw@tiscali.co.uk

Founded in 1937. Supports the contemporary visual-art scene in Wales by: annual art-work purchases for gifting to Welsh museums, art galleries and other public institutions; studentship awards; awards to other arts bodies; an annual national Eisteddfod purchase prize; publication awards; lectures and study visits (including abroad); exhibitions.

Subscription rates £4 for students; £24 for single membership; £35 for double membership.

Contemporary Glass Society

c/o Broadfield House Glass Museum, Compton Drive, Kingswinford, DY6 9NS T 01603 507737 F 01603 507737

E admin@cgs.org.uk

W www.cgs.org.uk

Founded in 1997 with the dual objectives of encouraging excellence in glass as a creative medium and developing a greater awareness and appreciation of contemporary glass worldwide.

Admissions Policy Membership is open to anyone interested in contemporary glass.

Subscription rates £30 for professional members; £20 for concessions; £80 for corporate members.

The Courtyard

Edgar Street, Hereford, HR4 9JR T 01432 346509

F 01432 346549

E info@courtyard.org.uk W www.courtyard.org.uk

Contact Helen London on 01432 346 509. A ten-year-old, highly regarded vibrant arts centre serving the whole of Herefordshire and the surrounding region. Featuring exhibition spaces, theatre, workshops, cinema etc.

Admissions Policy The Visual Arts panel meets in January and July. The panel welcomes submissions form artists working in either two or three dimensions. There are approximately six exhibition periods per year, showcasing a diverse range of work from local, national and international artists, ranging from established artists to those at the start of their career. Contact Helen London on 01432 346 509, e-mail: helen. london@courtyard.org.uk

Craft Central

33-35 St John's Square, London, EC1M 4DS T 020 72510276

E info@craftcentral.org.uk

Craft Central, the new name for Clerkenwell Green Association, is a not-for-profit organization established over 25 years ago. Crafts people and designer-makers can join Craft Central's Designers' Network, show work in exhibitions or in the online gallery, rent work spaces and get practical business help.

Admissions Policy See website for details.

Crafts Council

44A Pentonville Road, Islington, London, N1 9BY T 020 72787700

F 020 78376891

E reference@craftscouncil.org.uk

W www.craftscouncil.org.uk

The UK development agency for contemporary crafts. An independent organization, funded by Arts Council England, that offers a range of services to makers and the public. London base includes reference library, the National Register of Makers, and Photostore, an online visual database of selected makers.

Create

10-11 Earl St South, Dublin 8

T oi 4736600 F oi 4736599

E info@create-ireland.ie

W www.create-ireland.ie

Contact Katherine Atkinson (support@

artsincontext.com)

Established in 1983, a national development agency for collaborative arts providing services for arts development and practice in Ireland. Services are designed to support arts practitioners and arts organizations irrespective of their area of practice or arts programme.

Admissions Policy Particularly welcomes applications from practitioners involved in collaborative arts.

Subscription rates Membership rates: €30 for individuals and €60 for organisations.

Creative Learning Agency

Abbey Chambers, Kingston Buildings, Off York Street, Bath, BA1 1LT

T 01225 396 392

F 01225 396 442

E info@creativelearningagency.org.uk

W www.creativelearningagency.org.uk

Contact Donna Baber

An arts education agency which was established in 2001. The agency works to broker partnerships between artists, teachers, educators and arts organizations through its core service, a website and increasingly through one-to-one support for funding, continuing professional development, the Artsmark scheme and specialist arts colleges. The agency works across all artforms, age ranges and abilities. It undertakes activity across four local authorities: Bath and North East Somerset, Bristol, North Somerset and South Gloucestershire. Admissions Policy Current enhanced disclosure from the criminal records bureau, evidence of three creative learning projects in last two years, plus two referees.

Subscription rates Free to join the database.

Creative Partnerships

Great North House, Sandyford Road, Newcastle Upon Tyne, NE1 8ND

T 0844 8112145

E enquiries@creative-partnerships.com W www.creative-partnerships.com Provides schoolchildren across England with the opportunity to develop creativity in learning and to take part in high-quality cultural activities. Helps schools to identify individual needs and enables them to develop long-term, sustainable partnerships with organizations and individuals including architects, theatre companies, museums, cinemas, historic buildings, dance studios, recording studios, orchestras, filmmakers and web designers. Worked with 1,400 schools in England.

Creative Capital

c/o Platform 3, 3 Wilkes Street, London, E1 6QF T 020 7375 2973

E info@creative-capital.org.uk

W www.creative-capital.org.uk

Contact Jessica Akerman or Annabel Frearson
Promotes professional development for artists and
arts practitioners who live and work in London.
A network of arts organizations giving expert
advice to people looking for career development
and information on training, learning and other
relevant resources in London. Website and
e-bulletin offer up-to-date details of events and
opportunities.

Cultural Co-operation

First Floor, Pinchin Street, London, E1 1SA

T 020 7264 0000

F 020 7264 0009

Eldc@culturalco-operation.org

W www.culturalco-operation.org

Contact Charlotte Dove

An independent arts charity that promotes international and intercultural understanding through the arts. Established in 1987, its programme includes the summer Music Village, London Diaspora Capital (an internet-based resource that raises the profile of artists from London's diverse communities), an education programme for schools, regular continuing professional development for artists and a number of related projects.

Admissions Policy Welcomes contact from artists from London's diverse national and faith communities for possible inclusion on its web database.

Design and Artists Copyright Society (DACS)

33 Great Sutton Street, London, EC1V 0DX

T 020 73368811

F 020 73368822

E info@dacs.org.uk

W www.dacs.org.uk

Contact Janet Tod

Established in 1984. A not-for-profit organization promoting and protecting the copyright and

related rights of artists and visual artists in the UK and worldwide. Represents 52,000 artists and their heirs, comprising 36,000 fine artists and 16,000 photographers, illustrators, craftspeople. cartoonists, architects, animators and designers. Admissions Policy Membership is open to any visual creator.

Design Council

34 Bow Street, London, WC2E 7DL T 020 74205200 F 020 74205300 E info@designcouncil.org.uk W www.designcouncil.org.uk Seeks to demonstrate and promote the role of design in a modern economy. Admissions Policy Does not welcome submissions from artists.

Design Factory

Units 7 & 8 Navigation Wharf, Carre Street, Sleaford, NG34 7TW T 01529 414532 E info@designfactory.org.uk W www.designfactory.org.uk Creative development agency based in the East Midlands. A not-for-profit organization that provides a wealth of market opportunities and business support for the talented design and craft sector in Derbyshire, Leicestershire, Lincolnshire. Nottinghamshire, Northamptonshire and Rutland. Admissions Policy See website for membership/ associate membership details and costs. **Subscription rates** From £40, plus non-refundable £17.25 application fee.

Devon Guild of Craftsmen

committee.

Riverside Mill, Bovey Tracey, TQ13 9AF

T 01626 832223 F 01626 834220 E devonguild@crafts.org.uk W www.crafts.org.uk Contact Saffron Wynne (Exhibitions Officer) The largest contemporary crafts venue in the south-west, representing over 240 makers across the range of craft disciplines. A focus on craft culture for the region, including commissioning, education, professional development, workshops and lectures. Contact for free mailing. Admissions Policy Members and makers living in the south-west are welcome to apply. Benefits include retail sales, exhibition and marketing

opportunities. Work must be approved by selection

Subscription rates £92.50 for full members (associate rate also available).

East Street Arts (ESA)

Patrick Studios, St Mary's Lane, Leeds, LS9 7EH T 0113 2480040 F 0113 2480030 E info@esaweb.org.uk W www.esaweb.org.uk Contact Lara Eggleton

Founded in 1993 by two artists and now governed by board of directors/trustees. Promotes visual artists' career development through events and by offering high-quality, well-managed studios and facilities on two sites. Artists' support includes professional development programmes and training sessions tailored to artists' needs. Annual cost of studio space: fg per sq. ft for Patrick Studios (in city centre); £5.50 per sq. ft for Beaver Studios.

Enable Artists

Wayside Cottage, Ffordd Walwen, Lixwm, CH88LU E enableartists@btinternet.com

W www.enableartists.com

Contact Catherine Taylor Parry (north) or Alice Dass (south)

Started in 2001 to give artists with multiple sclerosis (MS) the opportunity to show their work in a virtual gallery and to exhibit together. Admissions Policy Artists with MS are welcome to apply, as well as other disabled artists who are interested in showing their work in a group. Artists who would like to be involved in finding and organizing exhibition spaces are particularly welcome. Membership from throughout the UK. **Subscription rates** *f* 10 pa for website and postage.

engage - National Association for Gallery Education

Rich Mix, 35-47 Bethnal Green Road, London, E16LA

T 020 77393688

F 020 72533918 E info@engage.org

W www.engage.org

An international association for gallery educators, artist educators and other arts and education professionals. Promotes access to the visual arts through 'gallery education', i.e. projects and programmes that help schoolchildren and the wider community become confident in their understanding and enjoyment of galleries and the visual arts.

Enterprise Centre for the Creative Arts (ECCA)

London College of Communication, University of the Arts London, Elephant & Castle, London, SE1 6SB

E info@ecca-london.org

W www.ecca-london.org

Offers students and graduates from the University of the Arts London one-to-one advice on setting up and running a business including: assistance with funding/sponsorship proposals, business planning, financial guidance, selling and promotion, and project-, business- and self-management.

Admissions Policy Does not accept submissions but when attending a session with a specialist creative-industry business adviser, it is recommended to bring along any relevant materials such as a portfolio, CV, cards, brochures etc.

Euroart Studios

Unit 22F, 784/788 High Road, Tottenham, London, N17 0DA

T 07802 502136

E studios@euroart.co.uk

W www.euroart.co.uk

Contact Nigel Young

A not-for-profit organization providing affordable studio spaces and opportunities for artists and makers. Established in 2002 in an old rag-trade factory by professional artist/curator Lorraine Clarke and space projects quality engineer Nigel Young. Now a complex of 43 studios of various sizes, hosting some 50 artists/creative businesses who are recipient to various business support services, organization of annual open studios events, off-site exhibitions, provision of information on business and network opportunities, and business mentoring. Proactively managed, Euroart promotes the work of its resident artists/creative businesses. Studio spaces from £95 to £550 per month.

Admissions Policy Send CV and images of work via email.

European Council of Artists (ECA)

Borgergade III, DK-1300 Copenhagen, Denmark, DK-1300 Denmark

T +45 35384401 / +45 35384417

E eca@eca.dk

W www.eca.dk

Contact Elisabet Diedrichs

An umbrella for national, interdisciplinary artists' councils and artists' organizations, currently in twenty-five European countries. Aims to safeguard the political and cultural position of the arts and artists in Europe and works for the interests of the professional artists in political, economic, judicial and social contexts.

Admissions Policy ECA is an organization of artists' organizations. Single artists cannot be members.

Fabrica

40 Duke Street, Brighton, BN1 1AG T 01273 778646

E info@fabrica.org.uk

W www.fabrica.org.uk

Contact Caitlin Heffernan

An educational charity with a gallery committed to promoting understanding of contemporary visual art and craft. Opened in 1996 in the defunct Holy Trinity Church in the heart of Brighton Fabrica produces three main exhibition projects a year, in contemporary craft, materials-based installation, lens-based media or digital/interactive art. A programme of talks, workshops and networking opportunities runs alongside the exhibitions. The Artist Resource, a free information centre and hub for artists' professional development, is situated at Fabrica.

Admissions Policy Commissions site-specific work. Contact the gallery for more information.

Federation of British Artists (FBA)

17 Carlton House Terrace, London, SW1Y 5BD

T 020 79306844

F 020 78397830 E info@mallgalleries.com

W www.mallgalleries.org.uk

A registered charity and umbrella organization for nine leading art societies. Aims to be the national focal point for contemporary art with timeless values. Has 614 artist-members and over 10,000 artists who submit to open shows. FBA member societies are the Royal Institute of Painters in Watercolours, the Royal Society of British Artists, the Royal Society of Marine Artists, the Royal Society of Portrait Painters, the Royal Institute of Oil Painters, the New English Art Club, the Pastel Society, the Society of Wildlife Artists and the Hesketh Hubbard Art Society

Admissions Policy Submissions should be made to individual member societies (see above).

Figurative Artist Network (FAN)

Unit 112, 62 Tritton Road, West Norwood, London, SE21 8DE T 020 87613443 E figurativeFAN@aol.com

W www.steveyeates.co.uk

An artist-led network set up with the aim of fighting the idea that figurative art is an outdated art form. Seeks to bring together artists who share the same aspirations to encourage and support, discuss and inspire the promotion of innovative work in contemporary culture. Holds group sessions and encourages the practice and making of figurative art with a view to setting up a collaborative exhibition.

firstsite

@ The Coach House, East Hill House, 76 High Street, Colchester, CO1 1UF T 01206 577067

F 01206 577161

E info@firstsite.uk.net

W www.firstsite.uk.net

A contemporary visual arts organization. Currently developing a permanent home designed by Rafael Viñoly as a social space for changing exhibitions, workshops, lectures and community events. Admission free.

Forma Arts & Media

2-8 Scrutton Street, London. EC2A 4RT T 020 7456 7820

F 0207 456 7822 E info@forma.org.uk

W www.forma.org.uk

Contact David Metcalfe

One of Europe's leading agencies for interdisciplinary art. Pioneers new projects with artists internationally. Generates, tours and publishes high-quality work, creating dialogues between artists, audiences and places.

Foundation for Women's Art (FWA)

55-63 Goswell Road, London, EC1V 7EN

T 020 72514881

E admin@fwa-uk.org

W www.fwa-uk.org

Contact Monica Petzal Director

A networking, administrative and educational organization that promotes women artists through exhibitions, events and education. The website is a prime UK source of information about, and of interest to, women artists.

Submission Policy Details of Friends scheme on the website.

GLOSS

Colwell Arts Centre, Derby Road, Gloucester, GL1 4AD

T 01452 550439

F 01452 550539 E gloss@gloss-aie.co.uk

W www.gloss-artsineducation.co.uk

Gloucestershire's arts education agency. Aims to provide opportunities for children, their carers and teachers to engage with a wide range of quality creative activity. It does this by providing advice. support and information to schools, youth groups, artists and arts organizations. Produces a termly magazine for teachers and artists. Contact the agency to be added to the mailing list. Admissions Policy See website to register on online artists' database.

Greenwich Mural Workshop

78 Kinveachy Gardens, Charlton, London, SE7 8EJ T 020 84737006

E steve@greenwichmuralworkshop.com W www.greenwichmuralworkshop.com

Contact Steve Lobb

Founded in 1975. An artists' cooperative specializing in the design and manufacture of murals, mosaics, banners and in the design and creation of urban parks, gardens and playgrounds. The group works with local authorities, businesses and community groups and has a strong reputation for its collaborative works.

Admissions Policy Artists experienced in drawing and design and interested in working with a variety of clients should send CV, letter and pictures.

Grizedale Arts

Lawson Park, East of Lake Coniston, Ambleside. LA218AD

T 015394 41050

F 015394 41910

E info@grizedale.org W www.grizedale.org

Contact Adam Sutherland or Alistair Hudson An international research and development agency for visual artists based in the Lake District National Park. The programme supports artists in making new works that relate to the context of the area. engaging with local communities and events, integrating artists' thinking and communication into mainstream and traditional activities. The emphasis is on developing new approaches to working and the dissemination of generated ideas. Up to ten research and development grants are awarded annually, to develop projects that

may feed into an annual programme of activity. Grizedale Arts was reconstituted in 2001 as a successor to the previous residency programme sited in Grizedale Forest.

Group 75

Tyddyn Squire, Bersham, Wrexham, LL14 4 LU

E m.tietze@btinternet.com

W www.group75.co.uk

Contact Margaret Tietze

A group of professional artists formed in 1975 by Margaret Tietze. Membership has varied over time; currently ten members, of whom seven live in Wales. Work is in mixed media and exhibitions are toured nationally and internationally with guest artists invited to contribute.

Admissions Policy Artists are invited to join only on recommendation of group members. A balance of media and skills is the criterion.

Guild of Aviation Artists

Trenchard House, 85 Farnborough Road, Farnborough, GU14 6TF

T 01252 513123

F 01252 510505

E admin@gava.org.uk

W www.gava.org.uk

Contact Susan Gardner

Founded in 1971. Aims to promote, foster and encourage all forms of aviation art by providing a forum for discussion of ideas between members through exhibitions, meetings and workshops. Holds an annual summer exhibition at the Mall Galleries in London, as well as regional exhibitions.

Admissions Policy Aviation art in any handapplied medium. Computer-generated or enhanced work excluded.

Subscription rates Entry membership as a Friend (artists and non-artists) £25 pa. Membership rates vary according to status.

Guild of Glass Engravers

87 Nether Street, London, N12 7NP
T 020 84464050
F 020 84464050
E enquiries@gge.org.uk
W www.gge.org.uk
Contact Christine Reyland

Founded in 1975 by a small group of British engravers. The primary aims are to promote the highest standards of creative design and

craftsmanship in glass engraving, and to act as a forum for the teaching and discussion of engraving techniques.

Admissions Policy Membership is worldwide and open to anyone interested in engraved glass. The guild welcomes new members, who may or may not practise engraving. There is a system of assessment and election within the guild for practising engravers.

Subscription rates $f_{37.50}$ for UK lay members.

here nor there

E info@herenorthere.org W www.herenorthere.org

Founded in 1998 to facilitate international collaborations in digital-media and audiovisual performances and events. Projects are developed through directly participating in international residencies, events and exhibitions. Utilizes Internet technology as a resource and as an arena for project development and creative collaboration. Admissions Policy Policy Artists are approached through invitation or project-based calls for submissions via the website.

Hesketh Hubbard Art Society

Federation of British Artists, 17 Carlton House Terrace, London, SW1Y 5BD

T 020 7930 6844

F 020 7839 7830

E info@mallgalleries.com

W www.mallgalleries.org.uk

Contact Simon Whittle

Runs regular life drawing and painting sessions in the evenings at the Mall Galleries. Three models pose, two life and one portrait, with a choice of short or long poses. Although not tutored, participants learn from the company of fellow artists.

Admissions Policy Membership is by annual subscription. A free taster session is offered. Subscription rates £200 per year.

Hinterland Projects

River Trent, Nottingham

E jennie@hinterlandprojects.com

W www.hinterlandprojects.com

Contact Jennie Syson

Begun along the river Trent in Nottingham in 2006, Hinterland projects aim to explore the term hinterland through contemporary art projects, including site specific installations and collaborations, in the public realm. Visit the projects section to find out about future events

and initiatives. Also included here is an extensive archive of previous projects.

Admissions Policy Open to proposals.

Independent Art School (IAS)

London

E editor@independent-art-school.org.uk W www.independent-art-school.org.uk

Contact Pippa Koszerek

An artist-run project set up in 1999, functioning as a nomadic university. Its online journal contains writings from past conferences and events. Has developed as an artistic concept whereby different artists can take it on.

Admissions Policy Welcomes emails from artists or organizations wishing to collaborate.

Indigo Arts

9 Cole Road, Aylesbury, HP21 8SU T 01296 423795

F 01296 392404

E antonia@glynnejones.freeserve.co.uk

Contact Antonia Glynne Jones

A group of artists originally founded by the painter Oliver Bevan. There is no house style but a commitment to making intense, evocative images, whether figurative, abstract or poetic in paint, collage, assemblage and print or drawing media.

Institute of Art & Law

Pentre Moel, Crickadarn, Nr Builth Wells, Powys, LD2 3BX

T 01982 560666

E info@ial.uk.com

W www.ial.uk.com

A small independent research and educational organization founded in 1995 to analyze the interface between the world of art and antiquities and that of the law. Main objective is to increase public knowledge concerning the contribution of law to the development of cultural tradition. Organizes seminars and distance-learning courses, and publishes a quarterly periodical and several specialist books.

Institute of International Visual Arts (inIVA)

Rivington Place, London, EC2A 3BA

T 020 77299616 F 020 77299509

E institute@iniva.org

W www.iniva.org Founded in 1994. Creates exhibitions, publications, multimedia, education and research projects designed to bring the work of artists from culturally diverse backgrounds to the attention of the widest possible public. Anchored in the diversity of contemporary British culture and society, inIVA engages with culturally diverse practices and ideas, both local and global. Invites artists and audiences to question assumptions about contemporary art and ideas, and acts as a catalyst for making these debates and art works part of mainstream culture.

Ipswich Art Society

89 Bucklesham Road, Ipswich, IP3 8TT T 01473 717521

E membership@ipswich-art-society.org.uk

W www.ipswich-art-society.org.uk

Contact The Treasurer

Founded in 1874. Deals with paint, print, sculpture and mixed media. Annual open each May and June, the Anna Airey Award (to young artists aged 16 to 25 and to a mature student) and an exhibition held in February each year.

Admissions Policy Membership decided by an election panel who look at sketch books, completed works, work in progress and statement of aims. Subscription rates £20 for members; £10 for Friends.

Ipswich Arts Association

The Town Hall, Ipswich, IP1 1BZ T 01473 836448 F 01473 836448

E secretary@ipswich-arts.org.uk W www.ipswich-arts.org.uk

Contact Vera Rogers (Secretary) Founded in 1984. Supports the work of arts organizations and individual artists in Ipswich and Suffolk, with over forty member groups. Provides opportunities to discuss matters of mutual concern and acts as a coordinating body for organizations and individuals. Offers advice and information on arts locally and promotes and gives help in presenting events related to arts organizations. Runs talks and workshops, led by professional and amateur practitioners. Works with local authorities and campaigns to secure, maintain and improve facilities for arts organizations.

Unit 114, The Custard Factory, Gibb Street, Birmingham, B9 4AA T 0121 7535301 E info@ixia-info.com W www.ixia-info.com ixia is the public art think tank - it provides

projects at the Drill Hall and Independent Quarry integrate the arts with the stone industry, ecology. geology, architecture and landscape and are a key initiative for the Dorset and East Devon World Heritage Coast, Fully equipped indoor studios

for stone-carvers, sculptors and painters with accomodation on site. Large exhibition space and technical support for commissions

Admissions Policy Facilities open to established and emerging artists. Initial email then follow up with telephone call for one-to-one discussion. Subscription rates \$20 per year for Friends scheme offers 10% reduction on courses, a

newsletter an annual Friends exhibition free lectures and events.

Kernow Education Arts Partnership (KEAP)

guidance on the role of art in the public realm.

independent and objective view of the factors that affect the quality of artists work in the public realm

Through its activities, ixia aims to provide an

by undertaking research and enabling debate.

It identifies and challenges restrictive practices

which result in limited and missed opportunities

for artists, ixia works with artists, policy makers

and implementers within the public and private

delivers training, and commissions new writing

sectors. It carries out research, supports events and

21b Pydar Street, Truro, TR1 2AY

T 01872 275187 F 01872 275182

and publications.

E hrevnolds@cornwall.gov.uk

W www.keap.org

Contact Helen Revnolds

KEAP is Cornwall's development agency for promoting creativity and arts in education activity in learning establishments. Its mission is to engage the whole community in creative learning through the arts and delivers this through providing a brokerage between the arts and cultural sector and the education sector. It currently works very closely with Creative Partnerships Cornwall and plays a significant role in the development of the local programme and partnership. KEAP supports various networks, is a lead organization for literature development in the Southwest and is developing work in the field of Early Years. Admissions Policy Email Helen Reynolds for a database form. Info required includes a CV with education experience, references, CRB and PLI details. KEAP is not an artist employment agency

Learning Stone Portland Sculpture and Quarry

but will recommend artists to schools.

The Drill Hall, Easton Lane, Portland, DT5 1BW T 01305 826736

F 01305 826736

E psqt@learningstone.org

W www.learningstone.org

Contact Hannah Sofaer MA (RCA) or Paul Crabtree MA (Ed)

Tout Quarry is the first sculpture quarry in the UK with work constructed and carved into the landscape. One week courses in stone carving/ sculpture, starting every Monday from May to October, with professional tuition for beginners and all levels of skill. Visual art and landscape

Live Art Development Agency

Rochelle School, Arnold Circus, London, E2 7ES

T 020 70330275 F 020 70330276

E info@thisisliveart.co.uk

W www.thisisliveart.co.uk

Contact Lois Keidan or Daniel Brine

Established in 1999. A leading organization for the support of live art in the UK. Provides practical information and advice, offers opportunities for research, training, dialogue and debate. Works in partnership with practitioners and organizations on curatorial initiatives, and develops new ways of increasing popular and critical awareness of live art. The Study Room is a free, open-access research facility used by artists, students, curators and academics and houses one of the largest libraries of live-art-related videos, DVDs and publications in the UK.

Admissions Policy Works exclusively with live art.

London Photographic Association

23 Roehampton Lane, London, SW15 5LS

T 020 83928557

E info@london-photographic-association.com W www.london-photographic-association.com

Contact Kevin O'Connor

A new association, having grown out of the London Photographic Awards. Membership includes UK and overseas photographers. Aims to give photographers and photography international exposure through an awards structure, online exhibitions, portfolio and essay space, public space exhibitions and relationships with other members of the media, creative and photographic community.

Admissions Policy Visit our website for further information.

Luna Nera

Unit 37 Canal Buildings, Shepherdess Walk, London, N1 7RR

E mail@luna-nera.com

W www.luna-nera.com

Contact Gillian McIver or Valentina Floris
An artist-curator group since 1997. Has created
a number of large-scale live-, visual- and mediaart events in London and around Europe. Also
producing video art live events and screenings.
Aims to stimulate interest in the environmental
and architectural heritage of localities.

Admissions Policy Interested in strongly siteresponsive, collaborative practice only. Does not curate shows for individual artists.

Manchester Academy of Fine Arts

c/o The Portico Library, Mosley Street, Manchester, M2 3HY

T 01457 875718

E secretary@mafa.org.uk

W www.mafa.org.uk

Contact Cliff Moorhouse (Honorary Secretary)
Founded in 1859. Approximately 120
members covering a broad range of media
and approaches. Committed to a developing
exhibition programme of members' work and the
continuation of the north-west of England's major
open exhibition.

Subscription rates £30 per year.

Media Art Bath

Abbey Chambers, Kingston Buildings, Bath, BA1 1LT

T 01225 442591

E info@mediaartbath.org.uk

W www.mediartbath.org.uk

Contact Lucy Sames

Founded in 1999. Specializes in artist commissions in public contexts in relation to new-media technologies. Also provides training and development opportunities, exhibition and production equipment, advice and support. Admissions Policy Welcomes intelligent, researched, provocative proposals from artists who have a proven capacity to deliver and produce high-quality work. The artist does not have to have prior experience of new-media technologies.

Midwest

P.O.Box 3641, Kidderminster, DY10 2WP E info@midwest.org.uk W www.midwest.org.uk

Contact Jason E. Bowman

Since 2003, Midwest has been working with artists, thinkers and organizations in the UK to develop initiatives that encourage artist-led culture on a global level. Hosts an online catalyst project that supports communication and collaboration in the visual arts at a global level. With free membership to date, it allows artists and interested parties to share information and seeks to support artist-led culture.

Admissions Policy The Midwest online 'Bugle' also accepts submissions of critical writing on artist-led culture.

Subscription rates Free.

Milton Keynes Society of Artists

16 Chalfont Close, Bradville, Milton Keynes, MK13 7HS

T 01908 225290

W www.mksa.org.uk

Contact Lisa Campbell

founded in 1980. Meets on the last Wednesday of the month at the Meeting Place in Westcroft in Milton Keynes. Meetings consist of demonstrations in all media and a critique. Members can exhibit four to five times a year with the society. Monthly newsletter sent to enrolled members.

Admissions Policy Only exhibits original art works. No prints, digital work or photographs. Subscription rates £20 individual per year; £30 joint.

Momentum Arts

Bolton's Warehouse, Tenison Road, Cambridge, CB1 2DG

T 01223 500202

F 01223 576307

E info@momentumarts.org.uk

W www.momentumarts.org.uk

Works with a range of partners in east England to enable the development of best practice in the arts. Formerly the Eastern Touring Agency, it changed its name to Momentum Arts in 2003. Main activities include: networks and forums; training; delivery of information, advice and consultancy; capacity building through specific projects (e.g. in regeneration or in cultural diversity); action-research projects; dissemination of best practice theory and research findings; providing routes to specialist knowledge and funding sources; making connections between companies, artists and promoters; and raising the profile of working partners.

National Association of Decorative and Fine Arts Societies (NADFAS)

NADFAS House, 8 Guilford Street, London, WC1N 1DA

T 020 74300730 F 020 72420686

E enquiries@nadfas.org.uk

W www.nadfas.org.uk

Launched in 1968 by Patricia Fay with eleven societies. Has expanded to over 330 societies in the UK, nine in Europe, twenty-eight in Australia and two in New Zealand. With ninety thousand members worldwide, NADFAS works towards promoting and preserving the arts. Concerns include voluntary work to maintain historic buildings, recording churches and their contents, working towards developing the arts for the young and maintaining lecture programmes and tours for members.

National Campaign for the Arts (NCA)

1 Kingly Street, London, W1B 5PA

T 020 7287 3777 F 020 7287 4777

E nca@artscampaign.org.uk

W www.artscampaign.org.uk Contact Louise de Winter (Director)

The UK's only independent lobbying organization representing all the arts. Founded in 1985 to safeguard, promote and develop the arts and win public and political recognition for their importance as a key element in the national culture. Relies on subscriptions to sustain its work and does not receive any public subsidy. Members gain access to the NCA's information and advice, networks, seminars, conferences and publications.

Admissions Policy Membership is open to organizations and individuals working in, or with an interest in, the arts.

Subscription rates f_{50} for individuals; f_{25} for the unwaged. Organizational rates vary according to turnover (see website for full details).

National Sculpture Factory

Albert Road, Cork City, Ireland

T 021 4314353

F 021 4313247 E info@nationalsculpturefactory.com

W www.nationalsculpturefactory.com National organization strengthening support networks for professional artists and acting as a public art resource centre. Advances the creation and understanding of contemporary art. Specifically, it provides and promotes a supportive environment for the making of art, opportunities for commissioning new works, collaborations, residencies and other artistic interventions. Offers annual awards and residencies.

Admissions Policy See website.

National Society for Education in Art and Design

The Gatehouse, Corsham Court, Corsham, SN13 OBZ

T 01249 714 825 F 01249 716 138

E anneingall@nsead.org

W www.nsead.org

Contact Anne Ingall

Offers combined membership of a professional association, a learned society and a trade union. Provides a coherent and comprehensive source of information for art and design teachers and lecturers. Aims to continually define and reassess policies in all areas of art, craft and design education, disseminate new ideas, research and good practice, and provide a forum for discussion. This is achieved through activities such as publishing (on-line, newsletter, journal and books), specialist book-selling, conference organisation, and by providing teaching resources and extensive in-service training opportunities. NSEAD also offers support and access to legal advice and assistance in professional matters whenever possible or desirable.

Admissions Policy Some membership categories are only available to those who are employed or resident in the United Kingdom. Corporate memberships and student memberships are available. The Ordinary membership is for those applying for NSEAD membership for the first time. Subscription rates Ordinary membership is £85, students pay between $f_{10}-f_{25}$. There are six membership categories in total.

National Society of Painters, Sculptors & **Printmakers**

122 Copse Hill, Wimbledon, London, SW20 0NL E sara@nationalsociety.org

W www.nationalsociety.org

Founded in 1930. Holds an annual exhibition in London representing all aspects of art for artists of every creed and outlook. Two newsletters per year for members.

Submission Policy £42.50 for associate members; £85 for full members.

Admissions Policy Submission to Honorary Secretary of six photographs of work and CV plus sae for the council's preliminary consideration. Original work will be requested later.

New Art Exchange

39–41 Gregory Boulevard, Nottingham, NG7 6BE T 0115 9248630

F 0115 9701102

E info@thenewartexchange.org.uk
W www.thenewartexchange.org.uk
Formed in 2003 to steer and manage the
development of Nottingham's first dedicated
cultural facility for Black contemporary arts as
a partnership between APNA Arts and EMACA
Visual Arts

New English Art Club

Federation of British Artists, 17 Carlton House Terrace, London, SE5 9AX E info@mallgalleries.com

W www.newenglishartclub.co.uk

Contact Bob Brown

Founded in 1885 in reaction to the academic artistic tradition of the time. Members have included John Singer Sargent, Wilson Steer, Walter Sickert, Augustus John, Stanley Spencer, Paul Nash and Duncan Grant. While still rooted in the figurative tradition, today's membership also includes artists who have moved towards abstraction and others whose interests are more narrative. All, however, share a belief in the necessity of good drawing. Holds an annual open exhibition in London.

Admissions Policy Membership is by election only but its annual exhibition at the Mall Galleries is open. Details of annual open exhibition are available from Patricia Renny, Federation of British Artists, 17 Carlton House Terrace, London SWry 5BD.

New Work Network

Toynbee Studios, 28 Commercial Street, London, E1 6AB

T 020 7539 9373

E info@newworknetwork.org.uk

W www.newworknetwork.org.uk

Contact Hannah Crosson (New Work Network Administrator)

Promotes and supports the development of new performance, live and interdisciplinary arts practice by providing demand-led networking support for artists and by facilitating engagement and collaboration between practitioners nationally and internationally.

Subscription rates flo membership fee.

Out of the Blue Arts and Education Trust

The Drill Hall, 30–38 Dalmeny Street, Edinburgh, EH6 8RG

T 0131 5557100 / 5557101

F 0131 5557101

E nicole@outoftheblue.org.uk

W www.outoftheblue.org.uk

Contact Nicole Lambeng

Founded in 1994 as a gallery space for new artists. Provides studio, production and performance space for Edinburgh's cultural community, while fostering innovative and accessible creative projects (e.g. international tours and exchanges, social inclusion projects, a quarterly arts market, exhibitions, events). Studio space from £40 to £500 per month. Main hall/exhibition space and rehearsal space for hire.

Pastel Society

Federation of British Artists, 17 Carlton House Terrace, London, SE5 9AX

E info@mallgalleries.com

W www.thepastelsociety.org.uk

Formed in 1898 with founder members and early exhibitors including Brangwyn, Degas, Rodin, Rothenstein, Whistler and G.F. Watts. Aims to promote the best contemporary work by painters who use the medium for its vibrant colour, immediacy and vitality. Also committed to restoring pastels to the levels of popularity they experienced during the seventeenth and eighteenth centuries and during the time of the Impressionists.

Admissions Policy Membership of the society is by

election only, but the annual exhibition at the Mall Galleries is open. Send an sae (35p) to 'PS Entry Details', FBA at the above address. Maximum of six works. Acceptable media are pastel, oil pastels, charcoal, pencil, conte, sanguine or any dry medium.

Pavilion

7 Saw Mill Yard, Round Foundry, Leeds, LS11 5WH T 0113 242 5100

E admin@pavilion.org.uk

W www.pavilion.org.uk

Contact Ruth Haycock

Formally established in 1983, a visual arts organization that engages with photography and lens-based media. Celebrates, develops and promotes the practice of photography as a powerful tool of creative expression and social empowerment. Admissions Policy Submissions for selected projects only (photography, film, writing). Details on website.

Peacock Visual Arts

21 Castle Street, off the Castlegate, Aberdeen, **AB115BQ**

T 01224 639539 F 01224 627094

E info@peacockvisualarts.co.uk

W www.peacockvisualarts.com

Contact Monika Vykoukal (Curator)

Started out in 1974 as a printmaking studio and has developed over the years into the main contemporary visual arts organization in Aberdeen and the Northeast of Scotland, Neither a conventional gallery nor a traditional artists' media workshop, it seeks to involve people of all ages and abilities in creative activity across all sectors of contemporary art.

Admissions Policy Exhibition proposals (any medium) are accepted by letter or email. Mark for the attention of Monika Vykoukal.

Phoenix Arts Association

10-14 Waterloo Place, Brighton, BN2 2NB

T 01273 603700 F 01273 603704

E info@phoenixarts.org

W www.phoenixarts.org

A charitable, non-profit arts organization, offering studio spaces, a gallery and education programme to bring together professional artists and the general public. Offers affordable studio space to over a hundred visual artists working across a range of fine- and applied-art practice, as well as short-term project space for community groups. Phoenix Gallery runs a programme of contemporary visual arts shows in all media. The education programme features workshops in a variety of practices, including life drawing, fine art, art therapy, children's after-school classes, metal jewelry and ceramic sculpture.

photodebut

Hoxton, London, E2 T 07751 212451

E cubs@photodebut.org W www.photodebut.org

Contact Jan von Holleben

Founded in 2003 by the photographers Jan von Holleben, Esther Teichmann and Andy Porter to connect and support talented photographers. Promotes the work of emerging photographers drawing on their collective strength to develop group shows, commissions, community projects, portfolio reviews and educational events. All photodebut photographers share a continuing desire to produce critically engaged work within a variety of contexts.

Admissions Policy Email a portfolio of up to 10 images, CV and cover letter with detailed statement of intent, plus sae. Subscription rates Free.

Printmakers Council

Ground Floor Unit, 23 Blue Anchor Lane, London, SE16 3UL

T 020 72376789 F 020 72376789

E pmcbox@printmaker.co.uk

W www.printmaker.co.uk/pmc

An artist-run, non-profit-making association founded in 1965. Promotes the art form of printmaking, mostly by exhibitions that show the public good examples of both the innovative and skilled use of print. Several shows per year, selected from the artist members, at different venues throughout the UK and occasionally abroad. Most shows include educational activities. Members receive a newsletter and have the opportunity to enter shows and be on the council's website database.

Admissions Policy Open to anyone interested in printmaking. Artist and student printmakers may enter for selection in shows. Associate members receive information.

Subscription rates £60 for UK artists; £30 for students; £35 for associate members; £65 for EU artists; f70 for non-EU artists.

Prison Arts Foundation (PAF)

Unit 3, Clanmil Arts & Business Centre, 2-10 Bridge Street, Belfast, BT 1 1LU T 028 90247872

F 028 90247872

E office@prisonartsfoundation.com

W www.prisonartsfoundation.com

Contact Mike Moloney

The trust was set up in 1996 with the aim of putting artists into prison to work with prisoners. Works in all art forms that are allowable by prison security in each establishment. Currently has writers, visual artists, three-dimensional artists, musicians, dancers, folklore artists, leathercraft artists, theatre practitioners, filmmakers and cartoonists engaged in various residencies of varying lengths.

Admissions Policy Operates only in Northern Ireland.

ProjectBase

The Old Grammar School, West Park, Redruth, TR15 3AJ

T 01209 315924

F 01209 315908

E info@projectbase.org.uk

W www.projectbase.org.uk

Contact Sara Black, Director

Contemporary, not-for-profit visual arts organization that commissions internationally established artists to work with local communities to present exciting and innovative projects. Aim to raise the profile of contemporary visual art in Cornwall by working with partner and other organizations to realize these projects and to make contemporary art accessible to a diverse audience.

proof

Unit 6 The Glass House, Royal Oak Yard, London, SE1 3GE

T 020 74070336

F 020 73781585

E multiples@proof.demon.co.uk

W www.metaproof.com

Contact Sue Withers or Andrew Moller Founded in 1999. An artist-run organization with three main functions: to create, curate, exhibit, sell and distribute a range of artists' multiples; to curate and organize exhibitions; and to provide technical help and digital-production facilities for fine artists.

Queens Park Arts Centre

Queens Park, Aylesbury, HP21 7RT T 01296 424332 F 01296 337363

E info@qpc.org

W www.qpc.org

Contact Louise Griffiths-Kimber or Irene Scott Founded in 1980. Exists to provide participatory arts activities to the community. Runs over fifty arts and crafts workshops per week including painting, drawing, pottery, woodcarving and willow craft. Also hosts one-off workshops with professional artists. Sells a selection of art materials.

Submission Policy £15 for full members; £8 for concessions.

RDS Foundation

Ballsbridge, Dublin 4 **T** 01 6680866 **F** 01 6604014 E arts@rds.ie

W www.rds.ie

The Royal Dublin Society was founded in 1731 to promote and develop agriculture, arts, science, and industry in Ireland. The current arts programme includes the RDS National Crafts Competition, RDS Student Art Awards and the RDS Travelling Art & Craft Exhibitions.

Admissions Policy Must be proposed by two existing members. See website.

Res Artis – International Association of Residential Arts Centres

Arie Biemondstraat 105, 1054 PD Amsterdam T +31 20 6126600

F+31 20 6126600

E office@resartis.or

W www.resartis.org

An international foundation founded in 1993. The sole worldwide network of residential arts centres. Represents the interests of more than two hundred centres and organizations that offer art facilities and conditions conducive for making art. Membership includes residential arts centres, individuals, artists' unions and organizations that represent numerous residential arts centres themselves.

Revolutionary Arts Group

35 Lanfranc Road, Worthing, BN14 7ES T 01903 526268

E rag@artistsandmakers.com

W www.artistsandmakers.com/rag

Contact Dan Thompson

A group of artists, makers and designers based in Sussex, Hampshire, Surrey, Kent & London. The group focus on professional development and networking, as well as working together to curate exhibitions.

Admissions Policy All artists, makers and designers are welcome to apply; preference is given to those in Sussex and surrounding counties.

Subscription rates £120

Royal Academy of Arts

Burlington House, Piccadilly, London, W1J 0BD

T 020 73008000

E info@royalacademy.org.uk

W www.royalacademy.org.uk

Founded by George III in 1768. Governed by artists to 'promote the arts of design' and the first institution in Great Britain devoted solely to the

promotion of the visual arts. Receives no public funding and is completely independent. Admissions Policy Annual Summer Exhibition (June to August) welcomes applications in February of each year. Details available on the website or on the number above. Subscription rates \$70 per year for Friends.

Royal Birmingham Society of Artists

4 Brook Street, St Paul's, Birmingham, B3 1SA T 0121 2364353 F 0121 2364555 E secretary@rbsa.org.uk

W www.rbsa.org.uk

Contact Marie Considine

Founded in 1814. Membership now stands at approximately two hundred professional artists. Aims to promote the arts through holding exhibitions by both regional and national artists. Artists have included Millais, Leighton, Burne-Jones and David Cox.

Submission Policy £22 per year for Friends. Admissions Policy Membership by election.

Royal British Society of Sculptors

108 Old Brompton Road, London, SW7 3RA T 020 73738615 F 020 73703721

E info@rbs.org.uk W www.rbs.org.uk

Contact Adele Love

A membership society for professional sculptors, founded in 1904 by a collective of eminent sculptors of the day. First granted royal patronage in 1911. A registered charity that exists to advance the art of sculpture, ensure a widespread understanding and involvement in contemporary sculpture, and promote the pursuit of excellence in the art form and its practice. Leading sculptors involved over the years include Sir Hamo Thorneycroft, Alfred Gilbert, Ivor Roberts-Jones, Dame Elisabeth Frink, Michael Kenny, Sir Anthony Caro, Eduardo Chillida, Richard Serra, Philip King, Allen Jones and Michael Sandle. Submission Policy £125 per year. Admissions Policy See website for membership

Royal Glasgow Institute of the Fine Arts

5 Oswald Street, Glasgow, G1 4QR T 0141 2487411 F 0141 2210417 Ergi@robbferguson.co.uk

W www.rgiscotland.co.uk

types and application guidelines.

Contact Mrs Leslev Nicholl

Founded in 1861 to promote art by means of annual exhibitions (in Glasgow) of oils, watercolour, sculpture, etc. Membership of 1,200. Open to all artists and small gallery available for solo or group exhibitions.

Admissions Policy Works in most media acceptable. Information available from June each year. Small gallery also available to rent. Subscription rates £35 for first year; £25 annually thereafter. No differentiation between artist and lay members.

Royal Hibernian Academy

Gallagher Gallery, 15 Ely Place, Dublin 2 T of 6612558 F 01 6610762

E rhagallery1@eircom.net W www.royalhibernianacademy.ie

Contact Ruth Carroll, Exhibitions Curator Established in 1823 to promote the practice and awareness of the visual arts in Ireland. Dedicated to developing, affirming and challenging the public's appreciation and understanding of traditional and innovative approaches to the visual arts. This is acheived through an international exhibition programme, educational courses, tours and studios visits for Friends of the RHA. Admissions Policy Applications for exhibition

proposals to the RHA Director, Patrick T Murphy.

Royal Institute of Oil Painters

Mall Galleries, 17 Carlton House Terrace, London, SW1Y 5BD

T 020 79306844 F 020 78397830 E info@mallgalleries.com W www.mallgalleries.org.uk

Founded in 1882 and dedicated to promoting the art of painting in oils. Annual exhibition takes place at the Mall Galleries in central London. Submission Policy Gallery tours are held during the annual exhibition at the Mall Galleries. £2.50 entry fee (£1.50 concessions).

Admissions Policy Open submission to the annual exhibition. A maximum of six works can be submitted, of which a maximum of four will be selected.

Royal Institute of Painters in Water Colours

Federation of British Artists, 17 Carlton House Terrace, London, SW1Y 5BD T 020 79306844

F 020 78397831

E info@mallgalleries.com

W www.mallgalleries.org.uk

Founded in 1831. A registered charity aiming to encourage diversity and innovation in the use of watercolours and water soluble medium. From its beginning, the society showed non-members' works alongside that of members.

Admissions Policy Artists are invited to submit to its annual open exhibition. Up to six works in a water-soluble medium. No metal frames, Send sae (35p) or see website for details.

Royal Photographic Society

Fenton House, 122 Wells Road, Bath, BA2 3AH

T 01225 325733

E reception@rps.org

W www.rps.org

Contact Jo Macdonald - Awards Manager on 01225 325721

Formed as the Photographic Society in 1853 and granted Royal Decree in 1894. Mission is 'to promote the Art and Science of Photography'. The Royal Photographic International Awards are offered annually to individuals who have made significant contributions to the art and science of photography. Offers 16 awards annually, plus two bursaries; Jeff Vickers/Genix Imaging Bursary and the Joan Wakelin Bursary. See individual entries for details.

Admissions Policy Membership open to everyone with a real interest in photography.

Royal Scottish Academy of Art and Architecture (RSA)

The Mound, Edinburgh, EH2 2EL T 0131 2256671

F 0131 2206016

E info@royalscottishacademy.org

W www.royalscottishacademy.org Contact Bruce Laidlaw (Administrative Secretary) The Royal Scottish Academy of Art and Architecture in Edinburgh offers two Scholarships and nine annual awards including the Annual Exhibitions Award list which itself offers 13 prizes. These awards are: Miss M O Taylors Trust Fund; RSA Alastair Salvesen Scholarship - see entry; RSA Annual Exhibition Awards – see entry; RSA New Contemporaries Scotland Award - see entry; RSA Barns-Graham Travel award - see entry; RSA Friends Bursary; John Kinross Scholarship; RSA Morton Award for Lens-Based Work; RSA William Littlejohn Watercolour Award - see entry; Royal Scottish Academy Residencies for Scotland - see entry.

Admissions Policy Check the website or contact directly for application details and dates for open exhibitions.

Royal Scottish Society of Painters in Watercolour

5 Oswald Street, Glasgow, G1 4QR

T 0141 2487411

F 0141 2210417

E rsw@robbferguson.co.uk

W www.thersw.org.uk

Contact Mrs Lesley Nicholl

A registered charity founded in 1878 to promote watercolour painting. Currently has 122 members. Holds annual exhibitions (usually in Edinburgh) open to all artists. A major showcase for watercolourists.

Admissions Policy Submissions to exhibitions must be in water-based media and are subject to selection. Information available from October each year. Membership by election.

Royal Society of Arts (RSA)

8 John Adam Street, London, WC2N 6EZ

T 020 79305115

E general@rsa.org.uk

W www.rsa.org.uk

Founded in 1754, today the RSA is an independent, non-aligned, multidisciplinary registered charity with over 22,000 fellows. Encourages sustainable economic development and the release of human potential through a programme of projects and a national lecture programme consisting of over one hundred events every year. The RSA journal is published bimonthly and automatically sent to all fellows.

Royal Society of British Artists (RBA)

Federation of British Artists, 17 Carlton House Terrace, London, SW1Y 5BD

E info@mallgalleries.com

Established in 1823 by a small group of artists who wished to form an alternative to the Royal Academy. Granted Royal Charter in 1887. Society has had thirty-six Presidents, including James McNeill Whistler, Walter Sickert and Peter Greenham RA. The society has developed a strong commitment to issues of education and in September 1995 supported the foundation of a new fine-art course based around figurative art, run by Northbrook College in Worthing. Annual open exhibition held at the Mall Galleries. Admissions Policy Send sae (35p) to 'RBA Details'

at the above address. Maximum of six works in any

medium, including sculpture and original prints. The galleries cannot hang works taller than 8ft.

Royal Society of Marine Artists

17 Carlton House Terrace, London, SW1Y 5BD T 020 79306844

F 020 78397830

E info@mallgalleries.com

W www.mallgalleries.org.uk

A registered charity devoted to the encouragement and display of contemporary marine painting, drawing, sculpture and printmaking of the highest standard. Founded in 1939, but the Second World War curtailed activity and the society's first exhibition took place in 1946. Granted royal title in 1966. Annual exhibition moved to the Mall Galleries in 1981.

Royal Society of Miniature Painters, Sculptors and Gravers

3 Briar Walk, London, SW15 6UD T 020 8785 2338

E info@royal-miniature-society.org.uk

W www.royal-miniature-society-org.uk Contact Phyllis Rennell (Executive Secretary) Founded in 1895. Aims to promote the fine art of miniature painting or any allied art. Seeks to provide facilities for the exhibition of works by artists in these fields. Annual exhibition held in October at The Mall Galleries, London, SWI. The Gold Memorial Bowl Award was established in 1985 and is one of the highest accolades for miniature art in the world. President: Elizabeth R Meek, PPSWA, HS, FRSA, Offers 11 awards annually. See website.

Submission Policy £90 for associate membership; f_{100} for full membership.

Admissions Policy Apply to the Executive Secretary for an exhibition and information sheet. Non-members may submit work.

Royal Society of Painter-Printmakers

Bankside Gallery, 48 Hopton Street, London, SE19JH

The Society of Painter-Etchers was founded in 1880 and granted its Royal Charter eight years later. It changed its name to the Royal Society of Painter-Printmakers in 1989. Holds an annual exhibition of members' work at Bankside Gallery and is involved in group exhibitions and mixed watercolour and print shows throughout the year. Committed to raising awareness of printmaking as an art through education, demonstrations and talks.

Royal Society of Portait Painters

Federation of British Artists, 17 Carlton House Terrace, London, SW1Y 5BD E info@mallgalleries.com

A registered charity that seeks to promote, maintain, improve and advance education in the fine arts and in particular to encourage the appreciation, study and practice of the art of portraiture. Founded in 1891 with the principal aim of overcoming the 'uncertainty attending the acceptance of portraits, however well painted, by all but academicians'. Became a Royal Society in 1911. Holds an annual exhibition at the Mall Galleries. Many substantial prizes are awarded through the exhibition, and exhibiting artists frequently receive commissions.

Admissions Policy For the open, artists may submit up to three works in any two-dimensional medium. Send sae (35p) to 'RP Entry Details' at the above address.

SAW (Somerset Art Works)

The Old Town Hall, Bow Street, Langport, **TA109OR**

T 01458 253800

E info@somersetartworks.org.uk

W www.somersetartworks.org.uk

SAW is a membership organization for practising artists, initiating and managing a range of events, projects, one-to-one mentoring surgeries and exhibition opportunities throughout Somerset. The Somerset Art Weeks event now runs annually during the autumn, with focus changing annually from open studios to exhibitions and events. Admissions Policy Membership for artists/makers living and working in the region, or affiliate membership open to group and organizations.

Subscription rates Artists: £40 or £25 for concessions, annual. Affiliate membership: £120 for two years.

Scottish Artists Union

c/o Equity, 114 Union Street, Glasgow, GI 3QQ T 07849 637546 E info@sau.org.uk

W www.sau.org.uk

Contact Executive Committee

The representative voice for artists in Scotland since 2001. A membership organisation representing six hundred visual and applied artists in Scotland. Registered as an official Scottish Trade Union. Involved in defence of artists' rights, lobbying to improve their working conditions and payments and representing their interests

to employers, local authorities, arts development agencies and the Scottish Government. Membership benefits include discounted art supplies and services and free Public Liability Insurance.

Submission Policy £35 per year.

Admissions Policy Applicants must work in Scotland for at least six out of twelve months and meet a further four criteria for full membership or two for associate membership. Select from a generous list, detailed on the website.

Subscription rates £35

Society for All Artists (SAA)

P.O.Box 50, Newark, NG23 5GY T 01949 844050 F 01949 844051

E info@saa.co.uk

W www.saa.co.uk

Founded in 1992 to inform, encourage and inspire all artists. With over thirty-four thousand members in sixty countries. Members range from complete beginners to amateurs, professionals and teachers. Welcomes anyone to join, whatever their ability, and provides benefits including a full art materials catalogue with ten thousand-plus products, the Paint newsletter, which appears six times a year, and the chance for artists to promote their work through the website.

Subscription rates £35

Society for Religious Artists (SFRA)

14 Squirrels Way, Badgers, Buckingham. **MK187ED**

T 01280 816828

E whitebird3@mac.com

W www.cosamara.com

Contact Constantina Wood

Founded in 2006, a forum for religious artists of any faith. Encourages interfaith collaboration, open discussion, sharing of ideas and others' beliefs through art, poetry and creative writing. Aims to promote peace through contemporary and traditional religious art.

Admissions Policy Membership is open to anyone interested in religious art.

Subscription rates fro per annum.

Society of Botanical Artists

1 Knapp Cottages, Wyke, Gillingham, SP8 4NQ T 01747 825718 E pam@soc-botanical-artists.org

W www.soc-botanical-artists.org

Contact Pam Henderson (Executive Secretary)

Founded 1986 to promote the fine art of botanical painting or any allied art and to provide facilities for the exhibition of works by artists practising such art. Also seeks to promote appreciation and conservation of botanical species.

Submission Policy £120 per year

Admissions Policy Membership by election based on consistent work. Apply to the Executive Secretary for entry schedule for the annual open exhibition.

Subscription rates f120 to members. f100 to associate members.

Society of Catholic Artists

Garden Flat, 36 Warham Road, South Croydon, CR2 6LA

T 020 86817633 / 07932 764929

F 020 72725458

E mj.sibtain@virgin.net

W www.catholicartists.co.uk

Contact Mary Davey

Founded in 1929. Aims to supply artists and craftsmen for the creation and restoration of church art, and fellowship for Catholics interested in the visual arts. Skills of members include painting, sculpture, stained glass, ceramics, metalware, woodcarving and pottery. Submission Policy £15 for members within fifty

miles of central London; fir for members outside London; f_5 for full-time students.

Admissions Policy Membership is open to any Catholic interested in the visual arts, though artists joining for commissions will need assessment. Subscription rates Annual membership £15.00 if within 50 miles of London; £11.00 outside that; Full time students $f_{5.00}$.

The Society of Graphic Fine Art

27 Lorne Avenue, Croydon, Surrey, CRO 7RQ T 020 8655 0221

E rogerlewissgfa@tiscali.co.uk

W www.sgfa.org.uk

Contact Roger Lewis

Established in 1919 by Sir Frank Brangwyn RA, the SGFA (The Drawing Society) exists to promote and exhibit works of high quality with the emphasis on good drawing and draughtsmanship in pencil, pen, brush, pastels, charcoal, conte or any of the forms of original printmaking. Membership numbers around 95. Welcomes artists working in modern or traditional styles in any wet or dry media and printmaking, though does not accept full oil paintings. Organizes an annual 'open' exhibition of around 170 works,

drawing events and usually a 'members only' event throughout the year.

Admissions Policy Membership submission: four original finished works (mounted but unframed) and folio of up to twelve original drawings (not copies) or original sketchbook.

Society of Portrait Sculptors

T 01962 860904

F n.a

E sps@portrait-sculpture.org

W www.portrait-sculpture.org

Contact Robert Hunt (Honorary Secretary) A representative body of professional sculptors committed to making portrait sculpture accessible to a wider public. Has an annual open exhibition and seeks to encourage education and training in the art through lectures, prizes and events.

Society of Scottish Artists (SSA)

2 Wemyss Ave, Glasgow, G77 6AR

T 0141 6162566

E ssa@tangledwebs.co.uk

W www.s-s-a.org

Contact Noreen Sharkey Paisley (Secretary) Founded in 1891. Represents 'the more adventurous spirit in Scottish art'. Welcomes members from every country and in all media. Hosts an annual open exhibition of contemporary art, held in the Royal Scottish Academy building in Edinburgh.

Submission Policy £40 for ordinary members;

 f_{50} for professional members.

Admissions Policy Anyone may join as an ordinary member. Professional membership is by election. Subscription rates Ordinary £40; Professional £50.

Society of Wildlife Artists

Federation of British Artists, 17 Carlton House Terrace, London, SW1Y 5BD

T 020 79306844

F 020 78397830

E info@mallgalleries.com

W www.mallgalleries.org.uk

Contact Andrew Stock

Founded in 1962. A registered charity aiming to foster and encourage all forms of wildlife art. The society's eighty members produce most of the work on display at the annual exhibition at the Mall Galleries, but non-members are invited to submit their work to be judged by the council for inclusion in the exhibition and outstanding artists are put forward as candidates for membership.

Admissions Policy To enter open annual exhibition download application form from website (maximum of six works, in any medium).

Society of Women Artists

I Knapp Cottages, Wyke, Gillingham, SP8 4NQ

T 01747 825718

E pamhenderson@dsl.pipex.com

W www.society-women-artists.org.uk

Contact Pam Henderson (Executive Secretary) Founded in 1855. Aims to promote visual arts

undertaken by women.

Admissions Policy Acceptable categories: painting, drawing and sculpture in all media; miniature work; engraving, lithography, etc.; ceramics of a non-utilitarian nature.

Subscription rates £110 for associate members; £130 for full members.

Spike Island

133 Cumberland Road, Cumberland Basin, Bristol, BS34NZ

T 0117 9292266

F 0117 9292066

E admin@spikeisland.org.uk

W www.spikeisland.org.uk

Combines working and exhibition spaces for the contemporary visual arts. Aims to provide gallery spaces for 'the making and showing of ambitious new work'. Also offers seventy affordable studios and an international programme of residencies. Admissions Policy Artists are welcome to apply for annual residency programme (see website). Applications for studio space are also welcome (forms and details available online or by post). A selection committee sits four times a year to select artists for the available spaces.

Suffolk Art Society

I Holly Cottages, Little Bealings, Woodbridge, IP13 6PN

T 01473 624141

F 01473 630451

E ferial.rogers@virgin.net

W www.suffolkartsociety.co.uk

Contact Ferial Rogers

Founded in 1954, with a membership of around 100 from Suffolk and surrounding counties. Both professional and amateur artists, mostly working in watercolour and oils but some threedimensional work. Holds three to four exhibitions annually, visiting important local churches including Holy Trinity, Long Melford and Sts Peter and Paul, Lavenham, Awards an annual

prize at Suffolk College to a Fine Art student on the BA (Hons) course, under 21 years old, showing the most progress in their studies. Regular newsletters, previews of exhibitions and an annual general meeting keep members in touch.

Submission Policy £10

Admissions Policy Membership by selection annually in spring. Applicants (both professional and amateur) should submit three recent works in any medium for consideration.

Subscription rates £10

Suffolk Open Studios

24 The Street, Bawdsey, Woodbridge, IP12 3AH T 01449 613077

E chair@suffolkopenstudios.co.uk

W www.suffolkopenstudios.co.uk

Contact Alison Calvesbert

Founded seventeen years ago. Attracts over seven thousand visitors to see the work of two hundred artists in studios across Suffolk. Aims to provide an artistic network for artists and public alike, giving opportunities to artists and helping to promote their work through publications, exhibitions and publicity. Studios are open to the public during the weekends of June each year and throughout the year by appointment. Also showcasing artists work in large venues and giving artists links in order to promote their work through galleries.

Submission Policy £70 per year.

Admissions Policy Open to all artists living or working in Suffolk.

Subscription rates A single artists entry into the Suffolk Open Studios directory is £70.

TotalKunst at The Forest

3 Bristo Place, Edinburgh, EH1 1EY **T** 0131 2204538

E totalkunstsubmissions@yahoo.co.uk

W www.totalkunst.com / www.theforest.org.uk Started in 2000, the Forest is a not-for-profit, artist-led initiative run by volunteers and financed through a vegetarian café. The funds are committed to providing a free events space, exhibition gallery, resource centre, free broadband, film nights, workshops, garden, live bands, etc. TotalKunst, the visual-art programme, launched in 2003.

Submission Policy See website for details: groups. yahoo.com/group/totalkunst/.

Admissions Policy Applications are accepted throughout the year. Places an emphasis on risk-taking works, collaborations and site specificity.

Trans Artists

Arie Biemondstraat 105, 1054 PD Amsterdam E info@transartists.nl

W www.transartists.nl

Contact Director: Maria Tuerlings

An independent information centre for artists, artist-run initiatives and cultural institutions. Offers details of cultural exchanges, artist-in-residence programmes and work opportunities worldwide.

UK Coloured Pencil Society

c/o Carol Bramley (Secretary), White Meadows, Horton, Devizes, SN10 3NB

T 01380 860205

E secretary@ukcps.co.uk

W www.ukcps.co.uk

Contact Carol Bramley (Secretary)

Founded in 2001 to promote the versatile medium of coloured pencils as well as to support and educate all artists who use it.

Submission Policy Within the UK: £25 for full members; £17.50 for associates. Outside the UK: £30 for full members; £22.50 for associates.

Admissions Policy Open membership. Art work submitted for the juried annual exhibition must be one hundred per cent coloured pencil; rules vary for other exhibitions.

Subscription rates £28 for UK members; £20 associates.

Vano

Kings House, Forth Banks, Newcastle upon Tyne, NE1 3PA

T 0191 2618281

F 0191 2618281

E info@vane.org.uk

W www.vane.org.uk

Contact Paul Stone / Christopher Yeats
Founded in 1997. Having worked with over 500 artists from around the world and presenting a series of one-off projects in a variety of temporary venues, Vane opened a permanent gallery space in Newcastle city centre in July 2005. Represents the work of a number of artists, both from across the UK and abroad, as well as showing the work of invited artists in collaboration with other galleries.

Admissions Policy Exhibitions are by invitation.

Visual Artists Ireland

37 North Great George's Street, Dublin, Dublin 1 **T** or 8722296

E info@visualartists.ie

W www.visualartists.ie

Contact Niamh Looney

An all-Ireland body for professional visual artists. It provides services, facilities and resources for artists, initiates artistic projects and publications and acts as an advocate on behalf of individual artists. The organisation was established in 1980 and has a current membership of over 1,400 artists.

Subscription rates €50 (€25 for concessions)

Visual Arts and Galleries Association (VAGA)

The Old Village School, Witcham, Ely, CB6 2LQ T 01353 776356

F 01353 775411

E admin@vaga.co.uk

W www.vaga.co.uk

A membership body open to organizations and individuals concerned with the exhibition, interpretation and development of modern and contemporary visual art on behalf of the public. Functions as a catalyst, sharing expertise and knowledge and campaigning for a healthy visual arts sector fit to meet the needs of audiences, creative practitioners and the broader public agenda.

Visual Arts Scotland (VAS)

6/8 Newhaven Road, Edinburgh, EH6 5PU

T 0797 9924744

E info@visualartsscotland.org

W www.visualartsscotland.org

Contact Tamara Ogilvie

Founded as SSWA in the 1920s (evolved to admit men) and became known as VAS. A rapidly expanding society of 370 artists, 160 of whom have been selected to professional membership. Annual exhibition in central Edinburgh.

Submission Policy f to for associate members (students, students graduated in the last three years and artists under 25); f for ordinary members.

Admissions Policy See website, posters or advertisements for annual open exhibition and various awards.

Visual Images Group

6 Dolphin Place, Aylesbury, HP21 7TG
E vi-group@btconnect.com
W www.bucks-open-studios.org.uk
Contact Sally Bulteel (Chairman)
Aims to promote public awareness of the
diversity of visual arts and crafts throughout
Buckinghamshire and surrounding counties.
Representing over four hundred artists,

craftspeople and art lovers, the group has run Bucks Open Studios for the past twenty years, when participating artists open their studios to the public.

Submission Policy £12 for individual membership; £18 for family or joint membership.

Subscription rates £12 individual membership; £18 family/joint membership.

Vital Arts

Ist Floor, 9 Prescot Street, London, E1 8PR T 020 74804654

F 020 73777317

E vitalarts@bartsandthelonon.nhs.uk

W www.vitalarts.org.uk

A groundbreaking programme of integrated arts projects for the comfort, healing and well-being of patients, staff and the hospital community. Arts projects are designed to involve and engage hospital staff, patients, relatives and the local community. Develops commissions and residencies, and shows art by artists, staff and community groups at a number of locations.

Voluntary Arts Network

121 Cathedral Road, Pontcanna, Cardiff, CF11 9PH

T 029 20395395

F 029 20397397

E info@voluntaryarts.org

W www.voluntaryarts.org

The UK development agency for the voluntary arts, working with policy-makers, funders and politicians to improve the environment for everyone participating in the arts. Provides information and training to those who participate in the voluntary arts sector. Has headquarters in Cardiff and four teams working in England, Ireland. Scotland and Wales.

Wales Arts International

o Museum Place, Cardiff, CF10 3NX

T 029 20376500

F 029 20221477

E info@wai.org.uk

W www.wai.org.uk

Established in 1997. A partnership between the Arts Council of Wales and British Council Wales to promote contemporary culture from Wales and encourage international exchange and collaboration.

Watercolour Society of Wales – Cymdeithas Dyfrlliw Cymru

4 Castle Street, Raglan, NP5 2JZ

T 01291 690260

W www.watercolourwales.co.uk
Formed in 1959 to promote the practice of
painting in water-soluble media. Membership of
mainly professional artists either living in or from
Wales. Members include Ivor Davies, Bert Isaac,
Jonah Jones, Mary Lloyd Jones, Richard A.Wills,
Des Hawkins and David Tress.

West Yorkshire Print Workshop

75A Huddersfield Road, Mirfield, WF14 8AT T 01924 497646 E info@wypw.org W www.wypw.org

An open access printmaking facility that runs a regular programme of specialist printmaking courses and other related activities including arts and crafts activities and workshops for young people. Supports artists and creative businesses by providing printmaking facilities, affordable studio spaces and exhibiting opportunities for members.

Westbury Farm Studios

Foxcovert Road, Shenley Wood, Milton Keynes, MK5 6AA T 01980 501214 E westburystudios@hotmail.co.uk Contact Annabelle Shelton or Sally Annett Formerly the Silbury Group, founded in 1991 as a handful of artists eager to make connections, find studios and have a place to show their work. Has evolved into one of the longest-running artist collectives in the country. Has two gallery/performance spaces, large grounds and a rolling programme of events, exhibitions and residencies.

Admissions Policy As a members-based collective, the group is always looking for inspirational visual artists. Notify interest by email in first instance.

Women's Arts Association

54A Bute Street, Cardiff Bay, Cardiff, CF10 5AF T 029 20487850 F 029 20487850

E info@womensarts.co.uk W www.womensarts.co.uk

Contact Rebecca Spooner

Aims to provide opportunities for and increase recognition of women in the arts in south-east Wales. Also seeks to increase awareness of the special needs of women in the arts.

Admissions Policy Any women over 18 who are artists or have an interest in the arts are welcome. Membership is free to any woman over 18. Subscription to the quarterly newsletter is £10 per year.

How to get the most from your career: advice for recent graduates

Elinor Olisa and Isobel Beauchamp

There is no denying that the artist-gallery dynamic has been shifting for several years: traditionally galleries owned 50 per cent of all work produced by a represented artist, but this has given way to a more independent approach by artists, forcing many galleries to adapt their consignment and exclusivity contracts. This change has been brought on largely by the advances in Internet based, social-networking sites, which allow artists to have previously unheard of freedom in promoting themselves through a variety of outlets and to make contact with artists, buyers and art enthusiasts all over the world, without the need for gallery consignment.

The benefits of working with galleries are not to be dismissed however. The client databases that galleries spend years building upon, honing and keeping close to their chests are valuable and lucrative to both artists and galleries. An artist alone would rarely get access to these clients and collectors who often prefer doing business with a gallery rather than directly with an artist. Buyers like the assurance that their transaction will be handled securely through a registered dealer and that the gallery has given their professional and qualified stamp of approval to an artist, ensuring that their purchase is a good investment.

Many galleries have adopted new ways of working with artists and a fairer system has evolved to the benefit of all involved in this industry. Galleries have become more relaxed about sharing artists with other outlets and realize that if several places spend their time and resources promoting the same artists this can benefit everyone. Increasing their pool of artists and incorporating emerging talent onto their books is also becoming an essential part of the successful, contemporary gallery model.

Over the last five years we have worked with and represented hundreds of emerging and

graduating artists and have seen many of them develop flourishing careers. Frustratingly, we have also witnessed many promising graduates fail to reach their potential. The following is a guide of what we look for in emerging artists and how artists can work productively with galleries. We hope that it may offer you an insight into what we have found has and has not worked for others.

First, a quick note to graduating artists

Consider your degree show as your opportunity to present your graduate collection and you as an artist to the world as well as to your peers and teachers. The degree show should be your career launch-pad as well as a celebration of your achievements to date.

Tip: Consider Saatchi buying your collection to be a nice surprise rather than a given outcome of your degree show! To maximize the potential of your being picked up/noticed by a gallery or collector at your degree show make sure that your work is labelled clearly, with info and details about the piece and your contact details. Be professional and always have an idea of prices for your work: don't be stumped when a potential client asks you and say the price with confidence and be prepared to negotiate. Companies like Artquest.org.uk and DegreeArt.com offer free help and advice with pricing. Throughout the show invigilate your area and make sure that you are always on hand to answer any questions about your work. It is only a week out of your life, which could lead to a successful career, so do make the effort to be there throughout.

Life as an artist

Employment: Most artists have to get a parttime job and this can be a necessity for several or many years. You will need to decide whether you want a job that merely pays the bills or one that could develop into a career: many artists find that their job develops at such a rate that their artistic career is swept under the rug. It is important not to see having a job as meaning

you have failed as an artist as this is far from true, it is a way of funding your true passion. Some artists find that getting a job within the arts helps them to make contacts and learn useful skills to aid their own art careers, others prefer to see their job as a break from the art world and an important time to see what the rest of the world is up to.

To ensure that your artistic practice is not neglected, you will need to find time and space to make your work. It may be that you work from home to begin with but there are lots of subsidized studio spaces available: you must get in there early to get one though. This book is an excellent resource for sourcing studio space in your area.

Tip: Consider sub-letting a studio space with another artist to reduce your rent and share ideas and contacts. It is important to try to maintain a presence within an artist community and network, as after leaving university and therefore the support of your peers, trying to go it alone can be daunting.

Self-employment: Current research shows that artists are three times more likely to be self-employed than any other sector of the UK population. As soon as you start selling work you must start to think about registering as self-employed. Organizations such as local authorities, arts organizations and galleries cannot legally pay artists unless they have self-employment status. An added bonus is that artists can claim back a huge amount of expenses against their tax bill by simply keeping receipts when purchasing materials and services necessary to their practice.

Stepping into official 'trading status' is a big step and many artists survive on a mixture of benefits and part-time work. It is perfectly legal to be an 'employee' of an organization or company (e.g., having a part- or full-time job working in a shop or restaurant) and to continue to be self-employed outside of employed work.

From the moment you decide to register as self-employed it is a good idea to allow some time before commencing; this is called the 'prestart-up' period and could last between eight and 12 months. Registering as self-employed is relatively straightforward, although you need to understand the process fully, keep appropriate records and be organized. www.artquest.org.uk has a comprehensive step-by-step guide to becoming self-employed.

Pricing and selling your work

Get your pricing sorted well before you show your work to anyone that may be remotely interested in buying, representing or even talking about your work.

Golden Rules:

- · It is essential to know the value of your work
- · Always be able to justify the price you set
- · Be prepared for people to bargain with you
- Know how much of a discount you are prepared to accept

How to price your work

To begin to determine a price for your work consider the following:

- The time it took you to formulate the concept
- The cost of materials
- The time it took to create the piece

This is your job, you should get paid accordingly, but be careful not put an unrealistic price tag on your work. Look at what established artists were charging for their work at a similar stage in their career. Most importantly, be professional and always have an idea of what you want to charge for your work. When a potential client asks you the price, tell them with confidence and be prepared to negotiate. Look at artquest. org.uk and DegreeArt.com for free help and advice with pricing. If you are selling or pricing your work for the first time, it is a good idea to consult one of these companies before hand to get a second opinion or clarification about your pricing thoughts.

Remember that it is a lot easier and more professional to put your prices up than to have to bring them down. Collectors also look for consistency in an artist's pricing, so ensure that if you are trying to sell a piece through more than one outlet, your pricing is consistent: you don't want to upset your buyers or dealers.

Contacting you

Make it easy for people to contact you, however they like, whether in person, by email, post or phone. Always carry a business card or postcard example of your work to give to people and remind them of your work.

Start building a contact list of people you meet. You can start with a list of friends and family. This will be one of your most valuable resources and must be kept up to date. Keep a record of everyone's contact details you come across. As you read publications, note down the journalist or critic, find their email and add them to your list. Reading relevant press will also help you keep abreast of what is happening in the art world.

Tip: People like to feel that they have discovered something, so make them feel special by staying in touch and giving them access to your new work.

Self promotion

As soon as you have put together your mailing list you can start keeping people informed of your progress. Sending out regular (once a month is enough) brief but informative emails to galleries, press and friends with details of your latest work, shows or competition and news will keep you at the forefront of their minds.

Keep your artist CV up to date and to hand – this will save you time when applying for jobs, grants or to competitions and can be emailed out to interested parties.

It is vital that you have a web presence and can be found by search engines. Whether you have your own site, showcase your work on a gallery site such as DegreeArt.com or utilize the Saatchi online website www.saatchi-gallery.

Tip: Plan ahead. Always have a plan for your 'Next Show'. Always consider the concept, but do not forget to think about:

Location: If it is your first show choose somewhere close to where people already know you: they can spread the word to others they know in the area. Visit the venue on a number of occasions and get a feel for the sort of crowd that frequent it and what else goes on in the area, so that you can tailor your marketing and promotion accordingly.

Sponsorship: Decide what you would like to get sponsorship for, e.g., money towards the printing costs for the show, gallery hire or maybe you would you like to try and get a drinks company to supply beverages for your private view. Put together a short sponsorship proposal and emphasize what you will do for the company in return and what they can stand to gain from being involved. If you are lucky enough to get more than one sponsor ensure that they are happy about another company being listed for their support and that there is not a conflict of interest between them or they may pull out.

Funding: Funding is different from sponsorship and can be applied for from government bodies such as the Arts Council. Start your funding application as early as possible and be realistic about the amount of money you need. You will be asked to produce a breakdown of all costs (down to the last penny) and whittle out any unnecessary costs. Applications for smaller amounts of money are likely to be more successful.

Promotion: It is a misguided belief that if the work is good enough it will sell itself. Firstly, people need to know that the exhibition exists and secondly, they will most often require background details on the work and the artist

before committing to purchase, so be prepared. A classic and easy mistake to make is to focus on the private view and forget about pre- and post-private view marketing.

Tip: A word of caution: if you are considering paying for a stand at an art or design fair always contact past exhibitors to see how successful the previous show was for them.

Gaining recognition

Seek out and enter as many competitions as you can as this will bring you to the attention of selection panels who are often influential. This book contains a wealth of competitions, awards and prizes for which you can apply.

Don't be overly selective about which ones you enter as the more you enter the more chance you have of being chosen and any nomination will add credibility to your CV.

We strongly recommend that artists become part of an artist community – these can be online as well offline. A network will ensure that you stay connected and provide you with a vital support network that is often lost post graduation.

Working with galleries

Finally, we come to the thorny issue of seeking gallery representation. In this day and age it is unlikely and not necessarily beneficial for an emerging artist to be represented by only one gallery. We have met many promising artists who were lured into signing consignment contracts giving a particular gallery the rights to all their work for up to five years. When they don't sell they are left high and dry, unable

to sell either independently or with another gallery. That said, though, it is usual for a gallery to ask for the right to first refusal on pieces which they will then endeavour to sell within an agreed time frame (usually months rather than years).

When you are seeking representation and approaching a gallery go with a good, well thought out proposal. Galleries are heavily subscribed and you may have to fight to get seen, but don't be put off.

Most galleries will charge between 40 and 60 per cent commission on work sold at their gallery, so be prepared and account for this in your pricing. If working with several galleries, it is best for you to have only one gallery in one area as this will allow you to build up a good relationship with each dealer without stepping on anyone's toes.

The biggest piece of advice we can offer is that working with a gallery should be a two-way relationship that both parties feel comfortable with and never exploited or cheated by. Everyone must be compensated for their time, effort and expertise. Galleries have access to clients and their daily business involves promoting you and sourcing new business, while you have the talent for creating the work and the ability to ensure that you have a lucrative and enduring career.

Elinor Olisa and Isobel Beauchamp are the founders of www.DegreeArt.com, an organization set up in 2003 to sell, commission and rent the finest artwork created by students and recent graduates emerging from the most prestigious art establishments.

10

Art magazines and public relations

Standing out from the crowd: an introduction to arts PR

Philip Abraham and Calum Sutton

'You can't spell TURNER PRIZE without "PR": Publicity, promotion and an artist's career

There is a lot of art out there today. In London alone there are, according to the Press Association, over 250 galleries and spaces exhibiting contemporary art and in 2006–2007 there were 26,945 students enrolled on fine art and related practice-based higher education degrees. Indeed, the contents of this very book testify to the scale, richness, complexity and diversity of the art scene in the UK.

The first decade of the 21st century, buoyed by economic success and inspired by the emergence of such institutions as Tate Modern in 2000 and Frieze Art Fair in 2003, witnessed an unprecedented growth in interest in contemporary art, and a colossal expansion in the number of people involved in making, exhibiting and selling work. Now, as the commercial cushion which supported the creative boom of the past decade becomes increasingly threadbare, it has never been more important for artists to find ways to attract attention to their art.

PR is the professional discipline responsible for an individual's or organization's reputation management and message communication. This may sound jargonistic and irrelevant to the needs of a working artist, but the basic principles and objectives of PR are no different for an artist than they might be for a charity, a political party or a multi-national corporation, and are just as necessary in a busy and complex cultural world. PR is essentially about working out what you want to say, and making sure that the right people get the message loud and clear. It's about thinking about the most appropriate lines of communication, how target audiences, consumers and stakeholders receive information and opinions that they trust, and using those channels effectively. It's not dark or sinister, but it is more and more essential if you want art dealers, curators, collectors, fellow artists and the art-enthused public to discover and engage with your work, and help push your career down the path you'd like to see it take.

Because of the different kinds of people that artists will want to reach out to in the course of their career, there are many approaches available within arts PR, and it's important always to think about how various tactics can achieve particular goals. Media relations is without doubt the dominant weapon in a publicist's armoury, but even within press liaison there is an immense range of work that can be done, including everything from generating exhibition listings in a local newspaper to trying to encourage rave reviews in the most august of arts journals. Yet while promoting art through the press is vitally important in developing an artist's career, forging personal connections at launches and events can be equally significant and is an integral part of arts PR. Networking, however evocative the phrase might be of a mercenary and very unappealing form of social behaviour. is nonetheless how creative relationships are made and opportunities are discovered. Attending, and indeed organizing, events such as private views and artist's dinners, and generally engaging with the social scene that swirls around the art world is not only fun, but is central to the job of arts PR.

Nuts and bolts – the fundamentals of a media relations campaign

None of the basic elements of a press campaign are particularly difficult to get right. However, each one needs to be in place in order to capitalize effectively on the prospect of positive editorial coverage. The challenge, therefore, is in being organized and disciplined enough to integrate PR planning effectively into all the other work that goes in to the making of an exhibition. Thinking about promotion and publicity at the outset of a project will make the task of achieving the kind of exposure you are after much more realistic. PR is not an exact science and while there are never any assurances about the results that even the most perfectly executed media relations campaign will yield, failure to observe a few fundamental

principles and procedures will mean that coverage is at best nonexistent and, at worst, hostile.

Press materials

Properly preparing the texts and images to accompany an exhibition should be the first task to be ticked off a PRO's to-do list. A press release should be prepared as early as possible (see below for more detail on the ideal duration of a press campaign) and should be conceived as a functional document rather than an exercise in creative writing. While many commercial galleries use their press releases as interpretation material for visitors to an exhibition, it is highly inadvisable to turn the press release into an artist's manifesto, rendered utterly bewildering by postmodern purple prose. Arts journalists generally resent being given a strong critical steer on an exhibition by a press release and many writers have reported on the overwhelming pretension and absurdity of an exhibition's press release, instead of the exhibition itself.

Rather than telling journalists what to think about an exhibition, a press release should simply provide information and context about the work on view. It should be concisely expressed and clearly laid out. The first thing a journalist should read is the basic details of the show (name of the gallery, name of the artist, title and dates of the exhibition). Then for the main text of the release, which should ideally be one side of A4 and should never be longer than two, we suggest the following basic structure:

- The opening paragraph should answer in prose these basic questions: who the artist is, what is being shown (often the medium will suffice) and what is interesting about the exhibition (for instance, if it's new work or the artist's first exhibition for a while).
- · The second paragraph should deal with the exhibition's content, the kinds of works that will be on view and introduce the reader to basic aspects of the artist's practice.
- The third paragraph should elaborate a little more about the content of the show, possibly by focusing on how particular works illustrate the

- artist's creative concerns, or referring to other well-known works in the artist's oeuvre which illuminate key aspects of the new exhibition.
- The final paragraph should offer a concise biography of the artist, including major previous exhibitions, and mention which major collections own works by the artist.

Once the press release has been written and approved, a suite of good-quality images should be prepared for use in the press. Strong images are the cornerstone of any arts PR campaign. Picture editors (the journalists in print media responsible for how the content of a publication looks) constantly crave good-quality images, so the more you can offer in the way of images, the better your chances of coverage. No press release should ever be distributed to media contacts without at least one suitable image ready to go: generating interest and an image request from a newspaper or magazine that you aren't able to satisfy is simply going to annoy that publication and threaten your relationship with them. Most picture editors or journalists will ask you to email images over. The specifications for images are generally standard: JPEG format, 300 dpi resolution, A4 size. Files should be at least IMB and less than 3MB in size. It's important also always to include appropriate captions and courtesies when images are emailed.

Most press campaigns for art exhibitions use one image as the exhibition's signature image, which is used for general press before a show opens and serves to provide a visual identity for the exhibition in the media. A wider selection of images are then held back and reserved, either for exclusive preview features or to illustrate reviews (see below for more detail on different kinds of coverage). Once an exhibition has been installed and opened, it's advisable to take photographs of the works in situ in the gallery; they are useful for press and are important documents for an artist's or gallery's archive.

Timings and sectors

One of the most important aspects of a press campaign (and one of the most common

reasons for a press campaign failing) is remembering when different publications need to be approached with information about an exhibition. Press work for an exhibition should ideally begin four months before an exhibition opens and continue until the doors close on the last day of the show. Long-lead publications, which include monthly fashion and style magazines, generally compose a piece three to four months before they hit the stands, and the monthly art magazines tend to work on issues two to three months before publication. The lead-time for weekly magazines, including glossy national newspaper supplements, tends to be six to eight weeks, while features desks on national newspapers and most relevant broadcast targets generally work four to six weeks ahead. Exhibition listings should be submitted to the Press Association (the service that provides information to the majority of publications that carry listings) four weeks before the show opens, and reissued weekly for the duration of the show. News desks, by definition, are far more responsive and can accommodate genuinely strong news stories the day before.

Pitching and securing different kinds of coverage

Press coverage comes in many varied forms and the best PR campaigns are those that successfully hit a number of different media nails on the head. The best way to plan a PR campaign is to focus on a few top targets, thinking carefully about what different kinds of coverage achieve for an artist and their work. The basic rules for approaching the media are to email the press release to a media target list (contact details for key arts magazine can be found at the back of this book and most publications will include a contact phone number and generic email address somewhere in the publication), and then follow up with a phone call to key contacts a day or two later. It is vital, however, not to hassle journalists. This is a fundamentally counterproductive way to conduct a media relations campaign and is the most common source of any antipathy between press and press officers. Simply use a phone call to remind journalists of the exhibition and

briefly explain why it's interesting, significant or newsworthy – then leave it to them to decide if they want to write about it.

Before an exhibition opens the aim is to build a buzz in the press about a show through preview features, which generally require either an interview with an artist or outstanding (and often exclusive) images of new work, and often both. Smaller previews and highlight listings also do a good job of driving visitors to an exhibition, and normally the information on the press release and an image will suffice. As an exhibition is about to open, it is sometimes worth inviting a photographer from a newspaper down to shoot the show and, rarely, a PR stunt is used to get coverage in the newspapers.

Securing reviews is probably the hardest part of a PR campaign, yet is often the form of coverage most coveted by a gallery or artist. All arts journalists jealousy guard their sense of editorial integrity and independence, and this is particularly true of critics. All one can do is make sure that key critics are made aware of a show in plenty of time, that they have access to an exhibition before it opens if they request it, and that they are furnished with as much information as they need. If a show has gained momentum through preview coverage and word of mouth, however, then critics are much more likely to regard an exhibition as significant enough to warrant a review. This is why thinking holistically about PR, linking all the different kinds of coverage into an overall campaign, as well as networking and spreading the message through personal connections and associations, is the most efficient and effective way for an artist's voice to be heard.

Philip Abraham and Calum Sutton specialize in public relations for visual arts organizations. Calum Sutton^{PR} was founded in October 2006.

According to the Higher Education Statistics Agency this figure excludes those who train in design, craft, film, cinematic and photographic arts drama, music or performing arts, many of whom obviously go on to work in the world of contemporary art, as dealt with in this book.

Art magazines and public relations Art magazines

a-n Magazine / a-n The Artists Information Company

1st Floor, 7-15 Pink Lane, Newcastle-upon-Tyne, NE15DW

T 0191 2418000

F 0191 22418001

E subs@a-n.co.uk

W www.a-n.co.uk

Magazine providing a window on the world of the visual arts for professional artists at all career stages and their collaborators. Includes Debate, Snapshot, Reviews, News, articles and selected opportunities listings to complement the in-depth resources on www.a-n.co.uk Ten issues annually. Available on subscription and through retail outlets.

Editor Gillian Nicol

AA Files

AA Publications, Architectural Association, 36 Bedford Square, London, WC1B 3ES

T 020 78874021 F 020 74140783

E publications@aaschool.ac.uk

W www.aaschool.ac.uk

Since 1981, the Architectural Association's (AA) journal of record, reflecting the current thoughts, practices and preoccupations of the school's academic and studio programmes, its tutors and its students. Published twice a year, AA Files contains articles on architectural theory, history and criticism, work by contemporary practitioners and designers, photography, painting, sculpture and music, and cross-disciplinary collaborations. Substantially informed by the AA's lecture and exhibitions programmes, the journal publishes original scholarship and projects by those who visit the school over the course of each year.

Editor Thomas Weaver

Aesthetica Magazine

P.O. Box 371, York, YO23 1WL

T 01904 527560

E info@aestheticamagazine.com

W www.aestheticamagazine.com

Founded in 2002, it explores the interdisciplinary nature of the arts, featuring visual arts, literature, poetry, music, theatre and film. Readership of 45,000 with subscriptions to public libraries, universities, arts centres and sixth forms.

Editor Cherie Federico

Afterall

Central St Martins College of Art & Design, 107-109 Charing Cross Road, London, WC2H ODU

T 020 75147212

F 020 75147166

E london@afterall.org

W www.afterall.org

Founded in 1999. A journal of contemporary art published twice a year by Central St Martins College of Art & Design, London and California Institute of the Arts, Los Angeles, providing analysis of significant art of our time. Each issue brings together several international artists whose work seems pertinent to the wider cultural debates of the moment, considered through a variety of texts and accompanied by high-quality reproductions. Also has an office in Los Angeles. Since 2006 has also published two series of books distributed by The MIT Press.

Editor Charles Esche. Thomas Lawson and Mark Lewis

Another Magazine

112-116 Old Street, London, EC1V 9BG

T 020 73360766

F 020 73360966

E info@anothermag.com

W www.anothermag.com

Founded in 2001, covering art, fashion and culture.

Apollo Magazine

22 Old Queen Street, London, SW1H 9HP

T 020 79610150

E editorial@apollomag.com

W www.apollo-magazine.com

A monthly international fine- and decorative-arts and antiques magazine. Founded in 1925 and relaunched in 2004 in full colour, with a more topical, contemporary flavour. Specializes in the publication of new scholarly research. Also publishes book and exhibition reviews, news and comment. Relaunched in 2006 in a smaller format. Editor Michael Hall

Art & Architecture Journal

134A Farringdon Road, London, EC1R 3AP T 00 39 058592540

E editor@artandarchitecturejournal.com

W www.artandarchitecturejournal.com Specializes in contemporary art and architecture collaboration, providing professional information on art commissions and projects in public places. Founded in 1980 and published quarterly.

Editor Jeremy Hunt

The Art Book

Laughton Cottage, Laughton, Nr Lewes, BN8 6DD

T 01323 811759 F 01323 811756

E ed-exec-theartbook@aah.org.uk

W www.blackwell-synergy.com/links/toc/artbook Published quarterly on behalf of the Association of Art Historians. Details newly published books on decorative, fine and applied art, art history, photography, architecture and design. Includes feature articles, reviews of exhibitions and their catalogues, reviews of artists' books and interviews with key figures in the art world. At least fifty reviews in each issue on art, photography and architecture books.

Editor Sue Ward (Executive Editor)

Art History

c/o AAH, 70 Cowcross Street, London, EC1M 6EJ

E ed-arthistory@aah.org.uk

W www.aah.org.uk/pubs/arthistory.html
The journal of the Association of Art Historians, providing an international forum for original research relating to all aspects of the historical and theoretical study of painting, sculpture, design and other visual imagery.

Editor David Peters Corbett

Art Monthly

4th Floor, 28 Charing Cross Road, London, WC2H 0DB

T 020 72400389

F 020 74970726

E info@artmonthly.co.uk W www.artmonthly.co.uk

A leading journal of contemporary art, founded in 1976, providing independent and opinionated commentary on emerging issues and trends. Interviews with top international artists and reviews of both British and international exhibitions. Regular columns include editions, artists' books, books, web art, art law and

Editor Patricia Bickers

The Art Newspaper

70 South Lambeth Road, London, SW8 1RL

T 020 77353331

salerooms.

F 020 77353332

E contact@theartnewspaper.com

W www.theartnewspaper.com

A leading paper for the international art world.

Editor Cristina Ruiz

Art Quarterly

7 Cromwell Place, London, SW7 2JN

T 020 72254821

F 020 72254807

E info@artfund.org

W www.artfund.org

The magazine of the National Art Collections Fund (Art Fund). Covers all aspects of the visual arts and includes a news section, opinion pieces, features by celebrated art experts, writers and personalities, book reviews, and exhibition listings. Published four times a year.

Editor Caroline Bugler

Art World Magazine

B5 MEDIA, 502 Clerkenwell Workshops, 27/31 Clerkenwell Close, London, EC1R 0AU

T 0207 0143437

W http://artworldmagazine.com.au
New bi-monthly launched in 2008 that focuses
on recent work by a broad selection of emerging
and established artists, practising across all
disciplines. It includes news, previews and inside
information, but also – importantly – provides
an opportunity for artists, curators and gallerists
to speak directly to everyone fascinated by
contemporary art.

The Artist

Caxton House, 63–65 High Street, Tenterden, TN30 6BD

T 01580 763673

F 01580 765411

W www.theartistmagazine.co.uk
Founded in 1931. Aims to provide inspiration,
instruction and ideas for all artists, professional
and amateur. Each monthly issue contains
masterclasses and 'in conversation' features
with leading artists, reports on materials, events,
exhibitions and news relevant to all practising
painters.

Editor Sally Bulgin

Artists & Illustrators

The Chelsea Magazine Co. Ltd, 26–30 Old Church Street, London, SW3 5BY

T 020 73493150

F 020 73493160

E info@artistsandillustrators.co.uk

W www.artistsandillustrators.co.uk

Established in 1986. The UK's best-selling magazine for practising artists. Also organizes Europe's biggest art materials exhibition.

Art Review

ı Sekforde Street, London, EC1R 0BE

T 020 71072760

W www.artreview.com

A monthly magazine with articles on the visual arts of the twentieth and twenty-first centuries written by international art critics and writers, novelists and cultural historians including Luc Sante, Geoff Dyer, Gordon Burn, Jonathan Lethem, Matthew Collings and Natasha Walter.

Arts Media Contacts

1516 High Street, Lewes, BN7 21XU **T** 01273 488996

F 01273 488497

E info@artsmediacontacts.co.uk

W www.mediacontacts.org.uk

A press information service in book and online format, researched specifically for the visual arts. Provides a continuously updated list of over four thousand visual-arts journalists working in all areas of the UK and international press. Also provides detailed insider information for each entry, including lead times, deadlines and preferred method of contact. Online service allows user to select own press list, paste in a press release and image and send it out. Published since 1995 by artsinform PR.

Editor Laura Charlton

Arts Research Digest

Corbridge Business Centre, Tinklers Yard, Corbridge, NE45 5SB

T 01434 636089 F 01434 634514

W www.arts-research-digest.com

A specialist journal providing up-to-date details about current and recent research in the arts and cultural sector around the world. Published three times a year and available by subscription only.

Editor Nessa O.Mahony

The Artspost

Lewisham Library, 199–201 Lewisham High Street. Lewisham, SE13 6LG

T 020 83147730

E arts.service@lewisham.gov.uk

A free publicity distribution service available to arts and community organizations throughout the borough. Distributes to over ninety venues in Lewisham.

Aspect Magazine

316 Summer Street, 5th Floor, Boston, MA 02210, USA

E mmittelman@aspectmag.com

W www.aspectmag.com

A biannual DVD magazine of new media art, with a mission to distribute and archive works of time-based art. Each issue highlights 5–10 artists working in new or experimental media, whose works are best documented in video or sound. Each work can be viewed with or without an additional commentator audio track.

Audio Arts

6 Briarwood Road, London, SW4 9PX

T 020 77209129

E editor@audio-arts.co.uk

W www.audio-arts.co.uk

Since 1973, the only art magazine regularly published on audio cassette, bringing listeners into contact with contemporary artists and the critical discourse surrounding contemporary art. Each year there are cassette and CD editions of up to 120 minutes' duration, accompanied by supporting texts and colour images.

Black & White Photography

Guild of Master Craftsman Publications Ltd, 166 High Street, Lewes, BN7 1XN

T 01273 477374 F 01273 402849

E ailsam@thegmcgroup.com

W www.thegmcgroup.com

Published thirteen times per year, aimed at both enthusiast and professional photographers who are passionate about the monochrome medium. Publishes interviews with known and up-and-coming photographers, as well as technique features and product reviews which cover both traditional and digital.

Editor Ailsa McWhinnie

Blueprint

Wilmington Media Ltd, 6–14 Underwood Street, London, N1 7JQ

T 020 73365225

E vrichardson@wilmington.co.uk

W www.blueprintmagazine.co.uk

A monthly magazine of contemporary architecture, design and culture, with emphasis on high quality photography and illustration. Editor Vicky Richardson

British Journal of Aesthetics

Oxford University Press, Great Clarendon Street,

Oxford, OX2 6DP T 01865 353907

F 01865 353485

E bja@queens.ox.ac.uk

W http://bjaesthetics.oxfordjournals.org/ Founded in 1960. An international forum for debate in aesthetics and the philosophy of art. Published to promote the study, research and discussion of the fine arts and related types of experience from a philosophical standpoint. Appears quarterly and includes a substantial reviews section.

Editor Professor John Hyman

British Journal of Photography

Incisive Media, Haymarket House, London, SW1Y 4RX

T 020 73169658

E bjp.news@bjphoto.co.uk

W www.bjp-online.com

Founded in 1854, BJP is the world's longestrunning weekly photography magazine. Focusing on professional photography, the magazine contains international news, listings, reviews and features, including interviews, market reports, book and exhibition reviews and businessrelated matters. Covers all areas of professional photography, from fine art, advertising and fashion, to editorial, industrial, weddings, scientific and medical.

Editor Simon Bainbridge

The Burlington Magazine

14–16 Duke's Road, London, WC1H 9SZ T 020 73881228

F 020 7388229

E burlington@burlington.org.uk

W www.burlington.org.uk

Has appeared every month since its creation in 1903. Selects concise, authoritative articles from internationally renowned scholars presenting new works, discoveries and fresh interpretations in painting, sculpture, architecture and the decorative arts, from the antiquity to the present day. Contains main articles, shorter notices, exhibition and book reviews, and a calendar of forthcoming exhibitions. Also contains advertisements with details of works currently on the market.

Cabinet Magazine

181 Wyckoff St, Brooklyn, New York, NY 11217, USA W www.cabinetmagazine.org

Award-winning quarterly magazine of art and culture 'for the intellectually curious'. Like the 17th-century cabinet of curiosities to which its name alludes, Cabinet is as interested in the margins of culture as its centre. Presenting wideranging, multi-disciplinary content in each issue through the varied formats of regular columns, essays, interviews, and special artist projects, Cabinet's hybrid sensibility merges the popular appeal of an arts periodical, the visually engaging style of a design magazine, and the in-depth exploration of a scholarly journal.

Editor Brian Dillon (UK editor)

Ceramic Review

25 Foubert's Place, London, W1F 7QF

T 020 7439 3377

E editorial@ceramicreview.com

W www.ceramicreview.com

Founded in 1970, published six times a year. Illustrated in full colour throughout, it includes practical and critical features on ceramic works from the UK and round the world. It also carries news of events and exhibitions as well as reviews of exhibitions and books plus a comprehensive 'what's on' listing. Aimed at anyone working or involved in the world of ceramics and studio pottery, as well as libraries, collectors, curators and museums.

Editor Emmanuel Cooper

Circa Art Magazine

43-44 Temple Bar, Dublin 2

T or 6797388
E info@recirca.com

W www.recirca.com

Ireland's leading magazine of contemporary visual art and culture. Published quarterly, it includes news, reviews, previews, interviews, feature articles and a host of images. Maintains a long tradition of quality reporting on the innovative Irish visual arts scene with a fresh, contemporary, critical perspective.

Editor Peter FitzGerald

Contemporary

Studio 56, 4 Montpelier Street, London, SW7 1EE T 020 70196205

F 020 71005998

E info@contemporary-magazine.com

W www.contemporary-magazine.com

Relaunched in 2002. A monthly magazine with an estimated readership of over 75,000. Covers visual

arts, books, architecture, design, fashion, film, music, media, photography, dance and books. Editor Brian Muller (Publisher); Michele Robecchi (Senior Editor)

Crafts Magazine

44A Pentonville Road, Islington, N1 9BY T 020 78062538 F 020 78370858

E editorial@craftscouncil.org.uk

W www.craftscouncil.org.uk/crafts/index.htm
Contemporary craft magazine published by the
Crafts Council. The only British magazine to
cover all craft forms, from studio work to public
commissions, and from modern experimental
work to traditional and historic designs. Published
on alternate months.

Dazed & Confused Magazine

II2—II6 Old Street, London, EC1V 9BG
T 020 73360766
F 020 73360966
W www.dazeddigital.com
Monthly magazine founded in 1992, dealing in cutting-edge art and fashion.
Editor Rod Stanley

Digital Camera Magazine

Future Publishing Ltd, 30 Monmouth Street, Bath, BA1 2BW

T 01225 442244

E digitalcamera@futurenet.com

W www.dcmag.co.uk

Founded in 2001, a monthly magazine with strong reputation for allowing photographs to 'do all the talking'. Also contains hands-on advice and practical techniques.

Editor Marcus Hawkins

Flux Magazine

42 Edge Street, Manchester, M4 1HN T 0845 6860396 F 0161 8191196 E editorial@fluxmagazine.com

W www.fluxmagazine.com

A UK-based bi-monthly magazine covering national and international fashion, music, art and culture.

Editor Lee Taylor

Foto8

1–5 Honduras Street, London, EC1Y 0TH T 020 7253 8801 F 020 7253 2752 E info@foto8.com

W www.foto8.com

A picture-led magazine presenting photo reportages by award-winning photographers and exclusive essays written by leading journalists. Published quarterly. Editor Ion Levy

frieze

81 Rivington Street, London, EC2A 3AY

T 020 78337238

E admin@frieze.com

W www.frieze.com

Covers all that is vital in contemporary art and visual culture, featuring emerging artists and highlighting new currents in art practice as well as offering a fresh perspective on more established artists. Includes exhibition reviews, interviews, city reports and worldwide listings. Published eight times a year. (Office relocating in Summer 2009.)

Galleries Magazine

Barrington Publications, 54 Uxbridge Road, London, W12 8LP

T 020 8740 7020

F 020 8740 7020

E art@galleries.co.uk

W www.galleries.co.uk
The UK's largest-circulating monthly arts listings magazine, describing current exhibitions and the stock of commercial and public art galleries, galleries for hire and art services. New shows diary, artist index, dealer index, stock index, entries updated monthly. Website at www.galleries.co.uk carries additional references and indexes as well as indexed gallery press releases and topical news.

Editor Andrew Aitken

The Good Gallery Guide

The Art House, Drury Lane, Wakefield, WF1 2DH T 01924 377740

F 01924 377090

E feedback@goodgalleryguide.com

W www.goodgalleryguide.com / www.the-

arthouse.org.uk

Aims to make visiting galleries easier for everyone. Initially started as a guide to help disabled people plan visits to art galleries but can now be used by all visitors. For each gallery there are details of how to get there, what facilities exist and a personal review of the gallery. Aims to work with galleries to improve their access.

Editor Stuart Bolton

HotShoe

29-31 Saffron Hill, London, EC1N 8SW T 020 7421 6009

F 020 7421 6006

E hotshoe@photoshot.com

W www.hotshoeinternational.com

A bi-monthly contemporary photography magazine that covers all categories including documentary, photojournalism, art, and creative. The title has been published for over 30 years, but was bought by World Illustrated in 2002. It has a new format (80% of A4) and content that includes interviews, portfolio features, book and show reviews, awards, and listings.

Editor Melissa DeWitt

I-D Magazine

124 Tabernacle Street, London, EC2A 45A

T 020 74909710 F 020 72512225

W www.i-dmagazine.com

Began as a fanzine dedicated to the street style of punk-era London in 1980. Has metamorphosed into a glossy magazine that documents fashion. Editor Terry Jones (Editor-in-Chief)

icon

Media 10 Limited, National House, 121-123 High Street, Epping, CM16 4BD T 01992 570030 F 01992 570031 E info@icon-magazine.co.uk W www.icon-magazine.co.uk A major monthly international design and architecture magazine.

Irish Arts Review

State Apartments, Dublin Castle, Dublin 2

T of 6793525

E sperkins@irishartsreview.com

W www.irishartsreview.com

Founded in 1984, one of Ireland's leading art magazines, published four times a year. Each edition runs to 150 fully illustrated pages and features articles on printing, sculpture, design, architecture, exhibitions and photography. Editor John Mulcahy

The Jackdaw

93 Clissold Crescent Road, London, N16 9AS T 020 72544027 E dg.lee@virgin.net

W www.thejackdaw.co.uk

Founded in 2000. A bi-monthly newsletter that takes a sometimes critical look at the visual arts world.

Editor David Lee

Journal of Visual Art Practice

London Metropolitan University, Sir John Cass Dept. of Art, Media & Design, London, E1 7PF

E c.d.smith@londonmet.ac.uk

W www2.ntu.ac.uk/ntsad/nafae/ publications.

Founded by the National Association of Fine Art Education in 2000 and published by Intellect. Aimed at tutors and students in the fine-art sector. Addresses issues of contemporary debate in fineart studios, in matters of both content and practice. Particularly welcomes contributions from studio tutors and students undertaking the Fine Art PhD. Available electronically on SAGE journals online at http://vcu.sagepub.com **Editor** Chris Smith

Journal of Visual Culture

Joanne Morra, Central St Martins College of Art & Design, London, WC1B 4AP E g.morra@csm.arts.ac.uk Published three times a year. Aims to promote research, scholarship and critical engagement with visual cultures from a range of methodological positions, at various historical moments, and across diverse geographical locations.

Editor Editorial Group: Marquard Smith (Editorin-Chief), Raiford Guins (Principal Editor), Joanne Morra (Principal Editor), Mark Little, Vivian Rehberg, Dominic Willsdon, Heidi Cooley, Susan pui san Lok and Rob Stone

Knight's Move Magazine

E knightsmovejournal@lgmail.com A quarterly journal of artists' writing, established in 2006. Aims to provide a public space in which visual artists can use the written word as another form of artistic endeavour. Editor David Howells and Charlie Woolley

Latest Art Magazine

Unit 1, Level 5 North, New England House, New England Street, Brighton, BN1 4GH T 01273 818150 W www.latest-art.co.uk

Covers the contemporary art scene in London,

Brighton and the southeast. Readership of 100,000.

Editor Colette Meacher

Map Magazine

DJCAD, 13 Perth Road, Dundee, DD1 4HT T 01382 381018

E editor@mapmagazine.co.uk

W www.mapmagazine.co.uk

Launched in 2005, a new international art magazine from Scotland published quarterly (February, May, August and November). Designed to appeal to artists, art professionals and an informed general arts audience. Each issue contains features and profiles of leading artists, reviews of major exhibitions at home and abroad, and book reviews. Also reports on new developments, events and news related to the visual arts.

Editor Alice Bain

Marmalade Magazine

Kent House, 14–17 Market Place, London, W1W 8BY

T 020 76121139

F 020 76121112

E mail@marmaladeworld.com

W www.marmaladeworld.com

Aimed at a readership from the creative industries, from art and design, fashion and advertising, to music and the media in general. Carries a mix of new ideas and trends, as well as being a committed showcase for new creative talent.

Editor Kirsty Robinson and Sacha Spencer Trace

Modern Painters

E info@modernpainters.co.uk
W www.modernpainters.co.uk
A monthly art publication founded in 1988. Covers

visual and performing arts and culture.

n.paradoxa: international feminist art journal

38 Bellot Street, London, SE10 OAQ

T 020 88583331 F 020 88583331

E k.deepwell@ukonline.co.uk

W web.ukonline.co.uk/n.paradoxa/index.htm
The only international feminist art journal
dedicated to contemporary women (visual) artists
and feminist theory. Contributions are published
by women writers, curators, artists and critics from
around the world. In print since 1998. A separate
edition started online in 1996. Online and print

versions contain different contents. Print editions are organized thematically.

Editor Katy Deepwell

NADFAS Review

NADFAS House, 8 Guilford Street, London, WC1N 1DA

T 020 74300730

F 020 72420686

E nadfasreview@nadfas.org.uk

W www.nadfasorg.uk

The quarterly magazine of the arts-based educational charity, with over 330 member societies and ninety thousand members worldwide. Offers in-depth articles on the decorative arts, current exhibitions listings and showcases of many of the volunteer projects that members are involved in.

Editor Judith Quiney and Danielle Green

Next Level

The Basement, 64 Hanbury Street, London, E1 5JL

T 020 7655 4350

F 020 7655 4350

W www.nextleveluk.com

Next Level is the cutting-edge resource for contemporary photographic art. Launched in March 2002 at the Institute of Contemporary Art in London, Next Level has quickly emerged as a unique venue from which to present emerging and established artists and writers, bringing awareness and debate to contemporary subjects from a visual perspective. Each edition revolves around a particular central theme. Working alongside creative design exposes the reader to different points of view and to encourage stimulating design. As a result, each issue functions as a collectable volume, a curated exhibition in magazine format. Welcome to Next Level. Editor Sheyi Antony Bankale

Object – Graduate Research and Reviews in the History of Art and Visual Culture

History of Art Department, University College London, 39–41 Gordon Square, London, WC1H 9PD

T 020 76797545

F 020 79165939

E object@ucl.ac.uk

W ucl.ac.uk/object

Founded in 1998. An annual journal produced and edited by postgraduate students from the History of Art Department at UCL, featuring articles drawn from ongoing research alongside reviews of recent exhibitions and publications. Contents represent the diversity of issues and methodologies with which the postgraduate students in the department are engaged.

Editor Emily Richardson (Editor-in-Chief)

Oxford Art Journal

Mary Hunter, Department of Art History, University College London, Gower Street, London, WC1E 6BT

W oaj.oupjournals.org

Has an international reputation for publishing innovative critical work in art history. Committed to the political analysis of visual art and material representation from a variety of theoretical perspectives, and has carried work addressing themes from antiquity to contemporary-art practice. Also carries extended reviews of major contributions to the field.

Performance Research

Sanda Laureri, Penglais Campus, Aberystwyth, SY23 3AJ

T 01970 628716

E performance-research@aber.ac.uk
W www.performance-research.net
Founded in 1995 and published quarterly. A
specialist journal that promotes the dynamic
interchange between scholarship and practice
in the expanding field of performance.
Interdisciplinary in vision and international in
scope, its emphasis is on research in contemporary

Portfolio – Contemporary Photography in Britain

performance arts within changing cultures.

43 Candlemaker Row, Edinburgh, EH1 2QB T 0131 2201911

F 0131 2264287

Editor Gloria Chalmers

E mag@portfoliocatalogue.com

W www.portfoliocatalogue.com
Magazine for innovative photographic art created
and shown in the Britain. Published in May and
November, combining the contemporary interests
and current reviews of a magazine with the
quality reproductions and detailed information
of an exhibition catalogue. Features the work of
established photographers and artists accompanied
by in-depth essays, a series of portfolios by
emerging artists, and reviews from esteemed
writers and curators. Large-format publication
(295mm high × 245mm wide), containing 96
pages of colour and duotone photographs.

Preview of the Visual Arts in Ireland

8 Oakley Park, Blackrock, County Dublin **E** info@preview.ie

W www.preview.ie

Founded in 1995, Preview is a listing guide to visual art exhibitions in Irish galleries, museums and art centres. The print guide, containing descriptive text and images of upcoming art shows and events, is published six times a year. The website contains listings as well as thumbnail images of artists' works. Listing, advertising and image rates are available on request or can be viewed on the website. Circulation of approximately 5,000 per issue.

Print Quarterly Publications

52 Kelso Place, London, W8 5QQ T 020 77954987 F 020 77954988 E admin@printquarterly.co.uk W www.printquarterly.co.uk Scholarly journal of prints from the fifteenth- to

Editor David Landau

the twenty-first centuries.

Printmaking Today

Cello Press Ltd, Office 18 Spinners Court, 55 West End, Witney, OX28 1NH

T 01993 701002

F 01993 709410

E Eds@pt.cellopress.co.uk

W www.printmakingtoday.co.uk

First published in 1990. The authorized journal of the Royal Society of Painter-Printmakers. Aims to provide a forum for printmakers, collectors and curators.

Editor Anne Desmet

RA Magazine

Royal Academy of Arts, Burlington House, Piccadilly, London, W1J 0BD

T 020 73005820

F 020 73005882

E ramagazine@royalacademy.org.uk

W www.ramagazine.org.uk

Founded in 1983. Published quarterly in association with the Royal Academy of Arts (RA) in London, and distributed to the ninety thousands Friends of the RA as part of their membership benefits. In addition, ten thousand copies of the magazine sell in the academy shop, on specialist news stands and by subscription. Editorial covers art, exhibitions and events at the RA and by Royal

Academicians, as well as art, architecture, books and culture more broadly in Britain and abroad. Editor Sarah Greenberg

Raw Vision

P.O. Box 44. Watford, WD25 8LN

T 01023 853175

E info@rawvision.com

W www.rawvision.com

Founded in 1080 to bring Outsider art to an international audience. Has since moved on to cover subjects that fall into the fields of Art Brut, Outsider art, contemporary folk art, visionary art and the marginal arts of the world. Produced quarterly but going up to five issues from 2006. Editor John Maizels

Royal Photographic Society Journal

Fenton House, 122 Wells Road, Bath, BA2 3AH

T 01225 325733

E reception@rps.org

W www.rps.org

The journal of the Royal Photographic Society. Published ten times a year. Promotes the art and science of photography, covering all aspects of the medium, and featuring interviews with key photographers, equipment and book reviews, comment and analysis.

Editor David Land

RSA lournal

8 John Adam Street, London, WC2N 6EZ

T 020 79305115

E amanda.jordan@rsa.org.uk

W www.thersa.org/fellowship/journal

The bimonthly journal of the Royal Society for the Encouragement of Arts.

Sculpture Journal

c/o The Ashmolean Museum of Art and Archeology, Beaumont Street, Oxford, Ox1 2PH

F 0151 7942235

E katherine.eustace@btinternet.com W http://sculpturejournal.lupjournals.org Founded in 1997. Britain's foremost scholarly journal devoted to sculpture in all its aspects. Disseminates information, scholarship and knowledge in the international field of sculpture from the late-medieval period to the present day and provides an international forum for sculptors, writers and scholars. Published twice a year (March and October), the journal includes illustrated scholarly articles on all aspects of sculpture, reviews of exhibitions and publications. Published for and reflects the aims of the Public Monuments and Sculpture Association. **Editor** Katharine Fustace

Selvedge

P.O. Box 40038, London, N6 5UW

T 020 83419721

F 020 83419721

E editor@selvedge.org

W www.selvedge.org

A magazine of textiles in all forms, including fine art, fashion and interiors. Six issues per year.

Editor Polly Leonard

Source Photographic Review

P.O. Box 352, Belfast, BT12WB

T 028 90329691

E info@source.ie

W www.source.ie

A quarterly Arts Council funded magazine providing informed critical debate around contemporary photographic culture. Reproduces portfolios of images from a wide range of contemporary photographers' work alongside exhibition and book reviews, and in-depth essays on photographic culture covering national and international material.

Editor John Duncan / Richard West

TATE ETC.

Millbank, London, SW1P 4RG

T 020 78878959 / 8724

F 020 78878729

E tateetc@tate.org.uk

W www.tate.org.uk/tateetc

Published three times per year, with a circulation of ninety thousand. Features in-depth articles by leading writers in their fields such as Alain de Botton, Paul Farley, Alison Gingeras and Lynne Cooke, and has a strong emphasis on giving a voice to artists. While a certain percentage of the magazine is devoted to exhibitions at the four Tates (Modern, Britain, Liverpool and St Ives) it also includes polemical, thematic features. Within these articles the magazine aims to blend the historical, modern and contemporary.

Editor Simon Grant

things magazine

c/o 73 Danby Street, London, SE15 4BT

T 020 72675891

E editors@thingsmagazine.net

W www.thingsmagazine.net

Originally founded in 1994 by a group of writers

and historians based at the Victoria & Albert Museum and the Royal College of Art in the belief that objects can open up new ways of understanding the world. The magazine is both online and an occasional print publication. Editor Hildi Hawkins and Jonathan Bell

Third Text

2G Crusader House, 289 Cricklewood Broadway, London, NW2 6NX

T 020 88307803

E subscriptions@tandf.co.uk

W www.tandf.co.uk

An international scholarly journal dedicated to providing critical perspectives on art and visual culture. Examines the theoretical and historical ground by which the West legitimizes its position as the ultimate arbiter of what is significant in this field. A forum for the discussion and (re-)appraisal of the theory and practice of art, art history and criticism, and the work of artists hitherto marginalized thorough racial, gender, religious and cultural differences.

Editor Rasheed Araeen

Time Out

Universal House, 251 Tottenham Court Road, London, W1T 7AB

T 020 78133000

F 020 78136001

W www.timeout.com

A guide to what's happening in London. First published in 1968.

V&A Magazine

V&A, South Kensington, Cromwell Road, London, SW7 2RL

T 020 7942 2000

E vanda@vam.ac.uk

W www.vam.ac.uk

The Victoria & Albert Museum's magazine includes subject matter such as contemporary design, interior design, photography, fashion, art, architecture, craft and textiles.

Other Fine Art courses V&A Magazine

Variant

1/2 189b Maryhill Road, Glasgow, G20 7XJ T 0141 3339522

E variantmag@btinternet.com

W www.variant.org.uk

A free, independent critical arts and culture publication published three times a year, with a circulation of 45,000 copies. Aims to widen the involvement of its readership in debate, discussion and awareness of social, political and cultural issues that are otherwise ignored, hidden, suppressed or censored. Looks to its readership to provide, inform and generate content for the magazine. All articles are freely archived on the website. Editor Daniel Jewesbury and Leigh French

Visual Culture in Britain

Manchester University Press, Oxford Road, Manchester, M13 9NR

T 0161 2752310

W www.manchesteruniversitypress.co.uk: Founded in 2000. Twice-yearly journal that aims to locate the range of visual culture - art, design, print, photography, the performing arts, etc. - in relation to the wider culture (historically and geographically), from the eighteenth century to the present. The journal addresses visual culture in the context of debates such as racial, ethnic and gender identities, nationality and internationalism, high and low culture, and models of production and consumption.

Wallpaper

Blue Fin Building, 110 Southwark Street, London, Sel 0SU

T 020 31485000

F 020 31488119

E editor@wallpaper.com

W www.wallpaper.com

A magazine 'for urban modernists and global navigators'. Aimed at an international audience, covering interiors, industrial design, architecture, entertaining, fashion and travel.

Public relations

Arts Marketing Association

7A Clifton Court, Clifton Road, Cambridge, CB1 7BN T 01223 578078

F 01223 245862

E info@a-m-a.org.uk

W www.a-m-a.org.uk

Supports the professional development of its members via a range of tools including a mentoring scheme, an accredited certificate in arts marketing, publications (many available free to members), a website, and a broad programme of events.

Artsinform Communications Ltd 15/16 High Street, Lewes, BN7 1XU

T 01273 488996

F 01273 488497

E jessica@mediacontacts.org.uk

W www.mediacontacts.org.uk

A marketing consultancy and public relations agency working exclusively within the visual arts sector. Set up in 1994 by arts journalists Jessica Wood and Rosie Clarke. Publishes the Arts Media Contacts directory.

Bolton & Quinn Ltd

6 Addison Avenue, Holland Park, London, W11 4OR

T 020 72215000

F 020 76032777

E erica@boltonquinn.com

Offers public relations services in the arts and culture sector.

Brunswick Arts Consulting

16 Lincoln's Inn Fields, London, WC2A 3ED

T 020 7936 1290

F 020 7936 1299

E bartsinfo@brunswickgroup.com

W www.brunswickgroup.com

Brunswick Arts was founded in 2001 to serve the specific communication needs of arts, cultural and charitable organizations in today's challenging climate. An in-house team craft tailor-made campaigns for each client, often combining wideranging arts and media experience with that of external consultants at the top of the arts and charitable professions. Has clients and offices around the world, with clients ranging from major organizations to individuals, and including festivals and exhibitions, tourism, funding and capital initiatives. Track record of successfully matching sponsors with appropriate arts and charitable organisations.

Callum Sutton PR

South Wing, Third Floor, Somerset House, London, WC2R 1LA

T 020 71833577

F 020 71833578

E info@suttonpr.com

W www.suttonpr.com

Agency was founded in October 2006 to meet the demand for an arts PR agency dedicated to delivering a consistently high quality service, tailored to clients' individual needs. Clients include some of the major events in the international contemporary art calendar: the British Council at the 53rd Venice Biennale, Manchester International Festival and Frieze Art Fair.

Cawdell Douglas

10-11 Lower John Street, London,

W1F 9EE

T 020 7439 2822

F 020 72875488

E press@cawdelldouglas.co.uk

W www.cawdelldouglas.co.uk

Offers public-relations services in the arts, heritage and culture sector.

Fine Art Promotions

T 07941 271244

F 01903 783354

W www.fineartpromotions.com

Established in 2006, offering a personal, professional and confidential marketing and PR service for commercial galleries, fine artists and

agents of fine art.

Editor Julie Badrick (Founder)

Hobsbawm Media 1 Marketing Communications Ltd (HMC)

15 Doughty Street, Bloomsbury, London,

WC1N 2PL

T 020 74309444

F 020 74309595

E julia@hmclondon.co.uk

W hmclondon.co.uk

An independent London-based communications consultancy with over a decade of experience.

Editor Julia Hobsbawm (Chief Executive and

Editor Julia Hobsbawm (Chief Executive and Founder)

HQ – International Communications for the Arts Ltd

11 Savile Row, London,

W1S 3PG

T 020 72873070

F 020 72873060

E info@hgcommunications.com

Created in 1998 in response to the demand from UK art institutions for stronger international media exposure, and from foreign equivalent institutions for increased visibility in the UK. Services are tailored to the clients' requirements by a small, dedicated and multi-lingual team. UK clients include The British Museum, the National Portrait Gallery, The Royal Academy of Arts, The Saatchi Gallery, Virgile and Stone (Designers/Architects) and Albion. Foreign clients include the Fondation Cartier pour l'art contemporain, Le Printemps de Septembre, Ambassade de France and Fung Collaboratives (The Snow Show).

Editor Daniele Reiber

Idea Generation

11 Chance Street, London, E2 7JB

T 020 77496850

E info@ideageneration.co.uk

W www.ideageneration.co.uk

Set up in 2000, specializing in public relations for the arts and entertainments sectors. Clients have included Frieze Art Fair, Sprueth Magers, Hauser & Wirth Zurich London, Lisson Gallery, Manchester International Festival, Amazon.co.uk, and European Firm Promotion. Check website for up-to-date client list.

JB Pelham PR

208 Latimer Road, North Kensington, London, W10 6QY

T 020 8969 3959

F 020 8964 4562

E jasmin@jbpelhampr.com

W www.jbpelhampr.com

Works with art galleries, arts organizations, art fairs and independent artists to provide strategic public relations campaigns. With over ten years' experience.

Parker Harris Partnership

15 Church Street, Esher, KT10 8QS

T 01372 462190

F 01372 460032

E info@parkerharris.co.uk

W www.parkerharris.co.uk

Founded by Emma Parker and Penny Harris in 1990, specializing in the creation, organization, marketing, press and public relations of fine-art exhibitions and events, including competitions.

Pippa Roberts Publicity & Communications 101 Mapledene Road, London Fields, London,

E8 3LL

T 020 79233188

E pr@pipparoberts.com

A public relations company founded in 2001, specializing in press relations, marketing communications and corporate activity for art and antiques fairs, events and retailers, art exhibitions, competitions and shows. Clients

since 2001 include Olympia Fine Art and Antiques Fairs, the London Silver Vaults, Olympia Loan Exhibitions (Augustus John, Edward Burra, Keith Vaughan, Graham Sutherland, Prunella Clough, Wyndham Lewis), Decorative Antiques and Textiles Fairs, BlindArt (charity) competition and exhibition, HALI Carpet Textile and Tribal Art Fair.

Rebecca Ward

33 Wellington Row, London, E2 7BB

T 020 7613 3306

E press@rebeccaward.co.uk

W www.rebeccaward.co.uk

A freelance public relations consultant with nearly fifteen years experience of promoting the arts and fashion. Current and past clients include the V&A, Port Eliot Lit Fest, Serpentine Gallery, Whitechapel Gallery, Crafts Council, SHOWstudio.com, The Women's Library, Thomas Williams Fine Art, University of the Arts, V&A's Museum of Childhood, Architecture Foundation, International PEN, English Heritage, Heritage Lottery Fund and the Iran Heritage Foundation.

Sue Bond Public Relations

T 01359 271085

F 01359 271934

E info@suebond.co.uk

W www.suebond.co.uk

Established in 1982, specializing in fine arts, antiques and cultural events.

Theresa Simon Communications

9 Cork Street, London, W1S 3LL

T 020 77344800

E info@theresasimon.com

W www.theresasimon.com

An agency specializing in public relations and marketing for visual and performing arts, design and architecture organizations. Recent clients include the Wallace Collection, the London Architecture Biennale, Archives Libraries Museums London, Arts Council England, Zoo Art Fair and Modus Operandi Art Consultants.

Editor Theresa Simon (Director)

General index

Alphabetical index to all entries.

All companies and organizations are listed according to their full names, e.g. Henry Moore Institute is found under 'H' and Paul Hamlyn Foundation can be found under 'P'.

The Art Shop (London) 227 01 Art Services Ltd 270 107 Workshop 279, 292 108 Fine Art 122 176 Gallery / The Zabludowicz Collection 1853 Gallery Shop 247 1871 Fellowship 388 198 Gallery 29 20/21 British Art Fair 376 20/21 International Art Fair 376 20-21 Visual Arts Centre 147 24 Hour Museum 208 291 Gallery 29 3 Lanes Transport Ltd 270 36 Lime Street Ltd 292 96 Gillespie 29 'A' Foundation -Greenland Street 74, 421 A&C Black Publishing 285 A. Bliss 263 A.P. Fitzpatrick 227 A.S. Handover Ltd 227 AA Files 473 AB Fine Art Foundry Ltd Abacus (Colour Printers) Ltd 279 Abbey Awards in Painting and Abbey Scholarship in Painting 388 Abbot Hall Art Gallery 162 Abbott and Holder Ltd 30 Abcon 245 Aberdeen Art Gallery 169 Aberdeen University Library 364 Aberystwyth Arts Centre 187 Abingdon & Witney College absolutearts.com and World Wide Arts Resources Corp. 213 Acacia Works 263 ACAVA - Association for Cultural Advancement through Visual Art 292 Access to Arts 127 Accrington & Rossendale College 344 ACE Award for Art in a Religious Context 388 ACE/MERCERS International Book Award 388 ACE/REEP Award 388 Ackermann & Johnson Ltd Acme Studios 292 Ad Hoc Gallery 159 Adolph & Esther Gottlieb Foundation Grants 389 Adonis Art 30 Advanced Graphics London 30 Advantage Printers 279 Aesthetica Magazine 473

Affordable Art Fair 376 Africa Centre 357 Afterall 473 The Afton Gallery 87 The Agency 30 Agnew's 30 Ainscough Gallery 74 Air Gallery 31 Air Space Gallery 437 Al's Studio and Camera Supplies 272 Akademie Schloss Solitude 389 Alan Cristea Gallery 31 Alan Kluckow Fine Art 87 Albemarle Gallery 31 Albert Sloman Library 356 Albion 31 Albion / AAR 88 Alec Drew Picture Frames Ltd 263 Alec Tiranti Ltd 237 Alexander Gallery 100 Alexander Graham Munro Travel Award 389 Alexander-Morgan Gallery Alexandra Wettstein Fine Art 88 Alfred East Art Gallery 147 Alison Jacques Gallery 31 All Arts 437 Allyson Rae 254 Alma Enterprises 31 Alms House 240 Alternative Arts 437 Alton College 347 Alustretch UK Limited 227 Amber Roome Contemporary Art 82 American Museum in Britain Library 367 Amersham & Wycombe College 347 Amersham & Wycombe College Learning Resources Centre 365 a-n Magazine / a-n The Artists Information Company 208, 437, 473 Analogue Books 247 Anderson Hill 31 Andipa Gallery 32 Andrew Coningsby Gallery Andrew Logan Museum of Sculpture 187 Anglia Polytechnic University 356 Anglo Pacific 270 Animal Arts 88 Ann Jarman 21 Anne Faggionato 32 Anne Peaker Centre for Arts in Criminal Justice (Unit for the Arts and Offenders) 437 Annely Juda Fine Art 32 Annetts (Horsham) Ltd 237 Annexe Gallery 79 Another Magazine 473

Anova Books Group Ltd Anthony Hepworth Fine Art Dealers Ltd 100 Anthony Reynolds Gallery Anthony Woodd Gallery 82 Anthroposophical Society in Great Britain Library Antique Collectors' Club 285 Aon Artscope 268 AOP Gallery 32 apob Original Art Galleries Apollo Gallery 127 Apollo Magazine 473 Appledore Visual Arts Festival 376 The Approach 32 APT Gallery 32 Arcadea 421 Archbishops' Council 357 Archeus 33 Archipelago Art Gallery and Studio 122 Architectural Association Architecture & Planning Library 364 Architecture Library, Cardiff University 368 Arcola Theatre 33 Ards Arts Centre 167 Arena Gallery 74 The Ark 197 Arklow Fine Art Gallery 127 Armagh County Museum 167 Arna Farrington Gallery 21 Arndean Gallery 33 Arnolfini 181 Arnolfini Bookshop 247 Art & Architecture Journal 473 Art & Architecture Thesaurus Online 216 Art & Craft Company 245 Art & Craft Emporium / Silkes One Stop Stationery 246 Art & Design 247 Art & Frame 263 Art 2 By Ltd 113 The Art Academy 310 Art and Soul 263 Art and Spirituality Network 438 Art at Bristol 240 The Art Book 474 Art Books Etc 247 Art Bronze Foundry (London) Ltd 261 The Art Café 226 The Art Café (Nottingham) 226 Art Centre (Halifax) 245 Art Centre (Weston-super-Mare) 240

Art Centre and Gallery (Bedford) 237 Art Centre and Tamar Valley Gallery 241 Art Choice Supplies 246 Art Connections 438 Art Consultants Ltd - Art For Offices 421 Art Data 248, 285 Art Essentials 226 Art Express 245 Art First 33 Art for All 237 Art Fortnight London Ltd 376 Art Guide 208 The Art Gym 182 Art History 474 The Art History Blog 211 The Art House (Manchester) 233 The Art House (Wakefield) 438 Art in Action (Fulham) 376 Art in Action Gallery (Wheatley) 88 Art in Context 211 Art in Partnership 438 Art in Perpetuity Trust (APT) 438 Art in the City 213 Art Industri 213 Art Ireland 376 Art Ireland Spring Collection 377 Art London 377 Art Marketing Ltd 279 Art Materials Company Art Matters Gallery 113 Art Mediums Ltd 236 Art MoCo 208 Art Monthly 474 Art Move Ltd 270 Art Movements 216 Art News Blog 208 The Art Newspaper 474 Art of Framing 263 Art on the Net 211 Art Point Trust 421 Art Quarterly 474 Art Safari 438 Art Sales Index Ltd 286 Art Sheffield 377 The Art Shop (Abergavenny) 243 The Art Shop (Darlington) 232 The Art Shop (Rutland) The Art Shop (Trowbridge) The Art Shop (Wanstead) The Art Shop (Whitley Bay) The Art Shop (York) 245 The Art Shop and Kemble Gallery 232 Art Space Gallery (London)

Art Space Gallery (St Ives) Art Space Portsmouth Ltd 292 Art Upstairs 246 Art World Magazine 474 ART.e @ the art of change Art@94 89 Art@Bristol 241 Artangel 421 artart.co.uk 214 Artboxdirect 241 Artcadia 33 ArtChroma 279 Artco 122 artcourses.co.uk 208 Artcraft 245 Artcyclopedia 216 artdaily.com 208 artefact 208 Artes Mundi Prize 389 ArtForums.co.uk 211 ArtFrame Galleries 100 ARTfutures 377 Arthouse Gallery (Brighton) 89 Arthouse Gallery (London) ArtInfo 216 ArtInLiverpool.com 208 Artisan 233 Artisan for Unusual Things Artist Eye Space 33 Artist of the Year by the Society for All Artists (SAA) 389 The Artist 474 artist-info: Contemporary Art Database 209 Artist-in-Residence, Durham Cathedral 390 Artistri 214 Artists & Illustrators 474 Artists & Makers Festival artists @ redlees 292 Artists and Restorers (A&R) Studios 292 Artist's Gallery 117 Artists' General Benevolent Institution 421 Artists in Berlin Programme (DAAD) 390 Artists' Network Bedfordshire 439 **Artists Residences** (Cyprus) 390 artistsprinting 272 Artizana 74 Artlex Art Dictionary 216 Artline Media 279 Artlines 263 Artlistings.com 209 artnet 217 ArtNews.info 211 Artolicana 122 art-online - The Fine Art Directory 208

Artpoint 439 artprice.com 217 Artquest 211, 258 Artquip 235 ArtRabbit 211 artrepublic 89 ArtReview 475 artroof.com 214 Arts & Business 439 Arts & Disability Forum 422 Arts & Interiors Ltd 241 Arts and Crafts in Architecture Awards 390 Arts and Humanities Research Council 422 Arts Awards 390 Arts Bibliographic 248 The Arts Catalyst 439 Arts Council England 358, Arts Council England -East England Arts 422 Arts Council England -East Midlands Arts 422 Arts Council England -Helen Chadwick Fellowship 391 Arts Council England -London Arts 423 Arts Council England -North East Arts 423 Arts Council England -North West Arts 423 Arts Council England -Oxford-Melbourne Fellowship 391 Arts Council England -South East Arts 423 Arts Council England -South West Arts 423 Arts Council England -West Midlands Arts 423 Arts Council England -Yorkshire Arts 423 Arts Council Ireland 422 Arts Council of Northern Ireland 423 Arts Council of Northern Ireland International Residencies 391 Arts Council of Northern Ireland Support for Individual Artists Programme 391
Arts Council of Wales 424 Arts Culture Media Jobs Arts Education Development 439 The Arts Foundation 424 Arts Gallery 149 **Arts Grant Committee** (Sweden) 392 Arts Hub 209 Arts Institute at Bournemouth Library The Arts Institute at Bournemouth 325, 351 Arts Journal 209

Arts Marketing Association Audio Arts 475 August Art 34 Arts Media Contacts 475 Aune Head Arts 440 Arts Professional Online Austin/Desmond Fine Art 209 Arts Project 440 Austrian Cultural Forum Arts Research Digest 475 London 149, 358 Autograph ABP 440 ARTS UK 440 Arts/Industry Artist-in-Awards for All 424 AXA Art Insurance Ltd 268 Residency 392 ArtsAccess.org 214 Axis 214, 441 Backlit 203 Artsadmin 424 ArtsCurator Ltd 214 Backspace 211 Bad Art Gallery 128 Artselect Ireland 127 Ballance House 79 ArtsFest 377 Balmoral Scholarship for Artshole.co.uk 214 art-shopper 208 Fine Arts 392 **BALTIC Centre for** Artsinform Communications Ltd Contemporary Art 159 BALTIC Shop 248 Bankfield Museum 192 ArtSouthEast 209 Bankside Gallery 149, 441 The Artspace Lifespace Bar Street Arts Ltd 245 Project 440 Artspace Studios 293 Barbara Behan Contemporary Art 34 The Artspost 475 Barbara Hepworth Artstat 233 Artstore at the Artschool Museum and Sculpture Garden 182 Ltd 236 Barber Fine Art Library. ArtSway 174 Artupdate.com 209 University of Birmingham 369 Artwords 248 Artwords at the Barber Institute of Fine Whitechapel 248 Arts 190 Artwork Sculpture Gallery Barbers 264 Barbican Art Gallery 150 89 Barbican Arts Trust / Artworker 238 Artworks 226, 263 Hertford Road Studios Artwrap Ltd 236 Bardon Enterprises 286 Art-Write (Hythe) Ltd 237 The Baring Foundation ASC 293 Ashburne Library, University of Sunderland The Barker Gallery 89 Barking College 338 Barn Galleries 89 Ashgate Publishing Ltd 286 Ashley Studio 225 Barn Gallery 128 Ashmolean Museum 174 Barnet College 341 **Barnet College** Ashmolean Museum Publications 286 Independent Learning Centre 358 Barnfield College 338 Ashmolean Museum Shop 248 Barnsley College 332, 354 Asian Art in London 377 Barrett Marsden Gallery 34 Asian Arts Access 211 Aspect Magazine 475 Barrow Sixth-Form College Aspex Gallery 175
Association of Illustrators 344 Barry College 352 Barry Keene Gallery 90 Basingstoke College of Association of Technology (BCOT) 347 Photographers (AOP) Open 392 The Bate Collection of Astley Hall Museum and Musical Instruments 366 Art Gallery 162 Astley House Bath Area Network for Contemporary 100 Artists (BANA) 441 Bath Artists' Studios Atishoo Designs 100 (formerly Widcombe Atlantis Art 227 Atlas Gallery 34 Studios Ltd) 293 Atrium Gallery 100 Bath School of Art and Attic Gallery 113 Design 325 Attic Picture Framing **Bath Spa University** College, Sion Hill Library Supplies 263

AUA Insurance 268

Battersea Contemporary

Bishop Grosseteste The Bottle Kiln 26 University College Lincoln 307 Biskit Tin 245 Black & White Photography Makers 264 Black Cat Gallery 128 Black Church Print Studio 280 Black Dog Publishing 286 College 350 Black Mountain Gallery Black Swan Arts 101 Blackburn College 344 Blackheath Gallery 35 Library 367 Blackpool and the Fylde College 316, 344 Blackrock Art & Hobby Shop 246 Bow Festival 378 Blackwell 248 Blackwell Art & Poster Shop 248 Blackwell Arts & Crafts House 162 Blackwell Publishing 286 Blades the Art Works 243 College 347 Blake College 341 Blake Gallery 122 The Bleddfa Centre 187 Blenheim Books 248 Blink Gallery 36 Bloomberg 425 Bloomberg New Contemporaries 393 Bloomberg SPACE 150 Blots Pen & Ink Supplies Gallery 36 233 Blow de la Barra 36 Bloxham Galleries 36 Blue Door Studios 293 Blue Dot Gallery 101 Blue Gallery 241 Blue Leaf Gallery 128 Blue Lias Gallery 101 Bluecoat Books & Art Ltd Bluecoat Display Centre 162 Bluemoon Gallery 90 Blueprint 475 Blyth Gallery 74 Gallery 175 Blyth's Artshop & Gallery **Bob Rigby Photographic** 378 Limited 273 Bodleian Library 365 Bohemia Galleries 123 Library 367 Bold Art Gallery 128 Bolton & Quinn Ltd 483 Bolton Museum, Art Bristol Guild 102 Gallery and Aquarium Bond Gallery 117 Bonhoga Gallery 442 Booer & Sons Ltd 228 **Book Works Publishing** com 214 286 The Boots Library, Nottingham Trent 358 University 357 British Arts 217

Boston College 340

Bottomleys Ltd 233 Boundary Gallery - Agi Katz Fine Art 36 Bourlet Fine Art Frame Bourn Vincent Gallery 197 Bourne Fine Art 82 Bournemouth & Poole Bournemouth & Poole 476 College Learning Resources Centre 367 **Bournemouth University** Bovilles Art Shop 238 Bow Arts Trust and Nunnery Gallery 150, 293 Bowes Museum 160, 370 249 Bowie & Hulbert 113 Boxfield Gallery 144 BP Portrait Award 393 BPD Photech Ltd 273 Brackendale Arts 238 Bracknell & Wokingham Bradbury Graphics 235 **Bradford Central Library** Bradford College 333, 355 Braintree College 338 Braithwaite Gallery 123 Braziers International Artists Workshop 393 Brent Artists' Resource and Brepols Publishers 286 Brewhouse Gallery 147 Brian Sinfield Gallery Ltd 90 Brick Lane Gallery 36 Bridge Gallery 128 21 Bridgeman Art Library 258, Bridgend College 352 Bridgwater College 350 Brighton Art Fair 378 Brighton Artists' Gallery of Contemporary Art 90 Brighton Festival 378 Brighton Museum and Art **Brighton Photo Biennial** Brighton University 322 **Bristol Art Reference** Bristol Creatives 442 Bristol Fine Art 241 Bristol School of Art, Media and Design 326 476 Bristol's City Museum and Art Gallery 182 britart.com / eyestorm. 236 British Academy 442 British Architectural Library British Association of Art

Therapists (BAAT) 442 The British Cartoon Archive, Templeman Library 366 British Council Arts Group British Council Visual Arts Library 358 British Glass Biennale 393 British Journal of Aesthetics British Journal of Photography 393, 476 British Library 358 British Museum 150 British Museum Anthropology Library British Museum Bookshop British Museum Department of Prints and Drawings 358 British Museum Press 286 **British Society of Master** Glass Painters 442 British Universities Film & Video Council 358 Brixton Art Gallery 37 Broad Canvas 238 Broad Oak Colour Ltd 280 Broadford Books and Gallery 236 Broadstone Studios 294 Broadway Modern 117 Bronze Age Sculpture Casting Foundry Ltd and Limehouse Gallery 261 Brooklands College 347 Brooklyn Art Gallery 113 Broughton House Gallery Browns Gallery 123 Browsers Bookshop 243 Brunei Gallery 150 Brunswick Arts Consulting Bruton Gallery 123 BT Batsford 286 Buckenham Galleries 21 **Buckinghamshire Art** Gallery 175 **Buckinghamshire** New University 322, 347 **Buckinghamshire** New University Library 365 Bureau **75** Bureau of Freelance Photographers 442 Burghley 147 The Burlington Magazine Burnley College 344 Burns & Harris (Retail) Ltd Burrell Collection 169 Burren College of Art 335 Burren College of Art Library 371 Burton Art Gallery and Museum 182

Burton College 340 Bury Art Gallery, Museum and Archives 163 Bury College 344 Bury St Edmunds Art Gallery 144 Rusiness Art Service 258 Business2Arts 258, 425 Butler Gallery 197 Buy Art Fair 378 Byam Shaw School of Art Byam Shaw School of Art Library 358 Byard Art 22 Byard Art Open Competition 394 C.S. Wellby 254 Cabinet 37 Cabinet Magazine 476 Cadogan Tate Fine Art Logistics 270 Cafe Gallery Projects London 151 Caffrey's Gallery & Framing Studio 264 Calder Graphics 245 Calderdale College 355 Callan Art Supplies 246 Callum Sutton PR 483 Calouste Gulbenkian Foundation 425 Calouste Gulbenkian Foundation Awards 394 Calumet Photographic UK Calvert 22 37 Camberwell College of Arts 310, 341 Camberwell College of Arts Library 358 Cambridge Open Studios Cambridge Regional College 338 Cambridge School of Art, Anglia Ruskin University 306 Cambridge School of Visual & Performing Arts 338 Cambridge University Press 286 Camden Arts Centre 151 Camera Box 273 Camera Centre 273 The Camera Club 294 Cameraking.co.uk 273 CameraWorld 273 Campbell Works 37 Campbell's of London 264 Candid Arts Trust 443 Cannock Chase Technical College 353 Canon Gallery 90 Canonbury Arts 228 Canterbury Christchurch University College 322 Canterbury ChristChurch **University College** Library 365

Canvas 120 CanvasRus 280 Capital Culture 37 Capsule 113 Cardiff County Central Library 368 Carlow Art and Framing Shop 246 Carlow Public Art Collection 197 Carmarthen Camera Centre 273 Carmel College 344 Caroline Harrison Conservation Ltd 254 Carroll & Partners 268 C'Art Art Transport Ltd 270 Cartwright Hall Art Gallery Cass Art 228 Cass Sculpture Foundation Cast Iron Co. Ltd 261 Castle Ashby Gallery 26 Castle College Nottingham Castle Fine Arts Foundry 261 Castle Galleries 117 Castle Gallery (Birmingham) 117 Castle Gallery (Inverness) Castlefield Gallery 75, 163 Catalyst Arts 168 Catherine Hammond Gallery 129 Cat's Moustache Gallery 82 Cavanacor Gallery 129 Cawdell Douglas 483 Celeste Prize 394 Celf 114 Celf Caerleon Arts Festival 378 cell project space 294 Centagraph 245 The Central School of Speech and Drama 341 Central St Martins College of Art & Design 310, 341 Central St Martins College of Art & Design Library Centre for Contemporary Arts (CCA) 169 Centre for Migration Studies at the Ulster-American Folk Park 364 Centre for Recent Drawing - C4RD 38 Centre Gallery 71 The Centre of Attention 38 Ceramic Art London 379 Ceramic Review 476 Ceres Crafts Ltd 241 Chagford Galleries 91 Chameleon Gallery 91 Chapel Gallery (Ormskirk) 163 Chapel Gallery (Plymouth) 102

Chapel of Art - Capel Celfyddyd 114 Chappel Galleries 22 Chapter 1 233 Chapter Gallery 188 Chapters Bookstore 249 Charing X Venue 38 Charles Vernon-Hunt Books 249 Charleston Farmhouse and Gallery 175 Chatton Gallery 71 Chaudigital 273 Chelmsford College 338 Chelsea Arts Club 443 Chelsea Arts Fair 379 Chelsea Bridge Studios 294 Chelsea College of Art & Design 311, 341 Chelsea College of Art & Design Library 358 CHELSEA space 151 Cheltenham Art Gallery & Museum 182 Cheltenham Artists Open Houses 379 Cheltenham Library 367 Chepstow Ceramics Workshop Gallery 113 Cherry Art Centre 241 Cherrylane Fine Arts 129 Chester Beatty Library 197 Chester Beatty Library Shop 249 Chester College Learning Resources 363 Chesterfield College 308, 344 Chichester College of Arts, Science and Technology Chichester Gallery 91 Children's Scrapstore 241 Chinese Arts Centre 163 Chinese Contemporary Ltd Chisenhale Gallery 151 **Chocolate Factory Artists** Studios 294 Choyce Gallery 22 Christ Church Picture Gallery 175 Christine Bullick 254 Christopher Wren Gallery Chromacolour International 228 Chromos (Tunbridge Wells) Ltd 238 Chrysalis Arts Ltd 443 Church House Designs 102 Ciara Brennan Conservation of Fine Art The Cill Rialaig Project Artists Retreat 394 Cinema Theatre Association 359 Circa Art Magazine 476 City and Guilds of London

Art School 341

City and Islington College 341 City Art 232 City Art Centre (CAC) 169 City Art Store 232 City College Brighton & Hove 347 City College Norwich 238 City College, Birmingham City Lit 341 City of Bath College 350 City of Bristol College 350 City of Sunderland College 314, 343 City of Westminster College 341
City of Wolverhampton College 353 Claire de Rouen Books 249 Clapham Art Gallery 38 Clare Finn & Co. Ltd 254 Claremorris Art Gallery 129 Clarion Contemporary Art Clark Galleries 26 Clevedon Craft Centre 294 Cleveland College of Art & Design - Hartlepool Campus 343 Cleveland College of Art & Design - Middlesbrough Campus 314, 343 Clifton Gallery 102 Clikpic 214 Clonmel Gallery 197 Coed Hills Rural Artspace Coin Street Community Builders 294 Colart Fine Art & Graphics Ltd 228 Colchester Institute 306, 347, 356 Coleg Gwent 352 Coleg Llandrillo College Coleg Meirion-Dwyfor 352 Coleg Menai 352 Coleg Powys 352 Colemans of Stamford 226 Colin Iellicoe Gallery 75 Collect 379 Collective Gallery 83, 169 College of North East London 341 College of West Anglia 306, 338 Collett Art Gallery 79 Colliers 71
Collins & Hastie Ltd 38 Collins and Brown 287 Collins Gallery 170 Colorworld Imaging 280 Colours and Crafts 233 Combridge Fine Arts Ltd Comme Ca Art Gallery 75 Commissions East 425 Common Ground 426

The Common Guild 443 Commonwealth Connections International Arts Residencies 394 Community Arts Forum Compass Gallery 83 The Compleat Artist 242 Compton Verney 190 Conceptual Artists Network - CAN 444 Conservation Register 200 Conservation Studio 254 Constable & Robinson Ltd 287 Constantine Ltd 270 Consultant Conservators of Fine Art 255 Contemporary 476 Contemporary Applied Arts Contemporary Art Society Contemporary Art Society for Wales - Cymdeithas Gelfydoyd Gyfoes Cymru Contemporary Ceramics 39 Contemporary Glass Society 444 Contemporary Studio Pottery 102 Context Gallery 79 Coombe Gallery 102 Cooper Gallery 193 CORE Program 395 Cork Art Fair 379 Cork Art Supplies Ltd 246 Cork Printmakers 280 Corman Arts 258 Cornerhouse 163 Cornerhouse Shop 249 Cornwall College 350 Cornwall College Camborne 350 Cornwall Galleries 103 Corrymella Scott Gallery 71 Corvi-Mora 39 Cosa Gallery 39 Counter 214 Counter Gallery 39 Country Love Ceramics 238 Courtauld Institute of Art Gallery 151 Courtauld Institute of Art Library 359 Courtenays Fine Art 103 Courthouse Arts Centre Courthouse Gallery, Ballinglen Arts Foundation 129 Courtyard Arts Limited 130 Courtyard Shop 249 The Courtyard 444 Coutauld Gallery Bookshop Cove Park Residency Programme 395

Coventry University 330. Custom House Studios Ltd Coventry University Customs House 71, 160 Lanchester Library 369 CY Gallery 130 Cowdy Gallery 103 Cybersalon 212 Cowleigh Gallery 118 The Cynthia Corbett Gallery Cowling & Wilcox Ltd 228 Craft Central 294, 444 Cynthia O'Connor Gallery Crafts Council 426, 444 Crafts Council Cyril Gerber Fine Art 83 **Development Award** Czech Centre London 152 D & | Simons & Sons Ltd Crafts Council Next Move and SimonArt 228 D FOUR Gallery @ The Scheme 395 Crafts Council Research Berkeley Court 130 Library 359 Daffodil Gallery 130 Crafts Magazine 477 Daintree Paper 246 Crafts Study Centre 176 Daisy Designs (Crafts) Ltd Craftsman Gallery 114 Craftsmen's Gallery 91 Dale Photographic 273 Cranbrook Gallery 91 Daler-Rowney Ltd 238 Craven College, Skipton Daler-Rowney Percy Street/ Arch One Picture Crawford College of Art & Framing 228 Design 335 Dalkey Arts 130 Crawford College of Art & Dalston Underground Design Library 371 Studios 295 Crawford Municipal Art Damon Bramley 270 Gallery 198 Daniel Laurence Home & Create 445 Garden 91 Creative Crafts 238 Danielle Arnaud Creative Learning Agency contemporary art 40 Darbyshire Frame Makers Creative Partnerships 445 Creative Shop Ltd 233 Darcy Turner 229 Creative Skills 426 The Darkroom UK Ltd 273 Creative Space Agency 217 The Darryl Nantais Gallery Creative World 238 CreativeCapital 445 Dartington College of Arts CreativePeople 211 326 Creativity 242 Dartington College of Arts Creekside Artists Studios Library 368 David & Charles 287 Creekside Open 395 **David Canter Memorial** Cregal Art 246, 264 Fund 396 The David Gluck Memorial Crescent Arts 123 Crescent Galleries Ltd 103 Bursary 396 Cricklade College 347 David Potter Ltd 225 Cristeph Gallery 130 David Risley Gallery 40 Croft Gallery 103 Davidson Arts Partnership Croft Wingates 26 Cromartie Hobbycraft Ltd Davies Turner Worldwide Movers 271 Cross Gallery 130 Dayfold Solvit 280 Crown Gallery 103 Dazed & Confused Magazine Crown Studio Gallery 71 Croydon College 311, 341 De Ateliers 396 Croydon Museum Service De La Warr Pavilion 176 De La Warr Pavilion Shop Cube Gallery 103 **Cubitt Gallery and Studios** De Lacey Fine Art 75 De Montfort University Cuckoo Farm Studios 295 308, 340 Cultural Co-operation 445 Dealg Design Ltd 264 culturebase.net 217 Dean Clough Galleries 193 Cunnamore Galleries 130 Dean Gallery 170 Cupola Contemporary Art Dean Gallery Shop 249 Ltd 123 Deeside College 352 Custard Factory 118 DegreeArt.com 40, 214 Custom House Art Gallery Delamore Arts 104 and Studios 83 Delfina Studio Trust 396

Deptford X 379 Derby College 340 Derby Museum and Art Gallery 147
Derek Hill Foundation Scholarship in Portraiture 396 Derwentside College 343 Design and Artists Copyright Society (DACS) 445 Design Collection Museum 182 Design Council 446 Design Factory 446 Design Museum 152 Design Museum Shop 249 DesignerPrint 280 Designspotter 209 Details @ Newcastle Arts Centre 232 Deutsche Börse Photography Prize 397 Deveron Arts Residency Programme 397 Devon Guild of Craftsmen 446 Dewsbury College 333, 355 Dick Institute 170 Dicksmith Gallery 40 Dickson Russell Art Management 259 Diesel House Studios 295 digital art source 212 The Digital Artist 212 Digital Camera Magazine Digital Consciousness 209 Digital Print Studio 280 Digitalab 274 Direct Lighting 274 Disability Cultural Projects Discount Art 245 Ditchling Museum 176 Djanogly Art Gallery 147 Djerassi Resident Artists Program 397 Dock Museum 164 doggerfisher 83 **Dolphin Fine Art Printers** Dolphin House Gallery 104 Dominic Guerrini Fine Art Domino Gallery 75 Dominoes of Leicester Ltd 226 Domo Baal 40 Doncaster College 333, 355 Doncaster College Learning Resource Centre 370 Dorling Kindersley Ltd 287 Dorset Art Weeks 380 **Dorset County Museum** dot-art 76 Douglas Hyde Gallery 198 The Dover Bookshop 249

Downtown Darkroom 274 Drajocht Arts Centre 108 The Drawing Room 40 Driffold Gallery 118 The Drill Hall 295 DTEK Systems 274 Dublin Art Foundry 261 **Dublin City Central Library Dublin City Gallery Hugh** Lane 198 Dublin Institute of Technology Library 371 Dublin Institute of Technology, Faculty of Applied Arts 336 Dublin Writers' Museum **Dudley College of** Technology 330, 353 Duff House Country House Gallery 170 Dulwich Art Fair 380 Dulwich Picture Gallery **Dumfries & Galloway Arts** Festival 380 Dun Laoghaire Institute of Art. Design & Technology 336 Dunamaise Arts Centre Duncan Campbell 41 Duncan of lordanstone College of Art & Design Library 364 Duncan of Jordanstone College of Art and Design 320 Duncan R. Miller Fine Arts Dundas Street Gallery 84 Dundee City Library Art and Music Department **Dundee Contemporary Dundee Contemporary** Arts Shop 249 Dunn's Imaging Group Plc Dunstable College 306, 339 **Durham Light Infantry** Museum and Durham Art Gallery 160 Dvehouse Gallery 130 E&R Cyzer 41 EAC Over 60s Art Awards Eagle Gallery Emma Hill Fine Art 41 Eakin Gallery Belfast 80 Ealing, Hammersmith and West London College Earagail Arts Festival 380 East Berkshire College 347 East End Academy 397 East International 397 East Lancashire Institute of

Higher Education 316

Fast London Printmakers

East Neuk Open 380 East Riding College 355 East Street Arts (ESA) 446

East Surrey College 348

East West Gallery 41

ecArtspace 41

FCO - Exeter

EDCO 235

Eddie Sinclair 255

Eden Imaging 274

Library 364

Festival 380 Edinburgh Printmakers 84 Edinburgh University

Library 364

Archive 365

234 e-flux 212

EggSpace 76

398

Eleven 42

Edinburgh Art Fair 380

Edinburgh College of Art

Edinburgh College of Art

Edinburgh International

Edward Barnsley Furniture

Edwin Allen Arts & Crafts

Egan, Matthews & Rose

EKA Services Ltd 239

Elastic Residence 42

Elephant Trust Award

Elizabeth Fitzpatrick Travel

Bursary 398
Elizabeth Foundation for

Elizabeth Greenshields

Foundation Grants 398

the Arts 398

Ellen L. Breheny 255

Embroiderers' Guild Library 365

Emerging Artists Art

Emily Tsingou Gallery 42

Enfield Arts Partnership

Association for Gallery

England & Co Gallery 43

English Heritage Library

English Heritage Photo

English-Speaking Union

Library 368

Scotland 84

Elliott Gallery 104

Emer Gallery 80

Gallery 215

The Empire 42

Enable Artists 446

42 Enfield College 342

engage - National

Education 446

England's Gallery 118

368

Elephant Trust 426

Eastleigh Museum 176

East Surrey College Library

Contemporary Open 398

Economy of Brighton 238

Enterprise Centre for the Creative Arts (ECCA) Epping Forest College 339 Fosom Library 365 Erna & Victor Hasselblad Foundation Awards and Bursaries 398 Estorick Collection of Modern Italian Art 152 Furgart Live Festival 380 Euroart Studios 447 European Association for **Jewish Culture Grants** European Associaton for lewish Culture 426 **European Council of Artists** (ECA) 447 ev+a - Limerick Biennial 380 Evergreen Gallery 26 Everyman Artist's Supply Co. 244 Exeter College 326, 350 Exmouth Gallery 104 Expressions 239 Eyecandy 124 Eyes Wide Digital Ltd 281 eyestorm 215 Eyestorm-Britart Gallery fa projects 43 F.J. Harris & Son 242 Fabrica 447 FACT Shop 250 Fado 131 Fairfax Gallery 43 Fairfields Arts Centre 183 Fairgreen Picture Framing 264 Falkiner Fine Papers 229 Fareham College 348 FarmiloFiumano 43 Farnell Photographic Laboratory 274 Farnham Maltings East Wing Gallery 92 Fashion Museum Research Centre 368 Fashion Space Gallery 152 Fastnet Framing 264 Fearnside's Art Ltd 244 Federation of British Artists (FBA) 426, 447 Federation of British Artists (FBA) Annual Open 399 Feiweles Trust 399 Felix Rosenstiel's Widow & Son Ltd 43 Fenderesky Gallery 168 Fenton Gallery 131 Fenwick Gallery 71 Ferens Art Gallery 193 Fermynwoods Contemporary Art 26 Ferndown Upper School

Enitharmon Editions Ltd

Ffordes Photographic Ltd Ffotogallery 188 Fielders 229 Fieldgate Gallery 43 Fife Contemporary Art & Craft (FCAC) 170 fifiefofum 71 Figurative Artist Network (FAN) 447 Filthy But Gorgeous 118 Filton College 326, 350 FindArtInfo.com 217 Fine Art Commissions Ltd Fine Art Framing Studio Fine Art Library 364 Fine Art Promotions 483 Fine Art Society Plc 44 Fine Art Surrey 215 Fine Art Trade Guild Archive 359 Fire Station Artists Studios firstsite 448 Fisherton Mill - Galleries Cafe Studios 104 Fitzgerald Conservation Fitzwilliam Museum 144, Five Years 44 Fixation 274 Flaca 44 Flameworks Creative Arts Facility 296 Flamin Awards 399 The Flash Centre 274 Flax Art Studios 296 Fleming Collection 153 Florence Trust Residencies Florence Trust Studios 296 Flowers East 44 Flux Magazine 477 Fly Art & Crafts Company 244 Flying Colours Gallery 44 Focal Point Gallery 144 Focal Press (an imprint of Elsevier) 287 Focus Gallery 26 Folk Archive 215 Folkestone Triennial Visitor Centre 381 Folklore Society Library 359 Folly 164 Forge Gallery 124 Forget Me Not 239 Form Gallery 131 Forma Arts & Media 448 Fosterart 44 Foto8 477 fotoLibra 259, 274 Fotonet 215 Foundation for Art and Creative Technology (FACT) 164, 212 Foundation for Women's Art (FWA) 448

Foundling Museum 153 Four Corners 275 Four Courts Press 287 Four Square Fine Arts 92 Fourwalls 92 Fox Talbot Museum 182 Foyles Bookshop 44, 250 Frame Tec 264 Framemaker (Cork) Ltd 265 Framework Gallery (Dun Laoghaire) 131, 265 Framework Picture Framing 265 Framework Studios 206 Frameworks 265 Framing Fantastic 265 The Framing Workshop Frances Lincoln Ltd 287 Frances Roden Fine Art Ltd 105 Francis Iles 92 Frandsen Fine Art Framers Ltd 265 Frank B. Scragg & Co. 265 Frank Lewis Gallery 131 Franklin Furnace Fund for Performance Art and Franklin Furnace Future of the Present 300 Fred [London] Ltd 45 Fred Aldous Ltd 234 Fred Keetch Gallery 242 Free Range 381 Freeform 427 Frewen Library, University of Portsmouth 368 Friends of Israel **Educational Foundation** Friends of the Royal Scottish Academy Artist Bursary 400 frieze 477 Frieze Art Fair 381 Fringe Arts Picture Framers 265 FringeMK Annual Painting Prize 400 Frink School of Figurative Sculpture 316 Friswell's Picture Gallery Ltd 118 Frith Street Gallery 45 Frivoli 45 Frost & Reed 45 Fruitmarket Gallery 171 Fruitmarket Gallery Bookshop 250 Fulham Reference Library Furtherfield 212 Future Factory 148 G.E. Kee 246 Gadsby's / Artshopper 226, Gagosian Gallery 45 Gainsborough's House Galerie Besson 45

Gallagher & Turner 72 The Getty Foundation 400 Galleria Fine Arts 224 Getty Images 259 Gallerie Marin 105 Getty Images Gallery 46 Galleries Magazine AT Getty Images Hulton The Gallery - text+work 183 Archive 359 Gallery 148.com 80 Gi - Glasgow International Gallery 1839 215, 400 Gilbert Collection 153 Gallery 2000 76, 266 Gallery 42 124 Giles Cameras 275 Gallery 44 131 Giles de la Mare Publishers Gallery 52 26 Ltd 288 **Gallery 75 131** Gillian Iason Modern & Gallery 93 26 Contemporary Art 46 Gallery 99 92 Gimpel Fils 47 Gallery at Norwich Glamorgan Centre for Art University College of the & Design 352 Glasgow Art Fair 381 The Gallery at Willesden Glasgow Print Studio 84 Green 45 Glasgow School of Art 320 Gallery Beckenham 92 Glasgow School of Art Gallery Gifts Ltd 229 Library 364 Gallery in Cork Street Ltd Glasgow University Library and Gallery 27 46 364 Gallery Kaleidoscope 46 Glass and Art Gallery 72 Gallery N. von Bartha 46 Glass House Gallery 105 Gallery of Modern Art 171 Glebe House and Gallery Gallery of Modern Art Reading Library 364 GlimpseOnline.com 215 Gallery of Photography 199 Global Art Jobs 209 Gallery Oldham 164 Global Arts Village 401 Gallery One (Cookstown) Globe Gallery - City 72 Globe Gallery - Hub 72 Gallery One (London) 46 GLOSS 448 Gallery Support Group 271 Gloucester City Museum Gallery Top 26 and Art Gallery 183 Gloucester College 350 The Gallery Upstairs 119
The Gallery – Manchester's Glynn Vivian Art Gallery Art House 76 188 The Gallery (Dunfanaghy) Godalming Art Shop 239 Godfrey & Watt 124 The Gallery (Leek) 119 Goethe-Institut Inter The Gallery (Masham) 124 Nationes Library 359 The GalleryChannel 209 Goethe-Institut London Galway Arts Centre 199 153 Golden Cockerel Press Ltd Galway-Mayo Institute of Technology 336 Garnet Publishing / Ithaca Golden Thread Gallery 168 Press 287 Golden Valley Insurance Garter Lane Arts Centre Services 268 199 Goldfish Contemporary Fine Art 105 Gascoigne Gallery 124 Gasworks 296 Goldsmiths - University of Gate Gallery 72 London 311 Goldsmiths Library 359 Gateshead College 343 Gateway College 340 The Good Gallery Guide Gayton Library 366 Geffrye Museum 153 Gorey School of Art 336 Geffrye Museum Archive Gormleys Fine Art 80, 131 Gorry Gallery Ltd 132 Gemini Digital Colour Ltd Goslings 266 Gosta Green Library, Gen Foundation 400 Birmingham Institute of Genesis Imaging Ltd 275, Art & Design 369 GPF Gallery 114 Geoff Marshall Graal Press 281 Photography Ltd / Graham Bignell Paper Cornwall Cameras 275 Conservation 255 Geoghegans Picture Graham Harrison Framing Framing Service 266 Ltd 266 George Street Gallery 92 Granby Gallery 27

Grantham College 355

Get Creative 236

Granthams Art Discount Graphic Studio Gallery 132 Graves Art Gallery 193 Gravs of Shenstone 266 Great Art (Gerstaecker UK Ltd) 239 Great Atlantic Map Works Gallery 105 Great Western Studios 206 Great Yarmouth College 330 Green and Stone of Chelsea 220 Green Door Studio (Dunfanaghy) 132 Green Door Studios (Kendal) 206 Green Dragon Museum and Focus Photography Gallery 160 Green Gallery (Swansea) Green Gallery Dublin 132 Green On Red Gallery 132 Greenacres 132 Greengrassi 47 Greenlane Gallery 132 Greenwich Community College 342 Greenwich Mural Workshop 448 Greyfriars Art Shop 236 Grimes House Fine Art 105 Grimsby College 355 Grimsby Institute of Further and Higher Education 308 Grizedale Arts 448 Grizedale Sculpture Park Grosmont Gallery 125 Grosvenor Gallery (Fine Arts) Ltd 47 Grosvenor Museum 164 Group 75 449 Grove Art Online 217 Grove Library, Bradford College 370 Grundy Art Gallery 165 Guild of Aviation Artists Guild of Glass Engravers 449 Guild of Master Craftsman Publications Ltd 288 Guildford College of Further and Higher Education 348 Guildford House Gallery Guildhall Art Gallery 153 Guildhall Library (Print Room) 359 **Gunk Foundation Grants** for Public Arts Projects Gwen Raverat Archive 145 Gwennap Stevenson Brown Ltd 268 The Gym 182

Hackelbury Fine Art 47 Hackney Community College 342 Halahan Associates 255 Hales Gallery 47 Halesowen College 353 Hallett Independent Ltd Hallward Gallery 133 Halsgrove Publishing 288 Hamiltons 47 Hamish Dewar Ltd 255 Hampshire County Council Museums Service Library 366 Hanina Fine Arts 47 Hannah Peschar Sculpture Garden 93 Harberton Art Workshop 242 Hardings 242 Harewood House 193 Harlequin Gallery 47 Harleston Gallery 22 Harley Gallery 27, 148 Harlow College 339 Harman Technology Ltd 275 Harrington Mill Studios (HMS) 297 Harris Fine Art Ltd 229 Harris Museum and Art Gallery 165 Harris-Moore Canvases Ltd 244 Harrison Learning Centre 369 Hart Gallery 27 Hartworks Contemporary Art 105 Harvard University Press Hastings College of Arts & Technology 348 Hatchards 250 Hatton Gallery 160 Haunch of Venison 48 Hauser & Wirth 48 Havering College of Further and Higher Education 339 Hayward Gallery 154 Hayward Gallery Library Hayward Gallery Shop 250 Hazlitt Holland-Hibbert 48 Head Street Gallery 22 Headrow Gallery 125 Healthcraft 236 Hearn & Scott 239 Heath Lambert Group 269 Heathfield Art 93 Heaton Cooper Studio Ltd Hedley's Humpers 271 Heffers Academic & General Books 250 Heffers Art & Graphics

Helen Hooker O'Malley **Roelofs Sculpture** Collection 200 Helios at the Spinney 119 Helix Arts 427 Henderson Art Shop 236 Henley College 348 Henry Boxer Gallery 48 Henry Brewer 27 Henry Donn Gallery 76 Henry Moore Foundation 356, 427 Henry Moore Institute 194, 370 The Hepworth Wakefield Herald Street 48 The Herbert 190 here nor there 449 Here Shop & Gallery 106 Hereford Museum and Art Gallery 190 Herefordshire College of Art & Design 330, 353 Herefordshire College of Art & Design Library 369 Hereward College 353 Heriot-Watt University 320 The Hermit Press 281 Hermitage Rooms at Somerset House 154 Hertford Regional College Hertfordshire Gallery 23 Hertfordshire Graphics Ltd Hesketh Hubbard Art Society 449 Hicks Gallery 48 Hidden Art 212 High Wycombe Study Centre 366 Highgate Fine Art 49 Highlands College 350 Hills of Newark Ltd 226 Hillsboro Fine Art 133 Hilmarton Manor Press 288 Hind Street Gallery and Frame Makers 106 Hinterland Projects 449 Hiscox Art Café 49 Hiscox PLC 269 Historical Manuscripts Commission 359 HMAG (Hastings Museum and Art Gallery) 177 HMC Logistics Ltd 271 Hobbycraft - The Arts & Crafts Superstore 225 Hobsbawm Media 1 Marketing Communications Ltd (HMC) 483 Hockles 239 Hodges Figgis 250 Hofer Printroom 49 Holborn Studios 297 Holburne Museum of Art Hole Editions 282

Holloway Art & Stationers Honor Oak Gallery Ltd 49 Hoopers Gallery 49 Hope Gallery 27 Hopwood Hall College Horniman Museum Library 359 Hot Chilli Studio 282 Hotel 49 Hothouse Gallery 49 HotShoe 478 Houldsworth 50 House Gallery 50 Hove Museum and Art Gallery 177 Howard Gardens Gallery Howarth Gallery 76 Howth Harbour Gallery Hoxton Street Studios 297 HQ - International Communications for the Arts Ltd 483 HS Projects 259 **HSBC** Insurance Brokers Ltd **269** Huddersfield Art Gallery 194 Huddersfield Technical College 355 Hudson Killeen 282 Hugh Baird College 344 Hull Maritime Museum 194 Hull School of Art and Design 333, 355 Hunt Museum 200 Hunter Gallery 23 Hunterian Art Gallery 171 Huntingdonshire Regional College 340 Hyman Kreitman Research Centre for the Tate Library & Archive 359 I.B. Tauris & Co. Ltd 288 Ian Dixon GCF Bespoke Framers 266 Ian Stewart 275 IBID Projects 50 ICA Bookshop 250 ICAS - Vilas Fine Art 23 IceTwice 93
Icetwice Gallery 250 icon 478 Icthus Arts & Graphics 234 I-D Magazine 478 Idea Generation 484 leda Basualdo 50 Ikon Gallery 191 Ikon Gallery Shop 250 Illustration Cupboard 50 imagiclee.com 282 Impact Art 259 Impact Arts 427 Imperial College of Science, Technology and Medicine Central Library 359

Imperial War Museum 154 Imperial War Museum. Photographic Archive Impressions Gallery 194 Inchbald School of Design Library 360 Independent Art School (IAS) 450 Indigo Arts 450 Ines Santy Paintings Conservation and Restoration 256 Information and Learning Services, University of Plymouth 368 Infrared Gallery 84 ING Discerning Eye Exhibition 401 Ingleby Gallery 84 Ingo Fincke Gallery and Framers 50 Initial Access Frank Cohen Collection 191 InkSpot 237 Innocent Fine Art 106 Inside Art 242 Insight Museum Collections & Research Centre 370 Inspires Art Gallery 93 Institute for the Conservation of Historic and Artistic Works in Ireland 256 Institute of Art & Law 450 Institute of Contemporary Arts (ICA) 154 Institute of International Visual Arts (inIVA) 154, Institute of International Visual Arts Library 360 Institute of Technology, Tallaght 337 Institute of Techonology Sligo 337 Insurancenow Services Ltd 269 Intaglio Printmaker 229 International 3 76 International Art Consultants Ltd 259 International Artists Centre, Poland -Miedzynarodowe Centrum Sztuki 401 International Ceramics Fair and Seminar 381 International Festival of the Image 381 International Fine Art **Conservation Studios** Ltd 256 Intro 2020 275 Intute Arts and Humanities Inverleith House 171 Ipswich Art Society 450 **Ipswich Arts Association** 450

Iris, International Women's Photographic Research Resource 427 Irish Academic Press 288 Irish Arts Review 478 Irish Museum of Modern Art 200 Irving Sandler Artists File 215 Isendyouthis.com 209 ISIS Arts 427 Island Arts Centre 168 Island Fine Arts Ltd 93 Isle of Man College 344 Isle of Wight College 348 Islington Arts Factory 297 Iveagh Bequest 154 ixia 450 J. Paul Getty Jr. Charitable Trust 427 Ruddock Ltd 227 J. Thomson Colour Printers Ltd 282 J.D. Fergusson Arts Award 401 The Jackdaw 478 Jackson's Art Supplies 230 IAM Studios 297 James Hockey Gallery 177 James Hyman Gallery 51 James Joyce House of the Dead 133 James Milne Memorial Trust 402 Jane McAusland Ltd 256 Jarred's Arts & Craft 232 Jarrold's 225 IB Pelham PR 484 Jeff Vickers/Genix Imaging Bursary 402 The Jerdan Gallery 85 Jerwood Charitable Foundation 428 Jerwood Contemporary Makers Prize 402 Jerwood Contemporary Painters 402 Jerwood Drawing Prize 402 Jerwood Sculpture Prize 402

Jerwood Space 51 lessops 275 Jewish Museum 154 Jill George Gallery 51 Jim Robison and Booth House Gallery and Pottery 125 Jim's Mail Order 242 Joan Clancy Gallery 133 Joan Wakelin Bursary 403 John Davies Gallery 106 John E Wright & Co. Ltd John Green Fine Art 85 John Hansard Gallery 177 John Jones Ltd 230 John Martin Gallery 51

John Moores Contemporary Painting Prize 403 John Noott Galleries 119

John Purcell Paper 230 John Rylands University Library 363 John Sandoe (Books) Ltd

The Jointure Studios 94 Jonathan Poole Gallery 106 Jones Art Gallery 133 Jordan & Chard Fine Art 106

Jorgensen Fine Art 133 Journal of Visual Art Practice

Journal of Visual Culture 478 IP Distributrion 275 Jubilee Library 366 Judith Gowland 256 Judith Wetherall (trading as J.B.Symes) 256

Julian Spencer-Smith 256 Julie Crick Art Conservation 256

Just-Art 237 K & M Evans 246 Kamera Direct 275 Kangaroo Kourt 107 Kate MacGarry 51 Kaz Studio 275 Keane on Ceramics 134 Keele University Library

Keith Talent Gallery 51 Kelmscott Manor 184 Kelvingrove Art Gallery and Museum 171

Ken Bromley Art Supplies 234 Kendal College 344 Kenmare Art Gallery 134 Kennedy Gallery 247 The Kenny Gallery 134

Kensington and Chelsea College 342 Kensington Central Library

Kent Potters' Gallery 94 Kent Services Ltd 271 Kentmere House Gallery

125 Kerlin Gallery 134 Kernow Education Arts Partnership (KEAP) 451 Kettle's Yard 145 Kettle's Yard Open / **Residency Opportunities**

Kevin Kavanagh Gallery 134 Kidderminster College of Further Education 353 Kidderminster Library 369 The Kif 77 Kilcock Art Gallery 134 Killarney Art Gallery 134 Kilvert Gallery 114 Kimberlin Library 357 King's Lynn Arts Centre 145

Kings Road Galleries 52 Kingsgate Workshops Trust and Gallery 297 Kingsley Photographic 276 Kingston College 342

Kingston University 311. Kingston University Learning Resources Centre 360 Kinsale Art Gallery 134 Kirkcaldy Museum and Art Gallery 171 Kirkintilloch Fine Arts 237 Knight's Move 478 **Knowsley Community** College 344 Koenig Books London 288

Koenig Books Ltd. 250 Kooywood Gallery 115 Krowji 297 KultureFlash 200 L. Cornelissen & Son 230 La Catedral Studios

(incorporating Phoenix Art Studios) 297 La Gallerie 134 La Mostra Gallery 115 Lab35 Imaging 276 The Lace Guild 369 Lady Artists Club Trust

Award 403 Lady Lever Art Gallery 165 Lady Lever Art Gallery Shop

Laing Art Gallery 161 Laing Solo 403 Lakeland Mouldings 261 Lambeth Palace Library 360

Lancaster and Morecambe College 345 Lancaster University 316 Lancaster University Library 363

Lander Gallery 107 Laneside Gallery 80 Largs Hardware Services & Gallery Eight 266 Latest Art Magazine 478

Laura Bartlett Gallery 52 Laurence King Publishing Ltd 288

Laurence Mathews Art & Craft Store 225 Lavit Gallery 134 Leamington Spa Art Gallery and Museum 191 Leapfrog 247

Learning Stone Portland Sculpture and Quarry

Trust 451 Leeds Art Fair 382 Leeds Art Library 370 Leeds City Art Gallery 194 Leeds City Art Gallery Shop

Leeds College of Art & Design 333, 355, 370 Leeds Met Gallery and Studio Theatre 195 Leeds Metropolitan University 355

Leeds Metropolitan University Learning Centre 370

Leeds School of Contemporary Art and Graphic Design 334 Leeds University Library

Leek College 345 Legge Gallery 135 Legra Gallery 94 Leicester City Art Gallery 148

Leicester College 340 Leicester Print Workshop 282 Leighton House Museum

Leinster Gallery 135 Leitrim Sculpture Centre

Lemon Street Gallery 135 Lemon Tree 237 Lena Boyle Fine Art 52

Lennox Gallery 52 Lesley Bower Paper Conservation 256 Lesley Craze Gallery 52 Letchworth Museum and

Art Gallery 145 Letter 'A' Gallery 23 Leverhulme Trust Grants and Awards 403

Lewis Glucksman Gallery

Lewisham College 342 Lexicon 242 Life - A New Life for Old Documents 257 The Lighthouse (Glasgow)

The Lighthouse (Poole) 184 The Lilliput Press 288

Lime 428 Lime Tree Gallery 72 Limerick City Gallery 200 Limerick Institute of Technology 337

Limerick Printmakers Studio and Gallery 135,

Limited Edition Graphics Lincoln Joyce Fine Art 94

Lincoln School of Art and Design 340 Linda Blackstone Gallery

Linenhall Arts Centre 201 Linhof & Studio Ltd 276 Lisson Gallery 52 Litchfield Artists' Centre

Little London Gallery 27 Live Art Development Agency 451 Liverpool Biennial 382 Liverpool Community

College 316, 345 Liverpool History Shop 77 Liverpool Hope University College 316

Liverpool John Moores University 317

Liverpool John Moores University Learning Resource Centre 363 Liverpool University Press Livingstone Art Founders 261 Llewellyn Alexander (Fine Paintings) Ltd 53 Lloyd Jerome Gallery 85 Lockson UK 271 Locus+ 428 London Art Fair 382 London Art Ltd 230 London Camera Exchange Group 276 London College of Communication 311, London College of Communication Library London College of Fashion 342 London College of Fashion Library 360 London Design Festival London Graphic Centre 230, 251 London Jewish Cultural Centre 155 London Metropolitan University 312, 342 London Metropolitan University Library and Learning Resource Centres 360 London Metropolitan University The Women's Library 360 The London Original Print Fair 382 London Photographic Association 404, 451 London Picture Centre 53 London Print Studio Gallery 155, 282 London Road Gallery 125 London South Bank University 312 London Transport Museum Reference Library 360 Londonart.co.uk 215 Long & Ryle 53 Loudmouth Art Eco-Printing 283 Loughborough University 308, 340 Loughborough University Library 357 Lowes Court Gallery 77 Lowestoft College 339 The Lowry 165 LS Sculpture Casting 262 Lucia Scalisi 257 Lucy B. Campbell Fine Art Luna Nera 452

Lund Humphries 289

Lunns of Ringwood 239 Lunts Castings Ltd 262 Lupe 53 Luton Sixth-Form College Lyndons Art & Graphics Lynn Painter-Stainers Prize 404 Lynne Strover Gallery 23 M Billingham and Co. 276 M&G Transport & Technical Services Limited 271 Maas Gallery 53 Mac Medicine Ltd 259 Macclesfield College 345 Macdonalds Fine Art 72 MADE Brighton 382 Magic Flute Gallery 94 Magil Fine Art 135 MAGMA Covent Garden Magma Design Ltd 251 MAGMA Manchester 251 Magpie Gallery 27 Mainstream Publishing Major Brushes Ltd 243 MAKE 360 The Makers Guild in Wales Makit 243 Malvern College 353 Manchester Academy of Fine Arts 452 Manchester Academy of Fine Arts Open 404 Manchester Art Gallery 165 Manchester Central Library Manchester City Gallery Shop 251 The Manchester College Manchester Craft & Design Centre 77 Manchester Metropolitan University 317, 345 Manchester Metropolitan University All Saints Library 363 Manchester University Press 289 Mandel's Art Shop 247 Manhattan Galleries 27 Manor Fine Arts 80 Manor House Gallery 177 manorhaus 115 Manser Fine Art 119 Manya Igel Fine Arts 54 Map Magazine 479 Marchmont Gallery and Picture Framer 85 Marcus Campbell Art Books 251 Margate Rocks 382 Mark Harwood Photography / LocaMotive 283

Mark Jason Gallery 54

Mark Tanner Sculpture Award 404 Market House Gallery 107 The Market House 201 Marlborough Fine Art 54 Marmalade Magazine 479 Marston House 289 Martin Tinney Gallery 115 Martin's Gallery 107 Martinspeed Ltd 271 Mary Evans Picture Library 360 Maryland Studios 298 Massarella Fine Art and Darren Baker Gallery 125 Masterpiece 269 Mat Sant Studio 283 Mathew Street Gallery 77 Matthew Boulton College of Further and Higher Education 353 Matthew Bown Gallery 54 Matt's Gallery 54 Maureen Paley 54 Max Mara Art Prize for Women 404 Max Wigram Gallery 55 Maxtrans London 271 Mayfield Gallery 107 Maynooth Exhibition Centre 201 Mayor Gallery 55 McNeill Gallery 23 McTague of Harrogate 126 Mead Gallery 191 Meadow Gallery 191 Media Art Bath 452 Medici Gallery 55 Mercer Art Gallery 195 Mere Jelly 27 Merrell Publishers 289 metamute 212 Metro Imaging Ltd 276, Metropole Galleries 177 MFH Art Foundry Ltd 262 Michael Dyer Associates Ltd 276 Michael Harding's Artists Oil Colours 230 Michael Hoppen Gallery 55 Michael Wood Fine Art Mid Cornwall Galleries 108 Mid Pennine Arts 428 Mid-Cheshire College 317, 345 Middlesex University 312 Middlesex University Art & Design Learning Resources 360 Midwest 452 Mifsuds Photographic 276 Mike Smith Studio 262 Mill Cove Gallery 135 Mill House Gallery 77 Millais Gallery 178 Millennium Galleries 195 Miller Fine Arts 28 Millers City Art Shop 237

Milliken Bros 235 Millinery Works Gallery 55 Milton Keynes College 348 Milton Keynes Gallery 178 Milton Keynes Society of Artists 452 Milwyn Casting 262 mima - Middlesbrough Institute of Modern Art Minerva Graphics 242 Mini Gallery 215 Minories Art Gallery 145 Mission Gallery 116 The Mitchell Library 365 Mivart Street Studios 298 Model Arts and Niland Gallery 201 Modern Art (London) 55 Modern Art Oxford 178 Modern Art Oxford Shop Modern Artists' Gallery 95 Modern Institute/Toby Webster Ltd 85 Modern Painters 479 Modus Operandi Art Consultants 259 Molesworth Gallery 135 MOMA Wales 188 Momart Limited 271 Momentum Arts 452 Monaghan County Museum 201 Monika Bobinska 56 Monnow Valley Arts Centre 192 Monolab 276 Monoprint 276 Montana Artists' Refuge Residency Program 404 Montpellier Gallery 119 Moray Office Supplies 237 Morco 276 Morris Photographic 277 Morris Singer Art Founders Mosaic Gallery 28 Mostyn Open 405 MOT INTERNATIONAL 56 Mother Studios 298 Mothers Tankstation 136 Mount Stuart 172 Moving Experience 272 Moya Bucknall Fine Art 119 MTec Freight Group 272 Mulberry Bush 237 Multiple Store 56 Mulvany Bros. 136 Mumbles Art & Craft Centre 243 Museum 52 56 Museum of Domestic Design & Architecture (MODA) 360 Museum of East Asian Art Museum of London Library 360

Museum of Science &. Industry in Manchester Museums and Galleries Month (MGM) 383 MXV Photographic 277 Myles Meehan Gallery 161 n.paradoxa: international feminist art journal 479 NADFAS Review 479 Nancy Victor 56 Napier University Merchiston Learning Centre 364 Narrow Space 136 National Arts Education Archive (Trust) 370 National Association of Decorative and Fine Arts Societies (NADFAS) National Campaign for the Arts (NCA) 453 National College of Art & Design Library 371 National College of Art and Design 337 National Disability Arts Forum (NDAF) 210 National Endowment for Science, Technology and the Arts (NESTA) 405, 428 National Gallery 155, 361 National Gallery of Ireland National Gallery of Ireland Library 371 National Gallery of Ireland Shop 251 National Gallery Of Scotland 172 National Gallery of Scotland Library 364 National Gallery of Scotland Shop 251 National Gallery Shop National Library of Ireland National Library of Scotland 364 National Maritime Museum 155 National Maritime Museum Caird Library National Media Museum 195 National Monuments Record Centre 184, 368 National Monuments Record of Scotland 365 National Museum and Gallery, Cardiff 189 National Museum of Scotland 172, 289 National Museum of Women in the Arts (NMWA) Library Fellows Programme 405

National Museums of Scotland Library 365 National Museums of Wales, Main Library 369 National Museums Online Learning Project 217 The National Open Art Competition 405 National Photographic Archive 202 National Portrait Gallery National Portrait Gallery Archive & Library 361 National Portrait Gallery Publications 289 National Portrait Gallery Shop 251 National Print Museum of Ireland 202 National Review of Live Art National Sculpture Factory 453 National Sculpture Factory Residencies 405 National Self-Portrait Collection of Ireland National Society for Education in Art and Design (NSEAD) 453 National Society of Painters, Sculptors & Printmakers 453 National War Museum 172 Natural History Museum Library 361 Nature In Art 184 Naughton Gallery at Queens 168 Nelson and Colne College NESCOT 348 Nest 28 Nettie Horn 56 nettime 212 Neville Pundole Gallery 95 New Art Centre 184 New Art Centre Sculpture Park & Gallery 108 New Art Exchange 454 New Art Gallery, Walsall **New Brewery Arts Centre** New College Durham 343 New College Nottingham 309, 340 New College Stamford 340 New Craftsman 108 New English Art Club 454 New Exhibitions of Contemporary Art 210 New Gallery (Birmingham) The New Gallery (Truro) New North Press 283 New Realms Limited 57 New Work Network 454

Newbury College 348 Newby Hall and Gardens 195 Newcastle Arts Centre 161 Newcastle College 315, 343 Newcastle College School of Art & Design Library Newcastle Libraries 363 Newcastle University 315 Newcastle-under-Lyme College 353 Newham College of Further Education 342 Newlyn Art Gallery 185 Newnum Art 283 NewsGrist 210 Next Level 479 Nicholas Bowlby 95 Nigel Moores Family Charitable Trust 429 Nine Days of Art 383 NMS Publishing Ltd 289 No 19 Cataibh, Dornoch Studio 298 No Knock Room 213 Noble & Beggarman Books Nolias Gallery 57 Norman Villa Gallery 136 North Devon College 350 North East Worcestershire College 331, 353 North Hertfordshire College 339 North Laine Photography Gallery 95 North Light Gallery 196 North Lindsey College 340 North Tyneside College North Wales School of Art and Design 328 North Warwickshire & Hinckley College 331, 354 North West Regional College - Limavady 346 North West Regional College - Londonderry 346 Northampton Museum and Art Gallery 148 Northbrook College 322, 348 Northbrook College Library 366 Northcote Gallery Chelsea Northern Art Prize 405 Northern Gallery for Contemporary Art 161 Northern Lights Gallery 78 Northern Regional College (formerly North East/ West Institutes of Further and Higher Education) 346 Northumberland College Northumbria University 315

Northumbria University Library 363 Norwich Castle Museum and Art Gallery 145 Norwich School of Art & Design 306 Norwich School of Art & Design Library 356 Nottingham Artists' Group Nottingham Arts Library 357 Nottingham Contemporary 148 Nottingham Studios 213 Nottingham Trent University 309 Number 15 116 Number Nine the Gallery Oaklands College 339 Oakwood Ceramics 28 Oasis Art & Graphics 244 Oberon Art Ltd 283 Object - Graduate Research and Reviews in the History of Art and Visual Culture October Gallery 57 Octopus Publishing Group 289 Offer Waterman & Co. 57 Office of Public Works 202 Oisin Art Gallery 136 Old Church Galleries 266 Old Coach House 28 Old Market House Arts Centre 202 Old Museum Arts Centre Oldham College 317, 355 OldTimerCameras.com Oliver Contemporary 58 Omell Galleries 95 One in the Other 58 Online Arts Consultants and Trainers Register On-lineGallery 216 On-linepaper.co.uk 239 Open Eye Gallery and i2 Gallery 85 Open Hand Open Space 178 **Open Studios** Northamptonshire 383 Open University Library 366 Openhand Openspace 298 Opus Gallery 28 The Orangery and Ice House Galleries 155 Organised Gallery 108 Oriel 116 Oriel Canfas Gallery 116 Oriel Davies Gallery 189 Oriel Gallery 136 Oriel Mostyn Art Gallery Shop 252 Oriel Mostyn Gallery 189

The Origin Gallery 137 Original Print Gallery 137 Ormeau Baths Gallery 80, OSB Gallery Ltd 137 Osborne Samuel 58 O'Sullivans 247 Out of the Blue Arts and **Education Trust 454** Owen Clark & Co. Ltd 231 Owen Taylor Art 120 Own Art 217 Own It 217 Oxford & Cherwell Valley College 323, 348 Oxford Art Journal 480 Oxford Brookes University 323, 348 Oxford Brookes University Library (Headington Library) 366 Oxford Craft Studio 239 Oxford Exhibition Services Ltd 272 Oxford University 323 Oxford University Press Oxfordshire Artweeks 383 Oxmarket Centre of Arts 95 P.H. Graphic Supplies 227 P.J. Crook Foundation 185 Paddon & Paddon 96 Paint Box 247 Paintings and Prints 2 -Artists of the World 216 Paintworks Ltd 231 Paisley Art Institute Annual **Exhibition Prizes and Biennial Scottish Drawing Competition** 406 Pallant House Gallery 178 Pallas Studios 137, 298 Palm Laboratory (Midlands) Ltd 277 Pangolin Editions 262 Pangolin Gallery 58 Panter & Hall 58 The Paper House 244 Paperchase Products Ltd 231 Paradise Row 58 Parasol Unit Foundation for Contemporary Art 58 Parham House 178 Park Cameras Ltd 277 Park Lane College Keighley 334, 355 Park View Gallery 120 Parker Harris Partnership Pastel Society 454 Patchings Art Centre 28 Paterson Photographic Ltd (UK) 277 Patrick Davies Contemporary Art 23 Paul Hamlyn Foundation Awards For Artists 406 Paul Kane Gallery 137 Paul Mason Gallery 59

Paul Mellon Centre for Plan 9 109 plan art consultants 260 Studies in British Art 361 Planet Janet 96 Paul Mitchell Ltd 266 Platform Gallery 78 Paul Treadaway 267 Plus One Gallery 60 Paulsharma.com 284 Pavilion 289, 454 Plymouth City Museums and Art Gallery 185 Pavilion Studios / Dukes Plymouth College of Art Meadows Trust 298 Peacock Visual Arts 86, 173, and Design 326, 350 Plymouth College of Art Peak Imaging 284 and Design Library 368 PM Gallery and House 156 Peer 59 Polish Cultural Institute Pembrokeshire College 352 Pen and Paper Stationery 407 Pollock-Krasner Co. 243 Foundation 407 Pendragon Frames 267 Penlee House Gallery and Pond Gallery 60 Portfolio - Contemporary Museum 185 Pennies from Heaven 252 Photography in Britain Penwith Galleries and Penwith Society of Arts Portsmouth City Museum and Records Office 179 People's Gallery 137 Positive Images (UK Ltd) People's Art Hall 137 Potosi Ltd 277 Pepinières Europeénnes Potteries Museum and Art Pour Jeunes Artistes 406 Percy House Gallery 78 Gallery 192 Performance Research 480 The Potters' Barn 234 Permanent Gallery 96 Potterton Books 252 Perrys Art & Office 231 Powderhall Bronze 262 Peter Moores Foundation Pratt Contemporary Art and Pratt Editions 284 Peter Robinson Fine Art 28 Prema 185 Premier Arts & Craft Store Peterborough Art House Ltd 24 247 Peterborough Regional Press On Digital Imaging College 339 284 Phaidon Press Ltd 290 Prestel Publishing Ltd 290 Preston College 345 Philip Davies Fine Art 116 Philip Wilson Publishers Preview of the Visual Arts in Ireland 480 Ltd 290 Priestley College 345 Philips Contemporary Art 78 Primavera 24 Phillippa Levy & Associates Primrose Hill Press Ltd **Phoenix Arts Association** 299, 455 Prince's Drawing School Phoenix Fine Arts Ltd 126 Photo Plus 277 Prince's Trust 429 PhotoArtistry Ltd 277 The Print Partnership 243 Print Quarterly Publications photodebut 455 480 Photofusion 59, 156 Printing House 234 Photographers' Gallery Shop 252 Printmaker Studio 284 Printmakers Council 455 The Photographers' Gallery Printmaking Today 480 156 Photoguard 269 The Printrooms 284 Priory Gallery Broadway Photo-London 383 Piano Nobile Fine Prism Proofing 284 Paintings Ltd 59 Picture This 429 Picturecraft Gallery Ltd 24 **Prison Arts Foundation** (PAF) 455 pictureframes.co.uk 267 Process Supplies (London) Ltd 277 Pieroni Studios 59 Proctor & Co. Ltd 236 Pierrepont Fine Art 96 Piet's Gallery 28 Project Arts Centre 202 The Pilar Juncosa & ProjectBase 456 Sotheby's Awards 406 proof 456 Pilot 260 Proud Galleries 60 **Public Art Commissions** Pippa Roberts Publicity & and Exhibitions (PACE) Communications 484

Pitt Rivers Museum 179

429

Public Art South West Pump House Gallery 156 Purchase Prize BlindArt Permanent Collection Purdy Hicks Gallery 60 Pure South 239 Pybus Fine Arts 126 Ouad Derby 148 Quantum Contemporary Art 60 Quay Arts 179 Queen Elizabeth Scholarship Trust 407 Queen Elizabeth Sixth-Form College 355 The Queen's Gallery, Palace of Holyroodhouse The Queen's Gallery (Buckingham Palace) Queens Park Arts Centre 456 R. Jackson & Sons 235 R.D. Franks 252 R.K. Burt & Co. Ltd 231 R.R. Bailey 232 RA Magazine 480 Rachel Gretton Glass Rachel Howells 257 Rachmaninoff's 60 Rafael Valls Ltd 60 Railings Gallery 267 Rainyday Gallery 109 Rapid Eye 278 Ravensbourne College of Design and Communication 348, Raw Arts Festival 383 Raw Vision 481 RDS Foundation 456 Reading University Library 366 Reaktion Books Ltd 290 Rebecca Hossack Gallery Rebecca Ward 484 Rebecca's Picture Framing 267 Red Box Gallery 72 Red Gallery 96 Red Gate Gallery & Studios Red House Museum and Art Gallery 186 The Red Mansion Foundation 61 Red Rag Gallery 109 Redbridge Arts Festival 384 Redfern Gallery 61 Redfoxpress 284 Reeves Art Studio 267 Regency Gallery 24
Reggie Hastings 284 Regional Cultural Centre

ROOM 63

361, 456

Shop 252

of Art 189

361

186

290

458

(RSA) 458

458

Reigate School of Art, Design and Media (East Surrey College) 323 Renaissance 2 267 The Rencontres Contemporary Book Prize 407 The Rencontres d'Arles Discovery Award 407 Rennies Arts & Crafts Ltd Reprotech Studios Ltd 284 Res Artis - International Association of Residential Arts Centres 456 The Residence 61 Resipole Studios 299 Resolution Creative 278 re-title.com 210 Retro Photographic 278 Retrospectives Gallery 120 Revolutionary Arts Group 456 **Rhizome Commissions** 213, 430 Rhizome.org 213, 430 RIAS Bookshop 252 RIBA Bookshop 252 Riccardo Giaccherini Ltd 267 Richard Goodall Gallery 78 Richard Green 61 Richards of Hull 278 Richmond Adult Community College 342 The Richmond American International University in London 312 Richmond-upon-Thames College 342 Riflemaker 62 Ritter/Zamet 62 Riverbank Arts Centre 203 Riverbank Centre 242 Riverfront 189 Riverside Gallery 267 Rivington Gallery 62 Roar Art Gallery and Archive 24 Robert Gordon University Robert Gordon University Georgina Scott Sutherland Library 365 Robert Phillips Gallery 96 Robert Sandelson 62 Robert White 278 Robinson Library 363 Roche Gallery 97 Rochester Art Gallery & Craft Case 179 Rocket 62 Roehampton Learning Resources Centre 361 Roehampton University 312 Rogue Artists' Studios 299 Rokeby 62 Rona Gallery 62

Ronald Moore Fine Art Artists (RBA) 458 Conservation 257 Royal Society of Marine Artists 459 Royal Society of Miniature Room for Art Gallery 97 Rostra & Rooksmoor Painters, Sculptors and Galleries 109 Gravers 459 Rotherham College of Arts Royal Society of Painterand Technology 356 Printmakers 459 RotoVision 290 Royal Society of Portait Routledge Publishers 290 Painters 459 Rowan Tree 137 Royal West of England Academy (RWA) 186 Rowley Gallery Contemporary Arts 63 Royal West of England Academy (RWA) Student Royal Academy of Arts 157, Bursaries 408 Royal Academy of Arts Royall Fine Art 97 RSA Barns-Graham Travel Royal Academy Schools 313 Award 408 Royal Armouries Library RSA John Kinross Scholarships 409 Royal Birmingham Society RSA Journal 481 of Artists 457 RSA New Contemporaries Scotland Award 409 Royal British Society of Sculptors 408, 457 RSA William Littlejohn Royal Cambrian Academy Watercolour Award Rubicon Gallery 137 Royal College of Art 157, 313 Royal College of Art Library Rugby Art Gallery and Museum 148 Runshaw College 317, 345 Royal Cornwall Museum Rupert Harris Conservation Royal Exchange Art Gallery Rural Art Company 239 Royal Glasgow Institute of Ruskin Gallery 165 the Fine Arts 457 Ruskin Library, Lancaster Royal Hibernian Academy University 363 Russell & Chapple 231 Royal Hibernian Academy Russell-Cotes Art Gallery & Thomas Dammann Museum 179, 368 **Junior Memorial Trust** Ruth Davidson Memorial Scholarship 409 Awards 408 Royal Institute of British Ruthin Craft Centre 189 Architects (RIBA) Gallery The RWS/Sunday Times Watercolour Royal Institute of Oil Competition 409 Painters 457 Rye Festival 384 Royal Institute of Painters SAA Home Shop 227 in Watercolours 457 Saatchi Gallery 157 Royal Jelly Factory 260, Sackler Library 366 Saddleworth Museum 165 Royal Photographic Society Sadie Coles HQ 63 Sadler Street Gallery 109 Royal Photographic Society Safehouse 169 Journal 481 Saffron Walden Museum Royal Scottish Academy 146 SAFLE 430 Alastair Salvesen Art Scholarship 408 SAFLE Graduate Award Royal Scottish Academy Building 173
Royal Scottish Academy of Sainsbury Centre for Visual Arts 146 Art and Architecture Sainsbury Research Unit Library 356 The Royal Scottish Sainsbury Scholarship in Academy Residencies for Painting and Sculpture Scotland 408 Salar Gallery 109 Royal Scottish Society of Salford College 345 Painters in Watercolour Salford Museum and Art Royal Society of Arts (RSA) Gallery 166 Salisbury Playhouse Gallery Royal Society of British

Sally Mitchell Fine Arts 28 Saltburn Gallery 72 Saltgrass Gallery 97 Salts Mill 196 SamedaySnaps - Mitcham Arts 278 Samuel Taylors 245 Sandford Gallery 138 Sandwell College 354 Sangam Books Ltd 290 Sarah Walker 138 Sarah Wiseman Gallery Sargant Fellowship 410 Sartorial Contemporary Art SAW (Somerset Art Works) 459 Scarborough Art Gallery Scarva Pottery Supplies 236 School House Gallery 24 School of Art Gallery and Museum 189 School of Jewellery Library, Birmingham City University 369 School of Oriental & African Studies Library 361 SCOPE Art Fairs 384 scotlandart.com 86, 216 Scottish Artists Union Scottish Arts Council 365, The Scottish Gallery 86 Scottish National Gallery of Modern Art 173 Scottish National Gallery of Modern Art Shop 252 Scottish National Portrait Gallery 173 Scottish National Portrait Gallery Library 365 Scottish National Portrait Gallery Shop 253 Scottish Sculpture Workshop Programme Scout 63 Sculpture Journal 481 Sculpture Lounge 126 SE8 Gallery 157 Seabourne Mailpack Worldwide 272 Search Press Ltd 290 Second Hand Darkroom Supplies 278 Selby College 356 Selfridges Book Department 253 Selvedge 481 Selwyn-Smith Studio 231 Seren 291 Serpentine Gallery 157 Sesame Gallery 64 Seven Seven Contemporary Art 64 Sevenoaks Art Shop 240

Shakespeare Centre Library Shawe's the Art Shop 227 The Sheen Gallery 64 Sheeran Lock Ltd 260 Sheffield Arts & Social Sciences Central Library Sheffield College 334, 356 Sheffield Hallam University 334 Sheffield Hallam University Library 370 Shell House Gallery 121 Sheppard Worlock Library 363 Shinglers 235 The Ship 64 Shipley Art Gallery 161 Shire Hall Gallery 192 shopforprints 216 Shoreline Studio 86 The Showroom 64 Shrewsbury College of Arts and Technology 354 Shrewsbury Museum and Art Gallery 192 Side Gallery 73 Sidney Cooper Gallery 179 Sigma Imaging (UK) Ltd 278 Simon Beaugié Picture Frames Ltd 267 Simon Fairless 97 Simon Gillespie Studio Simon Lee Gallery 64 Siobhan Conyngham Fine Art Conservation 257 Siopa Cill Rialaig Gallery Sir Alfred Munnings Art Museum 146 Sir John Soane's Museum Sirius Arts Centre 203 Site Gallery 196 Six Chapel Row Contemporary Art 98 Skopelos Foundation for the Arts 410 Skylark Galleries 65 Skylark Studios 24 Slade School of Fine Art (UCL) 313 Sligo Art Gallery 203 Smart Gallery 126 Smitcraft 240 Snowgoose 260 Society for All Artists (SAA) 269, 460 Society for Religious Artists (SFRA) 460 Society for the Protection of Ancient Buildings 361 Society of Antiquaries of London 361 Society of Botanical Artists 460 Society of Catholic Artists 460

Southern Regional College Newry Campus 347 Southgate College 342 Southgate Studios 299 Southport College 317, 345 Southport College Library Southwark College 343 Southwold Gallery 24 Sovereign International Freight Ltd 272 SPACE 299 Space Station Sixty-Five 65 SPACEX 186 Spectacle 121 Spectrum Fine Art & Graphic Materials (Birmingham) 244 Spectrum Fine Art (London) 65 Spencer Coleman Fine Art Spike Island 461 Spiller Art 138 Spitz Gallery 65 Spotlight Studios 299 SS Robin Gallery 65 St Andrews University Library 365 St Anthony Fine Art 116 St Barbe Museum and Art Gallery 180 St Brendan's Sixth Form College 351 St Bride Library 361 St Helens College 318, 345 St Hugh's Fellowship 411 St Ives Printing & Publishing Co. 285 St Ives Society of Artists Gallery 110, 186 St John Street Gallery 28 St Martin's College 318 St Mungo Museum of Religious Life and Art 173 St Paul's Gallery 121 Stables Gallery 81 Stafford College 354 Staffordshire University 331, 354 Staffordshire University Thompson Library 369 Stamford College 309 Standpoint Gallery 66 Stanley Picker Fellowships Stanley Picker Gallery 158 Stanley Spencer Gallery 180 Star Gallery 98 Start Contemporary Gallery Stationery/Art Ltd 242 Steam Pottery 110 Stephen Friedman Gallery 66 The Steps Gallery 66 Stills 87 Stockport Art Gallery Annual Open Exhibition

The Society of Graphic Fine

(SSÁ) **461** Society of Wildlife Artists

Society of Wildlife Artists

Society of Women Artists

Solihull College 331, 354

Solstice Arts Centre 203

Somerset Art Weeks 384

Somerset College of Arts

Somerville Gallery 110

Contemporary Arts

Sotheby's Institute of Art

South Cheshire College

South Devon College 351

South Downs College 348

South East Essex College

Ashford School of Art &

South London Gallery 157

and Art Gallery 161

South Thames College

South Tipperary Arts

South Tyneside College

South West College 346

Omagh Campus 347

Southampton City College

Southampton City Libraries

Southampton Institute

Southampton Solent

University 323

Libraries 356

Mountbatten Library

Southend-on-Sea Borough

Southern Regional College

Southern Regional College

- Lurgan Campus 347

Armagh Campus 347

South West College

Gallery 179

Southampton City Art

Centre 203

South Nottingham College

South East Derbyshire

South Kent College -

College 340

Design 349

309, 340 South Shields Museum

Source Photographic Review

(SCCA) Network

Residencies 411

Sorcha Dallas 86

Soros Centres for

and Technology 327, 350

Solomon Gallery 138

Art 460

Society of Portrait

Sculptors 461 Society of Scottish Artists

Bursaries 410

461

Solo Arte 138

Stockport College of Further and Higher Education 318, 345 Stockwell Studios 299 Stoke-on-Trent Libraries Information & Archives Stone Gallery 138 Stoney Road Press 285 STORE 66 Storm Fine Arts 25 stot 213 Stourbridge College 331, Strahan Framing 268 Strand Art Gallery 110 Stratford & York Ltd 232 Straumur International Art Commune 411 Street Gallery 111 Street Level Photoworks 87 Strode College 351 Stroud College 351 Stroud House Gallery 111 Stuart 216 Studio 1.1 66 Studio Art School 321 Studio Arts - Dodgson Fine Arts Ltd 235 Studio Glass Gallery 67 Studio Voltaire 67, 300 Studiopottery.co.uk 210 Studioworx Contemporary Art Ltd 216 Study Gallery 186 Stu-Stu-Studio 299 Sudley House 166 Sue Bond Public Relations Suffolk Art Society 461 Suffolk College 307 Suffolk College Library 357 Suffolk New College 339 Suffolk Open Studios 462 Summer Exhibition - Royal Academy of Arts 411 Summerleaze Gallery 111 Sunderland Museum and Winter Gardens 161 Sundridge Gallery 98 Susan Megson Gallery 111 Sussex Arts Club Ltd 98 Sussex Downs College 349 Sutton Coldfield College 331, 354 Sutton Lane 67 Sutton Library 366 Swan Gallery 111 Swansea Institute 328 Swansea Metropolitan University 352 Swansea Open 411 Swindon College 327, 351 **Swindon Community** Heritage Museum and Art Gallery 187 Swiss Cottage Library 361 Sydney Jones Library, University of Liverpool

T. N. Lawrence & Son Ltd T. Rogers & Co. Ltd 272 T.B. & R. Jordan Lapada 73 T.H.March & Co.Ltd 269 T.N. Lawrence & Son Ltd T.S. Two 240 TailorMadeArt 81 Talbot Rice Gallery 174 Talents Fine Arts 127 Tales Press 244
Tameside College 346 Tamworth & Lichfield College 354
Tapestry MM Ltd 278 Taschen UK Ltd 291 Tate Britain 158 Tate Britain Shop 253 TATE ETC. 481 Tate Liverpool 166, 253 Tate Modern 158 Tate Modern Shop 253 Tate Publishing 291 Tate St Ives 187 Tate St Ives Shop 253 Taurus Gallery 98 Taylor Galleries (Dublin) Taylor Gallery (Belfast) 81 Taylor Pearce Ltd 257 Taylor-Pick Fine Art 127 Team Relocations 272 Team Valley Brush Co. 232 Tees Valley Arts 431 The Teesdale Gallery 73 Telford College of Arts & Technology 331, 354 Temple Bar Gallery and Studios 139 Templeman Library 366 Tenby Museum and Gallery Terry Duffy - 340 Old Street 67 Terry Harrison Arts Limited 240 **Textile & Art Publications** 291 **Textile Conservancy** Company Ltd 257 Thames & Hudson 291 Thames Valley University 313, 349 Thanet College 349 the-artists.org 217 Theatro Technis 300 thecentralhouse 260 Theresa McCullough Ltd Theresa Simon Communications 484 theSeer.info 210 things magazine 481 Think Ink Ltd 285 Third Text 482 Thomas Dane 67 Thomas Ellis 268 Thomas Heneage Art Books 253 Thompson Gallery 25

Thoresby Gallery 29 Thornthwaite Galleries 78 The Threadneedle Prize for Painting and Sculpture Three Counties Bookshop Throatlake 81 Thurrock and Basildon College 349
Tib Lane Gallery 78 Tigh Filí 139 Time Out 482 Timespan 174 Timothy Taylor Gallery 68 Tim's Art Supplies 225 Tindalls the Stationers Ltd 225 Tiranti Tools 231 The Toll House Gallery 111 Tom Blau Gallery - Camera Press 68 Tom Caldwell Gallery 81 ToolPost 240 Torrance Gallery 87 TotalKunst at The Forest 462 Totton College 349 Tower Hamlets College Towneley Hall Art Gallery & Museum 196 Towner 180 TownHouse Dublin 291 Townhouse Gallery Portrush 81 Tracey McNee Fine Art 87 Trafford College 346 Trans Artists 213, 462 Transeuro (Fine Art Division) 272 Transition Gallery 68 Transmission 174 Transpacolor Ltd 278 Treeline Gallery 29 Tregony Gallery 111 Tresham Institute of Further and Higher Education 340 Trinity College 328 Trinity College Library 371 Trinity College Library Shop 253 Trinity Gallery 180 Triskel 204 Trolley 68 The Troubadour Gallery 68 Truro College 351 Tryon Galleries 68 Tuckmill Gallery 139 Tullie House Museum and Art Gallery 166 Tunbridge Wells Museum and Art Gallery 180 Tuppers 240 Turn of the Tide Gallery 112 Turner Gallery 112 Turner Prize 412 Turners Graphic Art & **Drawing Office Supplies**

Turnpike Gallery 166 Tyrone Guthrie Centre 204 **UHI Millennium Institute** 321 UK Coloured Pencil Society The UK Sponsorship Database 210 uk.culture.info 210 Ulster Museum 169 Ulster University 319 **UNESCO** Aschberg Bursaries for Artists 412 Unicorn Gallery 78 Unik Art & Craft 232 Union 69 Universes in Universe -Worlds of Art 213 University College Chester University College Chichester 324 University College Dublin Library 371 University College Falmouth 327, 351 University College London (UCL) Art Collections 158 University College London Library 361 University College Northampton Learning Resources 357 University College Worcester 332 University for the Creative Arts - Canterbury 349 University for the Creative Arts - Canterbury Library 366 University for the Creative Arts - Épsom 349 University for the Creative Arts - Epsom Library University for the Creative Arts - Farnham 349 University for the Creative Arts - Maidstone 324, 349 University for the Creative Arts - Maidstone Library University for the Creative Arts - Rochester 349 University for the Creative Arts - Rochester Library University Library (Surrey) University of Bath 327 University of Bath Library & Learning Centre 368 University of Bedfordshire Library 357 The University of Bolton University of Brighton Aldrich Library 367

University of Brighton Design Archives 367 University of Brighton Gallery 180 University of Brighton St Peter's House Library University of Bristol Arts & Social Sciences Library University of Cambridge Library 357 University of Central Lancashire 319 University of Central Lancashire Library Services 363 University of Cumbria (formerly Cumbria Institute of the Arts) 319, University of Cumbria Library 364 University of Derby 309 University of Derby Britannia Mill Learning Centre 357 University of East Anglia Library 357 University of East London University of East London **Docklands Learning** Resources Centre 361 University of East London **Duncan House Library** University of East London Stratford Library 362 University of Edinburgh University of Essex Collection of Latin American Art (UECLAA) University of Exeter Library & Information Service University of Glamorgan 329, 352 University of Gloucestershire 328, 351 University of Gloucestershire Pittville Learning Centre 368 University of Hertfordshire 307, 339 University of Hertfordshire (UH) Galleries 146 University of Hertfordshire Learning Resources Centres 357 University of Huddersfield University of Huddersfield Learning Centre 370 University of Hull 334 University of Kent 324 University of Leeds 334 University of Leicester Library 357

University of Lincoln 300 University of Liverpool Art Gallery 166 University of London Queen Mary Library University of London Senate Library 362 University of Luton 307 University of Northampton 310, 341 University of Nottingham Hallward Library 357 University of Paisley 321 University of Plymouth 328 University of Portsmouth 324, 349 University of Reading 325 University of Salford 319, University of Sheffield Main Library 370 University of Southampton 325, 349 University of Southampton. Winchester School of Art Library 367 University of Strathclyde Library 365 University of Sunderland 315, 344 University of Sussex Library University of Teeside 315 University of Teesside Library 363 University of the Arts London 313 University of the West of England 351 University of the West of England, Faculty of Art, Media & Design Library University of Ulster Library University of Wales College, Newport 352 University of Wales College, Newport Library 369 University of Wales Institute Cardiff 329, 352 University of Wales Institute, Howard Gardens Library 369 University of Wales, Aberystwyth 329 University of Wales, Bangor 329 University of Wales, Newport 329 University of Warwick Library 369 University of Westminster University of Westminster Harrow Library 362 University of Wolverhampton 332

University of York Library Upstairs at the Halcyon 98 Usher Gallery 148
Uxbridge College 343 V&A Illustration Awards 463 V&A Magazine 482 V&A Publications 291 V&A Shop 253 VADS 210 Valentine Walsh 258 Valentyne Dawes Gallery Vandy's Art and Graphic Centre 232 Vane 73, 462 Variant 482 The Vault 278 Verandah 99 Verdant Works 174 Vereker Picture Framing Vesey Art and Crafts 244 Vibes and Scribes 253 Victoria & Albert Museum 158 Victoria & Albert Museum Archive of Art and Design 362 Victoria & Albert Museum National Art Library 362 Victoria & Albert Museum Prints, Drawings, Paintings and Photographs Collection 362 Victoria & Albert Museum Theatre Museum 362 Victoria Art Gallery 187 Victoria Miro Gallery 69 Victorian Gallery 79 View Two Gallery 79 Viewpoint Photography Gallery 166 Viking Studios and Bede Gallery 300 Vilma Gold 69 Virginia A. Groot Foundation 412 Vision Applied Arts & Crafts 236 Visiting Arts 431 Visual Artists Ireland 462 Visual Arts and Galleries Association (VAGA) 463 Visual Arts Centre 300 Visual Arts Ipswich 146 Visual Arts Scotland (VAS) Visual Collections 217 Visual Culture in Britain 482 Visual Images Group 463 Vital Arts 463 Vitreous Contemporary Art 112 VIVID 431 Voluntary Arts Ireland 431 Voluntary Arts Network 463

W.H. Patterson Ltd 69 Waddesdon Manor 181 Waddington Galleries 69 Wakefield Artsmill 300 Wakefield College 356 Waldock Gallery 139 Wales Arts International Walford and North Shropshire College 354 Walker Art Gallery 167 Walker Art Gallery Library/ Archive 364 Walker Art Gallery Shop Walker Galleries Ltd 127 Wall Candi Ltd 285 Wallace Brown Studio 268 Wallace Collection 158 Wallace Collection Library Wallace Collection Shop Wallpaper 482 Walsall College of Arts & Technology 332, 354 Waltham Forest College Wapping Project 159 Warburg Institute 362 Ward's Arts & Crafts 232 Warehouse Express 279 Warrington Collegiate Institute 346 Warstone & Turner 121 The Warwick Gallery 121 Warwickshire College (formerly Rugby College of Art) 332, 354 Washington Gallery 116 Wasps Artists' Studios 300 Watercolour Society of Ireland's Permanent Collection 204 Watercolour Society of Wales - Cymdeithas Dyfrlliw Cymru 463 Waterford Institute of Technology 338 Waterfront Gallery 130 Watergate Street Gallery The Watermill 253 Watershed 187 Waterstone's 253 Watford Museum 146 Watling Street Galleries 29 Waygood Studios and Gallery 73, 300 Waytemore Art Gallery 25 Webb Fine Arts 99 Webster Gallery 99 Wellcome Collection 159 Wellcome Library 362 Wellcome Trust Arts Awards 431 Wendy I. Levy Contemporary Art 79 Wenlock Fine Art 121 Wesley-Barrell Craft Awards 412

West Cheshire College West Cork Arts Centre 204 West End Gallery 29 West Herts College 339 West Kent College 349 West Nottinghamshire College 341 West Suffolk College 339 West Thames College 314. West Wales Arts Centre West Wales School of the Arts 330, 352 West Walls Studios 300 West Yorkshire Print Workshop 285, 464 Westbourne Studios 301 Westbury Farm Studios 464 Western Light Art Gallery Westgate Gallery 87 Westland Place Studios Westminster Kingsway College 343 Weston College 328, 351 Wetpaint Gallery 260 Wexford Arts Centre 204 Weymouth College 351 Wharf Gallery 112 Wheatsheaf Art Shop 232 White Cube 69 Whitechapel Gallery 159 Whitechapel Project Space WhiteImage.com 81 Whitford Fine Art 70 Whitgift Galleries 70 Whittington Fine Art 99 Whittlesford Gallery 25 Whitworth Art Gallery 167, 364 Whitworth Gallery Shop Widcombe Studios Gallery Wigan & Leigh College 346 Wildlife Art Gallery 25 Wildwood Gallery 25 Wilkinson Gallery 70 William Frank Gallery 139 William Morris Gallery William Morris Society 362 William Thuillier 70 Williams & Son 70 Willis 270 Wiltshire College Salisbury (formerly Salisbury College) 351 Wiltshire CollegeTrowbridge 351 Wimbledon Art Studios Wimbledon College of Art 314, 343

Wimbledon College of Art Library 362 Winchester Gallery 181 Windsor & Royal Borough Museum (W&RBM) 181 Windsor Gallery 226 Windsor Insurance Brokers Ltd 270 Wingate Rome Scholarship in the Fine Arts 412 Winstanley College 346 Winston Churchill Memorial Trust 431 Wirral Metropolitan College 319, 346 **Wollaton Street Studios** Wolseley Fine Arts Ltd 121 Wolverhampton Art Gallery Women's Arts Association 464 Women's Studio Workshop Fellowship Grants 413 The Wonderwall Gallery 112 Woo Charitable Foundation 432 Woo Charitable Foundation Arts Bursaries 413 Woodbine Contemporary Arts 29 Worcester College of

Technology School of Art & Design 354, 369 Wordsworth Museum Art Callery 167 Working Men's College 314 Workplace Art Consultancy 261 Workplace Gallery 73 Workshop Wales Gallery 117 WorldwideReview.com

210
Worple Press 291
Worshipful Company of
Goldsmiths 362
Worthing Museum and Art
Gallery 181
Worthing Reference Library

367 The Worx 301 Wren Gallery 99 Wrexham Arts Centre 190 Wrights 226 Wyke College 356 Xaverian Sixth Form College 346 Yale College of Wrexham 353 Yale University Press 291 Yarm Gallery 73 Yarrow Gallery 25 Yello Gallery 139 Yeovil College 351 York Art & Framing 245 York City Art Gallery 196

York College 335, 356
York St John College 335
Yorkshire Artspace Society
301
Yorkshire Coast College
335, 356
Yorkshire Sculpture Park
196
Ziggy Art Ltd 235
Zimmer Stewart Gallery
99
Zoo Art Fair 384
Zoom In Ltd 301
Zoom In Photography
279

Subject index

Selected entries by category

ABSTRACT ART 108 Fine Art 122 176 Gallery / The Zabludowicz Collection 20-21 Visual Arts Centre Abbot Hall Art Gallery 162 absolutearts.com and World Wide Arts Resources Corp. 213 ACE Award for Art in a Religious Context 388 ACE/MERCERS International Book Award 388 Ainscough Gallery 74 Alan Kluckow Fine Art 87 Alexander-Morgan Gallery Andipa Gallery 32 Ann Jarman 21 Annely Juda Fine Art 32 Anthony Hepworth Fine Art Dealers Ltd 99 Anthony Reynolds Gallery AOP Gallery 32 Apollo Gallery 127 Archeus 33 Archipelago Art Gallery and Studio 122 Architectural Association The Art House 211 Art in Perpetuity Trust (APT) 438 Art Matters Gallery 113 Art Space Gallery (St Ives) 100 Art@9489 Artist of the Year by the Society for All Artists (SAA) 389 Artists' Network Bedfordshire 439 Arts and Crafts in Architecture Awards 390 Arts Gallery 149 ArtSway 174 Austin/Desmond Fine Art Ltd 34 Axis **214, 441** Bankside Gallery **149, 441** Barbara Behan Contemporary Art 34 The Barker Gallery 89 Barn Galleries 89, 128 Bell Fine Art Ltd 90 Benny Browne & Co. Ltd 74 Bettles Gallery 101 Bianco Nero Gallery 122 Big Blue Sky 21 Bircham Gallery 21 Birties of Worcester 117 Black Mountain Gallery 113 Blackheath Gallery 35 Bloomberg SPACE 150 Bloxham Galleries 36 Blue Leaf Gallery 128 Bluemoon Gallery 90

Bold Art Gallery 128 The Bottle Kiln 26 Bourne Fine Art 82 Bridge Gallery 128 Broadway Modern 117 Broughton House Gallery Brunei Gallery 150 Buckenham Galleries 21 Bury Art Gallery, Museum and Archives 163 Byard Art 22 Cafe Gallery Projects London 151 Calvert 22 37 Cambridge Open Studios Camden Arts Centre 151 Canvas 129 Castlefield Gallery 75, 163 Cavanacor Gallery 129 Celeste Prize 394 Celf 114 Centre for Contemporary Arts (CCA) 169 The Centre of Attention 38 Chapel Gallery 90 Charleston Farmhouse and Gallery 175 CHELSEA space 151 Chichester Gallery 91 Clapham Art Gallery 38 Clarion Contemporary Art Colin Jellicoe Gallery 75 Collective Gallery 83, 169 Collins Gallery 170 Context Gallery 79 Coombe Gallery 1012 Cooper Gallery 193 Courtauld Institute of Art Gallery 151 Courthouse Gallery, Ballinglen Arts Foundation 129 Courtyard Arts Limited 130 Craftsmen's Gallery 91 Crown Studio Gallery 71 Cube Gallery 103 Cupola Contemporary Art Ltd 123 Customs House 71, 160 The Darryl Nantais Gallery DegreeArt.com 40, 214 Delamore Arts 104 Design and Artists Copyright Society (DACS) 445 Domino Gallery 75 dot-art 76 Drasocht Arts Centre 198 Eagle Gallery Emma Hill Fine Art 41 ecArtspace 41 Edinburgh Printmakers 84 Elephant Trust Award 398 Elliott Gallery 104 Emer Gallery 80 The Empire 42

Enable Artists 446 Fairfax Gallery 43 Fairfields Arts Centre 183 FarmiloFiumano 43 Fenton Gallery 131 Ferens Art Gallery 193 Fermynwoods Contemporary Art 26 fifiefofum 71 Fine Art Society Plc 44 Fine Art Surrey 215 Flowers East 44 Forge Gallery 124 Four Square Fine Arts 91 Fourwalls 92 Frivoli 45 Gallagher & Turner 72 The Gallery - text+work 183 Gallery 42 124 The Gallery at Willesden Green 45 Gallery Kaleidoscope 46 Gallery Oldham 164 The Gallery (Masham) 124 Garter Lane Arts Centre 199 Gascoigne Gallery 124 George Street Gallery 92 Gilbert Collection 153 Gillian Jason Modern & Contemporary Art 46 Glass and Art Gallery 72 Goldfish Contemporary Fine Art 105 Green Door Studio 132 Greenacres 132 Greenlane Gallery 132 Grosmont Gallery 125 Grundy Art Gallery 165 Guild of Aviation Artists 449 Guildford House Gallery 176 Hanina Fine Arts 47 Harlequin Gallery 47 Harris Museum and Art Gallery 165 Hazlitt Holland-Hibbert 48 Headrow Gallery 125 Hermitage Rooms at Somerset House 154 Highgate Fine Art 49 Hillsboro Fine Art 133 Hind Street Gallery and Frame Makers 106 ICAS - Vilas Fine Art 23 Ingleby Gallery 84 Institute of Contemporary Arts (ICA) 154 **Ipswich Arts Association** Irish Museum of Modern Art 200 James Hyman Gallery 51 James Joyce House of the Dead 133 Iill George Gallery 51 Joan Clancy Gallery 133 John Davies Gallery 106 John Martin Gallery 51

Jones Art Gallery 133

Jorgensen Fine Art 133 The Kenny Gallery 134 Kentmere House Gallery Kerlin Gallery 134 Kettle's Yard 145 Kettle's Yard Open / **Residency Opportunities** Killarney Art Gallery 134 Kilvert Gallery 114 King's Lynn Arts Centre 145 Kooywood Gallery 115 Laing Art Gallery 161 Laneside Gallery 80 Leamington Spa Art Gallery and Museum 191 Leinster Gallery 135 Lena Boyle Fine Art 52 Limerick City Gallery 200 Limerick Printmakers Studio and Gallery 135, Linenhall Arts Centre 201 Lisson Gallery 52 Londonart.co.uk 215 The Lowry 165 Lucy B. Campbell Fine Art Magil Fine Art 135 Manchester Academy of Fine Arts Open 404 manorhaus 115 The Market House 201 Martin Tinney Gallery 115 Martin's Gallery 107 McNeill Gallery 23 Mercer Art Gallery 195 Michael Wood Fine Art 107 Mid Cornwall Galleries 108 Midwest 452 Millais Gallery 178 Milton Keynes Gallery 178 Mission Gallery 116 Modern Artists' Gallery 95 Montpellier Gallery 119 Museum 52 56 National Society of Painters, Sculptors & Printmakers 453 Naughton Gallery at Queens 168 New Art Gallery, Walsall 192 New Craftsman 108 New English Art Club 454 The New Gallery 108 New Realms Limited 57 Nicholas Bowlby 95 Norman Villa Gallery 136 Northcote Gallery Chelsea Number Nine the Gallery October Gallery 57 Offer Waterman & Co. 57 Oisin Art Gallery 136 On-lineGallery 216 Open Eye Gallery and i2 Gallery 85 Opus Gallery 28

The Origin Gallery 137 Original Print Gallery 137 Pallant House Gallery 178 Pallas Studios 137, 298 Patrick Davies Contemporary Art 23 Paul Kane Gallery 137 Peacock Visual Arts 86, 173, 455 Peer 59 Penwith Galleries and Penwith Society of Arts Peterborough Art House Ltd 24 Picturecraft Gallery Ltd 24 Queens Park Arts Centre 456 Rainyday Gallery 108 The Residence 61 Retrospectives Gallery 120 Revolutionary Arts Group Riverbank Arts Centre 203 Rocket 62 Room for Art Gallery 97 Royal British Society of Sculptors 408, 457 Royal Hibernian Academy Royal West of England Academy (RWA) 186 Sandford Gallery 138 Sarah Walker 138 Sargant Fellowship 410 School House Gallery 24 School of Art Gallery and Museum 189 The Scottish Gallery 86 Sesame Gallery 64 Seven Seven Contemporary Art 64 Shoreline Studio 86 Simon Fairless 97 Simon Lee Gallery 64 Siopa Cill Rialaig Gallery Six Chapel Row Contemporary Art 98 Skopelos Foundation for the Arts 410 Skylark Galleries 65 Society of Catholic Artists 460 Society of Scottish Artists (SSA) 461 Solstice Arts Centre 203 Sorcha Dallas 86 St Ives Society of Artists Gallery 110, 186 St John Street Gallery 28 Start Contemporary Gallery Stone Gallery 138 Stroud House Gallery 111

Studio 1.1 66

Art Ltd 216

Studio Glass Gallery 67

Suffolk Art Society 461

Studioworx Contemporary

Suffolk Open Studios 462

Summer Exhibition - Royal Academy of Arts 411 Swansea Open 411 Tate Modern 158 Tate St Ives 187 Taylor-Pick Fine Art 126 the-artists.org 217 Thoresby Gallery 29 Timothy Taylor Gallery 68 Tom Caldwell Gallery 81 The Troubadour Gallery 68 Turner Gallery 112 Union 69 University College London (UCL) Art Collections University of Brighton Gallery 180 Urban Retreat 98 Visual Arts Scotland (VAS) Vitreous Contemporary Art Walker Galleries Ltd 127 The Warwick Gallery 121 Washington Gallery 116 Waytemore Art Gallery 25 Wenlock Fine Art 121 West Cork Arts Centre 204 West Wales Arts Centre 116 Westgate Gallery 87 WhiteImage.com 81 Whitford Fine Art 70 Widcombe Studios Gallery Wildwood Gallery 25 Wingate Rome Scholarship in the Fine Arts 412 Wolseley Fine Arts Ltd 121 Wolverhampton Art Gallery 192 The Wonderwall Gallery 112 Woodbine Contemporary Arts 29 Wrexham Arts Centre 190 Yarm Gallery 73 York City Art Gallery 196 Zimmer Stewart Gallery 99 APPLIED AND **DECORATIVE ART** 176 Gallery / The Zabludowicz Collection 20-21 Visual Arts Centre 147 Aberdeen Art Gallery 169 absolutearts.com and World Wide Arts Resources Corp. 213 Access to Arts 127 ACE Award for Art in a Religious Context 388 ACE/REEP Award 388 Antique Collectors' Club 285 Arna Farrington Gallery 21 Art Centre and Gallery 237 The Art House 233 Art in Action Gallery 88

Art Matters Gallery 113

Architecture Awards 390 Arts Council of Northern Ireland 423 Arts Gallery 149 Artselect Ireland 127 Ashmolean Museum Shop 248 Axis 214, 441 Bankfield Museum 192 Barn Galleries 89 Barrett Marsden Gallery 34 The Beacon 162 Belford Craft Gallery 70 Big Blue Sky 21 Bircham Gallery 21 Bircham Gallery Shop 248 Birmingham Museum and Art Gallery 190 Black Swan Arts 101 Blackwell Arts & Crafts House 162 Blue Lias Gallery 101 Bluecoat Display Centre Bluemoon Gallery 90 Bolton Museum, Art Gallery and Aquarium The Bottle Kiln 26 The Bowes Museum 113 Bridge Gallery 128 Bristol School of Art, Media and Design 326 Bristol's City Museum and Art Gallery 182 Brunei Gallery 150 Buckenham Galleries 21 Burton Art Gallery and Museum 182 Bury Art Gallery, Museum and Archives 163 Byard Art Open Competition 394 Cartwright Hall Art Gallery Castle Gallery 117 Cavanacor Gallery 129 Celf 114 Chapel Gallery 163 Charleston Farmhouse and Gallery 175 CHELSEA space 151 Cheltenham Art Gallery & Museum 182 **Chepstow Ceramics** Workshop Gallery 114 Chinese Arts Centre 163 Cleveland College of Art & Design 343 Collins Gallery 170 Common Ground 426 Conservation Register 209

The Art Shop

Artizana 74

422

(Abergavenny) 232

Arts & Disability Forum

Arts and Crafts in

The Art Shop (Wanstead)

Contemporary Glass Society 444 Coombe Gallery 102 Cooper Gallery 193 Cosa Gallery 39 Courtauld Institute of Art Gallery 151 Courtyard Arts Limited 130 Coventry University 330, Craft Central 294, 444 Crafts Council 426, 444 Crafts Study Centre 176 Creative Skills 426 Crown Studio Gallery 71 Customs House 71, 160 De Montfort University 308, 340 Derby Museum and Art Gallery 147
Design and Artists Copyright Society (DACS) 445 Design Collection Museum 182 Design Museum 152 Dewsbury College 333, 355 Domino Gallery 75 Draíocht Arts Centre 198 Dunamaise Arts Centre Dunstable College 306, 339 Edinburgh College of Art Elliott Gallery 104 **Emerging Artists Art** Gallery 215 Exeter College 326, 350 Fairfields Arts Centre 183 Falkiner Fine Papers 229 Farnham Maltings 92 Fife Contemporary Art & Craft (FCAC) 170 Filthy But Gorgeous 118 Fine Art Society Plc 44 Four Square Fine Arts 92 The Framework Gallery 131. 265 Frivoli 45 Galerie Besson 45 Gallery 2000 76, 266 Gallery Oldham 164 The Gallery (Masham) 124 Garnet Publishing / Ithaca Press 287 Geffrye Museum 153 George Street Gallery 92 Gilbert Collection 153 GlimpseOnline.com 215 Gloucester City Museum and Art Gallery 183 Glynn Vivian Art Gallery 188 Graves Art Gallery 193 Grimsby Institute of Further and Higher Education 308 Grundy Art Gallery 370 Guildford House Gallery 176 Harewood House 193

Harley Gallery 27, 148 Harris Fine Art Ltd 220 Harris Museum and Art Gallery 165 Helix Arts 427 Herefordshire College of Art & Design 330, 353 Hermitage Rooms at Somerset House 154 Hidden Art 212 HMAG (Hastings Museum and Art Gallery) 177 Holburne Museum of Art Hull Maritime Museum 194 Hull School of Art and Design 333, 355 Framers 266 Impact Art 259 Impact Arts 427 Institute of Contemporary Arts (ICA) 154 Ipswich Arts Association Jackson's Art Supplies 230 James Hockey Gallery 177 larrold's 225 **Jerwood Contemporary** Makers Prize 402 Jerwood Space 51 Keane on Ceramics 134 Kelmscott Manor 184 Kelvingrove Art Gallery and Museum 171 The Kenny Gallery 134 Kent Potter's Gallery 94 Kettle's Yard 145 Kilvert Gallery 114 Kirkcaldy Museum and Art Gallery 171 Kooywood Gallery 115 Laing Art Gallery 161 Lander Gallery 107 Leighton House Museum Letchworth Museum and Art Gallery 145 Loughborough University 308, 340 Lowes Court Gallery 77 Lunts Castings Ltd 262 Magil Fine Art 135 The Makers Guild in Wales Manchester Art Gallery 165 Manchester Craft & Design Centre 77 Mark Harwood Photography / LocaMotive 283 McNeill Gallery 23 MFH Art Foundry Ltd 262 Middlesex University 312 Midwest 452 Millennium Galleries 195 Millinery Works Gallery 55 mima - Middlesbrough Institute of Modern Art 161

Mission Gallery 116 Montpellier Gallery 110 Art Gallery 192 Mount Stuart 172 Museum of East Asian Art Six Chapel Row National Association of Decorative and Fine Arts Societies (NADFAS) 269, 460 National College of Art and 460 Design 337 Naughton Gallery at Oueens 168 Nest 28 98 Neville Pundole Gallery 95 New Brewery Arts Centre New Craftsman 108 North Wales School of Art and Design 328 Thoresby Gallery 29 Northern Lights Gallery 78 Treeline Gallery 29 Nottingham Trent University 309 Oberon Art Ltd 283 Open Eye Gallery and i2 Art Gallery 166 Gallery 85 Opus Gallery 28 The Orangery and Ice House Galleries 155 349 Own It 217 Paddon & Paddon o6 Gallery 180 Penlee House Gallery and Museum 185 Percy House Gallery 78 Peterborough Art House Ltd 24 Phoenix Arts Association 307, 339 299, 455 Platform Gallery 78 Plymouth College of Art Gallery 166 and Design 326, 350 Portsmouth City Museum 325, 349 and Records Office 179 University of Wales Prema 185 Pure South 239 352 Queens Park Arts Centre Verandah 99 Rachel Gretton Glass 126 158 Red Gate Gallery & Studios 299 463 Red House Museum and Art Gallery 186 Wall Candi Ltd 285 Retrospectives Gallery 120 Revolutionary Arts Group 456 Riverbank Arts Centre 203 Gallery 73, 300 Riverfront 189 Robert Phillips Gallery 96 RotoVision 290 Royal College of Art 157, 313 Royal Cornwall Museum Russell & Chapple 231 Sainsbury Centre for Visual 261 Arts 146 Saltburn Gallery 72 Gallery 181 School of Art Gallery and Yarm Gallery 73 Museum 189 The Scottish Gallery 86 Shipley Art Gallery 161 Shoreline Studio 86

Siopa Cill Rialaig Gallery Contemporary Art o8 285 Society for All Artists (SAA) Society of Catholic Artists South Shields Museum and Art Gallery 161 Start Contemporary Gallery Stroud House Gallery 110 Studio Glass Gallery 67 Suffolk Art Society 461 Swansea Institute 328 The Teesdale Gallery 73 The Toll House Gallery 111 The Troubadour Gallery 68 Tullie House Museum and Ulster University 319 University for the Creative Arts - Maidstone 324, University of Brighton University of Cumbria (formerly Cumbria 287 Institute of the Arts) 319. University of Hertfordshire 287 University of Lincoln 309 University of Liverpool Art University of Southampton Institute Cardiff 329. Victoria & Albert Museum Visual Arts Scotland (VAS) Waddesdon Manor 181 Wallace Collection 158 The Warwick Gallery 121 Waygood Studios and West Wales Arts Centre 117 Wheatsheaf Art Shop 232 Widcombe Studios Gallery Wolverhampton Art Gallery Workplace Art Consultancy Worthing Museum and Art Wrexham Arts Centre 190 York City Art Gallery 196 York College 335, 356 Zimmer Stewart Gallery 99

Shrewsbury Museum and ART BOOK PUBLISHERS A&C Black Publishing 285 Anova Books Group Ltd Antique Collectors' Club Architectural Association Art Data 248, 285 Art Sales Index Ltd 286 Ashgate Publishing Ltd 286 Ashmolean Museum Publications 286 Bardon Enterprises 286 Belfast Exposed Photography 79, 167, 425 Black Dog Publishing 286 Blackwell Publishing 286 **Book Works Publishing** Brepols Publishers 286 British Museum Press 286 RT Ratsford 286 Cambridge University Press 286 Centre for Contemporary Arts (CCA) 169 Charleston Farmhouse and Gallery 175 CHELSEA space 151 Collins and Brown 287 Constable & Robinson Ltd David & Charles 287 Dorling Kinderslev Ltd 287 Enitharmon Editions Ltd Focal Point Gallery 144 Focal Press (an imprint of Elsevier) 287 Four Courts Press 287 Frances Lincoln Ltd 287 Fruitmarket Gallery 171 The Gallery – text+work 183 Garnet Publishing / Ithaca Press 287 Gilbert Collection 153 Giles de la Mare Publishers 1td 288 Golden Cockerel Press Ltd Golden Thread Gallery 168 Guild of Master Craftsman Publications Ltd 288 Halsgrove Publishing 288 Harvard University Press Hermitage Rooms at Somerset House 154 Hilmarton Manor Press I.B. Tauris & Co. Ltd 288 Inverleith House 171 Irish Academic Press 288 John Hansard Gallery 177 Kelvingrove Art Gallery and Museum 171 Koenig Books London 288 Laurence King Publishing Ltd 288 The Lilliput Press 288

Liverpool University Press 289 The Lowry 165 Lund Humphries 289 Mainstream Publishing Manchester University Press 289 Marston House 289 Merrell Publishers 289 National Gallery of Ireland National Portrait Gallery Publications 289 NMS Publishing Ltd 289 Octopus Publishing Group 289 Oxford University Press 289 Pavilion 289 Phaidon Press Ltd 290 Philip Wilson Publishers Ltd 290 Prestel Publishing Ltd 290 Primrose Hill Press Ltd 290 Project Arts Centre 202 Reaktion Books Ltd 290 RotoVision 290 Routledge Publishers 290 Royal Jelly Factory 260, 290 Sangam Books Ltd 290 Search Press Ltd 290 Seren 291 Taschen UK Ltd 291 Tate Publishing 291 Textile & Art Publications Thames & Hudson 291 TownHouse Dublin 291 V&A Publications 291 Waddesdon Manor 181 Whitechapel Gallery 159 Wordsworth Museum Art Gallery 167 Worple Press 291 Yale University Press 291

ART BOOKSHOPS 1853 Gallery Shop 247 Abbot Hall Art Gallery 162 Aberystwyth Arts Centre 187 Analogue Books 247 Architectural Association

149 Arnolfini Bookshop 247 Art & Design 247 Art Books Etc 247 Art Data 248, 285 The Art Shop (Abergavenny) 243 Artlines 263 Arts Bibliographic 248

Artstore at the Artschool Ltd 236 Artwords 248 Artwords at the Whitechapel 248 Ashmolean Museum Shop 248

Aspex Gallery 175 BALTIC Shop 248 Bankside Gallery 149, 441 BFI Filmstore 248 Bircham Gallery Shop 248 Blackwell 248 Blackwell Art & Poster Shop 248

Blenheim Books 248 Bluecoat Books & Art Ltd British Museum Bookshop

249 Broadford Books and Gallery 236 Browsers Bookshop 243 Brunei Gallery 150 Bury Art Gallery, Museum and Archives 163 Camden Arts Centre 151 Centre for Contemporary Arts (CCA) 169 Chapter 1 233 Chapter Gallery 188

Chapters Bookstore 249 Charles Vernon-Hunt Books 249 Charleston Farmhouse and Gallery 175

Chester Beatty Library Shop 249 Chinese Arts Centre 163 Claire de Rouen Books 249 The Compleat Artist 242 Compton Verney 190 Cornerhouse 163 Cornerhouse Shop 249

Courtauld Institute of Art Gallery 151 Courtyard Shop 249 Coutauld Gallery Bookshop

Cowling & Wilcox Ltd 228 David & Charles 287 De La Warr Pavilion Shop

Dean Gallery Shop 249 Design Museum Shop 249 **Dorset County Museum**

The Dover Bookshop 249 **Dundee Contemporary** Arts Shop 249 FACT Shop 250 Falkiner Fine Papers 229 Fielders 229 Foyles Bookshop 44, 250

Fruitmarket Gallery Bookshop 250 The Gallery - text+work

Geffrye Museum 153 Gilbert Collection 153 Giles de la Mare Publishers Ltd 288 Glynn Vivian Art Gallery

188 Harris Fine Art Ltd 229 Hatchards 250

Hatton Gallery 160 Hayward Gallery Shop 250 Heffers Academic & General Books 250 Hermitage Rooms at Somerset House 154 Hodges Figgis 250 ICA Bookshop 250 Icetwice Gallery 250 The Ikon Gallery Shop 250 Institute of Contemporary Arts (ICA) 154 Irish Museum of Modern

Art 200 Jackson's Art Supplies 230 John Hansard Gallery 177 John Sandoe (Books) Ltd 250

Kennedy Gallery 247 Kettle's Yard 145 Koenig Books Ltd. 250 Lady Lever Art Gallery Shop Leeds City Art Gallery Shop

251 Lewis Glucksman Gallery 200 London Graphic Centre 230, 251

The Lowry 165 MAGMA Covent Garden Magma Design Ltd 251

MAGMA Manchester 251 Manchester City Gallery Shop 251 Marcus Campbell Art Books 251

Modern Art Oxford Shop Museum of East Asian Art

184 National Gallery of Ireland Shop 251

National Gallery of Scotland Shop 251 National Gallery Shop 251 National Portrait Gallery

Shop 251 New Art Gallery, Walsall

Noble & Beggarman Books 252 Oriel Mostyn Art Gallery Shop 252

Owen Clark & Co. Ltd 231 Oxford University Press

Pallant House Gallery 178 Pennies from Heaven 252 Penwith Galleries and Penwith Society of Arts

Photographers' Gallery Shop 252 Potterton Books 252 Printing House 234 Project Arts Centre 202 R.D. Franks 252 RIAS Bookshop 252 RIBA Bookshop 252 Royal Academy of Arts Shop 252

Royal West of England Academy (RWA) 186 Sainsbury Centre for Visual Arts 146 Scottish National Gallery of Modern Art Shop Scottish National Portrait Gallery Shop 253 Selfridges Book Department 253 Serpentine Gallery 157 Society for All Artists (SAA) 269, 460 Tate Britain Shop 253 Tate Liverpool 166, 253 Tate Modern Shop 253 Tate St Ives Shop 253 Terry Harrison Arts Limited Thomas Heneage Art Books 253 Three Counties Bookshop Trinity College Library Shop 253 V&A Shop 253 Vesey Art and Crafts 244 Vibes and Scribes 253 Victoria & Albert Museum 158 Waddesdon Manor 181 Walker Art Gallery Shop Wallace Collection Shop The Watermill 253 Waterstone's 253

Whitechapel Gallery 253

Whitworth Gallery Shop 254 ART FAIRS AND **FESTIVALS**

20/21 British Art Fair 376 20/21 International Art Fair Affordable Art Fair 376 Appledore Visual Arts Festival 376 Art Fortnight London Ltd

376 Art in Action 376 Art Ireland Spring Collection 377 Art Ireland 376 Art London 377 Art Sheffield 377 **ARTfutures 377** Artists & Makers Festival 377 ArtsFest 377 Asian Art in London 377

Battersea Contemporary Art Fair 378 Belfast Festival at Queen's 378

The Big Draw 378 Bow Festival 378 Brighton Art Fair 378 Brighton Festival 378

Brighton Photo Biennial 378 Buy Art Fair 378 Celf Caerleon Arts Festival Ceramic Art London 379 Chelsea Arts Fair 379 Cheltenham Artists Open Houses 379 Collect 379 Cork Art Fair 379 Deptford X 379 Dorset Art Weeks 380 Dulwich Art Fair 380 **Dumfries & Galloway Arts** Festival 380 Earagail Arts Festival 380 East Neuk Open 380 Edinburgh Art Fair 380 Edinburgh International Festival 380 Euroart Live Festival 380 ev+a - Limerick Biennial Folkestone Triennial Visitor Centre 381 Free Range 381 Frieze Art Fair 381 Gi - Glasgow International 381 Glasgow Art Fair 381 International Ceramics Fair and Seminar 381 International Festival of the Image 381 Leeds Art Fair 382 Liverpool Biennial 382 London Art Fair 382 London Design Festival 382 The London Original Print Fair 382 MADE Brighton 382 Margate Rocks 382 Museums and Galleries Month (MGM) 383 National Review of Live Art Nine Days of Art 383 Open Studios Northamptonshire 383 Oxfordshire Artweeks 383 Photo-London 383 Raw Arts Festival 383 Redbridge Arts Festival 384 Rye Festival 384 SCOPE Art Fairs 384 Somerset Art Weeks 384

Zoo Art Fair 384

ART FOUNDERS AND
MANUFACTURERS

AB Fine Art Foundry Ltd
261

Art Bronze Foundry
(London) Ltd 261

Bronze Age Sculpture
Casting Foundry Ltd and
Limehouse Gallery 261

Cast Iron Co. Ltd 261

Artquip 235

Artstat 233

Arts & Interiors Ltd 241

Castle Fine Arts Foundry 261 Dublin Art Foundry 261 Lakeland Mouldings 261 Livingstone Art Founders LS Sculpture Casting 262 Lunts Castings Ltd 262 MFH Art Foundry Ltd 262 Mike Smith Studio 262 Milwyn Casting 262 Morris Singer Art Founders Pangolin Editions 262 Powderhall Bronze 262 **ART MATERIALS** RETAILERS A.P. Fitzpatrick 227 A.S. Handover Ltd 227 Abcon 245 Alec Tiranti Ltd 237 Alms House 240 Alustretch UK Limited 227 Annetts (Horsham) Ltd 237 Art & Craft Company 245 Art & Craft Emporium / Silkes One Stop Stationery 246 Art & Frame 263 Art at Bristol 240 The Art Café (Nottingham) Art Centre (Halifax) 245 Art Centre (Weston-super-Mare) 240 Art Centre and Gallery 237 Art Centre and Tamar Valley Gallery 241 Art Choice Supplies 246 Art Essentials 226 Art Express 245 Art for All 237 The Art House (Manchester) 233 Art Materials Company 246 Art Mediums Ltd 236 The Art Shop (Abergavenny) 243 The Art Shop (Darlington) The Art Shop (London) 227 The Art Shop (Rutland) 226 The Art Shop (Trowbridge) The Art Shop (Wanstead) The Art Shop (Whitley Bay) The Art Shop (York) 245 The Art Shop and Kemble Gallery 232 Art Upstairs 246 Art@Bristol 241 Artboxdirect 241 Artcraft 245 Artisan 233 Artlines 263

Artstore at the Artschool Ltd 236 Artworker 238 Artworks 226, 263 Artwrap Ltd 236 Art-Write (Hythe) Ltd 237 Ashley Studio 225 Atlantis Art 227 Bar Street Arts Ltd 245 Barbers 264 Berkhamsted Arts & Crafts Bird & Davis Ltd - The Artist's Manufactory 227 Biskit Tin 245 Blackrock Art & Hobby Shop 246 Blades the Art Works 243 Blots Pen & Ink Supplies Blue Gallery 241 Bluecoat Books & Art Ltd Blyth's Artshop & Gallery Booer & Sons Ltd 228 Bottomleys Ltd 233 Bovilles Art Shop 238 Brackendale Arts 238 Bradbury Graphics 235 Bristol Fine Art 241 Broad Canvas 238 Broadford Books and Gallery 236 Browsers Bookshop 243 Burns & Harris (Retail) Ltd 236 Calder Graphics 245 Callan Art Supplies 246 Canonbury Arts 228 Carlow Art and Framing Shop 246 Cass Art 228 Centagraph 245 Ceres Crafts Ltd 241 Chapter 1 233 Cherry Art Centre 241 Children's Scrapstore 241 Chromacolour International 228 Chromos (Tunbridge Wells) Ltd 238 City Art Store 232 City Art 232 Colart Fine Art & Graphics Ltd 228 Colemans of Stamford 226 Colours and Crafts 233 The Compleat Artist 242 Cork Art Supplies Ltd 246 Country Love Ceramics 238 Cowling & Wilcox Ltd 228 Creative Crafts 238 Creative Shop Ltd 233 Creative World 238 Creativity 242 Cregal Art 246, 264 Cromartie Hobbycraft Ltd D & J Simons & Sons Ltd and SimonArt 228

Daintree Paper 246 Daisy Designs (Crafts) Ltd Daler-Rowney Ltd 238 Daler-Rowney Percy Street/ Arch One Picture Framing 228 Darcy Turner 229 David Potter Ltd 225 Dealg Design Ltd 264 Details @ Newcastle Arts Centre 232 Discount Art 245 Dominoes of Leicester Ltd Economy of Brighton 238 **EDCO 235** Edwin Allen Arts & Crafts EKA Services Ltd 239 Everyman Artist's Supply Co. 244 Expressions 239 F.J. Harris & Son 242 Falkiner Fine Papers 229 Fearnside's Art Ltd 244 Fielders 229 Fly Art & Crafts Company 244 Forget Me Not 239 Framing Fantastic 265 Fred Aldous Ltd 234 Fred Keetch Gallery 242 G.E. Kee 246 Gadsby's / Artshopper 226, Galleria Fine Arts 234 Gallery 2000 76, 266 Gallery Gifts Ltd 229 Get Creative 236 Godalming Art Shop 239 Goslings 266 Granthams Art Discount Grays of Shenstone 266 Great Art (Gerstaecker UK Ltd) 239 Green and Stone of Chelsea 229 Greyfriars Art Shop 236 Harberton Art Workshop Hardings 242 Harris Fine Art Ltd 229 Harris-Moore Canvases Ltd 244 Healthcraft 236 Hearn & Scott 239 Heaton Cooper Studio Ltd Heffers Art & Graphics Henderson Art Shop 236 Hertfordshire Graphics Ltd Hills of Newark Ltd 226 Hobbycraft - The Arts & Crafts Superstore 225 Hockles 239 Holloway Art & Stationers

Ian Dixon GCF Bespoke Framers 266 Icthus Arts & Graphics 234 The Ikon Gallery Shop 250 InkSpot 237 Inside Art 242 Intaglio Printmaker 229 J. Ruddock Ltd 227 Jackson's Art Supplies 230 Jarred's Arts & Craft 232 Jarrold's 225 lim's Mail Order 242 John E Wright & Co. Ltd John Jones Ltd 230 John Purcell Paper 230 lust-Art 237 K & M Evans 246 Ken Bromley Art Supplies Kennedy Gallery 247 Kirkintilloch Fine Arts 237 L. Cornelissen & Son 230 Largs Hardware Services & Gallery Eight 266 Laurence Mathews Art & Craft Store 225 Leapfrog 247 Lemon Tree 237 Lexicon 242 Litchfield Artists' Centre London Art Ltd 230 London Graphic Centre 230, 25 Lunns of Ringwood 239 Lyndons Art & Graphics Major Brushes Ltd 243 Makit 243 Mandel's Art Shop 247 Michael Harding's Artists Oil Colours 230 Mike Smith Studio 262 Millers City Art Shop 237 Milliken Bros 235 Minerva Graphics 242 Moray Office Supplies 237 Mulberry Bush 237 Mumbles Art & Craft Centre 243 National Gallery Shop 251 Oasis Art & Graphics 244 On-linepaper.co.uk 239 O'Sullivans 247 Owen Clark & Co. Ltd 231 Oxford Craft Studio 239 P.H. Graphic Supplies 227 Paint Box 247 Paintworks Ltd 231 The Paper House 244 Paperchase Products Ltd Pen and Paper Stationery Co. 243 Perrys Art & Office 231 The Potters' Barn 234 Premier Arts & Craft Store 247 The Print Partnership 243 Printing House 234

Proctor & Co. Ltd 236 Pure South 239 R. Jackson & Sons 235 R.K. Burt & Co. Ltd 231 R.R. Bailey 232 Rennies Arts & Crafts Ltd Riverbank Centre 242 Rural Art Company 239 Russell & Chapple 231 SAA Home Shop 227 Samuel Taylors 245 Scarva Pottery Supplies 236 Selwyn-Smith Studio 231 Sevenoaks Art Shop 240 Shawe's the Art Shop 227 Shinglers 235 Smitcraft 240 Society for All Artists (SAA) 269, 460 Spectrum Fine Art & Graphic Materials (Birmingham) 244 Stationery/Art Ltd 242 Stratford & York Ltd 232 Studio Arts - Dodgson Fine Arts Ltd 235 T. N. Lawrence & Son Ltd T.S. Two 240 Tales Press 244 Team Valley Brush Co. 232 Terry Harrison Arts Limited 240 Thomas Ellis 268 Three Counties Bookshop Tim's Art Supplies 225 Tindalls the Stationers Ltd Tiranti Tools 231 ToolPost 240 Tuppers 240 Turners Graphic Art & Drawing Office Supplies Unik Art & Craft 232 Vandy's Art and Graphic Centre 232 Vesey Art and Crafts 244 Vision Applied Arts & Crafts 236 Ward's Arts & Crafts 232 Wheatsheaf Art Shop 232 Windsor Gallery 226 Wrights 226 York Art & Framing 245 Ziggy Art Ltd 235

ARTIST-LED GALLERIES AND ORGANIZATIONS AOP Gallery 32 Art Space Gallery (St Ives) Arthouse Gallery 89 Barn Gallery 128 Black Cat Gallery 128 Black Mountain Gallery 113 Bluemoon Gallery 90 Bureau 75

100

Campbell Works 37 Castlefield Gallery 75, 163 Celf 114 Centre for Recent Drawing C4RD 38 The Centre of Attention 38 Courtyard Arts Limited 130 Crown Studio Gallery 71 **Cubitt Gallery and Studios** Cupola Contemporary Art Ltd 123 The Digital Artist 212 **Disability Cultural Projects** EggSpace 76 Elastic Residence 42 Fermynwoods Contemporary Art 26 fifiefofum 71 Five Years 44 Fosterart 44 Fourwalls 92 The Gallery at Willesden Green 45 The Gallery (Masham) 124 Glasgow Print Studio 84 Here Shop & Gallery 106 Hothouse Gallery 49 House Gallery 50 Inspires Art Gallery 93 Kangaroo Kourt 107 Keith Talent Gallery 51 London Road Gallery 125 Matt's Gallery 54 Mere Jelly 27 The New Gallery 120 Open Hand Open Space 178 Oriel 116 The Origin Gallery 137 Own It 217 Oxmarket Centre of Arts 95 Pallas Studios 137, 298 Peterborough Art House Ltd 24 Plan 9 109 The Residence 61 Rowan Tree 137 Saltburn Gallery 72 Sarah Walker 138 Sartorial Contemporary Art Seven Seven Contemporary Art 64 Shoreline Studio 86 Siopa Cill Rialaig Gallery 138 Skylark Galleries 65 Space Station Sixty-Five 65 Spectacle 121 Standpoint Gallery 66 stot 213 Strand Art Gallery 110 Studio 1.1 66 Studio Voltaire 67, 300 the-artists.org 217 Transition Gallery 68

Transmission 174

The Troubadour Gallery 68

The Warwick Gallery 121

Waygood Studios and Gallery 73, 300 Widcombe Studios Gallery 112

BOOK PUBLISHERS see ART BOOK PUBLISHERS

BOOKSHOPS see ART **BOOKSHOPS**

CERAMICS 176 Gallery / The Zabludowicz Collection 20-21 Visual Arts Centre A&C Black Publishing 285 Aberystwyth Arts Centre absolutearts.com and World Wide Arts Resources Corp. 213 Access to Arts 127 ACE Award for Art in a Religious Context 388 ACE/MERCERS International Book Award 388 ACE/REEP Award 388 The Afton Gallery 87 Alec Tiranti Ltd 237 Alexander-Morgan Gallery Alexandra Wettstein Fine Art 88 Ann Jarman 21 Arna Farrington Gallery 21 The Art House 233 Art in Action 376 Art London 377 Art Matters Gallery 113 The Art Shop (Abergavenny) 243 artart.co.uk 214 artcourses.co.uk 208 Arthouse Gallery 89 artists @ redlees 292 Artists' Network Bedfordshire 439 Artizana 74 Arts & Disability Forum 422 Arts and Crafts in Architecture Awards 390 Arts Gallery 149 Arts/Industry Artist-in-Residency 392 Artselect Ireland 127 Artstore at the Artschool Ltd 236 ArtSway 174 Astley House Contemporary 100 Atishoo Designs 100 Austin/Desmond Fine Art Ltd 34 Axis 214, 441 Barn Galleries 89 Barnsley College 332, 354 Barrett Marsden Gallery 34

The Beacon 162 Beaux Arts 35 Belford Craft Gallery 70 Bell Fine Art Ltd 90 Bettles Gallery 101 Big Blue Sky 21 Bircham Gallery Shop 248 Bircham Gallery 21 Biscuit Factory 70 **Bishop Grosseteste** University College Lincoln 307 Black Cat Gallery 128 Black Mountain Gallery 113 Black Swan Arts 101 Blackheath Gallery 35 Blackwell Arts & Crafts House 162 Blue Leaf Gallery 128 Blue Lias Gallery 101 **Bluecoat Display Centre** Bluemoon Gallery 90 Blyth Gallery 74 Bohemia Galleries 123 Bolton Museum, Art Gallery and Aquarium The Bottle Kiln 26 Bourne Fine Art 82 Bowie & Hulbert 113 Brick Lane Gallery 36 Bridge Gallery 128 Brighton Museum and Art Gallery 175 Bristol Guild 102 Bristol's City Museum and Art Gallery 182 Broadway Modern 117 Broughton House Gallery Brunei Gallery 150 Buckenham Galleries 21 Buckinghamshire New University 322, 347 Burghley 147 Burton Art Gallery and Museum 182 Bury St Edmunds Art Gallery 144 Buy Art Fair 378 Byard Art Open Competition 394 Camberwell College of Arts 310, 341 Cambridge Open Studios Camden Arts Centre 151 Canterbury Christchurch University College 322 Canvas 129 Cat's Moustache Gallery 82 Ceramic Art London 379 Chagford Galleries 91 Chapel Gallery 163 Chapel of Art - Capel Celfyddyd 114 Charleston Farmhouse and Gallery 175 Cheltenham Art Gallery &

Museum 182

Cheltenham Artists Open Fine Art Surrey 215 Fisherton Mill - Galleries Houses 379 Cafe Studios 104 **Chepstow Ceramics** Workshop Gallery 113 Fitzwilliam Museum 144, Chesterfield College 308, 356 Four Square Fine Arts 92 Church House Designs 102 Francis Iles 92 Collect 379 Collins Gallery 170 Fred Aldous Ltd 234 Free Range 381 Frivoli 45 Conservation Register 209 Galerie Besson 45 Contemporary Applied Arts Gallery 52 26 Contemporary Ceramics 39 The Gallery at Willesden Contemporary Studio Green 45 Gallery Kaleidoscope 46 Pottery 102 Context Gallery 79 Gallery Oldham 164 Coombe Gallery 102 Gallery Top 26 Cooper Gallery 193 The Gallery Upstairs 119 Corman Arts 258 The Gallery (Masham) 124 Cosa Gallery 39 Country Love Ceramics 238 Galway-Mayo Institute of Technology 336 Courtyard Arts Limited 130 Garter Lane Arts Centre Coventry University 330, Gilbert Collection 153 353 Craft Central 294, 444 Glass and Art Gallery 72 Crafts Council 426, 444 Glass House Gallery 105 Crafts Study Centre 176 GlimpseOnline.com 215 Craftsmen's Gallery 91 Global Arts Village 401 Craven College, Skipton Glynn Vivian Art Gallery 188 333, 355 Crawford College of Art Godfrey & Watt 124 and Design 371 Great Atlantic Map Works Creative Skills 426 Gallery 105 Greenlane Gallery 132 Crescent Arts 123 Cromartie Hobbycraft Ltd Greenwich Mural Workshop 448 Crown Studio Gallery 71 Grosmont Gallery 125 Grundy Art Gallery 165 Croydon Museum Service Guildford House Gallery 152 Cube Gallery 103 Cupola Contemporary Art Harlequin Gallery 47 Ltd 123 Harleston Gallery 22 Customs House 71, 160 Harley Gallery 27, 148 The Darryl Nantais Gallery Harris Museum and Art Gallery 165 Delamore Arts 104 Hartworks Contemporary Design and Artists Art 105 Copyright Society Head Street Gallery 22 (DACS) 445 Headrow Gallery 125 Dolphin House Gallery 104 Helios at the Spinney 119 Domino Gallery 75 Helix Arts 427 The Hepworth Wakefield dot-art 76 Draíocht Arts Centre 198 194 The Herbert 190 **Dunamaise Arts Centre** Herefordshire College of Duncan Campbell 41 Art & Design 330, 353 East Neuk Open 380 Hermitage Rooms at Ellen L. Breheny 255 Somerset House 154 Elliott Gallery 104 Hertfordshire Gallery 23 **Emerging Artists Art** Hertfordshire Graphics Ltd Gallery 215 225 Enable Artists 446 Hidden Art 212 Eyecandy 124 Holburne Museum of Art 183 Fairfields Arts Centre 183 Fenwick Gallery 71 Hull School of Art and Fife Contemporary Art & Design 333, 355 Craft (FCAC) 170 ICAS - Vilas Fine Art 23 fifiefofum 71 IceTwice 93 Filthy But Gorgeous 118 Impact Art 259

Filton College 326, 350

Fine Art Society Plc 44

Institute of Techonology Sligo 337 International Ceramics Fair and Seminar 381 Ipswich Arts Association James Joyce House of the Dead 133 The Jerdan Gallery 85 Jerwood Contemporary Makers Prize 402 Jim Robison and Booth House Gallery and Pottery 125 John Noott Galleries 119 Jones Art Gallery 133 Keane on Ceramics 134 Kelmscott Manor 184 Kelvingrove Art Gallery and Museum 171 The Kenny Gallery 134 Kent Potters' Gallery 94 Kentmere House Gallery Kettle's Yard Open / **Residency Opportunities** Kettle's Yard 145 Kilvert Gallery 114 King's Lynn Arts Centre 145 Kooywood Gallery 115 Lander Gallery 107 Lavit Gallery 134 Leamington Spa Art Gallery and Museum 191 Leeds College of Art & Design 333, 355, 370 Lena Boyle Fine Art 52 Letchworth Museum and Art Gallery 145 Limerick Institute of Technology 337 Linda Blackstone Gallery Linenhall Arts Centre 201 London Road Gallery 125 Loughborough University 308, 340 Lowes Court Gallery 77 MADE Brighton 382 Magpie Gallery 27 Major Brushes Ltd 243 The Makers Guild in Wales Manchester Craft & Design Centre 77 Marchmont Gallery and Picture Framer 85 Market House Gallery 107 The Market House 201 Marston House 289 McNeill Gallery 23 Mead Gallery 191 Michael Wood Fine Art 108 Mid Cornwall Galleries 108 Midwest 452 mima - Middlesbrough Institute of Modern Art Impact Arts 427 Mission Gallery 116 Inspires Art Gallery 93 Modern Artists' Gallery 95

Montana Artists' Refuge Residency Program 404 Montpellier Gallery 119 Mova Bucknall Fine Art 119 Museum of East Asian Art Narrow Space 136 National College of Art and Design 337 National Museum and Gallery, Cardiff 189 National War Museum 172 Nest 28 Neville Pundole Gallery 95 **New Brewery Arts Centre** 184 New Craftsman 108 Newcastle College 315, 343 Norman Villa Gallery 136 North Wales School of Art and Design 328 Northampton Museum and Art Gallery 148 Northern Lights Gallery 78 Northumbria University 315 Nottingham Artists' Group 298 Number Nine the Gallery 120 Oakwood Ceramics 28 Oberon Art Ltd 283 Oisin Art Gallery 136 Open Eye Gallery and i2 Gallery 85 **Open Studios** Northamptonshire 383 Opus Gallery 28 The Orangery and Ice House Galleries 155 The Origin Gallery 137 OSB Gallery Ltd 137 Owen Clark & Co. Ltd 231 Own It 217 Oxford Craft Studio 239 Oxmarket Centre of Arts 95 Paddon & Paddon 96 Paisley Art Institute Annual **Exhibition Prizes and Biennial Scottish Drawing Competition** Patchings Art Centre 28 Penwith Galleries and Penwith Society of Arts Percy House Gallery 78 Peterborough Art House Phoenix Arts Association 299, 455 Pitt Rivers Museum 179 Platform Gallery 78 Plymouth City Museums and Art Gallery 185 PM Gallery and House 156 Pond Gallery 60 Potteries Museum and Art Gallery 192 The Potters' Barn 234 Prema 185 Pure South 239

Oueens Park Arts Centre Red Gate Gallery & Studios Red Rag Gallery 109 The Residence 61 Revolutionary Arts Group Riverbank Arts Centre 203 Room for Art Gallery 97 Rostra & Rooksmoor Galleries 109 Royal College of Art 157, 313 Royal Cornwall Museum Royall Fine Art 97 Safehouse 169 Saffron Walden Museum Sainsbury Centre for Visual Arts 146 Salar Gallery 109 Salford Museum and Art Gallery 166 Saltburn Gallery 72 Saltgrass Gallery 97 Sarah Walker 138 Scarva Pottery Supplies School of Art Gallery and Museum 189 The Scottish Gallery 86 Sculpture Lounge 126 Sheffield College, Hillsborough Centre 334, Shipley Art Gallery 161 Shoreline Studio 86 Siopa Cill Rialaig Gallery Six Chapel Row Contemporary Art 98 Skopelos Foundation for the Arts 410 Skylark Galleries 65 Society of Catholic Artists Society of Scottish Artists (SSA) 461 Society of Women Artists South East Essex College Southwold Gallery 24 St Helens College 318, 345 St John Street Gallery 28 Steam Pottery 110 Storm Fine Arts 25 Stroud House Gallery 111 Studiopottery.co.uk 210 Suffolk Art Society 461 Suffolk Open Studios 462 Swansea Institute 328 Swansea Open 411 Talents Fine Arts 127 Tate St Ives 187 Taurus Gallery 98 Taylor-Pick Fine Art 127 The Teesdale Gallery 73 Thoresby Gallery 29

Quay Arts 179

186

236

138

461

348

Thornthwaite Galleries 78 The Toll House Gallery 111 Tom Caldwell Gallery 81 Towneley Hall Art Gallery & Museum 196 Townhouse Gallery Portrush 81 Tracey McNee Fine Art 87 Treeline Gallery 29 Tregony Gallery 111 The Troubadour Gallery 68 Tuckmill Gallery 139 Turnpike Gallery 166 University of Bath 327 University of Brighton Gallery 180 University of Hertfordshire 307, 339 University of Liverpool Art Gallery 166 University of Wales Institute Cardiff 329, 352 University of Westminster 314 Urban Retreat 98 **VADS 210** Verandah 99 Victoria Art Gallery 187 Visual Arts Scotland (VAS) 463 Vitreous Contemporary Art 112 Waddesdon Manor 181 Walker Galleries Ltd 127 Wallace Collection 158 The Warwick Gallery 121 Waygood Studios and Gallery **73, 300** West End Gallery **29** West Wales Arts Centre 117 West Wales School of the Arts 330, 352 Westbury Farm Studios 464 Westgate Gallery 87 Widcombe Studios Gallery Wolseley Fine Arts Ltd 121 The Wonderwall Gallery 112 Woodbine Contemporary Arts 29 York City Art Gallery 196 York College 335, 356 Zimmer Stewart Gallery 99

COMMISSIONING 'A' Foundation 74. 421 Access to Arts 127 Art Consultants Ltd - Art For Offices 421 Art Point Trust 421 Artangel 421 Arts & Disability Forum 422 Arts Council England 358, 422 Artselect Ireland 127 The Baring Foundation 424 **Belfast Exposed** Photography 79, 167, 425 Blackheath Gallery 35

Blue Lias Gallery 101 Bridge Gallery 128 Bureau 75 Campbell Works 37 Castlefield Gallery 75, 163 Centre for Recent Drawing -C4RD 38 Chichester Gallery 91 Collective Gallery 83, 169 Commissions East 425 Common Ground 426 dot-art 76 Federation of British Artists (FBA) 426, 447 Fine Art Commissions Ltd Freeform 427 Glass and Art Gallery 72 Helix Arts 427 Henry Moore Foundation 356, 427 Impact Arts 427 International 3 76 ISIS Arts 427 Jim Robison and Booth House Gallery and Pottery 125 Lime 428 Locus+ 428 Magil Fine Art 135 Moya Bucknall Fine Art 119 Number Nine the Gallery Open Eye Gallery and i2 Gallery 85 Original Print Gallery 137 Patrick Davies Contemporary Art 23 Peer 59 Picture This 439 Plan 9 109 **Public Art Commissions** and Exhibitions (PACE) Public Art South West 430 **Rhizome Commissions** SAFLE 430 Six Chapel Row Contemporary Art 98 Sorcha Dallas 86 Taylor-Pick Fine Art 127 Tees Valley Arts 431 The Kenny Gallery 134 VIVID 431 COMPETITIONS.

AWARDS AND PRIZES Abbey Awards in Painting and Abbey Scholarship in Painting 388 ACE Award for Art in a Religious Context 388 ACE/MERCERS International Book Award 388 ACE/REEP Award 388 Artes Mundi Prize 389 Artist of the Year by the Society for All Artists

(SAA) 389

Arts & Disability Forum 422 Arts and Crafts in Architecture Awards 390 Arts Awards 390 Arts Council of Northern Ireland Support for Individual Artists Programme 391 Artsadmin 424 Association of Photographers (AOP) Open 392 Balmoral Scholarship for Fine Arts 392 Bankside Gallery 149, 441 Bloomberg New Contemporaries 393 BP Portrait Award 393 British Council Arts Group British Glass Biennale 393 British Journal of Photography 393, 476 Business2Arts 258, 425 Contemporary Art Society for Wales - Cymdeithas Gelfydoyd Gyfoes Cymru CORE Program 395 Crafts Council Next Move Scheme 395 Creekside Open 395 The David Gluck Memorial Bursary **396** Derek Hill Foundation Scholarship in Portraiture 396 Deutsche Börse Photography Prize 397 EAC Over 60s Art Awards East End Academy 397 East International 397 ECO - Exeter Contemporary Open 398 Elizabeth Greenshields Foundation Grants 398 Erna & Victor Hasselblad Foundation Awards and Bursaries 398 European Association for **Jewish Culture Grants** Federation of British Artists (FBA) Annual Open 399 Flamin Awards 399 Franklin Furnace Fund for Performance Art and Franklin Furnace Future of the Present 399 Friends of Israel **Educational Foundation** 400 Friends of the Royal Scottish Academy Artist Bursary 400 FringeMK Annual Painting Prize 400 Gallery 1839 215, 400

Gen Foundation 400 Permanent Collection Guild of Aviation Artists 449 Gunk Foundation Grants Queen Elizabeth RDS Foundation 456 for Public Arts Projects The Rencontres ING Discerning Eye Contemporary Book Exhibition 401 Prize 407 Ipswich Art Society 450 The Rencontres d'Arles **Ipswich Arts Association** Discovery Award 407 **Rhizome Commissions** Iris, International Women's Photographic Research Royal British Society of Resource 427 Sculptors 408, 457 J.D. Fergusson Arts Award 401 Thomas Dammann James Milne Memorial Trust 402 Awards 408 Jeff Vickers/Genix Imaging Royal Scottish Academy Bursary 402 Alastair Salvesen Art Scholarship 408 Jerwood Contemporary Royal Society of British Painters 402 Jerwood Drawing Prize 402 Artists (RBA) 458 Jerwood Sculpture Prize Royal West of England Joan Wakelin Bursary 403 Bursaries 408 Lady Artists Club Trust **RSA John Kinross** Award 403 Scholarships 409 Laing Solo 403 Leverhulme Trust Grants Scotland Award 409 and Awards 403 RSA William Littlejohn London Photographic Association 404, 451 Scholarship 409 Lynn Painter-Stainers Prize The RWS/Sunday Times Manchester Academy of Watercolour Competition 409 Fine Arts Open 404 Margate Rocks 382 Max Mara Art Prize for Sainsbury Scholarship in Women 404 Midwest 452 Mostyn Open 405 Sargant Fellowship 410 National Endowment for Scottish Sculpture Science, Technology and the Arts (NESTA) 405, 428 National Museum of Women in the Arts (NMWA) Library Fellows Programme 405 Society of Portrait The National Open Art Sculptors 461 Competition 405 Society of Scottish Artists New English Art Club 454 (SSA) 461 Society of Wildlife Artists North Wales School of Art Bursaries 410 and Design 328 Northern Art Prize 405 Society of Women Artists Paisley Art Institute Annual **Exhibition Prizes and** St Hugh's Fellowship 411 **Biennial Scottish** Stockport Art Gallery **Drawing Competition** 406 Suffolk Art Society 461 Paul Hamlyn Foundation Awards For Artists 406 photodebut 455 Academy of Arts 462 The Pilar Juncosa & Sotheby's Awards 406 Polish Cultural Institute Pollock-Krasner 462 Foundation 407 **UNESCO** Aschberg Purchase Prize BlindArt

Scholarship Trust 407 Royal Hibernian Academy Junior Memorial Trust Academy (RWA) Student **RSA New Contemporaries** Watercolour Award 409 Ruth Davidson Memorial Safle Graduate Award 409 Painting and Sculpture Workshop Programme Society for Religious Artists (SFRA) 460 Society of Botanical Artists Annual Open Exhibition Summer Exhibition - Royal The Threadneedle Prize for Painting and Sculpture **UK Coloured Pencil Society** Bursaries for Artists 412

V&A Illustration Awards 412 Visual Arts Scotland (VAS) 463 VIVID 431 Wingate Rome Scholarship in the Fine Arts 412 Women's Studio Workshop Fellowship Grants 413

CONSULTANTS

Acacia Works 263

ACAVA - Association for Cultural Advancement through Visual Art 292 Access to Arts 127 Acme Studios 292 Alan Kluckow Fine Art 87 Albion / AAR 88 Allyson Rae 254 Amber Roome Contemporary Art 82 Anderson Hill 31 Artquest 211, 258 Arts & Disability Forum 422 Atlas Gallery 34 Barbara Behan Contemporary Art 34 Barn Galleries 89 Bischoff/Weiss 35 Blue Leaf Gallery 128 Bluemoon Gallery 90 Boundary Gallery - Agi Katz Fine Art 36 Bridgeman Art Library 258, Broughton House Gallery Bureau 75 Business Art Service 258 Business2Arts 258, 425 C.S. Wellby 254 Campbell's of London 264 Canvas 129 C'Art Art Transport Ltd 270 Castle Fine Arts Foundry Cavanacor Gallery 129 Clapham Art Gallery 38 Clare Finn & Co. Ltd 254 Consultant Conservators of Fine Art 255 Corman Arts 258 Courtenays Fine Art 103 Cranbrook Gallery 91 Cristeph Gallery 130 Crown Studio Gallery 71 Cupola Contemporary Art Davidson Arts Partnership DegreeArt.com 40, 214 Dickson Russell Art Management 259 Diesel House Studios 295 dot-art 76 Dyehouse Gallery 130 Eagle Gallery Emma Hill Fine Art 41

East West Gallery 41 ecArtspace 41 Eddie Sinclair 255 Edinburgh Printmakers 84 Egan, Matthews & Rose 255 Eleven 42 Enfield Arts Partnership 42 England & Co Gallery 43 FarmiloFiumano 43 Fine Art Commissions Ltd Fitzgerald Conservation 255 Fosterart 44 fotoLibra 259, 274 Four Square Fine Arts 92 Fourwalls 92 Gallery One 164 Getty Images 259 Gillian Jason Modern & Contemporary Art 46 Gorry Gallery Ltd 132 Graal Press 281 Hallett Independent Ltd Hazlitt Holland-Hibbert 48 Headrow Gallery 125 Highgate Fine Art 49 Hillsboro Fine Art 133 HS Projects 259 ICAS - Vilas Fine Art 23 Impact Art 259 International Art Consultants Ltd 259 James Hyman Gallery 51 Jill George Gallery 51 Jorgensen Fine Art 133 Kentmere House Gallery Kilvert Gallery 114 Kings Road Galleries 52 Lakeland Mouldings 261 Laneside Gallery 80 Livingstone Art Founders 261 Long & Ryle 53 Mac Medicine Ltd 259 Magil Fine Art 135 Mark Harwood Photography / LocaMotive 283 Michael Wood Fine Art 108 Mike Smith Studio 262 Miller Fine Arts 28 Modern Artists' Gallery 95 Modus Operandi Art Consultants 259 Momart Limited 271 Nicholas Bowlby 95 Northcote Gallery Chelsea Number Nine the Gallery Oberon Art Ltd 283 Offer Waterman & Co. 57 Oisin Art Gallery 136 Pangolin Editions 262 Patrick Davies Contemporary Art 23 Paul Kane Gallery 137

Paul Treadaway 267 Art in Action 438 Art Matters Gallery 113 Peterborough Art House Art Mediums Ltd 236 1 td 24 The Art Shop and Kemble Gallery 232 Pilot 260 The Art Shop (Darlington) Plan 9 109 plan art consultants 260 232 The Art Shop (York) 245 Proud Galleries 60 Rachel Howells 257 artcourses.co.uk 208 Artcraft 245 Ronald Moore Fine Art ArtFrame Galleries 100 Conservation 257 ROOM 63 Artisan 233 Royal Jelly Factory 260, 290 Artists & Makers Festival Rupert Harris Conservation artists @ redlees 292 Artists and Restorers Sandford Gallery 138 (A&R) Studios 292 scotlandart.com 86, 216 Seven Seven Contemporary Artizana 74 Arts & Disability Forum Sheeran Lock Ltd 260 422 Shoreline Studio 86 Arts and Crafts in Simon Beaugié Picture Architecture Awards 390 Frames Ltd 267 Arts Council England 358, Simon Gillespie Studio 257 Arts Council of Northern Six Chapel Row Ireland 423 Contemporary Art 98 Snowgoose 260 Artselect Ireland 127 SPACE 299 Artstat 233 Artstore at the Artschool Stone Gallery 138 Studio Glass Gallery 67 Ltd 236 Swan Gallery 111 ArtSway 174 Artwrap Ltd 236 T.B. & R. Jordan Lapada 73 Astley House Taylor-Pick Fine Art 127 Contemporary 100 The Cynthia Corbett Gallery Atishoo Designs 100 474 Aune Head Arts 440 thecentralhouse 260 Valentine Walsh 258 Axis **214, 441** Bankfield Museum **192** Wall Candi Ltd 285 Barn Galleries 89 Wendy J. Levy The Beacon 162 Contemporary Art 79 Belford Craft Gallery 70 West Wales Arts Centre 117 Berkhamsted Arts & Crafts Wetpaint Gallery 260 Workplace Art Consultancy Big Blue Sky 21 Bircham Gallery 21 Birmingham Museum and **CRAFTS** Art Gallery 190 20-21 Visual Arts Centre Biscuit Factory 70 Aberystwyth Arts Centre Biskit Tin 245 Black Swan Arts 101 187 Blackwell Arts & Crafts absolutearts.com and World Wide Arts House 162 Resources Corp. 213 The Bleddfa Centre 187 Blue Gallery 241 ACE Award for Art in a Blue Lias Gallery 101 Religious Context 388 ACE/MERCERS Bluemoon Gallery 90 International Book Blueprint 475 Award 388 Bolton Museum, Art Alec Tiranti Ltd 237 Gallery and Aquarium Annetts (Horsham) Ltd 237 Bonhoga Gallery 442 Apollo Magazine 473 The Bottle Kiln 26 Art & Craft Emporium / Silkes One Stop Brackendale Arts 238 Brewhouse Gallery 147 Stationery 246 Bridge Gallery 128 Art Centre and Gallery (Bedford) 237 Bristol Guild 102 Art Centre and Tamar Broad Canvas 238 Brunei Gallery 150 Valley Gallery 241 Art Connections 438 Buckenham Galleries 21 Art for All 237 Burton Art Gallery and Museum 182 The Art House 233, 438

Bury St Edmunds Art Gallery 144 Calder Graphics 145 Cambridge Open Studios 443 Canvas 129 Carlow Public Art Collection 197 Cass Art 228 Castle Gallery 117 Cat's Moustache Gallery 82 Celf Caerleon Arts Festival 378 Centagraph 245 Ceres Crafts Ltd 241 Chagford Galleries 91 Chapel Gallery 102, 163 Chapel of Art - Capel Celfyddyd 114 Charleston Farmhouse and Gallery 175 Chelsea Arts Club 443 Cheltenham Art Gallery & Museum 182 Children's Scrapstore 241 Chinese Arts Centre 163 Chocolate Factory Artists Studios 294 Chromos (Tunbridge Wells) Ltd 238 Church House Designs 102 Circa Art Magazine 476 Clevedon Craft Centre 294 Collect 379 Collins Gallery 170 Common Ground 426 Conservation Register 209 Contemporary Applied Arts 38 Contemporary Glass Society 444 Cooper Gallery 193 Courtyard Arts Limited 130 Coventry University 330, Cowdy Gallery 103 Craft Central 294, 444 Crafts Council Development Award 395 Crafts Council Next Move Scheme 395 Crafts Council 426, 444 Crafts Magazine 477 Crafts Study Centre 176 Craftsmen's Gallery 91 Creative Crafts 238 Creative Shop Ltd 233 Creative Skills 426 Creative World 238 Creativity 242 Cregal Art 246, 264 Crown Studio Gallery 71 Daintree Paper 246 Daisy Designs (Crafts) Ltd 234 Daniel Laurence Home & Garden 91 De Montfort University 308, 340 Dean Clough Galleries 193 Delamore Arts 104

Design and Artists Copyright Society (DACS) 445 Devon Guild of Craftsmen 446 Dick Institute 170 Djanogly Art Gallery 147 Dominoes of Leicester Ltd Doncaster College 333, 355 Draíocht Arts Centre 198 Dun Laoghaire Institute of Art, Design & Technology 336 **Dunamaise Arts Centre** Dunstable College 306, Earagail Arts Festival 380 East Neuk Open 380 Eastleigh Museum 176 Economy of Brighton 238 Edwin Allen Arts & Crafts Elliott Gallery 104 **Emerging Artists Art** Gallery 215 Expressions 239 Fabrica 447 Falkiner Fine Papers 229 Fife Contemporary Art & Craft (FCAC) 170 fifiefofum 71 Filthy But Gorgeous 118 Fine Art Surrey 215 Fisherton Mill - Galleries Cafe Studios 104 Fly Art & Crafts Company Four Square Fine Arts 92 Francis Iles 92 Fred Aldous Ltd 234 Free Range 381 Frivoli 45 Gallery 2000 76, 266 Gallery Oldham 164 The Gallery (Leek) 119 The Gallery (Masham) 124 Geffrye Museum 153 Gilbert Collection 153 Glass and Art Gallery 72 Glynn Vivian Art Gallery 188 Godalming Art Shop 239 Godfrey & Watt 124 Grosmont Gallery 125 Grosvenor Museum 164 Grundy Art Gallery 165 Guild of Master Craftsman Publications Ltd 288 Guildford House Gallery Harley Gallery 27, 148 Headrow Gallery 125 Healthcraft 236 Helix Arts 427 Herefordshire College of Art & Design 330, 353 Hermitage Rooms at Somerset House 154 Hertfordshire Gallery 23

Hertfordshire Graphics Ltd Hidden Art 212 HMAG (Hastings Museum and Art Gallery) 177 Hove Museum and Art Gallery 177 Howard Gardens Gallery Hull School of Art and Design 333, 355 Ian Dixon GCF Bespoke Framers 266 Icthus Arts & Graphics 234 Impact Arts 427 Inches Carr Trust Craft Bursaries 360 **Ipswich Arts Association** Irish Arts Review 478 Jackson's Art Supplies 230 James Hockey Gallery 177 Jarrold's 225 Jerwood Contemporary Makers Prize 402 Jim Robison and Booth House Gallery and Pottery 125 lim's Mail Order 242 John Moores Contemporary Painting Prize 403 Keane on Ceramics 134 Kelmscott Manor 184 Kettle's Yard 145 King's Lynn Arts Centre 145 Largs Hardware Services & Gallery Eight 266 Leicester City Art Gallery 148 Letchworth Museum and Art Gallery 145 London Graphic Centre 230, 251 London Road Gallery 125 Loughborough University 308, 340 Lowes Court Gallery 77 Lunns of Ringwood 239 MADE Brighton 382 Magpie Gallery 27 The Makers Guild in Wales Makit 243 Manchester Art Gallery 165 Manchester Craft & Design Centre 77 Marchmont Gallery and Picture Framer 85 The Market House 201 Medici Gallery 55 Mid Cornwall Galleries 108 Midwest 452 Millennium Galleries 195 Millers City Art Shop 237 mima - Middlesbrough Institute of Modern Art Mission Gallery 116 Model Arts and Niland Gallery 201

Montana Artists' Refuge Residency Program 404 Montpellier Gallery 119 Mumbles Art & Craft Centre 243 Narrow Space 136 National College of Art and Design 337 National Museum and Gallery, Cardiff 189 Naughton Gallery at Queens 168 Nest 28 New Craftsman 108 North Wales School of Art and Design 328 Northern Lights Gallery 78 Nottingham Artists' Group Oakwood Ceramics 28 Oberon Art Ltd 283 **Open Studios** Northamptonshire 383 Opus Gallery 28 Originality by Jane Marsh O'Sullivans 247 Owen Clark & Co. Ltd 237 Own It 217 Oxford Craft Studio 239 Paddon & Paddon 96 Paperchase Products Ltd 231 Patchings Art Centre 28 Pen and Paper Stationery Co. 243 Penwith Galleries and Penwith Society of Arts Percy House Gallery 78 Perrys Art & Office 231 Picturecraft Gallery Ltd 24 Platform Gallery 78 Potteries Museum and Art Gallery 192 The Potters' Barn 234 Prema 185 Premier Arts & Craft Store Pump House Gallery 156 Pure South 239 Quay Arts 179 Queen Elizabeth Scholarship Trust 407 **Oueens Park Arts Centre** 456 Rachel Gretton Glass 126 RDS Foundation 456 Red House Museum and Art Gallery 186 Revolutionary Arts Group Rivington Gallery 62 Robert Gordon University Robert Phillips Gallery 96 RotoVision 290 Royal College of Art 157, 313 Rugby Art Gallery and Museum 148 Rural Art Company 239

Salar Gallery 109 Saltburn Gallery 72 Samuel Taylors 245 The Scottish Gallery 86 Sculpture Lounge 126 Search Press Ltd 290 Shipley Art Gallery 161 Shire Hall Gallery 192 Shoreline Studio 86 Six Chapel Row Contemporary Art 98 Smart Gallery 126 Smitcraft 240 South Tipperary Arts Centre 203 St John Street Gallery 28 Stationery/Art Ltd 242 Studio Arts - Dodgson Fine Arts Ltd 235 Suffolk Open Studios 462 Swansea Open 411 T.S. Two 240 Tales Press 244 Thoresby Gallery 29 Tindalls the Stationers Ltd 225 Tunbridge Wells Museum and Art Gallery 180 Turnpike Gallery 166 University of Brighton Gallery 180 University of Wales Institute Cardiff 329, 352 **VADS 210** Verandah 99 Vesey Art and Crafts 244 Vision Applied Arts & Crafts 236 Visual Images Group 463 Voluntary Arts Ireland 431 Ward's Arts & Crafts 232 Washington Gallery 116 West Cork Arts Centre 204 West Wales School of the Arts 330, 352 Wheatsheaf Art Shop 232 Widcombe Studios Gallery Winchester Gallery 181 Wrexham Arts Centre 190 York College 335, 356 Zimmer Stewart Gallery 99 CURATING 108 Fine Art 122 Access to Arts 127

108 Fine Art 122
Access to Arts 127
Alma Enterprises 31
AOP Gallery 32
The Art Gym 182
Ashmolean Museum
Publications 286
August Art 34
Bureau 75
Campbell Works 37
Castlefield Gallery 75, 163
Centre for Recent Drawing
— C4RD 364
The Centre of Attention 38
Clapham Art Gallery 38
Cubitt Gallery and Studios

Custom House Studios Ltd The Cynthia Corbett Gallery 39 Dartington College of Arts DegreeArt.com 40, 214 Dickson Russell Art Management 259 ecArtspace 41 EggSpace 76 Elastic Residence 42 The Empire 42 Enfield Arts Partnership The Gallery at Willesden Green 45 Here Shop & Gallery 106 House Gallery 50 HS Projects 259 IBID Projects 50 Impact Art 259 International 3 76 Kangaroo Kourt 107 The Kenny Gallery 134 McNeill Gallery 23 Modern Artists' Gallery 95 Molesworth Gallery 135 Monika Bobinska 56 Pallas Studios 137, 298 Red Gate Gallery & Studios The Residence 61 Royal College of Art 157, Rubicon Gallery 137 Sarah Walker 138 Seven Seven Contemporary Art 64 Sheeran Lock Ltd 260 Standpoint Gallery 66 The Steps Gallery 66 Stone Gallery 138 Studio Voltaire 67, 300 University of Southampton 325, 349 Wallace Brown Studio 268 Waygood Studios and Gallery 73, 300 **DECORATIVE ART see**

APPLIED AND **DECORATIVE ART**

DIGITAL, VIDEO AND **FILM ART** 176 Gallery / The Zabludowicz Collection 20-21 Visual Arts Centre 291 Gallery 29 Aberystwyth Arts Centre 187 absolutearts.com and World Wide Arts Resources Corp. 213 ACE Award for Art in a Religious Context 388 The Agency 30 Alan Cristea Gallery 31

Alma Enterprises 31 Anthony Reynolds Gallery Archipelago Art Gallery and Studio 122 Architectural Association The Art House 438 Art in Perpetuity Trust (APT) 438 ART.e @ the art of change 421 Artes Mundi Prize 389 Artist Eye Space 33 Artists & Makers Festival 377 Arts & Disability Forum 422 Arts Council England 358, Arts Gallery 149 Artsadmin 424 ArtSway 174 Aspex Gallery 175 Axis 214, 441 BCA Gallery 90 Beaconsfield 150 Bearspace 35 Big Blue Sky 21 Bischoff/Weiss 35 Blackheath Gallery 35 Blackpool and the Fylde College 316, 344 Bloomberg SPACE 150 Bradford College 333, 355 Braziers International Artists Workshop 393 Bristol School of Art, Media and Design 326 British Journal of Photography 393, 476 Bureau 75 Bury Art Gallery, Museum and Archives 163 Cafe Gallery Projects London 151 Calvert 22 37 Camberwell College of Arts

Cambridge School of Art, Anglia Ruskin University 306 Camden Arts Centre 151 Campbell Works 37 Canterbury Christchurch University College 322 Castlefield Gallery 75, 163 Cavanacor Gallery 129 Centre for Contemporary Arts (CCA) 169 The Centre of Attention 38 Chapter Gallery 188 CHELSEA space 151 Cheltenham Artists Open Houses 379

Chesterfield College 308, Chinese Arts Centre 163 Clapham Art Gallery 38 Cleveland College of Art & Design 294

Colchester Institute 306, 347, 356 Collective Gallery 83, 169 Collins Gallery 170 Cooper Gallery 193 Cornerhouse 163 Courthouse Arts Centre Coventry University 330, Crawford Municipal Art Gallery 198 Creative Skills 426 Croydon College 311, 341 **Cubitt Gallery and Studios** Customs House 71, 160 Cybersalon 212 The Cynthia Corbett Gallery 39 Danielle Arnaud Contemporary Art 40 De Montfort University 308, 340 DegreeArt.com 40, 214 Delfina Studio Trust 396 Derby Museum and Art Gallery 147 Dewsbury College 333, 355 digital art source 212 Digital Consciousness 209 Djanogly Art Gallery 147 doggerfisher 83 Domino Gallery 7 Douglas Hyde Gallery 198 Draíocht Arts Centre 198 The Drawing Room 40 **Dublin Institute of** Technology, Faculty of Applied Arts 336 Dun Laoghaire Institute of Art, Design & Technology 336 Dunamaise Arts Centre 199 Duncan of Jordanstone College of Art and Design 320 Dunstable College 306, 339 Eagle Gallery Emma Hill Fine Art 41 Earagail Arts Festival 380 East End Academy 397 e-flux 212 Elastic Residence 42 Elephant Trust Award 398 Emily Tsingou Gallery 42 The Empire 42 Enable Artists 446 Fabrica 447 Fairfields Arts Centre 183 Ferens Art Gallery 193 Ffotogallery 188 Filton College 326, 350 Fine Art Surrey 215 Flamin Awards 399 Focal Point Gallery 144 Folly 164 Forma Arts & Media 448 Foundation for Art and Creative Technology (FACT) 164, 212

Four Square Fine Arts 92 Free Range 381 Frith Street Gallery 45 Furtherfield 212 Future Factory 148 Gallery - text+work 477 Gallery at Norwich University College of the Arts 145 The Gallery at Willesden Green 45 Gallery N. von Bartha 46 Gallery Oldham 164 Galway Arts Centre 199 Galway-Mayo Institute of Technology 336 Garter Lane Arts Centre 199 Gilbert Collection 153 Gimpel Fils 47 Global Arts Village 401 Glynn Vivian Art Gallery 188 Goethe-Institut London 153 Golden Thread Gallery 168 Gorey School of Art 336 Green Dragon Museum and Focus Photography Gallery 160 Green On Red Gallery 132 Hatton Gallery 160 Haunch of Venison 48 Helix Arts 427 here nor there 449 Here Shop & Gallery 106 Herefordshire College of Art & Design 330, 353 Hermitage Rooms at Somerset House 154 HMAG (Hastings Museum and Art Gallery) 177 Hotel 49 Hothouse Gallery 49 Houldsworth 50 House Gallery 50 Hull School of Art and Design 333, 355 Impact Arts 427 Imperial War Museum 154 Impressions Gallery 194 Ingleby Gallery 84 Institute of Contemporary Arts (ICA) 154 Institute of International Visual Arts (inIVA) 154, Institute of Technology, Tallaght 337 Institute of Techonology Sligo 337 Inverleith House 171 Iris, International Women's Photographic Research Resource 427 Irish Museum of Modern Art 200 ISIS Arts 427 James Hockey Gallery 177 James Joyce House of the Dead 133 Jerwood Space 51

Kangaroo Kourt 107 The Kenny Gallery 134 Kerlin Gallery 134 Kettle's Yard 145 King's Lynn Arts Centre Learnington Spa Art Gallery and Museum 191 Linenhall Arts Centre 201 Lisson Gallery 52 London College of Communication 311, 342 London South Bank University 312 Londonart.co.uk 215 The Lowry 165 Luna Nera 452 Manchester Metropolitan University 317, 345 Margate Rocks 382 The Market House 201 Matt's Gallery 54 Maureen Paley 54 Media Art Bath 452 Midwest 452 Millais Gallery 178 Mission Gallery 116 Montana Artists' Refuge Residency Program 404 Mothers Tankstation 136 Mount Stuart 172 Museum 52 56 Myles Meehan Gallery 161 National College of Art and Design 337 National Media Museum Naughton Gallery at Queens 168 nettime 212 New Art Gallery, Walsall New College Nottingham 309, 340 Newcastle University 315 North Wales School of Art and Design 328 Northcote Gallery Chelsea Northumbria University 315 Number 15 116 **Open Studios** Northamptonshire 383 Own It 217 Oxford Brookes University 323, 348 Pallas Studios 137, 298 Patrick Davies Contemporary Art 23 Pavilion 289, 454 Peacock Visual Arts 86, 173, Peer 59 Photofusion 59, 156 Photo-London 383 Picture This 429 Plymouth College of Art and Design 326, 350 Prema 185 Project Arts Centre 202 proof 456

Public Art Commissions and Exhibitions (PACE) Pump House Gallery 156 Ouad Derby 148 Quay Arts 179 Queens Park Arts Centre Reigate School of Art, Design and Media (East Surrey College) 323 The Residence 61 Revolutionary Arts Group 456 **Rhizome Commissions** 430 The Richmond American International University in London 312 Riverbank Arts Centre 203 Robert Gordon University Robert Phillips Gallery 96 ROOM 63 Royal College of Art 157, 313 Royal Hibernian Academy Rubicon Gallery 137 Sadie Coles HQ 63 Sarah Walker 138 Sargant Fellowship 410 Sartorial Contemporary Art 63 Scout 63 Seven Seven Contemporary Art 64 Shoreline Studio 86 The Showroom 64 Shrewsbury Museum and Art Gallery 192 Simon Lee Gallery 64 Site Gallery 196 Skopelos Foundation for the Arts 410 Society of Scottish Artists (SSA) 461 Sorcha Dallas 86 South East Essex College 348 South London Gallery 157 South Tipperary Arts Centre 203 Southampton Solent University 323 Space Station Sixty-Five 65 Spitz Gallery 65 St Helens College 318, 345 Standpoint Gallery 66 Star Gallery 98 Start Contemporary Gallery The Steps Gallery 66 Stone Gallery 138 Street Level Photoworks 87 Stroud House Gallery 111 Studio 1.1 66 Studio Voltaire 67, 300 Suffolk Open Studios 462 Swansea Institute 328 Swansea Open 411

Swindon College 327, 351 Talbot Rice Gallery 174 Tate Modern 158 Temple Bar Gallery and Studios 139 Tigh Fill 139 The Toll House Gallery 111 Triskel 204 The Troubadour Gallery 68 Turnpike Gallery 166 Union 60 University College Chester 318 University College Chichester 324 University College Worcester 332 University for the Creative Arts - Maidstone 349 University of Bath 327 University of Brighton Gallery 180 University of Cumbria (formerly Cumbria Institute of the Arts) 319, 346 University of Derby 309 University of Gloucestershire 328, University of Hertfordshire 307, 339 University of Hull 334 University of Lincoln 309 University of Northampton University of Paisley 321 University of Portsmouth 324, 349 University of Salford 319, 346 University of Southampton 325, 349 University of Wales Institute Cardiff 329, 352 University of Wales, Aberystwyth 329 University of Westminster 314 VADS 210 Victoria Miro Gallery 69 Watershed 187 West Cork Arts Centre 204 Westbury Farm Studios 464 Whitechapel Gallery 159 Whitechapel Project Space Widcombe Studios Gallery Winchester Gallery 181 Wingate Rome Scholarship in the Fine Arts 412 Wolverhampton Art Gallery Wordsworth Museum Art Gallery 167 Yorkshire Coast College 335, 356 Zimmer Stewart Gallery 99 Zoo Art Fair 384

Arcadea 421 The Art House (Wakefield) 438 Arts & Disability Forum Arts Council England 358, Arts Council of Northern Ireland 423 Arts Council of Wales 424 Arts Project 440 Audio Arts 475 Disability Cultural Projects Enable Artists 446 The Good Gallery Guide 477 J. Paul Getty Jr. Charitable Trust 427 Lime 428 National Disability Arts Forum (NDAF) 210 Purchase Prize BlindArt Permanent Collection Scottish Arts Council 365, 430 DRAWING 108 Fine Art 122 176 Gallery / The Zabludowicz Collection 149 1871 Fellowship 388 20/21 International Art Fair 376 20-21 Visual Arts Centre 147 Abbot Hall Art Gallery 162 Abbott and Holder Ltd 30 absolutearts.com and World Wide Arts Resources Corp. 213 ACE Award for Art in a Religious Context 388 The Agency 30 Agnew's 30 Ainscough Gallery 74 Alan Kluckow Fine Art 87 Amber Roome Contemporary Art 82 Andipa Gallery 32 Anne Faggionato 32 Anthony Hepworth Fine Art Dealers Ltd 100 Anthony Reynolds Gallery Archipelago Art Gallery and Studio 122 Architectural Association Art First 33 The Art House 233, 438 Art in Action 376 Art in Perpetuity Trust (APT) 438 Art Matters Gallery 113 Art Safari 438 Art Space Gallery (St Ives) 100 artcourses.co.uk 208

DISABILITY ARTS

Artes Mundi Prize 380 Artists & Makers Festival 389 Artists' Network Bedfordshire 439 Artists Residences (Cyprus) 390 Arts Council England -Helen Chadwick Fellowship 391 Arts Council England -Oxford-Melbourne Fellowship 391 Arts Gallery 149 ArtSway 174 Ashmolean Museum 174 August Art 34 Austin/Desmond Fine Art Ltd 34 Axis 214, 441 Barbara Behan Contemporary Art 34 Barn Gallery 128 Barry Keene Gallery 90 Battersea Contemporary Art Fair 378 The Beacon 150 Beaux Arts 35, 101 Bell Gallery 79 Bianco Nero Gallery 122 Big Blue Sky 21 The Big Draw 378 Birmingham Museum and Art Gallery 190 Birties of Worcester 117 Blackheath Gallery 35 Blue Lias Gallery 101 Bold Art Gallery 128 Bolton MuseumArt Gallery and Aquarium 162 Boundary Gallery - Agi Katz Fine Art 36 Brick Lane Gallery 36 Bridge Gallery 128 Brighton Art Fair 378 British Museum 150 Broughton House Gallery Brunei Gallery 150 Buckenham Galleries 21 Bureau 75 Bury St Edmunds Art Gallery 144 Buy Art Fair 378 Cafe Gallery Projects London 151 Cambridge Open Studios Camden Arts Centre 151 Candid Arts Trust 443 Canvas 129 Castle Gallery 82, 117 Castlefield Gallery 75, 163 Cavanacor Gallery 129 Celeste Prize 394 Celf 114 Centre for Contemporary Arts (CCA) 169 Centre for Recent Drawing C4RD 38 The Centre of Attention 38 Chapel Gallery 102, 163 Charleston Farmhouse and Gallery 175 CHELSEA space 151 Cheltenham Art Gallery & Museum 182 Cheltenham Artists Open Houses 379 Chichester Gallery 91 Christ Church Picture Gallery 175 Colin Iellicoe Gallery 75 Collective Gallery 83, 169 Collins Gallery 170 Context Gallery 79 Coombe Gallery 102 Cooper Gallery 193 Cornerhouse 163 Courtauld Institute of Art Gallery 151 Courthouse GalleryBallinglen Arts Foundation 129 Courtyard Arts Limited 130 Craftsmen's Gallery 91 Cranbrook Gallery 91 Custom House Art Gallery and Studios 83 Customs House 71, 160 CY Gallery 130 The Cynthia Corbett Gallery 39 Daffodil Gallery 130 Dalkey Arts 130 Danielle Arnaud contemporary art 40 The David Gluck Memorial Bursary 396 DegreeArt.com 40, 214 Delamore Arts 104 Design and Artists Copyright Society (DACS) 445 Djanogly Art Gallery 147 Dominic Guerrini Fine Art Domino Gallery 75 Draíocht Arts Centre 198 The Drawing Room 40 Dublin City Gallery, The Hugh Lane 198 **Dunamaise Arts Centre** Duncan Campbell 41 Dyehouse Gallery 130 Earagail Arts Festival 380 East End Academy 397 East West Gallery 41 ecArtspace 41 Elastic Residence 42 Elephant Trust Award 398 Elizabeth Greenshields Foundation Grants 398 Elliott Gallery 104 The Empire 42 Enable Artists 446 Federation of British Artists (FBA) 426, 447 Fenton Gallery 131 fifiefofum 71

Fine Art Commissions Ltd Fine Art Society Plc 44 Fine Art Surrey 215 Fisherton Mill - Galleries Cafe Studios 104 Flowers East 44 Forge Gallery 124 Fosterart 44 Four Square Fine Arts 92 Fourwalls 92 Framework Gallery 265 Free Range 381 Friends of the Royal Scottish Academy Artist Bursary 400 Frivoli 45 Gainsborough's House Gallagher & Turner 72 The Gallery - text+work 183 Gallery 75 131 The Gallery at Willesden Green 45 Gallery Oldham 164 The Gallery (Dunfanaghy) Galway Arts Centre 199 Garter Lane Arts Centre Gilbert Collection 153 Glynn Vivian Art Gallery 188 Graves Art Gallery 193 Green On Red Gallery 132 Greenacres 132 Greenlane Gallery 132 Greenwich Mural Workshop 448 Grosvenor Museum 164 Guild of Aviation Artists Guildford House Gallery Guildhall Art Gallery 153 Harewood House 193 Haunch of Venison 48 Hazlitt Holland-Hibbert 48 Heathfield Art 93 Henry Boxer Gallery 48 The Hepworth Wakefield The Herbert 190 Here Shop & Gallery 106 Hermitage Rooms at Somerset House 154 Hertfordshire Gallery 23 Hesketh Hubbard Art Society 449 Hicks Gallery 48 Hillsboro Fine Art 133 Hind Street Gallery and Frame Makers 106 HMAG (Hastings Museum and Art Gallery) 177 Honor Oak Gallery Ltd 49 Hotel 49 Houldsworth 50 Howth Harbour Gallery 133 ICAS - Vilas Fine Art 23 Imperial War Museum 154

ING Discerning Eve Exhibition 401 Irish Museum of Modern Art 200 James Hyman Gallery 51 lames loyce House of the Dead 133 lerwood Drawing Prize 402 lerwood Space 51 lewish Museum 154 Iill George Gallery 51 John Davies Gallery 106 The Kenny Gallery 134 Kerlin Gallery 134 Kettle's Yard 145 Kettle's Yard Open / Residency Opportunities Kilvert Gallery 114 King's Lynn Arts Centre 145 Kings Road Galleries 52 Kinsale Art Gallery 134 Kooywood Gallery 115 La Gallerie 134 Laing Art Gallery 161 Lander Gallery 107 The Lighthouse 172, 184 Limerick City Gallery 200 Limerick Printmakers Studio and Gallery 135, Linenhall Arts Centre 201 Londonart.co.uk 215 The Lowry 165 Manchester Academy of Fine Arts Open 404 manorhaus 115 Margate Rocks 382 The Market House 201 Marlborough Fine Art 54 Martin Tinney Gallery 115 Maureen Paley 54 McNeill Gallery 23 Mid Cornwall Galleries 108 Midwest 452 Millais Gallery 178 Millinery Works Gallery 55 Milton Keynes Gallery 178 Model Arts and Niland Gallery 201 Modern Artists' Gallery 95 Molesworth Gallery 135 Monika Bobinska 56 Montana Artists' Refuge Residency Program 404 Mothers Tankstation 136 Moya Bucknall Fine Art 119 Museum 52 56 Narrow Space 136 National Gallery Of Scotland 172 National Monuments Record Centre 184, 368 National Society of Painters, Sculptors & Printmakers 453 New Art Gallery, Walsall New Craftsman 108 New English Art Club 454 The New Gallery 108

New Realms Limited 57 Newby Hall and Gardens Nicholas Bowlby 95 Norman Villa Gallery 136 Northcote Gallery Chelsea **Open Studios** Northamptonshire 383 Opus Gallery 28 The Origin Gallery 137 Own It 217 Oxmarket Centre of Arts 95 Paisley Art Institute Annual **Exhibition Prizes and Biennial Scottish Drawing Competition** 406 Pallant House Gallery 178 Pallas Studios 137, 298 Patchings Art Centre 28 Paul Kane Gallery 137 Peer 59 People's Gallery 137 People's Art Hall 137 Peterborough Art House Ltd 24 Phoenix Arts Association 299, 455 Piano Nobile Fine Paintings Ltd 59 Picturecraft Gallery Ltd 24 Plymouth City Museums and Art Gallery 185 Prema 185 Pump House Gallery 156 Pybus Fine Arts 126 Queens Park Arts Centre The Residence 61 Revolutionary Arts Group 456 Ritter/Zamet 62 Riverbank Arts Centre 203 Rivington Gallery 62 Robert Phillips Gallery 96 Roche Gallery 97 Rostra & Rooksmoor Galleries 109 Royal College of Art 157, 313 Royal Hibernian Academy Royal Institute of British Architects (RIBA) Gallery Royal Society of Marine Artists 459 Royal Society of Miniature Painters, Sculptors and Gravers 459 Royal West of England Academy (RWA) 186 Rubicon Gallery 137 Safehouse 169 Saffron Walden Museum 146 Sainsbury Scholarship in Painting and Sculpture Saltburn Gallery 72 Sarah Walker 138

Sartorial Contemporary Art Scarborough Art Gallery 196 School House Gallery 24 School of Art Gallery and Museum 189 The Scottish Gallery 86 Scottish National Portrait Gallery 173 Seven Seven Contemporary Art 64 The Sheen Gallery 64 Shire Hall Gallery 192 Shoreline Studio 86 Shrewsbury Museum and Art Gallery 192 Simon Lee Gallery 64 Siopa Cill Rialaig Gallery 138 Six Chapel Row Contemporary Art 98 Skopelos Foundation for the Arts 410 The Society of Graphic Fine Art 460 Society of Scottish Artists (SSA) 461 Society of Women Artists 461 Solomon Gallery 138 Sorcha Dallas 86 Space Station Sixty-Five 65 St Ives Society of Artists Gallery 110, 186 Stanley Spencer Gallery Start Contemporary Gallery Stone Gallery 138 Stroud House Gallery 111 Studio 1.1 66 Suffolk Art Society 461 Suffolk Open Studios 462 Summer Exhibition - Royal Academy of Arts 411 Sundridge Gallery 98 Swansea Open 411 Talbot Rice Gallery 174 Taylor Galleries 98 Taylor-Pick Fine Art 127 Tib Lane Gallery 78 The Troubadour Gallery 68 Turner Gallery 112 Turnpike Gallery 166 **UK Coloured Pencil Society** 462 Union 69 University College London (UCL) Art Collections University of Brighton Gallery 180 V&A Illustration Awards 412 Visual Arts Scotland (VAS) Waddesdon Manor 181 Waygood Studios and Gallery 73, 300 Wendy J. Levy Contemporary Art 79

West Cork Arts Centre 204 West Wales Arts Centre 117 Whitworth Art Gallery 167, Widcombe Studios Gallery Wildwood Gallery 25 William Frank Gallery 139 Wolseley Fine Arts Ltd 121 Wolverhampton Art Gallery Woodbine Contemporary Arts 29 Wordsworth Museum Art Gallery 167 Wrexham Arts Centre 190 Zimmer Stewart Gallery 99 Zoo Art Fair 384 **FAIRS AND FESTIVALS see** ART FAIRS AND **FESTIVALS** FIGURATIVE ART 108 Fine Art 122 176 Gallery / The Zabludowicz Collection 20-21 Visual Arts Centre 147 Abbot Hall Art Gallery 162 Abbott and Holder Ltd 30 absolutearts.com and World Wide Arts Resources Corp. 213 ACE Award for Art in a Religious Context 388 ACE/MERCERS International Book Award 388 Adonis Art 30 The Afton Gallery 87 Ainscough Gallery 74 Alan Kluckow Fine Art 87 Albemarle Gallery 31 Alexander-Morgan Gallery Amber Roome Contemporary Art 82 Andipa Gallery 32 Anthony Reynolds Gallery Apollo Gallery 127 Archipelago Art Gallery and Studio 122 The Art Academy 310 The Art House 211 Art Matters Gallery 113 Art Space Gallery (St Ives) Artist of the Year by the Society for All Artists (SAA) 389 Artists' Network Bedfordshire 439 Arts and Crafts in Architecture Awards 390 Arts Gallery 149 Artwork Sculpture Gallery

89

Austin/Desmond Fine Art Ltd 34 Axis 214, 441 Bankside Gallery 149, 441 The Barker Gallery 89 Barn Gallery 128 Beaux Arts 35, 101 Bell Fine Art Ltd 90 Benny Browne & Co. Ltd 74 Bianco Nero Gallery 122 Bircham Gallery 21 Birties of Worcester 117 Black Mountain Gallery Blackheath Gallery 35 Bloxham Galleries 36 Blue Leaf Gallery 128 Bold Art Gallery 128 The Bottle Kiln 26 Boundary Gallery - Agi Katz Fine Art 36 Bourne Fine Art 82 Braithwaite Gallery 123 Bridge Gallery 128 Bristol's City Museum and Art Gallery 182 Broadway Modern 117 Broughton House Gallery Brunei Gallery 150 Buckenham Galleries 21 Bury Art Gallery, Museum and Archives 163 Byard Art 22 Cafe Gallery Projects London 151 Calvert 22 37 Cambridge Open Studios Cavanacor Gallery 129 Centre for Contemporary Arts (CCA) 169 The Centre of Attention 38 Chapel Gallery 163, 102 Charleston Farmhouse and Gallery 175 Cheltenham Art Gallery & Museum 182 Chichester Gallery 91 Chinese Arts Centre 163 Clapham Art Gallery 38 Clarion Contemporary Art Clark Galleries 26 Clifton Gallery 102 Colin Jellicoe Gallery 75 Collective Gallery 83, 169 Collins & Hastie Ltd 38 Collins Gallery 170 Context Gallery 79 Coombe Gallery 102 Cooper Gallery 193 Courthouse Gallery, Ballinglen Arts Foundation 129 Courtyard Arts Limited 130 Coventry University 330, Cranbrook Gallery 91 Crown Studio Gallery 71 Cube Gallery 103

Cupola Contemporary Art Ltd 123 Dalkey Arts 130 The Darryl Nantais Gallery DegreeArt.com 40, 214 Delamore Arts 104 Design and Artists Copyright Society (DACS) 445 Djanogly Art Gallery 147 Dolphin House Gallery 104 Domino Gallery 75 dot-art 76 **Dunamaise Arts Centre** 199 Duncan Campbell 41 Dunstable College 306, 339 Eagle Gallery Emma Hill Fine Art 41 East West Gallery 41 Edinburgh Printmakers 84 Elephant Trust Award 398 Eleven 42 Elizabeth Greenshields Foundation Grants 398 Elliott Gallery 104 Emer Gallery 80 **Emerging Artists Art** Gallery 215 Enable Artists 446 Estorick Collection of Modern Italian Art 152 Fairfax Gallery 43 Fairfields Arts Centre 183 FarmiloFiumano 43 Ferens Art Gallery 193 fifiefofum 71 Figurative Artist Network (FAN) 447 Fine Art Commissions Ltd Fine Art Society Plc 44 Fine Art Surrey 215 Flowers East 44 Forge Gallery 124 Fosterart 44 Four Square Fine Arts 92 Fourwalls 92 Francis Iles 92 Frink School of Figurative Sculpture 316 Frivoli 45 Gallagher & Turner 72 The Gallery - text+work 183 The Gallery at Willesden Green 45
Gallery Kaleidoscope 46 Gallery Oldham 164 The Gallery (Dunfanaghy) The Gallery (Masham) 124 Garter Lane Arts Centre Geffrye Museum 153 George Street Gallery 92 Gilbert Collection 153 Gillian Jason Modern & Contemporary Art 46 Goldfish Contemporary Fine Art 105

Gorry Gallery Ltd 132 Londonart.co.uk 215 Green Door Studio 132 Long & Ryle 53 The Lowry 165 Greenacres 132 Lucy B. Campbell Fine Art Greenlane Gallery 132 Grimes House Fine Art 105 53 Magil Fine Art 135 Grosmont Gallery 125 Manchester Academy of Group **75 449** Grundy Art Gallery **165** Fine Arts Open 404 Guildhall Art Gallery 153 The Market House 201 Harewood House 193 Martin Tinney Gallery 115 Harley Gallery 27, 148 Martin's Gallery 107 Hazlitt Holland-Hibbert 48 McNeill Gallery 23 Medici Gallery 55 Head Street Gallery 22 Headrow Gallery 125 Mercer Art Gallery 195 Heathfield Art 93 Michael Wood Fine Art 108 Mid Cornwall Galleries 108 The Herbert 190 Midwest 452 Herefordshire College of Art & Design 330, 353 Millinery Works Gallery 55 Hermitage Rooms at Milton Keynes Gallery 178 Modern Artists' Gallery 95 Somerset House 154 Molesworth Gallery 135 Hesketh Hubbard Art Society 449 Montpellier Gallery 119 Narrow Space 136 Hicks Gallery 48 National College of Art and Highgate Fine Art 49 Hillsboro Fine Art 133 Design 337 National Portrait Gallery Hind Street Gallery and Frame Makers 106 Honor Oak Gallery Ltd 49 National Society of Hull School of Art and Painters, Sculptors & Printmakers 453 Design 333, 355 Hunter Gallery 23 Neville Pundole Gallery 95 ICAS - Vilas Fine Art 23 New English Art Club 454 The New Gallery 120 Imperial War Museum 154 Institute of Contemporary New Realms Limited 57 Arts (ICA) 154 Newcastle University 315 **Ipswich Arts Association** Nicholas Bowlby 95 Norman Villa Gallery 136 Irish Museum of Modern North East Worcestershire Art 200 College 331, 353 Island Fine Arts Ltd 93 North Wales School of Art James Hyman Gallery 51 and Design 328 Northcote Gallery Chelsea James Joyce House of the Dead 133 The Jerdan Gallery 85 Northern Lights Gallery 78 Jill George Gallery 51 Number Nine the Gallery Joan Clancy Gallery 133 120 John Martin Gallery 51 Offer Waterman & Co. 57 John Noott Galleries 119 Oisin Art Gallery 136 On-lineGallery 216 Iones Art Gallery 133 Jorgensen Fine Art 133 Open Eye Gallery and i2 Gallery 85 Kelvingrove Art Gallery and Opus Gallery 28 Museum 171 The Kenny Gallery 134 The Origin Gallery 137 Kentmere House Gallery Original Print Gallery 137 125 Paddon & Paddon 96 Kettle's Yard 145 Pallant House Gallery 178 Patchings Art Centre 28 Killarney Art Gallery 134 Kilvert Gallery 114 Patrick Davies King's Lynn Arts Centre 145 Contemporary Art 23 Kings Road Galleries 52 Paul Kane Gallery 137 Kooywood Gallery 115 Peer 59 Penlee House Gallery and Lander Gallery 107 Laneside Gallery 80 Museum 185 Leinster Gallery 135 Peterborough Art House Lena Boyle Fine Art 52 Ltd 24 Limerick Printmakers Piano Nobile Fine Studio and Gallery 135, Paintings Ltd 59 Picturecraft Gallery Ltd 24 Linenhall Arts Centre 201 Prema 185 Llewellyn Alexander (Fine **Oueens Park Arts Centre**

Paintings) Ltd 53

456

Rainyday Gallery 109 Red Rag Gallery 109 The Residence 61 Revolutionary Arts Group 456 Rona Gallery 62 Room for Art Gallery 97 Royal British Society of Sculptors 408, 457 Royal Hibernian Academy 457 Royal Society of British Artists (RBA) 458 Royal Society of Miniature Painters, Sculptors and Gravers 459 Royal West of England Academy (RWA) 186 Royall Fine Art 97 Sadler Street Gallery 109 Saltburn Gallery 72 Sandford Gallery 138 Sarah Walker 138 School House Gallery 24 School of Art Gallery and Museum 189 The Scottish Gallery 86 Sesame Gallery 64 Seven Seven Contemporary Art 64 The Sheen Gallery 64 Shoreline Studio 86 Simon Lee Gallery 64 Siopa Cill Rialaig Gallery 138 Six Chapel Row Contemporary Art 98 Skopelos Foundation for the Arts 410 Skylark Galleries 65 Society for Religious Artists (SFRA) 460 Society of Catholic Artists The Society of Graphic Fine Art 460 Society of Scottish Artists (SSA) 461 Society of Wildlife Artists 461 Society of Women Artists 461 Solomon Gallery 138 Sorcha Dallas 86 South Tipperary Arts Centre 203 Southwold Gallery 24 St Ives Society of Artists Gallery 110, 186 St John Street Gallery 28 Start Contemporary Gallery 98 Stone Gallery 138 Stroud House Gallery 111 Studio Art School 321 Suffolk Art Society 461 Suffolk Open Studios 462 Summer Exhibition - Royal Academy of Arts 411 Swansea Open 411 Swindon College 327, 351

T.B. & R. Jordan Lapada 73 Tate Modern 158 Taylor-Pick Fine Art 127 Thoresby Gallery 29 Tib Lane Gallery 78 Timothy Taylor Gallery 68 Tracey McNee Fine Art 87 Tregony Gallery 111 Turner Gallery 112 Unicorn Gallery 78 Union 69 University College London (UCL) Art Collections 158 University of Bath 327 University of Brighton Gallery 180 University of Hertfordshire 307, 339 University of Southampton 325, 349 University of Wales Institute Cardiff 329, University of Wales, Aberystwyth 329 Urban Retreat 98 V&A Illustration Awards Visual Arts Scotland (VAS) Vitreous Contemporary Art Wallace Collection 158 The Warwick Gallery 121 Washington Gallery 116 Waterford Institute of Technology 338 Waytemore Art Gallery 25 Wenlock Fine Art 121 West Wales Arts Centre 117 West Wales School of the Arts 330, 352 Westgate Gallery 87 WhiteImage.com 81 Whitford Fine Art 70 Widcombe Studios Gallery

Nildwood Gallery 25
Williams & Son 70
Williams & Son 70
Wolseley Fine Arts Ltd 121
The Wonderwall Gallery 112
Woodbine Contemporary
Arts 29
Wrexham Arts Centre 190
Yarm Gallery 73

Zimmer Stewart Gallery 99
FILM see DIGITAL, VIDEO
AND FILM ART

FOUNDERS see ART FOUNDERS AND MANUFACTURERS

FRAMING
A. Bliss 263
Acacia Works 263
The Afton Gallery 87
Alec Drew Picture Frames
Ltd 263

Alexander-Morgan Gallery Anderson Hill 31 Annexe Gallery 79
Anthony Woodd Gallery 82 Archipelago Art Gallery and Studio 122 Art & Craft Emporium / Silkes One Stop Stationery 246 Art & Frame 263 Art and Soul 263 Art Centre and Gallery 237 Art Centre and Tamar Valley Gallery 241 Art for All 237 Art of Framing 263 The Art Shop (Abergavenny) 243 The Art Shop (Darlington) The Art Shop (Wanstead) 227 Art@9489 ArtFrame Galleries 100 Artisan for Unusual Things Artlines 263 artrepublic 89 Artworks 226, 263 Atishoo Designs 100 Atrium Gallery 100 Attic Picture Framing Supplies 263 Barbers 264 Barry Keene Gallery 90 Baumkotter Gallery 35 Bell Fine Art Ltd 90 Bianco Nero Gallery 122 Bird & Davis Ltd - The Artist's Manufactory 227 Biscuit Factory 70 Blackheath Gallery 35 Blue Lias Gallery 101 Bold Art Gallery 128 Boundary Gallery - Agi Katz Fine Art 36 Bourlet Fine Art Frame Makers 264 Bourne Fine Art 82 Bovilles Art Shop 238 Braithwaite Gallery 123 Bridge Gallery 128 Broad Canvas 238 Broadford Books and Gallery 236 Caffrey's Gallery & Framing Studio 264 Campbell's of London 264 Canonbury Arts 228 Carlow Art and Framing Shop 246 Cherry Art Centre 241 Chromos (Tunbridge Wells) Ltd 238 City Art Store 232 Colin Jellicoe Gallery 75 Colliers 71 The Compleat Artist 242 Coombe Gallery 102

Cornwall Galleries 103

Courtenavs Fine Art 103 Cowling & Wilcox Ltd 228 Craftsmen's Gallery 91 Creative Shop Ltd 233 Cregal Art 246, 264 Cristeph Gallery 130 Croft Gallery 103 Croft Wingates 26 Crown Gallery 103 Cupola Contemporary Art Ltd 123 Daler-Rowney Percy Street/ Arch One Picture Framing 228 Dalkey Arts 130 Daniel Laurence Home & Garden 91 Darbyshire Frame Makers 264 The Darryl Nantais Gallery Dealg Design Ltd 264 Details @ Newcastle Arts Centre 232 Digitalab 274 Dolphin House Gallery 104 dot-art 76 Edinburgh Printmakers 84 Edwin Allen Arts & Crafts Egan, Matthews & Rose Emer Gallery 80 England's Gallery 118 Evergreen Gallery 26 Exmouth Gallery 104 Eyecandy 124 Fado 131 Fairgreen Picture Framing 264 Falkiner Fine Papers 229 Fastnet Framing 264 Fielders 229 Fine Art Framing Studio Frame Tec 264 Framemaker (Cork) Ltd Framework Gallery 131, 265 The Framework Gallery 131, Framework Picture Framing 265 Frameworks 265 Framing Fantastic 265 The Framing Workshop Francis Iles 92 Frandsen Fine Art Framers Ltd 265 Frank B. Scragg & Co. 265 Fred Aldous Ltd 234 Fred Keetch Gallery 242 Fringe Arts Picture Framers 265 Friswell's Picture Gallery Ltd 118 Frivoli 45 G.E. Kee 246 Gadsby's / Artshopper 226, 244

Gallagher & Turner 72 Galleria Fine Arts 234 Gallery 2000 76, 266 Gallery 42 124 Gallery 44 131 Gallery 99 **92** Gallery Kaleidoscope **46** Gallery One 80 The Gallery (Leek) 119 Geoghegans Picture Framing Service 266 George Street Gallery 92 Goslings 266 Graham Harrison Framing Ltd 266 Grays of Shenstone 266 Green and Stone of Chelsea 229 Green Gallery Dublin 132 Grimes House Fine Art 105 Harris Fine Art Ltd 229 Headrow Gallery 125 Helios at the Spinney 119 Hills of Newark Ltd 226 Hind Street Gallery and Frame Makers 106 Honor Oak Gallery Ltd 49 Howarth Gallery 76 Hunter Gallery 23 Ian Dixon GCF Bespoke Framers 266 ICAS - Vilas Fine Art 23 Ingo Fincke Gallery and Framers 50 Inspires Art Gallery 93 Jackson's Art Supplies 230 John Green Fine Art 85 John Jones Ltd 230 John Noott Galleries 119 John Purcell Paper 230 La Gallerie 134 Laneside Gallery 80 Largs Hardware Services & Gallery Eight 266 Laurence Mathews Art & Craft Store 225 Legge Gallery 135 Legra Gallery 94 Lincoln Joyce Fine Art 94 Linda Blackstone Gallery Litchfield Artists' Centre 242 Little London Gallery 27 Magil Fine Art 135 Manor Fine Arts 80 Manser Fine Art 119 Marchmont Gallery and Picture Framer 85 McNeill Gallery 23 Michael Wood Fine Art Mill House Gallery 77 Montpellier Gallery 119 Mulvany Bros. 136 The New Gallery 108 Northcote Gallery Chelsea Number Nine the Gallery Oberon Art Ltd 283

The Art House 211

Art in Partnership 438

Art in Action 438

Offer Waterman & Co. 57 Old Church Galleries 266 Open Eye Gallery and i2 Gallery 85 Oriel 116 Paint Box 247 Paintworks Ltd 231 Park View Gallery 120 Patchings Art Centre 28 Paul Mitchell Ltd 266 Paul Treadaway 267 Peak Imaging 284 Pendragon Frames 267 Picturecraft Gallery Ltd 24 pictureframes.co.uk 267 The Print Partnership 243 R. Jackson & Sons 235 Rachel Howells 257 Railings Gallery 267 Rebecca's Picture Framing Reeves Art Studio 267 Regency Gallery 24 Renaissance 2 267 Rennie's Arts & Crafts Ltd Riccardo Giaccherini Ltd Riverside Gallery 267 Rostra & Rooksmoor Galleries 109 Royall Fine Art 97 Rural Art Company 239 SamedaySnaps - Mitcham Arts 196 scotlandart.com 86, 216 Sevenoaks Art Shop 240 Shell House Gallery 121 Shoreline Studio 86 Simon Beaugié Picture Frames Ltd 267 Strahan Framing 268 Sundridge Gallery 98 Swan Gallery 111 T.S. Two 240 Talents Fine Arts 127 Taurus Gallery 98 The Teesdale Gallery 73 Terry Harrison Arts Limited 240 Thomas Ellis 268 Thoresby Gallery 29 Tib Lane Gallery 78
Tim's Art Supplies 225 Tindalls the Stationers Ltd Torrance Gallery 87 Tuppers 240 Vereker Picture Framing Vesey Art and Crafts 244 Wallace Brown Studio 268 Ward's Arts & Crafts 232 The Warwick Gallery 121 Westgate Gallery 87 Whitgift Galleries 70 Wildwood Gallery 25 Windsor Gallery 226 Wrights 226 Yarm Gallery 73

York Art & Framing 245

FUNDING BODIES 'A' Foundation 74, 421 Artists' General Benevolent Institution 421 Arts & Business 439 Arts and Humanities Research Council 422 Arts Awards 390 Arts Council England -East England Arts 422 Arts Council England -East Midlands Arts 422 Arts Council England -London Arts 423 Arts Council England -North East Arts 423 Arts Council England -North West Arts 423 Arts Council England -South East Arts 423 Arts Council England -South West Arts 423 Arts Council England -West Midlands Arts 423 Arts Council England -Yorkshire Arts 423 Arts Council England 358, Arts Council of Northern Ireland 423 Arts Council of Wales 424 The Arts Foundation 424 Awards for All 424 The Baring Foundation 424 Beam 441 Bloomberg **425** Calouste Gulbenkian Foundation 425 Commissions East 425 Crafts Council Development Award 395 Creative Skills 426 David Canter Memorial Fund 396 Elephant Trust 426 Elizabeth Foundation for the Arts 398 Elizabeth Greenshields Foundation Grants 398 European Association for Jewish Culture Grants European Associaton for lewish Culture 426 Franklin Furnace Fund for Performance Art and Franklin Furnace Future of the Present 399 Friends of Israel **Educational Foundation** Friends of the Royal Scottish Academy Artist Bursary 400 Gen Foundation 400 The Getty Foundation 400 **Gunk Foundation Grants** for Public Arts Projects Henry Moore Foundation 356, 427

J. Paul Getty Jr. Charitable Trust 427 lames Milne Memorial Trust 402 Jerwood Charitable Foundation 402 Leverhulme Trust Grants and Awards 403 Lime 428 Midwest 452 National Endowment for Science, Technology and the Arts (NESTA) 405, Nigel Moores Family Charitable Trust 429 Paul Hamlyn Foundation Awards For Artists 406 Peter Moores Foundation 429 Pollock-Krasner Foundation 407 Prince's Trust 429 **Public Art Commissions** and Exhibitions (PACE) Queen Elizabeth Scholarship Trust 407 Royal Scottish Academy Alastair Salvesen Art Scholarship 408 Royal West of England Academy (RWA) Student Bursaries 408 Ruth Davidson Memorial Scholarship 409 Scottish Arts Council 365, St Hugh's Fellowship 411 Stanley Picker Fellowships Wales Arts International 463 Wellcome Trust Arts Awards 431 Wingate Rome Scholarship in the Fine Arts 412 Winston Churchill Memorial Trust 431 Women's Studio Workshop Fellowship Grants 413 Woo Charitable Foundation 432 **GLASS ART** A&C Black Publishing 285 absolutearts.com and World Wide Arts Resources Corp. 231 Access to Arts 127 ACE Award for Art in a Religious Context 388

Alexander-Morgan Gallery

Art Centre and Gallery 240

Ann Jarman 21 Arna Farrington Gallery 21

Art Centre 226

Ipswich Arts Association

The Art Shop (Abergavenny) 243 artcourses.co.uk 208 artists @ redlees 292 Artists' Network Bedfordshire 439 Artizana 74 Arts & Disability Forum Arts and Crafts in Architecture Awards 390 Arts Gallery 149 Artselect Ireland 127 Artstore at the Artschool Ltd 236 Atishoo Designs 100 Axis 214, 441 Barn Galleries 89 Barrett Marsden Gallery 34 Belford Craft Gallery 70 Bell Fine Art Ltd 90 Bianco Nero Gallery 122 Big Blue Sky 21 Bircham Gallery 21 Bircham Gallery Shop 248 Biscuit Factory 70 Bishop Grosseteste University College Lincoln 307 Black Cat Gallery 128 Black Swan Arts 101 Blackheath Gallery 35 Blackwell Arts & Crafts House 162 Blue Dot Gallery 101 Blue Lias Gallery 101 Bluecoat Display Centre Blyth Gallery 74 Bohemia Galleries 123 Bolton Museum, Art Gallery and Aquarium Bridge Gallery 128 British Glass Biennale 393 British Society of Master Glass Painters 442 Broadway Modern 117 Buckenham Galleries 21 **Buckinghamshire** New University 322, 347 Burrell Collection 169 Bury Art Gallery, Museum and Archives 163 Buy Art Fair 378 Cambridge Open Studios Capsule 113 Cat's Moustache Gallery 82 Central St Martins College of Art & Design 310, 341 Chagford Galleries 91 Chapel Gallery 163 Charleston Farmhouse and Gallery 175 Choyce Gallery 22 Church House Designs 102

Cleveland College of Art & Design 343 Collect 379 Collins Gallery 170 Conservation Register 209 Contemporary Applied Arts Contemporary Glass Society 444 Coombe Gallery 102 Cooper Gallery 193 Cosa Gallery 39 Courtyard Arts Limited 130 Coventry University 330, Cowdy Gallery 103 Crawford Municipal Art Gallery 198 Creative Skills 426 Cupola Contemporary Art Ltd 123 Customs House 71, 160 The Cynthia Corbett Gallery Dalkey Arts 130 Delamore Arts 104 Design and Artists Copyright Society (DACS) 445 Domino Gallery 75 Dudley College of Technology 330, 353 East Neuk Open 380 Ellen L. Breheny 255 Elliott Gallery 104 **Emerging Artists Art** Gallery 215 Fenwick Gallery 71 fifiefofum 71 Filton College 326, 350 Fisherton Mill - Galleries Cafe Studios 104 Fred Aldous Ltd 234 Frivoli 45 The Gallery - text+work 183 Gallery 52 26 Gallery Beckenham 92 Gallery Top 26 Gilbert Collection 153 Glass and Art Gallery 72 Godfrey & Watt 124 Grosmont Gallery 125 Guild of Aviation Artists 449 Guild of Glass Engravers 449 Guildford House Gallery 176 Harleston Gallery 22 Harley Gallery 27, 148 Head Street Gallery 22 Headrow Gallery 125 Helios at the Spinney 119 Helix Arts 427 Herefordshire College of Art & Design 330, 353 Hermitage Rooms at Somerset House 154 Hertfordshire Gallery 23 Hertfordshire Graphics Ltd 225

Framers 266 ICAS - Vilas Fine Art 23 Impact Arts 427 Inspires Art Gallery 93 International Ceramics Fair and Seminar 381 The Jerdan Gallery 85 Jerwood Contemporary Makers Prize 402 Jim Robison and Booth House Gallery and Pottery 125 The Kenny Gallery 134 Kent Potters' Gallery 94 Kettle's Yard 145 King's Lynn Arts Centre 145 Letchworth Museum and Art Gallery 145 Linda Blackstone Gallery Linenhall Arts Centre 201 London Road Gallery 125 Lowes Court Gallery 77 MADE Brighton 382 Magil Fine Art 135 Magpie Gallery 27 The Makers Guild in Wales Marchmont Gallery and Picture Framer 85 Michael Wood Fine Art 108 Mid Cornwall Galleries 108 Midwest 452 Modern Artists' Gallery 95 Montpellier Gallery 119 Moya Bucknall Fine Art 119 National War Museum 172 Neville Pundole Gallery 95 New Craftsman 108 North Wales School of Art and Design 331, 354 Northcote Gallery Chelsea Northern Lights Gallery 78 Number Nine the Gallery Oberon Art Ltd 283 Open Eye Gallery and i2 Gallery 85 Open Studios Northamptonshire 383 Opus Gallery 28 Organised Gallery 108 The Origin Gallery 137 Owen Clark & Co. Ltd 231 Own It 217 Paddon & Paddon 96 Pallas Studios 137, 298 Paperchase Products Ltd Patchings Art Centre 28 Paul Treadaway 267 Platform Gallery 78 Prema 185

Hidden Art 212

Dublin City Gallery, The

Hugh Lane 344 Hull School of Art and

Hunter Gallery 23 Ian Dixon GCF Bespoke

Design 333, 355

Public Art Commissions and Exhibitions (PACE) Queens Park Arts Centre 456 Rachel Gretton Glass 126 Red Gate Gallery & Studios Riverbank Arts Centre 203 Robert Phillips Gallery 96 Royal British Society of Sculptors 408, 457 Royal College of Art 157, 313 Royall Fine Art 97 Saffron Walden Museum Saltgrass Gallery 97 Sarah Walker 138 The Scottish Gallery 86 Shipley Art Gallery 161 Shoreline Studio 86 Siopa Cill Rialaig Gallery 138 Six Chapel Row Contemporary Art 98 Skylark Galleries 65 Society of Scottish Artists (SSA) 461 Storm Fine Arts 25 Stroud House Gallery 111 Studio Glass Gallery 67 Suffolk Open Studios 462 Susan Megson Gallery 111 Talents Fine Arts 127 Taylor-Pick Fine Art 127 Thoresby Gallery 29 Tracey McNee Fine Art 87 Treeline Gallery 29 The Troubadour Gallery University of Bath 327 University of Brighton Gallery 180 Urban Retreat 98 Verandah 99 Visual Arts Scotland (VAS) The Warwick Gallery 121 Westgate Gallery 87 Wolverhampton Art Gallery The Wonderwall Gallery 112 Workplace Art Consultancy Yarm Gallery 73 York College 335, 356 Zimmer Stewart Gallery 99 ILLUSTRATION 20/21 British Art Fair 376 20/21 International Art Fair 376 Abbott and Holder Ltd 30 absolutearts.com and World Wide Arts Resources Corp. 213 ACE/MERCERS International Book Award 388 Andrew Coningsby Gallery

Archipelago Art Gallery and Studio 122 Architectural Association The Art House 233, 438 Art in Action 376, 88 Art Matters Gallery 113 Artists & Illustrators 474 Artists & Makers Festival Arts Gallery 149 Artselect Ireland 127 Association of Illustrators 440 Axis 214, 441 The Beacon 162 Big Blue Sky 21 Blue Lias Gallery 101 Blueprint 475 Bradford College 333, 355 Bridge Gallery 128 Brighton Art Fair 378 Brighton University 322 Bristol School of Art, Media and Design 326 Brunei Gallery 150 **Buckinghamshire** New University 322, 347 Cambridge Open Studios Cambridge School of Art, Anglia Ruskin University 306 Centre for Contemporary Arts (CCA) 169 The Centre of Attention 38 Charleston Farmhouse and Gallery 175 Cheltenham Art Gallery & Museum 182 Cheltenham Artists Open Houses 379 Chesterfield College 308, Circa Art Magazine 476 Cleveland College of Art & Design 294 Cooper Gallery 193 Courthouse Gallery, **Ballinglen Arts** Foundation 129 Courtyard Arts Limited Coventry University 330, Custom House Art Gallery and Studios 83 Customs House 71, 160 Dazed & Confused Magazine DegreeArt.com 40, 214 Design and Artists Copyright Society (DACS) 445 Domino Gallery 75 Dunstable College 306, Earagail Arts Festival 380 Forge Gallery 124 Fourwalls 92 Free Range 381

Friends of Israel **Educational Foundation** The Gallery - text+work 183 Gilbert Collection 153 Green Door Studio 132 Grundy Art Gallery 165 Guild of Aviation Artists Heathfield Art 93 Henry Boxer Gallery 48 Here Shop & Gallery 106 Herefordshire College of Art & Design 330, 353 Hermitage Rooms at Somerset House 154 Hind Street Gallery and Frame Makers 106 Hull School of Art and Design 333, 355 Illustration Cupboard 50 James Joyce House of the Dead 133 The Kenny Gallery 134 Kettle's Yard Open / **Residency Opportunities** Lander Gallery 107 Loughborough University 308, 340 The Lowry 165 McNeill Gallery 23 Michael Wood Fine Art 108 Middlesex University 312 Midwest 452 Molesworth Gallery 135 Narrow Space 136 New Art Gallery, Walsall Newby Hall and Gardens Nicholas Bowlby 95 North Wales School of Art and Design 328 Northcote Gallery Chelsea **Open Studios** Northamptonshire 383 Opus Gallery 28 Own It 217 Oxford & Cherwell Valley College 323, 348 Paddon & Paddon 96 Paintings and Prints 2 -Artists of the World 216 Patchings Art Centre 28 Picturecraft Gallery Ltd 24 Preview of the Visual Arts in Ireland 480 Queens Park Arts Centre 456 Reigate School of Art, Design and Media (East Surrey College) 323 The Residence 61 Revolutionary Arts Group Royal College of Art 157, 313 Saltburn Gallery 72 School of Art Gallery and Museum 189

Sheffield College, Hillsborough Centre 334, Shoreline Studio 86 Society of Catholic Artists The Society of Graphic Fine Art 460 Society of Women Artists 461 Southampton Solent University 323 St Ives Society of Artists Gallery 110, 186 Start Contemporary Gallery Stroud House Gallery 111 Studio Art School 321 Studioworx Contemporary Art Ltd 216 Suffolk Art Society 461 Suffolk Open Studios 462 Swansea Institute 328 Towneley Hall Art Gallery & Museum 196 The Troubadour Gallery 68 University for the Creative Arts - Maidstone 324, University of Brighton Gallery 180 University of Derby 309 University of Hertfordshire 307, 339 University of Lincoln 309 University of Luton 307 University of Northampton 310, 341 University of Southampton 325, 349 University of Wales, Aberystwyth 329 V&A Illustration Awards 412 Vitreous Contemporary Art Widcombe Studios Gallery Wolseley Fine Arts Ltd 121 Wordsworth Museum Art Gallery 167 York College 335, 356 Zoo Art Fair 384 INSTALLATION ART 176 Gallery / The Zabludowicz Collection 20-21 Visual Arts Centre 147 absolutearts.com and World Wide Arts Resources Corp. 213 The Agency 30 Anthony Reynolds Gallery Architectural Association 149 The Art House 233 Art in Perpetuity Trust (APT) 438

Artes Mundi Prize 389 Artist Eve Space 33 Artists & Makers Festival 377 Arts & Disability Forum 422 Arts and Crafts in Architecture Awards 390 Arts Gallery 149 Artsadmin 424 Artselect Ireland 127 ArtSway 174 Aspex Gallery 175 August Art 34 Axis 214, 441 Balmoral Scholarship for Fine Arts 392 Barbara Behan Contemporary Art 34 Beaconsfield 150 Bischoff/Weiss 35 Black Swan Arts 101 Bloomberg SPACE 150 Braziers International Artists Workshop 393 Brewhouse Gallery 147 Brick Lane Gallery 36 Brunei Gallery 150 Bureau **75** Bury St Edmunds Art Gallery 144 Cafe Gallery Projects London 151 Calvert 22 37 Camden Arts Centre 151 Campbell Works 37 Castlefield Gallery 75, 163 Centre for Contemporary Arts (CCA) 169 The Centre of Attention 38 Chapel Gallery 102, 163 Chapter Gallery 188 CHELSEA space 151 Cheltenham Artists Open Houses 379 Chinese Arts Centre 163 Collective Gallery 83, 169 Collins Gallery 170 Context Gallery 79 Cooper Gallery 193 Cornerhouse 163 Courthouse Arts Centre Creative Skills 426 **Cubitt Gallery and Studios** Customs House 71, 160 The Cynthia Corbett Gallery 39 Daniel Laurence Home & Garden 91 Danielle Arnaud Contemporary Art 40 DegreeArt.com 40, 214 Delfina Studio Trust 396 Design and Artists Copyright Society (DACS) 445 Djanogly Art Gallery 147 doggerfisher 83 Douglas Hyde Gallery 198

Draíocht Arts Centre 198 The Drawing Room 40 Dunamaise Arts Centre 199 Eagle Gallery Emma Hill Fine Art 41 Earagail Arts Festival 380 East End Academy 397 ecArtspace 41 EggSpace 76 Elastic Residence 42 Elephant Trust Award 398 Emily Tsingou Gallery 42 The Empire 42 Enable Artists 446 Fabrica 447 Fairfields Arts Centre 183 Fenton Gallery 131 Focal Point Gallery 144 Folkestone Triennial Visitor Centre 381 Forma Arts & Media 448 Foundation for Art and Creative Technology (FACT) 164, 212 Four Square Fine Arts 92 Free Range 381 Future Factory 148 The Gallery - text+work 183 The Gallery at Willesden Green 45 Gallery Oldham 164 Galway Arts Centre 199 Garter Lane Arts Centre 199 Gilbert Collection 153 Gimpel Fils 47 Global Arts Village 401 Glynn Vivian Art Gallery Goethe-Institut London 153 Golden Thread Gallery 168 Green On Red Gallery 132 Grosvenor Gallery (Fine Arts) Ltd 47 Group 75 449 Grundy Art Gallery 165 Hatton Gallery 160 Haunch of Venison 48 Helix Arts 427 Here Shop & Gallery 106 Hermitage Rooms at Somerset House 154 Hillsboro Fine Art 133 HMAG (Hastings Museum and Art Gallery) 177 Hothouse Gallery 49 Houldsworth 50 House Gallery 50 Impact Arts 427 Ingleby Gallery 84 Institute of Contemporary Arts (ICA) 154 Inverleith House 171 **Ipswich Arts Association** Irish Museum of Modern Art 200 James Hyman Gallery 51 James Joyce House of the Dead 133

Rhizome Commissions 430 INTERNET RESOURCES Riverbank Arts Centre 203 24 Hour Museum 208 Robert Phillips Gallery 96 absolutearts.com and Royal British Society of World Wide Arts Sculptors 408, 457 Resources Corp. 213 Royal College of Art 157, 313 a-n The Artists Information Royal Hibernian Academy Company / a-n Magazine 208, 437, 473 Royal West of England **APD 211** Academy (RWA) 186 apob Original Art Galleries Rubicon Gallery 137 Art & Architecture Sadie Coles HQ 63 Saltburn Gallery 72 Thesaurus Online 216 Sarah Walker 138 Art Guide 208 Sargant Fellowship 410 The Art History Blog 211 Sartorial Contemporary Art Art in Context 211 Art in the City 213 Scottish National Gallery of Art Industri 213 Modern Art 173 Art MoCo 208 SE8 Gallery 157 Art Movements 216 Seven Seven Contemporary Art News Blog 208 Art 64 Art on the Net 211 The Showroom 64 artart.co.uk 214 Simon Lee Gallery 64 artcourses.co.uk 208 Skopelos Foundation for Artcyclopedia 216 the Arts 410 artdaily.com 208 Sligo Art Gallery 203 artefact 208 Society of Scottish Artists ArtForums.co.uk 211 (SSA) 461 ArtInfo 216 ArtInLiverpool.com 208 Somerset Art Weeks 384 Sorcha Dallas 86 artist-info: Contemporary South London Gallery 157 Art Database 209 South Tipperary Arts Artistri 214 Artlex Art Dictionary 216 Centre 203 Space Station Sixty-Five 65 Artlistings.com 209 Standpoint Gallery 66 artnet 217 Star Gallery 98 ArtNews.info 211 Start Contemporary Gallery art-online - The Fine Art Directory 122 The Steps Gallery 66 artprice.com 217 Stone Gallery 138 Artquest 211, 258 STORE 66 ArtRabbit 211 artroof.com 214 Stroud House Gallery 111 Studio 1.1 66 Arts Culture Media Jobs Studio Voltaire 67, 300 209 Swansea Open 411 Arts Hub 209 Talbot Rice Gallery 174 Arts Journal 209 Tate Modern 158 Arts Professional Online Temple Bar Gallery and Studios 139 ArtsAccess.org 214 Timothy Taylor Gallery 68 ArtsCurator Ltd 214 Triskel 204 Artshole.co.uk 214 Turnpike Gallery 166 art-shopper 208 Union 69 ArtSouthEast 209 University of Brighton Artupdate.com 209 Gallery 180 Asian Arts Access 211 Wapping Project 159 Axis 214, 441 Washington Gallery 116 Backspace 211 Waygood Studios and britart.com / eyestorm. Gallery 73, 300 com 214 West Cork Arts Centre 204 British Arts 217 Westbury Farm Studios Clikpic 214 464 Conservation Register 209 Whitechapel Gallery 159 Counter 214 Wingate Rome Scholarship Creative Space Agency 217 in the Fine Arts 412 CreativePeople 211 Wolverhampton Art Gallery culturebase.net 217 Cybersalon 212 Yarm Gallery 73 DegreeArt.com 40, 214 Zimmer Stewart Gallery 99 Designspotter 209

digital art source 212

Zoo Art Fair 384

The Digital Artist 212 Digital Consciousness 200 Disability Cultural Projects e-flux 212 **Emerging Artists Art** Gallery 215 eyestorm 215 FindArtInfo.com 217 Fine Art Surrey 215 Folk Archive 215 Fotonet 215 Foundation for Art and Creative Technology (FACT) 164, 212 Furtherfield 212 Gallery 1839 215, 400 The GalleryChannel 209 GlimpseOnline.com 215 Global Art Jobs 209 Grove Art Online 217 Hidden Art 212 Intute Arts and Humanities 212 Irving Sandler Artists File 215 Isendyouthis.com 209 KultureFlash 209 Londonart.co.uk 215 metamute 212 Mini Gallery 215 National Disability Arts Forum (NDAF) 210 National Museums Online Learning Project 217 nettime 212 New Exhibitions of Contemporary Art 210 NewsGrist 210 No Knock Room 213 Nottingham Studios 213 Online Arts Consultants and Trainers Register On-lineGallery 216 Own Art 217 Own It 217 Paintings and Prints 2 -Artists of the World 216 re-title.com 210 Rhizome.org 213 scotlandart.com 86, 216 shopforprints 216 stot 213 Stuart 216 Studiopottery.co.uk 210 Studioworx Contemporary Art Ltd 216 the-artists.org 217 theSeer.info 210 Trans Artists 213, 462 The UK Sponsorship Database 210 uk.culture.info 210 Universes in Universe -Worlds of Art 213 **VADS 210** Visual Collections 217 WorldwideReview.com Your Gallery 216

The Afton Gallery 87 Alan Kluckow Fine Art 87 Albemarle Gallery 31 Alexander-Morgan Gallery

AOP Gallery 32
Apollo Gallery 127
Archipelago Art Gallery and
Studio 122
The Art House 233, 438
Art Matters Gallery 113
Art Safari 438
Art Space (St Ives) 100
Artists' Network
Bedfordshire 439
Arts and Crafts in
Architecture Awards 390
Arts Gallery 149
Artselect Ireland 127

Atlas Gallery 34 Austin/Desmond Fine Art Axis 214, 441 Bankside Gallery 149, 441 The Barker Gallery 89 Barn Galleries 89 Barn Gallery 128 Baumkotter Gallery 35 The Beacon 162 Beaux Arts 35, 101 Bell Fine Art Ltd 90 Benny Browne & Co. Ltd 74 Bianco Nero Gallery 122 Big Blue Sky 21 Bircham Gallery 21 Birties of Worcester 117 Bloxham Galleries 36 Blue Lias Gallery 101 Bluemoon Gallery 90 Bold Art Gallery 128 Bolton Museum, Art Gallery and Aguarium

162
Boundary Gallery – Agi
Katz Fine Art 36
Bourne Fine Art 82
Braithwaite Gallery 123
Bridge Gallery 128
Bristol's City Museum and
Art Gallery 182
Broadway Modern 117
Broughton House Gallery

Buckenham Galleries 21
Bury Art Gallery, Museum
and Archives 163
Cambridge Open Studios

443 Canvas 129 Castle Gallery 117 Cat's Moustache Gallery 82 Centre for Contemporary Arts (CCA) 169

Charleston Farmhouse and Gallery 175 Cheltenham Art Gallery & Museum 182 Chichester Gallery 91 Clapham Art Gallery 38 Clarion Contemporary Art

38 Clark Galleries 26 Colin Jellicoe Gallery 75 Combridge Fine Arts Ltd

129
Context Gallery 79
Coombe Gallery 102
Cooper Gallery 193
Cornwall Galleries 103
Courtauld Institute of Art
Gallery 151

Courtenays Fine Art 103 Courthouse Gallery, Ballinglen Arts Foundation 129

Courtyard Arts Limited 130 Craftsmen's Gallery 91 Cranbrook Gallery 91 Crawford Municipal Art Gallery 198 Crown Studio Gallery 71

Cupola Contemporary Art Ltd 123 Customs House 71, 160

Daniel Laurence Home & Garden **91** The Darryl Nantais Gallery

DegreeArt.com 40, 214
Delamore Arts 104
Design and Artists

Copyright Society (DACS) 445 Dolphin House Gallery 104 Domino Gallery 75 Dorset County Museum 182

Draíocht Arts Centre 198
Duncan Campbell 41
ecArtspace 41
Elephant Trust Award 398
Eleven 42
Elliott Gallery 104
Emer Gallery 80
Enable Artists 446
Exmouth Gallery 104
FarmiloFiumano 43
Ferens Art Gallery 193

Fermynwoods
Contemporary Art 26
fifiefofum 71
Fine Art Commissions Ltd

Fine Art Society Plc 44
Fine Art Surrey 215
Fisherton Mill – Galleries
Cafe Studios 104
Forge Callery 124
Foundling Museum 153
Four Square Fine Arts 92
Francis Iles 92

Frivoli 45 Gainsborough's House

144 Gallagher & Turner The Gallery – text+work 1Gallery 2000 **76, 266** Gallery 42 1Gallery 52 Gallery Oldham 1The Gallery (Dunfanaghy)

The Gallery (Masham) 124 Garter Lane Arts Centre

199
Gascoigne Gallery 124
George Street Gallery 92
Gilbert Collection 153
Gorry Gallery Ltd 132
Green Door Studio 229
Greenlane Gallery 132
Greenwich Mural

Workshop 448
Grimes House Fine Art 105
Grosmont Gallery 125
Grundy Art Gallery 165
Guildford House Gallery

176 Guildhall Art Gallery 153 Harewood House 193 Harley Gallery 27, 148 Harris Museum and Art

Gallery 165
Haunch of Venison 48
Hazlitt Holland-Hibbert 48
Heathfield Art 93
Hermitage Rooms at

Somerset House 154
Highgate Fine Art 49
Hind Street Gallery and
Frame Makers 106
Holburne Museum of Art

183
Honor Oak Gallery Ltd 49
Hunter Gallery 23
ICAS — Vilas Fine Art 23
Imperial War Museum 154
Island Fine Arts Ltd 93
James Hyman Gallery 51
James Joyce House of the

Dead 133
The Jerdan Gallery 85
Jim Robison and Booth
House Gallery and

Pottery 125 Joan Clancy Gallery 133 John Davies Gallery 106 Jones Art Gallery 133 Jordan & Chard Fine Art 106

106
Kelvingrove Art Gallery and Museum 171
The Kenny Gallery 134
Kerlin Gallery 134
Kettle's Yard 145
Killarney Art Gallery 134
Kilvert Gallery 114
Kings Road Galleries 52

Kings Road Galleries 52 Kooywood Gallery 115 Laing Art Gallery 161 Lander Gallery 107 Laneside Gallery 80 Leamington Spa Art Gallery and Museum 191 Leinster Gallery 135 Lena Boyle Fine Art 52 Letter 'A' Gallery 23 The Lighthouse 257 Lincoln Joyce Fine Art 94 Linenhall Arts Centre 201 Llewellyn Alexander (Fine Paintings) Ltd 53 Londonart.co.uk 215 Lowes Court Gallery 77 Lucy B. Campbell Fine Art

Magil Fine Art 135 Manchester Academy of Fine Arts Open 404 manorhaus 115 Marchmont Gallery and

Picture Framer 85 The Market House 201 Martin Tinney Gallery 115 McNeill Gallery 23 McTague of Harrogate 126 Meadow Gallery 191 Mercer Art Gallery 195 Michael Wood Fine Art 108 Mid Cornwall Galleries 108 Midwest 452 Modern Artists' Gallery 95 Molesworth Gallery 135 Narrow Space 136 National Society of Painters, Sculptors & Printmakers 453

New Art Gallery, Walsall 192 New Craftsman 108

The New Gallery 120 Newby Hall and Gardens

Nicholas Bowlby 95 Norman Villa Gallery 136 Northcote Gallery Chelsea

57 Northern Lights Gallery 78 Number Nine the Gallery

Oisin Art Gallery 136 On-lineGallery 216 Opus Gallery 28 The Origin Gallery 137 Own It 217 Paddon & Paddon 96 Paisley Art Institute Ar

Paisley Art Institute Annual Exhibition Prizes and Biennial Scottish Drawing Competition 406

Parham House 178
Patchings Art Centre 28
Paul Kane Gallery 137
Penlee House Gallery and
Museum 185

Penwith Galleries and Penwith Society of Arts 185

Percy House Gallery 78
Peterborough Art House
Ltd 24
Picturecraft Gallery Ltd 24

Prema 185 Pybus Fine Arts 126 Queens Park Arts Centre Rainyday Gallery 109 The Residence 61 Revolutionary Arts Group 456 Riverbank Arts Centre 203 Robert Phillips Gallery 96 Room for Art Gallery 97 Royal Hibernian Academy Royal Society of Miniature Painters, Sculptors and Gravers 459 Royal West of England Academy (RWA) 186 Rugby Art Gallery and Museum 148 Sadler Street Gallery 109 Sandford Gallery 138 Sarah Walker 138 School House Gallery 24 The Scottish Gallery 86 Sesame Gallery 64 Shipley Art Gallery 161 Shoreline Studio 86 Simon Fairless 97 Siopa Cill Rialaig Gallery Skopelos Foundation for the Arts 410 Society of Catholic Artists 460 The Society of Graphic Fine Art 460 Society of Scottish Artists (SSA) 461 Society of Wildlife Artists Society of Women Artists Solomon Gallery 138 Solstice Arts Centre 203 Southampton City Art Gallery 179 St Ives Society of Artists Gallery 110, 186 St John Street Gallery 28 Stanley Spencer Gallery 180 Start Contemporary Gallery Strand Art Gallery 110 Stroud House Gallery 111 Studioworx Contemporary Art Ltd 216 Suffolk Art Society 461 Suffolk Open Studios 462 Swan Gallery 111 Swansea Open 411 T.B. & R. Jordan Lapada 73 Tate Modern 158 The Teesdale Gallery 73 Tib Lane Gallery 78 Torrance Gallery 87 Tregony Gallery 111 The Troubadour Gallery 68 Turn of the Tide Gallery 112

Turner Gallery 112

Unicorn Gallery 78 Artshole.co.uk 214 Urban Retreat 98 ArtSouthEast 209 Victoria Art Gallery 187 The Artspost 475 Visual Arts Scotland (VAS) Artupdate.com 209 Aspect Magazine 475 Audio Arts 475 Vitreous Contemporary Art Black & White Photography The Warwick Gallery 121 Blueprint 475 Waytemore Art Gallery 25 West Cork Arts Centre 204 British Journal of Aesthetics West Wales Arts Centre 117 476 Western Light Art Gallery British Journal of Photography 393, 476 Westgate Gallery 87 The Burlington Magazine WhiteImage.com 81 Whittlesford Gallery 25 Ceramic Review 476 William Thuillier 70 Circa Art Magazine 476 Williams & Son 70 Contemporary 476 Wolseley Fine Arts Ltd 121 Crafts Magazine 477 Wolverhampton Art Gallery Dazed & Confused Magazine 192 Woodbine Contemporary Designspotter 209 Arts 29 Digital Camera Magazine Wordsworth Museum Art Gallery 167 Digital Consciousness 209 Zimmer Stewart Gallery 99 Flux Magazine 477 Foto8 477 MAGAZINES, JOURNALS frieze 477 AND LISTINGS Galleries Magazine 477 AA Files 473 The GalleryChannel 209 absolutearts.com and Global Art Jobs 209 World Wide Arts The Good Gallery Guide 477 Resources Corp. 213 HotShoe 478 Aesthetica 279 icon 478 Afterall 473 I-D Magazine 478 a-n Magazine 208, 437, 473 Intute Arts and Humanities Another Magazine 473 Irish Arts Review 478 Apollo Magazine 473 Art & Architecture Journal The Jackdaw 478 Journal of Visual Art Practice The Art Book 474 Art Guide 208 Journal of Visual Culture 478 Art History 474 Knight's Move 478 Art in Context 211 KultureFlash 209 Art MoCo 208 Latest Art Magazine 478 Art Monthly 474 Londonart.co.uk 215 Art News Blog 208 Map Magazine 479 The Art Newspaper 474 Marmalade Magazine 479 Art Quarterly 474 Modern Painters 479 Art World Magazine 474 n.paradoxa: international feminist art journal 479 artcourses.co.uk 208 artdaily.com 208 NADFAS Review 479 artefact 208 National Disability Arts ArtInfo 216 Forum (NDAF) 210 ArtInLiverpool.com 208 nettime 212 The Artist 474 New Exhibitions of artist-info: Contemporary Contemporary Art 210 Art Database 209 NewsGrist 210 Artists & Illustrators 474 Next Level 479 Artlistings.com 209 Object - Graduate Research art-online - The Fine Art and Reviews in the History Directory 208 of Art and Visual Culture ArtRabbit 211 479 ArtReview 475 Own It 217 Arts Culture Media Jobs 209 Oxford Art Journal 480 Arts Hub 209 Performance Research 480 Arts Journal 209 Portfolio - Contemporary Arts Media Contacts 475 Photography in Britain Arts Professional Online Preview of the Visual Arts in Arts Research Digest 475 Ireland 480

Print Quarterly Publications Printmaking Today 480 RA Magazine 480 Raw Vision 481 re-title.com 210 Royal Photographic Society Journal 481 RSA Journal 481 Sculpture Journal 481 Selvedge 481 Source Photographic Review 481 stot 213 TATE ETC. 481 theSeer.info 210 things magazine 481 Third Text 482 Time Out 482 The UK Sponsorship Database 210 V&A Magazine 482 Variant 482 Visual Culture in Britain 482 Wallpaper 482 WorldwideReview.com 210 **MANUFACTURERS** see ART FOUNDERS AND **MANUFACTURERS** MARINE ART Abbott and Holder Ltd 30 absolutearts.com and World Wide Arts Resources Corp. 213 Ackermann & Johnson Ltd The Afton Gallery 87 Anthony Woodd Gallery 82 The Art House 211 Art Matters Gallery 113 Art@94 89 Arts and Crafts in Architecture Awards 390 Atishoo Designs 100 Atlas Gallery 34 Baumkotter Gallery 35 The Beacon 162 Bell Fine Art Ltd 90 Birties of Worcester 117 Blue Lias Gallery 101 Bold Art Gallery 128 Bridge Gallery 128 Broadway Modern 117 Chichester Gallery 91 Clark Galleries 26 Cornwall Galleries 103 Courtyard Arts Limited 130 Craftsmen's Gallery 91 Cranbrook Gallery 91 Customs House 71, 160 Daniel Laurence Home & Garden 91 The Darryl Nantais Gallery DegreeArt.com 40, 214 Design and Artists Copyright Society (DACS) 445

Edinburgh Printmakers 84 Elliott Gallery 104 Exmouth Gallery 104 Federation of British Artists (FBA) 426, 447 Ferens Art Gallery 193 Fine Art Surrey 215 Foundling Museum 153 Francis Iles 02 Gallerie Marin 105 The Gallery (Dunfanaghy) George Street Gallery 92 Gilbert Collection 153 Gorry Gallery Ltd 132 Green Door Studio 229 Grosmont Gallery 125 Guildhall Art Gallery 153 Hermitage Rooms at Somerset House 154 Hind Street Gallery and Frame Makers 106 Hull Maritime Museum 194 Hunter Gallery 23 Ipswich Arts Association 450 Island Fine Arts Ltd 93 lames loyce House of the Dead 133 The Jerdan Gallery 85 Iordan & Chard Fine Art lorgensen Fine Art 133 The Kenny Gallery 134 Kettle's Yard Open / Residency Opportunities Killarney Art Gallery 134 Lander Gallery 107 Legra Gallery 94 Leinster Gallery 135 Lincoln loyce Fine Art 94 Magil Fine Art 135 Manchester Academy of Fine Arts Open 404 Manser Fine Art 119 McNeill Gallery 23 Michael Wood Fine Art 108 Midwest 452 National Maritime Museum 155 Nicholas Bowlby 95 Northcote Gallery Chelsea On-lineGallery 216 Oriel 116 The Origin Gallery 137 Own It 217 Paddon & Paddon 96 Paul Mason Gallery 59 Penlee House Gallery and Museum 185 Picturecraft Gallery Ltd 24 Plymouth City Museums and Art Gallery 185 Portsmouth City Museum and Records Office 179 Pybus Fine Arts 126 Rainyday Gallery 109 Red Rag Gallery 109

Richard Green 61 Bell Fine Art Ltd 90 Bircham Gallery 21 Royal Exchange Art Gallery Birties of Worcester 117 Royal Society of Marine Blue Lias Gallery 101 Bluemoon Gallery 90 Artists 459 Royal Society of Miniature Bold Art Gallery 128 Painters, Sculptors and Boundary Gallery - Agi Gravers 459 Katz Fine Art 36 Sadler Street Gallery 109 Bridge Gallery 128 Sarah Walker 138 Broadway Modern 117 Scarborough Art Gallery Cambridge Open Studios Cat's Moustache Gallery 82 School House Gallery 24 Shoreline Studio 86 Cavanacor Gallery 129 Charleston Farmhouse and Simon Fairless 97 Gallery 175 Skopelos Foundation for Cheltenham Art Gallery & the Arts 410 The Society of Graphic Fine Museum 182 Clarion Contemporary Art Art 460 Solstice Arts Centre 203 38 Southwold Gallery 24 Clark Galleries 26 Clifton Gallery 102 St Ives Society of Artists Cooper Gallery 193 Gallery 110, 186 Cornwall Galleries 103 Strand Art Gallery 110 Courtauld Institute of Art Suffolk Art Society 461 Gallery 151 Suffolk Open Studios 462 Swan Gallery 111 Courthouse Gallery, T.B. & R. Jordan Lapada 73 Ballinglen Arts Foundation 129 Taylor-Pick Fine Art 127 Thoresby Gallery 29 Courtyard Arts Limited 130 The Toll House Gallery 111 Cowleigh Gallery 118 Craftsmen's Gallery 91 Tregony Gallery 111 Crown Studio Gallery 71 The Troubadour Gallery 68 Daniel Laurence Home & Turn of the Tide Gallery 112 Garden 91 Urban Retreat 08 The Darryl Nantais Gallery Valentyne Dawes Gallery DegreeArt.com 40, 214 Western Light Art Gallery Delamore Arts 104 Design and Artists MATERIALS see ART Copyright Society (DACS) 445 Domino Gallery 75 MATERIALS RETAILERS MEDIA CONTACTS see dot-art 76 Edinburgh Printmakers 84 **PUBLIC RELATIONS** Elliott Gallery 104 Emer Gallery 80 NATURE AND STILL LIFE Abbot Hall Art Gallery 162 Exmouth Gallery 104 Federation of British absolutearts.com and Artists (FBA) 426, 447 World Wide Arts Resources Corp. 213 fifiefofum 71 The Afton Gallery 87 Fine Art Commissions Ltd Ainscough Gallery 74 Albemarle Gallery 31 Fine Art Surrey 215 AOP Gallery 32 Four Square Fine Arts 92 Fourwalls 92 Apollo Gallery 127 Frivoli 45 The Art House 211 Art Matters Gallery 113 The Gallery - text+work 183 Art Safari 438 Gallery Oldham 164 Artist of the Year by the The Gallery (Dunfanaghy) Society for All Artists 119 Garter Lane Arts Centre (SAA) 389 Artists' Network 199 Gilbert Collection 153 Bedfordshire 439 Gorry Gallery Ltd 132 Artselect Ireland 127 Atlas Gallery 34 Green Door Studio 229 Austin/Desmond Fine Art Greenacres 132 Greenlane Gallery 132 Ltd 34 Axis 214, 441 Grimes House Fine Art 105 Grosmont Gallery 125 Bankside Gallery 149, 441

Grundy Art Gallery 165

Barn Gallery 128

Guildhall Art Gallery 153 Hanina Fine Arts 47 Harris Museum and Art Gallery 165 Hazlitt Holland-Hibbert 48 Heathfield Art 03 Hermitage Rooms at Somerset House 154 Highgate Fine Art 49 Honor Oak Gallery Ltd 49 Hunter Gallery 23 ICAS - Vilas Fine Art 23 Inverleith House 171 Island Fine Arts Ltd 93 lames Hyman Gallery 51 The Jerdan Gallery 85 Ioan Clancy Gallery 133 Iones Art Gallery 133 Kelvingrove Art Gallery and Museum 171 The Kenny Gallery 134 Kerlin Gallery 134 Kettle's Yard 145 Killarney Art Gallery 134 Kilvert Gallery 114 Kings Road Galleries 52 Lander Gallery 107 Laneside Gallery 80 Leinster Gallery 135 Letter 'A' Gallery 23 Lincoln lovce Fine Art 94 Linenhall Arts Centre 201 Llewellyn Alexander (Fine Paintings) Ltd 53 Londonart.co.uk 215 Lowes Court Gallery 77 Lucy B. Campbell Fine Art 53 Magil Fine Art 135 manorhaus 115 Marchmont Gallery and Picture Framer 85 Mayfield Gallery 107 McNeill Gallery 23 Michael Wood Fine Art 108 Midwest 452 Miller Fine Arts 28 Molesworth Gallery 135 Narrow Space 136 National Society of Painters, Sculptors & Printmakers 453 Nature In Art 184 New Art Gallery, Walsall New Craftsman 108 The New Gallery 120 Newby Hall and Gardens Northcote Gallery Chelsea Oisin Art Gallery 136 On-line Gallery 210 The Origin Gallery 137 Original Print Gallery 137 Own It 217 Pallant House Gallery 178 Patchings Art Centre 28 Paul Kane Gallery 137 Picturecraft Gallery Ltd 24

Pybus Fine Arts 126 Queens Park Arts Centre 456 The Residence 61 Revolutionary Arts Group 456 Royal British Society of Sculptors 408, 457 Royal Hibernian Academy 457 Royal Society of Miniature Painters, Sculptors and Gravers **459** Royal West of England Academy (RWA) 186 Sandford Gallery 138 Sarah Walker 138 The Scottish Gallery 86 The Sheen Gallery 64 Shoreline Studio 86 Skopelos Foundation for the Arts 410 Society of Botanical Artists The Society of Graphic Fine Art 460 Society of Scottish Artists (SSA) 461 Society of Wildlife Artists 461 Society of Women Artists 461 Solomon Gallery 138 Solstice Arts Centre 203 St Ives Society of Artists Gallery 110, 186 St John Street Gallery 28 Start Contemporary Gallery Strand Art Gallery 110 Stroud House Gallery 111 Suffolk Art Society 461 Suffolk Open Studios 462 Summer Exhibition -Royal Academy of Arts 411 Swan Gallery 111 Tate Modern 158 Taylor-Pick Fine Art 127 The Teesdale Gallery 73 The The Toll House Gallery Tib Lane Gallery 78 Tregony Gallery 111 The Troubadour Gallery 68 Tryon Galleries 68 Turner Gallery 112 Urban Retreat 98 Visual Arts Scotland (VAS) Wallace Collection 158 West Wales Arts Centre 117 Western Light Art Gallery Westgate Gallery 87 Widcombe Studios Gallery Wildlife Art Gallery 25 Wildwood Gallery 25

Wolseley Fine Arts Ltd 121

Wren Gallery 99

NOT-FOR-PROFIT CALLERIES AND **ORGANIZATIONS** AOP Gallery 32 The Ark 197 Arthouse Gallery 80 The Art Gym 182 Barbara Behan Contemporary Art 34 Bluecoat Display Centre Bureau 75 Calvert 22 37 Camden Arts Centre 151 Campbell Works 37 Catalyst Arts 168 Centre for Contemporary Arts (CCA) 169 Centre for Recent Drawing - C4RD 38 The Centre of Attention 38 Chisenhale Gallery 151 Compass Gallery 83 Courthouse Gallery. **Ballinglen Arts** Foundation 129 Cubitt Gallery and Studios Draíocht Arts Centre 198 The Drawing Room 40 **Dunamaise Arts Centre** Edinburgh Printmakers 84 EggSpace 76 Elastic Residence 42 Golden Thread Gallery 168 House Gallery 50 Kangaroo Kourt 107 Kettle's Yard 145 Kingsgate Workshops Trust and Gallery 297 Limerick Printmakers Studio and Gallery 135, 282 Matt's Gallery 54 Monnow Valley Arts Centre 192 New Brewery Arts Centre 184 October Gallery 57 Oxmarket Centre of Arts 95 Parasol Unit Foundation for Contemporary Art 58 Peer 59 Permanent Gallery 96 Plan 9 109 The Red Mansion

Foundation 61

Saltburn Gallery 72

The Showroom 64

SE8 Gallery 157

138

SPACEX 186

Studio 1.1 66

Robert Phillips Gallery 96

Siopa Cill Rialaig Gallery

Space Station Sixty-Five 65

Sirius Arts Centre 203

Standpoint Gallery 66

Studio Voltaire 67, 300

Stroud House Gallery 111

Studios 130 Urban Retreat 98 Washington Gallery 116 OILS 108 Fine Art 122 Abbot Hall Art Gallery 162 Abbott and Holder Ltd 30 absolutearts com and World Wide Arts Resources Corp. 213 ACE Award for Art in a Religious Context 388 Ackermann & Johnson Ltd 30 Adonis Art 30 The Afton Gallery 87 Agnew's 30 Ainscough Gallery 74 Alan Kluckow Fine Art 87 Albemarle Gallery 31 Alexander-Morgan Gallery Alms House 240 Andipa Gallery 32 Anthony Woodd Gallery 82 Apollo Gallery 127 Archipelago Art Gallery and Studio 122 Art Centre and Gallery 240 The Art House 233, 438 Art Matters Gallery 113 The Art Shop (Abergavenny) 243 The Art Shop (Wanstead) Art Space Gallery (St Ives) 100 artcourses.co.uk 208 Artist's Gallery 117 Artists' Network Bedfordshire 439 Artizana 74 Artlines 263 Arts Gallery 149 Artselect Ireland 127 Artstore at the Artschool Ltd 236 Atishoo Designs 100 Austin/Desmond Fine Art Ltd 34 Axis 214, 441 Bar Street Arts Ltd 245 The Barker Gallery 89 Baumkotter Gallery 35 The Beacon 162 Beaux Arts 35 Bell Fine Art Ltd 90 Bell Gallery 79 Bettles Gallery 101 Bianco Nero Gallery 122 Big Blue Sky 21 Bircham Gallery 21 Bird & Davis Ltd - The Artist's Manufactory 227 Birties of Worcester 117 Bischoff/Weiss 35 Black Mountain Gallery 113 Blackheath Gallery 35 Blue Leaf Gallery 128

Temple Bar Gallery and

Blue Lias Gallery 101 Bluemoon Gallery 90 Bold Art Gallery 128 Bolton Museum, Art Gallery and Aquarium Boundary Gallery - Agi Katz Fine Art 36 Bourne Fine Art 82 Brackendale Arts 238 Bridge Gallery 128 Brighton Museum and Art Gallery 175 Bristol's City Museum and Art Gallery 182 Broadway Modern 117 Broughton House Gallery Buckenham Galleries 21 Bury Art Gallery, Museum and Archives 163 C.S. Wellby 254 Callan Art Supplies 246 Cambridge Open Studios Canon Gallery 90 Canvas 129 Cartwright Hall Art Gallery Cass Art 228 Cat's Moustache Gallery Cavanacor Gallery 129 Celeste Prize 394 Centre for Contemporary Arts (CCA) 169 Charleston Farmhouse and Gallery 175 Cheltenham Art Gallery & Museum 182 Chichester Gallery 91 Chromos (Tunbridge Wells) Ltd 238 Clapham Art Gallery 38 Clarion Contemporary Art Clifton Gallery 102 Colart Fine Art & Graphics Ltd 228 Colin Jellicoe Gallery 75 The Compleat Artist 242 Conservation Studio 254 Consultant Conservators of Fine Art 255 Context Gallery 79 Coombe Gallery 102 Cooper Gallery 193 Cornwall Galleries 103 Courtauld Institute of Art Gallery 151 Courtenays Fine Art 103 Courthouse Gallery, **Ballinglen Arts** Foundation 129 Courtyard Arts Limited 130 Craftsmen's Gallery 91 Creative World 238 Croft Gallery 103 Cube Gallery 103 Cupola Contemporary Art Ltd 123

Custom House Studios Ltd Customs House 71, 160 Daler-Rowney Percy Street/ Arch One Picture Framing 228 Daniel Laurence Home & Garden 91 The Darryl Nantais Gallery DegreeArt.com 40, 214 Delamore Arts 104 Design and Artists Copyright Society (DACS) 445 Dolphin House Gallery 104 Domino Gallery 75 **Dorset County Museum** dot-art 76 Draíocht Arts Centre 198 Dunamaise Arts Centre Duncan Campbell 41 ecArtspace 41 Eleven 42 Elliott Gallery 104 Emer Gallery 80 Enable Artists 446 England's Gallery 118 Exmouth Gallery 104 Fairfax Gallery 43 FarmiloFiumano 43 Federation of British Artists (FBA) 426, 447 Ferens Art Gallery 193 fifiefofum 71 Fine Art Society Plc 44 Fine Art Surrey 215 Forge Gallery 124 Foundling Museum 153 Fourwalls 92 Framemaker (Cork) Ltd Francis Iles 92 Fred Aldous Ltd 234 Frivoli 45 G.E. Kee 246 Gainsborough's House 144 The Gallery - text+work 183 Gallery 2000 76, 266 Gallery 52 26 The Gallery at Willesden Green 45 Gallery Kaleidoscope 46 Gallery Oldham 164 Gallery One 46, 80 The Gallery (Dunfanaghy) Garter Lane Arts Centre Geffrye Museum 153 George Street Gallery 92 Gilbert Collection 153 Gorry Gallery Ltd 132 Green Door Studio 229 Greenacres 132 Greenlane Gallery 132 Greyfriars Art Shop 236

Grimes House Fine Art 105

Grosmont Gallery 125

Grundy Art Gallery 165 **Guild of Aviation Artists** Guildford House Gallery Guildhall Art Gallery 153 Hanina Fine Arts 47 Harley Gallery 27, 148 Harris Museum and Art Gallery 165 Harris-Moore Canvases Ltd 244 Hazlitt Holland-Hibbert 48 Headrow Gallery 125 Healthcraft 236 Heathfield Art 93 Hermitage Rooms at Somerset House 154 Hertfordshire Graphics Ltd 225 Hicks Gallery 48 Highgate Fine Art 49 Hillsboro Fine Art 133 Hind Street Gallery and Frame Makers 106 Holburne Museum of Art 183 House Gallery 50 Hull Maritime Museum 194 Hunter Gallery 23 Ian Dixon GCF Bespoke Framers 266 ICAS - Vilas Fine Art 23 Imperial War Museum 154 Ines Santy Paintings Conservation and Restoration 256 InkSpot 237 Irish Museum of Modern Island Fine Arts Ltd 93 Jackson's Art Supplies 230 James Joyce House of the Dead 133 Jarrold's 225 The Jerdan Gallery 85 Joan Clancy Gallery 133 John Green Fine Art 85 John Noott Galleries 119 Jones Art Gallery 133 Iordan & Chard Fine Art 106 Jorgensen Fine Art 133 Julian Spencer-Smith 256 Kelvingrove Art Gallery and Museum 171 Kennedy Gallery 247 The Kenny Gallery 134 Kerlin Gallery 134 Kettle's Yard 145 Killarney Art Gallery 134 Kilvert Gallery 114

King's Lynn Arts Centre 145

Leamington Spa Art Gallery

Kooywood Gallery 115

Laing Art Gallery 161

Lander Gallery 107

Laneside Gallery 80

Leinster Gallery 135

and Museum 191

Lena Boyle Fine Art 52 Penlee House Gallery and Letchworth Museum and Museum 185 Peterborough Art House Art Gallery 145 Limerick Printmakers Studio and Gallery 135. Picturecraft Gallery Ltd 24 Plymouth City Museums and Art Gallery 185 Lincoln Joyce Fine Art 94 Linenhall Arts Centre 201 Prema 185 Llewellyn Alexander (Fine Pybus Fine Arts 126 **Oueens Park Arts Centre** Paintings) Ltd 53 London Graphic Centre Red Gallery 96 230, 251 Red Rag Gallery 109 Lowes Court Gallery 77 The Residence 61 The Lowry 165 Retrospectives Gallery 120 Lucia Scalisi 257 Lucy B. Campbell Fine Art Revolutionary Arts Group Lunns of Ringwood 239 Riverbank Arts Centre 203 Magil Fine Art 135 Rona Gallery 62 Manchester Academy of Ronald Moore Fine Art Conservation 257 Fine Arts Open 404 Manchester Art Gallery 165 Room for Art Gallery 97 Manor House Gallery 177 Royal Exchange Art Gallery Manya Igel Fine Arts 54 Marchmont Gallery and Royal Glasgow Institute of the Fine Arts 457 Picture Framer 85 Martin Tinney Gallery 115 Royal Hibernian Academy Martin's Gallery 107 McNeill Gallery 23 Royal Institute of Oil McTague of Harrogate 126 Painters 457 Royal Society of Miniature Michael Harding's Artists Oil Colours 230 Painters, Sculptors and Michael Wood Fine Art 108 Gravers 459 Royal West of England Mid Cornwall Galleries 108 Academy (RWA) 186 Midwest 452 Modern Artists' Gallery 95 Royall Fine Art 97 Russell & Chapple 231 Molesworth Gallery 135 Narrow Space 136 Sadler Street Gallery 109 National Gallery of Ireland Sally Mitchell Fine Arts 28 Saltburn Gallery 72 201 Saltgrass Gallery 97 National Society of Sandford Gallery 138 Painters, Sculptors & Printmakers 453 Sarah Walker 138 Sartorial Contemporary Art New Art Gallery, Walsall New Craftsman 108 Scarborough Art Gallery The New Gallery 108, 120 196 New Realms Limited 57 School House Gallery 24 School of Art Gallery and Nicholas Bowlby 95 Norman Villa Gallery 136 Museum 189 Northcote Gallery Chelsea Search Press Ltd 290 Selwyn-Smith Studio 231 Shell House Gallery 121 Northern Lights Gallery 78 Nottingham Artists' Group Shipley Art Gallery 161 Shire Hall Gallery 192 Shoreline Studio 86 Number Nine the Gallery Siopa Cill Rialaig Gallery Oberon Art Ltd 283 138 Offer Waterman & Co. 57 Six Chapel Row Oisin Art Gallery 136 Contemporary Art 98 Omell Galleries 95 Skopelos Foundation for On-lineGallery 216 the Arts 410 Opus Gallery 28 Skylark Galleries 65 The Origin Gallery 137 Society for All Artists (SAA) Owen Clark & Co. Ltd 231 269, 460 Society for Religious Artists Own It 217 (SFRA) **460** Society of Catholic Artists Paintworks Ltd 231 Pallant House Gallery 178 Patchings Art Centre 28 Society of Scottish Artists Paul Kane Gallery 137 (SSA) 461 Paul Mason Gallery 59

Society of Women Artists

Solstice Arts Centre 203

Spectrum Oil Colours Ltd

Sorcha Dallas 86

Spencer Coleman Fine Art St Ives Society of Artists Gallery 110, 186 St John Street Gallery 28 Stanley Spencer Gallery Star Gallery 98 Start Contemporary Gallery 98 Stone Gallery 138 Strand Art Gallery 110 Stroud House Gallery 111 Studio 1.1 66 Studioworx Contemporary Art Ltd 216 Suffolk Art Society 461 Suffolk Open Studios 462 Summer Exhibition - Royal Academy of Arts 411 Sundridge Gallery 98 Swan Gallery 111 Swansea Open 411 T.B. & R. Jordan Lapada 73 Taylor-Pick Fine Art 127 The Teesdale Gallery 73 Thornthwaite Galleries 78 Tib Lane Gallery 78 Tindalls the Stationers Ltd The Toll House Gallery 111 Tom Caldwell Gallery 81 Towneley Hall Art Gallery & Museum 196 Tregony Gallery 111 The Troubadour Gallery 68 Tunbridge Wells Museum and Art Gallery 180 Turner Gallery 112 **VADS 210** Valentine Walsh 258 Vereker Picture Framing Vesey Art and Crafts 244 Visual Arts Scotland (VAS) 463 Vitreous Contemporary Art 112 Waddesdon Manor 181 Washington Gallery 116 Waytemore Art Gallery 25 Webb Fine Arts 99 Webster Gallery 99 Wenlock Fine Art 121 West Wales Arts Centre 117 Western Light Art Gallery 139 Westgate Gallery 87 Wheatsheaf Art Shop 232 WhiteImage.com 81 Whitgift Galleries 70 Whittington Fine Art 99 Widcombe Studios Gallery Wildwood Gallery 25

Williams & Son 70 Mid-Cheshire College 317, Wolverhampton Art Gallery 345 Middlesex University 312 The Wonderwall Gallery Newcastle College 315, 343 North East Worcestershire Woodbine Contemporary College 331, 353 Arts 29 North Wales School of Art Workplace Art Consultancy and Design 328 Northumbria University 315 Yarm Gallery 73 Norwich School of Art & Zimmer Stewart Gallery 99 Design 306 Nottingham Trent PHOTOGRAPHY: ART University 309 **EDUCATION** Oxford Brookes University Barnsley College 332, 354 323, 348 Bedford College 321, 338 Plymouth College of Art Bradford College 333, 355 and Design 326, 350 Brighton University 322 Reigate School of Art, Bristol School of Art, Media Design and Media (East and Design 326 Surrey College) 323 Burren College of Art 335 Royal College of Art 157, 313 Cambridge School of Art, Sheffield College, Anglia Ruskin University Hillsborough Centre 334, 306 356 Central St Martins College South East Essex College of Art & Design 310, 341 348 Chesterfield College 308, Southampton Solent University 323 Cleveland College of Art & St Helens College 318, 345 Design 314, 343 Craven College, Skipton Stockport College of Further and Higher Education 318, 345 Croydon College 311, 341 Swansea Institute 328 De Montfort University University for the Creative 308, 340 Arts - Maidstone 324. Dewsbury College 333, 355 Dublin Institute of University of Central Technology, Faculty of Lancashire 319 Applied Arts 336 University of Derby 309 **Dudley College of** University of Technology 330, 353 Gloucestershire 328, 351 Dun Laoghaire Institute of University of Hertfordshire Art, Design & 307, 339 Technology 336 Duncan of Jordanstone University of Northampton 310, 341 College of Art and University of Portsmouth Design 320 324, 349 Dunstable College 306, 339 University of Southampton Exeter College 326, 350 325, 349 Glasgow School of Art 320 University of Wales Gorey School of Art 336 Institute Cardiff 329, 352 Herefordshire College of University of Wales, Art & Design 330, 353 Aberystwyth 329 Hull School of Art and University of Wales, Design 333, 355 Institute of Technology, Newport 329 University of Westminster Tallaght 337 Institute of Techonology 314 Waterford Institute of Sligo 337 Technology 338 West Wales School of the Kingston University 311, Arts 330, 352 Leeds College of Art &

Waterford Institute of Technology 338 West Wales School of the Arts 330, 352 PHOTOGRAPHY: ART FAIRS AND FESTIVALS Affordable Art Fair 376 Art Ireland 376 Art London 377 Artists & Makers Festival 377 Battersea Contemporary Art Fair 378

Design 333, 355, 370

Communication 311, 342

Manchester Metropolitan

University 317, 345

Limerick Institute of

Technology 337

London South Bank

University 312

London College of

Brighton Art Fair 378 **Brighton Photo Biennial** 378 Buy Art Fair 378 Cheltenham Artists Open Houses 379 Earagail Arts Festival 380 East Neuk Open 380 Edinburgh Art Fair 380 Free Range 381 International Festival of the Image 381 Margate Rocks 382 **Open Studios** Northamptonshire 383 Photo-London 383 Zoo Art Fair 384

PHOTOGRAPHY: ART MAGAZINES AA Files 473 Apollo Magazine 473 The Art Book 474 Black & White Photography Blueprint 475 British Journal of Photography 393, 476 Dazed & Confused Magazine Digital Camera Magazine Foto8 477 HotShoe 478 Irish Arts Review 478 Journal of Visual Culture 478 Next Level 479 Object - Graduate Research and Reviews in the History of Art and Visual Culture Portfolio - Contemporary Photography in Britain Preview of the Visual Arts in Ireland 480 Royal Photographic Society Journal 481 Source Photographic Review Third Text 482 Variant 482

PHOTOGRAPHY: ARTS
BOARDS, COUNCILS,
FUNDING AND
COMMISSIONING
ORGANIZATIONS
ART.e @ the art of change
421
Arts & Disability Forum
422
Arts Council of Northern
Ireland 423
Belfast Exposed
Photography 79, 167, 425
Common Ground 426
Creative Skills 426
Helix Arts 427
Impact Arts 427

Iris, International Women's Photographic Research Resource 427 **Public Art Commissions** and Exhibitions (PACE) **Rhizome Commissions** 213, 430

PHOTOGRAPHY: COMMERCIAL **GALLERIES, DEALERS** AND EXHIBITION SPACES 198 Gallery 29 96 Gillespie 29 'A' Foundation -Greenland Street 74, 421 Access to Arts 127 Adonis Art 30 The Agency 30 Alan Kluckow Fine Art 87 Alexander-Morgan Gallery

Amber Roome Contemporary Art 82 Andrew Coningsby Gallery Ann Jarman 21 Anne Faggionato 32 Anthony Reynolds Gallery

AOP Gallery 32 Archeus 33 Archipelago Art Gallery and Studio 122 Artselect Ireland 127 Atishoo Designs 100 Atlas Gallery 34 Barbara Behan

Contemporary Art 34 BCA Gallery 90 Bearspace 35 Belfast Exposed Gallery 197 Ben Brown Fine Arts 35 Big Blue Sky 21 Bischoff/Weiss 35 Black Cat Gallery 128 Black Swan Arts 101 Blink Gallery 36 Bloxham Galleries 36 Blue Lias Gallery 101 Bold Art Gallery 128 Bourne Fine Art 82 Brick Lane Gallery 36 Bridge Gallery 128 Brighton Artists' Gallery of

Contemporary Art 90 Bureau 75 Calvert 22 37 Canvas 129 Capital Culture 37 Capsule 113 Castlefield Gallery 75, 163 Cat's Moustache Gallery 82 Cavanacor Gallery 129 The Centre of Attention 38 Cherrylane Fine Arts 129 Chichester Gallery 91 Clapham Art Gallery 38 Context Gallery 79 Coombe Gallery 102

Courthouse Gallery, **Ballinglen Arts** Foundation 129 Courtyard Arts Limited 130 Cupola Contemporary Art Customs House 71, 160 The Cynthia Corbett Gallery 39

The Darryl Nantais Gallery DegreeArt.com 40, 214 Delamore Arts 104 doggerfisher 83 Domino Gallery 75 dot-art 76 ecArtspace 41 Edinburgh Printmakers 84 Emily Tsingou Gallery 42 The Empire 42 Evergreen Gallery 26 Fenton Gallery 131 Fermynwoods

Contemporary Art 26 fifiefofum 71 Flowers East 44 Fosterart 44 Four Square Fine Arts 92 Fourwalls 92 Fred [London] Ltd 45 Frith Street Gallery 45 Frost & Reed 45 Gallery 52 26 The Gallery at Willesden Green 45

Gallery Beckenham 92 George Street Gallery 92 Getty Images Gallery 46 Glass and Art Gallery 72 Green On Red Gallery 132 Greenacres 132 Grosmont Gallery 125 Hackelbury Fine Art 47 Hamiltons 47 Harley Gallery 27, 148 Haunch of Venison 48 Hazlitt Holland-Hibbert 48 Here Shop & Gallery 106 Hertfordshire Gallery 23 Hind Street Gallery and

Frame Makers 106 Hofer Printroom 49 Hoopers Gallery 49 Hotel 49 Houldsworth 50 Ingleby Gallery 84 James Hyman Gallery 51 Jerwood Space 51 Jones Art Gallery 133 The Kenny Gallery 134 Kerlin Gallery 134 Kings Road Galleries 52 Kooywood Gallery 115 Lavit Gallery 134 Leinster Gallery 135 Limerick Printmakers

Studio and Gallery 135, Lisson Gallery 52

Liverpool History Shop 77

London Road Gallery 125 Lowes Court Gallery 77 Lupe 53 Manchester Craft & Design

Centre 77 manorhaus 115 Marchmont Gallery and Picture Framer 85 Mark Jason Gallery 54

Matt's Gallery 54 Maureen Paley 54 McNeill Gallery 23 Medici Gallery 55 Michael Hoppen Gallery 55 Mission Gallery 116 Modern Artists' Gallery 95 New Gallery 210 Nicholas Bowlby 95 Norman Villa Gallery 136 North Laine Photography

Gallery 95 Northcote Gallery Chelsea

Northern Lights Gallery 78 Number 15 116 Opus Gallery 28 Oriel 116 Oriel Canfas Gallery 116 The Origin Gallery 137 Paddon & Paddon 96 Pallas Studios 137, 298 Patchings Art Centre 28

Patrick Davies Contemporary Art 23 Peacock Visual Arts 86, 173,

Peer 59 Percy House Gallery 78 Photofusion 59, 156 Picturecraft Gallery Ltd 24 Proud Galleries 60 Purdy Hicks Gallery 60 The Residence 61 Rivington Gallery 62 Rocket 62 Rubicon Gallery 137 Sadie Coles HQ 63 Salar Gallery 109 Saltburn Gallery 72 Sarah Walker 138 Sartorial Contemporary Art

63 Scout 63 Shoreline Studio 86 Side Gallery 73 Simon Fairless 97 Simon Lee Gallery 64 Siopa Cill Rialaig Gallery 138 Six Chapel Row

Contemporary Art 98 Spitz Gallery 65 SS Robin Gallery 65 St John Street Gallery 28 Star Gallery 98 Start Contemporary Gallery

The Steps Gallery 66 Stills 87 Stone Gallery 138 STORE 66 Street Level Photoworks 87

Stroud House Gallery 111 Studio 1.1 66 Temple Bar Gallery and Studios 139 The Toll House Gallery 111 Tom Blau Gallery - Camera Press 68 The Troubadour Gallery 68 Union 69 Victoria Miro Gallery 69 Vitreous Contemporary Art Waygood Studios and Gallery 73, 300 Western Light Art Gallery Westgate Gallery 87 White Cube 69 Widcombe Studios Gallery Yarm Gallery 73 Zimmer Stewart Gallery 99

PHOTOGRAPHY: COMPETITIONS, **AWARDS AND PRIZES** ACE Award for Art in a Religious Context 388 ACE/MERCERS International Book Award 388 Artes Mundi Prize 389 Association of Photographers (AOP) Open 392 British Journal of Photography 393, 476 Byard Art Open Competition 394 Delfina Studio Trust 396 Deutsche Börse Photography Prize 397 East End Academy 397 Erna & Victor Hasselblad Foundation Awards and Bursaries 398 Gallery 1839 215, 400 Global Arts Village 401 Jeff Vickers/Genix Imaging Bursary 402 Joan Wakelin Bursary 403 Kettle's Yard Open / **Residency Opportunities** London Photographic Association 404, 451 Montana Artists' Refuge Residency Program 404

Polish Cultural Institute The Rencontres Contemporary Book Prize 407 The Rencontres d'Arles Discovery Award 407 Sargant Fellowship 410 Summer Exhibition - Royal Academy of Arts 411 Swansea Open 411 Wingate Rome Scholarship in the Fine Arts 412

Women's Studio Workshop Fellowship Grants 413

PHOTOGRAPHY:
CONSERVATION AND
RESTORATION AND
CONSULTANTS
Bridgeman Art Library 258,
358
Corman Arts 258
Dickson Russell Art
Management 259
fotoLibra 259, 274
Getty Images 259
Impact Art 259
Life – A New Life for Old
Documents 257
Workplace Art Consultancy

PHOTOGRAPHY: FRAMING
A. Bliss 263
The Framework Gallery 131, 265
Ian Dixon GCF Bespoke
Framers 266
Railings Gallery 267
Renaissance 2 267
Wallace Brown Studio

261

PHOTOGRAPHY: INSURANCE AUA Insurance 268 Golden Valley Insurance Services 268 Photoguard 269

PHOTOGRAPHY: INTERNET RESOURCES absolutearts.com and World Wide Arts Resources Corp. 213 artart.co.uk 214 artcourses.co.uk 208 DegreeArt.com 40, 214 **Emerging Artists Art** Gallery 215 Fine Art Surrey 215 Foundation for Art and Creative Technology FACT) 164, 212 Gallery 1839 215, 400 Londonart.co.uk 215 On-lineGallery 216 Own It 217 Studioworx Contemporary

PHOTOGRAPHY: PRINTERS, PRINT PUBLISHERS AND PRINTMAKING Art Data 248, 285 ArtChroma 279 Digital Print Studio 280 Genesis Imaging Ltd 275, 281

Art Ltd 216

VADS 210

Loudmouth Art Eco-Printing 283 Mark Harwood Photography / LocaMotive 283 Mat Sant Studio 283 Metro Imaging Ltd 276, Oberon Art Ltd 283 Peak Imaging 284 Press On Digital Imaging Printmaker Studio 284 The Printrooms 284 Reggie Hastings 284 RotoVision 290 St Ives Printing & Publishing Co. 285 Wall Candi Ltd 285

PHOTOGRAPHY: PUBLIC
MUSEUMS AND ART
GALLERIES
20–21 Visual Arts Centre
147
Abbot Hall Art Gallery 162
Aberystwyth Arts Centre
187
Architectural Association
149
The Ark 197
Arts Gallery 149
ArtSway 174
Beacon 162
Beaconsfield 150
Bloomberg SPACE 150
Bolton Museum, Art

Gallery and Aquarium

Boxfield Gallery 144

Brunei Gallery 150 Bury Art Gallery, Museum and Archives 163 Bury St Edmunds Art Gallery 144 Cafe Gallery Projects London 151 Chapel Gallery 91 Charleston Farmhouse and Gallery 175 CHELSEA space 151 Chinese Arts Centre 163 Collective Gallery 83, 169 Collins Gallery 170 Cooper Gallery 193 Cornerhouse 163 Courtauld Institute of Art

Courthouse Arts Centre 197 Derby Museum and Art Gallery 147 Dianogly Art Gallery 147 Douglas Hyde Gallery 198 Draiocht Arts Centre 198 Dunamaise Arts Centre 199

Gallery 151

Eastleigh Museum 176
Fairfields Arts Centre 183
Fashion Space Gallery 152
Ferens Art Gallery 193

Ffotogallery 188 Focal Point Gallery 144 Folly 164 Foundation for Art and Creative Technology (FACT) 164, 212 Foundling Museum 153 Fox Talbot Museum 183 The Gallery - text+work 183 Gallery at Norwich University College of the Arts 145 Gallery of Photography 199 Gallery Oldham 164 Galway Arts Centre 199 Garter Lane Arts Centre Gilbert Collection 153 Glynn Vivian Art Gallery 188 Goethe-Institut London 153 Golden Thread Gallery 168 Green Dragon Museum and Focus Photography Gallery 160 Grundy Art Gallery 165 Guildford House Gallery 176 Hatton Gallery 160 Hermitage Rooms at Somerset House 154 HMAG (Hastings Museum and Art Gallery) 177 Hove Museum and Art Gallery 177 Hull Maritime Museum Imperial War Museum 154 Impressions Gallery 194 Institute of Contemporary Arts (ICA) 154 Inverleith House 171 Irish Museum of Modern Art 200 James Hockey Gallery 177 Kelvingrove Art Gallery and Museum 171 Kettle's Yard 145 King's Lynn Arts Centre 145 Laing Art Gallery 161 Learnington Spa Art Gallery and Museum 191 The Lighthouse 257 Linenhall Arts Centre 201 The Lowry 165 The Market House 201 Mead Gallery 191 Millais Gallery 178 Milton Keynes Gallery 178 Mount Stuart 172 Museum of East Asian Art Myles Meehan Gallery 161 National Media Museum National Monuments

Record Centre 184, 368

National Photographic

National Portrait Gallery

Archive 202

New Art Gallery, Walsall New Brewery Arts Centre Newby Hall and Gardens Old Market House Arts Centre 202 The Orangery and Ice House Galleries 155 Peacock Visual Arts 86, 173, Photofusion 59, 156 The Photographers' Gallery Prema 168 Project Arts Centre 202 Pump House Gallery 156 Quad Derby 148 Riverfront 189 Rochester Art Gallery & Craft Case 179 Royal College of Art 157, 313 Royal Cornwall Museum 186 Royal Institute of British Architects (RIBA) Gallery Saffron Walden Museum School of Art Gallery and Museum 189 Scottish National Portrait Gallery 173 Site Gallery 196 South London Gallery 157 South Tipperary Arts Centre 203 Tate Modern 158 Triskel 204 Tunbridge Wells Museum and Art Gallery 180 Turnpike Gallery 166 University of Brighton Gallery 180 Viewpoint Photography Gallery 166 Wapping Project 159 Whitechapel Gallery 159 Winchester Gallery 181 Windsor & Royal Borough Museum (W&RBM) Wolverhampton Art Gallery Wrexham Arts Centre 190 PHOTOGRAPHY:

PHOTOGRAPHY: SOCIETIES AND OTHER ARTISTS' ORGANIZATIONS Alternative Arts 437 Artists' Network Bedfordshire 439 Autograph ABP 440 Axis 214, 441 Bureau of Freelance Photographers 442 Cambridge Open Studios

443 Chelsea Arts Club 443 Design and Artists Copyright Society (DACS) 445 Fabrica 447 London Photographic Association 404, 451 Luna Nera 452 Midwest 452 Pavilion 289, 454 Peacock Visual Arts 86, 173, photodebut 455 **Oueens Park Arts Centre** 456 Revolutionary Arts Group 446 Royal Hibernian Academy Royal Photographic Society 458 Suffolk Open Studios 462 Visual Arts Scotland (VAS) 463 Westbury Farm Studios 464 PHOTOGRAPHY: STUDIO SPACE 107 Workshop 279, 292 36 Lime Street Ltd 292 ACAVA - Association for Cultural Advancement through Visual Art 263 Acme Studios 202 Art Space Portsmouth Ltd artists @ redlees 292 Artists and Restorers (A&R) Studios 292 Artspace Studios 293 ASC 293 Backlit 293 Barbican Arts Trust / Hertford Road Studios Bath Artists' Studios (formerly Widcombe Studios Ltd) 293 Blue Door Studios 293 Bow Arts Trust and Nunnery Gallery 150, 293 Broadstone Studios 294 The Camera Club 294 cell project space 294 Chelsea Bridge Studios 294 **Chocolate Factory Artists** Studios 294 Clevedon Craft Centre 294

Coin Street Community

Creekside Artists Studios

Cuckoo Farm Studios 295

Dalston Underground

Studios 295

The Drill Hall 295

Custom House Studios Ltd

Diesel House Studios 295

Fire Station Artists Studios

Builders 294

295

295

Flameworks Creative Arts Facility 206 Flax Art Studios 206 Florence Trust Studios 296 Framework Studios 206 Gasworks 206 Great Western Studios 296 Green Door Studios 296 Harrington Mill Studios (HMS) 297 Holborn Studios 297 Hoxton Street Studios 207 Islington Arts Factory 297 IAM Studios 297 Kingsgate Workshops Trust and Gallery 297 La Catedral Studios (incorporating Phoenix Art Studios) 297 Maryland Studios 298 Mivart Street Studios 298 Mother Studios 208 No 19 Cataibh, Dornoch Studio 298 Nottingham Artists' Group Openhand Openspace 298 Pallas Studios 137, 298 Pavilion Studios / Dukes Meadows Trust 298 Phoenix Arts Association 299, 455 Red Gate Gallery & Studios Rogue Artists' Studios 299 Southgate Studios 299 SPACE 299 Spotlight Studios 299 Stockwell Studios 299 Studio Voltaire 67, 300 Stu-Stu-Studio 299 Theatro Technis 300 Viking Studios and Bede Gallery 300 Visual Arts Centre 300 Wakefield Artsmill 300 Wasps Artists' Studios 300 Waygood Studios and Gallery 73, 300 West Walls Studios 300 Westbourne Studios 301 Westland Place Studios 301 Wimbledon Art Studios 301 Wollaton Street Studios 301 The Worx 301 Yorkshire Artspace Society Zoom In Ltd 301

PHOTOGRAPHY:

AND PRINTERS

Limited 273

Camera Box 273

Bob Rigby Photographic

BPD Photech Ltd 273

Cameraking.co.uk 273

London Camera Exchange Metro Imaging Ltd 276, Monolab 276 Monoprint 276 Morco 276 Morris Photographic 277 Palm Laboratory Park Cameras Ltd 277 Paterson Photographic Ltd PhotoArtistry Ltd 277 Process Supplies (London) Resolution Creative 278 Retro Photographic 278 Second Hand Darkroom Transpacolor Ltd 278 The Vault 278 Warehouse Express 279 Zoom In Photography 279 PORTRAITURE Abbot Hall Art Gallery 162 Abbott and Holder Ltd 30 Afton Gallery 87 Alan Kluckow Fine Art 87 Anthony Woodd Gallery SUPPLIERS, DEVELOPERS Calumet Photographic UK

82

AOP Gallery 32 Apollo Gallery 127 Art House 211 Art Matters Gallery 113 Artists' Network Bedfordshire 439 Artselect Ireland 127 Atlas Gallery 34 Axis **214, 441** Bankside Gallery **149, 441** Beacon 162 Beaux Arts 35 Black Mountain Gallery 113 Blackheath Gallery 35 Bolton Museum, Art Gallery and Aquarium

Carmarthen Camera

DTEK Systems 274

Farnell Photographic

Laboratory 274

fotoLibra 259, 274

Four Corners 275 Genesis Imaging Ltd 275,

Geoff Marshall

281

The Flash Centre 274

Photography Ltd /

Giles Cameras 275

IP Distributrion 275

Lab35 Imaging 276

(Midlands) Ltd 277

lan Stewart 275

Kaz Studio 275

Group 276

(UK) 277

Ltd 277

Supplies 278

283

Cornwall Cameras 275

Dunn's Imaging Group Plc

Centre 273

Digitalab 274 Downtown Darkroom 274 Roundary Gallery - Agi Katz Fine Art 36 Bourne Fine Art 82 BP Portrait Award 393 Bridge Gallery 128 Bristol's City Museum and Art Gallery 182 Brunei Gallery 150 Calvert 22 37 Cambridge Open Studios Cavanacor Gallery 129 Celeste Prize 394 Centre for Contemporary Arts (CCA) 169 Charleston Farmhouse and Gallery 175 Clarion Contemporary Art Collective Gallery 83, 169 Compton Verney 190 Context Gallery 79 Coombe Gallery 102 Cooper Gallery 193 Courtauld Institute of Art Gallery 151 Courthouse Gallery, Ballinglen Arts Foundation 129 Courtyard Arts Limited 130 Cranbrook Gallery 91 Customs House 71, 160 The Cynthia Corbett Gallery DegreeArt.com 40, 214 Delamore Arts 104 Derek Hill Foundation Scholarship in Portraiture 396 Design and Artists Copyright Society (DACS) 445 Domino Gallery 75 dot-art 76 Dublin Writers' Museum **Dunamaise Arts Centre** 199 Eleven 42 Elliott Gallery 104 Emer Gallery 80 Fairfax Gallery 43 FarmiloFiumano 43 Federation of British Artists (FBA) 426, 447 Ferens Art Gallery 193 fifiefofum 71 Fine Art Commissions Ltd Foundling Museum 153 Fourwalls 92 Gainsborough's House 144 Gallery Kaleidoscope 46 Gallery Oldham 164 Garter Lane Arts Centre Gilbert Collection 153 Gorry Gallery Ltd 132

Green Door Studio 229

Greenlane Gallery 132

Greenacres 132

Grosmont Gallery 125 Guildford House Gallery 176 Guildhall Art Gallery 153 Harewood House 193 Harris Museum and Art Gallery 165 Hazlitt Holland-Hibbert Heathfield Art 93 Helen Hooker O'Malley Roelofs Sculpture Collection 200 The Hepworth Wakefield Hermitage Rooms at Somerset House 154 Hesketh Hubbard Art Society 449 Hicks Gallery 48 Highgate Fine Art 49 Hind Street Gallery and Frame Makers 106 Holburne Museum of Art Imperial War Museum 154 **Ipswich Arts Association** James Hyman Gallery 51 Joan Clancy Gallery 133 Kelvingrove Art Gallery and Museum 171 The Kenny Gallery 134 Kerlin Gallery 134 Kettle's Yard 145 Kilvert Gallery 114 Kings Road Galleries 52 Kooywood Gallery 115 Laing Art Gallery 161 Lander Gallery 107 Laneside Gallery 80 Leamington Spa Art Gallery and Museum 191 Leinster Gallery 135 Limerick Printmakers Studio and Gallery 135, Linenhall Arts Centre 201 Long & Ryle 53 The Lowry 165 Magil Fine Art 135 Manchester Academy of Fine Arts Open 404 manorhaus 115 Martin Tinney Gallery 115 Mayfield Gallery 107 McNeill Gallery 23 Mercer Art Gallery 195 Michael Wood Fine Art 108 Midwest 452 Milton Keynes Gallery 178 Modern Artists' Gallery 95 Molesworth Gallery 135 National Gallery of Ireland National Gallery Of Scotland 172 National Museum and Gallery, Cardiff 189 National Portrait Gallery

155

National Self-Portrait Collection of Ireland 202 National Society of Painters, Sculptors & Printmakers 453 Naughton Gallery at Queens 168 New Art Gallery, Walsall The New Gallery 120 New Realms Limited 57 Nicholas Bowlby 95 Northcote Gallery Chelsea Oisin Art Gallery 136 The Origin Gallery 137 Pallant House Gallery 178 Parham House 178 Patchings Art Centre 28 Penlee House Gallery and Museum 185 photodebut 455 Picturecraft Gallery Ltd 24 Prema 185 Queens Park Arts Centre 456 The Residence 61 Revolutionary Arts Group Riverbank Arts Centre 203 Royal British Society of Sculptors 408, 457 Royal Hibernian Academy Royal Society of Miniature Painters, Sculptors and Gravers 459 Royal Society of Portait Painters 459 Royal West of England Academy (RWA) 186 Sainsbury Centre for Visual Arts 146 Sandford Gallery 138 Sartorial Contemporary Art Scarborough Art Gallery 196 School of Art Gallery and Museum 189 The Scottish Gallery 86 Scottish National Portrait Gallery 173 Sesame Gallery 64 Shoreline Studio 86 Simon Lee Gallery 64 Siopa Cill Rialaig Gallery 138 Skopelos Foundation for the Arts 410 Society of Catholic Artists 460 The Society of Graphic Fine Art 460 Society of Portrait Sculptors 461 Society of Scottish Artists (SSA) 461 Society of Women Artists 461 Solstice Arts Centre 203

South Tipperary Arts Centre 203 St Ives Society of Artists Gallery 110, 186 Stanley Spencer Gallery Start Contemporary Gallery Stroud House Gallery 111 Suffolk Art Society 461 Suffolk Open Studios 462 Summer Exhibition - Royal Academy of Arts 411 Taylor-Pick Fine Art 127 The Toll House Gallery 111 The Troubadour Gallery 68 Unicorn Gallery 78 Victoria Art Gallery 187 Vitreous Contemporary Art Waddesdon Manor 181 Widcombe Studios Gallery Wildwood Gallery 25 William Thuillier 70 Wolverhampton Art Gallery Woodbine Contemporary Arts 29 Yarm Gallery 73 Zimmer Stewart Gallery 99 PRINTS AND PRINTING 107 Workshop 279, 292 20/21 British Art Fair 376 20/21 International Art Fair 376 20-21 Visual Arts Centre 147 Abacus (Colour Printers) Ltd 179 Abbot Hall Art Gallery 162 Abbott and Holder Ltd 30 absolutearts.com and World Wide Arts Resources Corp. 213 Access to Arts 127 ACE Award for Art in a Religious Context 388 ACE/MERCERS International Book Award 388 Ackermann & Johnson Ltd Adolph & Esther Gottlieb Foundation Grants 389 **Advanced Graphics** London 30 Advantage Printers 279 Affordable Art Fair 376 The Afton Gallery 87 Alan Cristea Gallery 31 Alan Kluckow Fine Art 87 Alexandra Wettstein Fine Art 88 Amber Roome Contemporary Art 82 Andipa Gallery 32 Animal Arts 88 Ann Jarman 21 Anthony Woodd Gallery 82

AOP Gallery 32 Archeus 33 Archipelago Art Gallery and Studio 122 The Art House 233, 438 Art in Action 376 Art Marketing Ltd 279 Art Matters Gallery 113 ArtChroma 279 artcourses.co.uk 208 Arthouse Gallery 377 Artists & Illustrators 474 Artists & Makers Festival Artists' Network Bedfordshire 439 Artizana 74 Artline Media 279 artrepublic 89 Arts & Disability Forum Arts and Crafts in Architecture Awards 390 Arts Gallery 149 Arts Institute at Bournemouth 209 Artselect Ireland 127 Atishoo Designs 100 Atrium Gallery 100 August Art 34 Austin/Desmond Fine Art Ltd 34 Axis 214, 441 Bankside Gallery 149, 441 Barbara Behan Contemporary Art 34 Barry Keene Gallery 90 **Battersea Contemporary** Art Fair 378 The Beacon 162 Beaver Lodge Prints Ltd 280 Bell Fine Art Ltd 90 Benny Browne & Co. Ltd 74 Bianco Nero Gallery 122 Big Blue Sky 21 Bin Ban Gallery & Antiques 128 Bircham Gallery 21 Birties of Worcester 117 **Bishop Grosseteste University College** Lincoln 307 Black Church Print Studio Black Mountain Gallery 113 Blackheath Gallery 35 Blackpool and the Fylde College 316, 344 Blue Dot Gallery 101 Blue Lias Gallery 101 Bold Art Gallery 128 Bolton Museum, Art Gallery and Aquarium Bourne Fine Art 82 Bowie & Hulbert 113 Boxfield Gallery 144 Bradford College 333, 355 Braithwaite Gallery 123

Brewhouse Gallery 147

Bridge Gallery 128 Brighton Art Fair 378 Brighton Artists' Gallery of Contemporary Art 90 Brighton Museum and Art Gallery 175 **Brighton University 322** Bristol Guild 102 Bristol School of Art, Media and Design 326 British Museum 150 Broad Oak Colour Ltd 280 **Broughton House Gallery Buckinghamshire** New University 322, 347 Bury Art Gallery, Museum and Archives 163 **Byard Art Open** Competition 394 Camberwell College of Arts 310, 341 Cambridge Open Studios Cambridge School of Art, Anglia Ruskin University 306 Canvas 129 CanvasRus 280 Capsule 113 Castle Gallery 117 Castlefield Gallery 75, 163 Cat's Moustache Gallery Cavanacor Gallery 129 Celf 114 Central St Martins College of Art & Design 310, 341 Centre for Contemporary Arts (CCA) 169 The Centre of Attention 38 Chagford Galleries 91 Chapel Gallery 91 Charleston Farmhouse and Gallery 175 Cheltenham Art Gallery & Museum 182 Cheltenham Artists Open Houses 379 Cherrylane Fine Arts 129 Chester Beatty Library 197 Chichester Gallery 91 Chinese Arts Centre 163 **Christ Church Picture** Gallery 175 Christopher Wren Gallery Circa Art Magazine 476 Clapham Art Gallery 38 Cleveland College of Art & Design 294 Colin Jellicoe Gallery 75 Collins Gallery 170 Colorworld Imaging 280 Common Ground 426 Conservation Register 209 Context Gallery 79 Cork Art Fair 379 Cork Printmakers 280 Cosa Gallery 39

Courtauld Institute of Art Gallery 151 Courtenays Fine Art 103 Courthouse Gallery, Ballinglen Arts Foundation 129 Courtyard Arts Limited 130 Coventry University 330, Craftsmen's Gallery 91 Cranbrook Gallery 91 Craven College, Skipton 333, 355 Crawford Municipal Art Gallery 198 Creative Skills 426 Crescent Arts 123 Croft Wingates 26 Crown Studio Gallery 71 Croydon College 311, 341 Custom House Art Gallery and Studios 83 Customs House 71, 160 Daffodil Gallery 130 Dalkey Arts 130 Daniel Laurence Home & Garden 91 The Darryl Nantais Gallery Dayfold Solvit 280 De Lacey Fine Art 75 DegreeArt.com 40, 214 Delamore Arts 104 Design and Artists Copyright Society (DACS) 445 DesignerPrint 280 Digital Print Studio 280 **Dolphin Fine Art Printers** 281 Dolphin House Gallery 104 Dominic Guerrini Fine Art Domino Gallery 75 dot-art 76 **Dublin Institute of** Technology, Faculty of Applied Arts 336 Dun Laoghaire Institute of Art, Design & Technology 336 Duncan Campbell 41 Duncan of Jordanstone College of Art and Design 320 Dunstable College 306, 339 Eagle Gallery Emma Hill Fine Art 41 Earagail Arts Festival 380 East London Printmakers 281 East West Gallery 41 Edinburgh Printmakers 84 Eleven 42 Elizabeth Greenshields Foundation Grants 398 Elliott Gallery 104 **Emerging Artists Art** Gallery 215 The Empire 42 Enable Artists 446

England's Gallery 118 Evergreen Gallery 26 Exeter College 326, 350 Exmouth Gallery 104 Eyecandy 124 Eyes Wide Digital Ltd 281 Federation of British Artists (FBA) 426, 447 Felix Rosenstiel's Widow & Son Ltd 43 Fenton Gallery 131 Fenwick Gallery 71 Fermynwoods Contemporary Art 26 fifiefofum 71 Filton College 326, 350 Fine Art Society Plc 44 Fine Art Surrey 215 Fisherton Mill 104 Flowers East 44 Focal Point Gallery 144 Fosterart 44 Foundling Museum 153 Four Square Fine Arts 92 Fourwalls 92 Framework Gallery 265 Free Range 381 Friends of Israel **Educational Foundation** Friends of the Royal Scottish Academy Artist Bursary 400 Frivoli 45 Gainsborough's House 144 The Gallery - text+work 183 Gallery 1839 215, 400 Gallery 2000 76, 266 Gallery 42 124 The Gallery at Willesden Green 45 Gallery Kaleidoscope 46 Gallery Oldham 164 Gallery (Masham) 124 Galway-Mayo Institute of Technology 336 Garter Lane Arts Centre 199 Gemini Digital Colour Ltd Genesis Imaging Ltd 275, George Street Gallery 92 Gilbert Collection 153 Gillian Iason Modern & Contemporary Art 46 Glasgow Print Studio 84 Glass House Gallery 105 Glynn Vivian Art Gallery 188 Godfrey & Watt 124 Graal Press 281 Graphic Studio Gallery 132 Graves Art Gallery 193 Great Atlantic Map Works Gallery 105 Green Door Studio 229 Green On Red Gallery 132 Greenlane Gallery 132 Grosvenor Museum 164 Grundy Art Gallery 165

Gwen Raverat Archive 145 Harleston Gallery 22 Harley Gallery 27, 148 Harris Museum and Art Gallery 165 Hatton Gallery 160 Headrow Gallery 125 Helios at the Spinney 119 Helix Arts 427 Henry Donn Gallery 76 Henry Moore Foundation 356, 427 Herbert 190 Here Shop & Gallery 106 Herefordshire College of Art & Design 330, 353 The Hermit Press 281 Hermitage Rooms at Somerset House 154 Hicks Gallery 48 Hole Editions 282 Honor Oak Gallery Ltd 49 Hot Chilli Studio 282 Hotel 49 Howarth Gallery 76 Hudson Killeen 282 Hull School of Art and Design 333, 355 Hunter Gallery 23 Hunterian Art Gallery 171 imagiclee.com 282 Impact Arts 427 Imperial War Museum 154 Ingleby Gallery 84 Innocent Fine Art 106 Inspires Art Gallery 93 Institute of Techonology Sligo 337 Ipswich Art Society 450 Irish Arts Review 478 Irish Museum of Modern Art 200 J. Thomson Colour Printers Ltd 282 James Hyman Gallery 51 lames loyce House of the Dead 133 lewish Museum 154 Jill George Gallery 51 lim Robison and Booth House Gallery and Pottery 125 John Noott Galleries 119 Jones Art Gallery 133 Journal of Visual Culture 478 The Kenny Gallery 134 Kerlin Gallery 134 Kettle's Yard 145 Kilcock Art Gallery 134 Killarney Art Gallery 134 Kilvert Gallery 114 King's Lynn Arts Centre 145 Kooywood Gallery 115 La Gallerie 134 Lander Gallery 107 Laneside Gallery 80 Lavit Gallery 134 Leamington Spa Art Gallery and Museum 191 Leicester Print Workshop

Leinster Gallery 135 Limerick Institute of Technology 337 Limerick Printmakers Studio and Gallery 135, Linenhall Arts Centre 201 Liverpool History Shop 77 The London Original Print Fair 382 London Print Studio 53 Loudmouth Art Eco-Printing 283 Loughborough University 308, 340 Lowes Court Gallery 77 Lupe 53 Lynne Strover Gallery 23 Magic Flute Gallery 94 Manchester Academy of Fine Arts Open 404 Manchester Metropolitan University 317, 345 manorhaus 115 Margate Rocks 382 Mark Harwood Photography / LocaMotive 283 Mark Jason Gallery 54 Marlborough Fine Art 54 Martin Tinney Gallery 115 Mat Sant Studio 283 McTague of Harrogate 126 Mead Gallery 191 Mercer Art Gallery 195 Metro 212 Michael Wood Fine Art 108 Mid Cornwall Galleries 108 Midwest 452 Model Arts and Niland Gallery 201 Modern Artists' Gallery 95 Molesworth Gallery 135 Montpellier Gallery 119 Mount Stuart 172 Mulvany Bros. 136 National College of Art and Design 337 National Gallery of Ireland 201 National Gallery Of Scotland 172 National Museum of Women in the Arts (NMWA) Library Fellows Programme 405 National Photographic Archive 202 National Print Museum of Ireland 202 National Society of Painters, Sculptors & Printmakers 453 National War Museum 172 New Art Gallery, Walsall 192 New Craftsman 108 New Gallery 210 New North Press 283 New Realms Limited 57

Newcastle University 314

Newnum Art 283 Next Level 479 Norman Villa Gallery 136 North East Worcestershire College 331, 353 North Wales School of Art and Design 328 Northbrook College Sussex 366 Northcote Gallery Chelsea Northern Lights Gallery 78 Northumbria University 315 Number 15 116 Oberon Art Ltd 283 Object - Graduate Research and Reviews in the History of Art and Visual Culture October Gallery 57 Offer Waterman & Co. 57 On-lineGallery 216 Open Eye Gallery and i2 Gallery 85 **Open Studios** Northamptonshire 383 Oriel 116 The Origin Gallery 137 Original Print Gallery 137 Osborne Samuel 58 Own It 217 Oxford Brookes University 323, 348 P.J. Crook Foundation 185 Paddon & Paddon 96 Paisley Art Institute Annual **Exhibition Prizes and Biennial Scottish Drawing Competition** Pallant House Gallery 178 Parham House 178 Patrick Davies Contemporary Art 23 Paulsharma.com 284 Peacock Visual Arts 86, 173, Peak Imaging 284 Penlee House Gallery and Museum 185 Penwith Galleries and Penwith Society of Arts People's Gallery 137 The Photographers' Gallery Picturecraft Gallery Ltd 24 Plymouth City Museums and Art Gallery 185 Pratt Contemporary Art and Pratt Editions 284 Prema 185 Press On Digital Imaging Preview of the Visual Arts in Ireland 480 Print Quarterly Publications 480 Printmaker Studio 284

Printmakers Council 455

Printmaking Today 480

The Printrooms 284 Prism Proofing 284 Purdy Hicks Gallery 60 Queens Park Arts Centre 456 Redfoxpress 284 Regency Gallery 24 Reggie Hastings 284 Reprotech Studios Ltd 284 The Residence 61 Revolutionary Arts Group Richard Goodall Gallery 78 Riverbank Arts Centre 203 Robert Phillips Gallery 96 Roche Gallery 97 Rostra & Rooksmoor Galleries 109 Rowan Tree 137 Royal College of Art 157, 313 Royal Hibernian Academy Royal Society of Marine Artists 459 Royal Society of Painter-Printmakers 459 Royal West of England Academy (RWA) 186 Royal West of England Academy (RWA) Student Bursaries 408 Sadie Coles HQ 63 Saffron Walden Museum 146 Sally Mitchell Fine Arts 28 Saltgrass Gallery 97 Sarah Walker 138 Sartorial Contemporary Art Scarborough Art Gallery 196 School House Gallery 24 School of Art Gallery and Museum 189 The Scottish Gallery 86 Sculpture Lounge 126 Sesame Gallery 64 The Sheen Gallery 64 Sheffield College, Hillsborough Centre 334, Shell House Gallery 121 Shire Hall Gallery 192 shopforprints 216 Shoreline Studio 86 Shrewsbury Museum and Art Gallery 192 Siopa Cill Rialaig Gallery 138 Six Chapel Row Contemporary Art 98 Skopelos Foundation for the Arts 410 Skylark Galleries 65 Skylark Studios 24 Smart Gallery 126 Society of Catholic Artists The Society of Graphic Fine Art 460

Society of Scottish Artists (SSA) 461 Society of Women Artists Solomon Gallery 138 Solstice Arts Centre 203 Sorcha Dallas 86 South East Essex College 348 Southampton Solent University 323 St Ives Printing & Publishing Co. 285 St Ives Society of Artists Gallery 110, 186 Start Contemporary Gallery The Steps Gallery 66 Stone Gallery 138 Stoney Road Press 285 Storm Fine Arts 25 Street Gallery 111 Stroud House Gallery 111 Studio 1.1 66 Suffolk Art Society 461 Suffolk Open Studios 462 Summer Exhibition - Royal Academy of Arts 411 Swan Gallery 111 Swansea Open 411 Swindon College 327, 351 TailorMadeArt 81 Taylor Galleries 98 Taylor Gallery 139 The Warwick Gallery 349 Think Ink Ltd 285 Thoresby Gallery 29 Townhouse Gallery Portrush 81 Triskel 204 The Troubadour Gallery 68 Turn of the Tide Gallery 112 University College Falmouth 327, 351 University College London (UCL) Art Collections University of Brighton Gallery 180 University of Central Lancashire 319 University of Hertfordshire 307, 339 University of Luton 307 University of Northampton 310, 341 University of Southampton 325, 349 University of Wales Institute Cardiff 329, 352 University of Wales, Aberystwyth 329 University of Wales, Bangor 329 Urban Retreat 98 V&A Illustration Awards **VADS 210** Variant 482 Victorian Gallery 79 Visiting Arts 431

Visual Arts Scotland (VAS) Waddesdon Manor 181 Wall Candi Ltd 285 Washington Gallery 116 Watergate Street Gallery 79 Watling Street Galleries 29 Waygood Studios and Gallery 73, 300 Wendy J. Levy Contemporary Art 79 West Wales Arts Centre 117 West Yorkshire Print Workshop 285, 464 Westbury Farm Studios Western Light Art Gallery Westgate Gallery 87 Whitgift Galleries 70 Whitworth Art Gallery 167, 364 Widcombe Studios Gallery 112 Wildwood Gallery 25 Wolseley Fine Arts Ltd 121 Wolverhampton Art Gallery Women's Studio Workshop Fellowship Grants 413 The Wonderwall Gallery 112 Woodbine Contemporary Arts 29 Wordsworth Museum Art Gallery 167 Wrexham Arts Centre 190 Yarm Gallery 73 Yello Gallery 139 York College 335, 356 Zimmer Stewart Gallery 99 Zoo Art Fair 384

PUBLIC ART absolutearts.com and World Wide Arts Resources Corp. 213 Access to Arts 127 Architectural Association 149 Art Connections 438 The Art House 211 Art in Partnership 438 Art in Perpetuity Trust (APT) 438 Art Point Trust 421 ART.e @ the art of change Artpoint 439 Arts & Disability Forum 422 Arts and Crafts in Architecture Awards 390 Arts Council England 358, Arts Council of Northern Ireland 433 Arts Gallery 149 ARTS UK 440 Artsadmin 424 August Art 34

Axis 214, 441 **Bishop Grosseteste** University College Lincoln 307 Blue Lias Gallery 101 Bureau 75 Bury Art Gallery, Museum and Archives 163 Bury St Edmunds Art Gallery 144 Cafe Gallery Projects London 151 The Centre of Attention 38 Chinese Arts Centre 163 Chrysalis Arts Ltd 443 Cleveland College of Art & Design 294 Collective Gallery 83, 169 Common Ground 426 Contemporary Art Society Contemporary Glass Society 444 Courtauld Institute of Art Gallery 151 Courthouse Gallery, Ballinglen Arts Foundation 129 Creative Skills 426 Custard Factory 118 Danielle Arnaud contemporary art 40 DegreeArt.com 40, 214 Design and Artists Copyright Society (DACS) 445 **Dorset County Museum** ecArtspace 41 Enable Artists 446 Fairfields Arts Centre 183 Fine Art Surrey 215 Forma Arts & Media 448 Fosterart 44 Foundling Museum 153 Four Square Fine Arts 92 Freeform 427 The Gallery – text+work 183 Gilbert Collection 153 Global Arts Village 401 Glynn Vivian Art Gallery 188 Greenwich Mural Workshop 448 Guildford House Gallery **Gunk Foundation Grants** for Public Arts Projects Harley Gallery 27, 148 Helix Arts 427 Here Shop & Gallery 106 Herefordshire College of Art & Design 330, 353 Hermitage Rooms at Somerset House 154 Hind Street Gallery and

Frame Makers 106

Hull School of Art and

ICAS - Vilas Fine Art 23

Tate Modern 158

Design 333, 355

Impact Arts 427 Institute of Contemporary Arts (ICA) 154 Ipswich Arts Association Iris, International Women's Photographic Research 346 Resource 427 ixia 450 Kelvingrove Art Gallery and Museum 171 Kettle's Yard Open / **Residency Opportunities** Kooywood Gallery 115 Leamington Spa Art Gallery and Museum 191 Manchester Academy of Fine Arts Open 404 Media Art Bath 452 Middlesex University 312 Midwest 452 Milton Keynes Gallery 178 Mount Stuart 172 Naughton Gallery at Queens 168 Newcastle University 315 North Wales School of Art and Design 328 Northumbria University 315 Office of Public Works 202 Own It 217 Oxford Brookes University 323, 348 Pallas Studios 137, 298 Patrick Davies Contemporary Art 23 484 Peer 59 **Public Art Commissions** and Exhibitions (PACE) Public Art South West 430 Purchase Prize BlindArt Permanent Collection Revolutionary Arts Group 456 Royal British Society of Sculptors 408, 457 Royal Hibernian Academy 147 Sadie Coles HQ 63 Sartorial Contemporary Art 63 SAW (Somerset Art Works) Shoreline Studio 86 Society for Religious Artists (SFRA) 460 Society of Botanical Artists 460 Society of Catholic Artists 460 Solstice Arts Centre 203 Sorcha Dallas 86 South London Gallery 157 Southampton Solent University 323 Stanley Spencer Gallery 180

Tees Valley Arts 431 Triskel 204 Union 69 University of Northampton 310, 341 University of Salford 319, University of Southampton 325, 349 **VADS 210** Visiting Arts 431 Waddesdon Manor 181 York College 335, 356

PUBLIC RELATIONS Arts Marketing Association Arts Media Contacts 475 Artsinform Communications Ltd Bolton & Quinn Ltd 483 Brunswick Arts Consulting Callum Sutton PR 483 Cawdell Douglas 483 Hobsbawm Media 1 Marketing Communications Ltd (HMC) 483 HQ - International Communications for the Arts Ltd 483 Idea Generation 484 JB Pelham PR 484 Parker Harris Partnership Pippa Roberts Publicity & Communications 484 Rebecca Ward 484 Sheeran Lock Ltd 260 Sue Bond Public Relations Theresa Simon Communications 484

REALIST ART 108 Fine Art 122 20-21 Visual Arts Centre Abbott and Holder Ltd 30 absolutearts.com and World Wide Arts Resources Corp. 213 Adonis Art 30 Alan Kluckow Fine Art 87 Anthony Woodd Gallery 82 AOP Gallery 32 Apollo Gallery 127 The Art House 211 Art Matters Gallery 113 Artists' Network Bedfordshire 439 Axis **214, 441** Bankside Gallery **149, 441** Barn Gallery 128 Bell Fine Art Ltd 90 Blackheath Gallery 35 Bold Art Gallery 128 Bridge Gallery 128 Buckenham Galleries 21

Clifton Gallery 102 Colin Jellicoe Gallery 75 Context Gallery 79 Cooper Gallery 193 Cornwall Galleries 103 Courthouse Gallery, Ballinglen Arts Foundation 129 Courtyard Arts Limited 130 Crown Studio Gallery 71 Customs House 71, 160 Daniel Laurence Home & Garden 91 DegreeArt.com 40, 214 Delamore Arts 104 Design and Artists Copyright Society (DACS) 445 Edinburgh Printmakers 84 Elephant Trust Award 398 Eleven 42 Elliott Gallery 104 Fairfields Arts Centre 183 Fine Art Society Plc 44 Fine Art Surrey 215 The Gallery at Willesden Green 45 Gallery Oldham 165 Garter Lane Arts Centre Gascoigne Gallery 124 George Street Gallery 92 Gilbert Collection 153 Green Door Studio 229 Greenlane Gallery 132 Grosmont Gallery 125 Grundy Art Gallery 165 **Guild of Aviation Artists** 449 Hazlitt Holland-Hibbert 48 Heathfield Art 93 Hermitage Rooms at Somerset House 154 Highgate Fine Art 49 Hind Street Gallery and Frame Makers 106 ICAS - Vilas Fine Art 23 **Ipswich Arts Association** 450 James Hyman Gallery 51 John Davies Gallery 106 John Noott Galleries 119 Jones Art Gallery 133 Jordan & Chard Fine Art The Kenny Gallery 134 Kerlin Gallery 134 Kettle's Yard 145 Killarney Art Gallery 134 Kings Road Galleries 52 Kooywood Gallery 115 Lander Gallery 107 Laneside Gallery 80 Learnington Spa Art Gallery and Museum 191 Leinster Gallery 135 Limerick Printmakers Studio and Gallery 135, Lincoln Joyce Fine Art 94

Linda Blackstone Gallery Linenhall Arts Centre 201 Lynn Painter-Stainers Prize Manchester Academy of Fine Arts Open 404 manorhaus 115 Mark Jason Gallery 54 Martin Tinney Gallery 115 McNeill Gallery 23 Michael Wood Fine Art 108 Midwest 452 Modern Artists' Gallery 95 Molesworth Gallery 135 National Society of Painters, Sculptors & Printmakers 453 New Craftsman 108 Nicholas Bowlby 95 Northcote Gallery Chelsea Oisin Art Gallery 136 Open Eye Gallery and i2 Gallery 85 Opus Gallery 28 The Origin Gallery 137 Own It 217 Patchings Art Centre 28 Penlee House Gallery and Museum 185 Peterborough Art House Ltd 24 Plus One Gallery 60 Pybus Fine Arts 126 Quantum Contemporary Art 60 **Queens Park Arts Centre** 456 Rainyday Gallery 109 The Residence 61 Revolutionary Arts Group 456 Royal British Society of Sculptors 408, 457 Royal Hibernian Academy Royal West of England Academy (RWA) 186 Sally Mitchell Fine Arts 28 Sartorial Contemporary Art School of Art Gallery and Museum 189 The Scottish Gallery 86 Sesame Gallery 64 Shoreline Studio 86 Siopa Cill Rialaig Gallery 138 Skopelos Foundation for the Arts 410 The Society of Graphic Fine Art 460 Society of Women Artists 461 Solomon Gallery 138 South Tipperary Arts Centre 203 St Ives Society of Artists Gallery 110, 186

Start Contemporary Gallery Strand Art Gallery 110 Stroud House Gallery 111 Suffolk Art Society 461 Summer Exhibition - Royal Academy of Arts 462 T.B. & R. Jordan Lapada 73 Tate Modern 158 Taylor-Pick Fine Art 127 The Toll House Gallery 111 Vitreous Contemporary Art Washington Gallery 116 Waygood Studios and Gallery 73, 300 Widcombe Studios Gallery Wolverhampton Art Gallery Woodbine Contemporary Arts 29 Zimmer Stewart Gallery 99 RESIDENCIES 176 Gallery / The Zabludowicz Collection ACE/REEP Award 388 Akademie Schloss Solitude Artist-in-Residence. Durham Cathedral 390 Artists Residences (Cyprus) 390 Arts Council of Northern Ireland International Residencies 391 Arts Council of Northern Ireland Support for Individual Artists Programme 391 Artsadmin 424 ArtSway 174 Balmoral Scholarship for Fine Arts 392 Beaconsfield 150 Braziers International Artists Workshop 393 Camden Arts Centre 151 Castlefield Gallery 75, 163 Centre for Contemporary Arts (CCA) 169 Chapter Gallery 188 Chinese Arts Centre 163 The Cill Rialaig Project Artists Retreat 394 CORE Program 395 Cornerhouse 163 Cove Park Residency Programme 395 De Ateliers 396 Delfina Studio Trust 396 Derek Hill Foundation Scholarship in Portraiture 396 Deveron Arts Residency Programme 397 Djerassi Resident Artists Program 397 Draíocht Arts Centre 198

Dulwich Picture Gallery 152 Florence Trust Residencies 399 Focal Point Gallery 144 Friends of Israel **Educational Foundation** Gallery Oldham 164 Gilbert Collection 153 Global Arts Village 401 Helix Arts 427 Hermitage Rooms at Somerset House 154 HMAG (Hastings Museum and Art Gallery) 177 International Artists Centre, Poland -Miedzynarodowe Centrum Sztuki 401 Irish Museum of Modern Art 200 ISIS Arts 427 Island Arts Centre 168 Kettle's Yard Open / **Residency Opportunities** King's Lynn Arts Centre 145 Leverhulme Trust Grants and Awards 403 Mercer Art Gallery 195 Monnow Valley Arts Centre Montana Artists' Refuge Residency Program 404 National Sculpture Factory Residencies 405 Naughton Gallery at Queens 168 New Art Gallery, Walsall Pepinières Europeénnes Pour Jeunes Artistes 406 Picture This 429 Polish Cultural Institute The Royal Scottish Academy Residencies for Scotland 408 Sainsbury Scholarship in Painting and Sculpture Sargant Fellowship 410 Sirius Arts Centre 203 Site Gallery 196 Skopelos Foundation for the Arts 410 Soros Centres for Contemporary Arts (SCCA) Network Residencies 411 South London Gallery 157 Straumur International Art Commune 411 Triskel 204 Tunbridge Wells Museum and Art Gallery 180 Tyrone Guthrie Centre 204 **UNESCO** Aschberg Bursaries for Artists 401 Usher Gallery 148 Visiting Arts 431

VIVID 431 Wingate Rome Scholarship in the Fine Arts 412 Wordsworth Museum Art Gallery 167

RETAILERS see ART MATERIALS RETAILERS

SCULPTURE 108 Fine Art 122 176 Gallery / The Zabludowicz Collection 20/21 British Art Fair 376 20-21 Visual Arts Centre 291 Gallery 29 AA Files 473 AB Fine Art Foundry Ltd Abbot Hall Art Gallery 162 absolutearts.com and World Wide Arts Resources Corp. 213 Access to Arts 127 ACE Award for Art in a Religious Context 388 ACE/REEP Award 388 Adolph & Esther Gottlieb Foundation Grants 389 Adonis Art 30 Affordable Art Fair 376 The Afton Gallery 87 The Agency 30 Agnew's 30 Ainscough Gallery 74 Alan Kluckow Fine Art 87 Alec Tiranti Ltd 237 Alexander Gallery 100 Alexander-Morgan Gallery

Alexandra Wettstein Fine Art 88

Andipa Gallery 32 Andrew Logan Museum of Sculpture 187 Ann Iarman 21 Anne Faggionato 32 Annely Juda Fine Art 32

Anthony Hepworth Fine Art Dealers Ltd 100 Anthony Reynolds Gallery

Anthony Woodd Gallery 82 Apollo Magazine 473 The Art Academy 310 Art Bronze Foundry (London) Ltd 261 Art Centre and Gallery 240 Art Data 248, 285 Art History 474 The Art House 233, 438 Art in Action 376

Art in Partnership 438 Art in Perpetuity Trust (APT) 438 Art London 377

Art Matters Gallery 113 Art Space Portsmouth Ltd 292

ART.e @ the art of change artart.co.uk 214 artcourses.co.uk 208 Arthouse Gallery 377 Artist Eye Space 22 artists @ redlees 292 Artists' Network Bedfordshire 439 Artizana 74 Arts & Disability Forum

Arts and Crafts in Architecture Awards

Arts Gallery 149 Arts/Industry Artist-in-Residency 392 Artselect Ireland 127 Artstore at the Artschool Ltd 236 ArtSway 174 Artwork Sculpture Gallery

Ashmolean Museum Shop

Aspex Gallery 175 Attic Gallery 113 August Art 34 Axis 214, 441 Barbara Behan

Contemporary Art 34 Barbara Hepworth Museum and Sculpture Garden 182 Barn Galleries 80

Barry Keene Gallery 90 Bath School of Art and Design 325

Battersea Contemporary Art Fair 378 The Beacon 162 Beaconsfield 150

Bearspace 35 Beaux Arts 101 Bedford College 321, 338 Bell Fine Art Ltd 90 Bell Gallery 79

Bianco Nero Gallery 122 Big Blue Sky 21 Bircham Gallery 21

Birmingham Institute of Art and Design 330 Birties of Worcester 117 Bischoff/Weiss 35 Biscuit Factory 70

Bishop Grosseteste University College Lincoln 307 Black Mountain Gallery 113 Blackheath Gallery 35

Blades the Art Works 243 Blake Gallery 122 The Bleddfa Centre 187 Bloomberg SPACE 150 Bloxham Galleries 36 Blue Dot Gallery 101 Blue Leaf Gallery 128 Blue Lias Gallery 101 Bluemoon Gallery 90 Blyth Gallery 74

Blyth's Artshop & Gallery

Bold Art Gallery 128 Bolton Museum, Art Gallery and Aquarium

Boundary Gallery - Agi Katz Fine Art 36 Bourne Fine Art 82 Braziers International

Artists Workshop 393 Brewhouse Gallery 147 Brick Lane Gallery 36 Bridge Gallery 128 Brighton Art Fair 378 Brighton University 322 Broadway Modern 117 Bronze Age Sculpture

Casting Foundry Ltd and Limehouse Gallery 261 Brunei Gallery 150 Bruton Gallery 123 Buckenham Galleries 21 Bureau 75 Burrell Collection 169

Burren College of Art 335 Burton Art Gallery and Museum 182 Bury St Edmunds Art

Gallery 144 Buy Art Fair 378 Byard Art Open Competition 394 Cafe Gallery Projects

London 151 Calvert 22 37 Camberwell College of Arts 310, 341

Cambridge Open Studios Cambridge School of Art, Anglia Ruskin University

306 Campbell Works 37 Canonbury Arts 228 Canvas 129 Cartwright Hall Art Gallery

193 Cass Sculpture Foundation

Cast Iron Co. Ltd 261 Castle Fine Arts Foundry 261

Castle Gallery 117 Castlefield Gallery 75, 163 Cavanacor Gallery 129 Celf Caerleon Arts Festival

Centre for Contemporary Arts (CCA) 169 The Centre of Attention 38 Chapel Gallery 91

Chappel Galleries 22 Charleston Farmhouse and Gallery 175 Chelsea Arts Club 443 CHELSEA space 151 Cheltenham Artists Open

Houses 379 Cherrylane Fine Arts 129 Chesterfield College 308,

344 Chichester Gallery 91 Chocolate Factory Artists Studios 294

Clifton Gallery 102 Colin Jellicoe Gallery 75 Collective Gallery 83, 169 Collins Gallery 170 Common Ground 426 Compton Verney 190 Conservation Register

Contemporary Glass Society 444 Context Gallery 79 Coombe Gallery 102 Cooper Gallery 193 Cork Art Fair 379 Corman Arts 258 Cornerhouse 163 Courtauld Institute of Art

Gallery 151 Courthouse Arts Centre

Courthouse Gallery, Ballinglen Arts Foundation 129 Courtyard Arts Limited 130 Coventry University 330,

353 Craftsmen's Gallery 91 Crawford Municipal Art

Gallery 198 Creative Skills 426 Croft Wingates 26 Crown Studio Gallery 71 Cube Gallery 103 Cupola Contemporary Art

Custom House Studios Ltd Customs House 71, 160

CY Gallery 130 The Cynthia Corbett Gallery

Daffodil Gallery 130 Damon Bramley 270 Daniel Laurence Home & Garden 91

Darcy Turner 229 Dean Gallery 170 DegreeArt.com 40, 214 Delamore Arts 104 Delfina Studio Trust 396 Derby Museum and Art Gallery 147

Design and Artists Copyright Society (DACS) 445 Dickson Russell Art

Management 259 doggerfisher 83 **Dorset County Museum** 183

dot-art 76 Draíocht Arts Centre 198 The Drawing Room 40 Dublin Institute of Technology, Faculty of Applied Arts 336

Technology 330, 353

Dun Laoghaire Institute of

Dudley College of

Art, Design &

Technology 336

Dunamaise Arts Centre

Duncan of Jordanstone College of Art and Design 320 Dunstable College 306, Dyehouse Gallery 130 Earagail Arts Festival 380 East Neuk Open 380 East West Gallery 41 Edinburgh Art Fair 380 Edinburgh College of Art EggSpace 76 Elastic Residence 42 Elephant Trust Award 398 Eleven 42 Elizabeth Greenshields Foundation Grants 398 Elliott Gallery 104 Emer Gallery 80 **Emerging Artists Art** Gallery 215 Emily Tsingou Gallery 42 Enable Artists 446 Estorick Collection of Modern Italian Art 152 Fairfax Gallery 43 Fairfields Arts Centre 183 FarmiloFiumano 43 Federation of British Artists (FBA) 426, 447 Fenton Gallery 131 Ferens Art Gallery 193 fifiefofum 71 Filton College 326, 350 Fine Art Commissions Ltd Fine Art Society Plc 44 Fine Art Surrey 215 Fisherton Mill 104 Flax Art Studios 296 Flowers East 44 Flying Colours Gallery 44 Folkestone Triennial Visitor Centre 381 Foundling Museum 153 Four Square Fine Arts 92 Francis Iles 92 Frank Lewis Gallery 131 Free Range 381 Friends of the Royal Scottish Academy Artist Bursary 400 Frink School of Figurative Sculpture 316 Frith Street Gallery 45 Frivoli 45 Gainsborough's House 144 The Gallery – text+work 183 Gallery 52 26 **Gallery 75 131** Gallery at Norwich University College of the

Arts 145

The Gallery at Willesden Green 45 Gallery Beckenham 92 Gallery Kaleidoscope 46 Gallery Oldham 164 Gallery One 46, 80 Gallery Top 26 The Gallery Upstairs 119 Galway Arts Centre 199 Galway-Mayo Institute of Technology 336 Garter Lane Arts Centre Gilbert Collection 153 Gillian Jason Modern & Contemporary Art 46 Glass House Gallery 105 Global Arts Village 401 Glynn Vivian Art Gallery 188 Godfrey & Watt 124 Golden Thread Gallery Goldfish Contemporary Fine Art 105 Gorey School of Art 336 Gormleys Fine Art 80, 131 Gorry Gallery Ltd 132 Great Atlantic Map Works Gallery 105 Green Gallery 160 Green On Red Gallery 132 Greenacres 132 Greenlane Gallery 132 Grizedale Sculpture Park Grosmont Gallery 125 Grosvenor Gallery (Fine Arts) Ltd 47 Group 75 449 Grundy Art Gallery 165 Guild of Aviation Artists Guildhall Art Gallery 153 Hanina Fine Arts 47 Hannah Peschar Sculpture Garden 93 Harlequin Gallery 47 Harleston Gallery 22 Harris Museum and Art Gallery 165 Hart Gallery 27 Hartworks Contemporary Art 105 Hatton Gallery 160 Haunch of Venison 48 Hazlitt Holland-Hibbert 48 Head Street Gallery 22 Headrow Gallery 125 Helen Hooker O'Malley Roelofs Sculpture Collection 200 Helios at the Spinney 119 Helix Arts 427 Henry Moore Foundation 356, 427 Henry Moore Institute 194, The Hepworth Wakefield Here Gallery 190

Herefordshire College of Art & Design 330, 353 Hermitage Rooms at Somerset House 154 Hertfordshire Gallery 23 Hicks Gallery 48 Highgate Fine Art 49 Hillsboro Fine Art 133 Hind Street Gallery and Frame Makers 106 HMAG (Hastings Museum and Art Gallery) 177 Hope Gallery 27 Hotel 49 Houldsworth 50 Huddersfield Art Gallery The Hugh Lane Dublin City Gallery 344 Hull School of Art and Design 333, 355 Hunter Gallery 23 Hunterian Art Gallery 171 ICAS - Vilas Fine Art 23 IceTwice 93 Impact Art 259 Imperial War Museum 154 Ingleby Gallery 84 Institute of Contemporary Arts (ICA) 154 Inverleith House 171 Ipswich Art Society 450 Irish Arts Review 478 Irish Museum of Modern Art 200 James Hyman Gallery 51 James Joyce House of the Dead 133 The Ierdan Gallery 85 Jerwood Sculpture Prize 402 Jerwood Space 51 Jim Robison and Booth House Gallery and Pottery 125 John Martin Gallery 51 John Noott Galleries 119 Jonathan Poole Gallery 106 Jones Art Gallery 133 Jordan & Chard Fine Art 106 Jorgensen Fine Art 133 Journal of Visual Culture 478 Kangaroo Kourt 107 Keane on Ceramics 134 Kelvingrove Art Gallery and Museum 171 The Kenny Gallery 134 Kerlin Gallery 134 Kettle's Yard 145 Kilcock Art Gallery 134 Kilvert Gallery 114 King's Lynn Arts Centre 145 Kings Road Galleries 52 Kooywood Gallery 115 La Mostra Gallery 115 Laing Art Gallery 161 Lakeland Mouldings 261 Lander Gallery 107 Laneside Gallery 80 Lavit Gallery 134

Leamington Spa Art Gallery and Museum 191 Learning Stone Portland Sculpture and Quarry Leeds City Art Gallery 194 Leeds College of Art & Design 333, 355, 370 Leinster Gallery 135 Leitrim Sculpture Centre The Lighthouse 257 Limerick City Gallery 200 Limerick Institute of Technology 337 Limerick Printmakers Studio and Gallery 135, Linda Blackstone Gallery Linenhall Arts Centre 201 Lisson Gallery 52 **Liverpool Community** College 316, 345 Livingstone Art Founders 261 Londonart.co.uk 215 Loughborough University 308, 340 Lowes Court Gallery 77 LS Sculpture Casting 262 Lucy B. Campbell Fine Art Lunts Castings Ltd 262 Lynne Strover Gallery 23 Magic Flute Gallery 94 Magil Fine Art 135 Magpie Gallery 27 Manchester Academy of Fine Arts Open 404 Manchester Art Gallery 165 Manchester Metropolitan University 317, 345 Manser Fine Art 119 Marchmont Gallery and Picture Framer 85 Margate Rocks 382 Mark Tanner Sculpture Award 404 The Market House 201 Marlborough Fine Art 54 Martin Tinney Gallery 115 Martin's Gallery 107 Matt's Gallery 54 Maureen Paley 54 McNeill Gallery 23 Mead Gallery 191 Meadow Gallery 191 MFH Art Foundry Ltd 262 Michael Wood Fine Art 108 Mid Cornwall Galleries 108 Middlesex University 312 Midwest 154 Mike Smith Studio 262 Millais Gallery 178 Milton Keynes Gallery 178 Milwyn Casting 262 Minories Art Gallery 145 Model Arts and Niland Gallery 201 Modern Artists' Gallery 95

Molesworth Gallery 135 Monika Bobinska 56 Montana Artists' Refuge Residency Program 404 Montpellier Gallery 119 Morris Singer Art Founders 262 Mothers Tankstation 136 Mount Stuart 172 Moya Bucknall Fine Art 119 Museum 52 56 Myles Meehan Gallery 161 Narrow Space 136 National College of Art and Design 337 National Gallery of Ireland National Sculpture Factory Residencies 405 National Society of Painters, Sculptors & Printmakers 453 Naughton Gallery at Queens 168 Nettie Horn 56 Neville Pundole Gallery 95 New Art Centre 184 New Art Centre Sculpture Park & Gallery 108 New Art Gallery, Walsall 192 New Craftsman 108 New Realms Limited 57 Newby Hall and Gardens 195 Newcastle University 315 Nicholas Bowlby 95 Norman Villa Gallery 136 North East Worcestershire College 331, 353 North Wales School of Art and Design 328 Northbrook College Sussex 366 Northcote Gallery Chelsea Northern Lights Gallery 78 Northumbria University 315 Number Nine the Gallery 120 Oberon Art Ltd 283 Object - Graduate Research and Reviews in the History of Art and Visual Culture 479 479 October Gallery 57 Offer Waterman & Co. 57 Oisin Art Gallery 136 Open Eye Gallery and i2 Gallery 85 The Orangery and Ice House Galleries 155 Oriel Canfas Gallery 116 The Origin Gallery 137 OSB Gallery Ltd 137 Osborne Samuel 58 Own It 217 Oxford Brookes University Oxmarket Centre of Arts 95 Paddon & Paddon 96

Sadie Coles HQ 63 Pallant House Gallery 178 Sadler Street Gallery 109 Pallas Studios 137, 298 Pangolin Editions 262 Safehouse 169 Sainsbury Centre for Visual Patchings Art Centre 28 Arts 146 Patrick Davies Sainsbury Scholarship in Contemporary Art 23 Peacock Visual Arts 86, 173, Painting and Sculpture Salar Gallery 109 Peer 59 Penwith Galleries and Saltburn Gallery 72 Penwith Society of Arts Sandford Gallery 138 185 Sarah Walker 138 People's Gallery 137 Sargant Fellowship 410 Phoenix Arts Association Sartorial Contemporary Art 299, 455 Piano Nobile Fine The Scottish Gallery 86 Paintings Ltd 59 Scottish National Gallery of Modern Art 173 Pieroni Studios 59 Scottish National Portrait Pitt Rivers Museum 179 Plus One Gallery 60 Gallery 173 Scottish Sculpture Powderhall Bronze 262 Workshop Programme Prema 185 Preview of the Visual Arts in Sculpture Journal 481 Ireland 480 Sculpture Lounge 126 Priory Gallery Broadway 120 Sheeran Lock Ltd 260 Project Arts Centre 202 Sheffield College, Hillsborough Centre 334, **Public Art Commissions** and Exhibitions (PACE) Shoreline Studio 86 429 The Showroom 64 Queens Park Arts Centre Shrewsbury Museum and 456 Art Gallery 192 Rachel Gretton Glass 126 Simon Lee Gallery 64 Raw Arts Festival 383 Siopa Cill Rialaig Gallery Raw Vision 481 Red Gallery 96 138 Red Rag Gallery 109 Sir John Soane's Museum The Residence 61 Revolutionary Arts Group Six Chapel Row Contemporary Art 98 456 Skopelos Foundation for Ritter/Zamet 62 Riverbank Arts Centre 203 the Arts 410 Rivington Gallery 62 Skylark Galleries 65 Sligo Art Gallery 203 Robert Phillips Gallery 96 Robert Sandelson 62 Society of Catholic Artists Roche Gallery 97 460 Room for Art Gallery 97 Society of Portrait Rostra & Rooksmoor Sculptors 461 Society of Scottish Artists Galleries 109 Royal British Society of (SSA) 461 Society of Women Artists Sculptors 408, 457 Royal College of Art 157, 313 Royal Cornwall Museum Solihull College 331, 354 Solomon Gallery 138 Solstice Arts Centre 203 Royal Glasgow Institute of the Fine Arts 457 Sorcha Dallas 86 Royal Hibernian Academy South East Essex College 348 457 Royal Society of Marine South London Gallery 157 Artists 459 South Tipperary Arts Royal Society of Miniature Centre 203 Painters, Sculptors and Southwold Gallery 24 Gravers 459 Space Station Sixty-Five 65 Spitz Gallery 65 Royal West of England Academy (RWA) 186 St Ives Society of Artists Royall Fine Art 97 Gallery 110, 186 St John Street Gallery 28 Rubicon Gallery 137 Rupert Harris Conservation Standpoint Gallery 66 Star Gallery 98 Russell-Cotes Art Gallery Start Contemporary Gallery

and Museum 179, 368

The Steps Gallery 66 Stone Gallery 138 STORE 66 Stroud House Gallery 111 Studio 1.1 66 Studio Glass Gallery 67 Studio Voltaire 67, 300 Study Gallery 186 Suffolk Art Society 461 Suffolk Open Studios 462 Summer Exhibition - Royal Academy of Arts 411 Summerleaze Gallery 111 Sundridge Gallery 98 Swansea Open 411 Swindon College 327, 351 Talbot Rice Gallery 174 Tate Modern 158 Taurus Gallery 98 Taylor Galleries 81, 139 Taylor Pearce Ltd 257 Taylor-Pick Fine Art 127 The Darryl Nantais Gallery Theresa McCullough Ltd Third Text 482 Thompson Gallery 25 Thornthwaite Galleries 78 Tigh Fili 139 The Toll House Gallery 111 Tom Caldwell Gallery 81 Torrance Gallery 87 Towneley Hall Art Gallery & Museum 196 Tracey McNee Fine Art 87 Tregony Gallery 111 The Troubadour Gallery 68 Tryon Galleries 68 Tuckmill Gallery 139 Turnpike Gallery 166 Ulster Museum 169 Unicorn Gallery 78 Union 69 University College London (UCL) Art Collections 158 University of Bath 327 University of Brighton Gallery 180 University of Hertfordshire 307, 339 University of Liverpool Art Gallery 166 University of Northampton 310, 341 University of Salford 319, 346 University of Southampton 325, 349 University of Teeside 315 University of Wales Institute Cardiff 329, 352 Urban Retreat 98 **VADS 210** Valentine Walsh 258 Variant 482 Victoria Miro Gallery 69 Visiting Arts 431 Visual Arts Scotland (VAS) 463

Vitreous Contemporary Art Waddesdon Manor 181 Waddington Galleries 60 Walker Galleries Ltd 127 Wallace Collection 158 Wapping Project 159 The Warwick Gallery 121 Warwickshire College 332.

Washington Gallery 116 Waygood Studios and Gallery 73, 300 West Cork Arts Centre 204 West Wales Arts Centre 117 West Wales School of the Arts 330, 352 Westbury Farm Studios

464 Western Light Art Gallery 139

Westgate Gallery 87 Whitechapel Gallery 159 Whitford Fine Art 70 Whittington Fine Art 99 Whitworth Art Gallery 167, 364 Widcombe Studios Gallery

112 Wildwood Gallery 25 William Frank Gallery 130 Wimbledon College of Art

314, 343 Winchester Gallery 181 Wingate Rome Scholarship in the Fine Arts 402 Wolseley Fine Arts Ltd 121 Wolverhampton Art Gallery

Woodbine Contemporary Arts 29 Wordsworth Museum Art

Gallery 167 Workplace Art Consultancy

Worthing Museum and Art Gallery 181 Wrexham Arts Centre 190 Yarm Gallery 73 York College 335, 356 Yorkshire Sculpture Park

Zimmer Stewart Gallery 99 Zoo Art Fair 384

VALUATION Albion / AAR 88 Andipa Gallery 32 Beaux Arts 35 Bell Fine Art Ltd 90 Blackheath Gallery 35 Boundary Gallery - Agi Katz Fine Art 36 Bourne Fine Art 82 Cavanacor Gallery 129 DegreeArt.com 40, 214 Dickson Russell Art Management 259 East West Gallery 41 Emer Gallery 80 England's Gallery 118

Fine Art Society Plc 44 Gallery Kaleidoscope 46 Gillian Jason Modern &

Contemporary Art 46 Gorry Gallery Ltd 132 Hazlitt Holland-Hibbert 48 The Kenny Gallery 134 Headrow Gallery 125 Henry Boxer Gallery 48 Highgate Fine Art 40 Hillsboro Fine Art 122 Hind Street Gallery and

Frame Makers 106 Howarth Gallery 76 HS Projects 259 ICAS - Vilas Fine Art 23 John Noott Galleries 110 Laneside Gallery 80 Leinster Gallery 135 Lincoln Joyce Fine Art 94 Magil Fine Art 135 Manser Fine Art 119 Martin Tinney Gallery 115 McNeill Gallery 23 Michael Wood Fine Art 108 Molesworth Gallery 135 Nicholas Bowlby 95 Norman Villa Gallery 136 Number Nine the Gallery

Offer Waterman & Co. 57 Oisin Art Gallery 136 Open Eye Gallery and i2 Gallery 85

Patrick Davies Contemporary Art 23 Peterborough Art House Ltd 24

Ronald Moore Fine Art Conservation 257 Sandford Gallery 138 The Scottish Gallery 86 Swan Gallery 111 Taylor Gallery 139 Taylor-Pick Fine Art 127 Vereker Picture Framing 268

VIDEO see DIGITAL. VIDEO AND FILM ART

WATERCOLOURS Abbot Hall Art Gallery 162 Abbott and Holder Ltd 30 absolutearts.com and World Wide Arts Resources Corp. 213 Access to Arts 127 ACE Award for Art in a Religious Context 388 Ackermann & Johnson Ltd Adonis Art 30 The Afton Gallery 87 Agnew's 30 Ainscough Gallery 74 Alan Kluckow Fine Art 87 Alexander Graham Munro Travel Award 389 Alexander-Morgan Gallery 88

Alms House 240 Ann Iarman 21 Anthony Reynolds Gallery Anthony Woodd Gallery 82 Apollo Gallery 127 Archipelago Art Gallery and Studio 122 Art Centre and Gallery 237 The Art House 233, 438 Art Matters Gallery 113 Art Safari 438 The Art Shop (Abergavenny) 243 The Art Shop (Darlington)

The Art Shop (London) 227 The Art Shop (Rutland) 226 The Art Shop (Trowbridge)

The Art Shop (Wanstead) The Art Shop (Whitley Bay)

The Art Shop (York) 245 Art Space Gallery (St Ives) 100 artcourses.co.uk 208

Artists' Network

Ltd 236

Bedfordshire 439 Artizana 74 Artlines 263 Artselect Ireland 127 Artstore at the Artschool

Ashmolean Museum 174 Atishoo Designs 100 Axis 214, 441 Bankside Gallery 149, 441 Bar Street Arts Ltd 245 Barbara Behan

Contemporary Art 34 Barn Gallery 128 Barry Keene Gallery 90 The Beacon 162 Beaux Arts 35 Bell Fine Art Ltd 90 Bettles Gallery 101 Bianco Nero Gallery 122

Big Blue Sky 21 Bircham Gallery 21 Bird & Davis Ltd - The Artist's Manufactory 227

Birmingham Museum and Art Gallery 190 Birties of Worcester 117 Black Cat Gallery 128 Black Mountain Gallery 113 Blackheath Gallery 35 Blue Lias Gallery 101 Bluemoon Gallery 90 Blyth's Artshop & Gallery

233 Bold Art Gallery 128 Bolton Museum, Art Gallery and Aguarium

Boundary Gallery - Agi Katz Fine Art 36 Bourne Fine Art 82 Boxfield Gallery 144

Brackendale Arts 238 Bridge Gallery 128 Brighton Museum and Art Gallery 175 Bristol's City Museum and Art Gallery 182 Broadway Modern 117 Broughton House Gallery Burton Art Gallery and Museum 182 Bury Art Gallery, Museum and Archives 163 Callan Art Supplies 246 Cambridge Open Studios

Canon Gallery 90 Canvas 120 Cass Art 228 Cat's Moustache Gallery 82 Cavanacor Gallery 129 Centre for Contemporary Arts (CCA) 169 Charleston Farmhouse and Gallery 175 Cheltenham Art Gallery & Museum 182

Cherry Art Centre 241 Chromacolour International 228 Chromos (Tunbridge Wells) Ltd 238 Clifton Gallery 102

Colart Fine Art & Graphics Ltd 228 Colin Jellicoe Gallery 75 Collins Gallery 170 The Compleat Artist 242

Coombe Gallery 102 Cooper Gallery 193 Courtauld Institute of Art Gallery 151 Courtenays Fine Art 103 Courthouse Gallery.

Ballinglen Arts Foundation 129 Courtyard Arts Limited 130 Craftsmen's Gallery 91 Cranbrook Gallery 91 Creative Shop Ltd 233 Creative World 238 Croft Gallery 103 Cupola Contemporary Art

Custom House Studios Ltd

Customs House 71, 160 Cynthia O'Connor Gallery

Daler-Rowney Ltd 238 Daler-Rowney Percy Street/ Arch One Picture Framing 228 Dalkey Arts 130

The Darryl Nantais Gallery DegreeArt.com 40, 214 Delamore Arts 104

Design and Artists Copyright Society (DACS) 445

doggerfisher 83 Dolphin House Gallery 104 Dominic Guerrini Fine Art Domino Gallery 75 Dorset County Museum **Dunamaise Arts Centre**

Duncan Campbell 41 Dyehouse Gallery 130 Elliott Gallery 104 Emer Gallery 80 Emily Tsingou Gallery 42 Enable Artists 446 England's Gallery 118 Exmouth Gallery 104 FarmiloFiumano 43 Federation of British

Artists (FBA) 426, 447 Fenton Gallery 131 fifiefofum 71 Fine Art Society Plc 44 Fine Art Surrey 215 Fisherton Mill 104 Fitzgerald Conservation

255 Flowers East 44 Forge Gallery 124 Foundling Museum 153 Framemaker (Cork) Ltd

The Framework Gallery 131, 265 Francis Iles 92 Fred Aldous Ltd 234 Frivoli 45 G.E. Kee 246 Gallagher & Turner 72

The Gallery - text+work 183 Gallery 2000 76, 266 Gallery 42 124 Gallery 52 26 The Gallery at Willesden

Green 45 Gallery Kaleidoscope 46 Gallery Oldham 164 Gallery One 46, 80 The Gallery (Dunfanaghy)

The Gallery (Masham) 124 Garter Lane Arts Centre

199 Geffrye Museum 153 George Street Gallery 92 Gilbert Collection 153 Glass and Art Gallery 72 Gorry Gallery Ltd 132 Graves Art Gallery 193 Green Door Studio 229 Greenacres 132 Greenlane Gallery 132 Greyfriars Art Shop 236 Grosmont Gallery 125 Grosvenor Museum 164 Grundy Art Gallery 165 Guild of Aviation Artists

449 Guildford House Gallery 176 Guildhall Art Gallery 153

Harewood House 103 Harris Museum and Art Gallery 165 Hazlitt Holland-Hibbert 48 Headrow Gallery 125 Healthcraft 236 Heathfield Art 93

Heaton Cooper Studio Ltd

Henry Boxer Gallery 48 The Herbert 190 Hermitage Rooms at Somerset House 154 Hertfordshire Gallery 23 Hertfordshire Graphics Ltd

Hicks Gallery 48 Highgate Fine Art 49 Hillsboro Fine Art 133 Hind Street Gallery and

Frame Makers 106 Honor Oak Gallery Ltd 49 Hunter Gallery 23 Ian Dixon GCF Bespoke Framers 266

ICAS - Vilas Fine Art 23 InkSpot 237 Island Fine Arts Ltd 93 I. Ruddock Ltd 227 Jackson's Art Supplies 230 lames Hyman Gallery 51 lames loyce House of the

Dead 133 larrold's 225 The Jerdan Gallery 85 Iill George Gallery 51 John Davies Gallery 106 John Green Fine Art 85 John Purcell Paper 230 lones Art Gallery 133 Jordan & Chard Fine Art

lorgensen Fine Art 133 Kelvingrove Art Gallery and Museum 171

Kennedy Gallery 247 Kerlin Gallery 134 Kettle's Yard 145 Killarney Art Gallery 134 Kilvert Gallery 114 King's Lynn Arts Centre

145 Kings Road Galleries 52 Kooywood Gallery 115 Laing Art Gallery 161 Lander Gallery 107 Laneside Gallery 80 Learnington Spa Art Gallery and Museum 191 Leinster Gallery 135 Lincoln Joyce Fine Art 94 Linenhall Arts Centre 201 Llewellyn Alexander (Fine Paintings) Ltd 53

London Graphic Centre 230, 251 Lowes Court Gallery 77 The Lowry 165 Lunns of Ringwood 239 Magil Fine Art 135 Major Brushes Ltd 243

Manchester Academy of Fine Arts Open 404 Manchester Art Gallery 165 Manor House Gallery 177 manorhaus 115 Marchmont Gallery and Picture Framer 85 Martin Tinney Gallery 115 Martin's Gallery 107 McNeill Gallery 23 McTague of Harrogate 126 Mercer Art Gallery 195 Michael Wood Fine Art 108 Mid Cornwall Galleries 108 Midwest 452 Molesworth Gallery 135 Montpellier Gallery 119 Narrow Space 136 National Gallery of Ireland Scotland 172

National Gallery Of National Society of Painters, Sculptors & Printmakers 453 New Art Gallery, Walsall New Craftsman 108

The New Gallery 120 Newby Hall and Gardens Nicholas Bowlby 95

Norman Villa Gallery 136 Northcote Gallery Chelsea

Number Nine the Gallery 120 Oberon Art Ltd 283 Offer Waterman & Co. 57 Oisin Art Gallery 136 On-lineGallery 216

Open Eye Gallery and i2

Gallery 85 Opus Gallery 28 Oriel 116 Owen Clark & Co. Ltd 231 Own It 217 Paintworks Ltd 231 Pallant House Gallery 178 Paperchase Products Ltd

231 Parham House 178 Patchings Art Centre 28 Paul Kane Gallery 137 Penlee House Gallery and

Museum 185 Percy House Gallery 78 Peterborough Art House Ltd 24

Piano Nobile Fine Paintings Ltd 59 and Art Gallery 185

Picturecraft Gallery Ltd 24 Plymouth City Museums Pybus Fine Arts 126 Queens Park Arts Centre The Residence 61 Revolutionary Arts Group Riverbank Arts Centre 203 Room for Art Gallery 97 Royal Exchange Art Gallery Royal Glasgow Institute of the Fine Arts 457 Royal Hibernian Academy Royal Institute of Painters in Watercolours 457

Royal Scottish Society of Painters in Watercolour Royal Society of Miniature

Painters, Sculptors and Gravers 459 Royal Society of Painter-Printmakers 459

Royal West of England Academy (RWA) 186 Royall Fine Art 97 RSA William Littlejohn Watercolour Award 409 The RWS/Sunday Times

Watercolour Competition 409 Sadler Street Gallery 100 Sally Mitchell Fine Arts 28 Sandford Gallery 138 Sarah Walker 138 Scarborough Art Gallery

196 School House Gallery 24 School of Art Gallery and Museum 189

The Scottish Gallery 86 Scottish National Portrait Gallery 173 Search Press Ltd 290

Selwyn-Smith Studio 231 Shell House Gallery 121 Shipley Art Gallery 161 Shire Hall Gallery 192 Shoreline Studio 86 Siopa Cill Rialaig Gallery 138

Six Chapel Row Contemporary Art 98 Skopelos Foundation for the Arts 410 Society for All Artists (SAA)

269, 460 Society of Botanical Artists

Society of Catholic Artists The Society of Graphic Fine Art 460

Society of Scottish Artists (SSA) 461 Society of Women Artists 461

Solomon Gallery 138 Sorcha Dallas 86 Spencer Coleman Fine Art

St Ives Society of Artists Gallery 110, 186 St John Street Gallery 28 Star Gallery 98 Start Contemporary Gallery

Stone Gallery 138 Strand Art Gallery 110 Stroud House Gallery 111 Suffolk Art Society 461 Suffolk Open Studios 462 Summer Exhibition — Royal Academy of Arts 411 Swan Gallery 111

Swan Gallery 111
T.B. & R. Jordan Lapada

73 Taylor-Pick Fine Art 127 The Teesdale Gallery 73 Terry Harrison Arts Limited

240
The The Kenny Gallery 349
Thornthwaite Galleries 78
Tib Lane Gallery 78
Tindalls the Stationers Ltd
225

The Toll House Gallery 111 Torrance Gallery 87 Towneley Hall Art Gallery & Museum 196 Tregony Gallery 111

Tregony Gallery 111
Troubadour Gallery 68
Turner Gallery 112
University College London
(UCL) Art Collections

158 University of Liverpool Art

Gallery 166 Vesey Art and Crafts 244 Visual Arts Scotland (VAS)

463
The Warwick Gallery 121
Washington Gallery 116
Watercolour Society of
Ireland's Permanent
Collection 204
Watercolour Society of

Dyfrlliw Cýmru 463 Waytemore Art Gallery 25 Wenlock Fine Art 121 West Wales Arts Centre 117 Western Light Art Gallery

Wales - Cymdeithas

139
Westgate Gallery 87
Wheatsheaf Art Shop 232
Whitelmage.com 81
Whitgift Galleries 70
Whittington Fine Art 99
Whitworth Art Gallery 167,

364 Wildwood Gallery 25 Wolseley Fine Arts Ltd 121 Wolverhampton Art Gallery Woodbine Contemporary Arts 29 Wren Gallery 99 Yarm Gallery 73 Zimmer Stewart Gallery 99

WOOD ART

absolutearts.com and World Wide Arts Resources Corp. 213 ACE Award for Art in a Religious Context 388 Art Centre and Gallery 240 The Art House 233, 438 Art Matters Gallery 113 The Art Shop (Abergavenny) 243

(Abergavenny) 243 Artists' Network Bedfordshire 439 Artizana 74 Arts & Disability Forum

422 Arts and Crafts in Architecture Awards 390 Artselect Ireland 127

Artstore at the Artschool Ltd **236** Atishoo Designs 100 Axis **214**, **441**

Barn Galleries 89
Barrett Marsden Gallery 34
Belford Craft Gallery 70
Big Blue Sky 21
Bircham Gallery 21
Bircham Gallery 5hop 248
Biscuit Factory 70
Blue Lias Gallery 101
Bridge Gallery 128

Brighton Museum and Art Gallery 175 Broughton House Gallery

Buckenham Galleries 21 Burton Art Gallery and Museum 182

Museum 182
Cambridge Open Studios
443

443
Cat's Moustache Gallery 82
Chagford Galleries 91
Chapel Gallery 102, 163
Church House Designs 102
Common Ground 426
Conservation Register 209
Contemporary Applied Arts

38
Coombe Gallery 102
Cooper Gallery 193
Courtyard Arts Limited 130

Craftsmen's Gallery 91 Creative Skills 426 Cupola Contemporary Art Ltd 123

Customs House 71, 160 Damon Bramley 270 Daniel Laurence Home &

Garden 91
Delamore Arts 104
Design and Artists
Copyright Society

(DACS) 445 Duncan Campbell 41 Elliott Gallery 104 Enable Artists 446 England's Gallery 118 Exeter College 326, 350 Fenwick Gallery 71 fifiefofum 71

Fine Art Surrey 215
Fisherton Mill – Galleries
Cafe Studios 104
Fred Aldous Ltd 234
Frink School of Figurative

Sculpture 316
Frivoli 45
Gilbert Collection 153
Glass and Art Gallery 72
Grosmont Gallery 125
Harleston Gallery 22
Harley Gallery 27, 148
Helix Arts 427
Herefordshire College of

Art & Design 330, 353 Hermitage Rooms at Somerset House 154 Hunter Gallery 23 Ian Dixon GCF Bespoke Framers 266 Impact Art 259 Impact Arts 427

Ipswich Arts Association 450 James Joyce House of the Dead 133

The Jerdan Gallery 85 Jones Art Gallery 133 The Kenny Gallery 134 Kettle's Yard 145 Kettle's Yard Open / Residency Opportunities

403
Kooywood Gallery 115
Leitrim Sculpture Centre

200 Linenhall Arts Centre 201 London Road Gallery 125 Lowes Court Gallery 77 Magil Fine Art 135
The Makers Guild in Wales

Manchester Academy of Fine Arts Open 404 Marchmont Gallery and Picture Framer 85 Michael Wood Fine Art 108 Mid Cornwall Galleries 108

Midwest 452 Mount Stuart 172 National Society of Painters, Sculptors & Printmakers 453

Nest 28 New Craftsman 108 Newby Hall and Gardens

North Wales School of Art and Design 328 Nottingham Artists' Group 298

Oberon Art Ltd 283 The Origin Gallery 137 Own It 217 Paddon & Paddon 96 Platform Gallery 78 Primrose Hill Press Ltd

Queens Park Arts Centre 456

The Residence 61
Royal British Society of
Sculptors 408, 457
Royal West of England
Academy (RWA) 186

Saffron Walden Museum 146 The Scottish Gallery 86 Shoreline Studio 86 Siopa Cill Rialaig Gallery

138
Society of Scottish Artists
(SSA) 461
Southwold Gallery 24
St Ives Society of Artists

Gallery 110, 186
St John Street Gallery 28
Suffolk Open Studios 462
Thornthwaite Galleries 78
The Toll House Gallery 111
ToolPost 240

The Troubadour Gallery 68
Tuckmill Gallery 139
The Warwick Gallery 121
Westgate Gallery 87
Zimmer Stewart Gallery 99